PICTURESQUE EXPRESSIONS:

A Thematic Dictionary

PICTURESQUE EXPRESSIONS:
A Thematic Dictionary

SECOND EDITION

Laurence Urdang
Editorial Director

Walter W. Hunsinger
Editor in Chief
Second Edition

Nancy La Roche
Editor in Chief
First Edition

Gale Research Company ● Book Tower ● Detroit, Michigan 48226

Editorial Staff:
 Editorial Director: Laurence Urdang
 Editor in Chief, Second Edition: Walter W. Hunsinger
 Editor in Chief, First Edition: Nancy LaRoche
 Managing Editor: Frank R. Abate
 Editorial Assistants: Peter M. Gross, Linda M. D. Legassie,
 Emily Mitchell, Charles F. Ruhe

Gale Research Company:
 Publisher: Frederick G. Ruffner
 Executive Vice-President/Editorial: James M. Ethridge
 Editorial Director: Dedria Bryfonski
 Director, Indexes and Dictionaries Division: Ellen T. Crowley

 Production Director: Carol Blanchard
 Production Associate: Dorothy Kalleberg
 Art Director: Arthur Chartow

Library of Congress Cataloging-in-Publication Data

Main entry under title:

Picturesque expressions.

 Includes index.
 1. English language--Terms and phrases. 2. English
language--Etymology--Dictionaries. 3. Figures of
speech--Dictionaries. I. Urdang, Laurence.
II. Hunsinger, Walter W. III. LaRoche, Nancy.
PE1689.P5 1985 423'.1 85-25274
ISBN 0-8103-1606-4

Typographic and Systems Design by Laurence Urdang Inc.

Data Processing and Composition
by Shepard Poorman Communications Corp., Indianapolis, Indiana

Printed in the United States of America

Contents

Foreword to the Second Edition

In preparing this Second Edition of *Picturesque Expressions*, the editors have expanded the coverage to include a total of more than 7,000 expressions, representing an increase of some 50% over the First Edition.

Perhaps as significant as the increased coverage are the new features that make the information within the book far more accessible. Still keeping the thematic organization of the original, the Second Edition also includes an expanded list of categories, now numbered and enhanced by fuller cross references. Supplementing this list, which is to be found in the **Table of Thematic Categories**, is a great number of synonyms that refer the user to actual categories in the book. It is hoped that these improvements will afford broader and more convenient use of the thematic structure. In the text itself, all entries have been numbered in the order that they appear (alphabetically) beneath the categories (also numbered), allowing for easy reference from the **Index** to the text. The **Index**, as before, presents a single, alphabetical listing of all entries and their variants, allowing one to use *Picturesque Expressions* in the manner of a traditional dictionary.

While the editors believe that this new edition of *Picturesque Expressions* is markedly more informative and usable than its predecessor, we realize that even **Homer sometimes nods (186.5)**, and hence encourage readers to offer their suggestions and comments on how we may continue to improve it.

<div align="right">Frank R. Abate</div>

Introduction

Our language is rife with figurative expressions whose familiarity has obscured their peculiarity. Seldom do we pause to wonder about the origins or to note the often bizarre literal implications of phrases we hear and use daily. A contest may be won **hands down** and **with flying colors**, or it may be **nip and tuck** all the way, with the outcome determined **by a nose**. Some speakers always **beat around the bush** or **go around Robin Hood's barn**, while others **pull no punches** and **call a spade a spade**. Experts **know the ropes**; greenhorns are **wet behind the ears**. **Red-letter days** may find us **on cloud nine** and **in fine fettle**; but a **bad break** can put us **out of sorts** or **under the weather**.

Many such expressions have only recently made their way into our dictionaries, where they are defined but rarely explained. Others have yet to acquire lexicographical legitimacy. *Picturesque Expressions: A Thematic Dictionary* includes more than 7,000 examples of such phrases. Entries are defined, their origins explained, and the approximate date of their appearance in the written language cited whenever possible. In some cases, the editors have acknowledged the difficulty of pinpointing the origin of a phrase with any degree of accuracy. In such instances, probable theories have been offered, or oft-repeated etymological apocrypha have again been recounted—but with plausibility questioned or authenticity disproved. Where appropriate, entries include comments on connotations or usage, as well as illustrative quotations.

Phrases found in *Picturesque Expressions* have entered the general language from a variety of specialized fields: sports, politics, games, finance, the world of entertainment, the events of history, and the customs of long ago have all contributed a wealth of words and sayings. As might be expected, the Bible and other major literary works are the source of a significant number of expressions. In dealing with this plethora of material, our principles of selection were simple in nature and two in number: variety and interest. *Picturesque Expressions* includes both newly coined and vintage phrases. The slang and the literary, the commonplace and the esoteric have been placed side by side, as have the crude and the overly nice. In selection

and treatment, the editors have tried to avoid both obscurity and obvious-
ness. Despite a few self-evident expressions whose ubiquity or colorfulness
demanded their admission, most words and phrases found on the following
pages required some degree of explanation, offered particularly interesting
origins, or simply surprised us by their longevity in the language.

The editors have tried to make *Picturesque Expressions: A Thematic Dic-*
tionary a reference work that is both useful and enjoyable. We hope it **cuts**
the mustard.

How To Use This Book

Picturesque Expressions: A Thematic Dictionary is designed to serve as a browsing book for word fanciers, as a reference book for language students, and as a resource book for writers. This unique third purpose required a unique arrangement of entries. Expressions have been grouped according to thematic categories, each of which is numbered, a system which allows for use of the book as a thesaurus.

To use *Picturesque Expressions* as a browsing book, browse.

To use *Picturesque Expressions* as a dictionary-style reference book, go first to the **Index** to find whether the phrase about which you seek information is included in the book. The **Index** lists all entries and variant forms in alphabetical order, and gives for each the number of the thematic category and of the entry where the expression can be found, e.g.:

<p style="text-align:center">go to bat for, 26.5</p>

indicating that the expression **go to bat for** is to be found at category number **26** (which is ASSISTANCE) and is the fifth entry under that category.

To use *Picturesque Expressions* as a thesaurus, determine a likely category for the concept you wish to express (e.g., BRAVERY or INNOCENCE). An alphabetical list of the 408 thematic categories, under which all entries are organized in the text, can be found in the **Table of Thematic Categories**, along with ample cross references. To facilitate greater access to this thematic organization, more than 600 synonyms (also listed in the **Table of Thematic Categories**) refer the user from terms not used as categories to related terms that are categories in *Picturesque Expressions*, under which desired information may be found. All categories and synonyms, with their cross references, are shown in the text as well.

All entries, whether single words, phrases, or sentences, follow strict letter-by-letter alphabetization, both under their thematic categories and in the **Index**; exceptions to this principle are made for initial articles (*a, an,* or *the*), the *to* of verbal infinitive forms, and all words shown within brackets or parentheses. In all cases, the editors have sought to give an entry in the form in which it is most frequently encountered. Thus, phrases usually used negatively, for instance, may begin with *not* or *neither*, e.g., **not worth a continental.** Variant forms are included within entries and are listed in italics in the **Index**.

Entries that could be considered to belong to more than one category are treated in full only once, with cross references in other categories to the full entry. For example, **catch-as-catch-can** appears fully under UNRESTRAINT, but the expression itself is also listed under the categories DISORDER and EXPEDIENCE, where the user is referred to the entry at UNRESTRAINT.

Table of
Thematic Categories

N.B.: *In the following table, both actual categories used in the text and synonyms that are references to categories are listed in one alphabetic order. Categories are numbered and set in all capital letters, while synonyms are not numbered and have only their initial letter capitalized.*

Thematic Categories

Quickness . . . See 212. INSTANTANEOUSNESS; 261. PACE;
354. SPEEDING.

See also 283. PREJUDICE.

Rage . . . See 158. FURY.

Rambunctiousness . . . See 35. BOISTEROUSNESS.

Rank . . . See 212. INSTANTANEOUSNESS; 261. PACE; 354. SPEEDING.

Rashness . . . See 187. IMPETUOUSNESS.

Rate . . . See 261. PACE.

Rawness . . . See 204. INEXPERIENCE.

See also 284. PREPARATION.

Reasonability . . . See 339. SENSIBLENESS.

See also 293. PROTEST.

Recall . . . See 305. RECOLLECTION.

See also 88. DENIAL; 325. REVERSAL; 391. VACILLATION.

Recess . . . See 317. RESPITE.

See also 70. COOPERATION.

Recklessness . . . See 187. IMPETUOUSNESS.

Recuperation . . . See 306. RECOVERY.

Refuge . . . See 330. SANCTUARY.

See also 88. DENIAL; 138. EXPULSION; 310. REJECTION.

Reiteration . . . See 311. REPETITION.

See also 1. ABANDONMENT; 88. DENIAL; 138. EXPULSION;
308. REFUSAL.

Rejoinder . . . See 322. RETORTS.

Relaxation . . . See 317. RESPITE.

Remedy . . . See 353. SOLUTION.

Renewing . . . See 319. RESUMPTION.

Renown . . . See 144. FAME.

Repercussions . . . See 64. CONSEQUENCES.

Report . . . See 206. INFORMATION.

See also 78. CRITICISM; 146. FAULTFINDING.

PICTURESQUE
EXPRESSIONS:
A Thematic Dictionary

A

1. ABANDONMENT
See also 310. REJECTION

1. brain drain Emigration of highly skilled, professional people; the loss of scientists, trained technical personnel, and university professors to another country or organization. This expression was coined by the British immediately following World War II in reference to the extensive loss of their country's professionals and skilled workers to other countries, especially to the United States, which offered higher salaries and better working conditions. However, the term soon took on a more universal aspect as many of the industrialized nations of the world increased their capacities for production and entered the game of luring top people into influential positions. Thus was born the inverse term *brain gain*.

> For the recipient countries the emigrants produce the opposite of the brain drain, a brain gain. (Andrew H. Malcolm, *The New York Times*, November 7, 1977)

2. dead as Chelsea Useless; no longer of value. Chelsea, England, was the location of a military hospital for severely injured soldiers. Since many of these soldiers had lost limbs or were otherwise disabled, they were of no further value to the military effort. According to one source, this expression was first used during the Battle of Fontenoy (1745) by a soldier whose leg had been shot off by a cannonball.

3. empty nester A parent whose children have grown and left home to be on their own. This expression alludes to the annual ritual of birds' building a nest, rearing their young in it, and then abandoning it after the young have flown away. Both terms have been in use since the early 1960s.

> Like their grown children, the empty nesters are intent on living well. (*Maclean's*, July 1976)

Some parents seize upon the opportunity to establish a new life for themselves, while others sink into a melancholy state. Psychiatrists have coined an expression for the latter condition, *empty nest syndrome*.

> We knew, of course, about the empty nest syndrome but were not perceptive enough to recognize it in ourselves. (*McCall's*, January 1973)

4. left high and dry Left in the lurch, abandoned, forsaken, rejected, deserted, stranded. The allusion is to a vessel in dry dock or grounded on the shore.

> Meanwhile, Dr. Flood's successor had been appointed, and Dr. Flood was left high and dry without preferment owing to an undoubted breach of faith on the part of Duckworth. (E. W. Hamilton, *Diary*, 1881)

Both literal and figurative uses of this expression date from the nineteenth century.

5. left in the basket Abandoned; neglected. The allusion in this phrase is to the practice of leaving abandoned babies at the doorsteps of hospitals or private homes. At one time the practice was so common that some foundling institutions actually left baskets outside their doors to receive such infants. Hence, the implication that one *left in the basket* has been rejected.

6. left in the lurch To be deserted while in difficulty; to be left in a dangerous predicament without assistance. *Lurch* is derived from the French *lourche*

'discomfited,' implying that someone left in the lurch is likely to find himself in the uncomfortable position of facing a threatening or perilous situation alone.

> The Volscians seeing themselves abandoned and left in the lurch by them, . . . quit the camp and field. (Philemon Holland, *Livy's Roman History*, 1600)

In medieval times, a *lurch* was a lurking place where poachers would hide as they placed illegal animal traps. If a poacher were deserted by his companions when the authorities approached, he was *left in the lurch*. *Lurch* was also the name of an ancient, backgammon-like game in which the objective was to leave the other players as far behind as possible. *Left in the lurch* also describes the predicament of a cribbage player whose opponent wins before the player has even "turned the corner," i.e., moved his pieces halfway around the board.

2. ABEYANCE
See also 374. TEMPORIZING

1. drop the other shoe To relieve irritation or suspense by finally completing an action; to satisfy another's curiosity. This expression is most frequently heard to mean: 'Let's get on with what we're doing!' A common anecdote is said to account for its derivation. A certain man, checking into a hotel late one evening, is warned by the night clerk that the occupant of the room below him is extremely nervous and is easily agitated by noise. Upon retiring the man inadvertently drops a shoe on the floor and, recalling the clerk's warning, quietly places his other shoe beside the first. In the middle of the night he is awakened by the nervous man who complains that he has lain awake for hours waiting for the other shoe to drop. The phrase has been in use since at least the late 1800s.

2. hanging fire Undecided, up in the air; delayed, postponed. In munitions the term describes a delay in the explosion or charge of a firearm. The phrase

was used in its figurative sense by Sir Walter Scott in 1801.

3. in a holding pattern Waiting; in a state of suspension. The phrase is aeronautical in origin, referring to:

> a specified flight track . . . which an aircraft may be required to maintain about a holding point (*Chambers's Technical Dictionary*, 1958)

before being instructed by air traffic control to land. The term has been assimilated into everyday speech to describe a condition characterized by delay or systematic dilatory tactics.

4. in cold storage Temporarily put aside; on a back burner; in a state of readiness. Cold storage is literally the storing of provisions in refrigerated compartments for protection and preservation. Figuratively this expression applies to ideas, plans, etc., which are temporarily shelved.

> When may a truth go into cold storage in the encyclopedia? and when shall it come out for battle? (William James, *Pragmatism*, 1907)

5. in limbo In abeyance; in a suspended or uncertain state, usually one between two alternatives or extremes; in a figurative place of oblivion where useless or outdated things or persons are relegated; in prison or other place of confinement. According to early Christian theological writings, the souls of the righteous who died before the time of Christ, as well as the souls of unbaptized infants who died since, were sent to Limbo (from the Latin *limbus* 'edge'), a place on the border of hell. These souls are due to be reunited with those already in heaven during the second coming of Christ.

> Into a limbo large and broad, since called
> The Paradise of Fools, to a few unknown.
> (John Milton, *Paradise Lost III*, 1667)

> The piece . . . ran for 11 nights before descending into the limbo of oblivion. (J. Knight, *Garrick*, 1894)

6. Narrowdale's noon A long delay; indefinite postponement; in the distant future. In Dovedale, Derbyshire, there is an area where, because of the depth and narrowness of the valley, the sunlight never penetrates throughout the winter months, and only for a brief interval in the late afternoon in the spring. Consequently, to delay anything until *Narrowdale's noon* is to postpone it indefinitely.

7. on ice Set aside temporarily, postponed, held in abeyance; also, assured, certain, in the bag. Ice is a common food preservative. A longer phrase, *to put on ice* 'to assure or guarantee the certainty of a given outcome,' probably stems from the same sense of ice as a preservative. *On ice* may be related conceptually to *in the bag* in that bagged game or caught fish were often placed on ice until dressed. Both meanings of *on ice* gained currency in the late 19th and early 20th centuries.

8. on the back burner See 363. SUBORDINATION.

9. on the shelf In a state of inactivity or uselessness; set beyond immediate reach, postponed. A shelf is generally used to store concrete items not being used at the moment, such as canned goods or books. By extension, abstractions such as ideas or political issues not currently being acted upon are said to be *on the shelf*. The term is also often applied to people who because of age or infirmity are thought to be useless and unproductive to society; in such a context the phrase carries the implicit criticism that persons are being treated as objects. The figurative use of the phrase appeared as early as 1575 in *The Princely Pleasures at the Court at Kenelworth* by George Gascoigne.

10. rain check A promised but usually indefinite repeat invitation, so-called from the ticket stub or separate check issued for later use when events are interrupted or postponed due to inclement weather. The literal term *rain check* may have been coined by the Detroit Base Ball Association in 1890. The current figurative meaning must have already been in wide use when the following was written:

> The idea . . . was for an actual raincheck, to be handed to those jaunty types who say they will take a raincheck when declining an invitation. (*The New Yorker*, June 1945)

11. table In U.S. parliamentary procedure this verb means to 'postpone action on':

> The amendment which was always present, which was rejected and tabled and postponed. (*The Century XXXVII*, 1873)

In British parliamentary procedure, it means to 'present for discussion':

> If any more "Old Residents" wish to be heard, they must table their names. (*Pall Mall Gazette*, Jan. 3, 1887)

This is a confusing state of affairs and must be watched carefully by those encountering the term in what may be foreign contexts.

12. treading water Waiting; marking time; in suspension. A tired swimmer rests by treading water, an action which requires a minimal amount of effort since it involves merely keeping the head above water.

3. ABILITY
See also 55. COMPETENCE

1. all is fish that comes to his net A proverbial phrase describing the luck of one for whom nothing ever goes awry because of a seemingly innate ability to turn everything to profit. Most fishermen expect to discover undesirable animals or debris in their nets, but the fortuitous fisherman's net overflows with valuable fish only. The expression is used of one with an extraordinary capacity to develop invariably successful schemes

and make consistently lucrative financial investments.

2. anchor man The man who runs or swims the last leg in a relay race; the rear man on a tug-of-war team; the newscaster who coordinates a radio broadcast or television program. In sports jargon the *anchor man* runs or swims the *anchor leg*; he is usually the fastest or strongest member of the team. In broadcasting, as with sports, the *anchor man* is usually the strongest member of a news team. His function, however, is to operate from a control center and direct the gathering and dissemination of the news from various spots about the nation or the world.

> In the fall, NBC moved David Brinkley to Washington, as permanent anchor there for the news of the nation's capital. (John Gunn, *The Americana Annual*, 1978)

In the sports world the term *anchor man* has been in use since the late 1800s; in broadcasting it came into use in the 1930s and was shortened to *anchor* in 1956, thus eliminating any sexual identification.

3. double in brass To obtain income from more than one source; to be versatile; to serve two purposes; to play two roles; to be capable of doing more than one thing well. This phrase probably had its genesis in the theatrical world, most likely the circus, where it was often necessary for a performer to be able to play a musical instrument in the band along with his regular duties in the ring, *in brass* being short for *in the brass section*. Another practice common to the circus, which may have contributed to the popularity of the term, was to have some performers march along with the band and fake playing in order to make the band appear larger. Today the term is only heard figuratively to indicate doubling up.

4. get the hang of To get the knack; to get the significance; to be able to do; to come to understand the operation of something. This American expression, in common use since at least 1839, derives its meaning from a colloquial application of the word *hang*, 'familiar knowledge' or 'knack,' which, in turn, has its roots in the craft of the tailor or seamstress; one must get the proper hang of coats, skirts, drapes, curtains to satisfy the customer.

> Suggs lost his money and his horse, but then he hadn't got the hang of the game. (Johnson J. Hooper, *Simon Suggs*, 1845)

5. green thumb An above-average ability to grow plants; the knack of successfully cultivating and propagating plants. This phrase and its variant *green fingers* date from the early 1900s. A *green thumb* is like a magic touch which encourages rapid growth. Although the phrase is usually heard in the context of gardening, it can apply to any innate ability to make things grow and prosper.

> "Success with money is often accidental," she sighed. "One needs 'green fingers' to make it grow." (*Daily Telegraph*, April 26, 1969)

6. jack of all trades This expression refers to a person who can turn his hand to almost any trade but is not especially proficient in any one of them. The term is often used contemptuously to indicate one who pretends to be knowledgeable in many areas, one with a smattering of learning, a pretender. The phrase has been in common use since at least 1618.

> "How comes it that I am so unlucky? Jack of all trades and master of none," said Goodenough with a sneer. (Maria Edgeworth, *Popular Tales*, 1800)

7. keep [one's] hand in To keep in practice, to dabble in, to maintain one's proficiency in a certain activity. The expression usually implies sporadic or intermittent interest and activity.

8. know [one's] beans See 224. KNOWLEDGE.

9. lynx-eyed Keen of vision; having acute sight; sharp-eyed; having the ability to distinguish objects at a great distance. This expression is derived from the mythological figure Lynceus, a member of Jason's crew on the Argo, who had vision so sharp that he could see precious metals buried deep in the earth. It has erroneously been associated with the cat-like animal, the lynx, which has, in fact, rather poor vision.

> The lynx-eyed agent of some loan society. (*The Nineteenth Century*, May 1883)

10. not just another pretty face This expression, which came into greater prominence as a favorite catchphrase of the women's liberation movement, is a warning or putdown directed at men who view women merely as sexual objects, without any appreciation for their intellectual potential or ability. In essence the woman using this phrase is telling her male antagonist that she has ability and that her looks are not part of her qualifications. It is also used among men in speaking of women.

> "She's not just a pretty face," Philpott went on, "she's clever, too." (Miles Tripp, *Woman at Risk*, 1974)

In recent years the tables have been turned, and women often apply the term jocularly to men. It has also received broader metaphoric currency in reference, for example, to a piece of machinery that has been attractively designed yet, perhaps surprisingly, is able to accomplish its work effectively.

11. play a straight bat To know what you are doing, to know your business. This Briticism comes from the game of cricket.

12. to the manner born See STATUS.

13. wear different hats To perform more than one function simultaneously; to play two or more roles; to fulfill two positions concurrently. This expression alludes to someone who can perform two or more responsible duties while operating from the same position, with reference to the practice of wearing a distinctive hat that indicates one's occupation. A common variant is *wear two hats*.

> Except for Chairman Wheeler, each of these men wears two hats: one as topbraid officer of his service, the other as a member of the Joint Chiefs. (*Time*, February 5, 1965)

Abnormality . . .
See 386. UNNATURALNESS

4. ABSENCE

1. eighty-six Nothing left, no more, no, nix; from American restaurant argot for being sold out of a certain dish. The term was apparently chosen because it rhymes with *nix*, slang for 'nothing' or 'no.' Although this expression is still most commonly heard among restaurant workers, it has recently gained popularity in general slang.

2. gone with the wind Said of people, objects, or events that have passed and left no indication of their having once existed. This expression has been in the common vocabulary since the publication of Margaret Mitchell's celebrated best-selling novel *Gone with the Wind* in 1936, where the phrase was employed to characterize the permanent loss of the ante-bellum Southern culture and manners. The popularity of the phrase was reinforced when the motion picture of the same name was released in 1939 with great fanfare and ballyhoo; it has continued to enjoy popularity. Although the essence of the expression's connotation is found in a passage from Psalms:

> The wind passeth over it, and it is gone. (103:16)

the inspiration for the book's title actually came from Ernest Dowson's poem, *Non Sum Qualis Eram Bonae Sub Regno Cynarae* (1896).

> I have forgot much, Cynara! gone with the wind,
> Flung roses, roses riotously with the throng,

Dancing, to put thy pale lost lilies out of mind.

3. missing link The absent or unknown integral step in a progression; the lacking, unifying component of a series. This expression probably originated as an allusion to a chain that is minus a vital part. The phrase is most often applied to the unknown connection in the anthropological progression of man's theoretical evolution from the lower primates.

> Albertus [Magnus] made the first attempt to bridge the gap between man and the rest of the animal world by means of a kind of "missing link" in the shape of the pygmy and the ape. (R. and D. Morris, *Men and Apes*, 1966)

4. neither hide nor hair Nothing at all, not a trace. *Hide* here of course means 'skin.' The expression *in hide and hair*, in the language since the 14th century but now rarely heard, has an opposite meaning—'wholly, entirely.' The oldest citation for *neither hide nor hair* shows that more than a century ago it was used much the same as it most frequently is today: in a negative construction following *see*. However, contemporary usage usually limits its application to humans or animals—literal possessors of hide and hair.

> I haven't seen hide nor hair of the piece ever since. (Josiah G. Holland, *The Bay-path*, 1857)

5. play hookey To take off from school or work without permission; to be truant. This American expression from the mid 1800s seemingly has its origin in the verb *hook*, which according to *Webster's Third* means 'make off' or 'clear out.' The term was a favorite of Mark Twain, and apparently his writings helped to popularize its use.

> Whenever I got uncommon tired I played hookey, and the hiding I got next day done me good and cheered me up. (Mark Twain, *Adventures of Huckleberry Finn*, 1885)

6. scarce as hen's teeth Very scarce, nonexistent; rarely occurring. This Americanism dating from the mid 1800s is a superlative of 'scarce,' since a hen has no teeth.

> North of Mason and Dixon's line, colored county officials are scarce as hen's teeth. (*Congressional Record,* October 2, 1893)

This expression and the variant *rare as hen's teeth* are still in use.

> Stoppages are as rare as hen's teeth. (*The Times,* June 12, 1969)

7. sport [one's] oak To signify that one is not in his room; to indicate that one does not desire visitors. English college dormitories were usually provided with two doors to each room, an inner door and a sturdier outer door, made of oak. It became the custom to close the outer door as a sign that one didn't care to have visitors or to be intruded upon; hence, the figurative implication of this term. The phrase has been current in England since at least 1785.

> Your oak was sported and you were not at home to anybody. (Walter Besant, *The Demoniac*, 1890)

8. sweet Fanny Adams Nothing; usually used in reference to the failure of a potentially promising enterprise or occasion. Fanny Adams was a woman who was brutally murdered in 1810. Her hacked and mutilated body was thrown into a river. Because of the gruesomeness of the crime and the dour humor of the British Navy, Fanny Adams became the nickname for canned mutton served to the sailors. The implication is clear. Over the years, *Fanny Adams* became *sweet Fanny Adams*, or *Sweet F. A.*, with the abbreviated form serving as a popular euphemism for an obvious obscenity.

Abstinence . . .
See 373. TEMPERANCE

5. ABUNDANCE

See also 291. PROSPEROUSNESS;
366. SUPERFLUOUSNESS

1. at rack and manger In extravagance; reckless abundance; in the midst of plenty; wanting for nothing. This British expression, dating from at least 1378, alludes to the life of domestic beasts. They stand in a rack, protected from the elements, have their food placed before them in a manger, and never have to give any thought to the acquisition of their own provisions. *Live at rack and manger*, a variant, means 'to live without worry about the future.'

John Lackland . . . tearing out the bowels of St. Edmundsbury Convent . . . by living at rack and manger there. (Thomas Carlyle, *Reminiscences*, 1866)

2. cloud of witnesses A great number of observers; a host of onlookers; a multitude who will swear to what they saw. This expression is directly attributable to the Bible; it appears more than once in the King James version, but appears first in Hebrews 12:1:

Seeing we also are compassed about with so great a cloud of witnesses.

3. corn in Egypt Anything in abundance that can be purchased from a supplier; something waiting for a buyer to come along. This phrase has its origin in the Old Testament:

And he said, Behold, I have heard that there is corn in Egypt; get you down thither, and buy for us from thence; that we may live, and not die. (Genesis 42:2)

The original innocence of the Biblical expression has given way to a more sardonic application in modern usage: the product is available if the money is plentiful.

There is corn in Egypt while there is cash in Leadenhall. (Charles Lamb, *Letter*, c. 1830)

4. fat city An extremely satisfactory condition; a comfortable situation; sitting pretty. *Fat* in this American slang expression is obvious in its reference to abundance or plenty. *City* seemingly derives from the post-World War II use of *-sville*, a slang suffix added for emphasis, as in *dullsville*, meaning 'extremely dull.' *City* appeared in the early 1960s, and was popularized by a New York City propaganda campaign to promote tourism, in which the city advertised itself as *fun city*.

"I've put it behind me," Stockdale says of his long ordeal. "I think of it as just another tour of duty. In so many ways I'm in fat city." (*Newsweek*, February 25, 1974)

5. forty acres and a mule An illusion of plenty; an optimistic expectancy of future blessings; pie in the sky; a dream or fantasy of a future without want. On January 16, 1865 General William Tecumseh Sherman of the United States Army gave the following special field order.

Every family shall have a plot of not more than forty acres of tillable ground.

It was probably this order which was responsible for many Southern Blacks believing that upon their emancipation after the Civil War that their masters' plantations would be confiscated and divided among them. From about 1862 the fantasy had been *ten acres and a mule*, which undoubtedly accounted for the *mule* in the new version, *forty acres and a mule*. In England a similar cry of hopefulness arose during the 1880s, *three acres and a cow*. See also **three acres and a cow, below.**

6. hand over fist See 261. PACE.

7. happy hunting ground See 262. PARADISE.

8. land of milk and honey See 262. PARADISE.

9. loaves and fishes See 240. MONEY.

10. my cup runneth over Any state of abundance, profusion, or excess; a run of luck or good fortune. This phrase from the well-known Twenty-third Psalm ("The Lord is my shepherd") is now commonly used in a secular sense, though in its original context it referred to the plentitude of God's goodness and spiritual gifts.

> Thou preparest a table before me in
> the presence of mine enemies:
> Thou hast anointed my head with oil;
> My cup runneth over.
> Surely goodness and mercy shall
> follow me all the days of my life;
> And I shall dwell in the house of the
> Lord for ever.
> (Psalms 23:5-6)

11. spring up like mushrooms To proliferate; to appear in great quantity all at once. Mushrooms, a type of fungus, grow rapidly and abundantly following the slightest rainfall.

12. three acres and a cow Excessive optimism; an illusion of a future free from want; pie in the sky. Daniel Defoe had suggested as early as 1724 in *Tour through the Whole Islands of Great Britain* that each farmer should be allotted at least *three acres and a cow*. That may have been the source of the phrase, but it became current from a song popular in the 1880s. At any event, Jesse Collings, a leader of the Liberal party, picked up the phrase and used it as a campaign slogan (1887–1889). The phrase became so closely associated with Collings and his radical agrarian politics that he became known as *Three Acres and a Cow Collings*.

> An honest man who had worked long and well should have "three acres and a cow." (Dean Hole, *Then and Now*, 1902)

13. widow's cruse A seemingly inexhaustible supply; a meager supply of food that is, through clever management, made to last through several meals. In II Kings 4, Elisha comes to the rescue of a destitute widow who is about to lose her two sons as bondmen to her dead husband's creditor. Upon learning that the only thing she has in her house is a small amount of oil, he tells her to gather all the empty containers she can find in the village and bring them to her house. He then tells her to start pouring the oil from the cruse into the containers. Her small supply of oil miraculously multiplies as she pours, allowing her to fill all the containers, to sell the oil to pay off her debt, and to save her sons.

Academia . . .
 See 331. SCHOLARLINESS

Acceptance . . . See 23. APPROVAL

Acclaim . . .
 See 52. COMMENDATION

6. ACCOMPLISHMENT
 See also 58. COMPLETION;
 365. SUCCESS

1. feather in [one's] cap A distinction or honor, a noteworthy achievement. In the 14th century, a soldier added a feather to his cap for each enemy soldier he had killed. A similar practice existed among the American Indians who added feathers to their headdress. Among hunters, it was a common practice (and still is in Scotland and Wales) to pluck a feather from the first kill of the season and display it proudly in one's hunting cap. By the mid 1600s, the feather had lost much of its "killing" significance while retaining its symbolic value as a sign of bravery and honor. At that time, many British noblemen considered themselves to be men of distinction by virtue of their birthright and frequently wore feathers as a somewhat garish addition to their attire. Since men, regardless of virility or pugilistic prowess, no longer wear feathers as badges of accomplishment, in contemporary usage the expression is exclusively figurative.

He wore a feather in his cap, and wagg'd it too often. (Thomas Fuller, *The Church History of Belgium*, 1655)

2. grand slam Win everything; defeat all opposition thoroughly; a clean sweep. This expression has come to indicate a specific achievement in many fields of endeavor. In baseball, it is a home run with three men on base; in bridge or whist, it is the winning of all the tricks in one hand; in tennis or golf, it is the winning of certain pre-designated championships in one season. Originating in the rules of card playing, the term has become common in the world of business where it indicates the successful completion of an important deal.

In January, champion tennis players gather at the underside of the globe to contest the first jewel of the famed Grand Slam (the Australian, French, Wimbledon, and U. S. titles). (Eugene Scott, *Tennis: Game of Motion*, 1973)

3. hat trick A triple accomplishment; a streak of three successful undertakings. This (originally) British expression originated as cricket slang for the taking of three wickets, a feat for which the triumphant player was awarded a tall hat. The term's current figurative meaning is extended to include any triple achievements or victories.

British aircraft constructors are hoping that an official attempt will shortly be made on the world's height record, and the "hat trick" accomplished by the annexation of all three of the records which really matter in aviation. (*Statesman*, December 1931)

4. money player This American colloquialism has its roots in the sports arena, where a *money player* is one who can be counted on to perform his best under pressure. According to the October 1933 issue of *American Speech*, the original connotation of this term was one who participated only for the money and had no real fighting spirit. However, in today's sports lingo, the expression implies one who comes through when the chips are down, one who performs at his best when the most is at stake. By extension the term has become a part of the common vocabulary. A related term is *pressure player*.

5. notch on [one's] gun A tally of those killed by the gunbearer; a symbol of impending danger; a warning to others; a mark of achievement. The imposition of some mark, usually upon a weapon, to indicate kills is a practice as old as man himself. Ancient warriors notched their sword handles, or collected scalps or ears, or put feathers in their bonnets to display to the world their prowess as killers. Modern man paints bombs on airplanes or tanks or notches his knife or gun handle to demonstrate his accomplishments as a killer. The expression has come to be used figuratively of any symbol of accomplishment.

Accord . . . See 16. **AGREEMENT**

Accuracy . . . See 73. **CORRECTNESS**; 280. **PRECISION**

Accusation . . .
See 146. **FAULTFINDING**

Acquiescence . . . See 85. **DEFERENCE**; 316. **RESIGNATION**; 362. **SUBMISSIVENESS**

Activity . . .
See 202. **INDUSTRIOUSNESS**

7. ADAPTATION

1. act the part To demonstrate, especially in an exaggerated manner, the characteristics accompanying a role; to effect certain expected qualities. This colloquial phrase, usually expressed with derogatory intent, indicates that a person has achieved a different station in

life and is trying to personify the qualities expected of him in his new position.

A common variant is *play the part*. Both expressions have been in use since about 1600.

> Perhaps one never seems so much at one's ease as when one has to play a part. (Oscar Wilde, *The Picture of Dorian Gray*, 1891)

2. bow the knee to Baal Follow the fashion; satisfy one's selfish desires; do in Rome as the Romans do. Baal was the chief male deity of several ancient Semitic nations, among them the Phoenicians and Canaanites. By transference, in this expression he represents the high false gods of fashion, those designers who set the style which so many blindly follow. The implication in this phrase is that in order to be respected and admired by others, one must conform to the latest fashion trends.

3. cheveril conscience A conscience that stretches easily; an immoral conscience.

> Cheveril consciences, which will stretch any way for advantage. (Thomas Fuller, *Worthies of England*, 1662)

This British expression, which dates from the Middle Ages, has its genesis in the word *cheveril*, sometimes spelled *cheverel*. The allusion here is to the cheveril, a wild goat or kid. Cheveril leather is noted for its capacity for being stretched; in fact, a fine cheveril leather glove will stretch enough to hold two hands.

4. cut the coat according to the cloth To live within one's means; to adapt oneself to a situation. The implication is that given only enough cloth to make a waistcoat or vest, one cannot make a full-length coat. Thus, someone with limited funds should be prudent about expenses and not attempt to live beyond his means. Though first cited in the 16th century, the expression was already in common use at the time.

> I shall cut my coat after the cloth. (John Heywood, *Dialogue Containing Proverbs and Epigrams*, 1562)

5. do in Rome as the Romans do Adapt oneself to local customs and manners; follow the fashion or the crowd. Apparently this expression derives from the advice St. Ambrose offered St. Augustine. In his *Epistle to Januarius* (387), St. Augustine discloses:

> My mother having joined me at Milan, found that the church there did not fast on Saturdays as at Rome, and was at a loss what to do. So I consulted St. Ambrose . . . who replied: If you are in Rome, live after the Roman fashion; if you are elsewhere live as they do there.

The expression has often been used as an excuse for altering one's ways. The Spanish ambassador to the court of Henry VIII used it to explain his adoption of the Anglican religion. George Bernard Shaw in a radio address in New York on July 11, 1932, used another common variant:

> 'When in Rome do as the Romans do' is the surest road to success.

The version used by Shaw is often shortened to *when in Rome . . .* , with the balance unstated but implied. A related term indicating adaptation to circumstances is *go with the current*.

6. stretch [one's] legs according to the coverlet To live within one's means; to adjust to a situation, especially a financial one. This uncommon expression alludes to the way in which one must conform to an undersized bed, being sure not to extend himself beyond the bounds of his coverlet, or bedspread. Figuratively, the expression implies that one must be certain not to overextend himself beyond his resources.

7. trim [one's] sails To reshape or alter one's opinion, position, or policy to fit the situation; to adapt oneself to the circumstances or the times. To *trim the sails* was originally a nautical expression

meaning to adjust the sails of a ship according to the direction of the wind and the course of the vessel in order to gain the greatest possible advantage.

Addition . . .
See 28. AUGMENTATION

Adjustment . . . See 7. ADAPTATION

Adolescence . . . See 407. YOUTH

Adultery . . . See 205. INFIDELITY

8. ADVANCEMENT

1. a new wrinkle An innovation, a new development; an improved technique or method, or a hint or suggestion regarding one; sometimes, a new development that acts as a hindrance, snag, or further complexity. Precisely how *wrinkle* took on the colloquial meaning of *clever trick* some time in the 1800s remains unclear, but it is this usage from which the above current meanings derive. *Webster's Third* cites P. J. C. Friedlander's use of the term:

> . . . a new wrinkle whereby the exhaust gases are used to spin small turbines geared direct to the propeller shaft.

2. quantum leap A sudden enormous step forward; an unexpected discovery or breakthrough. This expression is a term from physics for the jumping of an electron from one energy state to another. As used figuratively, *quantum leap* denotes a great and sudden change in a positive direction, often with far-reaching consequences.

> The ability of marine technology to take "quantum" leaps in innovation means that a laissez-faire approach to the ocean mineral resources can no longer be tolerated. (Tony Loftas, *New Scientist*, December 1970)

9. ADVANTAGE

See also 258. OUTDOING

1. ace in the hole A trump card; something advantageous held in reserve until needed, and especially until needed to turn apparent failure into actual success. In stud poker a hole card is the card dealt face down in the first round. Since an ace is the highest and most valuable card, the player who receives an ace as his hole card has a decided advantage.

2. beat to the punch To get the drop on, to beat to the draw, to be a step ahead; to gain the advantage through quickness and alertness; to steal someone's thunder; to win at oneupmanship. *Webster's Third* cites W. J. Reilly's use of this boxing metaphor:

> . . . beats you to the conversational punch by having his say before you have a chance to open your mouth.

3. be on a good wicket To be in someone's favor; to be in an advantageous position. This Briticism comes from the game of cricket and carries a sense contrary to that of the more commonly heard *sticky wicket*.

4. catch a weasel asleep To gain an advantage over something due to its inattentiveness. A sleeping animal is an easy target. This expression is an older equivalent of the current *catch someone napping*.

5. catch napping To acquire an advantage over someone through his inattentiveness. A sleeping person or animal is easily taken off guard by another person or predator. As used in the phrase, however, *napping* does not carry its literal meaning of 'sleeping.' It means simply 'unawares, off guard, inattentive.'

6. get the drop on To have the advantage over someone; to be in a superior, controlling position, such that one cannot be taken unawares. Most sources cite the following quotation from Alexander K. McClure's *Three Thousand Miles through the Rocky Mountains* (1869) as

the first use of this colloquial American expression.

> So expert is he with his faithful pistol that the most scientific of rogues have repeatedly attempted in vain to "get the drop" on him.

This original use referring exclusively to a fast draw may be related to *at the drop of a hat*. (See 301. READINESS.) The idea of covering a person with a gun before he can draw his own soon gave rise to the current figurative use.

> At any rate, we will not let Arcturus get the drop on the reading public. (*Texas Siftings*, August, 1888)

7. get the weather gage of To obtain the advantage over; to get the better of. In the sea battles of bygone days, a ship on the weather gage, or windward, side of an adversary's vessel would have the advantage of being better able to maneuver into a strategic position. The expression's principal use still usually concerns war and fighting, although not necessarily of a maritime nature.

> He had got the weather gage of them, and for us to run down to them would be to run ourselves into the lion's mouth. (John Mackey Wilson, *Tales of the Borders*, 1835–40)

8. get the wood on [someone] To gain an advantage over; someone; to hold a past indiscretion over someone's head. This Australian slang term, dating from about 1920, is probably derived as a rhyming slang term from *get the goods on*. A variant is *have the wood on*.

9. Glaucus swap A one-sided trade; a trade wherein one person receives something of much greater value. The origin of this ancient expression is found in an incident recounted in Homer's *Iliad*. Glaucus, an ally of King Priam of Troy, meets Diomedes, a Greek warrior, on the battlefield. Diomedes immediately reminds Glaucus that they have ancient ties of friendship through their families and suggests that they exchange armor as a symbol of that friendship. Glaucus

agrees and trades his armor of gold for Diomedes' armor of brass. Homer wryly comments:

> Zeus, son of Cronos, took from Glaucus his wits. (*Iliad* VI, 234)

10. go in with good cards To have reason to expect success; to anticipate triumph. This expression is derived from a card player's foreknowledge of victory upon being dealt an exemplary hand. The phrase maintains limited use in the United States and Great Britain.

> They went in upon far better Cards to overthrow King Henry, than King Henry had to overthrow King Richard. (Francis Bacon, *Henry VII*, 1622)

11. have the ball at [one's] feet To be in a strategically advantageous position; to be in the driver's seat. In the British game of football (American soccer), whoever has the ball at his feet has the power to call the shots. This expression can be used in regard to politics, personal relations, or any area in which there are plays for power as one person or group attempts to gain control.

> We have the ball at our feet, and if the Government will allow us . . . the rebellion will be crushed. (W. E. Auckland, *Journal and Correspondence*, 1788–98)

12. have the upper hand Be in a superior position; have mastery over; in the catbird seat. The 17th-century translators of the King James version of the Bible made use of this term in Psalms 9:19:

> Up, Lord, and let not man have the upper hand.

The term is usually attributed to a rural game of chance played in 16th-century England. In a process similar to that used by American children when determining who is to bat first in a game of scrub or one old cat, two men wrapped their hands progressively higher about a stick until one had the upper hand. That man then had to throw the stick a predetermined distance to win the wager.

13. inside track An advantageous position granting one an edge over others; a favorable status; influence, or the power to secure favors. In racing, the *inside track* 'inner side of a curved track' is the shortest route. By the mid 19th century, this Americanism was used figuratively to refer to any position of advantage.

> When a woman knows where she stands, and has the inside track, . . . the man has no show whatever. (Atherton, *Perch of Devil*, 1914)

14. in the catbird seat In an advantageous position or condition; ahead of the game; also *sitting in the catbird seat*. This U.S. slang expression, dating at least from 1942, was popularized by baseball announcer "Red" Barber during his 1945–55 radio broadcasts of the Brooklyn Dodgers baseball games.

15. keep one jump ahead To advance or increase before someone or something else and thus maintain an advantageous position or superior status. The exact origin of this 20th-century expression is unknown; it may come from the game of checkers in which one player *jumps* 'takes possession of' another player's checkers—literally advancing one checker in front of another one—in order to win the game.

> That would allow the Government to permit wage rises to keep one jump ahead of prices. (*Sun*, January 6, 1973)

16. sitting pretty In a favorable situation or condition; at an advantage; successful; well-to-do; well-off; set. This expression has been in use since at least the 1920s.

17. steal a march on To gain an advantage over, to get the jump on, to be a step ahead of. This expression originally had to do with the stealthy movement of troops without the enemy's knowledge. It still retains connotations of furtiveness or secrecy.

> Happening to awake earlier than usual, he stole a march on his nurses,

and . . . walked out and tottered into the jail. (Charles Reade, *It Is Never Too Late To Mend*, 1856)

18. two heads are better than one Advice from others is often valuable; cooperation improves one's chances of success. This Biblical expression of the advantages of mutual fellowship has remained unchanged in its connotation through the ages. *Brewer's Dictionary of Phrase and Fable* remarks:

> . . . to the saying are sometimes added the words—*or why do folks marry?*

10. ADVERSITY

1. bad break An unfortunate piece of luck; bad luck. This American slang term is conjectured to have come from billiards, where to make a bad break is to cause the racked billiard balls to scatter in such a way that further shots are difficult. This meaning dates from the late 19th century and, though still occasionally encountered, has been largely displaced by the currency of *break* meaning 'a stroke of luck or fortune.'

2. bad cess Bad luck; a curse; evil. This term is taken from an old Irish curse, *bad cess to you*, meaning 'evil befall you.' The origin of *cess* is uncertain, but it may be a contraction of either *assessment*, a tax, or *success*, in the sense of 'luck,' hence "bad luck to you." The term has been in use since the early 1800s.

> Bad cess to you, can't you say what you're bid. (Samuel Lover, *Legends and Stories of Ireland*, 1831)

A possibly related term, *out of all cess*, meaning 'beyond all estimation or measurement,' appears as early as 1598 in Shakespeare's *Henry IV, Part I*.

> Poor jade, is wrung in the withers out of all cess. (II, i)

3. a bitter pill to swallow Something unpleasant to accept; something difficult to tolerate; an unexpected setback. The allusion here is to the sometimes very

disagreeable taste of medicine in the form of a pill that one must take in order to recover from an illness or injury. In use since at least the 1500s, the expression is restricted to figurative use.

> It was a bitter pill for the king and Lord Mansfield to swallow. (Horace Walpole, *Last Journals*, 1779)

4. black ox has trod on [one's] foot Said of a person who has been the victim of misfortune or adversity. This proverb, in use since 1546, is rarely heard today.

5. blood, sweat, and tears See 132. EXERTION.

6. cross to bear See 40. BURDEN.

7. crown of thorns Any excruciatingly painful hardship, tribulation, trial, suffering, etc.; a grievous and enduring wound. This expression refers to the crown which soldiers mockingly placed on Jesus' head before his crucifixion.

> And they platted a crown of thorns and put it upon his head, and a reed in his right hand; and they kneeled down before him, and mocked him, saying, Hail, King of the Jews! (Matthew 27:29)

8. dead end kids Children from the slums who have little hope for the future; ghetto children, especially those from New York City's lower East Side during the 1920s and 1930s. Born into the poverty-stricken slums, children so described seem to have early in life reached a *dead end*, a point from which progress cannot easily be made. Popularized by the acting group known as the *Dead End Kids*, who appeared in the play *Dead End* on Broadway in 1935 and the motion picture of the same name in 1937, the phrase came to signify any group of kids from city slums. The *Dead End Kids* made a series of movies between 1937 and 1939, after which they broke up into two acting groups, known as *The Bowery Boys* and *The Little Tough Guys*.

9. get [one's] lumps To be harshly treated or abused; to be punished, chastised, or criticized; to be physically beaten or harassed. In this expression a lump is literally a swelling on the body caused by physical violence.

> Their greatest fun is to see a cop getting his lumps. (H. Lee in *Pageant*, April, 1951)

This 20th century American slang expression is frequently used to describe nonphysical abuse and punishment or unpleasant, painful experiences.

> Now I take my lumps, he thought. Maybe for not satisfying Mary. (Bernard Malamud, *Tenants*, 1971)

10. lead a dog's life To live a miserable, servile life; to lead a wretched, harassed existence. This expression, which dates from the 16th century, apparently refers to the abuses heaped on the less fortunate of man's best friends.

> She . . . domineers like the devil: O Lord, I lead the life of a dog. (Samuel Foote, *The Mayor of Garret*, 1764)

11. most unkindest cut of all The cruelest of cruel treatment; the last and most painful of a series of hurts; used especially in reference to betrayal by a friend. The *cut* of the original expression referred to one of the rents in Julius Caesar's mantle, specifically that made by his dearest friend Brutus. The line is from Marc Antony's famous oration over the dead Caesar's body.

> This was the most unkindest cut of all,
> For when the noble Caesar saw him stab,
> Ingratitude, more strong than traitors' arms,
> Quite vanquished him.
> (Shakespeare, *Julius Caesar*, III,ii)

Today the phrase is most often found in contexts where *cut* means 'slight, snub, insult,' though the idea that the hurt involves a friend's rejection is usually retained. Other uses play on other mean-

ings of *cut,* such as deletions from a manuscript or bowdlerization of a text.

12. no butter sticks to [one's] bread This phrase suggests that everything that one attempts goes awry; that in spite of one's attempts to get ahead in the world, he never succeeds. It dates from the 17th century, and the image evoked is one of pitiable misfortune.

> But now I fear it will be said,
> No butter sticks upon his bread.
> (Jonathan Swift, *A Pastoral Dialogue,* 1727)

13. run the gauntlet To be subjected to attack from all sides; to be made to endure abusive treatment or severe criticism. Running the gauntlet was a form of military punishment in which the offender was compelled to run between two rows of men armed with whips or scourges, each of whom struck him a painful blow. The *gauntlet* (or *gantlet*) of the expression bears no relationship to *gauntlet* 'mailed glove,' but is a corruption of *gantlope,* from the Swedish *gatlopp* 'a running lane.' The literal expression came into English during the Thirty Years' War (1618–1648) and the phrase was used figuratively shortly thereafter.

> To print, is to run the gantlet, and to expose ones self to the tongues strapado. (Joseph Glanvill, "Preface" *The Vanity of Dogmatizing,* 1661)

14. Sejan horse A possession that is fatal to its owner; a symbol of extremely bad luck. This expression refers to the horse of a certain Roman, Gnaeus Sejus. A handsome bay, the horse supposedly brought death to whoever owned it. Sejus himself was put to death by Marc Antony; Cornelius Dolabella, the next owner, was killed in battle; Caius Cassius, the third owner, with the help of a friend killed himself after the Battle of Phillipi, and the last known owner, Marc Antony, committed suicide after the Battle of Actium. Thus, four Roman nobles supposedly were victims of the horse's mysterious power. No one re-

corded what eventually happened to the horse, but he lives on as a symbol of misfortune.

15. shoot a robin Have a streak of bad luck; suffer a continuing string of business or personal setbacks. This British slang expression, a jocular allusion to Coleridge's Ancient Mariner's shooting of the albatross, is said of one who seems to have had the world turn against him suddenly and for no apparent reason. The allusion is probably to the shooting of robin redbreast in the old nursery rhyme, and the accompanying bad luck for destroying such a pleasant songster.

16. slings and arrows See 78. CRITICISM.

17. through the mill Through much suffering, through many hardships and difficulties, through an ordeal or trial. The allusion is to the way a mill grinds whole grains of wheat into fine flour.

> His hardships were never excessive; they did not affect his health or touch his spirits; probably he is in every way a better man for having . . . "gone through the mill." (G. Gissing, *The Private Papers of H. Ryecroft,* 1903)

Use of the expression dates from the 19th century.

18. through the wringer Through an emotionally or physically exhausting experience.

> Workers, who have already undergone two loyalty or security investigations . . . must go through the wringer a third time. (Elmer Davis, as quoted in *Webster's Third*)

A wringer is an apparatus for squeezing out excess water or liquid, as from clothes after washing.

11. ADVICE

1. brain trust A group of advisors; a group of college teachers who acted as an advisory board to President Franklin D. Roosevelt. Although the origin of this term is generally attributed to James Kieran, a *New York Times* reporter,

there are earlier instances of its use. When President Franklin Delano Roosevelt assembled a group of Columbia University professors, experts in economics and political science, to assist him with the reins of government, Kieran referred to them in his column as FDR's *brains trust.* Shortly thereafter, the *brains* was shortened to *brain,* and on September 2, 1933, *Newsweek* printed:

> The President's Brain Trust, a little band of intellectuals, sat at the center of action as similar bands have done in revolutions of the past.

Apparently the first written use of the term was in a 1910 *Saturday Evening Post* article when a George Fitch used the term *brain trust* to refer to the faculty of "good old Siwash."

2. don't let anyone sell you a wooden nutmeg This bit of advice to the unwary to be on the lookout for fraudulent sales schemes derives from the 19th-century practice of selling imitation nutmegs made of wood.

> A Yankee mixes a certain number of wooden nutmegs, which cost him 1–4 cents apiece, with a quantity of real nutmegs, worth 4 cents apiece, and sells the whole assortment for $44 . . . and gains $3.75 by the fraud.
> (Hill, *Elements of Algebra,* 1859)

This practice was supposedly prevalent in Connecticut, "The Nutmeg State," although whether the sellers were itinerant peddlers or natives of Connecticut is debatable.

3. don't stir fire with a sword Don't add fuel to the fire; don't stir up a hornets' nest. This precept of Pythagoras, dating to the 6th century B.C., implies that one shouldn't irritate an inflamed person with sharp words nor agitate an explosive situation with displays of hostility. Horace, the Roman poet, picked up on the Pythagorean idea in his *Satires:*

> To your folly add bloodshed, and stir the fire with the sword.
> (II. 3.276)

4. don't take any wooden nickels This Americanism is used as a jocular bit of advice to someone about to depart. A wooden nickel is a wooden disc or souvenir which costs a nickel but has no legal value. The exhortation may have originated as a reminder not to be duped into buying such a worthless thing. Popular in the early 1900s, *don't take any wooden nickels* is less frequently heard today.

> In the mean wile [*sic*]—until we meet again—don't take no wood nickels and don't get impatient and be a good girlie and save up your loving for me.
> (Ring W. Lardner, *The Real Dope,* 1919)

5. first catch your hare First things first; don't overlook the basics; *catch the bear before you sell the skin.* This expression, said as if giving advice to one attempting a recipe to cook a hare, is usually attributed to Hannah Glass, author of *The Art of Cookery Made Plain and Easy* (1747). However, *Brewer's Dictionary of Phrase and Fable* suggests that the phrase is much older, and cites a passage from Bracton in *De Legibus et Consuetudinibus* (1300):

> It is a common saying that it is best first to catch the stag, and afterwards, when he has been caught, to skin him.

The *OED* contends the opposite, that the phrase must be of much more recent origin. At any event, the phrase is still heard today, usually in a jocular sense.

> "A soldier, Prince, must needs obey his orders: mine are . . . to seize wherever I should light upon him —"
> "First catch your hare! . . . "
> exclaimed his Royal Highness.
> (William Thackeray, *The Rose and the Ring,* 1855)

6. go to Goosebridge Control a wife; tame a shrew. Giovanni Boccaccio in *The Decameron* (1348) gives the following account. A young man, unable to control his shrewish wife, went to King Solomon with his problem. Solomon would only answer, "Go to *Goosebridge.*" Puzzled by the king's answer,

the young man started home, On the way he encountered a man trying to force his mule to cross a bridge. When the mule resisted, the man beat him until the beast complied. Asking the name of the bridge, the young man was told *Goosebridge*. The young man arrived home, seized upon his wife's first act of shrewish behavior, and beat her thoroughly so that she promised never to play the shrew again. The term is seldom heard today.

7. illegitimis non carborundum This pseudo-Latin expression is usually translated as 'don't let the bastards grind you down.' It was coined during World War II by the British; a useful reminder to the British during the dark days of the German heavy bombardment. The phrase is heard today only in a jocular vein. Martin Woodhouse in *Rock Baby* (1968) alludes to the phrase.

> *Nil carborundum* all right, I thought. Don't let the bastards grind you down, like it says in the book, but how was I to set about it?

8. keep your breath to cool your porridge This Briticism is an oblique admonition to "mind your own business" or "practise what you preach."

9. kitchen cabinet A group of unofficial, personal advisers to an elected official. The original *kitchen cabinet* consisted of three friends of President Andrew Jackson who met with him frequently for private political discussions. They reportedly entered by the back door (perhaps through the kitchen) so as to avoid observation and were believed to have had more influence than Jackson's official Cabinet. Use of the expression dates from at least 1832.

> One of the most important members of Gov. Stevenson's kitchen cabinet will be the new head of the State Department of Labor. (*The Chicago Daily News*, December, 1948)

10. reck [one's] own rede To follow one's own advice; to "practice what you

preach." *Reck* 'heed, regard' appears only in negative constructions. *Rede* 'advice, counsel' is now archaic and limited to poetical or dialectal use. This expression is found in Shakespeare's *Hamlet*.

> Do not, as some ungracious pastors do,
> Show me the steep and thorny way to heaven,
> Whilst, like a puffed and reckless libertine,
> Himself the primrose path of dalliance treads,
> And recks not his own rede.
> (I,iii)

Today *reck one's own rede* is met only in literary contexts.

11. say cheese Smile!; don't look so unhappy; said to one whose picture is about to be taken. This phrase is frequently uttered by a portrait photographer who wishes his subject to appear as if smiling. When one says "cheese," the lips spread as in a smile. An older but still popular phrase among portrait photographers is *watch the birdie*, used to direct the subject's gaze toward the camera.

12. sticks and stones This exclamation is inserted into a conversation to admonish someone for being overly sensitive about some criticism that has been said of him. The expression is derived from an old rhyme that dates back to the Middle Ages.

> Sticks and stones may break my bones,
> But words will never hurt me.

13. tell the truth and shame the devil This proverbial expression implies that if one but speak truly, one will not have to fear evil consequences. *The Oxford Dictionary of English Proverbs* records the first written use of this term as appearing in William Patten's *The Expedition into Scotland of Prince Edward* (1548). The obvious intent of the phrase becomes apparent in Shakespeare's *Henry IV, Part I*, when Hotspur, involved in a

heated discussion with Glendower, advises him:

> And I can teach thee, coz, to shame
> the devil
> by telling truth. "Tell truth and
> shame the devil."
> If thou have power to raise him, bring
> him hither,
> And I'll be sworn I have power to
> shame him hence.
> O, while you live, tell truth and
> shame the devil.
> (III,i)

14. tune the old cow died of Advice instead of aid, words in lieu of alms. This expression alludes to the following old ballad:

> There was an old man, and he had an
> old cow,
> But he had no fodder to give her,
> So he took up his fiddle and played
> her the tune;
> "Consider, good cow, consider,
> This isn't the time for the grass to
> grow,
> Consider, good cow, consider."

Needless to say, the old cow died of hunger. Occasionally *tune the old cow died of* is used to describe unmelodious or poorly played music.

> The tune the old cow died of
> throughout, grunts and groans of
> instruments. (Countess Harriet
> Granville, *Letters*, 1836)

12. AFFECTATION
See also 256. OSTENTATIOUS-
NESS; 286. PRETENSE

1. camp or **campy** Flagrantly and flauntingly effeminate or homosexual; affected, artificial; theatrical, exaggerated, ostentatious. Although the exact origin of this slang term is obscure, the second and third senses seem to be outgrowths of the first. *Campy* did not come into use until 1959, although the adjective *camp* dates from 1909. The verb *camp*, in use since 1931, means 'to flaunt one's homosexuality; to ham it

up; to overact or exaggerate'; often *camp up* or *camp it up*.

> Boys and men with painted faces and
> dyed hair flaunt themselves camping
> and whooping for hours each night.
> (*New Broadway Brevities* (N.Y.),
> 1931)

The noun *camp* refers to an "ironic or amusing quality present in an extravagant gesture, style, or form, especially when inappropriate or out of proportion to the content that is expressed" *(Random House Dict.).* When such a relationship is consciously used it is known as *high camp*, whereas when it is unwittingly or inadequately used it is called *low camp*.

> High Camp is the whole emotional
> basis of the Ballet . . . and of course
> of Baroque art. (Christopher
> Isherwood, *World in Evening*, 1954)

2. Grecian bend A stoop affected by some English women while walking, especially during the period, 1868–1890. This term was adopted to describe the strange fashion, which became popular among English women of means during the late 1800s. The upper torso was thrust forward, the buttocks thrust backward, and this outlandish posture was accentuated by the wearing of a bustle. An old Irish music hall song has:

> She was just the sort of creature, boys,
> That nature did intend
> To walk throughout the world, me
> boys, Without the Grecian bend.

Allegedly the practice of walking with a *Grecian bend* resulted from another eccentric fashion, the *Alexandra limp*. In 1860, the Princess of Wales, who became Queen Alexandra in 1901 when her husband, King Edward VII, succeeded to the throne, incurred a minor injury to her leg which caused her to walk with a slight limp. Many women of the court adopted this slight limp in fawning imitation, and the *Alexandra limp* soon was observed throughout the upper echelons of London's society.

3. kangaroo droop An attitude in which the elbows are bent and the forearms held horizontally, close to the stomach, with the hands allowed to hang loosely before one. It is a position sometimes assumed by young women who do not seem to know what to do with their hands and is usually associated, for some reason, with debutantes and others who affect sophisticated insouciance.

4. kewpie doll A woman who affects infantile behavior and mannerisms. This expression is derived from the cherubic doll designed by R. C. O'Neill, and named after the mythological god Cupid. The phrase is usually applied disparagingly to women who act overly cute and coquettish, assume baby talk, and dress younger than their years.

> She'd be like some kewpie doll, all sheen and varnish and eyes that really roll. (N. Cohn, *A WopBopaLooBop*, 1969)

5. la-di-da Exhibiting affectations in appearance, mannerisms, speech, style, or status; pretentious; foppish. This expression is an onomatopoeic and derisive imitation of the speech patterns of those with affected gentility. A variation is *lardydardy*.

> I may tell you we are all homely girls. We don't want any la-di-da members. (*The Westminster Gazette*, January 31, 1895)

La-di-da is sometimes used as a noun referring to a person who fits the above definition, or as an interjection, particularly when one intends derision or ridicule of those who put on the airs of high society. The latter usage received renewed popularity as a result of its repeated use in Woody Allen's movie, "Annie Hall" (1977).

6. little tin gods Pompous colonial government officials. Rudyard Kipling, in his poem, "Public Waste," satirized the British colonial government officials in India by the use of this term. The reference is to the cheapness and flashiness of tin, especially when compared to more expensive metals. In the poem Kipling registers his disgust with the *little tin gods* passing over a well-qualified sergeant from Exeter because a colonel from Chatham wished the position.

> Wherefore the Little Tin Gods
> married their little tin souls,
> Seeing he came not from Chatham,
> jingled no spurs at his heels,
> Knowing that nevertheless, was the
> first on the government rolls
> For the billet of Railway Instructor to
> Little Tin Gods on Wheels.

In today's usage the term signifies any authority who demonstrates overbearing self-importance.

7. macaroni See **360. STYLISHNESS.**

8. make dainty To be scrupulous, overly sensitive, or unnecessarily wary; to have great respect or awe for something and exercise restraint in all matters relating to it. Although no longer current, this expression was popular in the 16th century and appears in Shakespeare's *Romeo and Juliet:*

> Ah ha, my mistresses! which of you all
> Will now deny to dance? She that
> makes dainty,
> She, I'll swear, hath corns.
> (I,v)

As in the above citation, *make dainty* often connotes pretense and affectation.

9. niminy-piminy Affected, mincing, namby-pamby; artificially nice or refined; effeminate; childishly cute. This once popular British colloquialism, combining two rhyming nonsense words, was first used in *The Heiress* in an attempt to teach one of the characters, Miss Alscrip, to speak in a refined manner:

> The way to acquire the correct
> Paphian mimp is to stand before the
> glass and pronounce repeatedly
> "niminy piminy." The lips cannot fail
> to take the right ply. (John Burgoyne,
> *The Heiress*, 1786)

10. prima donna A temperamental, conceited woman; any vain person; the leading woman singer in an opera; a high-class prostitute. This term, the Italian for 'first lady,' was adopted into English during the late 1700s as a designation for the female lead in an opera.

> Margaret Halstead of Cincinnati . . . made her debut in opera last month as a prima donna at the Cologne Opera House. (*The New York Times*, November 20, 1932)

Because the leading female singer often demonstrated a tempestuous ego, the term soon came to symbolize any demanding, spoiled woman. About the mid 1800s the term was extended to include those pampered, high-priced prostitutes who lived in the same grandeur as the wealthy.

> "Prima Donnas" or those [seclusive prostitutes] who belong to the "first class", and live in a superior style. (Henry Mayhew, *London Labour and the London Poor*, 1851)

11. prunes and prisms Affectedly proper speech or behavior, mincing mannerisms. This expression, once used to ridicule a saccharine manner of speaking or writing, derives from Charles Dickens' *Little Dorrit* (1855), in which Amy Dorrit is urged to develop a more refined manner of speech:

> Father is rather vulgar, my dear. . . . Papa . . . gives a pretty form to the lips. Papa, potatoes, poultry, prunes, and prism, are all very good words for the lips; especially prunes and prism.

12. put on the dog To affect sophistication and urbanity; to adopt pretentious mannerisms. This expression, of dubious American origin, has seen an upsurge in usage during the 20th century.

> An editor's unexampled opportunities for putting on the dog and throwing his weight about. (P. G. Wodehouse, *Eggs, Beans, and Crumpets*, 1940)

13. Willie-boy A foppish fellow; a dandified young man; a dude. This slang expression, often heard as a substitute term for an effeminate fellow or a homosexual, is probably derived from the masculine name William. *Willie*, the diminutive of William, when combined with *boy*, creates an image of one quite removed from manhood. He's one of these here Willy-boy actors. (Sinclair Lewis, *Our Mr. Wrenn*, 1914)

13. AFFIRMATION

1. all tickety-boo Everything is okay; all is as it should be; everything is hunky-dory. This British slang expression, dating from the late 19th century, along with the occasionally heard variant *tiggerty-boo*, probably derives from *ticket* in *that's the ticket*, a phrase implying the suitable, proper, or correct thing. *Webster's Third* cites A. J. Liebling's use:

> Everything is going to be tickety-boo eventually.

2. Bob's your uncle A British informal expression like *there you are, there you have it*, often used at the end of a list of instructions; a phrase used in place of something unstated but obvious.

> Three curves and a twiddle, label it "object," and bob's your uncle. (N. Blake, *Head of Traveller*, 1949)

One conjecture says the phrase derives from Robert Peel's campaign slogan for a seat in Parliament: "Vote for Bob—Bob's your uncle." Robert Peel founded the Metropolitan Police Force in 1829, hence the label *bobby* for a police officer. Supposedly, *Bob* alluded to his stance on law and order and *uncle* implied benevolence. This theory is unlikely, however, considering that the earliest citation in the *OED* is from 1937, almost a century after the slogan would have been spoken.

3. cross [one's] heart To affirm one's oath; to prove one isn't telling a falsehood. This expression is restricted almost entirely to childhood use. The most seri-

ous affirmation of truthfulness, whole-hearted commitment, and declaration of bravery that a child can offer is *cross my heart and hope to die*. Either oath is usually delivered with the appropriate gesture of drawing a cross over the vicinity of the heart. A related term, which is now obsolete, implied much the same resoluteness: *crook one's elbow and never get it straight*.

4. O.K. All right, fine, correct, satisfactory; also, *okay, okey-dokey*. The origin of this saying has been the subject of much controversy among etymologists. One explanation traces it to a group of witty Bostonian writers who reveled in abbreviating ludicrously misspelled words. Their only abbreviation of any lasting consequence was *O.K.*, which stood for *oll korrect* 'all correct.' The accepted etymology today is the following: A group of Democrats, in support of Martin Van Buren's 1840 presidential bid, founded an organization entitled the Democratic O.K. Club, in which O.K. stood for *Old Kinderhook*, Kinderhook being the New York birthplace of Van Buren. *O.K.* soon became Van Buren's campaign slogan. By late 1840, *O.K.* was firmly established in American English and appeared in songs and literature of the day.

> I'm O.K.—off for the calaboose, and so is you. (*New Orleans Picayune*, January, 1841)

The expression has also developed the related meaning of a stamp of approval.

> The High Official added his O.K. to the others. (S. E. White, *Rules of the Game*, 1909)

Even though its usage has now spread to other English-speaking nations, *O.K.* is perhaps the most typical American colloquialism.

5. rubber stamp To approve as a matter of course; to authorize without the proper examination or review. This phrase is derived from the rubber stamps used in lieu of a signature on documents, letters, etc. The expression is often ap-plied adjectively to describe persons or groups without a will or mind of their own, whose decisions and judgments are totally determined by others.

> He has been more of a rubber stamp voter than most so-called "machine" officeholders. (*Chicago Sun Times*, April, 1948)

6. scout's honor A pledge of honesty or truth; a solemn declaration stated to reinforce a promise or an agreement; honor bright; honest Injun. This expression has been in use, often jocularly, since shortly after the founding of the Boy Scouts in the early 1900s. When uttered by a Boy Scout, the statement is taken to be a sincere pledge of honesty; however, among the general adult population, the term is used more frequently in lighter situations to express a humorous affirmation of a promise. The British equivalent expression is *honor bright*.

7. take [one's] davy on it To take one's oath; to state on faith. This expression is based upon a vulgar shortening of the word *affidavit*, a solemn or formal declaration given under oath. The phrase has been in use since the mid 1700s.

> They take their solemn oath and davy that they didn't do it. (Mortimer Collins, *Marquis and Merchant*, 1871)

8. ten-four Message received and understood; affirmative; roger; O.K. The *ten code*, used originally by the police and other land mobile units to pass messages quickly and efficiently, especially in an emergency, came into being in the 1950s. Picked up by CB (citizens' band) radio operators, the code became a part of their lingo shortly thereafter. The *ten code*, devised to minimize air time, has suffixes to deal with almost every transmitting and receiving situation from *ten one*, 'receiving poorly,' to *ten ninety-nine*, 'mission completed, all units secure.'

> "Ten-four, old buddy, see you on the flip," they yell as their trucks pass in a roar of spray and fumes. (Simon

Winchester, *The Manchester
Guardian Weekly*, May 30, 1976)

9. that's the ticket That's the proper or
correct thing; that's the right procedure
or attitude, that fills the bill. This ex-
pression, dating from the early 1800s,
probably derives from the 19th century
practice among charities of offering to
the needy tickets exchangeable for neces-
sities such as food or clothing.

> This [idealizing of portraits] is all
> wrong. Truth is the ticket. (Edward
> FitzGerald, *Letters and Literary
> Remains*, 1847)

10. three bags full Emphatic affirma-
tion; absolute agreement; as completely
as possible; totally. This expression is
taken from the old nursery rhyme that
begins: *Baa, baa, black sheep, have you
any wool?* It is a humorous method of
indicating total accord on the speaker's
part, as in:

> Q. "Do you think we should buy into
> that stock deal?"
> A. "Three bags full!"

The term has been in figurative use since
at least 1890.

11. thumbs up Approval, approbation,
affirmation. This expression stems from
the days when gladiators fought in the
Roman Colosseum and other large am-
phitheaters for the entertainment of the
spectators. When one of the combatants
was clearly vanquished, the victor
would look to the crowd before making
his next move—thumbs up (thumb close
to or inside a closed fist) indicated that
the throng approved of the effort ex-
pended by the loser, and his life was
spared. Thumbs down (thumb extended
downward from a closed fist) signified
disapproval, and gave the winner the li-
cense to slay his opponent. Eventually,
thumbs up was demonstrated by making
a fist, extending the thumb, and point-
ing it upward. This gesture assumed a
cultish popularity in the 1950s as evi-
denced by its frequent use in the ABC
television series *Happy Days*, a situation

comedy that started in 1974. See also
thumbs down, 308. REFUSAL.

14. AFFLUENCE
See also **240. MONEY;**
291. PROSPEROUSNESS

1. beggar on horseback An upstart,
nouveau riche, or parvenu; one who
goes from rags to riches overnight. Vari-
ous expressions incorporating this phrase
have been cited as its source. The earliest
is attributed to Robert Greene, a con-
temporary of Shakespeare's. In Richard
Burton's *Anatomy of Melancholy* (1621)
appears the line

> Set a beggar on horseback and he will
> ride a gallop.

Cited in *Bartlett* is Bohn: *Foreign Prov-
erbs (German):*

> Set a beggar on horseback and he'll
> outride the Devil.

And, finally, there is the folk proverb,
"If wishes were horses, beggars would
ride." All seemed to have influenced the
meanings of this expression.

2. [la] dolce vita An easy, fun-filled
way of life; a life of self-indulgent luxu-
ry; a decadent way of life. This loan-
word, from the Italian, translates literal-
ly as 'sweet life.' Adopted from the Fede-
rico Fellini film of the 1950s, *La Dolce
Vita*, the term originally connoted a so-
phisticated, leisurely life characterized
by wealth amid a glamorous interna-
tional social set. Today, the expression
has assumed a more ordinary connota-
tion, that *dolce vita* is available to all, as
demonstrated by this Ford Motor Com-
pany advertisement.

> Join the Mustangers. Enjoy a lot of
> dolce vita at a low, low price.
> (*Readers Digest*, September 1965)

Frequently, the Italian article is also
used with the term; so, *la dolce vita.*

3. eat high off the hog To be in a pros-
perous, luxurious situation, able to eat
the best food and to indulge one's extrav-
agant tastes; to live a life of material

comfort. This U.S. expression is said to derive from the fact that choice cuts of meat come from high up on a hog's side. *Eat* or *live high off the hog* dates from the early 1900s.

> I have to do my shopping in the black market because we can't eat as high off the hog as Roosevelt and Ickes and Joe Davis and all those millionaire friends of the common man. (*Call-Bulletin*, May 27, 1946)

4. fat cat See 269. PERSONAGES.

5. full-bagged Rich, wealthy, affluent. The allusion is to the full moneybags of a rich man. The term, now obsolete, appeared in John Taylor's *Works* (1630):

> No full bag'd man would ever durst have entered.

6. jet set A social set of affluent people who travel abroad by jet in pursuit of pleasure; the fast-paced smart set. This expression first appeared in the 1950s to describe those wealthy sophisticates who flew their own jet planes to vacation spots about the world. The implication behind the term is that not only do they move fast, but also live fast.

> The jet-set in New York are men and women in a hurry, who seek to get as much fun out of their nights as they can pay for or get somebody else to pay for. They seek so much and attain so little, they are usually bored. (*San Francisco Call Bulletin*, November 30, 1955)

7. Midas touch See 3. ABILITY.

8. moneybags A rich person; a nabob. This popular expression of obvious origin is used throughout the English-speaking world.

> Though squarsons and squires, landlords and moneybags leagued together against me, I was returned by a majority of 34. (Joseph Arch, *Story of His Life*, 1898)

9. money to burn Excessive wealth; money to spare; more than sufficient financial assets. This expression implies a large fortune which, if partially destroyed, would still be extraordinary. The phrase is frequently heard in the United States and Great Britain.

> People in the States have "money to burn." (*Sunday Express*, May, 1928)

10. on Easy Street Living a life of financial independence; enjoying a comfortable, prosperous life style. This expression first appeared in George V. Hobart's *It's Up to You* (1902) which tells of a young man "who could walk up and down Easy Street."

11. piss on ice To live luxuriously; to live high off the hog; to be wealthy, successful, or lucky. It was once the custom in posh restaurants to place a cake of ice in the urinals of men's rooms. Thus, this expression implies that the only men who urinated on ice were those wealthy enough to patronize these exclusive and expensive dining establishments.

12. ride the gravy train To become prosperous, to have much success or luck in acquiring wealth; to partake of the good life, to live high off the hog. Dating from the turn of the century, *gravy* refers to money or profits easily and sometimes illegally acquired. A *gravy train* or *boat* is a situation or position which offers the advantages necessary for putting prosperity and fortune within easy reach. *To board* or *ride the gravy train* is to take advantage of such a situation, to go for a free ride. This U.S. slang expression dates from the 1920s.

> They is on the gravy train and don't know it, but they is headed straight for 'struction and perdition. (Botkin, *My Burden*, 1945)

13. sugar daddy A wealthy man, usually middleaged or elderly, who spends freely on a young woman, providing material luxuries in exchange for companionship and sex. *Sugar* is a slang term for money. The expression was popular in the middle of the 20th century, especially in the jazz world. *Candy man* is another label for a similar type of

man. The material luxury he provides is "candy," a slang term for cocaine.

14. well-heeled Wealthy, affluent, monied. Though it might appear that this term evolved as the opposite of *down-at-the-heel*, such is not the case. Of American origin, *well-heeled* derives from the sport of cockfighting, and was first used in reference to the metal spurs put on fighting cocks. It later came to mean 'armed, equipped, furnished' with any kind of weapon, usually a revolver. This latter usage was common in the 19th century, toward the close of which is found the term's first application to being 'furnished with money.' This last is the only meaning retained.

> Though the million and a quarter left by his grandfather has been spread among a large family he is still well-heeled enough. (*The Daily Telegraph* [Color Supplement], January 1968)

Afterlife . . . See 262. PARADISE

15. AGE

See also 250. OBSOLESCENCE; 407. YOUTH

1. before [one] had nails on [one's] toes See 380. TIME.

2. brand-new Entirely or completely new; unused; absolutely or perfectly new; also *bran-new*. This term, in use since 1570, is said to have come from the Anglo-Saxon word *brand* 'torch' and formerly denoted metals or metal articles fresh from the fire or furnace. A synonym is *fire-new*, used by Shakespeare in *Richard III*:

> Your fire-new stamp of Honor is scarce current. (I,iii)

3. chair days Old age; the evening of life. The reference is to that time in a person's life when he is old, and perhaps feeble, and passes much of his time in the ease and comfort of a chair. Shakespeare made use of the phrase.

> Wast thou ordain'd, dear father

> To lose thy youth in peace, and to achieve
> The silvery livery of advised age,
> And, in thy reverence and thy chair-days, thus
> To die in ruffian battle?
> (*Henry the Sixth, Part 2*, V,ii)

4. geezer An eccentric old person; an unknown old man; a senior citizen. This slang expression, usually used in a derogatory manner, is probably a corruption of *guiser*, a masquerader or a mummer. The *OED* lists the first written use as:

> If we wake up the old geezers, we shall get notice to quit without compensation. ('Corin,' *Truth about the Stage*, 1885)

5. knee-high to a grasshopper See 272. PHYSICAL STATURE.

6. last leaf Very old; the last of a generation; one who clings to life; one who has lived past his time. This expression appeared in its figurative sense in the Oliver Wendell Holmes poem, *The Last Leaf* (1831). In the poem Holmes writes of Major Thomas Melville, a survivor of the Boston Tea Party, as one who, like the *last leaf*, finds himself still clinging to the tree in the spring when the new buds are bursting out all about him.

> And if I should live to be
> The last leaf upon the tree
> In the spring,
> Let them smile, as I do now,
> At the old forsaken bough
> Where I cling.

7. lay [one's] nuts aside To lay aside one's frivolities; to give up boyish extravagances; to become mature. The ceremony to which this expression alludes was practiced in old Roman wedding rites. As the bridegroom led his new wife home, he strewed nuts through the crowd to symbolize his newly found maturity.

8. long in the tooth Old; showing signs of old age. Although currently used of people, this expression originally applied exclusively to horses. It refers to the

seemingly longer length of an older horse's teeth, due to gum recession.

> To be honest I am getting quite long in the tooth and this is a method of bringing children into my Christmas. (*Sunday Express*, December 24, 1972)

9. over the hill Past the time of greatest efficiency or power, past the prime of life, too old, aging; also, past the crisis, over the hurdles. The expression's latter meanings may be derived from a traveler's achievement of crossing a hill, after which the going is easier. The phrase's more common meanings, however, allude to a hill as being the high point, or apex, of one's effectiveness and authority, after which the only course is downhill. In contemporary usage, the phrase most often describes a person of advancing age.

> As they say about boxers who are getting on in years, she is over the hill. (I. Cross, *God Boy*, 1957)

Agitation . . .
See 294. PROVOCATION

16. AGREEMENT

1. Lamourette's kiss A short-lived reconciliation, particularly one that is made insincerely; an ephemeral rapprochement; subterfuge; shrewd or cunning deceit. The *Lamourette* in this expression was Abbé Lamourette, a French politician who, on July 7, 1792, convinced the many discordant factions of the Legislative Assembly of France to lay aside their differences and work together for the common good. After much demonstration and protestation of peace-making, the legislators soon lapsed into their former hostilities, but with even more animosity and rancor than before. Since that time, the expression has been used figuratively, usually in reference to transitory or disingenuous political agreements.

2. make no bones about See 43. CANDIDNESS.

3. on the side of the angels Allied with good as opposed to evil; in agreement with the views of the speaker. This expression can be traced directly to Benjamin Disraeli. At the Oxford Diocesan Conference in 1864, he replied to a question about the controversy raging at that time over evolution:

> The question is this: Is man an ape or an angel? I, my lord, am on the side of the angels.

In modern use the term implies that the person spoken of is in accord with the speaker.

> He might have given us a hint that he was on the side of the angels. (Elizabeth Daly, *The House Without the Door*, 1942)

4. package deal An agreement or settlement in which all of the conditions must be either accepted or rejected; an all-or-nothing arrangement or plan which involves the acceptance of one or more negative elements as a requisite to achieving a generally favorable goal. Originally, a package deal was a group of goods which were wrapped in one package and sold at a bargain price, one lower than the combined cost of purchasing each item separately. Although this connotation is still retained, *package deal* usually refers to a political or industrial pact which contains several related or unrelated provisions, all of which must be accepted or rejected as a unit. *Package deal* has also enjoyed some jocular use, often in reference to a person's spouse or family.

5. see eye to eye To be of the same opinion with another; to agree in every respect; to think alike. This ancient expression, obvious in its intent, dates back to ancient times and may be found in the King James version of the Bible.

> Thy watchmen shall lift up the voice; with the voice together shall they sing: for they shall see eye to eye, when the Lord shall bring again Zion. (Isaiah, 52:8)

The term is often heard in the negative sense *not see eye to eye* usually to indicate an amicable difference of opinion.

6. Smithfield bargain A roguish bargain; a deal where the buyer is victimized; a marriage in which money, not love, is the main consideration. This expression, dating from the mid 17th century, owes its meaning to associations with *Smithfield*, which was described as early as the 12th century as:

> A plain field where every Friday there is a celebrated rendezvous of fine horses brought thither to be sold.

This expansive field lay outside the northwest walls of the city of London, and apparently many a shady bargain was struck there. The word *Smithfield* came to symbolize an attitude—making money regardless of the sacrifice. Later, by transference, the term came to signify a marriage where money was the principal motive, and any father who promised his daughter's hand for pecuniary reasons was said to have made a *Smithfield match*. Although the term is not obsolete, it is seldom heard today.

> Your daughter has married a gentleman—is not this better than a Smithfield bargain? (John Wilson, *The Cheats*, 1662)

7. strike a bargain To conclude a bargain or other deal; to settle or arrange the terms of a transaction; to agree on a compromise or other settlement. This expression alludes to the ancient Greek and Roman custom of sealing a business contract by striking (i.e., killing) an animal and offering it as a sacrifice to their deities. Although this tradition is long since gone, the expression persists.

> As soon as the bargain is struck, the property of the goods is transferred to the vendee. (Sir William Blackstone, *Commentary on the Laws of England*, 1766)

With the demise of sacrificial offerings, it became customary in many societies to seal an agreement by shaking or striking hands, thus the related and synonymous *strike hands*.

8. strike the right chord To say or do the right thing at the right time; to have ideas or opinions that are in harmony with another person's. The *chord* in this expression originally had nothing to do with a musical chord, but rather was a variant spelling of *cord*, the string of a musical instrument, which comes from a Middle English verb meaning 'agree,' from *accord*, a Middle English noun meaning 'agreement.' But later, to *strike the right cord* was taken as an allusion to *strike the right note*, and to *strike a sympathetic chord* developed, meaning to strike a string of an instrument which is so finely tuned that it will make any string tuned to the same pitch vibrate sympathetically, thus producing a harmonious sound. In *The Task: Winter Walk at Noon* (1784), William Cowper alludes to all three expressions.

> There is in souls a sympathy with sounds;
> And, as the mind is pitch'd, the ear is pleased
> With melting airs, or martial, brisk, or grave:
> Some chord in unison with what we hear
> Is touch'd within us, and the heart replies.

Aid . . . See 26. ASSISTANCE

Aim . . . See 152. FOCUS

Alcohol . . . See 109. DRUNKENNESS;
153. FOOD AND DRINK;
382. TIPPLING

17. ALERTNESS
See also 267. PERCEPTIVENESS;
344. SHREWDNESS

1. Argus-eyed Vigilant, watchful; keen-eyed, alert. Argus was a mythical 100-eyed giant set by Juno to keep watch over the heifer Io. Only two of his eyes slept at a time. Mercury, however, was

2nd Edition □ 71

able to charm him to sleep, and slew him, whereupon Juno set Argus' many eyes upon the peacock's tail. Language ignores his failure and preserves his vigilance with *Argus-eyed*.

2. beat to the punch See **9. ADVANTAGE.**

3. bright-eyed and bushy-tailed Alert and ready for action; ready for anything; wide-awake; prepared for any opportunity; vigilant; sharp; active. This expression, dating from at least the 1930s, alludes to the seemingly attentive behavior of squirrels, chipmunks, and other animals that display wide eyes, quick movements, and a high degree of energy. The expression is usually used in reference to those people who arise in the morning wide-awake and ready for the day's action or to those who are attentive, energetic, and prepared for any situation.

4. keep an eye on the ball To be alert; to be extremely attentive; on one's toes. This expression, dating from about 1900, is probably attributable to the game of baseball, and the necessity of the batter or fielder to keep his eye on the baseball as it moves toward him. However, the expression is applicable to any sport that requires hand-eye or foot-eye coordination. As with so many sporting terms, this phrase has been adopted by the business world as a warning that one should be constantly alert.

5. keep an eye on the sparrow Watch out for an unexpected source of trouble; beware of the possibility of evil in life. The allusion in this proverbial phrase is to bird droppings, even from so tiny a bird as the sparrow, that can mess one's appearance and deflate the ego.

6. keep [one's] ear to the ground To be alert to what's going on, to be abreast of rumors and hearsay, to be aware of the prevailing trends of public opinion. The expression is said to derive from a practice of plainsmen in the Old West. They reputedly believed that a neckerchief on the ground would amplify otherwise in-

audible sounds, such as the beating of horses' hooves. Consequently, they would often put an ear to a neckerchief so placed in order to discern another's approach. This expression and its variants *hold* or *have one's ear to the ground* date from the early part of this century, and still enjoy widespread currency.

> What's the gossip of the market, Tom? You fellows certainly do keep your ears to the ground. (Graham Greene, *The Quiet American*, 1955)

7. keep [one's] eyes peeled To be on the qui vive; to be alert and watchful; to keep a sharp lookout. Although this version of the expression is currently popular, it appears to be a variant of *keep one's eyes skinned*, which appeared in print presumably for the first time in *The Political Examiner* in 1833. The eyelid is the "skin" which must be "peeled" to permit one to see.

> I kept my eyes peeled, but I didn't see her in the afternoon crowd. (*Munsey's Magazine* XXIV, 1901)

8. keep tabs on To keep a check on something or someone; to observe someone closely; to see how someone is getting along. This American expression alludes to having something at one's fingertips, as the tabs on the cards in a filing system. The phrase has been utilized since the 1880s.

> I . . . lay on the big lounge by an open window where . . . I could keep tabs on the little ones at their sports. (H.L. Wilson, *Somewhere in Red Gap*, 1916)

A variant is *keep tab on*.

9. keep [one's] weather eye open To be vigilant, watchful, or alert; to observe closely. This expression's nautical origin refers to the diligent attentiveness of a sailor assigned to weather observation duty. The expression still carries its implication of astute observation.

> Job returned in a great state of nervousness, and keeping his weather eye fixed upon every woman who

came near him. (Rider Haggard, *She: A History of Adventure*, 1887)

10. no flies on [someone] Said of a person who is alert, astute, shrewd, or active, one not likely to be caught napping. The apparent allusion is to cattle which constantly move their tails in an attempt to discourage flying pests from settling and inflicting painful bites. Thus, the presence of flies implies stagnation or inactivity, while their absence implies the opposite.

There are no flies on Benaud. . . . No one will have to draw his attention to it. (*Observer*, April 23, 1961)

The expression is also used in reference to a business, project, or other matter which is thriving, reputable, and above reproach.

11. on the ball Alert, keen, quick, sharp; intelligent, bright, perspicacious. The now common truncated phrase and its earlier, longer antecedents derive from sport, though which sport it is difficult to determine. *Keep your eye on the ball* probably came from a game such as tennis or baseball, where timing and concentration on the rapidly moving object are crucial. *Have something on the ball* is still used literally of pitchers with extraordinary control over the ball's speed and direction. Being "on the ball" thus results from "having something on the ball" or "keeping one's eyes on the ball" and is equivalent to them. A person *on the ball* is on top of things, in control, ready for all emergencies and contingencies. The phrase connotes the coordinated, nearly simultaneous anticipation and action of the accomplished athlete.

12. on the qui vive On the lookout, on the alert; watchful, aware, awake. *"Qui vive?"* was the French equivalent to the English "Who goes there?": a sentinel's challenge to passersby to identify themselves as friend or foe. *"Qui vive?"* called for a response of allegiance such as *"Vive le roi"* 'long live the king' or *"Vive la France"* 'long live France.' Use of the expression *on the qui vive* dates from at least 1726.

"What now?" cried Burtis, all on the qui vive. (Edward P. Roe in *Harper's Magazine*, December, 1883)

13. on [one's] toes Alert, on the ball, ready to take advantage of an opportunity. A runner who starts a race "on his toes" has a decided edge over one who starts from a flatfooted position. Thus the phrase's figurative sense of preparedness and alertness. *Webster's Third* cites W. L. Gresham's use of the expression:

In working for real money you've got to be on your toes.

14. quick on the draw Alert; quick-thinking; vigilant. This expression originated in the Old West, where a gunfighter's survival depended upon the celerity with which he handled his weapon. The phrase is commonly used today to describe a keen-witted, sharp-minded person.

15. roughandready See 399. VITALITY.

16. take the ball before the bound To anticipate an opportunity, to be one step ahead of the game; to be overhasty or impetuous. Figurative use of this expression derives from a game such as cricket, tennis, or football. Whether such a move is advantageous or foolish depends on the situation. In the following citation, taking the ball before the bound has negative connotations.

It concerns you not to be over-hasty herein, not to take the ball before the bound. (James Howell, *Epistolae Ho-Elianae*, 1645)

17. up to snuff See 55. COMPETENCE.

18. ALLOCATION

1. Benjamin's mess A much larger portion than the others; the lion's share. This expression is based on a Biblical story, wherein *mess* is used to mean 'food supply.' When the ten sons of Jacob went into Egypt seeking food during a famine, they sought out Joseph, the vice-

roy of Egypt. Joseph, who was also one of Jacob's sons but went unrecognized by his brothers, forced them to bring Benjamin, the youngest, on a second trip. Joseph was so overjoyed at seeing his youngest brother for the first time.

> . . . he took and sent messes unto them from before him: but Benjamin's mess was five times so much as any of their's. And they drank and were merry with him. (Genesis 43:34)

2. earmarked Set aside for a particular purpose; allocated for use in specified ways; marked so as to be recognized. This expression, dating from the 1500s, alludes to the practice of marking the ears of cattle and sheep to show ownership. An even older example of "earmarking" comes from Exodus 21:6:

> . . . his master shall bore his ear through with an awl; and he shall serve him for ever.

Figuratively, *earmarked* is often used in regard to monetary allocations although it is heard in other contexts as well.

> I need only earmark sufficient time in the summer for certain people whose hospitality I've accepted. (S. McKenna, *Happy Ending*, 1929)

3. lion's share The largest portion; a disproportionately large share; all or most. This expression is derived from Aesop's fable in which three animals joined forces with a lion for a hunt. When dividing their quarry, the lion claimed three fourths as his: one fourth as his just share, one fourth because of his great courage, and one fourth for his lioness and cubs. The lion offered the remaining fourth to any of the fellow-hunters who was able to defeat him in a fight. The intimidated animals declined the challenge, however, and left empty-handed.

> The art of finding a rich friend to make a tour with you in autumn, and of leaving him to bear the lion's share of the expenses. (*Punch*, June 22, 1872)

4. piece of the action See 217. INVOLVEMENT.

5. piece of the pie A share in the profits; a portion of whatever is being divvied up and parceled out—usually money, but also applicable to intangibles such as attention, affection, time, etc. This expression probably has its origin in the graphic representation of budget allotments in circular, pie-shaped form, with various sized wedges or pieces indicating the relative size of allocations to different agencies, departments, etc. *Webster's Third* cites A. H. Rashkin using a related form:

> Industry is getting its share of the prosperity pie.

6. split a melon To distribute profits to those who are entitled to receive them; to distribute shares to those who have participated in a speculative venture. This American phrase, born about 1900 on the New York Stock Exchange, was originally Wall Street jargon for the distribution of dividends to stockholders. A melon has long been representative of an item to be joyously shared. An old Muslim proverb says that the sharing and eating of a melon produces a thousand good works.

> This year, a record number of your friends and neighbors will split a record 'melon' in our 1948 savings clubs. (*Aurora [Illinois] Beacon News*, November 7, 1948)

A common variant is *cut a melon*.

Allurement . . .
See 118. ENTICEMENT

19. AMALGAMATION
See also 239. MIXTURE

1. curate's egg Any amalgam of good and bad features; any combination of assets and liabilities, strengths and weaknesses, pros and cons, etc. This British term dates from an 1895 *Punch* cartoon in which a deferential, diplomatic curate, unwilling to acknowledge before

his bishop that he had been served a bad egg, insisted that "Parts of it are excellent!" The expression *curate's egg* came into vogue almost immediately, and still enjoys considerable popularity.

> All the same it is a curate's egg of a book. While the whole may be somewhat stale and addled, it would be unfair not to acknowledge the merits of some of its parts. (*Oxford Magazine*, November 22, 1962)

2. melting pot A place where the assimilation of racial groups and ethnic cultures occurs; the amalgamation of qualities or concepts, resulting in an improved or unprecedented end-product. This expression alludes to a large cauldron where dissimilar ingredients are blended to form a distinctive mixture. In the United States, the phrase often refers to the ongoing assimilation of vastly different immigrants into the mainstream of American society. Nonetheless, *melting pot* often carries its meaning of a medley of heterogeneous elements combined into a single work or idea; this concept is illustrated in the *American Guide Series: Connecticut*, as cited by *Webster's Third*:

> The architectural melting pot is seen in the tall Romanesque columns, the Gothic hammervault roofing. . . .

3. portmanteau word See 225. LANGUAGE.

Amazement . . . See 368. SURPRISE

Ambiguity . . .
See 126. EVASIVENESS

Amorousness . . . See 229. LOVE; 230. LUST

20. ANECDOTE

1. chestnut An old, stale joke; a trite, oft-repeated tale or story. Although the exact origin of this term is unknown, one plausible explanation is that it comes from an old melodrama, *The Broken Sword*, by William Dillon. In the play, Captain Zavier is retelling, for the umpteenth time, a story having to do with a cork tree. His listener Pablo breaks in suddenly, correcting cork tree to chestnut tree, saying "I should know as well as you having heard you tell the tale these twenty-seven times." The popularization of the term is attributed to the comedian William Warren, who had played the role of Pablo many times, and who is said to have repeated Pablo's line about the chestnut in response to an unoriginal story told at a dinner party. The expression has been in use since 1883.

2. cock and bull story See 246. NONSENSE.

3. fish story See 128. EXAGGERATION.

4. Joe Miller A stale joke; a chestnut. In 1739 a man by the name of John Mottley put together a book of jests and called it *Joe Miller's Jest Book*, after the name of an illiterate comedian who lived 1684–1738. Current use of this name to describe an overused joke or saying implies that Mottley's compilation was not very funny, and perhaps included jokes which were old even at that time.

> Many of the anecdotes are mere Joe Millers. (*Reminiscences of Scottish Life and Character*, 1870)

5. megillah A long, detailed explanation or account; a lengthy, often exaggerated story; frequently in the phrase *the whole megillah*. *Megillah* is Hebrew for 'roll, scroll' and commonly refers to any or all of a certain five books of the Old Testament to be read on specified feast days. The extraordinary length and tediousness of these readings gave rise to the slang sense of the term as it is popularly used outside of Judaism today.

> Feeding all the megillah to the papers about his family of Irish Polacks who came over with the Pilgrim Fathers. (*Punch*, May, 1968)

6. old wives' tale See 367. SUPERSTITION.

7. shaggy dog story An involved, often seemingly interminable story that derives its humor from its unexpected, absurd, or punning ending; any joke or story involving a talking animal, especially a dog. This expression describes the wryly humorous stories which feature a shaggy dog as the main character or as the speaker of a surprise punch line. Though most popular in the 1940s, shaggy dog stories are still recounted in certain contemporary circles.

8. song and dance See 128. EXAGGERATION.

21. ANGER

See also 158. FURY; 182. ILL
TEMPER; 223. IRRITATION;
394. VEXATION

1. bent out of shape Vexed, irritated, annoyed. This phrase, of recent vintage, has yet to find its way into our lexicons. The implicit analogy between an object's physical shape and an individual's mental state suggests that the latter condition has a specific cause, a temporary nature, and contrasts with one's "usual self."

2. cross as two sticks Angry, vexed, out of humor; irritated; in high dudgeon. This British pun alludes to the image of crossed sticks in the shape of an "X." The image of two sticks "passing or lying athwart each other" *(OED)* gives rise to associations of contrariness, opposition, and adversity.

> He has been as cross as two sticks at not having been asked to dinner at Court. (R. M. Milnes Houghton in *Life, Letters, and Friendships*, 1855)

3. fit to be tied Incensed, enraged, livid, irate, very angry. This expression probably comes from the hospital practice of restraining patients who pose a danger to themselves or others. In its contemporary hyperbolic usage, *fit to be tied* refers to anyone (not just a patient) who is extremely angry or who is acting irrationally, implying that if this person were in a hospital, he would be tied down for his own protection as well as for the protection of others.

> It threw the place into a tizzy. . . . The boss is fit to be tied. When he gets hold of you. . . . (C. Simak, *Strangers in the Universe*, 1956)

4. hot under the collar Angry, mad, infuriated; hot and bothered, distraught, upset, agitated. The allusion is to the red or "hot" color of an enraged person's neck and face due to the rush of blood to those areas.

> After years of this sort of puling imbecility one gets hot under the collar and is perhaps carried to an extreme. (Ezra Pound, *Letters*, 1918)

The expression dates from at least 1895.

5. in a snit In a tiff, peeved; agitated, in a fuss or stew, all worked-up. *Webster's Third* cites the following usage from *Information Please Almanac:*

> Wall Street brokers were in a snit because nobody bought stocks.

In an obsolete, literal sense *snit* was 'the glowing part of the wick of a candle when blown out,' perhaps the source of the figurative meaning of the word today.

6. in a tiff In a fit of anger; in a huff; with a slight outburst of temper. The origin of this phrase is obscure, but it may be imitative in nature, from the sound of a puff of escaping steam. It has been in common use since the early 18th century.

> Abrupt Captain Anthony being in some tiff of his own . . . (Thomas Carlyle, *Letters to Mrs. Carlyle*, 1871)

7. little pot is soon hot A small person is quickly provoked; a little person is easily roused to anger. A small pot, which naturally contains less water than a larger one, comes to a boil more quickly. *Little* in this expression apparently means both small in size and small in mind. Shake-

speare alludes to the proverb in *The Taming of the Shrew* (IV,i):

> Now, were not I a little pot and soon hot, . . .

Use of the expression dates from at least 1546.

8. mad as a baited bull Extremely angry; infuriated; in a rage; incensed; livid. Thomas Fuller in his *The Worthies of England* (1662) attributes the source of this phrase to:

> . . . as mad as the baiting bull of Stamford.

According to the account, one Earl Warren gave the town of Stamford a meadow to use as a public park, with the proviso that each year the townspeople provide a mad bull for baiting for six weeks before Christmas. *Baiting* consists of restraining the beast in some way, by chains, by ropes, or by confinement, and then tormenting it with dogs. Related terms are *mad as a baited bear* and *mad as a baited boar*.

9. mad as a hatter See 218. IRRATIONALITY.

10. mad as a tup Out of humor; vexed; distraught; hot and bothered. In *Shropshire Folk-Lore* (1883), Charlotte Burne maintains that the entire saying is *mad as a tup in a halter*, which helps to explain the expression, for a tup is a ram and rams were usually allowed to run freely with the ewes. Therefore, to place a ram in a halter would certainly be cause for his becoming irritated.

> In Derbyshire . . . there is no commoner saying to express anger shown by anyone than to say that he or she was 'as mad as a tup'. (*Notes and Queries*, December 21, 1901)

11. mad as a wet hen Very angry, furious, enraged. Chicken farmers maintain that this popular simile has no basis in fact, since hens do not get particularly excited when wet. These female fowl are, however, known for their angry clucking and pecking when provoked.

> The chicken farmers of Quebec . . . are mad as, well, a wet hen. (*The Wall Street Journal*, July, 1971)

12. mad as hops Extremely angry; livid, infuriated, incensed; enraged, furious. This expression is probably a twist on *hopping mad*, implying that a person has become so angry that he hops about in a frenzied rage.

> Such a grin! It made me mad as hops! (*Harper's Magazine*, October, 1884)

13. mean as hungry Tyson Extremely disagreeable; ignoble; beyond contempt. The allusion in this Australian phrase, dating from the late 1800s, is to a legendary farmer named Tyson who, out of his miserliness, cut back so severely on his family's food supplies that they were constantly in a state of hunger that made them extremely testy.

14. out of countenance Visibly abashed, ashamed, confounded, or disconcerted; upset, annoyed, perturbed. When a person is flustered or upset, the feeling is usually registered on his face. The phrase dates from the 16th century.

15. take it in snuff To become angry; to take offense at; to demonstrate indignation. The *OED* proposes that the original reference may have been to the irritating smell from the odor proceeding from a snuffed candle. *Brewer's* propounds that the phrase derives from the irritating quality of snuff powder, a tobacco derivative. However, a more likely explanation is that it derives from the act of sniffing as an expression of disdain or contempt. In *Retaliation* (1774) Oliver Goldsmith makes use of the term to create a double entendre about Sir Joshua Reynolds' greatness:

> When they talked of their Raphaels, Correggios, and stuff,
> He shifted his trumpet, and only took snuff.

The expression has been in use since the 16th century.

16. towering rage Extreme anger; such an intense state of fury that violence is conceivable. This expression apparently has its roots in the medieval practice of falconry. The word *towering* is used figuratively for extreme height or intensity, adapted from the practice of falcons or other birds of prey towering, i.e., soaring at their maximum height before attacking. Combined with the word *rage*, which means violently angry, a *towering rage* indicates the possibility of a murderous attack at any moment.

17. vent [one's] spleen To let loose one's anger, malice, or ill-humor on another; to release one's emotions in a fit of temper. The spleen, a flat, ductless, vascular organ lying near the stomach, was once regarded as the seat of various emotions: melancholy, ill-temper, and spitefulness. Therefore, to *vent one's spleen* was to release all these horrible emotions in one vehement tirade.

> To vent their spleen on the first idle coxcomb they can find. (Thomas Peacock, *Headlong Hall*, 1816)

Annoyance . . . See 223. IRRITATION; 394. VEXATION

22. ANXIETY
See also 148. FEAR;
184. IMPATIENCE

1. butterflies A queasy feeling in the stomach caused by anxiety, nervousness, fear, or excitement; the jitters, the willies, the heebie-jeebies; usually in the phrase *have butterflies in one's stomach.* The term, in use since 1908, provides an apt description of the fluttering sensation felt in the pit of the stomach during times of extreme anxiety or nervous tension.

2. cabin fever Restlessness; a feeling of confinement; agitation or irritability from periods of confinement in one's dwelling. Although the origin of this expression is uncertain, its use is common in colder areas where winter can inhibit

or prevent free movement out of doors for extended periods. Dr. Michael Edelstein, a psychiatrist at the University of Maryland, attributes the malady to

> . . . a result of sensory deprivation related to being cooped up. It can happen after a week or more, but it can also happen after one or two days of isolation. . . . In extreme cases people with cabin fever can become quite psychotic. (*The New York Times*, January 27, 1982)

3. cliff-hanger Any event or situation in which the outcome is suspensefully uncertain up until the very last moment. The term was originally applied to a serial film in which each episode ended with the hero or heroine left in a perilous plight, such as hanging from a cliff, so that the viewers anxiously awaited the next installment. The extended figurative sense of the term, and the only one commonly heard today, has been in use since at least 1948.

4. daymare An occurrence similar to nightmare experienced while one is awake; a frightful daydream. Matthew Green, an 18th-century British poet, is usually credited with the coining of this word in *The Spleen* (1737), a witty poem in sprightly verse about the meditative life.

> If I am right, your question lay,
> What course I take to drive away
> The daymare Spleen, by whose false pleas
> Men prove mere suicides in ease.

Although the term is seldom heard today, such famous writers as Samuel Taylor Coleridge and James Russell Lowell have admitted to suffering from daymares.

5. fussy as a hen with one chick Overprotective, overanxious, overparticular and fussy. A hen with one chick, as any mother with only one child, tends to be more possessive and protective than a parent with many offspring. This tendency usually manifests itself in finicky, fretful behavior.

6. get the wind up To be nervous; to be distressed or anxious. This British expression is similar to the American slang *jumpy* 'tense, edgy.' An analogous British colloquialism, *put the wind up*, carries a somewhat stronger sense of dread or fright.

> I tell you you've absolutely put the wind up Uncle Bob and Peter! They're scared to death of your finding them up. (C. Alington, *Strained Relations*, 1922)

7. heeby-jeebies A fit of nervousness; fright; the willies; the jim-jams; a feeling of uneasiness. This slang expression was coined by the American cartoonist Billy deBeck, the creator of the comic strip *Barney Google*. It is apparently a coined nonsense word. The word caught on however, and in 1926, Louis Armstrong recorded a pop song entitled *Heeby-Jeebies*, which contributed greatly to its popularity.

> A terrible girl in the next gallery, painted in the fearsome and fashionable "punk and plaster" manner, had given him what an American present might have called the "heeby-jeebies." (*Weekly Dispatch*, May 3, 1927)

Related terms are *the willies* and *the jim-jams*.

8. high-strung Nervous, tense, edgy; thin-skinned, sensitive, spirited. This expression, dating from the late 14th century, literally means 'strung to a high tension or pitch.' The allusion is probably to stringed musical instruments: the tighter the string, the higher the pitch. Taut strings are also more brittle and thus more likely to break.

> Writers often tend to be highstrung creatures. (M. Lowry, *Letters*, 1946)

9. in a stew In a state of worry or anxiety; in a mess; in a fret; in a state of excitement. This expression, likening anxiety to a sort of simmering, has been in use in English since at least the Middle Ages.

> What a stew a man would be in, in England, if he had his grain lying about out of doors in this way! (William Cobbett, *A Year's Residence in the United States of America*, 1817–1818)

10. keyed up Excited, highstrung; nervous, tense; intensified, stimulated; psyched up (for), full of nervous energy and anticipation. The verb *key* refers literally to tuning a musical instrument— that is, raising or lowering the pitch. Since the 17th century this term has been applied figuratively to a person's thoughts and feelings that affect the overall color or tone of his mood. Thus *key up* is to heighten, intensify, or stimulate feelings.

> Although he was emotionally keyed up, Sherman yawned. (Carson McCullers, *Clock Without Hands*, 1961)

11. like a cat in a strange garret Uneasy, nervous; fearful, afraid. This expression is an allusion to the behavior of a cat in strange surroundings. The March 16, 1824 edition of the *Woodstock* [Vermont] *Observer* contains the phrase:

> "What was King Caucus like?" said an old gentleman. "Why, like a cat in a strange garret, frightened at every step it took."

12. like a cat on a hot tin roof Very uncomfortable, uneasy, nervous. This self-evident expression is a more current variant of *like a cat on hot bricks*. The latter dates from 1862 and has the additional meanings 'swiftly, nimbly.' *Cat on a Hot Tin Roof* was the title of a 1955 play by Tennessee Williams.

13. a lump in the throat A choked-up or tight feeling in the throat at times of deep emotion. A person usually gets a lump in his throat when he is very touched and on the verge of tears—either from happiness or from sadness. A literal lump in the throat would inhibit speech and swallowing. The figurative

expression has been in use since the latter half of the 19th century.

> A lump always comes into my throat when I think of it. (Princess Alice, *Biographical Sketch and Letters,* 1878)

The similar expression *have the words stick in one's throat* implies an inability to express oneself due to intense emotion.

14. on pins and needles Apprehensive, anxious; in a state of nervous or uneasy anticipation; on tenterhooks. *Pins and needles* refers to the tingly, prickly sensation felt in the arms and legs when they are recovering from having been numbed or "asleep." Although a person who is *on pins and needles* might not be experiencing the attendant physical sensations, the expression implies that he is.

> He was plainly on pins and needles, did not know whether to take or to refuse a cigar. (*Pall Mall Magazine,* August 1897)

15. on tenterhooks Taut with anxiety; in a state of painful suspense of expectation; tense, uneasy, on edge. Tenterhooks are literally the hooks of a tenter, i.e., the frame on which cloth is stretched to shape it. The word was used figuratively as early as the late 17th century; *The Winthrop Papers* records a 1692 usage of "the tenterhooks of expectation" by G. Saltonstall. In *Roderick Random* (1748) Tobias Smollett writes:

> I left him upon the tenterhooks of impatient uncertainty.

Eventually such explanatory phrases became elliptically understood, leaving us with the now common *on tenterhooks.*

16. on the anxious bench In a state of anxiety or apprehension; concerned about one's own future; uneasy; in suspense. This expression, originating in the early 1800s, is derived from the practice at revival meetings, also known as *anxious meetings,* of placing a bench, also called an *anxious seat,* near the front to accommodate those who were uneasy

about their spiritual destiny and might wish to come forward to be "saved."

> Women pray and exhort in public, persons under excitement are called forward to the anxious benches to make confession. (Henry Caswall, *America, and the American Church,* 1839)

By extension, the term came to indicate anybody in a state of anxiety.

> The entire diplomatic corps at Havana is on the anxious bench. (*New York Evening Post,* November 23, 1906).

17. on the rack Under great pressure or strain; in painful suspense or acute psychological torment; on tenterhooks; tense, anxious, nervous. The rack, a former instrument of torture, consisted of a frame with rollers at either end to which the victim's ankles and wrists were attached in order to stretch his joints. The expression *on the rack* was used figuratively for psychological suffering as early as the 16th century.

> . . . Let me choose,
> For as I am, I live upon the rack.
> (Shakespeare, *The Merchant of Venice,* III,ii)

18. screaming meemies Excessive fretfulness or uneasiness; the jitters, the heebie-jeebies; fear-induced delirium. In World War II, American soldiers originated this phrase as a nickname for the German rocket shells. The terrifying noise and devastating effect of these weapons caused anyone within earshot to be petrified with fear. While the expression is still used today for dread and horror, it is occasionally applied jocularly to the extremes of other emotional states, such as frightful boredom.

> Madison [Wisconsin] is a town that would give the ordinary thrill seeker the screaming meemies in one quiet weekend. (G. S. Penny, in *Saturday Evening Post,* January 1945)

19. seven-year itch This expression can refer to a type of itch that allegedly requires seven years to heal.

> He stuck around like seven year itch.
> (*Chicago Daily News*, June 23, 1949)

Although the term is used to signify an indefinite period of time, in modern usage it is more apt to connote a sexual itch developed by married men after seven years of marriage. This usage grew after the release, in 1955, of the movie of the same name, starring Marilyn Monroe.

20. sit tight See 264. PATIENCE.

21. sit upon hot cockles See 184. IMPATIENCE.

22. sweat blood To worry or agonize; to be apprehensive or anxious; to be heavyhearted; to be under a great strain. This expression and its variant, *bloody sweat*, allude to Christ's agony in the Garden of Gethsemane:

> And being in agony he prayed more earnestly; and his sweat became like great drops of blood falling down upon the ground. (Luke 22:44)

These expressions have been used figuratively in various contexts, most of which refer to suffering occasioned by awaiting a likely, if not inevitable, fate.

> War . . . which yet, to sack us, toils in bloody sweat to enlarge the bounds of conquering Thessalie. (Thomas Kyd, *Cornelia*, 1594)

23. with bated breath With reduced or restrained breathing; with apprehension; with expectation. This expression appears in Shakespeare's *The Merchant of Venice*:

> Shall I bend low and in a bondsman's key,
> With bated breath and whispering humbleness,
> Say this: . . .
> (I, iii)

The suggestion inherent in this expression is that one's breathing is more subdued than usual because of a strong emotional reaction to a tense situation. The phrase remains in frequent use. The word *bated* is merely a shortened form of *abated*, i.e., 'stopped, halted.'

24. womble-cropped Uneasy; anxious; squeamish; feeling nausea; humiliated. This slang expression derives from the dialectal word *womble* a 'nauseous feeling' and *cropped* 'stomached.' Dating from the mid 16th century, the term had become almost exclusively American by 1800.

> I got back to the sloop and turned in awfully womble-cropped. (Jonathan Slick, *High Life in New York*, 1844)

Apathy . . . See 199. INDIFFERENCE

Apparel . . . See 49. CLOTHING

Appearance . . . See 271. PHYSICAL APPEARANCE; 286. PRETENSE

Appeasement . . .
See 273. PLACATION

Approbation . . .
See 52. COMMENDATION

23. APPROVAL
See also 52. COMMENDATION

1. amen corner A coterie of fervent believers or ardent followers, so-called from the place in a church, usually near the pulpit, occupied by those who lead the responsive "amens." A person in the amen corner is, figuratively speaking, a disciple or devotee; often a yesman or sycophantic toady. The expression is now thoroughly American, but it may well derive from the Amen Corner of London's Paternoster Row, the supposed point at which the Corpus Christi procession reached the "Amen" of the "Pater Noster."

2. applaud to the echo To applaud so energetically as to produce echoes; to demonstrate high acclaim or enthusiastic approval. In *Macbeth*, V, iii, Macbeth

informs his physician that if he can discover the sickness that infects the country and cure it:

> I would applaud thee to the very echo
> That should applaud again.

The expression has been in use since the early 1500s, although in *The Devil's Dictionary* (1906), Ambrose Bierce takes a rather darker view of the subject.

> Applause is the echo of a platitude.

3. get the nod To receive approval or affirmation; to be selected. In this expression, *nod* 'a slight, quick inclination of the head as in assent or command' is used figuratively more often than literally. A variation is *give the nod*.

> Paul L. Troast got the G.O.P. nod, beating his nearest rival . . . by more than 53,000 votes. (*The Wall Street Journal*, April 23, 1953)

4. in [one's] books In favor with one; in one's good esteem; have one's approval. At one time the word *book* meant any written piece, whether one page or many; hence, a list might be called a book, and to be *in one's books* was to be on one's list of friends. The expression dates from about 1500. A variant, *in one's good books*, is a more recent form.

5. Kentish fire Protracted applause; a prolonged volley of applause. This expression is said to have originated with the extended salvos of applause and cheering given to those who spoke in Kent in 1828–29 in opposition to the Catholic Emancipation Bill. *Brewer's Dictionary of Phrase and Fable* cites Lord Winchelsea, proposing a toast to the Earl of Roden on August 15, 1834:

> Let it be given with Kentish fire.

24. ARGUMENTATION

1. bandy words To exchange words, especially frivolously or angrily; to argue, wrangle; to pass gossip from one to another. This expression is derived from *bandy*, an old game similar to tennis; hence, to *bandy words* is to bat words

back and forth. The first written use of the phrase is recorded by the *OED* as 1800, but the term may be much older, for the game of bandy was popular in the 1500s.

2. beg the question To put forth an argument or proposition that assumes something not yet proven; to presume the conclusion in one's presentation of an argument. This expression can be traced directly to Aristotle. In the *Prior Analytics* section of *Organon* (*Logic*) he states:

> Begging or assuming the point at issue consists in failing to demonstrate the required proposition.

The technical term in logic is the Latin *petitio principii*.

3. chop logic See 245. NIT-PICKING.

4. devil's advocate One who argues an opposing cause or who takes the negative side of a case, primarily for the sake of argument. This expression derives from the custom in the Roman Catholic Church of appointing an *advocatus diaboli*, more properly known as *promotor fidei* 'protector of the faith,' whose task it is to argue the case against persons proposed for canonization.

5. What's that got to do with the price of eggs? An expression used to mean 'How does that apply to the subject under discussion?' Although the explanation for this phrase from the 1920s is uncertain, the question is still heard today as a facetious response to an irrelevancy. Barry Prentice in *A Dictionary of Catch Phrases* (1977) records the Australian equivalent as *What's that got to do with the price of fish?* and other commodities can be substituted at the end of the phrase, such as *beans*. Perhaps these modern terms have their roots in the Greek response to Thespis, when for the sake of variation the poet turned his songs of the vintage to subjects other than the god of wine: *what has that to do with Bacchus?* he was asked.

6. wrangle for an ass's shadow See 245. NIT-PICKING.

25. ARRANGEMENT

1. Indian file Single file, one after the other. The expression supposedly derives from the American Indian practice of moving stealthily through the woods in this fashion—each walker stepping into the footprints of the preceding, with the final man obliterating the single set of tracks thus leaving no trace of their course. *Webster's Third* cites a *Newsweek* article:

> Along this road the inhabitants slowly moved in Indian file.

2. round robin A document, usually of a grievous nature, in which the petitioners sign their names round a circle; a method of conducting a tournament or series of contests, especially in sports. A British newspaper report of an 18th-century mutiny appends a paragraph explaining this term.

> A round Robin is a name, given by seamen, to an instrument on which they sign their names round a circle, to prevent the ringleader being discovered by it if found; and in the circle is a solemn agreement of standing by each other, and executing whatever they shall afterwards agree on. (*British Gazeteer*, January 3, 1730)

French sailors, who devised this method, called it a *ruban rond* 'round ribbon'; English sailors appropriated the method but reversed the term to *round ruban*, which was further corrupted to *round robin*. The term is frequently employed in games and sports, in reference to tournaments or schedules in which every contestant meets every other contestant, and the winner is determined by the final won-lost record of each participant.

> Tennis promoters love round robins and double eliminations for the same reason NBA owners love playoffs: Drawing cards can't be rubbed out

early. (*Sports Illustrated*, December 28, 1981)

Arrogance . . .
See 171. HAUGHTINESS

Assay . . . See 376. TEST

26. ASSISTANCE
See also 70. COOPERATION

1. boy scout One who comes to the assistance of another; one who is overly helpful or insists on helping when no help is needed; a naive fellow who has much growing-up to do. The organization known as the *Boy Scouts* was founded in 1908 in England by General Sir Robert Baden-Powell to promote good citizenship through usefulness to others. One cardinal rule, that each member should do a good deed each day, soon became a butt for humorists: there is the familiar allusion to the little old lady being helped across a street by a zealous boy scout when she did not wish any help. Thus, the modern slang connotation for someone overly helpful arose about 1910, and the connotation for someone young and overly naive arose about 1920. As a slang term, the expression is most frequently heard today as a form of derision. The derision is undisguised in this English music hall song.

> On Sunday I walk out with a soldier,
> On Monday I'm taken by a tar,
> On Tuesday I'm out with a baby Boy Scout,
> On Wednesday an Hussar.
> (Arthur Wimperis, *I'll Make a Man of You*)

2. candle-holder An abettor; an assistant or attendant. The reference is to the Catholic practice of having someone hold a candle for the reader during a religious service. In everyday language, the expression applies to anyone who helps out in some small way, but who is not a real participant in the action or undertaking. Shakespeare used the term in *Romeo and Juliet:*

I'll be a candleholder and look on.
(I,iv)

3. give a leg up To lend a helping hand; to give someone assistance through a difficult or trying time. This expression, originally meaning to help someone mount a horse, now carries the figurative sense of assisting another over life's obstacles or helping someone advance through the ranks.

She was now devoting all her energies to give them a leg up. (William E. Norris, *Misadventure*, 1890)

4. good Samaritan A compassionate person who selflessly helps those in need; a friend in need; also simply a *Samaritan*. The allusion is to the Biblical parable (Luke 10:30–37) which tells of a man who had been beaten by thieves. He lay halfdead by the roadside while his neighbors, a priest and a Levite, passed him by. It was a Samaritan, his supposed enemy, who finally showed compassion for the man and took care of him. This expression dates from at least 1644.

I wish some good Samaritan of a Conservative with sufficient authority could heal the feuds among our friends. (Lord Ashburton, *Croker Papers*, 1846)

5. go to bat for To support actively, to stick up for or defend; to intercede for, to go to the assistance of. This American slang expression owes its origin to baseball—specifically the role of the pinch hitter. In the mid 1800s, *go to the bat* was used; by the turn of the century *go* or *come to bat for* gained currency. Now *go to bat for* is heard almost exclusively.

The daughter of old man Brewster who owns the *Evening Tab*, my meal ticket, came to bat when my show was ready to close. (J. P. McEvoy, *Show Girl*, 1928)

6. help a lame dog over a stile Help one in trouble; offer a helping hand; comfort one troubled in spirit. This expression, dating from at least the 1500s, alludes to

the obstacles one encounters in life, whether physical or spiritual, and the comfort one feels when he holds out a helping hand to someone in distress.

Let me display a Christian spirit And try to lift a lame dog o'er a style. (John Wolcott, *Works*, 1788)

Of course, one cannot always expect to be rewarded for displaying a virtuous conscience.

I once knew a man out of courtesy, help a lame dog over a stile, and he for requittal bit him by the fingers. (William Chillingworth, *The Religion of Protestants*, 1638)

7. Jack at a pinch One who offers a helping hand during a time of need; one called upon in an emergency, especially a stand-in clergyman. The first listing for this entry in the *OED* is James Mabbe's translation of *Alemans Guzman de Alfarache* (1622):

When there was need of my service, I was seldom or never wanting; I was Jack at a pinch.

Originally this term was used to designate a clergyman who had no parish, and who, as a result, would substitute for a fee in any church where his services were needed. Eventually it came to mean any person who lent a hand during an emergency situation. The term is seldom heard today except as a localism.

8. ka me, ka thee See 304. RECIPROCITY.

9. pelican crossing A pedestrian-controlled lighted crossing. Unlike the *zebra crossing*, named for the broad black and white stripes which mark zones for pedestrians to cross the street, the *pelican crossing* is named from the initial letters of the phrase *pe*destrian *li*ght *con*trolled (with a slight spelling change) and indicates a street crossing where the citizen activates the light. *Zebra crossings* have existed in Britain since 1952, and *pelican crossings* since 1968.

One particular concern is the pelican crossing: old people tend to distrust them, fearing the lights will change

before they can reach the other side of the road. (*London Times*, February 19, 1976)

10. pinch-hit To substitute for a regular worker, player, speaker, or performer, especially in an emergency; to take another person's place. In this expression, *pinch* refers to an emergency, a time of stress, and *hit* refers to a successful, or hopefully successful, attempt. A person called upon in such a predicament is called a *pinch-hitter*. Though it originated and is most commonly used in baseball to describe the substitution of a batter for the regularly scheduled one, usually at a crucial point in the game, *pinch-hit* has been expanded to include many other situations and contexts.

In his absence, he has called upon three good friends, also authors of daily columns, to pinch-hit for him and give his readers a "change of pace." (*Lubbock* [Texas] *Morning Avalanche*, February 1949)

11. yeoman service Efficient, loyal aid, as from a faithful servant; good, useful assistance; unflagging support to one's employer or master.

I once did hold it as our statists do,
A baseness to write fair and laboured much
How to forget that learning, but, Sir, now
It did me yeoman's service.
(Shakespeare, *Hamlet*, V,ii)

Yeoman, probably a shortening of *young man*, was originally applied to those superior grade servants in English households who performed many tasks. These young servants applied themselves so faithfully, so energetically, that the term *yeoman service* has been extended in meaning to include any outstanding continuing service.

Astonishment . . . See 368. SURPRISE

Astuteness . . . See 267. PERCEPTIVE-NESS; 344. SHREWDNESS

Attachment . . .
See 90. DEPENDENCE

Attire . . . See 49. CLOTHING

27. ATTRIBUTION

1. chalk it up To ascribe, credit, or attribute. In the 16th century, it became common practice in British pubs and alehouses to keep track of a customer's bill by making chalk marks on a slate. In this way, the barkeep had an accurate count of all drinks ordered on credit.

All my debts stande chaukt upon the poste for liquor. (*The Returne From Parnassus*, 1597)

In current usage, the expression is employed figuratively.

What [16-year-old Tracy Austin] has that the others don't is an uncluttered spirit—a clean slate, if you will, on which plenty of victories will be recorded and losses chalked up to experience. (AP wire story, March 25, 1979)

2. father upon To place the responsibility for the cause of something upon a person, often incorrectly; to attribute the authorship of a literary work or quotation upon a person; to attach; to foist upon. This expression, dating from the 16th century but seldom heard today, is derived from the assigning of the paternity of an illegitimate child to an alleged father, usually without concrete proof. Metaphorically, the term is most commonly used in assigning the authorship of an anonymous literary work to a particular writer.

28. AUGMENTATION
See also 127. EXACERBATION

1. beef up To strengthen, reinforce; to augment, increase. Prior to slaughter, cows, steer, and bulls raised for their meat are fattened in order to increase their body weight and thus the profits derived from their sale. An early figura-

tive usage appeared in 1941 in A. O. Pollard's *Bombers over Reich:*

When the Fortresses reach Britain from the United States certain alterations are made; the larger guns are . . . "beefed up" so as to give them a rate of fire of 900 rounds a minute.

2. blow the coals To increase, augment, or heighten; to exacerbate or aggravate. Like *fan the fires* or *add fuel to the fire,* the meaning and origin of this phrase are obvious, referring to the action of bellows on coals.

3. fatten the kitty To increase the stakes, usually in reference to gambling; to add money or chips to a common pot to be awarded to the winner. In many forms of gambling, particularly in card games such as poker, all the players bet by putting money into a pot or pool called a *kitty.* To *fatten the kitty* is to add more to it, to increase its size. According to several sources, however, *kitty* can also refer to a percentage of the pot set aside for some special purpose such as buying refreshments or paying the house share. Similar expressions include *sweeten the kitty,* and *fatten* or *sweeten the pot.*

4. gear up To accelerate or speed up; to increase or boost. Figurative use of *gear up* derives from the literal mechanical meaning 'to go into a higher gear so that the driven part goes faster than the driving part'—in other words, to shift into a higher gear in order to go faster. This expression is frequently heard in economic contexts, as in "to gear up production."

5. jack up To bring one to a sense of duty; to call to account; to increase; to force up; to reprimand for slackness on the job. This slang expression, which embraces a variety of meanings, alludes to a hoisting jack and its primary function of raising or lifting things. Probably the most common use of the phrase in the United States is to indicate an unnecessary forcing up of prices.

The country's biggest steel makers decided to jack up some of their prices again. (*Time,* March 11, 1948)

The term is used in both the United States and England.

I think I'll jack up our boys in the city room by hinting that there may be a shake-up coming under the new owner. (Samuel Hopkins Adams, *The Clarion,* 1914)

In England the term is used colloquially to designate collapse, bankruptcy, or abandonment of a job. In Australia it is used to indicate a refusal to cooperate, i.e., 'clam up.'

6. make the cheese more binding To improve matters; to strengthen, augment, or reinforce. This expression, dating from about 1945, refers to the constipating effect that cheese often has on the body; consequently, anything that *makes the cheese more binding* increases its efficacy. The phrase, originally conceived as a jocular comment, is in common use today in a figurative sense.

7. thereby hangs a tale There is an unusual story connected with that topic; there is interesting additional information about that subject. This expression, dating from at least the early 16th century, is often used to suggest that one might elaborate considerably upon the subject at hand but does not choose to do so at the moment.

GRUMIO: First, know my horse is tired, my master and mistress fall'n out.
CURTIS: How?
GRUMIO: Out of their saddles into the dirt, and thereby hangs a tale. (Shakespeare, *The Taming of the Shrew,* IV, i)

A humorous allusion to the phrase appears in *Meditations in Wall Street* (1940).

A tale that thereby hangs drops easily off the gossip's tongue.

8. up the ante To raise the stakes, to increase the risk. In poker the ante is the sum that each player pays into the pot in

advance; by extension, in other monetary contexts it refers to the share invested in a business venture. The variant *raise the ante* is usually limited to these more literal uses. *Up the ante*, however, frequently appears in a nonfinancial sense, with respect to the increased personal or emotional cost entailed by a given decision, relationship, or course of action.

Auspiciousness . . .
 See 255. OPPORTUNENESS

Authenticity . . .
 See 160. GENUINENESS

29. AUTHORITATIVENESS
See also 392. VALIDITY

1. arrow of Acestes The making of one's point in an authoritative manner; a dogmatic presentation of an argument. The allusion in this phrase is to the great force with which Acestes discharged his arrow. Portrayed in the *Aeneid* as the son of a river god and a Trojan woman, Acestes, while involved in a trial of skill, released his arrow from his bow with such force that it caught fire in flight. The expression is used to characterize an orator, or other public speaker, who presents his argument with fiery vehemence.

2. chapter and verse An authority that gives credence and validity to one's opinions or beliefs; a definitive source that can be specifically cited. The phrase derives from the Scriptures, which are arranged in chapters and verses, thus facilitating easy reference to particular lines. In non-Biblical contexts, *chapter and verse* is frequently a challenge to produce incontrovertible, detailed evidence for one's opinions. Figurative use dates from the early 17th century.

> She can give chapter and verse for her belief. (William Makepeace Thackeray, *The Adventures of Philip on His Way Through the World*, 1862)

3. ex cathedra Authoritatively, dogmatically, officially; Latin for 'from the chair.' *Cathedra* itself refers to the chair or seat of a bishop in his church. Most specifically, it refers to that of the Bishop of Rome, the Pope, who according to church doctrine is infallible when speaking *ex cathedra* since he is not speaking for himself but as the successor and agent of Saint Peter. More generally *cathedra* means any seat of office or professorial chair. Anyone speaking from such a seat of power or knowledge would naturally speak with great authority. The phrase dates from at least 1635.

4. from the horse's mouth On good authority, from a reliable source, directly from someone in the know; often in the phrase *straight from the horse's mouth.* The allusion is to the practice of looking at a horse's teeth to determine its age and condition, rather than relying on the word of a horse trader.

> The prospect of getting the true facts—straight, as it were, from the horse's mouth—held him . . . fascinated. (P. G. Wodehouse in *Strand Magazine*, August 1928)

5. in black and white In writing or in print—black referring to the ink, white to the paper; certain, verifiable. Written opinion or assertion is assumed to carry more weight than a verbal one. The phrase has been in use since the time of Shakespeare.

> Moreover sir, which indeed is not under white and black, this plaintiff here . . . did call me ass. (Shakespeare, *Much Ado About Nothing* V,i)

6. take for gospel To take as truth without question; to accept as infallibly true; to believe as absolutely accurate. The allusion here is to the first four books of the New Testament, which are considered the Christian Gospels. Since the Bible is supposedly the word of God, it follows that a true believer must accept the Gospels as absolutely truthful. The

phrase has been in common use in English since the Middle Ages. A related phrase, *gospel truth*, carries the same connotations.

> All is not gospel, out of doubt,
> That men say in the town about.
> (Geoffrey Chaucer, *The Romance of the Rose*, 1365)

7. write the book on To be the final authority; to have all the answers. This expression assumes that one who has written a book on a subject is about as knowledgeable on it as can be; therefore, he must be the final authority, the one in the know. The phrase is modern, having come into common usage during the 1970s.

> Merrill Lynch writes the book on IRA investments. (Advertisement in *New Yorker*, November 15, 1982)

Authority . . . See 278. POWER

Automobiles . . . See 393. VEHICLES

Avarice . . . See 91. DESIRE

Avoidance . . .
See 126. EVASIVENESS

Award . . . See 326. REWARD

Awareness . . .
See 344. SHREWDNESS

30. AWKWARDNESS
See also 247. OAFISHNESS

1. all thumbs Awkward, inept; clumsy, butterfingered. A forerunner of the current expression appeared in John Heywood's *Proverbs* in 1546:

> When he should get ought, each finger is a thumb.

The phrase as we know it was in use by 1870:

> Your uneducated man is all thumbs, as the phrase runs; and what education does for him is to supply

him with clever fingers. (*The Echo*, November 16, 1870)

2. awkward squad A squad of inept military recruits; a group unskilled in their roles or functions. This expression, dating from the 1700s, has its roots in the military. However, in today's usage, it refers to any group who are clumsy or ungraceful in their performance. The term generally implies derogation; however, it is occasionally applied in a jocular sense.

> The household regiments of Versailles and St. James would have appeared an awkward squad. (Thomas B. Macaulay, *Critical and Miscellaneous Essays*, 1842)

3. bear's service Mistakenly causing a person a serious problem while trying to be helpful to him; clumsiness; awkwardness. This expression has its origin in an old Russian fable which appeared for many years in children's schoolbooks. A man who lives in solitude in a barren place becomes lonesome and befriends a lonely bear. The bear wants to be helpful, so when the man rests after lunch, the bear sits beside him and chases the flies away. One fly returns and returns until the bear becomes angry, whereupon he grabs a huge stone, throws it at the fly and kills it, crushing the man's skull in the process.

4. bull in a china shop A careless person whose clumsiness produces devastation; a bungling oaf. The earliest recorded literary use of this phrase seems to have been in Marryat's *Jacob Faithful*, written in 1834. "I'm like a bull in a china shop." An article in the May 1929 issue of *Notes and Queries* suggests that the source of the expression may be in the following:

> This morning an overdrove bullock rushed into the china shop of Miss Powell, opposite St. Andrews Church, Holborn, where he frightened the lady into a hysterical fit, and broke a quantity of glass and china. (*London Packet*, March 17, 1773)

5. butterfingers One who lets things, especially a ball, slip or fall through his fingers; one who drops things easily; a clumsy or awkward person. This expression alludes to one who has been handling butter, or some other slippery substance, and whose hands have thus become so greasy that he cannot grasp whatever is handed or tossed to him. The term is common in English-speaking countries throughout the world, and the adjective form, *butter-fingered* has been in use since at least the early 17th century.

> When the executioner had come to the last of the heads, he lifted it up, but, by some clumsiness, allowed it to drop; at this the crowd yelled out, 'Ah, Butterfingers!' (William M. Thackeray, *Miscellanies*, 1857)

6. catch a crab To make a faulty stroke in rowing that causes one to lose one's balance in the boat. The explanation of this phrase has been a matter for some speculation. The allusion seems to be to encountering a crab so large that it can grab the oar and hold it in place in the water. The *OED* suggests that the expression refers to getting one's oar caught deeply in the water so that the resulting resistance drives the handle against the rower's body and pushes him out of his seat. The expression has also been used to indicate a missing of the water completely with one's oar and toppling backward; the *OED*, however, calls this "an improper use by the uninitiated." A variant, which is seldom heard today, is *cut a crab*. The image in the phrase suggests that the fault lies either in momentarily losing one's hold on the oar so that it falls in the water and is difficult to recover, owing to the force of the water as the boat moves, or in accidentally hitting the water with the oar on the backstroke, causing a sudden, unexpected resistance that can cause loss of balance and of one's hold.

7. flub the dub See 329. RUINATION.

8. have two left feet To be unusually clumsy; uncoordinated, maladroit. The expression does not constitute an image of deformity, but an emphasis on the negative concepts of *left* as 'gauche, awkward, clumsy.'

> Mr. Dawson . . . gave it as his opinion that one of the lady dancers had two left feet. (P. G. Wodehouse, *Psmith Journalist*, 1915)

9. hog in armor One who is stiff and clumsy; one who cuts a ridiculous figure because of his fine, but awkward manner of dress. This expression, which is seldom heard today, made its appearance in England during the Middle Ages. Its source is uncertain, but *Brewer's Dictionary of Phrase and Fable* suggests that it might be a corruption of *hodge in armor, hodge* being a condescending term for a farm worker.

> He did not carry his finery like a hog in armour, as an Englishman so often does, when an Englishman stoops to be fine. (Anthony Trollope, *The Three Clerks*, 1857)

B

Babbling . . . See 161. GIBBERISH

Bad luck . . . See 10. ADVERSITY

Bargain . . . See 16. AGREEMENT

Basics . . . See 157. FUNDAMENTALS

31. BEGINNINGS
See also 209. INITIATION;
318. RESTARTING; 357. STARTING

1. **at first blush** At first sight; apparently, at first appearances; on the first impression. The *blush* of this expression is from the Middle English *blusche* 'glance, glimpse.' Thus, given a brief exposure to something, one might qualify an evaluation by using this expression.

At the first blush, it would seem that little difficulties could be experienced. (Benjamin Disraeli, *Coningsby; or the New Generation*, 1844)

2. **back to the drawing board** See 141. FAILURE.

3. **blaze a trail** To be a pioneer; to lead the way; to dare the unknown. This American expression alludes to the practice of placing notches in a series of trees as one proceeds through a forest, thus marking a trail for those who follow. These people, the *trailblazers*, are those who lead the way into the unknown areas; consequently, by extension, the term has come to mean any one who *blazes the way* or *blazes a path* in any new venture or undertaking.

Professor Breal has blazed the way for future explorers in the wilderness of philology. (L. Mead, *Word-coinage*, 1902)

Watt, in his role of trail blazer, had one great aid two years ago. (*Syracuse Herald-Journal*, October 16, 1948)

4. **clean slate** *Tabula rasa*, a blank record; a fresh start, a new beginning; often in the phrase *to wipe the slate clean*, meaning to forget the past and make a fresh start.

I can conceive nothing more desirable in the interests of these embarrassed tenants than that they should have a clean slate. (*The Pall Mall Gazette*, September 1888)

Literally a slab of slate rock for writing, *slate* is used figuratively to represent the record or history of a person's life. A clean slate, then, is one from which the past has been erased and which is ready to be written on again. The equivalent Latin term, now a part of the English language, means 'tablet scraped clean.'

5. **foot in the door** An in, a start, an opportunity or chance; usually in the phrase *get one's foot in the door*. Although the exact origin of this expression is unknown, it may be an expansion of the phrase *get one's foot in*, dating from the early 19th century. Putting one's foot in a doorway prevents it from being closed completely. In this expression *foot* is synecdochic for the body as a whole, the point being that once one's foot is inside the door, the rest of the body will follow.

6. **from scratch** From the very beginning; without building on a preexisting product or structure; without using prepared ingredients. *Scratch* is a line or mark indicating the starting point in a race. Figurative use of *from scratch* stresses the idea of a true beginning which allows for no head start or short cuts, as implied in William DuBois' ref-

erence to "the task of organizing a major institution of learning almost from scratch" cited in *Webster's Third*. The expression is frequently heard in regard to cooking without using a "mix" or other ready-made ingredients.

7. get off on the right foot To begin propitiously, to have an auspicious start. The phrase's origin probably lies in the now less frequently heard *right foot foremost*, an expression related to the Roman superstition that one should always enter and leave a room or dwelling right foot first. Thus the current *right* 'correct' figurative meaning was originally *right* 'right side' contrasted with *left* 'left side' and its attendant sinister, evil connotations. See also **get up on the wrong side of the bed**, 182. ILL TEMPER.

8. get to first base To complete the initial step of a task; to finish the preliminaries of a project or undertaking. This expression originated in baseball, where a batter's initial task is to reach first base. The phrase's figurative meaning of making a preliminary breakthrough is commonly heard, though most often in a context of failure to do so.

I thought I'd read Italian to read Dante and didn't get to first base. (F. Scott Fitzgerald, *Letters*, 1938)

The expression is frequently used by men to describe a minor victory in the seduction of a woman.

She gives you the feeling that you'll never get to first base with her. (P. G. Wodehouse, *Service with a Smile*, 1962)

9. hang out [one's] shingle To advertise one's professional status; to open an office; to begin one's career. This colloquial Americanism derives from the practice of displaying a shingle, or sign, to advertise the names and services of professionals. Today the expression is used in referring to the beginning of a practice or career, regardless of whether an actual sign is involved.

Jobless, Metcalf put out his shingle as a food consultant. (*Newsweek*, August 22, 1949)

10. in on the ground floor Allowed to invest at the beginning of an enterprise; admitted into an enterprise on the same terms as the original investors; becoming involved in a speculative venture or business enterprise before the general public. Although the exact origin of this expression is unknown, the reference is generally believed to be to the advantage of an office on the ground floor before the advent of elevators, thus giving one the most favorable position. The phrase has been in figurative use since the mid 19th century.

He got in on the ground floor and was one of the privileged few that had a wide choice in selection. (*Natural History*, June 1949)

11. new lease on life A chance to start afresh; an opportunity to wipe out old debts and begin anew; the result of successful surgery that prolongs one's life. The *lease* in this phrase metaphorically alludes to the world of real estate, where a new lease alleviates the tenant's worry of whether there will be a roof over his head in the future.

Wherever Estates still existed, they seemed to have gained a new lease on life. (Sir John Seeley, *The Life and Times of Stein*, 1878)

12. pick up the threads To resume an undertaking after a period of absence or inactivity; to pick up where one left off. The allusion is to weaving.

13. stick [one's] spoon in the wall To move into new quarters; to establish residence. In former times, one of the first things a person did upon acquiring a new domicile was to hang a leather pouch on a wall by the fireplace for the placement of spoons, scissors, and other sundry items. The expression is rarely heard nowadays.

rending large pieces. If he can get the thin edge into a crack in the wood, his work becomes relatively easy. By extension, the term has come to connote getting a small start which one hopes, or perhaps fears, will lead to something larger. The figurative meaning has been in use since about 1850.

32. BELLIGERENCE

1. all horns and rattles Belligerent; angry; enraged. The allusion is to the horns of cattle, used to butt or gore when these animals are angered; and to the rattles of rattlesnakes—horny, loosely connected rings at the end of the tail which are shaken vigorously in warning when this reptile is provoked to attack. The expression was originally used in reference to American cowboys, who because of their work would be closely associated with both cattle and snakes.

2. at daggers drawn or **drawing** About to quarrel; on the verge of open hostilities; at swords' points. In the 16th century, gentlemen often carried daggers. When affronted by either look or gesture, these men would defend their honor by using the dagger.

> They . . . among themselves are wont to be at daggers drawing. (Nicholas Grimaldi, *Cicero's Offices,* 1553)

3. chip on [one's] shoulder A quarrelsome or antagonistic disposition; the attitude of one spoiling for a fight; an unforgiven grievance; usually in the phrase *have a chip on one's shoulder.* The following explanation of this American expression appeared in the May 1830 *Long Island Telegraph* (Hempstead, N.Y.):

> When two churlish boys were determined to fight, a chip would be placed on the shoulder of one, and the other demanded to knock it off at his peril.

4. clubs are trump Ready to fight; belligerent; enraged; prepared to use physical violence, if it becomes necessary; brute force alone will determine the outcome. A pun upon a game of cards, this expression, dating from the early 16th century, alludes to the fact that trumps rule, at the same time creating a twofold meaning for the word *clubs,* as a suit in cards and as weapons of violence.

> Taking up a cudgel, she swore solemnly that she would make clubs trump if he brought any bastard brat within her doors. (Robert Greene, *Pandosto,* 1588)

As sure as a club is a related term with the same connotation.

5. cross swords with To enter into physical or verbal conflict; to engage in controversy; to fight. In former times when dueling was a common means of settling a dispute, the combatants would cross swords as a preliminary gesture at the start of the conflict. Such a gesture came to signify any type of conflict, whether a battle to the death or simply a battle of words. The expression has been in use since at least the 16th century.

> They rarely met without crossing swords on one matter if not another. (Mrs. Lynn Linton, *Paston Carew,* 1886)

6. Doctor Strangelove A military man who advocates nuclear warfare; a military strategist who believes in nuclear deterrence; a war lover. This term had its genesis in the motion picture *Doctor Strangelove or How I Learned to Stop Worrying and Love the Bomb* (1964), a film spoof about a mad military scientist who constantly favors an all out nuclear attack against the enemy. Such a person is also referred to as a *Strangelove.*

> That was also the period when everyone who believed that nuclear weapons should not be tossed into the sea except after the Soviet Union tossed theirs into the sea was labelled a Strangelove. (William F. Buckley, *New York Post,* April 12, 1979)

tossed theirs into the sea was labelled a Strangelove. (William F. Buckley, *New York Post*, April 12, 1979)

7. gunboat diplomacy Military threat to enforce foreign policy; intimidation used by a country to protect foreign interests, investments, or facilities. This term, probably British in origin, refers to the threat of force, or, in some rare cases, the use of force to settle disputes with weaker nations. The British Armed Forces were often called upon, especially during the days of the Victorian empire, to coerce local rulers to bend to the wishes of British business interests. United States policy, in dealing with lesser nations, especially in Central and South America, has also been branded by the use of this term.

Many Latin American nations saw the invasion [of Grenada] as a revival of the type of gunboat diplomacy that has haunted them for more than a century. (*Time*, November 7, 1983)

8. hawk An exponent of war; an adamant proponent of warlike policy. This term, clearly derived from the aggressive bird of prey, was first used figuratively by Thomas Jefferson in 1798, prior to the War of 1812. The expression was revived during President John F. Kennedy's handling of the Cuban missile crisis in 1962. During the controversial Vietnam War, *hawk* became an American household word for any person in favor of the war, as opposed to *dove* 'peace advocate.'

The committee seems to have become immersed immediately in a struggle between doves and hawks. (D. Boulton, *Objection Overruled*, 1967)

9. horn-mad Belligerent, infuriated; mad enough to butt or gore with the horns, as cattle. This term, which dates from at least 1721, appeared in *The American Museum*:

He is horn mad, and runs bellowing like a bull. (1787)

10. on the warpath Antagonistic, hostile, deliberately looking for a fight. The warpath was the route taken by the North American Indians on warlike expeditions. By extension, this Americanism came to refer to any individual or group preparing for war or behaving in a hostile, contentious manner.

She was on the warpath all the evening. (Mark Twain, *A Tramp Abroad*, 1880)

11. rattle the saber Threaten war; assume a belligerent attitude toward one's enemies. The reference in this expression is to the sword-bearing officers of the past who would make as if to draw their swords when pushed too far in an argument. Despite the passing of swords as standard military equipment, the term continued in use, implying an aggressive display of military might, or an act of belligerence, especially by one country toward another. Related terms are *saber rattler* 'a rash militarist,' and *saber rattling* 'making threats of war.'

Henceforward, sabre-rattling in Prussia will be severely taboo. (*Bombay Chronicle*, August 5, 1932)

12. speak daggers To speak in such a way as to offend someone, hurt someone's feelings, or convey open hostility; to use words as weapons of attack; also *look daggers*.

I will speak daggers to her, but use none.
(Shakespeare, *Hamlet* III,ii)

And do thine eyes shoot daggers at that man that brings thee health? (Philip Massinger and Thomas Dekker, *The Virgin Martyr, A Tragedy*, 1622)

13. trail [one's] coat To spoil for a fight, to try to pick a fight, to look for trouble. This expression reputedly refers to an Old Irish custom whereby a person spoiling for a fight would drag his coat on the ground as provocation for another to step on it.

bative mental attitude toward another's idea or proposition.

> All the men of wit . . . were immediately up in arms. (Jonathan Swift, *A Tale of a Tub*, 1704)

Beneficence . . .

See 48. CHARITABLENESS

Benefit . . . See 9. ADVANTAGE

33. BETRAYAL

1. Billy Taylor carried off to sea An expression describing unfaithfulness or betrayal of one's lover. Its origin lies in an old ballad found in Oliver's *Comic Songs*.

> Billy Taylor was a brisk young fellow,
> Full of mirth and full of glee,
> And his mind he did discover
> To a maiden fair and free.
> Four and twenty brisk young fellows
> Clad in jackets blue array,
> And they took poor Billy Taylor
> From his true love out to sea.

His true love follows him disguised as a sailor named Richard Carr. With a naval engagement impending, Billy Taylor deserts the ship and goes to town. His true love follows, finds him with another woman, and shoots him.

> I rather think we should have been like Billy Taylor and carried off to sea. (Lord Byron, *A Letter to Hobhouse*, December 5, 1810)

2. fifth columnist A traitor, quisling; a subversive or an enemy sympathizer. This term's origin dates from the Spanish Civil War (1936–39) when the Loyalist government in Madrid had been infiltrated by many Franco sympathizers. In a radio broadcast to the Loyalists, General Gonzalo Queipo de Llano y Sierro, a Fascist revolutionary, stated, "We have four columns on the battlefield against you, and a fifth column inside your ranks." *Fifth Column* is also the title of a play (1938) by Ernest Hemingway. During World War II, these expressions received widespread use, usually referring to revolutionary sympathizers who had secured positions of influence in matters of security and policy decision. These insurgents spread rumors and practised espionage and sabotage, exploiting the fears of the people and often inciting panic.

> Parliament has given us the powers to put down the fifth column activities with a strong hand. (Winston Churchill, *Into Battle*, 1941)

3. go back on Break a promise; fail a person; prove disloyal; betray a friend. The implication in this expression is that one has turned around and gone the other way in violation of a promise.

> Godby has gone back on them and the Walkers are no more to be relied upon for church dues. (Archibald Gunter, *Miss Dividends*, 1893)

The expression has been in use since about 1860.

4. Judas kiss A sign of betrayal, duplicity, or insincerity. The reference is to the kiss Judas Iscariot gave Jesus in betraying him to the authorities:

> And he that betrayed him had given them a token, saying, Whomsoever I shall kiss, that same is he. (Mark 14:44)

The term dates from as early as 1400.

> Candour shone from his eyes, as insincere as a Judas kiss. (R. Lewis, *Blood Money*, 1973)

5. Judas sheep One who betrays his friends and acquaintances; one who leads others into trouble; a person who saves his own skin by betraying others. Although a *Judas sheep*, 'a sheep used to lead others to the slaughter in the stock yards,' is not morally aware of its actions, the term, when applied to human beings, has come to specify one who, like the biblical Judas who betrayed Jesus, intentionally betrays others for his own benefit or profit. A related term is *Judas goat*.

beings, has come to specify one who, like the biblical Judas who betrayed Jesus, intentionally betrays others for his own benefit or profit. A related term is *Judas goat.*

6. kiss and tell To betray another's confidence; to reveal private information in public; to expose supposedly secret material; to divulge confidential matters. This expression, dating from about 1600, implies that one has betrayed the trust of an intimate friend or lover by revealing private information. The original implication of the phrase was that there was a decided deficiency in the moral character of one who would *kiss and tell*, for he might destroy another's reputation.

> Some men kiss and do not tell, some kiss and tell; but George Moore told and did not kiss. (Susan Mitchell, quoted in Oliver St. John Gogarty, *As I Was Going Down Sackville Street*, 1937)

7. knight of the post A perjurer; a stoolpigeon; a betrayer of his fellow prisoners. This expression, in use since at least 1580, alludes to a person who, having once been punished at the whipping post, will give false evidence for the state rather than return to that horror. Some *knights of the post* in the past were able to procure a comfortable living by working as informers for the authorities.

> When once men have by frequent use lost the reverence that is due to an oath, they easily become Knights of the Post and may be hir'd to swear anything. (Offspring Blackall, *Works*, 1716)

8. most unkindest cut of all See 10. AD-VERSITY.

9. rat To inform or squeal; to desert and turn renegade, to bolt and join the opposition. The noun *rat* has been an opprobrious epithet since Elizabethan times. During the 18th century it took on, in political slang, the more specific denotation of traitor or turncoat. By the 19th century the corresponding verb us-

age appeared. It is generally believed that these slang meanings came by way of comparison with the apostate rats of the proverbial sinking ship, though the older more general 'scoundrel' meaning would suffice—rodents having long been objects of aversion and loathing to man.

10. scab A worker who resists union membership; a union member who refuses to strike. This disparaging expression likens the blue-collar maverick to a healing wound. The epithet is often applied to an employee who crosses picket lines or more specifically, to a person who takes over the job of a striker for the duration of the work stoppage.

11. sell down the river To abandon or desert; to turn one's back on another; to delude or take advantage of. This expression originated in the Old South, where uncooperative slaves were often punished by being shipped downstream to the harsh, sweltering plantations of the lower Mississippi. The phrase maintains regular usage today.

> I think we are, as a people, a little inclined to sell our state down the river in our thinking. (*Daily Ardmoreite* [Ardmore, Oklahoma], December 1949)

12. sell the pass Betray one's own cause; give an advantage to one's opponent; betray one's countrymen. The origin of this phrase lies in an incident in early Irish history. The story is told that an Irish regiment, sent by Crotha of Atha to hold a pass against Trathal and his invading troops, betrayed Crotha by selling out to the invaders. As a result Trathal easily won the battle and declared himself King of Ireland. Since that time *sell the pass* has connoted betrayal.

13. serpent in [one's] bosom Betrayal of one who provides assistance; biting the hand that feeds one; turning upon one's friend. A Greek legend tells of a man who found a frozen snake and placing it against his body, revived it. The snake upon recovering bit the man and poi-

soned him. A related term, *bosom-serpent*, is used to indicate one who can't be trusted.

> With matchless impudence they style
> a wife
> The dear-bought curse, and lawful
> plague of life;
> A bosom-serpent, a domestic evil,
> A night-invasion and a mid-day-devil.
> (Alexander Pope, *January and May*,
> 1709)

14. sing like a canary To give evidence against someone; to squeal; to inform on another; to tell the police about a crime or criminal activity. This underworld slang expression comes from the reference to another bird, the *stool pigeon*. Originally a bird used as a hunters' decoy, *stool pigeon* was transferred to thieves' argot to refer to a police decoy, then an informer. The pigeon is not known for its melodious song, and, when the sense of *sing* was adopted to mean inform, the bird commonly known both as captive and singer became the *canary*. Dating from the 19th century, the phrase is now common throughout the English speaking world.

> They've got plenty of trained canaries
> to sing anyway they tell them. (*I*,
> *Mobster*, 1951)

15. stab in the back A treacherous blow to one's character, especially from one considered a friend; an unexpected, cowardly blow. The implication here is that an attack on one's efforts or name has come from an unexpected source or from an unexpected direction. The term has been in use since at least the 16th century.

16. stool pigeon A person who acts as a decoy; an informer, particularly one associated with the police. This expression is derived from the former practice of fastening a pigeon to a stool to attract other pigeons. Today the phrase usually refers to an informer who is betraying his cohorts. A variant is *stoolie*.

> In New York City he is also called a
> Stool-pigeon. The "profession"

generally speaks of him as a Squealer. (Willard Flynt, *World of Graft*, 1901)

17. take Hector's cloak Betray a friend; deceive a friend who trusts implicity in one's loyalty. In his *Worthies of England* (1662), Thomas Fuller explains the origin of this expression.

> When Thomas Percy, Earl of
> Northumberland, in 1569, was routed
> in rebellion against Queen Elizabeth,
> he hid himself in the house of Hector
> Armstrong of Harlow . . . who for
> money betrayed him to the Regent of
> Scotland.

The expression is used today only in its figurative sense, i.e., to designate a treacherous friend. A related term, *wear Hector's cloak*, refers to the same betrayal. After revealing Percy to the Regent, everything collapsed in the life of Hector Armstrong. His fortunes slowly deteriorated until he departed this life a beggar in the street. Hence, to *wear Hector's cloak* is to be the recipient of poetic justice, to be justly punished for one's treachery.

18. turncoat One who abandons his convictions or affiliations; an apostate or renegade. This expression purportedly originated with a ploy of Emanuel, an early duke of Savoy, whose strategic territory was precariously situated between France and Italy. According to legend, in order to maintain peace with his powerful neighbors, Emanuel had a reversible coat made which was white on one side and blue on the other. He wore the white side when dealing with the French and the blue side when dealing with the Italians. The duke was subsequently called Emanuel Turncoat, and the epithet attained its now familiar meaning of renegade or tergiversator.

> The Tory who voted for those motions
> would run a great risk of being
> pointed at as a turncoat by the . . .
> Cavaliers. (Thomas Macaulay,
> *History of England*, 1855)

Bewilderment . . .
See 63. CONFUSION

Bias . . . See 282. PREFERENCE;
283. PREJUDICE

Bitterness . . . See 315. RESENTMENT

Blackmail . . . See 140. EXTORTION

34. BOASTING

1. **blow [one's] own trumpet** To brag or
boast; to call attention to one's own ac-
complishments, usually with the impli-
cation that no one else is likely to do so;
also, *toot one's own horn.* Though spe-
cific customs have been cited as giving
rise to the phrase, the widespread and
longstanding use of trumpets as
attention-getting instruments seems ex-
planation enough. Important person-
ages and proclamations have long been
heralded by a flourish of trumpets. In
the New Testament, Jesus tells his fol-
lowers not to blow their own horns, so to
speak:

> When therefore thou doest alms,
> sound not a trumpet before thee, as
> the hypocrites do in the synagogues
> and in the streets, that they may have
> glory of men. Verily I say unto you,
> They have received their reward.
> (Matthew 6:2)

2. **cracked up to be** Considered to be;
bragged about being; represented to be.
The *crack* in this phrase is the same as
in "He is a crack shot," implying that
one is at the top or near the top of his
class; similarly, if someone is *cracked up
to be* something, he is at the top of his
class. The negative form, *not all that
[one's] cracked up to be,* is very com-
mon.

> Martin Van Buren is not the man he's
> cracked up to be. (David Crockett,
> *Autobiography*, 1834)

A closely allied phrase with its founda-
tion in the same connotation of *crack* is
cracker jack, used to describe a person or

thing of great worth e.g., "He is a crack-
er jack shortstop."

3. **crow over** To exult over a victory or
accomplishment; to boast or vaunt. The
allusion is to a gamecock's exultant
crowing after defeating an opponent.
This expression dates from 1588.

4. **cry roast meat** To boast of one's good
fortune; to make known a bit of good
luck; to brag of receiving women's fa-
vors. This phrase, dating to the early
17th century, refers to the lot of peasants
who seldom had a good substantial meal
of roast meat; hence, to announce that
one had had roast meat, or was about to
have it, amounted to foolish braggado-
cio, especially in the latter case, for one's
neighbors might well show up and ask to
share.

> The foolish beast, not able to fare
> well, but he must cry roast meat.
> (Charles Lamb, *Essays of Elia:
> Christ's Hospital*, 1820)

How the term came to specify boasting
of a woman's favors is unknown; it may
simply be another example of the use of
meat in reference to sexual activity.

5. **Dutch courage** See 37. BRAVERY.

6. **geneva courage** See 37. BRAVERY.

7. **my son, the doctor** A mother's ex-
pression to show pride in her offspring's
achievement of professional status; an
interjection meant to put down another.
The origin of this expression is in the
stereotype of the Jewish mother who
makes use of the phrase as a goad to mo-
tivate a son to fulfill the mother's high
expectations; from the baby carriage
into maturity the sons are referred to as
my son, the doctor. First brought to the
public awareness by comedians who de-
picted the stereotypical Jewish mother,
the term has in recent years given birth
to many offspring; for example, *my son,
the attorney; my son, the psychiatrist;*
etc. Allen Sherman parodied this com-
mon stereotype with his album of satiri-
cal songs in the early 1960s entitled *My
Son, the Folk Singer.* Today the phrase

is employed both humorously and derisively.

8. Paul's man See 201. INDOLENCE

35. BOISTEROUSNESS

1. Bowery boys A group of rowdies from the Bowery district of New York City; a boisterous gang of notorious ruffians who roamed that area during the 1830s and 1840s. This term originally referred to a specific, undesirable gang of toughs whose name became synonymous with mayhem and murder. William Hancock, in *An Emigrant's Five Years in the Free States of America* (1860), states:

> The term 'Bowery Boy', or to give the customary pronunciation, 'Bowery B'hoy', is understood as implying the personification of vulgarity of manner, showiness of costume, facility in the use of slang, and mental imbecility generally, in their highest development.

However, as frequently occurs, when these characters were transferred to the stage they came to represent good-natured rascals who inevitably become accidental good samaritans. In a series of *Bowery Boys* movies (1940–1953), they were depicted as out-and-out "good guys" albeit illiterate and bumbling.

2. hell on wheels Rowdy, riotous, wild, boisterous. The expression is said to have been commonly applied to towns that sprang up along the Union Pacific Railroad line during the 1860s because of the gunmen, gamblers, and prostitutes who inhabited them in such large numbers. The phrase has been in use since at least 1843.

> He's hell on wheels on Monday mornings. (J. Pearl, *The Crucifixion of P. McCabe*, 1966)

3. joy ride A reckless, highspeed excursion, often made in a borrowed or stolen car; a pleasant jaunt in an automobile or aircraft. This expression conjures up an image of exhilarated teenagers screeching through city intersections in high-powered hot rods. Modern use of the phrase, however, usually carries an implication of illegality.

> A man who drove away two cars for a "joy ride" was fined 75 pounds. (*Scottish Sunday Express*, August 1973)

4. raise Cain To behave in a boisterous and rowdy manner, to create a disturbance, to raise a ruckus; also to protest vigorously, to raise a hue and cry, to make a fuss. Most sources relate the expression to the Biblical fratricide, Cain, but make no attempt to explain his transition from agent to object. It may be that his name became associated with evil incarnate and thus came euphemistically to replace *devil*, once considered profane, so that *raise the devil* gave way to *raise Cain* which found favor because of its greater brevity and musicality. Since the first recorded American usage involves a pun, it is safe to assume that the expression was commonplace by that time.

> Why have we every reason to believe that Adam and Eve were both rowdies? Because . . . they both raised Cain. (*St. Louis Pennant*, May 1840)

5. shivaree A discordant, mock serenade of a newlywed couple on their wedding night. This expression, a corruption of the French *charivari*, refers to an American practice popular during the late 19th and early 20th centuries, especially in middle America. The serenaders gathered quietly beneath the window of the newlyweds' bedroom and suddenly began beating frying pans and tin kettles, blowing tin horns and whistles, and creating a general medley of cacophonous sounds. Custom dictated that these serenaders must be rewarded with refreshments; if not, the groom was taken for a ride on a rail. The entire ceremony was executed in a jocular vein.

A variant is *chivaree*.

> 'What is it you call this thing . . . and you come out with horns and—'

'Charivari?' asked the Creoles. 'Yes, that's it. Why don't you shivaree him?' (George W. Cable, *Old Creole Days*, 1879)

6. shout blue murder To make a great hullabaloo; to cry in terror or alarm; to raise a horrible outcry; to become very perturbed. This 19th-century expression suggests a cry more of alarm than of real danger.

> The foolish beast would not budge, but kept yelling blue murder whilst the bull was cruelly punishing her. (Pollok and Thom, *Sport in British Burma*, 1900)

Although the origin is uncertain, the phrase may be a corruption of the French interjection, *morbleu*. Variants are *yell blue murder*, *cry blue murder*, and the slightly different *scream, cry,* or *shout bloody murder*.

7. Tom and Jerry Any boisterous young men about town; a hot whiskey drink; a cartoon cat and mouse. In the 1820s Pierce Egan published two books *Life in London*, or *The Day and Night Scenes of Jerry Hawthorne, Esq. and Corinthian Tom* (1821) and *Finish to the Adventures of Tom, Jerry, and Logic* (1828). Tom and Jerry were two young men who behaved riotously, drank excessively, and, in general, led merry lives. They were not malicious and their madcap adventures as they cut a swath through London social life gave birth to this phrase and to a verb form, *Tom and Jerrying*.

> We are too apt to take our ideas of English life from such vulgar sources as Tom and Jerry; and we appear to be Tom and Jerrying it to perfection in New York. (Washington Irving, *Life and Letters*, 1829)

Since their appearance, there has been a hot whiskey drink, usually reserved for the cold winter months, named after them, and two well-known cartoon characters, a roisterous cat and mouse.

8. visiting firemen A rowdy band of men. It was common practice in small towns of America to hold competitions between volunteer fire companies from neighboring communities. These firemen's conventions often turned into heavy drinking, free-spending, hell-raising affairs. From this the term has been extended to indicate any boisterous group or convention, especially those gathered in a large city.

> He meets a good many distinguished visiting firemen. (*New Yorker*, March 24, 1951)

Boldness . . . See 37. BRAVERY;
　192. IMPUDENCE

Bookishness . . .
　See 331. SCHOLARLINESS

36.　BOREDOM

1. cut and dried See 347. SIMPLIFICATION.

2. dry-as-dust Boring, extremely dull or dry; prosaic, unimaginative; concerned with petty, uninteresting details. Dr. Dryasdust is the name of a fictitious character created by Sir Walter Scott in the early 19th century. The Doctor, a learned antiquary, wrote the introductory material or was mentioned in the prefaces to Scott's novels. Currently, adjectival use of the term is most common.

> She considered political economy as a dry-as-dust something outside the circle of her life. (Mary E. Braddon, *Just as I Am*, 1880)

3. dull as ditchwater Uninteresting; prosaic; stupid; extremely boring. The allusion in this expression, in use as early as the 1300s, is to the dank water that collects in a ditch; it just lies there, dirty and unappealing.

> He'd be sharper than a serpent's tooth, if he wasn't as dull as ditchwater. (Charles Dickens, *Our Mutual Friend*, 1865)

Related terms are *digne as ditchwater*, an obsolete phrase meaning stinking with pride, *light as ditchwater*, meaning easy to accomplish, and *dull as dishwater*, a simple variant.

4. month of Sundays See 110. DURATION.

5. the screaming meemies See 22. ANXIETY.

Bothersomeness . . . See 170. HARASSMENT; 394. VEXATION

Bragging . . . See 34. BOASTING

37. BRAVERY

1. as bold as Beauchamp Brave, courageous, daring. Some say this now little-heard phrase derives from the celebrated feat of Thomas Beauchamp, who in 1346 defeated 100 Normans with one squire and six archers. Almost 300 years later a play entitled *The Three Bold Beauchamps* was written, which is cited as another possible source for *as bold as Beauchamp* or *bold Beauchamp*.

2. derring-do Daring deeds, brave feats, acts of heroism. The term owes its existence to a series of repeated printing and copying errors which converted the original verb phrase *daring to do* to the now common noun *derring-do*.

3. Dutch courage A false sense of courage or bravery induced by alcohol; pot-valor or pot-valiancy. This colloquial expression, in use since at least 1826, is an allusion to the heavy drinking for which the Dutch people were known. The term appeared in Herbert Spencer's *The Study of Sociology* (1873):

> A dose of brandy, by stimulating the circulation, produces "Dutch courage."

4. fear no colors To be audacious; to be unflinching in the face of hostility or danger. In this expression, *colors* carries its early military meaning of 'flag.' In Shakespeare's *Twelfth Night*, Malvolio ascribes this military origin to the phrase. The term was more figuratively used by Jonathan Swift in *Tale of a Tub* (1704):

> He was a person that feared no colours, but mortally hated all.

5. game as Ned Kelly Plucky; unyielding; brave; intrepid. This Australian expression became popular shortly after the capture of the notorious bushranger, Ned Kelly, in 1880. Like the American Jesse James, Kelly, an Australian outlaw, became something of a folk-hero. He was finally captured, wearing a suit of homemade armor, after holding out for two years against the police. He was hanged in Melbourne in 1880. In later years Kelly became the subject of an Australian catch-phrase, *Ned Kelly was hanged for less*, a jocular indictment of government officiousness.

6. geneva courage Courage produced by alcohol intoxication; foolhardy boasting triggered by drunkenness. The *geneva* of this expression has no connection with the Swiss city, but refers rather to a Dutch gin called *Hollands* or *geneva*. *Geneva courage* is thus virtually synonymous with *Dutch courage* or *potvalor*.

7. heart of oak A valiant, stalwart spirit; a man of great courage and endurance; a man of superior quality. The heart or core of a tree is the solid central part without sap or albumen, which yields the toughest wood. The expression has been in figurative use since at least 1609.

> Heart of oak are our ships, heart of oak are our men. (*New Song* in *Universal Magazine*, March 1760)

8. nip a nettle To take strong measures; to act firmly toward troublesome people; to be stalwart and courageous in action. This expression is derived from an old wives' tale about the proper method to avoid the stinging of a nettle's leaf hairs, as expressed in this rhyme:

> Tender-handed stroke a nettle,
> And it stings you for your pains;

Grasp it like a man of mettle,
And it soft as silk remains.
(Aaron Hill, *The Nettle's Lesson*,
1753)

The expression, dating from about 1579,
is seldom heard in any but its figurative
sense. A related term, *piss on a nettle*,
means to be peevish or ill-tempered.

9. screw up [one's] courage To set one-
self emotionally for a difficult or un-
pleasant chore; to force oneself to face a
difficult situation. This phrase seems to
be a variant of the venerable line from
Macbeth, in the mouth of Lady Mac-
beth:

We fail?
But screw your courage to the
sticking-place
And we'll not fail.

The *sticking place* may refer to the point
at which a screw becomes tight, or to
the tightening of a string on a musical
instrument by the turning of the peg. At
any rate, the expression *screw up one's
courage* made its appearance in print in
the 1600s.

I had some difficulty in screwing up
my courage to open an abscess.
(Henry B. Tristam, *The Land of
Moab*, 1873)

10. true grit Unfaltering courage; devo-
tion to that which is right; indomitable-
ness; of a solid character. *Grit* as an in-
dication of bravery or strength came
into existence as an American slang term
in the early 1800s. Shortly thereafter
true grit became a common expression in
the western United States to define one
who is devoted to doing what is right re-
gardless of the danger involved.

We don't like to leave a real true grit
American . . . among a lot of
cowardly Diegos. (*The Knicker-
bocker*, 1846)

In 1969, John Wayne won an Academy
Award for portraying Rooster Cogburn,
an old reprobate who discovers that he
has hidden courage, in the motion pic-
ture *True Grit*; as a result, the term has
enjoyed a recent revival in popular use.

38. BRIBERY
See also 140. EXTORTION;
165. GRAFT; 265. PAYMENT

1. blood money The price on someone's
head, the money paid as reward for in-
criminating evidence or betrayal, espe-
cially such as will result in another's
death. The term *blood money* also refers
to the Anglo-Saxon *wergild* or compen-
sation paid to the kin of a murder victim
to prevent continued retaliatory feuding.

2. buy yourself a hat An expression
used when offering money to someone,
especially as a bribe or safeguard against
prosecution. This expression was appar-
ently derived from the 18th- and 19th-
century practice of asking servants to
perform some questionable services and
slipping them a little extra money with
the excuse that it was to buy some small
item. From this phrase has been extract-
ed the term *hat*, meaning 'bribe' or 'un-
lawful bonus.'

This finally was rejected because the
policemen involved did not want to
lose the $200 monthly bonus or "hat"
for the dangerous job of making the
pickup themselves. (*The New York
Times*, May 7, 1972)

3. cross [someone's] palm To give mon-
ey to someone, especially as a bribe; to
grease someone's palm or hand. *Cross
[someone's] palm* is not as common, nor
as old, as *grease [someone's] palm*, and
its connotations not so strongly sinister.
Cross probably refers to the action of
placing bills across a person's hand as a
bribe is transacted. In another sense, it
was customary to pay fortune tellers, es-
pecially gypsies, by crossing their palms
(with silver), perhaps in a ritualized
making of the sign of the cross to ward
off prognostications of evil or merely for
a lucky reading.

4. glove money Bribe money; so-called
from the gratuity or tip given to servants

ent explanation of the expression in his book on folklore:

> The gift of a pair of gloves was at one time the ordinary perquisite of those who performed some small service; and in process of time, to make the reward of greater value, the glove was "lined" with money; hence the term "glove-money."

The term, no longer in current use, dates from the early 18th century.

5. grease [someone's] palm To bribe someone; to use money illegally for unauthorized services; sometimes *grease the hand* or *fist*. This slang phrase dates from the early 16th century.

> With gold and grotes they grease my hand. (John Skelton, *Magnificence*, 1526)

Grease, used figuratively, means 'to facilitate or smooth the way.' In the case of bribery, one smooths the way by placing money in someone else's hands. A variant of the full expression is the truncated *grease*. Current since the turn of the century is another variant *oil [someone's] palm*.

6. grease the wheels To take action to make things run smoothly; to use money as an expedient. In use since the 19th century, this expression does not necessarily connote financial deceit, although it clearly does so in the following citation:

> The party I mean is a glutton for money, but I will do my best with him. I think a hundred pounds . . . would grease his wheels. (Sir A. H. Elton, *Below the Surface*, 1857)

7. have an ox on the tongue To be paid to remain silent; to be bribed to secrecy. This obsolete expression originated in ancient times, when cattle were considered an important commodity for barter; moreover, early metallic coins often bore the visage of an ox. Thus to *have an ox on the tongue* came to mean 'made mute by money.'

8. oil of angels Money or gold, particularly when used as a gift or bribe. Angel in this expression refers to the 15th-century English coin which bore the visage of Michael the Archangel. Figuratively, the phrase implies that money provides soothing, oil-like relief to greedy hands.

> The palms of their hands so hot that they cannot be cooled unless they be rubbed with the oil of angels. (Robert Greene, *A Quip from an Upstart Courtier*, 1592)

9. sop to Cerberus A token intended to pacify another; a gift or tribute to appease an adversary; a bribe, hush-money. This expression is derived from the ancient Greek and Roman custom of placing a *sop* cake in the hands of a cadaver. The sop was intended to placate Cerberus, the three-headed dog that guarded the gates of Hades, who, after receiving the offering allowed the dead to pass.

> I will throw down a napoleon, as a sop to Cerberus. (Horatio Smith, *Gaities and Gravities*, 1825)

39. BRUTALITY

1. Attila the Hun A tyrant; a martinet; a brutal sadistic leader; one who demonstrates excessive cruelty. The allusion in this term is to Attila, the king of the Huns (406–453), also known as "The Scourge of God," who led his army through Europe with such barbaric ferocity that his name has become synonymous with bloodthirstiness and savagery. Today the term is often used simply to indicate any churlish or unkind person.

> The "snake in the grass" is the most common type followed closely by Attila the Hun clones and heel grinders. (*Family Weekly*, March 18, 1984)

40. BURDEN

1. albatross around the neck Burden, weight; any inhibiting encumbrance. In

Samuel Taylor Coleridge's *The Rime of the Ancient Mariner* (1798), the slayer of the albatross—a bird of good omen to sailors—was punished by having the dead bird hung about his neck. Though within the context of the poem the dead albatross symbolizes guilt and punishment for sin, its contemporary use rarely carries this connotation. Often an albatross around one's neck is no more than a burdensome annoyance, a "drag" that inhibits one's freedom or lessens one's pleasure.

2. ball and chain A wife; one's girl friend or mistress; any person perceived as a burden or hindrance. This figurative meaning of *ball and chain* is derived from the iron ball which is secured by a chain to the leg of a prisoner in order to prevent escape. Insofar as having a wife inhibits one's freedom, this slang expression is apt.

> He deliberately attempted to commit suicide by askin' me "How's the ball and chain?" meanin' my wife. (*Collier's*, June 25, 1921)

3. cross to bear A painful burden or affliction; an oppressive encumbrance. The expression derives from the heavy cross which Jesus was forced to carry up Mount Calvary, and upon which he was subsequently crucified. Though the phrase most often applies to serious illness, pain, or handicaps, it is frequently extended to include any bothersome annoyance, any unpleasant person or circumstance that must be endured.

4. millstone around the neck A heavy burden, an onus, a cross. A millstone is either of a pair of round, weighty stones between which grain and other like materials are ground in a mill.

> The millstone intended for the necks of those vermin . . . the dealers in corn, was found to fall upon the heads of the consumers. (Jeremy Bentham, *Defence of Usury*, 1787)

The metaphor is said to have been suggested by the Biblical passage (Matthew 18:6) in which Jesus warns those who would corrupt the pure and humble nature of children:

> But whoso shall offend one of these little ones which believe in me, it were better for him that a millstone were hanged about his neck, and that he were drowned in the depth of the sea.

5. monkey on [one's] back A depressing, often controlling burden; a cross to bear; an addiction or dependence. This phrase may be a variation of the obsolete *turkey on one's back*, but the implication remains the same: an addict carries an extra burden, one demanding a large, if not total, commitment of time, effort, and money to support.

> Having a monkey on your back . . . always worked out logically to be the first purpose in a junkie's life. (E. R. Johnson, *God Keepers*, 1970)

6. white elephant An unwanted or useless possession that is difficult to dispose of; a possession that costs more to keep and maintain than it is worth. This expression probably alludes to the albino elephants which were once considered sacred in Siam (now Thailand). Since an elephant of any color is inconvenient and expensive to own, it was purportedly a custom for a king to bestow one of these unique white elephants as a gift upon a courtier or other person whom he wished to subject to financial ruin. In the United States, tag sales, garage sales, and rummage sales are often appropriately nicknamed *white elephant sales*.

41. BURIAL

1. Boot Hill A frontier cemetery or burial ground, especially for cowboys. This expression, coined in the American West of the mid 1800s, alludes to the fact that most of the occupants of these graveyards were cowboys who died with their boots on, the implication being that they perished in gunfights or while working, not while bedridden with illness or infirmity. The term became so commonplace throughout the West that

their boots on, the implication being that they perished in gunfights or while working, not while bedridden with illness or infirmity. The term became so commonplace throughout the West that some *Boot Hills*, like those in Dodge City, Kansas, Tombstone, Arizona, and Deadwood, South Dakota, became famous.

> And if some of the wilder tales are to be believed, barroom brawls regularly culminated in sudden death, with the victims being carted off to resting places like Dodge City's notorious Boot Hill. (*Story of the Great American West*, 1977)

2. Davy Jones's locker A watery grave; the bottom of the ocean, especially as the grave of those who die at sea. In nautical slang, Davy Jones is the spirit of the sea, the sailor's devil. Of the many conjectures as to the derivation of this expression, the most plausible include theories such as: *Jones* is a corruption of Jonah; *Davy* is derived from *duppy*, a ghost or spirit among West Indian Negroes; and *locker* is a seaman's chest. While the phrase *Davy Jones's locker* has been in use only since 1803, the term *Davy Jones* dates from 1751.

3. God's acre A churchyard, a cemetery. Although Longfellow called this phrase "an ancient Saxon phrase," others claim that it is a more modern borrowing from the German *Gottesacker*.

> The Greeks call their Churchyards dormitories, sleeping-places. The Germans call them Godsacre. (John Trapp, *Annotations upon the Old and New Testament*, 1646)

According to *OED* citations, the phrase has been in print since the early 17th century.

4. hic jacet A tombstone or gravemarker; specifically, the inscription on such a tablet, from the Latin *hic jacet*

'here lies,' a common introduction to a gravestone epitaph.

> Among the knightly brasses of the graves,
> And by the cold Hic Jacets of the dead.
> (Alfred, Lord Tennyson, *Merlin and Vivien*, 1859)

5. marble orchard A graveyard or necropolis; also, *bone orchard*. This American slang expression is clearly derived from the multitudinous stone tablets in cemeteries.

> A couple more punches and it would have been the marble orchard for him. (B. Broadfoot, *Ten Lost Years*, 1973)

6. potter's field A burial place for strangers or the poor. After Judas Iscariot had betrayed Jesus Christ, his guilt led him to hand over to the priests the thirty pieces of silver which he had received for the betrayal. The priests, hoping to use the money judiciously, bought a field from a local potter in which to bury any strangers who might die in their city.

> The chief priests took the silver pieces . . . and bought with them the potter's field, to bury strangers in. (Matthew 27:7)

However, in time the *potter's field* came to be a place to bury, besides strangers, those who were too poor to afford a burial plot. Today, the term is often used figuratively to mean 'dumping ground.'

> When I wrote a letter . . . you did not put it in the respectable part of the magazine, but interred it in that 'potter's field', the Editor's Drawer. (Mark Twain, *Western Gazette*, November 26, 1906)

7. put to bed with a shovel See 109. DRUNKENNESS.

C

42. CALLOUSNESS

1. ask for bread and receive a stone To receive callousness rather than compassion. This ancient expression, appearing in various forms among the writings of the classical Greeks and Romans, refers to the old practice of enticing one's dog, in order to beat him, by offering a piece of bread in one hand while concealing a rock in the other. What is probably the most celebrated use of the phrase appears in Samuel Wesley's poem, *On Samuel Butler's Monument in Westminster Abbey* (1721):

> The Poet's Fate is here in emblem shown:
> He asked for Bread, and he received a Stone.

The allusion here is to the alleged hardheartedness of King Charles II, who promised to relieve Butler's destitution. He promised Butler £300 cash plus an annuity of £100 a year, but somehow the money was never forthcoming, and Butler is said to have died in penury. The phrase is occasionally heard today.

> When they ask for bread don't give them crackers as does the church, and don't, like the State, tell them to eat cake. Explain that man can't live by bread alone, and give them stones. (Nathanael West, *Miss Lonelyhearts*, 1933)

2. cold as a paddock Callous; lacking in personal warmth; hard-hearted; unfeeling; stoic. The allusion in this phrase is to the cold, clammy feeling of the skin of a paddock (another name for a frog or a toad), a symbol of the coldness of some people's hearts. Although commonly recognized from Shakespeare's use of the term to designate the attendant spirit of the Second Witch in *Macbeth*, the expression, which is seldom heard today, appeared in print as early as the Middle Ages.

> Here a little child I stand,
> Heaving up my either hand;
> Cold as paddocks though they be,
> Here I lift them up to Thee.
> (Robert Herrick, *A Child's Grace*, 1648)

3. hard as nails Hard-hearted; unsympathetic; callous; unbending; in top physical condition. Although this phrase is still used to denote one in fine physical condition, it is more commonly used today to describe a tough mental or emotional attitude. It is said especially of one who is callous enough, because of religious or business principles, to overlook another's mental anguish or physical suffering in order to achieve his own ends. The allusion, of course, is not to the nails themselves but to the hardness of the metal of which they are manufactured. The expression has been in use since the early 1800s.

> Hard and sharp as nails! I take my hat off to him. (S. J. Weyman, *Ovington's Bank*, 1922)

4. in cold blood Without emotion; deliberately and dispassionately. This ancient expression dates back to at least the Roman Empire. The allusion is to the ancient belief that the blood was the seat of the emotions. A person with hot blood was passionate, emotional, while a person with cold blood was calm, calculating. Somehow it has always been considered more outrageous to act in cold blood; the man who kills in the heat of passion is forgiven more readily than one who kills in a cool, calculating manner. George Bernard Shaw in *Man and Superman* (1903) takes a sarcastic swipe at such an attitude.

If you strike a child, take care that you strike it in anger, even at the risk of maiming it for life. A blow in cold blood neither can nor should be forgiven.

5. key-cold Completely lacking in personal warmth and compassion; emotionally frigid; apathetic. This expression is derived from a key's metallic coldness, a property which was once thought to remedy nosebleeds. This obsolete phrase saw its heyday during the 1500s.

The consideration of his incomparable kindness could not . . . fail to inflame our key-cold hearts. (Sir Thomas More, *Comfort Against Tribulation*, 1534)

6. Roman holiday A time of great amusement, especially one made possible through the suffering of others. In A.D. 101, the Roman emperor Trajan conquered an area north of the Lower Danube, which was designated as the Roman province of Dacia. He returned to Rome with 10,000 Dacian captives to exhibit in games. The expression *Roman holiday* was used by Lord Byron when he commented upon the fate of one of these Dacian captives:

He recked not of the life he lost nor prize,
But where his rude hut by the Danube lay,
There were his young barbarians all at play,
There was their Dacian mother—he, their sire,
Butcher'd to make a Roman holiday.
(*Childe Harold's Pilgrimage*, 1818)

7. weep millstones Said sarcastically of a callous, hardhearted person, implying that he is not likely to weep at all. This expression is probably derived from *The Tale of Beryn* (1400):

Tears . . . as great as any millstone.

Since a millstone is a large stone that grinds grain in a mill, its use here is, of course, hyperbolic. This expression was used several times by Shakespeare; for

example, in *Richard III*, Gloucester states:

Your eyes drop millstones, when fool's eyes drop tears.
(I,iii)

Calm . . . See 266. PEACE

Calmness . . . See 60. COMPOSURE;
199. INDIFFERENCE;
273. PLACATION

Calumny . . . See 350. SLANDER

Campaigning . . . See 275. POLITICS

43. CANDIDNESS
See also 348. SINCERITY

1. above-board In full view, in open sight; honestly, unsurreptitiously. The most widely held theory claims the phrase for card playing; gamblers were wont to engage in chicanery when their hands were out of sight and under the table (or board). Another source also attributes the term to the practice of gamesters, but to those who controlled wheels of fortune by means of a treadle hidden beneath a counter.

2. call a spade a spade To speak plainly or bluntly; to be straightforward and candid, sometimes to the point of rudeness; to call something by its real name. The ultimate source of this expression is Erasmus' translation of Plutarch's *Apophthegmata*. According to the *OED*, the phrase in question was mistranslated from the original Greek. The expression has been popular in English since Nicholas Udall's 1542 translation of the Erasmus version. An early example is in Humfrey Gifford's *A Posie of Gilloflowers* (1580):

I cannot say the crow is white, But needs must call a spade a spade.

3. flat-footed Direct, to the point; firmly resolved, uncompromising; often heard in the phrase *come out flat-footed* 'to make a direct and firm statement of

one's opinion or preference.' This American colloquial expression most likely derives from body language—a firm stance with legs slightly apart and both feet flat on the ground as a sign of determination and will. Both *flat-footed* and *come out flat-footed* have been in use since the mid 19th century.

> Mr. Pickens . . . has come out flatfooted for the Administration, a real red-hot Democrat, dyed in the wool. (*New York Herald,* June 30, 1846)

4. get something off [one's] chest To relieve oneself by expressing what one feels; to confess; to unburden oneself. In the Middle Ages the heart was believed to be the seat of the emotions; therefore, when one alleviated himself of a pressing emotional problem, he believed that he was literally getting it off his chest. Although modern man no longer believes that the heart is the center of the emotions, he continues to employ the phrase in its original sense.

> "I've got to get it off my chest," said he. I want to tell you that I've been every end of a silly ass." (W.J. Locke, *Simon the Jester,* 1910)

5. lay it on the line See 328. RISK.

6. let [one's] hair down To relax; to act or speak informally; to speak candidly or intimately; to behave in an uninhibited, unrestrained manner, particularly in a situation requiring dignity and reserve. This figurative expression alludes to the fact that until fairly recently, a woman was expected to maintain a very staid and formal public image, and as a result, often wore her hair pinned up on the top of her head. In the privacy and relative comfort of her own home, however, such a woman usually felt free to relax and would let her hair down. It was in these informal moments that her true personality would be revealed.

> You can let your hair down in front of me. (Jerome Weidman, *I Can Get It For You Wholesale!,* 1937)

A related expression is *hairdown* 'an intimate conversation.' In recent years, *let [one's] hair down* has largely been replaced by, and may in fact have given rise to, expressions such as *hang loose, loosen up,* and *let it all hang out.*

7. let it all hang out To be uninhibited; to let one's hair down; to be open and frank; to tell all the facts without holding anything back; to make a full confession. This expression, probably an allusion to the male sex organ, originated as a slang expression during the 1950s. However, the phrase was popularized by extensive media exposure during the Watergate proceedings in the early 1970s, for it was a favorite term of some of the principals in the case.

> As the current saying goes, NCR has it all hanging out. (*Forbes,* July 15, 1973)

8. make a clean breast To give a full confession, especially one that relieves guilt and anxiety; to make a complete disclosure. One explanation of this term lies in the ancient custom of branding a sinner on the breast with a symbol appropriate to his sin. The confession redeemed him and the punishment made a clean breast. A more reasonable allusion attributes the term to the heart as the seat of emotion; thus, confession cleanses the heart of any evil stains that might be lodged in the breast.

> The pagan Aztecs only confessed once in a lifetime . . . then they made a clean breast of it once for all. (Long, *Essays in Literature,* 1891)

9. make no bones about To be outspoken, to deal with someone directly and openly; to go along with, to acquiesce without raising any objections. Variants of this expression appeared in print as early as the 15th century. A number of theories have been suggested to explain its origin, the most plausible being that it grew out of the literal *find bones in,* referring to the bones in soup which are an obstacle to its being safely swallowed. Thus *find bones in* became *make bones*

about, meaning 'to scruple, to raise objections, to offer opposition.'

> Do you think that the Government or the Opposition would make any bones about accepting the seat if he offered it to them? (William Makepeace Thackeray, *The History of Pendennis,* 1850)

Currently the expression is heard almost exclusively in the negative.

> On the other hand, Dr. Libby makes no bones about the catastrophe of a nuclear war. (*Bulletin Atomic Science,* September, 1955)

10. naked truth Plain, unadorned truth; unvarnished truth. According to an ancient fable, two goddesses, Truth and Falsehood, were bathing. Falsehood came out of the water first and adorned herself in Truth's clothes. Truth, not wishing to wear the trappings of Falsehood, decided to go naked. Thus the expression.

11. not to mince the matter To be plain or outspoken; to speak frankly or bluntly; to be truthful about something; to get to the point. This expression was originally devised in the positive sense, *to mince matters,* and meant 'to put things delicately or moderately.' The allusion is to the mincing of meat to make it more readily digestible. However, the term is more commonly heard today in the negative sense.

> A man's speculative view depends— not to mince the matter—on the state of his secretions. (Willkie Collins, *Dead Secret,* 1857)

12. point-blank Direct, straightforward, explicit; blunt, frank, unmincing. In ballistics, a weapon fired point-blank is one whose sights are aimed directly at a nearby target so that the projectile travels in a flat trajectory to its destination. By extension, then, a point-blank comment, question, accusation, etc., is one which is direct and to the point, one which does not mince words.

> This is point-blank treason against my sovereign authority. (Samuel Foote, *The Lame Lover,* 1770)

13. put [one's] cards on the table See 137. EXPOSURE.

14. Quaker bargain A take it or leave proceeding; a yes or no bargain; a straightforward deal. This expression alludes to the honesty for which members of the Quaker sect are known, and for their no-nonsense directness in dealing with others in any aspect of life.

15. skin the bear at once To come straight to the point, to waste no time getting down to brass tacks.

> But now, to skin the *bar* at once, can you give me and five other gentlemen employment? (*The New Orleans Picayune,* September, 1844)

This U.S. colloquialism, the opposite of *beat around the bush,* refers to the skinning of an animal immediately after it is slain because the hide is more easily removed then.

16. speak by the card To express oneself in a clear and concise manner; to carefully select one's words; to speak honestly. This expression appears in Shakespeare's *Hamlet:*

> We must speak by the card, or
> equivocation will undo us.
> (V,i)

This phrase refers to a compass card, on which every point has its own precise and unambiguous designation.

> I speak by the card in order to avoid entanglement of words. (Benjamin Jowett, *Plato,* 1875)

17. straight from the shoulder Frankly; candidly; truthfully; directly. This expression originated as a boxing term for the delivering of a direct, full-force punch. Today, the phrase retains its figurative meaning of the voicing of a forthright, unembellished comment.

> A man that talks old-fashioned American Democracy straight from

the shoulder. (R. D. Saunders, *Colonel Todhunter*, 1911)

18. talk turkey To speak frankly or plainly, to talk seriously and straightforwardly, to get to the point.

Let's talk turkey about this threat to your welfare. (*Florida Grower*, February 1950)

Legend has it that an American Indian and a white man out hunting together bagged a turkey and a crow. When the time came to split the catch, the white man said, "You may have your choice, you take the crow and I'll take the turkey, or if you'd rather, I'll take the turkey and you take the crow"; whereupon the Indian replied "Ugh! you no talk turkey to me a bit." Although this bit of etymological folklore should be taken with a massive dose of salt, it does serve to point out the importance of the turkey as food and therefore as serious business, a fact which may have given rise to the expression as it is used today.

19. unvarnished tale A plain and simple recounting; a story told without any attempt to soften or disguise it; the unembellished facts. Another one of the many expressions attributed to the pen of Shakespeare, this phrase appears in *Othello* (I,iii). The Moor is trying to convince his superiors that he used no witchcraft to win Desdemona, whom he has taken to wife:

Yet, by your gracious patience,
I will a round unvarnished tale
 deliver
Of my whole course of love, what
 drugs, what charms,
What conjuration.

A common related term with the same connotation is *unvarnished truth*.

20. warts and all With no attempt to conceal blemishes, weaknesses, failings, vices, foibles, etc. Portrait painters, particularly those commissioned by the powerful and prideful, were wont to depict their subjects in a favorable and flattering light. In doing so, they fre-

quently completed canvases bearing but slight resemblance to the original, their artist's scalpel having excised warts, moles, scars, and other such blemishes; they also smoothed wrinkles, straightened bones, and otherwise played the plastic surgeon. The phrase *warts and all* has come to describe a visual or verbal portrait which aims at a realistic picture of its subject by presenting his "ugly" as well as his commendable side. According to William Safire's *Political Dictionary* (1978), the British statesman Oliver Cromwell (1599–1658) is reputed to have directed his portraitist:

Use all your skill to paint my picture truly like me, and not to flatter me . . . remark all those roughnesses, pimples, warts, and everything as you see me; otherwise I will never pay one farthing for it.

Occasionally the phrase is extended to intangibles such as plans, intentions, etc., when liabilities as well as assets are clearly communicated.

Capability . . . See 3. ABILITY;
55. COMPETENCE

Capacity . . . See 3. ABILITY

Carefulness . . .
See 45. CAUTIOUSNESS

44. CARELESSNESS

1. asleep at the switch Off one's guard; negligent; having slow reflexes. This expression derives from early American railroad terminology. To switch a train is to transfer it from one track to another, and an unaware or negligent worker who was "asleep at the switch" could cause a serious accident. The expression is no longer restricted to railroad usage and can apply to any irresponsible lack of attention which could have adverse consequences.

2. drop a brick Make a tactless remark; commit a *faux pas*, especially of speech; blunder. The allusion in this slang ex-

pression, coined in the 1920s, is to the accidental dropping of a figurative brick upon another person's ego. The term probably derives from the literal dropping of a brick on another's foot.

> The stones of Stonehenge are little pebbles compared to the bricks you dropped, but I forgive you. ('Sapper,' *Female of the Species*, 1928)

A related term is *make a bloomer*.

3. lick and a promise A hasty and perfunctory way of doing something; a halfhearted or nominal compliance with a request or command. In this expression, *lick* is used in the colloquial sense of 'slight and hasty wash,' implying a lackadaisical or superficial performance of a task. *Promise* implies an assurance that a more complete and thorough job will be done at some unspecified time in the future.

> The lassie gi'es a lick and a promise when I tell her to sweep! (E. F. Heddle, *Marget at Manse*, 1899)

4. slap-bang Hastily, often without consideration of possible consequences; hurriedly; haphazardly. This expression was originally used to describe sleazy eateries and "greasy spoons" where one received fast service by "slapping" his money down to pay for food that was indelicately "banged" onto the table.

> They lived in the same street, walked to town every morning at the same hour, dined at the same slap-bang every day, and revelled in each other's company every night. (Charles Dickens, *Sketches by Boz*, 1837)

Thus, by extension, *slap-bang* came to refer to anything done in a quick, careless, and unceremonious manner.

> After fooling a man like a child in leading-strings for half a year, to let him go slap-bang, as I call it, in a minute, is an infernal shame. (Theodore Hook, *The Parson's Daughter*, 1833)

5. slapdash Carelessly; in a hasty though thoughtless manner; hurriedly; haphazardly. Originally, *slapdash* was a technique of painting a wall to give it the appearance of wallpaper by "slapping" on a coat of paint and then "dashing" or splashing on spots or blotches of a contrasting color. Although *slapdash* is frequently applied as a criticism to a writer's or an artist's style, it is also applied in other contexts to denote careless haste.

> I cannot plunge, slapdash, into the middle of events and characters. (Sir George Trevelyan, *The Life and Letters of Lord Macaulay*, 1838)

45. CAUTIOUSNESS

1. butter [one's] bread on both sides See 190. IMPROVIDENCE.

2. cover all bases To protect oneself against possible loss by anticipating and preparing for all possible alternatives in a given situation; to hedge one's bets. This American slang expression derives from baseball. An infielder is stationed near or at a base at which a play is anticipated; the base is then said to be "covered."

3. cover [one's] tracks See 61. CONCEALMENT.

4. handle with kid gloves To handle very gingerly and tactfully, to treat very gently and with the utmost caution and care; to pamper or mollycoddle. Leather made from the skin of a kid, or young goat, is especially soft. Perhaps this expression, which dates from at least 1864, is in some way connected with the opposing phrase *to handle without gloves* or *with gloves off* 'to deal with harshly or with exceptional plainness or frankness,' in use as early as 1827. In James Bryce's *The American Commonwealth* (1888) he refers to

> . . . the Americans who think that European politics are worked, to use the common phrase, "with kid gloves."

5. have two strings to [one's] bow To have an alternative plan of action should an unexpected emergency occur; to have something to fall back on; not to put all one's eggs in one basket; to have more than one means of supporting oneself. In print since the 16th century, this expression alludes to the custom of archers carrying a spare bowstring in case the original one should break. In current use, such precaution can take the form of financial savvy, practicality in affairs of the heart (as in the following quotation), or any expedient employed to prevent one from being left in the lurch.

> Miss Bertram . . . might be said to have two strings to her bow. (Jane Austen, *Mansfield Park*, 1812)

6. hedge [one's] bets To protect against possible loss by cross-betting; to wager against a previous bet or other speculation in order to lessen possible losses; to equivocate or shift, to beat around the bush; also simply *hedge*. This expression, which dates from 1672, appears in Macaulay's *History of England:*

> He (Godolphin) began to think . . . that he had betted too deep on the Revolution and that it was time to hedge.

7. lay up in lavender See 285. PRESERVATION.

8. look to [one's] laurels To be aware of the ephemeral nature of one's preeminence; to continually strive to protect one's status as the lead in any field. The opposite of *rest on one's laurels*, this expression appeared in print by the middle of the 19th century.

> The fair widow would be wise to look to her laurels. (Mrs. J. H. Riddell, *Prince of Wale's Garden-Party*, 1882)

9. [the] mouse that has but one hole is quickly taken An old proverb expressing the necessity of alternate plans, somewhat similar to the currently popular *don't put all your eggs in one basket*. The original Latin was *mus non uni fidit antro* 'the mouse does not trust to one hole.'

10. play close to [one's] vest To take no unnecessary risks, to act cautiously or carefully. Originally a gambling phrase, this expression referred to a player who kept his cards close to his vest to hide them from the sight of others. By extension, the expression came to mean a skillful, cautious player who does not reveal his strengths or weaknesses, one who does not *tip his hand*. It subsequently came to be applied to a person who exercises extreme caution in any venture.

11. walk a tightrope To maintain a precarious balance between opposing forces; to manage to please, or at best not to offend opposing factions; to straddle the fence, to play both ends against the middle. Obviously drawn from the acrobat's act, the figure finds appropriate application in many political contexts. In *Gulliver's Travels* Swift describes the rope dancers at the court of Lilliput, conceptual if not verbal forebears of today's tightrope walkers.

> Those persons who are candidates for great employments, and high favour, at court . . . petition the Emperor to entertain his Majesty and the court with a dance on the rope, and whoever jumps the highest without falling, succeeds in the office.

The expression is not limited to political contexts, however, and can be applied to anyone trying to reconcile or mediate seemingly antithetical entities or enemies—labor and big business, for example, or as in the following recent usage, artistic value and financial profit.

> Mayer . . . is dedicated to the idea of books as works of the spirit and not just products for cost accounting. Those who are drawn to the spectacle of tightrope walking can look forward to more of Peter Mayer's inventive and exciting balancing acts. (Walter Arnold, in *Saturday Review*, February, 1979)

12. walk on eggs To act cautiously and carefully because of the delicacy of a situation, to skate on thin ice; also to *tread on eggs*. This expression dates from the early 18th century.

Celebrity . . . See 269. PERSONAGES

Censure . . . See 78. CRITICISM;
312. REPRIMAND

46. CERTAINTY
See also 73. CORRECTNESS

1. bet [one's] boots To be absolutely sure or certain of something. The reference is to a gambler (perhaps a cowboy, whose boots are among his most important possessions) so sure of winning that he will bet everything he owns, including his boots. The phrase appeared in 1856 in *Spirit of Times*. Similar expressions are *bet [one's] life* and *bet [one's] bottom dollar*.

2. dead to rights Indisputably, unquestionably; positively, assuredly; usually in the phrases *have someone dead to rights* or *caught dead to rights*, in which it is equivalent to 'in the act, redhanded.' Attempts to explain the origin of this American colloquial expression are frustrating and futile. *Dead* appears to be used in its meaning of 'absolutely, utterly'; but the equivalent British expression *bang to rights* suggests something closer to 'directly, precisely.' The context of wrongdoing in which the phrase always appears in early citations indicates that *to rights* may relate to the rights of the guilty party, but the theory does not withstand careful analysis. The *OED* suggests a connection between the *to rights* of the phrase and the obsolete *to rights* 'in a proper manner,' but no citations contain analogous syntactic constructions. Despite its refusal to yield an elucidating explanation, *dead to rights* has been a commonly used expression since the mid 1800s.

3. dollars to doughnuts A sure thing, a certainty; usually in the phrase *bet dollars to doughnuts*, in use since 1890. Although the precise origin of this expression is unknown, it obviously plays on the value of a dollar contrasted with the relative small worth of a doughnut, which once cost 5ᶜ. Anyone willing to wager dollars to doughnuts is confident of winning his bet. One use of the expression apparently referred to the declining value of the dollar:

> Dollars to doughnuts is a pretty even bet today. (*Redbook*, 1947)

4. eat [one's] hat To admit willingness to "eat one's hat" is to express certainty and confidence, and to be ready to abase oneself should things not turn out as one had anticipated. Should such cocksureness prove ill-founded, *eating one's hat* would be analogous to *eating crow* or *eating one's words*. The first use of this expression is attributed to Charles Dickens in *The Pickwick Papers* (1837).

> If I knew as little of life as that, I'd eat my hat and swallow the buckle whole.

Of British origin, *eat [one's] hat* is currently popular in the United States as well.

5. eggs is eggs Surely, definitely, absolutely, without a doubt. Usually used as an interjection or in the phrase *sure as eggs is eggs*, this British colloquialism is probably a humorous twist or an ignorant mispronunciation of "X" in the familiar algebraic equation, "X is X."

> [After examining me] the doctor shook his head and said, "Eggs is eggs." (Johnny Carson, on *The Tonight Show*, NBC Television, 1978)

6. far and away Absolutely, incomparably, easily, undoubtedly; by far. Used to increase the intensity of a superlative adjective, this expression implies that there are no competitors or contenders within reach of this description.

You are far and away the greatest scoundrel I ever saw. (William E. Norris, *Thirlby Hall*, 1883)

7. hands down See 114. EFFORTLESS-NESS.

8. hat to a halfpenny An exclamation of affirmation, said in the form of giving high odds on a wager, to assure others that one speaks the truth. In medieval times, when this expression was coined, a hat was an expensive and highly valued item in a man's wardrobe; therefore, to be willing to bet one's hat against a halfpenny was the equivalent of being certain in one's convictions.

My hat to a halfpenny, Pompey proves the best Worthy. (Shakespeare, *Love's Labour's Lost*, V,ii)

9. in spades Definitely, emphatically, to the utmost degree; without restraint or qualification; no ifs, ands, or buts. This expression connoting extremeness derives from the fact that spades are the highest suit in some card games. *In spades* is used as an intensifier, as in the following citation from *Webster's Third*:

[I] have thought him a stinker, in spades, for many years. (Inez Robb)

10. in the bag Assured, certain. The most plausible and frequent explanation holds that the reference is to game which has been killed and bagged, i.e., put in the gamebag. One source claims a cockfighting origin for the term; since a live gamecock is literally brought to the pits in a bag, for the owner confident of victory, "It's in the bag."

11. lead-pipe cinch An absolute certainty; a certain success; something that is easily accomplished; a piece of cake. In this expression, *cinch* refers to a saddle girth, the beltlike strap used to secure the saddle on a horse. If the cinch were tight enough, the rider did not have to worry about the saddle's slipping; in fact, it was a certainty that the saddle would stay in place. Although the rationale for the inclusion of "leadpipe" in this expression is unclear, it is possible that the relative ease with which lead for (waste) plumbing could be worked (compared with cast iron) gave rise to *lead-pipe* as an intensifier.

It is a doublebarrelled leadpipe cinch that you'll be more anxious to get it back than you ever were about a $10 loan overdue. (*Outing*, July 1921)

12. on ice See 2. ABEYANCE.

13. shoo-in A candidate, athlete, team, or other competitor considered to be a sure winner; the favorite. This expression employs the verb phrase *shoo-in* 'to cause to go into' as a noun.

In the [Republican presidential] preferential poll, Taft looked like a shoo-in over Stassen. (AP wire story, May 13, 1952)

14. sure as shooting Certainly without a doubt, most assuredly. This colloquialism of American origin appeared in print by the mid-1800s. It was probably a cowboy expression referring to one's need for *sure*, i.e., 'accurate' shooting to avoid being shot dead in turn.

Sure as shootin' . . . one of these days one of my customers will be coming in and telling me he caught a fish with one of your jackets. (*Field and Stream*, June 19, 1947)

15. that's flat An expression used to specify that one has just spoken the undeniable, absolute truth; defiant expression stating one's resolve to do or not to do something; a statement of bold rebelliousness. This expression is frequently heard as an emphatic conclusion to a preceding remark.

It's the greatest bogg of Europe . . . that's flat. (*A Survey of the Affairs of the United Netherlands*, 1665)

This expression, can also be used to demonstrate one's determination to take a stand even though one faces possible disciplinary action for taking such a position. Falstaff, in Shakespeare's *Henry IV, Part 1*, decides rather suddenly and defiantly to refuse to go into battle with

the ragtag army which he himself has assembled to bilk the crown of money.

I'll not march through Coventry with them, that's flat. (IV,ii)

The term has been in use since the mid-16th century.

47. CESSATION
See also 58. COMPLETION;

375. TERMINATION;

379. THWARTING

1. call off the dogs To ease up on; to lay off of; to discontinue some disagreeable line of conduct, conversation, inquiry, procedure, or the like. The reference is to hunting; when dogs are on the wrong track, they are called back.

2. cold turkey Complete and sudden withdrawal from a habit, especially smoking or drugs; any difficult process begun without careful preparation. Dating from approximately 1900, this expression may have originally denoted an action carried out hastily.

He had gone to Henry Gottrell cold turkey, and with authority from the department. (William A. DuPuy, *Uncle Sam, Detective*, 1916)

Picked up and popularized by its application to drug culture, the term assumed new proportions, and now is frequently used in reference to sudden withdrawal from habitual drinking or smoking.

She tried it cold turkey once, which she explained meant merely stopping completely, without any attendant medication. (*New York Times*, June 27, 1951)

Some contend that the term originally referred to withdrawal from a drug habit or addiction, arguing that such deprivation, if sudden, causes horripilation and, accompanied by pallor, gives the person's skin the appearance of that of a cold, plucked turkey.

3. cut the painter To make a complete break with; to sever all connection; to clear off. When the painter, the line that

holds a boat to its mooring, is cut, the boat is set adrift and all connections between the boat and land are severed. The expression, originating in the 18th century, has come to signify any complete break, especially between people. According to *Brewer's Dictionary of Phrase and Fable*, the expression was particularly popular in England during the 19th century, when there was a great deal of discussion about the possible severance of relations between Great Britain and her colonies.

I'll cut your painter for ye, I'll prevent ye doing me any mischief. (*Dictionary of the Canting Crew*, 1700)

4. knock it off An order or command to stop doing something immediately. This 20th-century expression, which gained popularity during World War II, may be attributable to the practice of auctioneers who, upon completion of a sale, give three raps with a gavel to indicate that the auction is closed; thus, the bidding for the item has been "knocked off." Another possible origin is in the practice of judges in court and the chairmen of parliamentary gatherings, who rap with a gavel to silence extraneous talking and noise. During World War II the term became a common command given by non-commissioned officers when they wanted the troops to stop talking.

Knock it off. I've got no argument with you. Forget it. We apologize. (Richard Prather, *Bodies in Bedlam*, 1951)

5. Mexican stand-off A deadlock; a situation or contest in which neither party wins. Exactly what the word *Mexican* adds to this expression is unclear; most likely it was originally a racial slur. It has been conjectured that American cowboys used *Mexican stand-off* in referring to conflicts in which one could get away alive without engaging in serious fighting.

6. nip in the bud See 375. TERMINATION.

7. peter out To diminish gradually and then cease; to fade, die out, come to an end. In this expression, *peter* is derived from saltpeter (potassium nitrate), a component of explosives. Miners nicknamed these explosives "peter," and used them to expose veins of gold or other valuable minerals. When a vein was exhausted and could yield no more ore, it was said to have been "petered out." Eventually, *peter out* assumed its figurative meaning and has been in widespread use for more than a century.

> Human effort of all kinds tends . . . to "peter out." (*Saturday Review*, January 9, 1892)

8. stalemate A deadlock, standstill, impasse; a draw or standoff; circumstances in which no action can be taken. This term originated in chess to describe a situation in which a player cannot make any moves without placing his king in check. As a result, the game ends in a draw, and neither player can claim a victory. *Stalemate* is derived from the old French *estal* 'fixed position' and the Middle English *mat* 'helpless.'

> So far as the public can see, the match [between two armies] ended in stalemate. (*Standard*, September 1912)

Challenge . . . See 96. DIFFICULTY

Chaos . . . See 103. DISORDER

Charge . . . See 74. COST

48. CHARITABLENESS

1. cast [one's] bread upon the waters To act charitably or generously without thought of return or personal profit. The reference is to Ecclesiastes 11:1:

> Cast thy bread upon the waters; for thou shalt find it after many days.

2. Lady Bountiful The village benefactress; a beneficent neighborhood lady; a generous woman who spends a great deal of her time and money in charity. This Briticism, seldom heard in the United States, was derived from the name of a character in *The Beaux Stratagem* (1707), a comedy by George Farquhar. *Lady Bountiful*, a great overbearing woman, was the typical parish busybody who went about curing ills and dispensing charitable good will among her neighbors. The phrase has been tempered to signify any local lady who devotes much of her time to benevolent activities.

> He [the magistrate] ought to be . . . a lady bountiful in every parish, a Paul Pry in every house. (Thomas B. Macaulay, *Essays*, 1830)

3. sprout wings To do an act of charity; to perform a good deed. This expression is based on the conventional depiction of angels as winged beings. It is usually used jocularly to suggest that one is progressing toward a more angelic nature. The expression is occasionally extended to mean death, perhaps as an assumption that those bound for eternal bliss develop the wings of angels.

4. widow's mite A small amount of money, especially a small contribution that represents a great sacrifice from one with limited financial resources. This expression is Biblical in origin, *mite* referring to a coin of very little value, less than an eighth of a penny.

> And there came a certain poor widow, and she threw in two mites, which make a farthing. . . . [And Christ said] this poor widow hath cast more in, than all they which have cast into the treasury: for all they did cast in of their abundance; but she of her want did cast in all that she had, even all her living. (Mark 12:42–44)

A commonly used variation is *mite*.

Chattiness . . .
See 371. TALKATIVENESS

Cheating . . . See 370. SWINDLING

Cleverness . . .
See 344. SHREWDNESS

Closeness . . . See 156. FRIENDSHIP;
295. PROXIMITY

49. CLOTHING
See also 360. STYLISHNESS

1. all gussied up Dressed in one's best clothes; wearing fancy or dressy clothes; in one's glad rags. Webster ascribes this American slang term to a nickname for the woman's name Augusta, but neglects to establish any association between anyone of that name and clothing. A more plausible explanation ascribes the term to the use of the *gusset,* a garment insert occasionally used to make clothing more presentable and more fashionable.

> When I get all gussied up, somebody says, "Pull in your pot!" (Harold Wentworth and Stuart Berg Flexner, *A Dictionary of American Slang,* 1975)

2. best bib and tucker Finery; Sunday-go-to-meeting clothes; glad rags. Though now applied to the dress of either sex, the phrase originally and properly described only that of women. Both items of clothing—bibs and tuckers— were lacy and frilly affairs worn about the bodice and neck in the 17th and 18th centuries.

3. brothel-creepers British slang for crepe-soled suede shoes. Such shoes were long associated in England with pimps, who were often seen to wear them. The term appeared in G. Smith's *Flaw in Crystal* in 1954:

> "Poncing about the place in those brothel-creepers of his!" . . . He always wore plush suede shoes.

4. glad rags One's best or finest clothes; fancy or dressy clothes, especially formal evening dress; also *glad clothes* and *glads.* This self-evident American slang term has been in use since 1902. An

equivalent but as yet not fully established slang term is *heavy threads.*

5. highwaters Unfashionably short trousers or slacks. This expression is derived from the humorous inference that one wearing blatantly short pants must be expecting a flood. Application of this phrase is obviously contingent upon the mandates of the fashion world.

6. loon pants Informal, tight-fitting pants that flare down from the knees. This Briticism, coined in 1971, alludes to a pair of slacks one wears when going out for an informal night on the town. The phrase probably derives from a 1960s' verb *loon,* meaning 'to dawdle away one's time in frivolous pursuits,' which, in turn, has its roots in the adjective *loony,* meaning 'scatterbrained or flighty.'

> Dress manufacturers who are in despair at the number of young customers in loon pants and T-shirts might now consider hiring not a designer but another Johann Strauss to restore a desire for expensive extravagant dress. (*The Times,* December 5, 1972)

Variants are *loon trousers* and *loons.*

7. monkey suit Formal clothes; a tuxedo; the full dress uniform of a serviceman, police officer, etc. This expression may be a modification of *monkey jacket,* a close-fitting coat formerly worn by sailors and similar in appearance to the stiff jacket worn by an organ-grinder's monkey. The phrase maintains some contemporary usage.

> I . . . demothed my monkeysuit and borrowed some proper shoes. (Dylan Thomas, *Letters,* 1950)

8. mud hooks Heavy shoes; marching boots; feet. This American expression became a favorite term for heavy military boots, or the feet, during the Civil War. Since the soldiers spent a great deal of time slogging around muddy battlefields, the allusion is readily understood.

The soldier boys called their feet *pontons, mud hooks, soil excavators,* and other names not quite so nice. (*Century Magazine,* December 1884)

9. plus fours Knickerbockers, as used especially by golfers, that are long and baggy at the knees. This name for a special style of knickerbocker was derived from the four extra inches of material that was necessary to allow them to hang below the knee; thereby, affording greater freedom for the sportsmen. These knickerbockers were especially popular among golfers in the 1920s and are only occasionally seen today.

10. set of threads A suit of clothes, especially a stylish or new one. This slang expression, derived from the world of jazz, is a variant of an older jazz term, *set of drapes.* Coined about 1946, the term has superseded *set of drapes* as the "in" phrase and is frequently heard in everyday speech.

He didn't dress in the smart set of threads as some jazzmen did; when he left town, he had on a borrowed pair of pants, and a friend's coat. (Stephen Longstreet, *The Real Jazz Old and New,* 1956)

11. soup-and-fish A man's formal clothing; a cutaway; white tie and tails. This term came to be jocularly applied to formal dress because soup and fish were so often served as the first courses of a formal dinner.

You will see more men informal than in soup and fish. (Jack Lait and Lee Mortimer, *New York Confidential,* 1948)

12. Sunday-go-to-meeting clothes One's best or finest clothes; also *Sunday clothes, Sunday best,* and *Sunday-go-to-meetings.* The term, in use since at least 1831, is an expansion of *Sunday clothes,* and refers to the days when most people wore their finery only on Sunday, which was reserved for churchgoing and visiting.

13. widow's weeds A widow's mourning garb; the black garments formerly worn by widows during their first year of widowhood. The origin of this term can be found in the Anglo-Saxon *wæd,* a word meaning 'garment.' Entering Modern English, *weed,* as used in this expression, is obsolete except in the phrase *widow's weeds.* The original apparel consisted of a long black crepe veil, broad white cuffs known as *weepers, black shoes and stockings, and a black gown or dress.* These weeds were customarily worn for one full year after the husband's demise.

Memory, in widow's weeds, with naked feet stands on a tombstone. (Sir Aubrey DeVere, *Widowhood,* 1842)

Clumsiness . . . See 30. AWKWARDNESS; 247. OAFISHNESS

Coarseness . . . See 247. OAFISHNESS; 404. WILDNESS

50. COERCION
See also 140. EXTORTION

1. Duke of Exeter's daughter The name given to the rack in the Tower of London. John Holland, the Duke of Exeter, served as Constable of the Tower of London in 1420. He is credited with introducing the rack to the Tower as an instrument of torture or punishment. As a result of its birthright, the instrument became known as the Duke of Exeter's daughter.

They threatened to make me hug the Duke of Exeter's daughter. (Sir Walter Scott, *The Fortunes of Nigel,* 1822)

An allied term, *Skeffinger's daughter* or *Scavenger's daughter,* another instrument of torture, was named for Leonard Skeffington who, along with his father, Sir William Skeffington, Lieutenant of the Tower of London in the 16th century, invented the device. The contrivance doubled a person's body so the head was brought against the legs with such great

pressure that blood was forced from the nose and ears.

> One of the instruments of torture, called the Scavenger's daughter, was employed in the Tower on Catholics. (William Andrews, *Critical Review of Foxe's Book of Martyrs*, 1826)

Another related term is *gunner's daughter,* a term for the gun to which sailors were lashed before they were whipped.

> I was . . . made to kiss the gunner's daughter. (Frederick Marryat, *Peter Simple,* 1833)

2. force [someone's] hand To pressure someone into taking a stand or revealing his beliefs or intentions; to compel someone to act immediately and against his will. In print since the mid 19th century, this expression perhaps derives from card games in which one player forces another to play a particular card and thereby reveal the contents of his hand. Another possible theory is that *force [someone's] hand* is like *twist [someone's] arm,* suggesting that the present figurative use derives from actual physical force.

3. jawbone To apply pressure from a position of influence; to use upper echelon arm-twisting. The modern sense of this term developed sometime during the 1960s. Today in Washington it is still used to denote strong unofficial pressure brought by an important government official upon labor and business, frequently with the intention of imposing government guidelines on spending, prices, and wages. Its popularity is often attributed to President Lyndon B. Johnson, who was especially fond of the term and used it frequently. See also **jawbone,** 149. FINANCE.

4. knobstick wedding The forced marriage of a pregnant, unwed woman; a shotgun wedding. Churchwardens (lay officers who dealt with the secular affairs of the church and who were the legal representatives of the parish) formerly used their authority to ensure such marriages. The term *knobstick* 'a knobbed stick, cane, or club used chiefly

as a weapon' refers to the churchwarden's staff, the symbol of his office, used as an instrument of coercion, or cudgel.

5. put the screws to To compel action by exercise of coercion, pressure, extortion, blackmail, etc. The expression derives from an early method of torture involving the use of thumbscrews to extract confessions.

6. put the squeeze on To pressure another for one's own purposes; to demand payment or performance by means of harassment or threats.

> She hired me to put the squeeze on Linda for a divorce. (Raymond Chandler, *High Window,* 1942)

7. ram down [someone's] throat To force one's point of view upon another; to declare forcefully without allowing opportunity for rebuttal; to deliver an opinion to another as if it were dogma. This phrase, along with its variations using the verbs *cram, thrust,* or *shove,* has been employed since the early 1700s. The allusion is to feeding someone ideas and opinions as one forcefeeds food. The expression is common today, especially in the world of sales.

> . . . Quha rammed and crammed, That bargain down their throats. (Allan Ramsay, *Vision,* 1724)

8. shanghai To kidnap a person and press him into service, especially as a seaman; to maliciously deceive someone. This term, apparently coined on the San Francisco waterfront in the early 19th century, is believed to have originated from the frequent voyages between that city and Shanghai, China. Since many sailors were reluctant to sign on for long voyages, the practice of *shanghaiing* arose. A sailor would be sated with drugs or drink until he passed out; he would awake at sea, a crew member on a vessel headed for Shanghai or some other distant port. In many instances those who procured able-bodied men by such means were paid a premium for each victim.

Before that they would have been drugged, shanghaied, and taken away from all means of making complaint. (*New York Tribune*, March 1, 1871)

By extension the word has come to signify any deceiving or misleading of another person.

9. shotgun wedding Any union, compromise, agreement, etc., brought about by necessity or threat; originally a wedding necessitated or hastened by the bride-to-be's pregnancy, a forced marriage; also *shotgun marriage*. The allusion is to an irate father attempting to protect his daughter's reputation by using a shotgun to threaten the man responsible for her condition into marrying her. Use of the expression dates from at least 1927.

> Werdel . . . characterized the Brannan plan as a "shotgun wedding between agriculture and labor." (*California Citrograph*, January 1950)

10. when push comes to shove See 127. EXACERBATION.

Cogency . . .
See 112. EFFECTIVENESS

Collaboration . . . See 70. COOPERATION; 263. PARTNERSHIP

Collusion . . . See 66. CONSPIRACY

51. COMBAT

1. battle royal A free-for-all; an encounter of many combatants; a heated argument or altercation. The term derives from the type of endurance contest, especially common in cockfighting, in which the ultimate victor is determined by a process of elimination through survival of many trial heats. The badly wounded survivor of these repeated pairings is often barely alive at battle's close. Another type of battle royal from which the expression might derive was the custom of entering a number of pugilists into the ring at once, who fought each other in random and brutal fashion until only one remained conscious. Ralph Ellison includes a graphic description of the barbarous practice in *Invisible Man*.

2. broach [someone's] claret To give someone a bloody nose. This euphemistically elegant expression for a very inelegant action and its result plays on the meaning of *broach* 'to draw liquor from a cask' and on *claret* as a red wine of Bordeaux.

3. donnybrook A wild fight or brawl, a melee or free-for-all; also *Donnybrook Fair*. For centuries, an annual two-week fair was held each summer in Donnybrook, Ireland. Invariably, vast amounts of whiskey were consumed and the huge crowds got out of control, turning the fair into a massive drunken brawl. Because of such consistently riotous behavior, the Donnybrook Fair was abolished in 1855, although to this day its name denotes any type of wild, general fighting.

4. duke it out To fight with the fists; to clash; to enter into physical conflict. This expression, which is often thought to be American in origin, actually can be traced back to early 19th-century England and Cockney rhyming slang. The key word is *duke* which underwent a rather unusual metamorphosis to acquire a meaning of fists. One uses the fingers to make a fist and the fingers were known as *forks*, which in rhyming slang became *Dukes of Yorks*, which, in turn, was reduced to *dukes*.

> There is nobody in our organization that takes second place when it comes to getting up and duking it out. (*Maclean's*, January 8, 1979)

Related terms are *put up one's dukes*, *duke-out*, and *dukes up*, all terms involving fighting with fists.

5. fight like Kilkenny cats To fight fiercely and bitterly until both sides have been destroyed; to argue or debate vi-

marginally plausible legends surround this expression, the most popular of which holds that in the Irish Rebellion of 1798, some sadistic soldiers stationed in Kilkenny enjoyed the "sport" of tying two cats together by their tails and hanging them over a clothesline so that, face to face, they would fight to the death. When an officer approached to break up this daily activity, a soldier cut off the cats' tails with his sword, and the cats escaped. When confronted by the officer, the soldier insisted that the cats had fought so viciously that they had eaten each other, leaving only the tails behind. A more likely explanation, however, is that the cats are allegorical symbols for two rival towns, Kilkenny and Irishtown, which for more than 300 years waged a bitter border dispute. By 1700, both towns were devastated and impoverished. A similar expression is *quarrelsome as Kilkenny cats.*

6. introduce the shoemaker to the tailor To kick someone in the buttocks or rear end; to kick someone in the pants. This euphemism is a British colloquial expression.

7. knock for a loop See 63. CONFUSION.

8. knock galley-west To incapacitate, to put someone out of action; to give such a severe blow as to cause unconsciousness; to knock for a loop, to throw off balance, to disorient or confuse. *Galley-west* is an alteration of the British dialectal *colly-west* 'awry, askew.' This colloquial Americanism dates from the latter part of the 19th century. The phrase is not limited in application to physical combat; it can also apply to mental or emotional disorientation resulting from the debunking of one's ideas, arguments, or beliefs.

> Your verdict has knocked what little [critical penetration] I did have galley-west! (Mark Twain, *Letters*, 1875)

9. knock the tar out of To thrash, whale, or beat senseless; also often *beat the tar out of.* The precise origin of the

phrase is unknown. A plausible conjecture says it derives from the former practice of caulking a ship's bottom with tar, which would require an extremely severe shock or blow to loosen.

10. lay out in lavender See 312. REPRIMAND.

11. lead a cat and dog life To fight or bicker constantly; to be contentious, quarrelsome, or argumentative on a regular basis. This expression alludes to the snapping and vicious battling associated with these two animals whenever they encounter each other.

12. lock horns To enter into conflict; to clash; to contend. Various species of mammals have horns for self-defense, and the reference is probably to the locking of bucks' horns when they "duel." The expression suggests a vehement entanglement between two people.

13. make [someone] see stars To hit someone on the head with such force that he experiences the illusion of brilliant spots of light before his eyes; to knock someone out.

14. make the fur fly To cause a ruckus or commotion, to create a disturbance, to shake things up; also *make the feathers fly.* The allusion is to animals or gamecocks engaged in such a violent struggle that they tear out each other's fur or feathers. Both expressions date from at least the 19th century.

> Al Hayman is going to make the fur fly when he gets back from Europe. (*New York Dramatic News*, July 1896)

15. measure swords To fight or do battle either physically or verbally; to compete or contest, to match wits with, to pit one's strength against. This expression originated when dueling was the gentlemanly method of settling disputes and defending honor. Swords chosen as weapons were measured against each other to guarantee that they were of the same length and that neither party had

an advantage. Although measuring swords was originally a preliminary to a duel or fight, by extension it came to mean the fighting itself. The equivalent French expression is *mesurer les épées*. Shakespeare uses the phrase in *As You Like It* (V,iv):

> And so we measured swords and parted.

16. pull caps To quarrel and wrangle in an undignified manner. *Cap* refers to 'headgear.'

> Our lofty Duchesses pull caps,
> And give each other's reputation raps.
> (Thomas Perronet Thompson,
> *Exercises, Political and Others*, 1842)

This obsolete expression dating from the 18th century reputedly applied only to women, although *OED* citations indicate that men also "pulled caps."

> Men are exhorted to struggle and pull caps. (John Wolcott, *Lyric Odes to the Royal Academicians*, 1785)

17. take up the hatchet To begin or resume fighting, to prepare for war; also *dig up* or *unbury the hatchet, ax,* or *tomahawk*. To symbolize the resumption of hostilities, North American Indians would dig up war weapons, which had been buried as a sign of good faith when concluding a peace.

> Three nations of French Indians . . . had taken up the hatchet against the English. (George Washington, *Daily Journal in 1751–52*)

The expression, now obsolete, dates from the late 1600s. See also **bury the hatchet, 266. PEACE.**

18. tan [someone's] hide To whip, beat, or thrash soundly; to knock the tar out of someone. Theoretically, severe, repeated beatings would harden or toughen one's skin, just as the tanning process does to hide in converting it to leather. The expression has been used in this figurative sense since the 17th century.

19. wigs on the green A fight, altercation, fracas, fray; a commotion; a differ-ence of opinion that could lead to fisti-cuffs. This expression stems from the days when British gentlemen wore pow-dered wigs and often settled differences "in manly fashion" on the public greens. Since their wigs were likely to be pulled off during the pugilistics, *wigs on the green* became a euphemistic reference to a scuffle or brawl.

> Whenever they saw them advancing, they felt that there would be wigs on the green. (Sir Montagu Gerard, *Leaves From the Diaries of a Soldier and Sportsman*, 1903)

Comedy . . .

See 174. HUMOROUSNESS

52. COMMENDATION

See also 23. APPROVAL;

150. FLATTERY; 326. REWARD

1. blurb A short, often witty, advertise-ment or laudatory recommendation; a descriptive paragraph on a book jacket; a squib or plug. The American humorist and illustrator F. Gelett Burgess (1866–1951) coined the term in 1907 when he humorously dubbed the allur-ing woman adorning a comic book jack-et Miss Blinda Blurb. Today, the term is commonly applied to short radio and television advertisements as well as to the descriptive paragraphs on book jack-ets.

2. just like New York This American slang expression, usually an isolated comment on successful performance, has a wide range of equally vague equiva-lents such as *right on, great, nice going, way to go*. The reference is to New York City as the epitome of success, society, and fashion.

3. man of wax A proper fellow; a man of commendable quality or praiseworthy character. This expression connotes an almost perfect man, one who has been styled in wax, one of perfect form. The term dates from at least the 1500s. In

Shakespeare's *Romeo and Juliet* (I,iii), Juliet's nurse praises Paris:

> A man, young lady! lady, such a man
> As all the world—why, he's a man of
> wax.

4. praise from Sir Hubert The highest compliment; the greatest possible praise. This expression, now languishing in oblivion, originated in Thomas Morton's comedy *A Cure for the Heartache* (1797):

> Approbation from Sir Hubert Stanley
> is praise indeed.

5. take [one's] hat off to To recognize the preeminent achievements of another; to praise or extol the superlative accomplishments of another. This common expression is derived from the custom of removing one's hat as a sign of respect.

> We should take off our hats to them
> and wish them godspeed. (*Harper's
> Magazine*, June 1886)

A variant, *hats off*, is commonly used as an imperative.

6. twenty-one-gun salute The highest military honor; the greatest possible compliment; showing the greatest of respect for another. According to the office of the United States Army, Public Information Division, this term is derived from the old naval practice of demonstrating respect for another by disarming oneself. The practice started with the British Navy when the loading of cannon at sea was a time-consuming exercise; thus to fire all twenty-one cannons on the side of a large man-of-war was tantamount to disarming oneself completely, an act displaying great trust and respect. The custom is carried on today; the number of shots fired ranges from five to twenty-one, depending on the prominence of the individual; however, it is always an odd number, reflecting the old sailing superstition about even numbers. The twenty-one gun salute is the honor accorded only to heads of state. The expression has found its way into the common vocabulary as a synonym for any gesture of great respect.

53. COMMUNICATION

1. body language Movements and postures which silently reveal one's attitudes toward others. With the publication of his book *Body Language* in 1970, Julius Fast popularized both a new science, *kinesics* and a new expression, *body language*. The book, a best seller (thus accounting for the immediate popularity of the term), explains the signals that people unconsciously give with their bodies to disclose their true reactions to others.

> When you could not hear the words,
> you concentrated on what an eye
> movement, an arm gesture, a posture,
> or a man's walk could tell you. You
> "listened" to body language.
> (Elizabeth McGough, *Your Silent
> Language*, 1974).

2. bounce off [someone] To exchange and discuss concepts and impressions with another; to get another's reaction or opinion about a new idea. The allusion in this modern slang expression, coined during the 1960s, is to bouncing an idea off another person as one bounces a ball off a wall.

> But Paul is very much a teamwork
> person. He doesn't like working just
> on his own. . . . He likes working
> with people, bouncing off people and
> having them bounce off him. (Paul
> Gambaccini, *Rolling Stone*, January
> 31, 1974)

3. bush telegraph A jocular reference to the communications system employed by African natives in which coded messages are sent over long distances by the beating of a drum or hollow log. A variant is *jungle telegraph*.

4. call [one's] shots To verbalize what one intends to do or in what manner one intends to act; to inform others of one's plans. This phrase probably derives from various billiards games in which a player

must call out the shot he plans to make before attempting it. The similar expression *call the shots* shifts the emphasis from one's personal domain to a larger frame of reference in which an individual attempts to direct or control events, to be in charge, or to be in the driver's seat. *Call the shots* may derive from the director's role in film making.

5. can't get a word in edgewise To fail in an attempt to insert oneself into a conversation; to try in vain to squeeze into a discussion. This phrase, also commonly heard with *edgeways*, is most frequent in negative constructions. The allusion is to trying to slide one thing between others by inserting the edge rather than the broad side. The term has been in use since the late 1700s.

> As if it were possible for any of us to slide in a word edgewise. (Mary Russell Mitford, *Our Village*, 1863)

6. chalk talk A lecture illustrated by diagrams on a chalkboard; a strategy session. Although this expression, in today's usage, most commonly refers to a sports coach holding a training session for his team, its original application denoted any lecture supplemented by chalkboard illustrations.

> The book consists of windy, if sincere, scenes that are written with all the flavor of a civics class chalk talk. (*The New York Times*, November 19, 1981)

Variants of this expression are *blackboard drill* and *skull session*; however, the latter doesn't necessarily imply the use of a chalkboard.

7. generation gap The disparity in lifestyles and mores that exists between generations. Coined by sociologists during the 1960s to describe the misunderstanding in thought and attitude that sometimes causes disagreement between parents and their children, this term has, in recent years, been incorporated into everyday speech. The seeming intensity of the problem in American society during the late 1960s and early 1970s gave added impetus to the use of the term.

8. get [one's] signals crossed To be involved in a mutual misunderstanding, to fail to communicate. This current expression may have derived from the telephonic "crossing" of circuits which can result in accidental connections, though the use of various types of signals for communication is so pervasive as to preclude a precise origin for the phrase. Figurative use of the expression plays on the idea of an "accident," implying mutual misunderstanding with no one at fault.

> Can we by any chance have got the wires crossed? . . . It *was* the idea, wasn't it, that we should pile on to a pot of tea together? (P. G. Wodehouse, *Hot Water*, 1932)

Today *signals* is heard more frequently than *wires*, perhaps reflecting technological advances which facilitate the transmission of signals without wires.

9. grapevine The route by which a rumor circulates. During the American Civil War, *grapevine telegraph* expressed the term's current figurative sense while *grapevine* referred to the rumor itself.

> Just another foolish grapevine. (B. F. Willson, *Old Sergeant*, 1867)

The expression attained its gossip circuit connotation by analogy to the labyrinthine network of branches characteristic of the climbing grape plant.

> The art world grapevine buzzed with rumors. (*New Yorker*, October 1970)

10. gut hammer A dinner gong. This slang term denotes the large steel triangle used as a dinner bell for ranches, logging camps, or any other place where a number of laborers, who work outdoors at a distance from the mess hall, need to be called to meals. At mealtime the cook hammers the triangle calling the men to "fill their guts."

11. Irish hint A broad hint, an unsubtle intimation or insinuation. This rarely used Americanism appeared in Henry J. Nott's *Novellettes of a Traveller* (1834):

Various young men, . . . intimated, in what might be called Irish hints that they had espied the worthy Mr. Hunt.

The reputed bluntness of the Irish may have given rise to the expression.

12. liar's bench A place where bits of information are passed on; a meeting place for gossips. The original *liar's bench* was at a specific location in London:

. . . place in St. Paul's Cathedral in the 16th century, so called because it was stated that the disaffected made appointments there. (Robert Nares, *A Glossary: New Edition*, 1859)

However, the *liar's bench* referred to in this expression is the one that sat in front of old New England general stores, where many of the townspeople, especially those interested in the local gossip, would gather each morning to exchange information about the people of the community.

13. mouthpiece A criminal lawyer; a defending attorney; one who acts as a spokesman for a group; one who speaks for another person. The term, of obvious derivation, has been in use since about 1800.

When his mouthpiece had delivered his [Lafitte's] commands, a nod of the captain called the lieutenant to his side. (Charles Sealsfield, *The White Rose*, 1829)

However, as an underworld slang term to denote an attorney, it has been in use only since about 1850.

The thief's inability to hire a . . . mouthpiece or lawyer results in a quick trial. (Emanuel H. Levine, *The Third Degree*, 1930)

14. powwow A conference or meeting. This expression originally referred to the festive tribal ceremonies of American Indians. The term is commonly used today for any important council or convention.

The Abolitionists are having a great powwow here as to whether they shall or shall not maintain their organization. (*Daily Telegraph*, May 1865)

Communities . . .

See 227. LOCALITIES

54. COMPARABILITY

1. hold a candle to To be comparable in degree or kind; to be equal to, or on the same level with; to compare favorably with. This expression dates from the 16th century. At that time, it was the custom for a servant to carry a candle to light the way for his master on a nighttime walk. This subordinate position required familiarity with the layout of a town. A servant who did not know his way around was considered unfit or unable to hold a candle to his master. Figurative use of this expression—heard almost exclusively in the negative, *not hold a candle to*—suggests that the disparity between two people or things is so great as to render comparison impossible. One who can not or does not hold a candle to another is considered inferior.

Edith is pretty, very pretty; but she can't hold a candle to Nellie. (William E. Norris, *No New Things*, 1883)

2. huckleberry above [one's] persimmon Beyond one's ability or capacity; also *persimmon above one's huckleberry*. This expression, of unknown origin, dates from the early 19th century. A huckleberry is a small edible fruit; a persimmon is a plum-sized fruit. Perhaps it is this concrete contrast in physical size that gave rise to the abstract contrast in ability implied in this and similar expressions. Thomas Bangs Thorpe uses the phrase in describing the hunting exploits of one of the characters in *The Mysteries of the Backwoods* (1846):

It was a huckleberry above the persimmon of any native of the country.

3. **stack up against** To compare with; to correlate with or compete with. This expression alludes to the common method of evaluation in which contrasting items are set side by side in piles, and examined for quantitative comparison. The phrase is quite common in the United States.

> For it tells him the productivity of his store, how one department stacks up against another. (*Business Week*, April 1950)

Comparison . . .

See 54. COMPARABILITY

55. COMPETENCE

See also 3. ABILITY

1. **admirable Crichton** A fine, all-around person; a skillful, inventive gentleman. This phrase first appeared in Sir Thomas Urquhart's *The Discovery of a Most Exquisite Jewel* (1652), in which he extols James Crichton of Clunie, a 16th-century scholar, traveler, and gentleman. Crichton, a prodigy, is said to have disputed in 12 languages in Paris at age 17 and to have been one of the finest swordsmen in Europe. He was killed in a brawl at Mantua at age 25. His name has come to represent any man who is accomplished in scholarly and gentlemanly pursuits.

> Windham was the admirable
> Crichton of his age and country.
> (Thomas Amyot, *Some Account of the Life of William Windham*, 1812)

The expression was given a boost in popularity in 1902 when James Barrie published *The Admirable Crichton*, his well-known play about a clever and ingenious butler who saves the day for a group of shipwrecked, aristocratic companions.

2. **answer the bell** To meet demands, requirements, or requests; to respond to a challenge, to pick up the glove or gauntlet. The allusion is to a boxing match in which a bell is sounded to signal the beginning of each round. If a boxer is too hurt to continue the fight, however, he will not answer the bell, i.e., come out of his corner to start the next round.

3. **cut the mustard** To meet or exceed performance requirements; to succeed or accomplish. Several marginally plausible derivations have been proposed, one of which relies on the definition of *mustard* as the strong spice considered by many chefs to be the finishing touch to several culinary masterpieces. As with most flavor enhancers, mustard is cut into the food, that is, added in small amounts. Another source suggests that the original expression may have been *cut the muster*, implying that a soldier passed inspection with flying colors.

> I looked around and found a proposition that exactly cut the mustard. (O. Henry, *Heart of the West*, 1907)

In contemporary usage, the expression is often employed in a negative phrase such as *can't cut the mustard* or *doesn't cut the mustard*.

4. **earn [one's] wings** To prove oneself proficient and reliable in a given skill or ability. The allusion is to the wing-shaped badges worn by pilots and other aircraft crew members upon completion of rigid requirements and strict training. Such badges are symbolic of competence.

5. **fill the bill** Meet or exceed requirements; achieve that which is expected or required.

> When good shrub cover is at a distance from the house and no tree is handy from which to hang a feeder, one upon a post will fill the bill. (*Massachusetts Audubon Society Bulletin*, February 8, 1945)

Dating from the early 1800s, this phrase had its beginnings in a practice of theatrical companies. To advertise performances, agents posted bills announcing the title and the stars. It became the goal of every star to become so celebrated

that his name would *fill the bill* to the exclusion of the remainder of the troupe.

6. pass muster To pass inspection; to meet or surpass certain standards; to be approved or accepted; to succeed. *Muster* is a military term for an assemblage of troops for inspection or some other purpose. Thus, in its original context, *pass muster* indicated that a soldier had successfully undergone an inspection. The expression soon expanded into more figurative applications, and continues in widespread use.

> [She has] enough good looks to make her pass muster. (William Thackeray, *The Newcomes*, 1855)

7. up to scratch Meeting specified standards; acceptable, satisfactory. The *scratch* of the expression was the line drawn on the ground in various sporting events: prize fighting, cockfighting, foot racing, and others. Contestants who came "up to [the] scratch" were worthy competitors, ready to undertake the challenge and prove their mettle. Thus the expression is similar in origin and current meaning to *toe the mark*. Today it is used primarily for performance evaluation, but may be varied in context to specify any type of judgmental standard.

> Bulls . . . that are not up to scratch as to size. (*Farmer's Weekly* [South Africa], cited in *Webster's Third*)

8. up to snuff Satisfactory, acceptable; up to par; meeting performance standards. *Webster's Third* cites W. H. Whyte:

> If your work wasn't up to snuff . . . you'd hear about it quick enough.

The British require more than mere acceptability for "up to snuff," however; for them it means 'alert, sharp, shrewd, not easily duped.' Etymologically related to the German verb *schnüffeln*, 'sniff,' the phrase *up to snuff* describes one who is quick to "smell out" a situation or to "be on the right scent"; one who is perceptive and discerning.

> Queer start, that 'ere, but he was one too many for you, warn't he? Up to snuff, and a pinch or two over. (Charles Dickens, *Pickwick Papers*, 1837)

9. up to the mark Passing the test, meeting the requirements. There is little evidence to support the theory that the *mark* here is specifically that fixed by the Assay Office as the standard for gold and silver. *Mark* has so many applications relevant to criteria that none can be definitively cited as the sole origin. It is quite possible that this *mark* is the same as that of *toe the mark*, and as such is also the equivalent of *scratch* in *up to scratch*.

10. walk the chalk To pass the test, to meet the requirements. Literally the phrase refers to the sobriety test formerly given seamen: walking between parallel lines chalked on deck. The expression is little used today.

11. win [one's] spurs To achieve recognition for one's accomplishments, to distinguish oneself in one's field, to prove one's worth or ability. This expression, dating from the 14th century, originally meant to attain the rank of knight, since a newly dubbed knight was presented with a pair of gilt spurs as a symbol of his chivalry. In order to become a knight, one first had to distinguish oneself by performing acts of bravery, usually on the battlefield. The expression is still current.

> Among them are David Giles (*Richard II*), Who won his spurs with *The Forsyte Saga*. (*Saturday Review*, February 1979)

56. COMPETITION

1. another Richmond in the field An unexpected adversary or another competitor in the same enterprise; a foe who suddenly appears on the scene. The allusion in this expression is to the presence of Henry Richmond, later King Henry VII, on the field of battle at Bosworth. According to observers, he

seemed to be everywhere that day. In Shakespeare's *Richard III*, King Richard, who is fighting to save his throne, comments on Henry's omnipresence:

I think there be six Richmonds in the field;
Five I have slain today, instead of him. (V,iv)

2. break a lance with Compete with; oppose in a competitive sport; accept a challenge. During the Middle Ages when chivalric attitudes prevailed, one of the major competitions of the lists or jousting tournaments was tilting, the attempt by two armed men on horseback to unseat each other with lances. Frequently the lances used in these tilts would break; hence, the origin of the phrase. By extension, the term came to include any competition between individuals or groups.

In 1800 Turner entered classical grounds to break a lance with Claude. (George W. Thornbury, *The Life of J. M. W. Turner*, 1861)

3. Devil take the hindmost Every man for himself; survival of the fittest; similar to the more current phrase *last one in is a rotten egg*, popular among children. This expression is said to have derived from an old legend concerning the Devil's school at Toledo where students were instructed in the art of black magic. Each year, as a sort of test, the graduating class was made to run through an underground hall. The last one, if caught by the Devil, would then become his servant. The phrase was used as early as 1611.

4. give [someone] a run for [his] money To provide keen and tough competition, thereby inciting one's opponent to go all out, to "give it all he's got" to win. Dating from the 19th century, this expression was originally racing slang. The then current *have a run for one's money* was suggestive of a determined struggle and subsequent victory or payoff. Today to *give [someone] a run for [his] money* means to make that person work for

what would otherwise have been an easy victory.

5. jockey for position To maneuver or compete within the ranks for an advantageous position; to manipulate or pull strings to gain a more favorable position. The allusion is to horse racing and the jockeys' skillful maneuvering. The expression is now frequently applied to any kind of competitive maneuvering although it has been used in reference to sports since the early part of this century.

In Alberta when there was no jury, congestion was caused by lawyers jockeying for position in order to appear before the right judge. (*The Times*, July 1955)

6. keeping up with the Joneses Trying to maintain the social standing of one's neighbors; creating the impression that one is on an equal social or economic stratum as one's neighbors. This expression was coined in 1913 by Arthur "Pop" Momand, a cartoonist for the *New York Globe*, who satirized his own social pretensions in his long-running comic strip. The surname *Jones* was undoubtedly picked to represent the average American of Anglo-Saxon descent.

Why . . . does John Doe choose to speculate on margin? . . . An ages-old desire to get something for nothing; keeping up with the Joneses. (E. C. Harwood, *Cause and Control of Business Cycles*, 1932)

7. law of the jungle Survival of the fittest; might over right; anything goes. A form of existence in which only the fittest survive, whether applied to animals in the wild or to humans who are not, or refuse to be, governed by any system of civilization. Figuratively, the term *jungle* has been applied in recent years to many "civilized" habitations where jungle, rather than civilized law seems to rule, such as the *blackboard jungle* for 'classroom or schoolhouse,' the *asphalt jungle* or the *concrete jungle* for 'city.' Upton Sinclair in his novel, *The Jungle*

(1906) made the metaphor popular by exposing the *law of the jungle* existence within the meat packing industry of the Midwest.

8. play catch up See 328. RISK.

9. rat race See 155. FRENZIEDNESS.

10. recover the ashes This expression is the result of a bogus obituary lamenting the death of English cricket.

> In Affectionate Remembrance of English Cricket Which died at the Oval on 29 August 1882. Deeply lamented by a large circle of sorrowing friends and acquaintances. R. I. P. N. B. The body will be cremated and the ashes taken to Australia. (*The Sporting Times*, September 2, 1882)

A competition in cricket is carried on periodically between representative teams from England and Australia, and until 1882, England had never lost the series. However, in 1882, when Australia finally defeated the mother country, the English sportsmen were understandably upset, for the student had defeated the teacher, the child had beaten the mother. As a result of the obituary, the "ashes" has become the mythical prize for which the two countries contend; hence, from the English point of view, if England wins, they *recover the ashes* or *retain the ashes*, and, if they are defeated, they *lose the ashes*.

11. take up the gauntlet To accept or undertake willingly any challenging task; to accept an offer to fight or duel. Similarly, *throw down the gauntlet* means 'to challenge one to a fight or duel.' Gauntlets were the armored gloves worn by knights in medieval times. A knight wishing to joust with another would cast his gauntlet to the ground as a challenge to combat. The other knight would pick up the gauntlet to show the challenge was accepted.

> Making a proclamation, that whosoever would say that King Richard was not lawfully king, he

would fight with him at the utterance, and throw down his gauntlet. (Hall, *Chronicles of Richard III*, 1548)

12. throw [one's] hat into the ring To enter a competition, to become a candidate for public office, to accept a challenge. This expression, dating from the mid 19th century, is said to derive from the custom of throwing a hat into the ring to signal the acceptance of a pugilist's challenge.

> When Mr. Roosevelt threw his hat into the ring the other day, he gave the signal for a contest the like of which has not been seen before in this country. (*Nation*, March 7, 1912)

13. up for grabs Open to competition; available, free for the taking. This U.S. expression made its appearance in slang dictionaries by the 1940s; it is now quite commonly used in informal writing, often in reference to positions, candidacies, etc.

> Right now every position is up for grabs. Every player is going to get a shot. (*Boston Globe*, April 1967)

While the phrase carries the connotation of wide-open competition, it also implies the necessity of effort and competence to attain the goal. A possible but totally conjectural origin is that *up for grabs* derives from the jump ball in basketball.

14. wipe the floor with [someone] To give one a sound thrashing; to defeat utterly in competition or argument; to reprimand so severely that there is no opportunity for rebuttal. This expression has been in use both literally and figuratively since the latter half of the 19th century. The literal sense indicates a thorough physical beating, and the figurative, a sound beating, either verbally, emotionally, or athletically.

> His only grief was that he was not allowed to "wipe the floor with that there Hamlyn." (George A. Birmingham, *Island Mystery*, 1918)

Common variations of the term with about the same date of origin are *wipe up the ground with* and *wipe the earth with*.

> He can wipe the earth with him easily. (*American Speech*, May 1927)

57. COMPLACENCY

1. laid back Relaxed; nonchalant; having a cool style; low-keyed. This slang expression, in its modern sense of being calm, of being a *cool cat*, has been in use since about 1969. *Barnhart's Dictionary of New English* suggests that the term may arise from the position of the seat on newer style motorcycles, where the rider speeds along sitting in a long seat with a laid back backrest.

> Yates' tenacity in a fight might come as a surprise to those whose judgment is based on his apparent laidback style. (*Chicago Sun Times*, October 3, 1976)

The term is frequently used to characterize the relaxed, unhurried lifestyle associated with (especially southern) California.

2. look like the cat that swallowed the canary To look smug; to appear very self-satisfied or pleased. This self-evident expression has been in use since 1871.

3. resting on [one's] laurels To be content with one's present or past honors, accomplishments, or prestige. The *laurels* in this expression have long been a symbol of excellence or success in one's field of endeavor. *Resting* indicates self-satisfaction and complacency with the implication that no further efforts will be expended to acquire additional figurative laurels. It is interesting to note that ancient philosophers and poets sometimes kept laurel leaves under their pillows for inspiration, a concept almost totally opposite to the phrase's contemporary meaning.

4. snug as a bug in a rug Extremely comfortable and content. This common expression of obvious derivation was purportedly used by Benjamin Franklin in 1772. The phrase enjoys frequent use in the United States.

Complaint . . . See 166. GRIEVANCE

Completeness . . .
See 377. THOROUGHNESS

58. COMPLETION
See also 6. ACCOMPLISH-
MENT; 47. CESSATION;
79. CULMINATION;
375. TERMINATION

1. finishing touch That which completes an enterprise or endeavor; the final skillful or artistic stroke; the final detail or effort given to anything. This phrase originally applied to painting and to those final strokes the artist applied to the canvas to alter or to smooth out any rough details in his work. By transference it came to mean any final detail in any line of endeavor, especially writing. The expression has been in use since about 1700.

> We tire of the painter's art when it wants those finishing touches. (Horace Walpole, *Anecdotes of Painting*, 1771)

2. go through-stitch To go through with; to finish or conclude; to follow through. This expression alluding to the work of a tailor was popular in the 17th century but is no longer heard today.

> For when a man has once undertaken a business, let him go through-stitch with it. (*The Pagan Prince*, 1690)

3. in for a penny, in for a pound Once involved in a matter, however slightly, one must carry it through whatever the consequences. The metaphor comes from the monetary units of Great Britain: formerly, the penny was $1/12$ of a shilling and the pound 20 shillings or 240 pence; since decimalization, the pound is 100 new pence.

4. sign off To complete or end a performance, project, or other matter; to terminate; to withdraw. In the 9th century and for several hundred years thereafter, a person could change his religious affiliation simply by *signing off*, i.e., by signing a legal paper that ended his membership in one religious organization and, if he so desired, enrolled him in another.

The revolution . . . broke up the State Church and gave to every man the liberty of "signing off" as it was called, to any denomination that pleased him. (Harriet Beecher Stowe, *The Poganuc People, Their Loves and Lives*, 1878)

Beginning in the late Middle Ages, *sign off* usually referred to a creditor's releasing a debtor from financial obligation by *signing off*, i.e., by affixing his signature to a document to that effect. A contemporary variation that refers to this practice of canceling a debt or amortizing an asset is *write off*.

The company wrote off the loss as a bad debt. (*Law Times*, 1891)

Since the 1930s, *sign-off* (as a noun) most commonly applies to a radio or television station's ending its broadcast day.

Because of the earlier sign-off required by the Federal Communications Commission . . . (*ABC Radio*, 1949)

5. tie up the loose ends To conclude or settle matters; to answer all questions and account for any seemingly superfluous details. *Loose ends* in this expression refers to the last bit of unfinished business, the apparently irrelevant or contradictory details of a plan, arrangement, project, etc. This figurative use may derive from the practice of tying the ends of thread that hang loose after a cloth is woven or a garment is knitted.

59. COMPLICATION
See also **96. DIFFICULTY**

1. can of worms A situation or specific problem which threatens to cause trouble and have unresolvable complications for all concerned; a sore spot; a sensitive topic better left unexplored. A can of worms might pass for an acceptable product before it is opened. However, to *open a can of worms* means to instigate trouble, to broach a subject or do something questionable which has uncontrollable, complex, and negative repercussions.

2. hydra-headed Applied to anything presenting many phases or aspects, or to a problem that increases in difficulty as one combats it. In Greek mythology, the second of the twelve labors of Hercules was to go to the marshes of Lerna and there to destroy the Hydra, an enormous serpent with nine heads. Hercules found that whenever he cut off one of the monster's heads, two new ones grew in its place. He finally resolved his problem by cauterizing each stump as he cut off the head. From this story came the application of *hydra-headed* to any problem that grows in complexity or is extremely difficult in its resolution. The term has been in common use in English since the Middle Ages.

'Tis a hydra's head contention; the more they strive the more they may. (Robert Burton, *The Anatomy of Melancholy*, 1621)

3. Pandora's box A source of afflictions and complications which plague one without warning; a loaded situation; something which appears in a positive light but is negative in effect. In Greek mythology, Pandora, the first woman, was showered with gifts from the gods, among them a magnificent box presented her by Zeus which she was told never to open. Disobeying the gods, she opened it, and unwittingly allowed all of the human ills contained within to escape. Only Hope remained. The term

appeared in English as early as the mid 16th century.

> I cannot liken our affection better than . . . to Pandora's box, lift up the lid, out flies the Devil; shut it up fast, it cannot hurt us. (Stephen Gosson, *The School of Abuse*, 1579)

4. red tape Excessive formality, officiousness, and petty routine, preventing expeditious disposal of important matters. The term derives from the literal red tape with which official and legal documents were formerly bound and sealed. Though its use has proliferated along with the proliferation of bureaucracy and departmentalization, its current figurative meaning is by no means recent:

> All the morning at the customhouse, plagued with red tape. (Henry Wadsworth Longfellow, *Life*, 1869)

5. rub of the green An accidental interference which produces good or bad luck. In golf, the *green*, the extremely smooth grassy plot on which the hole itself is found, occasionally has bumps which affect the roll of a putt. If the putted ball should be rolling directly for the hole, encounter a bump, and go astray, that is often said to be caused by the almost mystical *rub of the green*. The term has been extended, as a symbol of luck, to other aspects of the game. If two people accidentally hit their drives into the woods and one ball ricochets back out on the fairway while the other ball remains in the woods, that, too, is because of the *rub of the green*. The term, in vogue since the mid 19th century, has been adopted into everyday speech.

> If he is unfortunate in having finished his task before his problem was knocked completely out of shape by England's suspension of the gold standard, that is just the rub of the green. (*Times Literary Supplement*, December 31, 1931)

60. COMPOSURE

1. bedside manner A physician's attitude in the presence of his patient; a doctor's composure while attempting to inspire confidence in his patient. This expression, in currency since the mid 1800s, is quite obvious in its derivation.

> "What sort of doctor is he?"
> "Well, I don't know much about his ability, but he's got a very good bedside manner."
> (George Du Maurier, *Punch*, March 15, 1884)

The term is occasionally heard as a jocular, off-color remark about a person's ability to attract sexual partners.

2. cool as a cucumber Calm, cool, and collected; self-possessed, composed. Cucumbers have long been used in salads and relishes for their refreshing, cooling quality. This popular simile dates from 1732. See also **cold as a cucumber**, 296. PRUDISHNESS.

3. cool your jets Relax, calm down, take it easy; used chiefly as an admonition. This recent American slang expression is perhaps an extension of the 1950s slang term *cool it*. The *jets* in the phrase may refer to the jet engines of a plane which get extremely hot before takeoff, and are thus comparable to the feverishly excited condition of an individual to whom this remark would be addressed.

4. count to ten To take a deep breath, calm down, and gird oneself to do something difficult or trying; to pause and consider before acting impetuously; to redirect one's energy and attention to avoid becoming enraged. This common expression is often used by someone who is violently angry and on the verge of losing his temper. It is a warning to another person to behave in a certain manner or suffer the consequences when the counter reaches "ten."

5. hang loose To be relaxed; to stay calm; to take it easy; to be nonchalant about something. This American slang expression may be related to the earlier

phrase *let [one's] hair down* meaning 're-lax, let one's hair hang loose,' although the use of *loose* in this sense may also have been suggested by the antonymous phrase *be up tight*. The phrase is of recent origin having become popular in the late 1960s.

In the meantime, my survival plan is to hang loose, trust my own perceptions, and wear out my Rod Stewart and Joy of Cooking records. (Ellen Willis, *The New Yorker*, February 26, 1972)

See also **hang tough** under 268. PERSEVERANCE.

6. hold your horses Hold on, be patient, keep calm, don't get excited; nearly always used in the imperative. The allusion is to the way a driver holds his horses back by pulling up on the reins in order to slow them down. Of U.S. origin, this expression is thought to have first appeared in print in its figurative sense in the *New Orleans Picayune* (September 1844):

Oh, hold your hosses, Squire. There's no use gettin' riled, no how.

7. keep [one's] powder dry To keep cool, to keep control, to remain calm and ready for action. This expression is military in origin and refers to the reputed final words of Sir Oliver Cromwell to his troops before they crossed a river to attack on the opposite side:

Put your trust in God; but be sure to keep your powder dry.

8. keep your shirt on Stay calm, keep cool, don't get worked-up; also *hold on to your shirttail;* both expressions nearly always used in the imperative. Men usually remove their shirts before engaging in a fistfight; whence the expression. George W. Harris used this U.S. slang phrase in the *Spirit of the Times* (N.Y., 1854):

I say, you durned ash cats, just keep yer shirts on, will ye?

9. on an even keel Steady, stable, balanced; even-tempered; maintaining composure or equilibrium. *Keel* is a nautical term for a "central fore-and-aft structural member in the bottom of a hull" *(Random House Dict.)* which affects a vessel's stability. Nautical use of *on an even keel,* as in the following quotation from James Greenwood's *A Rudimentary Treatise on Navigation* (1850), has given rise to current figurative use of this expression.

A ship is said to swim on an even keel when she draws the same quantity of water abaft as forwards.

10. roll with the punches See 116. ENDURANCE.

11. saucered and blowed Cooled off, physically or emotionally. This American expression, dating from the mid 19th century, originally described the uncouth practice of pouring one's hot coffee or tea from the cup into the saucer, and then blowing on it to cool it. The practice is said to have existed also among the servants in the manor houses of England, where the custom was rendered, for some unknown reason, as to *go into the kitchen*. The term is also used figuratively to characterize the cooling of one's temper.

12. stroke the black dog down Cure one's blues; help one overcome a tantrum. The black dog in this phrase refers to a case of depression or low spirits. With children the term is usually employed with a tantrum, and to *stroke the black dog down* is to soothe the child by cuddling and petting. A black dog has been an enduring symbol for the devil; hence, the implication that the depression is a direct result of Satan's influence.

The black dog . . . is said to be on a child's back when he is fractious. (William Hazlitt, *English Proverbs*, 1869)

The expression, rarely heard today, has been in use since the 18th century.

13. without batting an eyelash Without losing one's composure, especially in the face of adversity; keeping one's cool; without betraying surprise. This expression has its roots in a 17th-century definition of the verb *bat*, meaning 'to flutter the eyelids rapidly.' Since it is quite common to flutter one's eyes when one is surprised, to suppress such an action indicates that one is truly unflappable. Variants are *without batting an eyelid*, *without batting an eye*, and *not bat an eye*.

> President Andrew Johnson . . . will not swerve from that conviction now nor even so much as bat his eye. (T. E. Coell, *Speech in House of Representatives*, February 12, 1867)

A related term, *bat one's eyes*, is used to indicate flirtation, especially on the part of a woman trying to attract a man.

> You hol' your head high; don't you bat your eyes to please none of 'em. (*Century Magazine*, May 1883)

14. without turning a hair Without batting an eyelash, showing no sign of excitement or emotion; completely calm and composed, unperturbed, unflustered.

> When I tried her with a lot of little dodges . . . she never turned a hair— as the sporting people say. (Richard D. Blackmore, *Dariel*, 1897)

The earliest recorded literal use of the expression is found in Jane Austen's *Northanger Abbey* (1798) in allusion to a horse which, though hot from racing, did not become sweaty or ruffle its hair.

Comprehensiveness . . .
See 195. INCLUSIVENESS

Compulsion . . . See 50. COERCION

61. CONCEALMENT
See also 332. SECRECY

1. all [one's] geese are swans See 128. EXAGGERATION.

2. angle with a silver hook To cover one's piscatory failure by buying fish at the market; to attempt to cover up one's failure; to conceal something embarrassing. This expression, which has been in popular use in Britain since at least the early 1600s, had its origin in Italy. John Ray in *Proverbs* (1678) comments:

> The Italians by this phrase mean to buy fish in the market. Money is the best bait to take all sorts of persons with.

3. cat in the mealtub Something concealed; a hidden danger; a snake in the grass. The allusion here is probably to the children's story of the cat who covered itself with the meal in the mealtub to facilitate catching the mice that were eating its master's grain.

> Is this the cat in the mealtub of refunding? (*Congressional Record*, May 10, 1880)

The phrase, in use since 1839, may owe some of its currency to the famous *Mealtub Plot* in England during 1679. In the aftermath of the *Popish Plot* the Duke of Monmouth was rumored to have conspired with the Whigs to prevent the Catholic Duke of York from his rightful succession to the throne upon the death of his brother, King Charles II. One Thomas Dangerfield claimed to have found evidence of the conspiracy concealed in the mealtub of a Mrs. Cellier. Investigation proved the entire story to be false and both participants were convicted of libel and perjury.

4. cover [one's] tracks To hide or conceal one's actions or motives, to cover up, to get rid of the evidence. The allusion is to the practice of American Indians, backwoodsmen, and such, who erased or otherwise obliterated their footprints to avoid being followed. See **Indian file, 25. ARRANGEMENT.**

> In corresponding, I endeavored to cover my tracks as far as possible. (Albert D. Richardson, *The Secret Service, the Field, the Dungeon, and the Escape*, 1865)

5. gild the pill To mask or ease an offensive or onerous task by providing attractive incentives; to cloak in euphemism. This expression is derived from the sugary coating applied to pills to make them more palatable.

> Palmerston must go . . . There was no attempt to gild the pill, since on reflection it seemed better that he should not lead the Commons. (Philip Guedalla, *Palmerston*, 1926)

6. plead the Fifth To refuse to offer information in response to a question; to refuse to answer questions about one's activities; to refuse to state one's reasons or opinions. The Fifth Amendment to the Constitution of the United States of America reads in part:

> No person shall be held to answer for a capital, or otherwise infamous crime, unless on a presentment or indictment of a Grand Jury . . . nor shall be compelled in any criminal case to be a witness against himself, nor be deprived of life, liberty, or property, without due process of law

Although the opportunity to *plead the Fifth* has existed since the writing of the Bill of Rights, the term first gained considerable popularity during the Kefauver Crime Commission hearings and the McCarthy Communist hearings in Congress in the early 1950s, when Americans heard a great many witnesses exercise their right to *take the Fifth* rather than answer questions impugning their integrity. The result of this public refusal to testify caused a great deal of controversy and discussion over the judiciousness of such a decision, thus bringing the term even more sharply into everyday focus. Today the term is most frequently heard in jocular repartee among friends.

7. put up a smoke screen To camouflage or conceal one's intentions, motives, or actions from one's rivals or opponents, or from the general public. A smoke screen is a cover of dense smoke produced to camouflage a ship, plane, or area from the enemy during top-secret military operations.

> A reply which General Waters considers was a skilful smokescreen to conceal a refusal. (*The Observer*, June 1928)

8. sweep under the carpet To cover up or conceal something embarrassing or disagreeable in the hope that it will escape notice or be forgotten; also *push under the carpet.*

> It would be self-deception to think that unemployment could be dealt with by emergency measures and pushed under the carpet. (*The Times*, January 1963)

Of fairly recent coinage, this expression refers to the lazy person's step-saving trick of literally sweeping dirt under the rug instead of picking it up.

9. under the counter In a clandestine, often illegal manner; out of sight, set apart from the regular stock; having to do with money changing hands unofficially or illegally. The counter or table is the one over which money is exchanged for merchandise. *Under-the-counter* or *under-the-table* practices or products are often connected with the black market. The expression was popular during World War II when certain luxury items were in demand but accessible only "under the counter." Banned books have also been popular "under-the-counter" items.

> Chief goods to "go under the counter" are fully fashioned silk stockings, watches, and silk handkerchiefs. (*Evening Standard*, December 20, 1945)

Under the counter is usually used interchangeably with *under the table*, though the latter is heard more often to describe payment made but not officially recorded, thus evading taxes.

10. whitewash To cover up defects, faults, or mistakes, especially to deceive the public about the disreputable goings on of a public figure; to make the guilty

look innocent or to condone a reprehensible action, by hiding or manipulating the facts and creating a façade of respectability. To whitewash is literally to whiten with a composition of lime and water, or ground chalk. Figuratively, this Americanism means to exonerate or give a clean slate to an unethical or guilty person. Also used substantively, the term is commonly heard in political contexts.

> Several Republican senators reported that the report was a "whitewash" of [Senator] McCarthy's charges. (AP wire story, July 20, 1950)

Conceit . . .
See 333. SELF-CENTEREDNESS

Conclusion . . . See 47. CESSATION; 58. COMPLETION; 79. CULMINATION; 375. TERMINATION

Concord . . . See 16. AGREEMENT

Condemnation . . . See 298. PUNISHMENT; 312. REPRIMAND

Confidence . . . See 46. CERTAINTY

Confidentiality . . .
See 332. SECRECY

62. CONFRONTATION

1. beard the lion in his den To confront face-to-face; to oppose another boldly and openly on his turf; to challenge. Sir Walter Scott used the expression in *Marmion*:

> And dar'st thou then,
> To beard the lion in his den,
> The Douglas in his hall?
> (VI,14)

2. bell the cat To dare to confront danger at its source, despite overwhelming odds. The allusion is to a fable recounted in Langland's *Piers Plowman* (1377). A group of mice continually harassed by a certain cat met to decide what to do

about the problem. One old mouse suggested that a bell hung around the cat's neck would serve to warn the mice of the feline's approach. This idea was greeted with much enthusiasm until a bright young mouse brought up the question, "But who will bell the cat?"

3. come to grips with To face up to a problematic situation and deal or cope with it; to tackle a problem head-on in an attempt to get it under control; to grapple or struggle with a dilemma or difficulty. The idea of confronting an opposing force suggests that the expression may derive from a sport such as wrestling. This theory is highly conjectural, however, because the many meanings and uses of *grip* allow for a variety of possible explanations.

4. face the music To confront stoically the consequences of one's deeds; to face up to an unpleasant or trying experience. This expression may have originated in the theater, where actors and actresses nervously awaited their cues to come onstage and thus "face the music" in the pit. Another origin may lie in the military practice of mustering soldiers in full battle regalia for inspection, often at the call of a bugle. Figuratively, this term refers to a personal confrontation for which one must gather courage.

5. full court press An all out effort; a full scale attack from a defensive position. This American term is derived from a basketball defense conceived in the early 1950s. It involves employing defensive pressure all over the court, from end line to end line, hoping to force the opposition into an error which will lead to an easy score for the attacking team. Because this is a concerted attack that often leads to a disorganization of an opponent's tactics, the term has been adopted into the vocabulary of the business and political worlds to indicate a disruption of one's opponents or a vigorous attack.

> . . . he seemed to be pulling back from most of his controversial

proposals. But now he has gone to a full court press. (*The Times*, April 6, 1978)

6. in the teeth of In direct opposition to; straight against, without a buffer; confronting, face to face; in defiance or in spite of. This expression of unknown origin dates from the 13th century. The oldest examples of its use describe direct confrontation between two forces:

> A Hector, who no less desires to meet them in the teeth. (Arthur Hall, tr., *Ten Books of Homer's Iliad*, 1581)

Since the 18th century, *in the teeth of* has broadened in its applicability to include confrontations of a less physical or tangible nature, such as between contradictory ideas.

> A judge has no right to enter judgement in the teeth of the finding of a jury. (*Law Times*, June 13, 1885)

The expression can also mean 'in the face or presence of.'

> They were in fact in the very teeth of starvation. (Charles Lamb, *Elia*, 1825)

7. one-on-one Face to face; a direct confronting of another. Although applicable to other sports, this Americanism, of recent origin, can be traced directly to the game of basketball where the *one-on-one* situation develops most frequently. One defensive player, without any assistance from his teammates, finds himself trying to stop the man with the ball from scoring. The business world has adopted this term, as it has so many sports terms, to indicate any direct confrontation that promises to be difficult to handle.

8. showdown A decisive confrontation between opposing parties to settle a dispute; a revelation of facts and other information, usually in hopes of resolving an issue. In poker, a showdown is the laying down of one's cards, face up, to determine the winner of that hand. *Showdown* has assumed its figurative implications by extension.

The opening game of the showdown Yankees-Red Sox series . . . (AP wire story, September 24, 1949)

9. square off To take on a defensive stance; to gird up one's loins. This phrase originated and is still used as a boxing term for the initial positions that boxers assume at the beginning of a round. The expression maintains widespread figurative use.

> The bow appeared to be rearing up to square off at the midday sun. (J. H. Beadle, *Undeveloped West*, 1873)

10. take the bull by the horns To attack a problem head-on; to confront without fear or evasiveness; to face up to danger, difficulty or unpleasantness without shrinking. In bullfighting, a matador grasps the horns of a bull about to toss him. Jonathan Swift used the expression in 1711:

> To engage with France, was to take a bull by the horns. (*Conduct of Allies*)

63. CONFUSION

See also 103. DISORDER

1. all balled up Confused; disorganized; perplexed; all mixed up; tangled. When horses were the principal means of transportation, one of the hazards of taking them out in winter was the formation of hard and uncomfortable balls of snow or ice under their hooves. These balls of snow sometimes caused horses, especially a team pulling a sleigh, to flounder and fall, resulting in a scene of complete confusion; hence, the expression *all balled up*. The term has been in use as a figurative expression since the late 1700s.

> His childhood had been tragically balled up by circumstances which had branded him with such a passionate bitterness as I have seldom seen in a man. (*Century Magazine*, March 1923)

2. at loose ends Unsettled, undecided, lacking direction or goal; uncommitted to one's present position and uncertain of

one's future status. A loose end is anything that is left hanging or not properly attached, as a piece of fabric or a seemingly superfluous detail. A person is "at loose ends" when his life lacks coherence or a sense of direction as exemplified in the following fragment quoted in *Webster's Third:*

> . . . feeling himself at loose ends—no job, no immediate prospects. (Dixon Wecter)

See also **tie up the loose ends**, 58. COM-PLETION.

3. at sea Confused, perplexed; without direction, design, or stability; in a state of uncertainty. Figurative use of this expression dates from the mid 18th century and is based on an analogy to a ship lost at sea, having no bearings and out of sight of land. *At sea* can refer to a person or state of affairs. *All adrift* is an analogous nautical expression with a similar figurative meaning 'aimless, confused.'

4. bear garden A place of confusion; a site of turmoil and agitation. Bears were kept and baited for public entertainment in establishments known as *bear gardens* during the latter years of the Tudor and the early years of the Stuart monarchies. In London these *bear gardens* were located on the south side of the Thames and became notorious for their scenes of chaotic disorder. Shakespeare moved to that area in 1597, at the time a district of rapid growth.

> . . . he was residing in the theatrical district on the Bankside, not far from the Bear Garden and near the site of the Globe. (Louis B. Wright, *Shakespeare for Everyman*, 1964)

A related term, *bear-garden language*, was a figurative expression for the foul and blasphemous language associated with this crude sport.

> He's as great a master of ill language as ever was bred at a Bear-Garden. (Edward Ward, *London Terraefilius*, 1707)

5. Chinese fire drill Any scene of great confusion or complete disorder. The origin of this phrase is uncertain. The most plausible explanation attributes the expression to British troops who served with the Chinese during World War II. Apparently these troops found the Chinese way of doing things confusing and disorderly; hence, the pejorative sense in such terms as: *Chinese national anthem*, any harsh, clangorous noise; *Chinese three-point landing*, a crash; and *Chinese landing*, one made by a *Chinese ace*, One Wing Low. Another plausible explanation attributes the term to the early 1950s and the Korean War specifically. Because the Chinese backed and eventually fought for the North Koreans, they were out of favor with the Western powers at that time. When the Chinese first entered the Korean War, their attacks were great cacophonies accompanied by thousands of troops rushing forward, blowing bugles, and screaming. Such an image of confusion could account for any disorderly situation being associated with the Chinese.

6. come unhinged To become extremely nervous; to become unstable; to be reduced to a state of confusion. The allusion in this term is to the condition of a door or window shutter that has lost one of its hinges and hangs in disarray. Dating from the late 16th century, the expression is most often heard today in its figurative sense.

> As for those wingy mysteries in divinity, and airy subtleties in religion, which have unhinged the brains of better heads, they never stretched the *pia mater* of mine. (Sir Thomas Browne, *Religio Medici*, 1643)

A variant, *come unglued*, dates from about the same period, and probably refers to a piece of furniture coming unglued, creating an unstable condition.

7. flutter the dovecotes To throw into a state of agitation or confusion; to upset the serenity of a society. A dovecote is a house for doves or pigeons that will ac-

commodate a number of birds simultaneously; hence, to *flutter the dovecote* is to upset the equanimity of the entire social structure. The expression has been in use since at least 1600.

> If you have writ your annals true, 'tis there
> That, like an eagle in a dove-cote, I
> Fluttered your Volscians in Corioli.
> (Shakespeare, *Coriolanus*, V,vi)

8. God writes straight with crooked lines Sometimes the will of the divine is a mystery to mankind; one doesn't always understand life's foibles. There is some controversy over the source of this expression. Some attribute it to St. Augustine, which would set the date of its origin at about 400, while others attribute it to an old Portuguese proverb from about 1400. Three correspondents to *American Notes and Queries*, in a series of articles between December 1964 and April 1965, conclude that the proverb is Portuguese, for, they maintain, the St. Augustine theory came about through an error in translation. Whatever the case, Paul Claudel, the French dramatist and poet, used the expression as the theme of one of his plays, *The Satin Slipper* (1931).

9. knock for a loop To disorient someone by saying or doing something shocking or unexpected; to strike a blow and cause one to lose balance and fall. The *loop* in this modern slang expression derives from the aeronautical term for the mid-air maneuver of an airplane. To knock someone for a loop is to hit that person hard enough to make him do a somersault. The feeling of dizziness and disorientation is carried over into the more common figurative use.

> That little charade of hers had knocked him for a loop. (D. Ramsey, *Deadly Discretion*, 1973)

Also current is *throw for a loop*.

> I was really confused. That memorandum threw me for a loop. (E. Ambler, *Intercom Conspiracy*, 1969)

10. knock galley-west See 51. COMBAT.

11. lose [one's] bearings To become lost; to lose all sense of direction; to become hopelessly disoriented, confused, or bewildered. In this expression, *bearings* carries the literal meaning of reference points or directions in relation to one's position; thus, the term's use to describe a person who is lost or disoriented.

12. not have the foggiest (idea) Not to have any notion at all; to be bewildered, perplexed; to find something cloudy, blurred, indistinct. The allusion in this expression is to the lack of clarity one experiences in the midst of a dense fog; one may lose all sense of direction, for even familiar objects become indistinct or obscure.

> Uncle: Wonder who she is?
> Niece: Haven't the foggiest. Must be pre-war.
> (*Punch*, August 22, 1917)

13. not know if [one] is afoot or on horseback So completely confused as to not know what one is doing, thoroughly befuddled or mixed-up; not to know whether one is coming or going. This self-evident American colloquialism dates from the late 19th century.

> "Fay Daniels!" gasps the girl, which don't know if she's afoot or horseback—and neither did I.
> (*Collier's*, October 1927)

14. not to know if [one] is coming or going Not to know what one is doing; extremely confused or mixed-up; not to know which end is up; ignorant, stupid.

> There's nobody at the Town Hall could take it on. Town Clerk doesn't know whether he's coming or going.
> (J. B. Priestley, *Fest. Frabridge*, 1951)

Use of the phrase dates from at least 1924.

15. not to know which end is up See 179. IGNORANCE.

16. not to make head nor tail of See make head or tail of, 95. DIFFERENTIATION.

17. rattle [one's] cage To joggle one's thoughts; wake someone up; confuse; embarrass; disconcert. This American slang expression refers to the inhumane practice of shaking a cage to awaken or excite a captive animal. The resulting reaction is entirely unpredictable; it may be one of confusion, of irritation, or of absolute fury.

18. razzle-dazzle An act to create a confusion or bewilderment; tricky maneuvers intended to astound another person; a flurry of rapid activity. Dating from the late 1800s, the roots of this American slang expression lie in the much older word *dazzle*, which means 'to overcome with an excess of bright lights.' The *OED* indicates that *dazzle* first appeared in Caxton's *The History of Reynard the Fox* (1481), and that the first written example of *razzle-dazzle* is:

> I'm going to razzle-dazzle the boys . . . With my great lightning change act. (Archibald Gunter, *Miss Nobody*, 1890)

In modern usage the expression seems to be restricted to sports and gambling jargon.

19. send to Dulcarnon The key word in this phrase is *Dulcarnon*, a word derived from the Arabic meaning 'possessor of two horns,' hence, to *send to Dulcarnon* is to place upon the horns of a dilemma, to put into a state of perplexity. Dating from at least the 14th century, the expression appears in Chaucer's *Troilus and Criseyde*

> I am, til God me bettre mynde sende
> At Dulcarnon, right at my wittes
> ende.

A variant, *be in Dulcarnon*, means 'to be on the horns of a dilemma.'

20. slaphappy See 145. FATUOUSNESS.

21. up a stump Confused; embarrassed; at a loss; in a perplexing position. This

American slang expression has been attributed to two different situations, each one involving the stump of a tree. The first ascribes the term to the fact that a person on a stump can't climb any higher; therefore, he is at a loss as to what to do next. The other explanation, and seemingly the more plausible, alludes to the political speaker who, delivering a speech from a tree stump, finds himself confined and surrounded by strange, often unfriendly, faces. He frequently becomes confused and embarrassed, and occasionally feels trapped. Whatever the case, the term has been in common use since the early 1800s.

> You're up a stump, ain't you? (Mark Twain, *Tom Sawyer*, 1876)

22. when the dust settles When the confusion has ended; when order has returned after a great commotion. The allusion is to a great cloud of dust created by vigorous activity, dust so irritating that seeing or breathing becomes difficult and one must wait for it to settle before one can continue to work.

> Most important, when the dust settled, it did seem that more often than not, votes were cast based on candidates' qualifications rather than their race, sex, or personal life. (*Time*, November 21, 1983)

Conglomeration . . .

 See 239. MIXTURE

Consent . . . See 23. APPROVAL

64. CONSEQUENCES

1. devil to pay See 298. PUNISHMENT.

2. domino theory The belief that if one of a cluster of small, neighboring countries is taken over by communism or some other political system the others will soon follow suit; the phenomenon of political chain reaction. This theory takes its name from the chain-reaction effect created when one in a line of standing dominoes topples, bringing the

rest down, one after the other. The concept arose during the 1950s and was popular during the '60s as an expression of the basis for American involvement in Southeast Asia at that time.

3. he that lieth with dogs riseth with fleas A person is known by the company he keeps; associate with riffraff and you'll soon be one of them. This well-known proverb appeared as early as 1640 in George Herbert's *Jacula Prudentum.*

4. pay the piper To bear the consequences of one's actions or decisions; to pay the cost of some undertaking; to foot the bill. This expression probably alludes to the 13th-century legend of the Pied Piper of Hamelin in which the piper, upon being refused the payment promised for ridding the town of rats, played his pipe again; this time, however, it was the children who were led out of town to their deaths. Thus, the residents suffered the consequences of their decision, having "paid the piper" with their children's lives. One source suggests that the derivation may be more literal, that is, it was customary to pay a piper or other street musician for the entertainment he supplied.

> After all this dance he has led the nation, he must at last come to pay the piper himself. (Thomas Flatman, *Heraclitis Ridens,* 1681)

A common variation is *pay the fiddler.*

5. sow the wind and reap the whirlwind A proverb implying that if a person acts in a self-indulgent, hedonistic, or dissolute manner, he will have to suffer the calamitous consequences. This adage is Biblical in origin, appearing in Hosea 8:7 as a warning to the Israelites to emend their iniquitous ways. *Sow the wind* implies senseless or unproductive activity, while *whirlwind* alludes to a violent and destructive force, the fate of one who "sows the wind."

6. stew in [one's] own juice To suffer the unhappy consequences of one's own

unfortunate actions, to reap what one has sown; also *fry in one's own grease.* According to the *OED, fry in one's own grease* dates from the 14th century when it was applied to persons burned at the stake. The phrase appeared in the prologue to *The Wife of Bath's Tale* by Chaucer:

> In his own grease I made him fry,
> For anger, and for very jealousy.

Stew in one's own juice, although the most popular form of the expression today, did not appear until approximately 300 years later. The equivalent French phrase is *cuire dans son jus* 'to cook in one's juice.'

65. CONSERVATISM

1. blimp See 276. POMPOSITY.

2. button-down Conservative in dress and manners; conventional and conformist in attitude; conforming to the establishment, especially politically. During the 1960s, when many of the nation's young people were rebelling against the big government-big business "establishment" by wearing unconventional clothing and hair styles, the button-down collar style of dress shirt came to symbolize conservatism and alliance with the "establishment."

> . . . the button-down, dispassionate, country club racism of the *nouveau riche.* (Paul Good, *Nation,* November 28, 1967)

3. Dame Partington and her mop Stubborn and futile opposition to the inevitable, particularly to economic, political, or social reform. This infrequently used expression is derived from English newspaper stories of November 1824 which tell of a woman who used only a mop in attempting to rid her nearly inundated seaside home of water during a raging storm. The woman eventually gave up her struggle and sought safety elsewhere. In October 1831, Rev. Sydney Smith compared the rejection of a reform bill by the House of Lords to the plight of Dame Partington.

4. die-hard See 268. PERSEVERANCE.

5. hard-hat A working-class individual, usually characterized as politically conservative, so called from the protective metal or plastic helmet worn by construction workers. *The Sunday Mail* (Brisbane, June 1970) offers the following explanation of the term:

> A "Hard Hat" is a construction worker, but his helmet symbolises all those beefy blue-collar workers who have suddenly become the knuckleduster on the strong right arm of President Nixon's silent majority.

6. redneck An ultraconservative. This disparaging term usually refers to the poor white farmers of the Southern backwoods who are notorious for their purported intolerance of liberals, intellectuals, Blacks, and hippies. *Redneck*, originating as an allusion to a farmer's perennially sunburned neck, is now an epithet for any person who shares similar prejudices.

7. right-wing Reactionary, conservative; averse to change, die-hard. The term reputedly arose from the seating arrangement of the French National Assembly of 1789, in which conservatives sat on the right side, or wing, of the chamber. As used today, *right-wing*, like *left-wing*, has pejorative connotations of extremism—in this case, of bigotry, prejudice, moneyed interests, anti-humanitarianism, etc. Both terms are used primarily to denigrate and stigmatize one's opponents; generally, a political conservative would not call himself a *right-winger*, just as a liberal would not call himself a *left-winger;* yet each might well label the other with the appropriate epithet.

Consideration . . .
 See 378. THOUGHT

Conspicuousness . . .
 See 252. OBVIOUSNESS

66. CONSPIRACY

1. hand in glove Intimately associated, on very familiar terms; closely related or connected; in cahoots, in conspiracy. Literary use of the expression dates from the late 17th century when it was properly *hand and glove*, a form now rarely heard. In contemporary usage the expression often carries connotations of illicit or improper association.

2. in cahoots In league or in partnership; in conspiracy; also *to go in cahoots* or *cahoot with*, meaning to join up with, to become partners; and *go cahoots* meaning to share equally. This U.S. slang expression, dating from 1829, is said to have derived from the kind of partnership that was expected of early American pioneers who shared a frontier cabin, or engaged in a joint venture. Originally, the phrase may have come from the French *cahute* 'cabin, hut,' although Dutch *kajuit* and German *Kajüte* have also been suggested as possibilities.

67. CONSTANCY

1. bird in [one's] bosom One's pledge to oneself; one's conscience; loyalty; fidelity. The *bird* in this phrase is the symbol of an overpowering virtue enclosed in one's body as an innocent bird is enclosed in a cage. According to Sir Walter Scott, in a footnote to his novel, *The Abbot* (1820), this expression was:

> . . . used by Sir Ralph Percy, slain in the battle of Hedgely-moor in 1464, to express his having preserved unstained his fidelity to the House of Lancaster.

A variant is a *bird in one's breast.*

> He cheerfully took his death, affirming he had a bird in his breast (his own innocency) that sung comfort unto him. (Thomas Fuller, *Worthies of England, Leicester*, 1662)

A related term, *bird of one's own brain*, signifies an idea or opinion of one's own creation.

2. carry out [one's] bat To outlast all the others; to have stick-to-it-iveness. This Briticism, adopted from cricket, harks back to the earlier days of the game when the batsman would leave his bat for the next batsman if he had been put out. If he had scored, he would take the bat with him; thus outlasting the others. In today's affluent society each batsman has his own bat, but the connotation of the phrase has not changed.

> We had made our 80 runs in less than two hours, and carried out our bats. (Wilkie Collins and Charles Dickens, *All the Year Round*, 1859)

3. Coventry blue True blue; constant; extremely loyal, steadfast; unwavering. As early as the 1500s, Coventry was producing a blue dye of extraordinary quality that was known for its fastness.

> Edge me the sleeves with Coventry blue. (Robert Greene, *James IV*, 1592)

From that reputation arose the saying, *true as Coventry blue*, to indicate one who was, like the dye, unwavering in constancy. This came to be shortened to *Coventry blue*.

4. dyed-in-the-wool Confirmed, inveterate; complete, thorough, unmitigated; out-and-out. When wool is dyed before being made into yarn, its color is more firmly fixed and lasting. A variant of this expression appeared in Sir Thomas North's translation of Plutarch's *Lives of the Noble Grecians and Romans* (1579):

> He had . . . through institution and education (as it were) died in wool the manners of children.

5. hard-and-fast Ironclad, binding, strict, rigid, unbending. The literal, nautical sense of the term denotes a ship on shore or aground, stuck and immovable. It is probably this sense that gave rise to the figurative meaning in popular use today. Both the figurative and literal meanings date from the late 19th century.

6. leopard can't change its spots A person's fundamental character remains constant; innate qualities in nature are immutable. This proverbial expression, used as a figurative representation of unchangeableness, alludes to Jeremiah 13:23 in the King James version of the Old Testament.

> Can the Ethiopian change his skin, or the leopard his spots? then may also do good you that are accustomed to do evil.

According to the *OED*, the phrase first appeared in print in English in 1560 in the Geneva Bible, but Wyclif alluded to it as early as 1382. An old Ashanti proverb puts it a bit differently:

> Rain beats a leopard's skin, but it does not wash out the spots.

7. man for all seasons A reliable, steadfast male; a man of principle who retains his integrity regardless of the situation. This expression alludes to a man who is unruffled by vicissitudes and who remains constant despite changing circumstances, like the weather. The phrase was popularized when Robert Bolt used it as the title of his dramatization of the life of Sir Thomas More (1960).

8. on the reservation Remaining true to a political party; staying within a faction. This expression, dating from about 1970, implies that one has remained close to his home or origin like an Indian who remains on the reservation. *Off the reservation*, 'to depart from one's party's policy temporarily so as to back an opposing candidate or policy,' is an earlier phrase, from about 1950, and is probably the source of *on the reservation*.

> The appointment of Dean Burch . . . is another White House attempt to keep conservatives (as they say in White House lingo) "on the reservation." (*National Review*, March 15, 1974)

9. pin to [one's] sleeve To attach one's soul to another; to pledge one's service to

another; to take a vow to satisfy another's bidding. The allusion in this expression is to the chivalric custom of a knight pinning a token from his lady love, usually a handkerchief, to his sleeve as a pledge of his love and his desire to gain the prize for her. The expression has been in use since at least the early 16th century, and it was a favorite quotation of Sir Thomas More.

> There was a good saying of Sir Thomas More: "I will not pin my faith upon any man's sleeve, because I know not whither he will carry it." (William Secker, *The Nonsuch Professor in his Meridian Splendor*, 1891)

10. regular brick An agreeable, sincere male; a regular guy. This expression, referring to the solid, unvariegated constitution of a brick, describes a man who is genuinely amiable, unaffected, and reliable.

> I don't stick to declare Father Dick . . . was a regular brick. (Richard H. Barham, *The Ingoldsby Legends*, 1845)

11. through thick and thin Through difficulties or adversity, in spite of any or all obstacles; faithfully, unwaveringly. According to the *OED*, *thick and thin* was originally *thicket and thin wood*. Thus this expression denoted an actual physical obstacle, as in the following quotation from Spenser's *Faerie Queene*:

> His tireling jade he fiercely forth did push
> Through thick and thin, both over bank and bush.

Currently *through thick and thin* is used figuratively as well, referring to any conceivable obstacle, and in context, connoting faithfulness.

> There's five hundred men here to back you up through thick and thin. (T. H. Hall Caine, *The Manxman*, 1894)

12. true as Troilus Reliable; steadfast; through adversity or difficulty. This expression alludes to Troilus's remaining constant in his love of Cressida despite her perfidy. According to classical Greek legend, Troilus had exchanged vows of everlasting love with Cressida, the daughter of a Trojan priest. Cressida, upon being exchanged to the Greeks for a group of Trojan prisoners, betrayed Troilus and, almost immediately, became the mistress of Diomedes. Troilus, however, honored his vows and remained faithful. Both Chaucer and Shakespeare made contributions to the tale. Their versions vary about the falseness of Cressida, but both agree about the constancy of Troilus. As Shakespeare put it:

> Yet, after all comparison of truth,
> As truth's authentic author to be cited,
> "As true as Troilus" shall crown up the verse,
> And sanctify the numbers.
> (*Troilus and Cressida*, III,ii)

13. true-blue Loyal, faithful; steadfast, staunch, unwavering, constant.

> The Old Beau is true-blue, to the principles high-flown [of] King Edward's First Protestant Church. (Edmund Hickeringill, *Priest-craft*, 1705)

The color blue has long been the symbol of truth and constancy. Some conjecture the association arose because of the renowned fastness of Coventry blue dye. According to the *OED*, *true-blue* was applied to the Scottish Presbyterian or Whig party of the 17th century, the Covenanters having assumed blue as their partisan color in opposition to the royal red. Their doing so may have been connected with Numbers 15:38 of the Bible, in which the Lord commands Moses to have the Israelites put a blue ribbon on the fringes of the borders of their garments as a reminder to keep His commandments.

14. **true to [one's] salt** Faithful to one's employer; conscientious about one's work; exceptionally loyal. This phrase stands in direct contrast to another, *not worth one's salt*. It was once the practice to pay Roman soldiers in salt, then a scarce and valuable commodity. When money became the medium for wages, it was called *salarium* 'salt money'; hence, a soldier who worked hard for his pay, gave his employer one hundred percent effort for his money, was *true to his salt* while one who goldbricked was *not worth his salt*.

Consummation . . .
 See 79. CULMINATION

Contemplation . . .
 See 378. THOUGHT

Contention . . .
 See 56. COMPETITION

Contentiousness . . . See 32. BELLIG-
 ERENCE; 51. COMBAT

Continuation . . . See 110. DURA-
 TION; 319. RESUMPTION

68. CONTRAPTIONS

1. **church key** A tool that opens capped bottles or punches a triangular hole in the top of a beer or soda can. Coined in the early 1900s, this expression didn't achieve popularity until World War II, when the distribution of beer and soda in cans became standard practice. Old-time brewery workers carried a bottle opener which they facetiously called a *church key*, probably in defiance of the church-sponsored temperance movement. With the advent of cans, the name was transferred to the new triangular opener. Today, the term is heard less frequently because of the widespread use of pop-top cans and twist-off caps.

2. **Dutch wife** A frame made of rattan or cane, used in bed in tropical countries to rest the legs upon; a bolster filled with strips of paper. The *Dutch wife*, apparently a jocular allusion to a substitute wife, is a European invention originally used in the Dutch East Indies to prop up the legs, thereby allowing free circulation of air to create a cooling effect. The term is also used to define a long, round bolster utilized for the same purpose in the tropics, but to a sailor it can also denote the pillow-like bolster which he keeps in his hammock. Albert Chevalier in his poem *My Old Dutch* (1906) alludes to the device.

> There ain't a lady in the land,
> As I'd swap for my dear old Dutch.

3. **gimmick** A gimcrack; a dishonest device for rigging a game of chance; any device of which the name is not known; a convenience to gain one's ends. This American slang word probably has its roots in carnival lingo, where *gimmicks* were devices used by the operators to regulate the frequency with which customers could win in a game of chance. One theory of the word's origin ascribes it to the German word *gemach*, 'easy,' but a more plausible explanation assigns it to an altered form of *gimcrack*, a showy object of little worth. From the carnival the term passed into the vocabulary of the magician, and about 1930 the word became part of the slang usage of the street. Today it is heard in the language of all levels of society.

> The gimmick the White House
> advisors are most fearful of is the
> amendment tacked on in the House.
> (*Chicago Daily News*, March 26,
> 1949)

4. **Heath Robinson** A proper name applied to ingenious but overly complicated and impractical mechanical contraptions. Heath Robinson (1872–1944) was a British caricaturist whose name became associated with his popular drawings of complicated mechanisms made out of every imaginable piece of junk and held together by the most unconven-

tional means. This British phrase is most often used adjectivally and is similar to the American *Rube Goldberg*.

> This "Heath-Robinson" jumble of wooden sheds, sluices, and water troughs looks ridiculous, yet it works all right. (*Discovery*, November 1934)

5. Rube Goldberg Any mechanical contrivance which is unnecessarily complex and impractical; used adjectivally, makeshift or improvised, jerry-built. Reuben Goldberg was an American cartoonist born in the late 19th century. His name evokes images of cartoons depicting ridiculously complex mechanical contrivances, and is used in referring to elaborate but ineffective repair work, inventions, etc. A "Rube Goldberg job" looks complicated but is unreliable.

69. CONTROL

See also 107. DOMINATION; 232. MANIPULATION

1. Aaron's serpent An all-controlling force; a power so great that it can overcome any other power. The reference in this expression is to Aaron's demonstration of God's power to the Pharaoh of Egypt in the book of Exodus. Obeying the Lord's instructions, Aaron cast down his rod before the Pharaoh, and it became a serpent. The Pharaoh then called forth his wise men and sorcerers, who did likewise, but Aaron's serpent swallowed up all the other serpents, thus proving the power of the Lord. The expression is still in use to demonstrate unusual power.

> And hence one master passion in the breast,
> Like Aaron's serpent swallows up all the rest.
> (Alexander Pope, *Essay on Man*, 1733)

A variant is *Aaron's rod*.

2. body English An attempt to control the movement of an object, as a billiard ball, bowling ball, pinball, etc., by contorting the body, without touching the object. This American expression, dating from the mid 1800s, probably has its roots in the game of billiards. In American billiards *English* is the spin given to the cue ball by striking it to the right or left of center; in other games, especially bowling, *English* is applied by spinning the ball at the moment of release. The British word is *side*. *Body English* is not restricted to game participants; it is often practiced by spectators as well.

3. call the shots See call [one's] shots, 53. COMMUNICATION.

4. carry the ball To assume responsibility for the progress of an undertaking; to be in charge and bear the burden of success or failure. This metaphorical expression stems from the role of the ball carrier in American football.

5. corner the market To possess, have access to, or be in control of something which is in demand; from the financial practice of attempting to secure control over particular stocks or commodities. This U.S. expression, dating from the mid 19th century, was originally heard only in financial contexts; however it is now heard in noncommercial contexts as well. In financial terms, a *cornering* involves one party buying all of one kind of stock or commodity, thereby driving potential buyers and sellers into a corner because they have no option but to acquiesce to the price demands of those controlling the stock.

6. flag down To catch the attention of and signal to stop; to cause to stop; to hail, as a taxi. This expression, used almost exclusively today in regard to automobiles, derived from the old railway practice of displaying a flag in order to stop trains at small stations that would normally be passed without even slowing down. The terms *flag stop* and *flag station* came to be used of small, jerkwater towns, while *flag down* was extended in use and has remained as a standard expression in the general language.

7. get the deadwood on Get someone in one's power; to have control over another; hold the upper hand. This phrase arises from the game of ten pins where, in the early days of the sport, deadwood, as the fallen pins were called, was allowed to remain. Such a situation gave the bowler greater control, for he could use the deadwood to sweep the standing pins from the alley. With the advent of mechanical pin setters, the deadwood was automatically swept from the alley; however, the deadwood is still allowed to remain in the game of candlepins.

> If they ask a man an embarrassing question, or in any way have placed him in an equivocal position, they will triumphantly declare that they have got the deadwood on him. (Louise Clappe, *The Shirley Letters from California*, 1851)

8. have a handle on To have a method of control; to be able to direct or guide. This phrase, which gained currency in the early 1970s, is obvious in its meaning; if one has a handle to hold or guide something by, he has much better control.

> Carter's State of the Union speech failed to convince foreign moneymen that the Administration has a handle on the economy's problems. (*Time*, January 30, 1978)

In contrast, to *lose the handle* means to 'drop the ball,' to lose control of a situation.

9. have the ball at [one's] feet See 9. ADVANTAGE.

10. have the world on a string See 115. ELATION.

11. hold the fort To take charge, often to act as a temporary substitute; to remain at one's post, to maintain or defend one's position. This expression is attributed to General Sherman, who in 1864 is said to have signaled this message to General Corse. In modern use, *fort* can refer to a place or a philosophical position.

> Elizabeth and her archbishops . . . had held the fort until their church had come . . . to have an ethos of its own. (A. L. Rowse, *Tudor Cornwall*, 1941)

12. hold the line To try to prevent a situation from becoming uncontrollable or unwieldy; to maintain the status quo. This Americanism probably comes from the game of football. It is frequently heard in an economic context, as in "to hold the line on taxes" or "to hold the line on prices."

13. hold the purse strings To determine how much money shall be spent and how much saved; to regulate the expenditure of money. *Purse strings* refers literally to the strings at the mouth of a money pouch which can be tightened or loosened, thereby controlling the amount of money put in or taken out. By extension, this term also refers to the right to manage monies. To *hold the purse strings* is to be in charge of the finances.

14. in the driver's seat To be in control of a vehicle; to be in a position of authority or superiority; to be able to control a situation. This expression, dating back to at least the 16th century, is obvious in its meaning; anyone who is in a position to control a vehicle is in control of his own destiny as well as that of those who accompany him. And since he is in such a position of trust, he must be prepared not to *steer [one] wrong*, both literally and figuratively.

> And the hardware's been designed to do the same. They won't steer you wrong. The trained salespeople . . . realize that you may never have been in this particular driver's seat before. (*New Yorker*, November 15, 1982)

15. in the saddle In control; in a position of authority; in readiness. This expression derives from the image of authority that is suggested by a good rider on horseback. Contributing to this sense is the fact that during the Middle Ages only the affluent could afford a horse;

consequently, those of wealth came to be *in the saddle*. Furthermore, a man afoot is in no position to dispute with a man on horseback. Today the term is heard only in its figurative sense.

> Let us put Germany, so to speak, in the saddle! you will see that she can ride. (Otto von Bismarck, *To the Parliament of the Confederation*, March 11, 1867)

16. muzzle the ox To place restrictions upon those whom one should trust; to deprive a person in one's employment of those little extra considerations he might expect. A provision of old Jewish law instructs that one must have faith in those whom he employs.

> Thou shalt not muzzle the ox when he treadeth out the corn. (Deuteronomy 25:4)

In Biblical times domestic animals were usually muzzled to keep them from grazing in the open farm lands; hence, the instruction to unmuzzle the ox which is working in one's fields and allow him a few well-earned perquisites. The expression is occasionally heard today.

> Isn't there a proverb about not muzzling the ox that treads out the corn? (Ethel White, *Fear Stalks the Village*, 1942)

17. put a bold face on Control one's countenance; repress a feeling outwardly. This phrase, although occasionally used to indicate impudence, is most commonly used to indicate a person who is trying to bear up under a disagreeable situation without showing his feelings to the public. The origin of the expression is uncertain; it has been in use since the 1600s. A synonymous phrase is *set one's face* while to *put on a bold front* is to display impudence or cheek.

18. run a tight ship To maintain good order and firm discipline; to manage a project or organization so that its interdependent parts and personnel function smoothly together, with machine-like efficiency and precision. A literal tight ship is one which is both water-tight and well-run, in that officers and crew carry out their respective roles with an absence of friction. Though *run a tight ship* may have connotations of martinetlike strictness, it is usually used positively to compliment an efficient administrator.

19. [the one] who pays the piper calls the tune An adage implying that a person has control of a project or other matter by virtue of bearing its expenses. The figurative use of this expression is derived from its literal meaning, i.e., someone who pays a musician has the right to request a certain song.

> Londoners had paid the piper, and should choose the tune. (*Daily News*, December 18, 1895)

See also **pay the piper**, 64. CONSE-QUENCES.

Conviction . . . See 46. CERTAINTY

70. COOPERATION
See also 26. ASSISTANCE;
263. PARTNERSHIP;
304. RECIPROCITY

1. chip in To make a contribution, either of money or of time and effort; to interrupt or butt in. This expression probably derives from the game of poker in which chips, representing money, are placed by players in the "pot." Putting chips in the "pot" is equivalent to entering the game. Figurative uses of the phrase play on the idea of "entering the game"—that is, becoming involved. Ways of "chipping in" range from giving money to a charity or participating in a joint enterprise to "putting one's two cents in." Such uses of the phrase gained currency in the second half of the 19th century. Only the 'interrupt, butt in' meaning is uncommon today.

2. go Dutch To have each person pay his own way, to share or split the cost; to go fifty-fifty or halves. Although the exact origin of this expression is not

known, it is perhaps an allusion to the qualities or independence and thrift characteristic of the Dutch people. The phrase *to go Dutch* probably arose from the earlier combinations of *Dutch lunch*, *party*, or *supper*, events or meals to which each person contributed his share, similar to today's potluck suppers or B.Y.O.B. parties where the guests furnish the food and drink. The oldest related "Dutch" combination is apparently *Dutch treat*, which dates from about 1887, and is closest in meaning to *go Dutch*.

> To suggest a free trade area to any of them in such circumstances looks rather like proposing to a teetotaller that you and he go dutch on daily rounds of drinks. (*The Economist*, October 1957)

The expression dates from the early part of the 20th century.

3. in cahoots See 66. CONSPIRACY.

4. in there pitching See 132. EXERTION.

5. it takes two to tango One person alone cannot do it; certain actions require partners; assign the blame equally. The tango was originally a dance performed by Spanish gypsies, and it became extremely popular in the United States following its introduction in the 1920s. The term may have emerged because the tango is a ballroom dance involving a great deal of impassioned posing that would be ludicrous, if not impossible, without a partner. The alliterative quality of the term, no doubt, has contributed to its popularity. Today it is only heard in the figurative sense.

> "It takes two to tango." That is how Ronald Reagan once described the condition necessary for cooperation with the Soviet Union. (*Time*, August 22, 1983)

6. keep [one's] end up To do one's fair share, do one's part; to hold one's own; to share the responsibilities involved in an undertaking. In print since the mid 19th century, this expression probably derives from the image of two people balancing a heavy load. It is widely heard today.

> Colonel Baden-Powell and his gallant garrison will have to keep their end up unassisted. (*Westminster Gazette*, November 24, 1899)

7. kick in To contribute, to put in, to donate or give, to pay one's share; usually in reference to money. This American slang expression probably derives from the poker slang meaning of *kick* 'to raise or up an already existing bet.'

> The lawyer guy kicked in with the balance of the ten thousand. (K. McGaffey, *Sorrows of Show-Girl*, 1908)

8. pick up the slack To compensate, offset or counterbalance. The expression usually indicates that a person or group must put forth extra effort to make up for another's absence, weakness, or low output.

9. play ball To work together toward a common goal; to cooperate; to act justly and honestly. This expression is perhaps derived from the set of rules agreed upon by youngsters before they play a game together or from the necessity of team effort and cooperation in athletic contests. The expression is heard throughout the English-speaking world.

> The police of Buffalo are too dumb— it would be redundant, I suppose, to say "and honest"—to play ball with the hold-up mobs. (C. Terrett, *Only Saps Work*, 1930)

10. pull [one's] weight To do one's rightful share of the work; to effectively perform one's job. This expression apparently originated from rowing, where an oarsman who does not apply all his strength to each stroke is considered a burden rather than an asset. Similarly, one who figuratively pulls his weight makes himself a valuable contributor to a team effort. In contemporary usage, the expression is often used in discussing the value or usefulness of an employee.

If the office boy is really pulling his weight . . . he is providing me with 3¾ days per week. (J. P. Benn, *Confessions of a Capitalist*, 1927)

11. Tinker to Evers to Chance John Tinker, John Evers, and Frank Chance formed the famous double play combination of the Chicago Cubs in the early part of the 20th century. The line "D.P. [double play]: Tinker to Evers to Chance" appeared so often in box scores of that time that it became a permanent part of American idiom. The expression is used currently to describe any cooperative effort with the fluidity and speed of a Tinker to Evers to Chance double play.

71. CORDIALITY
See also 156. FRIENDSHIP

1. friend of the family One who is well-behaved, cordial; a person who is on amicable or favored terms with the members of a family. The intimation in the figurative use of this phrase is that the *friend* is trustworthy and has only the most honorable of intentions, that in no way will he cause trouble or embarrassment.

They [the Americans] are returning this summer not with bombs or bands, as they have in the past, but quietly and assuredly, like friends of the family. (*Time*, July 25, 1983)

2. milk of human kindness Sympathy; compassion; understanding; empathy. Shakespeare coined this phrase in *Macbeth*. Lady Macbeth, while reflecting upon her husband's strengths and weaknesses, remarks:

Yet do I fear thy nature;
It is too full o' the milk of human
 kindness
To catch the nearest way.
(I,v)

The term, incorporating the ideas of wholesomeness and sustenance associated with milk, is still in everyday use.

He doesn't strike me as a man overflowing with the milk of human kindness. (R. A. J. Walling, *The Corpse with the Eerie Eye*, 1942)

3. press the flesh To shake hands; said as one offers to shake hands. This slang expression, which was probably derived from black jive talk, was employed as early as 1948 in the movie, *Look for the Silver Lining*. Its popularity was given added impetus from its occasional use by President Lyndon B. Johnson. It remains in frequent use to describe the common practice of campaigning politicians who *work the crowd*, shaking hands and kissing babies.

Domenici is a breathless, ebullient crowd pleaser, while strong low-key Jack Daniels, in contrast, is a diffident public speaker who prefers to press the flesh with individual voters in a kind of Western one-on-one campaign. (*Time*, November 6, 1972)

4. push out the boat To outdo oneself; to stand a round of drinks. This Briticism refers to someone who has acted most generously by treating his friends to a splendid dinner, buying a round of drinks, or making some other altruistic gesture. The implication is that one who agrees to *push out the boat*, after all the others have already boarded, is acting graciously, for chances are he'll get his feet wet. The term has been in use since the latter part of the 19th century.

5. slip some skin To slap hands with another as a sign of greeting; shake hands. This American slang expression, adopted from the lingo of jazz musicians, has been popular since the 1930s. When one wishes to *slip some skin* with another, he extends his hand(s), palm(s) up, for the other to slap in a downward motion; the procedure is then reversed. A related term, *give me five*, indicates the same action, but refers to the five fingers. Other variants are *give me some skin* and *lay the skin on me*. Recently, *high five*, referring to a slapping exchange of

hands held over the head, has become popular.

6. Tom Trot's dog A busy, friendly neighbor; one who enjoys visiting other people's homes. This expression, dating from the mid 1800s, refers to one who, like the neighborhood dog that makes his rounds each morning, is always busy trotting about the neighborhood doing good deeds but not above exchanging a bit of gossip at the same time. The origin of the term is obscure, the allusion to one who is *on the trot* is obvious, and probably *Tom* because of the alliterative quality it gives the phrase.

72. CORPULENCE
See also 271. PHYSICAL
APPEARANCE

1. Bartholomew pig A fat man; one who is extremely obese. Among the many refreshments to be found each year at Bartholomew Fair, a clothing fair that ran annually from 1133 until 1855, was *Bartholomew pig*: large, hot pieces of pork which had been cut from a pig roasted whole over an open pit. Eventually, the term became associated with overeating and overweight, finally coming to be used of fat people. Variants are *Bartholomew boar* and *Bartholomew boar-pig*. In Shakespeare's *Henry IV, Part II*, Doll Tearsheet uses the term to ridicule Falstaff.

Thou whoreson little tidy Bartholomew boar-pig, when wilt thou leave fighting o' days and foining o' nights, and begin to patch thine old body for heaven? (II,iv)

2. bay window Paunch, protruding belly, pot-belly. The visual image is of the type of window which projects outward in curved form, creating a bay or recess within. The term is an Americanism of long standing.

Since his bay window began to form . . . (*Cimarron News*, November 27, 1879)

3. beer-belly A protruding abdomen, supposedly caused by excessive indulgence in beer. The term has been in popular slang use since 1920.

4. black-silk barge British slang for a stout woman. This uncomplimentary comparison of a woman's physique to a large, flat-bottomed vessel generally used for transporting freight needs no further explanation.

5. broad in the beam Having disproportionately large hips or buttocks; hippy; steatopygous. The greatest breadth of a ship is called its 'beam,' from its transverse timbers or 'beams.' The term is thus similarly applied to the width of a person's hips or buttocks. Though most often used of women, early citations show the word was first used descriptively of men.

He stood watching disgustedly Bigges' broad beam. (H. Walpole, *Hans Frost*, 1929)

6. butterball A plump or chubby person, especially a short one. Used figuratively since 1892, this mildly derogatory term compares a person's physique to an individual serving of butter molded in the form of a ball.

7. fat farm A resort for overweight people; a lodging place that specializes in weight reduction programs. This slang expression stems from the introduction during the 1950s of ranches and camps that specialized in weight loss through a strict regimen of diet and physical exercise. The term grew considerably in popularity when the press began covering the frequenting of these places by movie stars and the wives of government leaders.

8. German goiter A bulging stomach, usually the result of excessive beer intake; a beer-belly. Goiter is a thyroid gland disorder manifested by protuberant swelling about the neck. Similarly, *German goiter* is a distention of the stomach due to the consumption of copi-

ous amounts of beer, a beverage that Germans particularly enjoy.

9. pot-belly A protruding abdomen; a person with same. This common term, coined by analogy to the rounded pot, dates from the early 18th century.

10. spare tire A roll of fat about one's middle; paunch, pot-belly. Such an excess of adiposity visually resembles a tire. The term has been around since 1925.

11. stuffed like a Strasbourg goose Fed to excess; fattened beyond reason; full to the point of bursting. A Strasbourg goose is confined in cramped quarters to eliminate any possibility of exercise, and force-fed excessive amounts of food in order to enlarge its liver, the liver from which is made the very finest *pâté de foie*. A related term, *Strasbourg pie*, refers to a pastry made with this fatted goose liver.

> Does the discovery that a young child can absorb large quantities of knowledge require that it be stuffed like a Strasbourg goose? (*Time*, August 15, 1983)

12. tun-bellied Extremely obese, gargantuan, elephantine. In this obsolete expression, *tun* 'tub, vat' alludes to rotundity. The phrase appeared in William Cartwright's *The Royal Slave* (1639):

> Some drunken hymn I warrant you towards now, in the praise of their great, huge, rowling, tun-bellyed god Bacchus as they call him.

73. CORRECTNESS
See also 46. CERTAINTY;
280. PRECISION; 290. PROPRIETY

1. get hold of the right end of the stick To have the proper grasp or perspective on a situation. The expression is more common in Britain than in the United States. See also **get hold of the wrong end of the stick**, 143. FALLACIOUSNESS.

2. hit the white To be right, to be right on target, to hit the bull's-eye. The allusion is to archery and the inner circle of the target or the bull's-eye, formerly of a white color. Since bull's-eyes are now usually painted or outlined in black, it is easy to see why this expression is rare or obsolete today.

> 'Twas I won the wager, though you hit the white. (Shakespeare, *The Taming of the Shrew*, V,ii)

3. on the beam On the right track; correct; accurate. The reference is to a radio beam used to direct the course of an aircraft. Thus, an airplane on the beam is right on the proper course. The phrase appeared as early as 1941 in the *Daring Detective*.

4. right as a trivet See 162. GOOD HEALTH.

5. right as rain Very right, exactly correct or accurate, quite right. This simile, although not as common today as formerly, is still popularly used to emphasize degree of correctness. Its origin would appear to be simply from alliteration.

6. right side of the altar Correct; in the proper place. This expression, translated from the New Testament, refers to the exalted spot according to Christian belief.

> And there appeared unto him an angel of the Lord standing on the right side of the altar of incense. (Luke 1:11)

This account of the vision seen by Zacharias is one of many such reports throughout the Bible placing angels and cherubim to either the right hand of God or the right side of the altar. In common use today, the figurative connotation is 'being in the right place at the right time.'

7. set the saddle on the right horse Let those who deserve it bear the blame; let those who are able bear the burden. This expression implies that one has

placed the blame on the wrong person. The phrase appeared as early as the 16th century.

> I suppose he would think it a wiser part to set the saddle on the right horse, and choose rather to live with the reputation of a plain-spoken, honest man, than to die with the infamy of an incestuous villain. (John Dryden, *All for Love*, 1678)

8. that's the cheese That is quite the thing; something or someone first rate in quality; genuine or to one's liking. The origin of this slang expression is uncertain. It has been attributed to the French word *chose*, meaning 'thing,' thus the French *c'est la chose* has been carelessly or humorously translated. Another explanation is that it comes from the Anglo-Saxon *chese*, meaning 'choice.' The most plausible explanation, however, is that it is of Anglo-Indian origin. Philip E. Curtis in the August 1929 issue of *Harpers* explains:

> 'He's the whole cheese' was originally Anglo-Indian slang . . . from Hindustani and, before that, from . . . Persian . . . 'chiz' meaning 'the thing' and was . . . current in London . . . generations ago.

The phrase originated in the early 19th century, and since that time a number of variations have developed, derived from the names of English cheeses; *that's prime Stilton* and *that's double Gloucester* are two of the more common. The expression is often presented in the negative, *not the cheese*, to indicate something improper.

> Well, I've heard Nudity is not the cheese on public occasions. (Charles Reade, *Hard Cash*, 1863)

Corruption . . . See 83. DECADENCE

74. COST

See also 265. PAYMENT;

337. SELLING

1. [an] arm and a leg An exorbitant amount of money; a popular American hyperbole.

2. bleed See 140. EXTORTION.

3. for a song Cheaply, inexpensively, at low cost, for little or nothing. *Song* meaning 'a trifle or thing of no consequence' may stem from the supposed retort of Baron Burleigh on being ordered by Elizabeth I to give Edmund Spenser an annuity of £100 for having composed the *Faerie Queene:*

> All this for a song?

4. for love or money At any price; by any means available. This phrase is most frequently used in the negative expression *not for love or money* to imply that someone or something is unobtainable at any price—either financial or emotional.

> He let me . . . use . . . Anglo-Saxon texts not elsewhere to be had for love or money. (Francis March, *A Comparative Grammar of the Anglo-Saxon Language*, 1870)

5. freebie Something free of charge, as complimentary tickets; anything given without cost to the recipient; a performance presented without charge to the audience. This show business expression for a complimentary ticket has extended into general use, and today is used most commonly as a synonym for *free*.

> That meal was a freebie and didn't cost me anything. (Louis Armstrong, *Satchmo, My Life in New Orleans*, 1954)

6. highway robbery Exorbitantly or outrageously high pricing. The allusion is to highwaymen, the holdup men of yesteryear who roamed the public roads robbing travelers. This expression is often used to express indignation at ridiculously high prices which one is neverthe-

less forced to pay for lack of an alternative, just as the victims of highwaymen had no choice but to surrender their money and goods at the risk of their lives. The expression has been in figurative use since at least 1920.

> Nothing on the wine list . . . under two-pound-ten. Highway robbery by candlelight. (J. B. Priestley, *It's Old Country*, 1967)

7. pay through the nose To pay an exorbitant price, financially or otherwise, unwittingly or through coercion. Many variations on one story line are cited as sources for this expression. The most popular is that the Danes in the 9th century imposed a "nose tax" on the Irish. Those who neglected to pay were punished by having their noses slit. Some say the Swedes or Norwegians were the oppressors. Others say the Jews rather than the Irish were the oppressed. However, *pay through the nose* derives from the punishment, irrespective of who inflicted the punishment on whom. The phrase was used as early as 1672 and is commonly heard today, often implying an unawareness or naiveté on the part of the person "paying through the nose."

8. pay too dearly for [one's] whistle To pay more for some desired object than it is worth; to expend a great deal of time, effort, or money for something which does not come up to one's expectations; to indulge a whim. This expression is based on Benjamin Franklin's *The Whistle* (1799), which tells of his nephew's wanting a certain whistle so much that he paid its owner four times its value. As soon as the whistle had been acquired, however, it lost its appeal of the unattainable, leaving the boy disappointed with his purchase.

> If a man likes to do it he must pay for his whistle. (George Eliot, *Daniel Deronda*, 1876)

Counsel . . . See 11. ADVICE

Countenance . . . See 398. VISAGE

Courage . . . See 37. BRAVERY

75. COWARDICE

1. candy ass A coward; one who is timid and helpless; an irresolute or unaggressive person. This American slang expression was coined shortly after World War II and plays on the childish associations of *candy* as well as the use of *ass* as a general term of abuse. The adjectival form *candy-assed* is also quite common.

> It's a pretty candy-assed biker who worries about what other people think. (*Playboy*, March 1974)

2. cold feet A feeling of fear or uncertainty; a loss of confidence or nerve; cowardice; usually, *get* or *have cold feet*. This expression, in popular use since at least 1893, is said to have come from Ben Jonson's play *Volpone*, produced in London in 1605.

3. lily-livered Cowardly, pusillanimous, craven. This expression is a variation of *white-livered*, *lily* 'pure white' serving to emphasize the color. According to ancient Roman and Greek custom, an animal was sacrificed before each major battle. If the animal's liver was red and healthy-looking, it was considered a good omen; if the liver was pale or white, it portended defeat. This tradition was based on the belief that the liver was the seat of love and virile passions such as bravery and courage. It was further believed that the liver of a poltroon contained no blood, either through a prenatal fluke of nature or more often as the result of a cowardly act.

> For Andrew, if he were opened, and you find so much blood in his liver as will clog the foot of a flea, I'll eat the rest of the anatomy. (Shakespeare, *Twelfth Night*, III,ii)

4. Scythian defiance Words without action; a false display of courage; withdrawing when the chips are down. Dari-

us, a king of ancient Persia, when he led his army into Scythia, was met by an ambassador who presented him with a bird, a frog, a mouse, and five arrows. Puzzled over this strange array, Darius was told that it meant that he should fly away like a bird, swim across the river like a frog, or hide his head in a hole like a mouse, or in five days the Scythians would slaughter him with their arrows. Darius ignored the ultimatum and he and his troops were victorious, proving the *Scythian defiance* ineffectual.

5. show the white feather To act in a cowardly, craven, dastardly fashion; to lack courage; to be fearful in the face of danger. This expression alludes to the gamecocks used in the sport of cockfighting. A purebred gamecock has only red and black feathers, while a crossbreed, usually a poor fighter in the pit, often has white feathers in its tail. Though these white feathers are usually covered by the colored ones, when one of these inferior hybrids knows its defeat is imminent, its tail droops, clearly showing the white feathers.

No one will defend him who shows the white feather. (Sir Walter Scott, *Journal*, 1829)

6. turn tail To turn one's back and run; to demonstrate cowardice; to take flight, especially from fear; to show a yellow streak. The origin of this term is not, as might be supposed, derived from the actions of human beings, but is, rather, a term derived from falconry. If falcons refused to fly after their prey or refused to kill it after overtaking it, they were said to *turn tail*. The expression, in use since at least the mid 1500s, was soon transferred to those human beings who showed their "tails" and refused to fight.

Such a haggard as would turn tail to a full fist. (Robert Greene, *Euphues, His Censure*, 1587)

7. turn turtle See 400. VULNERABILITY.

8. weak sister A person (male or female) who is unreliable or timorous, es-

pecially during emergencies; a group member whose support cannot be counted on under pressure or in a crisis.

There is always a weak sister who turns yellow or overplays his game through nervousness. (*Saturday Evening Post*, October 1925)

9. yellow belly A coward, a craven. *Yellow* has been a common American colloquialism for 'cowardly' since the mid 19th century. *Yellow-bellied* followed, a coinage perhaps due to the initial rhyming sounds. Both are still more frequently heard than the noun *yellow belly*. Reasons for the long association of the color yellow with cowardliness are unknown; they may simply lie in its connotations of sickliness and consequent lack of force and vigor.

Craving . . . See 91. DESIRE

Craziness . . .
See 218. IRRATIONALITY

Credit . . . See 27. ATTRIBUTION

76. CRIMINALITY

1. black leg A swindler; a dishonest man; a scab; a strike breaker. This American expression of uncertain origin probably had its roots in Natchez-under-the-Hill, a sordid river community in Mississippi abounding with gambling houses, barrooms, and brothels. The professional gamblers, who became known as black legs, organized into gangs which robbed and murdered the travelers along the Natchez Trace. In time the term passed into general use for any gambler, especially one who is underhanded. In England the term is used to refer to a person who accepts employment at a strike-bound factory, i.e., a *scab*.

2. bootlegger A smuggler; a dealer in illicit goods; originally, a dealer in contraband whiskey, so-called because the bottles were often carried hidden in the legs of tall boots. Though the term gained

currency during the era of Prohibition (1920–33), it dates at least from the mid 19th century. It was much used in the dry states of Kansas and Oklahoma in the 1880s. Back formation yielded *bootleg*, both verb and adjective.

3. Burke [someone] To murder by suffocation; to smother; to stifle; to suppress; to shelve. This expression arose from the actions of one William Burke, who, in 1829, was convicted, along with his accomplice William Hare, of smothering people and selling their corpses to surgeons in Edinburgh, who used the bodies for dissection.

> Perhaps he is Burked, and his body sold for nine pounds. (Theodore E. Hook, *The Parson's Daughter*, 1833)

The story is told that when Burke appeared on the scaffold to be executed, the public cried, "Burke him, Burke him," to the executioner, meaning smother him as he did his victims. A related term, to *Bishop [someone]*, 'to murder by drowning,' arises from the actions of a man named Bishop who drowned a boy in Bethnal Green in 1831 and sold his body for dissection.

> I Burked the papa, now I'll Bishop the son. (R. H. Barham, *Ingoldsby Legends*, 1840)

4. clink Jail or prison. This expression can be traced directly to a precinct, the Liberty of Clink, in Southwark, London. A manor house bearing the name *Clink* contained a prison which had acquired, as early as the 16th century, a reputation as a rather depressing spot. Thus, the *clink* became a general term for any prison, especially a small, dismal one.

> I was thrust into the clink, or lock-up. (Frederick Marryat, *Japhet*, 1836)

Among many related terms are: *calaboose*, an 18th-century borrowing from the Spanish *calabozo* 'dungeon'; *hoosegow*, an early 20th-century borrowing from the Spanish *juzgado* 'panel of judges' but bastardized to mean 'jail'

in English. Other related terms are *stir* from the mid 1800s:

> A man has time to think things out in stir. (Arthur Morrison, *A Child of Jago*, 1896)

and *jug* from the early 1800s.

> They sentenced me . . . to ten years in the jug. (James Russell Lowell, *The Biglow Papers*, 1861)

5. cutpurse A pickpocket, a thief. This term, in use since the 14th century, originally described those who stole by cutting purses off the belt or girdle from which they were hung. Since purses or money-holders are now carried in pockets rather than worn at the waist, the term *pickpocket* has all but replaced its older counterpart *cutpurse*.

6. Dick Turpin Any especially daring or flagrant highway robber or bandit. Dick Turpin (1706–39) was an infamous English highwayman renowned for his criminal derring-do. He appears as a character in William Harrison Ainsworth's romance *Rookwood* (1834), as well as in various thriller novels.

7. fall off the back of a lorry A jocular reference to the source of stolen merchandise. The *lorry* in this expression, which dates from the late 1940s, is the British word for *truck*. A likely context for the use of the phrase would be as a thief or robber offers a citizen a surprisingly inexpensive TV set or wristwatch, assuring him that it was acquired quite innocently.

> "It fell off the back of a lorry." That's the expression, friend. It covers everything from transistors to three-piece suits. From fountain pens to fur coats. They all "fall off the back of a lorry." And those mugs down there buy them at give-away prices. And don't ask awkward questions. (John Wainwright, *Cause for a Killing*, 1974)

8. five-finger A thief, pickpocket. In this expression, the obvious reference is to the hand and its role in stealing some-

thing or in picking someone's pocket. A similar expression, *five-finger discount*, is used to describe shoplifting, the implication being that by virtue of one's five fingers, a 100% discount has been obtained. Other similar expressions dealing with the use of the hand in theft are *light-fingered*, *sticky-fingered*, and *itchy palm*.

9. fly-by-night A temporary and usually unethical business; a poor credit risk; a person or enterprise of dubious reputation or questionable merit. This expression originally referred to a person who defrauded his creditors by hurriedly and furtively leaving town in the dead of night, thus flying (or fleeing) by night. In its usual context, however, *fly-by-night* is used adjectivally to describe a business which accepts orders and money but folds before delivering any goods or services, leaving both creditors and customers in the lurch. The expression is sometimes used in a more general sense to describe anyone or anything of uncertain character.

10. footpad A thief or other criminal who operates on foot. This expression refers to the padded shoes worn by a criminal to muffle his footsteps as he stealthily approaches a victim.

> Roads in the neighborhood of the metropolis were infested by footpads or highwaymen. (Charles Dickens, *Barnaby Rudge*, 1841)

11. hanky-panky See 237. MISCHIEVOUSNESS.

12. hatchet man A hired assassin; any writer or speaker, especially a journalist, who manipulates words in order to ruin someone's reputation. The former meaning dates from the mid 1800s when professional murderers actually carried hatchets.

> Some of them are called hatchetmen. They carry a hatchet with the handle cut off. (G. B. Densmore, *Chinese in California*, 1880)

The current figurative meaning, in use since the mid 1900s, refers to character assassination rather than actual murder. Related phrases include *hatchet job* and *hatchet work*.

> Exuberant hatchet jobs were . . . done on Foster Dulles because of his Wall Street connections. (*Time*, October 23, 1944)

13. hoodlum A street tough; a larrikin; a hooligan; a gangster. This American expression probably had its origin in San Francisco about 1870. Although its derivation is uncertain, one plausible explanation attributes it to the German-Swiss *hudilump*, a wretch or miserable fellow.

> The San Francisco hoodlum is different from the New York loafer. (Brander Matthews, *Harpers*, July 1891)

The word *hoodlum* has spread throughout the English-speaking world, but it is most commonly heard today in its shortened form *hood*.

14. hooligan A street tough; hoodlum; larrikin; a young ruffian. This expression has its roots in England in the 1890s. Although its origin is uncertain, one explanation attributes it to a mispronunciation, or perhaps a slurring, of Hooley's gang, a once-notable band of street toughs. A more plausible explanation attributes it to a song about a rowdy Irish family, popular about the time the word first appeared in print, 1898. Ernest Weekley in *Romance of Words* (1912) offers still another explanation.

> The original Hooligans were a spiritied Irish family of that name whose proceedings enlivened the drab monotony of Southwark towards the end of the 19th century.

Whatever the case, the word is still in common use today and has spread throughout the English-speaking world; it is even used in the Soviet Union, borrowed by the Russian to mean 'undesirable citizen.' A variant, *hooliganism*, means the practice of acting in a rowdy fashion.

15. horn-thumb A cutpurse; a pick-pocket or purse-snatcher. This obsolete term derives from a thief's practice of wearing a thimble of horn on the thumb for protection against the edge of his knife. The term appears in the 17th-century play *Bartholomew Fair:*

> I mean a child of the horn-thumb, a babe of booty, boy, a cut-purse.

16. Jack-in-a-box A thief; a sharp; a cheat. This expression has its roots in a 16th-century practice of business sharps who would bilk tradesmen by substituting empty boxes for those containing merchandise after the transaction had been consummated. The term is used almost exclusively today to specify the child's toy, a box from which a replica of a harlequin or clown springs upward when one opens the cover. Apparently the surprise is no greater to the child of today than it was to the tradesman of the past. A variant is *Jack-in-the-box.*

> My Lord Vitelli's love and
> maintenance,
> Deserves no other Jack i' the box but
> he.
> (Beaumont and Fletcher, *Love's Cure*, 1623)

17. jailbird A convict or prisoner; an ex-convict or ex-prisoner. This expression, derived from the iron cages to which inmates were formerly confined, usually refers to a prisoner who has spent the better part of his life behind bars.

> The one thing dreaded by the old jailbird is work requiring bodily exertion. (*Contemporary Review*, August 1883)

18. jaywalker A person who crosses a street without heeding the traffic laws; a presumptuous pedestrian. This expression, derived from the belligerent and defiant jaybird, is commonplace throughout the United States and Great Britain.

> Realizing his mistake, [he] pulls back quickly, narrowly missing the

jaywalker. (*Police Review*, November 1972)

19. larrikin A wild, lawless person; a young street tough; a hoodlum; a hooligan. This Australian slang expression made its appearance about 1870 in Melbourne. Although its etymology is unknown, it might possibly be a perversion of *lark*, in the sense of 'frolic' or 'romp.'

> Three larrikins . . . had behaved in a very disorderly manner in Little Latrobe-street. (*Melbourne Herald*, April 4, 1870)

20. lob's pound Prison; an entanglement; a difficulty; a perplexed state. This British term for prison dates from the 1500s. *Lob* was an old underworld slang expression for a till. Hence, one who was caught with his *fingers in the till* was sent to prison, *lob's pound*. A *lob sneak* was one who robbed tills, and *lob crawling* was to be on the prowl to rob tills.

> Crowdero, whom in Irons bound,
> Thou basely threw'st into Lob's
> pound.
> (Samuel Butler, *Hudibras*, 1663)

Variants are *Hob's pound* and *Cob's pound*. To be in *Hob's pound* was used more frequently to imply that one was in difficulty or in an embarrassing situation.

> What! Are you all in Hob's pound? (Francis Burney, *Camilla*, 1796)

21. lully prigger A thief of the lowest, most despicable sort. The origin of this expression is unknown; however, *lully prigger* originally referred to a thief who stole wet clothing from a clothesline, and *prigger* alone meant 'horse thief' as early as the 16th century. Today this chiefly British phrase describes any thief.

22. plug-ugly A hoodlum, thug, miscreant, or larrikin; a gangster; a boisterous, uncouth, physically unattractive person. This term was first used as the self-assumed name of a 19th-century gang that terrorized the city of Baltimore:

The class of rowdies who originated this euphonious name . . . [said] it was derived from a short spike fastened in the toe of their boots, with which they kicked their opponents in a dense crowd, or, as they elegantly expressed it, "plugged them ugly." (*Times*, November 4, 1876)

Although the gang is long since gone, the expression lives on in figurative contexts:

His friends were alternately the "plug-uglies" of Sixth Avenue and the dudes of Delmonico's. (*The Pall Mall Gazette*, July 4, 1884)

The term is also used adjectivally.

23. put to the horn Declared an outlaw; wanted by the law. In 16th-century Scotland, when the king proclaimed a man an outlaw, a messenger was dispatched to village and city squares where he blew three times upon a horn and made a public pronouncement of the outlaw's status. The term is still in occasional use.

Both of us were put to the horn and declared outlaw. (Samuel Crockett, *Men of Moss Hags*, 1895)

24. resurrection man Grave robber; body snatcher. This expression, dating from about 1800, had its origin in the practice of "resurrecting" bodies, usually by grave robbery but occasionally by murder, and selling the bodies to medical schools and anatomists. In 1829 two such operators, Burke and Hare, were convicted of supplying bodies to the medical school in Edinburgh. The earliest known occurrence was in 1777 when a corpse was removed from a graveyard near Gray's Inn Lane.

He had carried up every separate article in the dead of the night, and . . . had felt as wicked as a Resurrection Man. (Charles Dickens, *The Uncommercial Traveler*, 1860)

Related terms are *grave robber* and *body snatcher*.

25. rip off To steal; to rob; to exploit; to appropriate for one's own. This 1950s' term was rediscovered and achieved instant popularity during the late 1960s and early 1970s. As originally conceived, the phrase constituted a picturesque description of a robbery, the literal tearing away of something from its place. However, the political activists of the 1960s tried to narrow its connotation to one of protest against political or social injustice.

In defying the law, some young people claim not only innocence of wrong-doing but a special kind of moral superiority. 'Ripping off the Establishment,' they insist, is a political act. (Joyce Brothers, *Good Housekeeping*, February 1973)

The term remains a general term for describing any robbery, as is true of the noun derivative *rip-off*.

26. scofflaw A person who disregards the law. This term is clearly a combination of *scoff* 'mock, jeer' and *law*. The expression, used during Prohibition for a patron of a speakeasy, now usually refers to someone who ignores traffic regulations or refuses to pay traffic fines.

27. skulduggery Deceitful or dishonest conduct; underhanded scheming. Derived from the Scottish *skulduddery* 'illicit sexual intercourse; obscenity,' *skulduggery* is, by extension, often used to describe fraudulent or surreptitious business practices.

The United States Courts . . . are now very busy affixing the penalties for violations of the national banking laws and for general skulduggery in the management of institutions. (*Columbus* [Ohio] *Dispatch*, December 22, 1893)

28. St. Peter's fingers The fingers of a thief or a pickpocket. The patron saint of fishermen, St. Peter, himself a fisherman, is said to have once caught a fish with a coin in its mouth. Hence, a thief or pickpocket who surreptitiously lifts something, especially a coin, from its

rightful owner is said to have fish hooks for fingers, or *St. Peter's fingers.*

Peter's sons "with every finger a fish hook," referring to Saint Peter being the greatest or at least most famous of fishermen. (George Parker, *A View of Society,* 1781)

Related terms are *St. Peter's son* and *St. Peter's children,* both synonyms for thieves and pickpockets.

29. tenderloin See 227. LOCALITIES.

30. wetback An unauthorized immigrant. Although in its widest sense this term may refer to any person who illegally enters the country, *wetback* is most often applied disparagingly to Mexican laborers who wade or swim across the Rio Grande to the United States in search of temporary employment.

How do these "wetbacks" who slip across the border near Calexico, California manage to swim the Rio Grande? (*Newsweek,* May 1950)

Wetback is also frequently used as an offensive epithet for any Mexican-American. In addition, "wet" is sometimes prefixed to the names of various animals which are illegally imported from Mexico by American ranchers.

Pierce once brought three hundred Mexican ponies, "wet ponies," into Texas, at a cost of two dollars and fifty cents a head. (Douglas Branch, *The Cowboy and his Interpreters,* 1926)

77. CRITERION
See also 376. TEST

1. acid test Any crucial or conclusive test to judge value or genuineness; the "real" test. The term is an extension of a chemical test using nitric acid or aqua fortis, as it is sometimes called, to determine the gold content of jewelry. Used literally in 1892 in G. F. Gee's *The Jeweller's Assistant,* the expression was first used in its figurative sense in 1912:

Few professional beauties could have stood, as this woman did, the acid test of that mercilessly brilliant morning. (L. J. Vance, *Destroying Angel,* 1912)

2. Aunt Sally See 395. VICTIMIZATION.

3. bench mark A standard or touchstone against which to measure; a criterion or test. A bench mark is literally a surveyor's arrow-shaped mark indicating a given elevation used as a point of reference in measuring other elevations. According to the *OED* the name comes from the way a surveyor's angle-iron forms a bracket or bench to support the leveling-staff when taking a reading. The term was used figuratively as early as 1884 in *Science:*

These star-places . . . are the reference-points and benchmarks of the universe.

4. Caterpillar Club An unofficial organization for airmen who have made an emergency parachute jump. During World War II the Irwin Parachute Company awarded a small gold pin, designed in the likeness of a caterpillar, to any RAF member who was forced to make an emergency jump from a disabled plane, if he supplied the company with the number of the parachute. Why the caterpillar was used as a symbol is rather obscure—perhaps for the caterpillar that eats the mulberry leaf and produces the silk for the parachute, or because the airman and his parachute appear to undergo a metamorphosis similar to that of a caterpillar, i.e. from the cocoon stage, the unopened parachute, to the adult butterfly, the opened parachute. A similar type of organization was formed for those who were forced to ditch their planes in the ocean and use their rubber dinghies, the *Goldfish Club.*

5. Colonel Bogey An imaginary golfer the personification of an average golfer In Britain Colonel Bogey is a symbol o the average golfer, the player who shoot each hole, as well as the course, in the score expected of a good average player

Beating the Colonel or *beating bogey* is shooting a hole in fewer strokes than the Colonel. Apparently the origin of the expression lies in the title of a popular song of 1890, *The Bogey Man*. It seems that a Dr. Browne was playing at the Great Yarmouth Club with one Major Wellman, who was unaware of the system of playing against the recently introduced "ground score," now called "par." When the Major learned that he was, in a sense, playing against an invisible opponent, he exclaimed, thinking of the popular song, that he was playing against a regular "bogey man." Later, when the doctor reported the Major's remark to the other members of the club, it was received with enthusiasm and has remained in use since that time. In the United States, however, the term was shortened to *bogey*, which means 'one stroke over par' on a golf hole.

6. landmark decision A verdict issued by a high court (e.g., the Supreme Court) which determines the direction or disposition of a previously untried issue; a precedent-setting ruling. Traditionally, a landmark is a guide for direction in one's course, or, metaphorically, an event that marks a turning point in history. As an adjective, *landmark* has come to describe any decision or legislation of such significance that it will serve as a guide or criterion in similar matters in the future.

7. par for the course What one might expect; that which is considered normal; a standard or criterion; a touchstone by which to measure. This phrase, adopted from the game of golf in the early 1900s, has become a common colloquialism for measurement since World War II, especially in the world of business. In this expression *par* alludes to that standard set as the proper number of strokes which a golfer should take in playing a golf course.

8. play in Peoria To be accepted by the common man of "Middle America." Peoria, a small town in central Illinois, has come to represent traditional, down-to-

earth American values, perhaps originally from the experiences of traveling theater troupes in playing to small town audiences. Today the expression is most often heard in the political context; "playing in Peoria" successfully has become the touchstone for determining an idea's appeal to the American public at large. Frequently the expression is used in the form of the question: *Will it play in Peoria?*

9. Procrustean bed An arbitrary system or standard to which ideas, facts, etc., are forced to conform. In Greek mythology, the robber Procrustes made his victims fit the length of his bed by either stretching or amputating their limbs. Thus, to *stretch* or *place on the bed of Procrustes* is to produce conformity by violent, irrational means. Figurative use of *Procrustean bed* dates from the 16th century.

> Neither must we attempt to confine the Platonic dialogue on the Procrustean bed of a single idea. (Benjamin Jowett, tr., *The Dialogues of Plato*, 1875)

10. proof of the pudding is in the eating A proverbial admonition against passing judgment on something without first examining the evidence or facts; often shortened to *proof of the pudding*. Another popular proverb conveying basically the same message is the imperative *don't judge a book by its cover*.

11. rule of thumb A rough guide or approximate measurement; a practical criterion or standard. The thumb's breadth was formerly used in measurements to approximate one inch. Since such reckoning was imprecise and unscientific, *rule of thumb* has come also to indicate a guideline resulting from instinct rather than from scientific investigation. The phrase has been in figurative use for nearly three centuries.

> What he doth, he doth by rule of thumb, and not by Art. (Sir William Hope, *The Compleat Fencing-Master*, 1692)

12. separate the sheep from the goats
Set apart the moral from the immoral;
divide the pure from the corrupt or the
noble from the ignoble. This expression
from the Bible alludes to the division of
people at the Last Judgment.

> And before him shall be gathered all
> the nations; and he shall separate
> them one from another, as a
> shepherd divideth his sheep from the
> goats. And he shall set the sheep on
> his right hand, but the goats on the
> left. (Matthew 25:32,33)

In this phrase the innocense of the sheep
and the goodness of the right hand are
juxtaposed against the corruption of the
goats and the sinister nature of the left
hand. In modern usage, however, the
term usually connotes a simple separa-
tion of the good from the bad.

13. sounding board A person to whom
new concepts and ideas are presented for
his reaction or opinion. A sounding
board is a structure which reflects sound
back to an audience. Its figurative usage
was illustrated in *Atlantic*, as cited by
Webster's Third:

> . . . use the newspapermen merely as
> a sounding board.

14. Stopford law No investment, no re-
turn. Francis Grose in *A Provincial
Glossary* (1787) lists the following entry:

> Stopford law; no stake, no draw . . .
> Commonly used to signify that only
> such as contribute to the liquor, are
> entitled to drink of it.

The term is no longer in use.

15. toe the mark To conform to rules or
standards, to come up to scratch, to
shape up; to fulfill one's obligations, to
perform one's duty; also *toe the line*.

> To-day they had decided to toe the
> line with the progressive workers of
> the country. (*Daily News*, March
> 1910)

Originally and literally *toe the mark*
meant to line up in a row with the toes
touching a mark or line. It was probably

used in reference to runners at the start-
ing line of a race or to military personnel
arrayed for inspection. The earliest re-
corded written use of the expression was
in James K. Paulding's *The Diverting
History of John Bull and Brother
Jonathan* (1813).

16. touchstone A criterion or test; a
standard or measure. A touchstone is lit-
erally a smooth, black, siliceous stone
used to test the purity of gold and silver
alloys. By rubbing the alloy on the stone
and analyzing the color of the streak on
the stone, the gold or silver content can
be determined. The term was used both
literally and figuratively as early as the
mid 15th century.

17. trial balloon Literally, a balloon
which is used to test air currents and
wind velocity. By extension, a trial bal-
loon is any specific proposal, statement,
etc., used to test public reaction by pro-
voking feedback.

Criticality . . . See 390. URGENCY

78.　CRITICISM
See also 146. FAULTFINDING;
312. REPRIMAND

1. blue-pencil To delete or excise, alter
or abridge; to mark for correction or im-
provement. Used of written matter ex-
clusively, *blue-pencil* derives from the
blue pencil used by many editors to
make manuscript changes and com-
ments.

2. damn with faint praise To praise in
such restrained or indifferent terms as to
render the praise worthless; to condemn
by using words which, at best, express
mediocrity. Its first use was probably by
Alexander Pope in his 1735 *Epistle to
Dr. Arbuthnot:*

> Damn with faint praise, assent with
> civil leer.

3. dip [one's] pen in gall To write with
bitterness and and spite; to malign an-
other. Gall is the bile, the bitter organic

secretion produced by the liver, hence, the bitter connotation of this expression.

In the *Contemporary Review* an anonymous writer dips his pen in gall in order to depict the German Emperor. (*Review of Reviews*, 1892)

The *OED* suggests that a pun inherent in the word *gall* may be the source of this phrase, for *oakgall*, an excrescence produced by oak trees, is employed in the manufacture of ink. Shakespeare certainly used it in punning fashion in *Twelfth Night*:

Let there be gall enough in thy ink, though thou write with a goose-pen, no matter. (III,ii)

A related term, *gall of bitterness*, meaning the very bitterest of grief, has been in use since at least the Middle Ages.

4. don't come the uncle over me Do not criticize me too severely; do not exceed your right to censure me. This ancient expression dates from Classical Rome and is rooted in the Roman concept that an uncle's function was to point out a nephew's shortcomings. Nephews looked upon uncles as severe critics; hence, the figurative use of the word *uncle* in the expression.

Don't criticize too severely, as uncles are apt to do with nephews. (Erasmus, *Adagia*, 1500)

5. I knew him when! A caustic comment used of an ex-friend who has become successful to the point of being self-important; an expression to describe an acquaintance who has risen to such a level of prominence that he is no longer approachable. The phrase is an ellipsis for *I knew him when he was only a cab driver*, or some such similar expression of humble origin. During the 1930s the satirist-poet Arthur Guiterman utilized this expression in a poem which appeared in his *Prophets in their Own Country*.

Of all cold words of tongue or pen, The worst are these, 'I knew him when.'

The lines are, of course, a parody of the well-known lines from John Greenleaf Whittier's *Maud* (1856):

For all sad words of tongue or pen The saddest are these: 'It might have been.'

6. jump down [someone's] throat To criticize severely; to berate sharply; to attack in words angrily. This expression, obvious in its figurative meaning, has been in use since the early 1800s. The *OED* also lists an application of the phrase which is seldom heard, to 'give oneself up absolutely to another person,' and offers the following citation:

I might have jumped down this gentleman's throat in my foolish admiration for his powers of equitation. (Mrs. Nina Kennard, *The Right Sort*, 1883)

7. peanut gallery See 211. INSIGNIFI-CANCE.

8. pot shot A random, offhand criticism or condemnation; a censorious remark shot from the hip, lacking forethought and direction. *Webster's Third* cites C. H. Page's reference to:

subjects which require serious discussion, not verbal potshots.

Pot shot originally referred to the indiscriminate, haphazard nature of shots taken at game with the simple intention of providing a meal, i.e., filling the pot. By transference, the term acquired the sense of a shot taken at a defenseless person or thing at close range from an advantageous position.

9. slings and arrows Barbed attacks, stinging criticism; any suffering or affliction, usually intentionally directed or inflicted. The words come from the famous soliloquy in which Hamlet contemplates suicide:

Whether 'tis nobler in the mind to suffer The slings and arrows of outrageous fortune,

Or to take arms against a sea of
troubles
And by opposing end them.
(III,i)

As commonly used, the expression often
retains the *suffer* of the original phrase,
but usually completes the thought by
substituting another object for *outra-
geous fortune*, as in the following:

En route to the United States the
enterprise has suffered the slings and
arrows of detractors as diverse as
George Meany and Joseph Papp.
(Roland Gelatt, in *Saturday Review*,
February 1979)

10. **stop-watch critic** A hidebound for-
malist, whose focus is so riveted on tra-
ditional criteria or irrelevant minutiae
that he fails to attend to or even see the
true and total object of his concern.
Laurence Sterne gave us the term in
Tristram Shandy.

"And how did Garrick speak the
soliloquy last night?"
"Oh, against all the rule, my lord,
most ungrammatically. Betwixt the
substantive and the adjective, which
should agree together in number,
case, and gender, he made a breach,
thus—stopping as if the point wanted
settling; and betwixt the nominative
case, which, your lordship knows,
should govern the verb, he suspended
his voice in the epilogue a dozen
times, three seconds and three-fifths
by a stop-watch, my lord, each time."
"Admirable grammarian! But in
suspending his voice was the sense
suspended likewise? Did no expression
of attitude or countenance fill up the
chasm? Was the eye silent? Did you
narrowly look?"
"I looked only at the stopwatch, my
lord."
"Excellent observer!"

11. **write [someone] down** To make a
negative criticism of another; to dispar-
age another's actions or character in
writing; to make a list or a mental note
of another's misdeeds. This expression,

another of the many more familiar by its
use in Shakespeare, appears in *Much
Ado About Nothing* (IV,ii). Dogberry, a
clownish constable, conducts an investi-
gation, in which he has Verges, his as-
sistant, write everything and everybody
down. At the end of the scene Dogberry
comes to the conclusion:

O that he were here to write me down
an ass! But, masters, remember that I
am an ass; though it be not written
down, yet forget not that I am an ass.

The term is occasionally heard today,
most commonly in the figurative sense.

Crudeness . . . See 404. WILDNESS

Cruelty . . . See 107. DOMINATION;
395. VICTIMIZATION

79. CULMINATION
See also 58. COMPLETION;
375. TERMINATION

1. **last hurrah** A final moment of glory
or triumph; a last fling; a swan song.
This expression refers to *hurrah* 'hub-
bub, commotion, fanfare' and was pop-
ularized by Edwin O'Connor's novel,
The Last Hurrah (1956), which dealt
with a big-city political boss apparently
modeled after James M. Curley, long-
time mayor of Boston.

2. **light at the end of the tunnel** A vision
of success as one approaches the end of a
long journey; a beacon of hope. This ex-
pression alludes to the natural concern
one feels while confined, as in a dark
tunnel. As one approaches the exit, the
light at the end looms larger and larger
as does one's sense of security. The
phrase is frequently presented in verb
form: *see the light at the end of the
tunnel*. The expression became especial-
ly popular during the Vietnam War
when spokesmen for the government
used the image to suggest that their
seemingly futile efforts in the fighting
would eventually result in victory and a
successful end to the war. Opponents of
the war often mocked the administra-

tion's claims by ascribing the light to an oncoming train in a one-track railway tunnel.

> A proposal for a federal Ireland . . . could be the light at the end of the tunnel—in contrast to further well-meaning British suggestions, which only add fuel to the fire. (*National Review*, August 30, 1974)

3. payoff pitch The deciding moment in a business transaction; the moment when the conflict will be resolved in any action; the culminating event. This phrase is adopted from the sport of baseball, where it is used to refer to a pitch made to a batter with a full count, i.e., three balls and two strikes. Such a pitch is most likely to initiate a play, to provide a payoff, for both batter and pitcher must execute their roles in this situation or face adverse consequences. A common baseball term since the early 1900s, it wasn't until after World War II that *payoff pitch* came into common use to indicate a moment of truth.

4. see Naples and die This old Neapolitan expression implies that after viewing the beauty of Naples, one might as well die, for there is nothing comparable.

> This was the Highland's girl's devout belief; *Vedi Napoli e poi muori* (see Naples and then die); earth could not have anything to show more fair. (Margaret Oliphant, *Kirsteen*, 1890)

In the 18th century Neapolitans circulated this phrase throughout the major cities of France, causing a great influx of French tourists. Owing to the natural jealousy existing between Rome and Naples, some wags have expanded the saying:

> See Naples and die,
> Smell Naples! oh fie!

5. the straw that broke the camel's back The last in a series of cumulative irritations, unpleasant tasks, responsibilities, or remarks, especially a seemingly minor one that pushes a person's patience and endurance beyond their limits; a final setback, one which demoralizes someone or destroys an enterprise or other matter. The camel, a beast of burden, stubbornly refuses to move if given too heavy a load to bear. Although a single straw on a camel's back has an insignificant weight, many straws can produce a burden which may be too heavy to bear, figuratively breaking the camel's back. By implication, then, a person subjected to one too many misfortunes or vexations may be pushed beyond his limits and respond suddenly and explosively in a manner which seems disproportionate to the provocation. This expression has several variations, the most common of which is *the last straw*.

6. swan song The last work, words, or accomplishment of a person or group of persons, especially of a poet, writer, or musician; a final gesture, such as that of a politician or other public figure before retirement or death. This common expression is based on the ancient belief (cited by Euripides, Plato, Aristotle, Cicero, and others) that swans sing their most beautiful songs just before they die.

> Will you not allow that I have as much of the spirit of prophecy in me as the swans? For they, when they perceive that they must die, having sung all their life long, do then sing more lustily than ever, rejoicing in the thought that they are going to the god they serve. (Plato, *Phaedo*, circa 380 B.C.)

Although the song of a swan is actually somewhat unpleasant to the ear, and no evidence has ever supported the theory that its final song is unusually beautiful, the legend has persisted for centuries and has been incorporated into the works of Shakespeare, Byron, Chaucer, and many other literary masters.

> The Phoenix soars aloft, . . . or, as now, she sinks, and with spheral swan song, immolates herself in flame. (Thomas Carlyle, *Sartor Resartus*, 1831)

Culpability . . . See 169. GUILT

80. CURIOSITY
See also 235. MEDDLESOMENESS

1. **eavesdropper** One who clandestinely listens in on private conversations; a fly on the wall, a snoop or spy. It was formerly the practice of such persons to listen in on private conversations by standing under the eaves of the dwelling in which they occurred. The *dropper* part of the term seems to have some connection with rain dripping off the eaves and onto the listener standing under them, as indicated by the following passage describing the punishment prescribed by the Freemasons for a convicted eavesdropper:

> To be placed under the eaves of the house in rainy weather, till the water runs in at his shoulders and out at his heels.

The term dates from 1487.

2. **fly on the wall** An eavesdropper, an unseen witness. In this expression, the implication is that a small, inconspicuous fly that has settled on a wall is able to witness events without being noticed. The phrase is nearly always heard as part of a person's expressed desire to see and hear certain conversations or goings on ("I'd love to be a fly on the wall"); rarely is it used in contexts implying actual clandestine behavior. This same concept, that is, a small, unobtrusive insect acting as a witness, may have given rise to *bug* 'a concealed recording device or microphone.' However, it is more likely that *bug* was used to describe the tiny microphone, which resembles an insect.

3. **play the bird with the long neck** To be out looking for someone or something; to look at someone or something out of curiosity. This expression is closely related to *go gandering* or to *take a gander*. All three phrases refer to the natural curiosity of the male goose and his habit of stretching his long neck to observe what goes on about him.

4. **rubberneck** A person who gapes and gawks; one who stares intently at something or someone; a curious observer; a tourist. This expression alludes to the elasticlike neck contortions of one trying to view everything in sight. Although the phrase sometimes carries a disparaging implication of unjustified curiosity, *rubberneck* is more often applied humorously to conspicuous sightseers in an unfamiliar locale who gaze wonderingly at scenes taken for granted by the natives.

> They are the nobility—the swells. They don't hang around the streets like tourists and rubbernecks. (G. B. McCutcheon, *Truxton King*, 1910)

5. **take a gander** To glance at; to look at out of curiosity. This expression, derived from the inquisitive male goose, enjoys widespread use in the United States and Great Britain.

> Take a gander at the see-through door below. See that corrugated piece of steel? (*Scientific American*, October 1971)

D

81. DANGER

See also 279. PRECARIOUS-
NESS; 281. PREDICAMENT;
328. RISK; 400. VULNERABILITY

1. Bellerophontic letter A letter containing material dangerous to the person who delivers it; a document prejudicial to the bearer. This expression has its origin in Greek mythology. Bellerophon, the son of Sisyphus, while a guest at the home of Proteus, king of Argos, was accused by Proteus's wife of compromising her honor. Bellerophon, who was innocent of any such charges, which had been made out of revenge for his rejecting her advances, was sent to Iobates, king of Lycia, with a letter requesting that Bellerophon be killed. Iobates, loath to have him killed in cold blood, assigned many dangerous tasks to Bellerophon, who succeeded in carrying them all out triumphantly. Finally wearying of trying to kill him, Iobates gave him his daughter's hand in marriage and made him heir to his kingdom.

2. beware the ides of March See 367. SUPERSTITION.

3. cat ice Flimsy ground, precarious condition. Cat ice is extremely thin ice formed on shallow water which has since receded. It owes its name to the belief that it could not support even the weight of a cat. The phrase has been in use since 1884.

4. dirty work at the crossroads Foul play; skullduggery; deceitful dealing. This expression was probably coined in the 1880s by Walter Melville, who used it frequently in his music-hall melodramas. Since robbers found crossroads a convenient place to practice their trade, much dirty work did take place at cross-roads. Furthermore, it was common practice in Victorian England to bury suicides in graves at crossroads, with a stake driven through their hearts. In modern usage, the term is most commonly heard in a jocular sense, as:

> She's pregnant? There must have been some dirty work at the crossroads!

5. notch in his tail A phrase that refers to an extremely dangerous horse that is hard to handle. This expression, a descriptive term used by American cowboys for a man-killing bronco, draws a parallel to the notches that gunfighters of the Old West would cut in their gun handles for each man they had killed. The term, now figurative, is still heard around rodeos.

6. nourish a snake in [one's] bosom To show kindness to one who proves ungrateful. The allusion is to the Aesop fable in which a farmer, finding a snake frozen stiff with cold, placed it in his bosom. The snake, thawed by the warmth, quickly revived and inflicted a fatal bite on its benefactor.

> I fear me you but warm the starved snake,
> Who, cherished in your breasts, will sting your hearts.
> (Shakespeare, *II Henry VI*, III,i)

7. pad in the straw A hidden danger; a lurking peril; a snake in the grass. *Pad* in this phrase is short for *paddock*, 'a toad.' Toads were once represented as embodiments of attendant spirits to witches and other malignant creatures. For example, in *Macbeth* the second Weird Sister's attendant spirit is Paddock, a toad. The term, in use as early as 1530, became a jocular warning to young lovers to be careful of the invisible evil that lurks in the straw.

Take heed, wench, there lies a pad in the straw. (William Haughton, *English-Men for My Money*, 1605)

8. side winder A dangerous person; one who might strike at any moment; a villain. This American expression, in regular use since the early 1800s, has its origin in the old west and owes its modern popularity to grade "B" cowboy films. A favorite epithet for the villains of these movies, the term alludes to *sidewinder*, the term for a small rattlesnake that strikes with a sideways motion.

The trouble never actually reached the 'Draw, you sidewinder!' phase, but it had some unique angles. (*Omaha World-Herald*, May 15, 1949)

9. snake in the grass A sneak, dastard, skulker; a suspicious, treacherous, or disingenuous person; a traitor or craven; any lurking danger. This expression is derived from a line in Virgil's *Third Eclogue* (approx. 40 B.C.), *Latet anguis in herba* 'a snake lurks in the grass,' alluding to the potential danger posed by a poisonous snake that is hidden in the grass as if in ambush.

There is a snake in the grass and the design is mischievous. (Thomas Hearne, *Remarks and Collections*, 1709)

10. sword of Damocles The threat of impending danger or doom; also *Damocles' sword*.

Little do directors and their companies know of this sword of Damocles that hangs over them. (*Law Times*, 1892)

The allusion is to the sycophant Damocles, invited by Dionysius of Syracuse to a lavish banquet. But Damocles could not enjoy the sumptuous feast because Dionysius had had suspended over his head a sword hanging by a single hair. He dared not move lest the sword fall and kill him. See also **hang by a thread, 279. PRECARIOUSNESS.**

11. tiger by the tail An extremely precarious situation; the horns of a dilemma; a risk; flirtation with danger. The situation alluded to here is obvious; if one lets go, he's in grave danger, but if he holds on, he may be in more danger.

And all his life Jelly Roll held a tiger by the tail . . . all he had was the music of the Storyville bordellos—it was his tiger, and he bet his life on it. (Alan Lomax, *Mister Jelly Roll*, 1950)

A related Chinese proverb states *he who rides a tiger is afraid to dismount.*

82. DEATH

1. at the last gasp At the final extremity; *in extremis*; at the point of death; at the last possible moment; as one utters one's dying words. This ancient expression can be found in the Apocrypha. Antiochus IV, king of Syria, tried to force seven brothers and their mother to eat pork, a renunciation of their religious beliefs. When they refused, he had the oldest brother scalped, had his extremities cut off, and finally had him fried in a huge frying pan. The second brother was then scalped and asked to submit to eating pork, but he too refused and underwent the same treatment.

And when he was at the last gasp, he said thus: Thou indeed, O most wicked man, destroy us out of the present life: but the King of the world will raise us up, who die for his laws, in the resurrection of eternal life. (II Maccabees 7:9)

2. big jump An American cowboy who dies is said to have taken the big jump.

3. bite the dust To die; to come a cropper; to suffer defeat; to fail. The image created by the phrase is one of death: a warrior or soldier falling from a horse and literally biting the dust. In 1697, Dryden used the phrase in his translation of Virgil's *Aeneid*.

So many Valiant Heros bite the Ground.

Western stories popularized the phrase in expressions such as "many a redskin bit the dust that day" (*Webster's Third*). It is also said to have gained currency during World War II in R.A.F. circles. Today the phrase is used figuratively in reference to the defeat, disaster, or failure of a person or something closely associated with a person. One who is defeated is said to bite the dust, but rarely is the phrase used seriously in regard to someone's death.

4. bless the world with [one's] heels To suffer death by hanging. The *bless* of the expression carries its obsolete meaning 'to wave or brandish,' a meaning Dr. Johnson conjectured derived from the action of benediction when the celebrant blesses the congregation with the monstrance. In somewhat similar fashion a hanging man blesses the world with his heels.

5. bump off Kill; murder, especially with a gun. Although this American slang term was coined during the late 1800s, it didn't come into popular usage until the Prohibition era. The derivation is uncertain, but it probably alludes to the bump the victim seems to receive when the slug makes contact with the body. Whatever the case, the term creates a graphic image of murder, and is suggestive of gangsterism.

> I've got several good reasons why I don't aim to get bumped off just yet. (William Raine, *Bucky O'Connor*, 1910)

6. buy it To be killed; to die prematurely as a result of a tragedy. *Buy it* is a witty way of saying "pay for it with one's life." The phrase dates from the early 19th century when it was used primarily in military circles.

> The wings and fuselage, with fifty-three bullet holes, caused us to realize on our return how near we had been to "buying it." (W. Noble, *With Bristol Fighter Squadron*, 1920)

Today this British slang phrase is used in nonmilitary contexts as well.

7. buy the box To die, or be as good as dead. Many people buy their own coffins in order to spare their families the expense and trauma of the funeral and burial arrangements. The irony of "preparing for death" probably gave rise to this irreverent slang expression, the implication being that once a person "buys the box," he might as well be dead.

8. buy the farm To die; to be shot down and killed. The origin of this British slang phrase has been attributed to British pilots who were wont to say that when "it was all over," they were "going to settle down and buy a farm." Many pilots were never able to realize this dream because they were shot down and killed. Thus, *buy the farm* became a euphemism for 'die' because of the glaring disparity between the idealized dream cherished by the pilots and the tragic reality of the death they experienced.

9. cash in [one's] chips To die, to pass on or away. Also *cash* or *pass* or *hand in one's checks*. In use since the 1870s, this expression is a reference to the card game of poker, in which a player turns in his chips or checks to the banker in exchange for cash at the end of the game.

10. churchyard cough A foreboding cough that apparently foreshadows death; a death song. In common use since the 1600s, this expression alludes to impending interment in the local churchyard's cemetery because of a wracking cough.

> I was shaken by an ominous churchyard cough. (E.F. Beadle, *The Undeveloped West*, 1873)

The French vary the expression slightly; they say *un toix qui sent le sapin* 'a cough which smells of the churchyard.'

11. cross the Great Divide To die; to go west; to cross the Styx. *Cross over* is a euphemistic way of saying 'to die.' *Cross the Great Divide* is a longer, more emphatic, but still euphemistic way of saying the same thing. Here the "Great Divide" is being used figuratively to refer

to the illusory line between life and death. At one time, the unsettled area referred to as the "West"—across the Great Divide or Continental Divide—represented the "Great Unknown," and heading in that direction came to mean risking one's life.

12. curtains See 375. TERMINATION.

13. dance on air To be hanged; also *dance on nothing*. A person who is hanged may undergo involuntary muscle contractions. These jerky movements resemble dancing of a sort. Similar expressions include *dance in the rope* and *dance the Tyburn jig*, the latter in reference to Tyburn, a place for public executions in London, England.

If any of them chanced to be made dance in the rope, they thought him happy to be so freed of the care and trouble [that] attends the miserable indigent. (Sorel's *Comical History of Francion*, 1655)

Just as the felon condemned
 to die . . .
From his gloomy cell in a vision
 elopes,
To caper on sunny greens and slopes,
Instead of the dance upon nothing.
(Thomas Hood, *Kilmansegg, Her Death*, 1840)

14. dead as a doornail Dead, very dead, deader than dead; inoperative with no hope of repair. Many houses formerly had a heavy metal knocker on the front door. A doornail was a large, heavyheaded spike sometimes used as a striker plate against which the knocker was struck to increase its loudness and prevent damage to the door. Since the doornail was continually being struck on the head, it was assumed that nothing could be deader.

Old Marley was as dead as a doornail. (Charles Dickens, *A Christmas Carol*, 1843)

As knockers (and doornails) became less common, the word *doorknob* was often substituted in the expression. Other expressions such as *dumb as a doornail* and *deaf as a doornail* imply that someone is extremely stupid or stone deaf, respectively.

15. dead as mutton Absolutely dead; completely gone with no hope of return. This phrase, denoting finality, has been in use, especially in England, since at least 1770. A related term, *make mutton of someone*, means to kill someone.

Thus let me seize my tender bit of lamb—(aside) there I think I had her as dead as mutton. (Isaac Bickerstaff, *Spoiled Child*, 1770)

16. debt to nature Death. The implication is that life is a loan and, with or without interest, it must be paid off with death. *Pay one's debt to nature* means to die. Both these expressions, common since the Middle Ages, have been used as euphemistic epitaphs on tombstones, particularly those from the early 20th century.

Pay nature's debt with a cheerful countenance. (Christopher Marlowe, *Edward II*, approx. 1593)

17. die for want of lobster sauce See 130. EXCESSIVENESS.

18. die in harness To die while working or while in the middle of some action, especially while fighting. The allusion may be to a horse who drops dead while still in harness, as a plowhorse working a field. Another possibility is that *harness* is used in the archaic sense of armor for men or horses, as in the following passage from Shakespeare's *Macbeth:*

At least we'll die with harness on our back.
(V,v)

Two similar phrases are to *die in the saddle* and to *die with one's boots on*. The latter dates from the late 19th century and formerly meant to die a violent death, especially by hanging. To *die in the saddle* brings to mind cavalry or mounted soldiers while to *die with one's boots on* conjures up images of foot soldiers, as in the following citation:

They died with their boots on; they hardly ever surrendered. (*Listener Magazine*, 1959)

19. die like Roland See 175. HUNGER.

20. feed the fishes To die by drowning.

21. food for worms A dead and interred body; a corpse or carcass. The source of this saying is obvious. Another expression of similar zoological origin is *food for fishes*, referring to one dead from drowning.

He was food for fishes now, poor fellow. (Rider Haggard, *Mr. Meson's Will*, 1894)

22. give up the ghost To die, to expire, to breathe one's last. *Ghost* refers to one's soul or spirit, the essence of life. The expression is Biblical in origin:

But man dieth, and wasteth away: yea, man giveth up the ghost, and where is he? (Job 14:10)

23. go belly up An American slang expression meaning to die and float belly up in the manner of dead fish. It is used figuratively for any failure or nonsuccess, just as *death* is.

24. go the way of all flesh To die. This expression is of Biblical origin:

And, behold, this day I am going the way of all the Earth. (Joshua 23:14)

The phrase's evolution to its present form with *flesh* substituted for *the Earth* is not fully understood by modern scholars. The expression appeared in *The Golden Age* by Thomas Heywood (1611):

Whether I had better go home by land, or by sea? If I go by land and miscarry, then I go the way of all flesh.

25. go west To expire, die. This expression, obviously derived from the setting of the sun in the west, may be traced to the ancient Egyptian belief that their dead resided west of the Nile River. In addition, whites who traveled west of the Mississippi during the frontier days were considered fair game for Indians; hence, in the United States "going west" became synonymous with dying. The use of this expression has decreased since its heyday during World War I.

I shall once again be in the company of dear old friends now 'gone west.' (E. Corri, *Thirty Years as a Boxing Referee*, 1915)

26. have [someone's] number on it See 93. DESTINY.

27. hop the twig See 89. DEPARTURE.

28. a horse that was foaled of an acorn The scaffold; the gibbet; the gallows. This expression, appearing in print as early as the 17th century, alludes to the gallows situated in Tyburn, a location in London at the northeast corner of Hyde Park. The site is marked by three brass triangles sunk into the road at the intersection of Bayswater Road and Edgeware Road next to the Marble Arch. Malefactors were executed publicly at this spot until 1783. The phrase alludes to the oak lumber used to build the scaffold and the gibbet, and refers to the structure as a *horse,* in the sense of 'a supporting framework.'

As pretty a Tyburn blossom as ever was brought up to ride a horse foaled by an acorn. (Edward Bulwer-Lytton, *Pelham*, 1828)

29. join the majority To die; to pass on or away. Also *join the great majority, go* or *pass over to the majority, death joins us to the great majority.* Based on the Latin phrase *abiit ad plures*, this expression and variants have been in use since the early 18th century.

30. kick the bucket To die. Although several explanations as to the origin of this expression have been advanced, the most plausible states that the phrase came from an old custom of hanging slaughtered pigs by their heels from a beam, or *bucket*, as it is known in parts of England. In use since 1785, this irreverent synonym for *to die* is popular in both England and America. Shorter

variations include *kick, kick off,* and *kick in.*

31. king of terrors This expression, a personification of death, is found in the Old Testament.

His confidence shall be rooted out of his tabernacle, and it shall bring him to the king of terrors.(Job 18:14)

Some optimistic people, however, seem to give the phrase an entirely different implication.

The king of terrors is the prince of peace.(Edward Young, *Night Thoughts*, 1742)

32. leap in the dark An action of unknown consequences; a blind venture; death. The last words of Thomas Hobbes, philosopher and translator (1588–1679), are reputed to have been:

Now am I about to take my last voyage—a great leap in the dark.

33. make a hole in the water To commit suicide by drowning. The hole in this expression refers to a grave. To make a hole in the water, then, is to go to a watery grave intentionally. This slang phrase, rarely heard today, dates from the mid-19th century.

Why I don't go and make a hole in the water I don't know. (Charles Dickens, *Bleak House*, 1853)

34. make [someone's] beard See 107. DOMINATION.

35. necktie party A lynching or hanging; also *necktie social, necktie sociable, necktie frolic.* This euphemistic and irreverent American slang expression, popularized by western movies, is an extension of the slang *necktie* 'hangman's rope.'

Mr. Jim Clemenston, equine abductor, was on last Thursday morning, at ten sharp, made the victim of a necktie sociable. (*Harper's Magazine*, November 1871)

36. [one's] number is up A person is about to die—one is done for, one's time has come. At an earlier date, *number* referred to one's lottery number; currently, the full expression refers euphemistically to death.

Fate had dealt him a knock-out blow; his number was up. (P. G. Wodehouse, *Girl on Boat*, 1922)

This expression was common among American soldiers who may have been the first to use it in speaking of death.

37. Paddington Fair A hanging; a place of public execution. A bit north of Hyde Park in the West End of London lies Paddington, formerly a village in its own right. Within the boundaries of Paddington was located Tyburn, the place of public executions from the 17th to the 19th centuries. Paddington was also the seat of an annual fair, and because of the association with Tyburn, *Paddington Fair* became an allusion to hanging.

Those adventurous youths who make their exit at the fair of Paddington. (*New Canting Dictionary*, 1690)

A number of related terms accrued, all associated with hanging, e.g., *dance the Paddington frisk* 'to be hanged'; *Paddington spectacles* 'the cap drawn over the hanging victim's eyes.'

38. peg out To die; to bite the dust. In cribbage, the game is finished when a player pegs out the last hole. This expression is among the less frequently heard euphemisms for death.

Harrison . . . was then 67 . . . and actually pegged out in 1841. (H. L. Mencken, in *The New Yorker*, October 1, 1949)

39. preach at Tyburn Cross To be hanged; to dance on air; to be executed publicly. This expression refers to Tyburn's notoriety as a place in London where the majority of public executions were administered until 1783. The victim, who was to *preach at Tyburn Cross*, would *take a ride to Tyburn* to

dance the Tyburn jig at the end of a *Tyburn tippet*, 'the hangman's rope,' upon the *Tyburn tree*, 'the gallows.'

> Has he not a rogue's face? . . . a hanging-look to me . . . has a damn'd Tyburn face, without the benefit o' the Clergy. (William Congreve, *Love for Love*, 1695)

40. push up daisies To be dead and buried in one's grave; also *turn one's toes up to the daisies* and *under the daisies*. The reference is to the flowers often planted on top of new graves. The expression and variants have been in use since the mid-19th century.

41. ride backwards up Holborn Hill To be taken to be hanged. Until 1783 those criminals who were to be hanged in London were transported by horsecart to Tyburn, the place of public execution. These unfortunate men rode, with their backs to the horse's head from Newgate prison up Holborn Hill to the gallows.

> I shall live to see you ride up Holborn Hill. (William Congreve, *Love for Love*, 1695)

A related term, *afloat at Tyburn*, designated the actual hanging.

> Thou art at an ebbe at Newgate, thou hast wrong. But thou shalt be afloat at Tyburn, ere long. (John Heywood, *Proverbs*, 1546)

42. snuff out, snuff To kill, murder; to put down; to put an end to; to destroy; to eliminate. The analogy here is to the snuffing out of a human life as one snuffs out a candle.

> 'Tis strange the mind, that very fiery particle,
> Should let itself be snuffed out by an article.
> (Lord Byron, *Don Juan*, 1824)

The expression, employed figuratively since the 16th century, gave birth about 1975 to the terms, *snuff flick* and *snuff film*, a film, usually pornographic, that allegedly concludes with the actual murder of an unsuspecting actor or actress.

The supposed snuff films may show people involved in her killing and perhaps the killing itself, officials believe. (*New York Post*, September 17, 1979)

43. sprout wings See **48. CHARITABLENESS**.

44. stabbed with a Bridport dagger Hanged; executed by hanging. This British expression arises from Bridport's once having been the center of rope manufacture in England. According to the *OED*, a plant known as hemp, known today as wild hemp, grew in profusion in the area surrounding Bridport. With the raw material readily at hand, the Dorsetshire town came to monopolize the rope industry in England. Hence, this term, dating from the 1500s, alludes to the hangman's rope being made at Bridport.

> 'At Bridport be made good daggers.' Nowadays, at any rate, a Bridport dagger is a grisly humorous expression for the hangman's rope. (*The Times*, October 21, 1910)

45. step off To die; to be married. The expression's latter sense, often extended to *step off the carpet*, refers to the conclusion of the bride's procession to the altar. The phrase's former, more common, meaning is an allusion to the last footstep of life.

> The old man and I are both due to step off if we're caught. (Dashiell Hammett, *Blood Money*, 1927)

46. take for a ride To murder; to deceive or cheat; to pull someone's leg. This underworld euphemism for 'murder' dates from the early 1900s. Gangsters first abducted their victims, then took them to a secluded area where they were murdered.

> The gang believes he is getting yellow or soft, and usually takes him for a ride. . . . (Emanuel H. Lavine, *The Third Degree*, 1930)

Take for a ride also means 'deceive, cheat' because the driver is in a position

to manipulate or trick. The expression is often used of one who leads another on and then fleeces him.

> But the one who really took my friend for a ride was the electrician. He used more . . . cable . . . than . . . it takes to build a battle ship. (Roger W. Babson, in a syndicated newspaper column, 1951)

47. turn [one's] face to the wall To die; more precisely, to make the final gesture of acquiescence indicating that one is about to give up the ghost. The origin is Biblical (2 Kings 22:2); when Hezekiah was informed his death was imminent:

> He turned his face to the wall, and prayed unto the Lord.

The expression appears in works as varied as *Narratives of the Days of the Reformation* (1579):

> He turned his face to the wall in the said belfry; and so after his prayers slept sweetly in the lord.

and *Tom Sawyer* (1876):

> He would turn his face to the wall, and die with that word unsaid. (Mark Twain)

48. turn up [one's] toes To die; to be lying dead, toes up. This expression refers to the position in which the body is placed for burial. In reference to a body already in the ground, the term is often expanded to *turn up one's toes to the daisies*. The allusion is to the flowers that are often planted or placed upon graves. A related term, *toes up*, also indicates death.

> I thought I'd be by this time toes up in Stepney churchyard. (Henry Mayhew, *London Labour*, 1851)

Debate . . .
See 24. ARGUMENTATION

83. DECADENCE

1. bread and circuses Free food and entertainment, particularly that which a government provides in order to appease the common people. Such is reputed to bring about a civilization's decline by undermining the initiative of the populace, and the term has come to mean collective degeneration or debauchery. According to Juvenal's *Satires, panem et circenses* were the two things most coveted by the Roman people. *Bread and Circuses* was the title of a book by H. P. Eden (1914). Rudyard Kipling used the expression in *Debits and Credits* (1924):

> Rome has always debauched her beloved Provincia with bread and circuses.

2. the primrose path The route of pleasure and decadence; a frivolous, self-indulgent life. In Shakespeare's *Macbeth* the drunken porter, playing at being the tender of Hell gate, says:

> I had thought to have let in some of all professions that go the primrose way to the everlasting bonfire. (II,iii)

The expression connotes a colorful, blossomy course of luxury and ease, but as commonly used also includes the implication that such a carefree, self-gratifying life cannot be enjoyed without paying a price.

> Never to sell his soul by travelling the primrose path to wealth and distinction. (James A. Froude, *Thomas Carlyle*, 1882)

3. wine and roses Wanton decadence and luxury; indulgence in pleasure and promiscuity; la dolce vita. This expression, often extended to *days of wine and roses*, alludes to the opulence as well as the depravity of the primrose path. The longer expression was popularized by an early 1960s film and song so titled.

Decease . . . See 82. DEATH

Deceit . . . See 176. HYPOCRISY;
236. MENDACITY; 370. SWINDLING

Deception . . . See 236. MENDACITY;
274. PLOY; 286. PRETENSE;
370. SWINDLING; 384. TRICKERY

84. DECISIVENESS
See also 222.
IRREVOCABILITY

1. all one side, like Bridgnorth election
Describes an election result that is over-
whelmingly decisive; extremely lopsid-
ed. In the days before the Ballot Act
(1872) in England, a Whig opposed two
Tories in the borough of Bridgnorth.
The only vote the Whig received was his
own; hence, the election was all one
side. The term is now applied in many
ways to indicate an imbalance. A corre-
spondent to *Notes and Queries* (Febru-
ary 1932) offers the following experi-
ence:

> My efforts at carpentering were often
> crooked, and were thus criticised:
> "It's all on one side like the
> Bridgnorth election."

2. burn [one's] bridges To cut oneself
off from all possible means of retreat, lit-
eral or figurative; to make an irrevoca-
ble statement or decision from which
one cannot withdraw without consider-
able embarrassment, humiliation, or dis-
grace; also *burn one's boats* or *ships.*
This expression, in figurative use since
the late 1800s, is said to have come from
the military practice of burning the
troop ships upon landing on foreign soil
in order to impress upon the soldiers the
fact that only a victorious campaign
would ensure them a safe return to their
own country.

3. cross the Rubicon To take a decisive,
irrevocable step, especially at the start of
an undertaking or project; also *pass the
Rubicon.* This expression, which dates
from 1626, refers to the decision of Julius
Caesar in 49 B.C. to march with his army
across the Rubicon, the ancient name of
a small stream in northern Italy forming
part of the boundary with Cisalpine
Gaul. The decision was tantamount to

declaring war, since there was a law for-
bidding a Roman general to cross the
stream with armed soldiers. Caesar's
crossing did in fact mark the beginning
of the war with Pompey. Another phrase
with a similar meaning is *the die is cast*
(Latin *alea jacta est*)—the words said to
have been uttered by Caesar during the
crossing.

4. draw the line To define a limit be-
yond which one refuses to go; to fix a
limit of action, especially of acceptable
behavior.

> One must draw the line somewhere,
> or throw overboard all principles; and
> I draw it . . . against infidels and
> against Frenchmen. (Richard
> Doddridge Blackmore, *Springhaven*,
> 1887)

The exact origin of this term is un-
known, but one suggestion is that it lies
in the practice of frontiersmen and cow-
boys, who would draw a line in the dirt
with the toe of a boot and challenge an
adversary to step across it. A more plau-
sible theory is that farmers used to make
deep cuts with a plowshare across their
fields to indicate their property bounda-
ry lines.

5. fish or cut bait A request or demand
that someone take definitive action, re-
solve a situation, or make a choice. The
implication here is that one cannot both
fish and cut bait at the same time, and,
if he is not going to fish, he should step
aside and give someone else a chance
while he cuts bait. A similar common ex-
pression is *shape up or ship out.*

6. flatfooted See 43. CANDIDNESS.

7. put [one's] foot down To take a firm
stand; to decisively embrace a point of
view. The stance assumed by literally
putting one's foot down reflects a mental
attitude of determination and will pow-
er. Such decisiveness is often the re-
sponse to having been pushed to the lim-
its of endurance or patience.

8. put your money where your mouth is
To back up one's words with action; to support one's assertions by willingness to risk monetary loss. This expression, perhaps of gambling origin, implies that certain statements are worthless unless the assertor is willing to reinforce them with a cash bet. The expression is now in wide use throughout the United States and Great Britain.

> The squadron betting book the barman keeps . . . for guys who are ready to put their money where their mouth is. (A. Price, *Our Man in Camelot*, 1975)

9. sockdolager A decisive blow; a conclusive remark; a finisher; that which ends or settles a matter; something of unusual size; something exceptional or outstanding. Although this American slang expression is of obscure origin, it is generally believed that it was derived from a metathesis of the sounds in the word *doxology*, the closing words of a church service. As *doxology* was applied to the finishing of a church service, *sockdolager* was invented as a jocular reference to the finishing of an argument or fight. The term has been in use since about 1830. Apparently the sound of the word suggested to some an application to anything unusually large, for sometime in the mid 19th century it assumed that connotation.

> The pleasant remembrance of the capture of a real sockdolager [large fish]. (*Blackwood's Magazine*, February 1894)

10. take the plunge To make an important and often irrevocable decision despite misgivings; to choose to act, usually after much deliberation or a bout of indecision. The allusion is to a swimmer who dives into the water, in spite of doubts or fear.

Defamation . . . See 350. SLANDER

Defeat . . . See 141. FAILURE

Defectiveness . . .
See 186. IMPERFECTION

Defenselessness . . .
See 400. VULNERABILITY

85. DEFERENCE
See also 362. SUBMISSIVENESS

1. after you, my dear Alphonse This popular catch phrase is the first half of the complete expression "After you, my dear Alphonse—no, after you, my dear Gaston." It first appeared in the Hearst (King Features) comic strip *Happy Hooligan* written by F. Opper. The strip ran throughout the 1920s and for part of the 1930s. The characters Alphonse and Gaston were two extremely debonair Frenchmen who were so polite that they would jeopardize themselves in times of danger by taking the time to courteously ask each other to go first. Today, when two people go to do the same thing at the same time, one might humorously say to the other, "After you, my dear Alphonse."

2. cap in hand Submissively; with a deferential air or manner. The phrase alludes to the image of a rustic or servant who selfconsciously and humbly takes off his cap and holds it, usually against his chest, while speaking to someone of higher social status.

3. courteous as a dog in the kitchen Submissive; with cap in hand. This expression alludes to the perfect behavior a dog exhibits when near a source of food, hoping for a handout.

4. give the wall To yield the safest place; to allow another to walk on the walled side of a street. This expression is derived from an old custom which compelled pedestrians to surrender the safer, inner path bordering a roadway to a person of higher social rank. Modern social etiquette still requires a man to walk on the streetside of a female when walking along a sidewalk. A related expression, *take the wall*, describes the ada-

mant perambulator who assumes the safer path closer to the wall. The inevitable friction between "givers" and "takers" is discussed by James Boswell in his *Journal of a Tour of the Hebrides* (1773):

> In the last age . . . there were two sets of people, those who gave the wall, and those who took it; the peaceable and the quarrelsome. . . . Now it is fixed that every man keeps to the right; or, if one is taking the wall, another yields it, and it is never a dispute.

5. hat in hand With a respectful or a deferential air; in a courteous manner; with regard for another. This expression alludes to a gentleman who removes his hat in the presence of ladies or to show respect for another gentleman. In contrast to *cap in hand*, the action of an underling to indicate servility or obsequiousness, *hat in hand* connotes an action of one's own free will to signify respect or courtesy. The phrase has been in use since at least the Middle Ages.

> A man's hat in his hand never did him any harm. (Samuel Palmer, *Moral Essays on Proverbs*, 1710)

6. strike sail See 361. SUBMISSION.

Defiance . . .
See 302. REBELLIOUSNESS

86. DEGENERATION

1. go to hell in a handbasket To indulge in petty or sporadic dissipation; to carouse occasionally, in a small way; to degenerate bit by bit; gradually to go downhill morally. This slang expression is often used to describe typically adolescent anti-social behavior, usually of a temporary nature. However, it sometimes carries connotations of more serious and permanent moral decline. Its origin is unknown but it is interesting to speculate that it may be related to *go to heaven in a wheelbarrow* 'to be damned'—*handbasket* replacing *wheelbarrow* to indicate the relative smallness

of one's sins; *hell* replacing *heaven* to accommodate more literal minds. See **go to heaven in a wheelbarrow,** 298. PUNISHMENT.

2. go to pot To deteriorate, to go downhill, to degenerate, to fall into a state of disuse or ruin. Although the exact origin of this expression is unknown, it may be related to the earlier phrase *go to the pot*, literally 'to be cut into pieces like meat for the pot,' and figuratively 'to be ruined or destroyed.'

> If it were to save the whole empire from going to pot, nobody would stay at home. (*Pall Mall Gazette,* February 1884)

3. go to rack and ruin To degenerate, to deteriorate, to decline, to fall apart; also *to go to rack* and *to go to ruin*. *Rack* 'destruction' is a variant of *wrack* and *wreck*. The expression dates from at least 1599.

> Everything would soon go to sixes and sevens, and rack and ruin. (Elizabeth Blower, *George Bateman,* 1782)

4. go to the dogs To degenerate morally or physically, to deteriorate, to go to ruin. The expression, which dates from at least the early 17th century, is thought to have come from the earlier Latin phrase *addicere aliquem canibus* 'to bequeath him to dogs.'

> Rugby and the schoolhouse are going to the dogs. (Thomas Hughes, *Tom Brown's School Days,* 1857)

5. on the high-road to Needham On the road to poverty or ruin; on the skids; suffering a mental, moral, or financial decline. This British expression, of infrequent occurrence, simply puns on *need* without reference to a specific locality.

6. on the skids On the road to poverty, ruin, disgrace, or oblivion; in a state of rapid deterioration or decline. *The skids* as denotative of a moral condition may derive from *Skid Row*. (See 227. LOCALITIES.) It appears frequently in longer phrases such as *hit the skids* 'start

on the downward path' or *put the skids under* 'cause the ruin or decline' of a person or plan.

> By 1929 Bix [Beiderbecke] was on the way down—not yet on the skids, but the good time and the big time was behind him. (Stephen Longstreet, *The Real Jazz Old and New*, 1956)

7. the seamy side The most disagreeable, unsavory, and offensive aspect; the sordid, perverse, degenerate, or immoral features. Literally, *the seamy side* refers to the wrong, or underside, of pieced fabric which shows the rough edges and seams of an otherwise acceptable article of clothing, tapestry, etc. The figurative use of *the seamy side* was pioneered by Shakespeare:

> Oh fie upon them! Some such squire he was
> That turned your wit the seamy side without,
> And made you to suspect me with the Moor.
> (*Othello*, IV,ii)

A commonly used derivative is *seamy*.

8. take the gilt off the gingerbread To destroy the decorative surface and leave the dull base; to shatter the illusion; to take the wheat and leave the chaff. The reference in this expression is to the gingerbread cakes that were once commonly sold at English fairs. The gold leaf decoration made the gingerbreads desirable commodities, but if the gilt were removed they became unmarketable wares. Hence, to take the gilt off the gingerbread came to imply that something had been made inferior, that it had been stripped of its attractive qualities. The term, although used as early as the 1600s, did not come into common use until the late 1800s.

> He was always rubbing the gilt off some gingerbread theory. (James Payn, *The Canon's Ward*, 1884)

Degradation . . .
See 86. DEGENERATION

Degree . . . See 139. EXTENT

87. DEJECTION
See also 167. GRIEVING

1. black dog on [one's] back Depressed; in a state of melancholy; sulky. This expression, dating from the 1700s, is a reference to the superstition that ill luck supposedly accompanies a black dog. Horace, the Roman poet, notes that observing a black dog brings one bad luck. In the Middle Ages people believed that the devil often assumed the form of a black dog, the exact form he affects in Goethe's *Faust*. Hence, one who has the *black dog on his back* may be depressed because of the devil's influence.

> He did not seem to be enjoying his luck. . . . The black dog was on his back, as people say, in terrifying nursery metaphor. (Robert Louis Stevenson, *New Arabian Nights*, 1882)

A variant, *the black dog has walked over him*, is said of a sullen or morose person.

2. blue funk Mental depression; a depressed state of mind usually of short duration; extreme nervousness. An American expression which has recently undergone a resurgence of popularity, probably because of popular culture's utilization of *funky*, a term with an entirely different meaning and derivation. The term *blue funk* has been with us since the mid 19th century. According to the *OED* its earliest written use was:

> We encounter . . . the miserable Dr. Blanding in what is called . . . a blue funk. (*Saturday Review*, November 23, 1861)

3. blue Monday The Monday before Lent; any Monday in general. One explanation of this expression lies in the general mood of working people upon returning to their places of employment on a Monday morning after a weekend

of relaxation and recreation. Dating from the Middle Ages, the term took on its modern connotation (and lost its Lenten association) sometime during the latter half of the 19th century. Another plausible explanation of its source ascribes it to that day-after feeling that many working people suffer following a weekend spent in dissipation. The British have an expression for the loss of work after such a weekend, *to keep Saint Monday*.

> One Blue Monday in Los Angeles . . . he thought to relieve a bit of despondency by looking over his old book of records. (Charles Saunders, *The Southern Sierras of California*, 1923)

The expression's currency has increased with the popularity of Fat Domino's hit single, "Blue Monday," first released in the 1950s.

4. crestfallen Dispirited; lacking in confidence, spirit, or courage; humbled; in a blue funk. In use since the 16th century, this term is said to allude to the crests of fighting cocks which reputedly become rigid and deep-red in color during the height of battle but flaccid and droopy following defeat. This theory regarding the term's origin is unlikely, however, since the crests of fighting cocks are cut off.

5. down in the mouth Sad, dejected, disappointed, in low spirits, down in the dumps. This expression, dating from the mid-17th century, derives from the fact that the corners of a person's mouth are drawn down when he is sad or despondent.

> The Roman Orator was down in the mouth; finding himself thus cheated by the money-changer. (Bp. Joseph Hall, *Resolutions and Decisions of Diverse Practical Cases of Conscience*, 1649)

6. dying duck in a thunderstorm Woebegone; dejected; despondent; miserable. Although the origin of this expression is unknown, the *OED* records the

earliest written use as 1863. A correspondent to *Notes and Queries* indicates that the term *like ducks in thunder* was known as early as 1785. Another correspondent writing in the October 1926 issue relates an incident about a flock of ducks, caught in an August thunderstorm, waddling home safely and then immediately dying.

> He . . . rolled his eyes of blue
> As dying ducks in thunder storms
> Are often said to do.
> (William Schwenk Gilbert, *Lost Bab Ballads*, 1911)

7. eat [one's] heart out See *eat one's heart*, 335. SELF-PITY.

8. gloomy Gus A cheerless person; one who is burdened with depression, doleful, lacking in confidence, dejected. The *Gus* in this expression refers to anyone at all, and is probably used because of the alliteration it creates. The term frequently signifies one who seems to be *down in the dumps*. Along with its British equivalent, *dismal Jimmy*, the expression has been in use since the early 1900s.

> Shown in his true colors, as a dog-in-the-manger, a spoil-sport, a wet blanket, a dismal Jimmy. (Horace A. Vachel, *The Vicar's Walk*, 1933)

An older term for one of morose persuasion, *Jeremiah*, is derived from the Hebrew prophet's contribution to the Bible, *Lamentations*. To this day any lament or tale of woe is often referred to as a *jeremiad*.

> Puritanism restricted natural pleasures; it substituted the Jeremiad for the Paean. (Samuel Butler, *The Way of All Flesh*, 1903)

9. in the doldrums See 356. STAGNATION.

10. in the dumps In a dull and gloomy state of mind; sad, depressed, joyless, long-faced. No one knows the exact origin of *dump*, in use since the 16th century. One suggestion is that it derives from the Dutch *domp* 'exhalation, haze, mist,' and that this meaning gave rise to its as-

sociation with mental haziness. An even less convincing theory is that *dumps* is an allusion to King Dumops of Egypt, who, after building a pyramid, died of melancholia. Thus, one who suffers from melancholia, like King Dumops, is said to be "in the dumps." This expression, still current, and *in doleful dumps* were in use in the 17th century. *Down in the dumps* is another popular variant.

11. I should've stood in bed Describes one of those days when everything goes wrong; the height of frustration. This term was coined by Mike Jacobs, the famous fight promoter and manager, after the 1935 World Series between the Detroit Tigers and the Chicago Cubs. Suffering from a touch of the flu, Jacobs had flown to Detroit, had sat throughout the game in chilly weather, and had bet on Chicago. Detroit won the game and the World Series; Jacobs flew back to New York and, according to Dan Parker, sportswriter for the *New York Daily Mirror*, shortly after his arrival, made this famous remark at an interview with sports writers.

12. lick [one's] wounds To feel a sense of dejection after suffering a defeat; to go off by oneself to assuage one's feelings and honor. The reference in this expression is to an animal licking its wounds to alleviate the hurt and discomfort after suffering a defeat in a fight. The term has been in use since 1550.

> And when the arrows flew like hail,
> and hard,
> He licked my wounds, and all my
> wounds were mended.
> (Elinor Wylie, *Angels and Earthly
> Creatures: Sonnet IX*, 1929)

13. no joy in Mudville Pervasive sadness or disappointment, especially that accompanying the unexpected defeat of a local sports team. This expression, generally limited to use by sports reporters, is derived from "Casey at the Bat," a poem which tells of the untimely failure of the hometown baseball hero to save the day:

> Oh! somewhere in this favored land
> the sun is shining bright;
> The band is playing somewhere, and
> somewhere hearts are light;
> And somewhere men are laughing and
> somewhere children shout,
> But there is no joy in Mudville—
> mighty Casey has struck out.
> (Ernest Thayer, "Casey at the Bat,"
> 1888)

14. off [one's] feed See 181. ILL HEALTH.

15. a peg too low Moody, listless, melancholy. The drinking bouts of medieval England occasionally turned to brawls when one of several men drinking from the same tankard accused another of taking more than his share. This problem was remedied by the legendary St. Dunstan, who suggested that pegs be placed at equal intervals inside the cup to indicate each man's portion. Apparently, the expression evolved its figurative meaning in allusion to the dismay of one whose remaining portion was depressingly small. The phrase usually implies a desire for another go at "the cup that cheers."

16. the pits An extraordinarily poor state of mind; the depths of despond; the nadir; the worst of anything. This expression, alluding to an extremely deep shaft or abyss, enjoys widespread slang use in the United States. Columnist Erma Bombeck recently punned on the expression in entitling a collection, *If Life Is a Bowl of Cherries, What Am I Doing In the Pits?* (1978).

17. sing the blues To be despondent; to express a melancholy mood; to exhibit a pessimistic attitude; to complain. Although *blue* as a synonym for a depression of the spirits dates back to at least the 16th century, the allusion in this American phrase is to *the blues*; that slow, sad style of music. In the late 1800s, a group of black American musicians around the lower reaches of the Mississippi River adapted their folk music to a haunting type of jazz melody usually played in a slow tempo. Such

music, because of the mood it evoked, became known as *the blues*, and those singers who specialized in such music were known as *blues singers*.

> I got her a job understudying the blues singer in the show I'm handling. (*The Chicago Sun*, October 14, 1947)

Out of this musical context came today's figurative extension of the phrase.

18. slough of despond A feeling of intense discouragement, despair, depression, or hopelessness. In John Bunyan's *Pilgrim's Progress* (1678), the Slough of Despond was a deep, treacherous bog which had to be crossed in order to reach the Wicket Gate. When Christian, the pilgrim, fell into the Slough, he might have been totally consumed had not his friend Help come to his assistance. Eventually, *slough of despond* became more figurative, describing the seemingly helpless and hopeless predicament of being enmired in despair.

> I remember slumping all [of] a sudden into the slough of despond, and closing my letter in the dumps. (Thomas Twining, *Recreations and Studies of a Country Clergyman of the 18th Century*, 1776)

19. touch bottom To reach one's lowest point; to sink to the depths of despair; to know the worst; to feel that everything has gone wrong and nothing worse can happen. In print at least as early as the mid-19th century, this expression probably derives its figurative use from the nautical use referring to a ship which scrapes its bottom and is temporarily or permanently disabled.

20. waterworks Tears, crying, the shedding of tears; often to *turn on the waterworks;* also to *turn on the faucet.*

> Harry could not bear to see Clare cry. "Hold up!" he cried. "This will never do. Hullo! no waterworks here, if you please." (*F. Leslie's Chatterbox* [New York], 1885–86)

By implying that the flow of tears can be turned on and off virtually at will, these phrases place doubt on the sincerity of the tears being shed. This facetious use of the term dates from the 17th century.

elay . . . See 2. ABEYANCE; 372. TARDINESS

Delaying . . . See 374. TEMPORIZING

Delight . . . See 115. ELATION; 117. ENJOYMENT

Deliverance . . . See 314. RESCUE

Delusion . . . See 183. ILLUSION

88. DENIAL
 See also 303. RECANTATION;
 308. REFUSAL;
 310. REJECTION

1. did not lay a finger on To have avoided striking someone, even in the very slightest way. This phrase is very commonly used in the negative, as "I didn't lay a finger on him," or in the conditional, "if you dare lay a finger on him . . ." The *OED* lists the first written use of the term as:

> He wished he'd never laid a finger on him to save his life. (Robert S. Hawker, *Prose Works*, 1865)

See also **lay a finger on,** 95. DIFFERENTIATION.

89. DEPARTURE
 See also 122. ESCAPE

1. any more for the Skylark? Last chance; last call; now or never. Among the small excursion boats at English resort areas, almost invariably one was named *Skylark.* Generalizing from this situation, the practice arose among attendants of any of these boats to announce, "Any more for the Skylark?" shortly before departure, to solicit more passengers. Sometime in the early years of the 20th century, the phrase came to be used in British English as a summons

for any situation requiring last-minute action, such as:

> I'm driving into the village in a moment; any more for the Skylark?

The phrase is heard less frequently today.

2. bail out To make a hasty exit as from an airplane about to crash; to depart precipitously. This American slang expression alludes to the hasty departure one makes from an airplane in an emergency. The aeronautical sense derives from the nautical, 'to empty a ship of water.' In use since the 1940s, the term is usually heard when one wishes to discard a project, depart from a relationship which is unsuccessful, or to make an abrupt departure to avoid impending trouble, as:

> I could see that a fight was about to break out in the tavern, so I bailed out of there.

3. cut and run To leave as quickly as possible; to take off without further to-do; in slang terms, to split or cut out. These figurative meanings derive from the nautical use of *cut and run* which dates from the 18th century. According to a book on sailing entitled *Rigging and Seamanship* (1794), *cut and run* means "to cut the cable and make sail instantly, without waiting to weigh anchor." By extension, this expression can be used to describe any type of quick getaway.

> The alternative was to go to jail, or as the phrase is, to cut and run. (H. H. Brackenridge, *Modern Chivalry*, 1815)

Both nautical and figurative uses are current today.

4. cut [one's] stick To be off, to go away, to depart, to leave; also *to cut one's lucky*, although the sense here is more to decamp, to escape. This British slang expression, which dates from the early 19th century, is said to have come from the custom of cutting a walking stick prior to a departure.

5. do a Dunkirk Evacuate under pressure; depart hastily; abandon; cut and run. The allusion in this expression is to the hasty abandonment of Dunkirk, France by British troops in 1940. The evacuation, from the shores of France to the British Isles, was completed with the assistance of thousands of British citizens operating small pleasure and commercial craft, most of which had never before been taken from the inland waters of Britain. Under constant bombardment by German aircraft, the British Navy, abetted by these little boats, rescued hundreds of thousands of British and allied troops. Winston Churchill, prime minister at the time, called the operation a "miracle of deliverance." Today the term is used figuratively to indicate a rather abrupt or an emergency leave-taking.

6. French leave Sudden flight or departure, often leaving behind unpaid bills; leave taken secretly or without prior notice. This expression has its origin in the Parisian etiquette of the 18th century. Arriving guests were received lavishly, passing down a long receiving line which included all guests who had preceded them to the party. However, upon departure the guest simply left without any thank yous or farewells to anyone, including the host and hostess. Apparently this abrupt departure was designed not to interrupt the party.

> My only plan was to take French leave, and slip out when nobody was watching. (Robert Louis Stevenson, *Treasure Island*, 1883)

The French call such a precipitous exit taking *English leave (filer à l'anglaise)*.

7. hightail it To depart hastily; to run at full speed; to escape, especially by running away; to rush away in fright. This American slang expression was coined during the early 1800s by the trappers who roamed the American West. The allusion is to the practice of some wild animals, especially deer, of raising their tails as they rush away when startled or alarmed.

Often they'd scatter like a bunch of
antelope, and hightail it in any
direction excepting the right one.
(Will James, *Cow Country*, 1927)

Today the term is most commonly ap-
plied to a hasty exit or getaway, on foot
or in a vehicle.

We hightailed it for the hangout. (Hal
Moore, *Flynn's*, April 19, 1930)

8. hoist the blue peter To indicate or
advertise that departure is imminent. A
"blue peter" is a flag of the International
Code of Signals for the letter "P," used
aboard vessels to signal that preparations
are being made for departure. A blue
flag with a white square in the center, it
is a signal for hands on shore to come
aboard and for others to conclude busi-
ness with the crew. It dates from about
1800. By 1823, figurative use of *hoist the
blue peter* gained currency, as exempli-
fied in the following quotation from By-
ron's *Don Juan* (1823):

It is time that I should hoist my "blue
Peter,"
And sail for a new theme.

Blue peter is also the name for a move in
whist in which one plays an unnecessari-
ly high card as a call for trumps.

9. hop the twig To depart suddenly; to
go off; to run away; to die. The allusion
in this Briticism is to the bird that *hops
the twig* just before the hunter is ready
to shoot. The term is most commonly
used in Britain today to connote the
avoiding of one's creditors. First appear-
ing in the latter half of the 18th century,
the expression has also been used to con-
note the departure at death.

He kept his bed three days, and
hopped the twig on the fourth. (Mary
Robinson, *Welsingham*, 1797)

10. make tracks To leave rapidly; to
hotfoot it; to flee or escape. This expres-
sion alludes to the trail or tracks created
by the passage of human beings or ani-
mals through woods, snow, etc. The
phrase has been in widespread use since
the early 19th century.

I'd a made him make tracks, I guess.
(Thomas Haliburton, *Clockmaster*,
1835)

11. pull up stakes To move or relocate;
to leave one's job, home, etc., for anoth-
er part of the country.

They just pulled up stakes and left for
parts unknown. (*The New Orleans
Times-Picayune Magazine*, April
1950)

Stakes are sticks or posts used as markers
to delimit the boundaries of one's prop-
erty. In colonial times, literally pulling
up stakes meant that one was giving up
one's land in order to move on, just as
driving them in meant that one was lay-
ing claim to the enclosed land to set up
housekeeping.

12. saddler of Bawtry A person who
leaves his friends at the tavern too early.
The suggestion in this expression is that
if one leaves his drinking too soon, he
will suffer for it. The original saddler of
Bawtry, on his way to be hanged, re-
fused to stop at the local pub for the usu-
al free drink regularly offered to those
about to be executed. As a result, his re-
prieve arrived a moment too late: he had
already been hanged when the message
came.

He will be hanged for leaving his
liquor behind, like the saddler of
Bawtry. (Samuel Pegge, *Curialia
Miscellanea*, 1818)

13. shake the dust from [one's] feet To
depart resolutely from an unpleasant or
disagreeable place; to leave in anger, ex-
asperation, or contempt.

I then paid off my lodgings, and
"shaking the dust from my feet," bid a
long adieu to London. (Frances
Burney, *Cecilia*, 1782)

The expression, which implies a certain
abruptness, is found in Matthew 10:14
where Jesus is speaking to the disciples
before sending them out to preach the
Word:

And whosoever shall not receive you,
nor hear your words, when ye depart

out of that house or city, shake off the dust of your feet.

14. shoot the moon To remove one's household furnishings by night to avoid paying the rent or to avoid one's creditors. Although this British slang expression usually implies a stealthy departure from one's lodgings for nonpayment of the rent, it may also imply a furtive departure for some other clandestine reason. The term has been in use since the early 18th century.

> He having just "shot the moon" . . . I had to follow him to a cockloft in St. Giles's. (Colonel Peter Hawker, *Diary*, 1837)

Related terms, *do a moonlight flit* and *make a moonlight flitting* have the same meaning and are more commonly heard today.

> The whole covey of them, no better than a set of swindlers, . . . made that very night a moonlight flitting. (David M. Moir, *Mansie Wauch*, 1824)

See also **shoot the moon,** 328. RISK.

15. take a powder To depart hastily; to flee. This expression is usually associated with an underworld or underhanded situation, describing a person or persons who suddenly leave to avoid capture or detection. Apparently of American origin, the phrase has been in use since the early 1900s. Although the exact origin is uncertain, the *Oxford English Dictionary* does list a verb *powder,* labeled "colloquial and dialectal," whose meaning is 'to rush out impetuously.' There is also a variant *take a run-out powder.*

16. take to the tall timber To depart unexpectedly and with little to-do; to escape. *Tall timber* originally referred to a heavily timbered, uninhabited area in the forest. This colloquial Americanism, often used literally, dates from the early 1800s.

> I fell off *three times;* finally the disgusted critter took to the tall timber, leaving me to hike onward

and to get across the frigid stream as best I could. (*Sky Line Trail,* October 18, 1949)

Variants of this expression include *break* or *strike* or *pull for tall timber.*

Dependability . . .
See 67. CONSTANCY

90. DEPENDENCE

1. acid head This American slang term from the subcultural underworld signifies one who is a habitual user of LSD. The allusion here is to the shortening *acid* for the drug LSD, formally called lysergic acid diethylamide.

2. close as the bark to the tree See 156. FRIENDSHIP.

3. hang on [someone's] sleeve To be completely dependent on someone for support or assistance; to rely on someone else's judgment. The allusion is perhaps to children hanging onto their mother's sleeve. This expression, now obsolete, dates from at least 1548. It appears in Samuel Hieron's *Works* (1607):

> You shall see . . . a third hanging upon some lawyer's sleeve, to plot and devise how to perpetuate his estate.

4. hooked Addicted; entangled in a difficult situation; under someone else's power or influence; devoted to or obsessed by a person, occupation, or other matter. This expression refers to the plight of a fish that has been captured, or hooked, by a fisherman, a fate which usually leads to the animal's destruction. *Hooked* or the related *on the hook* often describes a person who is addicted to or dependent on drugs, alcohol, cigarettes, or some other potentially harmful habit; but it is used equally often in reference to one's consuming hobby or interest.

> "Poor Caudle!" he said to himself; "he's hooked, and he'll never get himself off the hook again." (Anthony Trollope, *The Small House At Arlington,* 1864)

See also **get someone off the hook**, 314. RESCUE.

5. meal ticket One's main source of income; a person, skill, or talent upon which one depends for his livelihood. This familiar expression originally referred to a prize fighter who was virtually the breadwinner for his agent and manager. Today, the phrase is usually used in reference to a working spouse.

> He was her meal-ticket. Why should she want him sent to the pen? (H. Howard, *Nice Day for a Funeral*, 1972)

6. on a string Dependent, easily manipulated, psychologically or financially tied to another person; unable to stand on one's own two feet. This expression dates from the 1500s although it is antedated by use of the single word *string* referring to a leash or other inhibiting tie or connection.

> Make him put his slippers on,
> And be sure his boots are gone,
> And you've got him on a string, you
> see.
> (*Circus Girl*, 1897)

Currently *on a string* is often heard in the context of relationships where one person is subject to the whims of another.

7. on [someone's] coattails Dependent upon or as a consequence of another's effort. The image is of a swallow-tailed coat, whose tapered ends naturally follow its body as sort of secondary appendages. The term is usually derogatory, implying a lack of ability to fare for oneself or to gain an undeserved benefit. Its most frequent use, as well as its origin, is probably political: to *ride in on someone's coattails* means to be carried into office because a popular candidate led the ticket. Abraham Lincoln used the term in 1848:

> Has he no acquaintance with the ample military coat tail of General Jackson? Does he not know that his own party have run the last five

Presidential races on that coat tail? (*Congressional Globe*)

8. string along with To follow someone with confidence; to accompany; to go along with; to join up with; to follow another's lead. The origin of this expression is unknown. One source attributes it to a string of pack animals all tied together following docilely along behind the leader. A more plausible explanation, however, seems to be the simple connecting tie that is made with a string. Although there is no written record of the phrase until the 1920s, it was probably in use by the late 19th century. The phrase enjoyed a brief surge of popularity during the late 1930s when a love ballad, *I'll String Along with You* (1937) was published. See **string someone along**, 286. PRETENSE.

> As long as you string along with me, your cafeteria days are over. (Jerome Weidman, *I Can Get It for You Wholesale*, 1951)

9. tied to [someone's] apron strings Completely under someone's thumb, totally dominated by or dependent on another person; usually used in reference to a husband or son's relationship with his wife or mother, respectively. The allusion is probably to the way small children cling to their mother's skirts for support and protection. Thomas Babington Macaulay used the expression in *The History of England from the Accession of James II* (1849):

> He could not submit to be tied to the apron strings even of the best of wives.

Depression . . . See 87. DEJECTION

Derision . . . See 213. INSULT; 327. RIDICULE

Desertion . . . See 1. ABANDONMENT

91. DESIRE
See also 230. LUST

1. Attic figs Things coveted but not attainable (used as a warning to one who is thinking unrealistically). Xerxes, king of Persia, boasted after he had defeated the Greeks at Thermopylae (480 B.C.) that he would go to Attica and eat the figs there. His boast proved hubristic, for he was decisively defeated by the Greek forces at Salamis later that year. Ever since, *Attic figs* has been used to denote covetousness or wishful thinking.

2. big eyes A great lust or desire for a person or object. This jazz term, in use since the 1950s, may have come from the older, less picturesque to *have eyes for* 'to be attracted to or desirous of,' used as early as 1810 in *The Scottish Chiefs* by Jane Porter. *Big eyes* has a corresponding negative expression, *no eyes,* also in use since 1950s, meaning 'lack of desire, or disinclination.'

3. forbidden fruit A tempting but prohibited object or experience; an unauthorized or illegal indulgence, often of a sexual nature. The Biblical origin of this phrase appears in Genesis 3:3:

But of the fruit of the tree which is in the midst of the garden, God hath said, Ye shall not eat of it, neither shall ye touch it, lest ye die.

The expression has been used figuratively for centuries.

The stealing and tasting of the forbidden fruit of sovereignty. (James Heath, *Flagellum*, 1663)

4. give [one's] eyeteeth To gladly make the greatest sacrifice to obtain a desired end; to yield something precious in exchange for the achievement of one's desire. The eyeteeth, so named because their roots extend to just under the eyes, are the two pointed canines which flank the front teeth of the upper jaw. Since excruciating pain accompanies their extraction, this expression came to imply making a painful sacrifice.

He'd give his eyeteeth to have written a book half as good. (W. S. Maugham, *Cakes & Ale*, 1930)

5. give [one's] right arm To be willing to make a great sacrifice or to endure great pain or inconvenience; to trade something as irreplaceable as part of one's body for an object of desire. In our predominantly righthanded society, to forfeit one's right arm signifies a great loss. This phrase has been popular since the early 1900s. Earlier, in the late 19th century, *willing to give one's ears* was a common expression. It is said to allude to the ancient practice of cutting off ears for various offenses.

Many a man would give his ears to be allowed to call two such charming young ladies by their Christian names. (William E. Norris, *Thirlby Hall*, 1883)

6. go through fire and water To be willing to suffer pain or brave danger in order to obtain the object of one's desire; to undergo great sacrifice or pay any price to achieve a desired end; to prove oneself by the most demanding of tests. The expression is thought to derive from ordeals involving fire and water which were common methods of trial in Anglo-Saxon times. To prove their innocence, accused persons were often forced to carry hot bars of iron or to plunge a hand into boiling water without injury. The phrase is now used exclusively in a figurative sense, as illustrated by the following from Shakespeare's *Merry Wives of Windsor:*

A woman would run through fire and water for such a kind heart. (III,iv)

7. itching palm Avarice, greed, cupidity; an abnormal desire for money and material possessions, often implying an openness or susceptibility to bribery. The expression apparently arose from the old superstition that a person whose palm itches is about to receive money. The figurative sense of *itching* 'an uneasy desire or hankering' dates from the

first half of the 14th century. Shakespeare used the phrase in *Julius Caesar:*

> Let me tell you, Cassius, you yourself
> Are much condemned to have an
> itching palm.
> (IV,iii)

8. make [one's] mouth water To excite a craving or desire, to cause to anticipate eagerly. This expression has its origin in the stimulation of the salivary glands by the appetizing sight or smell of food. Both literal and figurative uses of the phrase date from the 16th century.

> [She would] bribe him . . . to write down the name of a young Scotch peer . . . that her mouth watered after. (Daniel Defoe, *The History of D. Campbell,* 1720)

9. my kingdom for a horse! An expression used when one would gladly trade an obviously valuable possession for one of seemingly lesser worth, usually because the lack of the latter renders the former meaningless or useless. It was the cry of Shakespeare's Richard III at Bosworth Field:

> A horse! A horse! My kingdom for a
> horse!
> (V,iv)

10. wait for dead men's shoes To covetously await one's inheritance; to eagerly anticipate the position or property that another's death will bring. This expression, infrequently used today, derives from the former Jewish custom surrounding the transfer or bequeathing of property, as related in Ruth 4:7. A bargain was formally sealed by removing and handing over one's shoe. Similarly, inheritance due to death was signaled by pulling off the dead man's shoes and giving them to his heir. *Dead men's shoes* was often used alone to indicate the property so bequeathed or so awaited.

11. yen A craving or strong desire; a yearning, longing, or hankering. One theory regarding the origin of this expression claims that *yen* is a corruption of the Chinese slang term *yan* 'a craving,

as for opium or drink.' Another theory states that *yen* is probably an altered form of *yearn* or *yearning*. The term dates from at least 1908.

> Ever get a yen to "take off" a day or two and see the country? (*Capital-Democrat* [Tishomingo, Oklahoma], June 1948)

92. DESPERATION

1. any port in a storm See 135. EXPEDIENCE.

2. at the end of [one's] rope or tether At the end of one's endurance or resources, out of options; exasperated, frustrated. The rope or tether is generally conceded to be that formerly attached to a grazing animal, restricting his movement and area of pasturage.

> He was at the end of his rope when he had consumed all the provender within reach.

3. climb walls To be stir-crazy from confinement; to feel hemmed-in or trapped; to suffer from a lack of options. One who is "climbing the walls" suffers from a claustrophobic feeling of confinement—physical or mental—from which there is no apparent relief. The image is of a person trapped in a room with no doors or windows—the only way for releasing his pent-up energies being to climb the walls.

4. forlorn hope A desperate hope or undertaking; an expedition in which the survival of the participants is doubtful. This phrase is homonymously derived from the Dutch *verloren hoop* 'lost troop,' and formerly referred to the front line of soldiers in a military confrontation:

> Called the forlorn hope, because they . . . fall on first, and make a passage for the rest. (*Gaya's Art of War,* 1678)

5. grasp at straws To seek substance in the flimsy or meaning in the insignificant; to find ground for hope where none exists. In common use since the

18th century, the expression derives from the even older self-explanatory proverb: "A drowning man will catch at a straw."

6. last-ditch Made in a final, desperate, all-out attempt to avoid impending calamity; fought or argued to the bitter end, using every available resource. This expression has the military overtones of continuing one's efforts even though disaster seems imminent and all but the last line of defense (e.g., a ditch or foxhole) has been overcome. Its initial use is credited to William, Prince of Orange, who, in 1672, was asked if he expected to see his country (England) defeated by the French in the war that was raging at the time. He replied, "Nay, there is one certain means by which I can be sure never to see my country's ruin. I will die in the last ditch." He then rejected all offers of peace, intensified his efforts, and was victorious in 1678, not dying in the last ditch, but becoming King William III. A variation, derived from William's quote, is *die in the last ditch.* In contemporary usage, *last ditch* is not limited to military affairs, but is used to describe any all-out, no-holds-barred effort.

> Charlton himself surely was offside before McNab made his last ditch effort to recover the situation. (*The Times*, August 27, 1973)

7. play [one's] last trump This expression has been in use since the early 16th century, and, strangely enough, makes an appearance in the King James translation of the Bible.

> In a moment, in the twinkling of an eye, at the last trump: for the trumpet shall sound, and the dead shall be raised incorruptible, and we shall be changed. (I Corinthians 15:52)

The allusion is to card playing and reducing a player to his final expedient, his last trump. The assumption is that when one is reduced to his last trump he must make the ultimate decision, the one that will decide the outcome of the game. A related term, *put to one's last*

trump, implies that one is put on the spot, one is forced to make a decision here and now.

8. push the panic button To overreact to a situation, to react in a wildly impulsive, confused, or excessive manner, often because of pressures of work. Literally, a panic button is a control button or switch which can trigger the pilot's ejection from an aircraft in an emergency; thus, figuratively, a last resort to be used only when all else has failed.

9. root hog or die Fend for yourself with industry or suffer the consequences; go to work and earn a living. This expression, purely American, dates back at least to the early 19th century, appearing in Davy Crockett's *Autobiography* (1834):

> We are determined to go on the old saying, root hog, or die.

Although Crockett's statement is the first written example of the term cited by the *OED*, its origin is apparently rustic and it may well date from colonial America. The expression seems to be imperative, with *hog* as the predicate of *root* or a direct address (if so, then punctuated as such), but the explanation behind this and the etymology are obscure.

10. tear [one's] hair out To be visibly distressed or agitated; to show signs of extreme anger or anguish. Originally referring to a gesture of mourning or intense grief, this expression, dating from the 16th century, is no longer used literally. It continues to be said, however, of one who is extremely frustrated, or going through an intensely painful emotional experience.

> Sir Ralph the Rover tore his hair
> And curst himself in his despair.
> (Robert Southey, *Inchcape Rock*, 1802)

93. DESTINY

1. clogs to clogs From poverty to wealth to poverty. This expression, a shortened version of an old Lancashire

saying: *clogs to clogs is only three generations,* implies that no matter how much wealth a poor man may acquire, his great-grandson will have fallen back into poverty. The *clogs* in this expression allude to the wooden soled shoes worn by the poor. The famous Scottish-American philanthropist and industrialist Andrew Carnegie put it another way.

Three generations from *shirtsleeves to shirtsleeves.*

Why the process has been assigned to three generations is unknown, but the idea persists into modern times.

From *poverty to riches and back again* in three generations. (Edith Howie, *Murder's So Permanent,* 1942)

2. [one's] cup of tea See 282. PREFERENCE.

3. handwriting on the wall See 254. OMEN.

4. have [someone's] number on it To be the instrument of one's fate, usually the agent which causes someone's death. Apparently this expression originated from a superstition that one need not fear any bullet unless it has one's *number* 'code by which one may be identified' on it.

I'm as safe here as . . . anywhere . . . if it's got your number on it, you'll get it, no matter where you are! (C. Fremlin, *By Horror Haunted,* 1974)

Currently the expression is also heard in broader contexts where the stakes are not always as high as life and death.

5. ill wind that blows nobody good This expression alludes to the wind carrying along or influencing something, especially something spiritual. In use since at least the early 16th century, the phrase suggests that in the infinite possibilities of destiny we often find good and evil existing side by side in the same place. The wind may blow fortune to one and misfortune to another.

FALSTAFF: What wind blew you hither, Pistol?

PISTOL: Not the ill wind which blows nobody to good. (Shakespeare, *Henry IV, Part II,* V,i)

6. in the cards Likely to happen; probable; a sure bet, foreordained; sometimes *on the cards.* The phrase derives from either cartomancy or card playing. The earliest citations are from the beginning of the 19th century.

It don't come out altogether so plain as to please me, but it's on the cards. (Charles Dickens, *Bleak House,* 1852)

7. in the wind Imminent, about to happen; astir, afoot. Dating from the 16th century, this expression may have originally referred to something nearby which can be perceived by means of the wind carrying its scent.

There's a woman in the wind. . . . I'll lay my life on it. (Charles Kingsley, *Westward Ho!,* 1855)

However, *in the wind* refers more often to time than to physical distance.

There must be something in the wind, perhaps a war. (Benjamin Disraeli, *Vivian Grey,* 1826)

8. kiss of death A relationship or action, often appearing good and well-meaning, which in reality is destructive or fatal; the instrument of one's downfall or ruination. This expression is a derivative of the earlier phrase *Judas kiss,* the kiss Judas Iscariot gave Jesus in betraying Him to the authorities in the Garden of Gethsemane and which ultimately led to His death by crucifixion. It has been in use since at least 1948.

Let us hope that the critics' approval does not, at the box-office, prove a kiss of death. (*The Guardian,* December 1960)

See **Judas kiss,** 33. BETRAYAL.

9. lead apes in hell The fate of spinsters. The origin of the myth that old maids would be fated to lead parties of apes about Hell is unknown. It was well-established by the 16th century, and Shakespeare alludes to it in *Much*

Ado about Nothing, when Beatrice comments:

I will even take sixpence in earnest of the bearward, and lead his apes into Hell. (II,i)

A synonym for old maid, *ape-leader*, was coined from this expression.

I will rather hazard my being one of the Devil's Ape-leaders, than to marry while he is melancholy. (Richard Brome, *The Jovial Crew*, 1641)

10. on the knees of the gods Beyond human control or knowledge; wholly dependent upon chance; in the hands of fate.

All is on the knees of the gods. (Homer, *Iliad*)

This expression, dating back to pre-classical Greece, indicates that matters have been taken from mere mortals and placed with the gods. The phrase alludes to the ancient practice of making supplication by grasping the knees of the one being entreated. *On the knees of the gods* and its related phrase *in the laps of the gods* imply that man is helpless before the gods and any attempt to interfere would constitute an act of hubris.

These things surely lie in the laps of the gods. (Homer, *Odyssey*)

Currently the expression is used to imply that everything is up to chance.

Such things are yet upon the knees of the gods. (*Daily News*, August 17, 1900)

11. that's the way the ball bounces See 316. RESIGNATION.

Destitution . . . See 277. POVERTY

Destruction . . . See 108. DOWNFALL; 329. RUINATION; 379. THWARTING

Deterioration . . .
See 86. DEGENERATION

Determination . . .
See 268. PERSEVERANCE

Dialectics . . .
See 24. ARGUMENTATION

94. DICTION
See also 225. LANGUAGE

1. BBC English The speech of the announcers of the British Broadcasting Corporation, generally accepted as the epitome of correct British English pronunciation until the early 1970s, when announcers ("presenters" in England) with regional accents were allowed on the air. The term is often used disparagingly due to its connotations of affectation and pretentiousness:

Critics who enjoy making fun of what they are pleased to call "B.B.C. English" might with profit pay occasional visits to the other side of the Atlantic, in order to hear examples of our language as broadcast where there are no official "recommendations to announcers." (*Listener*, 1932)

The expression is rapidly losing its significance.

2. the King's English Perfectly spoken English; also, *the Queen's English*. The British monarch has long been considered the paragon of flawless diction, notwithstanding the fact that many of the kings and queens spoke with heavy accents. The expression was used in Shakespeare's *Merry Wives of Windsor*:

Abusing of God's patience, and the King's English. (I,iv)

3. Received Pronunciation British English as spoken at Oxford and Cambridge, and in England's public schools; often abbreviated *RP*. This term describes the speech of England's cultured, educated class; it has no dialectal or regional characteristics or boundaries but is recognized throughout the country as the hallmark of the educated Englishman.

Difference . . .
 See 106. DISSIMILARITY

95. DIFFERENTIATION
 See also 267. PERCEPTIVENESS

1. funny-peculiar or funny ha-ha Most often heard interrogatively, this expression serves to distinguish between two meanings of the word *funny*—'peculiar' and 'amusing or humorous.' In 1938, I. Hay used this expression in a play entitled *Housemaster*. Since then, *funny-peculiar or funny ha-ha* has gained currency and is frequently heard today.

2. know a hawk from a handsaw See 267. PERCEPTIVENESS.

3. know chalk from cheese See 267. PERCEPTIVENESS.

4. lay a finger on To identify something clearly and certainly; to discover the true nature of a problem. This expression implies that, rather than merely pointing to something, one actually puts his finger on it, eliminating the possibility of others misconstruing what is meant or indicated. The phrase has been in use since the late 19th century. See also **did not lay a finger on,** 88. DENIAL.

5. make head or tail of To make sense of, to understand or decipher; also *make heads or tails of.* The head and the tail are opposite sides of a coin. Tossing a coin is a common method of deciding by chance; the outcome is determined by which side is up when the coin lands. It is easy to see how a coin landing in such a way that it cannot clearly be called either heads or tails gave rise to the frequently heard negative *not make head nor tail of,* implying confusion and senselessness.

> Pray what is the design or plot? for I could make neither head nor tail on't. (Henry Fielding, *The Author's Farce,* 1729)

6. meum and tuum A Latin phrase meaning 'mine and thine'; that which belongs to me, and that which belongs to another. To tell a man that he does not know the difference between *meum and tuum* is to accuse him of taking what is not his, to call him a thief. The phrase, dating from the Middle Ages, is often expressed as *to confound meum and tuum.*

> I'm afraid you do not distinctly perceive the difference between those important pronouns meum and tuum. (Francis E. Smedley, *Frank Fairleigh,* 1850)

7. that's another story That is quite different from what one might expect; that has become a special situation. This expression is used to indicate an event or incident, in addition to the example cited, upon which the speaker does not care to elaborate. It has been in use since the early 1800s.

> If the scientific man comes for a bone or a crust to *us,* that is another story. (John Ruskin, *Sesame and Lilies,* 1865)

96. DIFFICULTY
 See also 59. COMPLICATION;
 99. DISCOMFORT;
 185. IMPEDIMENT

1. bed of nails An uncomfortable position; a difficult situation. This expression, alluding to the actual bed of nails which Indian fakirs lie on to demonstrate their faith, originally came into use about 1800, fell into disuse shortly thereafter, but returned to popularity because the media gave such extensive coverage to Ray Gunter's use of the term in 1966 to describe the position of Minister of Labour in the British government.

> I asked whether he thought he had been given a bed of nails in his job. He said, "No, it appeals to me as a challenge." (*The Times,* June 8, 1973)

2. dogs in dough A difficult predicament; an ungainly situation; inability to extricate oneself gracefully. This 19th-century expression refers to the stickiness of dough and invokes the image of a dog's inability to disengage himself from a mass of it: if he frees a foot, he must place it back in the dough to lift another foot, *ad infinitum*.

> Like dogs in dough, i.e., unable to make headway. (G.F. Northall, *Folk Phrases*, 1894)

3. a hair in the butter An American cowboy expression for a delicate or ticklish situation. The difficulty of picking a single hair out of butter makes this analogy appropriate.

4. a hard nut to crack A poser, a puzzler, a stumper; a hard question, problem, or undertaking; a difficult person to deal with, a tough cookie; also *a tough nut to crack*.

> You will find Robert Morris a hard nut to crack. (James Payn, *The Mystery of Mirbridge*, 1888)

5. hard row to hoe A difficult or uphill task, a long haul, a hard lot, a tough situation; also *a long row to hoe*. This American expression is an obvious reference to the dispiriting task of hoeing long rows in rocky terrain.

> I never opposed Andrew Jackson for the sake of popularity. I knew it was a hard row to hoe, but I stood up to the rack. (David Crockett, *An Account of Col. Crockett's Tour to the North and down East*, 1835)

6. have [one's] work cut out To be facing a difficult task; about to undertake a demanding responsibility of the sort that will test one's abilities and resources to the utmost; to have one's hands full. This common expression is a variation of the earlier *cut out work for*, meaning simply to prepare work for another, may have a sense that its origins in tailoring; it apparently carried no implications of excessiveness in quantity or difficulty. Perhaps it is the nature of superiors to be exceedingly demanding, or at least for underlings to assume so; in any event, when the expression "changed hands," so to speak, it took on these added connotations, along with the frequent implication that the person who "has his work cut out for him" has more than he can capably manage.

7. hold an eel by the tail To try to grasp something slippery and elusive; to try to control an unmanageable situation; to encounter or deal with a deceitful, unreliable person. In use since the early 16th century, this expression exemplifies what any angler knows: holding an eel by the tail is a near impossibility; the squirmy, twisting, slippery creature will wrench itself from the grasp of anyone who attempts the feat.

> He may possibly take an eel by the tail in marrying a wife. (Thomas Newte, *A Tour in England and Scotland in 1785*, 1791)

8. hot corner Third base in baseball; any difficult position. This term, which by extension has come to specify any situation that is hard to handle, is derived from the game of baseball. Baseball players nicknamed third base the *hot corner* because of the number of "hot" or fast-moving ground balls and line drives which are consistently hit to that spot. The business world, in particular, has picked up the phrase to indicate placement on a difficult job, one that could be too hot to handle.

9. hot potato A controversial question; an embarrassing situation. This familiar saying is of obvious origin.

> The Judge had been distressed when Johnny agreed to take the case, was amazed at first at the way he handled it—hot potato that it was. (Carson McCullers, *Clock Without Hands*, 1961)

The term is often used in the expression *drop like a hot potato*, meaning to swiftly rid oneself of any unwanted thing or person.

They dropped him like a hot potato when they learned that he had accepted a place on the Republican Committee of the State. (B. P. Moore, *Perley's Reminiscences*, 1886)

10. make heavy weather of Find more difficult than anticipated; make a relatively easy task more difficult than necessary; create a fuss about a simple job. The allusion in this British expression is to the stupidity or pessimism of some people over simple situations, such as the person who slogs along a muddy road during a heavy rain storm when he could make his way much more easily along the grassy edge of the highway.

11. Murphy's law This law states that if anything can possibly go wrong, it will, and at the worst possible moment. The term has been in use since at least the 1950s and was devised to describe the futility that is often characteristic of the human condition. There are many corollaries to the law, such as: if one gets in the shower, the phone will ring; if it's going to rain, it will happen on the weekend; if one is going to get the flu, it will occur during one's vacation. A related British term is *Sod's law*.

12. spit cotton To spit with difficulty; to suffer from thirst or embarrassment. This 19th-century Americanism alludes to the white, sticky spittle which forms in the mouth when one is extremely thirsty and one's mouth is unusually dry. Such a phenomenon also often takes place when one is aroused in some way emotionally, as with anger or fear.

The Kansas City vote frauds . . . have Attorney General Tom Clark spitting cotton, they believe. (*Chicago Daily News*, June 14, 1947)A related term, *cotton mouth thirst*, is a thirst which causes one to *spit cotton*, in both the figurative senses.

We were both old hands at the business, had each in our time suffered the cotton mouth thirst. (Stewart E. White, *Arizona Nights*, 1907)

Cotton mouth is also used to refer to a very parched condition of the mouth which frequently occurs the morning after consuming much wine.

13. sticky wicket A difficult predicament; a perilous plight; an awkward situation requiring delicate, cool-headed treatment. This expression, primarily a British colloquialism, alludes to the sport of cricket and describes the tacky condition of the playing field near the *wicket* 'goal' after a rainstorm. Because of the sponginess and sluggishness of the ground, the ball does not roll and bounce as predictably as on a dry field, and the player must therefore adapt to the situation by being exceptionally accurate and careful. The phrase is often used in expressions such as *bat on a sticky wicket, be on a sticky wicket*.

14. ugly customer A disagreeable person who is likely to cause trouble if interfered with; one who may turn vicious if not dealt with carefully; one who is quarrelsome, contentious; a person with whom one feels ill-at-ease. The term originated in reference to those customers of retail establishments whom salespeople found impossible to satisfy. By extension, the term came into general use for anyone difficult to get along with, especially one who might become verbally or physically abusive. The term has been in use since about 1800.

You will find him, my young sir, an Ugly Customer. (Charles Dickens, *Martin Chuzzlewit*, 1844)

A related term, *tough customer* implies that one is demanding but not necessarily unpleasant.

15. venom is in the tail The difficulty lies in the conclusion; the real trouble comes at the end; the danger arises just when one thinks safety is imminent. The allusion in this phrase is to a confrontation with a scorpion, where the real danger lies in the poisonous sting in its segmented tail. The term is also occasionally used in reference to the spur usually

found at the end of each lash on a cat-o'-nine-tails.

> The venom of a scorpion is in its tail, that of a fly in its head, that of a serpent in its fangs; but the venom of a wicked man is to be found in all parts of his body. (Anonymous, *Niti Sastras*, 1250)

16. vicious circle In logic, the proper definition of a *vicious circle* is a situation where the solution to one problem creates new problems which eventually bring back the original problem in a more difficult form. Consequently, the problem goes full circle. The term is often applied figuratively to situations other than those found in logic.

> Thus the practice proceeds, in a vicious circle of habit, from which the patient is rarely extricated without . . . injury to his future health. (Sir Henry Holland, *Medical Notes and Reflexions*, 1839)

A related term is *arguing in a circle*, in which one draws a conclusion, using the conclusion as part of the argument to reach that conclusion.

Dignitary . . . See 269. PERSONAGES

Dilemma . . .
See 281. PREDICAMENT

Diligence . . . See 132. EXERTION; 202. INDUSTRIOUSNESS

97. DIRECTION

1. as the crow flies In a straight line; by the most direct route. This expression stems from the widely held belief that a crow flies in a straight line from one point to another. *Sporting Magazine* used the phrase as early as 1810.

2. bolt upright Straight up; stiffly upright; on end. This expression derives from *bolt* meaning 'projectile, arrow.' It was used as early as 1386 in Chaucer's *Reeve's Tale*.

3. follow [one's] nose See 215. INTUITION.

4. go around Robin Hood's barn To arrive at one's destination by a circuitous route; to proceed in a very roundabout way. The origin of the expression is unknown. It has no logical association with the legendary Robin Hood, who, of course, had no barn, though it may have been formed by analogy with other possessives whose meanings are connected with that figure's exploits: *Robin Hood's mile* 'one several times the recognized length'; *Robin Hood's bargain* 'a cheap purchase.' The expression appeared in print at least as early as the 18th century.

> I can sell them abundantly fast without the trouble of going round Robin Hood's barn. (Mason Locke Weems, *Letters*, 1797)

5. make a beeline See 261. PACE.

6. southpaw A left-hander, especially in baseball or boxing; a portsider; a lefty. This expression probably has its source in baseball. Many early baseball parks were constructed so that the field opened to the east to avoid having the afternoon sun interfere with the batter's vision. Thus, a left-handed pitcher threw with his "southpaw." The term, in common use since about 1890, has, by extension, come to mean any left-hander.

> Bob Henry, a 19-year-old southpaw pitcher from the University of Texas, has been signed by the Chicago Cubs. (*Chicago Daily News*, March 18, 1950)

A related term is *portsider* for a left-hander, adapted from the sailing term for the left side of a boat.

Directness . . .
See 347. SIMPLIFICATION

98. DISADVANTAGE
See also 281. PREDICAMENT;
400. VULNERABILITY

1. behind the eightball At a disadvantage; in a jam or difficult situation. Originally American, this expression is said to have come from the game of Kelly pool. In one variation of this game, all the balls except the black eightball must be pocketed in a certain order. If, in the course of play, another ball strikes the eightball, the player is penalized. Thus, a player finding the eightball between the cueball and the one he intends to pocket is indeed in a disadvantageous position. John O'Hara used the phrase in *Appointment in Samarra* (1934):

> You get signing checks for prospects down at the country club, and you wind up behind the eightball.

2. Buckley's chance A forlorn hope; a remote chance. This Australian expression, dating from the 1850s, is of uncertain origin; however, two plausible explanations exist. The first attributes the term to the famous Melbourne business firm of Buckley and Nunn whose name gave rise to the dreadful pun, "There are just two chances, Buckley's or None." The second and more plausible explanation attributes the term to an escaped convict named Buckley, who dwelt for over thirty years among the Australian aborigines to avoid recapture. Marcus Clarke in his *Stories of Australia in the Early Days* (1897) devotes an entire section to the escaped Buckley.

3. cards stacked against [one] To be at a disadvantage beforehand; to have a rather remote chance of winning. This expression, dating from the late 19th century, originated in card playing where a clever dealer can manipulate the cards in such a way as to facilitate cheating. Figuratively, the term has come to represent any situation where one is almost certain to lose.

> You might make a success of your marriage, but I doubt it. There are

too many cards stacked against you. (Charles Norris, *Bricks without Straw*, 1938)

4. get the short end of the stick See 395. VICTIMIZATION.

5. give cards and spades To put oneself at a disadvantage; to take a chance of losing by granting odds to another. The allusion is to the game of casino where the object of the game is to capture the greatest number of cards and spades. To give another a certain number of the cards and spades before the game is, of course, to place oneself at a disadvantage. The term appears as early as 1870.

> He found a Chinaman . . . who could give him cards and spades and beat him out. (*The* [Toronto] *Grip*, May 1888)

6. have two strikes against [one] To be at a disadvantage, and thus have less chance of successfully reaching one's goal or following through with one's plans. This expression comes from baseball, where a batter has three chances to hit a ball in the strike zone. Sometimes this expression alludes to a disadvantage over which one has no control, such as one's sex, race, or ethnic background.

7. on the hip At a disadvantage, in an extremely vulnerable or helpless position, over a barrel. There is some dispute as to whether this expression derived from hunting or from wrestling. The wrestling theory seems more plausible and is supported by the *OED*. The phrase, now archaic, dates from the latter half of the 15th century. It appeared in Shakespeare's *The Merchant of Venice*:

> If I can catch him once upon the hip,
> I will feed fat the ancient grudge I
> bear him.
> (I,iii)

8. play into the hands of To do something, usually carelessly or unwittingly, that will give an advantage to an opponent or rival; to put oneself at a disadvantage with another. This phrase, dat-

ing from the late 18th century, owes its derivation to a game of cards where if by chance one leads the wrong card or follows carelessly, he may *play into the hands of* his opponents.

> I suspect the clerk of the kitchen and my steward of playing into one another's hands. (Alain R. LeSage, *Gil Blas*, 1715)

A related term, *fall into the hands of*, refers to one who has been captured, either physically or emotionally.

> Woman would be more charming if one could fall into her arms without falling into her hands. (Ambrose Bierce, *Epigrams*, 1906)

9. play with loaded dice To undertake a project or other matter in which the odds are against success; to have little chance. Literally, loaded dice are those which have been fraudulently weighted to increase the chances of throwing certain combinations—usually losing ones—in craps or other games of chance. Figuratively, then, to *play with loaded dice* is to engage in some undertaking in which the odds are fixed so that there is little chance of success. A related expression, *play with a stacked deck*, has the same implications and refers to cheating by stacking a deck of cards, i.e., arranging them in a certain order to force a desired result.

10. raisin in the sun Something or someone in a difficult situation or at a decided disadvantage; a person in an inferior position. This expression gained popularity from the Lorraine Hansberry hit play, *A Raisin in the Sun*, which won the New York Drama Critics Circle Award for the 1958–59 theatre season. Miss Hansberry took her title from a 1951 Langston Hughes poem, *Montage of a Dream Deferred*:

> What happens to a dream deferred?
> Does it dry up
> like a raisin in the sun?
> fester like a sore—
> and then run?
> . . .

> Maybe it just sags
> Like a heavy load.
> Or does it explode?

11. suck the hind teat See 395. VICTIMIZATION.

12. underdog A person in an inferior position; one who is expected to be defeated in a race, election, etc.; a dark horse. This expression may allude to a canine skirmish, in which both dogs vie for the more advantageous top position. The familiar phrase, while retaining its sense of an unlikely victor in a competition, is often used today to describe the victim of social conventions, government bureaucracy, and other virtually omnipotent institutions.

> The mission of the Democratic party is to fight for the underdog. (*Daily Chronicle*, June 1892)

13. wrong side of the tracks The poorer section of town; the area of the lower social classes. In many American towns in the late 1800s and early 1900s, the railroad tracks created a dividing line. The power and influence of the more affluent classes were used to convince the railways to construct their yards and warehouses in the less affluent sections of towns. Furthermore, new construction of houses by the middle and upper classes took place away from the noise and squalor of the railroad. Hence the figurative sense of the term, i.e., 'to be born into or to come from an inferior social group.'

> He was brought up on the wrong side of the tracks. (McKnight Malmar, *Never Say Die*, 1943)

Disappointment . . . See 87. DEJECTION; 141. FAILURE

Disapproval . . . See 78. CRITICISM; 101. DISFAVOR; 213. INSULT

Disarray . . . See 103. DISORDER

Discernment . . .

See 267. PERCEPTIVENESS

Disclosure . . . See 137. EXPOSURE

99. DISCOMFORT
See also 181. ILL HEALTH

1. agony column A newspaper column containing advertisements about lost or missing relatives and friends. The practice of running a special column in the newspaper for those who are missing began in Great Britain about 1870. These columns came to be called *agony columns* because each ad represented personal anguish for some unhappy individual.

> I read nothing except the criminal news and the agony column. The latter is always instructive. (Sir Arthur Conan Doyle, *The Noble Bachelor*)

2. ride bodkin To ride squeezed in between two other people in a seat designed for two. This expression, in use since at least the 1600s, has its roots in the original meaning of *bodkin*, a small dagger. The suggestion is that one is so slim, like a dagger, that his body will fit between two others; however, the usual result of *riding bodkin* is to cause great discomfort for all.

> Between the two massive figures . . . was stuck, by way of bodkin, the slim form of Mary McIntyre. (William Thackeray, *Vanity Fair*, 1848)

Related terms are *lie bodkin*, to lie in bed wedged in between two other people; and *sit bodkin*, to sit squeezed in between two others.

3. say an ape's paternoster This British expression, dating from the early 1500s, is usually said to one whose teeth are chattering either from the cold or from fright. The allusion, of course, is to the chattering noises that apes make. Occasionally, the term is also used to indicate a piece of nonsense. Rabelais in his

Library of St. Victor entitled one of the books *The Ape's Paternoster*.

4. sting to the quick To hurt someone's feelings; to injure one's innermost sensitivities. The allusion in this phrase is to cutting through the layer of skin to the living tissue, the sensitive part most susceptible to pain. *Quick*, in one of its meanings, refers to living tissue, especially that tender part that lies under the nails. The phrase has been in use since at least the 16th century.

> This stung the elder brother to the quick. (Daniel DeFoe, *Moll Flanders*, 1722)

100. DISCONTINUITY

1. lose the thread To lose one's train of thought in a discussion; to have the continuity of one's thoughts or words interrupted. *Thread* in this phrase is the central thought connecting successive points, a continuous flow which is carried on in spite of digressions or interruptions. This figurative use of thread dates from the mid-17th century.

> We laughed so violently . . . that he could not recover the thread of his harangue. (Frances Burney, *Diary and Letters*, 1782)

2. sidetrack To diverge from the main subject, course, or road; to go off on a tangent; to shelve or otherwise delay consideration of some matter. Literally, to *sidetrack* means to shunt a train onto a siding, off the main track, hence its figurative implications.

> The business of the minister is to preach the gospel, not . . . to sidetrack on great moral issues. (*Advance* [Chicago], June 1893)

A related expression which also employs railroad terminology is *off the track*.

Discord . . . See 105. DISSENSION

Discouragement . . .

See 87. DEJECTION

Discovery . . . See 9. ADVANTAGE

Discredit . . . See 101. DISFAVOR

Disdain . . . See 171. HAUGHTINESS

101. DISFAVOR

1. **bad hat** A bounder; a rascal. *Hat* has been a common slang expression for a man since the early 1800s; hence, a bad hat is a euphemistic way of referring to one who does not quite qualify as a criminal.

> He's more than the usual thoroughgoing bad hat. (Ngaio Marsh, *Vintage Murder*, 1940)

2. **black sheep** One who is rejected and scorned as a result of being different from other members of a group; a disreputable character, a bad apple. In a flock of white sheep, a black sheep represents an undesirable deviation from the norm. Some say shepherds dislike the black sheep because of its lesser value; others say because it is an eyesore; still others associate black with badness, evil, and the devil. The label is applied to any person who has flagrantly violated or even slightly deviated from the social norms of a particular group. A black sheep is considered a disgrace and is therefore ostracized from the group. Black sheep have been considered objectionable creatures for at least four centuries:

> Till now I thought the proverb did but jest,
> Which said a black sheep was a biting beast.
> (Thomas Bastard, *Chrestoleros*, 1598)

3. **blot on [one's] escutcheon** A blemish on one's reputation. During the Middle Ages when the rules of chivalry prevailed, it was common practice for titled noblemen to display their coats of arms upon their *escutcheons*, the faces of their shields. These escutcheons became moral representations of their bearers; hence, to say that one had a *blot upon his es-*cutcheon or his 'scutcheon was a comment upon his personal honor.

> A poor relation is an odious approximation—a preposterous shadow . . . —an unwelcome remembrancer—a rebuke to your rising—. . . a blot on your 'scutcheon . . . (Charles Lamb, *Poor Relations*, 1823)

In 1843 Robert Browning produced a three act tragedy entitled *Blot in the 'Scutcheon*, a tale of tainted love and moral dishonor.

4. **blue belly** A derogatory term used to designate policemen, cavalry troops of the Old West, and members of a superior social set. This expression, dating from the early 1800s, alludes to the blue uniforms of the police and cavalry. Apparently its use as a symbol of the superior social set was by transference from *blue blood*. Seldom heard today, this denigrating phrase was in common use among Southerners in reference to Union soldiers, who wore blue uniforms.

> Well, them bodies has got to be hid, or we'll have the tribe and the blue bellies from the fort a-scouring the hills. (Rex Beach, *Pardners*, 1905)

> No highfalutin' airs here, you know. Keep that for them Blue-bellies down East. (Thomas Gladstone, *An Englishman in Kansas*, 1857)

5. **foul ball** One whose personal philosophy or behavior is unacceptable to the mainstream of society; a nonconformist or eccentric. In baseball, a foul ball is one outside the field of play, which is hit or rolls outside of the designated "fair" area. The transference of this expression to an individual whose principles are outside the realm of established social standards is apparent.

6. **hit list** Any list of people in disfavor with someone in power; literally, a list of those scheduled to be murdered, usually by the hit man or hired gun of a crime syndicate. This 20th-century Americanism was originally gangster lin-

go but is no longer limited to under-world use.

7. hold no brief To be no advocate or supporter of someone or something; to be against. A *brief* is a lawyer's summary of a case he is to take to trial. Hence, to *hold a brief* is to be retained as an attorney and thus have a stake in a case; to *hold no brief* is the opposite. However, when the term is presented in its figurative sense, it always demands the negative, i.e., to show no interest in, or to demonstrate no support of a situation.

> When I was at Balliol, we used to adapt the phrase 'I hold no brief for So-and-So.' (R. A. Knox, *Spiritual Aeneid*, 1918)

8. in bad odor Out of favor; in bad estimation; in the doghouse. This expression implies that a person's reputation is presently so disgraceful that he is no longer welcome in his usual social group, or any other group, for that matter. A variant is *in ill odor*.

> When a person is in ill odour it is quite wonderful how weak the memories of his former friends become. (Charles H. Spurgeon, *The Treasury of David*, 1886)

9. in [someone's] black books Out of favor; in disgrace. Nicholas Amherst, in his *Terrae Filius: or The Secret History of the University of Oxford* (1721), speaks of the college's black book, pointing out that no student whose name appeared there could receive a degree.

10. in Dutch In trouble, in disgrace, out of favor, in the doghouse; often in the phrase to *get in Dutch*. No satisfactory explanation has yet been offered as to why one gets in Dutch as opposed to some other nationality, although this expression may have some connection with the older phrase to *talk to [someone] like a Dutch uncle*. This American slang term has been in use since at least 1912. See also **talk to like a Dutch uncle**, 312. REPRIMAND.

11. in the doghouse In disfavor or disgrace. Though most commonly applied to misbehaving husbands, the phrase also refers to general disaffection or rejection:

> Several big stars are in studio doghouses because of their political affiliations. (*Daily Ardmoreite* [Ardmore, Oklahoma], April 19, 1948)

This figurative use is considered American in origin, though in James M. Barrie's *Peter Pan* (1904) Mr. Darling literally lived in a doghouse as penance until his children returned from Never Never Land. He was responsible for their departure since he had chained up their nurse-dog, Nana, the night they ran off with Peter Pan.

12. lose face Feel that one has been treated with disrespect; have one's dignity affronted; lose esteem in the eyes of others. The implication in this expression, of Oriental derivation, is that *face* is representative of one's reputation or good name. Since family matters play such an important role in Oriental life, the business of *losing face* assumes major significance. The phrase was brought from eastern Asia during the mid-1800s and has become a common expression throughout the English speaking world.

> Even formal Japanese government committees . . . work more by general consensus than by formal votes, in which someone would lose face by being voted down. (Vera Dean, *The Nature of the Non-Western World*, 1957)

A related term, *save face*, does not seem to occur in the Chinese language, but rather was devised by the English-speaking communities of China to describe the practices used by the Chinese to avoid imposing disgrace or incurring loss of dignity.

13. [one's] name is mud A discredited or disreputable person; one who is ineffective, not respected, or untrustworthy; one held in low esteem; a pariah. In this

expression, *mud* implies the worst part of something, the dregs, scum. Since many people consider their name (with its attendant reputation and other abstract qualities) their most important possession, they are loath indeed to have it likened to mud.

> If tha' doan't put ring on finger shortly, my lad, tha' name will be mud in Mountaindale. (D. Robins, *Noble One*, 1957)

14. out of [one's] books In disfavor; out of one's esteem or friendship. This expression, dating from about 1500, takes its connotation from an old sense of the word *book*. Originally, *book* denoted any piece of writing, no matter how brief; hence, a list of one page might be considered a book. Therefore, to be *out of one's books* is to be off one's list of friends.

> So odious to him and far out of his books. (Bishop Miles Smyth, *Sermons*, 1624)

A variant, *in one's bad books*, is a more recent form but carries the same connotation.

> At that time they were in his bad books. (William Perry, *History of the Church of England*, 1861)

Disgrace . . . See 101. DISFAVOR

Disguise . . . See 61. CONCEALMENT

Dishonesty . . . See 176. HYPOCRISY; 236. MENDACITY; 389. UNSCRUPULOUSNESS

Dishonorableness . . . See 389. UNSCRUPULOUSNESS

102. DISILLUSIONMENT

1. burst [someone's] bubble To disabuse; to open someone's eyes; to shatter someone's illusions; also *pop* or *break [someone's] bubble* and to *prick* or *put a pin in [someone's] balloon*. This expres-

sion refers to the fragile nature of both soap bubbles and human illusions.

2. come out at the little end of the horn To be cheated or swindled in a deal; to fail in an enterprise, especially after boasting that one would make enormous gains from the venture. Pictures of a man being squeezed through a horn were rather common in the 15th and 16th centuries, especially to demonstrate the dangers of financial commitment. These pictures apparently contributed considerably to the popularity of the phrase. The expression's contemporary usage aften carries an implication of naiveté on the part of the person being squeezed.

> How did you make it? You didn't come out at the little end of the horn, did you? (William T. Porter, *Big Bear of Arkansas*, 1847)

3. cut the ground from under See 329. RUINATION.

4. Dead Sea Fruit Anything that appears useful or worthwhile, but upon closer examination proves useless or worthless; anything disappointing.

> Like Dead Sea fruits that tempt the eye
> But turn to ashes on the lips.
> (Thomas Moore, *Lalla Rookh: The Fire-Worshippers*, 1817)

Dead Sea fruit, or the *apples of Sodom*, are a beautiful, yellow fruit growing on trees along the shores of the Dead Sea. However, they are filled with tiny black seeds which feel like ashes in the mouth and are bitter to the taste.

5. everything tastes of porridge An expression used to inject a note of reality into our daydreams. The point is that no matter how grandiose our schemes or how successful our self-delusions, the taste of porridge or the reality of our domestic affairs will always be there to impinge on our fantasies. Porridge, formerly a staple in every household, is a most appropriate symbol of the practical, basic nature of home life.

6. Pagett, M. P. This expression was coined by Rudyard Kipling for the poem of the same name. Pagett has come to represent the type of person who takes a whirlwind tour of a country and returns home flaunting absolute knowledge of the country and its people. In the poem, Pagett, M. P. comes to India to gain knowledge of its problems, but the heat and insects drive him from the country before his inspection tour is finished.

> And I laughed as I drove from the station, but the mirth died out on my lips
> As I thought of the fools like Pagett who write of their "Eastern Trips,"
> And the sneers of the traveled idiots who duly misgovern the land,
> And I prayed to the Lord to deliver another one into my hand.
> (Rudyard Kipling, *Pagett, M. P.*, 1886)

7. pull the rug out from under See 329. RUINATION.

Disinterestedness . . .
See 199. INDIFFERENCE

Disloyalty . . . See 33. BETRAYAL

Dismissal . . . See 138. EXPULSION; 310. REJECTION

103. DISORDER
See also 63. CONFUSION; 155. FRENZIEDNESS

1. all shook up Excited; agitated; stimulated; shaken with worry or concern. This American slang expression came into the language about 1955 from the world of rock and roll music. It was given major impetus in 1958 when Elvis Presley recorded a hit song of that name; teenage slang has kept the term current since that time, along with a shorter version *shook up*.

> I lay back on my lumpy mattress in the reformatory so shook up I could not sleep. (*Life*, April 28, 1958)

2. at sixes and sevens In a state of disorder and confusion; higgledy-piggledy; unable to agree, at odds. Originally *set on six and seven*, this expression derives from the language of dicing and is said to be a variation of *set on cinque and sice*. This early form of the expression dates from the time of Chaucer when it often applied to the hazardous nature of one's fate in general. By the 18th century, the plural *sixes* and *sevens* was standard; earlier, the expression had undergone other changes: the verb *set* was dropped, *at* replaced *on*, and the applicability of the expression broadened to accommodate any situation or state of affairs. Although the *OED* authenticates the dicing theory as the source of this expression, many stories—some more plausible than others—have been related to explain its origin.

> If I was to go from home . . . everything would soon go to sixes and sevens. (Mrs. Elizabeth Blower, *George Bateman*, 1782)

3. bollixed up Thrown into disorder or confusion; chaotic, topsyturvy; messed up, bungled, flubbed. *Ballocks* 'testes' dates from 1000 and its variant *bollocks* from 1744. *Bollix* is close in pronunciation and related in meaning to *bollocks* although the former is used as a verb and the latter only as a noun. As a verb, *bollix* is akin to *ball up* 'make a mess, bungle.' The change in meaning from 'testes' to 'confusion, nonsense' is itself confusing and is a relatively recent development (late 19th century). *Bollix* and *bollixed up* date from the early 1900s.

> Watch your script. . . . You're getting your cues all bollixed up. (J. Weidman, *I Can Get It For You Wholesale*, 1937)

4. catch-as-catch-can See 388. UNRESTRAINT.

5. confusion worse confounded See 127. EXACERBATION.

6. Fred Karno's army A motley, disorganized group, a disorderly mob. The origin of this phrase can be traced directly to Fred Karno, a music-hall comedian, who incorporated into one of his acts a burlesque army. This army became a symbol of any milling, churning throng of people with little or no apparent purpose. In 1913 Karno brought his army in *A Night in an English Music Hall* to New York City; among his company of players were Charlie Chaplin and Stan Laurel. A related American term is *Coxey's Army*. Coxey led a large group of unemployed workmen to Washington, D.C., in 1894 to appeal to Congress for unemployment relief. The American term is seldom heard today except among the elderly.

Men and generals between them have made up 'Coxey's Army' and a very misty, queer, mixed up lot they are. (*Life*, May 10, 1894)

7. go haywire To go out of control, to go awry, to run riot; to go crazy, to go berserk, to go out of one's mind. One source hypothesizes that the phrase derived from the unmanageability of the wire used in binding bales of hay. More reputable sources see its origin in the adjective *haywire* 'poor, rough, inefficient' (from the use of haywire for makeshift or temporary repairs). The phrase dates from at least 1929.

Some of them have gone completely haywire on their retail prices. (*The Ice Cream Trade Journal*, September 1948)

8. a hell of a way to run a railway In a state of confusion and disorder; in chaotic disarray; in a disorganized manner; in a jumbled mess. This expression grew in national prominence after it appeared as a cartoon caption in a 1932 edition of *Ballyhoo* magazine. In the cartoon a railroad signalman makes this flippant remark as he looks down from his control tower upon two trains which are about to crash head-on. In modern use the term alludes to a lack of clear-cut leadership, or the chaos created when

two strong leaders attempt to take people in opposite directions. An excellent example of the latter use was made during the conflict between General MacArthur and President Truman over the extent of American aggressiveness toward China during the Korean War.

It is, in the idiom of Missouri, a hell of a way to run a railway. (Arthur Schlesinger, Jr. and Richard Rovere, *The General and the President*, 1951)

9. higgledy-piggledy In a confused state; topsy-turvy; helter-skelter. This amusing expression may have derived from the disheveled appearance of a pig sty.

In a higgledy-piggledy world like this it is impossible to make very nice distinctions between good luck and good work. (*Daily News*, January 1890)

10. hugger-mugger See 332. SECRECY.

11. hurly-burly Tumult; disorder; great noise or commotion. This expression, immortalized by the Weird Sisters in *Macbeth* (I.i),

When the hurly-burly's done, When the battle's lost or won.

is of uncertain origin. It may be a reduplication of the Middle English *hurlen*, 'to be driven with great force,' but the *OED* questions this derivation since the earliest written use of *hurly-burly* yet discovered is 1539, whereas the earliest written use of *hurly* is 1596. At any rate, the term is still in everyday use.

Nor could such a Deity ever have any quiet enjoyment of himself, being perpetually filled with tumult and *hurly-burly*. (Ralph Cudworth, *The True Intellectual System of the Universe*, 1678)

12. hurrah's nest A confused jumble, an unholy mess. The first recorded use of this expression (*hurra's nest*) appears to have been in Samuel Longfellow's biography of his poet-brother (1829). No clear explanation of its origin has been

found, though it seems likely the term is related to the matted, tangled branches of the hurrah bush. S. W. Mitchell in an 1889 issue of *Century Magazine* parenthetically defined a *hurrah's nest* as:

> a mass of leaves left by a freshet in the crotch of the divergent branches of a bush.

By that time, however, the expression had already attained its figurative meaning.

> Everything was pitched about in grand confusion. There was a complete hurrah's nest. (R. H. Dana, *Two Years Before the Mast*, 1840)

13. kettle of fish A confusing, topsy-turvy state of affairs; a predicament; a contretemps. Literal use of this originally British expression refers to the kettle of fish served at a riverside picnic, and by extension, to the picnic itself.

> It is customary for the gentlemen who live near the Tweed to entertain their neighbours and friends with a Fete Champetre, which they call giving "a kettle of fish." Tents or marquees are pitched . . . a fire is kindled, and live salmon thrown into boiling kettles. (Thomas Newte, *A Tour in England and Scotland in 1785*, 1791)

Some believe that *kettle* is a corruption of kiddle 'a net placed in a river to catch fish.' However, neither this suggestion nor the many other theories offered to account for the figurative use of *kettle of fish* are plausible.

> Fine doings at my house! A rare kettle of fish I have discovered at last. (Henry Fielding, *The History of Tom Jones*, 1749)

Fine, pretty, nice, and *rare* are frequently heard in describing *kettle of fish*. Ironic use of these adjectives serves to highlight the implied confusion and disorderliness.

14. make a hash of To botch, spoil, or make an unholy mess of. *Hash* is literally a hodgepodge of foods cooked together. By extension, it applies to any incongruous combination of things; and carried one step further, *make a hash of* is to inadvertently create a confused chaotic mess in an attempt to deal with the particulars of a situation or plan.

> Lord Grey has made somewhat of a hash of New Zealand and its constitution. (R. M. Milnes Houghton, *Life, Letters, and Friendships*, 1847)

15. mare's nest A state of confusion or disarray; a spurious and illusionary discovery. A mare's nest would indeed be a bogus discovery since horses do not display nesting habits.

> Colonel S.'s discovery is a mere mare's nest. (*The Times*, October 1892)

Perhaps as an allusion to the bewilderment which would accompany the finding of a *mare's nest*, the expression now denotes a jumbled or chaotic state of affairs.

16. the natives are restless An expression used to denote an unfriendly or dissatisfied audience or a disgruntled group of workers or students. This phrase is often used to explain one of those mysterious days when, for no apparent reason, an attitude of uneasiness and general unrest seems to pervade a sizeable group of people. The term has been common since about World War II and probably owes its popularity to its frequent use as a stereotyped scene in adventure films depicting the nervousness of, say, an African safari when it encounters a large and suspiciously hostile-looking native tribe. John Crosby, in *The White Telephone* (1974), writes of some lesser Federal agents who are eager to get started on an important case and have been troubling the President's secretary.

> The President picked up the phone. "The natives are getting restless," said Miss Doll.

17. no-man's-land An area, literal or figurative, not under man's control; a

scene of chaos or disorder; a desolate, hostile, or uninhabitable tract of land.

> Until the Dutchman Yermuyden came to the scene . . . to control . . . the river Great Ouse . . . much of the region was a marshy no-man's-land through which . . . the only means of transport was by boat. (*Country Life,* June 1975)

The expression is used in a similar sense to describe a land area sandwiched between two contending armies. Recently, however, *no man's land* acquired the new figurative meaning of a sphere of human undertaking marked by complexity and confusion.

> One question chased another . . . question that got lost in a no-man's-land of conjecture. (H. Carmichael, *Motive,* 1974)

18. out of joint Disordered, confused; out of kilter. In literal use, this phrase describes a dislocated bone. Figuratively, *out of joint* applies to operations, conditions, and formerly, to individuals in relation to their behavior. The phrase has been in print since the early 15th century, and is especially well known from Shakespeare's *Hamlet:*

> The time is out of joint. Oh cursed spite
> That ever I was born to set it right!
> (I,v)

19. out of kilter Out of working condition; out of order. This American expression refers to either machinery or the human body. The implication is that some small part is malfunctioning; therefore, the whole apparatus is running unevenly. The British equivalent of *kilter* is *kelter,* a form that predates American usage by at least 150 years. The date of origin is unknown; the *OED* lists the first written use as:

> Their Gunnes . . . they often sell many a score to the English, when they are a little out of frame or kelter. (Roger Williams, *A Key Unto the Language of America,* 1643)

20. pellmell See 187. IMPETUOUSNESS.

21. the right hand doesn't know what the left hand is doing Confusion, disorder, disarray. Now used derogatorily to indicate a lack of coordination, organization, or direction, in its original New Testament context (with hands reversed) the phrase denoted a desirable state. In his Sermon on the Mount, Jesus tells His listeners not to broadcast their good deeds, but to keep them to themselves:

> But when thou doest alms, let not thy left hand know what thy right hand doeth: that thine alms may be in secret. (Matthew 6:2–4)

The current meaning apparently stems from the fact that in different circumstances keeping something to oneself is undesirable, leading to a lack of communication, which in turn brings on chaos, confusion, and disorganization.

22. run riot To act in disorderly fashion; to go haywire; to run out of control. This expression arose in England during the Middle Ages to describe the actions of a pack of hunting dogs that had lost the scent of the game, and therefore were running wild. It was a simple step to transfer the actions of unruly dogs to those of a disorderly group of people.

> They ran riot, would not be kept within bounds. (Lord Chesterfield, *Letters,* 1748)

23. shambles A scene of slaughter; disorder; confusion; a slave market. Originally a *shamble* was a footstool, but in time the word came to signify the low tables butchers used to display their wares in a public market place. By the 14th century the *shambles* signified the slaughterhouse and market itself. The destruction and disorder so evident in the *shambles* soon led to the figurative use of the expression for any scene of carnage or of disarray.

> I've feared him; since his iron heart endured

To make of Lyon one vast human
shambles.
(Samuel Coleridge, *Robespierre*,
1794)

During the period in American history
preceding the Civil War, the term also
signified a slave market.

An older sister went to the shambles
to plead with the wretch . . . to
spare his victims. (Harriet Beecher
Stowe, *Uncle Tom's Cabin*, 1852)

Today the word is used almost exclu-
sively to indicate ruination, both physi-
cal and mental.

24. topsy-turvy Upside-down, helter-
skelter, in a state of utter confusion and
disarray. The expression appeared in
Shakespeare's *I Henry IV*:

To push against a kingdom, with his
help
We shall o'erturn it topsy-turvy down.
(IV,i)

Although the expression is of obscure ori-
gin, etymologists have conjectured that
its original form was *topside, turnaway*,
from which evolved *topside-turvy*, and
then finally *topsy-turvy*. The modern
form, dating from 1528, retains its figu-
rative meaning of dislocation or chaos.

A world of inconsistencies, where
things are all topsy-turvy, so to speak.
(Robert M. Ballantyne, *Shifting
Winds*, 1866)

Disorientation . . .
See 63. CONFUSION

104. DISPOSAL

1. deep-six To destroy, discard, or hide
embarrassing or incriminating material;
to reject or shelve an unwanted proposal
or project; to get rid of anything unde-
sirable. Originally an informal U.S.
Navy expression for burial at sea, *deep-
six* referred to the regulation that the
water at the burial site had to be at least
600 feet (100 fathoms) deep. Eventually,
deep-six referred to throwing anything
overboard. Also, since many states re-

quire that the dead be buried at least six
feet underground, *deep-six* sometimes
referred to any burial. Thus, *deep-six*
usually means to put a rejected object,
scheme, matter, etc., in a place where it
will receive little, if any, further notice
and will be, figuratively, if not literally,
buried. Since the Watergate scandal and
trial (1971–75), however, *deep-six* often
implies a political coverup, that which is
deep-sixed being not merely undesirable,
but politically sensitive and potentially
dangerous as well.

To destroy all incriminating
documents, [the Watergate
conspirators] . . . planned to deep-six
a file in the Potomac. (Jack Anderson,
New York Post, August 22, 1973)

2. file 13 A wastebasket; a figurative
place where something will receive no
further consideration. This expression
enjoyed limited popularity during
World War II. It has, for the most part,
been replaced in contemporary usage by
circular file. The use of "13" probably
stems from the negative qualities associ-
ated with that number by superstitious
people, and its consequent omission in
number sequences denoting floors,
rooms, restaurant tables, etc. Thus, to
put something in *file 13* is to put it in a
nonexistent place.

Disruption . . .
See 100. DISCONTINUITY

105. DISSENSION

1. apple of discord An object or source
of dispute; a bone of contention. Eris,
Greek goddess of discord, angry at not
having been invited to the wedding of
Peleus and Thetis, sought to foment dis-
cord among the wedding guests. She
threw into their midst a golden apple in-
scribed "for the fairest." When Hera,
Pallas Athena, and Aphrodite each laid
claim to the apple, Paris was called upon
to decide the issue. He awarded the ap-
ple to Aphrodite, thus bringing upon
himself the vengeance of the other two

goddesses, to whose spite is attributed the fall of Troy.

2. at loggerheads At odds, in disagreement, quarreling. Although numerous explanations have been offered, the origin of this expression remains obscure. The *OED* suggests that a loggerhead (a long-handled instrument for melting pitch and heating liquids) may have been formerly used as a weapon.

> I hear from London that our successors are at loggerheads. (John W. Croker, *The Croker Papers*, 1831)

3. at sixes and sevens See 103. DISORDER.

4. bone of contention A subject of disagreement or dispute; a cause of discord. This expression is an expanded version of the simpler *bone* from the phrase *cast a bone between.* The discord created when a single bone is thrown among several dogs is the obvious source.

5. a crow to pluck A dispute or disagreement; a bone to pick. Of unknown origin, this expression appeared as early as 1460 in the Towneley mysteries; its earliest version was *a crow to pull.*

> No, no, abide, we have a crow to pull.

6. have a straw to break Have a dispute to settle with someone; have something to quarrel about with another. This phrase had its inception in a feudal practice of the Middle Ages. A lord, when granting a fief to a new tenant, would give him a straw as a symbol of possession. If the vassal violated the terms of the agreement in any way, the lord would break their contract by appearing at the threshold of the tenant's door and breaking a straw, saying simultaneously, "As I break this straw, I break my contract with you." Shakespeare makes allusion to the expression in Hamlet, IV,iv:

> . . . Rightly to be great
> Is not to stir without great argument,
> But greatly to find quarrel in a straw
> When honour's at the stake.

7. quarrel with [one's] bread and butter Act against one's own best interests; quarrel with one's means of earning a living. The allusion in this phrase is to the essentials of life, one's *bread and butter,* or one's principal source of income, or means of livelihood. The term has been in use since about 1738.

> Edgar had shown his wisdom in not "quarreling with his bread and butter." (James Payne, *Thicker Than Water,* 1883)

8. sow dragon's teeth See 294. PROVOCATION.

106. DISSIMILARITY

1. another breed of cat Somebody different from the rest of the community; a person whose tastes and actions run contrary to the ordinary; a bohemian. This expression, obvious in its implication, is generally employed as a term of derision to describe someone who chooses to march to the beat of a different drummer.

2. another pair of shoes Another matter; a different state of things. This British expression, dating from the early 1800s, is alleged to be a distortion of the French *Tout à fait une autre chose,* 'that's quite another matter.' It seems more likely, however, that it is simply an alteration of the French expression *une autre paire de manches,* 'another pair of sleeves,' which dates from the 1600s.

> "That sir," replied Mr. Wegg, "is quite another pair of shoes." (Charles Dickens, *Our Mutual Friend,* 1865)

A variant is a *different pair of shoes.*

3. apples and oranges Unlikes; any two sets of objects, items, concepts, or ideas of essentially different natures, such as to render comparison meaningless or combination impossible. As used in context, this commonly heard phrase implies an inability to perceive crucial distinctions; it is often employed to counter an argument or destroy an opponent's

point. Its origin is unknown; but the longer, less-frequently heard *you can't add apples and oranges* suggests that its antecedents may lie in grade-school arithmetic problems requiring children to perform various mathematical functions in terms of concrete objects or associations.

4. a far cry Very different, totally dissimilar; a long way, a good distance away; usually *a far cry from.* This expression, which dates from 1819, probably derived from a crude means of measuring distance, such as how far away one's cry or call could be heard. The phrase appeared in *Tait's Magazine* (1850):

> In those days it was a "far cry" from Orkney to Holyrood; nevertheless the "cry" at length penetrated the royal ear.

5. a horse of another color Something totally different; something else altogether. Precisely why the color of a horse should be indicative of the essence of a matter is somewhat puzzling, but the phrase has existed in the language for several centuries. *A horse of a different color* is heard equally often today, but the variation *a horse of the same color* has little frequency. In Shakespeare's *Twelfth Night*, Maria, scheming with Sir Andrew and Sir Toby against Malvolio, says:

> My purpose is indeed a horse of that color. (II,iii)

Today the expression denotes difference almost exclusively, but it remains popular at all levels of speech and writing.

> A horse of a somewhat different colour is that tycoon of the brush, popman Salvador Dali. (*The Listener*, May 1966)

Dissipation . . . See 83. DECADENCE; 86. DEGENERATION

Distance . . . See 139. EXTENT

Distinction . . .
See 6. ACCOMPLISHMENT

Distinctiveness . . .
See 200. INDIVIDUALITY

Distress . . . See 99. DISCOMFORT

Districts . . . See 227. LOCALITIES

Docility . . .
See 362. SUBMISSIVENESS

107. DOMINATION
See also 69. CONTROL;
232. MANIPULATION;
395. VICTIMIZATION

1. browbeat To intimidate by stern looks or words; to bully; to push around. Dating from about 1600, this term refers to the brows of the beater and not the beaten, as is commonly supposed today. However, it is unclear whether *to beat* in the expression means to beat figuratively with one's brows or 'to lower' one's brows at, i.e., to frown at.

2. Captain Bligh One who rules with an iron hand; a strict disciplinarian who insists on following the letter of the law; a martinet; an oppressor. The allusion in this term is to the notorious Captain Bligh depicted in *Mutiny on the Bounty*. His iron-fisted discipline and strict interpretation of shipboard law led to the mutiny that displaced him as Captain of *H.M.S. Bounty*. Upon receiving another command, Bligh, as if to insure his place on a list of famous tyrants, brought on another mutiny, was relieved of the command of his ship, and was placed ashore in Hawaii by his crew. Furthermore, after serving a short period as the Governor-General of Australia, Bligh was placed in jail by the Lieutenant-governor and returned to England in chains. In each case, however, he was acquitted by a courts-martial jury. His name still stands as an allusion to harshness of authority.

Does Captain Bligh seem like a jolly good fellow compared to the guy who signs your paycheck? (*Family Weekly,* March 18, 1984)

3. crack the whip To command or control; to run a tight ship; to be strict with. The allusion is to the threatening crack of a whip used to keep horses and slaves moving or in line.

4. have by the short hairs To have complete mastery or control over, to have someone right where you want him. The British equivalent of this expression, *to have by the short and curlies,* makes this rather obvious reference to pubic hair more explicit. Use of the phrase dates from the latter half of the 19th century.

> Those Chinhwan really did seem to have got the rest of the world by the short hairs. (*Blackwood's Magazine,* February 1928)

5. have by the tail To be in control, to be in the driver's seat; to be certain of success. *Tail* in this phrase refers to the buttocks and backside. This American slang expression appeared in S. Longstreet's *The Pedlocks* (1951):

> Oh, I know all young people are sure they can have it by the tail, permit me that indelicate phrase, but can you and Alice really be happy?

6. have [one's] foot on [someone's] neck To be in a superior, dominating position; to have someone at one's mercy; to have complete control over another person. This expression owes its origin to the following Biblical passage:

> Come near, put your feet upon the necks of these kings . . . for thus shall the Lord do to all your enemies against whom ye fight. (Joshua 10:24–25)

A similar phrase is *have under one's thumb.*

7. juggernaut Anything that rides roughshod over people or treats them abusively; institutions, governments, or power groups that tyrannize, dominate,

or suppress. In Hindu mythology *Juggernaut* or *Jagganath* is a title of Krishna, the eighth avatar of Vishnu; however, it is also the name for the idol of this god which rests in a sacred temple. Once a year it is taken in an enormous, decorated machine, after a series of religious rites, to another temple where it is washed. After a stay of one week in the temple, the idol is returned to its usual sanctuary amid great rejoicing by the multitude. It was on this day that the fanatical believers used to throw themselves beneath the huge wheels to be crushed; thus, hoping to gain immediate spiritual union with Brahma. The term has been in use in the figurative sense since the early 19th century.

> The juggernaut corporation is a more anonymous organization than a small one and . . . inevitably a less human one. (Graham Bannock, *The Juggernauts,* 1971)

8. lead by the nose To completely dominate another, particularly one who is weakwilled or easily intimidated. This expression refers to the practice of leading some animals by their noses; horses and asses, for example, are guided by means of a bit and bridle, while cattle and camels frequently have a ring through the nose. Thus, the implication in this expression is both demeaning and derisive, i.e., that a person led by the nose has the intelligence, initiative, and decisiveness of a beast of burden.

> Because thy rage against me, and thy tumult, is come up into mine ears, therefore will I put my hook in thy nose, and my bridle in thy lips, and I will turn thee back by the way by which thou camest. (Isaiah 37:29)

> The Moor is of a free and open nature
> That thinks men honest that but seem to be so,
> And will as tenderly be led by the nose
> As asses are.
> (Shakespeare, *Othello,* I,iii)

9. **make [someone's] beard** To have a person totally under one's control or at one's mercy. This obsolete expression, dating from the 14th century, derives from the fact that a barber who is making (i.e., dressing) a man's beard has complete control over him. The longer expression *make [someone's] beard without a razor* carries this power to the limit—it is a euphemism for 'behead.'

> If I get you . . . I shall deliver you to Joselyn, that shall make your beard without any razor. (John Bourchier Berners' translation of Froissart's *Chronicles*, 1525)

10. **me Tarzan, you Jane** "I'm the macho man, you are the dependent female"; a phrase used to characterize an attitude of unquestioned male dominance. The Tarzan here is, of course, the Hollywood version of Edgar Rice Burrough's character. The original novel, *Tarzan of the Apes*, was published in 1914, but the expression did not become popular until the 1930s when a series of Tarzan films, starring Johnny Weissmuller, was produced. In these films Tarzan spoke words similar to these frequently to Jane, his consort. The allusion is to the utter dependence forced upon Jane when she became Tarzan's mate. The phrase has become, especially among advocates of the women's rights movement, symbolic of male dominance. It is also often used jocularly to indicate situations in which a man is being a male chauvinist. A reversal of the saying to *me Jane, you Tarzan* intimates a wish to be dominated.

11. **ride herd on** To dominate completely, to tyrannize; to crack the whip, to whip into line or shape, to maintain strict order and discipline; to drive hard, to oppress, to harass. The expression comes from the practice of driving cattle by riding along the outer edge of the herd, thus keeping their movement and progress under tight control. *Webster's Third* cites Erle Stanley Gardner's figurative use of the phrase:

> Here comes an officer to ride herd on us.

Though *ride herd on* most often connotes the use of pressure, harassment, or coercion, occasionally it is used in the milder sense of simple oversight—keeping an eye on another's performance.

12. **ride roughshod over** To treat abusively; to trample on or walk all over; to tyrannize, suppress, or dominate; to act with total disregard of another's rights, feelings, or interests. The expression usually implies that one is ruthlessly advancing himself at another's expense and hurt. A horse is roughshod when the nails of its shoes project, affording more sure-footed progress but also damaging the ground over which it travels. Robert Burns used the phrase in 1790; it remains in common currency.

> 'Tis a scheme of the Romanists, so
> help me God!
> To ride over your most Royal
> Highness roughshod.
> (Thomas Moore, *Intercepted Letters*, 1813)

13. **rule the roost** To be in charge or control, to dominate. Though the expression makes perfect sense when seen as stemming from the imperious habits of gamecocks, its origin more likely lies in a corruption of *rule the roast*, common in England since the mid-16th century but itself of uncertain origin. As used in some early citations, *roast* appears to suggest a council or ruling body of some sort. Though this latter form is rarely heard in the U.S., it remains more common in England than *rule the roost*. *Webster's Third* cites W. S. Gilbert's use of the phrase:

> Wouldn't you like to rule the roast,
> and guide this university?

14. **settle [someone's] hash** To subdue, control, suppress, or otherwise inhibit; to squelch someone's enthusiasm; to give a comeuppance; to make mincemeat of; to get rid of or dispose of someone. This expression alludes to hash as a jumbled mess; therefore, *to settle [someone's]*

hash originally meant to kill someone, implying that his murder settles, once and for all, the jumble of his mental and emotional woes.

> My finger was in an instant on the trigger, and another second would have settled his hash. (Edward Napier, *Excursions in Southern Africa*, 1849)

The expression has been extended somewhat to include less drastic means of subdual.

15. Simon Legree A cruel, heartless taskmaster; an employer, foreman, or overseer. Simon Legree was the villainous slave dealer in Harriet Beecher Stowe's *Uncle Tom's Cabin.* Nowadays, the expression is often applied somewhat humorously to any taskmaster.

> At least $20 is going into a kitty to help Lewis pay for some dead horses which he has managed to scrape up during his tenure as the miner's Simon Legree. (*Retail Coalman*, November 1949)

16. take in tow See 168. GUIDANCE.

17. wear the pants To be the dominant member; to be in control. This expression alludes to the stereotypic male dominance over women. In common usage, the expression usually refers to a domineering wife who, in essence, controls the household.

18. with a high hand Overbearingly, arbitrarily, arrogantly, imperiously, tyrannically, dictatorially. The expression originally meant 'triumphantly' as illustrated by this Biblical passage describing the delivery of the Israelites from Egyptian bondage:

> On the morrow after the passover the children of Israel went out with an high hand in the sight of all the Egyptians. (Numbers 33:3)

The phrase apparently entered the English language with John Wycliffe's translation of the Bible in 1382. There is, however, no explanation as to how or why the expression shifted in meaning from the original sense of 'triumphantly' to today's exclusive meaning of 'arrogantly' or 'imperiously.'

Doubt . . . See 349. SKEPTICISM

Doubtfulness . . . See 188. IMPROBABILITY; 349. SKEPTICISM

108. DOWNFALL
See also 141. FAILURE;
329. RUINATION

1. come a cropper To fail badly in any undertaking, particularly after its apparent initial success; to encounter a sudden setback after an auspicious beginning. This figurative meaning derives from the literal *come a cropper* 'to fall or be thrown headlong from a horse.' Although the precise origin of the expression is not known, it may be related to the earlier phrase *neck and crop* meaning 'bodily, completely, altogether.' Both literal and figurative uses of the expression date from the second half of the 1800s.

2. come a purler To be thrown head foremost from one's horse; to be knocked to the ground face forward; to fail badly, as in business. This colloquial expression, although often applied figuratively to indicate a failure or a fiasco, is more frequently used literally to describe a bad fall.

> All went well till . . . on a very slippery surface I came an awful 'purler' on my shoulder. (H. G. Ponting, *Great White South*, 1921)

One definition of the word *purl*, 'to turn head over heels,' gave birth to the colloquial term *purler*. Originally denoting a fall forward from a horse, *purler* later came to signify any fall. The term has been in use since the early 1800s.

3. Custer's last stand An all-out, noble effort that ends in utter, embarrassing failure. In June of 1876, U.S. General George A. Custer's troops were annihi-

lated by Sioux warriors under Sitting Bull at the Battle of Little Big Horn. Since then, *Custer's last stand* has gained currency as a phrase used in comparisons to emphasize those aspects of a given situation which fit the pattern of an all-out effort negated by total defeat, as established by the historical Custer's last stand.

4. go to the well once too often To make use of a trick or device once too often, so that one is finally thwarted; to try to carry on past one's ability to perform; to deplete one finances. This expression, dating from at least the 14th century, is derived from the parable of taking a pitcher to the well so often that eventually it gets dropped and broken. After he was defeated by "Gentleman Jim" Corbett for the heavyweight championship of the world on September 7, 1892, John L. Sullivan remarked:

> The old pitcher went to the well once too often.

5. hoist with [one's] own petard See 325. REVERSAL.

6. meet [one's] Waterloo To suffer a crushing and decisive defeat; to succumb to the pressures of a predicament, tragedy, or other unfavorable situation; to meet one's match; to get one's comeuppance. This expression alludes to the Battle of Waterloo (1815) in which Napoleon was decisively vanquished by the Duke of Wellington.

> Every man meets his Waterloo at last. (Wendell Phillipps, in a speech, November 1, 1859)

7. the slippery slope The path to hell; the road to destruction, ruin, or oblivion; the downhill route to moral degradation; the skids. The place of punishment or damnation is, in most religions, pictured as being in the underworld, a place to which one must travel downward. Hence, the road to hell is usually pictured as a slope upon which one finds it difficult to regain his balance or grip once he begins the downward trend.

Tennyson makes allusion to that fall in his poem, *Vision of Sin* (1842).

> At last I heard a voice upon the slope
> Cry to the summit, "Is there any hope?"

Dress . . . See 49. CLOTHING

Drinking . . . See 153. FOOD AND DRINK; 382. TIPPLING

109. DRUNKENNESS
See also 153. FOOD AND DRINK; 382. TIPPLING

1. all mops and brooms Intoxicated; half-drunk. In use since the early 19th century, the phrase is of uncertain origin. One conjecture is that the *mop* of the expression derives from that word's use in some districts of England for the annual fairs at which servants were hired, and at which much drinking was done. Women seeking employment as maids reputedly carried mops and brooms to indicate the type of work sought. Thomas Hardy's use of the expression in *Tess of the D'Urbervilles* (1891) makes its meaning clear:

> There is not much doing now, being New Year's Eve, and folks mops and brooms from what's inside 'em.

2. barfly A hanger-on at a bar; an alcoholic or heavy drinker; a barhopper. This U.S. slang phrase was in print as early as 1928.

> Andy Jackson, Kit Carson and General Grant—all good American barflies in their day. (B. de Casseres, *American Mercury*, August 1928)

This early use of *barfly* implies a good-natured backslapping attitude, without the stigma attached to heavy drinking. Today, calling someone a barfly is an insult; the label is often used judgmentally to describe a woman who flits from one bar to another.

3. brick in [one's] hat Intoxicated; drunk; in one's cups. The origin of this

American expression is rather obscure. An interesting explanation, attributed to one Timothy W. Robinson of Morrill, Maine, appears in the April 1948 issue of *American Speech*.

> Then they (matches) were made so that one using them had to have a brick to scratch them on, and the saying was that he carried a brick in his hat, so when anyone had been to the store and walked a little crooked, the boys would say 'he had a brick in his hat.'

Whether Mr. Robinson was being whimsical in his explanation cannot be ascertained; in any event, a more plausible explanation attributes the phrase to the loss of equilibrium anyone would experience from carrying the additional weight of a brick on his head.

> Her husband had taken to the tavern, and often came home very late "with a brick in his hat." (Henry W. Longfellow, *Kavanagh*, 1849)

4. drink like a fish To drink excessively, particularly alcoholic beverages; to drink hard. The allusion is to the way many fish swim with their mouths open, thus seeming to be drinking continuously. This popular simile, dating from at least 1640, is usually used to describe a drinker with an extraordinary capacity to put away liquor.

5. drunk as a fiddler Highly intoxicated, inebriated; three sheets to the wind. In the past, fiddlers received free drinks as payment for their services. Thus, their predictable and notorious overindulging gave rise to this popular expression.

6. drunk as a lord Intoxicated, soused, blind or dead drunk, pickled. In the 18th and 19th centuries, not only was gross intoxication prevalent, but men prided themselves on the amount they could consume at one sitting. It was considered a sign of gentility to overindulge. Thus, it was not an uncommon sight to behold dinner guests helplessly sprawled under the table in front of their chairs, having successfully drunk each other "under the table."

7. drunk as Davy's sow Extremely drunk or inebriated. According to Grose's *Classical Dictionary of the Vulgar Tongue* (1785), this expression arose from the following circumstances.

> A pub keeper in Hereford, David Lloyd, had a sow with six legs which he kept on public display. One day, after his wife had imbibed a bit too heavily, she retired to the pig sty to sleep it off. To some customers he brought out to see his porcine oddity, Davy exclaimed, "There is a sow for you! Did you ever see the like?" Whereupon one viewer replied,"Well, it's the drunkest sow I ever beheld." From that day Mr. Lloyd's wife was known as Davy's sow.

The expression has been in use since about 1670, sometimes in the form *drunk as David's sow*.

> When he comes home . . . as drunk as David's sow, he does nothing but lie snoring all night long by my side. (Nathan Bailey, tr. *Erasmus Colloquies*, 1725)

8. feel as if a cat has kittened in [one's] mouth To have an extremely distasteful sensation in the mouth as a result of drunkenness; the morning-after blues. This expression, one of the more graphic and picturesque, is used to describe the taste in one's mouth that often accompanies a hangover. It is first cited in the 1618 play *Amends for Ladies* by Nathaniel Field, a British playwright.

9. fishy about the gills Suffering the after-effects of excessive drinking; hung over. In this expression, *gills* carries its figurative meaning of the skin beneath the jaws and ears, a place where the symptoms of crapulence are often manifested. The phrases *blue around the gills* and *green around the gills* carry similar meanings, often extended to include the deleterious consequences of gross overeating.

10. full as a tick Extremely drunk, loaded, smashed; also *full as an egg* or *bull.* A tick is a bloodsucking parasite that attaches itself to the skin of men and certain animals. It buries its head in the flesh and gradually becomes more and more bloated as it fills up with blood. This Australian and New Zealand slang expression dates from the late 19th century.

11. half-cocked Partially drunk; tipsy. This American colloquialism, often shortened to merely *cocked,* is of unknown origin, though it may have some relationship to *half-cocked* 'foolish, silly.' See also **go off at halfcock,** 187. IMPETUOUSNESS.

12. half seas over Thoroughly drunk, intoxicated; having had a few too many, a mite tipsy. Authorities agree that the term's origin is nautical, but they have widely divergent explanations of its meaning. Those who say the expression means 'half-drunk' move from its early literal meaning of 'halfway across the sea' to the later figurative 'halfway to any destination' or 'halfway between one state and another.' Others see in it the image of a ship nearly on its side, about to founder and sink; hence, they consider the term descriptive of one decidedly unsteady due to drink, lurching and staggering, barely able to maintain his balance and likely to fall at any minute.

13. have a jag on To be drunk, to be inebriated or intoxicated, to be loaded. This U.S. slang expression apparently derives from the dialectal and U.S. sense of *jag* 'a load, as of hay or wood, a small cartload.' By extension, *jag* came to mean a "load" of drink, or as much liquor as a person can carry.

Others with the most picturesque "jags" on, hardly able to keep their feet. (*The Voice* [N.Y.], August 1892)

14. have a package on Drunk; loaded; having really tied one on. More common in Britain than in the U.S., this expres-

sion may have arisen as a variation of *tie a bag on.*

15. have the sun in [one's] eyes To be intoxicated or drunk, to be under the influence; also the slang phrase *to have been in the sun.* The expression may be a euphemistic explanation of the unsteady walk of one who has had a few too many, implying that his stagger is due to sun blindness. Another possibility is that the phrase refers to the red color one's complexion acquires or the bloodshot eyes resulting from too much sun as well as from too much drink. The expression dates from at least 1770.

Last night he had had "the sun very strong in his eyes." (Charles Dickens, *The Old Curiosity Shop,* 1840)

16. in bed with [one's] boots on Drunk, extremely intoxicated; passed out. The reference is, of course, to one so inebriated that he cannot take his boots off before going to bed.

17. in [one's] cups Intoxicated, inebriated. This expression has been common since the 18th century. Because of its literary and euphemistic tone, it is now often employed jocularly. Jeremy Bentham used the phrase in an 1828 letter to Sir F. Burdett:

I hear you are got among the Tories, and that you said once you were one of them: you must have been in your cups.

An early variant, now obsolete, is *cupped.*

Sunday at Mr. Maior's much cheer and wine,
Where as the hall did in the parlour dine;
At night with one that had been shrieve I sup'd,
Well entertain'd I was, and half well cup'd.
(John Taylor, *Works,* approx. 1650)

18. in the altitudes Light-headed; giddy; drunk. *In the altitudes,* as opposed to *having both feet planted on the ground,* is one of many similar expres-

sions meaning drunk. Attributed to the British dramatist and poet Ben Jonson, it is clearly analogous to contemporary expressions such as *high, spacey, flying,* and *in the ozone.*

19. in the bag Drunk; often *half in the bag.* This may be a shortened version of the now infrequently heard *tie a bag on,* which may itself be related to *bag* as nautical slang for 'pot of beer.' The precise origin is unknown.

20. jug-bitten Intoxicated. This obsolete expression is derived from the figurative sense of the liquid contents of a jug.

> When any of them are wounded, potshot, jug-bitten, or cup shaken, . . . they have lost all reasonable faculties of the mind. (John Taylor, *Works,* 1630)

21. like an owl in an ivy bush See 398. VISAGE.

22. loaded for bear See 301. READINESS.

23. malt above the meal Under the influence of alcohol; in one's cups; drunk. The reference in this expression is to the use of malt to make alcoholic beverages; therefore, a person who lets the malt take priority over food is losing control. First used in the late 1500s, the term is also used to indicate that one is verging on alcoholism.

> "Come, come, Provost," said the lady, rising, "if the malt gets above the meal with you, it is time for me to take myself away." (Sir Walter Scott, *Redgauntlet,* 1824)

24. one over the eight Slightly drunk, tipsy; one alcoholic drink or glass too many. One could infer from this British colloquial expression that a person should be able to drink eight pints or glasses of beer without appearing drunk or out of control. *One over the eight* appeared in print by 1925.

25. on the sauce Drinking heavily and frequently, boozing it up, hitting the bottle; alcoholic, addicted to alcoholic beverages; also to *hit the sauce* 'to drink excessively.' *Sauce* has been a slang term for hard liquor since at least the 1940s.

> He was already as a kid (like General Grant as a boy) on the sauce in a charming schoolboy way. (S. Longstreet, *The Real Jazz Old and New,* 1956)

26. pie-eyed Drunk, intoxicated, inebriated, loaded.

> He is partial to a "shot of gin," and on occasion will drink till he is "pie-eyed." (*T. P.'s and Cassell's Weekly,* September 1924)

The origin of this term is confusing, since drunkenness tends to cause the eyes to narrow, just the opposite of what *pie-eyed* implies.

27. put to bed with a shovel To be extremely drunk, dead drunk; to bury a corpse. The more common, former sense of the phrase refers to an extraordinarily intoxicated person who requires much assistance in getting home to bed. The latter, less figurative meaning, from which the former probably derives, is an obvious allusion to burial of a corpse. The expression is rarely used.

28. queer in the attic See 111. ECCENTRICITY.

29. shoot the cat See 181. ILL HEALTH.

30. three sheets in the wind Very unsteady on one's feet due to excessive indulgence in drink; barely able to stand or walk without weaving and lurching and swaying about. Though *three sheets to the wind* is more commonly heard today, *three sheets in the wind* is the more accurate term. This expression for drunkenness is another creation of some metaphorically minded sailor—*in the wind* being the nautical term describing the lines or 'sheets' when unattached to the clew of the sails, thus allowing them to flap without restraint. Older ships often had three sails, and if the sheets of all three were "in the wind," the ship would lurch about uncontrollably. The

currency of *three sheets to the wind* may be due to the erroneous belief that the sheets are the sails, rather than the lines that control them. This expression has been used figuratively to mean drunkenness since the early 19th century.

31. tie one on To go on a drunken tear; to get drunk. This very common American slang expression is probably an elliptical variation of *to tie a bag on*, which in turn could have spawned the phrase *in the bag*, all of which have the same meaning. It is uncertain whether they are related to the supposed nautical slang use of *bag* 'pot of beer.'

32. under the table Drunk, intoxicated to the point of stupefaction; not only too drunk to stand, but too drunk to maintain a sitting position. The expression derives from the days when excessive consumption of liquor was the mark of a gentleman. In subtle oneupmanship the lords would vie in "drinking each other under the table."

33. under the weather See 181. ILL HEALTH.

34. up to the gills Drunk, intoxicated; really soused, pickled. When used in reference to human beings, *gills* refers to the flesh under the jaws and ears. So one who has consumed liquor "up to the gills" has imbibed a considerable quantity.

35. walk the chalk See 55. COMPETENCE.

36. wine of ape At the point of drunkenness where one becomes surly; extremely intoxicated to the point of being incoherent or obnoxious. According to early Rabbinical literature, once when Noah was planting grape vines, Satan appeared to him and killed a lamb, a lion, an ape, and a pig to teach Noah that there are four stages which a man goes through in his drunkenness: in the first stage, or when he first begins to drink, he is like the lamb; in the second stage, like the lion; in the third stage, like the ape; and in the final or fourth stage, like the sow. The French *Kal-*

endrier et Compost des Bergiers (1480) also lists four stages, but as: the choleric man has *vin de lyon*, the sanguine *vin de singe*, the phlegmatic *vin de mouton*, and the melancholic *vin de pourceau*. Geoffrey Chaucer, in *The Manciple's Prologue*, the penultimate of *The Canterbury Tales* (1387–1400), has the manciple satirically describe the cook as being so inebriated that he is, neither playful nor jolly, but surly and dull.

I trowe that ye dronken han wyn ape.

Dullness . . . See 36. BOREDOM

Dumbness . . . See 359. STUPIDITY

110. DURATION
See also 116. ENDURANCE;
207. INFREQUENCY;
380. TIME

1. a coon's age A long time; a blue moon; usually in the phrase *in a coon's age*. This U.S. expression dates from 1843. Although its exact origin is not known, it may have derived from the raccoon's habit of disappearing for long periods of sleep during the winter months when it would not be seen out for "ages."

2. flash in the pan An instant but short-lived success; a brief, intense effort that yields no significant results; a failure after an impressive beginning. This expression refers to the occasional misfiring of the old flintlock rifles which caused a flash, or sudden burst of flame, as the gunpowder in the pan burned instead of exploding and discharging a bullet. The expression appears in an 1802 military dictionary edited by Charles James:

Flash in the pan, an explosion of gunpowder without any communication beyond the touch-hole.

3. live on borrowed time This expression implies that one continues to live af-

ter he should be dead, that he has borrowed time from death.

> With this ticker of mine I'm living on borrowed time. (G.H. Coxe, *Silent Are the Dead*, 1941)

4. long haul An extended period of time; a great distance, especially one over which material is transported. This latter use probably gave rise to the former figurative one referring to time. *In* or *over the long haul*, both currently popular, suggest a broad, inclusive perspective, one that sees everything as part of an ongoing process.

5. a month of Sundays An unspecified but usually prolonged period of time; a seemingly endless interval of time. Sunday, the Christian Sabbath, was observed in the 19th century with the utmost dignity and decorum. All entertainment and frivolity were strictly taboo; thus the day seemed never ending. As used today this expression describes a period of time experienced as longer than it actually is because of tediousness or boredom.

> I ain't been out of this blessed hole . . . for a month of Sundays. (Rolf Bolderwood, *Robbery Under Arms*, 1888)

6. nine days' wonder A person, object, or event that arouses considerable, but short-lived, interest or excitement; a flash in the pan. This expression probably derives from the activities surrounding the observation of major religious feasts during the Middle Ages. Usually nine days in length (hence the term *novena* 'a nine-day religious devotion'), these celebrations were accompanied by parades, festivities, and general merriment, after which the people returned to their normal lifestyles. One source suggests that the term may be derived from an ancient proverb: "A wonder lasts nine days, and then the puppy's eyes are open." This refers to the fact that dogs are born blind and do not realize their power of sight until they are about nine days old. It implies that the public is

temporarily blinded by the dazzling sensationalism of a person or event, but once its eyes are opened, the wonderment soon fades. In Shakespeare's *Henry VI, Part III*, the King responds to Gloucester's playful charge that his marriage would be a "ten days' wonder" with

> That's a day longer than a wonder lasts. (III,ii)

7. pissing-while A brief span of time; a few minutes. This obsolete expression, clearly derived from the short period of time required to urinate, appeared in Shakespeare's *The Two Gentlemen of Verona*:

> He had not been there a pissing-while, but all the chamber smelt him. (IV,iv)

8. stay until the last dog is hung To remain until the very last; to be one of the last to leave a party. The origin of this expression is obscure. It may be a reference to the old practice of actually hanging dogs, either for sport or because the dogs had been troublesome in some way. Whatever the case, it is only heard today in a derived sense to describe those who stay too long at a social gathering, such as a cocktail party.

> They were loyal. It was a point of honor with them to stay until the last dog was hung. (Stewart Edward White, *Blazed Trail*, 1902)

See also **hangdog look** under **398. VISAGE.**

9. till the cows come home For a long time, forever. This expression, dating from the 17th century, apparently first indicated shamefully late or early morning hours, as in this citation from Alexander Cooke's *Pope Joan* (1610):

> Drinking, eating, feasting, and revelling, till the cows come home, as the saying is.

A possible explanation as to the origin of the phrase is found in the English satirist

Jonathan Swift's literal use of it in *Polite Conversation* (1738), where it refers to a slugabed who did not get up until it was time for the cows to come home for the evening milking:

I warrant you lay abed till the cows come home.

Duress . . . See **50. COERCION**

E

Eagerness . . .

See 408. ZEALOUSNESS

Ease . . . See 114. EFFORTLESSNESS

111. ECCENTRICITY

See also 145. FATUOUSNESS;
385. UNCONVENTIONALITY

1. **barmy on the crumpet** Eccentric; a bit daft; wacko. This picturesque British expression plays on *barmy* 'balmy, foolish' and *barmy* 'yeasty'—a crumpet being a breadlike muffin, here metaphorically standing for one's head.

2. **bug house** Lunatic asylum; insane; extremely eccentric; crazy. This expression, dating from about 1800, is a slang term for the building or institution that accommodates the mentally deficient. The phrase apparently has its source in a slang expression for the inmates, *bugs*, coined because they seem to move about in a purposeless manner, like small insects.

> Thet thar man yer've jest hired's a lunatic, or was, last I knew. Was in the bughouse a long spell, anyhow. (Bertha Damon, *A Sense of Humus*, 1943)

Shortly after its inception as a noun, the term added the function of an adjective or an adverb, as in, "He is completely bughouse now." A related term *funny house* also denotes a mental institution.

> Who put me in your private funny house? (Raymond Chandler, *Farewell, My Lovely*, 1940)

3. **cockeyed** Confused; eccentric; chaotic; somewhat intoxicated; out of kilter. This term, originally designating a person who is cross-eyed or has a squint, may derive from the actions of a cock,

which tilts his head and rolls his eyes as he struts about the farmyard. The term, dating from about 1800, is in current use, usually employed figuratively to signify a state of confusion, misalignment, or inebriation.

> It's all cockeyed that a man who makes his living with a pen would rather wallow in a greasy boat bilge. (F. Tripp, *Associated Press Release*, July 31, 1950)

4. **crackpot** Eccentric; somewhat mad; a harmless fanatic. The allusion here is to the similarity of a crack in a pot, probably earthenware, to a crack in the brainpan. Dating from at least the 16th century, the term has somehow taken on the connotation of fanaticism, of extremism as seen in so-called mad scientists.

> Crackpotism finds it hard to get a foothold in the warm Florida sands. (*Harpers Magazine*, February 1955)

A related term, *crack-brained*, implies a less extreme case of eccentricity.

> The crack-brained bobolink courts his crazy mate,
> Poised on a bulrush tipsy with his weight.
> (Oliver Wendell Holmes, *Spring*, 1852)

5. **Doolally tap** Eccentric or neurotic behavior; temporary dementia. In the 19th century British soldiers who had completed their Indian service were sent to Deolali, a sanatorium in Bombay, to wait a troopship departing for home. They often had to wait for extended periods of time; as a result boredom set in, and they often got into trouble. Some were jailed, some acquired venereal diseases, and others became mentally disturbed. Their peculiar behavior became known as the *Doolally tap*, *tap* being the

Hindustani word for fever. Although the Deolali sanatorium was closed shortly after 1900, the expression is used occasionally today to indicate mental disorder.

6. flake One who is unconventional or eccentric; an offbeat person; a screwball; a nut. This word is a noun derivative of the adjective *flaky*, a 1950s slang term, of uncertain origin, used to denote unconventionality or eccentricity in a person.

> Republicans refer to him as the granola governor, appealing to flakes or nuts. (*The New York Times*, May 20, 1979)

Both terms received a boost in popularity during the 1960s when sports journalists began using them frequently to refer to wacky baseball players and some of their scatterbrained activities.

7. have a moonflaw in the brain To be a lunatic; to behave in a very bizarre or peculiar manner. A *moonflaw* is an abnormality or idiosyncrasy ascribed to lunar influence. This now obsolete expression appeared in Brome's *Queen and Concubine* (1652):

> I fear she has a moonflaw in her brains;
> She chides and fights that none can look upon her.

8. have a screw loose To be eccentric, crotchety, or neurotic; to be irregular or amiss. As early as 1884, the phrase *loose screw* was used figuratively to apply to a flawed condition or state of affairs.

> I can see well enough there's a screw loose in your affairs. (Charles Dickens, *The Life and Adventures of Martin Chuzzlewit*, 1884)

A more recent and increasingly common figurative meaning applies *have a screw loose* to states of mind or mental health. This slang meaning is used in regard to whimsical, unusual behavior rather than disturbed or sick behavior, although the phrase tends to conjure up images of

"falling apart" or "breaking down." A British variant is *have a tile loose.*

9. have bats in [one's] belfry To be eccentric, bizarre, crazy, daft. The erratic flight of bats in bell towers interferes with the proper ringing and tone of the bells, just as crazy notions darting about one's brain weaken its ability to function. The slang term *batty* is a derivative of this phrase, which appeared as early as 1901 in a novel of G. W. Peck:

> They all thought a crazy man with bats in his belfry had got loose. (*Peck's Red-Haired Boy*)

The analogy between sanity and finely tuned bells is an old one; its most famous expression is in Ophelia's description of the "mad" Hamlet:

> Now see that noble and most sovereign reason,
> Like sweet bells jangled, out of tune and harsh.
> (III,i)

10. midsummer madness Extreme folly; the height of madness. In 16th-century England midsummer madness was generally believed to be caused by the midsummer moon, the lunar month in which the summer solstice (about June 21) falls. During that period it was supposed that lunacy was prevalent because hot weather made one especially susceptible to lunar influences. In Shakespeare's *Twelfth Night*, Olivia, commenting on Malvolio's strange remarks, says:

> Why, this is very midsummer madness. (III,iv)

A related term, to *have but a mile to midsummer*, indicates a touch of lunacy; i.e., one doesn't have far to go to be *round the bend.*

11. Miss Nancy A prissy, overprecise man; a man who exhibits effeminate mannerisms and speech; a foppish youth; a homosexual male. This expression, originally conceived in Britain about 1824, is used to designate any

male who demonstrates decided feminine characteristics.

> I think a dash of femininity in a man is good; but I hate a 'Miss Nancy'. (Mrs. Lynn Linton, *The Speaker*, July 20, 1901)

Although occasionally used to insinuate that a man is homosexual, more common terms for homosexuality are *Nancy boy*; *queer*; *ginger*, from Cockney rhyming slang *ginger beer*, rhyming with *queer*; and *queen*, a shortened form of *Queen of the May*.

> The room beyond my beaverboard wall is occupied by a colored queen who always keeps his door open; well, not always but always when he's plucking his eyebrows. (Edward Albee, *The Zoo Story*, 1959)

12. off [one's] trolley Crazy, demented; in a confused or befuddled state of mind; ill-advised; senile. This expression alludes to the once-common spectacle of a motorman's attempts to realign the contact wheel of a trolley car with the overhead wire. Since this contact wheel is also called a "trolley," *off one's trolley* may refer either to the conductor's actions or to the fact that when the wires are "off the trolley," the vehicle no longer receives an electric current and is, therefore, rendered inoperative.

> The medium is clear off her trolley, for my father has been dead [for] three years. (Warren Davenport, *Butte and Montana Beneath the X-Ray*, 1908)

A similar expression is *slip one's trolley* 'to become demented.' In the more widely used variation, *off one's rocker*, *rocker* is most often said to refer to the curved piece of wood on which a cradle or chair rocks. But since both *off one's trolley* and *off one's rocker* became popular about the time streetcars were installed in major American cities, and since *rocker*, like *trolley*, also means the wheel or runner that makes contact with an overhead electricity supply, it is more

likely that the *rocker* of the expression carries this latter meaning.

> When asked if he had swallowed the liniment, he said, "Yes, I was off my rocker." (*Daily News*, June 29, 1897)

13. out in the sun too long Crazy; daft; in a confused state of mind; eccentric; bizarre. This American expression, dating from the early 1900s, alludes to the effect that the sun can have on the mind if is exposed to its heat for too long. It is usually used in a jocular vein.

14. queer in the attic Eccentric or feebleminded; intoxicated. In this expression, attic carries its British slang meaning of 'the mind'; thus, this colloquialism alludes to stupidity, insanity, or drunkenness, all of which may generate bizarre behavior.

15. round the bend Insane, crazy. In this British expression, *bend* describes one's mental faculties as being 'out of alignment, bent, or out of kilter.'

> Right round the bend . . . I mean . . . as mad as a hatter. (John I. M. Stewart, *The Guardian*, 1955)

Related expressions are *go round the bend* and *be driven round the bend*.

Economics . . . See 149. FINANCE

112. EFFECTIVENESS

1. blockbuster Something extremely forceful, violent, or effective; a success a winner, a hit. The term owes its origin to the name given the highly destructive bombs dropped on industrial targets in Britain during World War II.

2. corker A clincher or a sockdolager something that settles the question o closes the discussion; also, lollapalooza; something striking, astonishing, or extraordinary. In use since 1837, this slang term probably derive from the image of a cork "capping a bottle" (the first three meanings) or flying off a champagne bottle with a bang (th

latter meanings). *Corker* was also a baseball term in the late 19th century.

3. haymaker Any extremely forceful or effective argument, statement, ploy, maneuver, etc., especially a decisive and culminating one. The term is boxing slang for a violent punch or knockout blow. Hay is grass or alfalfa which has been cut or mowed down. Similarly, the recipient of a haymaker in a pugilistic encounter is "cut down." *Mow (someone) down* is a related expression.

> I deliberately pulled my right back and swung "haymakers" at Choinyski, intending to miss him. (J. J. Corbett, *Roar of the Crowd*, 1925)

4. hit [one's] stride To arrive at one's best speed or performance; to become competent; to move easily; to perform at a comfortable level. The reference in this phrase, coined about 1800, is to the regular or uniform movement of a horse's stride. The term has, by transference, come to mean any smooth, regular flow whether physical or mental.

> Mr. Southern has resumed his Solomon Wise column in the *Examiner* and is hitting his old stride again. (*Kansas City Times*, November 13, 1931)

A related term, *lose [one's] stride*, signifies the opposite, to lose the smooth, regular flow.

> The meter refuses to flow . . . the reader loses his stride and has to return to the beginning of the line to get a fresh start. (*The Athenaeum*, January 2, 1909)

5. the old one-two Any especially effective combination of two persons or things; a double whammy. The reference is to boxing and the highly effective combination punch consisting of a left jab immediately followed by a hard right cross, usually to the opponent's jaw and intended as a knockout blow.

6. put teeth into To make effective or enforceable; to give meaning or sub-

stance to. *Webster's Third* cites a contemporary use by E. O. Hauser:

> . . . started turning out the arms which would put teeth into neutrality.

The expression is most often used with reference to legislation.

7. rainmaker A powerful, effective lobbyist; a partner added to a business or law firm because of important connections. The reference in this term is to the American Indian rainmaker, who promised to make rain through his appeal to higher authority, the rain god. The term has been adapted to modern business practices, especially in the legal profession, where the rainmaker attempts to influence business or political authorities to further the interests of his firm. It has been used in this latter sense since the 1960s.

> In legal parlance, a "rainmaker" is a business-getter, and in the Shea Gould firm, Mr. Shea rattles the sky and produces thunderstorms. (*The New York Times*, December 6, 1978)

8. sledge-hammer argument A single statement or ploy which completely dissolves the opposition in a disagreement; a clincher. A sledge-hammer is a large, weighty hammer which, if used as a weapon, can easily incapacitate the victim. This expression is heard infrequently today.

113. EFFICIENCY

1. cooking with gas Operating at maximum efficiency; performing well, functioning smoothly; really in the groove or on the right track. The expression probably comes from the efficiency of gas as a cooking medium (as contrasted with coal, wood, kerosene, electricity, etc.). Occasionally the phrase is jocularly updated by variants such as *cooking with electricity* or *cooking with radar*.

2. hit on all six To run smoothly; to function properly; to work to one's fullest capacity; to be in physically fit and

trim condition. This Americanism was originally used in speaking of internal combustion engines, specifically the functioning of the cylinders, which often misfired in earlier cars. When the figurative use gained currency, the word *cylinder* was dropped from the end of the expression. Variants include *hit on all four* and other multiples of two.

> Modern science offers you a *natural* means to keep you "hitting on all six"—every minute of the day. (*Saturday Evening Post*, March 10, 1928)

3. in the groove In full swing, functioning smoothly, in top form. This U.S. slang expression was coined in the jazz age. *Groove* originally referred to the grooves of phonograph records. In the 1930s and '40s, *in the groove* meant to play jazz music fervently and expertly, or to appreciate such music and by association be considered "hep" and sophisticated.

> The jazz musicians gave no grandstand performances; they simply got a great burn from playing in the groove. (*Fortune*, August 1933)

Eventually *in the groove* and *groovy* grew to mean 'up-to-date' or 'fashionable,' although this use is now being phased out of current slang. When *in the groove* is used, as in the following quotation from *Webster's Third*, it emphasizes the quality of being in top form, rather than sophistication or fashionableness.

> It made no difference, when he was in the groove, what he chose to talk about. (Henry Miller)

Effort . . . See **132. EXERTION**

114. EFFORTLESSNESS

1. cake walk Something easy to do; a pleasure to perform; a walk-around dance competition. This expression originated among Southern Blacks sometime in the early 1800s. The original *cake walk* involved a sort of promenade or march by high-stepping and high-

kicking couples. The couple who demonstrated the most style were awarded the cake; in other words they *took the cake*. In time the *cake walk* became a popular dance form, and apparently from that it took on the meaning of something enjoyable and easy to do. It retains that connotation today.

> If the Yankees had our pitching staff, they'd cake walk to the pennant. (*Chicago Daily News*, July 1, 1946)

2. duck soup An easy task; a breeze, a cinch, a snap. This expression, originally and chiefly American slang, probably derived from the phrase *sitting duck* 'an easy mark or target,' literally a duck resting on the water and thus very likely to end up in duck soup. See also **sitting duck, 400. VULNERABILITY**.

3. easy as kiss [one's] hand The essence of simplicity; a piece of cake; effortlessly; a breeze; no sweat. This expression, dating from the 19th century, is obvious in the implication that to kiss one's hand is about as easy a task as one can conceive.

> It's as easy as kiss my 'and a-goin' to Paris now-a-days. (Sketchley, *Mrs. Brown at the Paris Expedition*, 1878)

4. easy as rolling off a log Extremely easy; a piece of cake; with little or no effort; a snap; a cinch. This expression, along with its variant, *easy as falling off a log*, has become so time-worn that it is of little value in the modern vocabulary. Both terms date from at least 1800.

> It could be fixed, as easy as rolling off a log. (Harold Frederic, *The Lawton Girl*, 1890)

In spite of the inelegance of the simile, it is still employed frequently.

> Then there are tricks that are as easy as falling off a log—or slipping between them. (*Green Bay Press-Gazette*, July 13, 1948)

5. easy meat Anything or anyone easily mastered or acquired; a loose woman This slang expression was originally ap

plied to things accomplished with great facility, but in time came to connote people who were easily gulled or dominated. Such people are also considered *pushovers* or *easy pickings*. By extension these terms have also come to connote a woman of easy virtue.

> The immigrants were easy meat for the politicians. (Norman W. Schur, *English English*, 1980)

6. hands down Easily, effortlessly; unconditionally, incontestably; beyond question, undoubtedly. The original expression was the horse racing phrase *to win hands down*, an allusion to the way a jockey, certain of victory, drops his hands, thus loosening his grip on the reins. The term dates from at least 1867.

7. leadpipe cinch See 46. CERTAINTY.

8. like water off a duck's back Easily, harmlessly; to no effect, without making any impression.

> I had taken to vice like a duck to water, but it ran off me like water from a duck's back. (C. Day Lewis, *Buried Day*, 1960)

This self-evident expression dates from at least 1824.

9. milk run A military aerial mission either of regular repetition or one lacking in danger. This expression, in common use by USAF and RAF personnel during World War II, alludes to delivering bombs to a target that is no more dangerous to the air crew than delivering milk to a house is to a milkman.

> The Fort was flying a wet beam . . . and it looked like a milk run. (*Colliers*, September 23, 1944)

Bombing the same target day after day parallels the milkman's routine, delivering day after day to the same locations, and thus creates a different implication of the term.

10. money for jam Money easily earned; an easy task; too easy. This Briticism, as so many others, uses jam as a symbol of affluence. If one is in a position to have *money for jam*, he has enough money to enjoy the luxuries of life; things come easy for him, for he has the wherewithal to obtain whatever he desires.

> If you've had the job offered you, take it: it's money for jam. (Frederick T. Wood, *English Colloquial Idioms*, 1969)

A related term, *money for old rope*, was originally used to indicate something for nothing, but since World War II it has been used synonymously with *money for jam*.

11. no sweat No problem, no trouble or bother, no difficulty; a cinch, a piece of cake. Working up a sweat and working hard have long been synonymous. Use of this American slang expression dates from at least 1955. It has lost its former crude associations and is now used readily in most informal contexts.

> No sweat, mate . . . We're not looking for trouble. (R. Giles, *File on Death*, 1973)

12. a piece of cake Any task requiring little or no effort; a cinch, a snap, a breeze; a pleasant or enjoyable experience. This expression, in use since at least 1936, obviously refers to the simple, pleasurable experience of eating cake.

13. plain sailing Easy going, without obstruction or interruption; according to plan. In nautical terminology, plane sailing is the supposedly uncomplicated art of determining a ship's position based on the assumption that the earth's surface is a plane and not spherical.

> Plane-sailing is so simple that it is colloquially used to express anything so easy that it is impossible to make a mistake. (William Henry Smyth, *The Sailor's Wordbook*, 1867)

Nautical use of this expression appeared in print by the late 17th century and shows *plain* used interchangeably with *plane*. Figuratively, as applied to any

plan or course of action, *plain sailing* is the standard form.

So far all was plain sailing, as the saying is; but Mr. Till knew that his main difficulties were yet to come. (Francis E. Paget, *Milford Malvoisin*, 1842)

Today *clear sailing* is heard as often as *plain sailing*.

14. take it in stride To do as a matter of course or without getting upset; to perform effortlessly, without interrupting one's normal routine. This expression is derived from the action of a skillful horseman taking his mount over an obstacle in his path without at all disrupting the animal's stride or pace, however fast. The term has been employed figuratively since the early 19th century.

I'd want something that would look more easy and natural, more as if I took it in my stride. (Edith Wharton, *House of Mirth*, 1905)

Egotism . . . See 333. SELF-
 CENTEREDNESS

Ejection . . . See 138. EXPULSION

115. ELATION
See also 117. ENJOYMENT

1. cock-a-hoop In a state of elation or exultation; also to *make cock-a-hoop* and the now obsolete phrase to *set cock a hoop* or *cock on hoop* 'to drink and make merry.' Although this expression is of obscure origin there have been several attempts to explain it. One such explanation maintains that *cock* formerly referred to the spigot on a barrel of ale. Supposedly, this cock was removed and placed on the hoop of the barrel, so that the free-flowing ale could be drunk with abandon. Thus, the drinkers were said to be cock-a-hoop. A somewhat more tenuous explanation uses the 'male fowl' meaning of *cock* and relates *hoop* to *whoop*, thus comparing the boisterous merrymaking to a cock whooping or

crowing. Variants of the expression have been in use since 1529.

2. could kick the arse off an emu To be so elated or exhilarated that one exhibits an extreme level of energy and activity. This Australian expression, dating from about the 1870s, has its roots in the lingo of the Outback cattleman. It would be an awesome feat, indeed, literally to *kick the arse off an emu*, a large ostrich-like bird native to Australia.

I feel in fine fettle . . . I could kick the arse off an emu. (*American Speech*, October 1958)

3. feel [one's] oats To feel spry, lively, and chipper, sometimes to the point of feistiness; to feel important or special. This expression refers to horse-feed which usually contains oats as one of its major components. A well-cared-for and well-fed horse is active and lively, or "feeling its oats."

You know that, and you feel your oats, too, as well as anyone. (Thomas Haliburton, *Attache*, 1843)

4. happy as a clam at high tide Quite happy, delighted, well-pleased, content; also *happy as a clam, happy as a clam at high water*, and other variants. The allusion is probably to the relative safety a clam enjoys at high tide when water hides its mud flat habitat from clam-diggers. Apparently the original version of this U.S. colloquial expression was simply *happy as a clam*, since it appears as such in the earliest citations of the phrase which date from the early 19th century.

Now I'm in business and happy as a clam at high tide. (*New York Evening Post*, June 1907)

5. have the world on a string To be in high spirits, to be on top of the world, to be "sitting pretty"; to feel as if one has life completely under control, that the forces of the world are waiting to be manipulated for one's pleasure. The word *string* referring to a tie of dependency or a means of controlling a person or an

mal dates from the 14th century. By the 16th century, *have the world in a string* appeared in print.

> Those that walk as they will, . . . persuading themselves that they have the world in a string, are like the ruffian Capaney, . . . (Brian Melbancke, *Philotimus*, 1583)

Today *in* has been replaced by *on*, but the expression continues to enjoy widespread use.

6. in fine feather In an excellent physical and mental state; in superb condition; also *in high feather*. The origin of these expressions is associated with the molting and subsequent new growth of a bird's plumage. Thomas Hardy uses the phrase "summer days of highest feather" in *Return of the Native* (1878).

7. in fine fettle In splendid condition; in a jubilant state of mind. The Old English *fetel* 'belt, girdle' is the likely ancestor of this expression, which apparently first referred more to physical appearance than mental state. One "in fine fettle" was well dressed and smartly attired. The transference of the term's application from external appearance to inner state of mind is easily seen in light of the fact that one's manner of dress is still considered to reflect and express one's emotional state. In this phrase, *fine* is occasionally replaced by another modifier to describe other states or conditions.

> I'm in terrible poor fettle with the toothache. (Henrietta Lear, *Tales of Kirkbeck*, 1850)

8. in merry pin Happy, cheerful, elated, light-hearted; in a good mood or frame of mind. The *pin* in this expression probably refers to the pegs which are used to tune a stringed musical instrument. One source suggests that *pin* may allude to the pegs on a peg-tankard, for which there were a number of uses. One use provided a favorite alehouse pastime: trying to drink only to the next lower pin on the tankard. If this were not done exactly, and it rarely was, the drinker had to try again and again until successful—attempts which inevitably led to intoxicated merriment and mirth.

> The calendar, right glad to find
> His friend in merry pin,
> Return'd him not a single word,
> But to the house went in.
> (William Cowper, *John Gilpin*, 1782)

A variation is *in jolly pin*.

9. in seventh heaven Intensely happy, blissful, ecstatic. Muslims believe in a seven-tiered heaven—as did the ancient Jews and Babylonians, whose highest— or heaven of heavens—was the abode of God and the highest angels. The Muslims' seventh heaven is ruled by Abraham and peopled by numberless mythical-type inhabitants ceaselessly chanting the praises of the Most High. The now common figurative use of the term appears as early as 1824 in the work of Sir Walter Scott.

10. light as a feather Conscious-free; elated; happy. According to Edwin Radford in *Unusual Words* (1946), the source of this expression dates to Egyptian civilization about 1300 B.C., and the account of its origin may be read in the *Book of the Dead*. Hunefar, an official in the service of the pharaoh, is present at the determination of his destiny after death. If he has led a good life, his heart will be lighter than the feather symbolizing right and will accompany him on his eternal journey; if, on the other hand, his heart should prove heavier than the feather, it will be consumed by the *Devourer*, a monster combining the qualities of a lion, a crocodile and a hippopotamus. Hunefar learns that his heart is as *light as a feather*, that he has passed the test, and that his heart may accompany him to the after-world. From this incident, according to Radford, we get the common expression.

> I hope he will soon shake off the black dog, and come home as light as a feather. (Samuel Johnson, *Letters*, 1778)

11. like a dog with two tails Delighted, elated, overjoyed; pleased as punch; tickled pink. This expression refers to the fact that a dog shows its happiness by wagging its tail. By implication, if a dog had two tails, both of which were wagging, it would be safe to assume that the animal was very happy indeed.

> Ned came in . . . looking scared. He was not at all like a dog with two tails. (P. H. Johnson, *Impossible Marriage*, 1954)

12. make whoopee To rejoice uproariously; to enjoy oneself hilariously; to have a ripping good time. Although the word *whoopee* has been in use since at least 1860, the expression *make whoopee* was coined sometime during the 1920s. The term, a favorite of Walter Winchell, who used it frequently in his column and on his radio program, received a tremendous boost in popularity during the late 1920s by Eddie Cantor's recording of Gus Kahn's *Making Whoopee*. Although the *New York Mirror* (January 17, 1935) credits Walter Winchell with coining the phrase, its origin is uncertain.

> How long have these people been making whoopee down here. (R. A. J. Walling, *The Spider and the Fly*, 1940)

13. merry as a grig Elated; well-pleased; intensely frolicsome; full of jest; delighted; cheerful. Although two plausible explanations have been forwarded as to the origin of this term, its exact derivation remains obscure. One school of thought assigns its origin to a corruption of *merry as a Greek*; the ancient Greeks had a reputation for high living, as suggested by the Latin word *graecari*, 'play the reveler.' The other explanation attributes the source to a small cricket, known as a *grig*, and to the happy sound emanating from this insect. The variant, *happy as a cricket*, had its beginnings in this latter source. At any rate, the first written example of the term appears in 1566; the expression is seldom heard today.

> They drank till they all were as merry as grigs. (Thomas Brown, *Works*, 1760)

14. on cloud nine Blissful, euphoric; enraptured, transported. The precise origin of the term is unknown; it may have begun as a variation on and subsequent intensification of *seventh heaven*, since *A Dictionary of American Slang* cites the phrase *on cloud seven*—no longer heard—as having the same meaning. The same source also indicates that *on a cloud* is commonly used to mean 'high,' i.e., under the influence of narcotics. Being "on cloud nine" may be akin to being "way out" or "spaced out."

> I don't like strange music, I'm not on Cloud Nine. (*Down Beat*, 1959)

15. over the moon Extremely happy; pleased as punch. This modern British slang expression alludes hyperbolically to the joy of extreme elation, giving the sense of being so high that one is over the moon.

16. pleasant as a basket of chips Extremely cordial; agreeable, genial, winning. An 18th-century Shropshire expression, *grin like a basket of chips* is probably the source of this Americanism. Transferred to the New World by British settlers, the term was soon altered to *pleasant as a basket of chips* and gained extensive popularity during the 19th century. The reference is obscure; several authorities have suggested that the reference is to the pleasant odor and appearance created by a freshly hewn basket of wood chips.

> They'll make up tonight, and she'll be as happy as a basket of chips. (Rose Cook, *Happy Dodd*, 1878)

Variants are *polite as a basket of chips*, synonymous with *pleasant as a basket of chips*, and *blooming as a basket of chips*, inferring health and vigor.

> She looks as blooming as a basket of chips. (William Dean Howells, *The Lady of Aroostook*, 1875)

17. pleased as a beefeater at Exeter Change Delighted; in a state of elation; overjoyed; on cloud nine. For over 700 years the royal lions were housed in state apartments at the Tower of London. A number of years before they were moved to the zoological gardens in Regents Park, they were quartered temporarily at Exeter Change. It is believed that this expression originated after observation of visits the beefeaters, Warders of the Tower of London, made to Exeter Change to view their "pets" which had been removed from the Tower.

18. pleased as Punch Very pleased or happy; delighted, elated, euphoric; tickled pink. This expression alludes to the cheerful singing and self-satisfaction which characterized the star of the "Punch and Judy" puppet show created by the Italian comedian Silvio Fiorillo in the early 1600s.

> I am as pleased as Punch at the thought of having a kind of denizenship if nothing more, at Oxford. (James Lowell, *Letters*, 1873)

The expression persists in contemporary usage, perhaps most notably as one of the favorite sayings of Hubert Humphrey (1911–78) during his political career as Senator and Vice President.

19. sight for sore eyes An expression of joy at seeing someone after a separation of indefinite duration or happiness at someone's timely arrival during a moment of difficulty. This phrase, in common use since the 18th century, suggests that someone's or something's sudden appearance is opportune and extremely pleasant or important to the speaker. The term is of uncertain origin.

> A sight of you, Mr. Hardy, is good for sore eyes. (Anthony Trollope, *Barchester Towers*, 1857)

20. slaphappy See 145. FATUOUSNESS.

21. sleep on a bag of saffron Said of a happy person; exhilarated; light-hearted. The allusion in this expression is to the exhilarating effects that saffron is

supposed to confer upon one. In Charles G. Harper's *The Newmarket Road* (1904) he describes a particularly merry fellow as:

> He hath slept on a bag of saffron.

The term has been in use since at least the 18th century.

22. tickled pink Delighted, elated, glad. This common expression alludes to the convulsive laughter as well as the pink skin tone produced by excessive tickling.

23. tickled to death Very happy, highly pleased, delighted, thrilled.

> They stopped as if they were tickled to death to see her. (Jonathan Slick, *High Life in New York*, 1844)

This expression is a simple combination of two earlier components: *to tickle* 'to please, to excite agreeably' plus the intensifier *to death* 'to an extreme degree, thoroughly.'

24. with bells on Dressed up and in high spirits; ready for a good time. The phrase may come from the following Mother Goose Rhyme:

> Ride a cock-horse to Banbury Cross,
> To see a fine woman upon a white horse;
> With rings on her fingers and bells on her toes,
> She shall have music wherever she goes.

Eminence . . . See 144. FAME

Emotionalism . . .
See 341. SENTIMENTALITY

Emulation . . . See 346. SIMILARITY

Ending . . . See 47. CESSATION

116. ENDURANCE
See also 110. DURATION;
268. PERSEVERANCE

1. bite the bullet To suffer pain without expressing fear; to grit one's teeth and do what has to be done. This phrase derives from the supposed practice of giving a wounded soldier a bullet to bite on to channel his reaction to intense pain. This practice preceded the first use of anesthesia (in the U.S.) in 1844. By 1891, the phrase was used figuratively.

> Bite on the bullet, old man, and don't let them think you're afraid.
> (Rudyard Kipling, *The Light that Failed*, 1891)

It is analogous to other phrases describing rituals such as *take a deep breath* and *grit your teeth*, which refer to preparing oneself or pulling oneself together in order to experience or do something unpleasant.

2. creaking gate hangs long on its hinges Because a gate creaks, one must not assume it has outlived its usefulness; frail people often outlive presumably healthier people. This expression is most commonly used to assure the elderly or infirm that life can be meaningful in spite of aches and pains. Originating in the 1700s, the term is heard occasionally today.

> Your mother may yet live a score of years. Creaky gates last longest. (S. Baring Gould, *Mehalah*, 1880)

A variant, *a creaking cart goes long on its wheels*, carries the same meaning.

3. keep the pot boiling Keep things going; maintain everyone's interest in the matter at hand; bring in enough money so as to earn a living. The most common sense for this phrase is 'provide for one's livelihood,' in other words, provide enough fuel to keep activity going. This expression came into use during the early 17th century.

> I think this piece will help to boil my pot.(John Wolcott [Peter Pindar], *The Bard Complimenteth Mr. West*, 1790)

Burton Stevenson in *The Home Book of Proverbs, Maxims and Familiar Phrases* (1948) theorizes that Wolcott's quotation may be responsible for the birth of the familiar literary term *potboiler*, 'an inferior piece of writing.'

4. roll with the punches To endure with equanimity, not to be thrown by the blows of fate; to be resilient, bending slightly under pressure then bouncing back; to have the balanced perspective that comes of experiencing hardship. This common metaphor obviously owes its origin to pugilism.

5. stand the gaff To endure punishment, criticism, or ridicule; to sustain oneself through a period of stress or hardship; to keep one's chin up. In this expression, *gaff* may refer to the steel spurs worn by fighting cocks, or it may derive from a Scottish term for noisy and abusive language.

> Neil has got to stand the gaff for what he's done. (W. M. Raine, *B. O'Connor*, 1910)

6. take it on the chin To face adversity courageously; to withstand punishment, to persevere against the odds; to bounce back from hardship with an undefeated attitude. This American slang expression originated in boxing.

> I liked the Williams' because of the way they took life on the chin. (D. Lytton, *Goddam White Man*, 1960)

117. ENJOYMENT
See also 115. ELATION

1. aim to please To attempt to furnish pleasure or enjoyment for others; to intend to make things satisfactory for another; to try to satisfy. This phrase is frequently heard in restaurants, motels, and other places of business that furnish service to paying customers. It is sometimes posted as a motto in businesses of lesser quality, "We aim to please," or

"Our aim is to please," the expression intended to cover up for a lack of genuine good service. The punsters' version of this expression is sometimes seen as a graffito on the walls of public restrooms: "We aim to please; your aim will help."

2. get a bang out of To derive pleasure from, to get a thrill from, to get a charge out of. In this common American expression, *bang* carries its slang meaning of intense exhilaration.

> He seems to be getting a great bang out of the doings. (Damon Runyon, *Guys and Dolls*, 1931)

3. get a charge out of To become physically or mentally exhilarated; to enjoy greatly; to get a kick out of. This expression, derived from the physical jolt caused by an electric charge, is commonplace in the United States, but is somewhat less frequently heard in Great Britain.

> It seems to me that people get a bigger charge out of their grandchildren than they did from their own offspring. (*The New York Times Magazine*, May 1963)

4. get [one's] kicks To feel a surge of pleasure or enjoyment; to derive excitement from something; to be stimulated. This expression, coined by jazz musicians during the late 1920s, alludes to the stimulating impact caused by a sudden jolt. It was long used in particular reference to the onrush of stimulation felt when certain drugs, such as heroin, take effect.

> Sock cymbal's enough to give me my kicks, man, even on the top of a cigar box with a couple of pencils. (Douglass Wallop, *Night Life*, 1953)

5. lick [one's] chops To eagerly anticipate, especially in reference to food; to take great delight or pleasure in, to relish. In this expression, *chops* refers to the mouth or lips. *Lick* refers to the action of the tongue in response to the excessive salivation that often precedes or accompanies the enjoying of food. By exten-

sion, one can "lick one's chops" over any pleasurable experience.

6. life of Riley A prosperous or luxurious life; the easy life; life high off the hog. Most scholars agree that this expression had its origin in a comic song written by Pat Rooney in the 1880s. Describing what Riley would do if he suddenly came into money, the song comments in the chorus:

> Is that Mr. Riley, can anyone tell?
> Is that Mr. Riley that owns the hotel?
> Well, if that's Mr. Riley they speak of
> so highly,
> Upon my soul, Riley, you're doing
> quite well.

Some versions of the song spell the name *Reilly*. Another less plausible version of the genesis of the phrase alludes to James Whitcomb Riley, the poet, and his images of barefoot boys and lazy summer days.

> He was having a wonderful time. He was living the life of Riley. (Samuel Hopkins Adams, *The Incredible Era*, 1939)

7. music to the ears Pleasing or agreeable news, good tidings, just what one wanted to hear; usually in the phrase *that's music to my ears*. Good news is as pleasant to hear as sweet music.

8. play for love To play a game, especially cards, without stakes; to play for fun. This expression is simply a 19th-century term for the modern *play for fun*, i.e., to play the game simply for the enjoyment of it, not to try to win money or prizes.

> I play over again for love, as the gamesters phrase it, games for which I once paid so dear. (Charles Lamb, *New Year's Eve*, 1821)

A more recent slang variant is *play for grins*.

9. pleasure bent A propensity for enjoying oneself; a tendency to get a kick out of things; eager to enjoy. This term, in which *bent* means 'inclination toward'

or 'leaning in favor of,' is obvious in its connotation. The first written example of the phrase appears in William Cowper's *John Gilpin's Ride* (1782).

O'erjoyed was he to find
That, though on pleasure she was bent,
She had a frugal mind.

In modern slang the term is sometimes heard in reference to bowlegs on a woman, an obviously carnal reference.

10. stolen sweets Things obtained by stealth, seeming to taste better; things gained illicitly and having an attractive aura of intrigue about them. The idea of stolen objects being more palatable to the tongue goes back at least to the days of Solomon who said:

Stolen waters are sweet, and bread eaten in secret is pleasant. (Proverbs 9:17)

Thomas Randolph's drama, *Amyntos* (1638), which was translated from its original Latin by the poet Leigh Hunt, contains the first known use of the term *stolen sweets*.

Stolen sweets are always sweeter,
Stolen kisses much completer,
Stolen looks are nice in chapels,
Stolen, stolen be your apples.

11. tickle [one's] fancy To appeal to someone, to please, to make happy, to delight, to amuse.

Such . . . was the story that went the round of the newspapers at the time, and highly tickled Scott's fancy. (John G. Lockhart, *Memoirs of the Life of Sir Walter Scott*, 1837)

Tickle in this phrase means 'to excite agreeably' and *fancy* is equivalent to 'imagination.' Figurative use of this popular expression dates from about the late 18th century.

12. warm the cockles of the heart To induce sensations of joy, comfort, or love. The cockle, a palatable mollusk, was often compared to the heart by early anatomists because of its shape and

valves. Furthermore, the scientific name for cockle is the Greek *cardium* 'heart.' The phrase enjoys frequent use today, usually in reference to the kindling of pleasurable emotions.

An expedition . . . which would have delighted the very cockles of your heart. (Scott, in Lockhart, *Letters*, 1792)

Entanglement . . .

See 59. COMPLICATION

Enthusiasm . . .

See 408. ZEALOUSNESS

118. ENTICEMENT

1. bank night A night when cash prizes are awarded to paying customers at motion picture theatres. This expression is derived from a popular ploy of cinema owners during the 1930s and 1940s to attract customers. During the great depression of the 1930s, people were loath to spend money, especially at places of entertainment. In order to draw paying customers during the work week, movie owners would conduct a lottery in which cash was given to the customer whose name was drawn. If the customer were not present to claim his winnings, the cash was added to the next week's drawing, thereby increasing the prize and the enticement to attend. Another inducement popular at that time was *dish night*, the awarding of a piece of merchandise, such as a dish, a piece of silver, or a glass, to each paying customer. By extension, *bank night* came to mean any giveaway and is sometimes used in that context today.

Radio's bank night has snowballed into a giveaway orgy in which $7,000,000 radio cash is being pitched at listeners in a season's cycle. (*Variety*, June 2, 1948)

2. drawing card An attraction; a person or thing noted for its drawing power—the ability to attract a great deal of attention or patronage. This expression

has been in use since the 1800s, although *drawing* 'attractive' dates from the 16th century.

> The Falls City team is the best drawing card here of any in the Association. (*Courier-Journal*, May 4, 1887)

A variant of *drawing card* is *selling card.*

3. Fata Morgana A mirage or illusion that entices one into danger or destruction; also, an alluring woman, a seductress. *Fata Morgana* often refers specifically to the mirage of a great city that appears occasionally in the treacherous Straits of Messina, and which has led many a sailor to an untimely death on the jagged rocks bordering the Straits. The term combines the Italian *fata* 'fairy' and *Morgana,* derived from Morgan le Fay, an enchantress of Arthurian fame believed to be the sister of King Arthur and the student of the magician Merlin. She was reputed to live in Calabria, an area of Italy adjacent to the Straits of Messina, where, with her enticing illusions of pleasure and grandeur, she lured unwary men to their destruction.

4. free lunch A lunch at one time available to drinking customers in a tavern or saloon; something to attract customers. This expression is most commonly heard in the old adage, "There ain't no such thing as a free lunch." The *free lunch,* introduced in the mid-1800s, was originally a ploy by saloon keepers to entice customers into their place of business. With the advent of prohibition in 1918, the *free lunch* disappeared along with the saloons, but with repeal of prohibition in 1933, the *free lunch* reappeared with a difference; in the bars that served these snacks prices were higher or drinks were smaller. In modern use the term connotes something that appears to be free, but is not.

> Even though voters want tax reductions, they were skeptical of a scheme that sounded so much like a free lunch. (*Time,* November 20, 1978)

5. honky-tonk girls Entertainers; dance-hall girls. This expression arises from the practice by saloonkeepers in the American West of hiring girls to dance with and entertain the customers. Because these establishments were frequently called honky-tonks or honkydonks, these women became known as *honky-tonk,* or *honky-donk girls*; and because the music was ordinarily furnished by hurdy-gurdies or fiddles, the girls were also called *hurdy-gurdies.* Commonly hired in groups of four along with a chaperone, the girls were usually of hardy country stock who often married and settled down locally.

6. jail bait One who serves as a temptation to commit crime, esp. an alluring female who has not reached the age of consent. This common expression of obvious origin usually refers to a young girl with whom sexual contact is the foundation for a statutory rape charge. A variant is *San Quentin Quail.*

> I'm not interested in little girls. Particularly not in jail-bait like that one. (J. Braine, *Room at the Top,* 1957)

7. lead up the garden path To deceive or mislead; to entice or beguile; to tempt with less than honorable intentions. Though no longer limited to affairs of the heart, this expression refers to the proclivity of many casanovas and coquettes to stroll among the flowers with a sweetheart in search of romantic privacy.

> They're cheats, that's wot women are! Lead you up the garden [path] and then go snivellin' around cos wot's natcheral 'as 'appened to 'em. (Ethel Mannin, *Sounding Brass,* 1926)

Entirety . . . See **195. INCLUSIVENESS; 377. THOROUGHNESS; 383. TOTALITY**

Enviousness . . .
See 315. RESENTMENT

Epithet . . . See 244. NICKNAMES

119. EPONYMS

1. Alibi Ike See 126. EVASIVENESS.

2. Annie Oakley A free ticket to a performance; a meal ticket. Annie Oakley (1860–1926) was the famous trickshot artist who traveled with Buffalo Bill's Wild West Show. Her reputed ability to throw a playing card into the air and shoot it full of holes before it fell to the ground supposedly explains how an *Annie Oakley* came to mean a free pass or meal ticket. A playing card riddled with bullet holes resembles a perforated ticket or punched meal ticket. The meal ticket use of the word is obsolete, and the free pass meaning is now rarely heard, although both were popular earlier in the 20th century.

> A newspaper circulation man gave him two "Annie Oakleys" to a boxing match. (*Life*, June 17, 1946)

3. Archie Bunker A sanctimonious working-class man; a bigot. This eponym became a common expression in 1971, shortly after the character of Archie Bunker was first revealed to the American people on *All in the Family*, a very popular television show, modeled on the British television series, *Till Death Do Us Part*. The character, depicted as an irascible blue-collar working man who is quick to voice his prejudiced views in the form of generalizations and slurs, seemed to typify some of the cruder aspects of American urban life.

> A self-employed iron worker with a self-described "Archie Bunker" perception of the world. (*The New York Times*, June 5, 1976)

A variant, *Archie Bunkerism*, arises from Archie Bunker's custom of misusing words, especially in the form of malapropisms.

4. Baron Münchhausen See 236. MENDACITY.

5. Becky Sharp A scheming young woman; an unprincipled trollop. This expression can be traced directly to the main character in Thackeray's *Vanity Fair* (1848), Becky Sharp, who, through her good looks and cunning mind, lifts herself to an elevated position in society. Through deception and guile she is able to maintain her position for a number of years, but eventually fails as a result of her own shortcomings. Although the eponym is still in use today, modern Becky Sharps do not necessarily fail. Whatever the case, her character was so well delineated by Thackeray that she has taken her place among the many fictional characters who represent certain moral and social characteristics.

6. Benedict Arnold A traitor; a turncoat; one who betrays a cause or group. This expression alludes to the infamous American turncoat, who after transmitting military information about the American forces to the British throughout 1779 and early 1780, accepted a commission with the British in September, 1780. Since that time his name has been used as a synonym for one who goes over to the other side. Occasionally it is used in a jocular sense, as in:

> You're cheering for the other team? Why, you're a regular Benedict Arnold!

7. blimp See 276. POMPOSITY.

8. blurb See 52. COMMENDATION.

9. Captain Armstrong In horseracing, a name for a cheating jockey. The source of this British term is obscure. Perhaps it was the name of an actual jockey in the mid-1800s, but more likely it was a pun designating any jockey known for a strong arm, i.e., for holding back sure winners. The related terms, *come Captain Armstrong*, and *to pull a Captain Armstrong* also indicate the "pulling" of a winner.

10. Charley Noble The galley stack on a ship. The exact origin of this term, dating from the mid 19th century, is unknown. It has been attributed to a proud merchant sea captain of that name who insisted that the copper galley funnel be kept brightly polished. Other sources suggest it originated with an outstanding ship's cook of the same name whose galley funnel became a symbol of his excellent meals. Whatever the case, the smokestack of a vessel's galley is still known as a *Charley Noble*.

11. Chinee A complimentary ticket. Damon Runyon in *Money from Home* (1935) describes the term.

> Bill Corum . . . gives me a Chinee for a fight at Madison Square Garden, a Chinee being a ducket with holes punched in it like old-fashioned Chink money, to show that it is a free ducket.

This American slang expression, popular in the early 20th century, is seldom heard today.

12. craps A game of chance using dice. This American term, which dates from 1843, is thought by some to be a French variant of the 18th-century English slang term *crabs* 'the lowest throw at hazard [a dice game], two aces.' Other less scholarly sources maintain that *craps* is short for Johnny *Crapaud,* the nickname given to the Creole Bernard Marigny, who is said to have first introduced dice-playing to the largely French city of New Orleans about 1800.

13. Dick Turpin See **76. CRIMINALITY.**

14. Doctor Fell In the 1680s the satirist Thomas Browne, while a student at Oxford University adapted one of Martial's epigrams, *Non Amo Te,* (xxxii) to describe his attitude toward the dean of the college.

> I do not love thee, Doctor Fell,
> The reason why I cannot tell,
> But this I know and know full well
> I do not love thee, Doctor Fell.

Doctor Fell, dean of Christ Church College and bishop of Oxford, was a great scholar and a highly respected man. A patron of the Oxford University Press, he was responsible for the acquisition of the punches and matrices of the Fell types, which are still in use. He directed the publication of many books, a few which he wrote or edited himself. He effected the building of the tower over the main gateway of Christ Church and had Great Tom, a famous recast bell, placed there. It is strange that such an accomplished man should have become a universal symbol for a person whom one dislikes for no apparent reason.

15. Dorothy Dix A woman employed to counsel people; a newspaper columnist who writes advice to the lovelorn. This expression alludes to the original Dorothy Dix, a pseudonym for Elizabeth Meriwether Gilmer (1870–1951), an American journalist and author of a syndicated advice-to-the-lovelorn column. Her name became a general term for all those who offer advice of a personal nature.

> Thousands of plants are now employing Dorothy Dixes, a name given to but not liked by women employed to counsel and help women workers with problems both intra- and extramural. (Henry L. Stephen, *Printers Ink*, September 10, 1943)

16. dunce See **179. IGNORANCE.**

17. goldilocks A pretty flaxen-haired girl or woman; a woman who is self-seeking and of questionable reputation. In this term the original innocent Goldilocks of fairy-tale fame has had her image reduced to that of a worldly woman who takes advantage of naive young men. This disdainful connotation of the term has been employed since at least 1550. William C. Hazlitt in *Remains of the Early Popular Poetry of England* (1864) quotes from *Pryde and Abuse of Women* (1550):

> Huffa! goldylocx, joly lusty goldylocx;
> A wanton tricker has come to towne.

18. Goody Two Shoes See 296. PRUDISH-NESS.

19. Grand Guignol A series of short plays emphasizing the macabre; the theater where such plays are performed; any production that resorts frequently to grotesque, horrific, or gory situations. The allusion in this term is to *Guignol*, the main character in a French puppet show from the 1700s. Like *Punch and Judy*, the shows were violent and often involved gruesome incidents. The term was transferred from the puppet show to the live stage sometime in the 19th century, and is still used today to characterize some modern "horror" shows.

20. Grub Street See 226. LITERATURE.

21. Jack Ketch An appellation for a hangman or executioner. Jack Ketch is said to be the name of the notorious English hangman in the 17th century who barbarously executed William Lord Russell, Duke of Monmouth, and other political offenders. Another conjecture is that this name derived from "Richard Jaquette," Lord of the Manor of Tyburn, where executions were performed until 1783. Another suggestion is that *Jack* is a common name and *Ketch* plays on the verb "catch."

> He is then a kind of jack-catch, an executioner-general. (John Wesley, *Works*, 1755)

22. Jim Crow See 300. RACISM.

23. John Hancock A person's signature or autograph, especially on legal documents; also *John Henry*. The allusion is to John Hancock's bold, legible signature, the first on the Declaration of Independence. The variation *John Henry* was originally a cowboy term. Both expressions are American in origin as well as in use. Although *John Hancock* as a synonym for signature dates only from the early part of this century, a reference to the bold style of his hand was made as early as 1846.

> After he got through filling in the blank spaces with his John Hancock,

he didn't have a window to hoist or a fence to lean on. (Ade, *People you Know*, 1903)

24. little Lord Fauntleroy See 204. INEXPERIENCE.

25. Lucy Stoner An advocate of women's rights; an emancipated woman, especially one who insists on retaining her maiden name after marriage. This expression is an adaptation of the name of Lucy Stone, a leader of the woman's suffrage movement in the 1800s. When she married Henry Brown Blackwell in the mid-19th century, she insisted on keeping her maiden name, answering to no other name her entire married life; thus her name came to symbolize any strong advocate of women's rights.

> Some willfulness, almost an anger, stirred in Liz who, the Lord knew, was no Lucy Stoner. "Actresses always keep their own names," she said. (*Saturday Evening Post*, February 12, 1949)

26. Mae West An inflatable life vest. These life preservers, worn by flying personnel during World War II whenever their missions took them over large bodies of water, were named for the buxom American movie star. The expression, coined during World War II, alludes to the large breastlike protuberances created when the jacket is inflated.

> A pilot . . . wearing a Mae West—a life jacket which bulges in the right places, in case he lands in the water . . . (*Readers Digest*, February 1941)

27. malapropism See 225. LANGUAGE.

28. maverick See 197. INDEPENDENCE.

29. Meddlesome Matty See 235. MEDDLESOMENESS.

30. Mister Clean An honest person; a politician of impeccable reputation; any person in a position of public trust who is considered incorruptible. This phrase was derived from the image of the man on the trademark of a liquid household

cleaner, Mister Clean. The term, in use since the early 1970s, commonly alludes to those in the political arena.

> There were serious fears that Mr. Callaghan might have damaged his reputation as "Mr. Clean" by confirming his son-in-law's appointment. (*Manchester Guardian Weekly*, May 22, 1977)

31. Molotov cocktail A weapon consisting of a bottle containing a combustible liquid and a wick that is lit before the device is thrown. These makeshift fire bombs, named for V. M. Molotov, the wartime foreign minister of Russia, were used by Russian civilians against the invading Nazi stormtroopers in 1941. This phrase has been in common use since World War II.

> Stationary tanks can be disabled by dropping grenades or Molotov cocktails through the ventilating openings. (T. Gorman, *Modern Weapons of War*, 1942)

32. Mother Bumby A seeress; a prophetess; a fortune teller. This Elizabethan term is a reference to a bumbling fortune teller whom Hazlitt describes as old, quaint, and vulgar. The subject of frequent reference in Elizabethan drama, *Mother Bombie* (1594) is the title of a John Lyly comedy.

33. Mother Bunch A teller of jokes; a merry woman; an aged woman. This expression is derived from the name of an actual *Mother Bunch*. A famous London ale-wife of the Elizabethan age, she had many anecdotes and gags attributed to her in books and plays of the period. *Pasquil's Jests, mixed with Mother Bunch's Merriments* (1604) contains an excellent description of this legendary individual:

> She spent most of her times telling of tales, and when she laughed, she was heard from Aldgate to the Monuments of Westminster, and all Southwarke stood in amazement, the Lyons in the Tower, and the Bulls and Beares of Parish Garden roar'd louder than the

> great roaring Megge . . . She dwelt in Cornhill neere the Exchange, and sold strong Ale . . . and lived an hundred, seventy and five years, two days and a quarter, and halfe a minute.

The term is used occasionally to represent any aged woman.

> The shapeless Mother Bunch, into the fac-simile of which she must eventually grow. (George J. Whyte-Melville, *Market Harborough*, 1861)

34. Okie Itinerant farmers from the south central United States, especially those who moved to California; refugees from Oklahoma and other Dust Bowl states who had to leave their farms because of drought, dust storms, and rural industrialization; a person from Oklahoma. This term first appeared as a disparaging nickname for those Dust Bowl farmers who were forced to emigrate to California during the 1930s to find employment. When much of the farming land of Oklahoma, Arkansas, Texas, Kansas, and Nebraska dried up during the drought of the 1930s, many families who operated small farms were forced to pack all their worldly possessions and make their way to the rich farmlands of California. Unable to find work there because of their burgeoning numbers, they soon became burdens to the taxpayers of that state; hence, the derogatory use of *Okie*.

> Okie use' ta mean you was from Oklahoma. Now it means you're scum. Don't mean nothing itself, it's the way they say it. (John Steinbeck, *The Grapes of Wrath*, 1939)

Despite the extensive efforts of Oklahoma's governors and congressmen to improve the state's image and the popular country-western song *I'm Proud to Be an Okie from Muskogee*, by Merle Haggard, the term persists as a disparaging term for a poor, itinerant farm worker.

35. Peck's bad boy See 237. MISCHIEVOUSNESS.

36. peeping Tom See 342. SEXUAL PROCLIVITY.

37. podsnappery Self-satisfaction; self-importance; self-indulgence; refusal to cope with a threat. In Charles Dickens' novel, *Our Mutual Friend* (1865), there appears a pompous, self-indulgent individual named Mr. Podsnap, whose character traits gave birth to the term *podsnappery*. Of Mr. Podsnap's overbearing self-satisfaction, Dickens writes:

> He never could make out why everybody was not quite satisfied, and he felt that he set a brilliant social example in being particularly well satisfied with most things, and, above all other things, with himself.

38. Pollyanna See 177. IDEALISM.

39. pooh bah See 276. POMPOSITY.

40. Simon Legree See 107. DOMINATION.

41. soapy Sam See 133. EXHORTATION.

42. son of Belial See 404. WICKEDNESS.

43. son of thunder See 133. EXHORTATION.

44. Typhoid Mary A person who carries a disease; one whom others try to avoid; a pariah; an outcast. This term is derived from the nickname of Mary Mallon, an immigrant Irish cook, who spread typhoid throughout many institutions in the New York City area. Typhoid carriers often do not show any of the symptoms of the infection themselves, but are capable of transmitting the disease to others. Such was the case with Mary Mallon who, even though she was aware that she was a carrier, continued to work as a cook in various restaurants and institutions, thus knowingly transmitting many typhoid cases to the patrons. When she was about to be discovered, she would quickly move on and change her name. Finally, the State of New York Health Authority confined her to an institution on Long Island where she remained until her death in 1938. The term is heard today almost entirely in its figurative sense, i.e., one that others find undesirable or that should be avoided. Richard Rovere, an American journalist, referred to the late Senator Joe McCarthy as the "Typhoid Mary of conformity."

45. Uncle Tom See 362. SUBMISSIVENESS.

120. EQUIVALENCE
See also 346. SIMILARITY

1. even steven Equal; fair; on a basis of share and share alike; without advantage to either side. Although the source of this expression is uncertain, it is often attributed to Jonathan Swift, who wrote, in a *Letter to Stella* (January 20, 1711):

> "Now we are even," quoth Steven, when he gave his wife six blows to one.

At any event, the phrase became popular in both the United States and Britain and is frequently heard in modern conversation in both countries.

> Give me the hundred and fifty, and we'll call it even steven. (Dashiell Hammett, *Blood Money*, 1945)

2. neck and neck Even, equal, on a par; abreast, at the same pace. Based on available citations, figurative use of this expression is as old as the literal horse-racing one, both dating from the early 19th century. It still finds frequent application.

> Production ran neck and neck in the studios, but the second version . . . reached the public screen last. (*The Times*, June 1955)

3. nip and tuck So close as to be of uncertain outcome; neck and neck, on a par, even; up in the air, questionable. This chiefly U.S. term is of puzzling origin and inconsistent form, appearing in print in the 1800s as *rip and tuck, nip and tack,* and *nip and chuck,* before assuming its present *nip and tuck.* Its original restriction to contexts describing close contests, usually athletic, lends cre-

dence to the claim that it originated as a wrestling term (Barrère and Leland, *Dictionary of Slang*, 1890). The expression is now employed in much broader contexts, indicative of any kind of uncertainty.

> It is nip and tuck whether such a last great achievement of the bipartisan foreign policy can be ratified before . . . the Presidential race. (*The Economist*, May 1948)

4. pull devil, pull baker Even; equal; each is as bad as the other, This expression, dating from the early 1700s, refers to the public's opinion of bakers. From the Middle Ages until the 1800s, bakers were considered to be underhanded fellows who overcharged for their bread and thus were prime targets for the devil. One of the old puppet shows presented a figurative tug-of-war between a baker and the devil, who had come for the baker's soul. The term *devil's dozen*, twelve plus one for the devil, establishes the association between devil and baker even more closely. In Rolf Boldrewood's *Robbery under Arms* (1888), Captain Starlight, a bush ranger, i.e., an outlaw operating in Australian bush country, comments:

> It's all fair pulling, "pull devil, pull baker," someone has to get the worst of it. Now it's us [bushrangers], now it's them [police] that gets . . . rubbed out.

5. strike a balance To achieve a position between two extremes; to take an intermediate position; to calculate the difference between two sides of a ledger; to attain mental tranquillity. The allusion in this phrase is to a set of balance scales and the equality of weight on each side. The first reference to the image given in the *OED* is:

> Those rewards and punishments by which . . . the balance of good and evil in this life is to be struck. (Bishop John Wilkins, *New World*, 1638)

6. swings and roundabouts Six of one and a half dozen of the other; bad luck one day, good luck the next. This Briticism is simply a shortened version of a longer expression, *what one loses on swings, he gains on roundabouts*; in other words, what one loses one way he gains another. The allusion is to common amusements to be found at playgrounds and fairs. *Roundabout* is the British term for a merry-go-round, and *swing* is a term common in meaning to both England and the United States.

> In money matters, as in most other things, one is prepared to make up on the swings what one loses on the roundabouts. (F. B. Young, *A Man About the House*, 1942)

A related term derived from the fishing industry is *lose in hake, gain in herring*. Although hake are an edible fish, they attack herring; therefore, herring fishermen attempt to drive hake away from their fisheries.

> What we lose in hake, we shall have in herring. (Richard Carew, *The Survey of Cornwall*, 1602)

121. ERRONEOUSNESS
See also 143. FALLACIOUSNESS

1. all wet Totally mistaken, in error; perversely wrong. This slang expression dates from the early 1930s and is still in common use.

> Alfalfa Bill Murray may be all wet in his stateline bridge and oil production controversies. (*Kansas City Times*, August 29, 1931)

Although the exact origin of *all wet* is unknown, *wet* as a negative word is familiar in phrases such as *wet blanket* and in the British use of *wet* to mean 'feeble or foolish.'

2. back the wrong horse To be mistaken in one's judgment, to support a loser. The expression, originally a reference to betting on a losing horse, is now used

popularly to denote the support or backing of any losing person or cause.

3. bad-ball hitter A person of questionable judgment, so-called from the baseball term for a batter who swings at pitches well outside the strike zone.

4. bark up the wrong tree To pursue a false lead; to be misled or mistaken. This Americanism clearly comes from hunting; specifically, according to some, nocturnal raccoon hunting in which the dogs would often lose track of their quarry.

> I told him . . . that he reminded me of the meanest thing on God's earth, an old coon dog, barking up the wrong tree. (*Sketches and Eccentricities of Col. David Crockett*, 1833)

5. full of prunes Mistaken; absolutely wrong; completely misinformed or totally unknowledgeable about the subject; exaggerated. This phrase is a euphemistic method of telling another that what he says does not seem believable, that he is *full of crap* or *full of shit*, the reference to prunes being to their laxative effect. Two common variants, *full of beans* (in one sense) and *full of hops*, both make the same inference; these foods cause flatulence or intestinal catharsis.

6. get the wrong sow by the ear Make a mistake; seize the wrong individual; give an unsatisfactory explanation. This expression, dating from at least the 16th century, is a rustic metaphor for the jeopardy that one might be placed in from dealing with the wrong individual or becoming involved with the wrong person.

> I knew when he first meddled with your Ladyship, that he had a wrong sow by the ear. (John Taylor, *Wit and Mirth*, 1630)

Common variants of this expression are *get the wrong pig by the ear*, *get the wrong bull by the tail*, and *get hold of the wrong end of the stick*.

7. in the wrong box In the wrong place; in a false position; in error. The origin of this expression is uncertain. One plausible explanation attributes the phrase to Cesare Borgia's placing poisoned comfits in a box to be served to a visiting cardinal. However, Borgia's father was served from the wrong box and died. Another explanation assigns the phrase to Lord Lyttleton who complained that whenever he went to Vauxhall, he was *in the wrong box*, for pleasure seemed to be all about him.

> I very much question whether the Clerkenwell Sessions will not find themselves in the wrong box. (Charles Dickens, *Oliver Twist*, 1838)

8. make a blot Commit a fault; make an error; expose a man. The reference in this phrase is to the game of backgammon. Dating from at least the Middle Ages, backgammon has remained a popular game through the years. If one leaves a piece exposed during the course of the game, he is in danger of having the piece taken and returned to the starting point; hence he has *made a blot*.

> He is too great a master of his art, to make a blot which may be so easily hit. (John Dryden, *Aeneld: Dedication*, 1698)

The counterplay in backgammon, *hit a blot*, implies taking advantage of another's error.

> You never used to miss a blot, especially when it stands so fair to be hit. (Henry Porter, *The Two Angry Women of Abingdon*, 1599)

9. miss the cushion To make a mistake; to fail in an attempt. It has been hypothesized that *cushion* is another word for 'target' or 'mark'; thus, the expression is thought to derive from the unsuccessful attempt of an archer to hit the mark. Now obsolete, *miss the cushion* dates from the early 16th century.

> Thy wits do err and miss the cushion quite. (Michael Drayton, *Eclogues*, 1593)

10. **off base** Badly mistaken, completely wrong. In baseball, a runner leading too far off the base is likely to be thrown out. This expression is also obsolete slang for 'crazy or demented.'

11. **off the beam** Disoriented; incorrect; confused; daft. The reference is to an airplane pilot that has lost, or failed to find, his radio directional signal. Thus, an airplane that is *off the beam* is wandering about helplessly among the clouds. The term has been extended to the human mental condition. It dates from the 1930s.

12. **out in left field** Wildly mistaken, absolutely wrong; disoriented, confused. This American slang term refers to the left outfield position in baseball, a game in which the infield is the center of activity. Nothing inherent in the game, however, makes the left field position more appropriate than the right for inclusion in the expression. Perhaps the negative associations of *left* (clumsiness, backwardness) account for its use.

13. **overshoot the mark** See 130. EXCESSIVENESS.

14. **pull a boner** To make an obvious, stupid mistake, to blunder; to make an embarrassing, amusing slip of the tongue. This originally U.S. slang expression dating from the turn of the century may have derived from the antics of the two end men, Mr. Bones and Mr. Tambo, of the old minstrel shows. The interlocutor would carry on humorous conversations with the end men who sometimes provoked laughter by "pulling a boner."

> Got his signals mixed and pulled a boner. (*American Magazine,* September 1913)

A common variant is *make a boner*.

> This Government has made about every boner possible. (*Spectator,* October 7, 1960)

15. **slip of the tongue** See 137. EXPOSURE.

16. **take in water** To be flawed or weak; to be invalid or unsound. This obsolete expression, dating from the late 16th century, alludes to a vessel that is not watertight. By extension, it applies to flawed ideas or statements.

> All the rest are easily freed; St. Jerome and St. Ambrose in the opinion of some seem to take in water. (Bishop Joseph Hall, *Episcopacie By Divine Right Asserted,* 1640)

See also **hold water**, 392. VALIDITY.

17. **wide of the mark** Inaccurate, erroneous, off base; irrelevant, not pertinent. Dating from the 17th century, this expression most likely derives from the unsuccessful attempt of an archer to hit the "mark" or target. Variants of this expression include *far from the mark* and *short of the mark*. See also **beside the mark**, 219. IRRELEVANCE.

18. **yellow dog under the wagon** Unreliable; untrustworthy; inconstant; erroneous. The origin of this expression, which is seldom heard today, is uncertain; however, it was in popular use throughout 19th-century America. Perhaps some tinker, or some other itinerant peddler, was accompanied by an unreliable yellow dog that would emerge from beneath the wagon and bite passers-by. At any event, *The Spirit of the Times*, a publication for race horse enthusiasts, uses the term to comment rather caustically on the reliability of another publication in its December 19, 1857 edition.

> For *Potomac's* pedigree, see page 407 of 'Edgar's General Stud Book' which is about as long and reliable as that of 'the big yellow dog under the wagon.'

122. ESCAPE
See also 89. DEPARTURE

1. **fly the coop** To escape, as from a prison; to depart suddenly, often clandestinely. In this expression, *coop* is slang for a prison or any other confining place, literal or figurative. Thus, while

the phrase is commonly applied to prison escapes, it is sometimes used to describe a child who has run away from home or an employee who quits suddenly because of the pressures and restrictions of his job.

2. give leg bail To run away; to escape from confinement on foot. Literally, bail is the surety, often provided by a third party, which allows a prisoner temporary liberty. In this rather droll expression, however, the prisoner is only indebted to his legs for his escape from custody.

> I had concluded to use no chivalry, but give them leg-bail instead of it, by . . . making for a deep swamp. (James Adair, *History of the American Indian*, 1775)

3. give the guy To give someone the slip, to escape; also *to do a guy* and *to guy* 'to run away, to decamp.' Although of unknown origin, *guy* in these phrases means 'a decampment, a running off on the sly.' All three of these British slang expressions date from the late 19th century.

4. give the slip To elude or to escape from a person; to steal away or slip away unnoticed. *Slip* as an intransitive verb meaning 'to escape or get away' dates from the 14th century; transitive use dates from the 16th century. No explanation for the change to the substantive in *give the slip* is very plausible. One possibility is that the expression derives from the nautical *slip* which means 'to allow the anchor-cable to run out when trying to make a quick getaway.' Another theory suggests that the expression alludes to the image of an animal "slipping" its collar in order to run free. Neither theory is convincing, however, since it is difficult to determine accurately which use came first.

5. make a bridge of gold Create an easy and attractive way of escape, either physically or verbally. This expression, which dates from the days of classical Greece, alludes to the practice of allow-

ing a person in a precarious position to retreat while maintaining his dignity.

> He (the good general) makes his enemy a bridge of gold, and disarms them of their best weapon, which is the necessity to fight whether they will or no. (Thomas Fuller, *The Holy State: The Good General*, 1642)

Originally a military precept, today the expression is used only in its figurative sense. A variant, *make a bridge of silver*, exhibits the same meaning.

> Not to stop the way of the enemy . . . but rather . . . to make him a bridge of silver. (Sir Geoffrey Fenton, *The Historie of Guicciardini*, 1579)

6. on the lam Escaping, fleeing, or hiding, especially from the police or other law enforcement officers. This popular underworld slang expression, in use since at least 1900, first received general acceptance and popularity during the 1920s. *Lam* probably derives from the Scandinavian *lemja* 'to beat' or, in this case, 'to beat it, flee.' A similar expression is *take it on the lam*.

> He plugged the main guy for keeps, and I took it on the lam for mine. (No. 1500, *Life in Sing-Sing*, 1904)

7. pull a hole in after [one] To hide utterly; to get away from the world; to escape trouble; to avoid all semblance of adversity. The phrase implies that one wishes to lose all contact with the rest of the world; he wants to dig a hole, disappear, and not leave a trace. The phrase is usually heard in the longer expression "I want to crawl into a hole and pull it in after me." The term has been in use since the 1930s.

> If I ever get into another case like it, I'm going to crawl into a hole, pull it in after me, and do some shallow breathing. (Clayton Rawson, *No Coffin for the Corpse*, 1942)

8. save [one's] bacon To escape injury to oneself; to keep oneself from loss; This expression probably alludes to the precautions taken in the past to store the ba-

con, preserved for the winter, out of the reach of the innumerable dogs about the premises. The expression has been in use since at least the early 16th century.

> So far as my mission was concerned, I had saved my bacon. (Francis Beeding, *The Twelve Disguises*, 1942)

9. show a clean pair of heels To escape by superior speed; to outrun; to run off; also *show a fair pair of heels* or *a pair of heels*. This expression, in use since 1654, is said to have derived from the ancient sport of cockfighting. Since Roman times gamecocks have fought wearing heels or metal spurs. If a rooster ran away instead of fighting, he was said to have shown his rival a clean pair of heels, since his spurs were unsullied by the blood of combat.

10. underground railroad A trail to freedom; a route out of slavery. This expression alludes to the secret network of hiding places, or "stations," maintained by anti-slavery proponents in the Civil War era to assist runaway slaves to freedom in the North or in Canada. The *railroad*, which had its origin during the 1820s, was spread throughout the East and Midwest, and, strangely enough, continued operation for a number of years after the Civil War had supposedly freed the slaves.

> More fugitives than ever came from the slave states, and the underground railroad was in fuller activity than before. (*North American Review*, 1875)

A common variant is *underground railway*.

123. ESSENCE

1. broth of a boy The very essence of what a boy ought to be; a really good boy who is expected to grow into a fine man. This colloquial phrase of Anglo-Irish extraction alludes to the nutritive value of a fine broth. Broths are thought to be extremely nourishing because it is believed that the nutritional value of all the ingredients are concentrated in the broth.

> Papa says you are the broth of a boy, for taking care of me. (Mrs. Tonna, *Judah's Lion*, 1843)

2. in a nutshell Concisely, tersely, pithily; briefly, simply, in few words; containing much of substance in a small space, as nutmeat within a nutshell. *Nutshell* as representative of conciseness has been in use since the 17th century; the phrase *in a nutshell* since shortly thereafter.

> A great complex argument, which . . . cannot by any ingenuity . . . be packed into a nutshell. (John Henry Newman, *Grammar of Assent*, 1870)

3. name of the game The true situation; the crux of the matter; the way it is; what it's all about. This American slang term came into use in the 1960s and is another of the profusion of sports terms that have found their way into the world of business and even the common language. It doubtless owes its popularity to the neat rhyme it contains.

> We guarantee the objectivity. Personally. That's what makes us worth a lot of money to any modern and properly objective management. Ergonomics, baby. That's the name of the game. (Desmond Cory, *The Circe Complex*, 1975)

4. nature of the beast The essence of a person or thing; human nature; the qualities and characteristics common to human beings and other animals. This expression combines *nature* 'essential qualities or properties' and *beast* 'any animal,' implying that there is a certain crudeness common to all animals, both human and nonhuman. It is often used in the context of explaining or excusing the behavior of someone who acts or has acted in an inappropriate or boorish manner. Such usage is illustrated in a 1683 letter by Jules Verney:

> I'm very sorry [that] John my coachman should be so great a clown

to you . . . but 'tis the nature of the beast. (*Letters and Papers of the Verney Family*, 1899)

In recent years, the usage of *nature of the beast* has been extended to describe the negative qualities often inherent in inanimate objects, bureaucratic systems, and other matters.

5. part and parcel An integral or essential component; a vital part of a larger entity. In this expression, common since the 14th century, *part* and *parcel* are synonymous, their juxtaposition serving to emphasize the importance of a given constituent to the whole.

The places referred to are, for all intents and purposes, part and parcel of the metropolis. (John McCulloch, *A Descriptive and Statistical Account of the British Empire*, 1846)

6. sixty-four-dollar question The crux of the matter; the basic or critically important question; the remaining unknown whose answer would provide the ultimate solution of a problem. This expression refers to the prize awarded for correctly answering the last and most difficult in a series of questions asked of a contestant on "Take It or Leave It," a popular radio quiz show in the 1940s. With the advent of television, the stakes were raised considerably in "The $64,000 Question" (1955–58), giving rise to the updated variation, *sixty-four-thousand-dollar question*.

Essentials . . .

See 157. FUNDAMENTALS

124. ESTABLISHMENTS

1. barrelhouse A cheap, disreputable saloon; also, a loud, forceful, unpolished type of jazz. The name *barrelhouse* probably came from the practice of serving beer from kegs or barrels in less expensive bars.Of American origin, this word appeared in its slang sense in 1883 in *Peck's Bad Boy* by George W. Peck. The musical sense of the term, however, which derived from the style of piano

entertainment associated with such places, did not appear until 1926 in H. O. Osgood's *So this is Jazz*.

2. blind pig An establishment where intoxicating beverages are sold illegally; a speakeasy; a type of cheap whiskey manufactured in such establishments. The origin of this expression, along with a common variant, *blind tiger*, is uncertain. A common theory attributes the origin of *blind pig* to a band of militia in Richmond, Virginia called the Public Guard, who wore militia hats with the initials *P.G.* on them. Apparently these soldiers spent a great deal of time in taverns and were disliked by the general population, for it soon became known that "P.G. is a pig without an *i* and a pig without an eye is a blind pig." However, this explanation is surely apochryphal, for the term was first recorded in 1840, and the militia group was not formed until 1858. A more plausible explanation is that the term derived from people getting, literally or figuratively, *blind as a pig* from the cheap whiskey served in such establishments.

Because he was perhaps, the most notable figure associated in the public mind with . . . blind pigs, speakeasies, and above all pussyfooters, he should merit at least a place in the dictionaries of the future. (*Chicago Daily News*, February 5, 1945)

The variant *blind tiger*, which dates from the 1850s, may derive from drinking establishments where the game of faro, also known by the slang term *tiger*, was played. The expression also became a synonym for *moonshine*.

An old Negress let us watch her put the corks in blind tiger liquor bottles. (Jonathan Daniels, *Tar Heels*, 1941)

3. but-and-ben A Scottish term for a two-room dwelling; a cottage. In use as early as 1724, the term is a combination of the Scots *but* 'outer or front room' and *ben* 'inner or back room.' R. Burton explains the term as follows:

Each house has two rooms, a "but" and a "ben" separated by a screen of corncanes. . . . The but, used as parlour, kitchen, and dormitory, opens upon the central square; the ben . . . serves for sleeping and for a storeroom. (*Central Africa*, in *Journal*, 1859)

4. cathouse A house of prostitution; a brothel; a whorehouse. The origin of this expression is uncertain; however, the *OED* lists prostitute as an obsolete meaning for *cat* with an accompanying citation dated 1401. The plausible explanation is that *cathouse* has retained that connotation through the years.

I had sex with a number of girls—off the street, out of bars, or in cathouses. (Harold K. Fink, *Long Journey*, 1954)

A related term, *cat wagon* alludes to the mobile brothels that serviced the cowboys, railroad men, and miners during the settling of the American West.

5. the cooler A jail or prison, especially a solitary confinement cell. This U.S. slang term, which dates from 1884, originally referred to isolated cells where drunk or violent inmates were kept in order to "cool off." The expression has since become more generalized and is now used popularly to mean simply jail or prison.

6. cow college A small agricultural school of higher learning; a college isolated in a rural area; a little-known college. This expression, dating from the 19th century, is a derogatory term applied sarcastically to those schools that do not seem to meet the standards of the institutions with more prestige. Many small colleges around the United States, which had focused their curricula on agriculture, grew into large universities in the 1900s, but somehow retained the *cow college* image. An old Yale cheer denigrating the University of Connecticut, once an agricultural college, declares:

Bulldog, bulldog, bow-wow-wow
UConn, UConn, cow-cow-cow!

7. flea bag A dingy, squalid residence; a decrepit hotel or rooming house. The term alludes to a small, confined area infested with roaches, fleas, and other vermin. In modern usage, *flea bag* usually refers to a run-down building where low-cost rooms are available to destitute people.

The flea bag where I was living did not permit dogs. (John O'Hara, *Pal Joey*, 1939)

8. fleshpot A luxurious establishment offering its customers wanton pleasure and depravity; a brothel or house of ill repute. In the Old Testament (Exodus 16:3) this term describes the plenty of Egypt so sorely missed by the wandering Israelites. Its modern figurative meaning is decidedly different.

He would sally out for the fleshpots to enjoy a hell raising binge. (W. R. and F. K. Simpson, *Hockshop*, 1954)

9. honky-tonk A disreputable nightspot; a tawdry cabaret; a chintzy establishment featuring cheap entertainment and music.

Others of possibly less talent were doing stalwart work as accompanists to the blues singers in the honky-tonks of New Orleans and St. Louis. (S. Traill, *Concerning Jazz*, 1957)

The origin of this expression lies in the tinny, honklike sounds of ragtime heard in cheap nightclubs and brothels; hence, the term's adjectival use describing the music itself.

Happy, beery men thumping honky-tonk pianos. (*Drive*, Spring 1972)

10. joss house A Chinese temple; an oriental place of worship; a house of idolatrous worship. Portuguese explorers were trading along the Chinese coast as early as the 15th century, and the Portuguese word for god, *dios*, was probably corrupted into the pidgin *joss*; hence, any Chinese religious building became known as a *joss house*, 'a house of god,' and a *joss house man*, 'a priest or missionary.' Within the *joss house*, *Joss*

flowers, Chinese sacred lilies, were placed around the idols, and *joss paper*, a type of gold and silver sacred paper, and *joss sticks*, symbolic sticks made of a paste of aromatic woods, were burned before sacred idols. The term *joss* has come to symbolize the romance and enigma associated with the Far East.

The whole narrative is permeated with the odour of joss-sticks and honourable high-mindedness. (Ernest Bramah [E. B. Smith], *The Wallet of Kai Lung*)

11. schlock shop This slang expression describes a store which specializes in cheap and inferior merchandise, a store where one can often haggle with the owner over prices. The key word in this term is *schlock*, which is defined in *Harpers Dictionary of Contemporary Usage* (1975) as:

. . . a Yiddicism used to describe any piece of inferior, cheaply made merchandise, from a bedroom suite (pronounced *suit* by those who sell schlock) to a trashy novel.

12. speak-easy A restaurant, bar, or nightspot where alcoholic beverages are sold illicitly. While the expression may have originated from the 19th-century British underworld's *speak-softly shop* 'a smuggler's home or business establishment,' it is more likely derived from the ease with which a tipsy person engages in conversation. The phrase was particularly commonplace during Prohibition, when it referred to the many clandestine establishments serving bootleg whiskey and moonshine.

Moe Smith and Izzy Einstein were the most dreaded prohibition agents who ever closed down a speak-easy. (*Life*, January 2, 1950)

13. sweat shop The original sweat shops were factories that employed unskilled laborers of any age or sex to work long hours at low pay. These employees were usually forced to work under unsanitary conditions, were treated miserably, and were often dismissed for the smallest infraction of the rules. Today *sweat shops* are illegal and are most frequently clandestine operations, employing illegal immigrants. Figuratively, the expression is often used pejoratively by labor leaders to decry working conditions in a non-union factory or in a union factory that refuses to meet the union's demands.

Shaw justified *Mrs. Warren's Profession* by blaming it on the sweat shop wages which capitalism paid the female proletariat. (*Time*, October 17, 1949)

A related term, *sweat a person*, means to work him for starvation pay or to require the greatest amount of labor at the lowest possible wage.

14. watering hole A bar or tavern; a local hangout where alcoholic beverages are sold. This modern American slang expression, often preceded by an affectionate *old* or *ole*, is usually used of a familiar tavern or barroom frequented by a congenial drinking crowd. The allusion is to the actual watering holes in the American West where, when they brought the cattle there to drink, the cowboys had an opportunity to refresh themselves and to engage in friendly conversation. The expression has been employed figuratively since shortly after World War II.

You're sitting on a stool at the local watering hole, dragging hard on one Marlboro after another. (*Hartford Courant*, March 27, 1983)

Etiquette . . . See 290. PROPRIETY

125. EUPHEMISMS

1. blankety-blank See 288. PROFANITY.

2. Bristol Cities The female breasts; the feminine bust; the bosom. This Briticism is another of the many Cockney rhyming slang expressions which have come into the common vernacular. Although there is only one city of Bristol, the Cockneys found it necessary to pluralize the term

since female breasts come in pairs. In re-
cent years the *cities*, which provided the
rhyme with *titties*, has been dropped
from the expression entirely, and the
term has been reduced to *Bristols*.

3. bushwa Baloney; bullshit; bunk.
Webster says that this term is a corrupt-
ed form of the old word *bodewash*,
meaning 'bosh' or 'trash,' which in turn
is derived from the French *bois de vache*
'cow's wood,' 'dried manure.' Coined in
the early 1900s, this once popular term,
more likely a euphemism for *bullshit*, is
seldom heard today, for in the language
revolution of the late 1960s it was re-
placed by the more direct vulgarism
bullshit.

> There has been a lot of bushwa tossed
> around about how moving pictures
> aren't worthy of their audience. (Otis
> Ferguson, *New Republic*, August 31,
> 1938)

4. by the great horned spoon A mild
oath, usually used to avoid blaspheming.
The origin of this term, especially popu-
lar in the United States in the 19th cen-
tury, is quite controversial. Some schol-
ars believe it derives from a reference to
Ursa Major, while others assign its
source to the American Indian practice
of making spoons from the horns of
Rocky Mountain bighorn sheep. Francis
Parkman in his studies of Indian life ob-
served them making large spoons, capa-
ble of holding more than a quart of liq-
uid, from the horns of mountain sheep.
How this great spoon, whatever its
source, came to be the subject of an oath
is anybody's guess.

> The more he thought on't, the madder
> he grew,
> Until he vow'd by the great horn
> spoon
> Unless they did the thing that was
> right,
> He'd give them a licking, and that
> pretty soon.
> (Author unknown, *French Claim*,
> 1842)

5. Chic Sale An outhouse; an outdoor
toilet; the little house behind the big
house. *Chic Sale* is really an eponymous
term used euphemistically for an out-
house. In the 1920s Chic Sale, a humor-
ist, published a satirical little book, a
catalogue of outhouses, that because of
its widespread circulation made the term
almost a household word throughout the
United States.

6. Chinese tobacco Opium. This term is
derived from the close association be-
tween China and the opium dens that
country once tolerated. When China
first opened its borders to foreign com-
merce in the 19th century, traders and
sailors were astonished to discover the
unrestricted use of opium. The drug
soon became closely linked to that nation
and gave rise to the term *Chinese
tobacco*, and the related *Chinese saxo-
phone* for an opium pipe.

> If you think I've been lacing my coffee
> with Chinese tobacco and want to
> check on this story, go ahead. (Billy
> Rose, *Pitching Horseshoes*, 1950)

7. Cousin Betty A trollop; a streetwalk-
er; a Bess of Bedlam; a half-witted wom-
an. Bedlam, a hospital for lunatics since
1402, adopted the practice of sending its
less dangerous inmates into the streets of
London to beg. These mendicants be-
came known by the nickname, *Bess of
Bedlam*, and those women of question-
able morality who were willing to sell
their favors soon were distinguished
from the others by the term *Cousin Betty*
or *Cousin Betsy*. Thus the term came to
imply either a strumpet or a half-wit.

> A gay bachelor who . . . was a great
> admirer of that order of Female
> Travellers called Cousin Betties. (Mrs.
> R. Goadby, *An Apology for the Life
> of Bampfylde Moore Carew*, 1749)

8. dickens See 288. PROFANITY.

9. ding my buttons An imprecation;
damn my lot in life. This expression is
attributed to the stage, especially to the
comedy of manners, and to the adoption

of euphemistic phrases as substitutes for blasphemy. Dating from the early 18th century, the phrase consists of two figurative references, *ding*, as a replacement for *damn*, and *buttons*, as a symbol of one's destiny or lot in life.

> Ding my buttons, if she ain't more Southern than any of our own gals. (Albion Tourgee, *A Fool's Errand*, 1879)

There are many variants of this term; among the more popular are *dash my buttons*, *dash my wig*, and *ding my wig*. An interesting related term *dang*, another euphemistic form of *damn*, is the past tense of the verb *ding*.

10. family jewels Clandestine operations; a man's testicles; skeletons in one's closet. This expression, as a CIA euphemism for covert operations, probably derives from an earlier meaning of the term, 'shameful secrets.'

> A turncoat . . . gave up to congressional investigating committees delicious CIA secrets, among them the notorious 693 page list of the "family jewels" —such tricks as the surveillance of journalists, interception of mail, drugging of unknown CIA employees, assassination attempts. (*Manchester Guardian Weekly*, June 11, 1978)

A more common meaning, dating from at least the 15th century, is 'a man's testicles,' for they are treasured as the seed of future generations in his family.

11. gone for a Burton Killed, especially in an air raid over Germany; had it; bought it. This British expression originated with the RAF in 1939. Although originally applied only to wartime aerial combat, the phrase is still in regular use in England today; however, the sinister implications no longer exist. The allusion in the original phrase is almost assuredly to going for a glass of Burton beer, Burton being famous for its brew. Hence, the absence of a departed friend came to be euphemistically attributed to

an innocent cause, thus modifying the blunt, "He was killed in combat."

12. go to Halifax This expression, a polite euphemism for *go to hell*, is derived from the longer expression *from Hell, Hull, and Halifax, Good Lord, deliver us*, which is said to be a beggar's litany referring to the three places of punishment most feared by beggars and thieves.

> Let them seek him, and neither in Hull, hell nor Halifax. (Thomas Nash, *Works*, 1599)

Hell is undesirable for obvious reasons; Hull had an efficient town government, and lawbreakers soon found themselves at hard labor; and Halifax beheaded thieves first and tried them afterwards.

> I told my critics to go to Halifax. (L. J. Jennings, *Chestnuts and Small Beer*, 1920)

13. Great Scott Exclamation of surprise or astonishment. This euphemistic expletive, which became popular in the mid-19th century, probably relates to General Winfield Scott, "Old Fuss and Feathers," an American hero popular after his successful campaign in the Mexican War. Apparently a dodge to avoid blasphemy, the term is a substitute for *Great God*.

> Great Scott! I must be bad! (F. Anstey [T. A. Guthrie], *The Tinted Venus*, 1885)

The variants *Great Caesar* and *Great Caesar's ghost* are obvious references to the Roman leader.

> Great Caesar's ghost! Who's takin' who to the prom? (*Chicago Tribune*, May 25, 1947)

14. Jack in the Cellar An unborn child. This expression, a translation of the Dutch *Hans in Kelder*, is a euphemistic method of referring to a pregnant woman's unborn infant. In use in England since at least 1600, the term is still heard both in England and in parts of the United States. A variant is *Jack in the Low Cellar*.

When his companions drank to the Hans in Kelder, or Jack in the low cellar, he could not help displaying an extraordinary complacence of countenance. (Tobias Smollett, *Peregrine Pickle*, 1751)

Popular related terms are *bun in the oven* and *cake in the oven*, alluding to the expansion of dough as it bakes. Italians say a woman has been *stung by a serpent*.

15. look upon the hedge To relieve oneself. Seldom heard today, this Briticism from the 1500s is another in a long list of phrases coined to avoid the direct mention of bodily functions. In Shakespeare's *The Winter's Tale*, Autolycus directs the clown and the shepherd to:

> Walk before toward the seaside; go on the right hand. I will but look upon the hedge and follow you. (IV,4)

16. love-brat A child born out of wedlock; a bastard. This obsolete expression, the equivalent of the modern *love-child*, appeared in the 17th-century *Old Chapbook:*

> Now by this four we plainly see
> Four love brats will be laid to thee:
> And she that draws the same shall wed
> Two rich husbands, and both well bred.

17. pillars to the temple British slang for a woman's legs. The sexual allusion in this coy euphemism is obvious.

18. pooper-scooper A shovellike device used to daintily pick up the feces of dogs or other pets. The expression, as well as the devices, has become especially popular since the mid-1970s when New York and other cities enacted laws requiring dog owners to clean up after their pets.

19. pope's nose That part of a fowl which, when the creature is jumping, goes over a fence last, especially the rump of a turkey, chicken, or goose. According to the *OED* this colloquial expression dates to at least the 1790s.

pope's nose—the rump of a turkey. (Francis Grose, *A Classical Dictionary of the Vulgar Tongue*, 1796)

Some scholars believe the term actually came into use shortly after the reign of King James II, the last Catholic King of England, who was forced to leave the throne in the Bloodless Revolution of 1688. Fearing another Catholic monarch, the people of England developed a strong anti-Catholic attitude, and the development of this term reflected that attitude. The *OED* records the first written use of its figurative parallel, *parson's nose*, as the 1830s.

> An epicurean morsel—a parson's nose. (Henry W. Longfellow, *Hyperion*, 1839)

20. powder [one's] nose To go to the bathroom; to go to relieve oneself. This euphemistic colloquialism has been in use since the early 1900s in the United States and Britain. It derives from the polite female excuse, "I'm going to powder my nose," used when departing for the ladies' room. It has even come to be used jocularly by men about to go to the men's room. The use of the expression has reinforced and popularized another euphemistic term, *powder room*, for *ladies' room*.

21. Sam Hill Hell. The person to whom this euphemistic expletive apparently refers is unknown. The *Random House Dictionary* suggests that *Sam* may be derived from *salmon*, a variation of *Sal(o)mon* 'an oath,' and that *Hill* may be a variation of *hell*. The term usually appears in expressions like *"What the . . .," "Who the . . .,"* etc.

> He wondered who the Sam Hill the "senator" was. (*Salt Lake* [City, Utah] *Tribune*, December 18, 1948)

22. see a man about a dog To go to the men's room; to go out for a drink; to visit a prostitute. This slang Americanism appears to have been coined in the mid to late 19th century as a Victorian euphemism to avoid direct reference to

bodily functions or frowned-upon activities.

> Although they were all out, at the bases, and the rest of our nine having gone to see a man, there was nobody to take the bat. (*The Ball Players' Chronicle*, September 12, 1867)

The appearance in print of the inverted *see a dog about a man* and the variant *see a man about a horse* attests to the nonsensicalness of the original expression.

> I'm in a rush—gotta see a dog about a man. (*Chicago Tribune*, March 21, 1948)

See a man about a dog is also used as an evasive response to almost any inconvenient or embarrassing question.

23. skinny dip To swim in the nude; a swim in the nude; a pool party where everyone swims in the buff. This American slang expression, used both as a verb and a noun, dates back to the 18th-century use of *dipping* for 'swimming.' Seldom heard for a number of years, it has regained currency since World War II.

24. son of a gun An evil person, a miscreant; a rogue, scamp, or scalawag; any person; a disagreeable or odious task or other matter; as an interjection, an exclamation of surprise, disappointment, or dismay. It has been suggested that *son of a gun* originated during the 18th century when nonmilitary women were permitted to live aboard naval ships. When one of these women gave birth to a child without knowing which of the sailors had fathered it, the paternity was logged as "gun" and the child as "son of a gun," alluding either to the sexual implications of *gun* or to the midship gun which was located near the makeshift maternity room. In any case, the expression is a popular and somewhat less offensive alternative to *son of a bitch*, which also intimates that a person is of uncertain paternity and that his mother was less than virtuous. Over the years, however, both expressions have lost much of their

derogatory connotations and are often applied in jocular and familiar contexts.

25. take [one's] coals in To contract a venereal disease, especially syphilis. The derivation of this phrase, used by seafaring men, is probably best explained by the use of *coal* for 'carbuncle, boil,' one of the manifest signs of a late stage of syphilis. The term and its variant, *take in [one's] winter coals*, have been out of use since the early 20th century.

26. T & A Gratuitous display of women, scantily clad and in provocative poses, used to lure an audience. This expression, a euphemistic abbreviation of *tits and ass*, enjoyed currency among show girls and models for many years, but did not enter the common vocabulary until its use in the long running, Pulitzer-Prize-winning musical *A Chorus Line*, which opened on Broadway in 1975. The lyricist, Edward Kleban, caught the public's fancy with the lyrics to *Dance: Ten; Looks: Three*.

> Dance: Ten; Looks: Three is like to die.
> Left the the'ter and called the doctor for my appointment to buy
> Tits and Ass. Bought myself a fancy pair.
> Tightened up the derriere.

27. watch the submarine races To engage in sexual activity in a parked car; to go parking. This expression, introduced in the late 1950s by New York disc jockey, Murray the K, is simply a euphemistic term for *parking* or *making out*, the common practice of teenagers who, in order to avoid parental watchfulness, drive to secluded areas at night to indulge in sexual pleasures.

28. Winchester goose A venereal disorder that produces a swelling in the groin; a prostitute. This term, although obscure in origin, is usually attributed to a series of brothels found on the south bank of the Thames in London during the Middle Ages, and may be merely a jocular euphemism.

In the times of popery there were no less than 18 houses on the Bankside, licensed by the Bishops of Winchester, to keep whores, who were, therefore, commonly called Winchester Geese. (*England's Gazeteer: Southwark*, 1751)

The name *Winchester goose*, or simply *goose*, for a venereal disorder probably arose from the transmission of such disease by these harlots on the Bankside.

126. EVASIVENESS

1. Alibi Ike One who repeatedly makes excuses; a shirker. This label, popularized in the U.S. during the 1930s and '40s, is the name of the main character in a 1924 Ring Lardner short story of the same title. By the time he coined the phrase, *alibi* had acquired its informal meaning of 'any excuse, pretext, or plea of innocence,' as opposed to the specific plea that one was elsewhere when an alleged act took place (from the Latin *alibi* 'elsewhere'). Lardner's choice of the name Ike was probably due simply to the catchy sound and rhythm of *Alibi Ike*.

2. beat around the bush To approach cautiously or in a round-about way; to be evasive; to refuse to come to the point. Nocturnal bird hunters in 15th-century Britain checked for birds lurking in bushes by cautiously beating around a bush with a bat and a light. The saying is now used figuratively in regard to discourse and can be expressive of timidity at one extreme or dishonesty at the other.

3. bone in [one's] throat An excuse not to speak. It is said that when the Milesians came to Athens seeking aid for their people, the great orator Demosthenes opposed their cause. However, when they offered him a bribe not to speak publicly against them:

> He refused to speak, alleging that he had a bone in his throat and could not speak. (Nicolas Udall, *Erasmus' Apothegms*, 1542)

Two common variants of the expression are: *a bone in [one's] arm* and *a bone in [one's] leg*. Both expressions date from the 17th century and are used to avoid performing some unpleasant task.

> The English say, He hath a bone in his arm and cannot work. (Giovanni Torriano, *Piazza Universale*, 1666)

> Panting and bright-eyed she would stop and say, "Eh, dear, I can't run any more: I've got a bone in my leg." (Edward F. Benson, *Our Family Affair*, 1920)

4. bury [one's] head in the sand To avoid reality; to hide from the truth; to ignore the facts. In times of danger ostriches lie on the ground with their necks stretched out in order to escape detection. It is presumably this behavior that gave rise to the myth that ostriches bury their heads in the sand when pursued, and, no longer able to see their enemies, believe themselves secure from danger.

5. creeping Jesus Someone who employs dilatory tactics to avoid personal contact with others; a whimperer; one who refuses to face an issue head-on; a person given to sneaking about and whining when faced with making a decision; one who hides himself as much as possible from the public view. It would appear that this term, if not coined, was at least popularized by William Blake, the mystical poet, who in 1818 used the term to indicate the probable evasiveness of an anti-Christ in *The Everlasting Gospel*:

> If he [Christ] had been Antichrist,
> Creeping Jesus,
> He'd have done anything to please us.

And again in his *Letters* (1827) he reveals:

> God keep you and me from the divinity of yes and no too, the yea, nay, creeping Jesus.

The term has also been a popular oath or exclamation in Australia since shortly before the beginning of the 20th century. It was brought to the United States

after World War II by servicemen returning from Australia and the South Pacific.

6. do an end run To evade or circumvent; to outmaneuver or outfox. This American slang expression is a figurative extension of the football term *end run* or *sweep*, a running play in which the offense blocks to center while the ball carrier runs toward the sideline and slips around the opposing blockers.

7. drink with Johnny Freeman To drink with one's friends but avoid paying one's share. This expression, which originated in the British Royal Navy, was coined sometime in the late 1800s and refers to one who joins his comrades in drink but leaves before it becomes his turn to buy a round. The term probably derived from a simple play on the word *free*, but it might have derived from an earlier term, *drink at Freeman's Quay*, meaning to drink at another's expense. It is said that at one time the first pot of beer was given free to all porters and carmen who stopped at Freeman's Quay, a wharf on the Thames near London Bridge.

8. fimble-famble A trivial excuse or explanation; balderdash, fiddle-faddle, nonsense. This British expression is probably a dialectal variant of skimble-skamble, which appears in Shakespeare's *I Henry IV*:

. . . and such a deal of skimble-
 skamble stuff
As puts me from my faith.
(III,i)

9. fire [one's] pistol in the air To purposely avoid offending or injuring an opponent in an argument or debate. This expression harkens back to the days when dueling was the gentleman's way of defending his honor. A dueler who did not want to injure his opponent would fire his pistol into the air—a harmless way of discharging his debt. In current usage, the expression is employed figuratively to indicate that someone deliberately avoids a direct personal attack on an opponent during the discussion of issues.

10. give the run-around To avoid personal contact by being perpetually unavailable; to avoid direct, open communication by evasive, misleading responses; to postpone action, or to employ dilatory tactics. In any case, the words *run* and *around* are suggestive of avoidance and evasion. *Give the run-around* appeared in print by the turn of the century.

Pitts is satisfied that he is the victim of the grandest run-around ever put over on a boxing promoter. (*Chicago Herald*, December 2, 1915)

11. hem and haw To speak evasively; to avoid answering a question directly; to procrastinate. This familiar expression is an onomatopoeic rendering of the unintelligible muttering of a noncommittal mugwumpian. The phrase, as used by Clifford Aucoin, is cited in *Webster's Third*:

Hem and haw and put it off,
apparently in the hope that things
will pick up.

12. in soaped-pig fashion Vaguely, ambiguously, equivocally; used in reference to speaking or writing of this nature.

He is vague as may be; writing in what is called the "soaped-pig" fashion. (Carlyle, *The Diamond Necklace*)

In former times, at fairs and carnivals, great sport was had chasing after and trying to catch the pig that was turned out among the crowd for their diversion. Before the pig was loosed, however, it was soaped in order to heighten both the difficulty and the fun.

13. Mickey Mouse around To avoid confronting a major issue or problem by wasting time; fooling around; indulging in trivial activities. The reference is to the animated persona that made its debut in Walt Disney's *Steamboat Willie* (1928), the first cartoon with sound, and

the allusion is to the playful though insignificant activities which characterize most Mickey Mouse cartoons.

> We can't Mickey Mouse around while faced with technological challenges from other countries. (R. G. Hummerstone, in *Fortune Magazine*, May 1973)

See also **Mickey Mouse**, 211. INSIGNIFICANCE.

14. pull punches To be evasive, hedge, or weasel; to pussyfoot and be mealymouthed; to lessen the impact of a disclosure or to discuss a sensitive topic with discrimination. This expression originated as boxing slang for an intentionally weak blow. It is most often used negatively as an implicit compliment to candor and openness, as in the following by Sara H. Hay, cited in *Webster's Third*:

> She has pulled no punches in coming directly to the extreme issues involved.

15. pussyfoot To proceed carefully; to avoid being straightforward in giving an opinion. The allusive reference in this expression is to the cautious, stealthy tread of a cat on the prowl. The connotation is that a person is acting contrary to the speaker's desires or well-being, or that he is vacillating or being treacherous. A variant is *pussyfooter*.

> The appeasers and pussyfooters of 1850 also provided that any territories that might come into the Union later could do so with or without slavery. (Stewart Holbrook, *Lost Men of American History*, 1946)

16. slippery as an eel Exceedingly difficult to keep in one's grasp, extremely tricky; elusive; evasive; untrustworthy. This expression has been in literal use since about 1412.

> Which made the ground as slippery as an eel. (John Lydgate, *Assembly of Gods*, 1420)

However, in 1633 in his drama, *A Fine Companion*, Shackerley Marmion employed the phrase to suggest a streak of craftiness in one of his characters. From that time the figurative application of the phrase has become so common that today it seems trite and almost meaningless.

17. steer clear of To avoid; to keep away from; to give a wide berth to; to take no part in; to shun. This expression, chiefly figurative in its use, had its origin in nautical lingo during the 17th century. The allusion is to the ship's helmsman avoiding hidden, as well as visible, obstacles so that the ship and its crew may reach port safely.

> It is our true policy to steer clear of permanent alliances with any portion of the foreign world. (George Washington, *Farewell Address*, September 17, 1796)

18. stick in the bark To avoid the heart of a matter; to stop on the outer edges of a problem; to neglect reality. This American expression, dating from the early 1800s, alludes to the boring into or the cutting of a tree. If one gets *stuck in the bark*, he never gets to the pith.

> He sticks in the bark about the mortal peril of promising 'independence'; but he does promise 'self-government.' (*New York Evening Post*, July 27, 1904)

19. within a mile of an oak Somewhere; near enough; within a general area. In 16th- and 17th-century England this expression was a common evasive reply to a question about where someone or something was. It amounted to telling an inquisitive person to mind his own business, oaks being so plentiful that almost everyone lived within a mile of one.

> "Where's your mistress?"
> "Within a mile of an oak, dear madam, I'll warrant you."
> (Aphra Behn, *Sir Patient Fancy*, 1678)

Evil . . . See 389. UNSCRUPULOUSNESS; 403. WICKEDNESS

Evilness . . . See 403. WICKEDNESS

127. EXACERBATION
See also 28. AUGMENTATION

1. add fuel to the fire To make a bad situation worse; to intensify; to say or do something to increase the anger of a person already incensed. Literally adding fuel to a fire increases the strength with which the flames blaze, just as metaphorically adding "something that serves to feed or inflame passion, excitement, or the like . . . especially love or rage" (*OED*), intensifies the passion.

2. add insult to injury To heap scorn on one already injured. The phrase is from the Aesop fable of a baldheaded man who, having been bitten on his pate by a fly, tries to kill the insect. In doing so, he gives himself a painful blow. The fly jeeringly remarks:

> You wished to kill me for a mere touch. What will you do to yourself, since you have added insult to injury?

3. confusion worse confounded Chaos compounded or made greater than before. John Milton uses the expression in *Paradise Lost* (1667):

> With ruin upon ruin, rout on rout, Confusion worse confounded.

The unusual syntactical structure of this expression may be clarified by noting that the obsolete or archaic meaning of *confound* was 'to overthrow, to bring to ruin' while the obsolete meaning of *confusion* was 'overthrow, ruin.' Thus, the line *confusion worse confounded* follows the pattern of repetition found in the previous line.

4. cut off [one's] nose to spite [one's] face To cause one's own hurt or loss through spiteful action; to cause injury to oneself or one's own interests in pursuing revenge. This proverbial expression first appeared in print in 1785, when it was defined in Francis Grose's *A Classical Dictionary of the Vulgar Tongue:*

> He cut off his nose to be revenged of his face. Said of one who, to be revenged on his neighbour, has materially injured himself.

This saying is believed to have come from the French *se couper le nez pour faire dépit à son visage.*

5. escape the bear and fall to the lion To be free of one predicament only to get involved in another more trying, complex, or dangerous one; to go from bad to worse. In use as early as the beginning of the 17th century, this expression suggests that there is danger to be met at every turn.

6. heap Pelion upon Ossa To make matters worse, to compound or aggravate things; also, to indulge in fruitless or futile efforts. The allusion is to the Greek myth of the giants who unsuccessfully tried to get to Olympus, home of the gods, by stacking Mount Pelion on Mount Ossa.

7. Job's comforter One who either intentionally or unwittingly adds to another's distress while supposedly consoling and comforting him. The allusion is to the Biblical Job's three friends who come to commiserate with him over his misfortunes and who instead of consoling him only aggrieve him more by reproving him for his lack of faith and his resentful attitude. The term has been in use since at least 1738.

> You are a Job's comforter with a vengeance. (Mrs. B. M. Croker, *Proper Pride*, 1885)

8. out of the frying pan into the fire From bad to worse, from one disastrous situation to one even worse.

> If they thought they could get away from the State by disestablishment, they would find that they were jumping out of the frying-pan into the fire. (*The Guardian*, October 1890)

Use of the expression dates from the early 16th century.

9. rub salt in a wound To maliciously emphasize or reiterate something unfavorable or disagreeable with the express purpose of annoying someone; to continually harp on a person's errors or shortcomings, especially those of which he is acutely conscious. Since salt, when placed on an open wound, causes painful stinging and discomfort, to actually *rub* salt into a wound would be excessively cruel and sadistic. Although recent medical research has shown that salt (such as in seawater) actually helps wounds to heal with minimal scarring, it is safe to assume that a person who figuratively rubs salt in a wound is not motivated by therapeutic concern. A popular and more widely used variation is *rub it in.*

> Ye needn't rub it in any more. (Rudyard Kipling, *Captains Courageous*, 1897)

10. when push comes to shove When a situation goes from bad to worse; when worse comes to worst; when the going gets tough. In this expression *shove* refers to an exaggerated—bigger and harder—push. Thus, *when push comes to shove* refers to the point at which subtlety gives way to flagrancy.

Exactness . . . See **73. CORRECTNESS; 280. PRECISION**

128. EXAGGERATION
See also **236. MENDACITY**

1. all [one's] geese are swans A proverbial expression said of one who is prone to overexaggeration and overestimation. Geese are rather unattractive, common birds in comparison to the rarer, more elegant swans; thus, to *turn one's geese to swans* is, figuratively speaking, to color reality considerably. Use of this phrase, which is infrequently heard today, dates from at least the early 17th century.

> The besetting temptation which leads local historians to turn geese into swans. (*Saturday Review*, July 1884)

2. all moonshine Not the real thing; an exaggeration; nonsensical talk; an incredible statement. Since the light of the moon is not real but only reflected from the sun, moonshine has come to symbolize anything unsubstantial or unreal. The expression, British in origin, has been in common use since the early 17th century. There are many variants, all connoting nonsense or nothingness: *moonshine in the water, a matter of moonshine,* and *moonshine in the mustard pot.*

> I care little about that nonsense—it's a' moonshine in water—waste thread and thrums as we say. (Sir Walter Scott, *Rob Roy*, 1817)

3. draw the longbow To exaggerate or overstate, to lay it on thick; to stretch the truth, to tell tall tales. The longbow, a weapon drawn by hand, was of central importance in the exploits of Robin Hood and his band. The farther back one stretched the bowstring, the farther the arrow would fly. It is easy to see how this literal stretching of the longbow came to mean a figurative stretching of the truth. This expression, in use since at least the latter part of the 17th century, appears in Lord Byron's *Don Juan* (1824):

> At speaking truth perhaps they are less clever,
> But draw the long bow better now than ever.

4. fish story A tall tale, an exaggeration; an absurd or unbelievable account of one's exploits. This colloquialism, in use since at least the early 19th century, derives from the propensity of many, if not all, fishermen to exaggerate the size of their catch. An important element in many fish stories is the angler's lament, "You should have seen the one that got away."

5. ham See **256. OSTENTATIOUSNESS.**

6. hyped-up Overblown, overly touted, inordinately promoted or publicized; artificially induced; bogus, contrived.

The term's origin stems from the use of a hypodermic injection to stimulate physiological response. In a 1950 syndicated column Billy Rose said of a movie:

> No fireworks, no fake suspense, no hyped-up glamour.

The term has now given rise to the truncated form *hype*, used disparagingly both as noun and verb.

7. lay it on See 150. FLATTERY.

8. make a mountain out of a molehill To make a to-do over a minor matter, to make a great fuss over a trifle. Although this particular expression did not appear until the late 16th century, the idea had been expressed centuries earlier by the Greek writer Lucian in his *Ode to a Fly*; it subsequently became the French proverb *faire d'une mouche un éléphant* 'make an elephant of a fly.'

> [This is] like making mountains out of molehills. (James Tait, *Mind in Matter*, 1892)

9. megillah See 20. ANECDOTE.

10. not so black as painted Not so bad as one's reputation would lead someone to believe. This phrase is an offspring of the proverbial expression, *the devil is not so black as he is painted*. It is usually said to point out that the speaker is overelaborating about another's shortcomings or faults. Common to many foreign languages—it takes practically the same form in German, Italian, and French— the expression has been established in English since the 16th century.

> Mr. Slope was not quite so black as he had been painted. (Anthony Trollope, *Barchester Towers*, 1857)

11. shoot the bull See 371. TALKATIVENESS.

12. snow job See 236. MENDACITY.

13. song and dance A misleading, false, or exaggerated story designed to evoke sympathy or to otherwise evade an issue; a rigmarole; a snow job. Though the derivation of this expression is unclear, it probably alludes to the "song and dance" acts that introduced or filled in between the main attractions in a vaudeville show.

> Labor leader Preble . . . was not impressed by the song and dance about [Stefan's] mother and sister being persecuted and murdered. (*Time*, September 5, 1949)

14. spin a yarn To tell a story, especially a long, involved, exaggerated account of one's exploits and adventures, both real and imagined; to tell a tall tale. Originally, *spin a yarn* was a nautical term that meant 'to weave hemp into rope.' Since this was a tedious, time-consuming task, sailors often traded tall tales and adventure stories to help pass the time. Thus, these stories came to be known as *yarns*, and their telling as *spinning a yarn*, by association.

> Come, spin us a good yarn, father. (Frederick Marryat, *Jacob Faithful*, 1835)

15. talk through [one's] hat To talk nonsense, to lie or exaggerate, to make farfetched or unsupported statements.

> But when Mr. Wallace says that . . . he is talking through his hat. (*The Chicago Daily News*, December 1944)

Use of this expression, whose origin as yet defies explanation, dates from the late 19th century.

16. talk through the back of [one's] neck To use extravagant, flowery language often sacrificing accuracy; to make unrealistic, illogical, or extraordinary statements.

> "Don't talk through yer neck," snarled the convict. "Talk out straight, curse you!" (E. W. Hornung, *Amateur Cracksman*, 1899)

Through the back of one's neck is here opposed to *straight*, which connotes directness, straightforwardness, and truthfulness.

> Anybody who gets up in this House and talks about universal peace know

he is talking through the back of his neck. (*Pall Mall Gazette*, 1923)

Exasperation . . .
See 92. DESPERATION

129. EXCELLENCE

1. A1 or A one Superior, excellent, first-rate. The term dates from the 1830s. Lloyd's *Register of British and Foreign Shipping* used letters to indicate the condition of a ship's hull, and numbers to designate the state of the cables, anchors, etc. The highest attainable rating was A1. In the United States the colloquial phrase *A number one* is often heard.

2. batting a thousand Absolutely right; completely error free; superb; the very best. This American expression is another of the many terms which came into everyday colloquial use from the game of baseball. In order to bat a thousand, a player must get a hit for every official time at bat, yielding a batting average expressed as *1.000*. This indicates that his performance is perfect, he is doing the best that is possible. The term has been in use since the late 19th century.

3. bear away the bell See 396. VICTORY.

4. bear the bell To be in the foremost position; to take the lead; to be the best. This expression refers to the bell worn on the neck of the bellwether, the leading sheep of a flock. It can be used quantitatively to mean the first in a series, or qualitatively to mean the best. Chaucer used it in the former sense:

And, let see which of you shall bear
 the bell
To speak of love aright?
(*Troilus and Criseyde*, 1374)

The judgmental use of *bear the bell* is more current today.

5. blowed-in-the-glass First-rate, superior, high quality. This American hobo slang expression alludes to the fact that the better liquors often had the brand name blown into the glass of the bottle.

6. blue ribbon The highest order of excellence; preeminence in a given area; first prize. The term may come either from the blue ribbon worn by members of the Order of the Garter, the highest order of British knighthood, instituted in the mid-14th century; or from the blue ribbon (*cordon bleu*) worn by members of the Order of the Saint Esprit, the highest order of knighthood in France, instituted in the late 16th century. The French term *cordon bleu* remains in use primarily for chefs of distinction. The first figurative use of *blue ribbon* has been attributed to Disraeli, who termed the Derby "the Blue Ribbon of the Turf" (1848).

7. bung up and bilge free In great shape; everything in a wonderful state. This expression is derived from the whaling trade and refers to the condition of the whale oil barrels after they have been filled and stored. If a barrel stored bung down lost its stopper, the resulting oily mess would require a lengthy cleanup. Furthermore, with the bilge free and no hand pumping necessary, to the sailor the immediate future holds nothing but the promise of happy sailing and carefree days.

"Bung up and bilge free," he cried in ecstasy. (Herman Melville, *White Jacket*, 1850)

The phrase appeared as early as 1830.

8. cat's meow Someone or something excellent, first rate, remarkable; the acme. Introduced in the early 1900s, this was among the most popular fad expressions of the Roaring '20s. It is rarely used now. *Cat's pajamas*, another popular phrase of the era, derives from the fact that pajamas had just been introduced and were still considered somewhat daring nighttime attire. The word *cat* is also used in expressions such as *cat's whiskers, cat's cuff links, cat's eyebrows, cat's galoshes, cat's roller skates,* and *cat's tonsils.*

In the 1920s, it was all the rage to combine an animal with an inappropriate body part or clothing item, e.g., *ant's pants, bee's knees, clam's garters, eel's ankles, elephant's instep, gnu's shoes, leopard's stripes, pig's wings, sardine's whiskers,* and *tiger's spots.*

9. copper-bottomed Excellent; financially sound; air-tight. This expression alludes to the shipping trade and the copper-bottoms that were applied, starting in 1761, to wooden ships to resist shipworms and delay the attachment of barnacles (copper being poisonous till oxidized). The fact that copper-bottomed pots and pans are more efficient and longer lasting serves to reinforce the idea. Hence, anything *copper-bottomed* is sound and anything *one hundred per cent copper-bottomed* is extremely sound.

> Copper-bottomed—In maritime circles, the expression has become popularly current, in a figurative sense, to signify the highest commercial credit. (John S. Farmer and William E. Henley, *Slang and its Analogues*, 1890)

10. corker See 112. EFFECTIVENESS.

11. crème de la crème 'Cream of the cream'; the most desirable of something which is itself desirable. This expression, borrowed directly from the French during the mid 1800s, is frequently heard in reference to the most select social group, the elite of the elite.

> It was the fashion among the creme de la creme to keep aloof from him. (Benjamin Disraeli, *Endymion*, 1880)

Two related terms, *cream of the crop* and *pick of the litter*, also indicate a desirable choice, the opportunity to pick the best from a normal lot; a far cry, however, from picking the best from a very select lot. J.J. Coddington in *No Past Is Dead* (1942) uses a jocular variation of the expression.

> You'd be a bit astray if you looked for her amongst the skim de la skim.

12. enough to make a cat speak Said in reference to something extraordinarily good, usually superior drink. The point is that the liquor is so good it will loosen even a cat's tongue. A variant of this expression appears in Shakespeare's *The Tempest* (II,ii):

> Here is that which will give language to you, cat; open your mouth.

13. first chop First-rate; highest quality; top rank or position; superior; excellent. This expression was introduced into Britain in the early 18th century by those people returning from the newly found trade markets in India and China. The origin of the term most likely derives from *chhap*, a Hindi word used to designate an official stamp, its seal or impression. These stamps indicated that the goods had passed through a custom house, in China known as a *chop house*, and also specified the nature or quality of those goods; hence, *first chop* for highest quality, *second chop* for second quality, etc. The expression remains in use today, especially in England and the Orient.

> You must be first chop in heaven, else you won't like it much. (George Eliot, *Middlemarch*, 1872)

14. flower of the flock Most attractive or desirable of a group; crème de la crème. This expression originally denoted the prize animal or fowl in a flock, the blue-ribbon winner, so to speak. In common use since the mid 1700s, it is used today almost entirely in its figurative sense, the choice person or persons in a group.

> "And I say Richard and Jacob were the flowers of the flock," sobbed Catherine. (Charles Reade, *The Cloister and the Hearth*, 1861)

A common variant of this term is *pick of the litter*.

15. golden oldie This expression refers to the record industry's custom of issuing a *gold record* to the artist upon the sale of a million copies. The term achieved

popularity from radio disk jockeys reaching into the past and occasionally reviving one, or even whole programs of these hits. A variant is *oldie-goldie*. The term has been in popular use since about 1950.

> . . . crank up a . . . golden oldie like "Honeysuckle Rose" by the immortal Fats Waller. (F. P. Tullis, *New Yorker*, August 13, 1973)

16. good as George-a-Green Said of one who is strong-willed and resolute, one who will carry on to defend the right, one who demonstrates a high degree of accomplishment. According to Hazlitt in *Tales and Legends*, George-a-Green won the pindership of Wakefield by besting all other applicants at quarter-staff, dismissed a messenger from Prince John without paying the contribution John demanded of Wakefield, eloped with a magistrate's daughter, and, single-handedly, successfully resisted Robin Hood, Will Scarlet, and Little John when they tried to enter Wakefield. These achievements are probably apochryphal, but *George-a-Green* still stands as a symbol of resoluteness.

> Were he as good as George-a-Greene, I would strike him sure. (Robert Greene, *George-a-Greene*, 1599)

17. have jam on it To be in luxury; to be in clover; to have things easy; to have an agreeable surplus. This Briticism, originating in the late 19th century, achieved popularity during World War I through extensive use by service personnel. The idea of enhancing one's food by putting jam on it gave birth to such other phrases as *to want jam on it*, indicating dissatisfaction, and *to want jam on both sides*, indicating unreasonableness.

18. hunky-dory In a fine state; in superb condition; A1 or A-OK. This American expression, derived from the Dutch *honk* 'goal, home,' as in the children's games of tag or hide and go seek, implies feelings of success, contentment, or satisfaction.

I thought everything was hunky-dory and you were well on the way to being a big executive. (D. M. Dakin, *Sullen Bell*, 1956)

19. lollapalooza Something outstanding; anything extraordinary; an excellent person or thing. This American slang expression, dating from the early 20th century, is of unknown origin. A spelling variant is *lalapalooza*.

> I have a filing system for keeping track of things that is, if I do say so myself, a lollapalooza. (Harold Medina, *New Yorker*, November 24, 1951)

20. numero uno The best; number one; the first; the most important; one's self; one's own best interests. This term, which has come into extreme popularity since the early 1960s, is derived from the Italian and Spanish *numero uno*, 'number one.' Utilization of the phrase was given considerable impetus during the late 1960s and early 1970s, when it became representative of the importance of considering one's self-interests before those of other people.

> All the Bicentennial rhetoric and campaign jingoism can't cover up the fact that we're not Numero Uno. (*Time*, June 21, 1976)

21. of the first water Perfect, consummate; pure, unblemished. The transparency, color, or luster of a diamond or pearl is its water. Diamonds are rated of the first, second, or third water. The phrase came to be applied to jewels in general, and subsequently to any person or object of outstanding quality. It is frequently used in negative contexts as an intensifier—*pure* as 'unmitigated, out-and-out, thoroughgoing, complete.'

> He was a . . . swindler of the first water. (Scott, *Journal*, 1826)

22. purple patches Passages in a literary work that are marked by ornate writing, especially as interlarded with an overuse of dramatic, exaggerated literary effects; inappropriately laden with rhetorical

devices. In this expression, *purple* means 'gorgeous.'

A few of the purple patches scattered through the book may serve as a sample of the rest. (*Academy*, April 1881)

23. the real McCoy See 160. GENUINE-NESS.

24. round as Giotto's O Said of a task, project, or other matter that is completed quickly, effortlessly, and with a high degree of perfection. According to legend, Pope Boniface VIII sent a messenger to secure the services of the famous Italian artist Giotto (c. 1266–1337). Seeking proof of Giotto's skill, the messenger asked for a sample of his work, whereupon the artist quickly drew a perfect circle on a sheet of paper. The pope was impressed, and the expression and its variants soon became almost proverbial in Italy and elsewhere.

I saw . . . that the practical teaching of the masters of Art was summed up by the O of Giotto. (John Ruskin, *The Queen of the Air*, 1869)

Rounder than the O of Giotto is sometimes said of a work that epitomizes perfection, one that is more perfect than perfect.

25. slap-up Excellent; superior; stylish; grand; luxurious; first rate; of unmistakably fine quality. This Briticism, dating from the early 1800s, became a vogue word in 19th century England, but is considered old-fashioned there today. The term was probably derived from an earlier expression with the same meaning, *bang-up*, which is still in current use, both in Great Britain and the United States.

Winston Churchill and his party crossed the Atlantic in slap-up style on the Queen Mary. (*New Yorker*, January 19, 1952)

A related term, *slap-up do*, refers to a magnificent party where no expenses were spared.

26. to a fare-thee-well Perfectly, to the utmost degree or fullest extent, to the maximum; also *to a fare-you-well*. This American expression, which dates from the latter part of the 19th century, comes from the parting phrase *fare you well*, used to express good wishes to one about to leave on a journey. Perhaps the connection lies in the finality of departure.

27. Toledo blade A sword blade of the very highest quality; of excellent construction and material. From the early 1600s, the most finely tempered sword blades were those made in the Spanish city of Toledo, about 40 miles south of Madrid.

The trenchant blade, Toledo trusty,
For want of fighting was grown rusty.
(Samuel Butler, *Hudibras*, 1663)

A newspaper in Toledo, Ohio, apparently playing upon the worldwide reputation of the sword, is called *The Toledo Blade*.

28. top-drawer Of the highest rank; usually in reference to social class. Conjecture is that the term stems from keeping one's most valuable possessions in the top drawer of a chest.

29. top-shelf Of superior quality, used especially in relation to social class or standing, as in *top-shelfer*.

The frontiersman calls them, as we have heard, "top-shelfers"; they are accompanied by their servants from England. (Baillie-Grohman, *Camps in the Rockies*, 1882)

Topshelf items are out of easy reach, for use or wear only on rare occasions; extraordinary or fine as opposed to everyday. One theory holds that *top-shelf* derives from the saloon keepers' practice of placing the most expensive, and consequently the least requested, brands of liquor on the higher shelves. The more frequently ordered house-brands were kept more readily accessible.

30. **tough act to follow** Said of a presentation, performance, project, or other matter that has been completed successfully and with a high degree of excellence, especially one that has received much acclaim. In variety shows, theatrical performances, concerts, etc., it has become customary to save the best act for last lest the audience become disappointed and leave before the entire show has been completed. *Tough act to follow* implies that the standards set by a previous performer will be difficult, if not impossible, to meet or exceed.

31. **whole team and the dog under the wagon** An individual of outstanding abilities; one who is gifted to handle any of life's situations. Dating from the mid-1800s, this American colloquialism has its roots in the importance of a team of horses and a wagon to the rural economy of the 1800s. The horses and wagon were basic, but the dog under the wagon was an embellishment indicating additional assets.

A clear-grit Yankee woman quite equal upon emergency, to what, in vulgar parlance, is quaintly styled 'a whole team and a dog under the wagon' to boot. (George Brewerton, *The War in Kansas*, 1856)

Excelling . . . See 258. OUTDOING

130. EXCESSIVENESS
See also 366.
SUPERFLUOUSNESS

1. **baker's dozen** Thirteen; a dozen plus one. Bakers at one time reputedly gave an extra roll for every dozen sold in order to avoid the heavy fines levied against those who short-changed their customers by selling lightweight bread. The phrase appeared in the early 17th century in *Tu Quoque* by John Cooke.

2. **bare as a barn** Barren; in need of interior furnishings and accouterments; extremely stark. This American expression, dating from at least the mid-19th century, reflects the condition of the interior of a barn, especially in late spring and early summer when the winter's hay has been consumed and the animals are all outdoors. The term is usually used in a derogatory manner and implies either lack of taste or penury.

The most contemptuous word that could be applied to an interior in those days was 'bare'—as bare as a barn. (*House and Garden*, April 1982)

3. **barnburner** See 408. ZEALOUSNESS.

4. **blue blazes** Impulsively; rashly; vehemently; in the extreme. This slang expression refers to the blue flames created by the burning of brimstone; hence, a direct reference to hell and the devil. An old superstition ascribed a blue flame to the presence of the devil. In his *History of the Devil* (1726), Daniel Defoe comments:

That most wise and solid suggestion that when the candles burn blue the Devil is in the room.

In modern use the term is employed almost exclusively to indicate anything excessive, and is usually preceded by *as* or *like*.

It was as cold as blue blazes. (Howell Vines, *The Green Thicket World*, 1904)

5. **break a butterfly on a wheel** To employ a degree of force or energy disproportionate to the needs of a situation; to overkill. The wheel was formerly an instrument of torture upon which a criminal was stretched and beaten to death. Considering the fragile nature of a butterfly, the analogy is self-evident. The phrase appears in Alexander Pope's *Epistle to Dr. Arbuthnot*:

Satire or sense, alas! can Sporus feel?
Who breaks a butterfly upon the wheel?

6. **Carthaginian peace** A peace so harsh that it cripples; a treaty with terms so severe that they destroy the defeated nation. This phrase arises from the destruction that Rome wreaked upon Carthage

at the conclusion of the Third Punic War in the 2nd century B.C. M. Porcius Cato, after visiting Carthage and recognizing the threat that state represented to Rome, concluded all of his speeches in the Senate with *Delenda est Carthago*, 'Carthage must be destroyed.' His constant warning influenced all of Rome to such a degree that after Carthage had been overwhelmed, the city was obliterated and the earth within and about it was sowed with salt to assure that nothing would ever rise there again. *Delenda est Carthago* has become a proverbial manner of saying "whatever stands in our path to greatness must be eliminated."

7. die for want of lobster sauce To die or suffer greatly on account of some minor disappointment, irritation, or disgrace. This expression is said to have had its origins in a sumptuous banquet given by Louis II de Bourbon (the great Condé) for Louis XIV at Chantilly. Legend has it that when the chef was informed that the lobsters which he had intended to make into a sauce had not been delivered in time for the feast, he was so overcome with humiliation that he committed suicide by running upon his sword.

8. drug on the market A commodity which is no longer in demand; anything which is so readily available that it tends to be taken for granted or undervalued; a glut on the market. *Drug* alone was used as early as the 1600s; *in the market* was introduced in the 1700s. The phrase "a drug in the market of literature" appeared in Thomas Walter's *A Choice Dialogue Between John Faustus, A Conjurer, and Jack Tory his Friend* (1720). Today *drug on the market* is more frequently heard. Perhaps this expression derives from the fact that drugs induce a dulling effect similar to that caused by too much of anything—in other words, by any type of overindulgence.

9. enough [something] to choke Caligula's horse A lot, a great deal, plenty, more than enough. Caligula, Roman

emperor from A.D. 37–41, was thought to be insane because of his extravagant claims, his wholesale murdering and banishment of his subjects, and his wild, foolish spending. It is perhaps in reference to this last quality that the expression *enough [something] to choke Caligula's horse* arose. There is, however, no evidence to substantiate this theory, and no theory at all regarding the rest of the phrase.

10. gingerbread Garish or tasteless ornamentation; superfluous embellishments. This term is derived from the ornate decorations a baker uses to adorn a gingerbread house. Figuratively, *gingerbread* describes excessive or tacky furnishings and decorations.

> Some people would have crammed it full of gingerbread upholstery, all gilt and gaudy. (Lisle Carr, *Judith Gwynne*, 1874)

11. go overboard To go to great extremes; to express either overwhelming opposition to or support for a person or cause. One who shifts all his weight to one side of a small boat may literally go overboard. Likewise, one who radically directs all his energies toward one thing figuratively "goes overboard." This very common phrase as used by Dwight Mac Donald is cited in *Webster's Third*:

> . . . went overboard for heroes and heroines who don't seem so heroic today.

12. go through the roof To go beyond prescribed limits; to climb precipitously and unexpectedly. The figurative use of this expression is usually associated with a sudden burst of prosperous financial activity; however, it is also occasionally associated with an extreme fit of passion, especially anger.

> Those who haven't traveled for a couple of years are going on a binge and the market is going through the roof. (*Time*, July 25, 1983)

13. had it up to here Unable to continue because of excessive fatigue; in such a state of exhaustion that one is unable to respond any further; so thoroughly annoyed and disgusted that one has lost all interest. This American expression, dating from about 1940, is usually accompanied by a hand gesture pointing to the neck just below the chin line, or to the top of one's ear, to indicate figuratively to what level one has had it.

14. make two bites of a cherry Take two turns to do a job when it might be done in one; to do something piecemeal; to separate something into pieces too small. This expression alludes to taking two bites of a cherry rather than popping the whole piece of fruit into one's mouth; i.e., wasting time and motion. The term dates from at least 1500.

> Take it all, man—take it all—never make two bites of a cherry. (Sir Walter Scott, *The Two Drovers*, 1827)

A variant is *make three bites of a cherry*.

15. nineteen bites to a bilberry Make a meal of a mouthful; much ado about nothing; go overboard; overdo. This British expression, which dates from the early 17th century, refers to making a major production of an inconsequential act. A *bilberry* is about one-quarter inch in diameter and to make nineteen bites of such a tiny fruit is, to say the least, excessive. A variant is *nineteen bits to a bilberry*.

16. out Herod Herod See 258. OUTDO-ING.

17. overshoot the mark To exceed or go beyond prescribed limits; to be off base, irrelevant, or inappropriate. Literally, a missile or other projectile "overshoots the mark" when it misses its target by going above or beyond it. Figuratively, this expression is said of any attempt or idea which errs on the side of excess. Such use dates from the late 16th century.

> The greatest fault of a penetrating wit is not coming short of the mark but overshooting it. (*The English Theophrastus*, 1702)

18. paint the lily To adorn or embellish an already beautiful object, thereby destroying its delicate balance and rendering it gaudy and overdone; to detract from the natural, full beauty of an object by trying to add ornamentation where none is required. This expression derives from Lord Salisbury's speech in Shakespeare's *King John:*

> Therefore, to be possess'd with double pomp,
> To guard a title that was rich before,
> To gild refined gold, to paint the lily,
> To throw a perfume on the violet,
> To smooth the ice, or add another hue
> Unto the rainbow, or with taperlight
> To seek the beauteous eye of heaven to garnish,
> Is wasteful, and ridiculous excess.
> (IV,ii)

Gild the lily is actually more familiar to most people, although few are aware that it is a corruption of *gild refined gold* and *paint the lily*.

19. run into the ground To overdo, to continue beyond a period of effectiveness to the point of counterproductivity; to beat to death. The expression frequently appears in contexts dealing with argument or with utilization of material objects. One runs a topic into the ground when he undermines a point already effectively made because his persistence and long-windedness antagonize his listeners. Objects are "run into the ground" when a user wrings the last ounce of service from them. In either case, what is "run into the ground" is effectively buried.

20. sow [one's] wild oats Indulge in excesses during one's youth; behave in a profligate manner. The origin of this expression is obscure, but it may have reference to the Biblical "Whatsoever a man soweth, that shall he also reap." (Galatians 6:7), with the implicit warn-

ing against irresponsible behavior, wild oats being utterly useless.

> We meane that wilfull and unruly age, which lacketh rypeness and discretion, and (as wee saye) hath not sowed all theyre wyeld Oates.
> (*Touchstone of Complexions*, 1576)

21. tempest in a teapot A great commotion, disturbance, or hubbub over a relatively insignificant matter; excessive agitation or turmoil caused by something of trifling importance. This expression and variations thereof have been common at least since the time of Cicero (106–43 B.C.), as evidenced in *De Legibus:*

> Gratidius raised a tempest in a ladle, as the saying is.

The implication, of course, is that something as small as a teapot (or ladle) is hardly an appropriate place for a *tempest* 'violent or stormy disturbance.'

> What a ridiculous teapot tempest.
> (*Peterson Magazine*, January 1896)

Common variations are *tempest in a teacup* and *storm in a teacup.*

> M. Renan's visit . . . to his birthplace in Brittany has raised a storm in the clerical teacup. (*Pall Mall Gazette*, September 19, 1884)

22. throw out the baby with the bath water To reject the essential or valuable along with the unimportant or superfluous. This graphic expression appeared in print by the turn of the century. It is frequently used in reference to proposals calling for significant change, such as political and social reforms or largescale bureaucratic reorganization.

> Like all reactionists, he usually empties the baby out with the bath. (George Bernard Shaw, *Pen Portraits and Reviews*, 1909)

23. towering ambition Aspiration that extends beyond limits; awesome intent of purpose; overweening resolve to get ahead. When a falcon reaches the highest point of its ascent and proceeds to hover at that point, it is said to *tower*, a meaning derived from a comparison to castle towers, the highest points in the countryside during the Middle Ages. Thus, *towering ambition* alludes to a reaching above normal heights.

> Nothing less than the writing of a play can satisfy his towering ambition.
> (*The English Theophrastus*, 1702)

Excitedness . . .
　See 155. FRENZIEDNESS

131.　EXCLAMATIONS
　See also 225. LANGUAGE;
　322. RETORTS

1. all right already That's enough; no more of that. This exclamation, promulgated by native speakers of Yiddish, was adopted into American use during the late 1800s but did not achieve any degree of popularity until after World War II. It is employed to indicate that one's patience is nearing its limit, that one can't take much more nagging, tantalizing, or criticizing.

2. all that jazz All that stuff; and all that sort of thing; and all that nonsense; et cetera. This American slang expression, derived from the jargon of the music world, originally connoted insincerity on the part of the speaker. Current since at least 1956, it is most commonly heard today as a replacement phrase for "and so forth."

3. another county heard from In *A Hog on Ice*, Charles E. Funk maintains that this term arose from the Tilden-Hayes presidential election of 1876. Tilden, who was supposed to carry the entire south, lost the states of Florida, Louisiana, and South Carolina. The ensuing recount in those states dragged on for several months, and as each county's tally arrived, the weary newspapermen reported, *another county heard from.* Another plausible explanation attributes the expression to state election results in general, and the report to the man at the tally board of the results arriving from

another county. Whatever the case, to-day the expression is in common use as a catch-phrase. When a person breaks his silence at meeting to interject his ideas, one is apt to hear *another county heard from*. The term is also heard jocularly when someone in a group breaks wind. A variant is *another country heard from*.

4. big deal See under **327. RIDICULE**.

5. by cock and pie A euphemistic exclamation to avoid the use of blasphemy a mild oath. This Briticism is believed to be a corruption of *God and pie*, where *cock* is a corruption of *God*, and *pie* refers to the Ordinal of the Roman Catholic Church—a table of rules governing the offices for each day.

> "Is he?" replied the host; "ay, by cock and pie is he." (Sir Walter Scott, *Kenilworth*, 1821)

6. by jingo An exclamation expressing surprise or strong feelings; by Jove. The first written record of this term appears in Peter Motteux's translation of Rabelais' works in 1694, when he substituted *by jingo* for the French *par Dieu*, 'by God.'

> By jingo, quoth Panurge, the Man talks somewhat like I believe him.

The origin of the term is somewhat obscure. One credible explanation suggests that *jingo* may be a substitution for the Basque word for God, *Jinko*, adopted into English from its use by Basque sailors in the British merchant fleet. The *OED* indicates that such a beginning is possible but, as yet, is unsupported, and that a more likely source would be an old conjurer's magical cry, *hey jingo*, a nonsense term designed to bid something to appear, the opposite of *hey presto*, to bid something to disappear. Hence, *by jingo* may originally have been derived from an exclamation of shock or surprise at the sudden appearance of something. In any event, the term remains in use.

> in every language even deafanddumb thy sons acclaim your glorious name by gorry

> by jingo by gosh by gum (e.e. cummings, *Collected Poems: 147*, 1938)

7. cheese it To run away; beat it; scram; clear out; watch out. The origin of this American slang expression, in common use since the mid-1800s, is uncertain. It is generally believed that it is a corruption of *cease*. Whatever the case, it is a common phrase usually assigned in usage to the criminal or shady element of society.

> Cheese it! they're coming this way. (Clyde Fitch, *The Girl with the Green Eyes*, 1902)

A variant is *cheezit*.

8. for crying out loud This U.S. colloquial exclamation expressing impatience, astonishment, or perturbation is a minced equivalent of similar profane ejaculations such as *for Christ's sake*, *Holy Christ*, and *Jesus H. Christ*.

> For crying out loud, why did you do it? (R. West, *Black Lamb*, 1941)

9. gardy loo Beware of the water; look out below; guard yourself. This exclamation was a call of Edinburgh housewives and maids when they were about to empty the contents of the slop pail or chamber pot out the window into the street below; it was adapted from the French, *gare de l'eau*, 'beware of the water.' The exclamation is no longer heard in a literal sense, as the practice of emptying slops into the street has, fortunately, stopped.

> At ten o'clock at night the whole cargo of the chamber utensils is flung out a back window that looks into some street or lane, and the maid calls "Gardy loo" to the passers-by. (Tobias Smollett, *Humphrey Clinker*, 1771)

10. Geronimo An exclamation of surprise or delight. This Americanism was a battle cry used by World War II paratroopers as they jumped from planes. Military use of the term derived from the American Apache Indian Chief, Geronimo (1829–1909), whose name carried as-

sociations of savage killing. After the war, *Geronimo* became a popular term in nonmilitary contexts, retaining the flavor of surprise and exhilaration.

11. God bless the Duke of Argyle Said when one is scratching his back or shrugging his shoulders. The Duke of Argyle owned a vast treeless estate in Scotland upon which he placed scratching posts for his sheep and cattle. Many a verminous shepherd expressed his thanks to the Duke as he rubbed his back and shoulders against one of the posts. A less plausible explanation is set forth in J. C. Hotten's *Slang Dictionary* 1859:

> A Scottish insinuation made when one shrugs his shoulders. . . Said to have been the thankful exclamation of the Glasgow folk, at finding . . . iron posts, erected by his grave in that city . . . very convenient to rub against.

This exclamation from the 19th century remains in use in Scotland and northern England today.

12. God save the mark This parenthetic phrase can be used as an exclamation of contempt, impatience, or derision; as a formula spoken to avert an evil omen; or as a phrase serving to soften or lessen the offensiveness of something said. Contrary to popular belief that this expression was originally used by archers, it is now believed to have been originally used by midwives at the birth of a child bearing a "mark." Shakespeare popularized the phrase and its variant *bless the mark* in his plays.

> He had not been there (bless the mark) a pissing while, but all the chamber smelt him. (Shakespeare, *Two Gentlemen of Verona*, 1591)

In modern use, *save the mark* is most often heard as an ironic expression of contempt.

> The crisis of apathetic melancholy . . . from which he emerged by the reading of Marmontel's Memoirs (Heaven save the mark!) and Wordsworth's poetry. (William

James, *The Varieties of Religious Experience*, 1902)

13. gosh all hemlock This American expression, in use since about 1880, is simply a non-profane person's way of saying *God Almighty*. The word *gosh*, a substitute for *God*, has been in use since the early 18th century, and has been employed to create a number of other euphemistic expressions: *gosh-a-mighty*, *gosh burned*, and *gosh all Potomac*, all terms still occasionally heard in regional speech.

> Gosh all hemlock . . . won't ye never stop twittin' a feller. (John T. Trowbridge, *Three Scouts*, 1865)

14. Heavens to Betsy This exclamation, usually spoken with a gently derisive tone, is of uncertain origin. There is the possibility of a connection with Betsy Ross, as some conjecture; this leaves unexplained the fact that the term didn't come into use in America until the early 1800s. Others theorize that there is some connection between the exclamation and the American frontiersman's calling his rifle *Betsy*; however, no reasonable interpretation has been forwarded to explain this further. Perhaps the most plausible explanation comes from the historical novelist Kenneth Roberts, to whom Charles Funk attributes the following account in his *Heavens to Betsy* (1955):

> Our family originated in Auvergne, lit out when things were being made rough for the Huguenots, settled in Stratford-on-Avon. I think . . . that "Heavens to Betsy" was nothing but a corruption of the words *Auvergne betisse*, meaning "What won't they think of next!"

Whatever the case, the exclamation is still commonly heard in everyday conversation, especially among the elderly.

15. hit the deck An exclamatory warning to fall to the ground; to take cover; (in nautical use) to get out of bed.

The whole House fell on its knees or went prone behind desks, as one Pacific veteran shouted out: "Hit the deck, you damn fools!" (*Manchester Guardian Weekly*, March 4, 1954)

This citation supports the theory that *hit the deck* had a nautical origin, based on the nautical use of *deck* for any floor, aboard ship and elsewhere. This expression is also used in boxing to mean to fall or be knocked down in the ring. Yet another (nonnautical) use of *hit the deck* refers to going to bed.

I'm going to hit the deck now, and I'm going to turn the lamp out. (J. Hackston, *Father Clears Out*, 1966)

These different uses have no common origin but share the connotations of speed and impact.

16. hold on to your hat An exclamatory warning to prepare oneself for something important or exciting, or for something new or unusual. This expression gained popularity with the advent of fast-moving vehicles, and the admonishment, *hold on to your hat*, was originally a literal warning. However, the exclamation soon became synonymous with "get ready for a new and exciting experience."

When you get behind the keyboard of the IBM Personal Computer, hold on to your hat. (*New Yorker*, November 15, 1982)

17. holy mackerel An exclamation expressing surprise or wonder. The only plausible explanation for this curious expression is that it was once felt to be vaguely anti-Catholic, since Catholics were enjoined from eating meat on Fridays and often partook of mackerel instead. Thus, the mackerel acquired a jocularly sacred character. A similar expression, *Holy cow*, evidently sprang up in reference to the sacred cows of Hinduism.

18. Hookey Walker Bunk; nonsense; an exclamation meaning that something is not true or an exaggeration. Coined

about 1810, the term is heard when someone wishes to express incredulity over a story or incident being related. Many stories have been advanced to explain the origin of this British phrase, but most of them seem unlikely. The *OED* comments that it probably referred to some hook-nosed person named Walker; but why the expression entered the language with such a connotation is unknown.

For mere unmeaning talk her parched lips babbled now—such as Hookey!— and Walker! (Richard Barham, *The Ingoldsby Legends*, 1845)

19. I want to know This rather strange American exclamation seems to be pretty much limited to the Midwest and Rocky Mountain areas. It is simply another way of expressing 'is that so!' or 'do tell!'

And you come from North Dakoty! I want to know! (Ralph Paine, *Comrades of the Rolling Ocean*, 1921)

20. let them eat cake A statement indicating a complete lack of empathy on the part of the speaker; a comment often interjected jocularly to offset another's misfortune. This expression is generally attributed to Marie Antoinette as her arrogant or naive reaction to the plight of the French peasantry when she was informed that they had no bread, literally, "*Qu'ils mangent de la brioche.*" However, Marie Antoinette did not arrive in Paris until 1770 and is said to have made the statement in the 1780s, whereas Jean Jacques Rousseau, in 1768, wrote in *Confessions*:

At length I remembered the thoughtless saying of a great princess, who, on being informed that the country people had no bread, replied, "then let them eat cake."

It is clear from this evidence that Marie Antoinette has been credited with an expression whose origin antedated her by some years.

21. my eye Stuff and nonsense; bunk; baloney—an emphatic exclamation of

disbelief. *My eye* is a current truncated version of *all my eye and Betty Martin*. The most popular and most far-fetched story offered to explain the origin of this expression tells of a sailor who overheard a poor Italian beggar cry out, "Ah mihi, beate Martini" which means "Ah, grant me, Blessed Martin." In relating the story to his friends, the sailor's faulty recollection of the beggar's words gave rise to the expression as it stands today: "All my eye and Betty Martin." Undermining the plausibility of this story is its attribution to "Joe Miller"—meaning that it was probably from a book of jests called *Joe Miller's Jest-Book*. (See **Joe Miller**, 20. ANECDOTE.) Other sources scoff at this explanation and suggest that the phrase derives from a gypsy named "Betty Martin" who gave a black eye to a constable who unjustly accused her of committing a crime. Obviously the exact origin of this expression is unknown although the former explanation is most often cited.

> That's all my eye, the King only can pardon, as the law says. (Oliver Goldsmith, *The Good Natured Man*, 1767)

22. my foot An exclamation of contradiction, usually spoken directly after the word or phrase being questioned, as in the following:

> Cooperation my foot. You're trying to trap me into admitting a motive for doing the old girl in. (L. A. G. Strong, *Othello's Occupation*, 1945)

The origin of this phrase is unknown. It appeared in print about the turn of the century.

23. my giddy aunt An exclamation of surprise or amazement; an exclamation of delight. *Charley's Aunt*, a farcical comedy which first appeared in December of 1892, is probably the source of this British expression. *My giddy aunt* and a related term, *my sainted aunt*, are often used euphemistically to avoid actual blasphemy.

24. put that in your pipe and smoke it Make what you can of that; digest that if you can; think about that for awhile. Although the origin of this exclamation is obscure, it is generally believed that it developed from the widely held concept that pipe smokers engage in a great deal of meditation. The term has been in regular use since its inception in the early 19th century.

> For this you've my word, and I never yet broke it,
> So put that in your pipe, my Lord Otto, and smoke it.
> (R. H. Barham, *The Lay of St. Odille*, 1840)

25. see you Good-by; so long; I'll be seeing you. This exclamation has achieved a great deal of popularity since World War II, especially among younger people. A shortened form of *I'll be seeing you*, this parting phrase has become almost as common as "good-by" or "so long."

> The two cadets exchanged the careless 'see you's' that people say when they know they will see each other again in a few hours. (*Life*, April 14, 1952)

See also **see-you**, 147. FAVORITISM.

26. see you later, alligator Good-by, as used especially by musicians. This expression originated with jazz musicians, in the 1930s, probably from the rhyming phrase, *see you later, alligator*, to which the jocular retort became *in a while, crocodile*. The epithet *alligator* for a jazzman was reinforced by *gate* that is, something that "swings." The popular song, performed by Bill Haley and the Comets, *See You Later, Alligator*, in the early 1950s, further established the expression in the language.

27. shiver me timbers An interjection, sometimes used as a mock oath. This expression is associated with buccaneers and old salts because of its popularity in comic fiction and children's stories, where it frequently appears as an epithet used by a pirate or other villain. *Timbers* here refers to a ship's structural

hull; literally, *shiver me timbers* means to deliver a severe shock to a ship's hull so as to imperil its safety, as from having run aground; figuratively, it means to rattle one's ribs.

I won't thrash you, Tom. Shiver my timbers if I do. (Frederick Marryat, *Jacob Faithful*, 1835)

28. shut my mouth An exclamation indicating that one is astonished or surprised, that he is dumbfounded, or that he has said more than he wished. This exclamation, perhaps derived from American Southern black dialect, gained widespread popularity during the 1930s through the medium of early talking pictures, which depicted stereotyped black characters using the expression. The term is occasionally heard today.

29. stuff and nonsense Rubbish; baloney; an exclamation expressing disbelief or contradiction. This colloquial exclamation is simply a euphemistic way of avoiding blasphemy while indicating one's disagreement with the speaker. The first written record of the exclamation, as listed in the *OED*, is in Henry Fielding's novel *Tom Jones* (1749), but the word *stuff*, used in the same context, antedates it by about 300 years.

"No, no!" said the Queen. "Sentence first—verdict afterwards."

"Stuff and nonsense!" said Alice loudly. (Lewis Carroll, *Alice's Adventures in Wonderland*, 1865)

30. tennis, anyone? An expression used to draw attention to oneself, especially when among people engaged in other activities; an expression used satirically to indicate boredom on the part of the speaker. This facetious question became popular in the 1920s as a stock theatrical phrase to clear the stage of performers. In the early days of his Broadway career, Humphrey Bogart once played a young man who repeatedly appeared on stage in white tennis duds, racquet in hand, cheerfully asking, "Tennis, anyone?" as a sort of repetitious joke.

You will emerge with something unreal as the juveniles in plays who come in impertinently swinging tennis rackets, and when the time for their exit arrives, make it with the remark: "Tennis, anyone?" (John Van Druten, *Playwright at Work*, 1953)

31. that'll be the day An emphatic exclamation of disbelief, usually heard in a derisive sense; also used to denote denial or disdain. This ironic expression is said to have originated among British officers during the early days of World War I as a sarcastic reply to the German "Song of Hate," which celebrated that day when the Germans would gloriously "come into their own." Today the phrase has spread throughout the English-speaking world and is usually heard as a rebuttal, either sarcastically or jocularly, to someone's contention or boast.

"I thought you were going to cut the grass," his wife said.

"I will," he said, "just let my lunch settle down. . . . You don't want me to get indigestion, do you?"

"Indigestion," she said, "that'll be the day." (C. P. Snow, *The Malcontents*, 1972)

32. you ain't heard [seen] nothin' yet The best is yet to come; the worst is yet to come; wait until you find out what happens next. The origin of this exclamation is somewhat obscure. It has been assigned to Kenyon Nicholson's play, *The Barker* (1927), but is more properly attributed to Al Jolson, whose use of it in the first talking motion picture, *The Jazz Singer* (1927), predates the Nicholson play. At any event, the phrase caught on and remains in current use.

We like ourselves a little bit,
Until to Aussie we get,
Wait till you get to New Guinea,
You ain't seen nothing yet.
(Martin Page, *Songs and Ballads of World War II*, 1972)

132. EXERTION
See also 202. INDUSTRIOUS-
NESS; 260. OVERWORK

1. **against the collar** With difficulty; at a disadvantage; requiring constant exertion. The collar in this phrase alludes to a horsecollar. When pulling a heavy load or going up hill, the horse strains *against the collar*, exerting constant, fatiguing effort.

> The high road ascends . . . until it comes in sight of Cumner. Every step against the collar yet so gradual is the ascent . . . (Charles Dickens, *Doctor Marigold*, 1868)

The expression dates from about 1850 and has given rise to two other terms, *collar-work* and *work up to the collar*.

2. **blood, sweat, and tears** Adversity, difficulty; suffering, affliction; strenuous, arduous labor. The now common expression is a truncated version of that used by Winston Churchill in addressing the House of Commons shortly after his election as Prime Minister.

> I say to the House, as I said to the Ministers who have joined this Government, I have nothing to offer but blood, toil, tears and sweat. (May 13, 1940)

The phrase gained additional currency when it was adopted as the name of a music group popular in the late 1960s.

3. **buckle down** To adopt a no-nonsense attitude of determination and effort; to set aside frivolous concerns or distractions and concentrate on the task at hand. *Buckle down to* dates from 1865, and appears to be but a variation on the earlier *buckle to* or *buckle oneself to*, both of which probably have their antecedents in the act of buckling on armor to prepare for battle.

4. **cleanse the Augean stables** See 307. REFORMATION.

5. **elbow grease** Strenuous physical effort or exertion; hard physical work or manual labor; vigorous and energetic application of muscle. This expression dates from at least 1672. A hint of its original meaning is provided by the definition found in *A New Dictionary of the Terms Ancient and Modern of the Canting Crew* (1700): "a derisory term for sweat."

6. **get [one's] teeth into** To work with vigor and determination; to come to grips with a task or problem; also, *sink one's teeth into*. This expression may be derived from the greater effort required to chew food than to sip it. Similarly, one who gets his teeth into something of substance is directing a great deal of physical or mental effort into completing the task.

7. **hewers of wood and drawers of water** Common workmen; drudges; slaves; the lowest type of laborers. This Biblical expression is from Joshua 9:21 and, although its literal meaning suggests those who are either in bondage or are the lowest kind of drudges, its figurative reference is to workers who are the backbone of a house of worship. Its most common use is in the literal sense.

> When Foes are o'er come, we preserve them from slaughter,
> To be Hewers of Wood and Drawers of Water.
> (Jonathan Swift, *A Serious Poem*, 1724)

8. **in there pitching** Putting forth one's best effort; working energetically and diligently; directing one's energy and talent toward a specific goal. It is debatable whether the sense of *pitch*, as used here, is originally from baseball or from the sales pitch of a carnival pitchman, reinforced by the greater frequency of the baseball term.

> Everybody on the system is in there pitching, trying to save a locomotive or piece of locomotive. (*Saturday Evening Post*, June 26, 1943)

9. **knuckle down** To apply oneself earnestly to a task; to attack a chore vigorously.

Knuckle down is a particular phrase used by lads at a play called taw, wherein they frequently say, *knuckle down to your taw, or fit your hand exactly in the place where your marble lies.* (Dyche and Pardon, *A New General English Dictionary,* 1740)

This expression, dating from at least the 17th century, has become generalized so that now it represents any diligent application to the situation at hand.

10. pump iron To lift weights; to work out on a weight machine; to be a weight lifter. This expression gained currency in the 1970s, primarily because of Arnold Schwarzenegger's propaganda campaign to make people more aware of the health-giving qualities of weight lifting. Using magazine articles, books, and films, Schwarzenegger and others popularized *pumping iron* so successfully that today the term has become a part of the common vocabulary.

When Lisa Lyon, 26, met muscleman-actor Arnold Schwarzenegger two years ago . . . she began to pump iron, and —voilà—today the 5'3" cutie can heft 265 lbs. like straw. (*New York Post,* October 19, 1979)

11. put in [one's] best licks In America *lick* has come to mean a burst of energy or effort; a further development has yielded the sense of an opportunity to make an effort, as in team sports like baseball, where *last licks* refers to the chance to win given a team that comes to bat in the second half of the ninth inning. Thus, *one's best licks* refers to the opportunity to make a winning effort. The term has been in use since the 1700s.

I saw comin' my gray mule, puttin' in her best licks, and a few yards behind her was a grizzly. (T. A. Burke, *Polly Peaseblossom's Wedding,* 1851)

12. put [one's] shoulder to the wheel To strive, to exert oneself, to make a determined effort, to work at vigorously. The reference is to the teamster of yesteryear who literally put his shoulder to the

wheel of his wagon when it got stuck in a rut or in mud in order to help his horses pull it out.

13. work up to the collar To labor diligently; to perform strenuous tasks energetically. A beast of burden is not considered to be working at its utmost capacity unless its collar is straining against its neck. This expression sees little use today.

133. EXHORTATION

1. Bible-thump To exhort people to practice the teachings of the Bible; to harangue; to evangelize in a feverish, almost hysterical, manner. This 1965 verb, a back formation from the noun *Bible-thumper,* is often used to designate the actions of those fundamentalist Protestant ministers who travel about the country holding evangelistic meetings.

The Defenders, a television series, may bible-thump a bit in an all-American way, but . . . never refuses a fence. (Monica Furlong, *Punch,* June 29, 1966)

Bible-thumper came into use in the mid-19th century, soon followed by the related terms, *Bible-banger* and *Bible-pounder,* each alluding to an overly excitable clergyman who, in his enthusiasm, might punctuate his words by pounding on his ever-handy Bible. Today, the term has been extended to include any fundamentalist Christian people, especially those from the so-called *Bible Belt.*

If they show a so-called adult movie, they cut it to shreds first, to ensure that it doesn't offend some Bible-banger in Mississippi. (*Playboy,* December 1973)

2. one for the Gipper A highly emotional appeal for an all-out effort; an exhortation to give it one's all for the sake of some emotionally charged cause; a sentimental pep talk. "The Gipper" was George Gipp (1895–1920), a football player at Notre Dame during the era of the renowned Knute Rockne. When it

was learned that "the Gipper," no longer on the active roster, was suffering from a fatal illness, Rockne reportedly aroused his "Fighting Irish" with the charge, "Let's win this one for the Gipper." As used today, the phrase more often carries associations of weepy sentimentality than of true poignancy.

3. soapbox orator An impassioned street orator, a vehement haranguer, a ranting, emotional speaker; also a *soapboxer*.

> Midday crowds gathered in the sun to hear soapbox speakers supporting labor solidarity. (*Time*, July 25, 1949)

Wooden boxes or crates such as those in which soap was once packed were formerly used as temporary, makeshift platforms by street orators declaiming to crowds.

4. soapy Sam A smooth, honey-tongued orator. This term was first applied to Samuel Wilberforce, the Anglican Bishop of Oxford. The Cuddeson College student body, wishing to honor the bishop as well as their principal, Alfred Pott, placed floral arrangements in the form of the initials S.O.A.P. (Samuel, Oxford, Alfred, Pott) upon two pillars. The bishop was shocked to see this rather satiric display, which ultimately served to perpetuate his already common nickname. According to legend, a young girl once inquired of the bishop why he had such an unusual sobriquet. Wilberforce replied "Because I am often in hot water, and always come out with clean hands." The expression still maintains some use as an epithet for a moralistic, unctuous speaker.

5. son of thunder An orator who bellows forth his beliefs in spellbinding manner; a vociferous demagogue. This expression is of Biblical origin:

> And James, the son of Zebedee, and John, the brother of James; and he surnamed them Boanerges, which is, the sons of thunder. (Mark 3:17)

The phrase alludes to the resonant, reverberating tones produced by a powerful speaker; originally, it carried no negative connotations. The expression is little used today.

6. tub-thumper A haranguer or ranter; an emotional, emphatic preacher or orator.

> An honest Presbyterian tub-thumper, who has lost his voice with bawling to his flock. (*Letters from Mist's Journal*, 1720–21)

The allusion is to a declamatory speaker, especially a preacher, who repeatedly thumps the *tub*, a humorous and disparaging term for a pulpit. Use of this derogatory British colloquialism dates from the 17th century.

134. EXONERATION

1. come out smelling like a rose To escape the negative consequences of one's own actions; to emerge in a positive light, or at least unscathed, after having been embroiled in an unpleasant situation. The expression usually implies that others are suffering the censure or opprobrium properly due the "innocent" one who "smells like a rose." Despite the phrase's implied vulgar origins, it is now commonly considered inoffensive and frequently appears in a variety of informal contexts.

2. get off scot-free To escape deserved punishment; to be excused from paying the appropriate fine or penalty; to be released without castigation or just punishment. This expression originated from *scot and lot* 'tax allotment,' which was formerly levied on all English subjects according to their ability to pay. Hence, a person who went scot-free was not required to pay the proper tribute. This expression now implies the legal but morally wrong release of someone from a deserved admonishment or penalty.

> . . . the notorious offender has got off scot free. (William Black, *Green Pastures and Piccadilly*, 1877)

3. **let bygones be bygones** Start with a clean slate; forgive and forget the past. The Greek philosopher Epictetus used this expression in his *Discourses* in the year 100. The expression remains in common use today.

> I am perfectly willing to let bygones be bygones. (M.V. Heberden, *Murder Makes a Racket*, 1942)

Expanse . . . See 139. EXTENT

135. EXPEDIENCE

1. **any port in a storm** Any refuge in a difficulty; any recourse in an emergency. The nautical meaning of this expression has given way to its figurative use, which implies that pressure limits choice, forcing one to abandon plans, principles, or standards.

2. **Band-aid treatment** See 151. FLIMSINESS.

3. **by hook or by crook** By any means necessary—direct or indirect, right or wrong, fair or foul. Most of the stories invented to explain the origin of this phrase are not plausible because of chronological inconsistencies; however, one recurring story stands out as being more convincing. Apparently, there was an ancient forestal custom giving manorial tenants the right to take as much firewood as could be reached by a crook and cut with a billhook. Various sources state that this "right" appears in old records: "a right, with hook and crook, to lop, crop, and carry away fuel."

4. **catch-as-catch-can** See 388. UNRESTRAINT.

5. **cut corners** To take the shortest, most convenient route; to do something in the quickest, easiest way possible; to choose a particular course of action in the hope of saving time, money, or effort. This expression is used almost literally when describing driving habits.

> The careless driver . . . cuts corners or tries to pass another car at the top

of a hill. (*Kansas City Times,* November 7, 1931)

Figuratively, *cut corners* often refers to any effort or behavior which represents a compromise for the sake of expediency, often without regard for quality or sincerity.

> He could cut a sharp corner without letting it bother his conscience. (S. Ransome, *Hidden Hour*, 1966)

However, *cutting corners* can also be used positively to describe the most viable and efficient mode of action.

6. **fair-weather friend** A person who is friendly only when convenient; someone who is a friend during favorable times and an acquaintance (at best) during adverse times.

> Am I to be only a fair-weather wife to you? (Rhoda Broughton, *Nancy*, 1873)

7. **jury-rigged** See 151. FLIMSINESS.

8. **know on which side one's bread is buttered** To be aware of what is and what is not in keeping with one's own best interests; to recognize what is to one's advantage in a given situation. This expression appears in John Heywood's *Works* (1562):

> I know on which syde my bread is buttred.

The implication is that a person will take are not to offend or alienate someone who has the power to grant or withhold favors. One who knows on which side his bread is buttered will do nothing to jeopardize his position.

9. **many ways to skin a cat** Many options possible to escape a tight situation; many ways to achieve a desired end. A popular variant is *more than one way to skin a cat.*

> She knew more than one way to skin a cat. (Mark Twain, *A Connecticut Yankee in King Arthur's Court*, 1889)

Among several possible sources of this expression, one points to boyhood jargon where *skinning the cat,* a gymnastic ex-

ercise, can be accomplished in a number of ways; each involves hanging from a horizontal bar and pulling the legs up and through the arms, whether over or under the bar. A more plausible explanation may lie in the literal skinning of a cat. In the past, cat's fur was used as trim on various articles of wearing apparel; consequently, many cats were raised only for skinning. Presumably the skinning could be accomplished in a variety of ways. A related term, *what can you have of a cat but its skin,* is used figuratively for something that has but one useful purpose, and arose because the flesh of a skinned cat was considered worthless.

Thou canst have no more of the cat but his skin. (Thomas Heywood, *Royal King,* 1637)

10. paper over the cracks To use stopgap or makeshift measures to give the outward appearance that all is well; to create an illusion of order or accord by means of a temporary expedient while ignoring the basic questions or issues. The expression is usually attributed to Otto von Bismarck, who reputedly used it in regard to the temporary nature of the Austro-Prussian settlement reached at the Convention of Gastein in August, 1865; war broke out between the two countries the next year.

Mr. Bevan agreed to paper over the cracks for the period of the election. (*Annual Register,* 1952)

11. politics makes strange bedfellows An adage implying that expedience—political or otherwise—often dictates the formation of alliances, however temporary, between two or more highly unlikely parties. In the Middle Ages, it was not unheard of for political allies to share the same bed, especially after long hours of negotiations or strategic planning. As a result, these collaborators came to be known as "bedfellows," a term which persisted even when this custom fell into disfavor. Popularized by Charles Dudley Warner in *My Summer in a Garden* (1870), *politics makes*

strange bedfellows is no longer limited to application in political contexts. The expression is sometimes used jocularly to describe a romance between people whose sole mutual attraction seems to be shared political or activist interests.

12. pull out all the stops See 388. UNRESTRAINT.

13. rob Peter to pay Paul To take from one person to give to another; to satisfy one obligation by leaving another unsatisfied. The popular theory explaining the origin of this expression is that in 1550, the Order which had advanced the Church of St. Peter to the status of a cathedral was revoked, and St. Peter's was not only reunited with St. Paul's Cathedral in London, but its revenues went toward the expenses of the latter. However, a chronological inconsistency refutes this theory, since Wyclif used the expression almost 200 years earlier in his *Selected Works* (1380):

How should God approve that you rob Peter, and give this robbery to Paul in the name of Christ.

Peter and Paul were popular apostles and saints, but even this fact does little to explain the use of their names in this expression.

14. see how the cat jumps See in which direction things are moving; choose the alternative that suits one best. The allusion in this expression is to the children's game known as *tip-cat.* The object is to strike the end of the tip-cat, a short piece of wood tapered at both ends, propelling it into the air, and then batting it before it returns to the ground; thus, the batter has to *see how the cat jumps.* The batter then runs to touch a base before returning to home base. A city game, it used to be played frequently on the streets or in vacant lots. The expression has been in common use since the 17th century.

I would like to be there, were it but to see how the cat jumps. (Nicholas Blake, *The Corpse in the Snowman,* 1941)

A slight modification in meaning is implied if one uses the form *see which way the cat jumps.*

15. shuttle diplomacy The reference in this phrase is to *shuttle flights,* and originally to the *shuttle trains* that ran between connecting lines or made regular short distance runs. *Shuttle trains,* in turn, were named for the weaver's shuttle that carries the thread back and forth on the loom. The term *shuttle diplomacy* became popular in reference to the frequent and hectic travels of Henry Kissinger, Secretary of State during part of the Nixon administration, who strove to negotiate a peace between Israel and the Arab states and to reopen peaceful relations between the United States and China. More recently, Secretary of State Alexander Haig exercised *shuttle diplomacy* in his attempts to negotiate a peaceful settlement between Great Britain and Argentina in their dispute over the Falkland Islands.

By the time Haig returned to Washington, he had set an exhausting new record for shuttle diplomacy: 32,965 miles covered during 71 hours, 40 minutes in the air on six flights between Washington, London, and Buenos Aires. (*Time,* May 3, 1982)

16. trim [one's] sails See 7. ADAPTATION.

17. trump up See 236. MENDACITY.

Expense . . . See 74. COST

Experience . . .
See 224. KNOWLEDGE

136. EXPLOITATION
See also
395. VICTIMIZATION

1. all is fish that comes to his net See 3. ABILITY.

2. butter [one's] bread on both sides See 190. IMPROVIDENCE.

3. double dip To work at a government job while receiving a government pension; to appropriate money twice from a single operation. This term, derived from the underworld term *dip,* 'to pick pocket,' was originally used to describe a retired military person or civil servant who had procured another government job while drawing a pension from his previous service with the government. Today, it has been extended to include state and municipal employees as well as federal employees. *Double dipping* has come to connote unethical behavior on the part of the *double dippers,* especially among those who are receiving disability pensions while working at another job.

The critics, including many Congressmen, consider "double-dipping" typical of the ways in which the military pension system has become overly generous and helped to inflate military manpower costs. (*The New York Times,* April 10, 1977)

4. feather [one's] nest To look after one's own interests; to accumulate creature comforts, money, or material possessions either through one's own efforts or at the expense of others; to be completely selfish, totally unconcerned with the well-being of others. This expression stems from the fact that many birds, after building a nest, line it with feathers to make it warm and more comfortable. The expression *line one's nest* is a variation.

5. fish in troubled waters To take advantage of adversity, stress, or unrest for personal gain; to make the best of a bad situation. Fishermen often experience their greatest success when the water is rough. In its figurative use, the phrase implies that though things may be troubled on the surface, at a deeper level, the situation holds potential for gains.

6. grist for the mill Any experience, fact, discovery, or object with potential for one's personal profit; a seemingly worthless item employed to one's personal gain or benefit. Grist is unground

grain to be converted to meal or flour by milling. In the figurative expression, *grist* is anything that serves as the raw material which a person's talents or abilities transform into something of value.

7. make hay while the sun shines To make the most of an opportunity, to take full advantage of an occasion for profit, to be opportunistic. Hay is made by spreading mown grass in the sun to dry, an impossibility if the sun is not shining both when the grass is cut and when it is set out to dry. A variant of the expression dates from at least 1546. It is often used as an admonition to be provident, as it was by an unknown American author in 1788:

> It is better to make hay while the sun shines *against* a rainy day. (*The Politician Out-witted*)

8. milk To extract all potential profit from a person or situation, often with connotations of excessiveness or victimization. Used figuratively as early as the beginning of the 16th century, this term derives from the literal act of extracting milk from an animal by manipulating its udder.

> This their painful purgatory . . .
> hath of long time but deceived the people and milked them from their money. (John Frith, *A Disputation of Purgatory*, 1526)

Unlike *bleed* (See 140. EXTORTION), *milk* is not limited in its figurative use to money-related matters.

> To overplay an audience for applause is called milking the audience. (Hixson and Colodny, *Word Ways*, 1939)

To milk someone usually implies taking unfair advantage, and is often heard in the expression *to milk [someone] for all he is worth.*

9. pick [someone's] brains To exploit the ideas of another; extract another's knowledge and use it without his permission; to avail oneself of another's artistic concepts. This colloquialism suggests the gathering of the fruit of another's labor, and the profit to be realized by such an act. The term, first used in the early 19th century, has gained fresh popularity since the 1960s with the increasing practice of *brain drain*, the wooing of outstanding scholars, especially scientists, from other countries.

> If one wanted to know what books to read in any line, one had only to pick his brains. (A. C. Benson, *From a College Window*, 1907)

10. play the field To remain open to multiple opportunities by not restricting one's role; to engage in a variety of activities, causes, etc., instead of focusing on just one; to socialize with no one person exclusively.

> Japan Plays the Field. Peace and Trade with Everyone. (*The New Republic*, March 1966)

In baseball, the outfielders have the largest area of ground to cover and therefore the widest range of playing room, a fact which probably gave rise to the expression. In addition, an outfielder often rotates among all three outfield positions. This American phrase has been in use since at least 1936.

11. robber barons Business and financial tycoons who were merciless in their despoilment of public lands and in the exploitation of people. In the foreword of Matthew Josephson's book, *The Robber Barons* (1934), the author quotes a description by Sir Francis Bacon that could have been formulated specifically for the *robber barons*.

> There are never wanting some persons of violent and undertaking natures, who, so that they may have power and business, will take it at any cost.

Coined in the late 1800s, this term typified a group of powerful financial magnates, who, unrestrained by government regulations or income tax and unhampered by ethical considerations, amassed huge fortunes and tremendous political power by their rapacious misuse of the land and the people. The modern con-

cept of the term has been modified somewhat to include any landowner or businessman who is guilty of exploitation.

> He was . . . about the greediest and cruelest robber baron in the West. (D. G. Phillips, *Plum Tree*, 1905)

12. seize the day To make the most of the day, to live each day to the fullest, to enjoy the present to the utmost; originally, Latin *carpe diem*. This proverbial expression of Epicurean philosophy was apparently first used by the Roman poet and satirist Horace. Both the original Latin and the later English version remain in common use.

> The reckless life of Algeria . . . with . . . its gay, careless carpe diem camp-philosophy. (Ouida, *Under Two Flags*, 1867)

13. strike while the iron is hot To lose no time in acting when an opportunity presents itself, to seize an opportunity to one's advantage, to act when the time is right. A blacksmith heats the iron he is working on until it is red-hot and most malleable before hammering it into the desired shape. The equivalent French phrase is *il faut battre le fer pendant qu'il est chaud.* A variant of the expression dates from at least 1386.

> It will become us to strike while the iron is hot. (W. Dummer, in *Baxter Manuscripts*, 1725)

14. take time by the forelock To act quickly in seizing an opportunity, to take full and prompt advantage of an opportunity for gain or advancement. Phaedrus, a Roman fable writer, describes Father Time (also called Father Opportunity) as an old man, completely bald at the back of his head but with a heavy forelock. Thus, a person who takes time by the forelock does not wait until opportunity passes before taking advantage of what it offers. The expression has been attributed to Psittacus of Mitylene, one of the seven sages of Greece. Variants of the expression date from the late 16th century.

15. work both sides of the street To avail oneself of every opportunity to attain a given end; to seek support from opposing camps, to court the favor of rival interests; to walk a tightrope or to play both ends against the middle. The phrase probably derives from salesmen's lingo. Currently it is said of one who compromises principle in an attempt to garner some desideratum, who slants his approach or pitch to align with what his listeners will "buy."

> In a crucial election year . . . was shrewdly working both sides of the street. (*Time*, cited in *Webster's Third*)

137. EXPOSURE

1. another lie nailed to the counter An Americanism referring to something false or misleading which is publicly exposed to forewarn possible future offenders and con artists. The popular story explaining the origin of this expression is that the keeper of a general store used to nail counterfeit coins to the counter to discourage future customers from trying to perpetrate the same fraud.

2. blow the gaff To divulge a secret; to reveal a plot; to blab, peach, or give convicting evidence. *Blow the gaff* is the British slang equivalent of *spill the beans*. As early as 1575, *blow* was used to mean 'expose or betray.' *Blow the gab* appeared in print in 1785, followed by *blow the gaff* in 1812. According to the *OED*, the origin of *gaff* is obscure, though *gaffe* 'blunder' is a common modern borrowing from French.

> I wasn't going to blow the gaff, so I told him, as a great secret, that we got it [the gun] up with a kite. (Frederick Marryat, *Peter Simple*, 1833)

3. blow the lid off To expose a scandal; to reveal an unethical state of affairs; to disclose an illegal practice. This expression, dating from the early 1900s, alludes to a container in which the contents are under pressure; if one heats it,

the pressure increases enough, to blow the lid off, revealing everything inside.

> He blew the lid off a notorious national condition of affairs. (*Daily Telegraph*, May 1, 1928)

A milder form of the expression is *take the lid off*. *Blow the gaff*, another related term, comes from underworld jargon and means 'to inform on one's companions, to squeal.' *Gaff* in this phrase is a variation of the verb *gab*. A phrase that implies the opposite, *put the lid on* means 'to restrain or hush up.'

4. blow the whistle To expose or threaten to expose a scandal; to put a stop to, put the kibosh on; to inform or squeal. This expression may come from the sports referee's whistle which stops play when a foul or violation has been committed or at the end of the game; or, more likely, from the policeman's whistle blown to call attention to a crime in the state of commission.

5. cackling geese Informers, warners; saviors, protectors, defenders. According to legend, the cackling of sacred geese alerted the Roman garrison when the Gauls were attacking the Capitoline, enabling them to save the city.

6. come out in the wash See 257. OUTCOME.

7. cough up To disclose; to hand over; to give information or material to authorities; to surrender something of value to another; to come clean. The exact origin of this slang term is unknown; however, the parallel between literally coughing something up and thereby making it manifest and figuratively coughing up information can easily be seen. The term has been in use since at least the 14th century.

> All that I knew was wicked by any of our convent, I coughed it up in the cloister. (William Langland, *Piers Plowman*, 1362)

8. debunk To expose the falseness or pretentiousness of a person or his attitudes, assertions, etc.; to divest of mystery, thereby bringing down from a pedestal; to destroy the illusions perpetuated by clever talk and feigned sincerity; to reveal the true and nonsensical nature of something. The root *bunk* is a shortened form of *buncombe* 'nonsense, gobbledygook.' Thus, to "debunk" is to eliminate the nonsense, or as below, to "burst the bubble."

> Michael, after drifting round the globe, becomes a debunking expert, a pricker of bubbles. (*Nation*, October 10, 1923)

See also **bunkum**, 246. NONSENSE.

9. dogs are barking it in the streets Something that is supposed to be a secret is known everywhere. This Australian expression, dating from about 1920, has been adopted by other English-speaking countries as a catch phrase to indicate that what once was a secret has been widely revealed.

10. Freudian slip A seemingly innocent slip of the tongue that has a concealed psychological significance. This expression comes from the psychoanalytical theories of Sigmund Freud, some of which hold that a person often reveals his true psyche in less than obvious ways, such as through slips in speech or through forgetfulness. In its contemporary usage, however, *Freudian slip* has been carried to extremes and is often used to call attention to any slip of the tongue, especially if such attention might be embarrassing (in a questionably humorous sort of way) to the speaker.

> It was an odd little slip of the tongue. . . . They call them Freudian slips nowadays. (N. Blake, *Deadly Joker*, 1963)

11. give the show away To divulge a secret; to expose the deficiencies of; to reveal the truth; to betray the pretentiousness of an affair; to blab. The allusion in this phrase is to a magician's show where the confidence of his assistants is a necessity. Since the success of the show de-

pends upon closely guarded secrets, any associate who reveals those secrets destroys the illusion, thus, *giving the show away.* The expression has been in use since about 1900.

12. kiss and tell See under 33. BETRAYAL.

13. lead with [one's] chin To expose oneself to a knockout blow; to expose oneself to unnecessary harm or danger; to set oneself up for a stinging barb in repartee. This expression, derived from boxing, is self-evident in its implication that one can suffer a devastating setback, physically or emotionally, if he exposes a vulnerable area to the enemy. The term is also often used jocularly.

14. let the cat out of the bag To divulge a secret, often accidentally. Most accounts claim that this expression derives from the county fairs once common in England and elsewhere at which suckling pigs were sold. After being purchased, the pigs were sealed in a sack. Occasionally, an unscrupulous merchant would substitute a cat for the pig and try to sell the sealed bag to an unsuspecting customer at a bargain price. If the buyer were cautious, however, he would open the sack before buying its unseen contents, thus "letting the cat out of the bag." This expression has enjoyed widespread figurative use ever since.

> We could have wished that the author . . . had not let the cat out of the bag. (*The London Magazine*, 1760)

See also **pig in a poke,** 370. SWINDLING.

15. a little bird See 215. INTUITION.

16. muckraker One who digs up and writes scandalous news about public figures; one who searches for and exposes real or alleged corruption in government or big business; a newsman who prefers to present sensational, particularly morally unsavory, news. The original *muckraker,* in John Bunyan's *Pilgrim's Progress* (1678), was so busy raking muck that he does not see a celestial crown held over his head. The term did not come into common use, however,

until the early 1900s, when it became a favorite expression of President Theodore Roosevelt for those who expose corruption and scandal. The term became extremely popular when *muckraking* reached the proportions of a movement, about 1902, coming to a climax about 1911 and then subsiding during World War I.

> Men with the muckrake are often indispensable to the well-being of society, but only if they know when to stop raking the muck. (Theodore Roosevelt, Address given in Washington, D. C., April 14, 1906)

Some well-known *muckrakers* were William Allen White, Finley Peter Dunne ("Mr. Dooley"), Ida M. Tarbell, and Lincoln Steffens.

17. murder will out The truth will manifest itself in time; the secret will be disclosed. Chaucer uses this expression in *The Nun's Priest's Tale:*

> Murder will out, that see we day by day.

A later version appears in Shakespeare's *Hamlet:*

> Murder, though it have no tongue, will speak
> With most miraculous organ.
> (II,ii)

It was once believed that a dead body would bleed if touched by the murderer. This and similar myths popular in the 16th century reinforced the belief embodied in this expression.

18. play the Dorian To expose one's naked body, used especially of women. This phrase, from a classical Greek reference to the practice of Dorian maids, was adopted into English as early as the Middle Ages, but is seldom, if ever, heard today. The Greek poet Anacreon used the term as early as 500 B.C., and Euripides alluded to it in *Hecuba.*

> Leaving her dear bed in a single garment like a Dorian maid.

19. put [one's] cards on the table To reveal deliberately all the facts; to disclose the extent of one's resources; give an honest declaration of one's position or intentions. The allusion is to a game of cards and turning all of one's cards face up so that all the players can read them. The figurative interpretation of the expression, along with a common variant, *lay [one's] cards on the table*, has been implied since the late 16th century.

> Put all your cards on the table when someone calls your bet. (Erle Stanley Gardner, *The D.A. Cooks a Goose*, 1942)

20. put the finger on To identify; to inform on; to point out one person to another who seeks him, such as a victim to a hit man or a criminal to a police officer; sometimes simply *finger*.

> Frank Lee . . . had fingered many, many dealers to the Feds. (*Flynn's*, December 13, 1930)

A related expression, *fingerman*, refers to an informer, one who puts the finger on someone else. *Fingerman* sometimes describes the person who cases (i.e., surveys or examines) a prospective victim or location and relays information to criminals such as thieves or kidnappers.

21. shout it from the rooftops To expose someone's personal affairs to the public; to let slip a secret before a number of people; to be excessively exuberant. Although often used to indicate that one has undergone a stroke of good fortune or is greatly elated over some recent success, this expression is most often framed in the negative as an ironic statement to one who has revealed or seems about to reveal a secret.

22. show [one's] true colors To reveal one's real character or personality; to strip oneself of façades and affectations; to expose one's true attitude, opinion, or position. Originally, *colors* referred to the badge, insignia, or coat of arms worn to identify and distinguish members of a family, social or political group, or other organization. Thus, to

show one's colors was to proudly display a sign of one's ideology or membership in an organization. With the rise in piracy, however, the expression took on implications of exposure after attempted or successful deception. More specifically, showing one's true colors involved lowering the bogus colors (i.e., the flag of a victim's ally) and raising the skull-and-crossbones. Used figuratively, this expression carries intimations of asserting oneself after having vacillated; used literally, it means exposure after deception. Variations are *come out in one's true colors* and *show one's colors*.

> Opponents who may find some difficulty in showing their colors. (William Gladstone, in *Standard*, February 29, 1884)

See also **sail under false colors**, 286. PRETENSE.

23. sing in tribulation To confess under torture; to act as an informer, especially when threatened with or subjected to bodily harm; to squeal. In the Middle Ages, a person who had previously refused to inform or reveal information was said to "sing in tribulation" when extreme suffering and torture finally loosed his tongue.

> This man, sir, is condemned to the galleys for being a canary-bird . . . for his singing . . . for there is nothing more dangerous than singing in tribulation. (Miguel de Cervantes, *Don Quixote*, 1605)

A related expression from the same work is *sing in agony*.

> One of the guards said to him, "Signor Cavalier, to sing in agony means, in the cant of these rogues, to confess upon the rack."

A widely used variation is the slang *sing* 'to inform.'

24. slip of the tongue An inadvertent remark, an unintended comment; a verbal mistake, a faux pas. This colloquialism plays on the idea of a tongue having a mind of its own. Or, as in *Freudian*

slip, it is implied that the *slip* reflects one's unconscious thoughts or desires.

> It was a slip of the tongue; I did not intend to say such a thing. (Frances Burney, *Evelina*, 1778)

The following anonymous verse advises how to avoid the problem:

> If you your lips
> Would keep from slips,
> Of these five things beware:
> Of whom you speak,
> To whom you speak,
> And how, and when, and where.

A similar expression is *slip of the pen*, referring to a written mistake. According to *OED* citations, this expression appeared in print by the mid 17th century, antedating *slip of the tongue* by 65 years.

25. spill [one's] guts To reveal one's most intimate thoughts and feelings; to lay bare one's soul; to divulge secret information, usually damaging to another; to confess or to inform on. In this expression, *guts* means bowels, in the latter's senses of deepest recesses and profoundest feelings. This common phrase often implies that the revealed information was obtained through coercion, as in the interrogation of a person suspected of a crime or a prisoner of war.

26. spill the beans To divulge a secret; to prematurely reveal a surprise, often by accident. This expression is one of the most common in the English-speaking world, but no plausible theory of its origin exists.

> "Tell me the truth," she says. "Spill the beans, Holly, old man!" (E. Linklater, *Poet's Pub*, 1929)

27. tell tales out of school To utter private information in public; to indiscriminately divulge confidential matters; to gossip. In this expression dating from the mid 16th century, *school* represents a microcosm, a closed society having its own standards and codes of behavior. The family unit is another such micro-

cosm. These and similar groups usually encourage confidentiality. Thus, to tell tales out of school is to share with members outside of the group information privy to it.

> A very handsome . . . supper at which, to tell tales out of school, . . . the guests used to behave abominably. (Thomas A. Trollope, *What I Remember*, 1887)

28. tip [one's] hand To reveal one's intentions, motives, or plans before the proper moment, to unintentionally or unwittingly give oneself away; also to *show one's hand*.

> He was perilously near showing his whole hand to the other side. (*Bookman*, October 1895)

The allusion is to the inadvertent display of one's hand to the other players in a card game.

29. wash [one's] dirty linen in public To discuss domestic problems with mere acquaintances; to reveal personal concerns to strangers; to expose the skeleton in the family closet. This common expression seems to have come to English via the French *il faut laver son linge sale en famille* 'one should wash one's dirty linen in private [at home, within the household].'

> I do not like to trouble you with my private affairs;—there is nothing, I think, so bad as washing one's dirty linen in public. (Anthony Trollope, *The Last Chronicle of Barset*, 1867)

138. EXPULSION
See also 308. REFUSAL;
310. REJECTION

1. the bum's rush The forcible removal or expulsion of a person, usually from a public place, especially by lifting him by the shirt collar and the seat of his pants to a walking position and propelling him toward the door; an abrupt dismissal; the sack. The image evoked is of the way a bum, having had too much to drink, is unceremoniously "escorted" to the door

of a bar. A synonymous American slang term is *French walk*. The British term is *frog-march*. Eugene O'Neill uses the phrase in *The Hairy Ape* (1922):

> Dey gimme de bum's rush.

See also **walk Spanish**, below.

2. buzz off To go away; to leave; to stop interfering; used especially as an admonition equivalent to *get lost, beat it*, or *scram*. This slang expression, which originated in England shortly after World War I, is now common in all of the English-speaking countries of the world. The allusion is to the sound an insect makes as it flies away.

> Buzz off, you idiot, or James'll see you. (*The Diary of a Public School Girl*, 1930)

3. fire To discharge someone from a job, usually suddenly and unexpectedly. This expression derives from *fire* in the ballistic sense of ejecting violently and forcefully just as a bullet is fired from a gun.

> He that parts us shall bring a brand from heaven,
> And fire us hence like foxes.
> (Shakespeare, *King Lear*, V,iii)

4. get the bounce To be ejected forcibly; to be fired; to be rejected; to be discharged from an institution. This popular American expression, dating back to the 1860s, is still in everyday use, most commonly to indicate forcible ejection from a public place, such as a tavern or dance hall, by a *bouncer*. Derived from the Dutch phrase, *de bons geven*,' literally, 'to give the bounce,' the term has a number of related forms; among them are *the bum's rush*, and *the old heave-ho*.

> "Had you ever thought," I asks, . . . "of giving her the bounce yourself?"
> (O. Henry, *Rolling Stones*, 1910)

5. get or **give [someone] the sack** To be dismissed, fired, or expelled. This chiefly British expression may have originated from the ancient Roman custom of elim-

inating undesirables by drowning them in sacks. Figuratively, the phrase often implies that the grounds for a person's dismissal are justifiable.

> If . . . the solicitor by whom he was employed, had made up his books, he [the plaintiff] would have been "sacked six months ago." (*Daily Telegraph*, 1865)

6. give a packing penny to To fire; to discharge from employment; to dismiss; to send packing; to expel. This Briticism is derived from the slang phrase *send packing*, i.e., 'tell someone to pack up his things and get out.' The inclusion of the penny may be from *pack and penny day*, or *packing-penny day*, the last day of a fair when the tradesmen were packing up their wares and often offered them at bargain prices, for a few pennies, in order to dispose of them. Whatever the case, the *packing penny* has become a symbol of dismissal, and the practice is carried on in some parts of England today. The expression has been employed since the late 16th century.

7. give [someone] running shoes To discharge an employee; to end a business association; to jilt a suitor. The figurative use of this expression implies that the dismissed person should make a speedy departure.

8. go fly a kite Go away; get lost; buzz off. Similar to other trite insults (such as *go jump in the lake, go play in traffic*, and *dry up and blow away*), *go fly a kite* is used as a command, usually issued with disdain, ordering someone to leave. Whereas the contemptuous element of the other phrases is transparent, precisely why flying a kite should carry the same scorn remains puzzling. Attempts to relate *go fly a kite* with *fly a kite* (See **370. SWINDLING**) are unconvincing.

9. go peddle your papers Get lost, scram, don't bother me. This imperative putdown implies that the person addressed, suited only for trifling pursuits, is interfering in matters of greater mo-

ment. Billy Rose used the expression in a syndicated column in 1949:

> He had been told to peddle his papers elsewhere.

10. go to Jericho Begone; get out of here. The Biblical origin (II Samuel 10:5) of this obsolete expression concerns a group of David's servants who, having had half their beards shaved off, were banished to Jericho until their beards were presentable. Figuratively, *go to Jericho* implies a command to go elsewhere and not return until physical or mental growth has occurred, or, more simply, to get lost.

> He may go to Jericho for what I care. (Arthur Murphy, *Upholsterer*, 1758)

11. go whistle Get lost; get away from here; scram; begone; buzz off. This expression, an unceremonious dismissal, implies that the person addressed has nothing worthwhile to contribute and would offer the greatest service by taking himself away from the scene.

> If any man pretend so great a curiosity about the person of Christ that he lacked the passion of anger, he may go whistle til he learns better. (Reginald Pecock, *Follower to Donet*, 1453)

The term is also used as a contemptuous refusal to abide by a decision or by the law.

> This being done, let the law go whistle. (Shakespeare, *The Winter's Tale*, IV,iv)

12. Jack out of office A discharged official; one dismissed from his job; an official who failed to gain reelection. This British expression is usually heard as a derisive comment about one who has failed to perform his public functions efficiently or honestly while in office. The term has been in use since early in the 16th century.

> I am left out; for me nothing remains. But long I will not be Jack out of office. (*I Henry IV*, I,i)

13. kick upstairs To get rid of an undesirable person who cannot be dismissed by promoting him to a higher position of greater prestige but one where his inefficiency or other shortcoming cannot affect the organization's everyday operations.

> The plot was devastatingly simple— Dibdin was to be kicked upstairs and Albert was to take his place. (W. Cooper, *Struggles of Albert Woods*, 1952)

14. pink slip A notice of discharge from employment; notification to a worker that he has been fired or laid off. It has long been the custom of personnel departments to formally notify an employee that he is being discharged by giving him a standard letter of termination. Since such a letter is often enclosed in an envelope with the worker's paycheck, many companies print the letter on colored (sometimes pink) paper so that it will be readily noticed.

> All 1,300 employees got pink slips today. (*Associated Press*, May 29, 1953)

In recent years, *pink-slip* has sometimes been used as a verb, and its meaning has occasionally been extended to include jocular reference to interpersonal relations, such as the jilting of a sweetheart.

15. ride on a rail See 298. PUNISHMENT.

16. send to the showers To reject; to send away or expel; also, *knock out of the box*. This expression originated in baseball, where a player, removed from the game because of poor performance or rudeness to the umpires, is sent to the locker-room for a shower. In contemporary usage, the phrase usually carries a mild suggestion of castigation or admonishment.

17. tie a can to [someone] To drive away; to dismiss; to expel; to frighten away, by cruel means if necessary. The allusion here is to the old sport of tying a can with a pebble in it to a dog's tail.

When the dog gave the first wag of its tail, the noise would startle it into running away to escape the noise; hence, to *tie a can to someone* usually connotes the driving away of one who is not particularly desirable. The term dates to the mid 19th century.

> When our brother fire was having his
> dog's day
> Jumping the London streets with
> millions of tin cans
> Clanking at his tail, we heard some
> shadow say
> 'Give the dog a bone.' (Louis
> MacNeice, *Brother Fire*)

A related term, derived from this expression, is *can*, 'to fire or dismiss from one's job.'

18. twenty-three skid(d)oo Go away! Hit the road! Make yourself scarce! A rather implausible theory suggests that this expression developed at the turn of the century in New York City. Twenty-third Street was a favorite haunt of the city's flirtatious dalliers, and the police reputedly dispersed these wolfish loiterers with the command "twenty-three skidoo!" The expression, which caught on in the 1920s, remains associated with that period. At that time *twenty-three skidoo* was more often a noncommittal greeting or an exclamation of surprise than an order of expulsion. Although general use of the term has significantly declined since its Roaring '20s heyday, it does retain some jocular use.

> When she swished past, this leering
> beast in human form would boldly
> accost her with such brilliant
> greetings as "Oh, you kid!" or
> "Twenty-three skiddoo." (*Houston
> Post*, June 14, 1948)

19. walk Spanish To physically eject from a public place; to bounce, force, or throw out; to give the sack. Although the exact origin of the phrase is unknown, it is said to refer to the way in which pirates of the Spanish Main compelled their captives to walk the plank. The expression appeared in February,

1815, in the *American Republican* (Downington, Pa.):

> The vet'ran troops who conquer'd
> Spain,
> Thought they our folks would banish;
> But Jackson settled half their men,
> And made the rest walk Spanish!

See also **the bum's rush**, above.

20. walk the plank To be forced or drummed out of office; to be unceremoniously discharged or compelled to resign. The expression derives from the 17th-century pirate practice of forcing blindfolded prisoners to walk off the end of a plank projecting from the side of the vessel in order to dispose of them.

Extemporaneousness . . .
 See 355. SPONTANEITY

139. EXTENT

1. at arm's length At a distance, hence avoiding involvement or familiarity; away from close contact. An obsolete synonym for this expression, *at arm's end* was in use as early as 1560; however, the expression itself did not appear until the mid 17th century. In law, the phrase is applied to a situation without fiduciary relationship, such as between trustee and client. In everyday use the term is seldom heard in any but the figurative sense.

> The parties must be put so much at
> arm's length that they stand in the
> adverse relations of vendor and
> purchaser. (Thomas Lewin, *Trusts*,
> 1879)

2. by a long chalk By a large amount, by a great degree, by far. This colloquial British expression derives from the practice of using chalk marks to keep score in various games. Thus, a "long chalk" would be a large number of marks or points—a high score. The equivalent American expression is *by a long shot* (see next) and both are frequently heard in the negative—*not by a long chalk* or *shot*.

3. by a long shot By a great deal, by far, by a considerable extent. This U.S. expression was in print as early as the 1870s.

> That's more'n I'd done by a long shot. (Edward Eggleston, *Hoosier Schoolmaster*, 1872)

A long shot is a contestant in any competition, most commonly athletic or political, with little chance of winning; therefore, with high odds in the betting. By extension, the phrase has come to refer to any bet or undertaking having little chance of success but great potential should the unexpected occur. *Long shot* connotes greatness of quantity or quality, if only in potential. Therefore, *by a long shot* means 'by a large amount or degree,' and the negative *not by a long shot* means 'not at all,' 'in no way, shape or form,' or 'hopelessly out of the question.'

4. by a long sight By a considerable amount; a great deal; to a large extent. *Sight* in this expression may carry its meaning of 'range or field of vision,' and hence, indicate distance. By further extension, *long sight* in this Americanism refers to great quantity or degree rather than spatial distance. This expression dates from the early 19th century and is most frequently heard in the negative. Other variants are interchangeable with *long*, as in the following quotation from Mark Twain's *Huckleberry Finn:*

> I asked her if she reckoned Tom Sawyer would go there, and she said not by a considerable sight.

5. by a nose By an extremely narrow margin, just barely, by a hair or whisker. The allusion is to a horse race in which the winner crosses the finish line only a nose ahead of his rival. This U.S. slang expression dates from the early part of the 20th century.

> Flying Cloud slipped by the pair and won on the post by a nose in one forty nine! (L. Mitchell, *New York Idea*, 1908)

6. country mile A long distance; a long way to go. *Country mile* has come to mean a greater distance than a regular mile, because distances seem greater when one is out in the open spaces of the country. The term is most frequently used in those phrases where distance is to be emphasized, as to "hit a baseball a country mile," or "loud enough to be heard a country mile."

7. higher than Gilderoy's kite Very high, higher than a kite, out of sight.

> She squandered millions of francs on a navy . . . and the first time she took her new toy into action she got it knocked higher than Gilderoy's kite— to use the language of the Pilgrims. (Mark Twain, *The Innocents Abroad*, 1869)

This chiefly U.S. expression is apparently a truncated version of *hung higher than Gilderoy's kite* 'to be punished more severely than the very worst of criminals.' The allusion is to the hanging of the notorious Scottish highwayman, Patrick Macgregor, nicknamed Gilderoy, and five of his gang in Edinburgh in 1636. According to legal custom at the time, the greater the crime, the higher the gallows, and so it was with the gallows of Gilderoy that towered above those of his companions. As for the *kite* in the expression, two explanations have been offered. One is that Gilderoy was hanged so high that he looked like a kite in the sky. The other, more scholarly, is based on the fact that *kite* or *kyte* meant 'the stomach, the belly' in Scottish and by extension was probably used to denote the whole body.

8. out of all scotch and notch Beyond all bounds or limits; incalculable, immeasurable, unlimited, unbounded. Rarely heard today, this expression is said to refer to the boundary lines, or scotches, and the corners, or notches, used in the children's game of hopscotch.

> The pleasure which you have done unto me, is out of all scotch and

notch. (Martin Marprelate, *Hay any Work for Cooper*, 1589)

9. room to swing a cat Plentiful space; ample room; a large area. This expression has several possible origins, none of them particularly plausible. One theory alludes to the sailors' pastime of twirling a cat about by the tail, while another possibility refers to the former training exercise in which a cat was suspended in a bottle and shot at for target practice. A third source may refer to the swinging of a *cat*, or *cat-o'-nine-tails*, which required considerable space. *Cat* was also an old Scottish word for rogue; thus, the expression may have derived from the amount of room necessary to hang a wrongdoer. In any case, the phrase is often applied negatively to describe a lack of space or cramped quarters.

June, I am pent up in a frowzy lodging, where there is not room enough to swing a cat. (Tobias Smollett, *Expedition of Humphry Clinker*, 1771)

10. womb to tomb From birth to death; one's entire lifetime; a long period of time. This expression, dating from the late 1960s, is obvious in its import, i.e., covering a person's entire life no matter what age. *Womb to tomb* may be simply a rhyming variant of an earlier, synonymous term, *cradle to grave*, which was coined about 1943.

And we'll be closer to the idea of a brokerage office providing womb to tomb financial coverage for its clients. (*The New York Times Magazine*, May 21, 1972)

140. EXTORTION
See also 38. BRIBERY; 50. COERCION; 165. GRAFT; 265. PAYMENT

1. badger game Extortion; blackmail; intimidation achieved through deception; most specifically, the scheme in which a woman entices a man into a compromising situation, and then victimizes him by demanding money when her male accomplice, often pretending to be the enraged husband, arrives on the scene, threatening violence or scandal. The expression, in common use in the United States since the early 1900s, arose from the cruel sport of badger baiting, in which a live badger was placed in a hole or a barrel so that it could be easily attacked by dogs. Thus, *to badger* came to mean 'to worry, pester, or harass,' and, more intensively, in the sense above, 'to persecute or blackmail.'

John Hill and his wife Mary . . . are said to have been the first persons in Chicago to work the badger game. (Herbert Asbury, *Gem of the Prairie*, 1941)

The woman decoy in the badger game is called the *badger-worker*.

A woman who decoys men and then her accomplice blackmails them is called a 'badger worker'. (*New England Magazine*, July 1910)

2. bleed To extort money from an individual or an organization; to pay an unreasonable amount of money; to force to pay through the nose. This slang term has been in use since the 17th century, at which time bleeding was a common surgical practice. Whether bleeding was natural or surgically induced, loss of blood was significant. The significance of money to most people, and the fact that it can be paid out with or without force, makes the figurative use of *bleed* relating to money a logical extension of the literal meaning. An intensified variant is *bleed [someone] white*.

3. fry the fat out of To obtain money by high-pressure tactics or extortion; to milk, put the squeeze on. Just as the frying process removes excess fat, so extortion or high-pressure fundraising tactics remove the "fat" or excess wealth from the affluent. This now little-used U.S. slang expression dates from the late 19th century.

His main qualification is admitted to be that of a good collector of funds. No one could, in the historic phrase, fry out more fat. (*The Nation*, April 1904)

4. put the bite on To solicit money from, to hit up for a loan; also, to do so through force, thus, to extort money from, to blackmail. Both uses play on the idea of extracting by exerting pressure. The alternate *put the bee on* is usually limited to the less forceful borrowing sense. *Webster's Third* cites Hartley Howard:

. . . some smooth hoodlum puts the bee on his daughter for two thousand bucks.

The stronger meaning is the more common, however:

Or did he just happen to see what happened and put the bite on you and you paid him a little now and then to avoid scandal? (Raymond Chandler, *High Window*, 1942)

5. shakedown Extortion, blackmail; a forced contribution, as for protection. This term originally referred to a method of getting fruits and nuts out of a tree. In its figurative applications, *shakedown* conjures images of a person's being turned upside down and shaken to forcefully remove the money from his pockets.

He [a New York City policeman] was fined 30 days' pay because he would not stand for a "shakedown," which means that he had refused to give from time to time upon demand 5 or 10 dollars from his meagre salary to his superiors to be used for purposes unknown. (A. Hodder, *The Fight For The City*, 1903)

Shake down 'to extort, plunder' is frequently used as a verb phrase.

For only last week they were shook down for five hundred by a stray fellow from the Department. (J. Barbicon, *Confessions of a Rum-Runner*, 1927)

See also **shakedown**, 216. INVESTIGATION.

Extraneousness . . .
 See 366. SUPERFLUOUSNESS

Extravagance . . . See 130. EXCESSIVENESS; 190. IMPROVIDENCE

F

Facial appearance . . .
See 398. VISAGE

Facility . . .
See 114. EFFORTLESSNESS

141. FAILURE
See also 108. DOWNFALL;
193. INABILITY

1. **back to the drawing board** An acknowledgment that an enterprise has failed and that one must begin again from scratch, at the initial planning stages. The drawing board in question is the type used by draftsmen, architects, engineers, etc., for blueprints and such schematic designs. A similar phrase is *back to square one*, by analogy to a games board. Its meaning is the same—"We've got to start all over, from the very beginning."

2. **bite the dust** See 82. DEATH.

3. **broken reed** An undependable thing; something not to be trusted; an unreliable person. This expression can be traced directly to the Bible.

> Lo, thou trusteth in the staff of this broken reed, on Egypt; whereon if a man lean, it will go into his hand and pierce it: so is Pharaoh King of Egypt to all that trust him. (Isaiah, 36:6)

The term has retained the same symbolic meaning through the years and remains in everyday use.

> You lean upon a broken reed, if you trust to their compassion. (Tobias Smollett, *The Reprisal*, 1757)

4. **[one's] cake is dough** One's project or undertaking has failed, one's expectations or hopes have come to naught; one never has any luck. A cake which comes out of the oven as dough is clearly a total failure. Shakespeare used this now obsolete proverbial expression in *The Taming of the Shrew* (V,i):

> My cake is dough; but I'll in among the rest,
> Out of hope of all but my share of the feast.

5. **damp squib** An enterprise that was to have been a great success, but fizzled out; a lead balloon; a dud. In this British colloquialism, *squib* is another word for a firecracker. If it is damp, it will not explode as expected. It may fizzle or, in some cases, turn out to be a dud.

6. **dead duck** A person or thing that has become completely worthless or has failed; any person or thing that is doomed to failure; a goner. This American slang expression is actually a shortened version of an old pioneer saw, *never waste powder on a dead duck*. From that advice the term *dead duck* came to represent anything that is done in or played out. The expression remains in common use.

> Any politician that doesn't come out 100 percent against the proposed dams . . . will be a dead duck politically. (*New Mexico Quarterly Review*, Spring 1948)

The British equivalent of the American term is *derby duck*.

7. **down the tube** To be lost, gone, finished; failed in a course in school; down the drain; down the pipe. The expression seems an obvious allusion to water going down a drain, but its recent popularity may be attributed to terms used in the sport of surfing. Surfers try to *shoot the tube*, that is, to ride under the curl on a big breaker as it moves toward shore. Since *shooting the tube* requires an awk-

ward stance on the board, and involves an above average chance for failure, *tube it* has become a surfers' slang term for failing an exam or a course in school.

By extension the term *down the tube* came to mean any irretrievable loss. Related terms are *down the drain* and *down the pipe*.

> After all, the President had twice picked Agnew as his running mate. Said one aide: "Let's face it; if Agnew goes down the tube, that rubs off on the old man, too." (*Time*, October 1, 1973)

A variant, *down the tubes*, has the plural form, probably a superfluous addition.

8. fall by the wayside To drop out, either from physical or emotional weakness; to give up; to give out; to collapse from sheer physical exhaustion. The metaphorical implication of this phrase is drawn from a person's actually collapsing by the roadside during the course of a journey. The term is used today to symbolize the dropping out of a project or the giving up of a cause, either by one's own accord or because of circumstances. It is also used in a religious sense to indicate one who has gone over to the ways of sin. The British say *fall by the way*.

> If you fall by the way, don't stay to get up again. (Jonathan Swift, *Polite Conversation*, 1738)

9. the game is up It's over; all has ended; the plan has come to naught; all is lost. This phrase usually implies the termination of some long-term scheme which has resulted in failure. In Shakespeare's *Cymbeline*, (III,iii), Belarius, who has kidnapped and raised Cymbeline's two sons as if they were his own, realizes that his masquerade is about to end.

> Myself Belarius, that am Morgan call'd, They take for their natural father. The game is up.

An equivalent term was used as early as 161 B.C. by Terence, the Roman dramatist.

10. get a duck To fall on one's face; to fail; to be a flop. This Briticism has its roots in the game of cricket, where *duck egg* is the equivalent of American *goose egg*, i.e., zero. A batsman who fails to score a run in an inning is said to *get a duck* or *be out for a duck*. If he fails to get a run in both innings—each team has two innings in first class cricket—he is said *bag a brace*, where *brace* is a synonym for *two*. When the batsman makes his first run he is said to *break his duck*, similar to an American baseball hitter *breaking his slump*; both terms are used to indicate that one has made a fresh start, is under way once more.

11. go belly up See 82. DEATH.

12. goose egg A term used figuratively for lack of success in any endeavor; an instance of not scoring or of missing a point, so-called from the slang term for the numeral "0." As far back as the 14th century, things were compared to goose eggs because of a similarity in shape and size. By the mid-1800s, the term was used in scoring at athletic contests. The British equivalent is *duck egg*.

> At this stage of the game our opponents had fourteen runs—we had five large "goose eggs" as our share. (*Wilkes' Spirit of Times*, July 14, 1866)

Goose egg can also be used as a verb.

> I now had twenty-two consecutive World Series innings in which I goose-egged the National League. (*Saturday Evening Post*, February 28, 1948)

13. go up in smoke To come to naught, to be wasted or futile; to be unsuccessful, to fail or flop; also *to end up in smoke* and other variants.

> One might let him scheme and talk, hoping it might all end in smoke. (Jane Welsh Carlyle, *New Letters and Memorials*, 1853)

Use of this expression dates from the 17th century.

14. lay an egg To flop or bomb, especially when performing before an audience; to fail miserably. During World War I, *lay an egg* was Air Force terminology for 'drop a bomb,' *egg* probably being associated with *bomb* because of its similar shape. In addition, *egg* or *goose egg* is common slang for 'zero, cipher,' also because of their similar shapes. Thus, to *lay an egg* is 'to bomb' (figuratively, in American English), or to produce a large zero, i.e., nothing in terms of a favorable response from an audience, supervisor, or other persons evaluating a performance. (Note, however, that in British English, *bomb* refers to success; a play that *bombs* or is a *bomb* is a hit.)

> You would just as well come wearing a shell if you ever took a job [singing] in a spot like this, that is how big an egg you would lay. (John O'Hara, *Pal Joey*, 1939)

15. lead balloon A failure, fiasco, or flop; an attempt to entertain or communicate that fails to elicit a desirable response. This phrase is relatively new, having appeared in print no earlier that the mid 1900s. *Lead balloon* was originally heard in the verb phrase *to go over like a lead balloon*, an obvious hyperbolic expression for failing miserably. Today the phrase is used alone substantively or adjectivally. Thus, a joke, plan, etc., can be called a "lead balloon."

> *What the Dickens?* was a lead balloon literary quiz wherein the experts showed only how little they knew. (*Sunday Times*, April 19, 1970)

16. lemon An object of inferior quality; a dud; something that fails to meet expectations. This expression alludes to the lemons painted on the reels of slot machines or "one-armed bandits." Whenever a lemon appears on one of the reels, regardless of what appears on the other reels, the gambler automatically loses his money. *Lemon* was in popular

use by 1905, less than ten years after slot machines were invented. The expression remains almost ubiquitous, particularly in its most common current application, i.e., in reference to automobiles which experience almost constant mechanical difficulties. Today, some states have so-called "lemon laws" to protect consumers from sellers of defective cars.

> Mechanics are less than delighted to see lines of lemons converging on their service departments. (*Saturday Review*, June 17, 1972)

See also **one-armed bandit**, 244. NICKNAMES.

17. lose [one's] shirt To be financially devastated. This common expression implies that a shirt is the last of one's possessions to be lost in a financial upheaval.

18. a miss is as good as a mile A proverb implying that it does not matter how close one comes to hitting or attaining a goal, a near miss is still a miss, a near success is still a failure, etc. This expression is probably a corruption of an earlier, more explicit adage, "An inch in a miss is as good as an ell." (An ell is a former unit of measurement.) It has also been suggested that the original expression was "Amis is as good as Amile," alluding to two of Charlemagne's soldiers who were both heroes, both martyrs, and both saints—thus, to many people, they were virtually indistinguishable.

> He was very near being a poet—but a miss is as good as a mile, and he always fell short of the mark. (Sir Walter Scott, *Journal*, 1825)

19. miss the boat To miss out on something by arriving too late, to lose an opportunity or chance; to fail to understand; also *to miss the bus*. These phrases bring to mind the image of someone arriving at the dock or bus stop just in time to see the boat or bus leaving without him. Although both expressions date from approximately the early part of this century, *to miss the boat* is by far the more common.

Some firms were missing the boat because their managements were not prepared to be adventurous. (*The Times*, March 1973)

20. my Venus turns out a whelp See 325. REVERSAL.

21. put the shutters up To go bankrupt; to go broke; close one's business at the end of the day. This British expression, dating from the mid 1800s, is usually associated with the permanent closing of an operation, especially a business establishment. The allusion is self-evident.

A few old established houses . . . put up their shutters and confessed themselves beaten. (Sir Arthur Conan Doyle, *Captain Polestar*, 1890)

22. sad sack An inept person; a luckless, forlorn person. Perhaps a polite contraction of *sad sack of shit*, this term originated in the early 1930s but achieved its great popularity from George Baker's cartoon creation, *The Sad Sack*. Carried by many armed services publications throughout World War II, the comic strip became so popular that it continued as a regular feature in many of the nation's newspapers. A maladjusted, downtrodden, but well-meaning soldier, Sad Sack manages to find himself in constant trouble. Consequently, the allusive use of the term has come to evoke either sympathy or derogation.

23. take a bath To be ruined financially, to lose everything, to be taken to the cleaners; usually used in reference to a specific financial venture. This figurative American slang use of *to take a bath*, meaning 'to be stripped of all one's possessions,' plays on one's physical nakedness when bathing.

24. washed out To have met with failure or financial ruin; disqualified from social, athletic, or scholastic pursuits. One theory suggests that this phrase originated as an allusion to the former military custom of whitewashing a target after shooting practice, but the connection is difficult to discern. In modern usage, this expression is often applied in an athletic context to one who, because of injury or inferior ability, can no longer compete. In addition, the expression often implies a total depletion of funds.

I would sit in with . . . hustlers who really knew how to gamble. I always got washed out. (Louis Armstrong, *Satchmo, My Life in New Orleans*, 1954)

25. wither on the vine To fail to mature, develop, or reach fruition; to die aborning; to go unused, to be wasted. The expression describes lost opportunity, unrealized ambitions or talents, unfulfilled plans, etc. It often implies negligence or oversight; if such had been properly tended and nourished, they would have blossomed. An obvious antecedent of the expression appeared in the 17th century:

Like a neglected rose
It withers on the stalk with languish't head.
(John Milton, *Comus*, 1634)

142. FAIRNESS

1. a cat may look at a king Even an inferior has certain rights in the presence of a superior. This proverb, which dates from 1562, was used by Robert Greene in *Never Too Late* (1590):

A cat may look at a King, and a swain's eye has as high a reach as a lord's look.

2. even break An equal or fair chance; no advantage or handicap; as much or little chance as the next person. Of American origin, this colloquial expression may derive from the custom whereby opponents break a stick to determine who will have the advantage in a given situation. The long end is the preferable portion; the short goes to the loser. However, if the break is even, neither party has an advantage—each party has an equal chance. *Even break* dates from the early part of this century.

The chances in the "quartermile" seem to give the Americans only an even break for a first place. (*Daily Express*, July 11, 1928)

3. every dog has his day Just as "the meek shall inherit the earth," everyone will come into a period of power or influence. This proverbial expression dates from the time of the Greek poet Pindar in the 5th century B.C.

Thus every dog at last will have his day—
He who this morning smiled, at night may sorrow;
The grub today's a butterfly tomorrow.
(*Odes of Condolence*)

4. fair and square Honestly; equitably; in a straightforward manner; in a just and open way. Dating from the early 17th century, this expression, probably assisted by its rhyme, remains current.

We'll settle it between ourselves, fair and square. (John Arbuthnot, *John Bull*, 1712)

5. fair dinkum Fair and square; honest; genuine; reliable. This Australian slang term achieved some popular usage in the United States immediately following World War II, probably because of American troops who brought the term home after serving in Australia. The term has, however, remained almost exclusively Australian since its inception in the late 1800s. It is so closely associated with that continent that the Australian troops who served in Gallipoli in 1916 were referred to as 'The Dinkums.' Its origin is unknown; however, it is known that the slang term *dinkum* meant 'work' and retains that meaning today. Related terms are *dinkum oil*, meaning 'the honest truth,' and *straight dinkum*, meaning 'dead honest.'

The answer must be dead honest, as a friend of mine used to say 'Cross my heart straight dinkum.' (*Public Opinion*, March 7, 1924)

6. fair shake Just, equitable, unbiased treatment; an even break. In this expression, *shake* refers to a throw of the dice. Unscrupulous gamblers often use shaved or loaded dice to increase their chances of winning. A fair shake implies that no cheating or other undue influence has been employed to affect a situation, and that justice has been done.

7. give the devil his due To proffer fairness, even to someone of disrepute; to give credit to an enemy; to be unbiased. This expression, first recorded in English in John Lyly's *Pappe with an Hatchet* (1589), implies fairness in judgment on the part of the speaker.

You have always used me in an officer-like manner, that I must own, to give the devil his due. (Tobias Smollett, *Peregrine Pickle*, 1751)

8. on the square Honest; forthright; playing fairly and justly. There are two plausible explanations for this term. The first ascribes it to masons, who constantly make use of squares; hence, the right angle applies not only to properly set bricks but also by transference to upright people. The second explanation alludes to the Masonic emblem of a square and compass and the corresponding promise to act on the square. The *OED* records its first written example about 1600, but the phrase probably dates back into the Middle Ages.

I am hoping that you will give him the message on the square—for the sake of my mother as well as your own. (Rudyard Kipling, *The Man Who Would Be King*, 1889)

A closely related term *square shooter* also implies one who is forthright and honorable.

Captain Mac . . . was known from Seattle to Nome and back again as a square shooter. (*The Boston Globe*, June 12, 1949)

Also frequent is the variant *on the level*.

9. **a place in the sun** See 144. FAME.

Faithfulness . . . See 67. CONSTANCY

Faithlessness . . .
See 205. INFIDELITY

143. FALLACIOUSNESS
See also 121. ERRONEOUSNESS

1. **break Priscian's head** To break the rules of grammar; to use bad English. This expression was probably made popular by Nikodemus Frischlin's play, *Priscianus Vapulans* (1578), a comedy wherein one of the characters accuses another of *breaking Priscian's head* by using ungrammatical constructions. A celebrated Roman grammarian of the early 6th century, Priscian became a symbol of proper grammatical usage.

> They hold no sin so deeply red
> As that of breaking Priscian's head.
> (Samuel Butler, *Hudibras*, 1664)

A variant, *Priscian a little scratched*, is sometimes used to indicate a minor grammatical error.

> Bone? *bone* for *bene*: Priscian a little scratched, 'twill serve! (Shakespeare, *Love's Labour's Lost*, V,i)

2. **get hold of the wrong end of the stick** To be mistaken, to have the story wrong or the facts twisted; to attack or approach a problem from the wrong direction. This expression is more common in Britain than in the United States. The similar *get the wrong end of the stick* may have the identical meaning or be equivalent to *get the short end of the stick*. See also 395. VICTIMIZATION.

3. **put the cart before the horse** To reverse priorities; to be illogical; to have an erroneous perspective; to do things backwards. Similar sayings exist in numerous languages. This one appears to have its direct antecedents in Latin and French expressions; it appeared in English by the 13th century and has been common ever since. In Shakespeare's *King Lear* the Fool puns:

> May not an ass know when the cart draws the horse? (I,iv)

4. **skin an eel by the tail** To do something the wrong way; to do something backwards. The usual method of skinning an eel involves slitting its body just under the head and pulling downward to remove the skin. The reverse simply does not work.

144. FAME

1. **in good odor** In favor, in good repute; highly regarded, esteemed. *Odor* in this phrase means 'repute, estimation.' *In good odor* appeared in print as early as the mid-19th century. Also current is its opposite *in bad* or *ill repute* 'out of favor, disreputable.'

> When a person is in ill odour it is quite wonderful how weak the memories of his former friends become. (Charles Haddon Spurgeon, *The Treasury of David*, 1870)

2. **in the limelight** In the public eye; famous or infamous; featured; acclaimed; exalted. Before the discovery of electricity, theater spotlights burned a mixture of hydrogen and oxygen gases in a lime (calcium oxide) cylinder. This produced an intense light which could be focused by lenses on a featured actor or actress. Despite its archaic referent, the expression persists and is quite common today.

> The town hardly gets its full share of the limelight because of the hero. (Aldous Huxley, *Letters*, 1934)

3. **name in lights** Fame, notoriety, recognition, acclaim. In the world of theater, the name of a well-known or featured actor or actress may be displayed in lights on the marquee over the theater's entrance, thus drawing the public's attention and, it is hoped, their patronage.

> I couldn't wait to get up there with the best of them and see my name up in lights—topping the bill at the Palladium. (*Guardian*, January 15, 1972)

In contemporary usage, this expression is sometimes employed figuratively, and is no longer strictly limited to performing artists.

4. a place in the sun A position of favor, prominence, or recognition; a nice, warm, comfortable spot; a share in the blessings of the earth. Theoretically every individual is entitled to the benefits symbolized by the sun—life, growth, prosperity. The expression has been traced back to Pascal's *Pensées*, translated as follows:

> This dog's *mine*, says the poor child: this is *my* place, in the sun. (Bishop Kennett, *Pascal's Thoughts*, 1727)

5. put on the map To establish the prominence of a person or place; to make well known or famous. This expression originally referred to an obscure community which, following the occurrence of a newsworthy event, was noted on maps. The common phrase now describes a happening that thrusts a person or object into the public limelight.

> "The Fortune Hunter," the play that put Winchell Smith on the dramatists' map. (*Munsey's Magazine*, June 1916)

6. set the world on fire To achieve far-reaching success and renown; to make a name for oneself. This expression originated from the British *set the Thames on fire*, in which *Thames* is sometimes mistakenly thought to be derived homonymously from *temse* 'sieve,' through feeble allusion to a hard worker who uses a sieve with such celerity that the friction causes a fire. This theory is discounted by the fact that the French, Germans, and Italians all have similar sayings in regard to their own historic waterways, sayings which predate the English phrase. Thus, *set the Thames on fire* is undoubtedly the English version of the foreign expressions. When the phrase reached the United States, it was apparently Americanized to *set the river on fire*. As worldwide commerce and communication evolved, the phrase assumed its more cosmopolitan but some-

what less phenomenal form of *set the world on fire*. While the expression today usually implies the success of a vital and ambitious person, it is also applied negatively to the nonsuccess of a slow or lazy person. The term perhaps gained greater popularity through its incorporation into the lyrics of Bennie Benjamin's song *I Don't Want to Set the World on Fire* (1941).

Familiarity . . . See 156. FRIENDSHIP

Fantasy . . . See 183. ILLUSION

Fashionableness . . .
 See 360. STYLISHNESS

Fate . . . See 93. DESTINY

Fatness . . . See 72. CORPULENCE

145. FATUOUSNESS
 See also 111. ECCENTRICITY;
 179. IGNORANCE;
 359. STUPIDITY;
 385. UNCONVENTIONALITY

1. airy-fairy Light and delicate; superficial; pretentious. This expression, originally designating someone or something exquisitely dainty, first appeared in Tennyson's poem *Lilian* (1830).

> Airy, fairy Lilian
> Flitting, fairy Lilian
> When I ask her if she love me,
> Claps her tiny hands above me,
> Laughing all she can.

There is some question as to whether Tennyson coined the term or simply "borrowed" it. Whatever the case, the phrase shortly assumed a connotation of pretentiousness or superficiality, as seen in William S. Gilbert's *Only a Dancing Girl* (1869).

> No airy-fairy she,
> As she hangs in arsenic green,
> From a highly impossible tree,
> In a highly impossible scene.

The phrase retains the same pejorative sense today. It is encountered mainly in Britain.

2. beans are in flower Temporarily demented; crack-brained; fatuous. Although the origin of this expression is uncertain, it may have derived from our ancestors' belief that the aroma from a flowering bean caused men to feel lightheaded. Thus, *beans are in flower* became a catch-phrase to explain away a man's temporary abnormal behavior.

> With the bean-flower's boon,
> And the blackbird's tune,
> And May, and June!
> (Robert Browning, *De Gustibus*, 1855)

3. cockamamie Absurd; ludicrous; nearly valueless; trifling; almost worthless; quixotic. Decalcomania, the process of transferring a decal, a design or picture on a specially prepared paper, to another surface, such as porcelain or glass, apparently gave birth to the word *cockamamie*. During the late 1920s, a process was devised to transfer nontoxic decals to the human skin. The application of these decals to various parts of the human anatomy became a fad among the young for a while, and the slang word *cockamamie* was coined in response to the absurdity of the practice; the ultimate origin remains obscure. However, Bob Kane, the creator of Batman, was quoted in the *New York Post* of January 9, 1931:

> When I make a statement on canvas, I'm not just doing cockamamie drawings.

In the vocabulary of today the term has taken on a number of meanings, all commonly connoting some degree of worthlessness or absurdity.

> I figure it has to be a lawyer to figure out this whole cockamamie scheme. (Maxwell Nurnberg, *I Always Look Up the Word E-gre-gious*, 1981)

4. ding-a-ling A person who repeatedly makes silly mistakes or foolish and inap-propriate remarks; one whose behavior is unconventional or eccentric. A *ding-a-ling* is one who behaves as if he hears bells in his head. The implication is that a head full of ringing bells must be devoid of brains and sense. A newer and equivalent American slang term is *dingbat*.

5. Doctor Doddypoll A dolt; a simpleton; a nincompoop; a blockhead. The origin of this expression is questionable. The most plausible explanation attributes it to a combining of the words *poll* 'head,' and *doddy*, an old form of the modern word *dotty*, meaning 'slightly demented or feeble-minded.' Occasionally the term is simplified to *doddypoll*.

> What ye brain-sycke fooles, ye hoddy peckes, ye doddye poulles! . . . are you seduced also? (Hugh Latimer, *Third Sermon before Edward VI*, 1549).

The term originated during the latter half of the 15th century. In 1595 a comedy, *The Wisdom of Doctor Doddypoll*, was staged in London. Although of unknown authorship, the play is often ascribed to George Peele. A related expression of ironic intent, *as wise as Doctor Doddypoll*, means 'not wise at all.'

6. an elephant in the moon A spurious discovery; a mare's nest; an illusion. This expression owes its genesis to an actual series of events. In the 17th century a scientist of the Royal Society, Sir Paul Neale, made the startling announcement that he had discovered *an elephant in the moon*. Close observation by one of his fellow scientists proved that a little mouse had somehow got into his telescope. Samuel Butler wrote a poetic satire directed against Neale and his amazing discovery. Butler's satire, *The Elephant in the Moon*, contributed to the popularity of the phrase, which is still in use in reference to chaos as a result of buffoonery.

7. find a giggles' nest This British expression, in use since the early 19th century, is said to have originated in Nor-

folk where it was directed at one who was laughing to excess, at someone who "has the giggles." The term itself suggests an imaginary giggles' nest, a place of plentiful giggles, or perhaps a room full of giggling girls.

8. full of beans Uninformed, ignorant, stupid; silly, empty-headed. This use of *full of beans* may have derived from an indirect reference to a bean's small value. Thus, to be "full of beans" is to be full of insignificance and inanity.

9. go to Battersea, to be cut for the simples This phrase, an admonishment to one who makes a foolish comment, is often truncated to *go to Battersea* or to *be cut for the simples*. The allusion here is to the *simples*, medicinal herbs which were once grown in great quantities in what is now the Battersea section of London. Apothecaries from London would travel to Battersea to select the choicest herbs. The term, dating from the mid 17th century, is also a pun on the word *simple*; hence, the expression, most often used jocularly or as a snide remark, implies that one is becoming weak in the mind. Variants are to *have their simples cut* and *He must be cut of the simples*. It is rarely encountered outside of England.

What evils might be averted . . . by clearing away bile, evacuating ill humors, and occasionally by cutting for the simples. (Robert Southey, *The Doctor*, 1834)

10. have windmills in [one's] head To be full of dreamlike illusions; to live in a fool's paradise. This obsolete expression implies the circulation of fanciful ideas in the vacuity of a daft mind.

He hath windmills in his head. (John C. Clarke, *Paroemiologia*, 1639)

See also **tilt at windmills, 183. ILLUSION.**

11. head of wax A head consisting of a substance that is easily molded, possessed by someone who is very impressionable, easily deluded. This term designates one who is easily led astray, one

who carries the opinions of the last person who spoke to him.

If your head is wax, don't walk in the sun. (Benjamin Franklin, *Poor Richard's Almanack*, 1749)

The expression has been in use since the early 18th century and is common throughout Europe. The French have a proverb: *If your head is wax, stay away from the fire.*

12. in the ozone In a daze, in another world; spacey, spaced-out. The ozone layer or ozonosphere is a region in the upper atmosphere characterized by a high concentration of ozone and a relatively high temperature owing to the assimilation of ultraviolet solar radiation. Hence, *in the ozone* is equivalent to *out in space.* This American slang expression appears to be of very recent coinage.

13. not have all [one's] buttons To be whimsical, odd, or crazy; to be out of it or not all there. In the 19th century, this expression was used to describe unintelligent, irrational behavior. It is now considered a slang phrase which emphasizes the eccentric, idiosyncratic aspects of behavior rather than characteristics indicative of stupidity or dullness.

14. silly as a coot Simple; stupid; witless; fatuous; inane. This simile, dating from the 17th century, alludes to the rather comic facial features of the coot, as well as to the bird's extravagant behavior at mating time. The males thrash about in the water, uttering weird cries, flapping their wings, thrusting their beaks and slashing their talons at other males. Frequently heard variants are *crazy as a coot* and *stupid as a coot.*

15. simple Jack A simpleton; a fool; a person of no consequence. This British expression is a simple transference of the French *Gros-Jean*. The famous French author, Jean de la Fontaine, in his *Fables* (1678) tells of a dairy maid, one Gros-Jean, carrying a full pail of milk on her head. As she is making her way to market, she thinks of all the things she

can do with the money she will get for the milk. However, the pail falls from her head before she arrives, and she is *Gros-Jean comme devant* 'Gros-Jean as before,' that is, no better than before. From this French expression comes the English *simple Jack* and the equivalent English proverb *simple Jack as before.*

16. slaphappy Severely confused or befuddled; cheerfully irresponsible; giddy; happy or elated, as if dazed. This term alludes to the apparent exhilaration which sometimes accompanies a concussion caused by a series of blows to the head, such as might be inflicted in a boxing match.

A sample [of talk] designed to knock philologists slap-happy. (*Newsweek*, May 23, 1938)

A related expression which, like *slap-happy*, employs an internal rhyme is *punch-drunk*. A variation is *punchy*.

17. social butterfly An irresponsible person who flits aimlessly from one social gathering to another. The source of this term is unknown, but the use of butterfly as a metaphor for one who flutters about from one place to another goes back to at least the 16th century. Today's *social butterfly* is often busy climbing the *social ladder* and flits about from ball to banquet, a member of the *social whirl*. The social ladder is, of course, for those trying to make it to the top rungs.

The noble has gone down on the social ladder, and the roturier has gone up. (John Stuart Mill, *Edinburgh Review*, 1840)

The *social whirl* refers to the cycle of activities sponsored each year during the "season," attended by fashionable society.

18. Tom Noddy A foolish or half-witted person; a simpleton; a name for a fool, an idiot. This name is probably a derivative of the verb *nod*; however, it may derive from puffins, also known as *noddies* or *Tom Noddies*, rather silly birds that one can walk up to and bash with a stick

or club. A third, but rather weak, suggestion is that the term is a nickname for Nicodemus. Dating to the early 19th century, the term was popularized by the Reverend Richard Harris Barham when *My Lord Tomnoddy* appeared as a character in *The Ingoldsby Legends* (1840).

My Lord Tomnoddy got up one day;
It was half after two; he had nothing
 to do,
So his lordship rang for his cabriolet.

And a few years later in a satirical poem, *My Lord Tomnoddy*, Robert B. Brough wrote of hereditary titles:

My Lord Tomnoddy is thirty-four;
The Earl can last but a few years
 more.
My Lord in the Peers will take his
 place:
Her Majesty's councils his words will
 grace.
Office he'll hold and patronage sway;
Fortunes and lives he will vote away;
And what are his qualifications—
 ONE!
He the Earl of Fitzdotterel's eldest
 son.

19. wimp A boring, introverted person; a person who is out of touch with current trends, fads, and ideas; a sissy or weakling. This American slang expression, dating from the late 1950s, is of uncertain derivation, but most experts believe it originated with Wimpy, the hamburger-gulping simpleton featured in the *Popeye* comic strip. However, Stanley Meisler, a *Los Angeles Times* correspondent in Toronto, Canada, attributes it to "an onomatopoeic merger of the words *whimper* and *limp*." Whatever the case, the term is popular today, especially among the young.

The sensitive, unathletic kid refused to stifle his artistic instincts. He served as President of the Art Association (Twenty of us little wimps reading *Artform*, says Wheelwright).
(William Casselman, *Macleans*, October 9, 1978)

20. wise men of Gotham Simpletons; stupid, foolish people; boneheads; dumbbells. Somehow during the Middle Ages the English village of Gotham acquired a reputation of being a village of idiots. The legend was strengthened by a collection of stories published during the reign of Henry VIII. Relating stupid actions on the part of the village people, the collection was entitled *Merry Tales of the Mad Men of Gotham.* One tale tells of a wall the men of Gotham built around a cuckoo so that the village would enjoy the season of spring all year round, for cuckoos stayed in their countryside only during the springtime; however, much to their chagrin the cuckoo flew away. Another tale recounts how King John visited Gotham with the idea of purchasing a castle there, but when he saw the idiotic games that the people played to amuse themselves, he decided to purchase it elsewhere and traveled on. The *wise men of Gotham* are said to have remarked, "More fools pass through Gotham than remain in it." Other cultures have their "Gothams": in Eastern Europe, the town is called *Chelm.*

146. FAULTFINDING
See also 78. CRITICISM;
245. NIT-PICKING;
312. REPRIMAND

1. armchair general A person removed from a given situation who thinks he could do a better job of directing it than those actually in charge. Although the phrase *armchair general* did not come into popular usage until World War II, similar combination forms (*armchair politician, armchair strategist, armchair critic*) have been in existence since 1858, with *armchair* clearly connoting a position of comfort and relaxation, remote from the hurly-burly or pressures attendant on those who must act. Consequently the term carries the negative implications of an ivory-tower theorizer, speculator, or academician—one ignorant of

practical realities, an observer rather than a doer.

2. back-seat driver A kibitzer; a giver of unsolicited advice or criticism; one who tries to direct a situation which is not his responsibility and over which he has no real control. The term is an extension of the name given to a person, usually sitting in the back seat of a car, who interferes with the driver's concentration by volunteering unnecessary warnings and directions. The phrase appeared as early as 1926 in *Nation* magazine.

3. a jaundiced eye See 283. PREJUDICE.

4. Monday-morning quarterback One who criticizes the actions or decisions of others after the fact, who uses hindsight to offer his opinions on what should have been done. The phrase is an extension of the name given to football buffs who spend their Monday mornings rehashing the particulars of the weekend games.

5. mote in the eye See 186. IMPERFECTION.

6. pick holes in To find fault with, to destroy the credibility or reputation of. The original expression *to pick* or *make a hole in someone's coat* was based on the notion that such a flaw in one's appearance would damage one's respectability or standing. The phrase is now used more often to apply to arguments than to persons, though this usage is itself very old.

> The lawyers lack no cases . . . Is his lease long . . . Then . . . let me alone at it, I will find a hole in it.
> (Thomas Wilson, *The Art of Rhetoric,* 1553)

7. point a finger at To accuse or to implicate another; to inform on others; to find fault with another person's actions or statements. This expression, dating from at least the Middle Ages, is obvious in its intent: when indicating which person is guilty in a group, one *points a fin-*

ger at the guilty party. Recently, the term has taken on an extended meaning. To *point a finger at* another during an argument, whether literally or figuratively, demonstrates strong disagreement, even disdain, for another's point of view.

> The first night it was just a party, a lark, . . . the second night people's tempers were getting short and they were pointing fingers. (*The New York Times*, May 17, 1984)

8. the pot calling the kettle black Said of a person who criticizes or blames someone else for a failing of which he is also, and usually more, guilty. First used by Miguel de Cervantes in *Don Quixote, Part II* (1615), this proverb is based on the idea that since both a pot and a kettle are blackened by exposure to a cooking fire, neither can accuse the other of being black without acknowledging its own blackness. This expression usually implies the presence of an unjustified holier-than-thou attitude on the part of the accuser.

> I've been as good a son as ever you were a brother. It's the pot and kettle, if you come to that. (Charles Dickens, *The Life and Adventures of Martin Chuzzlewit*, 1844)

9. raise an eyebrow To show disapproval; to register a look of disapprobation or skepticism; to appear mildly put off; to look askance. Popular since the early part of this century, *raise an eyebrow* derives from the fact that such a gesture is often an instinctive reaction, a natural response to being taken by surprise. However, the look of surprise is often tinged with disapproval or skepticism.

> Brown, though he raises his eyebrows a little at the usage, by no means condemns it outright. (G. H. Vallins, *The Pattern of English*, 1956)

10. strain at a gnat and swallow a camel See 176. HYPOCRISY.

11. trigger-happy See 187. IMPETUOUS-NESS.

Faultiness . . .
See 186. IMPERFECTION

147. FAVORITISM
See also 210. INJUSTICE;
283. PREJUDICE

1. apple of [one's] eye A prized or cherished possession, an object of special devotion or attention; a favorite or beloved person. The literal apple of the eye is the pupil, formerly thought to be a solid globular body. The figurative phrase, perhaps derived from the priceless value placed on vision, appears to be as old as the language itself, having been used by King Alfred in his translation of Boethius' *Consolation of Philosophy* (approx. A.D. 523). The expression also appears in Deuteronomy 32:10.

> He kept me as the apple of his eye.

2. blood is thicker than water This proverb from the early Middle Ages is a reference to the special relationship that supposedly exists among kinsmen. The implication is that the concern one shows a blood relative is deeper and longer lasting than that shown a stranger.

> Blood is thicker than water—and so is treacle. (Sir James Lockhart, *Epigram*, 1674)

When Commodore Joseph Tatnall of the United States Navy went to the aid of a British squadron in 1859 in the Pei-Ho river in China, he sent a message to the Secretary of the Navy to explain himself: *Blood is thicker than water*.

3. button of the cap The top; the most favored. This expression comes from the use of different types of buttons or knobs on the top of the caps worn by Chinese mandarins to distinguish various degrees of rank. Shakespeare used the phrase in *Hamlet* (II,ii):

> On Fortune's cap we are not the very button.

4. fair-haired boy A person being groomed for a position of leadership; a favorite of those in power. Throughout Western mythology and folklore, the hero, an embodiment of goodness and beneficence, is traditionally pictured as having a light complexion, blue eyes, and light-colored or blond hair. In many cultures, both past and present, a fair-haired person is considered to be a god, godlike, or in some way superior to dark-haired people in the same culture. Thus, the expression describes anyone, not necessarily only a blond male, favored for leadership in a given field.

> Joe Mooney . . . a blind [jazz pianist] . . . is the latest "fair-haired boy" of the musical world. (Dave Bittan, Temple University *News*, January 24, 1947)

> Vishinsky was Stalin's newest fair-haired boy. (*Time*, March 14, 1949)

Similar expressions include *fair-haired girl, blue-eyed boy* or *girl, blonde-haired boy* or *girl,* and *white-haired boy* or *girl.* In recent years, such terms have sometimes been used derogatorily to describe an employee who is in favor with his superiors, whether by chance, talent, or as a result of his obsequiousness.

5. handle with kid gloves See 45. CAUTIOUSNESS.

6. make chalk of one and cheese of the other To show favoritism; to treat one thing or person better than another. The terms *chalk* and *cheese* are often found in opposition to one another in proverbial expressions, where, though both are white, *chalk* stands for something worthless and *cheese* symbolizes something of value. Thus, *to make chalk of one and cheese of the other* means to treat two things or persons unequally, to favor one over the other.

7. make fish of one and flesh of another To favor one thing or person over another, to make unfair distinctions between similar things or persons; also *to make fish of one and fowl of another.* The allusion is to the practice of dividing meat into the categories of fish, flesh, and fowl. Thus, to make fish of one and flesh or fowl of another is to discriminate unnecessarily and unfairly between basically similar things or persons, to show partiality. Use of this expression, rarely heard today, dates from the early 18th century.

> This is making fish of one and fowl of another with a vengeance. (*The Manchester Examiner*, May 1885)

8. red-carpet treatment Preferential or royal treatment; also the phrase *to roll out the red carpet* 'to give someone preferred or royal treatment.' The reference is to the plush strip of red carpet traditionally laid out for the entrances and exits of kings and other heads of state.

9. sacred cow Any person, idea, or object held sacrosanct and consequently immune from attack or criticism. As commonly used, *sacred cow* carries the implication that inviolability is unwarranted, but that considerations of political expedience prevent dispassionate evaluations or judgments of merits. The expression is derived from the Hindu belief that cows are sacred; thus, they are never slaughtered and are allowed to roam about freely.

10. see-you This term, a part of merchandising jargon, is used to designate a regular customer who wishes to be waited on by the same salesman and will ask for him by name, if necessary. The origin of the expression is uncertain, but probably arises from the familiarity that develops from their seeing each other frequently.

> A 'see-you', which is a customer who always asks to see a particular salesman. (*The New York Times Magazine*, September 21, 1952)

See also see you, 131. EXCLAMATIONS.

Fawning . . .
See 248. OBSEQUIOUSNESS

148. FEAR
See also 22. ANXIETY

1. afraid of [one's] own shadow To be unusually fearful; to be unreasonably frightened or scared; to be exceedingly tense or jumpy. The suggestion here is, of course, that it is a mark of excessiveness to fear something so commonplace as one's own shadow. The expression has been in use since Plato, more than 300 years before Christ.

A considerable part of Concord are in the condition of Virginia today, afraid of their own shadows. (Henry D. Thoreau, *Autumn*, November 30, 1859)

2. the creeps A feeling of dread or fear; an unpleasant sensation as if things were creeping over one's body. This colloquialism dates from the early 19th century and alludes to the strange sensation one experiences when confronted with a fearful or eerie situation. The horripilation occasioned at such a moment creates a sensation of things creeping on one's skin.

In the old country mansions where the servants . . . commence . . . to have shivers and creeps. (Edmund Yates, *Broken to Harness*, 1864)

A related colloquialism, *creep*, was coined in the 1930s to signify the type of person who gives one *the creeps*, and is used more loosely to denote any repulsive individual.

3. goose pimples A condition of the skin resembling a plucked goose's skin, caused by cold or fear; a rough, pimply condition of the skin caused by erection of the papillae; horripilation. This expression, in use since at least the 1600s, had its inception as a result of the similarity between the flesh of a freshly plucked goose and the rough, prickly condition of the human skin at times of fear or cold. When a goose is plucked, the minute muscles that offer feather control contract, giving the same appearance as the skin of a frightened or cold human being; hence, *goose pimples*, or the variations, *goose flesh* and *goose bumps*.

The way it scraped in this maneuver makes goose pimples on my spine even now. (*The New York Times*, February 2, 1947)

4. have [one's] heart in [one's] mouth To be frightened or scared, apprehensive or afraid, anxious or tense. The allusion is to the throbbing feeling one experiences in the upper chest and lower throat in moments of tense excitement.

Having their heart at their very mouth for fear, they did not believe that it was Jesus. (Nicholas Udall, *Erasmus upon the New Testament*, translated 1548)

5. make the hair stand on end To terrify, to scare or frighten, to fill with fear. The allusion is to the way an animal's hair, especially that on the back of the neck, involuntarily stiffens and becomes erect in the face of danger and to the prickly sensation of the scalp felt at times of great emotion or excitement.

As for the particulars, I'm sure they'd make your hair stand on end to hear them. (Frances Burney, *Evelina*, 1778)

6. scare the daylights out of [someone] To frighten a person intensely; to make one's hair stand on end; to alarm inordinately. Originally, *daylights* was underworld and boxing slang for the eyes, but by extension came to mean one's consciousness or vital organs.

I scared the daylights out of you with the toy gun. (*The New York Times Everyday Dictionary*, 1982)

Variants are *shake the daylights out of someone* and *shoot the daylights out of someone*.

I'll shoot the everlasting daylights out of you! (E. S. Field, *The Sapphire Bracelet*, 1910)

7. shake in [one's] shoes To be petrified, terrified, panic-stricken; to be scar-

ed out of one's wits. The expression is not limited in application to people.

> It had set the whole Liberal party "shaking in its shoes." (*Punch*, March 15, 1873)

Variations are *quake* or *shake in one's boots*.

8. shake like an aspen leaf To tremble, quake; to shiver, quiver. This simile refers to the aspen tree with its delicate leaves perched atop long flexible stems that flutter even in the slightest breeze. The expression was used as early as 1386 by Chaucer in his *Canterbury Tales*.

Feat . . . See 6. ACCOMPLISHMENT

Fighting . . . See 51. COMBAT

Finality . . . See 375. TERMINATION

149. FINANCE
See also 196. INDEBTEDNESS;
240. MONEY; 364. SUBSISTENCE

1. bullish Optimistic, hopeful, confident. In the world of finance, a "bull" is an investor who speculates in stocks or commodities in anticipation of a profit to be realized when the market prices increase. Thus, the "bull" believes that the general business climate is or will soon be favorable. *Bullish* is used in other, nonmonetary contexts as well.

A related term, *bearish*, also derived from stock-market jargon, describes a pessimistic outlook. Since a "bear" believes financial conditions are worsening, he may try to sell short, hoping to repurchase the stocks or securities at a lower price at some future date. Since both "bulls" and "bears" often buy the rights to trade stocks on margin, i.e., at a percentage of their true market value, the "bear" may, in effect, sell what he has not yet purchased. It has therefore been conjectured that the origin of *bear* may lie in the proverb *to sell the bearskin before one has caught the bear*. As early as 1721, Nathan Bailey's *Universal*

Etymological English Dictionary included the following: "*to sell a bear: to sell what one hath not.*"

2. feel the draught See feel a draft, 267. PERCEPTIVENESS.

3. feel the pinch To sense one's precarious financial position; to be in a tight spot. In this expression, *pinch* carries its figurative meaning of an internal twinge of emotional discomfort. The expression most often refers to an economic situation which warrants austerity measures.

4. grubstake Money advanced in exchange for a share in a venture's expected return. The term, dating from at least 1863, originally referred to money "staked" to prospectors for "grub" and other provisions in return for a part of the profits from their finds.

> The farmer realizes the . . . plight of the out-of-work who . . . is left without a grubstake between himself and hunger. (*The Atlantic Monthly*, March 1932)

5. in the black Making a profit; out of debt. This Americanism is so called from the bookkeeping practice of entering profits in black ink. It is synonymous with *out of the red*.

> This time she appeared at the Italian Village, and within two weeks she had pulled it out of the red ink and into the black. (*American Mercury*, July, 1935)

6. jawbone To ask for credit or trust; to buy on credit; to borrow. The derivation of this American slang term is uncertain, although one suggestion ascribes it to the Phillipine Islands and the American bastardization of the Spanish *jabon*, 'soap'. The story is told of Phillipine washerwomen who would ask American service personnel stationed in the Islands, "*una peseta para jabon?*", 'a dime for soap?'. The money was not really needed for soap, however; it was simply a method of picking up extra cash. The Americans adapted the Spanish pronunciation, "habone," to "jawbone," and used it to

mean a request for credit. The term has been in use since the late 1800s and is occasionally heard today.

> He jawboned enough thousands of dollars to set up an office and hire his personnel. (Robert C. Ruark, in a syndicated newspaper column, December 9, 1952)

See also **jawbone, 50.** COERCION.

7. on a shoestring Dependent upon a very small sum of money; relying on a meager amount of money as capital in a working investment. This colloquial meaning of *shoestring* has been common in the U.S. since the early part of the century, though precisely how it acquired this sense is unclear. Perhaps *shoestring* was equivalent to "the cost of a shoestring."

> They accomplished their elegance on a shoestring, too. (*Ward County* [North Dakota] *Independent,* July 1944)

8. play the papers To gamble. This obsolete Americanism was current in the 19th century.

> Poor Kit was in a bad way one hour before we parted. The fact is, you know, he'd bin playin' the papers (meaning gamblin') and had lost everything. (De Witt C. Peters, *The Life and Adventures of Kit Carson,* 1858)

A similar expression with specific reference to horse racing is *play the ponies.*

9. prime the pump To attempt to rejuvenate an enterprise by channeling money into it; to try to maintain or stimulate economic activity through government expenditure. A pump is primed, or prepared for use, by pouring water into it to produce suction. The expression was used by T. W. Arnold, as cited in *Webster's Third:*

> This spending has not yet primed the pump.

10. salt away To save or hold in reserve money or other valuables for future use;

to build a nest egg. The figurative meaning of this expression is derived from its literal one, i.e., to preserve meat or other perishables by adding salt.

> [There is] no one to hinder you from salting away as many millions as you can carry off! (R. W. Chambers, *Maids of Paradise,* 1902)

11. sock away To set aside money in a savings account; to save or put money in reserve. This American expression implies that the money is being stowed away for some future investment. It may derive from the days when socks were a common storage receptacle for one's savings. The phrase appeared in *Life,* as cited by *Webster's Third:*

> (He) has socked away very little of his earnings with which to buy a ranch.

Finish . . . See 47. CESSATION

Firmness . . . See 84. DECISIVENESS

Fitness . . . See 55. COMPETENCE; 162. GOOD HEALTH

Flamboyance . . . See 256. OSTENTATIOUSNESS

150. FLATTERY
See also 52. COMMENDA-
TION; 248. OBSEQUIOUSNESS

1. applesauce See 246. NONSENSE.

2. blarney Flattery, soft soap, cajolery. The expression comes from the Blarney Stone located high in the wall of Blarney Castle near Cork, Ireland. Legend has it that an Irish commander of the castle by his cleverly evasive communiqués successfully duped an English commander demanding its surrender. A similar gift of forked or honeyed speech is thus said to come to whoever kisses the stone. The verb usage of *blarney* dates from 1803; the noun usage from shortly thereafter.

3. butter up To flatter someone, especially when one hopes to gain some private end; to curry favor for ulterior motives; to soft soap. The term *butter* is frequently used figuratively to indicate flattery. *Punch* calls it the milk of human kindness churned into butter. The expression has been in use since about 1700.

4. court holy water Flattery, hollow promises, fair but empty words; also court-water and court-element. The French equivalent phrase is *eau bénite de la cour*. According to Le Roux's *Dictionnaire Comique*, unfounded promises or empty compliments were called "court holy water" because there was no lack of fair promises in court, just as there is no lack of holy water in church. This obsolete proverbial expression dates from 1583.

5. flannelmouth A smooth talker; a silver-tongued devil; a flatterer or braggart; a person who talks incessantly and says nothing; one who mumbles or speaks with a thick accent. In this expression, *flannel*, a smooth, soft fabric, refers to a person's manner of speech: it may be smooth and soft like flannel, or it may be mumbled and confusing, as though the speaker had a mouthful of flannel.

6. lay it on To flatter or criticize excessively; to act or speak in an exaggerated manner. This expression alludes to the manual-labor trades such as masonry and painting where one might add more and more mortar, paint, etc., in an attempt to produce a superior product when, in actuality, a small amount would be just as effective, if not more so. As a result of such excessiveness, the final product is often messy and of questionable value. The figurative implications are obvious. Related expressions include *lay it on thick, lay it on with a shovel,* and *lay it on with a trowel.*

> Well said; that was laid on with a trowel. (Shakespeare, *As You Like It,* I,ii)

7. soft-soap To wheedle or cajole; to win over or persuade by means of flattery; to butter someone up for ulterior motives. In use since the early 18th century, the verb and corresponding noun are thought to derive from *soft soap,* the semiliquid soap whose oiliness is associated with unctuousness.

Flight . . . See 122. ESCAPE

151. FLIMSINESS

1. band-aid treatment Temporary, inadequate patching over of a major difficulty demanding radical treatment; makeshift or stopgap measures which temporarily relieve a problem without solving it. *Band-Aid* is a trade name for a small adhesive bandage used on minor cuts and scrapes. The expression is American slang and apparently of fairly recent coinage.

2. built upon sand Erected with an insecure base or foundation. The allusion in this expression is to sand as an unsuitable material upon which to construct anything, for any structure or scheme built upon such a shifting base is insecure and in imminent danger of collapse.

> Safe upon the solid rock the ugly
> houses stand;
> Come and see my shining palace built
> upon the sand.
> (Edna St. Vincent Millay, *A Few Figs from Thistles: Second Fig,* 1921)

The expression, often attributed to the words of Christ in Matthew 7:26, can be traced to the writings of the classical Greeks many years before.

3. half-baked Insufficiently planned or prepared, not well thought out, ill-considered; unrealistic, flimsy, unsubstantial, incomplete; sloppy, shoddy, crude; not thorough or earnest. It is easy to see how the literal sense of *half-baked* 'undercooked, doughy, raw' gave rise to the figurative sense of 'inadequately prepared or planned.' The use of this term in its figurative sense dates from the ear-

ly 17th century. The expression appeared in this passage from *Nation Magazine* (August 1892):

The half-baked measures by which politicians try so hard to cripple the Australian system.

4. house of cards Any insecure or unsubstantial structure, system, or scheme subject to imminent collapse; also *castle of cards*. The allusion is to the card-castles or houses children often build, only to blow them down in one breath a few moments later.

Painted battlements . . . of prelatry, which want but one puff of the King's to blow them down like a paste-board house built of court-cards. (John Milton, *Of Reformation Touching Church Discipline in England*, 1641)

5. jerry-built Cheaply made, poorly constructed, flimsy, unsubstantial, slapdash, haphazard, makeshift. The most plausible of the many theories as to the origin of this term relates it to the Jerry Brothers, Builders and Contractors of Liverpool, England, in the early 19th century. This company was apparently so notorious for its rapidly and cheaply constructed, though showy, houses that its name became synonymous with inferior, shoddy building practices. Of British origin, this expression dates from at least 1869.

It would soon be overspread by vulgar jerry-built villas. (George C. Brodrick, *Memories and Impressions*, 1900)

6. jury-rigged Makeshift, stopgap, temporary; a nautical term applied to a ship that leaves port partially, rather than fully- or ship-rigged, with rigging to be completed at sea; or to one temporarily rigged as a result of disablement. Though the *jury* has been said to derive from the French *jour* 'day' (hence rigged for the/a day only), the *OED* says the origin is unknown.

7. rope of sand Something of no permanence or binding power; an ineffective, uncohesive union or alliance; a weak, easily broken bond or tie. The phrase, of British origin, has been used metaphorically since the 17th century to describe worthless agreements, contracts, etc.

Sweden and Denmark, Russia and Prussia, might form a rope of sand, but no dependence can be placed on such a maritime coalition. (John Adams, *Works*, 1800)

152. FOCUS

1. draw a bead on To aim at carefully, to line up in the sight of one's gun; to zero in on a person or thing. The reference is to the bead or front sight of a rifle. George Catlin used the expression in his treatise on North American Indians (1833).

2. zero in on To focus one's attention on a specific person, proposal, issue, or other matter; to aim at; to set one's sights on. Originally, *zero in* referred to adjusting the sights of a gun to the zero or horizontal line so that when aimed and fired at a target, the projectile will hit it dead center. Though this meaning persists, the expression has been extended to include figurative application in various nonballistic contexts as evidenced in this example by J. N. Leonard, cited in *Webster's Third:*

. . . bird-dogs zeroing in on coveys of hidden quail.

Foiling . . . See 379. THWARTING

153. FOOD AND DRINK
See also 109. DRUNKENNESS;
382. TIPPLING

1. Adam's Ale Another name for water, sometimes applied humorously. On occasion the term is applied sardonically by drinking men, as Matthew Prior exhibits in "The Wandering Pilgrim":

A Rechabite poor will must live,
And drink of Adam's ale.

This name is based on the obvious fact that the first man, Adam, had nothing else available to drink.

> Adam's ale, about the only gift that has descended undefiled from the Garden of Eden! (Storrs, *Ale*, 1875)

2. banyan days Days when no meat is served; in the British Royal Navy, the two days in each week when no meat was served. In the late 16th century, Europeans exploring the coast of the Gulf of Persia near Bandar Abbas, Iran, discovered a huge tree under which a caste of Hindu tradesmen and moneylenders known as Banians or Banyans had built a small pagoda. These Hindu merchants observed strict religious rites, refusing to eat any type of flesh. Not only did that particular tree (a variety of the fig) become known as a *banyan*, from the name for the traders, but the name was extended to the entire species. Furthermore, the Banyans' refusal to eat meat gave rise to the use of *banyan* as a synonym for 'meatless.' The Australians in the Outback soon named those days when meat was not available as *banyan days*, and the British Royal Navy adopted the term to designate the two days a week when meat was not served to the sailors.

> I was not very much tempted with the appearance of this dish, of which, nevertheless, my messmates ate heartily, advising me to follow their example, as it was banyan day, and we could have no meat till next noon. (Tobias Smollett, *Roderick Random*, 1748)

3. belly-timber Food or nourishment; provisions. According to *Brewer's Dictionary of Phrase and Fable*, there is a connection between the French phrase *carrelure de ventre* 'refurnishing or resoling the stomach,' and the origin of *belly-timber*. Apparently Samuel Butler and his contemporaries were the last to use the term seriously.

> . . . through deserts vast
> And regions desolate they pass'd

> Where belly-timber above ground
> Or under, was not to be found.
> (Samuel Butler, *Hudibras*, 1663)

4. cambric tea This American expression, dating from the early 1800s, denotes a cup of hot water with milk added, usually served to children as a substitute for tea. *Cambric* is a fine, white linen cloth, originally manufactured at Cambray in Flanders (*Kameryk*, in Flemish), and apparently the expression is derived from the similarity of color of the fabric and of the tea.

> She gave me a vast easy chair to sit in . . . and offered me tea, cambric tea to be sure, but in a beautiful cup. (*Chicago Union Signal*, January 21, 1888)

5. eye opener A drink of whiskey, especially the first one in the morning; a *pick-me-up*. This American slang expression, dating from the early 1800s, originally referred to an alcoholic drink taken upon arising to alleviate the effects of a hangover or to shake off early morning drowsiness.

> Others, who, fuddled last night, are limp in their lazy beds, till soda water lends them its fizzle. Eye-openers these of moderate caliber. (Theodore Winthrop, *John Brent*, 1861)

The term is also used to indicate a person who delivers some startling bit of news or offers some knowledge that leads to sudden enlightenment about a subject, or to the news itself.

> He felt his mission to be that of an agitator, of an eye opener, of a merciless yet undogmatic critic. (*Manchester Guardian*, August 31, 1928)

A related term, *pick-me-up*, is used to indicate a drink taken at any time during the day to give one a quick lift.

6. fast food Food, such as pizzas, hamburgers, hot dogs, fried chicken, etc., that is prepared and served with minimal delay. This expression has arisen since World War II from the growing

popularity of eating establishments that are designed to get food out to the public quickly and inexpensively. Originating in the United States, these *fast food* chains have expanded throughout the world, making the term common to most English-speaking countries.

> The fast food pollution [in Paris] isn't new, or—hedonist faithful pray—fatal. (Graham Greene, *New York*, July 8, 1974)

7. firewater Whiskey; hard liquor. This expression is a literal translation of the Algonquin Indian *scoutiouabou* 'liquor.' The reference, of course, is to the burning sensation caused by the ingestion of strong liquor and, since most liquor at that time was of the clear "moonshine" variety, its waterlike appearance. *Firewater* was commonly used in the pioneer and Wild West days, but is now mainly a humorous colloquialism.

> He informed me that they [the American Indians] called the whiskey fire water. (John Bradbury, *Travels in the Interior of America*, 1917)

8. a hair of the dog that bit you A cure identical to the cause of the malady; usually and specifically, another drink of the liquor that made you drunk or sick the previous night or caused your present hangover. The expression derives from the former belief that the only effective antidote for a mad dog's bite was its own hair, a belief based on the homeopathic principle *similia similibus curantur* 'likes are cured by likes.' The expression dates from at least 1546.

9. hooch Intoxicating liquor, especially cheap, homemade whiskey; moonshine. This term originally designated an alcoholic whiskey distilled by the Hoochinoo Indians of Alaska. The drink, which was sold illicitly, was known originally by the tribal name, *hoochinoo*, but by the end of the 19th century it had been shortened to *hooch*.

> Among the Indians of the extreme north . . . there is a liquor made which . . . is called hoochinoo. The

ingredients . . . are simple and innocent, being only yeast, flour, and either sugar or molasses. (Edward R. Emerson, *Beverages, Past and Present*)

By the Prohibition Era the name *hooch* had come to designate any (then) illegal beverage, and the expression remains in common use.

10. hush puppy A deep-fried ball of cornmeal dough, popular in the American South; a cornmeal fritter. The origin of this term is uncertain, but the most popular explanation ascribes it to hunters who would carry these fried cornmeal cakes in their pockets and throw them to their dogs when they wanted them to be quiet. Another version attributes it to the outdoor fish fries of the South which would attract neighborhood dogs. To stop their whining and barking, the cook would fry up some cornmeal dough and throw it to them, crying "Hush, puppies." The expression arose about 1900.

> Fishing parties, dances, hush-puppy suppers, and fish fries left the MGMers almost too pleasantly busy to proceed with their filming. (*New Orleans Time-Picayune Magazine*, May 15, 1949)

11. L. L. Whisky A high-quality whiskey. The initials *L. L.* stand for "Lord Lieutenant." Apparently, the Duke of Richmond, Lord Lieutenant from 1807 to 1813, requested that a cask of his favorite whiskey be preserved. The cask was labeled "L. L.," and since then, *L. L. Whisky* has referred to any whiskey of a comparable high quality.

12. Mary Jane cookies Cookies containing marijuana; any cookies with drugs as part of the recipe. The origin of Mary Jane cookies is unknown; however, a well-known recipe is that of Alice B. Toklas, the live-in confidante of Gertrude Stein in her Paris salon. The term *Mary Jane* is a literal translation of *marijuana*, derived from two Spanish

female names, *Maria* and *Juana*; why the weed received the name is unknown.

13. Mexican breakfast This modern expression alludes to smoking a cigarette and drinking a glass of water for one's breakfast, usually because one is hung over, broke, or too tired to eat. Why such a breakfast is to be considered Mexican is unclear. A related term is *secretary's breakfast* which consists of a cup of coffee and a cigarette, a time-saving practice of the modern-day office worker that allows more time for sleep.

14. Mickey Finn A drink to which a drug such as a narcotic, barbiturate, or purgative has been added, sometimes as a joke but usually with the intention of rendering an unsuspecting person unconscious or otherwise causing him discomfort; the drug itself; knockout drops, especially chloral hydrate. This eponymous term purportedly refers to a notorious underworld character who lived in Chicago in the 19th century. Although originally a nickname for a horse laxative, *Mickey Finn* has, since the 1930s, been expanded to include a much wider range of drugs used as adulterants. It is commonly shortened to *Mickey* and frequently appears in expressions such as *slip someone a Mickey [Finn]*.

> She had been about to suggest that the butler might slip into Adela's bedtime ovaltine what is known as a knockout drop or Mickey Finn. (P. G. Wodehouse, *Old Reliable*, 1951)

15. moonshine Illegally distilled liquor. This expression is derived from the clandestine nighttime manufacture of whiskey, an industry particularly widespread during Prohibition (1920–33). The phrase was figuratively used prior to that era, however, especially in reference to the homemade spirits of the Appalachian backwoods.

> The manufacture of illicit mountain whiskey—"moonshine"—was formerly, as it is now, a considerable source of income. (*Harper's Magazine*, June 1886)

16. mountain dew Liquor, particularly scotch whisky, that is illegally distilled; moonshine. This expression is derived from the illicit manufacture of spirits in stills that are concealed in the mountains.

> The distilled spirits industry . . . wages an expensive propaganda campaign against . . . mountain dew. (*The Times*, October 1970)

17. mountain oysters The testicles of sheep, calves, or hogs when used as food. This expression originated perhaps as an analogy to the shape of oysters.

> I have consumed mountain oysters and prairie dancers that are actually poetic. (E. Paul, *Springtime in Paris*, 1951)

18. nightcap A bedtime drink, usually alcoholic, consumed to help one sleep; a final drink of the evening. This expression has two suggested derivations, one of which alludes to the nightcap, a now obsolete article of sleepwear worn on the head. Since for many people two essential activities before retiring were donning a nightcap and downing an alcoholic drink as a soporific, the latter came by association to be also called a *nightcap*. Since the decline in the popularity of nightcaps as headgear, *nightcap* now refers almost exclusively to a drink. A second possibility is that *cap* is used in the sense of 'to complete or finish.' Thus, one caps off an evening's activities with a drink before retiring.

> I neither took, or cared to take, any wine with my dinner, and never wanted any description of "nightcap." (Thomas Trollope, *What I Remember*, 1887)

In recent years, however, *nightcap* has been expanded to include any prebed beverage—alcoholic or nonalcoholic—consumed to aid one's falling asleep.

> "Ovaltine" . . . The world's best "nightcap" to ensure sound, natural sleep. (*Daily Telegraph*, April 9, 1930)

19. nineteenth hole A bar or restaurant where players congregate for refreshments and relaxation after playing eighteen holes of golf. This slang expression developed sometime during the early 1900s as a nickname for the country club bar, and, during Prohibition in the United States, for the locker room. Today, at most country clubs, the *nineteenth hole* has become a rather elaborate restaurant and cocktail lounge combination, usually serving food and drink until quite late in the evening.

> He dug into his pocket for $10,000 in prize money, played more for the fun of it than in the hope of beating anybody, and helped entertain on the 19th hole. (*Time*, January 19, 1948)

20. pot likker Juice of ham or fatback after cooking with turnip or collard greens. This expression from the American South is a phonetic spelling of the words *pot liquor*. Often served with corn pone, *pot likker* was the subject of an ongoing controversy among Southern epicures during 1931. Some maintained the corn pone should be dunked in the broth; others maintained it should be crumbled. In a poll of the general public conducted by an Atlanta newspaper, it was determined that the crumblers were in the majority; however, most politicians were careful to say that they liked it either way.

> He always smelled slightly of turnip greens, as Miss Amelia rubbed him . . . with pot liquor to give him strength. (Carson McCullers, *The Ballad of the Sad Cafe*, 1951)

21. potluck See **239. MIXTURE.**

22. punk and plaster Bread and butter; bread and margarine. Originally coined by American hoboes to describe bread and butter, this term first appeared about 1880. It was extended to signify food in general by the 1910s.

> She gives you a slice of sow-belly an' a chunk of dry punk. (Jack London, *The Road*, 1907)

One variant, *punk and plaster John* refers, in hobo lingo, to a vagrant who specializes in begging bread and butter, thereby avoiding work. Such beggars, often also called *chronikers*, work the *punk and plaster route*, Pennsylvania Dutch farm country.

23. put out the miller's eye To add too much water to a recipe, especially one thickened with flour; to dilute anything, especially spirits, with an excess of water. One plausible theory for the origin of this phrase points out that *miller's eye* was an expression for lumps of flour not fully mixed into batter or dough. In certain recipes, leaving such lumps is considered desirable, but adding too much liquid to the batter can eliminate them, hence, *putting the miller's eyes out.* Whatever its exact origin, the term has been in use since about 1678.

> If after . . . putting out the miller's eye by too much water, you add flour to make it stiff. (Esther Copley, *Housekeeper's Guide*, 1834)

The term *drown the miller* has the same sense but alludes to the fact that old-fashioned millers, who frequently employed water-wheels for power, had little need for more water. It has also taken on an additional connotation 'to go bankrupt.'

24. red-eye Low-quality liquor; cheap, strong whiskey. This expression is plausibly derived from the alcohol-induced dilatation of blood vessels in the eye. The now infrequently used phrase usually referred to bootlegged whiskey during its Prohibition heyday.

> This fellow paid a thousand dollars for ten cases of red-eye that proved to be nothing but water. (Sinclair Lewis, *Babbitt*, 1922)

25. rotgut Low-quality liquor; bootlegged whiskey; red-eye. This expression is derived from the deleterious effects that such intoxicants have on one's insides. The phrase is widely used in Great Britain as well as in the United States.

It's the real stuff—pure Prohibition rot gut. (H. Allen Smith, *Putty Knife*, 1943)

26. rubber chicken This term is the derogatory expression used by politicians, athletes, and other public figures to describe the customary fare served at banquets around the country. For politicians on the campaign trail, evening meals become a series of banquets sponsored by local political committees. This *rubber chicken circuit* is also traveled by many famous athletes during the so-called off season. As the principal speakers at these dinners, they are often subjected to the same fare for weeks at a time and develop what is known as the *rubber chicken syndrome*. *Rubber chicken* and *rubber chicken circuit* have been in use since the 1960s; *rubber chicken syndrome* is a more recent phenomenon.

This incidence has resulted in the discovery of a mysterious illness that a leading sociologist has termed "The Rubber Chicken Syndrome." (*New Haven Journal-Courier*, February 9, 1982)

27. sneaky pete Cheap wine, usually laced with alcohol or with a narcotic. Although this phrase is of unknown origin, it may perhaps refer to the slowly creeping inebriation caused by such spirits. Today, the expression often refers specifically to cheap wine.

. . . A pint of forty-cent wine known under the generic title of "Sneaky Pete." (*Commonwealth*, December 1952)

28. SOS Creamed chipped beef on toast; any sloppy, runny meat dish served over toast. A military slang term since the early 1900s, this expression has been adopted into the common vocabulary, probably through the agency of the large number of men who were in military service during World War II and brought the term home with them. Creamed chipped beef (dried beef served in a cream sauce and poured over

a piece of toast) was such a common, and apparently detestable, part of the military diet that it became known as *shit on a shingle*, abbreviated to *SOS*.

29. square meal A hearty, satisfying, stick-to-the-ribs type of repast. This American expression, in common use since the late 19th century, probably alludes to the sense of *square* 'honest, above-board'; hence, an honest and full meal.

I want . . . three square meals a day for which I'm willing to pay. (*Duluth News-Tribune*, January 19, 1947)

30. three-martini lunch A lunch with cocktails, purportedly for business purposes and hence used as a tax write-off. According to William Safire in *Safire's Political Dictionary* (1978), Senator George McGovern of South Dakota popularized this term during his 1972 presidential campaign. In his attack on the government's concessions to big business, the senator pointed to expensive entertainment as an example of unnecessary business deductions made at the expense of the taxpayers. Later, the Carter administration also exploited the term in attacking business practices that skirted the tax laws.

Other reforms that the President proposed would further restrict certain tax shelters for well-off people . . . and cut in half permitted deductions for business meals—an attack on the by now fabled three-martini lunch. (*Time*, January 30, 1978)

31. tiger's milk British slang for gin; also sometimes for whisky or for brandy and water. This term, apparently originally army slang, appeared as an entry in George R. Gleig's *The Subaltern's Log-Book*, published in 1828.

32. torpedo juice Homemade alcoholic beverages of the lowest quality. This expression originated during World War II, when soldiers who desperately craved intoxication developed makeshift bever-

ages to substitute for the unavailable quality whiskey. The expression itself arose from the grain alcohol drained from torpedos, although alcohol was also extracted from fuel, hair tonics, and medications. Usually, this alcohol was combined with fruit juice, resulting in a somewhat palatable concoction.

Foolishness . . .
See 145. FATUOUSNESS

Forbearance . . . See 264. PATIENCE

Force . . . See 50. COERCION

Forcefulness . . . See 112. EFFEC-
TIVENESS; 214. INTENSITY

Fortitude . . . See 37. BRAVERY

Fortune . . . See 93. DESTINY;
163. GOOD LUCK

Fragility . . . See 151. FLIMSINESS

Frankness . . . See 43. CANDIDNESS

Fraud . . . See 370. SWINDLING

154. FREEDOM

1. bra burner A militant feminist; a *women's libber*; one who is willing to fight for women's rights. Like their predecessors, the *suffragettes*, the women of today who fight for equal rights have become the target of a number of derogatory terms coined by men and women alike. One of these, *bra burner*, is derived from the practice of certain women who, early in the movement, burned their brassieres publicly to symbolize their rejection of the restrictions of traditional society in regard to women.

The media decided to henceforth label feminists as 'braburners' — a term that made the movement pretty darn mad. (*Esquire*, July 1973)

2. carte blanche Full discretionary power, unrestricted freedom, blanket permission; a blank check; literally, white paper or chart. In its original military usage, the term referred to the blank form used to indicate unconditional surrender, on which the victor could dictate his own terms. The phrase is now used only figuratively, and has been so used for some time:

Mr. Pitt, who had carte blanche given him, named every one of them. (Lord Chesterfield, *Letters*, 1766)

The figuratively synonymous *blank check* refers literally to an executed check on which the amount is left unspecified to be filled in by its bearer or receiver.

3. the coast is clear Nothing stands in the way of one's progress or activity; there is little danger that anyone in authority will witness or interfere with one's actions; "Go ahead, nobody's looking." This expression was originally used by smugglers to indicate that no coast guard was in the vicinity to prevent their landing or embarking. Its use is still largely limited to contexts implying wrongdoing, though such may range from mischievous misbehavior to criminal activity.

4. footloose and fancy free Without restriction or commitment; carefree; untrammeled; without any attachments to one of the opposite sex. This expression is a simple alliterative combination of *footloose*, 'unfettered,' with *fancy free*, 'without any romantic commitment at the moment,' to indicate absolute absence of any emotional attachments. The term has been in use since at least the early 20th century.

5. give a wide berth to To allow latitude, leeway, or freedom; to shun, to stay clear of; to remain a discreet distance from. Dating from the 17th century, *berth* is a nautical term which refers to a sufficient amount of space for a ship at anchor to swing freely, or enough distance for a ship under sail to avoid other

ships, rocks, the shore, etc. *Give* or *keep a wide berth* gained currency in the 1800s and has since been used in nautical and nonnautical contexts.

> I recommend you to keep a wide berth of me, sir. (William Makepeace Thackeray, *The Newcomes*, 1854)

6. give enough rope To give someone a considerable amount of freedom with the expectation that he will act in an embarrassing or self-destructive way; to grant just enough leeway that a person may set and fall into his own trap. This expression has been in use since the 17th century and is equally familiar in the longer version—*give [someone] enough rope and [he'll] hang himself.* A rope is often used as a leash or rein to control freedom of movement. Perhaps this expression derives from the fact that it is easy to trip or become entangled by too much rope. The second half of the expression plays on the idea of a rope as a cord for hanging a person.

> Give our Commentator but Rope, and he hangs himself. (Elkanah Settle, *Reflections on Several of Mr. Dryden's Plays*, 1687)

7. no strings attached No stipulations or restrictions; no fine print. This common expression, perhaps an allusion to puppets that are controlled by strings, implies the lack of catches or hidden conditions in an undertaking or purchase. The phrase may be varied to assume its opposite sense.

> The corporation . . . made its offer to California—an offer good for six months only, and having several untenable strings attached. (*Sierra Club Bulletin*, January 1949)

155. FRENZIEDNESS
See also 103. DISORDER;
218. IRRATIONALITY

1. get [one's] knickers in a twist To be upset; to make a fuss, especially unnecessarily. This Briticism, especially when heard in the phrase *Don't get your knickers in a twist,* is a common way to caution a friend not to get excited about some mundane situation. The key word here is *knickers,* which in Britain is synonymous with *panties* in America. The expression can also be used to indicate to a friend that he is getting his ideas confused.

2. go ape Behave in a wild, irresponsible manner; go into a frenzy; feel a strong attachment to another person or to a thing. This expression, coined during World War II, is an allusion to the panicky action of apes and other wild animals when placed in captivity. Darting about the cage in a wild frenzy, they mark up the area with their feces, which accounts for the original form of the expression, *go ape shit.* A modification of the original meaning took place during the 1960s, and the phrase was toned down to mean a strong liking or attachment for a person or an object.

> . . . people are quietly going ape over the girl, Modesty Blaise. (*Cosmopolitan*, November 1965)

3. have kittens To give vent to one's emotions—anger, fear, excitement, surprise, etc.; to flip one's lid, to blow one's top or stack. This U.S. slang expression dates from the turn of the century. Why *kittens* rather than *pups* or any other animal is not apparent.

> My doctor nearly had kittens when I suggested my being dropped to the *maquis* by parachute. (W. Plomer, *Museum Pieces*, 1952)

4. in a flap In a dither, all hot and bothered; excited, agitated. This primarily British expression was coined by analogy with the flapping and fluttering of birds when disturbed.

> Now don't go and get into a flap or anything, Mother, but Joan's broken her arm. (*Punch*, August 1939)

In the 1920s, *flap* saw navy use as a term for a high-pressure emergency; in air force parlance it denoted an air raid.

5. in a lather Highly agitated; greatly upset or excited; in a frenzy; angry; hot and bothered. This expression, dating from the early 17th century, is derived from the condition of a horse that is overheated, usually because it has worked hard and long. Perspiration appears on its hide in the form of a white foam, thus creating the image of having worked itself *into a lather*. Through the years the phrase has added many connotations, so that today *in a lather* may signify anything from simply worried to thoroughly agitated.

> This business of you being in a lather about it. (John Evans, *Halo in Blood*, 1946)

6. like a chicken with its head cut off Frenzied, frantic, harried; disoriented, disorganized; driven, moving erratically from one spot to another or from one task to another with no sense of order, direction, or control. This common simile, often part of the longer *running around like a chicken with its head cut off*, describes the behavior of one at an extreme emotional pitch—but the emotion engendering the behavior may vary from eager anticipation to raging anger to acute anxiety. The image derives from the fact that a decapitated chicken often continues to flutter his wings and flap about wildly for several seconds before succumbing to the fatal blow that has been dealt.

7. rat race Frenzied but unproductive activity; ceaseless and unrewarding struggle to get ahead; meaningless endeavor engaged in at a frenetic pace. The image of laboratory rats on a treadmill gave rise to this expression. The comparison of men to rodents also underscores the nastiness and viciousness that can erupt in competitive situations. *Webster's Third* cites Frances G. Patton:

> Life was a rat race . . . no time for gracious living or warm family feeling.

8. run amuck To run about in a frenzy attacking everyone one meets; crazed with homicidal mania; to rush headlong; to enter a fray heedless of one's safety. This expression, its source in the Malayan word *amoq*, was originally used to describe a nervous malady of the Malays, which caused the victim to rush about in a murderous frenzy attacking everyone he met. According to the *OED*, the term was first brought to Europe by the Portuguese, and appears in the writings of Barbosa as early as 1516 as *amuco*. It didn't come into use in English until the latter half of the 17th century. The second word in the expression is also spelled *amock, amok,* and *amoke*.

> Like a raging Indian . . . he runs a mucke (as they call it there) stabbing every man he meets. (Andrew Marvell, *The Rehearsal Transposed*, 1672)

Today the term is most often heard in its figurative sense, 'to act wildly or heedlessly.'

9. St. Vitus's dance Uncontrollable convulsive movements; maniacal dancing; restlessness; the jitters or fidgets. St. Vitus, a martyred Sicilian youth, had no known connection with dancing during his lifetime. In 16th-century Germany, somehow people came to believe that if one danced before the statue of St. Vitus on June 15th, his feast day, that good health would follow them the entire year. The dancing became almost a mania and by some means was confused with chorea, a convulsive nervous disorder, which became known as *St. Vitus's dance*. Although the confusion has been mostly eliminated and the term is seldom applied medically today, it is still encountered in its figurative connotation.

> Coleridge's mind is in a perpetual St. Vitus' dance—eternal activity without action. (H. D. Traill, *Coleridge*, 1804)

Frequency . . . See 110. DURATION; 380. TIME

Friendliness . . .
See 71. CORDIALITY

156. FRIENDSHIP
See also 71. CORDIALITY; 229. LOVE

1. bosom buddy A confidant; an intimate friend. This expression is an armed forces version of the old term *bosom friend*.

There is nothing better than a bosom friend with whom to confer. (Robert Greene, *Never Too Late*, 1590)

The inference here is that one cherishes in his bosom a person for whom he feels a special friendship, one with whom he can share his innermost secrets. During World War II the term *bosom buddy* became especially popular, apparently because of the common use of *buddy* as the armed services synonym for *pal*. Other common synonyms are *bosom chum* and *old buddy*.

2. close as the bark to the tree Intimate, close; interdependent, symbiotically related, mutually sustaining. The phrase is used particularly of the closeness between husbands and wives. Though occasionally used to indicate physical proximity, the expression usually carries implications that such is indicative of a spiritual or psychological intimacy or dependency.

She would stick as close to Abbot as the bark stuck to the tree. (Cotton Mather, *The Wonders of the Invisible World*, 1692)

The "bark and the tree" as symbolic of "husband and wife" was in print as early as the mid-16th century. The analogy assumes that spouses interrelate in the interdependent, mutually nourishing patterns characteristic of the relationship between a tree and its bark. See also **go between the bark and the tree**, 235. MEDDLESOMENESS.

3. eat [someone's] salt To share someone's food and drink, to partake of someone's hospitality. Among the ancient Greeks to eat another's salt was to create a sacred bond of friendship between host and guest. No one who had eaten another's salt would say anything against him or do him any harm. *Salt*, as it is used in this phrase, symbolizes hospitality, probably because it once was of considerable value. (Cf. the etymology of *salary*.) The first *OED* citation given for this expression is dated 1382.

4. good ole boy A friend; a familiar term of address, sometimes used disdainfully. This term, which dates from about 1890, has undergone a new surge of popularity since the advent of CB radios. Originally slang of the southern United States, in recent years the expression has spread throughout North America. A variant is *good buddy*, most commonly used as a form of direct address.

. . . it gives women's rights advocates something to cheer about, and it gives good ole boys something to cry in their beer about. (*New York Daily News*, November 22, 1981)

5. hand in glove See 66. CONSPIRACY.

6. hobnob To be chummy, familiar, or intimate with; also, *hob and nob*. This expression originated as *hab-nab* 'have or have not,' 'give or take.' Shakespeare employed this early sense in *Twelfth Night*:

He is a devil in private brawl
Hob, nob, is his word, give't or take't. (III,iv)

The 'give or take' sense of this expression was subsequently extended to include the exchange of toasts as a sign of comradeship. Consequently, the phrase evolved its contemporary figurative meaning of being on friendly or familiar terms.

It cannot be her interest to hob and nob with Lord Fitzwilliam. (Lady Granville, *Letters*, 1828)

7. the mahogany The dining room table, as symbolic of sociability, conviviality, friendship, conversation, etc. This popular 19th-century British colloquial term usually appeared in phrases such as *around the mahogany, over the mahogany,* or *with one's feet under the mahogany.*

I had hoped . . . to see you three gentlemen . . . with your legs under the mahogany in my humble parlour. (Charles Dickens, *Master Humphrey's Clock,* 1840)

Currently *mahogany* is a colloquial term for a bar.

From the moment Mr. Primrose appeared behind his own mahogany and superseded the barmaid, he dominated everything. (N. Collins, *Trinity Town,* 1936)

8. on a good footing with [someone] Have a friendly understanding with another; to be in a position to ask another for favors; to be in good standing. This expression has been attributed to a borrowing of the French, *Être sur un grand pied dans le monde,* which translates freely as 'to have a large foot in society.' However, a more credible explanation attributes it to a friendship or understanding as resting on a solid foundation, i.e., *on a good footing.*

The phrase has been in figurative use since the mid 18th century.

9. rub shoulders To mingle or socialize; to hobnob. This expression is derived from the bumping and grazing of bodies against each other at social gatherings. The phrase quite often describes the mingling of persons of diverse background and social status at cocktail parties, political gatherings, and the like.

10. stand sam Pay for the drinks; pay the reckoning. This expression, of uncertain origin, has been explained as an allusion to the *U.S.* on the knapsacks of American soldiers, as if a reminder to imbibing troops that *Uncle Sam* is *standing* for the drinks. A more likely ex-

planation lies in an early, now obsolete, definition of *sam,* 'to bring together in friendship.' One who bought a round of drinks was attempting to bring all the patrons together in conviviality.

I must insist upon standing Sam upon the present occasion. (William Ainsworth, *Rookwood,* 1834)

A related term, *Nunky pays for all* probably has some basis in fact in the explanation above, *Nunky,* a playful variant of *uncle,* being a frequent reference to *Uncle Sam.*

11. thick as thieves Intimate, familiar, friendly; close, tight. This expression is thought to derive from the notion that thieves must often cooperate closely to accomplish their aims. The *OED* dates the expression from the early 1800s. The English expression may well owe its existence to the French proverb *ils s'entendent comme larrons en foire* 'as thick as thieves at a fair,' where *thick* means 'crowded, densely arranged.' When *at a fair was dropped* from the expression, the figurative jump to *thick* 'close, intimate' occurred; Theodore Hook used the truncated form in *The Parson's Daughter* (1833):

She and my wife are as thick as thieves, as the proverb goes.

Pickpockets, cutpurses, and their kind frequented fairs and other large gatherings where the prospects of gain and escape were both high.

Fulfillment . . .
See 6. ACCOMPLISHMENT

157. FUNDAMENTALS

1. consider the lilies Be aware of simple, natural beauty; do not be attracted by showy, material things; enjoy that which is God-given. This expression is a direct quotation from Jesus' Sermon on the Mount.

And why take ye thought for raiment? Consider the lilies of the field, how they grow; they toil not, neither do

they spin: And yet I say unto you,
That even Solomon in all his glory
was not arrayed like one of these.
(Matthew 6:28)

Although the expression is still current, it is more frequently heard today in a cynical tone.

He considers the lilies, the rewards,
There is no substitute for a rich man.
(Geoffrey Hill, *To the (Supposed) Patron*, 1962)

2. down to bedrock Down to basics or fundamentals; down to the essentials. Bedrock is literally a hard, solid layer of rock underlying the upper strata of soil or other rock. Thus, by extension, it is any foundation or basis. Used literally as early as 1850 in Nelson Kingsley's *Diary*, the phrase appeared in its figurative sense by 1869 in *Our New West* by Samuel Bowles.

3. get down to brass tacks To get down to business; to get down to the essential or fundamental issues. Although the precise origin is unknown, this expression is said to have been originally a nautical phrase referring to the brass nails exposed during the cleaning of the decks on early sailing ships. The phrase appeared as early as 1897 in *Liars* by H. A. Jones.

4. meat-and-potatoes Basic, fundamental, essential, main; devoid of fancy trimming or elaboration. Meat and potatoes have long been the basic ingredients of a traditional hearty meal.

It's the meat-and-potatoes appeal—
the old pull at the heartstrings—
that'll put us over at the box office.
(S. J. Perelman, *Listen to the Mocking Bird*, 1949)

5. nitty-gritty The heart of a matter. This American slang term first appeared in 1963 as part of the Black militant slogan *get down to the nitty-gritty*.

The Negroes present would know perfectly well that the nitty-gritty of a situation is the essentials of it. (*Time*, August 1963)

The phrase is conjectured to be an oblique reference to the small hard-to-remove nits or lice that are often found attached to the hair and scalp of poor ghetto-dwellers because of unclean living conditions.

6. nuts and bolts Basics, brass tacks, the nitty-gritty, the heart of the matter. Nuts and bolts are essential parts of virtually any machine, but they have to do with the mechanics of structure, not with the theory or principle of operation. The expression is used in reference to the basic mechanics of anything in contrast to any art or other talent required to make it function. Apparently of fairly recent coinage, it dates from at least 1960.

His preference was for journalism. He learnt the nuts and bolts of his profession with the Montreal *Gazette*. (*The Times*, June 1971)

Funniness . . .
See 174. HUMOROUSNESS

Furtiveness . . . See 332. SECRECY

158. FURY
See also 21. ANGER; 182. ILL TEMPER; 223. IRRITATION; 394. VEXATION

1. bite [someone's] head off To answer curtly or sharply out of anger or annoyance, to snap at in reply; also *to bite* or *snap [someone's] nose off*. Although the nose was apparently the original object of the biting or snapping in this expression (predating *head* by nearly three centuries) *head* is more commonly heard today.

I . . . ask'd him if he was at leisure for his chocolate, . . . but he snap'd my nose off; no, I shall be busy here these two hours. (Susanna Centlivre, *The Busybody*, 1709)

2. blow a fuse To lose one's temper; to become angry or violent; to respond emotionally and dramatically. These fig-

urative meanings of *blow a fuse* allude to the fact that a fuse will blow if there is an overload on an electrical circuit. By the same token, a person can only stand so much before "reaching the breaking point" and "blowing up."

> Relax . . . or you'll blow a fuse. (S. J. Perelman, *Listen to the Mocking Bird*, 1949)

3. blow a gasket To lose one's temper. A gasket is used as a seal between parts in a machine that operate under extreme pressure. When the gasket can no longer contain the pressure, it bursts, and the contents spurt out. So too, when life is not running smoothly and patience has worn thin, the result is often uncontrollable, angry outbursts.

4. blow off steam To discharge suppressed feelings, especially resentment; to release tension by loud talking or shouting. This phrase alludes to actual steam engines, boilers, etc., which allow pressure to build up to a certain point, after which it is released forcibly and noisily. Figurative use of the phrase dates from the early 19th century.

> The widow . . . sat . . . fuming and blowing off her steam. (Frederick Marryat, *The Dog-Fiend*, 1837)

5. blow [one's] stack To be unable to contain oneself; to lose control. As a smokestack discharges smoke and soot, a fired-up person gives vent to angry, resentful words.

6. blow [one's] top To lose control; to fly off the handle; to be unable to contain oneself; also *blow one's lid*. This slang phrase plays on an analogy comparing the top of one's head to a lid. When a container is about to burst because of the internal pressure, the lid will fly off to allow the pressure to escape. Similarly, when one can no longer bear the pressure of intense emotions building up, one "loses one's head."

> He blew his top and lost his job and came bellyaching to Loraine. (John Steinbeck, *The Wayward Bus*, 1947)

7. carpet biter A very angry man; one subject to fearful rages; a person who exhibits uncontrollable fury. There are numerous accounts in history of actual carpet biting among the violent-tempered. A number of the Angevins were noted for doing this when they were in uncontrollable rages, but perhaps the most famous carpet biter, and one of the most recent, was Adolph Hitler.

8. conniption fit A tantrum; a fit of hysteria; a sudden outburst of anger, a burst of fury or other violent emotion. This American colloquialism was, according to H. L. Mencken, a pure case of American inventiveness. Research indicates that this phrase, in use since the early 19th century, had no roots in any other word, and is probably a purely fanciful creation. However, the *English Dialect Dictionary* suggests that the word might have its roots in *canapshus*, a slang term meaning 'ill-tempered, captious,' and *Dialect Notes* suggests *catnip fit* as its source.

> By golly, it was enough to drive any human critter into a conniption fit. (Jonathan Slick, *High Life in New York*, 1844)

9. duck-fit An outburst or fit of anger, a conniption fit. This American slang term, in use since at least 1900, is probably an allusion to the loud quacking of an angry duck.

10. fly off the handle To become furious, often suddenly and without warning; to lose self-control. The tendency of an ax blade to fly off its handle when forcefully struck against an object is the apparent origin of this expression. The current use of the phrase is almost exclusively in reference to loss of temper.

> He reckoned you would . . . get good and mad, fly off the handle . . . (C. E. Mulford, *Orphan*, 1908)

11. hit the ceiling To be enraged, agitated, or violently angry; to lose one's temper, to blow one's top. This slang expression dates from the early 1900s. Cur-

rently, *hit the roof* is a frequently employed variant.

> Larry hit the ceiling and said he *had* to come along, that he'd spoil everything if he didn't. (E. Dundy, *Dud Avocado*, 1958)

12. raise the roof To be exceedingly loud or boisterous; to create a noisy disturbance, especially in registering a protest; to complain bitterly. This American phrase is simply a hyberbolic expression to indicate the great extent of a person's disturbance, creating noise that reaches such a pitch that it could raise the roof right off a building.

13. see red To be extremely angry; to be furious; to be so angry that self-restraint disappears. Allusion to the fury of a bull aroused by a matador's red cape is the probable origin of this expression. However, there is the contention that in an extreme fury the blood vessels in the eye dilate, thereby causing the individual actually to see red, or, at least, look as if he should.

> It maddened me, I think, and I saw red—and before I knew what I was doing I stabbed him. (*Daily Mail*, June 19, 1923)

14. slow burn Gradual intensification of anger; escalation from a low level of displeasure to a high pitch of rage. This originally U.S. colloquial phrase dates from the early 1900s. Wentworth and Flexner (*Dictionary of American Slang*) attribute the phrase to the 1930s comedian Leon Erroll who was apparently well known for his facial expression of that name. *Slow burn* referred to the gradual reddening of his face as he took on the image of an enraged man.

> His slow burn at a Minnesota prof's constant use of the name when he was a student. . . . (*New Yorker*, March 3, 1951)

This phrase is often heard in the longer expression *do a slow burn*.

159. FUTILITY
See also
203. INEFFECTUALITY

1. bark at the moon To labor or protest in vain; to choose an ineffectual means to achieve a desired end, or to attempt the impossible, thereby making any effort futile by definition; also often *bay at the moon*. The phrase refers to the common practice of dogs to bay at the moon, as if to frighten or provoke it. Connotations of the foolishness of barking at the moon, based on the disparity between the earthly dog and the mystical moon, are carried over into the figurative usage, as if to imply that barking at the moon is like beating one's head against the wall.

2. beat [one's] head against the wall To attempt an impossible task to one's own detriment; to vainly oppose an unyielding force; also *to hit, knock,* or *bang one's head against the wall*, often *a stone wall*. The allusion is to the futility and frustration occasioning such an action and the resulting harm.

3. beat the air To strike out at nothing, to labor or talk idly or to no purpose; to shadowbox. The phrase may well derive directly from the last definition, as suggested by its use in the King James Version of the New Testament:

> I therefore so run, not as uncertainly; so fight I, not as one that beateth the air. (I Corinthians 9:26)

4. the blind leading the blind Ignorance on the part of both leaders and followers; lack of guidance and direction resulting in certain failure; futility. The phrase is of Biblical origin. Speaking of the Pharisees, Jesus says:

> They be blind leaders of the blind. And if the blind lead the blind, both shall fall into the ditch. (Matthew 15:14)

The expression is also the title of a famous painting by Pieter Breughel the Elder (1568).

5. bore four holes in the blue This expression, used to describe a useless mission or purposeless flight, had its inception during World War II. The allusion is to the four engines of a large aircraft accomplishing nothing better than "boring four holes in the sky."

> My navigator got lost, and there we were boring four holes in the blue. (*American Speech*, October 1956)

6. cast stones against the wind To labor in vain; to work without accomplishing anything.

> I see I swim against the stream, I kick against a goad, I cast a stone against the wind. (Grange, *Golden Aphrodite*, 1577)

7. cry for the moon To desire the unattainable or the impossible, to want what is wholly beyond one's reach; also *to ask* or *wish for the moon*. Although some sources conjecture that this expression comes from children crying for the moon to play with, that theory seems a bit forced. The moon has long typified a place impossible to reach or object impossible to obtain, and was so used by Shakespeare in *Henry VI, Part II* (1593):

> And dogged York, that reaches at the moon,
> Whose overweening arm I have plucked back.
> (III,i)

A similar French expression is *vouloir prendre la lune avec les dents* 'to want to take the moon between one's teeth.'

8. Dame Partington and her mop See 65. CONSERVATISM.

9. flog a dead horse To attempt to rekindle interest in a wornout topic, flagging discussion, doomed or defeated legislation, or other matter; to engage in futile activity. The figurative use of this expression is closely related to the literal, i.e., it is useless to attempt to revive or stimulate something that is dead.

> In parliament he again pressed the necessity of reducing expenditure.

Friends warned him that he was flogging a dead horse. (John Morley, *The Life of Richard Cobden*, 1881)

A variation is *beat* or *whip a dead horse*.

10. from pillar to post See 203. INEFFECTUALITY.

11. hog shearing An action which results in a great cry and little wool; something involving much labor and small reward, many words and little sense. The original proverb from the Middle Ages *great cry and little wool as the devil said when he sheared the hogs* alludes to the medieval mystery play, *David and Abigail*. Nabal, Abigail's first husband, is presented as shearing his sheep; the devil is seen beside him, imitating him, but shearing a hog which is making great squealing noises.

> Thou wilt at best but suck a bull,
> Or shear swine, all cry and no wool.
> (Samuel Butler, *Hudibras*, 1663)

12. Kafkaesque Resembling the world created in the writings of Franz Kafka, where man is overwhelmed by bureaucratic red tape or vanquished by an overpowering faceless authority; nightmarish; weird; frightening. This eponym was derived from the name of the eminent Czech novelist of the early 1900s. In Kafka's novels, *The Trial, The Castle*, and *Amerika*, as well as in the majority of his many short stories, man finds himself in a hopeless situation confronting the edicts of an authority which he cannot contact, or is faced with bureaucratic regulations which he can not fathom.

> Thanks to M. Blanchot there is now a "Kafkaesque" stereotype of the fantastic, just as there is a stereotype of haunted castles and stuffed monsters. (Jean-Paul Sartre, "Aminadab," *Literary Essays*, 1957)

13. kick against the pricks See 302. REBELLIOUSNESS.

14. make bricks without straw To try to accomplish a task without the proper

materials or essential ingredients. The current sense of this expression is traced to a misinterpretation of the Biblical story (Exodus 5:6–19) from which it comes. The Israelites were not ordered to make bricks without straw at all, as is popularly believed. Rather, they were told that straw for the sun-dried mud-and-straw bricks they were required to make would no longer be provided for them, and that they would have to go out and gather it themselves. Making bricks without straw would be an impossible task since straw was the essential element in holding the sun-dried mud bricks together. Use of the expression dates from the mid 17th century.

> It is often good for us to have to make bricks without straw. (Sir Leslie Stephen, *Hours in a Library*, 1874)

15. many words will not fill a bushel Words without actions are worthless; words don't fill one's stomach; promises don't feed the poor. This 17th-century expression indicates the practical need for solid foodstuffs, not mere words, to fill a bushel basket; hence, substance is necessary in any undertaking.

> For the more compliment, the less sincerity. Many words will not fill a bushel. (John Bunyan, *Christ, a Complete Saviour*, 1692)

16. milk the ram To engage in an activity destined to fail, to try in vain to do something which cannot be done; also *to milk the bull*. A ram is a male sheep and a bull is a male bovine. The old proverb "Whilst the one milks the ram, the other holds under the sieve" probably spawned this phrase; it appeared in *Several Tracts* by John Hales in 1656.

17. a nod is as good as a wink to a blind horse An obsolete proverb of obvious, explicit literal meaning. Figuratively, this expression implies that regardless of how obvious a hint or suggestion may seem, it is useless if the person to whom it is directed cannot be aware of it. Thus, subtlety and tact can, at times, be inappropriate, particularly when dealing with a person known for his obtuseness. It is likely that this adage had been current for several centuries before its earliest literary usage in 1794 by William Godwin in *The Adventures of Caleb Williams*.

18. oppose Preston and his mastiffs To be reckless or brash; to engage an overpowering force. This British term can be traced directly to one Christopher Preston, an entrepreneur of the late 17th century. Establishing a bear garden at Hockley-in-the-Hole, a place of questionable reputation, Preston used a small pack of mastiffs to protect himself and his place of business. It soon became apparent to the customers that it was futile to oppose Preston's orders because of his dogs. However, the dogs did him no good in the end, for he was mauled to death by one of his bears in 1700.

> . . . I'd as good oppose Myself to Preston and his mastiffs loose. (John Oldham, *Satire of Juvenal*, 1683)

19. pile Pelion upon Ossa See 127. EXACERBATION.

20. plow the sands To engage in fruitless or futile labor, to waste one's time trying to do an impossible or endless task.

> All our time, all our labour, and all our assiduity is as certain to be thrown away as if you were to plough the sands of the seashore, the moment that the Bill reaches the Upper Chamber. (Herbert Henry Asquith, *Speech at Birmingham*, 1894)

In *Richard II* (II,ii) Shakespeare used a similar expression with the same meaning:

> Alas, poor Duke! The task he undertakes
> Is numbering sands and drinking oceans dry.

21. put a rope to the eye of a needle To attempt the impossible. The metaphor is obvious.

22. roast snow in a furnace To pursue ludicrous or meaningless activities; to engage in futile, pointless tasks. The figurative implications of this expression are obvious.

23. seek a knot in a bulrush See 245. NIT-PICKING.

24. shoe the goose To engage in aimless, trivial, unnecessary, or futile activities; to do busy work; to waste time. As this expression implies, putting shoes on a goose is as ludicrous and pointless as it is futile.

Yet I can do something else than shoe the goose for my living. (Nicholas Breton, *Grinello's Fort*, 1604)

25. sleeveless errand Any aimless or futile activity; an endeavor that is sure to be unprofitable or unsuccessful. In this expression, *sleeveless* is probably derived from *sleave* 'knotted threads' such as on the ends of woven fabrics, implying that the task or errand has loose ends which are not tied together in any significant or worthwhile manner. Most popular in the 16th and 17th centuries, *sleeveless errand* commonly referred to a false mission or other bogus activity which would keep a person occupied, and therefore out of the way, for a period of time. Variations such as *sleeveless words*, *sleeveless reason*, etc., have appeared in works by Chaucer, Shakespeare, Milton, and others.

He was employ'd by Pope Alexander the third upon a sleeveless errand to convert the Sultan of Iconium. (Myles Davies, *Athenae Britannicae*, 1716)

26. square the circle To engage in a futile endeavor; to undertake an impossible task. Early mathematicians struggled to find a circle and a square with equal areas. This is an impossibility since a principal factor in the area formula for a circle is π (3.1416 . . .), an irrational number, whereas the factors in the area formula for a square are always rational numbers. The expression can now be applied to the attempting of any impossibility.

You may as soon square the circle, as reduce the several Branches . . . under one single Head. (Thomas Brown, *Fresny's Amusements*, 1704)

27. throw straws against the wind To vainly resist the inevitable, to sweep back the Atlantic with a broom. A similar expression appeared in John Taylor's *Shilling* (1622):

Like throwing feathers 'gainst the wind.

Both straw and feathers are very light and no match for the force of the wind.

28. wash a brick To work in vain, to engage in utterly useless or futile labor, to plow the sands.

I wish I could make him feel as he ought, but one may as well wash a brick. (Warner in John Heneage Jesse's *George Selwyn and his Comtemporaries*, 1779)

Rarely heard today, this self-evident expression is the English equivalent of the old Latin proverb *laterem lavare*.

29. wild-goose chase An impractical and ill-advised search for something nonexistent or unobtainable; a foolish and useless quest; a futile or hopeless enterprise. Originally, a wild-goose chase was a horse race where the second and all succeeding horses had to follow the leader at definite intervals, thus resembling wild geese in flight. Since the second horse was not allowed to overtake the first, it would become exhausted in its futile chase. It has alternately been suggested that *wild-goose chase* may refer to the difficulty of capturing a wild goose, implying that even if caught, the prize is of little value.

"I see you have found nothing," exclaimed Lady Gethin. . . . "It was a wild goose chase," he replied with a weary look. (Mrs. Alexander, *At Bay*, 1885)

G

Gamble . . . See 328. RISK

Generosity . . .
 See 48. CHARITABLENESS

160. GENUINENESS

1. all wool and a yard wide Genuine, authentic, bona fide; sincere, trustworthy, straightforward. Apparently the term was an early sales pitch used by yard goods merchants confronted with wary buyers. The earliest known print citation applying the phrase figuratively is from George W. Peck:

> You want to pick out (as the "boss combination girl" of Rock Co.) a thoroughbred, that is, all wool, a yard wide. (*Peck's Sunshine*, 1882)

2. hallmark A mark or stamp of superior quality or genuineness; a distinctive characteristic or feature, a trademark. The term takes its name from Goldsmiths' Hall in London where Goldsmiths' Company stamped its gold and silver pieces with an official plate mark indicating their grade of purity. Eventually the literal meaning of *hallmark* 'a symbol of the standard of quality of precious metals' became generalized so that it now represents any mark of excellence or distinguishing characteristic. Literal use of the term dates from the early 18th century while figurative use dates from the latter half of the 19th century.

3. in character True to one's nature; in accord with one's usual actions; befitting one's personality and customary behavior; appropriate; befitting. This expression, the antithesis of *out of character*, is derived from the idea that each of us has an established behavior pattern, which is more or less predictable. When a person says or does something that is com-

pletely consistent with what is expected of him, he is said to be *in character*. The *OED* lists the earliest written example as:

> That would be in character, I should think. (Philip Sheridan, *School for Scandal*, 1777)

4. the real McCoy Genuine, authentic; unadulterated, uncut; hence, excellent, of superior quality. Numerous attempts to account for the term's origin testify to the failure of any to be convincing. Among the more popular are those relating the phrase to a boxer, Kid McCoy, a former welterweight champion (1898–1900). These vary from simple transference by association (the champion is "the best," superior) to the hypothetical existence of a lesser pugilist with the same surname; two clearly apocryphal anecdotes concerning Kid McCoy's barroom exploits. It does seem certain, however, that this American colloquialism did come into usage shortly after his championship fame, and that it gained frequency during Prohibition when it described genuine, uncut whiskey. Stuart Berg Flexner (*I Hear America Talking*) conjectures the existence of a McCoy brand, since *the clear McCoy* was in use by 1908 to describe good whiskey. *The real McCoy* remains one of our most popular and puzzling picturesque phrases. During the strike of bagel bakers in December, 1951, a *New York Times* article said:

> Toasted seeded rolls, Bialystok rolls . . . and egg bagels, a sweeter variety but not the real McCoy, were being thrown into the bagel void with varying degrees of reception.

5. simon-pure Real, veritable, authentic; as a noun, the genuine article. In Susannah Centlivre's comedic play, *A Bold*

Strike For a Wife (1718), Simon Pure was a Quaker who was temporarily impersonated by Colonel Feignwell. When Feignwell had won the hand of Miss Lovely, Simon returned and, after much difficulty, proved that he was, in fact, the real Simon Pure and that Feignwell was the actual imposter.

> If we would come with him the other way he would show us the real mummy, the Simon Pure. (William C. Prime, *Boat Life in Egypt*, 1860)

6. true ring Said of something that seems to be of genuine worth or real value; a story that seems to be true. One credible explanation attributes this expression to the *true ring* of fine crystal, another to the *true ring* of genuine coins. Whatever the case, the term, dating from the late 19th century, is used almost exclusively today in a figurative sense, usually in commenting upon the quality of a person's character or upon the veracity of his story.

> She was a false coin, which would not stand the test of a ring. (Andrew Robinson, *Nuggets in the Devil's Punch Bowl*, 1894)

161. GIBBERISH

See also 225. LANGUAGE;
246. NONSENSE

1. abracadabra See 231. MAGIC.

2. Dutch Unintelligible gibberish, meaningless talk or writing; also, *double Dutch;* often in the phrase *it's Dutch to me.* The allusion is probably to the meaningless jumble of sounds any foreign language seems to those who do not understand it. *High Dutch* was apparently the oldest variant of this expression since it appeared in the earliest *OED* citation from 1789; however, *Dutch* and *double Dutch* are the only forms in use today. An illustration of the use of this term is found in Charles Haddon Spurgeon's *Sermons* (1879):

> The preacher preaches double Dutch or Greek, or something of the sort.

3. Greek Gibberish, unintelligible or meaningless language; usually in the phrase *it's Greek to me.* The allusion is most likely to the unintelligible and senseless sound of any foreign language to those who do not understand it. The expression dates from about 1600; it is found in Shakespeare's *Julius Caesar:*

> But, for my own part, it was Greek to me. (I,ii)

4. mumbo jumbo Meaningless chanting and ritual; nonsensical or pretentious language. This expression evolved as an English rendering for the African deity *Mama Dyumbo,* whom the Mandingo tribes venerated with mystical rites incomprehensible to the European explorers. The expression is now frequently used to describe senseless or ostentatious language contrived to obscure a topic or befuddle the listener.

> A mumbo jumbo of meaningless words and phrases. (*The Times,* May 1955)

5. scat singing Jazz singing with meaningless syllables improvised and sung to the melody. The style apparently originated in 1926 when Louis Armstrong was recording the song *Heeby-Jeebies* at the Okeh recording studio in New York City. Although he didn't know the lyrics, Armstrong had the sheet music before him. As he finished the first chorus, he dropped the sheet music. Without hesitation he bent over to retrieve the music, taking the microphone with him and singing nonsensical monosyllables. By the time he had retrieved the music, the chorus was over and *scat singing* had been born. The recording company issued the finished product unchanged. Why it is called *scat* singing is uncertain. One plausible conjecture suggests that the term was derived from the sheet music scatting or scattering.

> Armstrong's . . . powerful personality made him the greatest influence in jazz. His "scat" singing, throaty and sly, using nonsense syllables, was imitated by many later

singers. (Norman Lloyd, *The Encyclopedia of Music*, 1968)

6. ubble-gubble Nonsensical talk, drivel, prattle. This uncommon expression, perhaps derived as a rendering of inarticulate vocalizations, appeared in W. B. Johnson's *Widening Stain* (1942).

Gluttony . . .

See 164. GOURMANDISM

162. GOOD HEALTH

1. fit as a fiddle Healthy, very fit, in good physical condition. There are several possible derivations of this expression, one of which holds that a properly tuned fiddle looks and sounds so impressive that it is a compliment for a person to be compared to it. Two other possibilities claim that the original expression was *fit as a fiddler* in which *fiddler* was a nickname applied either to a boxer with fancy footwork or to the person who played the fiddle at lively Irish dances, most of which lasted from dusk to dawn without any breaks. In both cases, the fiddler would have to be physically fit and have great stamina to last throughout the event. Similar expressions are *fine as a fiddle* and *face made of a fiddle*, the latter used to describe someone who is exceptionally attractive.

I arrived at my destination feeling fit as a fiddle. (Harrington O'Reilly, *Fifty Years on the Trail*, 1889)

2. in fine feather See 115. ELATION.

3. in fine fettle See 115. ELATION.

4. in the pink In excellent health; robust. This familiar expression, derived as a shortening of the phrase *in the pink of condition* 'the most perfect state of something,' probably developed its current figurative sense as an allusion to the rosy complexion of a healthy person.

I am writing these lines to say I am still in the pink and hoping you are the same. (John B. Priestly, *Good Companion*, 1929)

5. keep [one's] bones green This expression, dating from the mid 18th century, directs one to stay in good health by maintaining youth and vigor like a supple or green bough. Through extension, the phrase has also come to connote the avoidance of aging through activity.

Ye might have gotten a commisaryship . . . to keep the banes green. (Sir Walter Scott, *St. Ronan's Well*, 1824)

A related term is *green old age*.

His green old age seemed to be the result of health and benevolence. (Oliver Goldsmith, *The Vicar of Wakefield*, 1766)

6. right as a trivet Stable, solid, sound; in good health or spirits, fine, very well; thoroughly or perfectly right.

"I hope you are well, sir." "Right as a trivet, sir," replied Bob Sawyer. (Charles Dickens, *The Pickwick Papers*, 1837)

The allusion is to a trivet, a three-legged stand or support, which stands firm on nearly any surface.

7. right as ninepence Perfectly well, in excellent health or spirits, in fine fettle, in good condition or shape.

I thought I was as right as ninepence. (Rolf Boldrewood, *A Colonial Reformer*, 1890)

The ninepence was originally a British shilling minted under Queen Elizabeth I and intended for circulation in Ireland. The coin so depreciated in value, however, that it was used as a ninepenny piece in England. Considering the unhealthy background of the ninepence, the expression's current meaning is somewhat ironic.

8. sound as a bell Healthy, fit, in fine fettle; secure or stable. The phrase appeared in Shakespeare's *Much Ado About Nothing* (III,ii):

He hath a heart as sound as a bell.

This expression is based on the fact that even the slightest imperfection markedly

affects the tone of a bell. Although the expression may refer to the quality and condition of an inanimate object, it is more often applied to the soundness of the human mind and body.

A single man . . . with prospects, an' as sound as a bell . . . is not to be had every day. (*Pall Mall Magazine*, July, 1898)

163. GOOD LUCK
See also 367. SUPERSTITION

1. born with a caul on [one's] head Immune to death by drowning; charmed; lucky. The caul is part of the fetal membrane sometimes present on the heads of newborns. The superstition regarding its magical properties was at one time so strong that such membranes, or some material claimed to be such, were sold. Mariners in particular sought them, for obvious reasons.

2. break a leg This theatrical slang expression implies that the speaker wishes the gods of entertainment to smile down on another's performance, that everything will go well for him. Although the origin of the term is obscure, many suggestions have been made about its possible beginnings. Some cultures believe that wishing the opposite will bring good luck; this is seen in the old German phrase offered to a skier before his descent, *Hals-und-Beinbruch*, meaning 'may you break your neck and leg'; another suggestion attributes it to an old Yiddish theatrical superstition which employs the same theory; and a third attributes it to telling an actor to emulate Sarah Bernhardt, who had a leg amputated in later life, but continued to perform upon the stage. Whatever the case, the term is still in common use throughout the world of entertainment and sometimes beyond. In a negative context, during the late 1600s, a lower-class woman who delivered an illegitimate child was said to *break a leg*.

3. the breaks A favorable opportunity; an unexpected chance to advance oneself. The origin of this expression is uncertain, but one plausible school of thought assigns the term to the pool hall. At the start of a game of billiards the first player breaks the triangle of racked balls. If, after the break, the balls are distributed favorably on the table, and if the player has easy access to the cue ball, then he has *gotten a good break*. The term is often applied in a negative sense, *get a bad break*, or in a neutral sense, *get an even break*, but the connotation in the statement, "Those are the breaks!" is one of resignation to an unlucky event or episode.

By a series of good breaks, he passed the required elements to result in his being presented with one 1948 model Ford car Saturday afternoon. (*Daily Ardmorite*, May 2, 1948)

4. carry a rope in [one's] pocket To be extremely lucky at cards. This expression is an allusion to the superstition that a piece of a hangman's rope carried in the pocket brings the bearer good luck at cards.

5. the devil's own luck Unbelievable or amazing good luck; also *the devil's luck*. This expression, in use since at least the mid 19th century, may have derived from the former belief that lucky people had consorted with the Devil.

6. fairy money Found money; good fortune. This British expression has its roots in an old legend, in which good fairies were said to place money in locations where it would be discovered by certain fortunate people who had been predetermined to receive a bit of good luck. However, some versions of the legend report the money as simply a sham, for it later is changed into worthless leaves.

Such borrowed Wealth, like Fairymoney . . . will be but Leaves and Dust when it comes to use. (John Locke, *An Essay Concerning Humane Understanding*, 1690)

7. fall on [one's] feet To be unexpectedly lucky; to have everything go right. The old theory that a cat always falls on its feet, thus avoiding injury, has apparently been applied to good fortune in this expression. A variant is *fall on one's legs.*

> There are some men who are fortune's favorites, and who, like cats, light for ever upon their legs. (Charles C. Colton, *Lacon*, 1820)

Dorothy Parker, in her inimitable way, wrote of her husband Alan in *You Might As Well Live* (1926):

> Oh, don't worry about Alan . . .
> Alan will always land on somebody's
> feet.

8. find the bean in the cake Be lucky; hit the mark; discover something of unexpected value.

> Cut the cake; who hath the beane shall be kinge. (John Nichols, *The Progresses of Queen Elizabeth: Speech at Sudely*, 1592)

The allusion here is to the celebration of Twelfth Night, an old English custom dating to at least the 800s, and the cutting and dispensing of the Twelfth cake. A bean was baked into a large cake, and a piece of this cake was served to each person present. The person who was lucky enough to discover the bean in his piece reigned as king of Twelfth Night. The term, *Bean-king's Festival*, another name for Twelfth Night, was coined from this ancient rite.

9. have a good innings To have a good long life; be lucky; have success financially. This Briticism, another cricket term adopted into everyday speech, refers to one's turn at bat, that is, to one's opportunity to accomplish something. The term may apply to a political party's tenure in office or to a businessman's continuing success in money matters, but it is most commonly used to indicate a lengthy life span.

> She's had remarkably good innings, and persons can't expect to live

forever. (Mary Bridgman, *Robert Lynne*, 1870)

10. hit the jackpot To win a large prize; to have a remarkable stroke of good luck; to achieve great success; to strike it rich. *Jackpot* is a poker term for the kitty or pot that accumulates until a player can open the betting with the required cards, often a pair of jacks or better. Thus, *jackpot* has come to mean 'a prize; success or luck,' often of an extraordinary nature because it has been long awaited and its value has accumulated over a period of time.

> We saw our first American audience-participation show. The prizes included a diamond wrist watch . . . The jackpot was 1,250 dollars! (*Radio Times*, July 15, 1949)

The expression *to hit the jackpot* probably derives from slot machine usage.

> There is always the chance that one or other number or artist will hit the jackpot. (*Sunday Times* Supplement, June 10, 1962)

11. in clover In the best place; in a desirable spot; in luxury; on velvet. This expression alludes to the most desirable spot for grazing animals. Since clover is usually considered the most apetizing form of forage, cattle that find themselves *in clover* are in a position of good fortune. The entire concept is reinforced by the association of a four-leaf clover with good luck.

> A man with coals and candles and a pound a week might be in clover here. (Charles Dickens, *Our Mutual Friend*, 1864)

12. manna from heaven A stroke of good fortune; a windfall; a boon or blessing, particularly one resulting from divine intervention. This expression comes from Exodus (16:15):

> And when the children of Israel saw it, they said one to the other, It is manna: for they wist not what it was. And Moses said unto them, This is the

bread which the Lord hath given you to eat.

13. on velvet In advantageous position; in a desired spot; operating on winnings; in luxury; sure of success. The allusion in this phrase is to velvet, the material of monarchs, and so to be *on velvet* is to be in a position of strength and good fortune. In modern use the term is usually restricted to gambling and other speculative money matters.

> Men who have succeeded in their speculations, especially on the turf, are said to stand on velvet. (John C. Hotten, *The Slang Dictionary*, 1874)

There are many related terms, all of which put the protagonist in a position of great advantage. To *stand on velvet* is the prerogative of winners; to *play on velvet* is to play with one's winnings; to *prophesy upon velvet* is to predict what is already known.

14. spit for luck This habit, a charm for averting evil, dates back to early Greece and Rome. Although the origin for such a belief is unknown, spitting was said to thwart witchcraft, to neutralize black magic, and to bring good luck and prosperity. Such beliefs are not entirely dead today—people still spit on their money, athletes on their hands, gamblers on the dice, horseshoe pitchers on the horseshoes, etc., hoping to improve their performance.

15. strike oil See 365. SUCCESS.

16. windfall An unexpected acquisition or gain, such as a legacy; a sudden stroke of good luck, especially financial; a godsend; a bonanza. This term may stem from post-medieval England where laws prohibited the people from cutting down trees because all lumber was earmarked for use by the Royal Navy. If a tree were felled by the wind (literally, a windfall), however, it was excluded from this restriction and could be used by the property owner as he wished, thus being considered exceptional and unexpected good fortune. One source suggests that *wind-fall* may refer to a fruit or other edible delight which is blown from a tree by the wind without requiring active exertion on the part of the recipient.

> [He] kept little windfalls that came to him by the negligence of customers— . . . loose silver, odd gloves, etc. (Maria Edgeworth, *Moral T. Forester*, 1802)

Goodness . . .
See 397. VIRTUOUSNESS

164. GOURMANDISM

1. belly-god A glutton or gourmand; one who makes a god of his belly. The term was in use in the mid 16th century.

2. chowhound A glutton; a hearty eater, a gourmand. The word combines the U.S. slang term for food with the aggressive and uncouth eating habits of a dog. J. B. Roulier describes a "chowhound" in *Service Lore: Army Vocabulary* (1943):

> He is not necessarily a prodigious eater; his unpopularity is usually caused by his roughshod methods in getting first to the best of the food.

The term enjoyed wide use among the Armed Forces in World War II and is occasionally heard in civilian speech.

3. eat [one's] head off To make a glutton of oneself; to eat more than one is worth; to gorge oneself. This phrase, popular since the early 1700s, originated as a description of an animal that cost more to feed than it would bring in cash at the marketplace; consequently, it was marked for an early death, In time the phrase became a metaphorical expression for anybody who ate too much. The *OED* lists the first written use of the term as:

> The eating his head off means that he would eat as much hay and corn as he was worth. (John Byrom, *Private Journal and Literary Remains*, 1763)

4. eat out of house and home To deplete another's supply of food or money by excessive gluttony, to batten on one's host or hostess to the point of their ruination. In Shakespeare's *Henry IV, Part II* (II,i), Mistress Quickly uses this expression when answering the Lord Chief Justice's question as to why she had Sir John Falstaff arrested:

> He hath eaten me out of house and home; he hath put all my substance into that fat belly of his.

5. goes down Gutter Lane Goes down one's throat and into one's stomach; puts away food like a glutton. This expression is most commonly heard in the catch phrase *it all goes down Gutter Lane* which suggests the spending of all one's earnings to satisfy one's gluttonous desires. The term contains a pun on *guttur*, the Latin word for 'throat,' and it may have been influenced by Gutter Lane in London. Whatever the case, it has been in use since at least the 13th century.

> Whatsoever he drains from the four corners of the city, goes in muddy taplash down Gutter-lane. (Richard Brathwait, *Whimzies*, 1631)

6. have the munchies To feel a strong desire to eat, especially after having smoked marijuana; to be hungry for snacks. This American slang expression usually refers to the desire to munch on sweets and starches after one has been smoking marijuana. The term is derived from the earlier slang term *munchie*, 'a snack, something to munch on.' In recent years the term has been popularized by the advertisers of snack foods, who, perhaps rather naively, have been publicizing their products as the ideal snack for those who *have the munchies*. The phrase has been in common use since about 1971.

> If they have never heard the terms in Vietnam, the POW's will quickly learn about . . . "munchies" (to be hungry, usually after ingesting marijuana). (*Newsweek*, February 12, 1973)

A related term is *munching out*, 'eating quantities of snack food.'

7. live like fighting cocks To gorge oneself, to eat too much rich food, to overindulge. This British colloquialism, dating from the early 19th century, is puzzling since gamecocks were kept on strictly controlled diets much like boxers and wrestlers. However, since the phrase means to have the best food as well as to have an abundance of it, perhaps the reference is to a fighting cock's diet as compared to that of an ordinary chicken.

> [They] live like fighting-cocks upon the labour of the rest of the community. (William Cobbett, *Rural Rides*, 1826)

8. play a good knife and fork To eat heartily. This expression plays on the image of dining utensils in constant motion as someone eats a hearty meal. It appeared in print by the turn of the 19th century in Benjamin Malkin's 1809 translation of LeSage's *Adventures of Gil Blas*:

> Domingo, after playing a good knife and fork . . . took himself off.

Graciousness . . .
See 71. CORDIALITY

165. GRAFT
See also 38. BRIBERY; 140. EXTORTION; 265. PAYMENT

1. feather [one's] nest See 136. EXPLOITATION.

2. line [one's] pockets To profit, especially at the expense of others; to receive money or other favors through bribery, blackmail, or graft. This expression reputedly stems from the English tailor who, hoping to become the clothes designer for the famous fashion plate, Beau Brummel (1778–1840), sent him an ornate coat, the pockets of which were lined with money. Although Beau sent a letter of thanks and added that he especially admired the lining, it is not known

whether the tailor received any more of his business.

3. piece of the pie See 18. ALLOCATION.

4. pork barrel Legislation providing federal funding for local projects designed to put congressmen in the good graces of their constituents. Thus, the pork barrel is, metaphorically speaking, the federal treasury viewed as a source of monies for "pet" local projects. Citations from the early 19th century indicate that the farmer's pork barrel was where he stored salted pork, which was eaten when fresh food was not available, as before the first spring crop. Hence, it became a symbol of provident management of resources. Use of this U.S. slang expression is restricted to politics and dates from the early part of this century.

> The River and Harbor bill is the pork barrel par excellence, and the rivers and harbors are manipulated by Federal machinery and not by State machinery. (*The New York Evening Post*, May 1916)

5. shoe [one's] mule To embezzle; to misuse or steal money entrusted to one's care and management. Some unscrupulous blacksmiths and grooms reputedly once engaged in the fraudulent practice of charging a horse (or mule) owner for shoeing the steed, and then either kept the money without performing the promised work or used the money to buy shoes for their own animals.

> He had the keeping and disposal of all the moneys, and yet shod not his mule at all. (*Sorel's Comical History of Francion*, 1655)

A variation is *shoe one's horse*.

Greed . . . See 91. DESIRE

Greenness . . .
See 204. INEXPERIENCE

166. GRIEVANCE

1. ax to grind A private or selfish motive, a personal stake; a grievance or complaint, especially a chronic one. The phrase stems from an 1810 story by Charles Miner in which a gullible boy is duped by a flattering stranger into turning a grindstone for him. According to the *Dictionary of Americanisms*, the frequent but erroneous ascription of the phrase's origin to Benjamin Franklin is owing to confusion between *Poor Richard's Almanac* and *Essays from the Desk of Poor Robert the Scribe*, the collection in which the story appeared.

2. a bone to pick A complaint or grievance; a point of disagreement or a difference to settle. Formerly, the expression *have a bone to pick* meant to be occupied, as a dog is with a bone. It was used in this sense as early as 1565. The similar French phrase uses a different metaphor, *une maille à partir* 'a knot to pick.'

3. a chip on [one's] shoulder See 32. BELLIGERENCE.

4. grumble in the gizzard To complain or grouse, to be dissatisfied or annoyed. In this British expression, which dates from the late 17th century, *gizzard* 'a bird's stomach' is applied jocularly to a human being's throat or craw.

> I was going home, grumbling in the gizzard. (Thomas Flloyd, *Gueullette's Tartarian Tales*, translated 1764)

167. GRIEVING
See also 87. DEJECTION

1. come home by Weeping Cross To suffer disappointment or failure; to mourn, to lament; to be penitent and remorseful. The origin of this now rarely heard expression is obscure. There are several place names of this designation in England, but the common explanation that they were the site of penitential devotions is without substance. Use of the expression may have given rise to the explanation, rather than vice versa; for example, the following passage from Lyly's *Euphues* (1580):

The time will come when coming home by weeping cross, thou shalt confess.

2. cry [one's] eyes out To sob long and bitterly; to weep excessively or immoderately; to exceed the limits of reasonable grief. The first written record of the idea behind this term is to be found in Cervantes' *Don Quixote* (1604). Don Quixote demands that Sancho, before conveying a letter to Quixote's Dulcinea, witness some of the Don's acts of penance. To which Sancho replies:

> Good sir, as you love me, don't let me stay to see you naked; 'twill grieve me so to the heart, that I shall cry my eyes out.

3. in sackcloth and ashes In a state of remorse and penitence; contrite, repentant; in mourning, sorrowful. This expression alludes to the ancient Hebrew custom of wearing sackcloth, a coarse fabric of camel's or goat's hair, and ashes (usually sprinkled on the head) to humble oneself as a sign of sorrow or penitence. Among the Biblical references to this custom is that in the Book of Daniel (9:3):

> Then I turned my face to the Lord, God, seeking him by prayer and supplications with fasting and sackcloth and ashes.

The expression has been used metaphorically for centuries.

> He knew that for all that had befallen she was mourning in mental sackcloth and ashes. (Hugh Conway, *A Family Affair*, 1805)

A common variation is *wearing sackcloth and ashes.*

4. Jamie Duff A professional mourner; one who enjoys attending funerals. This Scottish nickname for a mourner at a funeral is derived from an actual person named Jamie Duff, who, it is said, frequently attended funerals because he took pleasure in riding in the mourning coach. The term has been in use since the middle of the 19th century.

5. wear the willow To mourn the death of a mate; to suffer from unrequited love. The willow, especially the weeping willow, has long been a symbol of sorrow or grief. Psalm 137:1–2 is said to explain why the branches of the willow tree droop:

> By the rivers of Babylon, there we sat down, yea, we wept, when we remembered Zion. We hanged our harps upon the willows in the midst thereof.

Wear the willow appeared in print by the 16th century but is rarely, if ever, heard today.

> There's . . . Marie . . . wearing the willow because . . . Engemann is away courting Madam Carouge. (Katharine S. Macquoid, *At the Red Glove*, 1885)

Guardianship . . .
See **168. GUIDANCE**

168. GUIDANCE

1. bear leader The traveling tutor or guardian of well-heeled, aristocratic youths of the 18th century. Horace Walpole used the term in his *Letters to Sir Horace Mann* (1749):

> She takes me for his bear-leader, his travelling governor.

The phrase is said to have come from the old practice of leading muzzled bears around the streets and having them perform in order to attract attention and money.

2. hand on the torch To pass on or transfer the tradition of enlightenment and knowledge to succeeding generations. The allusion is to the ancient Greek torch races, precursors of the Olympics, in which a lighted torch was passed from one runner to the next in the manner of modern-day relay races. The torch or lamp has long been symbolic of enlightenment and learning. The expression dates from at least 1887.

3. lick into shape To make suitable or presentable; to develop, mold, or give form to. This expression refers to the belief, prevalent until the 17th century, that bear cubs are born as amorphous masses that assume their normal ursiform appearance only if they are licked into shape by their mother. This mistaken assumption was based on information in *The History of Animals* by Aristotle (384–327 B.C.) and *The Canon of Medicine* by Avicenna (979–1037), an Arab physician. Despite its unsound origin, the expression is extremely common.

> Their proposals . . . would be licked, by debate . . . into practicable shape. (*The Spectator*, December 12, 1891)

The French expression *ours mal léché*, 'an improperly licked bear' is used colloquially to describe a boorish person. *Whip into shape* and *beat into shape* are variations of *lick into shape* which refer to a different sense of *lick*, i.e., 'to strike or hit,' yet they retain the connotation of the original expression.

4. take in tow To guide, lead, take charge of, or assume responsibility for. Originally said of pulling a vessel through water with a rope, this expression applies figuratively to one person leading another. This use of *take in tow* dates from the 18th century.

> A young lama . . . took me in tow, and conducted me to all the tents. (James Gilmour, *Among the Mongols*, 1883)

Current usage frequently implies a need for discipline and control.

5. take under [one's] wing To protect, care for, or watch over; to nourish or nurture; to rear, teach. This expression alludes to a mother hen's protecting her chicks by taking them under her wing.

> I have gathered thy children together, even as a hen gathereth her chickens under her wings . . . (Matthew 23:37)

> They fled for their lives to find safety under Pompey's wing in Capua. (James Froude, *Caesar; A Sketch*, 1879)

Although implying protection, *take under one's wing* is most often applied in contexts where an experienced person takes it upon himself to show a neophyte "the ropes."

6. throw light on To make clear; to enlighten; to clarify; to provide facts so as to make something easier to understand. The allusion here is obvious; if one can't see something clearly from lack of light, if light is thrown on it, it will be seen more clearly. The phrase has been in figurative use since the 1760s. A variant which indicates a lesser degree of assistance in understanding is *shed light on*.

Guideline . . . See 77. CRITERION

169. GUILT

1. caught with [one's] hand in the cookie jar Taken by surprise in the process of wrongdoing; caught red-handed. This expression implies that the person caught is not only surprised, but is also in possession of self-incriminating material. Though the image is that of a mischievous child atop a counter engaged in normal childhood activities, in context the phrase is often used for serious adult wrongdoing, particularly in connection with political graft.

2. caught with [one's] pants down See 400. VULNERABILITY.

3. cry peccavi To confess one's guilt; to openly acknowledge one's fault or wrongdoing. The origin of this expression is the Latin *peccavi* 'I have sinned.' Both *peccavi* 'an acknowledgement of guilt' and *cry peccavi* date from the 16th century.

> Now lowly crouch'd, I cry peccavi, And prostrate, supplicate *pour ma vie*. (Jonathan Swift, *Sheridan's Submission*, 1730)

4. dead to rights See 46. CERTAINTY.

5. red-handed In the act, with clear evidence of guilt, *in flagrante delicto*. This term evolved from the earlier *with red hand and with bloody hand*.

6. tarred with the same brush See 346. SIMILARITY.

7. with bloody hand Guilty; caught red-handed or *in flagrante delicto*. According to the Forest Law of ancient Britain, a man found with bloody hand was presumed guilty of having killed the king's deer.

8. with egg on [one's] face See 173. HUMILIATION.

H

Handicap . . . See 98. DISADVAN-
TAGE; 193. INABILITY

Happiness . . . See 115. ELATION

Harangue . . .
See 133. EXHORTATION

170. HARASSMENT
See also 223. IRRITATION;
394. VEXATION

1. **bench jockey** A player in a team
game who harasses the opponents from
the bench, hoping to reduce their effi-
ciency by distracting them. One collo-
quial use of the word *ride* means to tease
or subject to ridicule. Hence, the *bench
jockey*, although not an active partici-
pant in the game, helps his team achieve
victory by riding his opponents.

> The doctor's orders were soon
> grapevined around the league, and all
> the bench jockeys on the circuit were
> quickly counting ten on every pitch
> Lefty made. (Cochrane, *Baseball, the
> Fans' Game*, 1939)

A related term, *ride the bench*, is used to
describe a substitute who rarely partici-
pates and spends the majority, if not all
of the game on the bench. Both expres-
sions have been in common use since
about 1900.

2. **buttonhole** To restrain for purposes
of conversation; check one's departure.
This expression, in common use since the
17th century, is literal in the sense that
one is held by the buttonhole or button,
and apparently had its origin from that
practice. Today it is used figuratively to
indicate one has been cornered or de-
tained by a wearisome bore.

> He went about buttonholing and
> boring everyone. (Henry Kingsley,
> *Mathilde*, 1868)

3. **dun** See 352. SOLICITATION.

4. **from pillar to post** See 203. INEFFEC-
TUALITY.

5. **get off [someone's] back** To stop
bothering, irritating, or criticizing an-
other person; similar to the currently
popular *get off [someone's] case*. This ex-
pression is usually spoken in the com-
mand form by a desperate victim of in-
cessant nagging or harassment.

> Then stop picking on me, will you?
> Get off my back, will you? (Joseph
> Heller, *Catch 22*, 1961)

6. **the heat's on** The police are hot on
one's trail; the pressure is on. *Heat* can
refer to a policeman or other external
source of pressure. In this originally U.S.
slang expression dating from the early
20th century, *heat* combines the latter
two meanings.

> But the word went out that the
> government heat was on. The FBI
> was known to be relentless in its
> pursuit. (H. Corey, *Farewell, Mr.
> Gangster*, 1936)

The heat's on currently applies to any
pressure-ridden situation, though its
most frequent usage is still police-relat-
ed.

7. **make it hot for** To make things very
uncomfortable or unpleasant for some-
one, especially through repeated harass-
ment or persecution; to make trouble
for. This expression and the variant *to
make it too hot for* were precursors of
the American slang phrase *to turn the
heat on* 'to apply pressure to.'

Caesar Augustus thought good to make that practice too hot for them. (Edmund Bolton, tr., *The Roman Histories of Lucius Julius Florus*, 1618)

8. play cat and mouse with To tease, toy with, or torment; to be engaged in a power struggle in which one takes the role of cat, or oppressor, and victimizes the mouse, or weaker party; to outwit one's opponent; to take part in a round of near capture and escape. The Cat-and-mouse Act, a nickname for the Prisoners Act of 1913 which enabled hunger strikers to be released temporarily, popularized use of the phrase *cat and mouse* in the early 1900s.

The Administration played a curious cat-and-mouse game with the Jewish self-defence organization. (Arthur Koestler, *Promise and Fulfillment*, 1949)

9. ride herd on See 107. DOMINATION.

10. stage-door Johnny A man who hangs around stage doors waiting for actresses to appear; one who seeks out the company of actresses. This American slang expression was first applied about 1870 to those theater lovers who hang about the door reserved for theater personnel hoping to attract the attention of the actresses as they depart. The *Johnny* is a hypocoristic diminutive of *John*, a name frequently used in phrases as a generic reference to males.

There is psychology involved in handling the Stage-Door Johnnies. (*Chicago Daily News*, March 15, 1950)

The phrase *stage-door Benny* has the same sense.

Hard work . . .
See 202. INDUSTRIOUSNESS

Hard-heartedness . . .
See 42. CALLOUSNESS

Hardship . . . See 10. ADVERSITY

Hastiness . . . See 44. CARELESSNESS; 187. IMPETUOUSNESS

171. HAUGHTINESS
See also 276. POMPOSITY

1. arrive in an armchair To be indifferent about one's tardiness; to be arrogantly unmoved. This expression, popular in the 1920s, indicates that although one is late for an appointment or a meeting, he is obviously unconcerned about those people who have been kept waiting. The armchair, like the old sedan chairs of Indian rajahs, connotes an insouciant, unconcerned attitude on the part of the tardy person.

2. Attic figs See 91. DESIRE.

3. be all things to all men

To the weak became I as weak, that I might gain the weak: I am made all things to all men, that I might by all means save some. (I Corinthians 9:22)

As originally used by St. Paul, this expression indicated his willingness to change his personality to fit those with whom he was dealing, so that he might convert them to Christianity. However, probably because of its boastful implication, the phrase has come to connote vanity, haughtiness, conceit.

If they, directed by Paul's holy pen,
Become discreetly all things to all men,
That all men may become all things to them,
Envy may hate, but Justice can't condemn.
(Charles Churchill, *The Prophecy of Famine*, 1763)

4. bridle To tuck in the chin and throw the head back as in vanity or scorn; to put on an air of disdain or offense; sometimes *bridle up* or *back*. The allusion is to the upward movement of a horse's head when the reins are abruptly pulled.

In use since 1480, the term appeared in Henry Fielding's *Amelia* (1751):

> "Is she," said my aunt, bridling herself, "fit to decide between us?"

5. high-hat To act in an aloof, snobbish, or condescending manner.

> Denver's dignity was mistaken by some for "high-hatting." (Noël Coward, *Australia Revisited*, 1941)

This expression, alluding to the tall headgear formerly worn by the wealthy, usually refers to a manner of behavior, although it is also often used in reference to a pompous or pretentious person.

6. high in the instep Haughty; conceited; overly proud. The origin of this expression can probably be ascribed to the belief that the nobility had more delicate features than the peasantry. A noble man or woman supposedly had a higher arch and a higher instep than the peasants whose feet were said to be flat because of their cheap footwear and their constant, heavy toil. To the common people the phrase, in use since about 1540, came to signify the haughtiness associated with the upper classes.

> Too high in the instep . . . to bow to beg a kindness. (Thomas Fuller, *The Church-History of Britain*, 1655)

7. hoity-toity Haughty or superior in manner; putting on airs. Although the exact origin of this expression is unknown, many scholars believe its source lies in the obsolete verb, *hoit*, which meant to 'act like a hoyden, romp riotously.' Others believe that *hoity* is a corruption of *haughty* with the reduplicative, *toity*, added for assonance and rhyme. Whatever the case, the term has been employed for more than 300 years. John Keats used it in his poem, *Caps and Bells*, (1820):

> It bodes ill to his Majesty—refer
> To the second chapter of my fortieth book,
> And see what hoity-toity airs she took.

8. Jack-in-office A conceited official; one who uses his office for his own gain; a petty official who is fond of power; an upstart; an insolent person in a position of authority. This term had its origins in the 17th century and, although often used in a general sense to indicate insolence, it is most often used to indicate pettiness on the part of one in a position of authority.

> A type of Jack-in-office insolence and absurdity . . . a beadle. (Charles Dickens, *Little Dorrit*, 1857)

9. look down [one's] nose To regard in a condescending manner; to view with disdain or disgust. A person who literally looks down his nose bears a countenance of disapproval or arrogance. The expression carries a strong suggestion of snobbery or haughtiness.

> It is getting more difficult for a lawyer to look down his nose at the courtroom, with consequent impairment of the prestige of the courts. (*Baltimore Sun*, October 1932)

10. Norman blood Aristocratic birth; blue blood; the highest social level; snobbishness. The allusion in this phrase is to William the Conqueror and his Norman host that overran the English at the Battle of Hastings in 1066. They immediately set themselves up as the aristocratic class and suborned the native English to lesser status; hence, the tone of disdain often associated with the term.

> Kind hearts are more than coronets,
> And simple faith than Norman blood.
> (Alfred Tennyson, *Lady Clare Vere de Vere*, 1832)

11. on [one's] high horse With one's nose in the air; pretentious, arrogant, affected; also *to ride* or *mount the high horse, to get down off one's high horse*, and other variants. In royal pageants of former times persons of high rank rode on tall horses, literally above the common people. Use of the expression dates from the late 18th century.

Only his mother felt that Mayo was not a rude boy, but his father frequently asked Mayo to get down off his high horse and act like everybody else. (William Saroyan, *Assyrian & Other Stories*, 1950)

12. on the high ropes To be excited; to be disdainful; to be arrogant. This expression refers to a tightrope walker who, performing high above, looks down at the audience. Dating from the late 17th century, the phrase suggests a figurative looking down upon someone, as in disdain.

Nora was rather on the high ropes, just then, and would not notice him. (Mrs. Henry Wood, *Trevlyn Hold*, 1864)

13. smart Alec(k) A cocky, conceited person; an obnoxious, pompous know-it-all; a haughty, self-important fool. Although the origin of this American colloquialism is obscure, it was first recorded in a Carson City, Nevada, newspaper in 1862. If the term is derived, and it probably is, from the name of an actual Alec, the apparent possessor of certain undesirable qualities, history does not record his identity.

In "A Word in Your Ear", the fourth collection of his columns from *The Times* [London], Mr. Howard comes across less like a smart aleck than like a learned uncle. (Calvin Trillin, *The New York Times Book Review*, January 8, 1984)

An adjective form, *smart alecky*, has achieved almost the same level of popularity as the noun form.

Few grown-ups enjoy an encounter with a smart-alecky child. (*Denison [Texas] Herald*, July 2, 1948)

14. stuffed shirt Self-important or ostentatious person who is actually insignificant; a pompous, haughty, grandiose person. The source of this expression apparently lies in the 19th-century practice of retailers' stuffing shirts with tissue paper for advertising display, manne-

quins being a later development. Appearing genuine on the outside, these stuffed shirts were really devoid of substance.

I have been accused of many things in my time, but never of being a stuffed shirt. (John Dickson Carr, *Death Turns the Tables*, 1941)

15. toffee-nosed Stuck-up, with one's nose in the air, conceited, pretentious, stuffy. Although the origin of this British slang term is not certain, it comes from *toff*, British slang for a pretentious swell.

Health . . . See 162. GOOD HEALTH; 181. ILL HEALTH

Healthiness . . . See 162. GOOD HEALTH

Heaven . . . See 262. PARADISE

Help . . . See 26. ASSISTANCE

Hindrance . . . See 40. BURDEN; 185. IMPEDIMENT

172. HOMECOMING

1. back to Blighty Return home to England; a wound serious enough to cause one to be sent home from the war. This British slang expression was coined by those British troops who were among the first to serve in India. *Bilayati*, the Hindustani word for 'foreign country,' was corrupted to *blighty*, and brought back to England. The word became extremely popular among the British troops serving in France during World War I, where *back to blighty* came to signify a wound serious enough to warrant a return to Britain but not serious enough to leave one dreadfully handicapped.

I'll send out the money and fags when I go back to blighty. (P. MacGill, *The Great Push*, 1917)

Honesty . . . See 73. CORRECTNESS;
142. FAIRNESS

Honorableness . . .
See 397. VIRTUOUSNESS

Hopelessness . . . See 92. DESPERA-
TION; 159. FUTILITY

Horror . . . See 148. FEAR

Humbling . . .
See 173. HUMILIATION

173. HUMILIATION

1. cut [someone's] comb To humiliate
or humble; to degrade, to take down a
peg or two. This expression, which dates
from the mid 1500s, is said to allude to
the supposed practice of cutting the
fleshy red combs of roosters in order to
humble their pride.

2. eat crow To be forced to do or say
something distasteful and humiliating;
to eat one's words or eat humble pie; to
be compelled to confess wrongdoing or
to back down. This colloquial expression
of American origin and its variant eat
boiled crow were used as early as the
mid 19th century. The most popular sto-
ry explaining this expression tells of an
American soldier in the War of 1812
who killed a crow for sport. Its owner
reacted by forcing him to eat the dead
crow at gunpoint. After a few bites, the
soldier was released, whereupon he
turned his gun on his foe and forced him
to eat the remaining portion. Later, the
soldier's only comment was that he and
the other party had "dined" together.
Today, eat crow continues to be a popu-
lar picturesque expression.

3. eat humble pie To come down off
one's high horse, swallow one's pride,
and submit to mortification and humili-
ation; to be forced to apologize and de-
fer to others; to eat crow, to eat dirt, or
to eat one's words. In this expression,
humble derives from the obsolete umbles

'heart, liver, and entrails of the deer.'
Apparently these parts were considered
leftovers suitable only for the huntsman
and other servants while the lord and his
company feasted on venison. Thus,
"umble pie" was suggestive of poverty
and lowly status. Since humble also con-
notes lowliness and subservience, the
simple fact of confusion gave rise to eat
humble pie, used as early as the begin-
ning of the 19th century.

4. eat the leek To be forced to humili-
ate oneself; to be compelled to eat one's
own words. The origin of this phrase has
been ascribed to Shakespeare, for it first
appeared in print in the historical dra-
ma, Henry V. Pistol scoffs at Fluellen for
wearing a leek, the national symbol of
Wales, in his hat. Finally, fed up with
the taunts, the saucy Welshman beats
Pistol and forces him to eat the leek, thus
humiliating himself before Gower, who
observes the entire scene. The term has
remained in use since that time.

> There was nothing for it but to
> obey. . . . [I]t was a leek to eat, and
> there was no denying it. (Robert
> Louis Stevenson, New Arabian
> Nights, 1882)

5. eat [one's] words See 303. RECANTA-
TION.

6. go to Canossa To humble oneself, to
submit oneself to humiliation. In Janu-
ary of 1077, Pope Gregory VII stayed for
a time at the castle of Canossa in Italy
on his way to Germany to take action
against the excommunicated Henry IV,
emperor of the Holy Roman Empire. To
forestall this event, Henry IV made the
pilgrimage to Canossa where he was
kept waiting outside, exposed to the
harshness of the elements, for three days
before receiving absolution from the
Pope. This example of secular submis-
sion to Church authority gave rise to the
expression in question, now used in the
general sense of submitting oneself to
humiliation.

7. put [someone's] nose out of joint To arouse someone's anger or resentment by replacing him in the affection or esteem of another; to humiliate, to spoil or upset someone's plans, to thwart.

> The King is pleased enough with her: which, I fear, will put Madam Castlemaine's nose out of joint. (Samuel Pepys, *Diary*, 1662)

It is easy to see how the literal *out of joint* 'dislocated, out of place' gave rise to the figurative 'supplanted, superseded.'

8. rub [someone's] nose in it To persistently humiliate a person by reminding him of a fault or error. This expression may have derived from the canine housebreaking technique of placing the pet's nose close to its mistake in hope of discouraging future indoor accidents. As used today, the expression implies unmerciful harping and castigation over a relatively minor mishap.

> I'm sorry. I've said I'm sorry. Don't rub my nose in it. (P. M. Hubbart, *Flush as May*, 1963)

9. take down a peg To humble, to lower someone in his own or another's estimation; to snub or put down. In print since the 16th century, this expression is said to derive from the raising or lowering of a ship's colors, or flag, by pegs, to mark the importance of an occasion: the higher the colors, the greater the honor, and vice versa. Another theory is that *peg* originally referred to the notches inside a cup to indicate each person's share. To take someone down a peg meant to drink his share. Today *take down a notch* is a common variant.

> I must take that proud girl down a peg. (Mrs. Humphry Ward, *Marcella*, 1894)

10. with egg on [one's] face Embarrassed or humiliated by some mistake; in the wrong, guilty. The origin of this expression is unknown. It may have derived from an audience's practice of throwing rotten eggs at actors during an especially poor performance. Another possible derivation is of a more agrarian nature. Weasels, foxes, and other such animals are known for their habit of sneaking into henhouses at night to suck eggs. To come out with egg on their faces would display to all the evidence of their wrongdoing.

11. with [one's] tail between [one's] legs Ashamed, humiliated, disgraced, embarrassed; cowed, dejected, beaten; afraid, scared.

> We shall have you back here very soon . . . with your tail between your legs. (William E. Norris, *Thirlby Hall*, 1884)

A dog, disgraced by having lost the scent on a hunt or punished for doing something forbidden, returns to its master with its tail hanging between its legs.

174. HUMOROUSNESS

1. Dad and Dave Two figures in Australian humor who have come to represent the knowledgeable underdog. *Dad and Dave*, the creations of A. H. Davis, came upon the scene in 1899 with the publication of *On Our Selection*, a series of humorous tales about the rural life of the time. In 1930, a radio serial about these two became very popular in Australia, and the term came into general use.

2. enough to make a dog laugh Hilarious; uproariously funny; ludicrous. This expression, which dates from the 16th century, is obvious in its implication.

> To hear how W. Symons do command and look sadly . . . would make a dog laugh. (Samuel Pepys, *Diary*, January 8, 1664)

In modern usage, however, it is most frequently used cynically to mean not funny at all. A variant is *enough to make a cat laugh*.

3. funny as a barrel of monkeys Very funny, hilarious, uproarious, riotous. Monkeys are known for their humorous antics; a barrel of them would undoubt-

edly serve to heighten one's amusement. But, since too many monkeys would not be funny for long, the expression is also used sarcastically to mean not funny at all.

4. funny bone The name given to an area near the bone of the upper arm where it forms the elbow joint. This expression has its roots in the Latin name for the bone that lies between the shoulder and the elbow, the *humerus*. *Funny bone* ostensibly was derived as a pun on *humerus* because a whack on the elbow at the point where the ulnar nerve passes over the *humerus* gives one a peculiar, tingling sensation.

> You see, dear, it is not true that woman was made from man's rib; she was really made from his funny bone. (Sir James Barrie, *What Every Woman Knows*, 1908)

A common American variant of this term is *crazy bone*.

5. funny-peculiar or funny ha-ha See 95. DIFFERENTIATION.

6. horselaugh A loud, boisterous, often mocking laugh; a coarse, vulgar laugh; a guffaw. Although the exact source of this term is unknown, it probably alludes to the lusty neigh of a stallion. Other explanations make reference to an obscure pun on the word *hoarse*, or to an implication on the part of the speaker that the person laughing is a coarse rustic. The term has been in common use since at least the early 18th century.

> The Horse-Laugh is a distinguishing characteristic of the rural hoyden. (Richard Steele, *The Guardian*, 1713)

7. in stitches Doubled over with laughter, in pain from laughing so hard. *Stitch* dates from the 11th century as a term for a sharp, spasmodic, localized pain. *In stitches* refers to the analogous spasms produced by uncontrollable laughter. Shakespeare used the phrase in *Twelfth Night* (III,ii):

> If you desire the spleen, and will laugh yourself into stitches, follow me.

8. laugh like a drain To guffaw or horselaugh; to laugh loudly and boisterously. This British colloquialism refers to the sound made by water as it gurgles down the drain, and is frequently used in the context of laughing in derision at another's discomfiture.

> Old Hester would laugh like a drain if she could see us singing hymns over her. (K. Nicholson, *Hook, Line and Sinker*, 1966)

9. merry-andrew One who amuses others through buffoonery or zaniness; a droll, witty person; a clown. This expression may have derived from the learned traveler and physician to Henry VIII, Andrew Borde, though the evidence for this theory is flimsy at best. In an attempt to instruct the common English people, Borde spoke at fairs and other festivals, often interjecting witticisms and puns into his rather unpretentious lectures. The many people who imitated him were thus called merry-andrews. The expression is still used today for an amateur comedian or a buffoon.

> Richter is a man of mirth, but he seldom or never condescends to be a merry-andrew. (Thomas Carlyle, *Tales by Musaeus, Tieck, and Richter*, 1827)

10. slapstick A type of comedy characterized by boisterousness, farcical facial expressions, and horseplay, and quasi-violent actions such as throwing pies, striking or tripping one another, etc. This comedic genre takes its name from the *slapstick* 'flexible lath or stick' used by clowns and harlequins to deliver a loud but painless blow to another actor. Slapstick comedy was perhaps epitomized by the Keystone Cops and other silent-film characters created by Mack Sennett (1884–1960). Even during its heyday in the early 1900s, but especially after the introduction of sound in motion pictures in the late 1920s, slapstick was

considered by some to be a low, if not base, form of humor because of its exaggerated visual effects and rampant, though innocent, acts of violence.

> It was a musical show—one of those . . . slapstick affairs which could never by any possibility satisfy a cultivated audience. (T. K. Holmes, *Man From Tall Timber*, 1919)

11. wear the cap and bells To willingly play the clown or buffoon, to act the fool, to be the life of the party; also, to serve as foil to the straight man, to be the butt of others' jokes. This now little-used expression derives from the headgear formerly worn by court jesters, a cap with bells attached.

12. zany A subordinate clown who aped the principal clown in the *Commedia dell' Arte*; one who acts the fool; a buffoon. When the *Commedia dell' Arte* was developed in Italy in the 16th century, an integral part of the cast was the *zanni*, Venetian for *Gianni*. By the 17th century the term had come to signify anybody who made a fool of himself. From the noun, the adjective form meaning 'crazy' evolved. The first extant use of the word in English is in Shakespeare.

> Some carry-tale, some pleaseman, some slight Zanie . . .
> That . . . knows the trick
> To make my lady laugh.
> (*Love's Labour's Lost*, V,ii)

175. HUNGER

1. cry cupboard To call for food; to be hungry; to crave food. This Briticism, dating from about 1660, employs a metonymy, referring to the provisions which are kept in the cupboard as a way of suggesting food for one's stomach.

> FOOTMAN: Madam, dinner's upon the table.
> COLONEL: Faith, I'm glad of it; my belly began to cry cupboard.
> (Jonathan Swift, *Polite Conversation*, 1738)

2. die like Roland To die from hunger or thirst. Legend has it that Roland, after having escaped the massacre at Roncevalles, ironically died of starvation and thirst while trying to cross the Pyrenees.

3. dine with cross-legged knights To go without dinner; to go hungry. The reference in this British expression is to the stone effigies of knights, many represented with legs crossed, of the Temple Church on Fleet Street in London. It was at this location that unemployed and hungry men once lingered, hoping to procure jobs as witnesses from the lawyers who regularly met their clients there. A variant, *to be the guest of the cross-legged knights*, also means to go dinnerless.

4. dine with Duke Humphrey To go hungry; to partake of a Barmecide feast. According to the usual but perhaps apocryphal account, the expression derives from the practice of London's poor who, come the dinner hour when the streets began to empty of those preparing to dine, were wont to wander the aisles of St. Paul's claiming to be in search of the monument to Duke Humphrey. Humphrey, Duke of Gloucester, was renowned for his hospitality, and at his death it was rumored that there was to be a monument to his bounty erected in St. Paul's. None such was ever built; thus, to dine with Duke Humphrey is to have no place at which to dine, to wander idly while others eat.

> A cadaverous figure who had been invited for no other reason than that he was pretty constantly in the habit of dining with Duke Humphrey. (Nathaniel Hawthorne, *Mosses from an Old Manse*, 1854)

Another explanation holds that the phrase originally meant to dine well; after the Duke's death, its meaning naturally became inverted to the current one.

5. hungry dogs will eat dirty puddings True hunger has no misgivings; famished people are not fussy about what

they eat. The origin of this expression is uncertain; it first appeared in print in the 1500s. At times, it is used to connote an undesirable person.

> The messenger (one of the dirty dogs who are not too scornful to eat dirty puddings) caught in his hand the guinea which Hector chucked at his face. (Sir Walter Scott, *The Antiquary*, 1816)

6. narrow at the equator Hungry, ravenous, famished. In this expression, purportedly used by American cowboys in the Old West, *equator* refers to a person's waist which, in cases of extreme or prolonged hunger, might be narrower than usual.

7. sup with Sir Thomas Gresham To go hungry. London's layabouts and idle poor commonly frequented the Exchange, which was built by Sir Thomas Gresham. Thus, those who had nowhere to dine, or no money with which to dine, were often said to sup with Sir Thomas Gresham. The phrase is not nearly so common as its near synonym *to dine with Duke Humphrey*.

Hurrying . . . See 354. SPEEDING

Hyperbole . . .
 See 128. EXAGGERATION

176. HYPOCRISY
 See also 286. PRETENSE

1. bow the knee to Rimmon To commit an act one knows to be immoral in order to save face; to comply with some reprehensible requirement. The allusion in this expression is to the Biblical story of Naaman asking Elisha's permission to worship the god Rimmon. Naaman, a captain in the service of the king of Syria, was cleansed of leprosy by following Elisha's command to bathe seven times in the River Jordan. Amazed by the miracle, Naaman turned his allegiance from his king's Syrian god to Elisha's Jehovah, but begged Elisha's permission to worship the false god when accompanying his master to the temple.

> In this thing the Lord pardon thy servant, that when my master goeth into the house of Rimmon to worship there, . . . and I bow myself in the house of Rimmon. . . . (II Kings 5:18)

2. butter wouldn't melt in [someone's] mouth An expression used of a person who is less honest in the image he conveys than he appears to be; implies that one should be on guard, for appearances are often deceiving. This expression demonstrates contempt toward a person, especially one of exceedingly innocent demeanor, the reference being to an underlying personality that is so cool and calculating that even butter would not be softened in his mouth.

> She smiles and languishes, you'd think that butter would not melt in her mouth. (Thackeray, *Pendennis*, 1850)

Although the term, which has been in use for well over 400 years, is most commonly used about women, it is occasionally applied to men. The oldest written example recorded in the *OED* employs the masculine form.

> He maketh as thoughe butter wolde not melte in his mouthe. (Palsgrave, *La Langue Francoyse*, 1530)

3. carry fire in one hand and water in the other To be duplicitous, to engage in double-dealing; to be two-faced, to speak with forked tongue. The expression comes from Plautus; it continues "to bear a stone in one hand, a piece of bread in the other." Thus, the expression indicates that a person is prepared to act in totally contradictory ways to achieve his purposes.

4. crocodile tears Pretended or insincere tears, hypocritical weeping, false sorrow. Legend has it that a crocodile sheds tears and moans in order to lure passersby into its clutches, and then, still weeping, devours them. A person who feigns deep sorrow in order to impress

others or gain their sympathy is thus said to cry crocodile tears. This expression, in use since 1563, is found in Shakespeare's *Henry VI, (Part II)*; Gloucester's show:

Beguiles him, as the mournful crocodile
With sorrow snares relenting passengers. (III,i)

5. cupboard love Untrue love; an insincere declaration of love to gain unscrupulous ends; toadying to someone for personal gain. Although the exact source of this expression is unknown, the concept of using love to acquire material gain is obvious. Cupboard love, along with its variant *cream-pot love*, also suggests the use of deceit to gain sensual ends.

Cream-pot love. Such as young fellows pretend to dairy-maids, to get cream and other good things of them. Some say cupboard love. (Ray, *English Proverbs*, 1678)

6. give pap with a hatchet To do or say a kind thing in an unkind way; to administer punishment under the guise of an act of kindness or generosity. This expression derives from the title of an anonymous pamphlet published in 1589 and attributed to John Lyly. The image of an infant being fed with a hatchet gives the phrase its obvious ironic tone. The recipient experiences more harm than good, thus undercutting any illusion of good intentions and suggesting the possibility of duplicity at play.

He that so old seeks for a nurse so young, shall have pap with a hatchet for his comfort. (Alexander Niccoles, *A Discourse of Marriage and Wiving*, 1615)

This expression usually indicates a disparity between reality and appearances, intentions, or expectations.

7. lip service From the lips only, and, therefore, insincere; from the lips, not the heart. This expression dates back to Biblical times; Jesus reproves the Phari-

sees by repeating Isaiah's prophecy about them:

This people draweth nigh unto me with their mouth, and honoreth me with their lips; but their heart is far from me. (Matthew 15:8)

The *OED* lists as the first written example in English:

Pleasing themselves in their lip-service in bearing a part in it. (*Directory for the Public Worship*, 1644)

The phrase is in common use and carries the same connotation today.

Lip service or leadership? What wins the "average" American vote in Middletown, U.S.A. Find out on the first of this six-part series on real people in a real town. (*T.V. Guide*, March 24, 1982)

8. mote in the eye See 186. IMPERFECTION.

9. odor of sanctity See 397. VIRTUOUSNESS.

10. Pecksniffian Hypocritical; used of a canting double dealer who speaks of benevolence and other virtues, but has selfish motives. Mr. Seth Pecksniff is another of the multitude of Charles Dickens's characters whose names have become synonymous with some special personality trait. In *Martin Chuzzlewit* (1843) Pecksniff tries to bully Old Chuzzlewit's adopted daughter Mary into marrying him. However, after falling under the spell of his unctuous insincerity for a number of months, Old Chuzzlewit finally becomes aware of Pecksniff's heartlessness and duplicity, and denounces him publicly, restores Young Chuzzlewit, who has been disowned, to his rightful position, and gives him Mary's hand in marriage. Thus, one who is *Pecksniffian* is one who espouses morality but does not practice it himself.

It seemed to smile a Pecksniffian smile of pity upon her. (Joseph Hatton, *Clytie*, 1874)

11. strain at a gnat and swallow a camel To make a great commotion about an insignificant matter while accepting grave faults and injustices without a murmur; to complain vociferously about minor transgressions while committing deplorable offenses. This expression originated in Christ's castigation of the hypocritical Pharisees:

> Ye blind guides, which strain at a gnat, and swallow a camel. Woe unto you . . . for ye make clean the outside of the cup and platter, but within they are full of extortion and excess. (Matthew 23:24–25)

In this expression, *gnat* alludes to something small and insignificant, while *camel* refers to something large or bulky which is difficult to "swallow" or accept.

> Can we believe that your government strains in good earnest at the petty gnats of schism, when it makes nothing to swallow the Camel heresy of Rome? (John Milton, *Church Government*, 1641)

12. talk out of both sides of [one's] mouth To espouse conflicting, contradictory points of view; to be inconsistent and hypocritical. This expression can be said of one who is two-faced or wishy-washy and afraid to take a stand.

I

177. IDEALISM

1. American dream The vision of attaining maximum security and fulfillment of opportunity as an individual without concern for social distinctions. James Truslow Evans in *The Epic of America* (1931) defined the term as:

. . . not a dream of motor cars and high wages merely, but a dream of a social order in which each man and each woman shall be able to attain the fullest stature of which they are innately capable, and be recognized by others for what they are, regardless of the fortuitous circumstances of birth or position.

The expression first appeared in print in 1835 but has probably been in use since about 1800. Today the term is often heard cynically with an implication of distrust or as a way of characterizing an affluent way of life that often tends toward money madness.

But no California nightmare is without its element of the American Dream: Foat now plans a book about her ordeal and a film company is already working on turning the tale into a movie. (*Time*, November 28, 1983)

2. Cloud-Cuckoo-Land A visionary project; an impractical scheme; a Utopian concept; Shangri-la; an ideal region; a dreamland. Aristophanes in his comedy, *The Birds*, created an imaginary town, *Nephelococcygia*, which, built in the air by the birds, was devised originally to separate the gods from man. *Cloud-Cuckoo-Land* or *Cloud-Cuckoo-Town*, translations of the Greek word, thus came to imply an imaginary paradise, a place where all one's wishes come true.

Wycherly had the saving grace to present his men and women as trammeled by the social restrictions of Cloud-Cuckoo-Land alone. (James Cabell, *Beyond Life*, 1925)

3. hitch [one's] wagon to a star To aim high, to have high ideals, to be idealistic. Ralph Waldo Emerson apparently coined this metaphor which appeared in his *Society and Solitude* (1870):

Now that is the wisdom of a man . . . to hitch his wagon to a star.

4. Jack Armstrong An All-American boy; the ideal young man; a virtuous youth. Jack Armstrong was the protagonist-hero of an afternoon children's radio serial, sponsored by the breakfast cereal Wheaties, during the 1930s. The program, with its opening statement extolling the virtues of the young All-American boy, accompanied by a chorus humming the Wheaties tune in the background, caught the ears of millions Americans, and *Jack Armstrong* soon became a by-word.

5. look through rose-colored glasses To be cheerfully optimistic; to see things in a bright, rosy, favorable light. The color of a rose has long connoted optimism, cheerfulness, and promise.

Oxford was a sort of Utopia to the Captain. . . . He continued . . . to behold towers, and quadrangles, and chapels, . . . through rose-coloured spectacles. (Thomas Hughes, *Tom Brown at Oxford*, 1861)

Implicit in this expression is the suggestion that a rosy view is unwarranted, perhaps even detrimental.

6. Pollyanna An incurable optimist. This expression comes from Eleanor Porter's book, *Pollyanna*, in which the title

character was a cheery little girl whose blitheness and buoyancy raised the spirits of all whom she met. In contemporary usage, however, this term is often applied disparagingly to one who exists in a fool's paradise.

7. rainbow chaser Daydreamer; visionary; one who hopes to achieve the impossible. This term refers to the old superstition that if one can discover the point where a rainbow touches the ground and digs there, he will find a pot of gold. Also, to most civilizations the rainbow has been a symbol of the hope of fulfilling an impossible dream; consequently, anybody who attempts to fulfill some impracticable, optimistic vision is said to be *chasing rainbows*.

The rainbow chasers of the Administration are not idle these days. (Henry Watterson, *Louisville Courier-Journal* October 1, 1892)

8. Walter Mitty In his *The Secret Life of Walter Mitty*, (1939), James Thurber unknowingly contributed an eponym for an idle dreamer. *Walter Mitty* represents a daydreaming idealist who makes his way in a hostile world by avoiding it mentally. He turns irksome situations into fantasy by imagining himself the absolute master of any circumstance. The term has become a jocular appellation for any such person.

Walter Cronkite is a Walter Mitty in reverse: He is a famous man who has fantasies of being ordinary. (Ron Powers, *Playboy*, June 1973)

178. IDLENESS
See also 201. INDOLENCE

1. bench warmer See 363. SUBORDINATION.

2. boondoggle To engage in work of little or no practical value; to look busy while accomplishing nothing.

They boondoggled when there was nothing else to do on the ranch. (*Chicago Tribune*, October 4, 1935)

This U.S. slang term of uncertain origin gained currency in the 1930s with the proliferation of public-sector jobs created to combat the extensive unemployment of the Depression. As a noun the term is still primarily used for windfall government contracts awarded to appease certain constituencies despite the project's questionable value. The *boon* of the term 'a favor or gift freely bestowed' clearly relates to its meaning, but the *doggle* element is puzzling. One source says that *boondoggle* is a Scottish word for a marble received as a gift, without having worked for it.

3. come day, go day, God send Sunday This phrase was coined by the British gentry to describe servants who only "put in their time" so that they might draw their wages and who were careless and apathetic. The expression, coined in the early 17th century, is still used today to characterize a shiftless attitude, sometimes with the additional connotation of extravagance or carelessness about money, as in *easy come, easy go*.

4. goldbrick A shirker, a loafer, a boondoggler, a scrimshanker. Though originally applied as an enlisted man's slang term of disparagement for a second lieutenant appointed from civilian life, probably from the gold bar insignia of these officers, the term is now applied both as a noun and a verb with reference to any who discharge their responsibilities in an inefficient or lackadaisical manner. Its easier sense of 'swindle, cheat' derived from a confidence game in which a brick-shaped block of metal was gold plated and sold to a dupe as solid gold. The senses of shirking and cheating (by not working) are sufficiently close to make the connection self-evident.

In the ranks, billeted with the stinking, cheating, foul-mouthed goldbricks, there were true heroes. (John Steinbeck, *Once There Was War*, 1958)

5. have lead in [one's] pants To think or act very slowly or ponderously; to be lethargic, apathetic, or lazy. The implication here is that one whose pants are weighted down with lead moves very slowly. Several related expressions were used as commands during World War II and for several years thereafter, but are rarely heard today. These include *get the lead out* and *get the lead out of one's pants*.

> She knows I'm in imminent danger of dying of malnutrition unless she takes the lead out of her pants and gets a move on with that picture. (P. G. Wodehouse, *Frozen Assets*, 1964)

6. Mickey Mouse around See 126. EVASIVENESS.

7. monkey around See 237. MISCHIEVOUSNESS.

8. on the beach Unemployed; without a job. This American slang term originally referred to seamen out of work; either retired or unemployed. It is probably an extension of the verb *to beach*, 'to haul [a ship] up on the shore or beach.' The phrase appeared in 1903 in *People of Abyss* by Jack London.

9. rest on [one's] laurels See 57. COMPLACENCY.

10. rest on [one's] oars See 317. RESPITE.

11. sit on [one's] hands To do nothing, especially when the circumstances dictate that action be taken; to withhold applause or to applaud weakly. Originally a theater expression, *sit on one's hands* clearly refers to the fact that one can do no clapping in such a position.

> Well, they were sitting on their hands tonight, all right. Seemed they would never warm up. (Edna Ferber, *Show Boat*, 1926)

By extension then, *sit on one's hands* is often applied figuratively to describe a person's inactivity in a situation where action would be more appropriate.

12. sit there like a Stoughton bottle To sit stolidly without expression; to sit dumbly apathetic; to sit like a bump on a log; to be completely disinterested in what is being said or done. This old New England expression is attributed to an earthenware bottle containing an elixir created by Dr. Richard Stoughton, an apothecary in Southwark, London. Granted *letters patent* in 1712, Dr. Stoughton shipped a great deal of his elixir to the American colonies. After the Revolutionary War, when the *letters patent* were no longer applicable in the colonies, a number of American companies began the manufacture of Stoughton's elixir, thus creating many forms of Stoughton bottles. When empty, the bottles were utilized as footwarmers or doorstops. They became commonplace and conspicuous about the average home, giving rise to the expression *don't sit there like a Stoughton bottle* and its variant, *don't stand there like a Stoughton bottle*.

13. twiddle [one's] thumbs To idle away the time; to be extremely bored. This expression refers to the indolent pastime of twirling one's thumbs around each other while the fingers are clasped together. The common phrase, while occasionally implying a state of involuntary inactivity, more often describes mere goofing off.

> You'd have all the world do nothing half its time but twiddle its thumbs. (Douglas Jerrold, *Mrs. Caudle's Curtain Lecture*, 1846)

179. IGNORANCE
See also 145. FATUOUSNESS; 359. STUPIDITY

1. as a hog does side saddle This American cowboy expression is used of a person who has little understanding of a situation:

> He knows as much about it as a hog does a side saddle. (*American Speech*, December 1927)

or who has little, if any, use, for something:

> He has no more use for it than a hog does a side saddle. (*American Speech*, December 1945)

The term had its inception in the late 19th century.

2. blockhead A dimwit, a numskull. The term comes from the dummy head used by wigmakers and hatters.

3. cork-brained Light-headed; giddy. This phrase plays with the analogy between cork cells, which are dead, airfilled cells, and one's brain. *Corkbrained* appeared in print as early as 1630.

4. dumb Dora Any stupid woman; any dull-witted or ignorant female; a giddy girl. In common use from the early 1900s, this expression achieved its greatest popularity during the era of the flappers, the 1920s. The origin of the word is obscure, with conjectures ranging from it being an allusion to David Copperfield's child wife to the suggestion that it refers to Great Britain's Defense of the Realm Act, or *DORA*, an unpopular emergency act of World War I which many people thought ill-conceived. In any event, the expression is seldom heard today.

5. dunce A dull-witted, stupid person; a dolt, blockhead, or ignoramus. This term makes use of the name of a scholastic theologian of the late 13th century, John Duns Scotus. Originally the term referred to a caviling sophist, derived from the fact that Scotus's doctrines were criticized as a conglomeration of hairsplitting distinctions. Such a person would be full of useless information and perhaps even opposed to progress and learning, as Scotus was regarded.

> A dunce, void of learning but full of books. (Thomas Fuller, *The Holy and Profane State*, 1642)

Dunce also referred to one who is uneducated or incapable of learning.

But now in our age it is grown to be a common proverb in derision, to call such a person as is senseless or without learning a Duns, which is as much as a fool. (Raphael Holinshed, *The First Volume of the Chronicles of England, Scotland, and Ireland*, 1577–87)

Today *dunce* has lost its connotations of overrefinement and pedantry; it means simply 'stupid, doltish, ignorant.'

6. dunderhead A thickheaded, stupid person; a numskull, blockhead, or dullard. The origin of this term is obscure, but it has been speculated that *dunder* is a corruption of the Spanish *redundar* 'to overflow' and is the name given to the lees or dregs of cane juice used in the fermentation of rum. Thus, a "dunderhead" is a head full of dregs, overflowing with this worthless substance. This term has been in use since the early 17th century.

7. hick A greenhorn from the country; lowbrow; ignoramus. This expression is rooted in a peculiarity of speech among the rural population of 16th-century England. A common method of forming nicknames among these people was to substitute *h* sounds for initial *r* sounds, as Hob for Rob, Hodge for Rog, and Hick for Rick. Reflecting this rural practice, the word *hick* came to signify any rustic, and eventually came to connote a bumpkin, especially one who falls prey to city slickers.

> One boob may die, but deathless is
> The royal race of hicks—
> When Ahab went to Ascalon
> They sold him gilded bricks.
> (Don Marquis, *Boob Ballad*, 1922)

A related term, *hick town*, describes any small, rural village, usually isolated from the main stream of progress.

8. Know-Nothing The name of a political faction; an ignoramus; an anti-intellectual; an agnostic. In 1852 a political group known as the American party set as the principal plank in their platform the elimination of immigrant influence on the American political scene by the

adoption of strong naturalization laws and the election of only native-born Americans to office. The name, suggested by the stock answer, "I know nothing," to any questions put to party members about the group's activities, was allegedly coined by E. Z. C. Judson, a leading member of the party. Metaphorical extensions grow out of the original, political sense.

> I am not a Know-Nothing. . . . How could I be? How can anyone who abhors the oppression of Negroes be in favor of degrading classes of white people. (Abraham Lincoln, *Letter to Joshua F. Speed*, August 24, 1855)

9. not know A from a windmill To be extremely ignorant or stupid. This expression is said to have been originally suggested by the similarity between the shape of a capital A and that of a windmill. This theory is further reinforced by the now rare or obsolete definition of windmill found in the *OED:* "a figure of a windmill; a sign or character resembling this, as a cross or asterisk." In popular usage until the late 19th century, the phrase appeared as early as 1402 in the Rolls of Parliament.

10. not know [one's] ass [or *Brit.* arse] from [one's] elbow Not know the first thing about something, not know what's what, completely ignorant or naïve.

> I wish I'd had a crowd like that for my first crew. We none of us knew arse from elbow when they pushed me off. (N. Shute, *Pastoral*, 1944)

11. not know B from a battledore To be illiterate, ignorant, or obtuse. *Battledore* is an obsolete word for a hornbook used as a child's primer. Not to know the letter from the book signified utter ignorance.

> He knew not a B from a battledore nor ever a letter of the book. (John Foxe, *Acts and Monuments of These Latter and Perilous Days*, 1553–87)

Many alliterative variations of the phrase exist, substituting *broomstick*, *bull's foot*, or *buffalo's foot* for *battledore*.

12. not know from Adam Be completely unacquainted with a person; in the dark as to someone's identity; unable to recognize a particular person. Although the source of this expression is uncertain, it seemingly arose from an ancient argument over whether Adam and Eve possessed navels. Many famous paintings depict them with navels, however, it has been argued that they had none, for they were never *in utero*. This anatomical detail was alluded to in 1944, when a number of contributors created *Profile by Gaslight*, a life of Sherlock Holmes. Among the contributions, a Dr. Logan Glendenning set forth a case in which Holmes, after his death, was called upon in heaven to locate Adam and Eve, who had been missing for a great period of time. Holmes located both of them quite readily, for he alone among all the searchers knew the others from Adam— only Adam and Eve were without navels.

> "Who's that fellow?" . . . "Don't know him from Adam." (G. J. Whyte-Melville, *Market Harbor*, 1861)

The French say *Je ne le connais ni d'Eve ni d'Adam*, 'I don't know him either from Eve or from Adam.'

13. not know from Adam's off ox Not have the slightest idea who someone is; in the dark as to someone's identity. The off ox is the one farthest from the driver; therefore, the one with whom he is the least familiar. Furthermore, since the driver can't see the terrain as well where the off ox is walking, the off ox has developed a reputation for being clumsy; hence, a stupid or clumsy person is often referred to as an *off ox*. Beyond that, the off ox is less readily manageable, and, as a result, has also come to connote a stubborn, unmanageable person.

> Ez to the answerin' o' questions, I'm an off ox at bein' druv. (James Russell Lowell, *Biglow Papers*, 1848)

Seemingly, the expression *not know from Adam's off ox* came about through a combination of factors. The well-known phrase, *not know from Adam*, somehow was combined with the words suggesting the unfamiliarity of the driver with the off ox, creating the longer phrase.

> People he didn't know from Adam's off ox were bowing to him. (Clive F. Adams, *And Sudden Death*, 1940)

14. not know if [one] is coming or going See 63. CONFUSION.

15. not know shit from shinola To be totally stupid or ignorant. *Shinola* is the brand name of a shoe polish. The expression is entirely alliterative, and no intentional disparagement of the product is intended. Because of its vulgar origin and implications, the phrase is somewhat limited in written usage.

16. not know which end is up Not know what's going on; ignorant, stupid; totally confused or mixed up.

17. out to lunch Stupid, daft, or flaky; socially incompetent. This expression relates physical absence to mental vacuity. The common phrase often describes a person whose social ineptness or exceedingly poor judgment is owing to a severe lack of common sense.

> A girl who would be attracted to Bud's mean streak and bad temper must be a little out to lunch. (*Toronto Daily Star*, June 1966)

180. IGNORING

1. turn a blind eye To refuse to see something; to be oblivious to; to ignore tactfully; to pretend not to see. The allusion in this expression is to a man with only one good eye; if he wishes to ignore something or someone, he simply turns his blind eye to the object or person.

2. turn a deaf ear See 308. REFUSAL.

181. ILL HEALTH
See also 99. DISCOMFORT

1. charley horse Muscular cramp or stiffness in an arm or, usually, leg. Reliable sources say the origin of this term is unknown. Nevertheless, a story is told of a limping horse named Charley who used to draw a roller in the White Sox baseball park in Chicago. Thus, the (apocryphal) origin of the term is based on the resemblance between the posture of an athlete suffering from a leg cramp and a limping horse.

> Toward the close of the season Mac was affected with a "Charleyhorse" and that ended his ballplaying for 1888. (*Cincinnati Comm. Gazette*, March 17, 1889)

Current today, this North American slang phrase has been popular since the 1880s.

2. climb up May Hill To survive the winter and spring months after suffering a long period of ill health. This British expression alludes to the old belief that surviving through the month of May indicates a passing beyond crisis for the sick and indigent. William Hone in his *Every-day Book* (1825) explains:

> The month of May is called a trying month to persons long ailing with critical complaints. It is common to say, "Ah, he'll never get up May-hill!" or "If he can climb over May-hill he'll do."

The term has been in use since about 1660.

3. collywobbles Dyspepsia accompanied by a rumbling in the intestines; an intestinal disturbance with moderate diarrhea; general indisposition. The *OED* attributes this term to a fantastic formation of *colic*, a stomach upset, and *wobble*, a quaking or trembling. The term has been in use since about 1820.

> He laughingly excused himself on the ground that his songs were calculated to give a white man collywobbles.

(Frank T. Bullen, *Sack of Shakings*, 1901).

4. [one's] days are numbered Dying, almost dead; with little time remaining, nearing the end. This expression is usually used to describe someone who is critically ill and has but a short time to live; so short, in fact, that one could count the days remaining. The phrase is also frequently used to describe the imminent end of anything, particularly one's employment.

5. feed the fishes To be seasick. Herbert Meade used this humorous metaphor in *A Ride through the disturbed districts of New Zealand* (1870):

His first act was to appease the fishes
. . . by feeding them most liberally.

6. a frog in [one's] throat Temporary hoarseness or thickness in the voice; an irritation in the throat. This colloquial expression dates from at least 1909 and is an obvious allusion to the hoarse, throaty croaking of frogs.

7. have been to Barking Creek Said of one troubled by a bad cough, laryngitis, or bronchitis. This British expression from the early 19th century is an obvious pun on the barking sound that emanates from the throat of one who is suffering from a serious chest or throat infection. A related term, which is also a pun on coughing, is a *representative for Berkshire*, pronounced "barkshuh," or a *candidate for Berkshire*.

8. have one foot in the grave Near death, at death's door, dying. This common expression often refers to one afflicted by a lingering, terminal illness.

He has twenty thousand a year . . .
And one foot in the grave. (J. Payn, *Luck Dorrells*, 1886)

9. Hippocratic countenance The look of one who is dying; the emaciated aspect of one who has suffered a long illness. This expression had its inception in the accurate description which Hippocrates, the ancient Greek physician, gave of the

shrunken and livid aspect of the human features immediately preceding death, or when in a state of exhaustion so severe that death appears to be imminent. The term has been in use in English since at least the 17th century.

. . . with a sharp pinched-up nose, hippocratic countenance. (Hanly, *Philosophical Transactions of the Royal Society*, 1770)

A related term, *Hippocratic face*, has the same meaning.

Succeeded by . . . Lethargy, a dismal Hippocratic face, staring eyes. (Spregnell, *Philosophical Transactions of the Royal Society*, 1713)

Another related term, *Austerlitz look*, may be only a nonce word; however, it was used to describe the look of complete discouragement and total exhaustion in British Prime Minister William Pitt's face after he received news of the French victory over the Austrians and Russians at Austerlitz in 1805.

10. in the straw In labor or giving birth; in childbed; pregnant. This expression probably refers to the ancient custom of placing straw on the doorstep of a house to muffle the footsteps of visitors so as not to disturb a woman in parturition. One source, however, suggests that *in the straw* may allude to the straw-filled mattresses once common among the poor.

In the phrase of ladies in the straw, "as well as can be expected." (Thomas DeQuincey, *Confessions of an English Opium-Eater*, 1822)

A related expression said of a woman who has just given birth is *out of the straw*.

11. Montezuma's revenge Diarrhea, particularly when it afflicts foreigners in Mexico. This expression is named for the last Aztec emperor, Montezuma, who lost his empire in 1520 through the trickery of the Spanish conquistadors. American and European tourists in Mexico are still plagued by this condition, perhaps

as a reaction to spicy Mexican food or from dysentery generated by impure water. This expression and some humorous variations appeared in *Western Folklore XXI* (1962):

> The North American in Mexico has coined a number of names for the inevitable dysentery and diarrhea: "Mexican two-step," "Mexican foxtrot," "Mexican toothache," and, less directly if more colorfully, "Montezuma's revenge," the "Curse of Montezuma," and the "Aztec hop."

In keeping with the tradition of *Montezuma's revenge*, various euphemisms for diarrhea have been coined by persons who travel to Egypt, India, Burma, and Japan, as delineated in this citation from an April 1969, *Daily Telegraph:*

> Prevent gippy tummy. Also known as Delhi belly, Rangoon runs, Tokyo trots, Montezuma's revenge.

12. off [one's] feed To be ill; to suffer from loss of appetite; to be depressed or disconsolate. This expression, originally a reference to an ailing horse, usually describes a person whose physical or emotional state effects a repulsion to food.

13. on [one's] last legs Moribund; in a state of exhaustion or near-collapse; about to break down or fail. In this expression, *legs* is usually used figuratively to describe that part of a person, machine, project, or other item which allows it to move forward or continue. *Last legs* implies that the person or object is tired and will be unable to function at all within a short time.

14. on the blink Unwell, in ill health, out of condition; in disrepair, not in working order, *on the fritz*. This common slang expression is of unknown origin. Two possible but highly conjectural theories relate it to the dialectal meaning of *blink* 'milk gone slightly sour,' and to the U.S. fishermen's use of the term for mackerel too young to be marketable.

15. out of sorts See 182. ILL TEMPER.

16. the runs Diarrhea. This slang expression is derived not only from the fluid consistency and movement of the feces, but also from the celerity and frequency with which one so afflicted reaches a bathroom. The phrase is commonplace in both the United States and Great Britain. A similar term is *the trots.*

17. a shadow of [one's] former self See 271. PHYSICAL APPEARANCE.

18. shoot [one's] cookies To vomit. This expression and innumerable variations euphemistically describe the regurgitation of recently eaten food.

> If I'm any judge of color, you're goin' to shoot your cookies. (Raymond Chandler, *Finger Man*, 1934)

Among the more popular variants are *toss one's cookies, shoot one's breakfast* or *lunch* or *dinner* or *supper, return one's breakfast* or *lunch*, etc., *lose one's breakfast* or *lunch*, etc., *blow lunch, spiff one's biscuits*, etc.

19. shoot the cat To vomit, especially as a result of excessive alcoholic indulgence. This British colloquialism alludes to a cat's purported tendency to vomit frequently.

> I'm cursedly inclined to shoot the cat. (Frederick Marryat, *The King's Own*, 1830)

Variations include *cat, jerk the cat, whip the cat*, and *sick as a cat.*

20. under the weather Not feeling well, ill; intoxicated; hung over. This expression is derived from the common but unproven belief that atmospheric conditions and health are directly correlated. The phrase usually suggests the affliction of minor ailments.

> They have been very well as a general thing, although now and then they might have been under the weather for a day or two. (Frank R. Stockton, *Borrowed Month*, 1887)

The expression is often extended to include drunkenness and its after-effects.

182. ILL TEMPER
See also 21. ANGER;
158. FURY

1. get up on the wrong side of the bed To be grouchy, peevish, or ill-tempered. Most probably this is another holdover from ancient superstitions associating the right side with good omens and fortune, the left with evil and ill luck. The transference to temperament and mode of arising is centuries old:

> Thou rose not on thy right side, or else blest thee not well. (*Gammer Gurton*, 1575)

2. have a worm in [one's] tongue To be quarrelsome or dyspeptic; to be irritable or grouchy. Dogs suffering from worms are unfriendly and disagreeable just as one with a figurative "wormy" tongue is spiteful and surly. This obsolete expression was used by Samuel Butler in *Upon Modern Critics*:

> There is one easy artifice
> That seldom has been known to
> miss—
> To snarl at all things right or wrong,
> Like a mad dog that has a worm in 's
> tongue.

3. like a bear with a sore head Irritable, peevish; in a disagreeable mood. The analogy here is self-evident:

> He grumbles and growls like a bear with a sore head. (John Davis, *Travels*, 1803)

This phrase seems to have been shortened at some point to the more common *sorehead*.

4. out of sorts Irritable, short-tempered; low-spirited, depressed; under the weather, slightly unhealthy. The origin of this expression is unknown. Some speculate that it derives from the literal typographical *out of sorts* meaning 'out of type.' Only a considerable stretch of the imagination renders this explanation plausible. *Out of sorts* has been popular since the early 17th century.

> He was extremely out of sorts because there was some company in the room who did not please him. (Madame D'Arblay, *The Early Diary of Frances Burney*, 1775)

This expression can also refer to things and situations, implying that something is amiss or not functioning properly.

5. serpent's tongue A shrewish disposition; a tendency toward vicious, vitriolic speech marked by scathing sarcasm. This expression appeared in Shakespeare's *A Midsummer Night's Dream* (V,i):

> Now to scape the Serpent's tongue,
> We will make amends ere long.

This phrase, clearly referring to a snake's forked tongue, was frequently employed in 18th- and 19th-century poetry.

> She is not old, she is not young,
> This woman with the serpent's
> tongue.
> (Sir William Watson, *The Prince's Quest*, 1880)

6. sorehead A poor loser; one who is disgruntled or dissatisfied. The term seems to be an abbreviated version of the phrase *like a bear with a sore head*. The current meaning of this word is said to have come into use during the presidential campaign of 1848.

7. take the pet To take offense at; to feel offended; to become ill-tempered or ill-humored; to sulk; to go into a fit of pique. The origin of this expression is obscure. One explanation proffered points to a meaning of the word *pet* to designate a spoiled child. Whatever the case, the term has been in use since the end of the 16th century. The variants, *on the pet* or *on a pet* indicate one who is in a peevish mood or in a fit of bad temper.

> But at his naming of the net,
> Venus had certainly took pet.
> (Thomas D'Urfey, *Stories Moral and Comical*, 1709)

2nd Edition □ 349

Illegality . . . See 76. CRIMINALITY

Illness . . . See 181. ILL HEALTH

183. ILLUSION

1. Barmecide feast An illusion of plenty; any illusion. In *The Arabian Nights*, Barmecide, a wealthy Persian noble, invited the beggar Schacabac to dine with him at a banquet table laden with dishes, all empty of food. The host feigned indulgence in the illusionary banquet, and when the beggar followed suit with gusto, Barmecide repented of his joke and served the pauper a sumptuous repast. This latter aspect of the story does not figure into the meaning of the phrase; *Barmecide feast* retains only that aspect of the story dealing with the nonexistent fare.

2. basswood ham A piece of wood cut and wrapped to give the appearance of a ham; any fake piece of merchandise. This term arises from a practice of Yankee peddlers in the early 1800s. Pieces of basswood, a soft, light-colored wood, were cut in the shape of whole hams, wrapped heavily and sent off to various parts of the country, especially the South. The practice was not limited to fake hams, however, for there were also *basswood buttons* and *basswood pumpkin seeds*. In time the term came to indicate anything counterfeit or fraudulent; a man who was guilty of bigamy became known as a *basswood Mormon*. These expressions are seldom heard today.

> I want to see how many wooden nutmegs, horn flints, and basswood hams have been made and sent to the South since the last census.
> (*Congressional Globe*, April 30, 1850)

3. cast beyond the moon To indulge in fanciful, outlandish thoughts about the future; to imagine the impossible. One definition of *cast* is 'to calculate or conjecture, to anticipate, to forecast' (*OED*). The moon was considered a mysterious force of inexplicable power. *Beyond the moon* reinforces the idea of a realm where nothing is impossible. The phrase appeared as early as the mid-16th century.

> But oh, I talk of things impossible,
> and cast beyond the moon. (Thomas Heywood, *A Woman Killed with Kindness*, 1607)

4. castles in Spain Fanciful notion; pipe dream—the opposite of all that is practical, reasonable, and grounded in common sense. The phrase appeared in English in *The Romance of the Rose* (approx. 1400).

> Thou shalt make castles then in Spain,
> And dream of joy, all but in vain.

Château en Espagne, the French equivalent, dates from the 13th century. The *OED* attributes the reference to Spain to the fact that it represents a "foreign country where one had no standing-ground." *Spain* was superseded by the now current *air* or *sky*.

5. castles in the air Visionary projects; daydreams or fantasies; impractical, romantic, or whimsical schemes; half-baked ideas without solid foundation. This phrase, common since 1575, is equivalent to *castles in the sky*.

> Things are thought, which never yet
> were wrought,
> And castles built above in lofty skies.
> (George Gascoigne, *The Steele Glas*, 1575)

6. Fata Morgana See 118. ENTICEMENT.

7. fool's paradise A self-deceptive state of contentment or bliss; a mental condition in which one's happiness is generated by delusions and false hopes. The expression is derived from the Latin *limbus fatuorum*, a quasilimbo where the mentally feeble went after death. The phrase has evolved to mean the fantasy world inhabited by certain daft individuals.

> You have been revelling in a fool's paradise of leisure. (James Beresford, *The Miseries of Human Life*, 1807)

8. man on horseback A deceiving or misleading hero; a man of straw; a fraudulent savior. This expression arises from the actions of one General George Ernest Jean Marie Boulanger, who, after his appointment as the French minister of war in 1886, became known as the *man on horseback*. The general, through his spectacular exhibitions on his splendid horse, aroused the emotions of the French crowds. Touted as the only man who could regain for France the glory lost in the Franco-Prussian War, the general proved to be something of a demagogue, a pawn in the hands of political manipulators, and the movement which bore his name soon faded for lack of a leader. *Men on horseback* have appeared in other countries, but like General Boulanger's, their movements have collapsed from lack of leadership.

> What a 'man on horseback' is to certain Frenchmen, a self-perpetuating President is to the vast masses of Americans. (*The Times,* February 9, 1927)

9. pie in the sky An illusion of future benefits and blessings which will never be realized; an unattainable state of happiness or utopia. This expression, probably alluding to the concept of *pie* as something sweet and desirable, and *sky* as in the air, beyond one's reach, was popularized in a World War I song often attributed to Joe Hill (1872–1915):

> You will eat, bye and bye,
> In the glorious land above the sky!
> Work and pray,
> Live on hay,
> You'll get pie in the sky when you die!

10. pipe dream An unrealistic and often fantastic plan, goal, or idea. One source suggests that this expression alludes to the dreams and schemes which may inspire an opium addict after he has smoked a pipeful of the drug.

11. tilt at windmills To combat imaginary evils, to fight opponents or injustices that are merely the figments of an overactive imagination. The allusion is to Cervantes' *Don Quixote de la Mancha,* in which the hero Don Quixote imagines the windmills he has come upon to be giants and proceeds to do battle, with the result that both the knight and his horse are injured and his lance destroyed. At this Quixote's squire Sancho Panza says that anyone who mistakes windmills for giants must have windmills in his head, i.e., suffer delusions, be crazy. The equivalent French phrase is *se battre contre les moulins à vent*. A variant of the expression appeared in Frederic W. Farrar's book on Christ:

> Dr. Edersheim is again—so far as I am concerned—fighting a windmill.

12. will-o'-the-wisp An illusive hope; a quixotic scheme; a phosphorescent marsh light. The reference in this term is to a mischievous marsh sprite who supposedly leads night travelers astray. The actual cause of the light is attributed to the spontaneous combustion of marsh gas emanating from decaying matter. When approached, the *will-o'-the-wisp* disappears only to reappear in another location, thus beguiling those who try to follow it.

> Proof positive that we have been on the wrong scent and running after a "Will-o-the-Wisp." (William Greener, *Gunnery in 1858,* 1858)

There are numerous variants for the term, many of them localisms that have been incorporated into the common vocabulary: *ignis fatuus* or *foolish fire, Spunkie, walking fire, Friar's Lanthorn, Fair Maid of Ireland,* and *Jack-a-lantern* or *Jack with a lantern.*

> Partridge . . . firmly believed . . . that this light was a Jack with a lantern, or somewhat more mischievous. (Henry Fielding, *Tom Jones,* 1749)

Illustriousness . . . See 144. FAME

Imbecility . . . See 359. STUPIDITY

Imbibing . . . See 382. TIPPLING

Imitation . . . See 346. SIMILARITY

Immaturity . . .
See 204. INEXPERIENCE

Immediacy . . .
See 212. INSTANTANEOUSNESS

Immoderation . . .
See 130. EXCESSIVENESS

Impartiality . . . See 142. FAIRNESS

184. IMPATIENCE
See also 22. ANXIETY

1. **champ at the bit** To show impatience; to wait restlessly or anxiously to begin. This expression, in figurative use since 1645, refers to the way a horse, eager to be off, chews on the bit in his mouth and stamps the ground with his hooves. Similar phrases with the same meaning are *to bite the bridle*, used figuratively since 1514, and *to strain at the leash*.

2. **cool [one's] heels** To impatiently await the promised and supposedly imminent arrival of one or more persons, especially when the arrival has been intentionally and rudely delayed. Dating from the early 1600s, this expression is an allusion to the fact that one's feet, hot from walking, are cooled by waiting in a stationary position.

Well, if we're not ready, they'll have to wait—won't do them any harm to cool their heels a bit. (John Galsworthy, *Strife*, 1909)

3. **money burns a hole in [one's] pocket** This expression, used only in reference to money, indicates that the owner is so impatient to spend what he has accumulated that the money actually feels hot; he must take it out and spend it quickly before it falls through the hole it is creating, and lost. The origin of the phrase, in use since the early 1500s, is obscure.

A man who has more money about him than he requires . . . is tempted to spend it. . . . It is apt to "burn a hole in his pocket." (Samuel Smiles, *Thrift*, 1875)

Another form of the phrase, *money burns a hole in [one's] purse*, although somewhat dated, is still heard occasionally.

4. **need it yesterday** Need it immediately if not sooner; want it now, without any delay. This modern business expression is spoken as a goad to prompt action. It is usually uttered by customers or bosses who seem to expect something to be done as soon as the words leave their mouths.

5. **sit upon hot cockles** To be very impatient or restive; to be on pins and needles. "Hot Cockles" is the name of an ancient children's game in which a blindfolded child tried to guess who had just struck him on the buttocks. Since *sit upon* can mean 'to await' or 'to be seated upon,' to *sit upon hot cockles* probably alludes either to one's fidgety anticipation of the blow, or to the squirming discomfort of one who sits down after having been struck by an enthusiastic player.

He laughs and kicks like Chrysippus when he saw an ass eat figs; and sits upon hot cockles till it be blazed abroad. (Thomas Walkington, *The Optick Glasse of Humors*, 1607)

6. **soft fire makes sweet malt** A proverbial expression meaning that reckless hurriedness often spoils an undertaking or project.

Soft fire, They say, does make sweet Malt, Good Squire. (Samuel Butler, *Hudibras*, 1663)

Malt is burnt and its sweetness lost by too intense a fire. This expression, synonymous with the common phrase *haste makes waste*, is now rarely heard.

7. **Sooner** One who acts prematurely to gain an unfair advantage; one who settles on government land before it is le-

gally open to claiming rights; a citizen of the state of Oklahoma. In the late 1800s the United States government proclaimed that federal territory in parts of Oklahoma would be thrown open to claim by those who were willing to settle permanently. A few tried to enter covertly and set up their claims on the choice pieces of land by moving in "sooner" than the officially proclaimed date, April 22, 1889.

> Then there were the "Sooners," who sneaked in too soon. . . . Most of these would-be settlers lost their claims but gave Oklahoma its nickname, the "Sooner State." (*Story of the Great American West*, 1977)

The term has stuck both as a nickname for Oklahomans and as a figurative expression for one who acts hastily or prematurely.

8. tirl at the pin To rattle the door latch to gain admittance; to demonstrate impatience; to try to hurry someone. The reference in this phrase, in use as early as 1500, is to *pin*, i.e., the latch of a door which is lifted to gain entrance. When the pin is in a locked position, one *tirls* or rattles the latch to gain the occupants' attention; thus, the variant *tirl at the latch*.

> She tirled fretfully at the pin, the servant maid opened, and we went within. (Samuel Crockett, *The Men of the Moss-Hags*, 1895)

The expression is also used figuratively to refer to someone acting impatiently.

9. a watched pot never boils Wishing will not make it so; anxiety never hastens matters. This proverbial expression, usually said to one who is exhibiting impatience, has become so trite that it has lost much of its impact.

> A watched pot never boils, they say only this one finally did. (Clare Boothe, *Europe in the Spring*, 1940)

Ogden Nash parodied the term in the title of one of his poems, "A Watched Example Never Boils" (1936).

185. IMPEDIMENT
See also **96. DIFFICULTY;**
281. PREDICAMENT;
379. THWARTING

1. albatross around the neck See **40. BURDEN.**

2. ball and chain See **40. BURDEN.**

3. bamboo curtain An invisible barrier of secrecy and censorship separating Communist China from the remainder of the world.

> The Communist bosses of Peiping dropped a bamboo curtain cutting off Peiping from the world. (*Time*, March 14, 1949)

After Mao Tse-Tung had successfully completed his revolution against the Republic of China and had achieved control of the entire country, he cut off all contact with the Western world, thus creating the so-called *bamboo curtain*, a term probably coined on analogy with *iron curtain*, used of Eastern Europe.

4. bottleneck A narrow passage; an impasse; congestion or constriction; a traffic jam. The reference is to the thin, narrow neck of a bottle, which is necessarily constrictive. By extension, the word is used for any point at which passage or flow becomes impeded because the volume of a larger area must move into a smaller. The equivalent French term is *embouteillage*. The word appeared in print by 1907 in the *Westminster Gazette*.

5. break the egg in [someone's] pocket To spoil somebody's plan; to create an obstacle in someone's path. This expression, dating from the early 18th century, is obvious in its implication: a broken egg in one's pocket would undoubtedly prove disconcerting enough to slow him down.

> This very circumstance . . . broke the egg . . . in the pocket of the Whigs. (Roger North, *Examen*, 1734)

6. choke-pear Something difficult or impossible to "swallow"; something "hard to take"; a difficulty. The figurative sense of this term is an extension of its literal meaning, i.e., a variety of pear with a harsh, bitter taste. Samuel Collins used the expression in *Epphata to F.T.* (1617):

> S. Austens testimony . . . is a chokepear that you cannot swallow.

The term has been used literally since 1530 and figuratively since 1573.

7. cooling card Anything that diminishes or lessens a person's ardor or enthusiasm; a damper. According to the *OED*, *cooling card* is apparently a term of some unknown game and is used figuratively or punningly with the meaning above. This expression, now obsolete, dates from 1577. In Henry Dircks' *Life*, the Marquis of Worcester is quoted as using it thus in 1664:

> It would . . . prove a cooling card to many, whose zeal otherwise would transport them.

8. cramp [someone's] style To inhibit another's freedom of expression or action; to make someone feel ill-at-ease and self-conscious; to have a dampening effect on another's spirits. The person who cramps another's style usually does so by his mere presence or the attitudes he embodies, rather than by explicit word or overt action. Impersonal forces such as rules or procedures also can cramp a person's style.

9. derby dog Something that gets in the way; an interruption that is sure to occur; a hindrance; an obstruction. On Derby Day at Epsom Downs, as soon as the race course is cleared, it seems inevitable that a stray dog wanders out on the course, thus stalling the beginning of the race. The reliability of such an action has brought about the figurative implication of this term, which has been in use since the 1870s.

10. fly in the ointment A triviality which ruins an otherwise enjoyable occasion; a negative element or consideration. The Biblical origin of this expression appears in Ecclesiastes (10:1):

> Dead flies cause the ointment of the apothecary to send forth a stinking savour.

In modern usage, the phrase also implies minor inconvenience or untimeliness:

> The present situation is not without its 'fly in the ointment' for those motorists who have patriotically lent the assistance of their cars to the military authorities. (*Scotsman*, September 1914)

11. iron curtain A term used to describe the dividing line between Communist Eastern Europe and the democracies of western Europe. Originally attributed to Winston Churchill from his speech at Westminster College, Fulton, Missouri in 1946, the term became the center of a controversy when Sir Vincent Trowbridge, in a letter to *Notes and Queries*, January 1948, revealed that he had used the expression in a *Sunday Empire News* article in October 1945. However, John Lukacs resolved the dispute in his *Great Powers and Eastern Europe* (1953). He revealed that the German Propaganda Minister Joseph Goebbels had made use of the term in an editorial in *Das Reich*, February 23, 1945.

> An iron curtain [*eisenen Vorhang*] would at once descend on this territory, which including the Soviet Union, would be of tremendous dimension.

The original use of the expression was literal and can be traced to the late 18th century when an actual iron curtain was installed in some theaters in Europe, to be lowered across the stage to protect the audience in case of fire.

12. a new wrinkle See 8. ADVANCEMENT.

13. pratfall A fall on one's buttocks; a humiliating blunder; a danger that lies in one's path. This expression is derived

from show business lingo. In both the burlesque show and the circus, the *pratfall*, a sudden and unepected loss of one's balance and footing, is a common device used by slapstick comedians and clowns to get laughs. By extension the term has developed the figurative connotation of a trap one must avoid or an obstacle that may trip one up.

> On the principles and pratfalls of the rhyming racket. . . . (Billy Rose, syndicated newspaper column, January 9, 1950)

14. red tape See 59. COMPLICATION.

15. skeleton at the feast A source of gloom or sadness at an otherwise festive occasion; a wet blanket, a party pooper; something that acts as a reminder that life holds sorrow as well as joy. According to the *Moralia*, a collection of essays by Plutarch (A.D. circa 46–120), the Egyptians always placed a skeleton at their banquet tables to remind the revelers of their mortality.

> The skeleton of ennui sat at these dreary feasts; and it was not even crowned with roses. (George Lawrence, *Guy Livingstone*, 1857)

It was also common practice for many monastic orders to place a skull or death's head on the refectory table to remind those present of their mortality.

16. there's the rub Said of an impediment, hindrance, or stumbling-block, especially one of an abstract nature; the crux of a problem. In this expression, *rub* alludes to the rubbing of a spoon inside a mixing bowl, an occurrence which interferes with smooth stirring. Although *rub* in this sense had been in use for some time before Shakespeare, he popularized the phrase by incorporating it into Hamlet's famous soliloquy:

> To be, or not to be: that is the question . . .
> To sleep: perchance to dream: ay, there's the rub. (III,i)

A variation is *here lies the rub*.

17. third wheel See 366. SUPERFULOUS-NESS.

18. wet blanket A discouraging or dampening influence on others' enjoyment of a party or similar pleasurable occasion; a person who is habitually grouchy or depressed; a killjoy, party pooper, spoilsport. Literally, a wet blanket is one that has been soaked in water and is used to smother or quench a fire. The figurative implications are obvious.

> Sometimes he called her a wet blanket, when she thus dampened his ardor. (Margaret Oliphant, *Annals of a Publishing House*, 1897)

186. IMPERFECTION

1. crack'd in the ring Flawed or imperfect at the perimeter or edge; of little value or use; (of women) nonvirginal. This expression, popular during Elizabethan times, is no longer used today. It was limited in application to money, artillery, and (figuratively) to women.

2. diamond in the rough One whose unrefined external appearance or ungraceful behavior belies a good or gentle character and innate value. This expression derives from the disparity between a diamond in its natural state, before being cut and polished, and in its refined state, when it has become an impressive gem. Analogously, graceful manners and social amenities can be learned. *Diamond in the rough* dates from the early 17th century.

3. every bean has its black Every man has a weak side; no man is without fault. The reference in this expression is to the small black spot which appears on every bean where it is attached to the pod. The expression is often used to indicate that a good man should be excused for an occasional transgression. Nathan Bailey explains in *Divers Proverbs* (1721):

> Every bean has its black. This is an excusatory proverb for the common failings of mankind; and intimates

that there is no man perfect in all points.

4. feet of clay An unforeseen blemish in the character of a person hitherto held above reproach.

The woman . . . finds that her goldenheaded god has got an iron body and feet of clay. (Anthony Trollope, *Fortnightly Review*, 1865)

This expression originated with Daniel's interpretation of Nebuchadnezzar's dream in the Old Testament (Daniel 2:31–45). The Babylonian king had dreamed of an image completely made of precious metals, except for its feet, which were made of clay and iron. Daniel explained that the feet represented man's vulnerability to weakness and destruction.

5. Homer sometimes nods An erudite way of saying, "Nobody's perfect." The expression is often used to indicate that a generally good artistic performance or endeavor has fallen below expectations at points. The phrase's origin lies in lines from Horace's *Ars Poetica*, usually translated as: "I think it shame when the worthy Homer nods; but in so long a work it is allowable if drowsiness comes on."

6. mote in the eye A fault or imperfection observed in a person by one who is guilty of something equally or more objectionable. This phrase comes from Matthew 7:3:

And why beholdest thou the mote that is in thy brother's eye, but considerest not the beam that is in thine own eye.

Mote refers to a small particle, as a bit of sawdust; *beam* refers to a glance, or eyebeam, formerly thought to be emitted from, rather than received by the eye. Shakespeare makes use of the allusion in *Love's Labour's Lost:*

You found his mote, the King your mote did see,
But I a beam do find in each of three.
(IV,iii)

An analogous proverbial exhortation is "People who live in glass houses shouldn't throw stones."

7. peacock's feet A flaw in an otherwise perfect thing; a bit of ugliness within a thing of beauty. According to an East Indian legend, the peacock originally had beautiful feet and legs to match the rest of his body, but he was cheated out of them by a partridge that convinced the peacock to switch with him during a dancing contest; however, the partridge flew away without returning the peacock's feet. Thus, the peacock continually mourns his loss, which explains the origin of an old Indian proverb, *The peacock looking at his feet wept.*

People are crying up the rich and variegated plumage of the peacock, and he is himself blushing at the sight of his ugly feet. (Sa'di, *Gulistan*, 1258)

8. a rift in the lute A flaw or imperfection, particularly one that endangers the integrity of the whole; the one rotten apple that spoils the whole barrel. The expression, more familiar to British than American ears, comes from Alfred, Lord Tennyson's *Idylls of the King* (1885):

It is the little rift within the lute,
That by and by will make the music mute,
And ever widening slowly silence all.

9. rough edges Characteristics or manners indicating a lack of polish, refinement, or completion. Use of *rough* meaning 'lacking in culture or refinement' dates from at least the time of Shakespeare. It is difficult to pinpoint exactly when *edges*, probably originally referring to the edges of sawed lumber which have not been trimmed or sized, was added to make the new phrase. In current use, *corners* is a common variant of *edges*.

Impermanance . . .
See 151. FLIMSINESS

187. IMPETUOUSNESS

1. cast [one's] heels in [one's] neck To leap in recklessly; plunge headlong. This expression, in use since at least the 16th century, connotes a hearty recklessness, an eager desire to be involved. The idea here is that one leaps forward so forcefully and runs so rapidly that his heels fly up as high as his neck.

> His yeomen bold cast their heels in their neck, and frisked it after him. (Thomas Nash, *Lenten Stuff*, 1599)

2. early days Premature, overhasty; too early or soon; jumping the gun. In use since the 16th century, this British expression has a self-evident meaning but may sound awkward to American ears.

> As regards the current year, it is early days to express any considered opinion, but trading conditions are bad. (*The Times*, December 23, 1957)

3. fools rush in To act in ignorance of the consequences; to want something so badly that danger is not a deterrent. This phrase, coined by Alexander Pope in *An Essay on Criticism* (1709), is frequently misrepresented as an expression of man's stupidity.

> Nay, fly to altars; there they'll talk you dead;
> For fools rush in where angels fear to tread.

In actuality Pope is criticizing those pompous people who designate themselves authorities but are really ignorant about their chosen field. O. Henry, in *The Moment of Victory* (1904), has it both ways:

> A kind of mixture of fools and angels—they rush in and fear to tread at the same time.

In modern parlance the expression is usually heard as a comment characterizing a foolish action.

4. from the hip Impulsively, impetuously, without preparation or thought; spontaneously, extempore. This expression is an abbreviated version of *to shoot from the hip*, literally to fire a handgun from the hip immediately upon drawing it from the holster and without taking careful aim.

> . . . second thoughts about letting their man shoot from the hip quite so much as his nature prompted him to. (R. L. Maullin as quoted in *Webster's 6,000*)

5. go off at half-cock To start prematurely; to leave unprepared; to act rashly, impetuously, or ill-advisedly; also, *go off half-cocked*. In this expression, *half-cock* refers to a position of a gun's hammer which renders the weapon inoperable; thus, one is unprepared if the gun happens to go off at half-cock. Figuratively, the phrase implies acting on a whim with no preparatory measures.

> Poor Doctor Jim! What disasters he brought down upon his country and his company by going off at half-cock. (*Westminster Gazette*, January 1896)

Half-cocked is used adjectivally to mean 'ill-prepared, ill-considered' and by extension 'foolish, silly, inane.'

6. head over heels See 214. INTENSITY.

7. jump the gun To begin prematurely; to start early with the prospect of gaining an advantage. This expression's origin lies in the false starts made by runners before the firing of the pistol that signals the race's start. The phrase maintains common usage in the United States and Great Britain.

> The Prime Minister has jumped the gun by announcing that it will take the form of government advances to building societies. (*Economist*, November 1958)

8. knee jerk An automatic response, especially one arrived at without due deliberation; an involuntary response. Sir Ernest Gowers attributes the origin of this phrase to his father's tenacity. A young neurologist in 1878, Dr. Gowers discovered the involuntary kick caused by a sharp rap of the tendon just below the knee cap. He insisted the lay term,

knee jerk, be adopted rather than the technical-sounding *patellar reflex*. He prevailed. The application of the phrase has generalized from the original medical usage, and now is frequently used adjectivally to mean 'so automatic as to be unfailingly predictable.'

The ABM decision can be seen . . . as one more gesture to the knee jerk hawks in the Congress. (William Jackson, *New Republic*, October 28, 1967)

9. on the spur of the moment See 355. SPONTANEITY.

10. pell-mell In a recklessly hurried fashion; in a confused or disordered manner. This expression is derived from the medieval French sport *pelle-melle*, in which the object was to knock a ball through a hoop suspended at the end of an alley. Known as *pall-mall* in England, this sport involved much reckless, headlong rushing of the players into the alley, inspiring the coinage of the term *pell-mell* to describe this frenzied scurrying.

We were an absurd party of zealots, rushing pell-mell upon the floes with vastly more energy than discretion. (Elisha Kane, *The U.S. Grinnell [First?] Expedition in Search of Sir John Franklin*, 1853)

11. take the ball before the bound See 17. ALERTNESS.

12. trigger-happy Impetuous, reckless, rash, irresponsible; overanxious, over-eager; overly critical, quick to point out mistakes and faults in others. This term originally referred to an overeager gunman just itching to pull the trigger of his gun and cut somebody down. The term has since become generalized and is now applied to anyone inclined to hasty or ill-advised actions.

Impishness . . .
See 237. MISCHIEVOUSNESS

Implication . . .
See 217. INVOLVEMENT

Importance . . .
See 234. MEANINGFULNESS

Importunity . . .
See 352. SOLICITATION

188. IMPROBABILITY

1. as a pig loves marjoram Not at all. This now rarely heard emphatic rejoinder derives from the maxim of the Roman poet Lucretius: *Amaricinum fugitat sus* 'swine shun marjoram.'

2. Chinaman's chance No chance at all; little or no prospect of gaining, achieving, or reaching one's immediate goal; the near certainty of being thwarted. It is assumed that the phrase derives from the days of the California gold rush (1849) when the Chinese immigrants were victims of discrimination and ill-treatment. Minorities, specifically the Chinese, were denied the opportunity of "striking it rich" and partaking of the "American Dream."

3. dark horse An unlikely winner, a long shot; an unfamiliar or unexpected candidate for political office; a person whose abilities and potential are unknown. The term originally referred to a horse whose ability and promise were kept secret until the day of the race. The evolution of the phrase's figurative meaning in American politics is obvious. A political candidate whose nomination is the result of a compromise is often called a *dark horse*.

4. extracting sunbeams out of cucumbers To attempt the impractical; to spin idle dreams; to indulge in fanciful notions; to plan unrealistically; to fantasize. This expression can be traced directly to Jonathan Swift's satire, *Gulliver's Travels* (1726). When Gulliver visits Lagado, the capital of the Land of Balnibarbi, he discovers all the people at

the Grand Academy are engaged in impractical pursuits of some type.

> He had been eight years upon a project for extracting sunbeams out of cucumbers, which were to be put in vials, hermetically sealed, and let out to warm the air in raw inclement summers.

The expression is seldom heard today.

5. finish Aladdin's window To attempt a task beyond human capacity; to try something verging on the impossible. This expression alludes to the unfinished window left by the jinni of the lamp in *The Arabian Nights*. The sultan's palace, built by the jinni, had 24 windows, all framed in precious stones, save one, which was left for the sultan to finish. He depleted his treasury, but was unable to complete the window. The expression has been in use since the early 18th century.

6. in a pig's eye No way; not on your life; fat chance. The phrase carries the conviction of absolute certainty, in the negative sense; it is often spoken with a degree of disgust or contentiousness, in response to another's expression of optimism or likelihood. No origin or explanation of this frequently used phrase has been found. A remote possibility is that it relates to a once popular shipboard game "placing the pig's eye," in which the figure of a pig was outlined on the deck, and blindfolded players had to place an object representative of a pig's eye in the proper anatomical position. Their chances of success were slim at best.

7. not a ghost of a chance Extremely unlikely; little likelihood; little or no prospect of achieving one's ends. Since a ghost is only an insubstantial image, a shadowy outline of something, this expression connotes that one's chances of success are rather insubstantial, flimsy at best. The phrase, which originated about 1850, remains in current use.

Says Hooks: "I don't think a black candidate has a ghost of a chance." (*Time*, August 22, 1983)

8. a snowball's chance in hell No chance at all, absolutely no possibility; also, *a snowflake's chance in hell;* usually in the phrase *as much chance as a snowball in hell.* This self-evident American slang expression has been in use since 1931.

189. IMPROPRIETY
See also
389. UNSCRUPULOUSNESS

1. bawdy basket A vendor, usually female, of indecent literature, ballads, cheap jewelry, etc.; a thief; a harlot. A group of women thieves, who thrived in England during the 1500s, became known as *bawdy baskets* from their practice of disguising their real occupation by carrying cloth-covered baskets from which they hawked obscene wares. These women, who often practiced prostitution to supplement their incomes, came to be associated with moral slackness, so that by the 17th century the term had come to indicate a harlot.

> . . . and she is called *A Bawdy Basket* . . . they are faire-spoken, and will seldome sweare whilst they are selling their waires; but will lye with any man that hath a mind to their commodities. (Thomas Dekker, *The Belman of London*, 1608)

2. beyond the pale Beyond the limits of propriety or courtesy; outside the bounds of civilized behavior. The word *pale* comes from the Latin *palus* 'stake' (cf. *palisade*), hence an enclosing or confining barrier; limits or boundaries. The phrase originally had a more literal meaning (still sometimes used today) 'outside an enclosed area' and by extension, 'outside one's jurisdiction or territory.'

3. blot [one's] copy book To commit a *faux pas*; to create a blemish upon one's moral character; to make a bad impres-

sion. This British expression implies a relationship between the copy book which one keeps in grammar school and one's moral character.

4. crash the gate To attend a social function without an invitation; to enter a place of public entertainment without paying admission; to intrude upon others. Why the verb *crash* is used in this phrase is unclear; the image created by this expression is quite different from the action itself: one attempts to *crash a gate* quietly so as to create no disturbance whatsoever. The phrase came into use about 1920.

> Even the discovery of Jerry Murphy and Pete Kift, who were sitting in back of us and declared they had crashed the gate, failed to depress me. (Harry C. Witwer, *Roughly Speaking*, 1925)

The related terms *gate-crasher*, one who enters without an invitation or without paying admission, and *gate-crashing*, the act of entering surreptitiously, are in current use. In modern usage, the phrase has given way to just *crash*, so that now use is made, for instance, of *crash the party*, 'attend a party without having been invited.'

5. cross [someone's] bows See 394. VEXATION.

6. do you know Dr. Wright of Norwich? A mildly sarcastic comment made to someone at a dinner party who does not pass the decanter, preventing other guests from helping themselves to wine. The popular story which gives the background for this British expression involves a man known as Dr. Wright of Norwich, a charming guest and gifted conversationalist. Asking a dinner guest, "Do you know Dr. Wright of Norwich?" implies that the person is holding up the decanter, as Dr. Wright was wont to do, but unlike the good Doctor, not compensating for this breach of manners by entertaining the company with enlivening conversation.

7. near the knuckle Near the limits of decency; slightly indecent; *near the bone*. This late 19th-century British expression is derived from a catch phrase with its roots in the 16th century, *the nearer the bone the sweeter the meat*, a slightly indecent saying that men use to describe the sexual attributes of a thin woman. By transference, the expression *near the knuckle*, adapted from *near the bone*, came to imply anyone or anything that approached indecency.

> A series of articles entitled 'Crimes of Passion', full of abominable details as near the knuckle as the police would allow. (*Westminster Gazette*, May 4, 1909)

8. off color Not quite proper; verging on the lascivious; tending to be obscene, but only suggesting rather than being obscene; risqué. Used as early as 1378 to describe diamonds, this expression has undergone a number of semantic changes through the years. Today it is used occasionally to indicate an appearance of ill health or of seediness, but is most commonly used to connote something bordering on the edge of lewdness.

> It seemed a bit strange for a minister to be so devoted a reader of such a decidedly off color publication. (*Kansas City Times*, March 25, 1932)

9. pigs in clover Well-to-do and supposedly refined people who act in a boorish manner; parvenus. Figuratively, a pig is a person with the characteristics or habits commonly associated with that animal, while *in clover* implies luxury or wealth. See also **in clover, 14. AFFLUENCE.**

10. plow with another's heifer To utilize another's resources to one's own advantage; to employ knowledge gathered in a devious manner; to cheat by using information obtained fraudulently. Of Biblical origin, this expression is attributed to Samson. When Samson posed his riddle to the men of Timnath, he gave them seven days to answer. Unable to solve the riddle, the men went to Sam-

son's wife and, under the threat of burning her to death, forced the answer from her. When they approached Samson with the solution, he reproached them with:

> If ye had not plowed with my heifer, ye had not found out my riddle.
> (Judges 14:18)

The term remains in occasional use to indicate the gaining of an advantage through ill-gotten information.

11. put [one's] foot in [one's] mouth To say something inappropriate, gauche, or indiscreet; to commit a verbal faux pas. This expression implies that by saying something out of line, a person has figuratively put his foot in his mouth, an imprudent and untoward activity in any situation. A variation is *put [one's] foot in it.*

> I put my foot into it (as we say), for I was nearly killed. (Frederick Marryat, *Peter Simple*, 1833)

A related, more contemporary expression is *foot-in-mouth disease,* a play on hoof-and-mouth disease of cattle, and a jocular reference to an affliction in which a person exhibits a marked tendency to constantly "put his foot in his mouth."

12. sail close to the wind To act in a manner that verges on the illegal, immoral, or improper; to say or do something that borders on being in bad taste; to observe the letter but not the spirit of the law. Literally, to sail close to the wind is to head one's ship into the wind at enough of an angle to keep the sails filled. This is a risky tactic as the ship is in constant danger of being in irons if there is even a slight change in the wind direction. Figuratively, this expression implies that one's words or actions put him in a precarious position because they are so close to the limits of propriety.

> A certain kind of young English gentleman, who has sailed too close to the wind at home, and who comes to the colony to be whitewashed. (Henry

Kingsley, *The Hillyars and the Burtons,* 1865)

A variation is *sail near to the wind.*

13. step on toes To upset, offend, or irritate, especially by encroaching on someone's territory; to overstep one's bounds. Literally stepping on someone's toes is a violation of space or territory. On a figurative level, the "territory" usually refers to one's area of responsibility or realm of authority. The expression is often said of an upstart who prematurely assumes authority or responsibility delegated to someone else. An *OED* citation dates the expression from the 14th century, but whether the use was literal or figurative is difficult to determine.

14. wrong side of the blanket Out of wedlock, said of the birth of a child. In use since at least the Middle Ages, this expression is a euphemistic allusion to a hidden birth, under the blanket, rather than a natural, open birth, above the blanket.

> My mother was an honest woman. I didn't come in on the wrong side of the blanket. (Tobias Smollett, *Humphry Clinker,* 1771)

Improvement . . .

See 307. REFORMATION

190. IMPROVIDENCE

1. butter-and-egg man See 247. OAFISH-NESS.

2. butter [one's] bread on both sides To be wasteful or extravagant; also, to gain favor from two sides at once, to work both sides of the street. The two different figurative meanings of this expression, which dates from 1821, neatly express the two sides of the single literal action to which it refers, i.e., unnecessary indulgence and prudent foresight.

3. cut blocks with a razor To waste ingenuity; perform a prodigious feat using trivial methods; do something more

curious than useful. This ancient expression alludes to an incident involving Nevis, a Roman soothsayer, and Tarquin the Elder, king of Rome in the 6th century B.C. When Tarquin wondered aloud if he could cut a whetstone with a razor, Nevis told him to cut boldly and Tarquin severed the stone.

'Twas his fate unemployed or in place, sir, To eat mutton cold and cut blocks with a razor. (Oliver Goldsmith, *Retaliation*, 1774).

4. from hand to mouth See 279. PRECARIOUSNESS.

5. let leap a whiting To miss an opportunity; to allow a chance for advantage or gain to slip away; to waste one's chance for advancement. The allusion here is to fishing and the allowing of a whiting, a superior fish for eating, to leap away after its capture. The expression has been in use since at least 1546.

A man may . . . let leap a whiting, whilst he is looking on a codshead. (Nicholas Breton, *Works*, 1597)

A *codshead* is a stupid fellow, a dolt, one whose intelligence is about equal to that of a codfish.

6. pay too dearly for [one's] whistle See 74. COST.

7. penny wise and pound foolish Said of a person who is prudent or thrifty in small or trivial matters but careless in large or important ones. This expression, with its obvious implications, refers to two denominations of British money, the penny and the pound.

8. play ducks and drakes with To waste or squander, to spend foolishly or recklessly; also *to make ducks and drakes of;* usually in reference to money or time.

His Majesty's Government never intended to give over the British army to the Governors of this Kingdom to make ducks and drakes with. (Arthur Wellesley, Duke of Wellington, *Dispatches*, 1810)

Ducks and drakes is the name of an idle pastime which consists of skipping flat, smooth stones across the surface of water. Thus, to play ducks and drakes with one's money is to throw it away, as if using coins instead of stones. Also, to spend one's time playing ducks and drakes is to waste one's time in indolent pleasure. Use of the expression dates from at least 1600.

9. scattergood A spendthrift, squanderer, profligate; a big spender. This term is a combination of *scatter* 'to throw loosely about' and *good[s]* 'valuables.'

You have heard what careless scattergoods all honest sailors are. (Richard Blackmore, *Tommy Upmore*, 1884)

10. send the helve after the hatchet To be reckless; to throw away what remains because the losses have been so great; to send good money after bad; also *throw the helve after the hatchet.* The allusion is to the fable of the woodcutter who lost the head of his ax in a river, and then, in disgust, threw the helve, or handle, in after it. John Heywood used the phrase in a collection of proverbs published in 1546.

11. set up shop on Goodwins Sands To be shipwrecked; to run a ship aground; to have a venture go awry; to blunder; to make a serious mistake. These sand banks off the coast of East Kent once belonged to Earl Godwin, hence, the slightly altered name. Under Godwin's ownership, the area consisted of lowlands protected from the ocean by a seawall; however, after William the Conqueror granted the lands to the abbey of St. Augustine, Canterbury, the seawall was allowed to deteriorate, and in 1099 the ocean overran the lowlands, creating these perilous sandbanks which have been the undoing of many ships. The term has been applied figuratively since about 1540.

You leave all anchor hold, on seas or lands,

And so set up shop upon Goodwins Sands.
(John Heywood, *Proverbs*, 1546)

12. silly Juggins A spendthrift; a simpleton; a person easily imposed upon; a big spender; a squanderer. According to the *OED*, Juggins is a plebeian surname, known as early as 1604 in Worcestershire. Somehow it came to symbolize a fool or simpleton, probably because of its rustic origins. At any rate, the term was popularized in the 1880s by one Ernest Benzon, who became known as *Jubilee Juggins*, or the *Jubilee plunger*. It seems that Mr. Benzon was a foolish young man who had inherited a fortune. Over a period of two years, beginning shortly before Queen Victoria's Jubilee (1887), he managed to gamble away his entire fortune at the race tracks. He gained such notoriety among the population that *silly Juggins* became the byword of the Jubilee celebration, and a cartoon of Benzon even appeared in *Vanity Fair*, a popular periodical of the day.

Yah, Wot a old juggins he is! (*Punch*, July 17, 1886)

13. spare at the spigot and spill at the bung To be frugal in inconsequential matters while being wasteful in important affairs. This expression alludes to the foolishness of a person who halts the outflow of a cask at the spigot while allowing the orifice through which the cask is replenished to remain open. The saying, synonymous with the common phrase *penny wise and pound foolish*, is now virtually obsolete.

14. spend money like a drunken sailor To spend money extravagantly or foolishly, to throw money away. This self-evident expression enjoys widespread popular use.

191. IMPRUDENCE

1. cast pearls before swine To offer something precious to those who are unable to appreciate its worth; to give a valuable gift to someone who responds by abusing or defiling it. The phrase, which derives from the Sermon on the Mount, is still current today.

Give not that which is holy unto the dogs, neither cast your pearls before swine, lest haply they trample them under their feet, and turn and rend you. (Matthew 7:6)

2. Doctor Feelgood A pill pusher; a doctor who freely prescribes tranquilizers and stimulants. This expression is self-explanatory in that it describes a physician who is willing to make his patients happy by keeping them supplied with mood-elevating drugs. Figuratively, the term has come to mean any one or any thing that gives one's spirits a lift. The term has been in use since the early 1970s.

The Carter Administration has responded with a Doctor Feelgood litany that the dollar's health is sound . . . but the world's money traders are not buying that happy talk. (*Time*, October 9, 1978)

3. lock the stable door after the horse has gone To take precautions after the damage is done; to procrastinate too long; to lose something of value because of lack of action. This proverbial expression dates back to the early 14th century and may derive from an old French proverb which is translated 'too late one shuts the stable when the horse is lost,' in use as early as the 1100s. The saying, common in many languages, was brought to America with the first settlers; however, in America one is likely to hear *barn door* rather than *stable door*. The expression, along with its many variations, is so well established that allusions to it are also common.

The horse having apparently bolted, I shall be glad to assist at the ceremony of closing the stable door. (Ngaio Marsh, *Death of a Peer*, 1940)

4. put new wine in old bottles To take inappropriate action; to fail to make the measures fit the need; to impose greater stress than the recipient can bear.

Though this expression most often refers to the imposition of newness or change where age will resist it, the application of the phrase is not restricted to contexts of time disparity. Old wineskins lack the flexibility of new ones and consequently burst under the pressure of fermentation. The *wineskins* of the original Biblical context in the course of time became *bottles*, and the meaning of the phrase became muddled.

> Neither is new wine put into old wineskins; if it is the skins burst, and the wine is spilled and the skins are destroyed: but new wine is put into fresh wineskins, and so both are preserved. (Matthew 9:17)

5. reckon without [one's] host To act, plan, or conclude without adequate consideration of significant factors or circumstances; to fail to take into account the role of others, particularly those whose position would make their input determinative. The expression was originally literal; to reckon without one's host was to calculate food or lodging expenses without first consulting the innkeeper. This early meaning, dating from the 17th century, has been totally lost in the now figurative one indicating shortsightedness, improvidence, or lack of foresight.

> He reckoned strangely in this matter, without the murderous host into whose clutches he had fallen. (John A. Symonds, *The Renaissance in Italy*, 1886)

6. a rolling stone gathers no moss A proverb meaning that one with nomadic tendencies is unlikely to prosper. This expression, equivalents of which exist in numerous other cultures, was popularized in the English language following its use in Thomas Tusser's *Five Hundred Points of Good Husbandrie* (1573). A stationary stone accumulates moss which protects it from erosion and weathering. Likewise, one who settles down is more likely to amass a fortune than one whose life is spent wandering from place to

place. The expression maintains widespread usage today.

> The sudden turning up of Jack as a roving brother, who, like a rolling stone, gathered no moss. (Sarah Tytler, *Buried Diamonds*, 1886)

7. send a sow to Minerva A proverb said of one who presumes to teach another, more learned person something that he already knows. This expression is derived from an ancient Latin adage, *sus Minervam docet* 'a pig teaching Minerva,' alluding to the inappropriateness of something as ignorant as a pig trying to instruct the goddess of wisdom.

> In Latin they say *sus Minervam* when an unlearned dunce goeth about to teach his better or a more learned man, . . . or as we say in English, the foul sow teach the fair lady to spin. (Edward Topsell, *The History of Four-Footed Beasts*, 1607)

8. swap horses in midstream To change leaders during a crisis; to change the rules after the game has started; to change one's approach, to alter one's method at an unpropitious time. This Americanism is attributed to Abraham Lincoln. On June 9, 1864, after his renomination to the presidency, Lincoln delivered a speech in which he alluded to the fact that he was reelected even though many felt that he had mismanaged the War Between the States:

> . . . they have concluded it is not best to swap horses while crossing the river, . . . I am not so poor a horse that they might not make a botch of it in trying to swap.

The expression nearly always appears as part of an admonition not to do so.

9. teach [one's] grandmother to suck eggs A proverb, said of one who tries to teach or advise an older and more experienced person. This adage, similar in spirit to *teach a bird to fly* and *teach a fish to swim*, alludes to the inappropriateness of trying to teach a person something which he already knows. It is usu-

ally directed at someone, particularly an adolescent, who is presumptuous enough to think that his newfound knowledge is so unique that his elders could not possibly be privy to it and so takes it upon himself to educate them. Specifically, this expression refers to the technique—usually passed from generation to generation—of sucking out the contents of an egg through a small hole in one end without breaking the shell, a skill important to one who wishes to decorate Easter eggs, for example. An anonymous English poem captures the sentiments of this ancient proverb:

> Teach not a parent's mother to extract
> The embryo juices of an egg by
> suction:
> The good old lady can the feat enact
> Quite irrespective of your kind
> instruction.

192. IMPUDENCE

1. bold as brass Immodest; shameless; impudent; unblushing. The reference here is to the coldness and hardness of brass, as it is in the related term *brazenfaced*. Dating from about 1700, the expression is often used in a jocular sense.

> He died . . as bold as brass. (George Parker, *Life's Painter*, 1789)

2. brazen out To treat with effrontery or impudence; to outface with brash self-assurance; to ignore public opinion. The allusion in this expression is to the hardness of brass. The implication is that one will adhere to an allegation even knowing he is wrong. The term dates from the 1500s.

> He would talk saucily, lie, and brazen it out. (John Arbuthnot, *Law Is a Bottomless Pit*, 1712)

Impulsiveness . . .
See 187. IMPETUOUSNESS

193. INABILITY
See also 141. FAILURE;
203. INEFFECTUALITY;
406. WORTHLESSNESS

1. above [one's] hook Beyond one's comprehension; out of one's reach or grasp; beyond one's mark. The origin of this expression is uncertain. *Brewer's Dictionary of Phrase and Fable* suggests that the allusion may be to hat pegs placed row upon row, with the higher rows beyond the reach of small people. The expression remains in occasional use.

2. deaf as a post Inattentive or not paying attention; quite deaf; dull; tedious; slow-witted. The comparison in this expression is easily explained: that one might as well speak to a piece of wood.

> Anybody would think you were as deaf as a post. (Matthew Head, *The Smell of Money*, 1943)

From its literal reference to deafness, the application of the simile has been extended to anyone who is oblivious to sounds and voices, then to one who seems dull or stupid because of lack of awareness. A related term is *deaf as a beetle*, the *beetle* signifying a wooden mallet used for pounding, not an insect.

3. look two ways for Sunday To be cross-eyed or cockeyed; to squint; to be shown as incapable. This expression, dating from the early 19th century, originally alluded to someone looking in vain for something obvious because he is near-sighted or cross-eyed. *Look six* or *nine ways for Sunday* and *look both ways for Sunday* are common variants, and these forms are frequently used as equivalents of *look all ways for Sunday*, an English North Country colloquialism for someone who is stupid or confused.

> He has . . . a bad squint, so that . . . he seemed to be looking two ways for Sunday. (Alexander Macdonald, *Love, Law, and Theology*, 1869)

Inaccuracy . . .
See 121. ERRONEOUSNESS

Inactivity . . . See 178. IDLENESS;
201. INDOLENCE

Inadequacy . . . See 151. FLIMSINESS

Inanity . . . See 145. FATUOUSNESS

Inapplicability . . .
See 219. IRRELEVANCE

194. INAPPROPRIATENESS

1. carry coals to Newcastle To bring something to a place where it is naturally abundant; hence, to do something wholly superfluous or unnecessary. Newcastle lies in the heart of England's great coal-mining region. The equivalent French expression is *porter de l'eau à la rivière* 'carry water to the river.'

2. caviar to the general Something too sophisticated or subtle to be appreciated by hoi-polloi; beyond the taste of the general public. This expression derives from Shakespeare's *Hamlet:*

> The play, I remember, pleased not the million; 'twas caviar to the general. (II,ii)

In this line, "general" refers to the general public, the common people. Caviar, of course, is the very expensive gustatory delicacy prepared from sturgeon roe. It is a food appreciated only by those who have acquired a taste for it.

3. fit like a saddle fits a sow Said of garments that hang awkwardly upon one. This expression, originally British but brought to America by the early colonists, had its roots in the late 15th century. The allusion is to the ridiculous figure a sow would make with a saddle upon its back, as ridiculous as some people in ill-fitting clothes.

> These clothes become thee, as a saddle does a sow. (Aphra Behn, *Amorous Prince*, 1671)

A variant which expresses the same mocking intent is *meet as a cow to bear a saddle.*

4. goose among swans The uncultivated among the cultivated; the ignorant among the learned; the crude among the sophisticated. This ancient expression, which is still in occasional use, indicates one who is out of place, who does not measure up to those in the circle in which he is traveling or to those with whom he is being compared. The image was used as long ago as the 1st century B.C. by Vergil, the Roman poet:

> I too have written songs. I too have heard the shepherds call me bard. But I am incredulous of them. I have the feeling that I cannot yet compare with Varius or Cinna, but cackle like a goose among melodious swans. (*Eclogues* IX, 35)

5. out of character False to one's nature; not in accord with one's usual actions; not befitting one's personality and customary behavior; not appropriate; not befitting. This expression derives from the observation that each person has a behavior pattern that is more or less consistent and that when he says or does something that is out of keeping with what might be expected of him, he is said to be *out of character*. The *OED* lists the earliest written example as:

> It is always self-ignorance that leads a man to act out of character. (John Mason, *Self-Knowledge*, 1745)

6. send owls to Athens To do something completely useless, unnecessary, or extraneous; to carry coals to Newcastle; also *carry owls to Athens*.

> I may be thought to pour water into the sea, to carry owls to Athens, and to trouble the reader with a matter altogether needless and superfluous. (Henry Swinburne, *A Brief Treatise of Testaments and Last Wills*, 1590)

The owl, as emblem of the Greek goddess Athena, patron of Athens, was naturally plentiful in that area.

Incantation . . . See 231. MAGIC

Incapacity . . . See 193. INABILITY

Incitement . . .
See 294. PROVOCATION

Inclination . . .
See 282. PREFERENCE

195. INCLUSIVENESS
See also 377. THOROUGH-
NESS; 383. TOTALITY

1. **across-the-board** General; all-inclusive and comprehensive; treating all groups or all members of a group equally and without exception. The term refers to the board used to display the betting odds and totals at race tracks. An across-the-board bet is a combination wager in which the same amount of money is bet on a single horse to win, place, or show, thereby ensuring a winning ticket if the horse places at all. The original sporting use of the term dates from about 1935; the more general usage dates from about 1950.

2. **all along the line** At every point; in every particular or detail; entirely, completely. Common variants include *all down the line* and *right down the line.* What the original line was, if indeed one did exist, is uncertain. The expression does, however, seem to presuppose some sort of actual line, be it a line of soldiers going into battle, a geographical line of some kind, or any of the other sundry types of lines that exist. Charles Haddon Spurgeon used the phrase in *The Treasury of David* (1877).

3. **all around the Wrekin** To all one's friends everywhere; to all mankind. This old toast dates from at least the 17th century. Using the Wrekin, a mountain in the Shropshire Hills south of Shrewsbury, England, as a center, the speaker expands his toast to encompass all mankind. Apparently the toast is particularly popular during the Christmas holidays.

For Christmas Eve rejoicing, put a large clog of wood on the fire, a Yule Clog, and feast and toast all friends 'round the Wrekin. (*Gentleman's Magazine*, 1784)

The dedication of George Farquhar's *The Recruiting Officer* (1706) reads:

to all friends round the Wrekin.

4. **all the king's horses (and all the king's men)** Everybody who can be of assistance; every single person; everybody involved in the situation; everything. This expression, adopted from the child's nursery rhyme, *Humpty-Dumpty*, connotes a multitude of people attempting to solve a problem, sometimes implying that there are so many that they get in each other's way.

And if all the king's horses and all the king's men can't make a couple get along on the screen? (*TV Guide*, March 24, 1984)

5. **all the world and his wife** Everybody, especially everybody of important social position; everyone without exception; all men and women; the whole shooting match. This hyperbole, in use since at least the early 18th century, is usually employed to signify a large gathering of people, usually of both sexes.

How he welcomes at once all the world and his wife,
And how civil to folk he ne'er saw in his life.
(Christopher Anstey, *The New Bath Guide*, 1766)

Related terms which are also used to indicate that everybody was present are *everybody and his brother* and *every mother's son.*

The Romans . . . slew them, every mother's son. (Roger Ascham, *Toxophilus*, 1545)

6. **alpha and omega** Everything; from beginning to end; the whole works; the whole nine yards. *Alpha* and *omega* are the first and last letters, respectively, of the Greek alphabet, hence the signification of all-inclusiveness. Strangely

enough, during the Middle Ages the last letter was sometimes listed as *tau*. Consequently, in Middle English literature one often encounters *alpha to tau* rather than *alpha to omega*.

> The siege of Dresden is the alpha to whatever omegas there may be. (Thomas Carlyle, *Frederick the Great*, 1865)

7. bag and baggage With all one's personal belongings; completely, totally. This phrase was military in origin and applied to the possessions of an army as a whole (baggage), and of each individual soldier (bag). The original expression *to march out [with] bag and baggage* was used in a positive sense to mean to make an honorable retreat, to depart without having suffered any loss of property. The equivalent French expression was *vie et bagues sauves*. The term is now used disparagingly, however, to underscore the absolute nature of one's departure; it implies quite the opposite of an honorable retreat. Used in the original military sense in 1525 by John Bourchier Berners in his translation of Froissart's *Chronicles*, the phrase did not appear in its more contemporary sense until the early 17th century in Thomas Middleton's *The Witch*.

8. count noses To take note of the number in attendance; to count the number present, especially those of one persuasion in a vote. This phrase dates back to the 9th century, when, it is said, the Danish conquerors of Ireland took the census by a nose count, and then used that census for the collection of taxes, with those who neglected or refused to pay actually having their noses slit. It is believed that the two expressions *pay through the nose* and *bleed one for his money* also originated from this practice. The term is frequently used today to indicate a count of those voting on one side of an issue.

> Some modern zealots appear to have no better knowledge of truth, nor better manner of judging it, than by counting noses. (Anthony Ashley Cooper, *Characteristics of Men, Manners, Opinions, Times*, 1711)

A variant is *telling noses*.

9. every man Jack Every single person without exception. The precise origin of this phrase is unknown. A plausible but not entirely convincing theory traces the source of *every man Jack* to the early form *everych one* 'every one,' which in the 16th and 17th centuries was often written as *every chone*. By corruption, *every chone* became *every John*, and since *Jack* is the familiar form of *John*, the phrase was corrupted once again giving rise to the current form *every man Jack*. Thackeray used the phrase in *Vanity Fair*.

> Sir Pitt had numbered every "Man Jack" of them.

Thackeray's use of quotation marks and capitalization of *man* casts doubt on the theory of the origin of *every man Jack* presented above.

10. everything but the kitchen sink Everything imaginable, everything under the sun; also *everything but the kitchen stove*. Both expressions date from the first half of this century, although *everything but the kitchen stove* predated *everything but the kitchen sink* by about twenty years according to the *OED* citations. In his *Dictionary of Forces' Slang* (1948) Partridge says that *kitchen sink* was "used only in the phrase indicating intense bombardment—'They chucked everything they'd got at us, except, or including the kitchen sink.'" In other words, every possible kind of missile, including kitchen sinks.

11. everything that opens and shuts All-inclusive; everything imaginable; *the whole kit and caboodle*. This Briticism, the equivalent of the American *everything but the kitchen sink*, implies that not only are the necessities there, but also the luxurious extras, too. It can apply to a new house with all the necessary appliances, a new car with every imaginable accessory, or a poker hand with

four aces. The expression has been in use since World War II.

12. from A to Izzard From A to Z; from beginning to end; from first to last; completely; entirely; the whole ball of wax. This British colloquialism, in use by the early 1700s, employs an old word for the letter Z. Although the word *izzard* for the letter *z* has itself become obsolete, replaced by *zee* in America and *zed* in England, it continues to be heard in this phrase.

> They want everything checked from A to Izzard. (H. S. Keeler, *The Man with the Wooden Spectacles*, 1941)

13. from China to Peru All over the world; from Dan to Beersheba; from one end of the world to the other. This term, dating from the 17th century, is a figurative expression to designate something, usually spiritual, occasionally material, that is world-wide in its scope.

> Let observation with extensive view Survey mankind from China to Peru. (Samuel Johnson, *The Vanity of Human Wishes*, 1748)

The phrase is in use today, usually in reference to the popularity or unpopularity of a political or social issue.

14. from Dan to Beersheba From one outermost extreme or limit to the other; everywhere. This expression is based on a Biblical reference:

> Then all the children of Israel went out, and the congregation was gathered together as one man, from Dan to Beersheba. (Judges 20:1)

Judges 19 and 20 discusses the reasons that all of the Israelite nations gathered to attack the Benjamites. Dan was the northernmost city in Israel, Beersheba the southernmost. Thus, from Dan to Beersheba implied the entire kingdom. In more contemporary usage, this expression is often employed by political writers to describe the extent of a person or issue's popularity.

15. from Land's End to John o' Groat's [House] From one end of Great Britain to the other; all the way; thoroughly; from alpha to omega; from one extreme to the other. This term, dating from the early 19th century, designates all of Britain by naming those landmarks found in the most southwestern and most northeastern corners of the island, respectively. *John o' Groat's* refers to a house, still standing, located in the northeastern corner of Scotland. It is named for a Dutch immigrant, Jan Groot, who built the house along with his brothers. *Land's End* is the southwestern tip of England that juts out into the Atlantic.

> If you laid it down in sovereigns . . . it would have reached from the Land's End to John o Groat's. (James Payn, *The Burnt Million*, 1890)

16. from soda to hock From beginning to end; from A to Z; from first to last; from soup to nuts; from alpha to omega. This Americanism is derived from the game of faro, where the first card, displayed face-up in the dealing box before any bets are made, is called *soda*; and the last card, which may not be used, is known as *hock*, for it is said to be *in hock*. The expression had its origin in the western United States in the late 1800s.

> Young Bines played the deal from soda card to hock. (Harry L. Wilson, *The Spenders*, 1902)

17. from soup to nuts From A to Z, from first to last; absolutely everything, as in the phrase *everything from soup to nuts*. This American slang expression alludes to an elaborate multicourse meal in which soup is served as the first course and nuts as the last.

> Today's drugstores may have everything from soup to nuts, but they can't boast fascinating remedies like Gambler's Luck, Virgin's Milk, . . . or Come-Follow-Me-Boy. (*New Orleans Times-Picayune Magazine*, April 1950)

18. **from stem to stern** Completely; entirely; from one end to the other. On ships the stem is the vertical bow member of the vessel, and the stern is the rear. The phrase maintains common figurative use.

> I had him stripped and washed from stem to stern in a tub of warm soapsuds. (Elizabeth Drinker, *Journal*, 1794)

19. **kith and kin** All one's relatives and friends; all one's fellow countrymen. This expression, dating from the days of the Anglo-Saxons, continues in everyday use. The Old English *cyth* meaning relationship and *cynn* meaning family were combined into one phrase to create an all-inclusive term. Originally, the term encompassed all one's countrymen, friends, neighbors, and relatives, but during the 15th century its significance was limited to one's relatives and close friends.

> One would be in less danger
> From the wiles of the stranger,
> If one's kin and kith
> Were more fun to be with.
> (Ogden Nash, *Family Court*, 1931)

20. **ragtag and bobtail** See 358. STATUS.

21. **right and left** From all directions at once, everywhere you look, on all sides; every time, repeatedly. This phrase implying inclusiveness or ubiquity dates from the beginning of the 14th century. *Webster's Third* cites both current usages:

> . . . troops looting right and left (A. N. Dragnich)

> [S]ocial events . . . have been rained out right and left. (*Springfield Daily News*)

22. **run the gamut** To include the full range of possibilities; to extend over a broad spectrum; to embrace extremes and all intermediate degrees of intensity. The gamut is the whole series of notes recognized by musicians. The term was used figuratively by the 18th century;

Hogarth referred to "the painter's gamut."

> The stocks were running . . . up and down the gamut from $1 to $700 a share. (*Harper's Magazine*, 1883)

The vitriolic wit of Dorothy Parker once described an actress's performance as "running the gamut of emotion from A to B."

23. **Tom, Dick, and Harry** Men, or people in general; everyone, everyone and his uncle. The phrase, usually preceded by *every*, has been popular in America since 1815, when it appeared in *The Farmer's Almanack*. Tom, Dick, and Harry are all very common men's first names and so are used in this expression to represent average, run-of-the-mill people. Although first used only in reference to men, the phrase is currently applied to everyone, male or female.

24. **Uncle Tom Cobleigh and all** And all the crew; and everybody else who should be there. This expression usually appears at the end of a partial list of names to avoid naming each individual and to indicate that everybody who should be was there. The phrase was derived from the lyrics of an old ballad, *Widdicombe Fair*. There is an old tale in Devon that at one time seven members of the village borrowed Tom Pearce's grey mare to ride to the Fair. The ballad goes on:

> When the wind whistles cold on the
> moor of a night,
> All along, down along, out along lee,
> Tom Pearce's old mare doth appear
> gashly white,
> Wi' Bill Brewer, Jan Stewer, Peter
> Gurney,
> Peter Davy, Dan'l Whidden, Harry
> Hawk,
> Old Uncle Tom Cobleigh and all,
> Old Uncle Tom Cobleigh and all.

The expression is still in use but is heard less frequently today.

25. the whole kit and caboodle The whole lot, the whole bunch; the entire outfit; also *the whole kit and boodle, the whole kit and biling, the whole kit, the whole boodle, the whole caboodle.* The word *caboodle* or *boodle* in this expression is probably a corruption of the Dutch *boedel* 'property, possessions, household goods.' The phrase has been in use since 1861.

26. the whole shooting match Everyone and everything, the whole shebang; the entire matter or affair, the whole deal, the whole ball of wax.

> You are not the whole shooting match, but a good share of it. (*Springfield* [Mass.] *Weekly Republican*, March 1906)

A literal shooting match is a contest or competition in marksmanship, but how it gave rise to this popular American slang expression is unclear.

27. whole shtick The entire enterprise; all one's talents and attributes. This Yiddicism, which has gained considerable popularity in theatrical circles, especially since World War II, has, in recent years, become widely used as a slang term by the general population.

> The whole shtick is that the taped remarks of a number of political figures are tacked onto questions dreamed up by writers. (*Playboy*, February 1966)

The German word *Stück* for 'play, piece, bit' was the origin of the Yiddish term, which was adopted by theatrical people because it provided them with a single word with which to indicate an act or turn, a talent or ability that elicits a response or appeals to another, an essential in theater parlance.

Incorrectness . . .
 See 143. FALLACIOUSNESS

Increase . . .
 See 28. AUGMENTATION

Incredulity . . . See 349. SKEPTICISM

196. INDEBTEDNESS
 See also 149. FINANCE; 277.
 POVERTY; 281. PREDICA-
 MENT; 400. VULNERABILITY

1. gone to my uncle's Gone to the pawnbrokers; in hock; pawned. Although this term was used in its present sense as early as 1607 by John Dekker, it didn't attain popular use until the mid 18th century. In some unknown manner the word *uncle* became synonymous with the word *pawnbroker*. William R. and Florence K. Simpson in *Hockshop*, (1954) offer the following plausible explanation:

> These Simpson nephews . . . were responsible for the word 'uncle' becoming a slang synonym of pawnbroker. When offered unfamiliar collateral . . . they would tell the customer, "I'll have to ask my uncle."

The term has retained its figurative meaning over the years and may be heard in similar context in *call one uncle*, meaning 'to swindle or cheat.' The reference here is to the underhand methods of some pawnbrokers.

2. hung on the nail Pawned. The allusion is to the old practice of pawnbrokers' tagging each article with a number, giving the customer a duplicate tag, and hanging the article on a nail. Shelves have replaced the nails, but the expression is still heard as a synonym for anything in pawn.

3. in Queer Street In difficulty; short of money; in poor circumstances. This Briticism, of uncertain origin, has been in use since the early 19th century. Alluding to an imaginary street, its origin may lie in the word *query*, for a business man recording his debts might enter such a remark in his books after a delinquent debtor's name. Whatever the case, the term invariably connotes serious financial difficulty today.

The more it looks like Queer Street, the less I ask. (Robert Louis Stevenson, *Dr. Jekyl and Mr. Hyde*, 1886)

4. in the hole In debt; in financial difficulties. The story behind this U. S. slang expression has to do with proprietors in gambling houses taking an amount of money out of the pots as a percentage due the "house." When money must be paid up, one "goes to the hole" with a check. The "hole" is a slot cut in the middle of the poker table leading to a locked compartment below. All the checks "in the hole" become the property of the keeper of the place. The gamblers' losses were the keeper's gain. *In the hole* has been popular since the 1890s, although *put [someone] in the hole* 'to swindle or defraud' dates from the early 1800s.

How in the world did you manage to get in the hole for a sum like that? (P. G. Wodehouse, *Uncle Fred in Springtime*, 1939)

5. in the ketchup Operating at a deficit; in debt; failing to show a profit. *Ketchup* is a more graphic term than *red* but the meaning of *in the ketchup* is synonymous with *in the red*. The former, a slang expression of U.S. origin, dates from the mid-1900s.

Ridgway . . . has wound up in the ketchup trying to operate a gym. (Dan Parker, *Daily Mirror*, September 11, 1949)

6. in the red Operating at a deficit; in debt. This 20th-century colloquial Americanism is so called from the bookkeeping practice of entering debits in red ink. The opposite *out of the red* 'out of debt' (or *in the black*) is also current.

Rigid enforcement of economies in running expenses will lift the club's balance sheet out of the red where it now is. (*Mazama*, June 1, 1948)

7. lame duck See 203. INEFFECTUALITY.

8. lose [one's] shirt See 141. FAILURE.

9. on the rocks Ruined, especially financially; hence, bankrupt, destitute. The concept, but no record of the actual phrase, dates from the days when a merchant's wealth depended on the safety of ships at sea. Shipwreck—or going on the rocks—meant financial disaster. In Shakespeare's *Merchant of Venice*, Salarino asks Antonio:

Should I . . . not bethink me straight
 of dangerous rocks,
Which touching but my gentle vessel's
 side
Would scatter all her spices on the
 stream,
Enrobe the roaring waters with my
 silks—
And, in a word, but even now worth
 this,
And now worth nothing?
(I,i)

10. over [one's] head See 281. PREDICAMENT.

11. take a bath See 141. FAILURE.

12. washed out See 141. FAILURE.

Indecision . . .
 See 391. VACILLATION

Indecisiveness . . . See 203. INEFFECTUALITY; 391. VACILLATION

Indecorousness . . .
 See 189. IMPROPRIETY

Indefiniteness . . .
 See 198. INDETERMINATENESS

197. INDEPENDENCE
 See also 336. SELF-RELIANCE

1. his hat covers his family Said of one who is alone in the world. The implication of this expression, dating from the mid 1800s, is clear: if one's hat covers his family, he must have no living relatives and, therefore, no one to provide for but himself. The term is frequently used

metaphorically for one with little or no responsibility.

> His hat covers his family, don't it? He has no one belonging to him that I ever heard of. (Mrs. J. H. Riddell, *Daisies and Buttercups*, 1882)

2. independent as a hog on ice Cockily self-assured; pigheadedly independent.

> He don't appear to care nothing for nobody—he's "independent as a hog on ice." (*San Francisco Call*, April 1857)

It has been unconvincingly conjectured that this American expression, popular since the 1800s, derives from the Scottish ice game of curling in which *hog* refers to a pucklike stone that stops short of its goal, thus coming to rest and sitting sluggishly immovable on the ice. But no other proffered explanation appears plausible either. The puzzling simile nevertheless continues on in popular usage.

> They like to think of themselves as independents—independent as a hog on ice. (*Time*, August 1948)

3. independent as a woodsawyer's clerk Having complete freedom of action and decision; characterized by freedom from outside influences. Dating from the early 19th century, this expression apparently alludes to the position of the wood-sawyer's clerk as a purveyor of wood to steamboats, especially on the Mississippi River system. Since wood as a fuel to operate these boats was an absolute necessity, the woodsawyer's clerk was treated very judiciously by potential customers.

> But if you live in the forecastle, you are as independent as a woodsawyer's clerk. (Richard H. Dana, *Two Years Before the Mast*, 1840)

4. lone wolf A loner; one who, although leading an active social life, chooses not to divulge his personal philosophies; a person who pursues neither close friendship nor intimate relationships. Although most wolves live in small packs, some choose to live and hunt soli-

tarily. The expression's contemporary usage often carries an implication of aloofness to or disillusionment with the mainstream of society.

> An individualist to be watched unless he should develop into too much of a lone wolf. (G. F. Newman, *Sir, You Bastard*, 1970)

5. march to the beat of a different drummer To follow the dictates of one's own conscience instead of prevailing convention; to act in accord with one's own feelings instead of following the crowd; also, to be odd or eccentric. This expression comes from these now famous words of Henry David Thoreau in *Walden, or Life in the Woods* (1854):

> If a man does not keep pace with his companions, perhaps it is because he hears a different drummer. Let him step to the music which he hears, however measured or far away.

If one man in a marching column is out of step, it may look as if he is marching to the beat of another drummer, or as if he is simply "out of it." Such a one is considered either an independent or an eccentric.

6. maverick An intractable or refractory person; a person who adheres to unconventional or unpopular ideals that set him apart from society's mainstream; a dissenter, a loner. This expression is credited to the early 19th-century Texas rancher Samuel Maverick, who consistently neglected to brand his cattle, and it still maintains its meaning of an unbranded cow, steer, or calf. Through allusion to these unmarked cattle, *maverick* evolved its now more common nonconformist sense by the late 1800s:

> A very muzzy Maverick smote his sergeant on the nose.
> (Rudyard Kipling, *Life's Handicaps*, 1892)

In the United States the expression has developed the additional meaning of a politician who resists affiliation with the established political parties, or whose

views differ significantly from those of his fellow party members.

> One Republican Senator, and by no means a conspicuous maverick, pointed out that the Senate might have acted. (*Chicago Daily News*, 1948)

7. mugwump A politically independent person; a person who is indecisive or neutral on controversial issues. This expression is derived from the Algonquian Indian word *mogkiomp* 'great man, big chief,' and was first used by Charles A. Dana of the *New York Sun* in reference to the Republicans who declined to support their party's 1884 presidential candidate, James G. Blaine. The term thus evolved its current figurative sense of a political maverick.

> A few moments after Secretary Wallace made his pun, he hastened to add that he himself had been a mugwump. (*Tuscaloosa News*, March 1946)

A jocular origin is ascribed to the word: a *mugwump* is one who sits on the fence, with his *mug* on one side and his *wump* on the other. In addition to its political sense, the British use *mugwump* to describe a self-important person who assumes airs and behaves in an aloof or pompous manner.

8. on [one's] own hook Through one's own efforts; on one's own authority; by oneself; at one's own risk. This expression apparently arises from the lot of the fisherman who is wholly responsible for whatever he takes on his own hook, whether the action reflects credit or discredit on him. Another possibility comes from yachting, where *hook* refers to the anchor. If anchored alone, one's actions are independent, which is not the case if one shares a mooring with others.

> Some troops are marching about the street, "upon their own hook," I suppose. (Philip Hone, *Diary*, 1832)

9. sail against the wind To think or act independently of popular or accepted convention, opinion, trends, etc.; to march to the beat of a different drummer. This expression refers to the impossibility of sailing directly into a wind in order to reach one's destination. Although *sail against the wind* is sometimes applied figuratively to a person who is inflexible and stubborn, it more often refers to one who does not succumb to peer or social pressure, but rather pursues his own course irrespective of the opinions and customs of others.

198. INDETERMINATENESS

1. between hawk and buzzard Hovering in the balance between two extremes; caught in the middle; neither one nor the other. The early uses of this phrase, dating from the early 17th century, were based on the disparity between a hawk and a buzzard, although they are both birds of prey. According to the *OED*, the buzzard is an inferior type of hawk, useless for falconry. Elsewhere, the hawk is referred to as a "true sporting bird," and the buzzard is called a "heavy lazy fowl of the same species." Thus, *hawk* has positive connotations and *buzzard* negative. Brewer's 1895 edition of *The Dictionary of Phrase and Fable* makes reference to tutors, governesses, etc., as being "between hawk and buzzard" because they are neither masters and mistresses nor lowly servants. The phrase is also sometimes used in referring to twilight, which is neither day nor night. Therefore, anything that is caught in the tension between two extremes, such as good and bad, light and dark, high and low, is "between hawk and buzzard."

2. between hay and grass Neither one thing nor the other; indeterminate; in an in-between and undefinable stage. Just as a hobbledehoy is neither a man nor a boy, something is between hay and grass when it cannot be categorized or fitted into a slot.

3. fart in a colander Agitated; jumpy; characterized by restless movement. This British slang expression alludes to a gaseous emission bouncing about a colander and trying to decide which hole to escape through. Metaphorically, it describes a person who is unable to make up his mind about what action is needed to resolve a problem or to a person who jumps from one chore to another. The expression dates from about 1890. A synonymous British slang term, *tit in a trance*, describes a restless person who can't decide which of two tasks to attack first. The allusion is to women's breasts and dates from about World War I.

4. hab-nab At random; hit or miss; by hook or crook; by fair means or foul; get or lose; however it may turn out. The term is probably derived from the Middle English *hab or nab*, meaning 'to have or not have.' However, the *OED* points out that there is a long gap between the disappearance of these verb forms in Middle English and the first appearance of *hab-nab*, about 1542, thus making such a derivation probable but uncertain. The term, along with a common variant, *hob or nob*, is seldom heard today.

> The chance and hazard of a throw of the dice, hab nab, or luck as it will. (Sir Thomas Urquhart, tr., *Rabelais*, 1693)

5. knight's tour A series of chess moves; an erratic tour of an area; a jumping about from place to place.

> The knight's tour, one of the oldest and most popular chess recreations, requires a knight starting at a given square to be moved in turn to each of the 64 squares on the board, visiting each square only once. (*Games*, July/ August 1982)

The allusion here is to the movement of the knight in a chess game. To the uninitiated the knight's movement seems rather erratic, as he must move two squares in one direction and one square at a right angle to those two, or in the

shape of an L. As a result, a *knight's tour* has come to represent any erratic hopping about the countryside.

6. leave the door open To decide not to commit oneself or limit one's options. Figurative use of *door* is as old as the literal. This particular expression dates from at least 1863.

> Which left open a door to future negotiation. (Alexander W. Kinglake, *The Invasion of the Crimea*, 1863)

7. neither fish nor flesh nor good red herring Neither this nor that; a person of uncertain or oscillating principles. This phrase originated in medieval England, where, on certain fast days, all strata of society abstained from their staple foods; monks abstained from fish, the general populace abstained from meat, and beggars abstained from herring. In its figurative sense, this term refers to a nondescript object or a wishy-washy person.

> Damned neuters, in their middle way of steering,
> Are neither fish nor flesh nor good red herring.
> (John Dryden, "Epilogue" to *The Duke of Guise*, 1682)

8. Scotch verdict An inconclusive determination; an ambiguous pronouncement; an indecisive outcome. The allusion in this term is to the strange process in Scotch criminal law that allows a jury to return a verdict of "not proven" rather than "not guilty." In *The Art of Murder* (1943) William Roughead explains the implications:

> Our national nostrum, "Not Proven" . . . a verdict which has been construed by the profane to mean, "Not Guilty, but don't do it again." What Sir Walter Scott calls, "that Caledonian *medium quid*."

9. swing of the pendulum Vacillation between extremes; a swing from one opinion to another. This expression, dating from the mid-18th century, compares the swinging of opinion with the

constant back-and-forth movement of the pendulum of a clock.

> George Eliot's fame has suffered from "the swing of the pendulum." (Theodore Watts-Dunton, *British Weekly*, November 15, 1906)

10. twist in the wind To be left in a predicament with any reprieve denied, so as to suffer even further humiliation. Apparently the allusion in this expression is to the old practice of leaving the dead bodies of criminals hanging, as a symbol to passers-by of the fate awaiting those who disobey the law. Its popularity mounted after its use by John Ehrlichman, former White House adviser, was made public during the course of the Watergate investigations. Ehrlichman is reputed to have told John Dean that L. Patrick Gray, who at that time was undergoing confirmation hearings in the Senate before his appointment as the Director of the F.B.I., should be "left to twist slowly, slowly in the wind," thereby forcing him to suffer all the more. The figurative use of the phrase is common today.

> There were those who felt that for one who had sat on the ducking stool, and been tarred and feathered in addition, I had suffered enough. But the inquisitors thought otherwise. For ten months I was left hanging there, twisting in the wind. (Herbert L. Porter, *Harper's*, October 1974)

199. INDIFFERENCE

1. cold as charity This expression refers to the indifferent, almost mechanical, attitude that often accompanies an act of charity and the administration of public charities. The term is usually attributed to John Wyclif, who in his 1382 translation of the New Testament rendered Matthew 24:12 as:

> . . . the charity of many shall wax cold.

All other major versions render it as:

> . . . the love of many shall wax cold.

The expression has been in use since the early 1400s, which lends credence to the Wyclif theory of origin.

> Organized charity, scrimped and iced,
> In the name of a cautious, statistical Christ.
> (John Boyle O'Reilly, *In Bohemia*, 1880)

2. have other fish to fry To have other, more important matters to attend to; to have better things to do or more pressing business to occupy one's time and attention. A stock phrase used to give someone the brushoff, this expression dates from the 17th century. It implies that one has no time to waste on unimportant (usually someone else's) concerns.

> "I've got other things in hand . . . I've got other fish to fry." (Margaret Oliphant, *A Poor Gentleman*, 1889)

3. I could care less It doesn't matter one way or the other; it is really of little concern. This exclamation, its illogicality perhaps adding shock effect, is usually thrown at another as a retort to indicate that one is entirely indifferent to a situation or a person. Coined by the British in the late 1930s, the term was soon adopted in the United States and is still current in both countries. The variant *I couldn't care less*, the original and logical form, is also occasionally heard.

> I haven't any idea where Rocko went, and I couldn't care less. (John Macdonald, *Dress Her in Indigo*, 1969)

4. no skin off [one's] nose None of one's concern; does not affect adversely. This expression probably derives from the admonition to keep one's nose out of another's business. If one refrains from interfering, he won't be hit upon the nose. In common use today, the phrase also suggests that whatever misfortune befalls another is his problem. In F. C. Davis's *The Graveyard Never Closes* (1941), the protagonist comments upon another's pressing problems:

It's no skin off any nose of mine.

Common variants of this expression are *no skin off one's back, no skin off one's teeth,* and, more recently, *no skin off one's ass.*

5. not care a pin To be totally indifferent toward someone or something; not to care in the least; to have little, if any, interest in; to consider of less importance than something of insignificant value. The implication here is obvious since the pin is an object of such little value. The expression has been in continuing use since the early 15th century.

'Tis evident you never cared a pin for me. (Richard Sheridan, *School for Scandal,* 1777)

6. not give a continental To be so scornful as to refuse to give up even so worthless as a continental. The continental was paper scrip issued by the Continental Congress during the American Revolution and was of no value as a medium of exchange.

7. not give a damn Not to care, not to be concerned, to have no interest or stake in. *Damn* is a mild curse which has no connection with the practically worthless old Indian coin, a dam, as has been repeatedly and mistakenly conjectured.

It was obvious, as one angry young woman remarked, that he didn't give a damn—and so they were enraged. (J. Cary, *Captive and Free,* 1959)

8. not give a fig To be indifferent or actively hostile toward. The term *fig* has been in use since 1450 to denote a worthless or insignificant object. Some trace this meaning to ancient Greece where figs were so plentiful as to be worth little or nothing. Others relate it to the *fig* or *fico* of the phrase *to give the fig* (See 213. INSULT). Shakespeare plays on the two senses of the term in *Henry V:*

A figo for thy friendship!—

The fig of Spain. (III,iv)

9. not give a hoot To be indifferent toward, to be totally unconcerned about. *Hoot* in this expression is short for *hooter,* which in turn is thought to be a corruption of *iota* 'a whit, a jot.' Although the abbreviated form *hoot* did not appear until the early 20th century, *hooter* was in use in this and similar phrases during the 19th century. *Not give a hoot* has combined with the similar expression *not give a continental* to form the currently popular *not give a continental hoot.* See **not give a continental,** above.

I do not give a hoot if it's colder, and I do not give two hoots what any given cabbie thinks about it. (*The Chicago Sun,* November 1947)

10. not give a rap Not to care or be concerned about. A rap was a counterfeit coin worth about half a farthing which was circulated in Ireland during the 18th century because of the shortage of genuine currency. The worthlessness and neglibility of the literal rap gave rise to the figurative expression.

For the mare-with-three-legs [the gallows], boys, I care not a rap. (William Harrison Ainsworth, *Rookwood,* 1834)

11. not give a tinker's dam To care so little as not to give even something without value; also, *not give a tinker's damn.* Conflicting views are current as to the origin of this expression. A *dam* is a worthless bit of metal used (by tinkers, among others) to keep molten solder in a certain place till it has cooled and solidified. On the other hand, itinerant tinkers were considered of the lowest class, traditionally ill-mannered and given to the use of foul language. To such a one, *damn* may have been so mild a curse as to have no meaning in a string of invective.

Indigence . . . See 277. **POVERTY**

200. INDIVIDUALITY

1. bag Personal style; special interest or point of view; manner of playing jazz. *Bag* was originally a jazz term referring to a particular musical conception, style, attack, etc. By extension, it came to be applied to any aspect of a person's characteristic style, such as one's values, interests, motivations, or actions. It is probably an abbreviation of *bag of tricks.*

> I dig everything about this lady, but what was her bag (B. B. Johnson, *Death of a Blue-Eyed Soul Brother,* 1970)

See also **bag of tricks,** 274. PLOY.

2. the cut of [one's] jib One's outward appearance or manner, a person's characteristic demeanor or countenance; often in the phrases *to like* or *dislike the cut of one's jib.* This expression, which dates from at least 1823, is of nautical origin. A jib is a triangular foresail by which sailors formerly identified the nationality of passing ships and thus recognized them as friend or foe.

3. a fine Italian hand A distinctive or characteristic style; subtle craftiness. The literal Italian hand is the graceful penmanship which replaced the heavy Gothic script of northern Europe in the 17th century, and is now used throughout Western Europe and America. Figuratively, *a fine Italian hand* may refer to that characteristic or distinguishing quality of an object or work of art which identifies its creator. In its more negative sense, however, this expression describes a cunning scheme in which the plotter's identity is revealed through his subtle yet intrinsic design.

4. hallmark See 160. GENUINENESS.

201. INDOLENCE

See also 178. IDLENESS

1. bed of roses A situation or state of ease, comfort, or pleasure; the lap of luxury. This phrase and its variants *bed of down* or *flowers* were used as early as the first half of the 17th century by Shakespeare and Herrick, among others. The rose is a symbol of perfection and completeness, giving it more weight than *down* or *flowers,* which may account for why *bed of roses* is the preferred form today. The expression is often used in the negative, as *no bed of roses,* to emphasize the disparity between what is and what could be.

2. dolce far niente Delightful idleness, carefree indolence; relaxation, peacefulness, tranquillity. Attesting to the great appeal of such a lifestyle is the fact that equivalent phrases have appeared in different languages dating back to the Roman writer Pliny. English use of the Italian *dolce far niente* 'sweet doing nothing' dates from at least the turn of the 19th century.

> It is there . . . that the dolce far niente of a summer evening is most heavenly. (Henry Wadsworth Longfellow, *Life,* 1830)

3. lazy as Lawrence Extremely sluggish; indolent; lethargic. In the 3rd century when St. Lawrence was being put to death by roasting upon a grill, he asked his captors to turn his body so the other side would be done equally. The torturers somehow misinterpreted this act of Christian courage as an act of laziness and reported it as such; hence *lazy as Lawrence.*

> He was found early and late at his work, established a new character and . . . lost the name of 'Lazy Lawrence.' (Maria Edgeworth, *The Parent's Assistant,* 1796)

A variant is *lazy as Lawrence's dog.* Somehow the laziness was transferred to Lawrence's dog; perhaps, simply from Lawrence himself, but more likely from another expression *lazy as Ludlam's dog.* The allusion in this term is to a sorceress, Ludlam, who had a dog that was so lazy that when people approached the cave in which they lived, the dog had great difficulty rousing itself to bark.

English rustics talk of a man 'as lazy as Ludlam's dog' that leaned his head against the wall to bark. (J. L. Kipling, *Beast and Man*, 1891)

Another variant, *Lawrence bids him high wages*, meaning that a person is lethargic or listless, is apparently a reference to St. Lawrence's Day, August 10, falling during the heat of summer.

When a person in hot weather seems lazy, it is a common saying that Lawrence bids him high wages. (*Gentleman's Magazine*, 1784)

4. live in cotton wool See **204. INEXPERIENCE.**

5. lotus-eater An idle dreamer, one who lives a life of indolence and ease. The Lotus-eaters, or Lotophagi, are a mythical people found in Homer's *Odyssey*. Odysseus discovers them in a state of dreamy forgetfulness and contentment induced by their consumption of the legendary lotus fruit. Having lost all desire to return to their homelands, they want only to remain in Lotus-land living a life of idle luxury. Use of the term dates from the first half of the 19th century.

A summer like that of 1893 may be all very well for the lotus-eater, but is a calamity to people who have to get their living out of English land. (*The Times*, December 1893)

6. Paul's man A shirker; a loafer; one who idles away his time; a braggart; a boaster. During the late 1500s and early 1600s it became a common practice for idlers of all types to spend their time walking the center aisle of Old St. Paul's in London, where they enjoyed bragging of their past exploits. Among these *Paul's walkers*, as they were also called, were many retired soldiers who would sit and recount for hours their adventures in the military to any passer-by who would listen. In Ben Jonson's *Every Man in his Humour* (1616), one of the major characters, Captain Bobadil, a man who takes a back seat to none when it comes

to bragging about his military exploits, is referred to as a *Paul's man*.

Who goes to Westminster for a wife, to Paul's for a man, and to Smithfield for a horse, may meet with a whore, a knave, and a jade. (James Howell, *Proverbs*, 1659)

7. sit like a bump on a log Stupidly dumb; to sit in vacuous silence; remain lethargically inarticulate. The first recorded use of this term is to be found in Kate Douglas Wiggin's *The Birds' Christmas Carol* (1887).

Ye ain't goin' to set there like a bump on a log 'thout sayin' a word ter pay for yer vittles, air ye?

The origin of the expression is uncertain; however, it probably arises from the similarity between the incommunicativeness of a bump on a log and an oafish mute.

8. woolgathering Daydreaming, idle imagining or fantasizing; absentmindedness, preoccupation, abstraction; often *to go woolgathering*.

Ha' you summoned your wits from woolgathering? (Thomas Middleton, *The Family of Love*, 1607)

Although the practice of woolgathering (wandering about the countryside collecting tufts of sheep's wool caught on bushes) is virtually obsolete, the figurative term is still current.

202. INDUSTRIOUSNESS
See also 132. EXERTION

1. nature abhors a vacuum Man cannot abide nothingness; a man must keep busy, must have something to do, either mentally or physically. The origin of this expression is unknown; however, Rabelais did make use of a Latin form of the phrase in *Gargantua* (1534). In modern use the phrase is most commonly heard as a figurative admonition to keep the mind active.

Whatever philosophy may determine of material nature, it is certainly true

of intellectual nature, that it abhors a vacuum: our minds cannot be empty. (James Boswell, *Life of Samuel Johnson*, 1791)

2. work like a Trojan To be industrious and hard working; do more than is expected of one; to show determination. In Homer's *Iliad* and Virgil's *Aeneid* the Trojans are depicted as courageous and energetic people who endure to the end. Such a reputation has given rise to many terms of favorable connotation; *a regular Trojan* and *like a Trojan*, are both commonly used in a complimentary manner. All these terms can be traced to the Middle Ages.

I worked hard at that gown . . .
Dear little Elsie helped me with it like a Trojan. (Grant Allen, *The Typewriter Girl*, 1897)

Inebriation . . .
See 109. DRUNKENNESS

203. INEFFECTUALITY
See also 159. FUTILITY;
193. INABILITY

1. all talk and no cider All talk and no action; much ado about nothing; great cry and little wool. This colloquial Americanism dates from the turn of the 19th century. The popular story explaining its origin tells of a party supposedly organized for the purpose of sharing a barrel of superior cider. Apparently the subject of politics was introduced and its talk supplanted pleasure and drinking as the focal point of the party. Disappointed guests left the gathering with the complaint of "all talk and no cider."

Fine stories are cold comfort, when it is as they say "All talk and no cider." (Nelson Kingsley, *Diary*, 1849)

2. bear sucking his paws Uselessness; zealously active, but accomplishing nothing. During the Middle Ages a general belief among the people was that a bear, when denied access to food, would suck its own paws for sustenance. In lat-

er years when the truth came to light, the term became a synonym for one who strived laboriously with little or no real purpose. A common variant is a *badger sucking his paws*, for badgers, it seems, engage in the same activity.

3. beat [one's] gums See 371. TALKATIVENESS.

4. cold comfort Comfort that offers little, if any, consolation; something offered as comfort which actually gives none or even causes additional hardship; comfort that is chilling to the receiver. First recorded about 1325 in *Early English Alliterative Poetry*, this expression is still in use today. William Bradford, in a letter of May 1622, reveals that a small ship containing seven men arrived at Plymouth Colony in Massachusetts. They bore a letter from Thomas Weston apologizing for their having no food, but Weston promised that the colonists would be repaid for providing for them. Bradford wrote:

All this was but cold comfort to fill their hungry bellies; and a slender performance of his former late promises; and as little did it either fill or warm them. (William Bradford, *Of Plymouth Plantation*, 1630)

5. could not hit the broad side of a barn To be unable to hit a very easy target, usually applied jocularly in reference to a target too large to be missed. This expression, of rural origin, is applied to the ineffectuality of one's aim. Dating from the early 17th century, it is most commonly heard today in a figurative sense. An older variant uses the term *barn door*, with allusion to its great width.

My old Mr. Clodplate would have been hanged before he would have missed such a barndoor. (Tom Ticklefoot, *Trials of Wakeman*, 1679)

6. cut no ice To have no effect or influence; to fail to impress; to carry no weight, to mean nothing; also *to cut ice* meaning 'to impress, to make an effect,' although the phrase is almost exclusively

used in the negative. In common usage since the late 19th century, the expression apparently owes its coinage to the fact that only keen and strong instruments can make an impression on the hard and glossy surface of ice.

7. fair words butter no parsnips Merely saying something, however beautifully, has no material affect on a difficult situation. This British expression from the late 16th century is of uncertain origin. The allusion is to the emptiness of words spoken without conviction.

> Relations, friendships are but empty names of things, and words butter no parsnips. (Sir Roger L'Estrange, *Fables*, 1692)

Variants include *fair words butter no cabbage, fair words butter no fish, mere praise butters no turnips.* William Thackeray indicates in *Vanity Fair* (1847) that he would modify the phrase.

> Who . . . said that "fine words butter no parsnips"? Half the parsnips of society are served and rendered palatable with no other sauce.

8. from pillar to post Aimlessly or futilely from place to place; purposelessly from one thing to another; from predicament to predicament, often with the sense of being beleaguered or harassed. The expression is among the oldest in the language, first appearing as *from post to pillar*.

> Thus from post to pillar was he made to dance. (Lydgate, *Assembly of Gods*, 1420)

There is little agreement regarding its origin. One theory holds that it stems from tennis but fails to explain how. Other sources see its roots in man]ege: the pillar being the column at the center of the riding ground, the posts those that in pairs mark its circumference. Yet another hypothesizes that it derives from the custom of bloodthirsty crowds following convicted persons "from pillory to whipping-post." Today the phrase most often describes a lack of direction or purpose or the futility of receiving the

runaround, as with bureaucratic red tape. It also exists as an adjective.

> The pillar-to-post travels from one official to another. (*Pall Mall Gazette*, August 1887)

9. go in one ear and out the other To be heard but not heeded; to be ignored or forgotten; to make no impact or impression. The implication here is that whatever is being said does not stay inside the listener's head because he is emptyheaded; information just passes straight through to the other side. A variant of this expression dates from 1400.

10. great cry and little wool Much ado about nothing; a lot of fuss and bother with little or nothing to show for it; also *more cry than wool.* Stephen Gosson relates the proverbial origin of this expression in *The School of Abuse* (1579):

> As one said at the shearing of hogs, great cry and little wool, much ado and small help.

A similar current phrase is *all talk and no action.*

11. guinea pig See 395. VICTIMIZATION.

12. kittle kattle Unreliable or undependable people. In this expression *kittle* is used in the sense of 'difficult to deal with because of unpredictability or flightiness,' and *kattle* is merely a respelling of *cattle* for the sake of "visual alliteration." The term originated in Scotland during the 15th century and is occasionally heard today.

> For women are kittle cattle and nobody knows which way they are going to jump in any emergency. (Dorothy Dix, *Philadelphia Bulletin*, March 29, 1949)

13. lame duck An elected public official who is completing his term in office but has not been reelected; a stockbroker or speculator who has lost a great deal of money, or who has committed himself (through stock options, buying on margin, etc.) to more than he can afford; an inefficient or injured person. In the

United States, this expression is usually political in nature, while in England, it is financial. *Lame duck* refers to an injured bird which is unable to care for itself and waddles around aimlessly as it awaits its imminent death. The implication is that a lame duck politician has, in essence, been rendered impotent; he is without a constituency and without bargaining clout—thus totally ineffective.

A "lame duck" Administration was in power, and a "lame duck" Congress still in being. (*The Times*, December 14, 1932)

In 1933, Congress approved the 20th Amendment to the Constitution of the United States, popularly known as the *Lame Duck Amendment* because it provided that newly elected Senators and Representatives would assume office on January 3 instead of March 4, thus reducing the length of the Congressional lame duck period. The Amendment also set the date for the presidential inauguration on January 20 instead of March 4.

14. like water off a duck's back See 114. EFFORTLESSNESS.

15. man of straw See 395. VICTIMIZATION.

16. mealy-mouthed Indecisive; compromising or vacillating; namby-pamby; afraid or disinclined to assert oneself; timidly softspoken or mincing; avoiding plain and direct language. This expression alludes to the concept of *meal* 'ground grain' as dry, soft, and crumbly, lacking form or substance. A common variation is *mealy*.

He was not mealymouth'd, but would . . . have talked his mind to knights, or anybody. (Tom Ticklefoot, *Some Observations Upon the Late Trials of Sir George Wakeman*, 1679)

17. milk-and-water Insipid or jejune; lackluster, wishywashy. This expression, alluding to the bland, vapid mixture that results when milk is diluted with water, is used to describe a person or thing virtually devoid of any interest, character, or vitality.

Change the milk-and-water style of your last memorial; assume a bolder tone. (*Journal of the American Congress*, 1783)

18. milksop A man who lacks courage and spunk; a spiritless, babyish man or youth. This term alludes to the obsolete meaning of *milksop* referring to an infant fed on only milk. Chaucer used the label figuratively in the 14th century. Today it sees little use except in literary contexts.

I ought to be d—n'd for having spoiled one of the prettiest fellows in the world, by making a milksop of him. (Henry Fielding, *Tom Jones*, 1749)

19. much smoke, little fire Much talk, little action. This expression is usually said of one who boasts a great deal about a minor accomplishment or of one who takes little, if any, action but makes a great commotion. It alludes to the sort of fire that is very smoky but in which little is consumed. The expression may well owe something to the familiar proverb, *Where there's smoke, there's fire*, although with an almost opposite connotation.

20. namby-pamby Wishy-washy; insipid, lacking character or strength; weak or indecisive; childishly cute or affectedly sentimental. This expression was first used in a 1726 poem nicknaming and ridiculing Ambrose Philips (1674–1749), who purportedly had written a children's verse employing affected, "cutesy" language.

Namby Pamby's little rhymes, Little jingle, little chimes. (Henry Carey, *Namby Pamby*, 1726)

Namby is a baby-talk corruption of the name Ambrose, and *pamby* is simply a nonsensical rhyming word. The expression received almost immediate acceptance and popularity. Though now extended to contexts such as affected or ef-

feminate behavior, *namby-pamby* (or the unhyphenated *namby pamby*) is still most commonly used to describe inferior writing.

> At a very advanced age he condescended to trifle in namby pamby rhymes. (James Boswell, *The Life of Samuel Johnson*, 1791)

21. out of [one's] depth In water too deep, beyond one's capacity for understanding; *in over one's head*; beyond one's resources. The allusion here is obvious; literally, one is in water so deep that he can't touch bottom without sinking, figuratively, one is dealing with a concept beyond his comprehension. In Shakespeare's *Henry VIII*, Cardinal Wolsey reflecting upon his fall from power comments:

> . . . I have ventured
> Like little wanton boys that swim on
> bladders,
> This many summers in a sea of glory,
> But far beyond my depth.
> (III,ii)

22. paper tiger A person or thing that seems impressive or powerful but is, in actuality, weak or ineffectual; a sheep in wolf's clothing. Figuratively, a *tiger* is a brave or forceful person, one with the qualities associated with the feline tiger. Since *paper* implies flimsiness, *paper tiger* refers to any person or thing whose impressiveness is actually a façade, whose bark is worse than his bite. This expression, part of an ancient Oriental proverb, first received public attention in 1946 when Mao Tse-tung, leader of Communist China, accused the United States of being a "paper tiger." He repeated the charge during the Korean War, specifically in reference to President Truman. Although now applied in widely varying contexts, *paper tiger* remains an effective political invective:

> I disagreed with nearly all of Mr. Hoffer's conclusions but one. That is where he stated that the Negro is doing battle with a paper tiger when he aims his wrath at the white liberal.

> (*The New York Times Magazine,* April 25, 1965)

23. Peter principle The principle can be so stated: In a hierarchy every employee tends to rise to his level of imcompetence. This expression was formulated in 1969 by Dr. Laurence J. Peter and Raymond Hull and was the title of their best-selling book. They maintain that their experience in analyzing hundreds of cases of occupational incompetence led to such a conclusion. They also produced two rather important corollaries to the principle.

> In time, every post tends to be occupied by an employee who is incompetent to carry out its duties.

> Work is accomplished by those employees who have not yet reached their level of incompetence.

Life Magazine, demonstrating remarkable prescience, commented in its July 18, 1969 issue:

> It is a minor cultural phenomenon and its title phrase . . . is certain to enter the language.

24. plough with dogs To do something useless or ineffective. The implication in this phrase is that one won't make much headway harnessing dogs to the plough rather than horses or oxen. The expression dates from the 17th century, but is seldom, if ever, heard today.

> I have seen a friendly dame, winding a ravelled skain of thread or yarn exclaim with a curse, "This is as bad as ploughing with dogs."
> (*Gentleman's Magazine,* 1795)

25. queer as Dick's hatband When Oliver Cromwell died in 1658, he named his son Richard to succeed him as Lord Protector of the Commonwealth. Richard, who was sometimes disdainfully called *King Dick* or *Queen Dick,* was a weak and ineffective man, a mere figurehead. He was removed in 1659 after eight months as Lord Protector and, in 1660, King Charles II was restored to the throne. The allusion in this expres-

sion is to the crown and how queerly it sat on Richard's head.

> As queer as Dick's hatband, made of pea straw, that went nine times around and would not meet at last. (D.E. Marvin, *Curiosities in Proverbs*, 1916)

There are many variations to this expression: *tight as Dick's hatband, Dick's hatband was made of sand*, allusions to the uneasiness of the crown on Dick's head; and *that happened in the reign of Queen Dick*, another slur upon the junior Cromwell's weakness.

26. that won't wash That won't stand up under investigation; that excuse won't do. This phrase, usually posed in the negative, derives from the inability to remove the soil from one's person or one's garments, thus figuratively from one's story or explanation.

> I see that the government's going after the tobacco industry again. Well, it just won't wash. (Gerald Walker, *Atlantic*, February 1973)

The expression, which has been in use since the 1840s, is occasionally put in a positive sense.

> Pluck . . . That's the only thing after all that'll wash. (Thomas Hughes, *Tom Brown's School Days*, 1857)

27. wishy-washy Indecisive, insipid, vacillating, weak; namby-pamby; lacking quality, character, or strength. Originally, *wishy-washy* referred to a weak, watered-down drink or to soup that was so watery that it was devoid of substance. Eventually, the expression was applied in other contexts to describe persons or ideas of weak and unimpressive character.

> A weak, wishy-washy man who had hardly any mind of his own to speak of. (Anthony Trollope, *The Last Chronicle of Barset*, 1867)

28. write on water To leave no lasting record, to make no permanent impression; also *to write in the dust, on sand, or on the wind*. The equivalent Latin

phrase is *in aqua scribere*. This expression, a comment on the ephemerality of human life and works, is found in the epitaph of the English poet John Keats.

> Here lies one whose name was writ in water.

204. INEXPERIENCE

1. babe in the woods A naive, unsuspecting person; one easily duped or victimized. Attempts to trace the term to a popular pantomime story well-known in Norfolk, England, are unconvincing. The conventional figurative associations of both *babe* (innocence, ingenuousness) and *woods* (complexity, darkness) seem explanation enough; the phrase's origin remains unknown.

2. first-of-May Inexperienced; uninitiated. This expression dates back to the early part of this century when circuses toured the country throughout the late spring, summer, and fall. After the winter layover, the circus had to hire many new laborers and performers to assure that the tour would run smoothly and successfully. Generally, these people would be hired by the first of May so that they could be trained before the tour began; hence the expression *first-of-May*.

> These first-of-May guys are a little off time. (R. L. Taylor, in *The New Yorker*, April 19, 1952)

3. greenhorn An unsophisticated, inexperienced, or naive person; a dupe or fall guy; an immigrant or newcomer, an uninformed person. In the 15th century *greenhorn* applied to a young ox whose horns had not yet matured. By the 1700s the word referred to a raw, inexperienced person, and not until the turn of the century did *greenhorn* mean 'immigrant.' Today the term is most often used contemptuously to refer to any novice or unsuspecting person.

> I suppose you are not hoaxing us? It is, I know, sometimes thought allowable to take a greenhorn in. (Sir

H. Rider Haggard, *King Solomon's Mines*, 1885)

4. little Lord Fauntleroy A naïve and unsophisticated child of gentle nature; an impeccably mannered and fastidiously dressed child. This eponym comes from the hero of Frances Hodgson Burnett's novel *Little Lord Fauntleroy* (1885). It is usually employed in an ironic tone, as in the following:

> Some little Lord Fauntleroy who had just found out there were rotters in the world. (D. Powell, *Time to be Born*, 1942)

Fauntleroy can also stand alone as an adjective describing a particular style of children's dress or hair style popularized in the book.

> Myself aged seven—thicklipped, Fauntleroy-haired. (Dylan Thomas, *Letters*, 1933)

5. live in cotton wool To be naïve, to lead a sheltered, protected existence. Cotton wool or absorbent cotton is the kind used as padding or wadding. In this British colloquial expression it symbolizes insulation from the harsh realities of life. The phrase was used earlier as a metaphor for superfluous comfort or luxury—insulation, once again, from the difficulties of everyday life.

> Letty would never be happy unless she lived in clover and cotton-wool. (Dinah M. Mulock, *The Woman's Kingdom*, 1869)

6. low man on the totem pole See 358. STATUS.

7. pigeon See 395. VICTIMIZATION.

8. salad days See 15. AGE.

9. tenderfoot A greenhorn, a novice; a raw, inexperienced person.

> We saw a man in Sacramento when we were on our way here, who was a tenderfoot, or rawheel, or whatever you call 'em, who struck a pocket of gold. (*American Speech*, 1849)

This term originated in the American West where it was used to describe newcomers unaccustomed to the hardships of rugged life. It now applies to a person inexperienced in any area or endeavor.

10. wet behind the ears Immature, inexperienced, green; naïve, unsophisticated, innocent; also *not dry behind the ears*.

> Married! You're still wet behind the ears. (Ben Ames Williams, *It's a Free Country*, 1945)

At birth most animals are literally wet from the amniotic fluid previously surrounding them. The recessed area behind the ears is one of the last to become dry.

> They aren't dry behind the ears, so to speak, but still believe in Santa Claus. (*The Chicago Daily News*, August 1945)

Inferiority . . .

See 363. SUBORDINATION

205. INFIDELITY

1. backdoor man An illicit lover; a person with whom one is having an affair. Such a one presumably enters by the back door to avoid being seen.

2. bedswerver An adulteress; a woman who strays from the marriage bed. Shakespeare used the term in *The Winter's Tale*:

> That she's
> A bedswerver, even as bad as those
> That vulgars give bold'st titles.
> (II,i)

3. cuckold This term for the unwitting husband of an unfaithful wife supposedly derives from the cuckoo bird's habit of depositing its eggs in other birds' nests. The theory would have more plausibility if the word were *cuckoo* itself and were applied not to the injured party but to the adulteress, as is the case in several other languages. According to Dr. Johnson, the cry of "cuckoo" was formerly

used to inform the husband, who subsequently came to be dubbed by the term himself. But even this does not account for the transformation from *cuckoo* to *cuckold*. A possibly more plausible explanation may be that the suffix *wold*, akin to *wild*, was coupled with *coke* 'cock' to create a compound meaning 'hornmad,' which may well describe a frustrated husband's condition, in the circumstances. See also **wittol**, below.

4. false as Cressida Unfaithful, perfidious; pledging love and fidelity while practicing cuckoldry and adultery; two-faced, hypocritical; traitorous. According to legend set during the Trojan War, Cressida, the daughter of a Trojan priest, had exchanged a pledge of everlasting love and fidelity with Troilus, her beloved. When Cressida was offered to the Greeks in exchange for a group of prisoners, the pledge of fidelity was renewed and sealed with an exchange of gifts. But Cressida had barely arrived in the Greek camp when she succumbed to the charms of Diomedes. To make her abandonment of Troilus even more bitter, she wanted Diomedes to wear Troilus' gift of a sleeve during their frequent encounters. The legend has been immortalized by Chaucer in *Troilus and Criseyde* and by Shakespeare:

"Yea," let them say, to stick the heart
 of falsehood,
"As false as Cressid."
(*Troilus and Cressida*, III,i)

5. freeman of Bucks A cuckold. Although the *Bucks* in this 19th-century phrase is a literal reference to the English county of *Buckinghamshire*, the figurative reference is to the cuckoldry represented by the horns of the buck. Why horns as a symbol came to be associated with cuckoldry has never been satisfactorily explained, even though the association has existed in England since before the Norman conquest in 1066.

6. hanky-panky See 237. MISCHIEVOUS-NESS.

7. Punic faith Faithlessness; violation of faith; perfidy. The Romans, who believed the Carthaginians had broken faith with them, considered them treacherous and untrustworthy. The Carthaginians felt the same way about the Romans, but since the Roman influence has prevailed, the term has come into the English language as a synonym for treachery. A related term *French faith* developed in England during the Hundred Years' War.

French faith became the same among us, as Punic faith had been among the Romans. (Abraham Tucker, *The Light of Nature*, 1770)

8. wear the bull's feather To be cuckolded. The bull's feather was a symbol of cuckoldry. A 17th-century song entitled "The Bull's Feather" popularized this expression.

It chanced not long ago as I was
 walking,
An eccho did bring me where two
 were a talking,
Twas a man said to his wife, dye had
 I rather,
Than to be cornuted and wear a *bulls
 feather.*

9. wear the horns To be made a cuckold, to have an unfaithful wife. The association of horns with cuckoldry appears in many European languages, but no totally satisfactory explanation of the link has been offered. The most plausible relates the cuckold's "horns" to the spurs of a castrated rooster, formerly implanted at the roots of the excised comb where they reputedly grew into appendages resembling horns. The fact that the German word for *cuckold* formerly meant 'capon' lends considerable credence to this otherwise questionable account. Since the deceived husband has been symbolically stripped of his manhood, the association is logical as well. Whatever the connection, the usage was pervasive. The following appeared in *Hickscorner*, a pre-Shakespearean drama.

My mother was a lady of the stews'
blood born,
And, . . . my father wore a horn.

10. wittol A husband who knows of—
and tolerates—his wife's infidelity. The
word is modeled on the older *cuckold*,
with *wit*-'knowledge' as a prefix. Both
cuckold and *wittol* trace back to Middle
English; the latter—at least the word—
is archaic. See also **cuckold**, above.

Influence . . .

See 232. MANIPULATION

206. INFORMATION

1. get a line on To obtain knowledge
about; to receive news of. In this expres-
sion, *line* often means an anticipated tid-
bit of information:

> If you want to get a line on how she
> feels, she gave me a letter to give you
> . . . Here it is. (P. G. Wodehouse,
> *Luck of Botkins*, 1935)

The phrase is occasionally used by po-
licemen or journalists to indicate a hot
tip or lead obtained clandestinely.

2. get wind of To acquire advance in-
formation about something hitherto un-
known; to get a hint of something about
to happen. This expression is derived
from the olfactory ability of animals to
detect the airborne scent of other ani-
mals. The phrase often refers to the at-
tainment of foreknowledge which war-
rants special action.

> They retreated again, when they got
> wind that troops were assembling.
> (Princess Alice, *Memoirs*, 1866)

3. low-down The inside scoop; the bare
facts. This common American colloqui-
alism implies that the unadorned facts
lie at the bottom of a situation.

> One of the minions will . . . give me
> the official lowdown on Fisher.
> Possible police record, etc. (M.
> Mackintosh, *King and Two Queens*,
> 1973)

4. scuttlebutt Gossip, hearsay; a vague,
unconfirmed rumor; also, *water-cooler
talk*. This expression originated in the
United States Navy, where the *scuttle-
butt* 'water pail, drinking fountain' was
the scene of much idle chitchat. It origi-
nated in nautical lingo: the butt was a
large cask containing the ship's water
supply; the scuttle was a cover for it. The
crew would meet there to refresh them-
selves and exchange gossip. The expres-
sion was carried over to civilian life,
where it describes office rumors, many
of which are created around the water-
cooler.

> And worry about a slump, according
> to business scuttlebutt, is making some
> unions concentrate on share-the-job
> plans. (S. Dawson, AP wire story,
> March 1953)

5. stable push The inside scoop; infor-
mation from reliable or important peo-
ple. This expression originated and is
still virtually confined to the horse-rac-
ing world, where it refers to hot tips
from knowledgeable people concerning
a horse's prospects for victory.

6. straw vote An opinion poll; an unof-
ficial vote taken to ascertain the relative
strength of political candidates or the
general trend of opinion on a given is-
sue. In the 19th and early 20th centuries
in the United States, informal polls were
taken by handing out a piece of straw to
each of the voters who would break the
straw to signify a "nay" vote, or leave it
intact to signify approval.

> Straw votes, which have recently been
> taken in the New York State
> campaign, indicate that Mr. Hearst
> will be badly beaten. (*Daily
> Chronicle*, October 24, 1906)

A somewhat cynical evaluation of the
validity of a straw vote was once offered
by O. Henry in *Rolling Stones* (1913):

> A straw vote only shows which way
> the hot air blows.

7. white paper A government bulletin
which establishes the official position on

a specific topic. This term is derived from the white binding of such publications. The expression is commonly used in the United States and Great Britain for the vast number of government reports released to the public.

207. INFREQUENCY
See also 380. TIME

1. once in a blue moon Very rarely. A *blue moon* occurs when there is a full moon twice in the same month, an unusual event, but one that takes place from time to time.

2. rare as hen's teeth See scarce as hen's teeth, 4. ABSENCE.

3. when two Fridays come together Never. Since two Fridays never come together, this expression is usually used as a sarcastic quip when one is asked when he intends to do something of an onerous nature such as complete a project, pay back a personal loan, or the like.

208. INGRATITUDE

1. bite the hand that feeds you To repay the kindness of a benefactor with ill will or injury; to act ungratefully. This expression, which dates from 1770, probably refers to the way a surly dog snaps at the hand of the one who offers it food.

A variant of this proverbial expression dates from at least 1546.

2. egg in [one's] beer This American slang expression is most commonly heard as a retort to an unjustified complaint, as "Whaddya want, egg in your beer?" The term arises from the practice of literally putting a raw egg in a glass of beer. Dating from the early 1900s, this phrase has graduated from the local taverns and barrooms to become a ubiquitous reply. The addition of an egg to a beer, besides enhancing the flavor for some drinkers, is alleged to increase one's sexual powers; hence, one not only gains the pleasure of the beer but also receives a bonus in the process.

3. look a gift horse in the mouth To criticize ungratefully; to find fault with something received gratis; to check for defects. This expression, with counterparts in most western European languages, has been traced to the writings of St. Jerome, a Latin father of the fourth century. It has been in use in England since at least 1546, when John Heywood listed the term in his *Proverbs:*

> No man ought to look a gift horse in the mouth.

The intent of the phrase as it is normally used (with a negative) is to discourage a display of bad manners that results from inquiring too closely about the innate value of a proffered gift. The allusion is to the practice of horse traders, who determine the age and condition of a prospective purchase by examining its mouth and teeth.

> Who the hell am I to look a gift horse in the mouth? (G. H. Coxe, *Murder for Two*, 1943)

209. INITIATION
See also 31. BEGINNINGS;
318. RESTARTING;
357. STARTING

1. baptism of fire An extremely trying initial experience; a first encounter which tests one to the utmost. The phrase applies literally to the first time a soldier faces battle fire, but even that usage was originally figurative. The expression has its origin in the early Christian belief that an as yet unbaptized believer who suffered martyrdom by fire was thereby baptized, i.e., received into the community of the faithful and consequently saved. A synonymous term for other kinds of martyrdom is *baptism of blood*. Conventional baptism is called *baptism of water*.

2. break the ice To initiate a conversation or make a friendly overture; to overcome existing obstacles, prepare the way; begin, dive in, get started; broach a new subject. In the late 16th century, *break the ice* meant literally to facilitate

a ship's passage by breaking the ice. Soon after, it was used figuratively in regard to any efforts made to begin a new project or to upset the status quo of a stalemate, deadlock, impasse or such. In modern figurative use, *break the ice* is heard mostly in the context of interpersonal relationships. Any attempt to cut through another person's reserve is considered "breaking the ice."

> I availed myself of a pause in the conversation to break the ice in relation to the topic which lay nearest my heart. (Henry Rogers, *The Eclipse of Faith*, 1853)

3. get [one's] feet wet To get a start in or begin something new; to get one's first taste of, to get the feel of. The allusion is to the way a bather tests the water by putting his toes or feet in before committing himself to total immersion.

4. get the ball rolling To initiate or begin; to assume active leadership of a project, event, or other matter; to set an activity in motion. This expression probably originated in the ancient British game of *bandy*, a hockeylike sport in which players kept a ball in constant motion as they attempted to score points by getting it in the goal of the opponent. A variation is *start the ball rolling*.

A related expression, *keep the ball rolling*, is probably also derived from bandy. It means to continue or to spark renewed interest and enthusiasm in an activity or project already underway. One source credits the popularity of this expression to the 1840 presidential campaign of William Henry Harrison whose followers wrote political slogans on a huge paper ball and then pushed it from city to city shouting, "Keep the ball rolling."

5. get under way To get started, begin moving. This is borrowed from an old nautical idiom *under way* 'in forward motion.'

6. pave the way See 284. PREPARATION.

7. ring up the curtain on To begin or initiate a project, plan, or activity; to start the ball rolling. Originally limited to use in the theater, this expression referred to raising the curtain on cue (usually the ringing of a bell) to mark the start of a performance. Though still used in this theatrical context, *ring up the curtain on* is often applied figuratively to describe the inauguration of a project or other endeavor.

> Before the curtain was rung up on the great spectacular drama of Vaal Krantz . . . (M. H. Grant, *Words by an Eyewitness; The Struggle in Natal*, 1901)

A variation is the shortened *ring up*.

> Look sharp below there, gents, . . . they're agoing to ring-up. (Charles Dickens, *Sketches by Boz*, 1837)

See also **ring down the curtain on**, 375. TERMINATION.

210. INJUSTICE
See also 147. FAVORITISM;
283. PREJUDICE

1. get away with murder Do something unconventional or illegal and not be punished; violate the rules of decency. This expression, dating from about 1910, is heard primarily in social situations. If one flaunts social custom and the impropriety is overlooked, he is said to *get away with murder*.

2. Montgomery's division, all on one side A one-sided distribution of the gains; a concern only for one's own profit; victimization of others engaged in a mutual project. This expression originated in the time of free companies, bands of discharged soldiers who plagued France during the mid 1300s sacking and looting the countryside for their own gain. This phrase, a translation of an old French apothegm, refers to a certain man named Montgomery who, as leader of a medieval free company, became notorious for keeping the spoils of plunder for himself.

3. **We wuz robbed** Describing a situation felt to be completely unjust or absolutely wrong; the officials cheated. Mike Jacobs, the manager of Max Schmeling, shouted this remark into the microphone on a nationwide broadcast, immediately after Jack Sharkey had been awarded the heavyweight boxing title by decision on the night of June 21, 1932. Since that fateful evening, it has become a jocular cry used by those questioning a decision in any field of endeavor.

Innovation . . . See 9. ADVANTAGE;
318. RESTARTING

Inquisitiveness . . .
See 80. CURIOSITY

Insanity . . . See 111. ECCENTRICITY;
218. IRRATIONALITY;
385. UNCONVENTIONALITY

Insensitivity . . .
See 42. CALLOUSNESS

211. INSIGNIFICANCE
See also
406. WORTHLESSNESS

1. **anise and cumin** Insignificant matters, petty concerns. The term is usually found within a context implying that one ought to be about more important work or focus his attention on larger concerns. The origin of the phrase lies in Jesus' reproach to the Scribes and Pharisees:

> Ye pay tithe of mint and anise and cummin, and have omitted the weightier matters of the law, judgment, mercy, and faith; these ought ye to have done, and not to leave the other undone. (Matthew 23:23)

Anise and cumin are aromatic herbs often used in both cookery and medicine.

2. **beautiful downtown Burbank** This American expression was born in 1968 on the popular TV show *Laugh-In*.

Gary Owens, the announcer, used the phrase with ironic intent as part of his introductory spiel:

> . . . coming to you from beautiful downtown Burbank.

(The show originated from studios in Burbank, California, a suburb of Los Angeles.) The phrase gained immediate recognition through its national exposure each week on prime-time television, and it came to represent any architecturally poor and culturally deprived community in the United States.

3. **cat's cradle** A children's game; a complicated or fanciful idea with little or no meaning; a worthless accomplishment. The origin of this term, which dates to at least the early 18th century, is uncertain. The game is played by looping a piece of string through the fingers, and, by passing the string from player to player, intricate and symmetrical designs are formed. It is suggested that the name came from the first pattern in the game which resembles a *cratch*, an obsolete word meaning 'hayrack,' and from the final pattern which resembles a cradle; hence, the original form of the term *cratch-cradle*, which in later years was corrupted to its present form *cat's cradle*. The *OED*, besides listing the noun form of *cratch*, also lists an obsolete verb form which meant to snatch or grab, thus lending more credence to this concept of the expression's origin. A less plausible supposition is that the term derived from a kitten playing with a ball of yarn. Whatever the case, the expression is still in common use, both literally and figuratively.

> One of those cat's-cradle reasoners who never see a decided advantage in anything but indecision. (*Edinburgh Review*, 1824)

4. **cheap-Jack** Any insignificant or inconsequential person, especially one who travels about selling cheap goods; a small time hawker. This expression makes use of the ubiquitous English *Jack*, a common appellation assigned to

an unknown person. Coined sometime in the mid 1800s, the term originally was applied only to itinerant small-time salesmen who went about the countryside offering cheap wares at cheap prices; hence, the epithet for anyone of small consequence.

> Making a sort of political Cheap Jack of himself. (George Eliot, *Middlemarch*, 1872)

A common variant is *cheap-John*.

> Another chapter, gents, in the hist'ry of that air crazy institution, to wit an' namely, Uncle Sam's Cheap John Congress. (Stuart Henry, *Conquering Our Great American Plains*, 1930)

5. chronicle small beer To register insignificant events; to write down matters of little or no importance. Since the 16th century *small beer* has been synonymous with weak beer, hence, figuratively, something trifling or of little consequence.

> She had found that most worried men felt better if she chronicled small beer. (H. C. Bailey, *The Apprehensive Dog*, 1942).

6. come from Wigan To be completely provincial; to behave like a rustic. In use since at least 1890, this Briticism is of uncertain origin. Somehow Wigan, a small manufacturing community northeast of Liverpool, has come to be a national symbol of provincialism, one of those dull, out-of-the-way towns that has lost contact with the outside world—counterpart to the mythical *Podunk, U.S.A.* A common music hall gag, *that went better in Wigan*, frequently fired at the audience when a joke flopped, probably helped create Wigan's unhappy image.

7. dog's body A menial; an errand boy; any insignificant, unskilled drudge; a junior naval officer, especially a midshipman. Originally a sailor's slang expression for dried peas boiled in a cloth, this Briticism has been in use since the mid 19th century. For some unknown

reason it also came to mean a junior naval officer, and by extension any undistinguished underling.

> A midshipman is known in the service as a 'snottie' . . . if he is a junior midshipman he is also a dog's body. I defy anyone to be accurate and sentimental about a snottie who is a dog's body. (*Daily Express*, April 3, 1928)

A related term is *gofer*, any flunky whose main function is to go for this and to go for that.

8. down in the boondocks In a remote rural area; away from civilization; in isolated terrain. This American slang expression originated among armed forces personnel stationed in the Philippine Islands and achieved great popularity during World War II. Although other branches of the armed forces make use of the term, it seems to be especially popular among the Marine Corps.

> Today, Marines use boondock clothes and boondock shoes for hikes and maneuvers. (Harvey L. Miller, *Wood Study*, October 1950)

The word *boondock* is most likely a corruption of the Tagalog *bundok*, meaning mountain. A related term *boondockers* refers to a heavy hiking shoe, especially used in troublesome terrain.

9. a drop in the bucket An absurdly small quantity in relation to the whole; a contribution so negligible or insignificant that it makes no appreciable difference; also *a drop in the ocean*. The expression appears in the following passage from the King James version of the Bible:

> Behold, the nations are as a drop of a bucket, and are counted as the small dust of the balance. (Isaiah 40:15)

A drop in the ocean was apparently coined by analogy. It dates from the early 1700s.

10. fly in amber An unimportant person or incident remembered only through association with a person or

matter of significance. The origin of this phrase is credited to certain extinct pine trees that produced a resin called amber which, while flowing down the trees, trapped and preserved small insects, thus fossilizing organisms of virtually no scientific interest.

> Full-fledged specimens of your order, preserved for all time in the imperishable amber of his genius. (C. Cowden Clarke, *Shakespeare-characters*, 1863)

11. forgotten man The decent, hard-working, everyday citizen; the average American working man. This term was coined in 1883 by William G. Sumner, a professor at Yale University, who characterized as the *forgotten man* that industrious, ordinary sort of man who supports his family, pays his taxes, but never seems to profit in the larger scheme of things. Franklin Delano Roosevelt revived its popularity during the 1932 presidential campaign but with a slightly different connotation; he made the *forgotten man* more of an *underprivileged man*.

> These unhappy times call . . . for plans that put their faith once more in the forgotten man at the bottom of the pyramid. (Radio Address, April 7, 1932)

12. hill of beans Of little value, insignificant; trifling. This expression alludes to the once small value of beans. A bean has been used symbolically since at least the 13th century to designate a thing of small value, whether material or spiritual, and carries the same connotation today.

> Captain Willard didn't know beans about fighting Apaches. (*Range Riders Western*, May 1948)

A *hill of beans* is almost always used in a negative or derogatory sense; the most common forms are *not worth a hill of beans, doesn't amount to a hill of beans,* and *does not know beans about,* as in the citation above.

> That oath he took here don't amount to a hill of beans. (*Chicago Tribune,* January 23, 1947)

13. Jack-a-Dandy An insignificant person; a contemptuous name for a fop or a dandy; a loafer; a sponge. Although conjectures are rife, the origin of this term is uncertain. The *OED* records its first appearance in English as 1632 and further states that the term is probably the root for *dandy*, which didn't make its appearance in the language until the late 18th century.

> Tom did not understand French but . . . despised it as a jack-a-dandy acquirement. (Samuel Lover, *Handy Andy*, 1842)

Variants are *Jack-o-Dandy* and *jack-a-dandyism*.

14. Meriden audience This expression is a theatrical term for a specific audience, one man and one boy. The term refers to an evening in the autumn of 1888 in Meriden, Connecticut. One of Countess Helena Modjeska's traveling troupes, led by the destined-to-be-famous Julia Marlowe, opened in Meriden that autumn evening to an audience of two people, a man and a boy. Dr. Davis, the mayor and a local surgeon, wrote a letter of glowing praise about Miss Marlowe's performance to a local newspaper. Apparently he was the man; who the boy was has never been discovered.

15. Mickey Mouse Cheap or inferior; small, insignificant, worthless; petty, trivial; simple, easy, childish. The allusion is to the cartoon character created by Walt Disney in 1928. Because this character is internationally famous, *Mickey Mouse* has been applied figuratively in innumerable and widely varied contexts. The connotation of cheapness and inferiority probably originated in the mid 1930s when the Ingersoll Watch Company marketed a popular wrist-watch, with Mickey Mouse on its face and his arms serving as pointers or hands, which sold for $2. The watch was not made well enough to last long,

hence the allusion to flimsiness and poor quality.

> One reason for the AFL's reputation as a Mickey Mouse league is that it gave new life to NFL rejects. (J. Mosedale, *Football*, 1972)

> At Michigan State [University] . . . a "Mickey Mouse course" means a "snap course." (Maurice Crane, "Vox Box," in *American Speech*, October 1958)

See also **mickey mouse around**, 126. EVASIVENESS.

16. mom and pop Relating to a small business establishment, frequently a retail store, usually run by a husband and wife or by a family. The allusion in this phrase is to a small business establishment that can't afford to employ any help outside the family. Conceived about 1962, the term has, in recent years, come to mean any small, low-overhead business.

> What started as a "Mom and Pop" television shop, with two reporters and six line producers, has grown into a factory employing more than 70 people, including 21 producers and 16 film editors. (*The New York Times Magazine*, May 6, 1979)

17. no great shakes Unimportant or unimpressive; not exceptional or extraordinary; common, dull, boring. There are several suggested derivations of this expression: a low roll on a shake of the dice, a negative appraisal of someone's character made on the basis of a weak handshake, or a negligible yield resulting from shaking a barren walnut tree. Alternate meanings of *shake* are also cited: 'reputation,' 'a shingle from the roof of a shanty,' or 'plant stubble left after harvesting.' One source alludes to the Arabic *shakhs* 'man.' At any rate, *no great shakes* has long implied that a person or thing is common, unimportant, or of no particular merit or ability.

> [He] said that a piece of sculpture there was "nullae magnae quessationes" ['of no great shakes'] and the others laughed heartily. (Lord Henry Broughton, *Recollections*, 1816)

18. not worth an iota Insignificant; worthless; hardly worth mentioning; of little, if any, use. *Iota*, a letter of the Greek alphabet composed of a small, single stroke, came to represent anything insignificant or trifling, as Edmund Burke demonstrated in his *Correspondence* (1771):

> They never depart an iota from the authentic formulas of tyrany and usurpation.

The expression, *not worth an iota*, came into use during the 17th century in Britain; *not worth a jot* followed hard upon, for, since the letters *i* and *j* were originally interchangeable, *iota* and *jot* referred to the same thing. A related expression from the Italian is *not worth an h*, for in the Italian language the letter *h* is seldom used, and when it does appear, it has no spoken value, i.e., it is always silent.

19. one-horse town An extremely small, insignificant town. A farmer whose plow was pulled by one horse instead of two was considered small-time and of limited resources. Similarly, a one-horse town refers to a small, often rural community which could presumably survive with only one horse. The phrase maintains common usage in the United States despite the fact that horses are no longer the principal means of transportation.

> In this "one-horse" town, . . . as our New Orleans neighbors designate it. (*Knickerbocker Magazine*, 1855)

20. oyster part One line to speak in a theatrical production; insignificant; unimportant. This theatrical slang term for a one-line part in a play apparently is derived from the uncommunicativeness of an oyster. Like a clam, an oyster is a symbol of one who is tight-lipped or close-mouthed. The term has been in theatrical jargon since the 1920s.

21. peanut gallery A source of unimportant or insignificant criticism; in a theater, the section of seats farthest removed from the stage. In many theaters, peanuts and popcorn were sold only to the people in the least expensive seats, usually those in the rear of the balcony, hence the nickname *peanut gallery.* Since these seats are traditionally bought by those of meager means and, by stereotypic implication, those with a minimal appreciation of the arts, comments or criticisms from people in the *peanut gallery* carried little, if any, weight, thus the expression's more figurative meaning.

22. pebble on the beach An insignificant or unimportant person, especially one who was once prominent; a face in the crowd, a fish in the sea. This expression is one of many that minimize the importance of someone by virtue of the fact that he is just one of a multitude. It usually follows phrases such as "There's more than one . . . " and "You aren't the only . . . ," and is most commonly used in situations involving a jilted sweetheart.

23. penny-ante Insignificant or unimportant; strictly small-time; involving a trifling or paltry amount of money. Originally, *penny ante* was a poker game in which the ante or minimum wager was one penny. Though this literal meaning persists, the term is used figuratively as well.

Compared to the man Bilbo, 63-year-old John Rankin is strictly penny ante and colorless. (*Negro Digest,* August 1946)

24. play footsie To fool with idly; to treat with little concern; to indicate a casual interest. The allusion in this phrase is to the surreptitious passing of foot signals underneath a table, either while participating in a game of cards or as a message sending device used by clandestine lovers, especially while in the presence of their spouses. Modern use has broadened its application to characterize any act of a frivolous nature.

"But eventually we have to make a decision," he said. "The last impression we want to give is that we're playing footsie with the thing." (*The* [*New London, Conn.*] *Day* January 5, 1984)

25. Podunk Any hick town; the boondocks, the sticks; the middle of nowhere. This name, of Indian origin, may refer ·either to the Podunk near Hartford, Connecticut, or to that near Worcester, Massachusetts. But how either gained the notoriety necessary to make it representative of all such insignificant, out-of-the-way towns is unknown.

He might just as well have been John Smith of Podunk Centre. (*Harper's Weekly,* September 1901)

26. shoot deer in the balcony This colorful image refers to a theater so devoid of paying customers that the actors feel as if they are playing to open spaces. Derived from the old show business expression "Business was so bad you could shoot deer in the balcony," the phrase became standard theatrical jargon for a sparse or empty house. Raquel Welch in an article in *Family Weekly,* November 7, 1982, used *shoot moose in the theater,* a somewhat corrupted version of the traditional phrase.

I figured if the critics hated me, even if you could shoot moose in the theatre, they couldn't close me because it was only two weeks.

27. small potatoes An inconsequential, trivial person; an irrelevant or unimportant concept or notion; a small amount of money. This familiar saying is evidently derived from the short-lived satiation of one who has eaten a small potato. Although the expression retains its human application, *small potatoes* more often describes an insignificant amount of money, especially when such a pittance is compared with one's projected future earnings or with a much greater cash sum.

Insincerity

The $7 billion was of course pretty "small potatoes" compared to the vast inflationary borrowings of the federal government. (*Proceedings of the Academy of Political Science*, May 1948)

28. tank town A small town located on a railroad; a one-horse town; a hick town. This American colloquialism, in common use since the late 1800s, designates a tiny town with a railroad water tank, but too small for a station. It is a representative term for scores of such towns throughout the United States and symbolizes a slow-paced type of life with little interest in the progress of the world.

Out they went for sixteen weeks in the theatres, opera houses, and musty lodge halls of the tank towns. (*Saturday Evening Post*, April 9, 1949)

A few of the many variants for this term are: *jerkwater town, one-horse town, hick town,* and *cowtown.*

29. three blue beans in a blue bladder Empty words; many words with little matter; a meaningless torrent of words. This British expression has its roots in the Middle Ages when a common practice among peasants was to create a baby's rattle by putting beans in a bladder. The resulting rattling noise, loud but meaningless, characterized an idea that was soon transferred to the noise emanating from some people's mouths.

Putting all his words together,
'Tis three blue beans in one blue bladder.
(Matthew Prior, *Alma*, 1718)

Insincerity . . . See 176. HYPOCRISY

Insolvency . . .
See 196. INDEBTEDNESS

212. INSTANTANEOUSNESS
See also 261. PACE;
354. SPEEDING

1. at the drop of a hat See 301. READINESS.

2. before you can say "Jack Robinson" Instantly, immediately. There are two common but equally unsubstantiated theories as to the origin of this phrase. One holds that a rather mercurial gentleman of that name was in the habit of paying such brief visits to neighbors that he was gone almost as soon as he had been announced. The other sees the source in these lines from an unnamed play:

A warke it ys as easie to be done
As tys to saye, Jacke! robys on.

In popular use during the 18th century, the expression appeared in Fanny Burney's *Evelina* in 1778.

3. before you can say "knife" Very quickly or suddenly; before you can turn around. This colloquial British expression is equivalent to *before you can say "Jack Robinson."* Mrs. Louisa Parr used it in *Adam and Eve* (1880).

4. curry a short horse This phrase, frequently heard in the passive, a *short horse is soon curried*, and in use since the Middle Ages, is simply a figurative way of saying that a little chore is soon completed, that a little business is soon transacted.

A short tale is soon told—and a short horse soon curried. (Sir Walter Scott, *The Abbot*, 1820)

5. in a jiffy In a trice, in a minute, right away. Although the exact origin of this expression is unknown, it is thought by some to be the modern spelling of the earlier *gliff* 'a glimpse, a glance,' and by extension 'a short space of time, a moment.' The phrase dates from the late 18th century.

They have wonderful plans for doing everything in a jiffy. (Charles Haddon

Spurgeon, *John Ploughman's Pictures*, 1880)

6. in a pig's whisper In a short time; soon. A pig's whisper was originally a short grunt, one so brief that it sounded almost like a whisper.

> You'll find yourself in bed, in something less than a pig's whisper. (Charles Dickens, *Pickwick Papers*, 1837)

7. in the twinkling of a bed staff Immediately, instantly; in two shakes of a lamb's tail; right away. One explanation of the source of this expression attributes it to a playful tilt in the late 13th century between Sir John Chichester, armed with a sword, and one of his servants, armed with a bed staff, in which the servant was accidentally killed. Another interpretation attributes it to the action of a maid beating the bedding with a bed staff. The *OED* offers the most plausible explanation. Bed staffs, an aid for making beds that had been built into recesses, were readily available sturdy household items; consequently, they were readily accessible as weapons in an emergency. A later variation is *in the twinkling of a bed post*. The common, related phrase, *in the twinkling of an eye* first appears in the Book of Corinthians:

> We shall not all sleep, but we shall all be changed,
> In a moment, in the twinkling of an eye, at the last trump: for the trumpet shall sound, and the dead shall be raised incorruptible, and we shall be changed. (15:51–52)

8. in two shakes of a lamb's tail Immediately, right away; instantly. *The Ingoldsby Legends* (1840). Anyone familiar with sheep knows the quivering suddenness with which those animals twitch their tails.

9. one fell swoop All at once; with a single blow or stroke. The *swoop* of the phrase may carry its obsolete meaning of 'blow,' or refer to the sudden descent of a bird of prey; *fell* carries its meanings of 'fierce, savage, destructive.' Macduff uses the phrase in Shakespeare's *Macbeth* when he learns that his wife, children, and servants have all been killed. In doing so, he plays on its associations with birds of prey:

> All my pretty ones?
> Did you say all? Oh Hellkite! All?
> What, all my pretty chickens, and their dam
> At one fell swoop?
> (IV,iii)

Contemporary usage does not restrict the phrase to serious contexts of fatal destruction; in fact, the expression is so often used lightly that it has generated the common spoonerism *one swell foop*.

10. on the double Instantly, without delay; quickly, at a swift pace. This expression originated as military jargon for double-time marching. The term's current civilian use is commonplace in the United States.

> They came with me on the double. (James M. Cain, *The Postman Always Rings Twice*, 1934)

11. p. d. q. Immediately, at once. This widely used abbreviation of "pretty damn quick" was coined in 1867 by Don Maginnis, a Boston comedian.

> He changed her mind for her p. d. q. (John O'Hara, *The Horse Knows the Way*, 1964)

12. right off the bat Immediately; at once; instantaneously. This very common expression is of obvious baseball origin.

> You can tell right off the bat that they're wicked, because they keep eating grapes indolently. (*The New Yorker*, May 1955)

The less frequently heard synonymous *right off the reel* may derive from the specific sports use of *reel* in fishing, though many of the more general uses of *reel* could account equally well for its origin.

13. sudden death Extra playing time added at the end of a regulation game that ends in a tie, in which the first team to score, or the first team to score a set number of points, becomes the victor; any undetermined situation that is settled suddenly and conclusively. The precise origin of this expression is obscure, but it is believed to have its source in the game of basketball. To eliminate tie games, which are always a source of dissatisfaction to the fans, overtime periods were devised, in which teams played a certain number of minutes to determine a victor, with as many overtimes played as were necessary to determine a winner. The sudden death overtime was later created to determine a winner in a reasonable amount of time, avoiding the problem of successive overtime periods that would physically exhaust the players. Several sports picked up the practice, notably ice hockey, soccer, and, recently, professional football. In golf, *sudden death* (extra) holes are played by those who have finished a tournament with a tie score, play continuing until one winner has been decided. In tennis, the *sudden death* is called a *tiebreaker*, the winner being the player who first wins five out of nine points, or seven out of twelve with a margin of two. In recent years the term has come into vogue in the business world, where it is used to indicate the rapid, and sometimes unexpected, resolution of a pending deal.

Instigation . . .
See 294. PROVOCATION

Instinctiveness . . .
See 215. INTUITION

213. INSULT
See also 327. RIDICULE

1. Anne's fan The gesture of placing the tip of the thumb to the end of the nose and spreading wide the fingers, an indication of disdain. This expression, dating from the early 18th century, signifies a universal gesture of contempt meaning

'kiss the cheeks of my posterior.' The gesture can be made more forceful by wiggling the fingers or by adding the other hand with the fingers similarly outspread. The term was derived from the fact that the English Queen Anne (1665–1714) was wont to conceal part of her face with her outspread fan. Variants are *Queen Anne's fan* and *Spanish fan*. Related verb forms describing the gesture are *pull bacon* and *cock a snook*. See also **cock a snook**, 213. INSULT.

2. barrack To boo or hiss; to voice loudly one's disapproval of a player, performer, or team at a public event. This British term is thought by some to be a back formation of the cockney word *barrakin* 'senseless talk,' although the *OED* claims an Australian origin. The word appeared in use in the late 19th century. The term *to barrack for* has the opposite meaning: 'to cheer for, or support vocally.'

3. bite [one's] thumb at To insult or show contempt for someone. The gesture, as defined by the 17th-century English lexicographer Randle Cotgrave, meant "to threaten or defy by putting the thumb nail into the mouth, and with a jerk [from the upper teeth] make it to knack [click or snap]." A famous use of the phrase is from Shakespeare:

> I will bite my thumb at them; which is a disgrace to them, if they bear it.
> (*Romeo and Juliet*, I,i)

4. catcall A harsh, whistling sound, something like the cry of a cat, used by theater and other audiences to express their disapproval, displeasure, or impatience; the whistlelike instrument used to make this sound. This term dates from the mid 1600s.

5. cock a snook A British slang expression for the gesture of putting one's thumb on one's nose and extending the fingers, equivalent to *thumb one's nose*. The origin of *snook* is obscure, and based on citations from as early as 1879, it can refer to other derisive gestures as

well. An earlier form of this phrase is *to take a sight.*

"To take a sight at a person" a vulgar action employed by street boys to denote incredulity, or contempt for authority, by placing the thumb against the nose and closing all the fingers except the little one, which is agitated in token of derision. (John C. Hotten, *A Dictionary of Modern Slang, Cant, and Vulgar Words,* 1860)

A current variant of *snook* is *snoot,* a slang term for the nose.

6. fork the fingers To use one's digits in a disdainful motion toward another person, in an apparent imitation of the appearance of two horns. The gesture symbolizes a curse invoking the devil, like, "May the Devil take you!"

His wife . . . Behind him forks her fingers. (Sir John Mennes and J. Smith, *Witts Recreations,* 1640)

See also **make horns at,** below.

7. give the bird To hiss or boo; to dismiss or fire; to receive unsupportive, hostile feedback. The original phrase was *give the goose,* a theater slang expression dating from the beginning of the 19th century. *Goose* or *bird* refer to the hissing sound made by an audience mimicking the similar sound made by a goose. It expresses disapproval, hostility, or rejection, and was directed at a performer or the play. Today it is a popular sound effect used by crowds at sporting events, although *give the bird* is also heard in other unrelated contexts. For example, an employer who dismisses an employee is said to *give the bird,* akin to *give the sack.* And in interpersonal relationships, *the bird* is analogous to *the brushoff* or *the gate.*

She gave him the bird—finally and for good. So he came to Spain to forget his broken heart. (P. Kemp, *Mine Were of Trouble,* 1957)

Another familiar meaning of *give the bird* is to make the obscene and offensive gesture of extending the middle finger.

8. give the fig To insult; also *the fig of Spain* and the now obsolete *to give the fico.* The fig or Italian *fico* is a contemptuous gesture which involves putting the thumb between the first two fingers or in the mouth. English versions of both expressions date from the late 16th century. The equivalent French and Spanish phrases are *faire la figue* and *dar la higa* respectively.

9. give [someone] the finger To extend the middle finger, outward and upward, as an obscene gesture meaning 'fuck you,' or 'up your ass,' made maliciously, derisively, or jocularly. This term refers to a gesture that was originally used only as an extreme insult but has in recent years come to indicate simple distaste or disagreement. Figuratively, the expression has come to be used when one's attempts to achieve something have been thwarted or frustrated by another.

Let me show you how to give that guy the finger . . . she was giving me the polite finger. (Budd Schulberg, *What Makes Sammy Run,* 1941)

10. give the raspberry To show ridicule or disapproval by making a vulgar noise; to respond in a scornful, acrimonious manner. *Raspberry,* a slang term dating from the turn of the century, refers to any expression of disapproval or scorn.

The humorist answered them by a gesture known in polite circles as a "raspberry." (T. Burke, *Nights in Town,* 1915)

Convict son totters up the steps of the old home and punches the bell. What awaits him beyond? Forgiveness? Or the raspberry? (P. G. Wodehouse, *Damsel in Distress,* 1920)

However, the most common raspberry is the sound effect known also as the *Bronx cheer,* made by sticking out the tongue through closed lips and blowing. *Razz,* short for *raspberry,* is a slang verb

meaning 'to ridicule or deride,' akin in use to *jeer*.

11. go to Putney Go to the devil; go to the deuce; get out of here. Among a number of common Cockney street sayings originating from music hall songs of the early 1800s, this expression was first conceived as *go to Putney on a pig*. The phrase is seldom heard today.

> Now in the year 1845, telling a man to go to Putney was the same as telling a man to go to the deuce. (Charles Kingsley, *The Water-Babies*, 1863)

12. left-handed compliment An insincere compliment; an insult that masquerades as praise. *Left-handed* denotes underhandedness, insincerity, derogation; hence, a *left-handed compliment* implies no compliment at all, but rather an incivility; for example, "Mary celebrated her 40th birthday yesterday." "Oh, really! She doesn't look a day over 39." One explanation of how *left-handed* came to imply something undesirable is the practice of ancient Greek seers who, during an augury, faced north with the east, the lucky side to their right, and west, the unlucky side to their left. From this practice the left came to imply misfortune. Another explanation attributes it to the *left-handed marriages* or *morganatic marriages* of Germany. In such marriages, a noble married a commoner, but as a symbol that neither she nor their common progeny might inherit his titles and properties, the noble offered his left hand to the bride during the ceremony. The most credible explanation attributes the undesirableness of being left-handed to a prehistoric attitude that viewed anything different with great suspicion and often assigned irrational qualities to any unusual trait. Whatever the case, *left-handed* connotes insincerity, and a *left-handed compliment* is undesirable.

13. make horns at To insult by making the offensive gesture of extending the fist with the forefinger and pinkie extended

and the middle fingers doubled in. This now obsolete derisive expression implies that the person being insulted is a cuckold.

> He would have laine withe the Countess of Nottinghame, making horns in derision at her husband the Lord High Admiral. (Sir E. Peyton, *The Divine Catastrophe of the . . . House of Stuarts*, 1652)

See also **fork the fingers**, above.

See **wear the horns**, 205. INFIDELITY.

14. Parthian shot The last word; any barbed, parting remark; a parting shot. The Parthians, a tribe from what is now northeast Iran, developed the ability to fire their arrows backward over their shoulders as they retreated or feigned retreat. Consequently, the term connotes any aggressive action or remark made upon departure.

> Casting back Parthian glances of scornful hostility. (Lisle Carr, *Judith Gwynne*, 1874)

Related terms are *Parthian glance*, *Parthian shaft*, and *Parthian fight*. *Parting shot* is a corruption of *Parthian shot* and carries the same meaning.

15. a plague on both your houses An imprecation invoked upon two parties, each at odds with the other; often a denunciation of both of America's two leading political parties. Shakespeare coined this expression in *Romeo and Juliet* (III,i):

> I am hurt.
> A plague o' both your houses! I am sped.
> Is he gone, and hath nothing?

16. a slap in the face A stinging insult; a harsh or sarcastic rejection, rebuke, or censure. This expression alludes to a literal blow to the face, a universal sign of rejection or disapproval. The implication is that a verbal blow, particularly an unexpected one, can be just as painful and devastating as a physical one.

[He] could not help feeling severely the very vigorous slap on the face which had been administered to him. (Thomas Trollope, *La Beata,* 1861)

17. thumb [one's] nose Literally, to put one's thumb to one's nose and extend the fingers, a gesture expressive of scorn, derision or contempt. This U.S. phrase came into use concurrently with *give the raspberry* in the early 1900s and is popular today. The gesture is considered offensive, but not as vulgar as the gesture known as *the bird.*

> He thumbed his nose with both thumbs at once and told me to climb the Tour d'Eiffel and stay there. (B. Hall, *One Man's War,* 1916)

In Britain the expression is *cock a snook.*

Intellectuality . . .
 See 331. SCHOLARLINESS

Intelligentsia . . .
 See 331. SCHOLARLINESS

Intensification . . .
 See 127. EXACERBATION

214. INTENSITY

1. back and edge Wholeheartedly, vigorously; entirely, completely. The allusion is to the thin sharpened side of a blade, or "edge," and the blunt side of the same blade, or "back." Together the two sides constitute the whole of the blade; thus the figurative extension in meaning to 'completely,' 'wholeheartedly,' 'with one's entire self.'

2. to beat the band Vigorously; enthusiastically; intently; rapidly; to perform any activity with great force and gusto, so as to drown out or exceed the tempo of the band, as it were. The expression dates from the turn of the century.

3. blow up a storm To engage in any activity with such enthusiasm and vigor as to effect a noticeable change in one's surroundings; also with the implication of being so caught up in the activity as to get carried away oneself. The most plausible explanation says the term comes from jazz trumpeting; another holds it stems from the storm of dust raised from the pit floor by the spectacular beating of wings and flurry of movement in a cockfight. Though *blow up a storm* appears to be the oldest and still most frequently heard form, *up a storm* itself is now commonly appended as an adverbial intensifier to many verbs of physical activity—one can work up a storm, sing up a storm, dance up a storm, and so on.

4. deepest dye Intensely; completely; to the utmost. This expression, dating from about 1600, usually connotes negativism of some type.

> He is a criminal of the deepest dye. (*Manchester Examiner,* June 16, 1885)

The allusion is to the depth of penetration into the material, whether it be a manufactured product or a human being. Related terms are *blackest dye* and *darkest dye.* It also occurs, in adjectival form, as *deep-dyed.*

5. full blast Maximum capacity, volume, strength, or speed; full swing; often in the phrase *in* or *at full blast.* In use as early as the 1830s, this phrase apparently originally connoted exaggerated or extreme behavior, appearance, etc., based on the following quotation from Frederick Marryat's *Diary in America II* (1839):

> "When she came to meeting, with her yellow hat and feathers, wasn't she in full blast?"

Although the expression's origin is unknown, it may be related to the use of *blast* in relation to machinery: air forced into a furnace by a blower to increase the rate of combustion.

6. full tilt At maximum speed, force, strength, or capacity; straight at or for, directly. This expression is said to have come from the way knights rode straight for one another at full gallop and with

lances tilted when jousting. The phrase, which dates from about 1600, appears in Frederic E. Gretton's *Memory's Harkback through Half-a-century* (1805–58):

The Earl rode full tilt at him as though he would have unhorsed him.

7. **go great guns** See 291. PROSPEROUSNESS.

8. **go to town** See 291. PROSPEROUSNESS.

9. **hammer and tongs** Forcefully, violently, strenuously; energetically, vigorously, wholeheartedly. A blacksmith uses tongs to hold the hot iron as he pounds and hammers it into shape. To go at anything hammer and tongs is to exert similar strength and force to accomplish a goal.

10. **head over heels** Intensely, completely, totally; rashly, impetuously. This expression, dating from the late 18th century, is a corruption of *heels over head*, which dates from the 14th century; both relate literally to body movement, as in a somersault. A similar phrase dating from the late 19th century is *head over ears*, a corruption of *over head and ears* 'completely or deeply immersed or involved.'

11. **hot stuff** One overblown with his own self-importance; a lusty person; a person of questionable morals; anything or anyone worth noting because of originality, energy, or curiosity. This American slang expression is used in a variety of ways; however, it invariably implies something that immediately catches one's attention, such as a boastful egotist, an attractive individual, etc.

12. **life in the fast lane** A daring, fast-paced manner of living; an exciting, prosperous lifestyle; an adventuresome, almost reckless style of life. This phrase, which came into common use during the 1970s, alludes to the furthest left-hand lane (in America), or the *fast lane*, of a modern divided expressway, comparing the danger, speed, and exhilaration of

driving in it to that of some people's manner of life.

A 16 bit microprocessor in the system unit makes the . . . computer right at home in the fast lane. (*The New Yorker*, August 8, 1983)

13. **like a house afire** See 261. PACE.

14. **play hardball** To play intensely; to be tough; to use aggressive tactics. The reference in this phrase is to baseball, either as contrasted to slow-pitch softball or to the use of the fast ball by a pitcher. The implication of the phrase is always that very serious effort and concentration is being mustered in order to bring success, that one is *playing for keeps*. The term gained popularity during the Nixon presidency (1969–1974), an administration which seemed to have a propensity for incorporating sports terms into political jargon.

The sense of discouragement left by the breakdown of the private meetings caused the publishers to offer an ultimatum to Moffett . . . At a meeting with the publisher's negotiators, Moffett said, "Evidently, you guys have decided that you are going to play hardball." (*The New Yorker*, January 29, 1979)

15. **swear like a trooper** See 288. PROFANITY.

16. **tooth and nail** Fiercely, vigorously, with all one's powers and resources. Despite its physical connotations of clawing, biting, and scratching, this phrase is almost always used figuratively. Such usage dates from the 16th century.

17. **with might and main** Vigorously, strenuously; using one's powers and resources to the utmost. The obsolete *main* is synonymous with *might* 'power, strength' and continues in the language only in this phrase as an intensifier, *with might and main* being a bit more forceful and somewhat more formal than *with all one's might*.

Interference . . .
See 235. MEDDLESOMENESS

Interjections . . .
See 131. EXCLAMATIONS

Interment . . .
See 41. BURIAL

Intermission . . . See 317. RESPITE

Intoxication . . .
See 109. DRUNKENNESS

Introduction . . .
See 209. INITIATION

Intrusiveness . . . See 80. CURIOSITY

215. INTUITION

1. by ear Relying on an innate sense of what sounds or feels right; without referring to, or depending upon prescribed procedures or written music. This use of *ear*, referring to an ability to recognize musical intervals, dates from the early 16th century. At that time, *play it by ear* meant to sing or play an instrument without printed music. By the 19th century, the same phrase came to mean to proceed one step at a time, trusting intuition and a subtle sense of timing, rather than a prearranged plan, to determine the proper course of action.

"What happens then?" "I don't know.
. . . We're playing it by ear at the moment." (A. Smith, *East Enders*, 1961)

Both this figurative use and the earlier one heard in musical contexts are current today.

2. by the seat of [one's] pants By instinct or intuition. This expression was originally an aviation term meaning to fly without instruments, and thus to be forced to rely upon the instincts and "feel" acquired through past experience. The metaphor has been extended to include the planning, operation, or direction of any enterprise without the aid of statistics, research, or other support of guidance for one's personal judgement.

3. feel in [one's] bones To know by intuition; to know instinctively; to sense something before it becomes apparent. This expression probably stems from the ability of people who suffer from bone diseases such as arthritis and rheumatism to predict changes in the weather because of increased pain. This ability is owing to the fact that changes in atmospheric pressure and humidity may affect the bones and joints of such individuals. Since changes in pressure and humidity often precede a change in the weather, these people seem to sense the change before it becomes apparent. In its current usage, *feel in one's bones* is no longer limited to people with bone disorders or to changes in the weather.

4. follow [one's] nose To be guided by instinct, to play it by ear. The expression clearly derives from an animal's keen and usually unerring sense of smell. The phrase was used figuratively as early as 1692 by Richard Bentley in one of his Boyle lectures:

The main maxim of his philosophy was, to trust to his senses, and follow his nose.

The expression also has the similar but somewhat less figurative meaning of 'go straight forward, continue on in a direct course.'

5. gut feeling An intuitive sense about something or someone; something deeply or strongly felt; gut reaction. The allusion here is to a deep intuitive or emotional reaction to a situation, a story, a person, etc., that one feels and that seems to overrule any logical conclusions.

If there is one thing common to . . . all races, all ages, in America today, it is this deep gut feeling that they want to be part of things. (*The New York Times*, January 19, 1969)

6. know which way the wind blows See 344. SHREWDNESS.

7. a little bird An undisclosed source; a secret witness; intuition. This phrase refers to the ubiquitous yet unobtrusive nature of a small bird that, theoretically at least, is able to observe many covert goings-on as it flies through the air. Since the beginning of recorded history (and no doubt before), birds have been respected and, at times, revered for their godlike powers of flight and sight. Many Greek and Roman soothsayers cited their purported understanding of avian language as a source of their knowledge and intuitive or psychic abilities. According to the Koran, the sacred book of Islam, Solomon was advised of Queen Sheba's activities by a tiny lapwing, and Muhammad himself was counseled by a pigeon. In addition, some early religious woodcuts show various popes listening to the whispered advice of a small bird. These and many other legends have given rise to the almost universal adage, *a little bird told me*, an expression indicating that the speaker knows a secret or other confidential matter by virtue of intuition or some undisclosed source.

> Curse not the king, no not in thy thought; and curse not the rich in thy bedchamber: for a bird of the air shall carry thy voice, and that which hath wings shall tell the matter. (Ecclesiastes 10:20)

> We bear our civil swords and native fire
> As far as France. I heard a bird so sing,
> Whose music, to my thinking, pleased the king.
> (Shakespeare, *Henry IV, Part II*, V,v)

8. my little finger told me that See 254. OMEN.

9. rule of thumb See 77. CRITERION.

10. a shot in the dark A wild guess; a random conjecture. This widely used expression combines *shot* 'an attempt' with the phrase *in the dark* 'uninformed' to imply that a given conjecture is made without the benefit of relevant information or assistance. In most cases, however, *a shot in the dark* does involve an element of intuitive reasoning. *Shot in the Dark* was the title of an amusing 1964 movie that starred Peter Sellers as the bumbling Inspector Jacques Clouseau.

Invaldation . . . See 329. RUINATION

216. INVESTIGATION

1. case the joint To investigate a building carefully; to examine a tavern, night club, or any place of entertainment. This slang expression, apparently coined by the underworld, has been in use since the 1880s. In the original underworld jargon, the term meant to inspect a potential robbery site thoroughly so that nothing might go amiss during the actual commission of the crime. However, during the 1930s the term was used so frequently in B-grade crime movies that it passed into the speech of the general public, and in recent years its usage has generalized to denote any sort of examination, as of a place of entertainment to see if it is worth patronizing.

2. deep throat Anyone who operates as a secret source of information within a large organization; one who reports criminal activities within the government while maintaining anonymity. This expression, adapted from the title of a popular pornographic motion picture of 1972, was used by *Washington Post* journalists, Carl Bernstein and Bob Woodward, to conceal the identity of the high government official who allegedly fed them information throughout the Watergate scandal from 1972 to 1974. The term was soon adopted by other members of the media as a nickname for any anonymous source of information and remains in common use today.

> Experience has taught, for example, that the media must be able to protect the identity of confidential sources, "deep throats," in order to maintain

access to crucial information. (*The New York Times*, May 14, 1978)

3. feel the pulse of To try to discover the underlying attitudes prevalent at the moment; to try to discern the sentiments, opinions, intentions of the people. The allusion in this expression, dating from the early 15th century, is to a physician attempting to discover the general health of his patient by taking his pulse. The expression also connotes the utilization of discretion and finesse in observation rather than outright inquiry.

A variant, *take the pulse of*, implies that one will obtain a general consensus before taking action.

4. fishing expedition An investigation conducted without definite purpose, plan, or regard to standards of propriety, in hopes of acquiring useful (and usually incriminating) evidence or information; apparently aimless interrogation designed to lead someone into incriminating himself. This expression refers to the literal fishing expedition in which, armed with basic equipment, one goes after his prey without knowing exactly what, if anything, he will catch. The more skillful and experienced the fisherman, though, the better are his chances of successfully catching his quarry.

I am not going to permit counsel to go on a fishing expedition. (Erle Stanley Gardner, *The Case of the Bigamous Spouse*, 1961)

5. go over with a finetooth comb See 377. THOROUGHNESS.

6. leave no stone unturned See 377. THOROUGHNESS.

7. private eye A private investigator; a detective for hire. This expression is the brainchild of Allan Pinkerton, founder of the detective agency that bears his name. After having served as personal bodyguard to President Abraham Lincoln and head of the United States Secret Service, he established his well-known detective agency. Playing upon the *I* in

private *i* nvestigator, he chose a huge human eye as a symbol of his firm. The term *private eye* caught on, receiving increased popularity from both the early dime novels and the many detective movies of the 1930s.

In turning the cabbies into private eyes for the police, Mr. Keenan said . . . that passengers would not be spied upon. (*The New York Times*, July 24, 1949)

8. see how the land lies To check out the land over which one must travel; to make a preliminary investigation into the state of affairs; to try to find out how things stand; to see if the time is propitious. This expression has been in use at least since the 17th century. The *OED* lists the first written entry as:

How lies the land? How stands the reckoning? (E. B. Gent, *Dictionary of the Canting Crew*, 1696)

Mostly used literally in nautical contexts for many years, today the phrase is heard almost always in a figurative sense.

Uncle Charles' eyes had discovered how the land lay as regarded Rose and himself. (Mary Bridgman, *Robert Lynne*, 1870)

9. shakedown A thorough search, as of a prison cell, in hopes of finding hidden weapons or other contraband. This expression alludes to shaking a tree to expose and acquire fruits or nuts which might be hidden within the foliage, and implies that something is turned upside-down and shaken to reveal the desired items. The expression is often used as a verb, to *shake down*.

A couple of patrolmen to shake down the neighborhood . . . (Richard Starnes, *And When She Was Bad She Was Murdered*, 1951)

As an adjective, *shakedown* is often applied to a cruise or flight undertaken to expose any mechanical flaws and to orient the crew while breaking in and ad-

justing the new equipment. See also shakedown, 140. EXTORTION.

10. take soundings To investigate, to try to find out what is going on or how things stand; to psych out a situation. To take soundings is literally to measure the depth of water under a vessel by letting down a lead line or, more often in recent times, by sonar. Figurative use of *sounding* appeared in print during the time of Shakespeare.

> Old Dan bears you no malice, I'd lay fifty pounds on it! But, if you like, I'll just step in and take soundings. (Charles J. Lever, *The Martins of Cro' Martin*, 1856)

11. the third degree Intensive, prolonged interrogation, often in conjunction with physical abuse, to obtain information or force a confession. Usually used in the context of the questioning of a prisoner or suspect by the police, *third degree* refers to the severity of the techniques employed. Just as a third-degree burn is the most damaging and extreme type of burn, so is a "third degree" the most drastic form of interrogation.

> He was at first arrested merely as a suspicious person, but when put through the "third degree" at the station, admitted that he entered the house last night. (*The New York Times*, July 6, 1904)

217. INVOLVEMENT

1. be in the same boat To be in the same situation; to have equal involvement. Two or more people who are in the same boat must undergo the same risks, suffer the same consequences.

> Therefore the sinner and the saint Are often in the selfsame boat. (Ward, *Nuptial Dialogues*, 1710)

The expression, dating back to classical Greece and Rome, is found in the writings of both Sophocles and Cicero. Making its first recorded appearance in print in English in 1584, the term remains in popular use today.

2. finger in the pie See 235. MEDDLESOMENESS.

3. have the ball in [one's] court To be at the time to take action; to be in a situation requiring action before opportunity slips by. The allusion in this expression is to the game of tennis and the necessity of striking the ball before it passes by or bounces twice; hence, the necessity of taking action. The phrase has been in common use since the mid-19th century. A related term, *have the ball before one*, dates from at least 1660, but it is uncertain from what sport the metaphor is adopted.

4. in the swim Actively involved in current affairs or social activities, in the middle or thick of things; abreast of the current popular trends in fashion, business, society, politics; in the know; also the opposite, *out of the swim*.

> The second category of companies is usually so managed that the originators do pretty well out of it whether those of the shareholders who are not "in the swim" gain a profit or lose their capital. (*The Graphic*, November 1884)

In angling, a swim is that part of a river much frequented by fish, and consequently that in which an angler fishes. Figurative use of this expression dates from the 19th century.

5. keep abreast with To keep oneself up to date; to stay on a level with; to understand modern trends. This expression derives from the old military practice of sending troops into combat in precise lines. In order to provide themselves with the best opportunity for survival, it was necessary for infantrymen to *keep abreast of* the soldiers on either side of them. About the middle of the 17th century it took on its current figurative significance.

> Nothing else could have enabled him to keep abreast with the flood of communications that poured in. (Samuel Smiles, *Self-Help*, 1859)

6. a piece of the action Active, and usually remunerative, involvement in any undertaking; a share in the profits, a piece of the pie; personal and immediate participation in any activity. *Webster's 6,000* cites Charlie Frick:

> Guys . . . rubbing their hands slowly together with dollar signs in their eyes. . . . Managers and agents and producers and all the others that had a piece of the action.

7. a piece of the pie See 18. ALLOCATION.

Irascibility . . . See 182. ILL TEMPER

218. IRRATIONALITY
See also 155. FRENZIEDNESS

1. beside [oneself] In an intensely emotional state; unable to control or contain one's feelings; highly excited. Though one may be beside oneself with feelings ranging from pleasure to rage, the essence of the state is irrationality—being out of one's wits. The phrase is akin to the French *hors de soi*, and both relate to the concepts of being possessed or transported. Caxton used the expression in the late 15th century.

2. coop-happy Insane from confinement; stir-crazy; punch-drunk from being cooped up. *Coop* 'a confined area,' is also a slang term for jail. *Happy* is used euphemistically in this phrase to mean dull-witted or "feeling no pain," whence the term.

3. crazy as a bedbug Completely insane; absolutely irrational; stark, raving mad; off one's trolley. The image conveyed by this early American expression suggests one who has become completely psychotic, but why the simile with *bedbug* is uncertain. Perhaps because (with transferred use), their victims twitch and jump about madly when bitten.

> On the subject of the relations of organized capital and organized labor it [*The New York Sun*] is as crazy as a bedbug. (*Buffalo Commercial*, August 2, 1904)

4. crazy as a loon Insane; demented; irrational; erratic; stark, raving mad. One of the cries of the loon, an aquatic bird of North America, is a rather dismal cry which resembles the laughter of a demoniac; hence, the inception of this phrase to indicate one who has lost his wits. Of American origin, the expression has been in use since about 1840.

> The next morning Costler was as crazy as a loon. . . . the mountain fever had attacked him. (Charles D. Ferguson, *Experiences of a Forty-Niner*, 1888)

The term *loony* does not have its origin in *loon*, as some people believe, but rather is a slang term derived from *lunatic*.

5. flip [one's] lid To react wildly or enthusiastically; to be delighted or outraged; to be knocked off one's feet or bowled over with shock; to lose one's head. This relatively new slang phrase of American origin plays with the idea that a "lid" serves to prevent something from escaping—in this case one's common sense and control. Thus, to "flip one's lid" is to lose self-control, leaving one unbalanced or crazed.

> Present war emergencies plus strain and stress seem to have been too much for local governmental officials. I fear they have flipped their lids. (Letter to the editor, Ithaca, N.Y., *Journal*, January 30, 1951)

Currently, *flip* is heard more frequently than the longer *flip one's lid*.

> Our food and service are great. Our decor's delightful. Your club treasurer will flip over our low rates. (*Boston Globe*, May 18, 1967)

Another variant, *flip out*, implies a more serious degree of losing control, as from drugs, a nervous breakdown, etc. It is analogous to *freak out* and *go off the deep end* in flavor and usage.

6. freak out To withdraw from reality; to become irrational; to abandon normal conventions and values; to suffer a bad experience as a result of taking drugs; a bad trip. This expression, popularized during the 1960s, originally denoted one who suffered from mental aberrations, especially resulting from a bad reaction to drugs. From the drug sub-culture, the expression was soon adopted into the common vocabulary to indicate anyone who acted in an irrational manner.

> One of the men happened upon the shrine in the isolated town of Hawley . . . sometime before the New Year's Eve fire, freaked out at the sight of the Oriental architecture and planned the fire with the other two men. (AP Release, January 5, 1984)

7. go bananas To go wild with excitement or rage, to act in an irrational or uncontrollable manner. The phrase supposedly comes from the chattering antics of a hungry monkey at the sight of a banana. It is nearly always used hyperbolically to indicate reason temporarily overcome by emotion; rarely would it be used to describe true mental derangement or disturbance.

8. go haywire See 103. DISORDER.

9. go off the deep end To overreact, to get inappropriately angry or excited; to go overboard, to overdo it; to go in over one's head; to freak out. The "deep end" refers to the end of a swimming pool at which the water is deepest. Floundering unprepared and confused in the "deep end," one is apt to behave wildly and without a sense of propriety or concern for appearances. Dating from the early 1900s, this expression most often describes emotional outbursts, including occasionally those severe enough to be classified as mental breakdown.

10. go round the bend To go crazy; to go out of one's mind; to lose control. This 19th-century expression suggests that one's mind has taken a turn away from normalcy. During World War II the phrase and a transitive form, *drive round the bend,* became especially popular. Both expressions are heard frequently today, chiefly in Britain.

11. lose [one's] head To lose one's equilibrium or presence of mind; to be out of control, off balance, or beside oneself. The head is associated with reason, sense, and rationality. Thus, to "lose one's head" is to become irrational and out of control. Its figurative use dates from the 1840s.

> It has now and then an odd Gallicism—such as "she lost her head," meaning she grew crazy. (Edgar Allan Poe, *Marginalia,* 1849)

The phrase is often used to explain behavior (such as a temper tantrum or show of affection) that would otherwise be considered out of character or inappropriate.

12. lose [one's] marbles To go crazy; to act or speak in an irrational manner. Since the early 1900s, *marbles* has been equated with common sense and mental faculties. Therefore, to lose one's marbles is to lose one's wits, especially when there has been a sudden behavioral change which manifests itself in eccentric or irrational acts or babblings.

> You lost your goddam' marbles? You gone completely crazy, you nutty slob? (J. Wainwright, *Take-Over Men,* 1969)

A related expression is *have some marbles missing.*

13. mad as a hatter Crazy, insane, demented; stark raving mad; violently angry, livid, venomous. It is probable that this expression is a corruption of *mad as an atter,* in which *atter* is an Anglo-Saxon variation of *adder* 'viper,' a poisonous snake. Thus, the original expression implied that a person was venomous, ready to strike with malicious intent. One source suggests that *mad as a hatter* may allude to the insanity and loss of muscular control caused by prolonged exposure to mercurous nitrate, a chemical once commonly used in the manufacture of

felt hats. At any rate, in current usage, *mad as a hatter* refers to lunacy more often than to anger.

> In that direction . . . lives a Hatter; and in that direction . . . lives a March hare . . . They're both mad. (Lewis Carroll, *Alice's Adventures in Wonderland*, 1865)

14. mad as a March hare Agitated, excited, worked up; frenzied, wild, erratic; rash; insane, crazy. This expression probably alludes to the behavior of hares during mating season when they thump the ground with their hind legs, and jump up and down, twisting their bodies in midair. Several sources suggest that the original expression may have been *mad as a marsh hare*, implying that due to lack of protective shrubbery in marshes, these hares act more wildly than others.

> As mad not as a March hare, but as a mad dog. (Sir Thomas More, *The Supplycacyon of Soulys*, 1529)

This expression was undoubtedly the inspiration for the March hare in Lewis Carroll's *Alice's Adventures in Wonderland* (1865). A common variation is *wild as a March hare*. The related term *harebrained* describes a person who is reckless or eccentric, or a plan, scheme, project, or other matter that is of dubious merit.

> Whilst they, out of harebrained lunacy, desire battle. (John Stephans, *Satyrical Essays, Characters, and Others*, 1615)

15. stir-crazy To behave neurotically as a result of long-term imprisonment; to be climbing the walls; to act dull-witted or punch-drunk from confinement. *Stir* is a slang term for jail or prison. Although originating as underworld lingo, *stir* is now fairly common, especially in the phrase *stir-crazy* which is no longer limited in use to prison-related neurosis. Rather, any lack of activity or temporary isolation can make one stir-crazy. The term is rarely if ever used literally—almost always hyperbolically.

16. tarred with the troppo brush Insane, especially from prolonged tropical duty; extremely agitated from overexposure to tropical conditions. This Australian slang expression is derived from a shortening of *tropical*, adding the ubiquitous Australian *o*, and *tarring*, defiling the body and brain with the noxious horrors of the tropics.

> "Speak for yourself, Captain," said another voice. "We are not all tarred with the troppo brush. You can call yourself barmy if you like, but there's nothing wrong with me." (Colleen McCullough, *An Indecent Obsession*, 1981)

219. IRRELEVANCE

1. beside the cushion Irrelevant, beside the point; wrong. This obsolete expression dating from the 1500s is synonymous with *beside the mark*. Both expressions are thought to derive from archery. An idea or comment which misses the point or is "beside the cushion" is like an arrow which misses the target (cushion) entirely.

> He rangeth abroad to original sin altogether besides the cushion. (James Bell, *Walter Haddon Against Osorius*, 1581)

2. beside the mark Irrelevant, not to the point, inapplicable; off base, off target. This expression is thought to derive from the unsuccessful attempt of an archer to hit the "mark" or target. *Beside the mark* appeared in print by the 1600s. *Miss the mark*, a verbal expression meaning 'to be irrelevant or far-fetched,' appeared in a slightly different form as early as the 14th century.

> But now has Sir David missed of his marks. (Laurence Minot, *Poems*, 1352)

220. IRRESPONSIBLITY

1. do a moonlight flit To evade responsibility by leaving town during the night; to leave a hotel without paying

the bill. This common British colloquialism, the equivalent of the American *fly by night*, uses *flit* in the sense of moving from one residence to another, and *moonlight* to imply furtiveness associated with the move.

2. dodge the column To avoid one's share of the work; to shirk one's duty; to goof off; to goldbrick. This American expression of military origin, dating from the 1800s, was used derisively of one who feigned sickness or injury, thereby not appearing in his usual place in the column of troops that day. By extension the term came to mean the avoiding of any responsibility or duty, whether military or civilian.

3. go between the moon and the milkman To leave town in order to evade creditors or other interested parties; to fly by night. This British colloquialism, the equivalent of the American *fly by night*, implies that, to avoid his personal and financial obligations, a person may depart clandestinely sometime between the rising of the moon (dusk) and the arrival of the milkman (dawn).

4. goof off Goldbrick; kill time; shirk; loaf. This term is derived from the noun *goof*, one who is stupid or silly. The implication here is that if one acts stupid or silly enough he may be able to avoid work that others who appear more intelligent are forced into. The term gained extensive popularity during World War II, although it was coined in the early 1930s.

> This is the great era of the goof off, the age of the half-done job. The land from coast to coast has been enjoying a stampede away from responsibility. (Charles Brower, *Speech to the National Sales Executive Commission*, May 20, 1958)

During World War I the British used a term to indicate the same type of irresponsibility, *dodge the column*, failure to join your military comrades in the daily activities. The modern British slang for evading responsibility is *on the*

mike, of uncertain origin, signifying one who hangs about waiting for a job.

5. harum-scarum Reckless; in a giddy fashion; irresponsible; hare-brained; a scatterbrained, frivolous type person. This rhyming expression, dating from the mid 17th century, can be traced to the old verb *hare*, 'to frighten or harass,' and the verb *scare*, thus creating the original form of the word *hare' em-scare' em*. *Brewer's Dictionary of Phrase and Fable* suggests that there might be an additional allusion—the madness of the March hare. During the mating season the male hare jumps about wildly, thumping its hind legs, and twisting its body recklessly, thus acting in a *harum-scarum* manner; and since *mad as a March hare* pre-dates *harum-scarum* by more than 100 years, *Brewer's* suggestion may well be true.

> A dissolute, harum-scarum fellow . . . always in debt. (Edward Bulwer-Lytton, *Eugene Aram*, 1832)

6. let George do it Let someone else do the work or assume the responsibility; pass the buck. This American colloquial expression dates from the turn of the century. *George* is a male generic term which derives from the Greek word for husbandman or farmer. By the 1920s this term was used by the British to refer to an airman, corresponding to *Jack* for a sailor (bluejacket) and *Tommy* for a soldier. *George* is also a British slang term for an automatic pilot in an aircraft or ship.

7. pass the buck To evade responsibility or blame by shifting it to someone else. Originally, *pass the buck* was a poker expression that meant handing the "buck" (a buckskin knife or other inanimate object) to another player in order to avoid some responsibility (such as dealing, starting a new jackpot, etc.) which fell on whoever possessed the "buck."

> I reckon I can't call that hand. Ante and pass the buck. (Mark Twain, *Roughing It*, 1872)

As the expression became more figurative, it enjoyed widespread popular use, particularly in reference to bureaucratic procedures:

> The Big Commissioner will get roasted by the papers and hand it to the Deputy Commish, and the Deputy will pass the buck down to me, and I'll have to report how it happened. (William Irwin, *The Red Button*, 1912)

By the mid 1900s, *pass the buck* had become so intimately associated with governmental administration that during his presidency (1945–53), Harry Truman adopted the now-famous motto, "The buck stops here."

8. pay with the roll of the drum Not to pay; to evade or ignore a debt. In this expression, *roll of the drum* implies a soldier on the march, i.e., in active military service. Since in many countries a soldier on active duty cannot be arrested for debts incurred while a civilian, it was common practice for debtors to join the armed services to avoid either having to make good on the debt or going to prison. The military connotations have faded over the years so that in contemporary usage, *pay with the roll of the drum* is usually applied figuratively.

9. ski bum This expression refers to a young male skier who travels from one ski resort to another taking odd jobs to stay near the slopes. His preoccupation with skiing and the people who frequent ski areas serves to disrupt both his occupational opportunities and his home life; he often lives on the hospitality of wealthy ski fans. The term has been in popular use since the 1920s. Related terms are *tennis bum* and *golf bum*, each of whom practices a life style similar to that of the *ski bum*.

10. ski bunny A female ski bum; an attractive woman skier who spends much time around ski resorts. This expression often connotes a sexually submissive girl who frequents ski resorts in order to associate with men who ski and to identify with a special group who somehow add meaning to her life. The term is also used occasionally in a positive sense to identify a particularly beautiful female skier. A related term is *snow bunny*.

221. IRRETRIEVABILITY

1. by the board Ruined, disregarded, forgotten; over and done with; literally, by or over a ship's side, overboard; often in the phrase *go by the board*. This expression comes from the nautical sense of *board* 'the side of a ship.' The phrase was used literally in its nautical sense as early as 1630 but did not appear in figurative usage until 1859.

2. down the drain Wasted, lost, gone. The phrase, in use since 1930, probably refers to the way liquid disappears down a drainpipe. A more recent variant, equally popular today, is *down the tube(s)*. The extended expression *pour down the drain* denotes an unnecessary or extravagant waste of time or money.

3. lost in the wash Lost in the confused and chaotic jumble of events, proceedings, etc. Considered literally, this expression brings to mind the occasional but mysterious disappearance of various articles of clothing in automatic washing machines. However, *wash* refers not to laundry but to a body of water, as in the following lines from Shakespeare's *King John*:

> I'll tell thee, Hubert, half my power this night,
> Passing these flats, are taken by the tide.
> These Lincoln Washes have devoured them.
> (V,vi)

4. out the window Irretrievably lost or forfeited. The image conveyed by this American slang expression reinforces the idea of irretrievable loss, both of material possessions and emotional security, such as that provided by one's career, reputation, and the like.

5. up the spout Pawned, in hock; ruined, lost, gone. In a pawnbroker's shop the spout is the lift used to carry pawned items to an upper floor for storage. While the phrase was used literally as early as 1812, it did not appear in its figurative sense until 1853 in Dods' *Early Letters:*

> The fact is, Germany is up the spout, and consequently a damper is thrown over my hopes for next summer.

Irreversibility . . .
See 222. IRREVOCABILITY

222. IRREVOCABILITY
See also 84. DECISIVENESS

1. burn [one's] bridges See 84. DECISIVENESS.

2. cross the Rubicon See 84. DECISIVENESS.

3. cry over spilt milk To regret or bemoan what cannot be undone or changed, to lament or grieve over past actions or events. This proverbial expression, in common use in both America and Britain, was apparently first used by the Canadian humorist Thomas C. Haliburton in *The Clockmaker; or the Sayings and Doings of Samuel Slick of Slickville* (1835), in which a friend of the hero says,

> "What's done, Sam, can't be helped, there is no use in cryin' over spilt milk."

4. the die is cast A statement meaning that a decisive and irrevocable step has been taken, that the course has been decided once and for all and that there will be no going back. The original Latin *alea jacta est* would have more meaning for modern ears if rendered in the plural—'the dice have been thrown.' The phrase is attributed to Julius Caesar at the time of his famous crossing of the Rubicon. Although the *OED* dates this specific expression from 1634, Shakespeare's *Richard III* contains a similar concept:

> I have set my life upon a cast,
> And I will stand the hazard of the die.
> (V,iv)

5. the fat's in the fire What's done is done, and the negative consequences must be paid; usually used in reference to an irrevocable, potentially explosive situation; also *all the fat is in the fire.* The allusion is probably to the way fat spits when burning. This expression, in use since 1644, appeared in an article by William Dean Howells in the February 1894, issue of *Harper's Magazine:*

> The die is cast, the jig is up, the fat's in the fire, the milk's spilt.

6. let the dead bury the dead Let bygones be bygones; don't dwell on past differences and grievances. The implication in this expression is that one should not be tied down by things in the past, but should begin anew and look toward favorable prospects in the future.

> Jesus said unto him, Follow me; and let the dead bury their dead.
> (Matthew 8:22)

7. point of no return A situation or predicament from which there is no turning back; a crucial position or moment in an argument, project, or other matter which requires total commitment of one's resources. This expression was first used by aircraft pilots and navigators to describe that point in a flight when the plane does not have enough fuel to return to its home base, and so must continue on to its destination.

8. that's water over the dam A proverbial phrase expressing the sentiment that what's past is past and nothing can be done about it; also *that's water under the bridge.*

Irritability . . . See 182. ILL TEMPER

223. IRRITATION
See also 21. ANGER;
158. FURY; 170. HARASSMENT;
394. VEXATION

1. bad blood This phrase is most commonly found in such expressions as *to stir up bad blood, to breed bad blood, to create bad blood*, or any number of other verbal phrases which indicate that one is stirring up strife or reviving revengeful attitudes in or toward others. Another frequently used combination adds the preposition *between*, e.g., "there is bad blood between the two candidates."

2. browned off Depressed; disgusted; fed up; disillusioned; irritated. Although this slang phrase came into common use during World War II, its actual coinage dates back to at least 1915 when it first appeared in the speech of regular British army units.

Browned off has almost completely displaced the colloquial 'to be fed up.'

A variant *pissed off*, or euphemistically *peed off, teed off, ticked off*, or *ticked*, came into common use among American servicemen during World War II. A bit more extreme, *pissed off* implied that one was highly irritated, almost to the point of violent reaction. Today, with the recent slackening of language mores, it means little more than a mild upset. The British use *piss off* as an expletive imperative meaning 'Get the hell out of here,' a term utilized since the late 19th century.

3. cat among the pigeons To throw a controversial issue into a conversation; to incite a group to heated debate. The allusion in this British expression is obvious; if one drops a cat among pigeons, a great commotion is certain to ensue.

4. flea in [one's] ear Discontent or uneasiness caused by a broad hint or warning, especially one which arouses suspicion; restlessness caused by an unexpected or undesired reply, usually one which is a vicious or humiliating rebuff

or reproach. Cited for centuries in literature from throughout the world, this expression refers to the restless and distressed behavior characteristic of a dog afflicted with a flea in its ear.

> He went away with a flea in his ear,
> Like a poor cur.
> (Francis Beaumont and John Fletcher, *Love's Cure*, 1625)

5. gadfly A pest, nuisance, or bother; one who irritates, annoys, or tries to involve others in one's cockeyed schemes. Literally, a gadfly is an insect which bites and goads other animals, especially cattle. Figurative use of the term dates from the mid 17th century. Currently, *corporate gadfly* is frequently heard to describe one who disrupts corporate or stockholder meetings with unconventional questions and challenges. *To have a gadfly*, dating from the late 16th century, means 'to gad about,' or 'to rove idly.' *Gadfly* can also be used adjectivally, as in the British *gadfly mind*, denoting an inability to concentrate.

6. get [one's] dander up To become angry or irritated; to become concerned; to rouse oneself to vigorous action. This expression has its roots in 17th-century America. Although it has been attributed to *dander*, 'dunder, ferment,' a more plausible source is the Dutch *donder*, 'thunder,' and its derivative, *op donderen*, 'explode into a violent rage.' The term probably entered the language by transference from the early Dutch settlers.

> He was as spunky as thunder, and when a Quaker gets his dander up, it's like a Northwester. (Sebar Smith, *Letters of Major Jack Downing*, 1830)

The usage of the phrase has doubtless also been reinforced by another sense of *dander*, i.e., 'dandruff.'

7. get in [someone's] hair To pester, annoy, irritate; to nag, henpeck; to be a nuisance. The persistent irritation of the scalp caused by head lice is the probable source of this common expression.

She got in my hair until I couldn't bear it another day. (J. Tey, *Shilling for Candles*, 1936)

8. get under [someone's] skin To irritate or annoy; to impress or affect deeply. This expression alludes to mites, ticks, chigoes, and other small, parasitic arachnids and insects which embed themselves in the skin of a victim, causing itching, irritation, and inflammation. In contemporary usage, the phrase frequently implies deep affection or love, emotions exemplified in the classic Cole Porter song, "I've Got You Under My Skin" (1936).

9. kissing bug A person who is given to freely kissing others; an overbearing young man who is intent on kissing any pretty girl he meets. In the summer of 1899 a strange phenomenon struck the United States. A venomous, bloodsucking insect, *Melanolestes picipes*, which inflicts painful bites on the lips and cheeks of sleeping persons, assaulted such a large number of people that the newspapers began to speak of the pest as the *kissing bug*. L. O. Howard, in an article entitled *Spider Bites and Kissing Bugs* which appeared in *Popular Science Monthly* (November 1899), wrote:

> Several persons suffering from swollen faces visited the Emergency Hospital in Washington and complained that they had been bitten by some insect while asleep . . . Thus began the "kissing bug" scare.

Later in the article, he added:

> The kissing bug, in its own way, and in the short space of two months, produced almost as much of a scare as did the San Jose scale.

The figurative use of the term developed from the notoriety of this peculiar and memorable plague. In modern use the term is often applied jocularly to very young children who demonstrate an abundance of affection.

10. nose out of joint Irritable; displaced by the redirection of affections to anoth-

er. In common use since the 1500s, this expression refers to a physical impossibility. Inasmuch as the nose has no joint, it is apparent that the phrase has had only a figurative implication since its inception. Although it has many general applications, the term is sometimes used to describe the behavior of older children upon the arrival of a new baby.

> Every baby puts someone's nose out of joint. (E. V. Lucas, *London Lavender*, 1912)

11. pea in the shoe Any petty irritation or annoyance; a source of minor discomfort or distress; a thorn in the side. A literal pea in one's shoe is too small to seriously affect one's walking ability, but nevertheless large enough to be a source of considerable discomfort.

12. rub the wrong way To annoy; to irritate; to affect painfully or disagreeably; to make someone's hackles rise. This term apparently has its roots in Elizabethan England, where it was necessary to wet rub and dry rub the wooden floors in the homes of the gentry frequently to maintain a fine luster. Such rubbing required that the servants follow the grain carefully, for to rub the wrong way raised the grain of the floors and irritated the mistress of the house.

> Philip . . . was always rubbed the wrong way by Lady Flanders. (Hawthorne, *Dust*, 1883)

The British use this term, but also employ *rub up the wrong way*.

13. thank-you-ma'am This colloquial American expression from the early 1800s refers to a slightly hollowed out break, extending from berm to berm, built into mountain roads to divert the flow of water. These hollows, which cause a vehicle to bounce when passing over them, also cause the vehicle's occupant to bow or bob his head, as if to a lady when thanking her courteously.

> "Life's a road that's got a good many thank-you-ma'ams to go bumpin'

over," says he. (Oliver Wendell Holmes, *The Guardian Angel*, 1867)

14. a thorn in the flesh A source of constant irritation, affliction, or inconvenience; a perpetual pain-in-the neck. A sect of Pharisees used to place thorns in the hem of their cloaks to prick their legs in walking, and make them bleed. The expression no longer refers to self-imposed suffering, however, but to objectionable external conditions or parasitical acquaintances. St. Paul used *thorn in the flesh* in 2 Corinthians 12:7:

And lest I should be exalted above measure through the abundance of the revelations, there was given to me a thorn in the flesh, the messenger of Satan to buffet me, lest I should be exalted above measure.

A common variant is *thorn in the side.*

The Eastern Church was then, as she is to this day, a thorn in the side of the Papacy. (James Bryce, *The Holy Roman Empire*, 1864)

Jubilation . . . See 115. ELATION

Justice . . . See 142. FAIRNESS

K

224. KNOWLEDGE

1. burn [one's] fingers To hurt oneself, physically or mentally, by meddling in other people's affairs or by acting impetuously. The expression usually implies that one has learned from the painful experience, and will avoid such situations or involvements in the future. The phrase has been in figurative use since 1710, often in proverbial statements like the following:

> The busybody burns his own fingers. (Samuel Palmer, *Proverbs*)

A similar current American slang expression is *get burnt*, which has the additional meaning of suffering financial loss.

2. burnt child avoids the fire The reference is to an inexperienced individual who becomes knowledgeable through experience, i.e., who learns the hard way. This old expression, dating from at least the 14th century, has an extremely large number of variants; among them are: *the scalded dog fears even cold water; a shipwrecked man fears the sea; a man bitten by a serpent fears a rope; once bitten, twice shy; a singed cat dreads the fire*, and many more. Still cited frequently today, each of these proverbs alludes to gaining practical knowledge through suffering or fear.

> A burnt child feareth the fire, and a beaten dogge escheweth the whippe. (Thomas Wilson, *The Art of Rhetorique*, 1553)

3. by rote From memory; mechanically, automatically, unthinkingly, without understanding or feeling; usually as modifier of verbs such as *learn, get, know, recite*. Conjecture that *rote* comes from the Latin *rota* 'wheel,' and that *by rote* consequently relates to the repeti-

tious turning round and round in the mind that accompanies memorizing, lacks solid etymological basis. George Gordon, Lord Byron, used the expression in *English Bards and Scotch Reviewers* (1809):

> Take hackney'd jokes from Miller got by rote.

4. cut [one's] eyeteeth To gain knowledge or understanding; to become sophisticated or experienced in the ways of the world; also *to have one's eyeteeth* meaning 'to be worldly-wise or aware.' This expression, which dates from the early 1700s, derives from the fact that the eyeteeth are cut late, usually at about the age of twelve. The implication then is that a person who has already cut his eyeteeth has reached the age of discretion. A similar phrase with the same meaning is *to cut one's wisdom teeth*. Wisdom teeth are cut even later than eyeteeth, usually between the ages of seventeen and twenty-five.

5. go to school on To learn by observing another's actions; to learn from another's mistakes. This modern American slang expression is most often used in reference to the golf course, especially the putting green, where one golfer, who has an almost identical lie as another, has an opportunity to observe his opponent's shot and learn from it. Use of the expression has extended from the golfing context to any situation where one profits from seeing another's mistake or success.

6. have [someone] taped To know someone's motivations; to have someone sized up; to understand someone thoroughly; to have things under control. This British expression, dating from about World War I, alludes to the measuring of a person's body with a tailor's

tape; thus implying that he has been sized up. In the modern world of sophisticated electronics, the term has acquired the additional connotation of having someone's voice or visual image recorded on electronic tape, thus having even greater knowledge, and possibly control of that person.

7. know a thing or two Be wise to another person's motives; be wise in the ways of the world; be cunning. This phrase is simply a common method of expressing worldly wisdom. The term has been in use since the latter half of the 18th century. Cockneys used to say *know a thing or two or six* or occasionally *know a thing or six*. However, they seldom use these terms today.

> She loved a book, and knew a thing or two. (Sir Walter Scott, *The Search after Happiness*, 1817)

A related term, *know one's way about or around*, dates from about 1860 and is virtually synonymous with *know a thing or two*.

8. know [one's] beans To be generally knowledgeable and aware; to know a subject thoroughly; to be proficient, to have mastered a particular skill. Popular since the 19th century, this expression may be a contraction of the British *know how many beans make five*, an expression also used figuratively and said to derive from the practice of using beans to teach children how to count.

> One has to know beans to be successful in the latest Washington novelty for entertainment at luncheons. (*Chicago Herald*, 1888)

In the U.S., the negative construction *not to know beans* is more frequently heard, and may even antedate the other two.

> Whatever he knows of Euclid and Greek,
> In Latin he don't know beans.
> (*Yale Literary Magazine*, 1855)

Know one's onions is a common U.S. slang variant, as are *know one's stuff* and *know one's business*.

9. know like the back of [one's] hand To know some person or some place extremely well; to have intimate knowledge about something or someone. This folksy expression, obvious in its connotation, is still in common use, in this form and with several slight variations.

> I know him as well as I know the back of my hand. (Margaret Millar, *Wall of Eyes*, 1943)

10. know the ropes To completely understand the operational methods of one's occupation or enterprise; to know the tricks of the trade. A sailor who understands the arrangement and functions of the numerous ropes on a ship is considered an invaluable crew member. Similarly, a person familiar with the ins and outs of his job or company establishes himself as a most valuable employee.

> The circle was composed of men who thought they "knew the ropes" as well as he did. (John N. Maskelyne, *Sharps and Flats*, 1894)

11. street smarts Knowing the ways of city streets; common sense about life. This slang expression refers to one who has accumulated, through experience, a storehouse of knowledge about life on city streets, and how best to survive in such an environment. The key word in this term, *smarts*, is a slang expression for a special type of intelligence, for an understanding that results from practical knowledge. By extension, the term has come to connote a special understanding of any situation.

> They thought always about winning, and one way or another, they almost always did win. Like the A's, these Yankees have street smarts. They win. (Roger Angell, *The New Yorker*, November 20, 1978)

L

Lack . . . See 4. ABSENCE

Lamentation . . . See 167. GRIEVING

225. LANGUAGE
See also 94. DICTION;
131. EXCLAMATIONS; 161. GIB-
BERISH; 288. PROFANITY

1. bombast Pretentious speech; high-flown or inflated language. It is but a short step from the now obsolete literal meaning of *bombast* 'cotton-wool padding or stuffing for garments' to its current figurative sense of verbal padding or turgid language. Shakespeare used the word figuratively as early as 1588:

> We have received your letters full of love,
> Your favors, the ambassadors of love,
> And in our maiden council rated them
> At courtship, pleasant jest and courtesy,
> As bombast and as lining to the time.
> (*Love's Labour's Lost*, V,ii)

2. bumf Official documents collectively; piles of paper, specifically, paper containing jargon and bureaucratese; thus, such language itself: gobbledegook, governmentese, Whitehallese, Washingtonese. This contemptuous British expression comes from *bumf*, a portmanteau contraction for *bum fodder* 'toilet paper.' It has been used figuratively since the 1930s.

> I shall get a daily pile of bumf from the Ministry of Mines. (Evelyn Waugh, *Scoop*, 1938)

3. buzz word An important-sounding word often employed by members of a profession or by politicians to impress laymen; a catch word in current popular use. This term was originally coined in

the world of technology to describe those words that specialists used to impress the general public, or, as was frequently the case, to complicate an issue to such a degree as to befuddle the general public. In recent years the expression has taken on the more benign meaning, referring to any popular use of a specialized term.

> The buzz words these days are "commitment," "intimacy," and "working at relationships." (*Time*, April 9, 1984)

4. civic illiteracy The lack of understanding of technical issues. This expression was coined to explain the average citizen's growing confusion about the jargon employed by technological experts to befog issues. Such *civic illiteracy* causes citizens to make uninformed decisions, to depend upon so-called experts with blind faith. The expression first came into use in the late 1970s.

> Bafflement over technical jargon used in the MX missile debate and the 1979 Three Mile Island nuclear power crisis were cited as examples of civic illiteracy. (*The Hartford Courant*, November 26, 1981)

5. claptrap Bombast, high-sounding but empty language. The word derives from the literal *claptrap*, defined in one of Nathan Bailey's dictionaries (1727–31) as "a trap to catch a clap by way of applause from the spectators at a play." The kind of high-flown and grandiose language actors would use in order to win applause from an audience gave the word its current meaning.

6. dirty word A word which because of its associations is highly controversial, a red-flag word; a word which elicits responses of suspicion, paranoia, dissension, etc.; a sensitive topic, a sore spot.

Dirty word originally referred only to a blatantly obscene or taboo word. Currently it is also used to describe a superficially inoffensive word which is treated as if it were offensive because of its unpleasant or controversial associations. Depending on the context, such a word can be considered unpopular and taboo one day and "safe" the next.

7. ghost word A word that never actually existed; a word created by a typographical error. This expression alludes to an accidental word form that was never in established usage. For example, *Webster's Third* cites: *phantomnation* a ghost word combining the words *phantom* and *nation* and erroneously defined as though a formation with the suffix *-ation*.

According to *Harper Dictionary of Contemporary Usage*, another ghost word, *Dord* after a series of printing convolutions and editorial errors, appeared in *Webster's Second* listed as a noun, and was allowed to stand, even after discovery by the editorial staff. *Harper's* further reports that the word was allowed to remain through a number of printings out of the editors' curiosity about reader reaction.

8. gobbledegook, gobbledygook Circumlocutory and pretentious speech or writing; official or professional jargon, bureaucratese, officialese. The term's coinage has been attributed to Maury Maverick.

> The Veterans Administration translated its bureaucratic gobbledygook. (*Time*, July 1947)

9. inkhorn term An obscure, pedantic word borrowed from another language, especially Latin or Greek; a learned or literary term; affectedly erudite language. An inkhorn is a small, portable container formerly used to hold writing ink and originally made of horn. It symbolizes pedantry and affected erudition in this expression as well as in the phrase *to smell of the inkhorn* 'to be pedantic.'

The expression, now archaic, dates from at least 1543.

> Irrevocable, irradiation, depopulation and such like, . . . which . . . were long time despised for inkhorn terms. (George Puttenham, *The Art of English Poesy*, 1589)

10. jawbreaker A word difficult to pronounce; a polysyllabic word. This self-evident expression appeared in print as early as the 19th century.

> You will find no "jawbreakers" in Sackville. (George E. Saintsbury, *A History of Elizabethan Literature*, 1887)

11. malapropism The ridiculous misuse of similar sounding words, sometimes through ignorance, but often with punning or humorous intent. This eponymous term alludes to Mrs. Malaprop, a pleasant though pompously ignorant character in Richard B. Sheridan's comedic play, *The Rivals* (1775). Mrs. Malaprop, whose name is derived from the French *mal à propos* 'inappropriate,' continually confuses and misapplies words and phrases, e.g., "As headstrong as an allegory on the banks of the Nile." (III,iii)

> Lamaitre has reproached Shakespeare for his love of malapropisms. (*Harper's Magazine*, April 1890)

A person known for using malapropisms is often called a *Mrs. Malaprop*.

12. mumbo jumbo See 161. GIBBERISH.

13. pidgin English A jargon used to bridge the gap between certain exotic languages, especially Chinese, and English; a simplified mixture of Chinese and English used for communication between people of those cultures, especially in business. English traders, when they first started trafficking along the Chinese coast in the 17th century, needed to create a simple form of communication between two entirely different tongues; hence, *pidgin English*. In *pidgin English* many short words take the place of a longer, more difficult word

not known by the natives. The term, which was later shortened to *pidgin*, probably developed from the Chinese mispronunciation *bidgin* for 'business,' hence, *this is not my pidgin* means 'this is not my business, this is not my affair.'

> I include pidgin-English . . . even though I am referred to in that splendid language as 'Fella belong Mrs. Queen.' (Duke of Edinburgh, *Speech* [to English-Speaking Union Conference at Ottawa], October 29, 1958)

A related term, *bêche-de-mer* or *Beach-la-Mar*, designates a kind of pidgin, now called Neo-Melanesian, that developed about the same time between European traders and the people of the South Pacific islands.

14. portmanteau word A word formed by the blending of two other words. *Portmanteau* is a British term for a suitcase which opens up into two parts. The concept of a *portmanteau word* was coined by Lewis Carroll in *Through the Looking Glass* (1872):

> Well, 'slithy' means "lithe and slimy" . . . You see it's like a portmanteau— There are two meanings packed into one.

Carroll's use of *portmanteau* has been extended to include the amalgamation of one or more qualities into a single idea or notion. This usage is illustrated by D. G. Hoffman, as cited in *Webster's Third*:

> Its central character is a portmanteau figure whose traits are derived from several mythical heroes.

15. red-flag term A word whose associations trigger an automatic response of anger, belligerence, defensiveness, etc.; an inflammatory catchphrase. A red flag has long been the symbol of revolutionary insurgents. *To wave the red flag* is to incite to violence. In addition, it is conventionally believed that a bull becomes enraged and aroused to attack by the waving of a red cape. All these uses are interrelated and serve as possible antecedents of *red-flag* used adjectivally to describe incendiary language.

16. rigmarole A long-winded, disconnected account; a rambling, unending yarn; a series of incoherent statements. This term is a corruption of *Ragman Roll*, a document presented to King Edward I by Balliol, the king of Scotland, in 1296. Edward, who had gone to Scotland to receive homage, was presented with a signed and sealed scroll from which was appended such a large number of seals that it was nicknamed the *Ragman Roll*. Sometime thereafter the monotonous intoning of any endless list came to be called a *rigmarole*. The original roll may still be seen in the Records Office in London.

> His speech was a fine sample, on the whole,
> Of rhetoric, which the learn'd call rigmarole.
> (Lord Byron, *Don Juan*, 1818)

17. sling the bat To be able to speak the colloquial language of a foreign country. This 19th-century Briticism is derived from the Hindi word *bat* 'speech or language,' and was brought back to England by the men who had served in India. Applied originally only to the tongues of India, the term came to include all foreign languages. A common variant is *spin the bat*.

> Native words picked up by the soldier in India who had learned to sling the bat. (*Atheneum*, July 18, 1919)

18. weasel words Words that seem to promise much but actually guarantee nothing; words that destroy the force of another word or expression; equivocating words that weaken a statement. This expression appeared in "The Stained Glass Political Platform," an article by Stewart Chapman in the June 1900 issue of *Century Magazine*.

> "The public should be protected —"
> "Duly protected," said George.
> "That's always a good weasel word."

The term is derived from the practice of weasels, who suck the substance from eggs while leaving the shell intact. President Theodore Roosevelt offered an explanation in a speech he delivered in 1916.

> One of our defects as a nation is a tendency to use what have been called weasel words. When a weasel sucks eggs, the meat is sucked out of the egg. If you use a weasel word after another word, there is nothing left of the other.

Lasciviousness . . .
 See 297. PRURIENCE

Last resort . . .
 See 92. DESPERATION

Lateness . . . See 372. TARDINESS

Latitude . . . See 154. FREEDOM

Laughter . . .
 See 174. HUMOROUSNESS

Lawbreaking . . .
 See 76. CRIMINALITY

Laziness . . .
 See 178. IDLENESS; 201. INDOLENCE

Leave-taking . . .
 See 89. DEPARTURE

Lewdness . . . See 297. PRURIENCE

Liability . . . See 98. DISADVANTAGE

Liberty . . . See 154. FREEDOM

License . . . See 154. FREEDOM

Licentiousness . . .
 See 289. PROMISCUOUSNESS

Likeness . . . See 346. SIMILARITY

226. LITERATURE

1. chapbook A small book containing popular literature; a cheap, little book embodying a wide variety of written material; a pamphlet containing poems, ballads, stories, etc. *Chapbooks* were the most important method of disseminating popular literature during the early 19th century in the United States. Their name was derived from the *chapmen*, itinerant salesmen who traveled about the country selling a variety of wares. The *chapbooks* were replaced later in the 19th century by the *giftbooks*, more elaborate publications containing stories and poems of higher quality.

> A hero of the popular chapbooks of old times. (Miss Yonge, *Cameos*, 1852)

2. climb Parnassus To pursue the arts, particularly poetry; to court the Muses. Parnassus, a mountain in central Greece near Delphi, was sacred to Apollo and the Muses. It is thus identified with literary endeavors such as the Muses would inspire.

3. Grub Street Literary hacks or drudges collectively. This expression takes its name from Grub Street (now Milton Street) in London. The area was once a haven for poor, inferior writers and literary hacks. *Grub Street*, which dates from at least 1630, is also used adjectivally to mean 'inferior, lowgrade, poor.' Ralph Waldo Emerson used the expression in this passage from *Society and Solitude:*

> Now and then, by rarest luck, in some foolish Grub Street is the gem we want.

4. hack A drudge, especially a literary one; a writer or artist who denies his creative talent and does inferior, unoriginal, dull work in an effort to attain commercial and financial success. An abbreviation of *hackney*, this term originally referred to a horse for hire as well as to the driver of a hackney coach or carriage. It was named for the town of

Hackney, in Middlesex, England. This last meaning of *hack* gave rise to the term's current meaning.

5. potboiler An inferior literary or artistic work executed solely for the purpose of *boiling the pot* 'earning a living'; a literary or artistic hack, such as produces potboilers.

> Such . . . was the singular and even prosaic origin of the "Ancient Mariner" . . . surely the most sublime of "potboilers" to be found in all literature. (Henry Duff Traill, *Coleridge*, 1884)

See also **boil the pot**, 364. SUBSISTENCE.

6. smell of the lamp Said of a literary composition that demonstrates labor and study rather than inspiration; a literary work that is labored. This expression, dating from the days of ancient Greece, has been attributed to Pytheas, who coined the term in reference to Demosthenes' orations and to the underground room, lit only by a lamp, which he employed as a study. John North in his translation of *Plutarch: Demosthenes* (1579) gives the following account:

> Pytheas . . . taunting him on a time, told him, his reasons smelled of the lamp. Yea, replied Demosthenes sharply again: so is there great difference, Pytheas, betwixt thy labor and mine by lamplight.

Adopted into many languages, the phrase is still heard to indicate that a piece of writing contains substance but wants vigor.

> We say of some compositions that they smell of the oil and of the lamp. (Montaigne, *Essays*, 1580)

7. whodunit A murder mystery; a piece of fiction based on the solution of a crime, usually a murder; any mystery to be solved. The origin of this American colloquial term has been something of a whodunit itself. It seems to have arisen in the early 1930s, with several individuals laying claim to its coinage.

Connery takes over the interrogation and in the process beats the man to death. This much we know almost from the beginning, so the film is less of a whodunit than a whydunit. (*Time*, June 4, 1973)

The October 1950 issue of *Ellery Queen's Mystery Magazine* added two variations patterned on the term, variations which came into common use shortly after World War II, *howdunit* and *whydunit*. In the *whodunit* the emphasis is placed on the solution, in the *howdunit* on the method, and in the *whydunit* on the motive.

The psychological mystery, or whydunit, now fills the air with inferiority complexes that account for some of the hundreds of crimes actually perpetrated each month. One whydunit, *Detour*, even has a psychiatrist as a narrator. (*Newsweek*, July 24, 1950)

Liveliness . . . See **399**. VITALITY

227. LOCALITIES

1. asphalt jungle A big city. Also, more recently, *concrete jungle*. The reference is both to the vast labyrinth of paved thoroughfares that make up any large city, and to the "law of the jungle" that rules its streets—might makes right, dog-eat-dog, and survival of the fittest. The term was used as early as 1920 in *Hand-Made Fables* by George Ade.

2. bedroom community A suburb; an outlying community whose inhabitants almost literally only sleep there, since most of their time is spent traveling to and from or working in a nearby major metropolitan area. In England, such a colony is called a *commuting-town*, a *dormitory town*, or sometimes simply a *dormitory*.

3. the Big Apple Any large city, but especially New York City; the downtown area of a city. Also the title of a ballroom dance popular in the 1930s, the term is thought to have derived from its

2nd Edition □ 421 227.4–227.8

use in jazz meaning anything large, such as the earth, the world, or a big northern city, by analogy with the shape of the planet. In use since 1930, the term has recently spawned the derogatory variation *the Rotten Apple*.

4. Bluegrass A nickname for the Commonwealth of Kentucky; a forage grass especially associated with Kentucky; a region, in central Kentucky, centered about Lexington, famous for its race horses and its abundant bluegrass. This term, its figurative use dating from the early 19th century, has been afforded a great deal of popularity by the annual running of the *Kentucky Derby*, considered by most race aficionados as the premier event each year in American horse racing.

Radjunas promises that Lexington will be the greatest [high school coaches' meeting] ever. The pride of the Bluegrass faithful will make it happen. (*National Coach*, April 1984)

See **bluegrass**, 241. MUSIC.

5. borscht belt The Catskill region of New York State, particularly the resort hotels located there; also *borscht circuit*. In theater use since 1935, the expression was coined by entertainers who played there to the predominantly Jewish clientele, whose tastes the menus catered to by featuring borscht, or beet soup, popular with many eastern Europeans.

6. Dixie Those southern states which made up the Confederacy during the United States Civil War; the southern portion of the United States east of New Mexico; also known as Dixieland.

In Dixieland, I'll took my stand,
To lib an' die in Dixie,
Away, away,
Away down South in Dixie.
(Emmet, *I Wish I Was in Dixie's Land*, 1859)

A term familiar to Americans because of Daniel Decatur Emmet's classic song, its derivation lies in much controversy. One explanation attributes the name to a New York City plantation named Dixy which was supposedly a slave's paradise. The most plausible theory is the extension of the French *dix* 'ten,' on a New Orleans bank issue of a ten-dollar note, to *dixie* as a nickname for New Orleans and thence for the entire South. A correspondent to *American Speech*, January 1951, maintains that the song was written in 1856 and named for a Philadelphia minstrel called Dixie. He further claims, rather unconvincingly, that the region was named for the song and the song for the minstrel.

7. down East The seacoast districts of northeastern New England, especially those of Maine; the cities and towns along the Maine shoreline. The original Massachusetts Bay Colony included the present state of Maine; consequently, a great deal of trading took place between the Maine coastal area and the city of Boston, almost entirely by sailing vessel. Since the run is usually downwind and since Maine is east of Boston, the local skippers started to refer to Maine as *down East*, and the term stuck. A related term *down Easter* refers to a native of the state of Maine or a sailing vessel constructed there.

A party of regular 'down-Easters,' that is to say, people of New England. (Washington Irving, *Captain Bonneville*, 1837)

8. Elephant and Castle A district in South London; a stop for the underground in that district; a public house in South London. This British term arises from the action of a publican, who adopted the crest of the Cutlers' Company for his public house sign. The Cutlers' Company, located in that section of London, and at that time the largest importers of ivory in England, used an elephant with a castle upon its back as a trade symbol. Another, less plausible theory, connects the name with Eleanor of Castile (d. 1290), wife of Edward I of England. In time, perhaps because of the unusualness of the name, the section became known as *Elephant and Castle*,

and when the Bakerloo and Northern lines of the underground put in stops in the area, they adopted the same name for their stations. The term has been in use since the time of Shakespeare who makes an allusion to the public house in *Twelfth Night*; when Sebastian asks Antonio for a recommendation, Antonio replies:

In the south suburbs, at the Elephant
Is best to lodge.
(III, iii)

9. Hell's Kitchen A section of midtown Manhattan, from 42nd Street to 57th Street, west of Times Square, and including 8th through 11th Avenues. Until the 1940s, the elevated subway line on 10th Avenue turned the area into one notorious for its slums and high rate of crime. It is the setting for of Richard Rodgers's ballet, *Slaughter on Tenth Avenue* (1936).

10. horse latitudes Regions of calm air about the earth at about 30 degrees north and south latitudes. The large influx of settlers during the 1700s in the Americas created a necessity for more and more horses. As a result horses were a common cargo on the ships bound for the New World. This term is said to arise from sailing vessels jettisoning cargoes of horses in this area of light winds because, after days of being becalmed, a shortage of water for the animals would develop. Another explanation attributes the name to the transference of the Spanish name for that area of the Atlantic Ocean between Spain and the Canary Islands, *Golfo de las Yeguas*, Gulf of Mares. In any event, the term has been in use since the mid 1700s, and is sometimes heard today in the figurative sense of a befogged mind or a state of befuddlement. H. Allen Smith made use of that sense in the title of one of his works, *Lost in the Horse Latitudes*.

11. neck of the woods Neighborhood, region, locality, territory; parts. *Neck* 'a narrow stretch' of land, woods, ice, etc.—by analogy with the shape of the neck—took on the additional *of the woods* in the United States to denote a settlement in a wooded area. However, it very quickly came to mean colloquially any neighborhood, for in his *Americanisms: the English of the New World* (1871), M. Schele DeVere writes:

He will . . . find his neighborhood designated as a neck of the woods, that being the name applied to any settlement made in the well-wooded parts of the Southwest especially.

12. the old stamping ground The place of one's origin; one's home; an area or establishment that one frequents, a haunt or hangout. This expression apparently derives from the way in which an animal, upon determining where it will rest, tramples down the grass or brush so as to create a more comfortable spot for itself. Nowadays, the phrase often applies to the area where a person spent his childhood.

I made my way from Milledgeville to Williamson County, the old stamping ground. (H. R. Howard, *History of Virgil A. Stewart*, 1839)

13. one-horse town See 211. INSIGNIFICANCE.

14. Podunk See 211. INSIGNIFICANCE.

15. red-light district A neighborhood containing many brothels. This common expression is derived from the red lights which formerly marked houses of prostitution.

16. silk-stocking district The elegant section of an American city or town; a wealthy, posh neighborhood. The figurative sense of *silk-stocking* 'aristocratic, wealthy' was employed as early as 1812 by Thomas Jefferson. The expression maintains usage in the United States.

In as chairman . . . went 47-year-old Hugh Scott Jr., a three-term Congressman from a suburban "silk-stocking" district. (*Time*, July 1948)

ders or carrying a truck trailer on a railroad flatcar.

2. ride shanks' mare To walk; to go on foot. This expression employs a wry twist on *shanks* 'legs' to imply, especially to the uninitiated, that Shanks is actually the name of the owner of a horse which is to be used as a means of conveyance. Common variations substitute *pony, nag, horse,* etc., for *mare.* The closely allied *shank it* means 'to walk.' Related drolleries include *go by the marrow-bone stage* and *ride Walker's bus.*

3. walkabout A journey; a tour; a walking tour. This Australian expression was taken from *pidgin English* about the mid 19th century.

> Under the title "Walkabout"—the pidgin word for "journey" in the Western Pacific—Lord Moyne has written a book on his latest expedition in his yacht *Rosaura* to little-known lands between the Pacific and Indian Oceans. (*The Times,* September 8, 1936)

A related Australian term, *have the walkabouts,* meaning 'to have a temporary loss of concentration,' was made popular during the 1970s by Evonne Goolagong, the famous Australian tennis player, who often explained a sudden lapse in her play in the midst of a match by saying:

> I had the walkabouts for a few games in the second set.

The expression *walkabout* is also used in England, where it describes the queen visiting her subjects abroad.

Longing . . . See 91. DESIRE

Looks . . . See 271. PHYSICAL
 APPEARANCE

Looseness . . .
 See 289. PROMISCUOUSNESS

Loss . . . See 221. IRRETRIEVABILITY

229. LOVE
 See also 156. FRIENDSHIP

1. carry a torch for To suffer from unrequited love; to love one who doesn't reciprocate; to carry the memory of a rejected love; to crusade for a cause. Originally, this expression alluded to carrying a torch in a parade while one was marching for a cause. In time, it came to symbolize any person, sometimes called a *torch-bearer,* who crusaded wholeheartedly to win others to what he considered the "right" way of thinking, and, finally, in the early 1920s came to indicate anyone who crusaded to regain a lost love or to win the love of one who did not reciprocate.

> He fell in love with a beautiful girl, only to find that she was carrying the torch for W. C. Fields. (*Philadelphia Bulletin,* September 6, 1949)

A related term, *torch song,* denotes a sentimental song of unrequited love, usually sung by a *torch singer.*

> If love is returned the popular song is a simple ballad; if it is unrequited, the song is a torch song. (*Haskins News Service,* August 12, 1952)

2. get under [someone's] skin See 223. IRRITATION.

3. heartthrob A lover, paramour, or sweetheart; a romantic idol. This common expression describes the exhilarating cardiac pulsations that supposedly accompany every thought, sight, or touch of one's true love. *Heartthrob* may also refer to a celebrity of whom one is enamored.

> Rudolph Valentino was the great heartthrob of the silent screen in the nineteen-twenties. (*The Listener,* June 1966)

4. hold [one's] heart in [one's] hand To offer one's love to another; to make an open display of one's love. In Shakespeare's *The Tempest* (III,i), Ferdinand

offers his hand to Miranda, to which she responds in kind:

And mine, with my heart in it.

Christopher Marlowe, a contemporary of Shakespeare's, also used this expression.

With this hand I give to you my heart. (*Dido*, III,iv)

5. look babies in the eyes To gaze lovingly into another's eyes; to look at closely and amorously. Two unrelated theories have been advanced as to the origin of this expression. One states that the reference is to Cupid, the Roman god of love, commonly pictured as a winged, naked baby boy with a bow and arrows. The other maintains that the phrase originated from the miniature reflection of a person staring closely in the pupils of another's eyes. In use as early as 1593, the term, now obsolete, was used to describe the amorous gaze of lovers:

She clung about his neck, gave him ten kisses.
Toyed with his locks, looked babies in his eyes.
(Thomas Heywood, *Love's Mistress*, 1633)

6. love-tooth in the head A propensity to love. This obsolete expression implies a constant craving for romance.

I am now old, but I have in my head a love-tooth. (John Lyly, *Euphues and His England*, 1580)

7. rob the cradle To date, marry, or become romantically involved with a significantly younger person. This self-explanatory expression, often substituted by the equally common term *cradlesnatch*, usually carries an implication of disapproval.

I don't usually cradlesnatch. But there was something about you that made me think you were older. (J. Aiken, *Ribs of Death*, 1967)

8. take a shine to To take a liking or fancy to, to be fond of, to have a crush on. This colloquialism of American ori-

gin dates from the mid 19th century. Perhaps *shine* refers to the "bright and glowing" look often attributed to love.

I wonst had an old flame I took sumthin of a shine to. (*Davy Crockett's Almanac*, 1840)

9. tender trap Love; marriage; emotional involvement with one of the opposite sex. This post-World War II colloquialism, implying that love is really a trap which one falls into, gained popularity as a result of the 1954 Broadway comedy production, *The Tender Trap*, written by Max Shulman and Robert Paul Smith. In 1955 the play was adapted as a film starring Debbie Reynolds and Frank Sinatra, whose recording of the title song became a smash hit, further promoting popular usage of the phrase.

10. wear [one's] heart on [one's] sleeve To make no attempt to hide one's lovesickness; to plainly show that one is suffering from unrequited love; to publicly expose one's feelings or personal wishes. This expression is said to come from the practice of a knight wearing his lady's favor pinned to his sleeve when going into combat. In Shakespeare's *Othello* (I,i), the duplicitous Iago says:

For when my outward action doth demonstrate
The native act and figure of my heart
In compliment extern, 'tis not long after
But I will wear my heart upon my sleeve
For daws to peck at.

Loyalty . . . See 67. CONSTANCY

Luck . . . See 163. GOOD LUCK

Lunacy . . . See 218. IRRATIONALITY

Luridness . . .
 See 338. SENSATIONALISM

230. LUST
See also 91. DESIRE;
289. PROMISCUOUSNESS;
297. PRURIENCE

1. cast a sheep's eye To look at amorously, longingly, covetously, or lustfully; to look at with bedroom eyes; to flirt. This expression alludes to the large, innocent, friendly eyes of a sheep.

Don Manuel cast many a sheep's eye at my wife, and his good lady at me. (William R. Chetwood, *The Voyages and Adventures of Captain Robert Boyle*, 1726)

2. casting couch A couch conveniently located in a producer's or director's office to allow the taking of sexual favors from young, aspiring actresses. The *casting couch* became, in Hollywoood legend, at least, a part of any successful movie executive's office. It is rumored that many actresses were rewarded with their first starring roles after yielding to their prospective employers on the *casting couch*. The term, which was popular from the 1920s through the 1940s, is seldom heard today.

3. cooch A lascivious dance; later, the female crotch. This expression, originally American circus and carnival slang, is a truncation of *hoochy-coochy*, a well-known Turkish muscle dance. The girls, who performed these dances in the sideshows, often used them as a front. For a small additional fee one could enter the deeper recesses of the tent and there see a complete strip-tease with the accompanying bumps and grinds. Such lewd exposure soon gave rise to the salacious term *cooch* for a dancer's crotch.

Your cooch shows. (Frederic Brown, *Dead Ringer*, 1948)

4. dance the antic hay See 324. REVELRY.

5. dirty weekend This Briticism suggests an amorous weekend, a weekend spent with one's lover or mistress. Dating from about 1930, the phrase is now often used in a jocular context to designate a weekend spent with one's wife when the children are elsewhere.

6. get [one's] ashes hauled To have sexual intercourse; to be sexually gratified; to experience sexual release. This expression appears in many blues lyrics, and may be of black origin. In the black community the term is used for both males and females; whites relate *ashes* with *semen* and thus limit the expression's application to the male. No explanation of the term is entirely satisfactory. Blues lyrics also contain similar phrases with the same sexual implications: *empty my trash* and *my garbage can is overflowing*, giving rise to the *ashes/semen* equation. However, the many references to the use of ashes in casting voodoo spells has led to the conjecture that getting one's ashes hauled may originally have meant escaping the hex that had been put on one's sex life. Increasing cross-cultural interaction among blacks and whites has made the expression more familiar; and an increasing openness in speaking about sex in general has made the term, though not quite parlor talk, something less than taboo.

We'll get a box at the Comique, then go get our ashes hauled. Never had an Indian girl myself. (S. Longstreet, *The Pedlocks*, 1951)

7. give a girl a green gown To roll with a girl in the fields; take a girl's virginity. This 16th-century expression alludes to the staining of a girl's gown by cavorting in the fields and rolling with her in the grass. Figuratively, a green gown has come to symbolize a girl's loss of virginity.

At length he was so bold as to give her a green gown when I fear me she lost the flower of her chastity. (Anthony Munday, *Palmerin of England*, 1602)

8. go all the way Allow sexual desires to reach their natural culmination; engage in sexual intercourse. This American expression achieved extensive popularity during World War II as a euphemistic phrase used by young men to describe

women who would go beyond the heavy petting stage and would actually engage in sexual intercourse. Today, the phrase is a part of the common American vocabulary.

9. have hot pants Be sexually aroused; be in a lustful state. This expression, in vogue since the 1920s, suggests a person who is easily aroused by the mere presence of a member of the opposite sex. The term received a boost in popularity during the late 1960s when a new style of very revealing shorts called *hot pants* appeared upon the fashion scene. They have passed out of style, but the term has continued in use.

10. horny Sexually aroused; lustful; craving carnal pleasures. This American saying, derived from *horn* 'erect penis,' was formerly used only in reference to male libido.

> You are a gorgeous lookin' piece, Cass. Gets a guy all horny just lookin' at you. (J. L. Herlihy, *Midnight Cowboy*, 1965)

In contemporary usage, however, *horny* is extended to include female lasciviousness or desire.

11. hot to trot Sexually aroused, horny; lustful, lascivious. This currently popular slang expression was apparently coined by adding to the conventional *hot* 'desirous, eager' the rhyming *trot* as a pun on the slang meaning of *ride* 'to have sexual intercourse.'

12. proud below the navel Amorous; sexually excited. This uncommon expression is derived from the conspicuous manifestation of sexual arousal in males.

> Whenever I see her I grow proud below the navel. (William Davenant, *Albovine, King of the Lombards*, 1629)

13. roll in the hay To make love, to go to bed, to have sex; hence the noun *a roll in the hay* 'lovemaking.' This colloquial expression perhaps stems from bygone days when lovers often used hay for a bed.

> He gets something out of it . . . Maybe just a good roll in the hay. (L. Lewis, *Birthday Murder*, 1945)

14. wham, bam, thank you, ma'am A quickie; abrupt sexual intercourse; hasty copulation. This American slang expression dates from about 1895 according to the *Dictionary of American Slang*. The phrase seemingly alludes to the rapidity and roughness of a male rabbit's breeding activities. Applied to humans, it refers to hurried, mechanical sexual intercourse, usually with an unfamiliar woman. Its current use is almost entirely jocular.

Lying . . . See **236. MENDACITY**

M

231. MAGIC

1. abracadabra A magical incantation or conjuration; any meaningless magical formula; nonsense, gibberish. Although the precise origin of this ancient rune is not known, it is said to be made up from the initials of the Hebrew words *ab* 'father,' *ben* 'son,' and *Ruach Acadosch* 'Holy Spirit.' Formerly believed to have magical healing powers, the word was written in triangular form on parchment and hung from the neck by a linen thread as a charm against disease and adversity. By extension, *abracadabra* is also commonly used to mean nonsense, jargon, and gibberish, as in:

> Leave him . . . to retaliate the nonsense of blasphemy with the abracadabra of presumption.
> (Coleridge, *Aids to Reflection*, 1824)

2. fairy rings A ring of grass different in color from that surrounding it, or a ring of mushrooms, superstitiously believed to have been left by dancing fairies. The actual cause of *fairy rings* is the diffusion of the mycelia of certain underground fungi, which spread equally in all directions each year, thus creating rings of darker grass, and, upon occasion, rings of mushrooms around the outer edge of the circle. People of an earlier day, unable to explain the phenomenon scientifically, attributed these rings to dancing fairies. The term has been in use since at least the 16th century.

> There are no fairy folk in our Southwest,
> The cactus spines would tear their filmy wings,
> There's no dew anywhere for them to drink

And no green grass to make them fairy rings.
(Mary Hunter Austin, d. 1934, *Western Magic*)

3. follow the yellow brick road To find a simple and wondrous solution to one's problems; to discover a magical escape from the problems of life; to find the good life. In the popular film, *The Wizard of Oz*, the *yellow brick road* leads to the Emerald City, wherein dwells the wonderful wizard who can resolve all one's problems. Although L. Frank Baum's book, *The Wonderful Wizard of Oz*, was published in 1900, and a stage version was presented in 1901, this expression did not achieve popularity in the U.S. until the late 1950s, after the 1939 film, starring Judy Garland, began to be shown annually on network television.

4. hagstone This expression, alluding to a stone with natural perforations used as a charm against witches' spells and nightmares, probably originated in the early 16th century. The stones, usually flint, were strung like necklaces and hung about the neck for luck. To ward away evil they were often hung on the outside of the house, and to prevent *hag-knots*, tangled snarls in a horse's mane used as stirrups by witches, they were hung on a horse's collar or harness. Francis Grose lists a further use in *A Provincial Glossary* (1787).

> A stone with a hole in it, hung at the bed's head, will prevent the nightmare; it is therefore called a hagstone.

5. hocus-pocus A conjurer's incantation, a magic formula or charm; sleight of hand, legerdemain; trickery, deception; mumbo jumbo, gobbledegook,

nonsense. The original 17th-century meaning of the term, now obsolete, was 'a juggler, a conjurer.' According to the *OED*, this use of the term was apparently an eponymic extension of a certain magician's assumed name. The name itself is thought to have derived from the mock Latin incantation which he used: 'Hocus pocus, tontus talontus, vade celeriter jubeo.' It has also been theorized that *hocus-pocus* was a corruption of the Latin words *hoc est corpus* 'here is the body,' uttered by priests at the consecration of the Mass. Magicians and conjurers picked up the sounds in mocking imitation.

> These insurgent legions . . . which, by the sudden hocus pocus of political affairs, are transformed into loyal soldiers. (Washington Irving, *Life and Letters*, 1843)

6. magic carpet A means of transportation that defies conventional limitations such as gravity, space, or time; a means of reaching any imaginable place. Stories tell of legendary characters who owned magic silk carpets that could be ordered to take a rider wherever he wanted to go. Today the phrase is used figuratively to describe something which has a magical "transporting" effect, such as drugs, or as in the following quotation, a good book.

> His Magic Carpet is a book of travels, by means of which he is transported into lands that he is fated never to see. (*Times Literary Supplement*, August 20, 1931)

7. Medea's kettle A method of making one young again; a fountain of youth. This expression alludes to a classical Greek myth. The daughters of Pelias observed the enchantress Medea cut up an old ram and throw the pieces into a kettle. Pronouncing a few magic words over the kettle, Media caused a lamb to emerge. Hoping to achieve a similar effect, the daughters cut up their aging father and threw him into the kettle. Medea, however, refused to utter the magic words and the father perished.

Apparently, Medea's kettle only had magic qualities when Medea chose.

> Change the shape and shake off age; get thee Medea's kettle and be boiled anew. (William Congreve, *Love for Love*, 1695)

A variant of this expression is *Medea's cauldron*.

8. open sesame See 353. SOLUTION.

9. serpent-licked ears Gift of prophecy; power to foresee the future. This expression has its origin in Greek superstition and refers to the gift of prophecy bestowed upon Priam's son and daughter, Helenus and Cassandra. According to one myth their ears were licked by serpents while they slept in the Temple of Apollo; hence, it was said that they acquired the gift of prophecy from Apollo himself.

10. sieve and shears A method of divination. This expression relates to the ancient practice of coscinomancy, i.e. divination by observing the motion of a sieve blanced on a pair of shears. Mentioned as early as the 3rd century B.C., the procedure is supposedly most effective in determining the names of thieves or future marriage partners. If one wishes to know who the party is, he balances the sieve upon the shears, mentions those who might be involved, and when the true name is spoken, the sieve will supposedly spin around.

> Thinkest thou . . . I can read all riddles without my sieve and shears. (Edward Bulwer-Lytton, *The Last of the Barons*, 1843)

A variant is *riddle and shears*.

Maliciousness . . .
See 403. WICKEDNESS

232. MANIPULATION
See also 69. CONTROL;
107. DOMINATION;
395. VICTIMIZATION

1. backstairs influence Indirect control, as of an advisor; power to affect the opinions of one in charge. *Backstairs* refers to the private stairways of palaces, those used by unofficial visitors who had true access to or intimate acquaintance with the inner circles of government. Connotations of deceit and underhandedness were natural extensions of the "indirect" aspect of the backstairs. Examples of this usage are cited as early as the beginning of the 17th century. Today *backstairs influence* has come to mean the indirect influence or sway that certain individuals or groups are able to exert over persons in power.

2. brainwashing A method of changing an individual's attitudes or allegiances through the use of drugs, torture, or psychological techniques; any form of indoctrination. Alluding to the literal erasing of what is in or on one's mind, *brainwashing* used to be associated exclusively with the conversion tactics used by totalitarian states on political dissidents. This use of the word gained currency in the early 20th century.

> Ai Tze-chi was Red China's chief indoctrinator or, as he was generally called, Brainwasher No. 1. (*Time*, May 26, 1952)

Today application of the phrase has been extended to include less objectionable but more subtle sources of control such as television and advertising.

3. clockwork orange Something mechanical that appears organic; a human automaton. This paradoxical expression, derived from the Cockney *queer as a clockwork orange*, alludes to a human being who has been so transformed by scientific conditioning that his response, even if it involves moral choice, has become automatic. The term came into popular use shortly after 1962, when Anthony Burgess's novel, *A Clockwork Orange* was published; it was also made into a popular film. Set in the future, the story tells of Alex, a violent, teen-age gang leader, who, primarily through aversion therapy, is transformed into a conforming member of proper society, a thorough-going automaton in a human body.

> Bandura feels the behavior-modification process is misunderstood by the public. "They see salivating dogs, shocks, clockwork oranges. They misunderstood the process," he says. (*Science News*, March 16, 1974)

4. in [someone's] pocket To be under another's influence or control; to be at the disposal or mercy of someone else. Dating from the turn of the 19th century, this expression evokes an image of one person being held in the pocket of another, much larger person, and thus conveys feelings of manipulation, insignificance, and helplessness.

> Lord Gower . . . seemed charmed with her, sat in her pocket all the evening, both in a titter. (Countess Harriet Granville, *Letters*, 1812)

Although usually used in this interpersonal sense, *in [someone's] pocket* is applied to the control of inanimate objects as well.

> He was sitting with the family seat in his pocket. (William Makepeace Thackeray, *The English Humorists*, 1851)

5. nose of wax A malleable or accommodating nature; a flexible or yielding attitude. This expression is clearly derived from the pliability of a waxen nose. Originally, the phrase alluded to the Holy Scriptures which, in 16th-century England, were subjected to multitudinous and often conflicting interpretations. The expression was later extended to include other controversial philosophies and laws that were subject to numerous explications.

> Oral Tradition, that nose of wax, which you may turn and set, which

way you like. (Anthony Horneck, *The Crucified Jesus,* 1686)

Although the expression's initial figurative meaning has been virtually obsolete since the 16th and 17th centuries, *nose of wax* is still occasionally used in describing a wishy-washy or easily manipulated person.

He was a nose of wax with this woman. (Benjamin Disraeli, *Endymion,* 1880)

6. play both ends against the middle To play two opposing forces off against each other to one's own advantage. According to several sources, "both ends against the middle" is a technique used to rig a deck of cards in dealing a game of faro; a dealer who used such a deck was said to be "playing both ends against the middle." His maneuvers ensured that competing players lost and that he (or the house) won.

7. play cat and mouse with See 170. HARASSMENT.

8. play fast and loose To connive and finagle ingeniously but inconsiderately to gain one's end; to say one thing and do another; to manipulate principles, facts, rules, etc., irresponsibly to one's advantage. "Fast and Loose," also called "Pricking the Belt," was a cheating game from the 16th century practised by gypsies at fairs. The game required an individual to wager whether a belt was fast or loose. However, the belt would be doubled and coiled in such a way that its appearance prompted erroneous guesses and consequent losses. Shakespeare referred to the trick in *Antony and Cleopatra:*

Like a right gypsy hath at fast and loose
Beguiled me to the very heart of loss.
(IV,xii)

And in *King John,* Shakespeare uses *play fast and loose* figuratively as it is also currently heard:

Play fast and loose with faith? So jest with heaven, . . .
(III,i)

9. Procrustean bed See 77. CRITERION.

10. pull [someone's] chestnuts out of the fire To be forced to save someone else's skin by risking one's own; to extricate another from difficulty by solving his problem; to be made a cat's paw of. This expression derives from the fable of the monkey and the cat. See also **cat's paw, 395. VICTIMIZATION.**

11. pull strings To influence or manipulate persons or things secretly to one's own advantage; used especially in reference to political maneuvering; also *to pull wires.*

Lord Durham appears to be pulling at 3 wires at the same time—not that the 3 papers—the Times, Examiner and Spectator are his puppets, but they speak his opinions. (Samuel Rogers, *Letters to Lord Holland,* 1834)

The allusion is to a puppeteer who, from behind the scenes, controls the movements of the puppets on stage by pulling on the strings or wires attached to them. Although both expressions date from the 19th century, *to pull wires* apparently predated *to pull strings.* The latter, however, is more commonly used today.

12. twist [someone] around [one's] little finger To have complete control over, to have limitless influence upon, to have at one's beck and call; also *wind* or *turn* or *have [someone] around one's little finger. Twist* connotes the extreme malleability of the subject; *little finger,* the idea that the slightest movement or merest whim will suffice to manipulate him. The expression is often used of a woman's power over a man.

Margaret . . . had already turned that functionary round her finger. (John Lothrop Motley, *Rise of the Dutch Republic,* 1855)

13. under [someone's] thumb Under the influence, power, or control of; subordi-

nate, subservient, or subject to. This expression alludes to controlling someone in the same way one can control a horse by pressing his thumb on the reins where they pass over the index finger.

> She is obliged to be silent. I have her under my thumb. (Samuel Richardson, *The History of Sir Charles Grandison*, 1754)

14. work the oracle To wheel and deal, to scheme to one's own advantage, especially for money-raising purposes; to engage in artful behind-the-scenes manipulation of those in a position to grant favors. This British expression uses *oracle* as the means or medium through which desired information or goods are obtained.

> With . . . big local loan-mongers to work the oracle and swim with them. (John Newman, *Scamping Tricks*, 1891)

15. the world's [one's] oyster Great pleasure and profit are there for the taking with little or no effort. The allusion in this phrase is to a prize pearl in an oyster which only needs to be opened in order for someone to claim the treasure. This expression, like so many others, came from the pen of William Shakespeare. When Falstaff refuses to lend money to him, Pistol replies:

> Why, then the world's mine oyster,
> Which I with sword will open.
> (*The Merry Wives of Windsor*, II, ii)

233. MARRIAGE

1. better half Wife; spouse; a close friend. Originally, this term was used to indicate an intimate friend, but after 1580, when Sir Philip Sydney used the expression to signify *wife*, *better half* took on its modern connotation. The phrase is most frequently heard today in a jocular sense.

> Ed Harding will be filling a call for the murder of his better half. (*The Lantern*, August 6, 1887)

2. cheese and kisses Rhyming slang for *missis*, one's wife. This British expression is popular in Australia, where it is frequently shortened to simply *cheese*. It also enjoys some use on the West Coast of the United States. Ernest Booth used the phrase in *American Mercury* in 1928.

3. chip off Bede's chair This expression is directly attributable to an old superstition followed in Jarrow Church, near the site of the monastery where the famous English ecclesiastical historian, the Venerable Bede, once dwelled. Following the wedding ceremony, the bride would proceed from Hymen's Altar to the vestry where she would chip a small piece off Bede's chair to assure early conception. If she should show signs of pregnancy early in her marriage, it was said of her, "She has a chip of Bede's chair in her pouch."

4. dance in the hog trough Said of an older sister when a younger sister marries before her. This disparaging term was popular in America during the 1800s when the prevailing attitude was that sisters should be married in chronological order from oldest to youngest. To have a younger sister marry first was considered humiliating for the older girl. Apparently this attitude was widespread, for there are many variants, among them *dance in the half-peck*, another Americanism, and *dance barefoot*, a British term that predates the American phrases by about 300 years.

> The eldest daughter was much disappointed that she should dance barefoot, and desired her father to find out a match for her. (Mary Delany, *Life and Correspondence*, 1742)

5. Darby and Joan A happily married, older couple; an old-fashioned, loving couple. According to one account, the pair was immortalized by Henry Woodfall in a love ballad entitled "The Joys of Love Never Forgot: A Song," which appeared in a 1735 edition of

Gentleman's Magazine, a British publication. Darby is John Darby, a former employer of Woodfall's. Joan is Darby's wife. The two were inseparable, acting like honeymooners even into their golden years. *Darby and Joan* was also the name of a popular 19th-century song. *Darby and Joan Clubs* are in Britain what Senior Citizens' Clubs are in the United States. The word *darbies* is sometimes used as a nickname for handcuffs. The rationale is that handcuffs are an inseparable pair.

6. eat the Dunmow flitch Live in domestic tranquillity with one's spouse. The allusion in this phrase is to the practice instituted for a few years at Dunmow in Essex, England, in 1111 and restored from 1244 until 1772, when it was discontinued. Any married couple who knelt on the two stones at the church door in Dunmow and swore that they had lived in perfect conjugal harmony for at least the past year and a day, could claim the flitch of Dunmow bacon. Between 1244 and 1772 only eight couples were awarded the flitch.

> While I, though I have married been,
> So many years, at least sixteen;
> Yes, I with honest heart and hand,
> Can now the Dunmow flitch demand.
> (William Combe, *Doctor Syntax in Search of a Wife,* 1821)

The practice was reestablished in the late 19th century. Variants are *fetch a flitch of bacon from Dunmow* and *eat Dunmow bacon.*

7. Fleet marriage A clandestine marriage; a marriage performed by an unlicensed clergyman. These marriages, which were pronounced illegal by the Marriage Act of 1753, were performed by *Fleet parsons,* clergymen who hung about the Fleet, a famous London prison, to perform clandestine marriages without benefit of licenses or banns. Some of these *Fleet parsons* were actually inmates of Fleet prison and performed the marriage ceremony through the prison's walls. The expression has become obsolete.

A worthy woman whose daughter had been entrapped into a Fleet Street marriage. (*Cornhill Magazine,* June 1861)

8. go to the world To be married or wed, to become man and wife. *World* in this expression refers to the secular, lay life as opposed to the religious, clerical life. The phrase, no longer heard today, dates from at least 1565. It appeared in Shakespeare's *All's Well that Ends Well:*

> But, if I may have your ladyship's
> good will to go to the world, Isbel the
> woman and I will do as we may.
> (I,iii)

9. Gretna Green marriages Elopements; marriages without parental permission; hasty marriages; unsanctified marriages. Until 1856, couples could be married in Gretna Green, a Scottish village a few miles northwest of Carlisle, without license, banns, or benefit of clergy. A simple declaration of intention before witnesses of the couple's desire constituted a legal marriage. After 1856, it became necessary for one of the couple to have lived in Scotland for at least 21 days before the declaration. After 1940 marriage by declaration became illegal, but minors may still be married there without parental consent.

> Caroline, Marchioness of Queensbury,
> . . . was the heroine of a genuine
> Gretna Green marriage. (*Daily Chronicle,* February 17, 1904)

10. grey mare is the better horse Said of a woman who bosses her husband; said of a wife who rules the household. The source of this expression is uncertain. Thomas Macauley in his *History of England* (1849–61) attributes it to the grey mares of Flanders and the preference shown for them over English coach horses. However, since the saying dates at least to 1528, many years before the first Flemish greys were brought to England, chances are this explanation is incorrect. Whatever the case, the figurative connotation has been applied to the term since the early 1500s.

She began to tyrannize over my master, . . . and soon prov'd, as the Saying is, The grey Mare to be the better Horse. (William R. Chetwood, *The Adventures of Captain Robert Boyle*, 1726)

11. hung in the bellropes Said of one whose marriage has been postponed or called off after the publication of the banns. The source of this expression is the similar phrase, *hanging in the bellropes*. Thomas DeQuincy explains:

During the currency of the three Sundays on which the Banns were proclaimed by the clergyman from the reading desk, the young couple elect were said jocosely to be 'hanging in the bellropes,' alluding perhaps to the joyous peal contingent on the final completion of the marriage. (*Works*, 1838)

If, however, one of the betrothed postponed or called off the marriage, then the other was said to be *hung in the bellropes*. The expression came into use about 1750 but is seldom heard today.

12. jump over the broomstick To get married; said of those whose wedding ceremony is informal or unofficial. Variants include *to marry over the broomstick*, *to jump the besom*, and *to jump the broom*. This expression, which dates from the late 18th century, refers to the informal marriage ceremony in which both parties jumped over a besom, or broomstick, into the land of holy matrimony. Although neither the ceremony nor the phrase is common today, they were well-known to Southern Negro slaves, who were not considered important enough to merit church weddings, and so were married by jumping over the broomstick.

There's some as think she was married over the broom-stick, if she was married at all. (Julian Hawthorne, *Fortune's Fool*, 1883)

13. live tally Cohabitation without benefit of marriage; live together as man and wife.

He had for years been 'living tally' with a woman—that is in cohabitation without marriage. (Mabel Peacock, *Folklore*, June 1901)

This British slang expression was born in the mining districts of western England in the mid 1800s. The term suggests that a couple who *live tally*, or *make a tally bargain* to live together, apparently choose to do so, not out of necessity, but because their tastes *tally*.

14. love in a cottage A marriage for love with insufficient money to maintain one's accustomed life style; a marriage for love at the expense of one's standing in the social community. This Briticism, frequently used euphemistically, describes a young person who sacrifices his inheritance and social position, often dramatically, to marry someone with whom he is desperately in love. Such a marriage usually entails leaving the family estate and moving into low-cost housing of some type; hence, the appropriateness of the image. Today the term, in use since the early 19th century, is most often heard in a jocular or ironic sense.

Love in a cottage, with a broken window to let in the rain, is not my idea of comfort. (Alexander Smith, *Dreamthorp: On the Writing of Essays*, 1863)

15. mother of pearl Girl friend or wife. This phrase is rhyming slang for *girl*, but applies almost exclusively to females who are girl friends or wives.

16. my old dutch Wife. This expression of endearment is a British colloquialism for one's spouse. Here *dutch* is short for *duchess*.

17. plates and dishes Cockney rhyming slang for *missis*, one's wife. *Plates and dishes* are a rather pointed reference to the household duties of a wife.

18. step off See 82. DEATH.

19. tie a knot with [one's] tongue [one] can't untie with [one's] teeth Get married; take the wedding vows. This old

expression, an extended version of *tie the knot*, contrasts the ease of tying the wedding knot by taking an oral oath with the difficulty of untying it.

> Marriage . . . may make or mar you . . . The tongue useth to tie so hard a knot that the teeth can never untie. (James Howell, *Familiar Letters*, February 5, 1625)

In some modern societies, however, the proverb is no longer valid.

20. tie the knot To get married; to conduct the marriage ceremony. In use as early as the 1200s, this common expression for the rite of marriage implies that one has become seriously entangled, as a rope or string tied in a knot. Shakespeare alludes to the phrase in *Romeo and Juliet*, IV,ii:

> Send for the County; go tell him of this.
> I'll have this knot knit up tomorrow morning.

In contrast, *cut the knot* or *untie the knot* implies a divorce or separation.

21. trouble and strife Cockney rhyming slang for *wife*, dating from the early 1900s. According to Julian Franklyn (*A Dictionary of Rhyming Slang*), this is the most widely used of the many rhyming slang phrases for *wife*, including *struggle and strife*, *worry and strife*, and the American equivalent *storm and strife*.

Mastery . . . See 69. CONTROL; 107. DOMINATION

Matrimony . . . See 233. MARRIAGE

Maturity . . . See 15. AGE

Maudlinness . . .
See 338. SENSATIONALISM

234. MEANINGFULNESS

1. great pith and moment Import, significance, weight. This expression is

taken from Hamlet's most well-known ("To be or not to be") soliloquy:

> And enterprises of great pith and moment
> With this regard their currents turn awry
> And lose the name of action. (III,i)

2. speak volumes To be highly meaningful; to be pregnant with significance; to indicate a great deal through a gesture. The allusion in this phrase is to books and the ability to pass as much meaning in a simple gesture as one may read in several volumes of books. A look, a sound, a movement of the body may pass the equivalent of reams of material to another. The *OED* lists the first written use of the phrase as 1810.

> A pause ensued, during which the eyes of Zastrozzi and Matilda spoke volumes to each guilty soul. (Percy Bysshe Shelley, *Zastrozzi*, 1810)

Meaninglessness . . .
See 246. NONSENSE

235. MEDDLESOMENESS
See also 80. CURIOSITY

1. barge in To intrude; to enter abruptly or rudely; to interrupt; to enter a place without hesitation or ceremony. Although the verb *barge* was used as early as the mid 16th century, the expression *barge in* didn't appear until the late 19th century. The term probably implies river barges and refers to the difficulty of stopping these heavily-laden vessels once they are under way: more than one barge has made an unceremonious entry into a docking place. Hence, the association with bursting upon a scene.

> His first mishap was to barge into Isabel's fiancé, his second to be barged into by Isabel. (Christine Orr, *Glorious Thing*, 1919)

2. come in with five eggs Come in fussily with an idle rumor or a facetious story. Originally this phrase was *five eggs a penny and four of them rotten*, but over the years it has been transposed to its present form. The idea here is that if eggs are so cheap as to sell for five a penny then four must be rotten; figuratively, the rumor or story is so ridiculous it must be false. The expression, dating from the 16th century, is usually heard today in response to a person who interposes some idle comment or half-truth into a conversation simply to become involved.

> Persons coming in with their five eggs, how that Scylla had given over his office. (Nicolas Udall, *Erasmus' Apothegms*, 1542)

3. finger in the pie Meddlesome officiousness because of one's interest in a matter or concern; an interest or share in some endeavor or enterprise; a piece of the pie or the action. This expression may derive from the propensity of some children to taste "Mom's apple pie" by sticking a finger into it, often using "But I helped" as an excuse. Though the child may have had an interest or share in the project, his sticking a finger in does nothing to improve the final product. Though the expression may refer to legitimate or innocuous involvement, *finger in the pie* usually implies interference of a harmful or malicious nature.

> The devil speed him! no man's pie is freed
> From his ambitious finger.
> (Shakespeare, *Henry VIII*, I,i)

4. gatemouth One who knows and discusses the affairs of others; a gossip, busybody. This American expression, deriving from Black English, implies that the "gate" to the mouth of a gossip-monger is perpetually opening and closing.

5. go between the bark and the tree To intervene in the private concerns of intimates; most specifically, to meddle in the affairs of husband and wife.

An instigator of quarrels between man and wife, or, according to the plebian but expressive apophthegm, one who would come between the bark and the tree. (Maria Edgeworth, *Modern Griselda*, 1804)

See also **close as the bark to the tree**, 156. FRIENDSHIP.

6. guardhouse lawyer One who presumptuously gives advice; one who discusses matters of which he knows nothing. This expression is traced to soldiers who, deeming themselves authorities on military law, counsel their peers on a variety of military matters. Today, the term is often used disparagingly to describe a pretentious meddler.

7. Meddlesome Matty An officious meddler, a busybody; one with a finger in every pie and an ear to every keyhole. This epithet, from the title of a poem by Ann Taylor, has been in common American use since the early 1800s. *Webster's Third* cites a contemporary usage by Walter Lippmann:

> When men insist that morality is more than that, they are quickly denounced . . . as Meddlesome Matties.

8. Nosey Parker A busybody, a stickybeak. Apparently originally a descriptive term for one with an excessively large nose, *nosey* became in concept *nosy* 'inquisitive, prying' and the epithet is now restricted to that usage.

> "But Nosey Parker is what *I* call him," she said. "He minds everybody's business as well as his own." (P. G. Wodehouse, *Something Fresh*, 1915)

9. Paul Pry A busybody, a meddler; a nosy, interfering person. Paul Pry was the meddlesome hero of a play by the same name written by Englishman John Poole in 1825. A popular Briticism, the phrase is relatively unknown in the United States.

> The magistrate . . . ought to be a perfect jack-of-all-trades . . . Paul Pry in every house, spying, eavesdropping, relieving, admonishing

[etc.]. (Macaulay, *Critical and Miscellaneous Essays*, 1829)

10. put a sickle in another's corn To meddle in another's affairs; to stick one's nose into another's business; to interfere in private matters. This expression from the Old Testament draws a parallel between helping oneself to another's crops and helping oneself to another's privacy. The phrase was adopted into English during the Middle Ages but is seldom heard today. Moses warns his people in the book of Deuteronomy (23:25):

Thou shalt not move a sickle unto thy neighbor's standing corn.

11. put in [one's] oar To interfere in another's affairs; to meddle in private matters; to intrude or butt in. This expression, a shortening of the original *put one's oar in another's boat*, is still heard occasionally.

Now, don't you put your oar in, young woman. You'd best stand out of the way, you had! (Sir Walter Besant, *The Children of Gibeon*, 1886)

12. quidnunc A busybody or gossip. This expression, derived from the literal translation of the Latin *quid nunc* 'what now?', was first used in Arthur Murphy's *The Upholsterer, or What News?* (1757). The term maintains some frequency in the United States and Great Britain.

He was a sort of scandalous chronicle of the quid-nuncs of Granada. (Washington Irving, *The Alhambra*, 1832)

13. the redding stroke This expression denotes the blow one receives when he interferes in a fight or quarrel; it can be fatal. The term dates from the Middle Ages and is derived from the verb *redd*, 'to disentangle, to part or separate combatants'; hence, the noun *redder*, one who attempts to mediate a dispute and, therefore, is in danger of receiving the *redding stroke* or *redding blow*.

The Earl of Crawford was mortally wounded—"got the redding stroke" in

an attempt to stop the fight. (Andrew Lang, *The History of Scotland*, 1900)

14. stickybeak A busybody, quidnunc, or newsmonger. This Australian slang term clearly alludes to someone who thrusts his nose into everyone else's business.

Meekness . . .
See 362. SUBMISSIVENESS

Melancholy . . . See 335. SELF-PITY

Melodrama . . .
See 341. SENTIMENTALITY

Memory . . .
See 305. RECOLLECTION

236. MENDACITY

1. Baron Münchhausen A teller of tall tales; one who embellishes and exaggerates to the point of falsehood; a creator of whoppers; a liar. Baron von Münchhausen (1720–97), a German who served in the Russian army, gained renown as a teller of adventurous war stories. These were collected by Rudolph Erich Raspe and published in 1785 as *Baron Münchhausen's Narrative of His Marvelous Travels and Campaigns in Russia*. His name has since become synonymous with tall tales and untruths, whether their intent be to entertain or to deceive.

2. Cock Lane ghost story A horror story without truth; a fictitious account of ghostly activities. In 1762 William Parsons reported hearing strange knocking in his residence at 33 Cock Lane, Smithfield, England. Attributed to the ghost of one Fanny Kent, an alleged murder victim, the strange noises were later discovered to be made by Parson's daughter rapping on a board in her bed. The story spread rapidly throughout England and many people, including some royal parties, visited the scene. When the hoax was discovered, Parsons was indicted and punished by being pilloried. The ex-

pression arose shortly after the discovery of the fraud.

3. cry wolf To give a false alarm; to use a trick or other deceitful stratagem to provoke a desired response. This well-known expression alludes to the equally well-known fable about a shepherd lad who often cried "wolf" to get the attention of his neighbors. When they finally grew wise to his trick, a real wolf appeared and the boy cried "wolf," to no avail—no one heeded his call. *OED* citations date the phrase from the late 17th century.

> She begins to suspect she is "not so young as she used to be"; that after crying "Wolf" ever since the respectable maturity of seventeen— . . . the grim wolf, old age, is actually showing his teeth in the distance. (Mrs. Dinah M. Craik, *A Woman's Thoughts About Women*, 1858)

Equivalent expressions and fables appear in many nations throughout the world.

4. draw the long bow See 128. EXAGGERATION.

5. dress the house Seat the customers so as to give the appearance of a full theater. This expression derives from theater parlance and refers to a technique whereby the manager of a theater, by the astute assigning of seats, creates the illusion of a full house. A related term, *paper the house*, alludes to another such practice. The manager hands out a good many free passes, *paper* in theatrical jargon, to give the illusion of a sellout performance.

6. from the teeth outward To say but not mean; to speak insincerely. This archaic phrase implies that vocal protestations of friendship, trust, etc., are often of questionable value after their utterance.

> Many of them like us but from the teeth outward. (John Udall, *Diotrephes*, 1588)

7. Lamourette's kiss See 16. AGREEMENT.

8. lie for the whetstone To be a great liar; to exaggerate outrageously; to present a fanciful prevarication. This expression, dating from the Middle Ages, had its inception in the old custom of placing a whetstone about the neck of a liar. This custom probably arose from the lie-matches once staged at the Whitsuntide celebration, when a contest was held to determine which entrant could tell the largest lie. The winner was rewarded by having a whetstone hung about his neck with which he could sharpen his wit for the next contest.

> This is a lie well worthy of a whetstone. (*Harleian Miscellany*, 1625)

Related terms are *give the whetstone*, implying to another person that the speaker has just told a "whopper" and *get the whetstone*, implying to the speaker that he himself has just told a "whopper."

9. lie through [one's] teeth To purposely tell flagrant and obvious falsehoods; to speak maliciously and untruthfully; to prevaricate with blatant disregard for the truth. The use of *teeth* in this expression serves to underscore the severity of the lie or lies. Variations include *lie in one's teeth, lie in one's throat*, and *lie in one's beard*.

10. lie with a latchet A great falsehood; a thorough-going lie; a flagrant and obvious falsehood. Although the origin of this expression is somewhat shrouded, it was probably derived about 1600 from an older phrase, *go above* (or *beyond*) *one's latchet*. A *latchet* is a strap or thong used to fasten a shoe, and to *go beyond one's latchet* was to meddle in affairs not of one's concern; hence, to *lie with a latchet* came to mean to go beyond others in the extent of one's lying, to tell a falsehood with only the flimsiest of evidence to back it up, to lie on a shoestring, so to speak. Thomas Fuller demonstrates the term with a bit of doggerel in his *Gnomologia* (1732):

That's a lie with a latchet.
All the Dogs in the Town cannot
match it.

11. out of whole cloth False, fictitious, fabricated, made-up; also *cut out of whole cloth.*

Absolutely untruthful telegrams were manufactured out of "whole cloth." (*The Fortnightly Review*, July 1897)

The origin of this expression is rather puzzling in that literal whole cloth (i.e., a piece of cloth of the full size as manufactured, as opposed to a piece cut off or out of it for a garment) seems to lend itself to positive figurative senses rather than negative ones. It has been conjectured that the change in meaning came about because of widespread cheating on the part of tailors who claimed to be using whole cloth but who actually used pieced goods, or cloth stretched to appear to be of full width. Thus, ironic use of the phrase may have given rise to the reversal in meaning. On the other hand, it may come from the sense of 'having been made from scratch,' that is, 'entirely made up' or 'fabricated.' The expression dates from the late 16th century.

12. snow job An attempt to deceive or persuade, usually by means of insincere, exaggerated, or false claims; a line, particularly one used to impress a member of the opposite sex or a business associate; excessive flattery; a coverup. Snow, especially in large amounts, tends to obscure one's vision and mask the true nature or appearance of objects on which it falls; thus, the expression's figurative implications.

13. trump up To devise in an unscrupulous way; to fabricate; to make up something, as a lie or an alibi; to create through one's ingenuity. The key word in this expression, *trump*, derived during the 14th century from the French *tromper* 'to deceive or beguile,' still carries the denigratory connotation usually associated with the word.

He had to flee ignominiously with a trumped up explanation, for how

could he confess the simple truth. (Conrad Aiken, *Ushant*, 1952)

14. a white lie A harmless or innocent fib; a minor falsehood that is pardonable because it is motivated by politeness, friendship, or other praiseworthy concern. This expression draws on the symbolism often associated with the color "white" (purity, harmlessness, freedom from malice). An interesting definition of *white lie* was offered in a 1741 issue of *Gentleman's Magazine:*

A certain lady of the highest quality . . . makes a judicious distinction between a white lie and a black lie.
A white lie is that which is not intended to injure anybody in his fortune, interest, or reputation but only to gratify a garrulous disposition and the itch of amusing people by telling them wonderful stories.

William Paley, on the other hand, presents a different view:

White lies always introduce others of a darker complexion. (*The Principles of Moral and Political Philosophy*, 1785)

15. window dressing Misrepresentation or deceptive presentation of facts, particularly those relating to financial matters, to give a false or exaggerated impression of success or prosperity. Literally, window dressing is a technique of attractively displaying goods in a store window. The expression is figuratively applied to any specious display, but is used most often in contexts implying financial juggling which borders on the illegal, usually obeying the letter, though certainly not the spirit, of the law.

The promise of high duties against other countries deceives nobody: it is only political window-dressing. (*Westminster Gazette*, March 9, 1909)

Merriment . . . See **324. REVELRY**

Merrymaking . . . See **324. REVELRY**

Miscellaneousness . . .

See 239. MIXTURE

237. MISCHIEVOUSNESS

1. apple-pie bed A bed in which the bottom sheet is so folded that a person can only get his legs halfway down; a short-sheeted bed. Alfred Holt in *Phrase and Word Origins* (1961) assigns the origin of this term to the folding and tucking of the bed sheet like a pie crust; so too does Francis Grose in *A Classical Dictionary of the Vulgar Tongue* (1788):

> A bed made apple-pye fashion, like what is termed a turnover apple-pye.

However, another plausible suggestion is that the term is a corruption of the French *nappe pliée*, 'a folded sheet.' The term has been in use since at least the 18th century.

2. cut a dido To play clever pranks; to fool around or cavort about; to take part in monkey business; to cut a caper. An entertaining story which is held by some to be the origin of this expression concerns the mythical queen Dido, who founded the African city of Carthage. She obtained the land by the clever ploy of paying for only as much land as could be enclosed with a bull's hide. That amount, however, exceeded the seller's expectations when Dido cut the hide into thin strips and proceeded to encircle enough land to found the new city. *Dido* 'prank or caper' can stand alone; the U.S. slang *cut a dido* dates from at least as early as the beginning of the 19th century.

> A jolly Irishman, who cut as many didos as I could for the life of me. (J. R. Shaw, *Life*, 1807)

3. goose [someone] To prod or poke someone unexpectedly between the buttocks; to shove a thumb or finger into someone's anus; to goad someone into action. The origin of this expression is obscure; however, a number of explanations have been proffered. One plausible explanation attributes the term to the tendency of geese to go for the groin area when attacking human beings; another to the resemblance of the upturned thumb to a goose's neck, and a third to the poolroom contraption, called a *goose*, that was often, as a practical joke, jabbed into the buttocks of a player about to shoot. In any event, because the action of *goosing* does cause an immediate response, the term has taken on the added meaning of goading a person into action.

> As she was bending over her worktable, a playful lab assistant goosed her. (Max Shulman, *Barefoot Boy with Cheek*, 1943)

4. gremlin A mythical being fancied to be the cause of aircraft troubles; the personification of other inexplicable mishaps. This term, possibly derived from "goblin," was originally used by England's Royal Air Force in World War II. Its various meanings are discussed in the following citation:

> Gremlins are mythical creatures who are supposed to cause trouble such as engine failures in aeroplanes, a curious piece of whimsy-whamsy in an activity so severely practical as flying. Now the gremlin seems to be extending its sphere of operations, so that the term can be applied to almost anything that inexplicably goes wrong in human affairs. (*American Speech*, 1944)

5. hanky-panky Monkey business, shenanigans, mischief; any illegal or unethical goings-on; colloquially often used for philandering or adultery. The current British sense of this term 'legerdemain, jugglery, sleight of hand' was apparently the original meaning of *hanky-panky*, thought to be related to the similar rhyming compound *hocus-pocus* or its variant *hokey-pokey*. The expression dates from at least 1841.

6. jack-a-napes One who acts like a monkey or an ape; an upstart; a vulgar fellow. The most common explanation for this term is that Jack Napes was the

derogatory nickname of William de la Pole, Duke of Suffolk, whose badge was an ape's ball and chain, such as those attached to a tame ape. The Duke was murdered in 1450. *Brewer's Dictionary of Phrase and Fable* offers a different theory.

. . . *Jack-a-napes* being a *jack* (monkey) of Naples, just as *fustian-a-napes* was fustian from Naples. There is an early 15th-century record of monkeys being sent to England from Italy; and by the 16th century, at all events, *Jackanapes* was in use as a proper name for a tame ape.

The term has been in common use since about 1450, which would seem to confirm the Jack Napes theory. Variants are *jackanapes, Jack-an-ape, Jack-and-Apes*.

And then a whoreson jackanapes must take me up for swearing; as if I borrowed mine oaths of him and might not spend them at my pleasure. (Shakespeare, *Cymbeline*, II,i)

7. monkey around To fool around; to waste time or loaf; to engage in aimless activities; also *monkey around with*, to tinker or play with something, usually out of curiosity; to interfere with; to tamper with. This expression and its alternative, *monkey about*, allude to the playful behavior and curiosity associated with monkeys.

I don't see how you fellows have time to monkey around here. (Rudyard Kipling and Wolcott Balestier, *The Naulahka: A Story of West and East*, 1891)

Any attempt to "monkey about" with the powers or composition of the Upper House would destroy the balance of the constitution. (*The Times*, June 27, 1955)

8. monkey business Improper, unethical, or deceitful conduct or dealings; shenanigans, pranks, or mischief; hanky-panky. This expression refers to the frisky and often unpredictable behavior associated with monkeys.

Because I've seen her talking with one of the neighbors isn't to say there was any monkey business between them. (H. Carmichael, *Naked to the Grave*, 1972)

Monkey Business, the title of a 1931 movie, aptly described the zany antics of its stars, the Marx brothers.

9. monkeyshines Shenanigans, tomfoolery, high jinks; horseplay, monkey business; pranks, practical jokes. This term combines the informal meaning of *shine* 'foolish prank' with an allusion to the frolicsome antics often associated with monkeys.

Why all the monkeyshines to get rid of Lucy? He'd been divorced before and he could be divorced again. (H. Howard, *Highway to Murder*, 1973)

A related expression, *cut up monkeyshines* 'to behave in a mischievous or frolicsome manner,' gave rise to other variations such as *cut monkeyshines, cut shines*, and *cut up*.

People recognizing you and staring at you cutting up monkeyshines. (Sinclair Lewis, *Cass Timberlane*, 1945)

10. naughty but nice Proper but with a bit of the devil in one's personality; something that borders on impropriety. This term is probably derived from an English music-hall song of 1875 which contained the line:

Some say it's naughty, but it's really very nice.

The word *naughty* became something of a catchword during the latter half of the Victorian period, when sexual morals became more relaxed and a more hedonistic approach to life was adopted, especially by the more fashionable circles. In fact, the final decade of Queen Victoria's reign was nicknamed the "Naughty Nineties." The term has remained in use since that time.

She knew how to be "so naughty and so nice" in a way that society in London likes and never punishes.

237.11–238.3 442 ☐ *Picturesque Expressions*

(Ouida [Louise de la Ramée], *Moths*, 1860)

11. Peck's bad boy A mischievous child. This affectionate epithet for a naughty child derives from the main character in *Peck's Bad Boy and His Pa*, a book written in 1883 by George W. Peck.

12. play the devil To act in a mischievous way; or, more seriously, to act diabolically, in a destructive and harmful manner. This expression dates from the mid 16th century.

> Your firm and determined intention . . . to play the very devil with everything and everybody. (Charles Dickens, *The Life and Adventures of Nicholas Nickleby*, 1838)

13. play the goat To behave foolishly, to act in an irresponsible, uncontrolled manner. *Goat* has traditionally connoted a wide range of human folly or vice, with meanings ranging from 'butt' to 'lecher.' This colloquial expression dates from the 1800s. Variants include *play the giddy goat* and *act the goat*.

> You'll find some o' the youngsters play the goat a good deal when they come out o' stable. (Rudyard Kipling, *From Sea to Sea*, 1887)

14. play the jack To mislead; to deceive; to practice unethical conduct; to behave in an irresponsible manner; *play the knave*. This expression is probably derived from the misleading tactics of the *Jack-o'-lantern*, or *ignis fatuus*, which deceives people by leading them astray. The phrase has been in use since at least 1610.

> Sir R. Brookes overtook us coming to town; who played the jack with us all, and is a fellow that I must trust no more. (Samuel Pepys, *Diary*, February 23, 1668)

15. when the cat's away the mice will play Subordinates will always take advantage of the absence of one in authority. This still common saying appeared in John Ray's *Collection of Proverbs* in the

17th century. It is based on a pessimistic view of human nature, one holding that external constraints are needed to insure proper behavior.

238. MISERLINESS

1. bang goes sixpence Said to someone to indicate that he is being miserly or overly concerned about the cost of something. This exclamation, satirizing Scottish thrift, originally gained popularity when it appeared as a caption under a Charles Keene drawing in *Punch* (December 5, 1868).

> PEEBLES BODY (to townsman supposed to be in London): E-eh Mac! you're sune hume again.
> MAC: E-eh, it's just a ruinous place that. Mun, a had na been there abune two hours when bang went saxpence.

Repopularized by Sir Harry Lauder, the exclamation is usually heard today in a jocular context or as a disdainful comment to one who is afraid to spend a small amount of money.

2. box Harry To do without a meal to save money; to eat a snack rather than a meal in order to economize. This expression alludes to a time-honored practice of British traveling salesmen, who, to save money, often forgo lunch and have a large afternoon tea, or eat lunch but have a large afternoon tea to avoid the expense of a dinner. The most plausible explanation of the phrase attributes it to another expression:

> To box a tree is to cut the bark to procure the sap, and these travellers drain the landlord by having a cheap tea instead of an expensive dinner. (*Brewer's Dictionary of Phrase and Fable*)

Harry in this expression represents the generic use of the name, here used to mean any landlord.

3. cheeseparing Penny-pinching, stinginess; excessive economy or frugality. This British expression, which dates

from the mid 1800s, is a reference to the practice of taking excessive care when paring the rind from cheese so as to waste as little as possible.

4. close as a clam Close-fisted; parsimonious; stingy. This phrase alludes to the difficulty involved in opening a clam. One who is "close as a clam" hoards his possessions, making them inaccessible to others.

5. clutch-fist A miser; a close-fisted person; a stingy, ungenerous character. This obsolete phrase, as well as the truncated *clutch*, appeared in print as early as 1630. The image is of a hand selfishly grasping or clutching.

6. last of the big spenders A sarcastic descriptive phrase for someone who is miserly or is reluctant to pay his share. This expression first appeared about 1960 but did not really achieve popularity until the 1970s, when Edie Adams made extensive use of it in a cigar commercial. The term is heard either as a caustic comment to or about one who is intolerably penurious, or in humorous repartee.

7. MacGirdie's mare A victim of miserliness; one who suffers from another's parsimony. This Scottish expression is simply another version of a classical Greek anecdote. In order to save money, MacGirdie reduced his mare's ration of hay by degrees. On the day he finally conditioned her to a straw a day, she died. The story is derived from the classical *Analecta Minora*.

8. nickel nurser A miser, tightwad, or penny pincher. This expression, clearly alluding to the disproportionate amount of affectionate attention that a churl gives to his money, is infrequently used today.

9. penny pincher A miser, skinflint, or tightwad; a stingy or niggardly person; an overly thrifty or frugal person. In this expression, *penny* 'one cent' emphasizes the pettiness of *pincher* 'one who saves in a miserly manner.' A variation is *pinch-*

penny. Similarly, *to pinch pennies* is to stint on expenditures, to economize.

10. piker A tightwad, a cheapskate. This Americanism appears to have originated during the Gold Rush, when the Forty-Niners applied this epithet to those among them who had come from Pike County, Missouri. By 1880, when *piker* denoted a two-bit gambler, its connotations were clearly derogatory, and the term was well on its way to its more general current application.

> My companion immediately produced the coin and not wishing to seem a piker, I followed suit. (Robert W. Service, *Ploughman of the Moon,* 1945)

11. skinflint A miser, penny pincher, tightwad; a mean, avaricious, niggardly person. This term is derived from the earlier *to skin a flint* which was based on the idea that only an excessively rapacious person would even attempt to remove and save the nonexistent skin of a rock such as flint. One source recounts the tale of an Eastern caliph who was so penurious that he issued his soldiers shavings that he had "skinned" from a flint to save the cost of their using complete flints in their rifles.

> It would have been long . . . ere my womankind could have made such a reasonable bargain with that old skinflint. (Sir Walter Scott, *The Antiquary,* 1816)

12. tight as the bark on a tree Extremely stingy or close-fisted. This American colloquialism conveys the idea of tightness, or miserliness, by using an image with the flavor of frontier life familiar to the early settlers.

> If you wasn't tighter than the bark on a tree, your wife wouldn't have to do her own washing. (*American Magazine,* November 1913)

13. tightwad A miser, a cheapskate, a scrooge, a tight-fisted, stingy person.

Pauline . . . despises the "tightwads" who have saved money. (E. Gilbert, *The New Republic*, 1916)

The allusion is to the way a miser, not wanting to part with his money, tightly clutches his wad or folded roll of bills. Use of this popular Americanism dates from about the turn of this century.

14. Vermont charity A now little used hobo term for sympathy—the implication being that Yankee frugality and independence would refuse handouts to those seeking them, offering instead only the inedible solace of sympathy.

Misfortune . . . See 10. ADVERSITY

Mistakenness . . . See 121. ERRONE-OUSNESS; 143. FALLACIOUSNESS

239. MIXTURE
See also 19. AMALGAMATION

1. cabbages and kings Anything and everything; odds and ends; assorted and diverse topics, items, etc. The expression comes from Lewis Carroll's *Through the Looking-Glass* (1871):

> "The time has come," the Walrus said,
> "To talk of many things:
> Of shoes—and ships—and sealing-wax—
> Of cabbages—and kings—
> And why the sea is boiling hot—
> And whether pigs have wings."

2. chip basket A hodgepodge; an olio; a medley; a conglomeration. This American expression was apparently derived from the variegated appearance of different shapes and colors created by a basket of wood fragments. In use since the 1800s, the term is seldom heard today.

> She throws you into her chip basket of beaux and goes on dancing and flirting as before. (Harriet Beecher Stowe, *Dred*, 1856)

3. hodgepodge A heterogeneous mixture, a jumble, a farrago, a gallimaufry, a potpourri. This term is a corruption of the earlier *hotchpotch*, which in turn is a corruption of *hotchpot*, from the French *hochepot* (*hocher* 'to shake, to shake together' + *pot* 'pot'), a cookery term for a dish containing a mixture of many ingredients, especially a mutton and vegetable stew. *Hodgepodge* itself was used figuratively as early as the 15th century.

> They have made our English tongue a gallimaufry or hodgepodge of all other speeches. (E. K., *Epistle Dedicatory and Glosses to Spenser's Shepherds Calendar*, 1579)

4. mishmash A jumble, hodgepodge, or potpourri; a confused mess. *Mash* alone means 'confused mixture,' suggesting that *mishmash* may have originated as alliterative wordplay. It has also been suggested that *mishmash* comes from the Danish *mischmasch*. Still current, the term and its variants *mishmosh* and *mishmush* have been in print since the 16th century.

> The original *Panorama* had consisted of a mishmash of disconnected and frequently frivolous items. (*The Listener*, October 30, 1975)

5. olla podrida An olio; a mixture of meat and vegetable scraps; any heterogeneous mixture; a miscellany. This expression is a borrowing from the Spanish, and although it translates as putrid pot, it signifies an edible *pot au feu*, a mixture of leftover vegetables, meat, and spices all cooked together. The term, originally used in English in the 16th century, took on a connotation of a mélange of miscellaneous pieces in art, literature, music about the mid 17th century.

> My little Gallimaufry, my little Oleopodrido of Arts and Arms. (Abraham Cowley, *Cutter of Coleman-street*, 1663)

6. potluck Leftovers, odds and ends; potpourri, hodgepodge; an entity of uncertain composition. This expression is derived from, and still most commonly refers to, leftover food that has been placed in a pot, usually over a period of several days, and then served as a meal at a later date. The rationale for *luck* is that one takes his chances, that is, does not know what food to expect, when he is invited to partake of a potluck dinner. By extension, *potluck* can refer to any conglomeration from which a person makes a blind or indiscriminate selection.

> [He] took the same kind of pot-luck company in those days when he was not so shy of London. (Madame D'Arblay, *The Early Diary of Frances Burney*, 1775)

7. threads and thrums Odds and ends, scraps, fragments; a hodgepodge, a mishmash. Thrums are the unwoven portions of warp yarn which remain attached to the loom when the web is cut off, useless fragments of knotted threads.

> The confused and ravelled mass of threads and thrums, ycleped Memoires. (Thomas Carlyle, "Diderot," *Miscellaneous Essays*, 1833)

See also **thread and thrum, 383. TOTALITY.**

Mockery . . . See **327. RIDICULE**

Modification . . .
 See **7. ADAPTATION**

Molestation . . .
 See **170. HARASSMENT**

240. MONEY
 See also **14. AFFLUENCE;**
 149. FINANCE; 265. PAYMENT

1. Abe's cabe A five-dollar bill; a fin; a fiver. This American slang expression, originating in the 1930s, was born in the world of jazz. Adopted by the rock and rollers about 1955, the term continued in common use in the world of subculture. *Cabbage*, a common slang expression for money, has been shortened to *cabe*, and combined with an allusion to the picture of *Abe*, Abraham Lincoln, on a five-dollar bill, to form this rather unusual slang expression. The term is seldom heard outside the realm of jazz.

2. almighty dollar Money as an object of worship; money conceived of as a source of power; commercial idolatry. Washington Irving apparently coined this term in 1836 in an essay, "The Creole Village," which appeared in an 1837 Christmas annual, *The Magnolia*, and in a collection of his essays.

> The almighty dollar, that great object of universal devotion throughout our land, seems to have no genuine devotees in these peculiar villages. (Irving, *Woolfert's Roost*, "The Creole Village," 1855)

Probably patterned after Ben Jonson's *almighty gold* (1616), the phrase describes some men's belief that the power of money can achieve anything.

3. axle grease Australian slang for money, which greases the wheels of life, so to speak, helping things to run along more smoothly.

4. boodle A street term for money; ill-gotten gains; bribery. This American slang expression, apparently derived from the Dutch *boedel* 'property,' probably gained popularity when the New York newspapers of 1884 used the term in reference to the New York Board of Aldermen who were charged with taking bribes for granting a franchise for a street railroad on Broadway. Today the term is in general use as the money one receives as the recipient of a bribe. A variant form of the word is part of the expression *the whole kit and caboodle*.

5. chicken feed Small change; a paltry or inconsequential amount of money. This American slang expression, which

dates from 1836, is an allusion to the scraps and seeds fed to chickens.

6. cry all the way to the bank Although the source of this phrase is unknown, it is generally attributed to the famous pianist Liberace, who popularized the expression in the 1950s.

> He likes to say that he and his brother George cry all the way to the bank and to dedicate his theme song, *I Don't Care*, to his critics. (*Current Biography: Liberace*, November 1954)

It is usually heard today as an ironic justification for engaging in an activity that, despite adverse criticism, is nonetheless financially rewarding.

7. fast buck Money acquired quickly and effortlessly, usually through illegal or unscrupulous methods. In this expression, *buck* carries the American slang meaning of dollar, making the origin of the term self-evident.

> Trying to hustle me a fast buck. (A. Kober, *The New Yorker*, January 1949)

8. filthy lucre Money; money or other material goods acquired through unethical or dishonorable means, dirty money. This expression was first used in an epistle by St. Paul:

> For there are many unruly and vain talkers and deceivers . . . who subvert whole houses, teaching things which they ought not, for filthy lucre's sake. (Titus 1:10–11)

9. golden handshake Originating in Great Britain, this expression refers to a generous gift of money presented to a departing officer or an outstanding employee at retirement. The term has been in use since about 1950. See also 332. SECRECY.

10. harp shilling An Irish coin worth twelve pence in Ireland but only ninepence in England; something not worth its face value.

> The said Harp shillings should have . . . the name and value only of twelve pence Irish . . . being in true value no more than nine pence English. (Rogers Ruding, *Annals of the coinage of Britain and its Dependencies: A Proclamation of 1606*, 1817)

The so-called *harp shillings* received their name not only from the fact that they were issued in Ireland but also because the image of a harp was stamped on the coin. Because of the lesser value of the coin, the term soon came to connote cheapness or tawdriness.

11. a king's ransom A very large sum of money. This expression, perhaps familiarized by the hefty sum demanded for the release of the kidnapped King Richard the Lion-Hearted, maintains frequent usage.

> I couldn't look upon the babby's face for a king's ransom. (Mrs. Anna Hall, *Sketches of Irish Characters*, 1829)

12. loaves and fishes Monetary fringe benefits to be derived from public or ecclesiastical office; the personal profit one stands to gain from an office or public enterprise. This use of *loaves and fishes* derives from John 6:26:

> Jesus answered them and said, Verily, verily, I say unto you, Ye seek me, not because ye saw the miracles, but because ye did eat of the loaves, and were filled.

Today the phrase is also sometimes heard in referring to any unanticipated, miraculous proliferation or abundance. This emphasis on abundance rather than personal gain derives from the actual description of the miracle of the loaves and fishes (John 6:11–13).

13. mad money Money for frivolous purchases or little luxuries; money for a bit of riotous living-it-up. Originally mad money was that carried by a woman in the event her escort made advances prompting her to leave him in the lurch and finance her own return home. It subsequently came to be applied to money used for any emergency, but at some

point took the grand leap from necessity to luxury. Perhaps today it might qualify as what economists call *discretionary income.*

14. make [one's] pile To accumulate a fortune; to become wealthy; to make enough money to retire. This expression derives its meaning from the piling up of any substance. In modern idiom, however, it has been restricted to the amassing of money. The idea of piles of money has been expressed since the Middle Ages, but the elliptical sense of this term, as an implication of accumulated wealth, didn't come about until the early 1700s.

> Capitalists who had made their pile were consumed by a desire to walk over their own broad acres. (Augustus Jessopp, *Arcady for Better or Worse,* 1887)

15. Midas touch An uncanny ability to make money; entrepreneurial expertise. Midas, legendary king of Phrygia, was divinely granted the power to transform anything he touched to gold. The gods relieved Midas of his power when the king realized that everything he touched, including food and his daughter, changed to gold. Still in general use, this expression often describes the moneymaking abilities of an entrepreneur.

> Picasso, with his Midas touch, has at first try made the lino-cut a more dignified medium. (*The Times,* July 1960)

16. money burns a hole in [one's] pocket See **184. IMPATIENCE.**

17. money doesn't grow on trees This truism, dating from the 19th century, is most frequently directed toward children by their parents. The phrase, of course, is supposed to make the hearer aware that there is no unending source of supply for money, that it all must be earned by hard work. An exasperated tone usually accompanies the phrase.

18. monkey's allowance A trifling amount of money; a pittance; a paltry sum. This expression is derived from the saying, "He gets a monkey's allowance—more kicks than halfpence." At one time, trained monkeys performed tricks and then collected money from passers-by. If the monkey performed poorly, its owner often kicked or otherwise punished the animal. Thus, the monkey's allowance was frequently more abuse than money. By extension, a person who receives a "monkey's allowance" is one who works diligently but receives little, if any, payment for his labor. A related expression is *monkey's money* 'something of no value.'

19. nest egg Money saved, particularly a reserve fund for use in emergencies or retirement; a bank account or other form of investment which regularly increases in value by virtue of interest accrued or additional deposits made. Originally, a nest egg was a natural or artificial egg which was placed in a hen's nest to induce her to lay eggs of her own. Though the term retains this connotation, it has been extended to imply that once a person has saved a certain amount of money, he is likely to save more.

> A nice little nest egg of five hundred pounds in the bank. (John Ruskin, *Fors Clavigera,* 1876)

20. nimble ninepence A pliable silver coin worth nine pence; an Irish shilling; a love token. A silver ninepence was in circulation in Britain until 1696, when all were recalled by the government. These *nimble ninepence,* made of pliable, or nimble, silver, were often used as love tokens. The popularity of the term was given a boost in the mid 1800s by the business proverb *a nimble ninepence is better than a slow shilling,* meaning that it is a better business practice to move articles that cost ninepence than to stagnate with articles that cost a shilling (12 pence).

21. pin money A small amount of money set aside for nonessential or frivolous expenditures; an allowance given to a woman by her husband. When common or straight pins were invented in the 13th century, they were expensive and relatively scarce, being sold on only one or two days a year. For this reason, many women were given a regular allowance called pin money which was to be saved until the pins were once again available for purchase. In the 14th and 15th centuries, it was not uncommon for a man to bequeath to his wife a certain amount of money to be used for buying pins. Eventually, as pins became cheaper and more plentiful, the pin money was used for trifling personal expenses, but the expression persisted.

> If he gives me two hundred a year to buy pins, what do you think he'll give me to buy fine petticoats? (Sir John Vanbrugh, *The Relapse*, 1696)

22. pretty penny A relatively large sum of money; an exceptionally large sum of money. The origin of this phrase is uncertain, but it is often attributed to the special gold pennies, worth 20 silver pennies, that Henry III had coined in 1257. Since they were more valuable, and more noticeable, than the silver pennies, they became known as *pretty pennies*.

> The captain might still make a pretty penny. (Bret Harte, *Maruja*, 1885)

23. raise [one's] screw To get an increase in wages; to improve one's salary; to gain a better way of life. A practice of some employers in the past was to hand out wages screwed up in a piece of paper, and from that practice the British slang term *screw*, for wages, was born.

> It was in payment of my screw—my salary. (Hunter and Whyte, *My Ducats and My Daughter*, 1884)

The more money the paper contained, the higher it had to be twisted or *screwed*; hence, when one *raised his screw*, he received more money.

24. ready rhino Ready cash; money. This British slang expression, which never caught on in the United States, has been in use since the late 1600s. Although the origin of the term is obscure, a most credible explanation attributes it to the value of the horn of the rhinoceros. In the Far East, especially in Malaya, it was—and in some areas, is still—believed that the powdered horn of the rhinoceros is a powerful aphrodisiac; it therefore commands a high price. Hence, to have a rhino was like having cash in one's hand. Related terms that developed from the slang expression are *rhino fat* and *rhinocerical*, both meaning 'rich' or 'having plenty of money.'

> Cash, cash, cash, that's what we're looking for,
> There's nothing like the good old rhino.
> (M. H. Rosenfeld, *There's Nothing Like It*, 1887)

25. root of all evil The original Biblical quotation as it appeared in I Timothy, 6:10 is:

> The love of money is the root of all evil.

However, later misuse of the expression shortened it to *money is the root of all evil*, a phrase which misrepresents the original's intention. Both Mark Twain and George Bernard Shaw are credited with a more jocular, but perhaps more believable version:

> The lack of money is the root of all evil.

26. rubber check A bad check; a check not covered by sufficient funds. A check issued for an amount greater than the account balance is said to bounce, because it is returned to its payee.

> She had bought the car and paid for it with a rubber check. (*This Week Magazine*, September 1949)

27. a shot in the locker A reserve, usually financial; a last resource or chance. *Locker* is a nautical term for the compartment on board a vessel in which are

stored ammunition, clothes, etc. *Shot in the locker* is literally stored ammunition; figuratively, it refers to a stash of money.

> As long as there's a shot in the locker, she shall want for nothing. (William Makepeace Thackeray, *Vanity Fair,* 1848)

This expression is often heard in the negative *not a shot in the locker,* meaning no money or means of survival.

28. slush fund Money procured from the sale of grease or garbage on a naval vessel and used to buy small luxuries for the crew; money set aside for corrupt or unethical ends; money raised by a group, such as office personnel, for gifts, parties, or other special occasions. The origin of this term lies in the word *slush,* meaning the fat or grease accumulated on shipboard during a voyage. The excess slush, which had amassed from the boiling of meat, was sold in port and put into a fund to buy small luxuries for the crew. Eventually this expression, which had its origin in the 18th century, found its way into 20th-century American political slang, where the fund was used to bribe those who were willing to corrupt themselves for luxuries they otherwise couldn't afford. In later years the phrase was added to office jargon to designate a fund for entertainment or other special uses.

> They gave liberally to a slush fund which he collected periodically and distributed where it would do the most good. (Asbury, *Sucker's Progress,* 1938)

29. small potatoes See 211. INSIGNIFICANCE.

30. sugar and honey Rhyming slang for *money.* This expression dates from the mid 19th century. *Sugar* alone is a popular slang term for *money,* in Britain as well as in the United States, where most people are unaware that the term is a truncated version of a rhyming slang expression.

31. that ain't hay That's a great deal of money; an expression referring to a great deal of anything, material or spiritual, most often money. In this expression, *hay* is used to symbolize something of little or no value. The phrase is always used to contrast hay to something, usually to money, as in "He brings home $250,000 a year and that ain't hay." Of unknown origin, the phrase was originally used only in reference to a sum of money, but later its application broadened to other objects of value, especially of spiritual value. In *Strong Cigars and Lovely Women* (1951), John Lardner makes such use in reference to Lou Ambers, the lightweight boxing champion from 1936–1938 and 1939–1940.

> If Louie Ambers
> Should come our way,
> He brings the title,
> And that ain't hay.

32. widow's mite See 48. CHARITABLENESS.

33. worship the golden calf To abandon one's convictions for the sake of money; to humble oneself before riches; to worship wealth. The expression is an allusion to the Biblical tale found in Exodus: 32. When Moses was called up to Mount Sinai to receive instructions from God, the people who waited for his return eventually grew restless and lost faith. Finally, they called upon Aaron to create an idol which they might worship. Aaron collected all their gold, melted it, and fashioned an idol in the form of a golden calf to which the people made sacrifices. Hence, to *worship the golden calf* is to throw aside one's deepest convictions and pay homage to the false god, gold.

Monotony . . . See 356. STAGNATION

Mortification . . .
 See 173. HUMILIATION

Motion . . . See 228. LOCOMOTION

Mourning . . . See 167. GRIEVING

Movement . . . See 228. LOCOMO-
TION; 261. PACE

241. MUSIC

1. bluegrass A variety of country music
that originated in Kentucky, character-
ized by a rapid tempo, polyphonic
sound, and typically performed on ban-
jo, guitar, mandolin, bass, fiddle, and
sometimes other instruments. *Bluegrass*
as a style of music has been popular since
at least the 19th century, but it has only
been used as a term for that style since
the 1940s when Bill Monroe founded his
famous group known as "The Blue Grass
Boys." Their name was derived from the
nickname of their home state of Ken-
tucky, the *Bluegrass State*.

In his teens, Jason sang and played
guitar in bluegrass, folk and country
bands, and from there it was . . .
going to Nashville . . . to seek fame
and fortune. (*Rolling Stone*, April 12,
1984)

See **bluegrass**, 227. LOCALITIES.

Mutuality . . . See 304. RECIPROCITY

N

Naïveté . . .

See 204. INEXPERIENCE

Nakedness . . . See 271. PHYSICAL
APPEARANCE

Names . . . See 119. EPONYMS;
244. NICKNAMES

242. NATIONALITY

1. American as apple pie Characterized
by traditional American values; display-
ing typically American traits. This ex-
pression arises from the supposition that
apple pie is an old-fashioned, traditional
American food. The phrase has been in
popular use since the early 1960s, and is
often used in conjunction with the flag
and motherhood, in such phrases as "for
the flag, apple pie, and you, Mom," es-
pecially in a satirical or jocular sense.

> Could the Cuban vision of life, as
> reflected in these films, be so
> appealing that it would corrupt and
> endanger apple-pie America?
> (*Saturday Review*, June 17, 1972)

2. Irish as Paddy's pig One hundred
percent Irish; as Irish as one can be. This
alliterative expression alludes to the
nickname for the popular Irish given
name, *Padraig* or *Patrick*, and occasion-
ally is rendered *Irish as Paddy Murphy's
pig*, adding the popular Irish surname,
Murphy, apparently to create a greater
aura of being Irish. The phrase, dating
from about 1890, may have arisen from
an earlier expression which William
Hazlitt records in *English Proverbs*
(1869):

> As Irish as pigs in Shudekill market. A
> related term, also used to indicate
> extreme Irishness, is *straight from the*

bog, a direct reference to the peat
bogs, so representative of Irish life.

3. wearing of the green Dressing in the
national color of Ireland; wearing a bit
of green on one's clothing to indicate pa-
triotism to Ireland or the honoring of
St. Patrick's Day.

> They're hanging men and women
> there
> For the wearin' o' the green.
> (*The Wearin' o' the Green*, 1798)

This old Irish street ballad, alluding to
the color adopted by the Nationalist par-
ty of Ireland in its rebellion against Brit-
ish dominance, is the source of this ex-
pression. The color is said to have been
chosen to represent the luxuriant green
vegetation that dominates the country-
side of the island. Many other examples
of the dominance of green in Irish senti-
ment are evident in such terms as *Green
Erin*, *The Green Island*, and *Emerald
Isle*, first penned by Doctor William
Drennan in his poem *Erin* (1795).

> Nor one feeling of vengeance presume
> to defile
> The cause, or the men, of the
> Emerald Isle.

However, he claims to have taken the
phrase from a political song current at
the time, *Erin, to her Own Tune* (1795).
The term is used commonly in the U.S.
to refer to the practice of wearing some-
thing green for the celebration of St.
Patrick's Day, March 17.

Naughtiness . . .

See 237. MISCHIEVOUSNESS

Nearness . . . See 295. PROXIMITY

243. NEATNESS

1. apple-pie order Excellent or perfect order. The phrase may seem "as American as apple pie," but its origin is British, and murky. The *OED's* first citation is from Sir Walter Scott in 1813. Some theorize the expression derived from the French *cap-à-pie* 'from head to foot'; others see it as a corruption of the French *nappes pliées* 'folded linen.' The story that it gained popularity in the United States because of the systematic and orderly arrangement of apple slices in pies baked by New England women is at least as amusing as the others are credible.

2. clean as a whistle Very clean; completely clean; also *clear* or *dry as a whistle.* This proverbial simile, which dates from the 1780s, is said to have derived from the fact that a whistle must be clean and dry in order to produce a sweet, pure sound.

3. neat as a bandbox Conspicuously neat in appearance, spiffy, smart-looking, fresh, sharp; in the United States, usually *looking as if [one] just stepped out of a bandbox.* This American phrase appeared as early as 1833 in *The Knickerbocker* and has been in common use since, despite the impossibility of a bandbox ever containing a human being. A bandbox is a small receptacle for collars and millinery, much used in the 17th century for storing the ruffs, or bands, commonly worn then. The following citation hints at the elliptical process by which the person himself rather than the item of apparel came to be described as *neat as* or *out of a bandbox:*

Why, he is a genteel, delightful looking fellow, neat as a starched tucker fresh from a bandbox [*sic*]. (Samuel Woodworth, *The Forest Rose,* 1825)

4. neat as ninepence Unexpectedly neat; in apple-pie order; spick and span; cleverly adept. This expression appeared as early as 1678 in John Ray's *English Proverbs* and is a corruption of another term, *neat as nine-pins.* In that game the pins are arranged in three rows of three each with the same precision as ten-pins in modern bowling; this precision possibly also gave rise to the expression *neat as a pin.*

If I didn't see him whip a picture out of its frame, as neat as ninepence. (*Blackwood's Magazine,* 1857)

It is not entirely clear which sense of *nice* is intended in the 19th-century expression *nice as ninepence,* 'neat, precise' or 'pleasant.' It is usually taken to mean 'extremely cordial or helpful.'

5. a place for everything Things should be kept in or returned to the place where they belong. This expression, an elliptical form of the common maxim *a place for everything and everything in its place,* implies not only that one will keep things neat but also that one will be able to find things when they are needed. The term has been in use since the early 19th century.

Order is most useful in the management of everything. . . . Its maxim is, A place for everything and everything in its place. (Samuel Smiles, *Thrift,* 1875)

6. shipshape In good order; trim; tidy. The original nautical term meant fully rigged or ship-rigged, as opposed to temporarily or jury-rigged. The word often appears in the full phrase *all shipshape and Bristol fashion,* dating from the days when ships of Bristol, famous for its maritime trade, were held in high regard. An entry under "Bristol fashion and shipshape" in Smyth's *Sailor's Word-book* (1867) reads:

Said when Bristol was in its palmy commercial days . . . and its shipping was all in proper good order.

7. spick and span Spotlessly clean, neat and tidy; a shortened form of the expression *spick and span new* meaning 'completely brand-new.' Although the exact

origin of the expression is unknown, it has a possible connection with *span* 'a chip or piece of wood' and the obsolete meaning of *spick* 'spike-nail.' Thus, a brand-new ship would have all new spicks and spans. According to the *OED* the longer expression first appeared in the late 1500s, while the abbreviated term more popular today came into use about 1665. It would seem that in dropping the *new* from the expression the emphasis shifted from newness itself to those qualities usually associated with new things such as freshness, cleanliness, tidiness, and neatness.

8. spit and polish Meticulous attention given to tidiness, orderliness, and a smart, well-groomed appearance. This expression found its first widespread use in the armed forces, where it alluded to the common custom of spitting on a shoe or other leather item and buffing it to a high polish. While the phrase retains its military application, it now carries the suggestion of extreme fastidiousness in maintaining a sharp, scrubbed, disciplined appearance.

> To lessen the time spent in spit and polish to the detriment of real cavalry work. (*United Service Magazine*, December 1898)

Necessity . . . See 390. URGENCY

Neglect . . . See 1. ABANDONMENT

Negligence . . .
> See 44. CARELESSNESS

Newness . . . See 15. AGE

News . . . See 206. INFORMATION

244. NICKNAMES

1. Aunt Emma Morphine. This underworld term, in use since the early 20th century, is simply derived from *Emma*, as a symbol for the letter *M*, the initial letter of *morphine*. A variant form is *Miss Emma*.

2. banana belt Those tropical areas often used as vacation retreats, especially the Caribbean Islands. This American slang expression, in popular use since the early 1960s, is of uncertain origin. One source attributes it to jocular use by workers on Baffin Island, lying between mainland Canada and Greenland, who referred to the mainland of Canada as the *banana belt* because it appeared so warm to them. A more plausible explanation is the obvious reference to tropical countries or islands as ideal vacation spots, sometimes referred to as *banana republics* because their economies rely heavily on the export of bananas. Whatever its origin, the term has come to be used jocularly to refer to an area perceived as much milder in climate.

> Skiers enjoying the sport at some of the giant-sized areas in New England and upper New York have cause to thank this southern Catskill Mountain county—often joshingly referred to as "The Banana Belt." For it was in this Sullivan County region that machine-made snow was first produced on a practical basis.(*The New York Times*, January 6, 1977)

3. Beecher's Bible A rifle; any sort of firearm; Henry Ward Beecher (1813–1887), the noted Brooklyn clergyman, preached from his pulpit that a Sharps rifle in the hands of a Free Stater could convince pro-slavery forces to abandon the contested border states faster than any passages quoted from the Bible. In support of his own preaching, he bought and shipped Sharps rifles to Kansas with the money he raised; hence, the origin of the term *Beecher's Bible* for 'rifle.'

> You marched an armed body of men into my town before ever a Beecher's bible was sent to Kansas. (*Congressional Record*, April 5, 1879)

4. bit of fluff A young woman; an attractive young lady. This Edwardian expression for a lively girl has become common British colloquialism. It is today regarded as denigrating and is often used to refer to a mistress.

Got a little party on, you know, two
bits of fashionable fluff. (W. Deeping,
Second Youth, 1920)

The allusion in this phrase may be to the
hair but is more likely to feminine attire,
and is probably derived from an earlier
term, a *bit of muslin*, which came into
use as early as 1820.

She's a neat little bit o' muslin, ain't
she now? (Richard Whiteing, *No. 5
John Stuart*, 1899)

Other British variants are *bit of goods*
and *bit of stuff*; related American terms
are *piece of goods*, *quite a dish*, and
quite a number.

5. Blue Hen's chickens During the Rev-
olutionary War a Captain Caldwell
commanded a Delaware regiment. De-
veloping his regiment into a crack fight-
ing force, Caldwell inspired his men by
reminding them that no cock was game
whose mother was not a blue hen. His
axiom was transferred to his regiment
who became known as *Blue Hen's chick-
ens*. Subsequently, the blue hen was
named the state bird of Delaware, and
the inhabitants of the state became
known as *blue hens*. Today, athletes at
the University of Delaware are known as
the *Fightin' Blue Hens*.

Delaware, small but mighty in its
influence, well represents the
character and reputation of the Blue
Hen's Chicken. (*Louisville Courier*,
November 8, 1856)

6. boob tube A television set. This
rhyming expression was coined during
the 1950s as a negative commentary
about the quality of programming to be
found on network television shows. The
reference to *tube* is to the screen which
is, in fact, a cathode ray tube. In recent
years the television has become known as
simply *the tube*.

A self-described easy weeper . . .
Wilson thinks the only way to watch
the tube is by herself. (*The Dial*,
September 1983)

A related term *idiot box*, like *boob tube*,
is another denigrating commentary
about the level of the material pre-
sented, as based on the broadcasters' as-
sessments of the average viewer. In Brit-
ain, as in the United States, some affec-
tionate nicknames have been introduced
for the TV, *telly* and *goggle box* are two
of the more common. The British also
say that a habitual telly watcher *has
square eyes*.

I seen him on the telly. (Angus
Wilson, *Anglo-Saxon Attitudes*, 1956)

7. Brandy Nan See 382. TIPPLING.

8. breadbasket Stomach, abdomen.
This figurative slang term, whose literal
origins are obvious, has been in common
usage since the mid 18th century.

9. Brother Jonathan A nickname for
American patriots; another name for
Uncle Sam; a personification of the
United States or any of its citizens. This
expression is usually attributed to
George Washington, who allegedly
coined the phrase in reference to Colonel
Jonathan Trumbull of Connecticut,
Washington's aide-de-camp during the
Revolutionary War. The story is told
that one day, when Washington learned
that his army was short of ammunition,
he called certain officers together for ad-
vice, but no one had a solution to his
problem. At which point he is said to
have remarked, in reference to the ab-
sent Trumbull, "We must consult Broth-
er Jonathan." This explanation, howev-
er, is apocryphal, the earliest known
date for it is 1816. A more credible ex-
planation is that the term developed as
an exclamation of derision used by Brit-
ish soldiers and loyalists toward patriotic
Americans. In 1901 the following ex-
tract, suggesting an earlier use but no
clue as to origin, appeared:

I saw several Gentlemen who came
out of Boston last evening. . . . They
[the British] left Bunker Hill last
Lsday (*sic*) Morning 17th at Eight
O'clock, leaving images of Hay
dressed like Sentries standing, with a

Label on the Breast of one, inscribed 'Welcome Brother Jonathan.' (Ezra Stiles, *Publication of the Colonial Society of Massachusetts*, 1776)

10. bull pen A warm-up area for relief pitchers in baseball; the corps of relief pitchers on a baseball team; a temporary prison for people awaiting official judgment. Dating from about 1800, this expression, utilizing an image from animal husbandry, was at first a prison term for the small enclosure where those prisoners who were waiting to be transferred or interrogated were kept. However, in the early 1900s, the term was adopted to describe that area on a baseball field where relief pitchers can warm up prior to entering a game. Exactly when and how this term came into being is unknown, but it was doubtless the result of a sports writer or player who associated the set-off area enclosing the corps of relief pitchers with the pen in which a bull is kept.

"You usually have trouble convincing a young guy his future is in the bull pen," Monbouquette recalls. (*New York Daily News*, August 28, 1983)

11. Cape Cod turkey Salt fish; codfish. This American colloquialism was used chiefly among the sailors of the 1800s as a humorous appellation for codfish, especially that cod which had been preserved for long voyages by salting it. The term is used only occasionally today.

A salted codfish is known in American ships as a Cape Cod turkey. (Charles Nordhoff, *Letters*, May 1, 1865)

The nickname *Bombay duck* is applied to dried bummalo, a fish of the Indian Ocean.

12. Cape Hope sheep Albatrosses; gooney birds; mollyhawks. This strange nickname for the albatross is said to come from British seamen, who, upon seeing them in such large numbers in the vicinity of Cape Horn were reminded of the large flocks of sheep which frequent the fields of England. Often referred to as *gooney birds* because of their awkward behavior, they caused the U. S. Navy a great deal of trouble on Guam during World War II. Since albatrosses must run a great distance in order to take off from the land, the newly created naval airport runways presented a natural take-off area for them. However, apparently unaware of aircraft, the birds created a real hazard to take-offs and landings. They are also known as *mollymawks* and *mollyhawks*, an Anglicized version of the Dutch *mollemok*, meaning stupid gull.

13. carpet knight A knight who performs better in milady's boudoir than on the field of battle; one knighted at court rather than on the battlefield; an American Civil War term for a member of the State or National Guard. This term, first employed about 1576, was originally a contemptuous allusion to those knights who ignored the combat of the battlefield, in preference for the combat of the bedroom. Randall Cotgrave in *Dictionaries of the French and English Tongues* (1611) defines the term as:

> *Mignon de couchette*, a Carpet-Knight, one that ever has to be in women's chambers.

After 1800 the term became a recognized synonym for a stay-at-home soldier. In modern terminology the vast majority of knights are those of the carpet variety. During the American Civil War *carpet knight* was a name for a member of the National Guard or State militia. That use, however is now obsolete.

> There is a prodigious cry of 'On to Richmond' among the carpet knights of our city, who will not shed their blood to get there. (George B. McClellan, *McClellan's Own Story*, 1862)

14. coffin nail A cigarette; anything that tends to hasten the end of one's life. This term is derived from *drive another nail into one's coffin*, an 18th- and 19th-century expression for any deleterious practice.

Care to our coffin adds a nail, no
doubt;
But every grin so merry draws one
out.
(John Wolcott, *Expostulatory Odes*,
1789)

When cigarettes began replacing cigars
and pipes in America—about 1885—
they became known as *coffin nails*, a
term that was popularized by the anti-
smoking crusaders.

The Anti-Cigarette League had
announced that every cigarette
smoked was a nail in one's coffin. (O.
Henry, *The Higher Abdication*, 1907)

The term is in common use today.

Dutch took the cigarette from
between his thick lips and extended it
toward me. "Have a coffin nail," he
chuckled. (Richard S. Prather, *Bodies
in Bedlam*, 1951)

15. crackers This American slang ex-
pression arose during the 1700s to de-
scribe the poor white farmers from the
scrub pine territory of the American
South. One explanation attributes the
term to the fact that since the basic sta-
ple of these people was corn, they be-
came known as *corn crackers*, which
was subsequently shortened to *crackers*.
Another explanation suggests that the ex-
pression alludes to their practice of
cracking enormous whips over their
teams as they drove produce to market.
Whatever the case, the term was popu-
larized by Chief Justice Anthony Stokes
of colonial Georgia when he publicly
commented that the Southern colonies
were being overrun by *crackers* from
western North Carolina and Virginia.
The term is still in common use today.

She was about sixteen going on
seventeen—and fated to be what the
Crackers down our way call 'a good
breeder.' (*Good Housekeeping*,
January 1948)

16. dogie A stray or motherless calf;
something weak or helpless that needs
assistance. The origin of this word is un-
certain. The most plausible explanation

attributes the term to a shortening of
dough-guts, from the sagging bellies
which characterized these prematurely
weaned calves. The term, coined during
the late 1800s, is most commonly heard
in its literal sense; however, it is occa-
sionally heard in a figurative sense, in
reference to something weak and in need
of assistance.

The Old Man . . . was a one-lunger
when this dogie enterprise started.
(Herbert Quick, *Yellowstone Nights*,
1911)

17. doughboy A U.S. Army infantry-
man. The exact origin of this colloquial
term is unknown. It gained currency
during World War I after seeing sporad-
ic use during the Civil War. One of the
many explanations for this term was put
forth by E. Custer in *Tenting on Plains*
(1887):

A "doughboy" is a small, round
doughnut served to sailors on
shipboard, generally with hash. Early
in the Civil War the term was applied
to the large globular brass buttons on
the infantry uniform, from which it
passed, by a natural transition, to the
infantrymen themselves.

Another theory suggests a connection be-
tween *adobe*, a name used by Spaniards
in the Southwest in reference to army
personnel, and *doughboy*. The third
most common explanation is that the
infantrymen wore white belts, and had
to clean them with "dough" made of
pipe clay.

18. fire bug An arsonist, pyromaniac.
In this expression, *bug* has the slang
meaning of one who has great enthusi-
asm for something, in this case, for fire.

It is believed there exists an organized
band of firebugs. (*Pall Mall Gazette*,
September 12, 1883)

19. the flicks Motion pictures; a motion
picture theater. This slang expression
dates from the early 1900s when motion
pictures first made their appearance.
The allusion in this term is to the flicker-

ing effect of the early motion pictures, especially the silent ones, caused by the individual frames of the film passing before the projector lamp, the border of each frame blocking the light momentarily. *Flicks*, and the variant singular form *flick*, are back formations of the original slang term for the motion pictures, *flickers*. In 1982, PBS television ran a *Masterpiece Theatre* series entitled *Flickers*, a comedy about the hardships of the early days of British movie making.

> We'll occupy the afternoon with a 'flick.' I love the movies—especially the romantic ones. (E. Wallace, *Square Emerald*, 1926)

20. fly trap The human mouth. This disparaging term of obvious origin is often shortened to merely *trap*.

> You can count on Angelo's keepin' his trap tight. (L. J. Vance, *Baroque*, 1923)

21. Foggy Bottom The State Department of the United States government; the name of an area in Washington, D.C., where the State Department building stands. This term, as a synonym for the State Department, was first used in 1947 by James Reston, who at that time was the Washington correspondent to *The New York Times*. The designation originally described a swampy bottomland in the city where a gasworks once stood. Early residents had called the area Foggy Bottom because of the heavy morning mists. When the State Department built and occupied its new building there in 1947, the name was extended to the State Department.

> Johnson had noted in Foggy Bottom a seeming hostility to Chiang's government. (*Time*, June 25, 1951)

Wags immediately saw a parallel between the language and policies of the State Department and the name of its new location.

22. four-eyes A person who wears eyeglasses. The implication in this derisive expression is that a person has an extra pair of eyes by virtue of his spectacles. A similar expression, sometimes used by one who is putting on his eyeglasses, is *putting on one's eyes*, implying that without the glasses, he is, in essence, blind.

23. Fourth Estate The newspapers; the public press as a distinct and influential power in the state. The original three estates, as represented in the British Parliament, were the Lords Spiritual, the Lords Temporal, and the Commons. A great controversy has developed over the original coinage of the term *Fourth Estate*. Initially it was attributed to Sir Edmund Burke.

> Burke said there were Three Estates in Parliament; but in the Reporters' Gallery yonder, there sat a Fourth Estate more important than they all. It is not a figure of speech or witty saying; it is literal factivery momentous to us in these times. (Thomas Carlyle, *Heroes and Hero-Worship*, "The Hero as a Man of Letters," 1833–34)

However, Thomas Babington Macaulay had employed the expression at least five years prior to Carlyle:

> The gallery in which the reporters sit has become a fourth estate of the realm. (Macaulay, *On Hallam's Constitutional History*, Sept. 1828)

Seemingly the earliest reference to the phrase is that presented by a correspondent to *Notes and Queries*, Vol. XI, p. 452, in which he states that he has heard Henry Peter Lord Brougham use it in Parliament in 1823 or 1824, and at the time the members reacted as if it were an original term. The *fourth estate* has also been used in reference to the army and to the mob; in fact, the earliest use recorded in the *OED*, is by Henry Fielding in the *Covent-Garden Journal*, June 13, 1752:

> None of our political writers . . . take notice of any more than three estates, namely Kings, Lords, and Commons

. . . passing by in silence that very large and powerful body which form the fourth estate in the community—the Mob.

24. fruit salad Colorful ribbons or buttons worn as campaign decorations; medals or badges which adorn the uniforms of servicemen. The infrequently heard expression is derived from the motley colors present in a fruit salad.

25. Gabriel's hounds A name given to wild geese as they fly through the air. This expression, dating from at least the 1500s, is the superstitious name applied to flocks of wild geese as they pass through the autumn air on their annual migratory flights. Besides omens of evil, these noises were, according to an old superstition, the cries of the souls of unbaptized children condemned to wander through the air until the day of judgment.

> At Wednesday in Staffordshire, the colliers going to their pits early in the morning hear the noise of a pack of hounds in the air to which they give the name of Gabriel's Hounds, though the more sober and judicious take them only to be wild geese. (White Kennett, *Provincial Words*, 1700)

Other terms used to describe this superstitious phenomenon are *Gabriel rache* and *Gabriel rachet*.

26. Golden Gate The entrance to heaven; the name given to the strait connecting San Francisco Bay with the Pacific Ocean. This expression, originally coined to indicate the entrance to heaven, was ascribed to the entrance to San Francisco Bay by Spanish explorers and Sir Francis Drake, because they considered it the gateway to El Dorado, or the land of gold. Ironically, in 1849 it did become a golden gate for it led the way to the gold sought by the so-called '49ers. The city of San Francisco, to this day, is known as the *Golden Gate City*.

> The relative intelligence of mules and men is easily demonstrated: men voluntarily jump off the Golden Gate

bridge . . . No mule jumps off the Golden Gate bridge; you cannot by any possibility even push a mule off that long span. (*Sierra Club Bulletin*, May 1947)

27. good buddy A salutation, especially among citizens' band (CB) radio practitioners; a name for a friendly person; a friend. This expression achieved popularity in conjunction with the CB radio craze in the U.S. in the 1970s. Originally a greeting used by truck drivers, the term was later adopted by most CB users on the highways. A related term is *old buddy*.

> Aaay 10-4 on that. You got the Jack of Diamonds on this end, and we definitely westbound. How's it look over your shoulder, good buddy? (Michael Harwood, *The New York Times Magazine*, April 25, 1976)

28. grass widow A woman whose husband is away for an indefinite, extended period of time; a woman who is separated, divorced, or living apart from her husband. The oldest use of the term, now obsolete, dates from the early 16th century. It referred to a discarded mistress. The expression gained currency in the United States during the California gold rush when it was used for the wives of the forty-niners. The popular theory that the term is a corruption of *grace-widow* 'a widow by grace or courtesy, not in fact' has been disproved by evidence of parallel forms in several other languages.

> Grass widows in the hills are always writing to their husbands, when you drop in upon them. (John Lang, *Wanderings in India*, 1859)

29. gringo A Mexican-American contemptuous name for foreigners, especially Americans and Englishmen. This expression has its roots in the Spanish word *griego* for 'Greek,' and was applied to people who spoke a language other than Spanish, a sort of "Spanish *it's Greek to me.*" Originally attributed to a corruption of a song from the Mexi-

can War (1848) *Green Grow the Rushes O*, subsequent research has revealed that the word appeared as early as 1787 in *Terreros y Pando Diccionario Castellano*, a Spanish dictionary.

> We were hooted and shouted at as we passed through, and called 'Gringoes.' (John Audubon, *Western Journal*, 1849)

30. heifer paddock A school for older girls. This Australian slang term creates a facetious parallel between a young cow, approaching the age for mating, and a girl who is approaching womanhood. The term has been in use since about 1880.

> I shall look over a heifer paddock in Sydney and take my pick. (Mrs. Campbell Praed, *Australian Life*, 1885)

31. human zoo A city; a large institution. Although this term was bantered about from as early as the 1920s, it didn't achieve widespread usage until 1959 when Desmond Morris's *The Human Zoo*, a non-fiction work examining the behavior of mankind, was published. Morris maintains:

> Clearly, then, the city is not a concrete jungle, it is a human zoo. It is not a place made up of buildings, but rather a place made up of human animals, caged as animals are caged in a zoo and afforded little or no communication with nature.

Today the term is more often applied to institutions, especially to prisons and mental hospitals.

32. Irish confetti Bricks, brickbats, rocks, or any other weighty material thrown during a brawl. This jocular slang expression is obvious in its meaning. Because the Irish acquired a reputation for brawling, heavy objects thrown during a melee came to be humorously designated as *Irish confetti*; however, the term has certainly not been restricted to the Irish. *The New York Times* of September 3, 1950 headlined an article,

Saskatchewan Confetti, with the opening comment:

> The Saskatchewan Government is building a new brick plant.

33. Jack among the maids A ladies' man; a favorite with the ladies; a gallant; a lecher. *Jack*, among the English, is a general term for any male; hence, *Jack among the maids* indicates any man who prefers to spend his free time in the company of a woman or women. The term, in use since the late 18th century, usually has a sexual implication.

> The Mayor . . . was a pleasant man, and Jack among the maids. (John Trusler, *Modern Times*, 1785)

34. Jack Tar An appellation for a sailor. This name apparently derived from the fact that sailors tarred their pigtails. Sailors were called Jacks as early as the 1600s and by association were called Jack Tars by the mid 18th century. *Jack-tar* can also be used attributively, as in the following quotation:

> He had mixed it [brandy and water] on the Jack-tar principle of "half-and-half." (William Schwenk Gilbert, *Foggerty's Fairy and Other Tales*, 1892)

35. jock An athlete. This American slang expression is a shortening of *jockstrap*, the term for a supporter worn by men when participating in certain sports. It is most often applied to high school and college athletes, frequently with some degree of disparagement. In recent years the term has also been applied to females who actively participate in sports.

> Rocks for jocks, elementary geology course popular among athletes at Pennsylvania. (*Time*, October 2, 1972)

36. knight of the . . . The word *knight* is used in a large number of slang and colloquial phrases to denote one who is a member of an occupation or trade, or to designate some particular characteristic. This method of identification began in

the 16th century as a jocular practice to indicate certain traits. Two of the earliest examples are *knight of the collar*, one who is to be hanged, and *knight of the field*, a tramp. During the 17th century the practice was extended to occupations and large numbers of such terms were added to the language; among them were *knight of grammar*, a 'teacher' or 'schoolmaster,' *knight of the pestle*, an 'apothecary.' During the 18th, 19th, and 20th centuries many additional *knight* terms have been coined. Some of the more well-known expressions and their meanings are: *knight of the awl* a 'cobbler'; *knight of the cleaver* a 'butcher'; *knight of the hod* a 'bricklayer'; *knight of the napkin* a 'waiter'; *knight of the needle, knight of the shears*, or *knight of the thimble* a 'tailor'; *knight of the oven* a 'baker'; *knight of the pen* a 'clerk'; *knight of the pisspot* a 'physician' or an 'apothecary'; *knight of the quill* an 'author'; *knight of the spigot* a 'bartender'; *knight of the green cloth or green baize* a 'gambler'; *knight of the sun* an 'adventurer' or a 'wanderer.' (See also **knight of the road** and **knight of the rueful countenance**, below.) Many more such appellations exist and the list grows with time. Many of the terms have become obsolete over the years because of progress or disuse, and many have undergone extensive changes of meaning, but many are so well established in the language that they may remain for some time.

37. knight of the road A footpad; a highwayman; a tramp; a traveling salesman; *a gentleman of the road*. This expression has undergone a number of meaning changes through the years. Conceived in the early years of the 17th century, the phrase originally denoted a highwayman, especially one of notoriety. By the 19th century, 'thief' had become another definition. But today, both of those interpretations have become obsolete, and a *knight of the road* has come to mean either a 'tramp' or 'a traveling salesman.'

38. knight of the rueful countenance A dreamy, impractical fellow; a whimsical

visionary. Miguel de Cervantes created one of the most famous characters in all of literature in 1605, Don Quixote. Dubbing him *El Caballero de la Triste Figura*, knight of the rueful countenance, Cervantes proceeded to lead his woeful knight through a series of idealistic adventures, all the result of an unrealistic quest. Besides the *knight of the rueful countenance*, the book has provided the language with a wide range of words and phrases that are in common use; among them are *quixotic* and *tilting at windmills*.

39. liberty cabbage Sauerkraut. Shortly after America's entry into World War I in 1917, with anti-German sentiment running high, citizens were urged to avoid using the German word *sauerkraut* and in its place to substitute the term *liberty cabbage*. Although the term is no longer in standard use, it serves as a reminder of the strong nationalistic feeling that permeated the United States at that time.

> Here we were . . . doing everything we were told to do: eating rye bread instead of wheat, calling sauerkraut 'Liberty cabbage.' (*Haldeman-Julius Quarterly*, July–September 1927)

40. limey An Englishman; a Briton. This expression is a variation of *lime-juicer*, a somewhat derogatory nickname applied to English sailors, referring to the British regulation requiring all merchant vessels to carry a supply of lime juice to be used as a preventive measure against scurvy. Since scurvy is caused by a deficiency of vitamin C, regular doses of lime juice (rich in vitamin C) were used to prevent the disease.

> "English, eh " said the manager. "I ain't too keen on you limeys." (J. Spencer, *Limey*, 1933)

41. lizard scorcher This American slang expression for a dining car chef has its roots in the colorful and jocular language of the railroad crews, especially

among those crew members who worked aboard the highballing passenger trains that ran between distant cities. The chef on a long run often had to make do with dwindling provisions, a practice which led to the (apparent) exaggeration implied by the term.

42. Locofoco A faction of the Democratic party; a self-igniting match or cigar. The origin of this term is unclear. The word was invented in 1834 as the name of a patented, self-igniting cigar, a name which was soon applied to self-igniting matches. It is generally believed that the word is based on the *loco* in *locomotive*, wrongly thought to mean 'self-moving,' and *foco* from the Italian *fuoco*, meaning 'fire.' In 1835 a radical faction of the Democratic party was meeting in Tammany Hall in New York. The Whig landlord extinguished the lights, but, suspecting that such an event might occur, the party members had come prepared and were able to continue the meeting by lighting candles with *locofoco* matches. From that evening until the faction's demise in 1840, they were known as *Locofocos*.

> The night that the Moore match monopoly boom fizzled out like an old-time sulphur locofoco, the city's rich men gathered at the home of old Phil Armour. (*Chicago Daily News*, May 8, 1944)

43. Lud's Town A nickname for London. According to Geoffrey of Monmouth, Lud, a mythical king of Britain, was responsible not only for beautifying the city of London, but also for fortifying it by building a wall completely encircling the city. Ludgate, where he is supposedly buried, still bears his name, and the statues of Lud and his two sons, which once stood at Ludgate, are now in the entrance to St. Dunstan's school.

> When I have slain thee with my proper hand,
> I'll follow those that even now fled hence,

> And on the gates of Lud's town, set your heads.
> (Shakespeare, *Cymbeline*, IV,ii)

44. mackerel snapper A Roman Catholic. This derogatory nickname, now uncommon, was applied to Roman Catholics by non-Catholics. It alludes to the former Roman Catholic practice of not eating meat on all Fridays and certain other days, a rule that now has been virtually eliminated. Mackerel, usually one of the least expensive fishes, was one of the favorite substitutes for meat. Variations of the term are *mackerel grabber* and *mackerel snatcher*. All three terms have been in use since at least 1900.

45. Nobby Clark A common nickname for anyone with the surname of *Clark* or *Clarke*. The key word here is *nobby*, a British slang word for 'elegant' or 'dressy.' Although the origin of this expression is somewhat obscure, it is believed to have originated in the British army. Mr. C. O'Driscoll, an authority on British army slang, states that during the early 19th century army clerks were poorly paid individuals who, because of their positions, felt it necessary to dress in a stylish manner. Because of their dress, and the accompanying airs they often affected, they became known as *nobs*, or *nobby clerks*. The British slang expression *nob*, indicating a person of wealth or position, probably gave rise to the name of *Nob Hill* in San Francisco, for that area became an exclusive residential area for the wealthy.

46. Nosey Parker See 235. MEDDLESOMENESS.

47. the Old Lady of Threadneedle Street A popular British nickname for the Bank of England, located on Threadneedle Street. There is some confusion as to whether the epithet owes its origin to Gilray's caricature (1797) depicting "The Old Lady of Threadneedle Street in Danger" at a time when its financial solvency was in jeopardy, or to the essayist William Cobbett, who dubbed the bank's directors the Old Ladies of

Threadneedle Street because of their conservatism. In any event, the phrase was well known less than a century later when in *Doctor Marigold's Prescriptions* (1865), Dickens referred to a bank note as:

> . . . a silver curl-paper that I myself took off the shining locks of the ever-beautiful old lady of Threadneedle Street.

48. Old Nick Another name for the devil; Satan; Old Scratch; Lucifer. The source of this label for the devil is unknown. It has been related to *Nickel*, a German mischievous demon of the mines and to *nickers*, Scandinavian water monsters. However, two famous British literary figures seem to attribute this appellation to Niccolò Machiavelli (1469–1527), the Florentine writer on unscrupulous political action.

> Nick Machiavel had ne'er a trick,
> Though he gave his name to our Old Nick.
>
> (Samuel Butler, *Hudibras*, 1662)

And Thomas Babington Macaulay, writing for the *Edinburgh Review*, March 1827, commented:

> Out of his surname they have coined an epithet for a knave and out of his Christian name a synonym for the Devil.

49. old salt A sailor, particularly an old or experienced one; a sea dog. The allusion is to the salt in the seawater to which a sailor is constantly exposed.

> If you want to hear about the sea, talk to an "old salt." (Charles Spurgeon, *Sermon XXIII*, 1877)

Common variations include *salt* and *salty dog*.

50. one-armed bandit A slot machine used for gambling. These popular devices are operated by placing a coin in the slot and pulling down on a lever or "arm" on the side of the machine. Since the odds are fixed against the player, usually causing him to lose more than he wins, slot machines soon came to be known as "one-armed bandits," and have been outlawed in most of the United States.

> The machine that brought him from rags to riches was the notorious One Armed Bandit slot machine.
> (*American Mercury*, September 1940)

See also **lemon**, 141. FAILURE.

51. outward Adam A nickname for one's own body; the human body. This early 19th-century colloquial phrase is seldom heard today. The allusion, of course, is to the Bible's first man in his natural state as a representation of all succeeding men.

> I had no sooner elongated my outward Adam, than they at it again, with renewed vigor. (David Crockett, *Colonel Crockett's Exploits and Adventures in Texas*, 1836)

52. Pall Mall A nickname for the British War Office; a street in London, the center of London club life. In the mid 17th century the Italian game *pall-mall*, (*palla*, 'ball;' *maglio*, 'mallet') was introduced in London. The game was played with a boxwood ball in a long alley, the object being to drive the ball with the mallet through an iron ring hanging above the ground. A certain London street came to be called *pall-mall alley* after the fact that the game was frequently played in an alley located near there; for many years now that street has been known as *Pall Mall*, regarded as one of the more fashionable streets in London.

> If one must have a villa in summer to dwell,
> Oh, give me the sweet shady side of Pall Mall.
>
> (Charles Morris, *The Contract*, 1838)

Pall Mall not only became the location of some of London's better clubs, but also the home of the British War Office. During the 19th century *Pall Mall* became metonymous for that office and continues to carry that connotation today.

It would be a very strong thing for Whitehall or Pall Mall to overrule the joint discretion of the military and municipal authorities. (*London Daily News*, April 17, 1893)

53. passion pit A drive-in theater; an outdoor movie theater. This American expression, dating from the 1940s, alludes to the primary use to which these theaters are put by many young people. Rather than attending to view the films, many young couples take advantage of the privacy and the darkness to pursue amorous dalliance.

The official name of the theater may be *Starview*, but the patrons may refer to it as the passion pit, because of the lovers attending. (*American Speech*, October 1957)

54. plastic money This phrase is simply a synonym for *credit cards*, especially when they are utilized as a complete substitute for checks or cash. A related phrase, *slap it on the plastic*, implies that one is making a purchase which he actually can't afford, but he hopes to have the money by the time the bill arrives. Both terms had their inception in the early 1970s.

One advantage of using "plastic money"—bank credit cards in place of cash—was the interest free ride if monthly bills were paid on time. (*The New York Times*, September 11, 1976).

55. plumber One who investigates and stops leaks of information, especially of government secrets. This expression became current from its use by the Nixon administration. In 1971 John Ehrlichman, President Nixon's domestic advisor, organized a group to stop the leaks of top-secret information which had become evident upon *The New York Times'* publication of *The Pentagon Papers*, documents containing top-secret information about the war in Vietnam. Later these government "plumbers" engineered the notorious Watergate break-

in of Democratic Party National Headquarters in 1972.

Subsequently, any employee of a business corporation, as well as those of the government, whose principal function was to stop leaks within the organization, became known as a *plumber*.

Cronies, if they are well placed and well chosen, can tell even a President what he needs to know, and perform a few tasks without the aid of plumbers. (*Harper's*, August 1974).

56. pork chops American slang for sideburns or side whiskers, from the similarity in shape to the cut of the meat.

57. Saturday night special An inexpensive handgun that is easily obtainable through a gun store or a mail-order house. While the origin of this common expression is not documented, Robert Blair Kaiser, writing in a February 1974, issue of *Rolling Stone*, offers a plausible explanation of its derivation:

Since a great many of these purchases were made to satisfy the passions of Saturday Night, Detroit lawmen began to refer to the weapons as Saturday Night specials.

58. scrambled eggs The gold decoration on the bill of a military officer's hat. The phrase's denotation is sometimes extended to include other gold garnishes on the uniform, though these are more properly denoted by the slang term *chicken guts*. Because such embellishments are reserved for senior officers only, enlisted men occasionally use the expression for the high-ranking officers themselves.

59. sin tax A tax on those commodities and activities, such as tobacco, liquor, and gambling, which are considered of questionable moral value by certain elements of society. This expression, made popular in 1963 in New Hampshire, was coined by those people who opposed raising revenue by income or general sales taxes and favored the enactment of the so-called *sin laws*, taxing cigarettes and alcoholic beverages especially. The

term is now in common use throughout the United States and Canada.

> Though federal taxes have been reduced since 1960, the cuts have been offset by severe state and city income taxes, sales taxes, . . . and "sin" taxes on liquor and cigarettes. (*Time*, March 13, 1972)

60. Smokey Bear A state trooper; a highway patrolman; a policeman. This term, originating in the early 1970s with citizens' band (CB) radio enthusiasts, especially truckers, is a jocular reference to the wide-brimmed hats worn by most state highway policemen. Smokey the Bear, the well-known figure used by the U.S. Forestry Service to warn against forest fires, is customarily depicted as wearing a ranger's hat, which closely resembles those worn by many state policemen. The term is frequently truncated to *Smokey*.

> Once limited to truckers and their Smokey Bear antagonists on highway patrols, Citizens Band radio has grown to the point where about 20 million American "good buddies" have CB rigs in their cars or homes. (*Time*, January 23, 1978)

61. soupbone The throwing arm of a baseball pitcher. This American slang term had its inception in the game of baseball in the late 19th century. Conceived as an expression of the importance of a pitcher to a baseball team, the term alludes to the making of soup, where a combination of ingredients goes in but the success of the dish often depends on a soupbone being added as the key. So too an effective pitcher, as well as a team, relies on his throwing arm. The term is sometimes used as a general reference to one's arm and its usefulness.

> "My old soupbone," says Kilroy, "was so weak that I couldn't break a pane of glass at fifty feet." (Christy Mathewson, *Pitching in a Pinch*, 1912)

62. squaw man A white man or black man married to an Indian woman; an effeminate Indian. This American colloquial term has been in use since the middle of the 19th century to designate a frontiersman with an Indian wife, who by virtue of his marrying her has gained access to all tribal rites. Among some Indian tribes, the expression is used to specify an effeminate brave, who is required to dress like a woman and do women's work.

> A negro squaw man . . . who went by the name of Smoky. (*Outing*, 1894)

63. stogy See **prairie schooner, 393. VEHICLES.**

64. tarheel A native of North Carolina; a person from the North Carolina pine barrens. The most likely explanation is that the term alludes to the great production of rosin, turpentine, and tar from the pine forests of North Carolina. This characteristic product of the state explains the story from the Civil War about a force of North Carolinians who were driven from their position on a hill by Union troops. A nearby brigade of Mississippians laughed at them saying that they had forgotten to tar their heels that morning. At any rate, the first written use of the word is in a recounting of a speech by Governor Zebulon B. Vance of Virginia to some North Carolina troops in 1864.

> I don't know what to call you fellows. I can not call you fellow soldiers, because I am not now a soldier, nor fellow citizens because we do not live in the same state. So I have concluded to call you 'Fellow Tarheels.'

65. Third World This term is in common use today to define those countries in the United Nations which are not members of the Western Alliance, of the Soviet bloc, nor of the Chinese political sphere. The *Third World* is mostly made up of the *developing countries*, those countries that have recently gained autonomy and are searching for their own identities and for their own roles in the

world political picture. In recent years they have assumed a more important function in the operation of the U.N., and their votes are often wooed by the so-called civilized or developed countries. Occasionally voting as a bloc, they have often succeeded in thwarting the ambitions of other political alliances.

Development in the Third World usually means over-development of objects and the underdevelopment of people. (*The Manchester Guardian*, November 30, 1976)

66. three-legged mare An old English slang term for the gallows. The gallows was so named for its construction, three posts over which were connected three crosswise beams. A variant is the *two-legged mare*. Both terms date from the 16th century, but became obsolete by the end of the 19th century.

For the mare with three legs, boys, I care not a rap, 'Twill be over in less than a minute. (William Ainsworth, *Rookwood*, 1834)

67. Tinsel Town Hollywood; that area of Los Angeles identified with the motion picture and television industries. As with the shiny tinsel that decorates Christmas trees, this name developed from the glittery illusion with which Hollywood, center of American moviedom, seems to surround itself. Although the term dates to the 1930s, it has only recently achieved popular usage.

Hollywood Wives by Jackie Collins. The struggle for money and power in Tinsel Town. (*The New York Times Book Review*, August 7, 1983)

68. Tommy Atkins The nickname given to a typical, low-ranking soldier in the British armed forces. In 1815, the British War Office issued a manual to all military personnel in which each soldier was required to enter certain personal data, such as name, age, and medals received. Enclosed with each manual was a sample guide in which the fictitious name *Thomas Atkins* was employed. Before long, the manuals themselves were

called *Tommy Atkins*, and subsequently, the epithet acquired its current application to any British soldier, particularly privates.

Some years ago, Lord Wolseley . . . said "I won't call him Tommy Atkins myself, for I think it a piece of impertinence to call the private soldier Tommy Atkins." (E. J. Hardy, in *United Service Magazine*, March 1898)

The British have extended the term's application to include a private in any military force, or to the rank-and-file membership of a group or organization.

The Egyptian Tommy Atkins inspires one rapidly with feelings of sheer affection. (Francis Adams, *The New Egypt*, 1893)

69. trick cyclist A shrink; a psychiatrist; a psychoanalyst. This pejorative British slang expression reflects the disregard some people feel towards the practice of psychoanalysis. The term first came into use during World War II. A related verb form is *trick cycled*.

He got himself trick cycled out of the Army either legitimately or fraudulently. (Lewis Hastings, *Dragons Are Extra*, 1947)

70. Uncle Sam The personification of the United States; the American government, its prestige, or its citizenry.

The thirteen stripes turned vertically . . . thus indicating that a civil . . . post of Uncle Sam's government is here established. (Nathaniel Hawthorne, "Introduction," *The Scarlet Letter*, 1850)

This expression purportedly originated during the War of 1812, at Elbert Anderson's provisions stockyard in Troy, New York, where all shippable items were stamped E. A.—U. S., for Elbert Anderson—United States. Through allusion to the yard's chief inspector, Samuel Wilson, whose nickname was Uncle Sam, the workers suggested that U.S. actually stood for Uncle Sam. This epithet

rapidly became a synonym for the United States, its usage being reinforced as a wartime rebuttal to Great Britain's trademark of John Bull. In 1868, Thomas Nast, the political cartoonist for *Harper's Weekly*, depicted Uncle Sam as he is familiarly known today. From the Civil War onward, Uncle Sam has appeared on military recruitment posters throughout the nation. The term has maintained frequent usage as a fond name for the United States.

> Let patriots everywhere . . . prepare to do the clean thing by Uncle Sam and his bald headed eagle. (*Newton Kansan*, June 1873)

71. WASP An acronym for *white Anglo-Saxon Protestant*, designating a social group that comprises a dominant segment of the American middle-class establishment. This term, coined shortly after World War II, was originally used to designate those Americans, descendants of the early English immigrants who, some hold, represent the most established and influential group in the United States today. The expression became extremely popular during the rebellious years of the late 1960s and early 1970s, when it assumed a derogatory connotation. The term became a common epithet to deride anyone from that class of people who accept traditional American values. Today the expression has lost much of its rancor.

> Art Buchwald, perceptive sociologist, has observed that WASPs now form just another ethnic group. (*The New York Times Magazine*, December 19, 1976)

72. Yankee Doodle An American, especially one from New England; a patriot. The origin of this expression is uncertain. One most credible explanation asserts that in 1758, during the French and Indian War, Lord Jeffrey Amherst was piecing together a force of British regulars and American recruits at Albany, New York. A British officer, Dr. Richard Shuckburg, inspired by the awkwardness of the American recruits, wrote a set of satirical lyrics, which he set to the tune of an old martial air of the 1660s, *Nankee Doodle*. Shuckburg named his tune *The Yankees Return to Camp*. After George Washington took command of the Continental Army on July 3, 1775, Edward Bangs, a Harvard student, who may also have been a minuteman, rewrote the lyrics of Shuckburg's song, and these words are still sung today. Another plausible explanation attributes the term to the Dutch. *Yankee* may have come from the Dutch, *Janke*, a diminutive of the name *Jan*, and it is believed that this was applied as a derisive nickname by the New York Dutch to people from New England. Lending credence to this theory is an old Dutch harvest song with a refrain *Yanker didel doodel doon*. Another theory attributes the song to an old dance tune for the flute or fife, *Yankee Tootle*. Whatever the case, from the time of the Revolutionary War, Americans embraced this originally satirical song, and it has flourished over the years as a symbol of American nationalism. The first written record of the term appeared in a Boston paper.

> Those passing in boats observed great rejoicings, and that the Yankee Doodle song was the capital piece in the band of music. (*Journal of the Times*, September 29, 1768)

245. NIT-PICKING
See also **146. FAULTFINDING;**
270. PERSPECTIVE

1. chop logic To argue, dispute, or to pettifog, to bandy words; split hairs. This expression, which dates from 1525, is most likely an extension of the now obsolete meaning of *chop* 'barter, trade, or exchange.' Shakespeare used the noun form *chop-logic* in *Romeo and Juliet*:

> How, now! How, now! Chop-logic!
> What is this?
> "Proud," and "I thank you," and
> "I thank you not,"
> And yet "not proud."
> (III,v)

2. nit-pick To be overly concerned with picayune details; to look for inconsequential errors, often to the point of obsessiveness. A nit is the egg or larva of a louse or other parasitic insect. The task of removing all the nits from an infected person or animal can be almost overwhelming as it requires a millimeter-by-millimeter examination with a magnifying glass and tweezers. By extension, a pedantic person immersed in minutiae is often called a *nitpicker*.

> When the nitpickers and parliamentary horse-traders had finished with it, the program had shrunk to much smaller proportions. (*Washington Post*, July 3, 1959)

3. seek a knot in a bulrush To look for errors or difficulties where there are none; to nit-pick; to pursue trivial, futile activities. Since knots occur only in woody plants, it would be both time-consuming and futile to try to find one in a bulrush, a grasslike, herbaceous plant.

> Those that sought knots in bulrushes to obstruct the King's affairs in Parliament . . . (Roger North, *Examen; or An Enquiry Into the Credit and Veracity of a Pretended Complete History*, 1734)

4. split hairs To make gratuitously fine or trivial distinctions. This expression refers to the fineness of hair and the subsequent difficulty involved in splitting a single strand. The expression is in common use today.

5. wrangle for an ass's shadow To fight or bicker over trivial and insignificant matters; to nit-pick. This expression, once popular in England, is derived from a legend recounted by the Greek orator and statesman, Demosthenes (c. 384–322 B.C.). A traveler who had hired an ass to take him from Athens to Megara was in such discomfort from the noonday sun that he dismounted and sought relief by sitting in the shadow cast by the animal. The ass's owner, however, also wanted that shade and claimed that the traveler had rented the ass and not its shadow. The two men soon resorted to fisticuffs and the frightened animal fled, leaving both of them without any shade whatsoever. When the issue was pursued in the courts, the litigation was so lengthy and expensive that the two men were financially ruined. An earlier variation is *gone to the bad for the shadow of an ass*.

246. NONSENSE
See also **161. GIBBERISH;**
359. STUPIDITY

1. applesauce Nonsense, balderdash, bunk; lies and exaggeration; flattery and sweet talk. The first of these meanings is now most common, and the last, least in use. According to a 1929 article in *Century Magazine*, however, the term originally meant "a camouflage of flattery" and derived from the common practice of boarding houses to serve an abundance of applesauce to divert awareness from the paucity of more nourishing fare. It seems equally plausible, though, that its origin might lie in the association of applesauce with excessive sweetness, mushiness, pulpiness, and insubstantiality.

2. balderdash Nonsense; a meaningless jumble of words. Used throughout most of the 17th century to mean a hodgepodge of liquors, this word began to be used in its current sense in the latter part of the same century.

3. banana oil Bunk, hokum, hogwash, nonsense. This American slang term for insincere talk derives from the literal banana oil, a synthetic compound used as a paint solvent and in artificial fruit flavors, itself so called because its odor resembles that of bananas. Its figurative use combines its characteristics of excessive sweetness and unctuousness.

4. bunkum Empty or insincere talk, especially that of a politician aiming to satisfy local constituents; humbug; nonsense; also *buncombe* or the shortened

slang form *bunk;* sometimes in the phrase *talk* or *speak for* or *to Buncombe.* The term comes from a speech made by Felix Walker, who served in Congress from 1817 to 1823. It was so long and dull that many members left. The exodus of his fellow Congressmen did not bother Mr. Walker in the least since he was, in his own words, bound "to make a speech for Buncombe," a North Carolina county in his district. *Bunk,* the abbreviated slang version of *bunkum,* did not appear until 1900, although *bunkum* itself dates from much earlier:

"Talking to Bunkum!" This is an old and common saying at Washington, when a member of congress is making one of those humdrum and unlistened to "long talks" which have lately become so fashionable. (*Niles' Register,* 1828)

5. cock and bull story A preposterous, improbable story presented as the truth; tall tale, canard, or incredible yarn; stuff and nonsense. Few sources acknowledge that the exact origin of this phrase is unknown. Most say it derives from old fables in which cocks, bulls, and other animals are represented as conversational creatures. In one of the Boyle Lectures in 1692 Richard Bentley says:

. . . cocks and bulls might discourse, and hinds and panthers hold conferences about religion.

Matthew Prior's *Riddle on Beauty* clearly shows the nonsensical flavor of "cock and bull":

Of cocks and bulls, and flutes and fiddles,
Of idle tales and foolish riddles.

The phrase is current today, as are the truncated slang forms—*cock* in Britain and *bull* in the United States—which mean 'nonsense.'

6. fiddlesticks Nonsense, hogwash, balderdash. This word is virtually synonymous with *fiddle-de-dee* and *fiddle-faddle.* Literally, a fiddlestick is the bow used to play a fiddle. Figuratively, it is

often used as an interjectional reply to a totally absurd statement.

Do you suppose men so easily damage their natures? Fiddlestick! (William Makepeace Thackeray, *Miss Tickletoby's Lecture,* 1842)

7. go to Bath The inference in this expression is that the person addressed has spoken nonsense or balderdash, and should *go to Bath* to gain the benefit of the mineral waters to cure his mental disorder. The waters of Bath were believed, especially during the 18th century, to cure physical and mental disorders; hence, lunatics were often sent there to benefit from the water's curative powers. The term has been in use since the 17th century.

8. moonshine Nonsense, hogwash; foolish notions or conceptions. Moonshine is the light which, although appearing to be generated by the moon, is actually sunlight reflected off the lunar surface; hence, the expression's figurative connotation of illusion or fallacy.

Coleridge's entire statement upon that subject is perfect moonshine. (Thomas DeQuincey, *Confessions of an English Opium-Eater,* 1856)

See also **moonshine, 153. FOOD AND DRINK.**

9. tommyrot Nonsense, poppycock, balderdash. This expression combines *tommy* 'simpleton, fool,' with *rot* 'worthless matter' to form a word denoting foolish utterances.

My fellow newcomers . . . thought nothing of calling some of our instructor's best information "Tommy Rot!" (Mary Kingsley, *West African Studies,* 1899)

Nosiness . . .
 See **235. MEDDLESOMENESS**

Notability . . . See **144. FAME**

Nourishment . . . See **153. FOOD AND DRINK**

Nuisance . . . See **223. IRRITATION.**

O

247. OAFISHNESS

1. bogtrotter Any rustic or country bumpkin; specifically, the rural Irish. The term, which dates from 1682, is most commonly used as an insulting epithet for unsophisticated countryfolk. *Bogtrotter* formerly referred to one who knew how to make his way around the bogs or swamps (which, the English maintain, abound in Ireland), or to one who fled to them for refuge.

2. butter-and-egg man A rich, unsophisticated farmer or small-town businessman who spends money freely and ostentatiously on trips to a big city. This American slang expression, which dates from the 1920s, is said to have had its origin in the heyday of Calvin Coolidge's administration, when highly paid workers and newly made millionaires threw their money around in wild splurges. *Butter-and-egg* is a rather pointed reference to dairy farming and serves to underscore the unsophistication of the men it is used to describe. *The Butter and Egg Man* is the title of a play by George S. Kaufman written in 1925.

3. clodhopper A rustic; a clumsy, awkward boor; a clown; a churl or lout; a plowman or agricultural laborer. Literally, a clodhopper is one who walks over plowed land among the *clods* 'lumps of earth or clay.' The common association of all that is unsophisticated, boorish, and gauche with simple countryfolk and farmers gives *clodhopper* its figurative coloring. The *OED* suggests that *clodhopper* is a playful allusion to *grasshopper*. By the early 18th century, *clodhopper* was used figuratively as an offensive epithet.

Did you ever see a dog brought on a plate, clodhopper? Did you? (Susanna Centliver, *Artifice*, 1721)

Today, the literal use is rarely heard.

4. country bumpkin An unsophisticated, awkward, clumsy country person; a rube or hick. *Bunkin*, presumably a variant, was used humorously as early as the 16th century to mean a Dutchman, particularly a short, stumpy man. It is thought that the term derives from the Dutch *boomken* 'little tree' or *bommekijn* 'little barrel.' The word *country* is actually redundant and is often dropped from the phrase.

5. hayseed A humorous nickname for a farmer or rustic. The term is said to have originated in American politics where the delegates of rural constituencies were known as the hayseed delegation in state legislatures. The word appeared as early as 1851 in Herman Melville's *Moby Dick*.

6. nerd An undesirable or unpleasant person; a jerk; a square; one who is not with it. A contribution of surfing slang from about 1965, this expression was derived from the older word *nert*, a late 1930s corruption of *nut*, slang for 'fool' or 'jerk.' Variants are *nurd* and the adjective form *nerdy*.

As the novel begins, the hero, another loser named Walter Starbuck, is serving time for a contemptible minor role he played in the Watergate scandal . . . He's 67 years old and a nerd, but he still has lots of energy. (*New York Sunday News*, August 26, 1979)

7. Ralph Spooner An oaf; a fool; a dunce; an unsophisticated, awkward boor. The exact derivation of this expression is obscure, but it is said that it came from Suffolk sometime in the late 17th

century, where the term was so well known that *Ralph* or *Rafe* sufficed to convey the meaning to other Suffolk natives.

8. rough edges See 186. IMPERFECTION.

9. rough-hewn Uncultured, unrefined, unpolished; crude, coarse, gauche; blunt, tactless. Literally, *rough-hewn* refers to a piece of lumber that has been crudely and roughly shaped (by an ax or adze) without being finished or polished (by a mill). The expression is often applied figuratively to a person who lacks refinement or social grace.

> Smooth voices do well in most societies . . . when rough-hewn words do but lay blocks in their own way. (Gabriel Harvey, *Pierce's Supererogation, or A New Praise of the Old Ass*, 1593)

10. sodbuster A derogatory term for a farmer or one who works the soil, especially in contradistinction to a cattleman. Originally Western slang, this word appeared in Carl Sandburg's *The American Songbag* (1927).

11. Tom Fool A silly, nonsensical fool; a half-wit; a blockhead; one lacking in common sense or good judgment; a mental defective. This expression appears during the 14th century in Middle English as *Thome Fole*, a name given to half-witted people, apparently using the common given name *Tom* generically in the sense of 'man.' The term has remained in common use since that time. *Tomfoolery*, meaning 'nonsensical behavior' derives from *Tom Fool*.

> Had he been whistled up to London, upon a Tom Fool's errand, in any other month of the whole year, he should not have said three words about it. (Laurence Sterne, *Tristram Shandy*, 1759)

An adjective form, *tom-fool*, is also used, having the sense 'extremely stupid.'

Obesity . . . See 72. CORPULENCE

Objection . . . See 78. CRITICISM; 293. PROTEST

Obscenity . . . See 288. PROFANITY

248. OBSEQUIOUSNESS
See also 150. FLATTERY; 362. SUBMISSIVENESS

1. affable as a wet dog Overly-gracious; servile; subservient. The origin of this 19th-century expression is obvious to any dog owner. It seems that any dog which has just emerged from the water has an overwhelming desire to endear itself to its master or to any other nearby person, often shaking itself vigorously to get rid of excess water on its coat, wetting anyone nearby.

2. apple-polisher A sycophant or toady; an ingratiating flatterer. This informal U.S. term stems from the schoolboy practice of bringing an apple to the teacher, supposedly to compensate for ill-prepared lessons. It has been in common student use since 1925 and has given us the now equally common verb phrases *apple-polish* and *polish* or *shine up the apple*, both meaning to curry favor with one's superiors.

3. ass kisser A fawning flatterer, especially one who is two-faced—submissively deferential to superiors in their presence but boldly badmouthing them in their absence. The once taboo, self-explanatory term has gained general currency in spoken usage. It has yet to become an acceptable word in the written language, however. It is sometimes abbreviated to *A.K.*

4. bootlick A self-explanatory but stronger term for an apple-polisher or toady. The phrase *to lick [someone's] boots* or *shoes* has the same connotation of abject servility and devotion.

5. brownie points Credit earned by servility, or by performing beyond expectations to ingratiate oneself with one's superiors. This expression alludes to the points accumulated for particular accomplishments by Brownies, junior

members of the Girl Scout organization. The term, in popular use since about 1940, has been reinforced by *brown nose*, a common slang expression for a bootlicker.

6. brown-nose A fawning flatterer, an obsequious sycophant. The term is more strongly derogatory than *apple-polisher*, and was once considered vulgar owing to its derivation from the image of the ass kisser. Frequent use has rendered the term innocuous, though still insulting. Its corresponding verb form means to curry favor.

7. curry favor To seek to ingratiate oneself with one's superiors by flattery or servile demeanor. The original term *to curry Favel*, in use until the early 17th century, derived from a 14th-century French satirical romance in which the cunning, duplicitous centaur Fauvel granted favors to those who curried, or rubbed down, his coat. The natural English transition to *favor* appeared as early as 1510, and after a century of coexistence, totally replaced the earlier *favel*.

8. dance attendance on To be totally servile to another; to wait upon obsequiously. This expression originated from an ancient tradition that required a bride to dance with all the guests at her wedding. The phrase, found in literature dating from the 1500s, appears in its figurative sense in Shakespeare's *Henry VIII* (1613):

> A man of his place, and so near our favour,
> To dance attendance on our lordship's pleasure.
> (V,ii)

9. lickspittle The most servile of sycophants, the basest of groveling, parasitic toadies. An early use underscores the self-evident origin of the term:

> Gib, Lick her spittle
> From the ground.
> (Sir William Davenant, *Albovine*, 1629)

10. make fair weather To conciliate or flatter by behaving in an overly friendly manner; to ingratiate oneself with a superior by representing things in a falsely optimistic light. Shakespeare used this expression in *Henry VI, Part II*; however, it goes back even earlier to the turn of the 15th century.

> But I must make fair weather yet awhile,
> Till Henry be more weak, and I more strong.
> (V,i)

11. Stepin Fetchit An obsequious, shuffling black servant; a servile, Uncle Tom type of black person. This eponym is derived from the famous vaudeville and film actor, Lincoln Theodore Monroe Andrew Perry, who adopted the stage name, *Stepin Fetchit*, from the name of a racehorse on which he had won some money. Appearing in many Hollywood productions of the 1930s and 1940s, Perry was typecast as the eye-rolling, shucking and jiving, fawning black servant who "yassuh"-ed and "no-ma'am"-ed his way through life. During the Black movement of the 1950s, *Stepin Fetchit* came to represent a stereotype, the black man who demonstrated servility before whites; the term retains that negative connotation today.

> The driver, from a small town outside Houston, though white, seemed to have taken a course at the Stepin Fetchit school of etiquette. No matter what I said or asked, his answer was the same, "Yassuh." (*Maclean's*, March 1974)

12. Tantony pig Anyone who follows another in a servile manner; anyone who follows another closely. This term, dating from the late 16th century, was originally applied to the smallest pig in a litter which, according to legend, would follow its owner wherever he went. *Tantony* is a contraction of *St. Anthony*, the patron saint of swineherds.

> Lead on, little Tony, I'll follow thee, my Anthony, my Tantony, sirrah, thou shalt be my Tantony, and I'll be

thy pig. (William Congreve, *The Way of the World*, 1700)

13. toad-eater A servile and obsequious attendant or follower; one who will go to any lengths to comply with a superior's wishes; a toady (whence the term) or sycophant. According to the *OED*, the original toad-eaters were charlatans' assistants who ate, or pretended to eat, poisonous toads, thus providing their mountebank masters with the opportunity to display their curative powers by expelling the deadly toxin.

14. tuft-hunter A self-seeking flatterer, particularly of the prestigious and powerful; one who attempts to enhance his own status by consorting with those of higher station. Formerly, titled undergraduates at Oxford and Cambridge were, in university parlance, called *tufts*, after the tuft or gold tassel worn on their mortarboards as an indication of their rank. Those of lesser standing who sought their attentions and company thus came to be known as *tuft-hunters*.

15. ward heeler A minor political hanger-on who undertakes party chores, often of an underhanded nature. This American slang expression, in use since the late 1800s, usually connotes dishonesty. A ward is a division of a city made for the convenience of political organization; the *heeler* is usually a servile underling who runs about the ward delivering messages and performing other services. Like a dog, he heels at his master's command. Some heelers, however, may rise to positions of power.

> The local man, often called a heeler, has his body of adherents. (A.B. Hart, *Actual Government*, 1903)

249. OBSESSION

1. have a bee in [one's] bonnet To be obsessed by a delusive notion or fantasy; to be preoccupied by a whimsical or perverse fancy; to be eccentric or crotchety. Variants of this phrase, such as *bees in the head* or *brains,* and *maggots in the head* or *brains,* were used as early as the

beginning of the 16th century, although *bee in one's bonnet* is heard almost exclusively today. As for its origin, it seems evident that anyone with a live bee buzzing inside his hat would be preoccupied indeed. Perhaps the use of alliteration accounts for its currency.

2. one-track mind A mind completely obsessed with a single thought, idea, or desire; an extremely narrow point of view. This common expression alludes to a single set of railroad tracks on which trains can move in only one direction. As used today, the phrase often carries the disparaging implication that the possessor of such a mind stubbornly resists any consideration of alternative viewpoints.

> The persons with the one-track mind are the ones who usually have the most collisions. (*Kansas City Times*, May 1932)

3. ride a hobbyhorse To pursue a favorite project or idea relentlessly and unceasingly; to be obsessed with a single notion or scheme. A *hobbyhorse* was the term given to a wickerwork horselike frame used in the old Morris dances, as well as to the stick toy with a horse's head ridden in mock fashion by children. The expression originally meant to play an infantile game of which one soon tired, since riding such a hobbyhorse involved little more than monotonous repetition of unvaried movements. In the 1700s John Wesley referred to *hobbyhorse* as "the cant term of the day."

250. OBSOLESCENCE
See also 15. AGE

1. back number An old-fashioned person or outdated object; one whose mode of thought, dress, or behavior is generally regarded as passé. Issues of magazines are designated by number and the literal term refers to those no longer current. The figurative meaning has been current, however, for almost a century.

> There is always some old back number of a girl who has no fellow.

(George W. Peck, *Peck's Sunshine,* 1882)

2. dead as a dodo Hopelessly passé; obsolete; absolutely and irrevocably dead; completely washed up; utterly extinct; a thing of the past. Discovered by the Dutch on the islands of Mauritius and Réunion in the early 16th century, dodo birds, quite large and flightless, were barely able to run, and they and their eggs became easy targets for the pigs, dogs, and rats that accompanied the settlers to the islands. The common name was borrowed from Portuguese *doudo,* 'stupid'. Shortly after the last bird had been eliminated, by the late 17th century, the dodo became a symbol of extinction as well as of stupidity. Will Cuppy, in *How to Become Extinct* (1941), sums up the ill-fated bird's existence:

> The Dodo never had a chance. He seems to have been invented for the sole purpose of becoming extinct and that was all he was good for.

3. old hat Old-fashioned; out of style; passé. This expression derives from dated headgear. The term is commonplace throughout the United States and Great Britain.

> For that matter, tubular stuff [furniture] is now old hat. (*The New Yorker,* October 1949)

Obstacle . . . See 185. IMPEDIMENT

251. OBSTINACY

1. deaf as an adder Obstinate refusal to listen; stubborn unwillingness to pay attention. The origin of this phrase lies in ancient Oriental folklore. An adder was thought to protect itself against the music of a snake charmer by blocking one ear with its tail while pressing the other ear to the ground. This belief was mentioned in the Old Testament of the Bible:

> They are like the deaf adder that stoppeth her ear

Which will not hearken to the voice of charmers, charming never so wisely.
(Psalms 58:4–5)

2. hidebound Narrow-minded; obstinately set in opinion; bigoted; adhering to one's prejudices. This expression, its figurative use dating from the 16th century, was originally applied to the emaciated condition of cattle during the winter months when their skin literally clung to their bones. It was an easy step to transfer the condition to the *hidebound* minds of some narrow-minded, obstinate people.

3. Hunt's dog An obstinate person; a discontented person who will not be pleased or satisfied; an unreasonable person. The story is told of one Hunt, a Shropshireman, who owned a dog, a huge mastiff, which would not enter the church with his master, but if left at home howled and barked and disturbed the whole congregation. The story may be found in Francis Grose's *Classical Dictionary of the Vulgar Tongue* (1785) and dates to at least the mid 17th century.

4. mumpsimus An old fogy; an obstinate conservative; a stubborn, pig-headed fool. In R. Pace's *De Fructu* (1517) is found the tale of an English priest who insisted on reading during the Mass *quod in ore mumpsimus,* rather than *quod in ore sumpsimus,* the correct form. When corrected, he retorted that he wouldn't change "my old *mumpsimus* for your new *sumpsimus.*" The term has come to symbolize a bigot or anyone opposed to reform.

> The chancellors of England . . . which be all lawyers and other doctor mumpsimuses of divinity were called up suddenly to dispute the matter. (William Tindale, *The Practice of Prelates,* 1530)

5. stiff as a poker Unbending; resolute; unyielding; stubborn; inflexible. The reference in this phrase is to the stiff metal rod used to stir up the fire in a fireplace or stove. Figuratively, it refers

to the stiffness of a person's will, to one who is resolute in his beliefs and unbending in the face of opposition. It is also used to describe a person who is stiff in posture, one who seems unable to relax. The term has been in use since at least the early 18th century.

> Lady Elizabeth, as stiff as a poker, sat with her mouth pursed up, vexed to death. (Mrs. Hervey, *The Moutray Family*, 1800)

6. stiff-necked Obstinate; stubborn; contumacious; haughty. This phrase, alluding to a stubborn horse, ox, or mule that keeps a rigid neck when someone pulls upon the reins, was in common use in Biblical times.

> But they obeyed not, neither inclined their ear, but made their neck stiff, that they might not hear, nor receive instruction. (Jeremiah 17:23)

Through the ages the term has retained the same metaphorical interpretation, that one who is *stiff-necked* is not open to another's ideas, that he is thickheaded and inflexible in his opinions. The expression has been in popular use in English since the early 1500s.

> I shall therefore give up this stiff necked Generation to their own Obstinacy. (Sir Richard Steele, *The Tatler*, 1710)

252. OBVIOUSNESS

1. darkest place is under the candlestick Too close to a situation to understand it; overlooking the obvious. This expression is patent in its figurative and ironic intent, that, while seeking an answer to a problem, one often misses what is directly under his nose.

2. goldfish in a glass bowl A person in a place completely lacking in privacy; one in a position where all his actions can be seen, where it is impossible to hide. Goldfish, introduced into England from China as early as 1691, became popular pets. This expression, referring to the way in which these animals were displayed, was coined in the late 1800s.

> I might have been a goldfish in a glass bowl for all the privacy I got. (Saki [H. H. Munro], *The Innocence of Reginald*, 1904)

3. plain as a pikestaff Plain as day; obvious; clearcut; evident. This proverbial expression, dating from the late 16th century, is a variant of the earlier, now obsolete, *plain as a packstaff*. The allusion is to a long, shafted weapon formerly used by infantry; of some weight and equipped with a metal point, it could not be concealed and its purpose was obvious, as well.

> The evidence against him was as plain as a pikestaff. (Anthony Trollope, *The Last Chronicle of Barset*, 1867)

4. plain as the nose on your face Exceedingly obvious; extremely conspicuous. This concept was conveyed by Shakespeare in *The Two Gentlemen of Verona*:

> Oh jest unseen, inscrutable, invisible,
> As a nose on a man's face, or a
> weathercock on a steeple.
> (II,i)

The expression, clearly derived from the prominence of the nose on the human face, has maintained common usage through the centuries.

> It is as plain as the nose on your face that there's your origin. (Thomas Hardy, *Pair Blue Eyes*, 1873)

5. point-blank See 43. CANDIDNESS.

253. OCCUPATIONS

1. busker A street singer and dancer; one who performs in public places, usually as an itinerant musician or magician. This Briticism is derived from the verb *busk* 'improvise.' According to Henry Mayhew in *London Labour and the London Poor* (1851):

> Busking is going into public houses
> and playing and singing and dancing.

However, the term has broadened in concept, and today most buskers can be found performing in village squares, on the streets, at beaches, or in pedestrian walkways of the underground.

The words and tune of which I remember hearing from the lips of a busker at Margate. (*Referee*, June 29, 1884)

In recent years the term has come into use in the larger cities of the United States where such entertainers have flourished.

2. called to the bar To be admitted as an attorney; to be allowed to practice law. In England the barrier or wooden bar which marked off the judge's bench from the remainder of the court became known as *the bar* during the early 1500s, and the term soon became synonymous with the court. At the Inns of Court those law students who had attained the requisite standing were called from the body of the hall to accept their place at the bar.

3. costermonger A street-vendor, a hawker of fresh fruits, vegetables, fish, etc.; also simply *coster*. This British expression comes from the earlier *costardmonger* 'apple-seller' (*costard* 'a large, ribbed variety of apple' + *monger* 'dealer, trader'). It has been in use since 1514.

4. counter-jumper A sales clerk in a retail establishment. This Briticism makes jocular or sarcastic reference to the "shop assistants" whose lack of eagerness and enthusiasm has become proverbial everwhere.

5. disc jockey A radio announcer who plays popular recorded music with intervening advertisements and commentary. This term, coined as a slang term just prior to World War II, has in its short history become standard English. Its derivation is probably by transference from a horse jockey, who selects and directs his charge just as a *disc jockey* selects his *discs*, i.e., records, and directs his program. Once *disc jockey* had been established as an occupational term, a large number of such terms began to appear: *hammer jockey* for a carpenter; *desk jockey* for a stenographer or secretary; even the recently coined *video jockey* for one who hosts a program of rock music videos. The word *jockey* is frequently shortened to *jock* in these expressions.

Duke [magazine] asks a leading disc jockey for his selection of the most played records as well as the discs he feels will click in coming weeks. (Jesse Owens, "Duke on Discs," *Duke*, August 7, 1957)

6. flatfoot A police officer. This expression, in widespread use since the early 20th century, implies that a police officer on a beat becomes flatfooted from walking. *Flatfoot* and other expressions of derision became firmly entrenched in American speech during the Prohibition era (1920–33) when the general public was particularly contemptuous of those who enforced the law.

He got sore as a boil and stepped up to the lousy flatfoot. (J. T. Farrell, *Studs Lonigan*, 1932)

7. flesh-tailor A surgeon. The derivation of this British colloquialism is obvious.

8. free-lance An unaffiliated person who acts on his own judgment; a writer or journalist who works for various publishers without actually being employed by any of them; a person hired on a part-time or temporary basis to perform tasks for which he has been specially trained. This expression dates from the Middle Ages when, after the Crusades, bands of knights offered their services to any country that was willing to pay. Also known as mercenaries or free companies, these bands were commonly called *free-lances* in reference to their knightly weapon, the lance. Eventually the term was applied to unaffiliated politicians. In contemporary usage, however, a *freelancer* is anyone (though usually a writer) who offers his services on a temporary basis with payment upon completion of the work, as opposed to payment in the form of a salary or retainer.

If they had to rely on the free-lance articles . . . they could close down tomorrow. (*Science News*, 1950)

9. gandy dancer Railroad slang for a section hand or tracklayer. The term, in use as early as 1923, derives from the rhythmic motions of railroad workers who laid tracks with tools made by the now defunct Gandy Manufacturing Company of Chicago.

10. ghost writer A person who is paid to write a speech, article, or book—particularly an autobiography—for another, usually more famous person who receives and accepts credit for its authorship; a hack writer. This expression alludes to the classic definition of *ghost* 'an unseen spirit or being existing among living persons.' The implication is that though a ghost writer exists, his presence is hidden from the general public; thus, his existence is unknown or unrecognized. A back formation is *to ghostwrite* or *to ghost* 'to write for another who accepts credit for the work.'

> The autobiographical baloney ghost-written by Samuel Crowther for Ford . . . (*New Republic*, February 10, 1932)

11. gumshoe A detective or plain-clothesman; so called from the rubber-soled shoes reputedly worn in order to assure noiseless movement. Consequently *gumshoe* can also be used as a verb meaning 'to move silently; to sneak, skulk, or pussyfoot.'

12. ink-slinger A disparaging appellation for a writer, especially one who writes for his livelihood; also *ink-jerker*, *spiller*, or *shedder*. The reference is probably to a newspaper writer under such pressure to finish an article by a specified deadline that he "slings" the ink onto the paper without regard for the quality of writing. This American slang term dates from the latter half of the 19th century. The noun *ink-slinging* appeared in *The Spectator* (November 1896):

> There is . . . no picturesque ink-slinging, as the happy American phrase goes.

13. knight of St. Crispin A shoemaker; a cobbler. The allusion here is to Crispinus or St. Crispin, the patron saint of cobblers. St. Crispin, while preaching Christianity in Soissons in the early 4th century, earned his livelihood by making and repairing shoes, and therefore was adopted by the trade as a symbol of their craft. *Knights of St. Crispin* is often adopted by cobblers' unions or their benefit societies as a name for their organizations. Related terms are *St. Crispin's lance*, 'a shoemaker's awl,' and *serve at Crispin's shrine*, 'to practice the craft of the cobbler.'

> His work was strong and clean and fine,
> And none who served at Crispin's shrine
> Was at his trade more clever.
> (Jan Van Ryswick, *Hans Grovendraad*, 1843)

14. knockabout man One who is willing to do any kind of work; a handy man; a roustabout; *jack of all trades*. The key word in this expression is *knockabout*, 'to wander irregularly.' A variant is *knockabout hand*.
Although both terms are heard on occasion in the United States and England, they are everyday phrases in the vocabulary of Australia. In *A Colonial Reformer* (1890) Rolf Boldrewood, an Australian writer, who creates an outstanding picture of the life of an Australian squatter, comments:

> We're getting rather too many knockabout men for a small station like this.

15. Mrs. Mop A cleaning lady; a charwoman. This Briticism is a term of endearment, especially among supervisory personnel, for the charwomen who clean their offices each night.

> My Mrs. Mop is a jewel. (Norman W. Schur, *English English*, 1980)

The term gained considerable popularity during World War II when a radio show entitled *It's That Man Again* featured a character named *Mrs. Mop*.

16. pencil pusher An office worker who does a considerable amount of writing. This U. S. slang term is a disparaging comment on the lack of productive labor in office work. The phrase also implies that such work is menial and mechanical.

The number of pencil pushers and typists has increased in the past 25 years out of proportion to the increase in factory workers. (Sam Dawson, AP wire story, July 9, 1952)

17. put on the buskins To write tragedy; to act in a tragedy. A *buskin* is a thick-soled, high boot that was traditionally worn by classical Greek actors while performing in a tragedy. The word has been used to symbolize tragedy or the tragic style.

Our English dramatists combine the office of comedy and tragedy writers in one and the same person . . . Aristophanes, Plautus, and Terence never put on the buskin. (Arthur Windsor, *Erotica*, 1860)

A special sense of the word *sock*, refers to the low shoe worn by those classical Greek and Roman comic actors; thus *sock and buskin* is a familiar theatrical phrase for comedy and tragedy, or for all drama.

He was critic upon operas, too,
And knew all niceties of the sock and
buskin.
(Lord Byron, *Beppo*, 1817)

18. sawbones A surgeon; any doctor. The allusion in this term is gruesomely obvious.

"What, don't you know what a Sawbones is, sir," enquired Mr. Weller; "I thought every body know'd as a Sawbones was a surgeon." (Charles Dickens, *Pickwick Papers*, 1837)

19. shrink A psychiatrist or psychoanalyst. This derogatory expression is a shortening of *headshrinker*, which may have been coined by analogy to the primitive tribal custom, practised by medicine men, of shrinking a decapitat-

ed head by removing the brain and stuffing the head with hot sand.

You talk like one of those headshrinkers—a psychiatrist. (S. McNeil, *High-Pressure Girl*, 1957)

20. sling hash To work as a waiter or waitress; to serve as a counterman at a diner or roadside cafe. This Americanism is derived from *hash house*, a common slang term for a cheap restaurant. Originally, these people who *sling hash*, or *hash slingers* as they are also known, were responsible for dishing up the food as well as serving it. With the advent of attached kitchens on these cheap diners and restaurants, their primary function became waiting on the customers. A variant, which has become obsolete, was *biscuit shooter*.

Bills of fare were not fashionable, but instead the "hash slinger" (if a gentleman) or "biscuit shooter" (if a lady) repeated a list of grub. (Edmund C. Stedman, *Bucking the Sagebrush*, 1904)

21. taxi dancer A woman who is available as a dancing partner for a fee, either for a certain period of time or by the dance. This expression, dating from about 1900, refers to a girl or woman who, either as a vocation or an avocation, earns money dancing with customers in a dance hall. The allusion is to the hiring of a dance partner for a period of time as one hires a taxicab.

I'm a taxi dancer but that don't mean I'm your slave. (Wessel Smitter, *F.O.B. Detroit*, 1938)

A related term, *taxi dance hall*, is the common name for the establishments where such dancers work.

The real gyp joints were the dance schools, the taxi dance halls, and . . . (Stephen Longstreet, *The Real Jazz: Old and New*, 1956)

Offensiveness . . .

See 313. REPULSION

Officiousness . . .

See 235. MEDDLESOMENESS

Old age . . . See 15. AGE

Oldness . . . See 15. AGE

254. OMEN

1. **handwriting on the wall** A portent or prophecy of disaster, a sign of impending and unavoidable doom, an indication or sense of what is to come; often *the writing on the wall*. The allusion is to the Book of Daniel, in which a hand mysteriously appeared and wrote a message on Balshazzar's palace wall foretelling his destruction and the loss of his kingdom.

2. **my little finger told me that** Pain or pleasurable sensation in the fingers was considered by the ancient Roman augurs a sign of evil or joy to come. The pricking of one's thumb was considered a portent of evil.

> By the pricking of my thumbs
> Something wicked this way comes.
> (Shakespeare, *Macbeth*, IV,i)

Thus, one's finger or thumb can be said to "tell" the future. Sometimes *my little finger told me that* is used to indicate that one has access to certain information, the source of which may be controversial and unscientific.

3. **speak from the tripod** To make a prediction; to present something in an oracular style; to prophesy, to foretell, to advise. The allusion in this phrase is to the ancient Greek prophetess, the oracle at Delphi, who seated herself upon a tripod when presenting her prophecies.

4. **stormy petrel** One whose arrival is seen as a harbinger of trouble. Stormy petrels *(Procellaria pelagica)* are the sea birds which sailors call Mother Carey's chickens. *Petrel* is derived from the Italian *Petrello* 'little Peter,' in allusion to the way these birds appear to walk on the sea, just as St. Peter walked on the Lake of Gennesareth. Stormy petrels are most often observed just prior to and during a storm; thus, their arrival por-

tends deteriorating weather conditions. The expression may now be applied to anyone whose coming is inevitably followed by disaster or tragedy.

> Dr. von Esmarch is regarded at court as a stormy petrel, and every effort was made to conceal his visit to the German emperor. (*The World*, April 1892)

See also **Mother Carey is plucking her chickens, 402. WEATHER.**

5. **weather breeder** See 402. WEATHER.

Openness . . . See 43. CANDIDNESS

255. OPPORTUNENESS

See also 380. TIME;

381. TIMELINESS

1. **field day** A favorable time for accomplishment; a time rich with opportunity for enjoyment, profit, or success. This expression originally referred to a day scheduled for military maneuvers and war games. It still carries the literal meaning of a school day set aside for various outdoor activities and amusements, such as sports, games, or dances. The phrase was used figuratively by Aldous Huxley in his *Letters* (1953):

> Industrial agriculture is having a field day in the million acres of barren plain now irrigated.

2. **the goose hangs high** Things are looking good, everything is rosy, the future looks promising. No satisfactory explanation has yet been offered to account for the origin of this expression. The theory that the phrase was originally *the goose honks high*, based on the unsubstantiated notion that geese fly higher on clear days than on cloudy ones, must be discounted for lack of evidence. This expression, which dates from at least 1863, was used to describe fine weather conditions before it was applied to the state of affairs in general.

> If you believe there is a plethora of money, if you believe everything is lovely and the goose hangs high, go down to the soup houses in the city of

New York. (*Congressional Record*, February 1894)

3. pudding-time A favorable or opportune time; not too late; often in the phrase *to come in pudding-time.* This expression, now obsolete, literally meant in time for dinner since pudding was at one time served at the start of this meal. Later, when pudding was served as a dessert, it aptly came to mean a particularly opportune moment, as one had arrived for the sweet. The term dates from 1546.

4. strike while the iron is hot See 136. EXPLOITATION.

5. Tom Tiddler's ground Any place where it is easy to pick up money or other considerations. This expression is derived from a children's game originating in the 1800s. In the game one player represents Tom Tiddler and protects an area marked off by lines on the ground. The other players run onto *Tom Tiddler's ground* and cry, "Here we are picking up gold and silver on Tom Tiddler's ground." When another player is caught, he becomes Tom Tiddler. The term has come to symbolize any area where one can make easy money or receive information or favors that will lead to success.

> I would rather regard literature as a kind of Tom Tiddler's ground, where there is gold as well as silver to be picked up. (Arthur C. Benson, *From a College Window*, 1907)

Opposition . . . See 62. CONFRONTATION; 293. PROTEST

Optimism . . . See 177. IDEALISM

Oratory . . . See 133. EXHORTATION

Order . . . See 25. ARRANGEMENT

Orderliness . . . See 243. NEATNESS

256. OSTENTATIOUSNESS
See also 12. AFFECTATION;
276. POMPOSITY

1. Bartholomew doll A gaudily dressed woman; a flashy or overdressed female; a prostitute. This term is derived from the similarity between the original *Bartholomew dolls*, flashy, bespangled handmade dolls offered for sale at Bartholomew Fair, and the tawdry, overdressed women to be found at the Fair. From 1133 the Fair was held annually in the priory of St. Bartholomew in West Smithfield, London. As the years progressed the Fair became more and more boisterous and unruly, until finally in 1840 it was moved to Islington, where, 15 years later, it was closed for good.

2. cut a swath To show off or attract attention to oneself; to make a pretentious display; to cut a dash. This expression, which dates from 1843, is a figurative extension of *swath* 'the strip or belt cut by the sweep of a scythe.'

3. drugstore cowboy This expression describes the young men who loiter at drugstores, dairy bars, and candy stores, showing off and trying to impress the girls. The exact origin of the term is uncertain; however, it clearly alludes to the masculine image of the American cowboy which many try to emulate. Originating in the 1930s, the expression is still in popular use.

> . . . bell-bottom trousers so much in vogue with the drugstore cowboys of today. (Alan Hynd, *We Are the Public Enemies*, 1949)

A related variant, *urban cowboy*, became popular with the release of a movie by that name in 1980.

4. English Any extra something that gives flourish or pizzazz to an otherwise ordinary movement or gesture; side spin on a ball. The following explanation of the origin of this American term appeared in the *Sunday Times* [London] in April 1959:

The story goes that an enterprising gentleman from these shores travelled to the United States during the latter part of the last century and impressed the Americans with a demonstration of the effect of "side" on pool or billiard balls. His name was English. This expression, which dates from 1869, is most often used in reference to billiard or tennis balls, though it is sometimes used in other contexts.

5. fine feathers make fine birds This saying suggests prententiousness, over-concern with one's appearance, or overdressing to impress. The expression, in varying forms, dates back to the 1500s. From the outset its connotation was primarily sarcastic.

> It may rightly be said of these costly clad carcasses, that the feathers are more worth than the bird. (Stefano Guazzo, *Civil Conversation*, 1574)

Based on Aesop's fable of the jay and the peacock, the phrase apparently was put into its present form by Bernard Mandeville in *The Fable of the Bees* (1714). In modern use the term is applied only derisively.

> Fine feathers make fine birds, but they don't make lady-birds. (J.C. Bridge, *Cheshire Proverbs*, 1917)

6. flat hat To fly dangerously low in an airplane; to hedgehop; to buzz; to show off; to make an ostentatious display. This expression derives from an incident alleged to have happened in the 1920s when the hat upon a man's head was crushed by a low flying plane. It is more likely that it is a colorful coinage not owing to any real incident. A variant *flat hatter* signifies a pilot who flies in such a manner.

7. flourish of trumpets An unnecessarily flamboyant introduction; a pretentious display. This expression is derived from the musical fanfare associated with the arrival of royalty or other distinguished, high-ranking officials. The expression is used figuratively to describe an inappropriate show of pomposity.

8. foofaraw Ostentation; gaudy wearing apparel; cheap and showy; a braggart; a windbag; a blowhard. This colloquial expression is a derivation of the French *fanfaron*, 'fanfare.' Corrupted in spelling and meaning, the word has taken on a connotation of anything or anyone that is showy or gaudy, or one who draws attention to himself by causing an unnecessary disturbance. First used in the 1600s, the term has many variants, among which are *fofaraw*, a simple variation in spelling; *fanfaron*, retaining its original French meaning but in addition signifying a braggart; *fanfaronade*, 'boisterous language'; and *fanfarrado*, a nonce word.

> She had no business acting so foofaraw for she was just a yaller gal. (Leland Baldwin, *The Keelboat Age on Western Waters*, 1941)

9. froufrou Elaborate ornamentation; unnecessary decoration; affected elegance; fanciness. Originally used to describe the rustling sound of women's petticoats and dresses, this term, by transference, came to describe any type of elaborate decoration on a woman's dress. In time it was extended to any kind of decoration, especially to overly ornate or trivial adornment. Today the term is used almost exclusively to indicate frilly fashions in women's wear.

> Is that what you want in a girl—chi-chi, frou-frou, fancy clothes, permanent waves? (Max Shulman, *Dobie Gillis*, 1951)

A related term, *chi-chi*, suggests a less startling bit of embellishment than *froufrou*.

> Another bit of chi-chi that has come to our notice lately is Eleanor Roosevelt's letterhead. (*The New Yorker*, December 1, 1951)

10. fuss and feathers Pretentious, ostentatious display; exaggerated concern and preoccupation with one's appearance. *Fuss and feathers* is reputed to have been the nickname given to U.S. General Winfield Scott by those who thought him finicky, vain, and self-important.

According to the *OED*, this expression appeared in print by 1866, the year of Scott's death.

11. grandstand Done to impress onlookers; done merely for effect or attention, used especially of an athletic feat.

> It's little things of this sort which makes the 'grandstand player.' They make impossible catches, and when they get the ball they roll all over the field. (M. J. Kelly, *Play Ball*, 1888)

This common expression is sometimes extended to *grandstand play*, an athletic maneuver done to draw applause from the spectators, and *grandstand finish*, a thrilling, neck-and-neck finale to a sporting event.

12. ham A performer who overacts and exaggerates to show off on stage; an inexperienced, inferior actor; frequently extended to any person who enjoys being the focus of others' attention and behaves in such a way as to attract it; an exhibitionist or showoff. There are several different but related theories as to the origin of this phrase. One of the best known states that, for economic reasons, poorly paid performers used cheap ham fat instead of the more costly cold cream to remove their makeup, thus giving rise to the term *ham*. Similarly, the *OED* theorizes that *ham* is short for *hamfatter* 'an ineffective, low-grade actor or performer.' A related synonymous term is *hamfat man*, also the title of a popular minstrel song. All of these terms are U.S. slang and date from the 1880s.

13. hot-dog To show off, especially by performing flashy, difficult, intricate maneuvers in sports; to grandstand, to play to the crowd; also *to hot-dog it*. The verb *to hot-dog* is a back formation from the surfing slang terms *hotdogging* 'riding a hot dog surfboard' and *hotdogger* 'a surfer who rides a hot dog board.' A *hot-dog* surfboard is relatively small and probably got its name from its cigarlike shape, similar to that of a hot dog. Although the verb *to hot-dog* dates only from the 1960s, the noun *hot dog* 'hot shot, showoff' dates from the early

part of this century. This figurative sense of the noun probably derived from the exclamation *hot dog!* 'great, terrific,' used originally in reference to the food.

> Looking good on a little wave is hard. If you can hot dog on two foot waves you are "king." (*Pix* [Australia], September 1963)

14. play to the gallery To overact or overplay to get a rise out of the less refined and educated members of a group; to appeal to the vulgar tastes of the common man; to seek recognition by showy, overdramatized antics. This expression dates from the 17th century when the *gallery* referred to the less expensive seats in the theater where the *gallery gods* (See 359. STATUS) congregated to watch a play.

> His dispatches were, indeed, too long and too swelling in phrase; for herein he was always "playing to the galleries." (*Standard*, October 23, 1872)

Today *gallery* refers to any uncultured group of undiscerning judgment. An analogous expression deriving from baseball is *play to the grandstand*.

15. posh Sumptuously opulent; luxurious. Although the origin of this term is in dispute, many people still adhere to the expression's purported acronymous derivation from 'port out, starboard home,' a reference to the shady, more comfortable north side of a ship traveling between England and India. The phrase, originally a British saying, is now commonplace on both sides of the Atlantic.

> I'd like to have . . . a very cozy car, small but frightfully posh. (John B. Priestley, *The Good Companions*, 1929)

16. Saint Audrey's lace Cheap lace sold at the annual fair of Saint Audrey, from which the word *tawdry* was derived. When Ethelreda, a daughter of a 6th-century king of Northumbria, was a child, she enjoyed wearing pretty necklaces. Hundreds of years later, after Ethelreda had been canonized as Saint

Audrey and had become the patron saint of Ely, the townspeople sold necklaces at their annual fair. These Saint Audrey's laces, as they were called, soon gave way to a cheap and showy lace that became known throughout Britain for its gaudiness. About 1700 the word *tawdry* appeared, a corruption of *Saint Audrey*, to describe these necklaces, and to this day denotes anything cheap or gaudy.

17. shoot [one's] cuffs To show off; to flaunt or strut one's stuff; to grandstand; to put on the dog. In the Middle Ages, affectedly ostentatious noblemen often wore shirts with large, flamboyant lace cuffs which protruded from the sleeves of their equally ornate coats. Since the display of this type of cuff was clearly intended to impress, these quasi-aristocrats were derisively said to be "shooting their cuffs." With the decline in the popularity of such garish forms of dress, the expression became figurative and still enjoys occasional contemporary use. A variation is *shoot one's linen*.

18. tinhorn gambler Pretentious bettor who wagers only small amounts; small-time gambler who pretends to be big-time. Two plausible explanations exist for the genesis of this American slang expression, coined early in the 19th century. One involves the use of a gaming device, called a *tinhorn*, which gambling house operators of the American Old West employed for those wishing to wager on a small scale. The second and more plausible explanation compares the fine appearance but poor quality of an actual tin horn with the fine appearance but poor financial condition of some gamblers.

19. zoot suiter A person of brash tastes; one who dresses in loud clothing; one who thinks he's with it. The suggestion in this term is the flamboyance demonstrated by one who will wear garish clothing. The *zoot suit*, developed in the late 1930s, consists of high-waisted, striped or multi-colored trousers, called *peg trousers*, full in the legs but tight at the ankles, a drape-shape jacket with ex-

cessively padded shoulders and very wide lapels, a wide, flowing tie, a broad-brimmed hat, and a knee length key or watch chain. Although this faddish style died out shortly during World War II, because of the shortage of materials, the term *zoot suiter* has remained in occasional use to designate certain ostentatious types of people.

> I thought you'd begin to like me again if I changed into a zoot suiter. (*Miss America*, June 1948)

257. OUTCOME

1. bottom line The end result, the final outcome, the upshot; the net profit or loss of any transaction or undertaking, financial or otherwise. This accounting term for the final figure on a profit and loss statement has been incorporated into more general usage and extended in meaning as indicated above.

2. come out in the wash Work out for the best in the long run; turn out all right; become known. Just as dirt and stains are removed when clothes are washed, anything which hinders or serves to cloud the truth will be removed in the end.

3. pan out See 365. SUCCESS.

4. Pyrrhic victory A victory gained at too great a cost. Pyrrhus, king of Epirus, invaded Italy and carried on a series of campaigns against the Romans from 280–275 B.C. At the battle of Asculum, which he reputedly won, he lost so many of his troops, especially from the elite corps of his army, that he questioned if he had really gained a victory.

> The armies separated; and it is said, Pyrrhus replied to one that gave him joy of his victory that one other such would utterly undo him. (Plutarch, *The Lives of the Noble Grecians and Romans*)

5. spinoff A by-product or offshoot; a new company, invention, product, etc., that develops as a result of the success of a related, pre-existing concern. This expression has been popularized by its fre-

quent application in the television industry to a new program centering around a supporting character from an already successful show. The expression also enjoys widespread use in the business and medical worlds.

The vaccine is the result of a new type of ultra high-speed centrifuge that is a spinoff from atomic weapons work conducted here by the Atomic Energy Commission. (Richard D. Lyons, in the *The New York Times*, February 1968)

258. OUTDOING
See also 9. ADVANTAGE

1. beat all hollow To surpass completely or thoroughly; to outdo; to excel. The exact origin of this phrase is unknown. *Hollow* is the key word, meaning 'thoroughly, outandout,' and *all hollow* is an American colloquial variant. Various forms of the phrase (*have* or *carry it hollow*) were used as early as the middle of the 17th century. Today the most frequently heard form is the full phrase *beat all hollow*, which appeared as early as 1785 in the *Winslow Papers:*

Miss Miller . . . is allowed by your connoiseurs in beauty to beat Miss Polly Prince all hollow.

2. beat Banagher To outdo, excel, or surpass in absurdity, incredibility, or preposterousness. This Irish expression has been said to derive both from an actual town of that name, and from a hypothetical storyteller of that name, but no authenticating anecdote or evidence for either theory has been proffered.

3. beat the Dutch To astonish or surprise owing to excess of any sort; to outdo or surpass. The expression is an Americanism dating from the days of the early Dutch settlers. Some say it owes its origin to their reputation as merchants and traders offering the best bargains and fairest prices. Others see it as an outgrowth of the English-Dutch hostility in the New World. Either theory may be correct, since the phrase is used either positively or negatively.

4. knock [one's] socks off Beat soundly; overwhelm; astound; astonish; overcome with amazement. This Americanism, dating from the 1840s, is used figuratively in two different ways. It is used to express a thorough and decisive beating, a beating so thorough that one's socks are literally torn from one's feet, probably a variation of the older term, *knock someone's block off*. It is also used to express astonishment.

Dressing sexy is great, but it's undressing sexy that really knocks your socks off. (*Playboy*, December 1973)

5. knock the spots out of To surpass or excel by an exceeding degree; to prove superior in a given skill or talent. This phrase, common in the United States in the 19th century, is said to derive from the former practice of developing one's proficiency in the use of firearms by aiming at the spots on playing cards which had been nailed to a tree. A marksman able to hit any given spot from a regulation distance could "knock the spots out of" another or another's performance. In describing the Duke "learning" Hamlet's soliloquy to the King, Huck Finn says:

All through his speech, he howled, and spread around, and swelled up his chest, and just knocked the spots out of any acting ever *I* see before. (Mark Twain, *The Adventures of Huckleberry Finn*, 1885)

6. out-Herod Herod To outdo in excessiveness or extravagance; to be more outrageous than the most outrageous. The expression first appeared in Shakespeare's *Hamlet:*

I would have such a fellow whipped for o'erdoing Termagant—it out-Herods Herod. Pray you, avoid it. (III,ii)

In these lines Hamlet is admonishing the players to perform with restraint, warning that a bombastic style of acting is not to his taste. In medieval mystery plays Herod was conventionally presented as a roaring tyrant, much given to ranting

and raving and extravagant gesture. Use of the expression *out-Herod Herod* dates from the early 19th century. While it still most often describes blustering behavior or speech, it is by no means limited to such contexts. A person may "out-Herod Herod" by going beyond any other in any particular.

> As for manner, he [Alexander Smith] does sometimes, in imitating his models, out-Herod Herod. (Charles Kingsley, *Miscellanies*, 1853)

Out-Herod often occurs alone, with the character and characteristic in question completed by context; e.g., "He out-Herods Muhammad Ali in fancy talk and footwork."

7. run rings around To be unquestionably superior; to easily surpass another's performance; to defeat handily. No satisfactory explanation of this very common phrase has been found. One source conjectures it stems from races in which one contestant could literally run around his opponent and still come out the victor. Another says the phrase derives from Australian sheepshearing contests, but fails to provide a clear explanation of the relationship; however, the earliest known citation is from Australia, lending this latter theory a degree of credibility.

> Considine could run rings around the lot of them. (*Melbourne Argus*, October 1891)

8. steal the show To be the outstanding or most spectacular person or item in a group, especially unexpectedly; to usurp or get the credit for. This expression is rooted in the theater and refers to an actor or actress whose performance is so impressive and striking that it is the most memorable element in a stage production. Although still used in theater, *steal the show* is applied figuratively in varied contexts to describe a person or thing whose extraordinary qualities totally overshadow those of other members of a group. One who or that which "steals the show" is often called a *showstealer*.

9. steal [someone's] thunder See 379. THWARTING.

10. take the cake To be conspicuously good or bad; to be so extraordinary or preposterous as to surprise or stun into momentary incredulity; to excel or surpass. Cakes were often prizes in competitions of different sorts in many cultures, but most theorists agree that this phrase comes from the Black American dance competition called the cakewalk, in which couples would promenade around a large cake, and the one judged most graceful would get the cake as a prize. Though originally used in this sense of "win the prize" or "bear away the bell," the expression is now almost always heard used ironically. *Take the cake* more often means to be the worst than to be the best.

> Pack up and pull out, eh? You take the cake. (Theodore Dreiser, *Sister Carrie*, 1900)

11. upstage To outdo or surpass; to be a standout; to steal public attention and acclaim from another; to ignore or snub, especially condescendingly. In theater, upstage is the back half of the stage. To upstage an actor, then, is to stand toward the rear of the stage foreing the other actor has to turn his back to the audience so that its attention is effectively diverted from one actor and focused on the one who is doing the upstaging. By extension, *upstage* is applied in many nontheatrical contexts where one person overshadows or otherwise diminishes the importance of another.

> Nada Nice has upstaged the Kid . . . at your order. (Harry Witwer, *The Leather Pushers*, 1921)

As an adjective, *upstage* means condescending, aloof, haughty, stuckup.

> Although Costello . . . had definite ideas . . . in connection with his art, as he took pictures seriously, he was never the least bit "upstage" with us youngsters. (*Sunday Express*, May 10, 1927)

Outlook . . . See 270. PERSPECTIVE

Overburden . . .
 See 260. OVERWORK

Overdoing . . .
 See 259. OVEREXTENSION

Overeating . . .
 See 164. GOURMANDISM

259. OVEREXTENSION

1. bite off more than [one] can chew
To undertake more than one can handle;
to overextend oneself. John H. Beadle
used the phrase in *Western Wilds, and
the Men Who Redeem Them* (1877).

2. burn the candle at both ends To
overextend oneself; to overdo; to use up
or squander in two directions simulta-
neously. The phrase often carries conno-
tations of dissipation. It comes from the
French expression *brusler la chandelle
par les deux bouts*, and first appeared in
Randle Cotgrave's *A Dictionary of the
French and English Tongues* (1611).

3. bust a gut To try with all one's vigor;
to try so hard as to overreach one's phys-
ical limits; to strain oneself. This Ameri-
can slang expression, in use since the mid
1900s, alludes to the actual causing of a
hernia by straining beyond one's physi-
cal limits. Figuratively, it is also applied
to mental processes.

4. lazy man's load A burden too heavy
to be carried; a task too large to be com-
pleted. This expression alludes to the
purported tendency of lazy people to
overburden themselves on one trip rath-
er than make two trips with loads of a
reasonable size.

5. serve two masters To split one's ener-
gies between pursuits of good and evil,
uprightness and decadence, kindness
and cruelty, etc.; to attempt to ade-
quately meet conflicting demands; to
work against oneself. This expression, of
Biblical origin, alludes to the self-defeat-
ing nature of the impractical if not futile

attempt to obey two opposing sets of ide-
ologies, morals, or ethics.

> No one can serve two masters; for
> either he will hate the one and love
> the other, or he will be devoted to the
> one and despise the other. You cannot
> serve God and mammon. (Matthew
> 6:24)

6. spread [oneself] thin To overextend
oneself, to be involved in so many pro-
jects simultaneously that none receives
adequate attention; to overdo, to have
too many irons in the fire. This popular
expression compares a person's limited
capabilities and resources to a given
amount of a literally spreadable sub-
stance, such as jam or butter, which can
cover just so much bread before it be-
comes too thin to be tasted.

7. too many irons in the fire Too many
projects requiring one's attention, to the
detriment of them all; so many under-
takings in progress that none gets ade-
quate attention. This expression, in use
as early as 1549, refers to the pieces of
iron a blacksmith heats in the forge be-
fore working on them; they must be
hammered into the desired shape at pre-
cisely the right temperature. If he tries
to prepare several at once, his efforts be-
come counterproductive: he either gives
short shrift to working the metal, or risks
overheating it so that its malleability is
adversely affected. A similar phrase,
many irons in the fire, has the more pos-
itive meaning of several alternative ways
to achieve one's ends.

Overlooking . . . See 180. IGNORING

Overshadowing . . .
 See 258. OUTDOING

Overstatement . . .
 See 128. EXAGGERATION

260. OVERWORK
 See also 132. EXERTION

1. burn the midnight oil To study or
work late into the night; to lucubrate. In
the days before electricity students and

scholars who wished to read or study at night used oil lamps for light. The term *midnight oil* for latenight study was in use as early as 1635; the entire phrase appeared somewhat later.

2. keep [one's] nose to the grindstone See 268. PERSEVERANCE.

3. a lot on [one's] plate British slang for a lot to do, much to think or worry about.

4. moonlighting Working a job at night to supplement one's daytime income. Although it was formerly used in Ireland and other countries to describe nighttime excursions of violence, the expression's current figurative sense is of American origin. The term is now used frequently in the United States and Great Britain, always in reference to a second job.

> Several attempts have been made to ban moonlighting on the ground that it robs the unemployed of jobs. (*Economist*, December 1961)

5. salt mines One's place of employment; any unnamed place, real or imaginary, that represents habitual punishment, confinement, isolation, or drudgery. This expression alludes to the salt mines of Siberia (U.S.S.R.) where political and other prisoners were sent to serve sentences at hard labor. *Salt mines* often appears in *back to the salt mines*, a jocular and somewhat derogatory reference to returning to work.

6. snowed under Overwhelmed; inundated, buried, or overburdened by work or other responsibilities. This expression alludes to the fact that while a single snowflake seems completely innocuous, a large amount of snow can be totally overpowering.

> What he stood for (and he came to stand for more all the time) came under the lash of many tongues, until a frailer man than he would have been snowed under. (F. Scott Fitzgerald, *This Side of Paradise*, 1920)

P

261. PACE

See also 212. INSTANTA-
NEOUSNESS; 354. SPEEDING

1. at a snail's pace Very slowly; at an
exceedingly slow rate of movement or
progress. According to one source which
claims to have actually measured its
speed, a snail moves at the rate of one
mile in fourteen days. The snail, like the
turtle, is one of the slowest-moving crea-
tures on the earth and has symbolized
extreme slowness, tardiness, and slug-
gishness for centuries.

> That snail's pace with which business
> is done by letters. (Madame D'Arblay,
> *Diary and Letters*, 1793)

2. blue streak See **talk a blue streak**,
371. TALKATIVENESS.

3. faster than greased lightning At the
highest possible speed; moving at a tre-
mendous velocity. Lightning travels
at nearly the speed of light. The concept
of lubricating a lightning bolt to reduce
its friction with the air and consequently
increase its already enormous speed is
the apparent origin of this American
term.

> He spoke as quick as "greased
> lightning." (*Boston Herald*, January
> 1833)

4. fast track A hard and dry race track;
a place where the pace of life moves rap-
idly; the big time. This expression, origi-
nally applied to an open railway route
for express trains carrying perishable
goods, has, in recent years, been pretty
much restricted in its use to describe the
condition of a horse race track. Figura-
tively, the term has come to specify a
fast-paced life style. William Safire re-
ports that when Richard Nixon moved to
New York City in the mid 1960s, he

characterized his new residence as being
on the *fast track*. A recent variant is *fast
lane*, shortened from *life in the fast lane*,
an expression connoting a modern, fast-
paced lifestyle, alluding to the high-
speed lane on some expressways that re-
quires daring to negotiate successfully.

5. full tilt See 214. INTENSITY.

6. go through like a dose of salts To go
through at an extremely rapid pace; to
go like greased lightning; to defeat com-
pletely; to rout or vanquish. This Ameri-
canism alludes to the speedy action one
gets from taking a dose of purgative
salts:

> He'd gone through the pockets like a
> dose of salts. (Kirk Monroe, *The
> Golden Days of '49*, 1889)

and can be used to suggest thoroughness
or success:

> I'll go through the Mexicans like a
> dose of salts. (David Crockett,
> *Almanac*, 1837)

The expression dates from the early
1800s.

7. hand over fist Left and right, by
leaps and bounds, a mile a minute, rap-
idly; usually in reference to making
money. The original expression, dating
from at least 1736, was *hand over hand*,
a nautical term with the literal meaning
of advancing the hands alternatively, as
when climbing up or down a rope or
when raising or hauling in a sail. Still in
nautical use, the phrase acquired the fig-
urative sense of advancing continuous-
ly, as one ship gaining rapidly on anoth-
er. It is in this sense that *hand over fist*
was first used, about 1825, according to
OED citations. The figurative use of
hand over fist, the only form of this ex-

pression current today, dates from the 19th century.

8. hellbent See 408. ZEALOUSNESS.

9. like a bat out of hell Very rapidly, swiftly, speedily. The precise origin or explanation is unknown. A plausible conjecture is that bats, because of their aversion to light, would beat a hasty retreat from the illuminating flames of the infernal regions. The phrase is of American origin.

> We went like a bat out of hell along a good state road. (John Dos Passos, *Three Soldiers*, 1921)

10. like a house afire Quickly, rapidly, like greased lightning; vigorously, enthusiastically, hammer and tongs. This expression refers to the swiftness with which a fire can consume a house, particularly one built of wood or other highly flammable materials.

11. make a beeline To proceed directly and with dispatch; to hasten, hurry; to rush, race, or make a mad dash toward. It is commonly believed that pollen-carrying bees return to the hive speedily and directly; hence *beeline* meaning 'the most direct route.' The term is believed to be originally American; it appeared in 1848 in *The Biglow Papers* by James Russell Lowell.

12. quick as a wink Very quickly, in no time at all; in the twinkling of an eye. This is an obvious metaphor referring to the split second it takes to blink the eye.

13. sell like hot cakes To sell very quickly; to be disposed of immediately and without effort, usually in quantity; to be in great demand; also *go like hot cakes*. Originally, hot cakes referred to corn cakes, but the term now applies to griddlecakes or pancakes. Freshly baked cakes, still warm from the oven, would presumably sell quickly because people would want to "get 'em while they're hot." The expression dates from the early 19th century.

> Ice cream sold like hot cakes Saturday, and hot cakes didn't sell at all, as the temperature began to climb early in the morning and kept it up until 4:30 p.m. (*The Fort Collins Coloradoan*, June 1946)

14. slapbang See 44. CARELESSNESS.

15. slapdash See 44. CARELESSNESS.

16. slow as molasses in January Very slow, barely moving. Molasses, naturally thick and sluggish, becomes even more so in cold weather owing to the crystallization of its high sugar content. Among the numerous variants are the expanded versions *slow as molasses going uphill in January* and *slow as cold molasses*.

Pacification . . . See 273. PLACATION

Pain . . . See 99. DISCOMFORT

262. PARADISE

1. Abraham's bosom The abode of the blessed dead. The phrase, of Scriptural origin, is usually confined to literary usage.

> And it came to pass that the beggar died, and was carried by the angels into Abraham's bosom. (Luke 16:22)

Resting one's head on another's bosom was an ancient gesture of close friendship; John, the Beloved Disciple, reclined on the bosom of Jesus at the Last Supper.

2. Camelot A legendary, utopian locality; a spectacular world of knights and ladies, of benevolent rulers and happy peasants. The location of the original Camelot, the fabled palace of King Arthur, has never been pinpointed. Although the question of its actual existence has never been satisfactorily answered, archeologists have recently uncovered artifacts and fortifications on a hill at South Cadbury in Somerset, England, which seem to lend some credence to local claims that King Arthur's palace was situated there. At any rate, because

of the romantic and mysterious atmosphere and the presence of such heroic figures as King Arthur, Queen Guinevere, Sir Lancelot, Merlin, and a host of others, the term has assumed a utopian connotation. In modern usage it has come to designate an elite social circle comprised of the "beautiful people." 1960 was a banner year for the expression, for the Broadway musical comedy opened:

> In short there's simply not
> A more congenial spot,
> Than happy, everaftering
> Here in Camelot.
> (Alan Jay Lerner, *Camelot*, 1960)

1960 was the year that John F. Kennedy was elected President of the United States. The Kennedy White House was often alluded to as Camelot, for it produced a glittering opulence of balls and banquets, and was viewed as engendering a sort of romantic optimism. Seemingly reminiscent of King Arthur and Queen Guinevere, Jack and Jackie Kennedy were felt to preside like regal monarchs over the lords and ladies of their "court."

3. happy hunting ground Heaven, paradise; the abode of American Indian warriors after death, where game was plentiful. The phrase in this literal sense was first used by Washington Irving in *The Adventures of Captain Bonneville* in 1837. It has since come to mean any region of abundant supply or fertile yield:

> Marin County—naturalists' happy hunting ground—supplied the thirty nature subjects now displayed in . . . North American Hall. (California Academy of Sciences, *News Letter*, 1948)

4. kingdom come The next world, the afterlife; paradise; Hades, hell.

> And forty pounds be theirs, a pretty sum,
> For sending such a rogue to kingdom come.
> (Peter Pindar, *Subjects for Painters*, 1789)

This term is an irreverent excision from the Lord's Prayer: "Thy kingdom come, thy will by done." It is still in common usage, as illustrated by a citation in *Webster's Third:*

> . . . the guns that would blow everyone to kingdom come. (Meridel Le Sueur)

5. land of milk and honey An area of unusual fertility, abundance, and beauty; a paradise; a mecca; Israel. This expression appears in the Bible (Exodus 3:8; 33:3; Jeremiah 11:5) as a description of the Promised Land (Israel), a place where Moses and the oppressed Hebrews would have freedom, peace, and abundant blessings.

> And I [God] am come down to deliver them out of the hands of the Egyptians, and to bring them up out of that land unto a good land flowing with milk and honey. (Exodus 3:8)

6. Shangri-La A hidden paradise; utopia; a land of love and youth and beauty. This term refers to the Buddhist lama colony which serves as the setting in *Lost Horizon* (1933) by James Hilton. A veritable Garden of Eden, *Shangri-La* represents not only all that is good and beautiful in man and nature, but also that which is mysterious and enigmatic. Early in World War II, General Jimmy Doolittle led a daring raid against Tokyo with 16 B-25s that took off from the aircraft carrier *U.S.S. Hornet.* The term gained extensive popularity at that time because President Franklin D. Roosevelt, when questioned about the bombers home base, announced that they had taken off from *Shangri-La.* The term received a further boost in popularity when a song of the same name was recorded in the early 1960s by a number of popular recording groups. In modern usage the expression usually indicates any ideal spot for a vacation or for retirement.

> As a naval officer I saw five continents. But I found my Shangri-

La in a Hawk home in Vermont. (*The New Yorker*, April 12, 1982)

Parity . . . See 120. EQUIVALENCE

Partiality . . . See 147. FAVORITISM

Participation . . . See 70. COOPERATION; 217. INVOLVEMENT

263. PARTNERSHIP
See also 70. COOPERATION

1. the devil and Dr. Foster Boon companions; close associates. The *Dr. Foster* in this expression, dating from the 1600s, is an Anglicized version of the name of the legendary Dr. Faustus. It is generally believed that since the two were inordinately close, the two names came to be linked together. However, Daniel Defoe apparently did not believe the legend, as revealed in his *A History of the Devil* (1726):

> It is become a proverb, as great as the devil and Dr. Foster, whereas poor Faustus was no doctor, and knew no more of the devil than another body.

Passion . . . See 230. LUST

264. PATIENCE

1. patient as Griselda Extraordinarily patient, humble, and submissive. In Boccaccio's *Decameron* (1353), Griselda was a common woman who married the Marquis of Saluzzo, a wealthy nobleman who subjected her to numerous tests of her womanly virtues. Griselda endured these tests without complaint, thus proving her patience, obedience, and meekness. The *Griselda* personage soon became the paragon of patience in the medieval miracle plays, and was further popularized by an appearance in Chaucer's *Canterbury Tales*. The name *Griselda* is still used in reference to a persevering, exceedingly patient woman.

2. sit tight To wait patiently; to bide one's time; to await (sometimes anxious-

ly) the results of an earlier activity; to refrain from voicing one's opinions or ideas. This expression was originally a poker term applied to a person who, when it was his turn, neither bet higher nor threw in his cards, choosing instead to await the outcome of the game. Thus, while *sit tight* once smacked of stinginess, in contemporary applications, it usually implies patience.

Paunchiness . . .
See 72. CORPULENCE

265. PAYMENT
See also 38. BRIBERY; 74. COST; 140. EXTORTION; 165. GRAFT; 240. MONEY; 326. REWARD; 352. SOLICITATION

1. cash on the barrelhead Immediate payment; money on the spot. This Americanism probably gained currency during the days when many perishable items were kept in barrels to retain freshness. To purchase something, one had to put *cash on the barrelhead*. Today the phrase is used to indicate that no credit is extended.

> No more divorces in Holt County until there is cash on the "barrelhead," is the edict. (*Kansas City Times*, April 7, 1932)

2. County Clare payment No payment at all; a thank-you rather than payment. This 19th-century British expression probably alludes to the indigence of the Irish farmer and his inability to pay for even the smallest of services.

> Only a thank-you job; a County Clare Payment, "God spare you the health." (Lady Gregory, *New Comedies*, 1913)

3. foot the bill To pay or settle an account; to assume responsibility for expenses incurred by others. This expression stems from the custom of signing one's name at the bottom, or foot of a bill, as a promise of payment. Over the years, this phrase has come to describe

someone who pays an entire bill himself, rather than allow or force it to be divided among the parties involved.

> The annual bill we foot is, after all, small compared with that of France. (*Leeds Mercury*, July 18, 1891)

4. fork over To pay up immediately; to hand over; to pay out. This expression, in common use since about 1840, alludes to the similarity between the fingers of the human hand and the tines of a fork; hence, *fork over* is simply another way to say *hand over*.

> He accordingly forked over the castings, 600 in number. (*Spirit of the Times*, September 21, 1844)

Variants are *fork out* and *fork up*.

5. the ghost walks Salaries will be paid; there is money in the treasury; it's payday. This expression, inspired by Shakespeare's *Hamlet*, has two possible explanations, one of which cites Horatio's asking the ghost (of Hamlet's father) if it walks because:

> . . . thou hast uphoarded in thy life Extorted treasure in the womb of earth.
> (I,i)

A more plausible, and certainly more colorful, theory tells of a 19th-century British theater company that threatened to strike because their salaries had not been paid for several weeks. The ghost was played by the leader of the company, a highly acclaimed actor. During a performance, the ghost, in answer to Hamlet's exclamation, "Perchance 'twill walk again," shouted from the wings, "No, I'm damned if the ghost walks any more until our salaries are paid!" Their salaries were paid and the performance continued. From then on, the actors met every payday to determine whether the ghost would walk, i.e., whether they would be paid. This expression gave rise to *ghost*, theatrical slang for a paymaster or treasurer of a theater or theater company.

6. go on tick To buy an item on credit; to be indebted for what one purchases; also, *get on tick*. In this expression, *tick* is a shortening of *ticket*, where *ticket* carries its obsolete meaning of a written note acknowledging debt. Although the phrase never attained great popularity in the United States, it has been a commonplace expression in Great Britain for centuries.

> A poor wretch that goes on tick for the paper he writes his lampoons on. (William Wycherley, *Love in a Wood*, 1672)

7. lay it on the line See 328. RISK.

8. the never-never plan Installment buying, buying on credit; the layaway plan. This British colloquialism for their own *hire-purchase* is usually abbreviated to the slang *never-never*. It appeared in print as early as the 1920s, and continues in common usage.

> They've still not paid off their mortgage, you know, and I wouldn't mind betting that Rover of theirs is on the never-never. (J. Wilson, *Truth or Dare*, 1973)

9. nickel and dime to death To drain a person of his money bit by bit; to eat away at one's monetary resources a little at a time; to exhaust one's finances by an accumulation of small expenses. This U.S. colloquial expression has become common in recent years, probably because of continued inflation and "built-in obsolescence." It might appear in a context such as: "It's not the initial outlay or major maintenance that makes automobile ownership expensive, but they nickel and dime you to death with piddling repairs that result from shoddy workmanship."

10. no tickee, no washee Pidgin English for no ticket, no laundry; no goods or services without a receipt or payment; no credit. Arthur Taylor in *The Proverb* (1931) explains:

> No tickee, no washee, i.e., "without the essential prerequisite, a desired

object cannot be obtained," with its evident allusion to the Chinese laundryman, bespeaks for itself a recent origin.

The expression dates from the late 19th century and has most commonly been applied, seriously or jocularly, to a situation where credit or the return of goods is denied if certain conditions are not met. A variant is *no tickee, no shirtee*. A related term, *no money, no Swiss*, indicates no assistance as well as no credit. The term originated from the willingness of Swiss soldiers to serve as mercenaries for the crowned heads of Europe; they continue to serve as armed guards for the Pope today.

> After long observation I find it to hold truer *no money, no mistress* than *no money, no Swiss*. (Thomas Brown, *Works*, 1704)

11. on the cuff On credit; on a special payment plan; on tick. Although the origin of this expression is obscure, a plausible derivation is that, at one time, storekeepers and bartenders kept track of debts by making marks on their shirt cuffs, which, till the 1920s, were available in Celluloid and, like collars, were not sewn to the shirt. Written on in pencil, they could easily be wiped clean. The phrase is used frequently today.

> Money was not important at all. All business was transacted on the cuff. (B. Macdonald, *Egg and I*, 1945)

12. on the nail On the spot, at once, immediately, right away or now; used in reference to money payments. Although the origin of this expression is obscure, it may be related to the French phrase *sur l'ongle* 'exactly, precisely' (literally, 'on the (finger)nail'). The expression appeared in Maria Edgeworth's *Popular Tales* in 1804:

> The bonnet's all I want, which I'll pay for on the nail.

No longer in common use, this phrase dates from the late 16th century.

13. on the nod On credit, on the cuff, with no money down. This expression, in use since the late 19th century, is said to have come from the practice of bidders at auctions, who signify their acceptance of a stated price with a nod of the head, on the understanding that the formalities of paying would be taken care of later. In any case, this gesture has long been used to show assent or agreement when entering into a bargain.

> Drunks with determined minds to get bacon, bread, cheese, on the nod. (*The Bulletin* [Sydney], July 1934)

14. pay as you go This term, although it was in use as early as 1855, did not achieve popularity until the federal government's introduction of periodical income tax withholding during World War II. Beardsley Ruml, treasurer of Macy's and a director of the New York Federal Reserve Bank, presented the program, his own brainchild, to the Senate Finance Committee in 1942. Originally rejected by the Committee because of the Treasury Department's opposition, the plan was finally implemented in 1943 after President Franklin D. Roosevelt announced his approval. Advertising agencies soon picked up the phrase and popularized it through the media.

> Now, thanks to the pay-as-you-go policy, there are many who find they owe the government nothing. (*Saturday Evening Post*, March 5, 1949)

In Great Britain a similar program was initiated under the acronym *P. A. Y. E.* 'pay as you earn.'

15. pay [someone] peanuts To pay someone extremely low wages; to earn an insignificant profit. Peanuts are so cheap and plentiful that they have for many years symbolized anything trifling and unimportant. In this American slang term, dating from the late 1800s, they characterize a sum of money so trivial that it is almost not worth mentioning.

They got you working for peanuts.
(Budd Schulberg, *What Makes
Sammy Run*, 1941)

The British equivalent, *pay someone in
washers*, is, like the American term, al-
most always uttered contemptuously.

16. pay [one's] scot To make payment;
to pay one's share, especially for enter-
tainment; to settle one's tavern score.
From the 1200s until about 1400 *scot*
meant 'contribution,' a direct carryover
from the Old English *sceot*; but about
1400 the term took on the meaning of a
tax, an assessment according to one's
ability to pay, especially in the phrase,
scot and lot. Consequently, the two
phrases are often confused as to mean-
ing. To *pay scot and lot* connotes to pay
in full, to settle with once and for all; to
pay one's scot connotes a contribution
toward the ethical, rather than the prac-
tical, modes of life.

> No system of clientship suits them; but
> everyman must pay his scot. (Ralph
> W. Emerson, *Conduct of Life:
> Wealth*, 1860)

17. shell out To hand over money; to
pay up. This figurative expression prob-
ably derives from the similarity between
shelling vegetables, such as peas from
the pod, and shelling money out of one's
pocket or purse. The *OED* lists the
word's earliest use as 1801.

> If you are one of the taxpayers who
> are paying by installments, get ready
> to shell out again. (A.P. Release,
> October 12, 1949)

266. PEACE
See also 273. PLACATION

1. all quiet on the Potomac A period of
peace during a war; any time marked by
the absence of fighting or quarreling.
This expression (now used ironically or
humorously) is generally thought to have
originated and gained currency during
the Civil War. It appeared as early as
1861 in an article by E. L. Beers in
Harper's Weekly. Simon Cameron, then
Secretary of War, frequently used the
phrase in his bulletins reporting the state
of the war. Its origin has been attributed
also to General George McClellan.

2. all quiet on the Western Front
Peaceful, calm. This phrase is an update
of the earlier *all quiet on the Potomac*. It
was the official statement issued each
day by the War Department during the
periods of relatively little trench fighting
in World War I; it was adopted as a
book title (later a film) by Erich Maria
Remarque (1929).

3. bury the hatchet To lay down arms,
to cease fighting, to make peace; also
bury the ax or *tomahawk*. The allusion
is to the North American Indian custom
of burying tomahawks, scalping-knives,
and war clubs as a sign of good faith
when concluding a peace. The proce-
dure is described by Washington Irving
in *The Adventures of Captain Bonneville*
(1837):

> The chiefs met; the amicable pipe was
> smoked, the hatchet buried, and
> peace formally proclaimed.

The expression dates from the late 1600s.
See also **take up the hatchet, 51. COMBAT**.

4. calm before the storm A period of
relative peacefulness preceding an out-
break of confusion and tumult; the quiet
and sane minutes just before chaos
erupts. A drop in the barometric pres-
sure prior to a thunderstorm produces an
uncomfortable, eerie feeling of calm-
ness.

5. clean sword and a dirty Bible A
phrase connoting peaceful times; rough-
ly equivalent to *make love, not war*.
This expression originated as a toast to
peace and piety in late 18th-century
England. The suggestion is that if one's
sword is clean (unused), and if one's Bi-
ble is dirty (used), then times have been
peaceful; used in a toast, it is expressive
of the wish that times may remain so. A
variation of the term is *rusty sword and
a dirty Bible*.

At famous dinners at the White Lion posting-inn at Hadleigh, Suffolk, at the beginning of the 19th-century, it was the custom to drink to rusty swords and dirty Bibles. (*Notes and Queries*, April 1952)

6. dove A pacifist, one who opposes war, in contrast to a *hawk*, who advocates a belligerent, warlike policy; one who favors negotiation and compromise as a means of resolving differences. The dove has been a symbol of peace in art and literature since Noah sent a dove from the ark to see if the waters had abated (Genesis 8:8–12). *Dove* referring to an antiwar advocate gained currency in 1962 during the Cuban Missile Crisis, and eventually became the label for those advocating withdrawal of U.S. troops from Vietnam.

The hawks favored an air strike to eliminate the Cuban missile bases.. . . The doves opposed the air strikes and favored a blockade. (Alsop and Bartlett in *Saturday Evening Post*, December 8, 1962)

7. halcyon days A time of peace and prosperity; palmy or golden days. The halcyon was a bird, usually identified as a type of kingfisher, which bred in nests floating on the sea. The ancients believed that these birds charmed the winds and waves of the sea into tranquillity during their breeding season. Thus, *halcyon days* originally referred to the two weeks of calm weather about the time of the winter solstice during which the halcyons bred. The current, figurative sense of *halcyon days* dates from the latter half of the 16th century.

8. hold out the olive branch To make an overture for peace; to indicate one's peaceful intentions. Long considered a token or symbol of peace, the olive branch was represented as such in Genesis 8:11:

And the dove came in to him in the evening; and, lo, in her mouth was an olive leaf pluckt off: so Noah knew

that the waters were abated from off the earth.

A more recent example of its use appears below:

My mother . . . had first tendered the olive branch, which had been accepted. (Frederick Marryat, *Percival Keene*, 1837)

Today this phrase still frequently appears in formal contexts.

9. raise the white flag See 361. SUBMISSION.

10. smoke the peace pipe To make peace; to agree to lay down arms; to bring bickering factions to an agreement. The *peace pipe*, or *calumet*, played an important symbolic role in the rituals of many North Amerian Indian tribes. The pipe, usually two to three feet in length with a reed stem and a bowl carved from stone, had many uses. For example, it was offered to strangers as a token of hospitality. To smoke it meant one could move about the Indian village with complete safety; to refuse to smoke it was an act of hostility that usually resulted in immediate banishment from the village. It was also smoked as a ceremonial symbol of peace between tribes and to seal alliances. The expression has been in use since at least 1691. In modern use it generally indicates the reaching of an accord between business or political factions who have been embroiled in a dispute.

The nation's scientists whose chief tool is the microscope will meet at the Stevens Hotel June 10–12 to smoke the peace pipe. (*Chicago Daily News*, April 28, 1948)

Penalty . . . See **298. PUNISHMENT**

Pensiveness . . . See **378. THOUGHT**

267. PERCEPTIVENESS
See also 17. **ALERTNESS**;
344. **SHREWDNESS**

1. feel a draft To sense negative feelings of others toward oneself; to perceive subtle manifestations of hostility, often racial. This phrase, obviously based on the dual dimensions of physical and emotional coldness, originated in the jazz world.

> The black audience would send a draft toward the Negro leader who hired a white man instead of a black man of comparable talent and stylistic inclination. (*Downbeat*, May 16, 1968)

The British use the expression *feel the draught* to describe a sense of inconvenience or discomfort, often in relation to one's financial situation.

> With only so much national advertising to go round . . . the oldest commercial stations are feeling the draught as well. (*Listener*, June 1966)

2. have [someone's] number To know a person's real motives or intentions; to be a perceptive and astute judge of character; to size another up. The practice of assigning numbers to identify people is the probable source of this expression. Although one's *number* is a superficial designation, the expression connotes a deeper, more profound understanding of a person. *Have [someone's] number* dates from the mid 19th century and is current today.

> Do you remember the day before when he made that crack at you in front of Miss Crozier? I had his number right then. (R. D. Paine, *Comr. Rolling Ocean*, 1921)

3. I wasn't born yesterday Said by one who asserts that he is not a fool, not easily taken in; said by a person who wants to inform another that he is aware of the other's attempt at manipulation. The implication is, of course, that one is not naive or easily misled owing to inexperi-

ence. The expression has been in use since the early 19th century.

> The widow read the letter and tossed it into the fire with a "Pish! I was not born yesterday, as the saying is." (Frederick Marryat, *Snarleyyow*, 1837)

4. know a hawk from a handsaw To be capable of differentiating between two things; to be wise, not easily fooled or duped. *Handsaw* is a corruption of *heronshaw* 'a young heron.' Thus, to differentiate between two similar things implies a more refined intelligence than is suggested by the expression in its present form. Shakespeare used this expression in *Hamlet*:

> I am but mad north-northwest. When the wind is southerly, I know a hawk from a handsaw. (II,ii)

It has also been conjectured that *hawk* refers not to the bird of prey but to a tool like a pickax. In that case, both *hawk* and *handsaw* would denote instruments.

5. know chalk from cheese To be able to differentiate between two things that are superficially alike but essentially dissimilar; to be discerning, to have a keen mind; to know the real thing from a counterfeit. As early as the 14th century, these two words were set apart as opposites.

> Lo, how they feignen chalk for cheese. (John Gower, *Confessio Amantis*, 1393)

The implication is that cheese is superior to or finer than chalk. Thus, to be as *different as chalk and cheese* is to be as different as black and white, or day and night, even though chalk and cheese are similar in appearance.

6. look beneath the surface To go beyond appearances to try to perceive the true nature of something; not to be fooled by superficial glitter or plainness. This proverbial saying is attributed to the Roman Emperor, philosopher, and writer Marcus Aurelius (121–180):

Look beneath the surface; let not the several quality of a thing nor its worth escape thee. *(Meditations)*

7. look through a millstone To be discerning and sharpsighted; to exercise keen powers of perception. A millstone is a large, opaque stone used in grinding grains. Therefore the physically impossible challenge to see through a millstone can be met only figuratively by one of extraordinarily keen perception. The expression appeared in print by the mid-16th century.

Your eyes are so sharp, that you cannot only look through a Millstone, but clean through the mind. (John Lyly, *Euphues and his England*, 1680)

8. read between the lines To understand the implications of another's words or actions; to see beyond the explicit and be sensitive to the implications of subtleties and nuances; to get the underlying message, whether intended or not, regardless of the words that couch it or the actions that convey it. The phrase was once literal; methods of cryptogrammic communication included the use of invisible ink for writing between the lines or the practice of relating the secret message in alternate lines. Thus, *reading between the lines* was crucial to receiving the message sent. Today the expression often refers to an ability to sense an author's tone or a person's ulterior motives.

People who have not the shrewdness to read a little between the lines . . . are grievously misled. (*The Manchester Examiner*, January 1886)

9. read [someone] like a book To perceive another's motives; to understand the subtleties of another's actions; to know a person thoroughly. This expression, dating from the early 19th century, refers to a person's ability to discern another's character, simply by observing him and talking to him, as easily as one can read a book.

That lady, who read him like a book, preserved an appearance of complete

unconsciousness. (George Whyte-Melville, *Uncle John*, 1874)

10. see through [someone] To perceive or understand another person's motives or intentions; to judge another with precision. The quality expressed in this phrase most frequently connotes negativism, i.e., the understanding of ulterior motives or sly intentions. The implication is that the person the speaker *sees through* is not acting charitably but selfishly and surreptitiously. The expression has been in use since the early 16th century.

He is a mere piece of glass, I see through him. (Ben Jonson, *Cynthia's Revels*, 1599)

Related terms, meaning 'astute' or 'sagacious' and dating from about the same time, are *see through a millstone* and *see far in(to) a millstone*.

She thought she had seen far in a millstone when she got a husband. John Heywood, *Proverbs*, 1546.

Another related term, which appeared somewhat later but is still heard today, is *see through a brick wall*.

He could see through a brick wall as well as most men. (Henry Kingsley, *Ravenshoe*, 1861)

Perfection . . .
See 129. EXCELLENCE

Perilousness . . .
See 279. PRECARIOUSNESS

Permission . . . See 154. FREEDOM

Perplexity . . . See 63. CONFUSION

268. PERSEVERANCE
See also 116. ENDURANCE

1. bloody but unbowed Beaten but not subdued; defeated but unyielding; proud in adversity. This expression can be traced directly to William E. Henley, who penned the term while a patient in a tuberculosis hospital:

In the fell clutch of circumstance
I have not winced nor cried aloud.
Under the bludgeonings of chance
My head is bloody, but unbowed.
(*Invictus*, 1888)

Originally intended in a serious vein, the phrase has become so overworked that today it is generally employed in a jocular sense.

2. come hell or high water Come what may, no matter what; also *in spite of hell or high water*. P. I. Wellman in *Trampling Herd* (1939) claims the following as the origin of the expression:

"In spite of hell and high water" . . . is a legacy of the cattle trail when the cowboys drove their hornspiked masses of longhorns through high water at every river and continuous hell between.

Whether originally a cowboy expression or not, *hell* and *high water* symbolize any difficulties or obstacles to be overcome. The expression has been in use since at least 1915.

3. diehard A hardcore supporter; one who struggles and resists to the bitter end, particularly against change or innovation; literally one who dies hard. This expression reputedly had its origin in the Battle of Albuera (1811) where the 57th Regiment of Foot of the British Army fought desperately to maintain a strategic position. In the midst of the fighting, Colonel Inglis is said to have urged his men on by shouting "Die hard! 57th, die hard!" The last-ditch courage and stamina with which the 57th fought that day earned them the nickname the *Diehards*, by which their regiment is known to this day. Use of this term dates from at least 1844.

4. do a Nelson To withstand great danger; to be undaunted by adversity; to maintain one's courage and resolve; to stand firm. This expression became popular in England during World War II, and, strangely enough, refers to the statue of Lord Nelson which stands in Trafalgar Square rather than to the naval

hero himself. The term became almost a catch phrase among the Civil Defense people who served during the 'great blitz' of 1940–42. Laurie Atkinson summed up their attitude in a speech on July 1, 1948:

Knowing that whatever may befall, as upon Nelson on his column in Trafalgar Square, one will, like him, "be there" tomorrow.

5. dog in a doublet A bold, determined man. This phrase alludes to the practice in northern Europe during the Middle Ages of protecting boarhounds with a leather jacket buttoned about their bodies. These dogs presented such a resolute appearance in these doublets that they came to symbolize a determined man. They are pictured in many of Peter Paul Rubens' paintings. A variant of this expression is *as proud as a dog in a doublet*.

Boswell: I think it is a new thought in a new attitude.

Johnson: It is the old dog in the new doublet. (James Boswell, *Life of Johnson*, 1778)

A related expression, *a dog in one's doublet*, is used to signify a false friend.

6. don't give up the ship Keep fighting or trying, hang in there. Although this expression was not new at the time of the Battle of Lake Erie (September 10, 1813) when Commodore Perry adopted it as his battle cry, it was he who popularized the words and made them memorable. The expression has extended beyond its naval origins and application and is now currently used to give encouragement to people in all walks of life.

7. hang in there Don't give up; stick to it; persevere; refuse to give in. This exclamation, used as a phrase of encouragement, is usually addressed to one who is struggling to continue under difficult or adverse circumstances. Although the phrase's origin is unknown, it may come from the world of boxing,

where a fighter, who is tiring near the end of the bout is often told to *hang in there*, literally meaning that he should go into clinches and hand on his opponent to save his energy. The term soon became a part of the general sports vocabulary and rather quickly after that found its way into everyday use as a general term of encouragement to a friend who is suffering from depression or seems about to surrender in the midst of a difficult endeavor.

> The way those tough Bronx mothers wouldn't have quit. The way my mother would have hung in there. (*Playboy*, October 1973)

8. hang tough To persevere; to remain firm in one's resolve; to refuse to give up. This American slang expression dates from about 1970 and probably owes its genesis to the expressions *hang loose* and *hang in there*.

> Chretien decided to hang tough rather than give in to opposition demands for sweeping cuts in personal income taxes. (Ian Urquhart, *Maclean's*, November 27, 1978)

See also **hang in there**, above; **hang loose**, 60. COMPOSURE.

9. happy warrior One who is undaunted or undiscouraged by adversity, a diehard; often used of a politician who is a perennial candidate for nomination or election to high office. The nickname *Happy Warrior* was first applied to Alfred E. Smith, Democratic candidate in the presidential election of 1928.

> He [Alfred E. Smith] is the "Happy Warrior" of the political battlefield. (Franklin Delano Roosevelt, *The New York Times*, June 1924)

The term was later applied to Hubert Humphrey, Democratic candidate for President in 1968 and many times a candidate for the Democratic presidential nomination. The term was first used in the conventional sense of an excellent soldier, a fighter—a meaning which is reflected in its figurative application to political warriors.

10. have scissors to grind To have ends to attain or ambitions to achieve; to have labor to do or a purpose to serve. Not to be confused with the more common *have an ax to grind*, which connotes selfishness, this term deals with one's aspirations and duties in life, and most commonly connotes "We all have problems in life, and I must get on with solving mine; I don't have time for yours."

11. hold [one's] ground To firmly maintain or defend one's position; to resist the pressure to compromise one's ideals. Although this expression can refer to maintaining ground literally, as in a battle, it is more frequently heard in regard to defending a philosophical stance. The two levels of usage are related, however, because even in war there is a philosophical basis for defending one's *ground*, meaning 'territory, land,' etc. This expression and its variants *keep* or *stand one's ground* appeared in print by the 17th century.

> It is not easy to see how it [Individuality] can stand its ground. (John Stuart Mill, *On Liberty*, 1859)

12. keep a stiff upper lip To keep one's courage when confronted with adversity, to remain resolute in the face of great difficulties, not to lose heart. The allusion is to the quivering of the upper lip when a person is trying to maintain control and keep from crying in the face of danger or great emotional stress.

> "What's the use o' boohooin'? . . . Keep a stiff upper lip; no bones broke—don't I know?" (John Neal, *The Down Easters*, 1833)

The expression dates from the early part of the 19th century.

13. keep [one's] chin up To maintain one's courage and resolve, to keep one's spirits up, to keep one's head held high. This American expression has been in use since at least 1938.

> Keep your chin up honey. (I. Baird, *Waste Heritage*, 1939)

14. keep [one's] nose to the grindstone To persist in an unpleasant task; to labor continuously, especially at hard, monotonous work; to labor unceasingly; to drudge. The allusion is perhaps to laborers hovering over grindstones or whetstones to sharpen tools made dull from constant use. The expression and variants, which date from at least 1532, originally meant to oppress someone else by exaction of labor.

15. keep [one's] pecker up To *keep one's chin up,* to hold one's head high, to keep one's spirits or courage up. In this British slang expression *pecker* means 'spirits, courage.' It probably derives from the term *pecker* for a bird's beak or bill. Cockfighting is sometimes cited as the source of the phrase, since a gamecock's pecker or beak sinks when he is tired and near defeat. Thus, the expression literally means to keep up one's beak (British slang for *nose*). This of course cannot be done without keeping the head and chin up as well. The expression, which dates from at least 1853, is avoided in the United States, where *pecker* has an altogether different and vulgar slang meaning.

16. nail [one's] colors to the mast To fight or hold out until the bitter end; to refuse to compromise, concede, or surrender; to persist or remain steadfast, especially in the face of seemingly overwhelming opposition. It has long been nautical custom for a ship to signify its nationality or allegiance by flying that country's colors (i.e., flag) from its tallest mast. In battle, a captain could signal his surrender or defeat by lowering the flag. If the colors were nailed to the mast, however, they could not be lowered, implying that surrender was not possible.

If they catch you at disadvantage, the mines for your life is the word, . . . and so we fight them with our colours nailed to the mast. (Sir Walter Scott, *The Pirate,* 1821)

17. praise the Lord, and pass the ammunition Keep up the struggle, don't give up. This expression, although rarely used today, was the title of a popular song during World War II. It has been attributed to Chaplain Howell Forgy, who was on board the cruiser *New Orleans* in Pearl Harbor at the time of the Japanese attack in 1941. During the assault the chaplain helped fuel a counterattack by carrying ammunition to the ship's guns. He is purported to have said the now famous words "Praise the Lord, boys—and pass the ammunition."

18. the show must go on One must persevere; one must be undaunted by adversity; the public must be served. Contrary to popular belief, this expression had its origin in the circus, not in the theater. In case of an emergency, such as a fire, the band was to continue playing, the troupers to continue performing, with the hope that the audience, thus distracted, would not panic. Today, the term is common in theater usage with the sense that in spite of injury or illness a performer should not disappoint the audience nor fail his fellow troupers.

The hotel business is like the theatre. No matter what happens, the show must go on. (R. Holden, *Speak of the Devil,* 1941)

19. stick to [one's] guns To stand firm; to persist in one's point of view, argument, or beliefs; not to yield or give in; to hold one's ground.

An animated colloquy ensued. Manvers stuck to his guns. (Mrs. Alexander, *Brown, V.C.,* 1899)

Of military origin, this phrase was originally *to stand to one's gun(s),* meaning literally to stand by one's gun, to keep fighting no matter what.

Persistence . . .
See **268. PERSEVERANCE**

269. PERSONAGES
See also 358. STATUS

1. big brass V.I.P.'s; high-ranking officials, either military or civilian. The phrase, which appeared in the *Boston Herald* in 1899, referred to the gold braid or insignia on the uniforms of high-ranking military officers. The term is now commonly applied to both military and civilian officials, and often appears simply as *the brass*. A related term for military and naval officials is *brass hat*.

2. Big Brother Someone supportive and protective; one who befriends a fatherless or delinquent boy; watchful and dictatorial officialdom. This expression has followed a rather circular course in its connotative suggestions. Originally the term was applied to any male who demonstrated a loving, protective concern for a younger person, especially another male. With the popularity of George Orwell's novel *1984*, the term's connotation underwent abrupt pejoration. *Big Brother* in the novel represents a dictatorial tyrant whose omnipresence reaches into the inner recesses of each citizen's mind. He symbolizes absolute control by government. Quickly adopted into everyday speech, *Big Brother* implied any governmental intrusion into personal freedom. In the United States the expression was used of the IRS, the CIA, and especially the FBI, by those objecting to the policies of these agencies. In its August 16, 1975, edition, the *Washington Star* offered the following comment about Clarence Kelley, head of the FBI:

> Kelley's Big-Brother-is-watching-you philosophy, in the name of national security, smacks of police-state dictatorship rationale.

Recently the term has been used extensively with its original implication, probably because of the advertising campaign of the Big Brother organization, a charitable group whose function is to provide surrogate fathers for fatherless boys.

3. big shot An important or influential person. Although the exact origin is unknown, this expression is most likely a derivative of the earlier *big gun*, in use since 1834, and the phrase *carry big guns*, since 1867. Still widely used today, this term dates from the 1930s.

4. big wheel An important or influential person. In use since 1950, this term is thought to have come from the mechanics' expression *roll a big wheel* 'to be powerful or important.' Other similar phrases include *big bug* (since 1827), *cheese* or *big cheese* (since 1920), and the equivalent French term *grand fromage*. All but *big bug* are still in popular use today.

5. bigwig A person of importance and prominence, so called from the days when aristocrats and other men of note wore powdered wigs, somewhat more ponderous than those still worn by barristers and judges in England. According to one source, the larger the wig, the more important the person. The term is usually used contemptuously or humorously. It appeared in its present figurative meaning as early as the 18th century:

> Though those bigwigs have really nothing in them, they look very formidable. (Robert Southey, *Letters*, 1792)

6. chief cook and bottle washer One who manages a menial operation, wearing different hats to accomplish whatever needs to be done; often used in reference to the wife and mother of a family. The origin of *chief cook and bottle washer* is not known. It may have originated as military jargon, or, as has been speculated, the phrase may be a derivative of *chiff chark and bottle washer*, found occasionally as a listing in old Salem logs. *Chiff chark* is a name for a variety of Russian wine glass. The expression has been in use since the beginning of the 19th century.

7. chief itch and rub The most important person; head honcho; big wheel or big deal; the "alpha and omega." One possible explanation for this phrase relates to the role of a leader as an instigator, one who stirs up interest and sees to it that what needs to be done is accomplished. In this capacity, a leader is considered a source of irritation, an *itch*. *Rub* could be a synonym for *itch* (emphasizing the nagging, irritating characteristics of a leader), or it could mean 'to soothe or relieve an itch.' This would refer to the role of a leader as a mediator or reconciler. Another very different explanation is that having the problem and solution (itch and rub) contained in one person precludes the need for other people. Such a self-sufficient person would be recognized as leadership material, or in slang terms, *chief itch and rub*.

8. fat cat A wealthy and influential person, especially one who finances a political campaign or candidate; a bigwig or name in any field. In this expression, *cat* is used in a mildly derogatory sense; *fat* implies that the wealthy lead lives of self-indulgence and thus tend toward obesity. In contemporary usage, however, *fat cat* does not always carry its original connotation of the stereotypical wealthy politician's physical appearance.

> Hollywood celebrities and literary fat cats . . . (Bennett Cerf, *Saturday Review of Literature*, April 16, 1949)

9. high-muck-a-muck American slang for an important or high-ranking person, especially one who is pompous or conceited. The term is from Chinook Indian jargon *hiu muckamuck* 'plenty [of] food.' Its current figurative use dates from 1856.

10. high priests of technology A jargon-spouting specialist; a technical expert who baffles his audience with arcane vocabulary. This recently coined expression alludes to the use of foggy technical jargon by some experts to becloud the general public's understanding of complicated issues. Such *high priests* are often accused of concealing their own uncertain comprehension of a situation by obscuring the facts with unintelligible language.

> Specialists who talk in such lanaguage were described as high priests of technology. (*Hartford Courant*, November 26, 1981)

11. his nibs A person of importance, often the boss, chief, or head honcho; a self-important person, a puffed-up egotist; also *her nibs*. The expression may derive from a little-used slang term of the mid 19th century: *nib* 'gentleman.' It is usually used contemptuously.

> I wish I could just lie on a bed and smoke, like His Nibs. (H. Croome, *Forgotten Place*, 1957)

12. honcho The leader or boss; the person in charge; also *hancho* or *head honcho*. This American slang term was picked up by U.S. Armed Forces stationed in Japan during the occupation, and gained currency during the Korean conflict. It is from the Japanese *hanchō* (*han* 'squad' + *chō* 'chief') 'squad or group leader,' and has been in use since 1947.

13. kingpin The most critical person in a business or project; leader, chief. In bowling, the kingpin is the foremost, number one pin which, if hit correctly, causes the other nine pins to fall. Correspondingly, the expression is figuratively used in reference to a bigwig whose elimination would bring about the collapse of an enterprise or undertaking.

> The owner of three shops was the kingpin behind a wholesale shoplifting plot. (*Daily Telegraph*, October 1970)

14. leading light An important or influential person; a leader. *Leading light* is a nautical term for a lighthouse or other visible beacon (such as a buoy) that helps guide a sailor or pilot into port. The figurative implications are obvious.

15. name to conjure with, a A person so powerful and influential that the mere mention of his name evokes awe and respect and can work magic. The term's conceptual origin lies in the notion that only the names of important personages could conjure up the spirits of the dead.

> Write them together, yours is as fair a name;
> Sound them, it doth become the mouth as well;
> Weigh them, it is as heavy; conjure with 'em,
> Brutus will start a spirit as soon as Caesar.
> (Shakespeare, *Julius Caesar*, I,ii)

The actual wording *a name to conjure with* dates from the late 19th century; it is still widely used.

> His name, little known to the public, is one to conjure with in Hollywood. (Iris Murdoch, *Under Net*, 1954)

16. old warhorse An old military campaigner; a veteran politician. Originally used in reference to a horse that was battle-wise and could be counted upon in times of stress. During the 1800s this term took on the figurative application of a veteran public dignitary, usually of a military or political persuasion. In recent years it is commonly heard to describe one hardened in the ways of political campaigns or one resolute in his political philosophy.

> Which reminds us of the well-known admission of the party 'warhorse' that he would vote for the enemy of mankind if he got the regular party nomination. (*American*, 1884)

17. panjandrum A personage of great pretensions; an imaginary character of great authority. Samuel Foote, an 18th-century dramatist and actor, created this word as part of a passage to test another actor's mnemonic claim. When Charles Macklin declared that he could hear any passage once and repeat it word for word, Foote constructed a long farrago which included the following excerpt:

> . . . and there were present the Picninnies, and the Joblillies, and the Garyulies, and the Grand Panjandrum himself, with the little round button at the top.

It is said that when Macklin was presented with the passage that he threw it down in disgust and stormed from the room. However, Foote, without knowing it, had succeeded in adding another useful nonsense word to the language.

18. straw boss An assistant boss or supervisor, especially one who gives orders but lacks the status, power, or authority to enforce them; a laborer who acts as leader or foreman of a crew of fellow workers. This expression originated with the custom of a boss's supervising the loading of grain into a thresher while his assistant, the straw boss, watches the end-products as they leave the machine—a nominal job at best, and one that involves little responsibility. The term is commonly applied in nonagricultural contexts to an immediate supervisor who oversees and often participates in the work, but who is himself answerable to a person in a higher position.

> These employees . . . [having suffered] the continual oppression of the "straw bosses" . . . were in no condition to be trifled with by the Company. (William Carwardine, *The Pullman Strike*, 1894)

19. toast of the town A person who is, at the moment, the most celebrated figure in the community; the outstanding personage in the eyes of one proposing a toast. This expression, dating from at least the 15th century, arises from the old custom of toasting, i.e., putting a piece of spiced toast in a drink to add flavor. In *Merry Wives of Windsor* Falstaff ordered:

> Fetch me a quart of sack, put a toast in't. (III,v)

When a person became famous, especially a lady, toasts were drunk to her health, and she became the toast of the

town. Today the expression has come to mean anybody who is momentarily the subject of the community's admiration.

Sizzle places Loni Anderson in 1927 . . . avenging her fiance's murder and . . . becoming the toast of the town. (*TV Guide,* "This Week's Movies," November 29, 1981)

20. top banana The best in a particular field; the senior or leading comedian in musical comedy, burlesque, or vaudeville. This American slang term, in use since the 1950s, is said to have come from the soft, water- or air-filled banana-shaped club carried by early comedians. These were used in slapstick routines for hitting other comedians over the head.

21. top dog The boss, the person in charge; the best, number one.

22. V.I.P. An important or well-known person; a big shot. This widely used expression is an abbreviation of *Very Important Person.* It was first used during World War II by an army officer who was arranging a secret flight of dignitaries to the Middle East. To avoid disclosing their identities, he listed each of them as *V.I.P.* on his transport orders. This appellation became an almost overnight sensation and though most frequently used to describe an officer, executive, or politician, *V.I.P.* has, over the years, been applied to virtually anyone in a position of importance.

23. wheeler-dealer A person of importance or authority, usually in the business world, especially one who makes bold agreements and decisions with little hesitation; a sharp operator. This American slang expression has been in popular use since the mid 1950s, originating, perhaps, as early as World War II. Apparently an extension of the term *big wheel,* which comes from the mechanics' expression *roll a big wheel,* i.e. 'to hold an important position,' a *wheeler-dealer* frequently indicates a man who takes over control of an established business

and operates it according to his own desires and methods.

270. PERSPECTIVE

See also 245. NIT-PICKING

1. by and large From an overall perspective; on the whole; in general; without going into details. The origin of this phrase and its current literal use are both nautical. It means to sail to the wind and slightly off it, or with the wind near the beam.

Thus you see the ship handles in fair weather and foul, by and large. (Samuel Sturmy, *The Mariner's Magazine,* 1669)

By and large was used figuratively as early as 1706 in Edward Ward's *Wooden World Dissected.* The jump from literal to figurative use is difficult to follow. This method of sailing is generally faster, a bit safer and easier (it offers less chance of being "taken aback" than sailing directly "by the wind")—on the whole, better in the long run. It is the quality of being preferable 'on the whole' or 'in general' (even if a detailed analysis proved otherwise) that is transferred to nonnautical situations.

The virtue of sound broadcasting was that, by and large, the content mattered more than anything else. (*The Times,* May 23, 1955)

2. change of scene A holiday away from home; a trip to another country; pulling up stakes and moving to a new place; a new job. This expression, dating from at least the 16th century, had its beginnings in the theater where a change of scene put an entirely different complexion and setting on the action. The term was soon applied figuratively to situations in everyday life.

Everything I see seems to me a change of scene. (Mary Wortley Montagu, *Letters,* 1716)

3. in the long run In the end, when all is said and done; from the perspective of knowing the outcome or end result. This

expression alludes to a long-distance race in which runners who start slowly and conserve their energy often pull ahead and win the race, as in the story of the tortoise and the hare.

4. not see the forest for the trees To be so concerned with details as to lose a sense of the larger whole; to ignore the obvious, to miss the main point; to have tunnel vision. This expression appeared in print by the 16th century, at which time *wood* was used instead of *forest*. Today *wood, woods,* and *forest* are used interchangeably.

5. number the streaks of the tulip To be overly concerned with details and thereby miss the main point. This expression derives from Imlac's dissertation on poetry in Johnson's *Rasselas,* in which he contends that a poet should be concerned with the general rather than the particular. A related current expression is *not see the forest for the trees.*

6. over the long haul See the long haul, 110. DURATION.

7. stumble at a straw To become bogged down in petty details; to suffer a setback because of a minor or trifling incident. This expression is derived from a proverb cited in *Homilies* (1547):

They were of so blind judgment, that they stumbled at a straw and leaped over a block.

The implication is that either as a result of misplaced priorities or poor judgment, a person may concentrate on the picayune while ignoring issues of greater significance.

He that strives to touch the stars
Oft stumbles at a straw.
(Edmund Spenser, *The Shepheardes Calendar,* 1579)

8. trade off the orchard for an apple Not to see the forest for the trees, to be myopic; to be so concerned with details that one loses sight of the larger whole.

9. tunnel vision A narrowness of viewpoint; a restricted perspective; a limited view of a problem. This phrase, adapted from medical terminology, has been in figurative use since about 1970. A person suffering from the medical condition known as *tunnel vision* is one whose range of vision is restricted to 70% or less from the rectilineal position, thus eliminating peripheral vision. Metaphorically, the term designates one who refuses to consider different sides of an issue.

Like most single-minded policies, this one too suffers from the tunnel vision of its perpetrators. (*Science,* February 20, 1978)

Pettiness . . . See 245. NIT-PICKING

271. PHYSICAL APPEARANCE
See also 72. CORPULENCE;
272. PHYSICAL STATURE;
398. VISAGE

1. bag of bones A very thin person; someone who has become extremely emaciated. This bit of hyperbole, dating from the early 19th century, implies that a person or animal has lost all its fat and muscle so that nothing remains but skin and bones. It is usually used in a jocular context.

Get down stairs, little bag o' bones. (Charles Dickens, *Oliver Twist,* 1838)

2. bald as a coot To be so bald as to resemble a coot. The coot has a straight and slightly conical bill whose base extends onto the forehead forming a broad white plate. Anyone whose pate resembles a coot's forehead is said to be *bald as a coot.* This phrase was used as early as 1430, as cited in the *OED.*

3. bandy-legged Bowlegged; having legs curved laterally, especially with the convex side outward. This expression is probably derived from the old Irish game called *bandy,* a game similar to modern ice hockey or field hockey, where the player used a stick with a

curve at the end to impel a hard wooden ball. Since the stick itself was called a *bandy*, the transference of the word to a person with legs of similar shape was an easy step. The expression has been in use since the early 17th century.

> Nor makes a scruple to expose your bandy legs, or crooked nose. (Jonathan Swift, *Works*, 1755)

4. beauty is only skin deep Strength of character is more important than pleasing outward appearance. This proverbial expression, in use since the early 1600s, has in recent years been subjected to some humorous variations. Saki (H. H. Munro) in *Reginald's Choir Treat* (1904) added a wry twist:

> I always say beauty is only sin deep.

And Redd Foxx on his television show came to the defense of the saying.

> Beauty is only skin deep, but ugly goes right to the bone.

5. black as isel Dark as soot; black as cinders. This expression, found only in dialectal use today, dates from the Dark Ages. The *OED* dates the earliest written example found at approximately 1000. The word *isel*, derived from the Anglo-Saxon *ysel*, designates particles of soot or burned out embers.

> Killmoulis . . . often torments the goodman sorely by throwing isels or ashes out when sheelin or shelled oats are spread out to dry. *(The Reader*, December 15, 1866)

A variant is *black as itchul.*

6. black as the devil's nutting-bag This expression dates from at least the mid 1600s and is a direct allusion to an old superstition.

> The devil as some people say, A-nutting goes Holy Rood day. (*Poor Robin's Almanack*, 1693)

Historically the young people of England have gone nutting together on Holy Rood Day, September 14th. Whether the warning was sincere and it was actually believed the young people might

meet the devil and be swept into the darkness of his nutting-bag, or whether it was a method of frightening the young, thereby lessening the possibility of sexual temptation, is not certain. Whatever the case, the expression is seldom, if ever, heard today.

7. blush like a black dog Not to blush; to have a brazen mien; to be shameless. The allusion in this expression, coined in the late 16th century, is probably to the devil, who supposedly assumes the form of a black dog on occasions.

> A black saint can no more blush than a black dog. (Thomas Adams, *Sermons*, 1629)

A variant of later inception is *blush like a blue dog*, in which *blue* is used in a sense suggestive of immorality.

> You'll make Mrs. Betty blush. Blush! ay, blush like a blue dog! (Jonathan Swift, *Polite Conversation*, 1738)

8. bottlearse A person broad in the beam; thicker in one end than the other. This expression, dating from the latter half of the 18th century, refers to handcast letters in the printing trade. These letters, thicker at one end, were known as *bottlearse letters*. The transference to humans with the same physical appearance took place shortly thereafter.

> Bottlearsed, type thicker at one end than the other—a result of wear and tear. (John Farmer and William Henley, *Slang and its Analogues*, 1890)

A common variant is *bottleass.*

9. cauliflower ear This expression refers to a deformed, puffy ear, usually the result of a boxing or wrestling injury. The inordinate growth of reparative tissue actually gives the ear the appearance of a cauliflower. The term, in use since the early 1900s, is an acceptable medical designation.

> Cauliflower ears attest to his earlier ring career about the time of Jeffries and Britton. (*Chicago Sun*, December 26, 1947)

10. deadpan An expressionless or blank face, a poker face; to show no emotion; to display a completely expressionless face. This American slang term, which is frequently used to characterize a comic ploy, has been in use since about 1830. *Pan* in this phrase refers to the face, probably not, as some sources say, because it is broad, shallow, and often open, but more likely from the use of pans in lieu of mirrors. Since, other than water, pans were often the only mirror-like objects that early pioneers had, it is at least conceivable that the use of *pan* for *face* came from them, and that *dead pan* is a surviving illustration of this usage with the addition of the adjective *dead* in one of its usual senses.

> It's enough to make even deadpan Gromyko laugh. (*New York Daily News*, September 12, 1951)

11. flat as a pancake Flat; having a surface that is free from projections or indentations. Though usually used literally, this expression is sometimes employed in its figurative sense to describe something that is flatter than it should be or flatter than one would expect. In his play, *The Roaring Girl* (1611), Thomas Middleton used the expression to describe a woman with small breasts.

12. freckled as a turkey's egg This expression describes one whose face or body is liberally sprinkled with freckles. The turkey, a fowl of relatively recent domestication, lays an egg with protective coloration, buff and spotted. The phrase, of American origin, dates from the early 1800s.

13. Fu Manchu mustache A long, thin mustache that hangs down from the sides of the mouth. This expression alludes to a malevolent Chinese physician found in the novels (1932–1948) of Sax Rohmer, a British mystery writer. Doctor Fu Manchu, a sort of Oriental underworld leader, presented a sinister image to the world with his drooping mustache and long fingernails. The expression has been in use since the late 1930s.

Roman is a boat bum, at 32, he wears shoulder length hair, Fu Manchu mustache, and glasses thick enough to burn holes in the mainsail. (Peter Wood, *The New York Times Magazine*, September 5, 1976)

14. handsome is that handsome does A saying implying that skillfulness of execution is what counts, not merely one's appearance or one's promises. This popular proverb contends that a man's worth is measured by the quality and quantity of work he produces, not by his being agreeable to the eye or dignified of mien. The first recorded use of this term found in the *OED* is:

> She would answer, "they are as heaven made them—handsome enough, if they be good enough; for handsome is that handsome does."

A common variant is *handsome is as handsome does*. However, other forms of the term preceded its use by many years. In the *Wife of Bath's Tale*, Chaucer wrote:

> That he is gentil that doth gentil dedis . . .

and in 1580, the proverb appeared in *Sunday Examples* as:

> Goodly is he that goodly dooth.

15. homely as a mud fence Extremely plain or crude in appearance. This American expression, dating from the 1830s, alludes to the crude fences made of earth built by the pioneers in the prairie states. Since lumber and rocks of suitable size were in short supply, the building of such rather formless mud fences was a practical solution for enclosing farm animals or marking property lines.

> He didn't care whether she was as beautiful as Lana Turner or as homely as a mud fence. (*Chicago Tribune*, May 29, 1948)

A variant of this term is *homely as a hedge fence;* sometimes the form is *ugly as a mud fence.*

16. hunker down To squat close to the ground with the weight resting on the calves of the legs. This phrase, in use since at least the 18th century, may be derived from the Dutch *huken*, meaning 'to squat or to sit upon one's hams'; the etymology is uncertain. Although people don't *hunker down* so much today, the term conjures up a picture of rustic conviviality, of farmers with time on their hands engaged in conversation before a general store.

> Tir'd wi' the steep an' something
> dizzy, I hunker'd down. (David
> Davidson, *Thoughts on the Seasons*,
> 1789)

A related term, *on one's hunkers*, means to be in a squatting position.

17. in the buff Nude; naked; in one's birthday suit; ready for action. In this expression, which first appeared about the 15th century, the key word is *buff*, a type of leather made from the hide of a buffalo, elk, or, most commonly, ox. Treated with oil, the hide assumes a color similar to that of human skin, a tannish-white.

> Stripping ourselves to the buff, we
> hung up our steaming clothes.
> (Clarence King, *Mountaineering in
> the Sierra Nevada*, 1872)

Today the phrase, and a variant, *stripped to the buff*, have the additional meaning of one 'thoroughly prepared for action,' with allusion to the boxing ring or gymnasium. Theodore Roosevelt, running on the Progressive Party ticket, proclaimed in a 1912 interview:

> My hat's in the ring. The fight is on
> and I'm stripped to the buff.

A related term, *in one's birthday suit*, dates to the late 18th century and is a jocular allusion to the nudity of birth.

18. in the pudding club Pregnant; great with child. The original English pudding was a mixture of ground meat, oatmeal, seasoning, and, if desired, a few vegetables, packed into the stomach or entrails of an animal, usually a sheep or

pig, and boiled separately or roasted within the animal. The parallel here is, of course, to the similarity in appearance between an animal stuffed with a pudding and a pregnant woman. Related terms are *join the pudding club*, 'to become pregnant'; *be put in the pudding club*, 'to make pregnant'; *preggers*, and *preggy*, both slang terms for 'pregnant.' All these terms are of British origin.

> There was your bag, simply preggy
> with bank notes, lying there on the
> writing table. (Ngaio Marsh, *Death in
> a White Tie*, 1938)

In Australia the slang term for 'pregnant' is *prego*.

19. naked ape A man; the human animal. Although man has been called a *naked ape* for many decades, especially since Charles Darwin's *The Origin of the Species* (1859) was published, the use of the term became even more popular when Desmond Morris's *The Naked Ape* appeared in 1967.

> There are one hundred and ninety-
> three living species of monkeys and
> apes. One hundred and ninety-two of
> them are covered with hair. The
> exception is a naked ape self-named
> *Homo sapiens*.

20. Newgate knocker A lock of hair twisted into a hard curl and worn back from the temple toward the ear. This expression originated with a practice of the criminals in Newgate prison. They twisted their hair *knocker* style, so named because in appearance it resembled a door knocker. The term came into use in the late 1700s. The *OED* lists as the first written use:

> As for the hair they say it ought to be
> long in front and done in figure six
> curls or twisted back to the ear
> Newgate knocker style. (Henry
> Mayhew, *London Labour and the
> London Poor*, 1851)

A number of related terms developed from this practice. *Black as the knockers of Newgate* alludes to the lot of the Newgate inmates, *hard as the knockers of*

Newgate refers to the degree of intensity of the braiding, and Newgate fringe designates the fringe or beard under the chin located where the hangman's rope will adjoin. A Newgate frill is another name for Newgate fringe.

21. pilgarlic A bald-headed man; an unfortunate, pitiable wretch. Originally peeled garlic, the term was applied to one whose hair loss was due to disease (venereal by implication) and whose naked scalp supposedly resembled the flaky, shiny bulb of that plant. Eventually pilgarlic came to be applied to persons deserving of contempt or censure, probably because of the reputed source of the affliction. It was often used in a quasi-affectionate way, however; frequently for oneself, as in the following passage from Rabelais's Pantagruel (1532):

> Never a bit could poor pilgarlic sleep one wink, for the everlasting jingle of bells.

22. plugugly See 76. CRIMINALITY.

23. a shadow of [one's] former self Said of one who has become extremely feeble or emaciated. This expression uses shadow in the sense of something that resembles the original but lacks substance, thus implying that a person has been reduced to a mere shadow, either through the ravages of disease, aging, stress, etc., or by choice. The expression is sometimes shortened to shadow of oneself.

> He appeared to wither into the shadow of himself. (Sir Walter Scott, Guy Mannering; or The Astrologer, 1815)

A shadow of one's former self is sometimes used complimentarily in good-natured reference to a formerly corpulent person who has lost weight as a result of dieting.

24. starkers Nude; in the altogether; also, starko. This British colloquialism, a variation of stark naked (itself a corruption of start naked), has been in use since about 1910.

The salesgirl had taken away all her clothes and hidden them. It was only the threat of running starkers into the street that brought them back. (Brigid Keenan, in The Sunday Times [London], September 1964)

25. ugly duckling See 325. REVERSAL.

26. widow's peak See 398. VISAGE.

272. PHYSICAL STATURE
See also 271. PHYSICAL APPEARANCE

1. dandiprat A dwarf, midget, or pygmy. This archaic word was originally the name of a three halfpence coin issued in 16th-century England. It took on its present meaning when Richard Stanyhurst referred to Cupid as a dandiprat in his 1582 translation of the Aeneid.

2. go-by-ground A very tiny person, a homunculus, a Lilliputian. This obsolete expression is obviously derived from the little distance between the earth's surface and a small person's head.

> I had need have two eyes, to discern so petit a go-by-ground as you. (Copley's Wits, Fits, and Fancies, 1614)

3. hop-o'my-thumb A diminutive person, a midget or pygmy; a mean, small, contemptible person, fit only to be ordered about and looked down upon. In early usage the term was primarily one of contempt; but, perhaps through confusion with Tom Thumb, it has become increasingly descriptive and less offensive, indicative of small stature rather than lowly status.

4. humpty-dumpty A deformed, dwarfish person; a short, dumpy individual. This term, frequently used as a physical description, is also used to describe one who shatters easily and cannot be restored. The allusion, of course, is to the character in the well-known nursery rhyme.

She . . . could not, by all the miracles of millinery, be made other than a humpty-dumpty. (John W. Sherer, *At Home in India*, 1883)

Humpty-dumpty was also once the name of an alcoholic drink that was first concocted in the late 1600s.

They drank humpty-dumpty, which is ale boiled with brandy. (Benjamin Disraeli, *Venetia*, 1837)

5. knee-high to a grasshopper Very short or small, especially because of a young age. This popular American expression and its many variants are jocular extensions of the simpler term *knee-high*, in use about 70 years before the earliest extended variant.

You pretend to be my daddies; some of you who are not knee-high to a grasshopper! (*The Democratic Review*, 1851)

273. PLACATION
See also 266. PEACE

1. balm in Gilead A comfort in time of affliction; oil on troubled waters. This expression can be traced directly to the Bible, where Jeremiah, aware of the Lord's approaching vengeance upon his people, is lamenting their condition.

Is there no balm in Gilead; is there no physician there? (Jeremiah 8:22)

The allusion here is to *balm*, a corruption of *balsam*, the resinous product of the balsam tree, which affords soothing relief to various aches and pains. The popularity of the phrase can probably be attributed to Edgar Allan Poe's *The Raven* (1845).

"On this home by Horror haunted—
tell me truly, I implore—
Is there—is there balm in Gilead?—
tell me—tell me, I implore!"
Quoth the Raven "Nevermore."

2. let sleeping dogs lie To avoid any word or action that could disturb a person or situation which is, for the moment at least, peaceful and calm; to re-frain from resurrecting an issue, discussion, argument, or other matter which had previously aroused heated emotional debate or controversy. The implication here is that, if a sleeping dog is awakened, it may respond by snapping or biting.

It is good therefore if you have a wife that is . . . unquiet and contentious, to let her alone, not to wake an angry Dog. (Edward Topsell, *The History of Serpents*, 1607)

3. mend [one's] fences See 275. POLITICS.

4. pour oil on troubled waters To calm or pacify with soothing words or acts.

His presence and advice, like oil upon troubled waters, have composed the contending waves of faction. (Benjamin Rush, *Letters*, 1786)

Pouring oil on rough waters does indeed serve to quiet the waves, though perhaps not to the extent recounted by the Venerable Bede in his *Ecclesiastical History* (731). He relates the story of a priest sent to fetch the bride-to-be of King Oswy. Before the priest's departure, Saint Aidan warned him of a violent storm and gave him a bottle of oil that he was to pour on the sea when the water grew rough. As predicted, a great tempest came up during the voyage; when the priest poured his vessel of oil on the turbulent waters, they became calm.

5. smooth ruffled feathers To calm or soothe an upset or angry person; to assuage, pacify, placate; to help someone regain his composure; to reconcile. Alluding to the erect feathers of an angry bird, this expression describes the action of one who mediates a dispute or otherwise calms an agitated or angry person. See also **ruffle feathers, 394. VEXATION.**

6. a sop to Cerberus See 38. BRIBERY.

Pleasure . . . See 117. ENJOYMENT

Plenty . . . See 5. ABUNDANCE

274. PLOY

See also 384. TRICKERY

1. ace up [one's] sleeve A surprise; something of special effectiveness that is held in reserve or hidden from others; a trump card; sometimes *card up one's sleeve*. Very similar to an *ace in the hole*, this expression comes from the cardsharper's stratagem of hiding needed cards (e.g., aces) in his sleeve until the most advantageous moment to play them. By extension, it has come to mean any secret asset or ploy.

2. bag of tricks All of one's resources; the means to an end. This phrase derives from La Fontaine's fable of the fox and the cat.

> But fox, in arts of siege well versed,
> Ransacked his bag of tricks accursed.
> (Elizur Wright, trans., *La Fontaine's Fables*, 1841)

Bag of tricks can refer to one's survival techniques in general, or to a specific design one might have up one's sleeve.

> Men were all alike. A woman didn't have to carry a very big bag of tricks to achieve her purpose. (L. C. Douglas, *White Banners*, 1936)

3. bottom of the bag The last resort or expedient in one's bag of tricks; a trump card held in reserve; an ace up one's sleeve. Thomas Burton used the phrase in his *Diary* in 1659:

> If this be done, which is in the bottom of the bag, and must be done, we shall . . . be able to buoy up our reputation.

4. have [something] up [one's] sleeve To have a secret scheme or trick in mind, to have a surprise planned. The allusion is probably to the way magicians use their sleeves as convenient hiding places for the articles employed in executing their feats of magic.

5. ladies of Barking Creek This expression refers to women who refuse to engage in sexual intercourse, feigning their menstrual cycle as an excuse. The

term is derived from the opening line of a well-known limerick from about 1910.

6. patch the lion's skin with the fox's tail To employ craft when force will not work. This saying has been ascribed to Lysander, the famous Spartan commander, who, when told that he should not wage war by deceit, was said to reply, "Where the lion's skin will not reach, it must be patched out with the fox's." The expression has been employed in English since the Middle Ages, but is seldom heard today.

> The Duke of Savoy . . . though he be valiant enough, yet he knows how to patch the lion's skin with a fox's tail. (James Howell, *Letters*, November 30, 1621)

7. red herring A diversionary tactic or misleading clue, a subject intended to divert attention from the real issue; a false trail; from the phrase *draw a red herring across the trail*. In the 17th century, dog trainers followed this practice to sharpen the scent discrimination of hunting hounds. Smoked herring drawn across the trail of a fox is said to destroy or markedly affect the original scent. Figurative use of the term outside the complete phrase dates at least from the late 19th century.

> The talk of revolutionary dangers is a mere red herring. (*Liverpool Daily Post*, July 11, 1884)

8. roorback A falsehood published and circulated for political effect. This expression originated in 1844 during the successful campaign of James K. Polk to become the 11th President of the United States. In order to frustrate Polk's chances of election, a group of opponents circulated a falsehood damaging to his reputation. The falsehood involved a fictitious traveler named Roorback who supposedly had written a book of travels in 1836 entitled *Tour through the Western and Southern States*. In this nonexistent book, he had supposedly revealed an incident disparaging to Polk's character. The entire deception was ultimately

revealed, but the term has remained in use since that time as a synonym for political duplicity.

He saw the headlines in the other papers calling it a roorback and him a fool. (Samuel Blythe, *The Fakers*, 1913)

9. sit up with a sick friend An expression intended as an excuse to step out on one's spouse or fiance(e) for a night with a member of the opposite sex; an excuse used to get away from one's mate for a night. This American and British colloquial phrase has become so trite that today it is almost always heard as a jocular expression to taunt one who did not make it home on a certain night, whatever the reason. It has been in use since at least the mid 1800s.

10. springes to catch woodcocks Snares for the unsuspecting; traps for the unwary. This expression appears in Shakespeare's *Hamlet* (I,iii), when Polonius warns Ophelia that Hamlet's protestations of affection are but the wily words of a youthful lover, meant to ensnare his naive victim: "springes to catch woodcocks," he calls them. The phrase usually refers to a deceitful ploy.

Alas, poor woodcock, dost thou go a birding? Thou hast even set a springe to catch thy own neck. (John Dryden, *Wild Gallant*, 1663)

11. stalking horse Anything used to conceal a design or scheme, a pretext; a person who serves as a means of allaying suspicion or obscuring an ongoing activity; the agency through which an underhanded objective is attained. The expression appeared in Shakespeare's *As You Like It:*

He uses his folly like a stalking horse, and under the presentation of that he shoots his wit. (V,iv)

In bygone days, hunters hid themselves behind a horse as they stalked to within shooting range of the game. The expression early carried its still current figura-

tive sense of the intended concealment of plans, projects, or intentions.

Do you think her fit for nothing but to be a Stalking Horse to stand before you, while you aim at my wife? (William Congreve, *Double Dealer*, 1694)

The expression has evolved the extended political meaning of a person whose candidacy is intended to conceal the true candidacy of another, or whose place on the ballot is meant to split the opposition.

12. stone soup A wily stratagem; a deceptive procedure; a trumped-up operation. This expression is derived from a tale which was a favorite in Europe during the 16th and 17th centuries. A beggar, sometimes identified in the story as St. Bernard, stopped at a lord's estate and asked for food, but the servants said they had none. The man asked if he might boil some water to make soup with a stone. Piqued with curiosity, the servants provided him with water and a pan. After the water boiled, the beggar put in the stone and asked for salt and pepper; he then inquired if they had any old scraps of meat or vegetables lying about; they provided some, and when the ingredients were cooked, the servants tasted the *stone soup* and wondered at its savoriness. This guileful concoction is also known as *St. Bernard's soup*. The term is seldom, if ever, heard today, but for many years it served as a metaphor for any act of subterfuge. James Kelly alludes to the idea in *Scottish Proverbs* (1721):

Boil stones in butter and you may sup the broth.

13. throw a curve or **a curve ball** To employ clever and often deceptive artifice in verbal dealings with another; to trick or surprise so as to entrap; to accomplish one's ends by indirection. The expression derives from baseball; a curve ball is a pitched ball which is thrown with extra rotation, causing it to curve or dip more than a batter might expect.

Metaphorically, the expression refers to something that acts in an unusual or unexpected manner, especially a verbal ploy.

14. throw a tub to the whale To create a diversion, or to mislead or bamboozle, in order to avoid an awkward, embarrassing, or dangerous situation.

> It has been common to throw out something to divert and amuse the people, such as a plot, a conspiracy, or an enquiry about nothing, . . . which method of proceeding, by a very apt metaphor, is call'd throwing out the tub. (Charles Molloy, *Select Letters taken from Fog's Weekly Journal*, 1728)

Jonathan Swift explains the origin of this expression in the preface to *A Tale of a Tub*:

> Seamen have a custom when they meet a whale, to fling him out an empty tub, . . . to divert him from laying violent hands upon the ship.

Tale of a tub meaning 'an apocryphal story' dates from the 1500s. However, Swift's use of *throw a tub to the whale* in 1704 is the earliest cited use of the expression in the *OED*.

15. Trojan horse A snare or trap, a treacherous device or ploy, particularly one appearing as an attractive lure. The allusion is to the tale recounted in Homer's *Odyssey*. The Greeks, pretending to abandon their siege of Troy, left at its gates a gigantic wooden horse, within which were concealed several Greek soldiers. Interpreting the horse as a gift or peace-offering, the Trojans brought it into the city, whereupon those within stole out during the night to admit the entire Greek force and thus conquer the city. See also **beware of Greeks bearing gifts**, 286. PRETENSE.

16. trump card An ace in the hole; a decisive, winning argument, ploy, piece of evidence, etc.; a clincher.

> Justice . . . is the trump card of the western world. (*The Times Literary*

Supplement as quoted in *Webster's Third*)

A *trump card* is literally any card of a suit which outranks all cards of the other three suits in a card game. *Trump* in this term is a corruption of the now obsolete *triumph* 'a trump card.'

Poise . . . See 60. COMPOSURE

Politeness . . . See 85. DEFERENCE

275. POLITICS

1. barnstorm To make a whirlwind campaign drumming up political support and enthusiasm. The term nearly always appears in its participle or gerund form. Its current political use shows up as early as 1896 in the *Congressional Record*, but its origin is theatrical, referring to itinerant troupes or players who performed in barns to appreciative (and unsophisticated) audiences. Hence it still carries the connotation that such campaigning is done in remote, rural areas or small towns.

2. dollar diplomacy A country's use of financial investments to further its interests in another country; a foreign policy designed to promote and protect a country's economic interests abroad; a policy designed to motivate American businessmen to expand their operations to foreign countries. This expression, coined during the Taft administration (1909–1913), originally indicated governmental support of business interests abroad to promote American diplomatic success. The brain-child of Philander C. Knox, Taft's Secretary of State, the policy was promoted with the use of the slogan, "Every diplomat a salesman." Knox's program was extremely successful, especially in Latin America and the Far East.

> The dollar diplomacy of the Taft administration found its reflection in the Far East in efforts to promote American railroad and financial interests in Manchuria. (Bragdon and

McCutchen, *History of a Free People*, 1969)

However, after World War II the practice of *dollar diplomacy* backfired in many parts of the world and the term came to be used with cynical connotation.

3. filibuster See 374. TEMPORIZING.

4. Know-Nothing See 179. IGNORANCE.

5. logrolling See 304. RECIPROCITY.

6. mend [one's] fences To renew or reinforce one's position or esteem through diplomacy; to engage in political wire-pulling. This American political slang purportedly originated just prior to the 1880 presidential elections, when John Sherman, an aspirant to the executive office, left Congress and retreated to his Ohio farm to develop campaign strategy. While he was repairing a fence one day with his brother-in-law Colonel Morton, a reporter approached Morton and inquired about Sherman's activities. Colonel Morton replied that Sherman was obviously mending his fences. Although the expression occasionally carries the nonpolitical sense of trying to make one's peace with another, its more common use describes the standard pre-election attempts of public officeholders to re-establish communication with the voters.

An early adjournment of the session is deemed essential in order that the members may go home to mend their fences, as the saying is. (*Forum*, April 1906)

7. mud-slinging See 350. SLANDER.

8. politics makes strange bedfellows See 135. EXPEDIENCE.

9. pork barrel See 165. GRAFT.

10. sound on the goose To be in favor of slavery; to have the desired political opinions; to be free of political flaws. This phrase was coined in the Kansas and Nebraska territories sometime during the 1840s as a cryptic expression of a pro-slavery stance. The reason for the use of *goose* has never been explained. At any rate, in the early days of settlement in these territories, the majority of the people were pro-slavery, and the question "Are you sound on the goose?" was put to each newcomer. If he proved to be an abolitionist, he was received coldly and usually asked to move on.

The border ruffians held a secret meeting in Leavenworth, and appointed themselves a vigilance committee. All persons who could not answer "all right on the goose," according to their definition of right were . . . threatened with death. (Mrs. Sara T. L. Robinson, *Kansas*, 1856)

After the Civil War and the resolution of the slavery question, the term took on the more general application to views that were considered politically suitable or orthodox.

Chairman Tom Taggart once more vouches for Mr. Bryan's soundness on the goose. And who's vouching for the voucher? (*Boston Herald*, October 12, 1904)

11. take to the hustings To campaign or electioneer; to take to the stump; to barnstorm, to conduct a whistlestop tour. The *hustings* of this expression refers to the platform from which political speeches are made; earlier it specifically meant the platform from which candidates for the British parliament stood for nomination. Its oldest antecedents are in the Norse word for the assembly hall of a king, from which the term came to be applied to assembly meetings in general. Today it is associated with political speechmaking exclusively.

An unpopular candidate had frequently to beat a hasty retreat from the hustings. (Samuel C. Hall, *Retrospect of a Long Life*, 1883)

12. take to the stump To tour the country making political speeches; to harangue, to rant. This Americanism is from the days when the stump of a felled

tree was used as a platform from which political speeches were delivered.

276. POMPOSITY
See also 171. HAUGHTINESS;
256. OSTENTATIOUSNESS

1. **big head** Pomposity; conceit; an exaggerated opinion of oneself; arrogance; a hangover. Although some sources suggest that this term was derived from observation of a condition called osteoporosis, an actual swelling of the head of cattle and other range animals from the eating of Saint-John's-wort, a more likely derivation is from the idea that one must have a *big head* to accommodate all the brains he believes he has, as evidenced by his conceit.

> A boss with a case of big head will fill an office full of sore heads. (George H. Lorimer, *Letters from a Self-Made Merchant to his Son*, 1902)

The term is also used as a synonym for *hangover*, the feeling of malaise and discomfort that often follows on the morning after an evening of heavy alcoholic consumption. People suffering from hangovers frequently experience the sensation of a swollen head.

2. **blimp** A pompous reactionary; a dyed-in-the-wool Tory. This British colloquialism was given us by cartoonist David Low and his creation Colonel Blimp, whose name and figure clearly derive from the air-filled dirigibles of the same name.

3. **cock of the walk** A leader; the ruling spirit of a group, especially one who is dominating and cocksure. Gamecocks being trained for fighting are put out on a walk with a small group of hens. Here the fighting instinct is developed to the point where one gamecock cannot stand the presence of another. Two placed together will fight to the death. Recorded use of the phrase dates only from the early 19th century, but it is likely that the expression was used long before then.

4. **fuss and feathers** See 256. OSTENTATIOUSNESS.

5. **highfalutin** Pompous, highflown; bombastic; in a pretentious manner. This American colloquial expression, seemingly only a corruption of *highflown*, was probably coined on the frontier in the mid 1800s. The word, often applied to bombastic orators, usually carries a derogatory connotation.

> Such highfalutin horseplay was enough to make a man's gorge rise. (*Popular Western*, June 1948)

6. **high-muck-a-muck** See 269. PERSONAGES.

7. **his nibs** See 269. PERSONAGES.

8. **mugwump** See 197. INDEPENDENCE.

9. **pooh bah** A pompous individual. Pooh Bah, a character in Gilbert and Sullivan's *The Mikado* (1885), derived a feeling of superiority from the many positions he held. A few of his titles included "First Lord of the Treasury," "Lord Chief Justice," "Commander in Chief," and the all-inclusive "Lord-High-Everything-Else." Thus *pooh bah* is currently used of any self-important person who holds several positions at once.

10. **the pope's mustard maker** A pretentious, self-important person. This expression originated in the 14th-century Avignon court of Pope John XXII. The pontiff, whose propensity for luxurious living and exquisite dining was common knowledge throughout Europe, had a particular fondness for mustard seasoning and required all his meals to be so spiced. In order to guarantee that the spicing was done properly, the pope created the office of *Moutardier* 'mustard maker,' which he bestowed upon his nephew. The nephew was so enthralled with the glamor and dignity of the position that he eventually became the target of satire and droll witticisms. The expression *Moutardier du Pape* 'the pope's

mustard maker' is still commonly used in France for a pompous person.

11. too big for [one's] britches Smartalecky, wise, presumptuous, arrogant, swell-headed; also *too big for one's breeches, boots,* etc.

When a man gets too big for his breeches, I say Goodbye. (David Crockett, *An Account of Col. Crockett's Tour to the North and down East,* 1835)

A person who has an inordinately high opinion of himself is said to have a swelled head. The same concept underlies this expression in spite of the different point of reference.

Portent . . . See 254. OMEN

Postponement . . . See 2. ABEYANCE; 374. TEMPORIZING

Potential . . . See 3. ABILITY

277. POVERTY
See also 196. INDEBTEDNESS;
364. SUBSISTENCE

1. bag lady This American slang term, in popular use since the 1970s, is used to describe those women who roam city streets, carrying shopping bags in which they keep all their worldly possessions, and picking through trash containers to find items that might be useful to them in their vagabond style of life. Homeless, these women sleep in doorways, subway stations, or any other convenient place that affords them protection from the elements. They are seldom, if ever, beggars, and have become a symbol of independence. The expression is a shortened version of *shopping bag lady.*

I did a bag lady number on one of the platforms here in the bus station last year, and I almost got arrested. They thought I was the real thing. (*The New Yorker,* October 17, 1977)

2. beggar's bush Beggary, financial ruin, bankruptcy; often in the phrases *go by beggar's bush* or *go home by beggar's bush.* The allusion is to a certain tree on the left side of the London road from Huntingdon to Caxton, where beggars once frequently gathered. This British expression, rarely heard today, dates from the late 16th century.

We are almost at Beggars-bush, and we cannot tell how to help our selves. (Andrew Yarranton, *England's Improvement by Sea and Land,* 1677)

3. bindle stiff A vagabond who carries his few personal belongings with him. This hobo slang expression, originating in the early 1900s, denotes a hobo or tramp who carries his bedroll with him as he moves from place to place. *Bindle* is simply a variant of *bundle,* and *stiff* in this phrase is hobo jargon for 'man'. In the 1920s H. L. Mencken popularized the writings of an ex-boxer and vagabond named Jim Tully. Tully, a bona fide resident of the hobo jungles, the makeshift refuges of these drifters, explains:

I was a *bindle stiff.* That's the class that will do some work once in a while. The *grifters* are the desperate characters; the *hobos* are the philosophers.

4. clay eater One who is poverty-stricken or abjectly poor; a poor white from the southern United States. This expression, dating from the early 19th century, originally designated certain poor folk who actually ate a sort of clay found in some sections of the American south. However, the term soon came to connote reproach or scorn and became a synonym for poor white trash.

He was a little, dried-up, withered atomy,—a jaundiced "sand-lapper" or "clay-eater" from the Wassamasaw country. (W. G. Simms, *The Kinsmen,* 1841)

Related terms, *sand-hiller* and *sand-lapper,* derive from the condition of the

land from which these people tried to scratch out a living.

5. down-at-the-heel Poor, destitute; of slovenly or shabby appearance; also, *out-at-the-heel*. The latter usually refers to holes in one's stockings; the former, to the run-down condition of one's shoes.

Thus the unhappy notary ran gradually down at the heel. (Henry Wadsworth Longfellow, *Outre-Mer*, 1835)

Some rich snudges . . . go with their hose out at heels. (Thomas Wilson, *The Art of Rhetoric*, 1553)

6. drown the miller See **put out the miller's eye, 153. FOOD AND DRINK.**

7. from hand to mouth See **279. PRECARIOUSNESS.**

8. guttersnipe A person, male or female, who gathers a living from the gutter; a beggar who picks up junk and trash from the streets; a bag lady; a street Arab. The snipe, a bird native to swamps and marshes, picks a living from the mud along the edge of pools and streams. This expression probably arises from the similarity of impoverished people trying to pick a living from the gutters of city streets. Today the term is used disparagingly.

Unfurl yourselves under my banner, noble savages, illustrious guttersnipes. (Mark Twain, *Sketches New and Old: Niagara*, 1869)

9. hard up In financial straits, short of cash, out-of-pocket. Originally nautical, this expression was usually used in the imperative, directing that the helm or tiller be pushed as far windward as it would go in order to turn the ship's bow away from the wind. Since this maneuver was usually necessitated by a storm or other potentially disastrous situation, the phrase took on the general sense of difficulty or straits. The nonnautical use of this expression dates from the early 19th century.

You don't feel nearly so hard up with elevenpence in your pocket as you do with a shilling. (Jerome K. Jerome, *The Idle Thoughts of an Idle Fellow*, 1886)

10. high road to Needham On the way to financial ruin; in need; poverty-stricken; going broke. This expression, dating from the mid 16th century, is simply a pun on *need*. Although some sources attribute the reference in the phrase to the village of Needham in Suffolk, it is most likely that no such reference is intended as the village and its people have never demonstrated any particularly outstanding symptoms of need.

They are already a long way on the road to Needham. (Charles H. Spurgeon, *John Ploughman's Talk*, 1869)

11. Hooverville A jerry-built camp, usually located on the outskirts of a town, built by the jobless to house themselves and sometimes their families. Although *Hoovervilles* were found throughout the United States during the depression of the 1930s, they were especially plentiful in California, where the influx of the Okies created a massive poverty problem. These settlements were often nothing more than a ramshackle combination of packing crates, tin sheets, and the like knocked together to provide makeshift dwellings. They were named for Herbert Hoover, who, as President at the beginning of the depression, was blamed by some for the severe economic decline.

The early 1930s . . . Hunger marches and Hooverville stories took up a lot of space in our press. (King Vidor, *A Tree Is a Tree*, 1953)

12. in Carey Street Penniless, flat broke, destitute. This British colloquial expression takes its name from Carey Street in London, the former location of the Bankruptcy Court. It has been in use since 1922.

13. **in low water** Financially hard up, strapped, broke, impoverished. Although the exact origin of this expression is unknown, it may be related to the precarious condition of a ship finding itself in low water or about to go on the rocks. This expression dates from the latter half of the 18th century.

> Law-breakers . . . who, having been "put away," and done their time, found themselves in low water upon their return to the outer world. (*Chambers's Journal of Popular Literature*, February 1885)

See also **on the rocks, 196. INDEBTEDNESS.**

14. **on [one's] beam-ends** In financial difficulties, in imminent danger of bankruptcy. The reference is to a vessel on her beam-ends, that is, on her side such that the beams—the transverse timbers supporting the deck—are practically touching the water. Obviously, any vessel in such a state is in immediate danger of overturning. The phrase has been used figuratively since the early 19th century.

15. **on the highroad to Needham** See **86. DEGENERATION.**

16. **on [one's] uppers** Impoverished, down-and-out; shabby-looking, down-at-the-heel. This phrase, of U.S. origin, appeared in *The Century Dictionary* (1891). The *uppers* are the upper leathers of shoes or boots; a person *on his uppers* has worn through both sole and welt. Footgear as indicative of financial status is also found in the term *well-heeled* (though this is probably of unrelated origin), and in the above-noted *down-at-the-heel.*

> The rumor whirled about the Street that Greener was in difficulties. Financial ghouls . . . said . . . "Greene is on his uppers." (*Munsey's Magazine*, 1901)

17. **out at elbows** Shabbily dressed; down-and-out, poverty-stricken; in financial difficulties. A coat worn through at the elbows has long been a symbol of poverty. The expression appeared in print by the time of Shakespeare.

> He was himself just now so terribly out at elbows, that he could not command a hundred pounds. (Mrs. Mary M. Sherwood, *The Lady of the Manor*, 1847)

18. **poor as a churchmouse** Extremely poor; impoverished, insolvent; poor but proud. This expression, popular since the 17th century, is probably derived from a tale which recounts the plight of a mouse that attempted to find food in a church. Since most churches, including that of the story, do not have kitchens, the proud mouse found it difficult to survive since its pickings were slim at best.

> The owner, 'tis said, was once poor as a churchmouse. (*Political Ballads*, 1731)

19. **poor as Job** Poverty-stricken, indigent, destitute. The allusion is to the extreme poverty which befell the central character in the Book of Job. In spite of a series of devastating calamities, Job remained steadfast in his faith and trust in God, and has long been the personification of both poverty and patience.

> I am as poor as Job, my lord, but not so patient. (Shakespeare, *Henry IV, Part II*, I,ii)

A related expression, *poor as Job's turkey*, is credited to Thomas C. Haliburton (1796–1865), a Canadian judge and humorist. Haliburton, using the pseudonym Sam Slick, described Job's turkey as so poor that it had only one feather, and so weak that it had to lean against a fence in order to gobble. Job, of course, never had a turkey—poor or otherwise—as the bird is a native of North America. A variation is *poor as Job's cat.*

20. **ragamuffin** A ragged, dirty boy or man; an unkempt guttersnipe; a dishonorable tatterdemalion. The term *ragamuffin* is derived from the name of a demon, *Ragamoffyn*, who appears in Langland's *Piers Plowman*, (1360–

1399). The term came to mean any dirty, disreputable man, but by the 1800s it had become fairly well limited to a descriptive term for street urchins. Charles Dickens made use of it in the latter sense in *Barnaby Rudge* (1840):

A set of ragamuffins comes a-shouting after us, 'Gordon for ever.'

21. tobacco road A poverty stricken area; an impoverished section of a community marked by shabbiness, general slovenliness, and little, if any, moral restraint. This phrase gained popularity in the United States in the early 1930s with the appearance of Erskine Caldwell's novel, *Tobacco Road* (1932), depicting a squalid region of rural Georgia; the long-running Broadway stage production (3,182 performances) based on it followed in 1933.

278. POWER

1. big stick A symbol of power; a display of force; military or political pressure. This expression can be traced directly to President Theodore Roosevelt, who used it in a speech delivered in September 1901.

I have always been fond of the West African proverb:

Speak softly and carry a big stick; you will go far.

The idea of using strength to obtain what one wishes was, at the time, a perfect analogy to Roosevelt's own political philosophy for the United States. The term has become a synonym for any forceful display.

Mr. Joyce Kilmer, known as a poet and a critic . . . on this occasion performs in the latter capacity with a "big stick." (*Literary Digest*, August 21, 1915)

2. come on like gangbusters To burst upon the scene with noisy exuberance; to come on with great power or force; to be officious or overbearing at first meeting. This expression derives from the blaring sound effects that opened a 1936 radio program called *Gangbusters*. These included the sounds of marching feet, machine-gun fire, and a screaming siren.

3. money talks Wealth means power; almost anything can be secured with money. This expression alludes to the way money and its procurement direct one's life, as well as to the automatic respect and deference given to the wealthy by the less affluent.

4. power game A stratagem to outmaneuver another so as to gain control; to apply excessive pressure in an attempt to defeat another, especially in the business world. This expression is probably an extension from its use in the game of tennis, where one who plays a *power game* tries to defeat his opponent by hitting so hard that the opponent can't cope with the speed and impact of the ball.

While I was there, one other sort of power game was taking place: the elections for a new head of the printers' union. (*The Listener*, June 8, 1978)

5. the powers that be The authorities; a group or individual exercising complete control and having the power to make decisions affecting large numbers of people. This phrase is Biblical in origin.

For there is no power but of God: the powers that be are ordained of God. (Romans 13:1)

It is implied that *the powers that be* are impersonal and inaccessible.

6. pull rank To make use of one's higher status in order to obtain a desired objective. This expression originated in the armed forces, where one of subordinate rank must comply absolutely with the orders of a superior. The term is now also applied to civilians, particularly in describing certain employer-employee interactions. In either case, the expression usually suggests the unexpected or unfair use of authority in resolving a dilemma or in demanding submission.

7. throw [one's] weight around To exert one's influence inappropriately or unfairly, to pull strings; to lord it over subordinates, to pull rank. *Weight*, meaning 'power or influence,' probably derives from the advantage of added pounds or extra weight in contact sports.

Powerlessness . . .
See 203. INEFFECTUALITY

Practicality . . .
See 135. EXPEDIENCE

Praise . . . See 52. COMMENDATION; 150. FLATTERY

Prankishness . . .
See 237. MISCHIEVOUSNESS

279. PRECARIOUSNESS
See also 81. DANGER;
281. PREDICAMENT; 328. RISK;
400. VULNERABILITY

1. behind the power curve In a very precarious position, in danger of imminent downfall. The expression is of aeronautical origin; the power curve is a graph of velocity versus the power needed to overcome wind resistance or "drag." To be *behind the power curve* is to have insufficient power to remain aloft—rather risky for an aviator. Like many phrases from sports and technology, this expression has found widespread application in political contexts, where it describes persons not up to date or not in synchrony with a superior's decisions and policies, and thus headed for a fall.

2. by the seat of [one's] pants See 215. INTUITION.

3. by the skin of [one's] teeth Just barely; hardly; narrowly. The allusion is to Job 14:20:

I have escaped with the skin of my teeth.

Since teeth have no skin, the implication of this expression is clear.

4. close shave A narrow escape; a close call; a rescue from impending harm or dire trouble; a narrow difference. This informal American expression dating from the mid-19th century is said to be based on the narrow margin between a smooth, closely shaven skin and a serious cut. However, one meaning of *shave* is 'a slight or grazing touch' (*OED*); therefore, the expressions *close* or *near shave* can be taken literally as well. This literal meaning might well have spawned the figurative meanings of *close shave* common today.

5. cut it close To succeed, but just barely; to squeak by; to just make it; to come within an ace of failure. This multipurpose expression can describe just about anything achieved by a narrow margin, whether because of tight, rigid planning or because of a lackadaisical absence of planning. Since the *it* has an indefinite referent, and the *cut* and *close* each has a multitude of relevant meanings, whether taken singly or in combination, pinning down a precise origin for this phrase is impossible. The likelihood is there is none, but for a possible relationship, see **cut corners, 135. EXPEDIENCE.**

6. dicey Uncertain, unpredictable, like a throw of the dice; risky, dangerous, unreliable; touch-and-go. According to the *OED*, this 20th-century British slang term was originally Air Force lingo. An equivalent but less common English term is *dodgy.*

The river got a little dicey. I thought we'd wait for the moon. (P. Capon, *Amongst those Missing*, 1959)

7. from hand to mouth From day to day, precariously; improvidently; in imminent danger of starvation. This expression is an obvious allusion to someone so poor and starved that whatever food he gets goes immediately from his hand to his mouth. In a more general sense the phrase denotes consumption of one's resources, food, money, etc., as soon as they are obtained. Use of this expression dates from the early 16th centu-

ry. William Cowper uses the phrase in his *Letters to Newton* (1790):

I subsist, as the poor are vulgarly said to do, from hand to mouth.

8. hairbreadth escape By official measure a hairbreadth is the forty-eighth part of an inch; therefore, a *hairbreadth escape* is by an extremely narrow margin. The same image was employed by the classical Greeks and has been in use in English since at least 1420. Shakespeare makes use of the term in *Othello*, I,iii.

Wherein I spake of most disastrous chances,
Of moving accidents by flood and field,
Of hair-breadth 'scapes i' the imminent deadly breach, . . .

9. hang by a thread To be in a very precarious situation or perilous position.

But this hangs only upon the will of the prince—a very weak thread in such a case. (Thomas Starkey, *England in the Reign of Henry the Eighth*, 1538)

The expression comes from the story of the flatterer Damocles, who was invited by the tyrant Dionysius to experience the luxury he so envied and praised. When Damocles sat down to a sumptuous feast, he discovered a sword suspended over his head by a single hair. Fear that the sword would fall and kill him prevented him from enjoying the banquet. See also **sword of Damocles**, 81. DANGER.

10. hang by the eyelids To have a very slight hold on something, to be just barely attached, to be in a dangerous or precarious position. This particularly vivid expression, although rarely heard today, requires no explanation. It dates from the latter half of the 17th century, and appeared in James T. Fields' *Underbrush* (1877):

A magic quarto . . . with one of the covers hanging by the eyelids.

11. on thin ice In a precarious position, in a risky situation, on shaky ground. This self-evident expression is often used of a person's arguments or reasoning. The similar *skate on thin ice* most often refers to one's behavior, and is indicative of questionable, dangerous, risk-taking conduct. The expression has been used figuratively for more than a century.

The incessant, breathless round of intermingled sport and pleasure danced on the thin ice of debt. (Ouida, *Fortnightly Review*, 1892)

12. touch and go Risky, precarious; not to be taken for granted, uncertain; flirting with danger, avoiding disaster by a narrow margin. A ship is said to *touch and go* when its keel scrapes the bottom without stopping the boat or losing a significant amount of speed. Another nautical use refers to the practice of approaching the shore to let off cargo or men without actually stopping, thus avoiding the involved procedure required to stop. It has been speculated that the great risk and uncertainty involved in this maneuver has spawned the current figurative use of *touch and go* which emphasizes motion—however slow, erratic, or precarious—rather than arrested movement. Examples of this expression used adjectivally date from the 19th century; however, the less common substantive use of *touch and go* dates from the 17th century, and the verbal use from the 16th century.

13. walk a tightrope See 45. CAUTIOUSNESS.

280. PRECISION
See also 73. CORRECTNESS

1. bang on Exactly on; directly on; precisely as planned; apt or appropriate. This British slang phrase often appears as *bang on target*, popularized by bomber lingo during World War I.

It [a play] has enough quality and sense of the theatre to suggest that before long he will land one bang on

the target. (*Oxford Magazine*, February 27, 1958)

By extension, the phrase also describes anything which is just right, apt, or appropriate.

As a realistic tale of low life in London, it is bang on. (*Spectator*, February 14, 1958)

Spot on is British slang phrase which is used interchangeably with *bang on*.

2. dot [one's] *is* and cross [one's] *ts* To be precise or meticulous down to the last or smallest detail; to particularize in detail so as to leave no room for doubt or uncertainty; to cite chapter and verse. This expression is said to have sprung from the possibility of confusing *is* with *ts* if they are carelessly written without the respective dot and cross. The phrase has been in use since the 1800s.

3. hit the nail on the head To do or say the most fitting thing; to cut through extraneous details and come right to the point; to make a clear, pithy statement. This expression has been in print since the 16th century. Hitting a nail properly—that is, squarely on the head—is likened to communicating effectively, or to the point. On the other hand, a bad hit which bends the nail is like rambling which fails to get to the crux of a matter.

At least they ignorantly hit the nail on the head, saying that the Devil was in him. (*Fryke's Voyage*, 1700)

4. Occam's razor The maxim that unnecessary facts or assumptions used to explain a subject must be eliminated. William of Occam, the 14th-century English scholastic philosopher known as "the Invincible Doctor," believed that general ideas have no objective reality outside the mind (nominalism). *Razor* in this expression is a metaphorical term for the precise, dissecting, incisive methods which characterize Occam's intellectual approach.

5. on the button Exactly, precisely; punctually, promptly; on the dot; often *right on the button*. This expression de-

rives from the boxing slang use of *button* to mean the point of the chin. Literally then, *on the button* indicates a perfectly aimed punch to the chin or jaw area intended to knock a fighter out or at least seriously impair his ability to retaliate.

6. on the money At precisely the right time or place, right on target; often *right on the money*. This American slang expression appears to refer to money placed as a bet against a certain, previously stated outcome.

7. on the nose Precisely; right on target; on time. *On the nose* is old radio parlance describing the producer's gesture of putting his finger on his nose to signify that the program was running according to schedule. The phrase is now used especially in regard to time but can describe anything which is accurate, precise, or apt. *On the button* is akin to *on the nose* in meaning and usage, and both are American equivalents of the British phrases *bang on* and *spot on*.

8. to a T Exactly; precisely; perfectly.

All these old-fashioned goings on would suit you to a T. (Harriet Beecher Stowe, *Dred*, 1856)

The *OED* dismisses as untenable the popular belief that this expression is an allusion to the T square, a draftsman's T-shaped ruler for the accurate drawing of right angles, parallel lines, etc. It conjectures instead that it was the initial of a word, perhaps *tittle* 'dot, jot,' since this was in use nearly a century before *to a T* in exactly the same constructions. Use of the expression dates from at least the late 17th century.

281. PREDICAMENT
See also **81. DANGER; 96. DIFFICULTY; 98. DISADVANTAGE; 185. IMPEDIMENT; 196. INDEBTEDNESS; 279. PRECARIOUSNESS; 328. RISK; 400. VULNERABILITY**

1. all wopsed up Entangled; entrapped;

trapped; wrapped up hastily. This American expression, in limited use today, had its origin in the late 19th century.

> There's a poor leetle muskrat . . . wopsed up in a mess o' weeds.
> (Rowland Robinson, *Uncle Lisha's Outing*, 1897)

Variants include *wopsed down*, said of crops ruined or knocked down by a storm; and *in a wopse and a wudget*, said of anything badly wrinkled, especially clothes.

2. between a rock and a hard place In a tight spot, in an uncomfortable position; trapped, cornered, pressured, with no way out; with equally undesirable alternatives, hence no true choice at all. This relatively recent and seemingly prosaic phrase is often used in reference to one's financial plight; hence it may be conceptually related to **on the rocks**, 196. INDEBTEDNESS.

3. between hawk and buzzard To be caught in a precarious position between two undesirable alternatives; to have a choice semantically, but actually no choice worth mentioning. Since hawks and buzzards are both birds of prey, to be literally between hawk and buzzard is a frightening and dangerous prospect. The phrase is used figuratively although it is rarely heard. There is, however, another meaning of *between hawk and buzzard* which is more current. See 198. INDETERMINATENESS.

4. between Scylla and Charybdis To be in an extremely vulnerable position between two powerful and dangerous alternatives, either of which is difficult to avoid without encountering the other. This expression alludes to Homer's *Odyssey* in which the hero Odysseus had to sail between Charybdis, a raging whirlpool on the Sicilian coast, and Scylla, a rock personified as a ravenous sea monster on the Italian side of the Straits of Messina. Odysseus tried to save his crew and ship, only to lose both and

barely save his own life. The following citations from *Webster's Third* show how the phrase is currently used.

> . . . the Scylla of incomprehensibility and the Charybdis of inaccuracy have both been avoided. (*Times Literary Supplement*)

> . . . between the Scylla of national parochialism and the Charybdis of complete exoticism. (Bernard Smith)

5. between the devil and the deep blue sea In a perilous position; having two equally undesirable and dangerous alternatives. *Devil* in this expression is literally a nautical term for a seam in the hull of ships, on or below the water line. The location of this seam made repair work hazardous, and any sailor ordered to make necessary repairs was put in a precarious position. Today the phrase is used figuratively. It is a popular saying, although few people are aware that *devil* does not refer to Satan.

6. Buridan's ass Said of one who is undecided between two courses of action; a man of indecision. This expression is adopted from the sophism attributed, probably erroneously, to Jean Buridan, a French philosopher of the 14th century. The original dilemma consists of an ass placed equidistant from a bundle of hay and a pail of water. The question is posed as to whether the ass will die of hunger and thirst because he has no determining motive to prompt him to choose one or the other, or will he exercise his free will and make a choice. Sometime later the dilemma was altered to a choice between two bundles of hay. The term is often used to designate a person who stands between two courses of action and, unable to choose, neglects both.

7. catch-22 A double-bind, a no-win situation; a seeming choice which is no choice; the dilemma of the single alternative. The term owes its origin and currency to *Catch-22*, a Joseph Heller novel about World War II popular in the 1960s. It is said to have been a coinage

by Robert Gottlieb, Heller's editor. As used therein, *22* is the number of the regulation which contains the *catch* 'hidden trick or snag.' The regulation provided that an airman could request release from combat duty only on grounds of insanity; but to do so was itself considered proof of sanity, because no sane person would willingly risk his life in such insane fashion.

8. Hell or Connaught This phrase arose under the Puritan regime in Britain (1644–1660), when Cromwell gained control of the British government and proclaimed the Commonwealth. At that time many Irish people were dispossessed of their lands and given a sort of *Hobson's choice*: take their worldly possessions and settle in the province of Connaught in northwestern Ireland or die and, as Cromwell believed happened to all Catholics, go to hell. Thus the phrase came to symbolize 'little or no choice at all' throughout Ireland, and the use of the expression soon spread throughout the British Isles. Sir William F. Butler alludes to the term in his *Autobiography* (1911):

> The alternative was like that which Cromwell gave, . . . only that Connaught was left out.

9. Hobson's choice The dubious choice of taking what is offered or nothing at all; the absence of any viable alternative, no real choice at all. The reference is to Thomas or Tobias Hobson (1544–1631), the owner of a Cambridge livery stable, who gave his customers the questionable choice of taking the horse nearest the stable door or none at all, despite the good selection usually in his stable. This proverbial expression dates from at least 1660.

> The Masters were left to Hobson's choice, to choose Bennet and no body else. (Anthony Wood, *Athenae Oxonienses*, 1691)

10. hold a wolf by the ears To be in a dangerous, precarious situation; to have no viable alternative; to be in a jam or

predicament. The problematic nature of holding a wolf by the ears is well expressed in the following quotation from Francis Quarles's *The History of Samson* (1631):

> I have a Wolfe by th'eares; I dare be bold,
> Neither with safety, to let go, nor hold:
> What shall I do?

Originally an old Greek saying, this expression appeared in print by the mid-1500s.

11. in a box Experiencing a perplexing situation or predicament; in difficulty; in a fix; in a corner. Although the origin of this term is often attributed to baseball, the expression actually was coined sometime in the 1700s, long before baseball originated.

> You are now in a bad box; for if you take no notice of him at all, he is sure to turn mad. (Mason Weems, *The Drunkard's Looking Glass*, 1818)

In baseball, a base runner is said to be *in a box* or *in a pick(le)* when he is between bases and being forced to run back and forth between opponents who are trying to tag him out. This situation is also known as a *hot-box*. A variant, *in the same box*, means 'in the same difficulty as someone else.'

12. in a jam In a difficult or awkward situation, in a fix, in a tight spot, in a bind. This expression, of American origin, dates from the early part of this century. It could have derived either from the verb *jam* 'press, push, wedge, squeeze' or the noun *jam* 'blockage, bottleneck,' as in log jam or traffic jam.

> Henare would give his wholehearted sympathy and his last shilling to anyone in a bit of a jam. (R. D. Finlayson, *Brown Man's Burden*, 1938)

13. in a pickle In a sorry plight, in quite a predicament; in hot water, on the hot seat; usually used with a modifier such as *pretty, sad, fine, sweet*. The

now colloquial expression was formerly used in more serious contexts:

In this pickle lyeth man by nature, that is, all we that be Adam's children. (John Foxe, *Sermons,* 1585)

It has been conjectured that its origin lies in the Dutch *in de pekel zitten* 'sitting in pickle juice,' since such a position in the brinish, vinegary liquid would be unpleasant indeed.

14. in a scrape In trouble, in a fix, in a fine mess.

I was generally the leader of the boys and sometimes led them into scrapes. (Benjamin Franklin, *Autobiography,* 1771)

Several explanations have been offered as to the origin of this expression, which dates from the early 18th century. One such explanation cites the holes that deer scrape in the ground during certain seasons, while another claims that in Scotland *scrape* was a term for a rabbit's burrow (a dangerous trap for a golfer's ball). The *OED,* however, conjectures that the verb *scrape* gave rise to the noun form *scrape* as used in this expression. The most plausible explanation is the most obvious: a person in danger, who survives with a mere scrape, is better off than one who is more seriously injured. Hence, a *scrape* is a situation from which one escapes with his skin intact.

15. in chancery In a predicament; unable to extricate oneself from an embarrassing, awkward position. *In chancery* is also a wrestling term describing the position of the head when held under the opponent's left arm, thus the expression *have one's head in chancery.* This vulnerable position of the head has given rise to figurative use of the phrase referring to any predicament; however, the wrestling term itself alludes to the absolute control of the Court of Chancery which was notorious for holding up suits and subjecting involved parties to great inconvenience.

When I can perform my mile in eight minutes or a little less, then I feel as if I had old Time's head in chancery. (Oliver Wendell Holmes, *The Autocrat of the Breakfast-table,* 1858)

16. in deep water In trouble, in a difficult or dangerous situation, in over one's head. *Deep waters* 'difficulties, troubles' is found in Psalm 69.

17. in hot water In big trouble, in Dutch, in a scrape. This expression, which dates from the first half of the 16th century, refers to the obvious discomfort caused by scalding hot water.

This poor fellow was always getting into hot water. (Richard H. Dana, Jr., *Two Years before the Mast,* 1840)

18. in over [one's] head Beyond one's capability or resources; usually in reference to one's financial situation 'in debt, in the red.' The allusion is to a swimmer floundering about in water over his head, without the stamina or the ability to reach the shore.

19. in the cactus An Australian term meaning in an uncomfortable or awkward situation.

20. in the soup In trouble, in hot water, in a difficult situation.

After collecting a good deal of money, the scoundrels suddenly left town, leaving many persons in the soup. (*The Lisbon* [Dakota] *Star,* April 1889)

Although several explanations have been proposed as to the origin and popularization of this U. S. expression, no substantial evidence has yet been found to support any of them, leaving the original meaning of the phrase as obscure as ever.

21. kettle of fish See 103. DISORDER.

22. king stork for king log The allusion here is to Aesop's fable of the frogs who asked Jupiter for a ruler. In response to their request he sent them a log, who ruled passively; but the frogs were dis-

contented and requested a different king. Jupiter replaced the log with a stork which proceeded to eat up the frogs. The tale is generally told to demonstrate the contrast between quiet, peaceful rulers who don't make their power evident and excessively active rulers who often flaunt their power before their subjects.

> I like neither devouring stork, nor a Jupiter's log. (Owen Feltham, *Resolves*, 1620)

Some versions of the story replace *king stork* with *king crane*.

> If you despise King Log, you shall fear King Crane. (Thomas Fuller, *Gnomologia*, 1732)

23. on the horns of a dilemma Compelled to choose between two equally undesirable alternatives; in dire straits. A person *on the horns of a dilemma* must select an alternative that will surely result in a negative outcome; he will be caught or impaled no matter his choice. The word *horn* is used singularly to denote either of the undesirable alternatives.

> This seems a smart dilemma at first . . . yet I think neither Horn is strong enough to push us off from our belief of the Existence of God. (Henry More, *Divine Dialogue*, 1668)

24. on the spot In a dangerous situation; in a life-threatening position; in a dire predicament; also, *put on the spot*. This common phrase is derived from the pirates of old, who used the one-spotted ace of spades as an indication to a stool pigeon or poltroon that his days were numbered. In contemporary usage, the expression often refers to a situation in which one is forced into a self-incriminating position.

> Some of the questions directed at him were obviously designed to put Stassen on the spot. (*Chicago Sun-Times*, March 1948)

25. Patty Hodge's chair Broken in three halves; a predicament; a difficult situation; an unsolvable problem. This Briticism, probably originating in Somersetshire during the late 1800s, is used jocularly to indicate that one has got himself into an irremediable situation.

> His position is like Patty Hodge's chair, broken in three halves. (*Notes and Queries*, February 1936)

As with so many British expressions, *Hodge* is used here to signify the typical rustic.

26. up a gum tree To be in a predicament; to be stuck in a difficult situation; to be cornered. The original implication of this expression, dating back to about 1830, was that one was done for, that one was on his last legs. Opossums, which seem to have an affinity for gum trees, often run up them to take refuge from pursuing dogs, thus becoming easy targets for hunters. However, over the years the term has assumed a more subdued meaning. In modern use it implies that one is stuck in an endeavor and can't seem to make any headway. The Australians have since the 1890s employed a term similar in meaning to the original American interpretation, *have seen one's last gum tree*, meaning 'one is done for.'

27. up the creek In trouble, in a tight spot. This common U.S. euphemism (a truncated version of *up shit creek without a paddle*) first appeared in print in the 1930s. Most who use it are unaware of its vulgar origins.

> "How 'bout writing a composition for me, for English? I'll be up the creek if I don't get the goddam thing in by Monday." (J. D. Salinger, *The Catcher in the Rye*, 1951)

Variations are *up Salt Creek* and *up Salt River*, though some sources claim the latter to be a totally unrelated expression, giving conflicting, geographically erroneous, and equally implausible accounts for its reputed limited application to losing political candidates.

Prediction . . . See 254. OMEN

Preeminence . . .
　See 129. EXCELLENCE

282. PREFERENCE
See also 147. FAVORITISM

1. after [one's] own heart Suiting one's personal preferences; conforming to one's taste; with exactly the same intent; with a similar purpose. This ancient expression appears in the King James Version of the Bible. Samuel admonishes Saul that he hasn't kept God's commandment:

> But now thy kingdom shall not continue: the Lord hath sought him a man after his own heart . . . because thou has not kept that which the Lord commanded thee. (I Samuel 13:14)

The phrase's connotation has remained unchanged to the present day.

> I am going to give you a mission after your own heart. (Hungerford, *Rossmoyne*, 1883)

2. bag See 200. INDIVIDUALITY.

3. [one's] cup of tea Suited to one's interests, talents, or taste; that which hits the spot, does the trick, or suits one's fancy.

> Broadway by night seemed to be my cup of tea entirely. (Noel Coward, *Present Indicative*, 1937)

A logical extension of this sense is the British *cup of tea* meaning 'one's fate or destiny.' However, if something is neither suited to one's interest, nor a matter of destiny, it may well be *another* or *different cup of tea*; 'something of an altogether different kind.'

> A Fred racked with ideals, and in the grip of Federal Union, was quite a different cup of tea from the old, happy-go-lucky Fred. (Nancy Mitford, *Pigeon Pie*, 1940)

4. if I had my druthers If I had my choice; if I could choose one or the oth-er; if I had my way. This American folk phrase stems from a corruption of *I had rather* or *I would rather*, as in the sentence, "if I had my druthers, I'd ruther go to town," i.e., 'I would rather go to town than stay home.' Variants are *if I had my rathers* and *if I had my ruthers*. The first recorded use of the term appears in Bret Harte's *The Argonauts* (1875).

5. a man of my kidney See 346. SIMILARITY.

6. throw the handkerchief To express a preference, often in a condescending way; to make a choice. This expression alludes to the genteel custom of bestowing one's handkerchief upon the person of one's choice, a gesture often indicative of one's preference toward a member of the opposite sex. The original interpretation of the phrase was restricted to its literal sense, but in time it came to connote a superior attitude.

> "And so . . . you condescend to fling to me your royal pocket handkerchief," said Blanche. (William M. Thackeray, *Pendennis*, 1850)

The term also owes something to an old bit of politesse, the stratagem whereby a young lady would drop her handkerchief beside a young gentleman, thus forcing an introduction when he retrieved and returned it to her.

7. up [one's] alley Suited to one's natural capabilities or interests; one's concern or business; where one feels at home; sometimes *down one's alley*. *In* or *up one's street* has the same meaning, although the exact origin of either expression is anybody's guess. Both are cited as early as 1929.

> Fun's fun, but boxfighting's your trick and anything else is out of your alley. (Witwer, *Yes Man's Land*, 1929)

> A great many of the books published today are, as the saying is, right up her street. (*Publisher's Weekly*, December 21, 1929)

Up one's alley is currently the more common American expression; *up one's street* is more frequently heard in Britain.

8. you pays your money and you takes your choice One buys the right to choose; any number of different ways exist for doing something, so make a choice; if one becomes involved in something, he must express opinions as to the proper course of action.

> Whichever you please, my little dears:
> You pays your money and you takes
> your choice.
> You pays your moneys and what you
> sees is
> A cow or a donkey, just as you
> pleases.
> (V. S. Lean, *Collectanea*, 1904)

Still occasionally heard in everyday speech, this expression, most frequently used as a humorous retort to another's query, first appeared in *Punch* in 1846.

283. PREJUDICE
See also 210. INJUSTICE;
282. PREFERENCE; 300. RACISM

1. a jaundiced eye A prejudiced perspective or point of view; a skeptical, critical attitude; distorted vision that perceives everything as faulty, inferior, or undesirable. The disease of jaundice gives a yellowish cast to the whites of the eyes. This phrase is based on the assumption that everything appears "yellow"— i.e., negative, distorted—to such eyes.

> All seems infected that the infected
> spy,
> As all looks yellow to the jaundiced
> eye.
> (Alexander Pope, *An Essay on
> Criticism*, 1709)

2. lily-white See 300. RACISM.

3. look through blue glasses To see things in a preconceived, usually distorted light; to be biased, to be unable to see things for what they are. This expression plays on the negative connotations often carried by the color blue. The image of

spectacles gives tangible form to the nonmaterial prejudice which colors one's perceptions.

4. nothing like leather An expression mocking one who has a chauvinistic attitude toward his own craft or field. Attributed to an Aesop fable, *nothing like leather* was popularized by the following anonymous verse which explains its origin.

> A town feared a siege, and held
> consultation
> Which was the best method of
> fortification;
> A grave, skilful mason said in his
> opinion
> Nothing but stone could secure the
> dominion.
> A carpenter said, "Though that was
> well spoke,
> It was better by far to defend it with
> oak."
> A currier, wiser than both these
> together,
> Said, "Try what you please, there's
> nothing like leather."

Preoccupation . . .
See 249. OBSESSION

284. PREPARATION
See also 301. READINESS;
357. STARTING

1. batten down the hatches To prepare for adversity, to ready one's defenses. The expression is of nautical origin: battens are narrow strips of wood nailed down to secure the edges of the tarpaulin over the hatchways during rough weather at sea. The phrase is commonly used figuratively for the precautions necessary to prepare a dwelling against a literal storm of any sort; and, by further extension, to take defensive precautions when faced with any upcoming trial or ordeal.

2. bite the bullet See 116. ENDURANCE.

3. boots and saddle A U.S. Army bugle call for mounted drill and formation. This expression denoting a cavalry trumpet sound is a corruption of the French *boutes la selle* 'put on the saddle,' and consequently has no semantic relationship with *boots*. However, since boots are logically associated with horsemen, whether cavalry or cowboys, *boots and saddle* has come to carry connotations of the American West more than of the military.

4. game plan Originally a plan for winning a game in sports, the term is now applied to any strategy that involves achieving a desired end. The term gained popularity during the Watergate hearings in 1973, and that popularity has been reinforced by the overuse of the expression by TV sports announcers. Today the phrase is in common use in the world of business.

> Every week *Business Week's Corporate Strategies* section reveals a company's game plan: Where it is going and how it plans to get there. Who the key players are in management. What are their motivations. And what the likelihood is of their success or failure. (Advertisement in *The New Yorker*, November 15, 1982)

5. get [oneself] in gear To ready oneself to take whatever action is necessary; to stop lazing about and get ready to go. This expression may derive from the use of *gear*, as in *put in gear, gear up*, or *get in gear*, all of which in literal use refer to the harnessing of an animal. Another possibility is a more modern use of *gear*. In this latter sense, *in gear* applies to the state of parts in which they are connected or meshed with each other. Both possibilities involve the idea of preparation and are plausible explanations for the current use of *get oneself in gear*. A variant expression is *gear oneself up* which refers to preparing oneself psychologically, or psyching oneself up, to do something demanding or distasteful.

6. get up steam To get up energy, gear oneself up, psych oneself up, motivate oneself. The allusion is to the steam-operated engines formerly used to propel riverboats and locomotives. These engines were powered by boiler-generated steam, a certain amount of which had to be produced before the boat or locomotive could begin moving forward. Because of its use as a power source for engines, *steam* has come to be used figuratively to mean energy, vigor, drive. The expression appeared in Francis Francis Jr.'s *Saddle and Mocassin* (1887):

> "And he [the bull] came for you?"
> "When he got up the steam he did."

7. gird up [one's] loins To prime oneself for a test of endurance or preparedness; to ready oneself for scrutiny. The expression appears in Proverbs 31:17:

> She girdeth her loins with strength,
> and strengtheneth her arms.

The phrase may have derived from the loosefitting clothes of ancient people, which needed to be tucked in or girdled, usually about the loins, in preparation for work.

> It was necessary, therefore, to gird up our loins and walk. (Leitch Ritchie, *Wanderings by the Loire,* 1833)

The expression is the literary equivalent of the modern *get psyched up*, a colloquialism for putting oneself into a state of readiness.

8. grit [one's] teeth To steel oneself to do what has to be done, to ready oneself for an unpleasant task or experience; to clench or grind one's teeth in anger or determination; also *set one's teeth*. This expression, which dates from the late 18th century, is an allusion to the involuntary, reflexive clenching of one's teeth in moments of extreme anger or stress.

> The duellist gritted his teeth as he cocked the gun a second time. (*The Southern Literary Messenger,* 1840)

9. pave the way To prepare the way for, to lead up to; to smooth the way, to facilitate or make easier; to be the first

step toward. Literal paved roads are, of course, much smoother to travel on than those of dirt and gravel. A variant of the expression was in use as early as the 16th century.

It was Einstein who paved the way for the big-bang theory. (*Newsweek,* March 1979)

10. psych up To prepare oneself mentally or emotionally; to prepare for a demanding situation. In classical Greek mythology Psyche, who was loved by Cupid, represented the soul. In English, the word *psyche,* from the Greek word for 'soul,' came to be a synonym for the human spirit or soul and was used in that context for years. With the advent of psychology, the slang verbs *psych* and *psych up* developed, the first meaning 'adversely influence an opponent's mental state,' the second 'stimulate one's feeling of confidence and mental preparedness.'

When a long lengthed, bristled fellow comes in for the shearing, the hair dressers said they know he's been psyching himself up for the appointment. (A. Fisher, *Arizona Wildcat,* 1974)

A related term, *psych out,* means 'get the advantage of another by upsetting his mental stability,' and another, *get psyched,* means 'begin mental preparation in advance of an expected event.'

11. red up To clean up; to put in order; to tidy up a room, closet, house; to make ready for occupancy. Dating from the Middle Ages, this expression has its roots in the Middle English word *rede* 'to arrange, to put in order.' Brought to America by Scottish and British immigrants, the term is currently in use in some regions of the country.

Your father's house—I knew it full well—a but and a ben [i.e., only two rooms] and that but ill red up. (Sir John Sinclair, *Statistical Account of Scotland,* 1791–99)

12. screw [oneself] up to concert pitch To prepare for a particularly challenging task; to ready oneself for superior performance; to psych oneself up. This expression is an extension of the literal meaning of *concert pitch,* i.e., the slightly higher-than-usual pitch to which instruments are tuned for a concert in order to heighten the effect and brilliance of the music.

13. square off See 62. CONFRONTATION.

14. whomp up To imagine, create, or concoct; to whip up; to cook up. The source of this American slang expression is unknown. It came into being shortly after World War II and has remained a popular phrase since that time.

Instead of getting sleep, I whomped me up one heck of a nightmare. (Billy Rose in his syndicated newspaper column, September 18, 1950)

Preparedness . . .
See 301. READINESS

285. PRESERVATION

1. lay up in lavender To put away carefully for future use; to pawn; to use clothing or household linens as security to float a loan; to take great care of; to put a person out of the way of doing harm; to imprison. This expression is derived from the old practice of actually storing clothes and linens in lavender to preserve them from moths. Hence, the original meaning of to *lay up in lavender* was 'to store something carefully.' About 1600 it became a slang phrase for 'to pawn,' and later in the same century added another slang connotation, 'to imprison,' both examples, by extension, of storing something.

Good faith, rather than thou shouldst pawn a rag more I'll lay my ladyship in lavender. (Chapman and Marston, *Eastward Hoe,* 1605)

See also **lay out in lavender,** 312. REPRIMAND.

286. PRETENSE

See also 12. AFFECTATION;
176. HYPOCRISY

1. Abraham man During the days of the Tudor and Stuart kings of England, those inmates of Bedlam who were not considered dangerously insane were kept in a special ward, called the *Abraham ward*. Dressed in costumes which identified them as *Toms o' Bedlam* 'authorized beggars from the asylum,' these inmates made their way about the streets of London requesting alms from passers-by in order to supplement their meager rations.

> . . . my cue is villainous melancholy, with a sigh like Tom o' Bedlam.
> (Shakespeare, *King Lear*, I,ii)

Soon, a group of impostor-lunatics began to appear upon the streets of London, fattening their own purses by posing as *Toms o' Bedlam*. These impostors became known as *Abraham men*, apparently derived from the name of the ward, and from this term arose the expressions, *Abraham-sham* and *sham Abraham*, both meaning to feign illness to avoid work.

2. ass in a lion's skin A pretender; a fool posing as a sage. The allusion is to the fable of an ass that donned a lion's skin in an attempt to masquerade as the noble beast, but betrayed itself by its braying.

3. beware of Greeks bearing gifts Distrust the kindnesses of known enemies; suspect an ulterior motive when adversaries act as benefactors. This warning to look for guile lest one be made the victim of treachery is a variation on the words of Laocoön in Book II of Virgil's *Aeneid*:

> Whatever it is, I fear Greeks even when they bring gifts.

The lines were spoken in reference to the so-called Trojan horse, left outside the gates of Troy supposedly as a gift or peace-offering from the Greeks, with whom Troy was at war. Laocoön's advice went unheeded, however, and the horse was brought inside the city gates; the Greeks hidden therein thus successfully sacked Troy and razed it to the ground.

4. borrowed plumes An ostentatious display; pretense to what one is not; making an ass of oneself. The allusion here is to Aesop's fable of the jay and the peacock. The jay arrayed itself in peacock feathers and went swaggering about, only to become the object of derision of the other birds.

> In the process of his examination, he is stripped of his borrowed plumes.
> (*Medical and Physical Journal*, 1802)

5. four-flusher A bluffer; a pretender; a deadbeat, particularly one who pretends to have money but sponges or borrows from others. This expression derives from the card game of poker in which a flush is a hand (set of five cards) with all cards of the same suit. A *four-flush* is a hand with four cards of one suit and one card of another suit—worthless in poker. A good bluffer, particularly one who is pokerfaced, upon finding himself with a four-flush, might bet in such a way as to make the other players think he is holding a five-card flush—almost a certain winner. Since this kind of bluffing requires heavy betting and involves a substantial risk, many a four-flusher has overextended himself and been unable to cover his losses. Thus, the expression was extended from its poker reference to its current, more general application.

> So, perhaps, was a four-flushing holdup man named Gunplay Maxwell. (Wallace Stegner, *Mormon Country*, 1942)

6. fox's sleep Pretended indifference to what is going on; noticing or observing a person, situation, or event without seeming to do so. This expression refers to the belief that foxes sleep with one eye open. Although this is not true in the literal sense, foxes and many other animals seem to remain on a "standby alert" when they sleep, ready for action and

totally awake on a moment's notice. A related expression is *sleep with one eye open.*

7. humbug A hoax; a fraud; a perpetrator of a hoax. This slang word of obscure origin came into use about the middle of the 18th century. The word made its first appearance, according to the *OED*, in the January 1751 edition of *Student*. The use of the term by Scrooge in Charles Dickens' *A Christmas Carol* brought the word into such popular usage that it became acceptable in standard English.

> I had no idea in those days of the enormous and unquestionably helpful part that humbug plays in the social life of great peoples dwelling in a state of democratic freedom. (Winston Churchill, *My Early Life*, 1930)

8. iron hand in a velvet glove Tyranny, harshness, or inflexibility hidden under a soft, gentle exterior. At least one source has attributed this expression, in use since about 1850, to Napoleon. One of the several variations of the expression appeared in *The Victorian Hansard* (January 1876):

> They [the Government] have dealt with the Opposition with a velvet glove; but the iron hand is beneath, and they shall feel it.

9. look as if butter wouldn't melt in [one's] mouth Used contemptuously to describe a person of deceptively modest appearance, a goody-goody. The implication is always that the person's true nature is something quite different from what it seems. Hugh Latimer uses the expression, which dates from the early 1500s, in his *Seven Sermons Made Upon The Lord's Prayer* (1552):

> These fellows . . . can speak so finely, that a man would think butter should scant melt in their mouths.

10. method in [one's] madness A reason, plan, or orderliness that is obscured by a person's apparent or feigned insanity or stupidity. This expression devel-

oped from a line in Shakespeare's *Hamlet:*

> Though this be madness, yet there is method in 't. (II,ii)

It has enjoyed widespread popular usage since the 17th century.

> He may be mad, but there's method in his madness. There nearly always is method in madness. It's what drives men mad being methodical. (G. K. Chesterton, *The Man Who Knew Too Much*, 1922)

11. mutton dressed as lamb An elderly woman dressed in youthful fashion. This expression, still in popular use, is a variant of an earlier phrase, *an old ewe dressed lamb-fashion*

> Here antique maids of sixty three Drest out lamb-fashion, you might see.
> (*Gentleman's Magazine*, 1777)

The reference in both phrases is to the practice of those few butchers who try to pass mutton as lamb.

12. paper tiger See 203. INEFFECTUALITY.

13. pass the bottle of smoke To countenance a white lie; to sanction a falsehood. The allusion in this expression is to smoke as a means of covering or camouflaging. *Smoke* as a synonym for 'dishonesty' has been in use since at least the 1600s, when to *sell smoke* was to defraud or to cheat.

> I abandoned their conversation, because I found they were but sellers of smoke. (*Sorel's Comical History of Francion*, 1655)

This expression seemingly gave birth in the 1800s to *pass the bottle of smoke*, 'obscure the facts through pretense'.

> . . . to keep up the pretense as a labour and study and patience . . . and all the rest of it—in short, to pass the bottle of smoke according to rule. (Charles Dickens, *Little Dorrit*, 1857)

14. play possum To deceive or dissemble; to sham illness or death. This expression alludes to the opossum's defense mechanism of feigning death to ward off predators. In contemporary usage, the common phrase often suggests the feigning of ignorance.

> By last week, in the Senate investigation of Washington five-percenters, it became plain that John had been playing possum the whole time. (*Time*, September 1949)

15. Potemkin village A false front; a sham; something created so as to deceive or to mislead. This term can be traced directly to Prince Gregory Potemkin, a Russian army officer, political personage, and favorite of Catherine the Great. The Prince is said to have had false cottage fronts and pleasant rural scenes built along the roadway before taking the Empress on a tour of the countryside, thus shielding from her view the poverty that gripped the nation.

16. quacksalver A quack; one who pretends to have medical skills; a medical charlatan; a phony. *Quacksalver* is the original name given to itinerant peddlers who set up at country fairs and "quacked" the praises of their salves and medicines. The term came into being in the 16th century and was especially popular during the 17th century, but gave way to the more popular shortened version *quack*.

> He's such a quack I'll bet he's web-footed. (A. M. Stern, *The Case of the Absent-Minded Professor*, 1943)

Today *quack* is not restricted to the practice of medicine but has been extended to include anyone who professes skill in any field of which he knows little.

17. Quaker guns Empty threats; harmless barbs; all bark and no bite. This expression comes from the former use of counterfeit guns, simulated to bluff the enemy into thinking that a ship or fort was well-fortified. Such were described as *Quaker* owing to that sect's doctrine of nonviolence. This U.S. expression is rarely heard today.

> "He's like a Quaker gun," said Haxall—"piles of appearance, but no damage done." (Ella L. Dorsey, *Midshipman Bob*, 1888)

18. ringer A person or thing entered in a contest under false pretenses; a person or thing bearing an uncanny resemblance to another. The expression's first sense usually implies the misrepresentation of the contender's identity or potential. Although this American term finds its principal use in the horseracing world, it may be applied to human competitors as well.

> As a ringer in the Sadie Hawkins race, she was last heard of pursuing a panicstricken Dogpatcher. (*Newsweek*, November 1947)

The phrase's meaning of two nearly identical persons or things, most often expressed as *dead ringer*, is quite common in the United States.

> I saw once . . . an outlaw . . . who was a dead ringer for him. (O. Henry, *Options*, 1909)

19. sail under false colors To pretend or appear to be what one is not; to put up a false front or façade; to act or speak hypocritically. In the days when buccaneers plundered on the open seas, it was common practice for a pirate ship to hoist the colors (flag) of a potential victim's ally in order to sneak up on the ship without arousing suspicion. At the last moment, the pirates would lower the false colors, "show their true colors," the Jolly Roger, and attack. This expression and its variations are now used figuratively.

> Our female candidate . . . will no longer hang out false colors. (Sir Richard Steele, *The Spectator*, 1711)

20. slyboots See 344. SHREWDNESS.

21. string [someone] along To manipulate another, psychologically, financial-

ly, or romantically; to deceive or mislead; to cheat or beguile. The reference in this phrase is to keeping another dangling on the end of a string while one makes up his mind. Dating to about 1810, the expression was originally used in business dealings to indicate that one was manipulating another's finances. Currently, the phrase is often heard in a romantic context.

I'm afraid that he's just stringing me along, trying to encourage me. (Percy Marks, *The Plastic Age*, 1924)

22. Suffolk milk Skim milk; pretension; something which puts on the dog. Robert Bloomfield records in *Suffolk Garland* (1818):

Suffolk milk. Three times skimm'd sky-blue.

In Suffolk a cheese was developed from skim milk which when compared to the richer cheeses of England left much to be desired. The term has come to connote imposture. A related term is *skim milk masquerading as cream*.

What a lamentable example you are of skim milk masquerading as cream. (R. A. J. Walling, *The Spider and the Fly*, 1940)

23. wolf in sheep's clothing One who hides his true evil intentions or character behind a façade of friendship; a hypocrite or deceiver. This expression derives from an Aesop fable in which a wolf, wrapped in the fleece of a sheep, enters the fold and proceeds to devour the unsuspecting lambs. A *wolf in a lamb's skin*, in use as early as 1460, seems to be an older variation of the current phrase, which did not appear until 1591. A well-known Biblical passage has served to increase the phrase's familiarity:

Beware of false prophets, who come to you in sheep's clothing, but inwardly are ravening wolves. (Matthew 7:15)

Pretentiousness . . .
See 256. OSTENTATIOUSNESS

Price . . . See 74. COST

Pride . . . See 171. HAUGHTINESS

Priggishness . . .
See 296. PRUDISHNESS

Prize . . . See 326. REWARD

Probability . . . See 93. DESTINY

Probing . . .
See 216. INVESTIGATION

287. PROCESSING

1. in the hopper In the works, in the making, in the process of realization. The hopper of this expression is the box on the desk of an official of a legislative body. It serves as the receptacle for proposed bills. Consequently anything *in the hopper* is on its way toward realization.

Your show is in the hopper and you might just as well . . . not worry. (E. J. Kahn, cited in *Webster's Third*)

2. in the pipeline Under way, in action or operation; in the works. This picturesque expression alludes to the use of pipelines for transporting oil. If oil is in the pipeline, it's well on the way to its destination.

Procrastination . . .
See 374. TEMPORIZING

Prodigality . . .
See 190. IMPROVIDENCE

288. PROFANITY
See also 225. LANGUAGE

1. air [one's] lungs To curse or swear. American cowboy slang.

2. billingsgate Vulgar or obscene language. The reference is to the coarse language commonly heard at Billingsgate, a London fishmarket. The term was in use as early as the 17th century.

3. blankety-blank A euphemism for profane or four-letter words. This expression, in use since at least 1854, derived from the practice of leaving dashes or blank spaces to represent unprintable, vulgar words, as h--- for *hell* or d--- for *damned*. M. Diver used the phrase in *The Great Amulet* (1908):

> Colonel Stanham Buckley . . . inquired picturesquely of a passing official when the blank this blankety blank train was supposed to start.

4. dickens A euphemistic word for the devil or Satan, common in such exclamations as *why the dickens* and *what the dickens*. The derivation of this slang term is not known although it has been in use since the time of Shakespeare. *Dickens* is also used in mild imprecations such as *the dickens take you, raise the dickens*, and *go to the dickens. Play the dickens* means to be mischievous, or to instigate or stir up trouble and confusion.

5. dip into the blue To tell an off-color story; to speak of the erotic or obscene. *Blue* 'lewd, obscene, indelicate, offensive' has been in use since at least as early as the mid 19th century. *Dip into the blue* is a picturesque but rarely heard euphemism.

6. locker-room talk Vulgar ribaldry; obscene, scurrilous, or vile language; also, *bathroom talk*. This expression derives from the lewd conversations that males purportedly indulge in when in the confines of a locker room or bathroom.

7. pardon my French Please overlook my profane language; excuse my use of taboo words. This expression, dating from the early 20th century, probably originated with British soldiers returning from the the front in France during and immediately after World War I. The phrase is most commonly used immediately preceding or immediately following a burst of blasphemy or obscenity, as a sort of mild excuse.

> Does she cut ball? — if you will pardon my French. (John Mortimer, *The Collaborators*, 1973)

8. swear like a trooper To use extremely profane language. This simile, dating from the late 18th century, derives from the language reputedly used by British soldiers. It has become almost a cliché that the language of men in exclusively male company, e.g., soldiers and athletes, is riddled with profanities.

> Women *got drunk* and *swore* like troopers. (William Cobbett, *A Year's Residence in the United States of America*, 1819)

Today the expression *like a trooper* is often used with other verbs to indicate forcefulness, intensity, enthusiasm, etc. One can *sing like a trooper, dance like a trooper, play like a trooper*, and so on.

9. Sweet Fanny Adams See 4. ABSENCE.

10. talk the bark off a tree To express oneself in strong, usually profane, language. This informal Americanism dates from the 19th century.

> The tracker will be led, perhaps, for mile after mile through just the sort of cover that tempts one to halt and "talk the bark off a tree" now and then. (*Outing*, November 1891)

Profession . . .
See 253. OCCUPATIONS

Proficiency . . .
See 55. COMPETENCE

Profusion . . . See 8. ADVANCEMENT

Proliferation . . . See 5. ABUNDANCE

289. PROMISCUOUSNESS
See also 230. LUST

1. alley cat A sexually promiscuous person; a prostitute, especially one who walks the streets at night. This American slang expression, its figurative use dating from the early 20th century, originally denoted a homeless or stray cat that roamed about the back streets and alleys of a city in search of food. By extension, it came to designate a prostitute or a street walker furtively seeking customers. In time the term came to indicate any sexually promiscuous person.

> I'm not trying to whitewash the alley cats among the weekend war brides. (*Chicago Daily News*, August 2, 1945)

A verb form, *alley-catting around*, was coined in the late 1930s, perhaps by Kaufman and Hart, who used the term in *The Man Who Came to Dinner* (1939). A related term, *painted cat*, was especially popular in the early American West as a designation for a frontier harlot.

2. Athanasian wench A loose woman, one of easy virtue, ready to grant sexual favors to any man who desires them. This somewhat irreverent slang phrase has its origin in the opening words of the Athanasian creed—*quicumque vult* 'whoever desires.' The creed, a Christian profession of faith dating from the 5th century, emphasized the doctrines of the Trinity and the Incarnation to combat the Arian heresy which denied the divinity of Jesus Christ.

3. bank-walker Exhibitionist; flasher. This American dialect expression (Appalachian region) for a male who enjoys displaying his physical endowments comes from the supposed practice of such a youth to strut about the riverbank unclothed, while his companions quickly hid their nakedness by plunging into the old swimming hole with all deliberate speed.

4. blue gown A harlot, prostitute. This British expression came from the blue garb formerly worn by women in houses of correction. In the United States, however, it has no such meaning. Though nonexistent as a discrete term, the phrase would be associated by most people with the all-time popular song "Alice Blue Gown," from the 1919 hit musical *Irene*. As such it would carry connotations of gentility and demureness rather than of brazenness and promiscuousness.

5. Don Juan A rake; a libertine; an aristocratic profligate; an intemperate philanderer; a lecher. The legend goes that Don Juan Tenorio was the son of a leading family of Seville who seduced his commander's daughter and killed the commander. Later, when a statue of the commander was placed in a Franciscan convent, Don Juan mockingly invited it to attend a feast. The story has it that the statue agreed and after the evening ceremonies delivered Don Juan to Hell. Don Juan's reputation as a seducer of women is explained by his valet in the Mozart opera *Don Giovanni* (1787), when he says that the Don has in Italy 700 mistresses, in Germany 800, in Turkey and France 91, and in Spain 1003. The prototype of Don Juan was created and his story was first dramatized in *El Burlador de Sevila* by Gabriel Tellez (1571–1641), writing under the name Tirso de Molina. The story was retold by a number of well-known writers and composers, among them Molière, Mozart, Shadwell, Byron, Browning, and Shaw.

> If Don Juans and Don Juanesses only obeyed their desires, they'd have very few affairs. They have to tickle themselves up imaginatively before they can start being casually promiscuous. (Aldous Huxley, *Point Counter Point*, 1928)

6. gay Lothario A libertine; a seducer of women; a rake. In *The Fair Penitent* (1703) Nicholas Rowe created the character Lothario, a debauchee who attempted to seduce any woman he met.

Is this that Haughty, Galiant, Gay Lothario?

The term has become a synonym for any breezy, young womanizer and remains in common use. Related terms, all based on the names of famous male lovers, are *Don Juan*, *Casanova*, and *Romeo*.

> One realizes with horror, that the race of men is almost extinct in Europe: only Christ-like heroes and woman-worshipping Don Juans, and rabid equality-mongrels. (D.H. Lawrence, *Sea and Sardinia*, 1921)

7. **group grope** An assemblage of people engaging in sex play; an orgy, bacchanalia, or love-in. This American expression is also applied to the mental or physical probing that transpires during encounter sessions, with the implication that all are floundering about, the blind leading the blind.

8. **high-kilted** Obscene, risqué; or indecent in one's manner of dress; literally wearing one's kilt or petticoat too short or tucked up. This British and Scottish expression dates from the early 17th century.

> To dazzle the world with her precious limb,
> —Nay, to go a little high-kilted.
> (Thomas Hood, *Kilmansegg*, 1840)

9. **laced mutton** A prostitute, strumpet, trollop; a loose or promiscuous woman. The derivation of this expression is uncertain, but there is general agreement that *mutton* 'prostitute' refers to the sheep, an occasional victim of bestiality by shepherds. *Laced* may refer to the elaborately tied bodices worn by ladies of the evening from the 17th through the 19th centuries. One source suggests that the reference may be to *lacing* 'flogging,' a common punishment for harlots at that time. The most plausible explanation is that *laced* is a corruption of *lost*, and that the original expression was a variation or perhaps even a deliberate pun on *lost sheep*. This concept received the punning treatment of William Shakespeare:

> Ay, sir: I a lost mutton, gave your letter to her, a laced mutton; and she, a laced mutton, gave me, a lost mutton, nothing for my labor. (*Two Gentlemen From Verona*, I,i)

10. **Lolita** A girl in pubescence considered sexually desirable; a nymphet. This expression was derived from Vladimir Nabokov's novel *Lolita* (1955), the story of a man in later middle age, Professor Humbert, who becomes involved in a torrid love affair with a twelve-year-old girl. Stanley Kubrick made the novel into a film in 1962. *Lolita* is rapidly becoming the vernacular term for a sexually precocious teenage girl.

11. **make time with** To date a girl or woman for the sole purpose of having sexual relations; to indulge in such endeavors with another's sweetheart or wife. Literally, *make time* means to move swiftly so as to recover lost time. Figuratively, one trying to *make time with* another is attempting a quick seduction with little or no intention of forming a lasting relationship.

> At another table, two young men were trying to make time with some Mexican girls. (William Burroughs, *Junkie*, 1953)

12. **masher** A playboy or womanizer; a man who attempts to seduce any woman he meets. This expression, derived from *mash* 'flirtation,' originally referred to certain 19th-century Englishmen who feigned wealth and sophistication while pursuing female companionship at the fashionable society establishments.

> The once brilliant masher of the music hall. (Walter Besant, *Bells of St. Paul's*, 1889)

In modern usage, however, this term is used to describe any male flirt or libertine.

13. **one-night stand** A single sexual encounter; a casual, one-time sex partner. This American slang term comes from the expression's theatrical use to denote either the town in which a touring com-

pany gives only one performance, or the single performance itself.

14. painted cat A prostitute, harlot, strumpet, daughter of joy. This expression combines *painted* and *cat*, terms both associated with prostitutes: *painted woman, cathouse.* Its usage was limited to American cowboys in the Old West.

15. quench [one's] thirst at any dirty puddle To be promiscuous; to obtain partners for sexual activity indiscriminately. This self-explanatory expression is infrequently heard today.

> I had before quenched my thirst at any dirty puddle [of women]. (Davis, *Travels*, 1803)

16. rag on every bush This expression is used to describe a young man who pays marked attention to more than one lady at a time. The situation is similar to a sailor who supposedly has a *girl in every port.* The expression, in use since the early 1800s, probably derives from the old practice of hanging rags on bushes as targets, thus creating several possibilities at which one might shoot. When a young man finally decided upon one girl, she was said to *take the rag off the bush.* This term is also heard as an expression of a young lady's beauty:

> That gal certainly takes the rag off the bush. (William Harben, *Westerfelt*, 1901)

It is sometimes used as a jocular method of expressing astonishment.

> One of my neighbors greeted his first airplane with: "Gawd damn! Don't that take the rag off'n the bush?" (*American Speech*, October 1929)

17. roué A libertine or playboy; one who leads a life of frivolty and self-indulgence; one who follows the primrose path. This expression was first used figuratively in the early 18th century for the decedant cronies of the Duke of Orleans. *Roué* 'wheel' refers to the punishment for wrongdoers of that time; thus, the term implies that the Duke and his coharts deserved such a penalty.

> I knew him for a young roué of a vicomte—a brainless and vicious youth. (Charlotte Brontë, *Jane Eyre*, 1847)

18. shack up To cohabit or live together (usually in reference to an unmarried couple); to have a relatively permanent sexual relationship; to have sexual intercourse. During World War II, this expression was a popular means of describing the living arrangements of a soldier who, with a local woman, rented and intermittently lived in an apartment or inexpensive house or *shack* located near the base where he was stationed. Since the 1950s, the expression's major application has shifted somewhat from the idea of actually setting up housekeeping to its more contemporary implications of promiscuous, and oftentimes indiscriminate sexual behavior.

> If you drink and shack up with strangers you get old at thirty. (Tennessee Williams, *Orpheus Descending*, 1957)

19. sow [one's] wild oats See 130. EXCESSIVENESS.

Pronunciation . . . See 94. DICTION

Prophecy . . . See 254. OMEN

Propitiousness . . .
See 255. OPPORTUNENESS

290. PROPRIETY
See also 73. CORRECTNESS;
296. PRUDISHNESS

1. according to Cocker By the book; in strict accordance with the rules; proper, correct. This British expression comes from the name of Edward Cocker (1631–75), arithmetician and author of several books including the well-known *Arithmetick*, viewed by many as the last word on correctness. Despite the work's popularity and authoritativeness, it is thought to have been a forgery.

2. according to Gunter This is the American answer to the British expression *according to Cocker.* In use as early as 1713, it was taken from the name of Edmund Gunter (1581–1626), famed English mathematician, astronomer, and inventor. Apparently neither the British expression nor its American equivalent is very well known on the opposite side of the ocean.

The average American may not know what we mean by *according to Cocker;* while the average Englishman may be unaware of the meaning of *according to Gunter.* (G. A. Sala, *Illustrated London News,* November 24, 1883)

3. according to Hoyle By the book; in strict accordance with standard usage or rules; absolutely correct. A close synonym of *according to Cocker* and *according to Gunter,* this expression derives from the name of Edmond Hoyle, an 18th-century English writer. Hoyle was one of the first experts on the card game whist, which he spent several years teaching, and he did much to improve the game. His *A Short Treatise on Whist,* published in 1743, established him once and for all as the leading authority on the rules of the game. He was later to put together a whole encyclopedia of the rules of numerous other games. By extension his name has come to mean 'by the rules; correct.'

4. bread and butter note A letter expressing gratitude for hospitality. About 1900 *bread and butter note* or *bread and butter letter* became the standard term for a letter of thanks for entertainment or hospitality. Convention dictates that one who has been a guest in another's home acknowledge the hospitality by a note of thanks. Since bread and butter has come to symbolize the providing of hospitality, the expression has evolved rather naturally.

There came to me in the mail a copy of *The Boston Cookbook,* even ahead of the conventional bread and butter note. (Marjorie Rawlings, *Cross Creek,* 1942)

A variant of this term is a *Collins.* William Collins, a boorish and snobbish young clergyman in Jane Austen's *Pride and Prejudice,* wrote such a solemn letter of thanks after his stay with the Bennet family that his name has become a colloquialism in England for a *bread and butter note.*

5. cricket Fair play, gentlemanly behavior, honorable conduct; especially in the phrase *not cricket* 'unfair, not proper, ungentlemanly.' Cricket is a popular British sport whose name has become synonymous with fair play because of the honorable and proper conduct expected from players of this game. The term dates from 1851.

6. keep [one's] nose clean To behave properly or appropriately, to keep out of trouble, to maintain a spotless record. This expression, which dates from at least 1887, is thought to have a vulgar origin.

Do what people tell you, keep your nose clean and work out your academic progress. (Neil Armstrong et al., *First on the Moon,* 1970)

7. mind [one's] *ps* and *qs* To act or speak in a proper and dignified manner; to be on one's best behavior; to mind one's own business. There are several suggested derivations of this expression, the most likely of which alludes to a child's difficulty in distinguishing the letter *p* from the letter *q* because of their similar appearance. One source suggests that the expression may have been originated by King Louis XIV of France who advised his formally dressed noblemen that they could avoid disturbing their ornate attire by minding their *pieds* 'feet' and *queues* 'wigs.' Another source postulates that barkeeps may have said, "Mind your *ps* and *qs*!" to remind an alehouse patron that he had chalked up a large bill by ordering pints (*ps*) and quarts (*qs*) on credit.

He minds his P's and Q's—and keeps himself respectable. (William S. Gilbert, *Utopia Limited*, 1893)

8. play gooseberry To act as chaperon for a pair of lovers; to accompany as a propriety-third; to give young lovers an opportunity to be in each other's company. Although the source of this 19th-century phrase is obscure, most sources ascribe it to the actions of some legendary chaperon, who, while the young people were together, kept occupied picking gooseberries so that they might enjoy each other's affection. The term has taken on the connotation of accompanying the couple for appearance's sake only.

Let the old woman choose between playing gooseberry or loitering along behind. (William E. Norris, *Matrimony*, 1881)

9. put [one's] best foot forward To make a good impression, to show oneself off to advantage. This grammatically puzzling expression may have developed by merger of its earlier form *best side outward* with the expression *get off on the right foot;* see 31. BEGINNINGS.

A conceited man, and one that would put the best side outward. (Samuel Pepys, *Diary*, 1663)

10. stand on ceremony To insist that all formalities be followed; to demand observance of all ceremonies; to behave courteously; to refuse to continue without the proper formalities or protocol. This expression, which is obvious in its intent, dates from the 16th century. Shakespeare made use of it in *Julius Caesar*.

I never stood on ceremonies
Yet now they fright me.

The phrase is often used with a negative to connote the avoidance of courteous or proper behavior.

11. stick to [one's] last To keep to the field of one's prowess; not to meddle in affairs of which one is ignorant. In this expression, *last* refers to a foot model with which shoes are shaped. According to ancient legend, Apelles, a famous Greek artist, showed one of his paintings to a cobbler, who immediately detected an error in the artist's rendering of a laced shoe. After the artist corrected this flaw, the shoemaker overstepped himself by criticizing the artist's depiction of the legs. Apelles is purported to have replied "stick to your last." This legend is supported by the fact that the expression was originally *a cobbler should stick to his last* before it evolved its current form. The phrase's figurative sense was illustrated by Thomas Barbour, as cited in *Webster's Third:*

Curators . . . shirk any responsibility for exhibits and . . . want to stick to their lasts in the research collections.

12. way of the kami The proper life; honorable conduct; a dignified manner. This expression came into English by way of the Shinto religion of Japan. Christian missionaries used the name *kami* as a title for the Supreme Being, the Christian God, in order to present a term with which the Japanese could relate. Upon their return to England, these missionaries introduced the phrase to the language.

Although the word *kami* was known in England as early as 1727, the expression did not come into use until the mid-1800s.

291. PROSPEROUSNESS
See also 14. AFFLUENCE; 365. SUCCESS

1. chicken in every pot A promise of prosperity; hope for the future. This expression gained great popularity during the election campaign of 1932 when Herbert Hoover, who was seeking a second term, used it as a campaign promise to the people of the United States. The term's origin is often erroneously attributed to him; however, it dates back to at least 1589 when Henry IV assumed the crown of France and promised:

If God grants me the usual length of life, I hope to make France so

prosperous that every peasant will have a chicken in his pot on Sunday.

Neither Henry IV nor Hoover was able to convince the common man, for Henry was assassinated in 1610 and Hoover was defeated in his re-election bid. Probably as a result of these two ludicrous promises, the phrase is most often heard in a cynical sense today.

2. flourish like a green bay tree To thrive vigorously; to succeed overwhelmingly. Every year, the bay tree is adorned with numerous new branches growing along the entire length of its trunk. This characteristic, from which the expression is derived, is alluded to in the Bible:

> I have seen the wicked in great power, and spreading himself like a green bay tree. (Psalms 37:35)

3. go great guns To proceed with great momentum toward one's goal; to be well on the way to success; to act with gusto or go full steam ahead. Dating from the early 15th century, *great gun* referred to a large firearm like a cannon, as opposed to a *small gun* 'musket, rifle.' By the late 1800s, these uses of *great* and *small* became obsolete—however, the exclamation *great guns* gained currency, perhaps alluding to the loudness, forcefulness, and bigness of cannon and other large firearms.

> But great guns! is a man obliged to blurt out everything he honestly thinks? (*Pall Mall Magazine*, August 1895)

Go great guns appeared later and has since been current.

> A moment later Louvois shot out, passed Sanquhar and Fairy King, and going great guns . . . beat the favorite by a head. (*Field*, May 3, 1913)

4. go to town To be successful, to thrive or prosper; to work very hard or energetically. This American slang expression is thought to have originated among the rural inhabitants of the backwoods

who really whooped it up when they went out on the town for a spree.

5. land-office business A highly successful, very profitable, rapidly expanding business or enterprise; any period of high-volume sales. Although this expression has been in use for well over a hundred years, its popularity increased when the United States Government Land Office, after the passage of the Homestead Act of 1862, was swamped with work as hundreds of thousands of families and speculators sought free or low-cost land. Though the onslaught had eased by 1900, the Homesteading Program was not terminated until 1974. The phrase, however, has continued in widespread figurative use.

> A practical printer . . . could do a land-office business here. (*New Orleans Picayune*, April 2, 1839)

6. sail before the wind To be successful or prosperous; to proceed smoothly and easily, without outside interference; to breeze through a task, project, or other matter. This expression alludes to a sailing vessel's moving forward smoothly and rapidly when it has a following wind to fill the sails.

292. PROTECTION

1. Balaam's ass A savior; a person who protects others despite their ignorance of their precarious position. According to the Bible, Numbers 22–24, Balaam had asked for and received permission from God to go to Balak at Moab. However, to teach Balaam His might, the Lord placed in Balaam's path an angel with a drawn sword, visible to the ass but not to Balaam. Three times the ass strayed from the path until Balaam in his anger beat him, unaware that the donkey was saving him from the avenging angel. Finally:

> The Lord opened the eyes of Balaam, and he saw the angel of the Lord . . . his sword drawn in his hand . . . and the angel of the Lord said unto him . . . the ass saw me and turned from

me three times: unless she had turned from me, surely now also I had slain thee.

Hence our figurative use of *Balaam's ass* as one who protects us from unseen danger.

2. ride shotgun To guard goods or protect persons susceptible to attack. The expression originated with the custom of having armed guards riding beside stagecoach drivers in the days when they were frequently held up by bandits. It gained new currency with books and films on organized crime, since gangsters' bodyguards were often spoken of as *riding shotgun.* The phrase is now used not only for one who provides armed security, but also for one who plays any sort of protective role, as witness these citations from *Webster's Third:*

> Armed security forces . . . have ridden shotgun on every Israeli civilian flight since the Athens raid. *(Newsweek)*

> . . . a front-seat passenger riding shotgun and calling out road conditions ahead. (P. J. C. Friedlander)

3. run interference To protect or defend a person, his reputation, a project, or any other matter which has come under attack; to prepare the way or lay the groundwork for a potentially controversial plan, project, etc. This expression is derived from *running interference* in football, i.e., running ahead of a ball-carrier and blocking prospective tacklers out of the way. Though still commonly used in football, *run interference* is applied figuratively in contexts in which one diverts or otherwise deals with opposition, often with the implication that by so doing, he may be placing himself in jeopardy.

4. safety net Insurance; assurance of protection from financial loss; monetary security. The allusion in this expression is to the net into which people leap to escape from a burning building, or to the net which is strung beneath trapeze and

high-wire performers in a circus as protection in case of a fall. Figuratively, the term has been in everyday use since about 1960, and has become a particular favorite of the business world.

> Today's move follows . . . a $3.9 billion International Monetary Fund loan and agreement by Western bankers for a $3 billion "safety net" credit to stabilize Britain's official sterling reserves. (*The New York Times*, January 25, 1977)

5. security blanket A blanket carried about by a child as a protection against anxiety; any familiar object, person, or place that prevents or dispels anxiety. Children have always carried with them some comforting object, a blanket, a teddy bear, a favorite toy, as a feeling of security, but it wasn't until the late 1950s that the common figurative use arose. About that time, Charles Schulz, creator of the comic strip, *Peanuts*, introduced the character of a preschooler who had frightful anxiety attacks whenever his blanket was wrested from his control; this character, Linus, was destined to make the world aware of the value of a *security blanket.*

> The hijacker, alternating between his seat and the galley in the rear of the aircraft, apparently was holding the rear rest room as his security blanket. (*Saturday Review*, June 10, 1972)

6. take under [one's] wing See 168. GUIDANCE.

7. under [someone's] umbrella Under someone's influence or protection; under another's control. The allusion in this phrase is to the umbrellas that were carried over some African chieftains to symbolize their authority and influence. To be under another's umbrella is to accept from him protection from the elements; therefore, to be under a ruler's umbrella is to accept protection from him and, symbolically, to submit to his influence. The popularity of the term was enhanced during World War II when land or naval forces often found themselves

under an umbrella of friendly fighter aircraft as a protective covering from enemy bombardment or observation. The phrase has been employed allusively since the 19th century.

293. PROTEST
See also 302. REBELLIOUSNESS

1. anvil chorus A clamorous, vociferous protest on the part of many; a clangorous complaining; a squawking. The anvil is an imitative percussive instrument consisting of steel bars and a striker, used largely in opera, and then on the stage rather than in the orchestra. The musical composition often referred to as *The Anvil Chorus* is from Verdi's *Il Trovatore*.

2. hue and cry Public, popular protest or outcry; noise, hullabaloo, clamor, uproar. The original, legal sense of this expression was a shout or cry calling for the pursuit of a felon, raised by the injured party or by an officer of the law. The phrase came from the Anglo-Norman *hu e cri*. *Hue,* now obsolete in this sense except in this expression, means 'outcry, shouting, clamor, especially that raised by a multitude in war or chase;' it is the noun form of the French verb *huer* 'to hoot, cry, or shout,' apparently of onomatopoeic origin. It has been suggested that *hue* originally referred to an inarticulate sound, such as that of a horn or trumpet as well as that of the voice, and was therefore distinct from *cry.* The legal sense of this expression dates from the late 13th century, while the general sense dates from the late 16th century.

> The public took up the hue and cry conscientiously enough. (John Ruskin, *Modern Painters*, 1846)

3. perish the thought An exclamation indicating that one should not even consider an idea just mentioned, or that something is unthinkable, unpleasant, or undesirable. This expression, dating from the early 18th century, first appeared in written form in Colley Cib-

ber's version of Shakespeare's *Richard III*. It is still in everyday use. A related term, *perish forbid,* was popularized during the 1940s by Ed Gardner who, as Archy the bartender, starred on the radio show *Duffy's Tavern.* This expression, a combining of *perish the thought* and *God forbid,* is seldom heard today.

4. raise Cain See 35. BOISTEROUSNESS.

5. a voice in the wilderness A lone dissenter, a solitary protestor; one whose warnings are unheeded, whose exhortations are ignored, or whose attempts to rally others around a cause are unfruitful; a minority of one, or similar small minority; frequently *a voice crying in the wilderness.* The phrase owes its origin to the words of the prophet Isaiah:

> The voice of him that crieth in the wilderness, Prepare ye the way of the Lord, make straight in the desert a highway for our God. (40:3)

According to Matthew 3:3, Isaiah was referring to John the Baptist's heralding the coming of Jesus Christ.

Provability . . . See 392. VALIDITY

294. PROVOCATION
See also 394. VEXATION

1. build a fire under To goad into action; to activate a response; to urge on; to provoke into motion. This expression may be related to the simile *stubborn as a mule,* for the origin of this phrase is attributed to the actual building of a fire under a mule in order to get it moving. In *Animal Crackers: A Bestial Lexicon* (1983), Robert Hendrickson cites a letter from Mrs. Palmer Clark:

> Aunt Clellie said when she was a young girl she distinctly remembered that her brother-in-law literally and actually built fires under the mules who hauled cedar to get them going.

According to Hendrickson this recollection was from about 1921 in middle Tennessee. Common variants of the

phrase are *light a fire under* and *set a fire under*.

"Sidney's lit a fire under his horse now," said Stephens of Slew o' Gold, trained by Sidney Watters. (*The* [New London, Conn.] *Day*, June 10, 1983)

2. burning question A topic that arouses the public to enthusiastic discussion; that which is the issue of the moment; a hot subject. The prevailing idea behind *burning* in this phrase is 'flaming,' something that is conspicuous, something that is noticed by all with an associated suggestion of 'hotness,' which metaphorically suggests intensity of activity. The expression has been in use since the early 19th century.

Who will burden himself with your liturgical parterre when the burning questions of the day invite to very different toils. (Karl Rudolf Hagenbach, *Fundamentals of the Liturgy and Homiletics*, 1843)

A variant of the phrase is *burning matter*.

3. egg on To urge on; to incite; to provoke; to instigate an action. The first use recorded in the *OED* of *egg*, meaning 'urge on,' was about 1200, but *egg on* did not appear in print until 1566 in Drant's *Horace's Satyres*:

Ile egge them on to speake some thynge.

Apparently the phrase is not derived from the egg, as one might suspect. One source attributes the source of the expression to an ancient weapon, the *ecg* 'a type of spear.' Shortly after the Norman conquest of England, Anglo-Saxon prisoners were linked together on a long tether and driven about the countryside to perform various chores for their captors. When the prisoners became weary and faltered, they were cruelly urged on by a sharp prick from the point of the *ecg*. Another plausible explanation is that *egg* is a cognate of *edge*; hence *edge on* 'drive nearer the edge until some type of action is undertaken.'

4. firebrand One who incites others to strife or revolution, an agitator; any energetic and impassioned person who inspires others to action. Literally, a firebrand is a burning stick that is used to set other materials on fire. The development of its figurative use is obvious.

Our firebrand brother, Paris, burns us all.
(Shakespeare, *Troilus and Cressida*, II,ii)

5. get a rise out of To tease or goad someone in order to evoke a desired response; to provoke a person to react; to bait. This expression was originally angling parlance—*rise* describes the movement of a fish to the surface of the water to reach a fly or bait. By the 1800s, expressions such as *get* or *take a rise out of* referred to teasing or making a butt of someone. Today the expression has a wider application and can refer to evoking any desired response.

6. ginger group A faction which serves as the motivating or activating force within a larger body; Young Turks; a splinter group. Ginger is a pungent and aromatic substance used as a spice and sometimes used in medicines as a carminative or stimulant. Its qualities have spawned figurative use of the word meaning 'animation, high spirits, piquancy.' Thus, *ginger group* is an animating, stimulating subgroup. This British colloquial expression dates from the turn of the century.

The appearance of ginger groups to fight specific proposals, is not necessarily a bad thing—particularly if the established bodies aren't prepared to fight. (*New Society*, February 5, 1970)

7. look at cross-eyed To do the least little thing wrong, to commit the tiniest fault which provokes a response all out of proportion to its significance. This expression has no connection with internal strabismus but merely means to look at someone the wrong way. Use of the phrase dates from the mid-20th century.

8. make waves To disrupt or upset the equilibrium of a situation, to cause trouble, to stir things up.

> An unimaginative, traditional career man who does not make waves. (Henry Trewhitt, cited in *Webster's Third*)

Another expression, *to rock the boat*, is probably the source of this phrase, since moving a small boat from side to side creates waves in otherwise smooth water. Literally rocking a boat, especially a canoe or kayak, is a rather risky action since these boats readily capsize.

> Unfortunate publicity had a tendency to rock the boat. (Frederick Lewis Allen, *Only Yesterday*, 1931)

9. movers and shakers People who cause things to happen; influential people, especially in business or politics, who stir things up in order to get things done. People so referred to are characteristically concerned with achieving some goal and are unafraid and unashamed about agitating others. The same idea of agitation is present in expressions such as: *shake a leg*, 'to get moving,' and *rattle someone's cage*, 'to stir someone to action.'

> These inside peeks at Washington, D.C.'s movers and shakers are at the core of Lifetime's *Private Lives/Public People*, hosted by John and Janet Wallach. (*TV Guide*, March 24, 1984)

10. policy of pin pricks A strategy in which a series of petty hostile acts is meant to provoke the opposition; a course of trivial annoyances undertaken as a part of national policy. This expression, equivalent to the French *un coup d'épingle*, was first applied during the Fashoda incident, a period of strained Anglo-French relations in 1898:

> Such a policy of "pinpricks" is beginning to be recognized by sensible Frenchmen as a grievous error. (*The Times*, November 1898)

While the phrase's usage has declined since the Fashoda incident, it retains occasional use in describing irritating, but usually harmless, government policies.

> Russian provocation is at present but a policy of pin-pricks. (*Daily Telegraph*, March 1901)

11. put a cat among the pigeons To start trouble by introducing a highly controversial topic of discussion; to arouse passions by bringing an inflammatory subject into a conversation. This British colloquial expression is equivalent to the American phrase *put a match in a tinderbox*.

12. ringleader One who leads an insurrection; the head of a street gang or underworld syndicate; any instigator or fomenter of trouble. At the elegant soirées of the 16th century, the person who led off the dancing was called the ringleader. He was so named because the participants, prior to the start of the dance, arranged themselves in a circle. In contemporary usage, the term always carries negative connotations, so it is difficult to determine if the current sense did not indeed derive from the earlier.

> The conspiracy is so nicely balanced among them that I shall never be able to detect the ringleader. (James Beresford, *Miseries of Human Life*, 1806–07)

13. sow dragon's teeth To incite a riot or other conflict; to foment revolution; to kindle the flames of war; to plant the seeds of strife. This expression is based on the ancient Greek myth of Cadmus, a legendary hero who, after slaying a dragon that had devoured his servants, was advised by Athena to plant the monster's teeth in the ground, apparently to placate Mars, the deity who owned the dragon. The teeth produced fully armed soldiers who fought among themselves until all but five had been killed. Thus, while Cadmus thought his actions would have a pacifying effect, they did, in fact, cause more strife—a concept often im-

plicit in the figurative use of *sow dragon's teeth.*

> Jesuits . . . sowed dragon's teeth which sprung up into the hydras of rebellion and apostasy. (John Marsden, *The History of the Early Pilgrims,* 1853)

14. stir up a hornets' nest To activate latent hostility, to ask for trouble; to provoke a great stir and commotion of an antagonistic or controversial nature. The hornet has been symbolic of a virulent attacker for centuries; the phrase *hornets' nest* appeared in Samuel Richardson's *Pamela* (1739); the now more common *stir up a hornets' nest* is widely used in both the United States and Britain:

> Judges have stirred up a hornets' nest in the sacred territory of "the right to strike." (*The Listener,* August 1966)

15. wave the bloody shirt To incite to vengeance or retaliatory action; to foment or exacerbate hostilities. Two plausible theories are offered as to the origin of this phrase. One traces it to the Scottish battle of Glenfruin recounted by Sir Walter Scott in *Rob Roy,* after which the widows of the slain rode before James VI bearing their husbands' bloody shirts on spears. The other traces it to the Corsican custom of mourning victims of feudal murder: the dead man's bloody shirt, hung above his head as wailing female mourners surrounded his body and armed men guarded them all, was suddenly snatched and brandished about by one of the women, amidst increasingly loud lamentation. The men echoed her cries and vowed vengeance. *Wave the bloody shirt* was much used in the United States during the period of Reconstruction after the Civil War in reference to those who exploited and perpetuated sectional hostilities.

295. PROXIMITY

1. as near as dammit Very nearly; almost exactly; extremely close. This Briticism, dating from the late 19th century, has its origin in the longer phrase *as near as dammit is to swearing.* Truncated to *as near as dammit,* the expression is used to indicate very close approximation in distance or in time. A variant *as quick as dammit* means as quickly as one can.

> "Outside as quick as dammit!" he cried. (E. Wallace, *Angel Esquire,* 1908)

2. ballpark figure A reasonable guess; a satisfactory estimate. This expression, first used in the 1960s, has its roots in another expression from the 1960s, *in the ballpark,* meaning 'within limits, within bounds.' The term was soon transferred to the business world where an estimate was said to be *in the ballpark,* or *out of the ballpark* 'not within the realm of reason.' In time an estimated figure that seemed to be reasonable was designated a *ballpark figure.*

> Then, in 1968, we first recorded *a ballpark figure* from the *Seattle Times.* (*The New York Times,* November 29, 1981)

3. cheek by jowl Side by side, in close proximity. *Cheek by jowl,* in use since 1577, is a variation of the older *cheek by cheek,* which dates from 1330. In modern English *jowl* means either 'jaw' or 'cheek,' although it is more often construed as the former. Shakespeare used the expression in *A Midsummer Night's Dream:*

> Nay, I'll go with thee, cheek by jowl. (III,ii)

4. chockablock Jammed, crammed, or crowded tightly together; squeezed into a small place; packed in very tightly; chock-full. The figurative application of this term is a simple transfer from the nautical *chockablock,* a term meaning that two blocks of a hoisting tackle are drawn together so that they touch each other, making it impossible for the tackle to work.

> No chapter in this collection is longer than a dozen pages and most are considerably shorter; all are

chockablock with quotations.
(Maxwell Nurnberg, *I Always Look
Up the Word E-gre-gious*, 1981)

In America the term *chock-full* is heard
more frequently than *chockablock*,
while in Britain *bungfull* or *packed out
with* are common synonymous terms.

A popular restaurant in London may
be packed out with people at
lunchtime. (Norman W. Schur,
English English, 1980)

5. in spitting distance Close, at arm's
length. This expression denoting a short
distance is based on the simple, crude
idea that one can spit only so far.

6. a stone's throw A short distance;
close by.

Three mighty churches, all within a
stone's throw of one another.
(Augustus Jessopp, *Coming of the
Friars*, 1889)

This common expression obviously al-
ludes to the limited distance that one can
throw a small rock.

7. within an ace of Very close; within a
hair's-breadth; just barely; by an ex-
tremely narrow margin; on the brink or
verge; almost. This expression has its
roots in the term *Ambs-as* or *Ambes-ace*,
derived from the Latin *ambas as*, mean-
ing 'both aces or two aces,' which is the
lowest throw at dice. It is undoubtedly
also influenced by the general figurative
use of *ace* to mean a 'minute portion;
jot.' Although not in common use, these
terms may still be heard on rare occa-
sions; however, *within an ace of* has
continued in everyday use since the
1700s.

I was within an ace of being talked to
death. (Thomas Brown, *Letters*,
1704)

In modern gambling parlance the com-
mon expression for a pair of aces at dice
is *snake eyes*.

Prudence . . . See **45. CAUTIOUSNESS**

296. PRUDISHNESS
See also 290. PROPRIETY

1. banned in Boston This expression
originated during the 1920s when the
Watch and Ward Society of Boston un-
der the leadership of Anthony Comstock
became overly enthusiastic in its censor-
ship of books. The term came to be a
jocular synonym for *naughty*, and to
have a book banned in Boston became
the actual goal of some publishers, for
such censorship usually assured in-
creased sales throughout the rest of the
country. Comstock's name has been im-
mortalized in the term *comstockery*,
meaning prudishness or overzealous cen-
sorship, on moral grounds, of books,
films, etc.

2. blue laws Those statutes that seek to
regulate personal morals and individual
freedom of choice; laws written to regu-
late activities on Sunday, especially
those activities dealing with business and
entertainment. In the 17th century the
settlement of New Haven in the colony
of Connecticut passed a series of statutes
designed to regulate the behavior of its
residents on Sundays; these were said to
have been published on blue paper. The
Reverend Samuel A. Peters in his *Gener-
al History of Connecticut* (1781) lists
these original blue laws. One such law
reads:

No one shall run on the Sabbath day,
or walk in his garden, or elsewhere,
except reverently to and from
meeting.

Although Connecticut became known as
"The Blue Law State," such statutes
were also adopted by the other colonies.
Many blue laws survived into the 20th
century, and, in spite of the fact that
many have been eliminated in recent
years, some still exist and are, on occa-
sion, enforced, especially Sunday closing
laws in several states.

Simple hearts . . . play their own
game in innocent defiance of the
Blue-laws of the world. (Ralph Waldo
Emerson, *Essays*, 1876)

3. bluenose An ultraconservative in matters of morality; a puritan, prude, or prig.

That this picture may aggravate blue nose censors is not beyond the bounds of possibility. (*Variety*, April 3, 1929)

As early as 1809 Washington Irving used the adjective form *blue-nosed*. The form in the above citation and the noun *bluenose* appeared later. The color blue has long been associated with conservatism and strictness, though for what reason is not clear. In the mid-19th century, conservative students at Yale and Dartmouth were called *blues*.

I wouldn't carry a novel into chapel to read, . . . because some of the blues might see you. (*Yale Literary Magazine*, 1850)

The usage may derive from Connecticut's "blue laws"—stringent restrictions on moral conduct with harsh penalties for their infraction—which obtained in the 17th and 18th centuries. They were presumably so called because originally printed on blue paper.

4. cold as a cucumber Completely lacking in sexual desire; continent; chaste. This phrase, which predates the more common *cool as a cucumber* (See **60. COMPOSURE**) by about 200 years, was current in the early 16th century. The expression was originally used to denote a complete lack of sexual drive. Sir Thomas Elyot in *The Castle of Health* (1541) reveals that the eating of cucumbers produces a "cold and thick humor" which "will abate lust."

I do remember it to my grief;
Young maids were cold as cucumbers,
And much of that complexion.
(Beaumont and Fletcher, *Cupid's Revenge*, 1615)

By the early 18th century, *cold* had been modified to *cool*, with the phrase then indicating that one was feeling composed and collected; the sexual connotation almost completely disappeared.

Thucydides . . . is as cool as a cucumber upon every act of atrocity.

(Thomas De Quincey, *Greek Literature*, 1838)

5. Goody Two Shoes A goody-goody, a nice nelly; an appellation for a person of self-righteous, sentimental, or affected goodness; also *Miss Goody Two Shoes*. The original Little Goody Two Shoes was the principal character in a British nursery rhyme thought to have been written by Oliver Goldsmith and published by Newbery in 1765. According to the story, Little Goody Two Shoes owned only one shoe and was so delighted at receiving a second that she went around showing both to everyone, exclaiming "Two shoes!" Although it is not clear why the nursery rhyme character Little Goody Two Shoes came to symbolize self-righteous, excessive, and affected goodness, the term appeared in the writing of the 19th-century author Anthony Trollope in just such a context:

Pray don't go on in that Goody Two-shoes sort of way.

6. little old lady from Dubuque Harold Ross, long the editor-in-chief of *The New Yorker*, created the *little old lady from Dubuque* in the 1930s. She serves as the provincial grandmotherly type with whom caution must be exercised in all moral considerations. Her English counterpart is *Aunt Edna*, the brainchild of Terence Rattigan, the dramatist, who comments on her eternal moral presence in the preface to his *Collected Plays*, Volume II:

Aunt Edna is universal, and to those who may feel that all the problems of the modern theatre might be solved by her liquidation, let me add . . . she is also immortal.

7. Mrs. Grundy The personification of conventional opinion in issues of established social propriety; a prudish, straight-laced person who becomes outraged at the slightest breach of decorum or etiquette. In Thomas Morton's *Speed the Plough* (1798), Mrs. Grundy was the unseen character whose opinions in mat-

ters of social propriety were of constant concern to her neighbors:

> If shame should come to the poor child—I say Jummas, what would Mrs. Grundy say then.

The expression is still used figuratively as the embodiment of public opinion.

> And many are afraid of God—and more of Mrs. Grundy. (Frederick Locker, *London Lyrics*, 1857)

8. nice Nelly A prudish person of either sex; one who prefers civility to competence. This term can be traced directly to Franklin P. Adams, who created a number of representative characters in his column, *The Conning Tower*. Nice Nelly, one of these characters, represented prudishness and refinement to the point of absurdity.

> I've got to use *heck* for *hell* because practically all my editors are . . . being more rabidly nice Nelly than usual. (George Dixon, *New York Daily Mirror*, July 8, 1952)

Nice Nellyism is used to mean prudishness or excessive modesty.

9. wowser A contemptuous term for a puritanical-type person; a kill-joy; a narrow-minded zealot; a teetotaler. This expression, originally Australian slang, has spread to most of the English-speaking world to indicate a moralistic bigot who openly disapproves of other people's minor vices. The origin of the word, in use since the late 19th century in Australia, is obscure. In recent years the term has been used almost exclusively to signify a teetotaler.

> Men of letters, who would swoon at the sight of a split infinitive, such wowsers they are in regard to pure English, will in conversation address you as 'Old thing.' . . . (*New Statesman*, February 4, 1928)

297. PRURIENCE
See also 230. LUST

1. pinup A photograph or poster of a provocatively posed, scantily attired woman, usually one of the latest sex symbols among female movie stars. The term was most popular during World War II when soldiers commonly pinned such photographs up on the barrack walls. An equivalent American slang term is *cheesecake*, which combines the conventional association of food and sex with the photographer's cliché 'say cheese' used to make subjects smile. The male counterpart of *cheesecake* is *beefcake*, an American slang term for sexually provocative photographs of partly-clad men. *Centerfold*, the current term for such photographs, comes from the two-page spreads featuring nude or semi-nude models, popular in magazines such as *Playboy* and *Playgirl*.

2. skin flick A movie that emphasizes nudity; a pornographic film. This expression, obviously derived from the blatant and frequent nakedness of cast members, describes erotic motion pictures which luridly depict sexual activity.

298. PUNISHMENT

1. beech seal A beating administered with the branches of a beech tree. When Vermont was known as the New Hampshire Grants, agents from New York State, which was trying to annex the territory, moved in and attempted to evict the Vermonters from their lands. The Green Mountain Boys sent the New York agents home with the *beech seal* on their backs, supposedly a substitute for the Great Seal of New Hampshire. The expression today designates any sound thrashing or whipping.

2. bridewell A prison or a jail; a house of correction; a place of forced labor. Near the site of St. Bride's Well, sometimes called St. Bridget's, a holy well in London, Henry VIII had a royal dwell-

ing constructed which became known as *Bridewell*. After his father's death, Edward VI gave the structure to the city for use as a hospital, but shortly thereafter the city transformed it to a prison. Provincial leaders visiting London saw the prison and carried the name back to their villages, thus popularizing the name throughout the country. The prison was closed in 1864, but the term is still used in England today.

> There are very few bridewells where much work is done or can be done. (John Howard, *The State of the Prisons in England and Wales*, 1777)

A related term is *bridewell bird*, the equivalent of *jailbird*.

3. [the] devil to pay Consequences to be suffered; a dear price to be paid; trouble, confusion, or a fate worse than death to be endured. The first and most convincing of the three possible origins of this expression is that it alludes to the alleged bargains made between the devil and an individual such as Faust, the chief character in a medieval legend who traded his soul for knowledge and power. Another popular explanation is that many London barristers mixed work and pleasure in an inn called the Devil Tavern in Fleet Street. Their excuse for working was that they had to pay *the Devil* for their drinks. Still other sources cite the significance of the nautical use of *devil to pay* and the longer *devil to pay and no pitch hot*. The *devil* is a seam in a ship near the keel and *to pay* is to cover the seam with pitch. The difficulty of *paying the devil* is said to have given rise to the figurative uses of *the devil to pay*. This expression has been in print since the early 18th century. See also **between the devil and the deep blue sea**, 281. PREDICAMENT.

4. get it in the neck To be reprimanded or disciplined; to be severely chastised; to bear the brunt. This expression has its origins in the punishment of decapitation, in which the guillotine's blade cleaved off one's head at the neck. Figu-

ratively, the phrase usually refers to an undeserving victim of castigation or loss:

> It's the poor old vicar who gets it most in the neck. . . . He runs the risk of losing the best-kept-village competition because . . . the churchyard is looking its shaggiest. (*Guardian*, June 1973)

The expression is not limited in application to that which has a neck, even a figurative one:

> You probably don't know what a village looks like when it has caught it in the neck. (D. O. Barnett, *Letters*, 1914)

5. get [one's] lumps See 10. ADVERSITY.

6. give a whaling to To beat; to flog; to strike repeatedly with a whip so as to mark with stripes; to thrash; to attack vehemently. The exact origin of this phrase is clouded. Some sources attribute its origin to the use of a whalebone whip, an instrument quite popular during the 18th and 19th centuries as a riding whip, but often used to deliver punishment to menials and other lowly servants who disobeyed their master's orders. Other sources attribute its origin to a variation in the spelling of the word, *wale*, 'a stripe or mark raised on the flesh from a beating with a stick or whip,' or to *wale*, 'beat or flog so as to raise wales'; thus, *give a waling to*. Whatever the case, the term has been adapted figuratively to other types of beatings, as in sports or speech. The phrase has been in use since the late 18th century.

> You remember that one that came around a spell ago, a whalin' away about human rights. (Frances M. Whitcher, *The Widow Bedott Papers*, 1856)

7. go to heaven in a wheelbarrow To be damned to eternal suffering; to go to hell. This obsolete expression has been traced to a window in Gloucestershire, England, depicting Satan wheeling

away a termagant woman in a wheel-barrow.

> This oppressor must needs go to heaven, . . . But it will be, as the byword is, in a Wheelbarrow; the fiends, and not the Angels will take hold on him. (Thomas Adams, *God's Bounty*, 1618)

See also **go to hell in a handbasket**, 86. DEGENERATION.

8. have a rod in pickle To prepare a punishment for future use; to have a whipping in store. To keep them more pliable, birch rods used to be kept in a solution of lye, called *pickle*; hence, a *rod in pickle*, or a *rod in lye*, was one that was already prepared for administering punishment. Figuratively, the term has come to indicate any punishment that lies in store, whether mental or physical.

> I fear that God hath worse rods in pickell for you. (Benjamin Spenser, *Vox Civitatis*, 1625)

> I know one, that experimentally proved what a rod in lye could do with the curstest boy in the Citty. (Gabriel Harvey, *Pierces Supererogation*, 1593)

A related term, *kiss the rod*, means 'receive a beating.'

9. heads will roll Those responsible will be held accountable; there's trouble in the offing. This American slang expression is of fairly recent vintage, though it alludes to former times when beheading was common and heads literally did roll as a result of an enraged monarch's fit of anger at his subjects' incompetence, betrayal, or rebelliousness.

10. Jedburgh justice Connoting legal procedure which applies the principle "hang first and try afterwards." The origin of this expression can be traced directly to Jedburgh, the capital of Roxburghshire, Scotland. The justice in this provincial town was noted for its summary character.

Variants are *Jeddart justice*, *Jedwood*

justice, and *Cupar justice*. Jeddart and Jedwood are simply variants of Jedburgh; *Cupar justice* arises from a similar practice of justice in the baron-baile of Coupar-Angus.

> The memory of Dunbar's legal proceedings at Jedburgh are preserved in the proverbial phrase, "Jeddart justice," which signifies trial after execution. (Sir Walter Scott, *The Minstrelsy of the Scottish Border*, 1802)

See also **Lydford Law**, below.

11. kiss the counter To go to prison, to be confined in the clink. Originally the word *counter* was used to designate the office or court of a mayor, but by the mid 1400s had come to include the jail or prison attached to such a city court. Prisons in London, Southwark, and Exeter, as well as in a few other cities, became known as the Counter; hence, to *kiss the counter* was to be sentenced to one of these prisons. Related terms are *kiss the clink*, after a prison in Southwark, and *kiss the stocks*, meaning to be confined in the stocks.

> Then some the counter oft do kiss, If that the money be not paid. (Henry Huth, ed., *Ancient Ballads*, 1560)

12. kiss the rod See 362. SUBMISSIVENESS.

13. lay up in lavender See 285. PRESERVATION.

14. lower the boom To punish; to chastise or discipline severely; to prohibit. This expression originally described a nautical maneuver by which one of the ship's booms was directed so as to knock an offending seaman overboard. The expression later developed into a prize-fighting term for delivering a haymaker. In contemporary usage, the phrase is often applied to an activity which is abruptly terminated through anger or castigation.

> Just as they were about to pawn my studs . . . my patience evaporated

and I lowered the boom on them.
(*The New Yorker*, June 1951)

15. Lydford Law The practice of punishing first and trying afterwards. The duchy of Cornwall, made up of the counties of Cornwall and Devon in England, had its own parliament until 1752 and its own courts, called stannary courts, until 1896. Lydford, a village in Devon where the stannary courts were held, was noted for its unusual justice. Prisoners were confined in a dungeon so abominable that they often succumbed before their trial. If they didn't, they were often hanged or flogged before the trial.

But here he thought to call us thieves, and wicked Judges, and to charge us with the Law of Lydford. (John Jewel, *A Reply unto Harding*, 1565)

Variants of this expression are *Abingdon law*, describing the practice during the Commonwealth when Major-General Browne, sitting in judgment at Abingdon, hanged his prisoners in the morning and tried them that same afternoon; and *Halifax law*, describing the swift justice meted out formerly in the city of Yorkshire.

At Halifax the law so sharpe doth deale,
That whoso more than thirteen pence doth steale,
They have a jyn that wondrous quick and well
Send thieves all headless into heaven or hell.
(John Taylor, *Halifax Law*, 1630)

See also **Jedburgh justice,** above.

16. lynch law The administration of punishment, usually hanging, without benefit of trial; mob justice. Although the origin of this term is uncertain, two explanations seem more plausible than any others. Henry Howe in *Historical Collections of Virginia* (1845) lists the following derivation.

Colonel Charles Lynch, a brother of the founder of Lynchburg, was an officer of the American Revolution.

The country was thinly settled and infested by lawless bands of Tories and desperadoes. . . . Colonel Lynch, then a leading Whig, apprehended and had them punished without any superfluous legal ceremony. Hence, the origin of the phrase "Lynch law."

A less credible conjecture is that the expression can be attributed to Lynch's Creek, South Carolina, where a band of colonists called the "Regulators" administered their own special brand of criminal justice, locally called *lynch law*, to those believed to be Tories. Whatever the case, *lynch law* is still occasionally practiced in the United States. Related terms are *lynch court*, a self-appointed court to administer *lynch law*; *Judge Lynch*, the imaginary authority at one of these courts; and *swamp law*, a synonym for *lynch law*.

17. pin [someone's] ears back See **have [one's] ears slapped back,** 312. REPRIMAND.

18. pommel [someone] To beat someone with something knoblike, as the pommel of a sword; to beat or strike with the fists. Originally, this expression meant to *beat another with the pommel*, 'the knoblike protuberance on top of the hilt of old swords.' Today the term is used to indicate 'a beating with the fists.' It has been in use since about 1500.

There is a degree of absurdity in two mortals setting solemnly to work to pommel one another. (Ouida, *Held in Bondage*, 1863)

19. ride on a rail To punish severely, to chastise mercilessly; to subject to public abuse and scorn; to banish, ostracize, or exile; in the latter sense usually *ride out of town on a rail*. It was formerly the practice to punish a wrongdoer by seating him astride a rail, or horizontal beam, and then carrying him about town as an object of derision. Often he was then taken to the village limits and warned not to set foot in the town again

under pain of yet more severe punishment.

> The millmen . . . [hesitated whether to] ride him on a rail, or refresh him with an ablution at the town-pump. (Nathaniel Hawthorne, *Twice Told Tales*, 1837)

20. ride the Spanish mare This old nautical punishment, which caused great physical discomfort as well as much mental anguish, consisted of forcing the malefactor to straddle a boom with a slackened stay, the *Spanish mare*, and to ride it as the ship pounded through the sea. Variations of the punishment were devised, giving rise to the terms *ride the wild mare* and *ride the wooden mare*.

> Bestriding the mast I got . . . towards him, after such manner as boys are wont (if you ever saw that sport) when they ride the wild mare. (Sir Philip Sidney, *The Countess of Pembrokes Arcadia*, 1586)

21. ride the wooden horse To be flogged; to be lashed to a wooden apparatus and whipped. In this obsolete form of British military punishment, dating from the 1400s, the offender, with his hands tied behind his back, was seated upon a sharp wooden ridge, called 'the back of the horse,' and flogged. Figuratively, the term came to mean any form of abuse, physical or verbal.

> I ride the wooden horse e'er be troubled with her impertinence. (Thomas D'Urfey, *The Virtuous Wife*, 1680)

22. riding Skimmington This expression alludes to an ancient custom in the rural parts of England and Scotland, a custom usually reserved for nagging wives but on occasion used for unfaithful husbands. A man and a woman, representing married couples, rode horseback with the husband behind the wife and facing the tail of the horse, while the wife beat him with a ladle. A procession was formed which passed slowly and noisily through the village, stopping at each house where a wife dominated her husband to give the threshold a symbolic sweeping. The origin of the term is uncertain, but it may be from *skimming* for, in *Divers Crabtree Lectures* (1639), the frontispiece captioned *Skimmington and her Husband* portrays a wife beating her husband with a skimming ladle.

> You would do well not to forget whose threshold was swept when they last rode the Skimmington upon such another scolding jade as yourself. (Sir Walter Scott, *The Fortunes of Nigel*, 1822)

A related term *ride the stang* describes the treatment afforded a husband who beat his wife or was unfaithful to her. He was placed on a pole, called a *stang*, which was lifted to the shoulders of the bearers. In this uncomfortable position he was carried through the village to the taunts and gibes of the townspeople.

23. run the gauntlet See 10. ADVERSITY.

24. send to Coventry To ostracize or exclude from society because of objectionable behavior; to refuse to associate with, to ignore. Several explanations have been proposed as to the origin of this expression. The most plausible was put forth by Edward Hyde Clarendon in *A History of the Rebellion and Civil Wars in England* (1647). It stated that citizens of a town called Bromigham were in the habit of attacking small groups of the King's men and either killing them or taking them prisoner and sending them to Coventry, then a Parliamentary stronghold. A less plausible explanation maintains that the inhabitants of Coventry so hated soldiers that any social intercourse with them was strictly forbidden. Thus, a soldier sent to Coventry was as good as cut off from all social relations for the duration of his stay.

25. send up the river To send to prison. This American expression originally referred to the incarceration of an offender at Sing Sing—a notorious correctional facility located up the Hudson River from New York City. The phrase has

now been extended to include any imprisonment.

> I done it. Send me up the river. Give me the hot seat. (*Chicago Daily News*, March 1946)

26. Sing Sing An infamous prison in Ossining, New York. The name of the prison was derived from the original name of the community. When white men first settled the city that is now known as Ossining, they named it *Sing Sing*, a corruption of the Delaware Indian designation for the spot, *assinesink*, meaning 'at the small stone.' However, by the late 1800s the prison had become so well known throughout the United States as the hardest, most brutal penitentiary in the country that its name had become allusive of harsh confinement.

> 'Tis an extempore Sing Sing built in a parlor. (Ralph Waldo Emerson, *Society and Solitude*, 1870)

The townspeople, with the prison's shameful reputation motivating them to action, voted in 1901 to change the name of their community to Ossining. The prison is still well known, and the term remains as a synonym for a penitentiary.

> Those who are in Albany escaped Sing Sing, and those who are in Sing Sing were on their way to Albany. (Elbert Hubbard, *Book of Epigrams*, 1911)

27. Stafford law A beating; the administration of corporal punishment with a club. This expression arises from a play on words, *staff* for the 'stick or cudgel used to beat a prisoner or suspect.' Randall Cotgrave in *A Dictionary of the French and English Tongues* (1611) describes a beating:

> He hath had a trial in Stafford Court.

The expression, no longer in use, was coined in the mid-15th century. Variations are to *clothe in Stafford blue*, 'to beat one until he is black and blue,' and *a treat in Stafford court*, 'a thorough thrashing.'

28. stand in a white sheet To perform penance; to undergo disciplinary action for incontinence. This expression, used figuratively since about 1550, originated with the old religious practice of forcing one who was guilty of fornication to stand, draped in a white sheet, before the congregation throughout mass as a form of penance. In later years the punishment was imposed for a variety of other transgressions.

> On Sunday last the Parish Church of St. Mary, Lambeth, was . . . unusually crowded . . . to see Mr. John Oliver . . . do penance in a white sheet, for calling Miss Stephenson, the domestic female of a neighboring Baker, by an improper name. (*London Courier*, November 29, 1797)

29. stand the gaff See 116. ENDURANCE.

30. take the bark off To flog or chastise, to give one a hiding. This 19th-century Americanism, implying a flogging or whipping so severe as to flay one's skin, likens the skin on a person to the bark on a tree.

> The old man's going to take the bark off both of us. (Johnson J. Hooper, *The Adventures of Captain Simon Suggs*, 1845)

31. take the rap To accept or be given the responsibility and punishment for a crime, especially one committed by another; to take the blame. Although this expression apparently employs *rap* in its sense of 'blame or punishment,' one source suggests that the phrase may in fact be a corruption of the theatrical *take the nap* 'to be dealt a feigned blow.'

> I don't think though, I shall be able to take the nap much longer. (*Era Almanach*, 1877)

> He carried the banner and took the rap for Roosevelt in the Senate for years. (*Saturday Evening Post*, July 2, 1949)

Related expressions are *bum rap* 'a frameup; a conviction for a crime of

which one is innocent,' and *beat the rap* 'to be acquitted or absolved of blame,' usually with the implication that one is indeed guilty.

> [Senator] Kefauver [and his Congressional committee] realize that as dope peddling and bootlegging are made more difficult, the crooks will start looking for new ways to beat the rap. (P. Edson, AP wire story, September 1951)

Rap itself is often used as a synonym for an arrest, a trial, or a jail sentence.

> Gangs with influence can beat about 90% of their "raps" or arrests. (Emanuel Lavine, *The Third Degree: A Detailed Exposé of Police Brutality*, 1930)

32. tar and feather To punish harshly or castigate severely. This expression is derived from the brutal punishment in which the victim was doused with hot tar and subsequently covered with feathers. In 1189, this form of chastisement received royal sanction in England. While it was never ordained as a legal penalty in the United States, it nevertheless became a form of punishment by the masses for a crime or misdoing which fell outside the realm of the law. It retains frequent hyperbolic use.

33. throw the book at To give a convicted criminal the maximum penalty or sentence; to prosecute on the most serious of several charges stemming from a single incident, especially when it would be possible to try a person on a lesser charge; to accuse of several crimes. This expression conjures images of a judge's referring to a law book to compile a list of all possible wrongdoings of which a prisoner may be accused, or a list of the most severe penalties that may be assessed for the crime(s) of which a person has been convicted.

> He was formally charged with "breaking ranks while in formation, felonious assault, indiscriminate behavior, mopery, high treason, provoking, being a smart guy, listening to classical music, and so on." In short, they threw the book at him. (Joseph Heller, *Catch-22*, 1962)

34. wages of sin Recompense for leading an evil life.

> For the wages of sin is death; but the gift of God is eternal life . . . (Romans 6, 23)

This ancient expression, taken directly from the Bible, is an exhortation for righteousness, a plea for holy living. Its figurative use implies a fitting return for an evil action. The term is often used ironically to express an uneven administration of justice.

> They tell us that the wages of sin is death; we know very well that it is not always. (Somerset Maugham, *The Mixture as Before*, 1940)

Pusillanimity . . .

See **75. COWARDICE**

Q

Quality . . . See 129. EXCELLENCE

299. QUEST

1. draw a bow at a venture To take a shot in the dark; to guess at the truth; to fish for information. This expression refers to one who hopes to hit the mark with an arrow by firing casually aimed shots from his bow. The phrase, in use since the 16th century, appears at least twice in identical form in the King James version of the Bible:

A certain man drew a bow at a venture and smote the king of Israel. (I Kings, 22:34; II Chronicles, 18:33)

The expression is occasionally heard today.

"And your mother was an Indian," said Lady Jane, drawing her bow at a venture. (Mrs. Lynn Linton, *Paston Carew*, 1886)

2. go gathering orange blossoms To search for a wife. This expression is derived from the snow-white orange blossom, a popular wedding decoration that symbolizes the innocence of a young bride. The development of this phrase's figurative sense is obvious. Its use by William E. Norris was cited by James M. Dixon in the latter's *Dictionary of Idiomatic English Phrases* (1891):

"What has he come to this lovely retreat for? To gather orange blossoms?"

3. go in search of the golden fleece To pursue one's destiny; to seek one's fortune; to embark on an adventurous quest. This expression's origin lies in the Greek myth of Jason and the Golden Fleece, in which Jason and a band of cohorts, called the Argonauts after their ship, set forth on a virtually hopeless quest to recover the golden fleece. Jason and his companions were victorious only after numerous perils. Figuratively, this expression is applied to a person who searches against great odds for great fortune.

4. pound the pavement To walk the streets seeking employment, to be out looking for a job, to go from door to door in search of work; also *pound* or *hit the sidewalks*. The allusion is to feet walking back and forth beating the paved street. This American slang expression appeared in one of its variant forms, *pound the asphalt*, in O. Henry's *Options* (1909):

I'm pounding the asphalt for another job.

5. set [one's] cap for To try to gain the affections of someone to whom one is attracted; to set one's romantic sights on; to flirt with; to make a play for. In the days when ladies always wore hats in public, a woman would don her most alluring bonnet in hopes of attracting that certain man of her dreams.

Instead of breaking my heart at his indifference, I'll . . . set my cap to some newer fashion, and look out for some less difficult admirer. (Oliver Goldsmith, *She Stoops to Conquer*, 1773)

6. wild-goose chase See 159. FUTILITY.

Quibbling . . .

See 146. FAULTFINDING

Quickness . . . See 212. INSTANTA-
NEOUSNESS; 261. PACE;
354. SPEEDING

R

300. RACISM

See also 283. PREJUDICE

1. black and tan A mixed crowd of blacks and whites; a racially integrated establishment or situation. This term originated shortly after the Civil War as the name of a faction of the Republican party which favored proportionate representation of blacks and whites within the party. Those who most fervently favored such a plan were called the *blacks*; those who were more moderate were called the *tans*; thus the name of the faction became the *black and tan*. The phrase quickly became a slang expression for any place or organization where racial integration was allowed or encouraged.

> The Commissioner looked at me "You heard what the Captain said, boy. We'll close you down if you allow dancin'." I guess what worried them was my place was black and tan.
> (Alan Lomax, *Mister Jelly Roll*, 1950)

2. Jim Crow Racial discrimination; laws which forbid interracial contact, as in public places and schools; also, *Jim Crowism*. This term originated in the popular plantation song by Thomas D. "Daddy" Rice (1828):

> Wheel about and turn about
> And do jis so,
> Ebry time I wheel about
> I jump Jim Crow.

After the Civil War Reconstruction, the phrase was applied to the many laws which limited the rights of Blacks, and more loosely, to racial bigotry itself.

> One hundred years of frustration and battle have not resulted in victory over Jim Crow and racism.
> (*Freedomways*, XIII, 1973)

The expression has also become a disparaging epithet for any Negro.

3. lily-white Prejudiced or discriminatory against blacks; racially segregated. This term gained popularity immediately following the Civil War, especially as a description for those white people who wished no contact with blacks and attempted to thwart them from exercising their newly won rights. A group of Southern Republicans who favored excluding Negroes, not only from the Republican party, but from any political activity whatsoever, actually adopted the term as a name for their faction, calling themselves *The Lily-Whites*. The term was soon extended to describe those social organizations that had written a color ban into their constitutions.

> Our attitude derives from the past 'lily white' tradition of the clubs. (*Chicago Maroon*, October 22, 1948)

The phrase continues to carry the same connotation today. See also 397. VIRTUOUSNESS.

Rage . . . See 158. FURY

Rambunctiousness . . .
See 35. BOISTEROUSNESS

Rank . . . See 212. INSTANTANEOUSNESS; 261. PACE; 354. SPEEDING

Rashness . . .
See 187. IMPETUOUSNESS

Rate . . . See 261. PACE

Rawness . . . See 204. INEXPERIENCE

301. READINESS
See also 284. PREPARATION

1. **all systems go** All set, everything's ready, let 'er roll. This expression denoting readiness for an undertaking gained frequency following the televised space flights of the 1960s and '70s, but its popularity soon waned. As originally used, it indicated that all of a spacecraft's systems were functioning properly so the countdown could begin and the launching occur.

2. **A-OK** This recent (1960s) American version of *A1* gained currency from television coverage of space flights. Astronauts and ground crew used the term to denote the condition of a spacecraft's systems, or their own situation. In common usage its connotations are less of superiority and excellence than of preparedness or satisfactoriness.

3. **at the drop of a hat** Immediately; at a moment's notice. This term, dating from at least the early 19th century, is still in common use today. Alfred H. Holt in *Phrases and Word Origins* attributes its source to the old practice of dropping a hat as a signal at the beginning of a fight, which probably accounts for the common American descriptive phrase, "He'll fight at the drop of a hat." The transfer to any situation requiring immediate action was inevitable.

He made a speech at the drop of a hat, at political meetings, church suppers, or almost any other gathering that wants to listen. *(Time, July 19, 1948)*

4. **Barkis is willin'** An expression denoting availability, willingness, readiness, eagerness, desirousness. Charles Dickens gave us the phrase in *David Copperfield*. Barkis is enamored of the maid to David's mother. On learning from the youth that she is not spoken for, he sends her the message, via David, that "Barkis is willin'."

5. **come up to scratch** To reach the required standard; to come up to the point of readiness; to measure up; to be in prime condition. This expression is derived from the old practice of leading competitors in sporting events up to a starting line known as a *scratch line* or *scratch*, from which point the contest began. By transference, the term came to imply that one was in good condition if he *came up to scratch*. An obsolete variant with the same meaning is *bring to the scratch*.

6. **loaded for bear** To be prepared for any possibility; to be armed and ready to fight; to have girded up one's loins. This phrase originated during the westward movement, when a man was not considered ready for hunting unless he had enough ammunition to kill a bear. The expression, as used by E. G. Love, is cited in *Webster's Third*:

Learning that every outfit . . . was of full strength, sober, and loaded for bear.

The expression has recently acquired the additional meaning of being drunk, undoubtedly as a lengthening of the common term *loaded* 'to be intoxicated.'

7. **the noose is hanging** Everything is set; everyone is ready and waiting. This expression alludes to the restive anticipation of a crowd awaiting a public hanging. The phrase has never gained widespread popularity.

The noose is ready—All the musicians are primed for a real cutting session. (E. Horne, *For Cool Cats and Far-Out Chicks*, 1957)

8. **raring to go** Enthusiastically eager to begin; primed, psyched, ready. This American slang expression, of uncertain origin, has been in print since the early 1900s. *Raring* may be related to *roaring* or *rearing* (as of horses), but either connection is pure hypothesis.

Both sides are rarin' to go, and they are not liable to touch their

peremptory challenges. (F. N. Hart, *The Bellamy Trial*, 1923)

9. taxi squad A group of professional athletes who are not listed on the club roster, but are available to play in an emergency; players under contract who practice with the team but are not eligible to play in games. This term arose from the practice of Arthur McBride, one of the early owners of the Cleveland Browns professional football team. McBride brought many players to Cleveland to try out for his team, but because athletic leagues determine the maximum number of players a team may carry on its official roster, he was not able to keep them all as active players. However, rather than lose to another team those players who showed potential, he would hire them to drive for a taxi company that he owned and thus keep them available to work out with the team until needed. An alternate version of the term is *cab squad*.

Reasonability . . .
See 339. SENSIBLENESS

302. REBELLIOUSNESS
See also 293. PROTEST

1. beat generation That group of people, who, during the late 1940s and early 1950s, rejected the values and conventions of modern society; beatniks. The social rebels of the post-World-War-II decade, often called *beatniks*, expressed themselves through unconventional dress and behavior, which was characteristic of their general dissatisfaction with a materialistic civilization.

The *Beat Generation* is really a private vision. The originals . . . dreamed of a generation of crazy illuminated hipsters suddenly rising and roaming America . . . (E. Burdick, *The Reporter*, April 3, 1958)

The coinage of this term is usually ascribed to the novelist and poet Jack Kerouac, who along with poets Allen

Ginsberg and Lawrence Ferlinghetti, is generally regarded as the spiritual leader of the group. Ferlinghetti, especially, increased the popularity of the term by establishing the City Lights Press in San Francisco, where he published much of the work of the *Beat* writers. The movement grew in popularity, spreading to Britain and the rest of Europe, but it dwindled to practically nothing during the early 1960s. Some elements of it revived in altered form in the *hippy movement* of the late 1960s.

2. brush fire The implication in this term is that a *brush fire* may become a full-blown forest fire at any moment. In its figurative sense it suggests the eruption of any small-scale problem into major proportions. The term has been in use since about World War II.

The family outcast is stirring up a brush fire of liberal resentment against the Truman administration. (*Chicago Daily News*, May 15, 1947)

Since the mid 1950s the expression appears most frequently in *brush-fire war*, a term used to designate a small scale rebellion that has drawn the political attention and sometimes the military intervention of the superpowers. Occasionally, brush-fire wars expand into major military conflicts, as in Vietnam in the 1960s.

3. come-outer One who comes out or withdraws from an established organization, especially from a religious body; a radical reformer; a religious dissenter. In the early 1800s, a mystical religious group, believing that organized Christianity was unnecessary because the only source of divine truth was that which God revealed directly to one in his heart, was founded on Cape Cod. Since these *come-outers* were so decisive in their views of the church, the term soon came to be applied to any religious rebel and eventually to any reformer who left any kind of an organization on principle.

I am a Christian man of the sect called come-outers, and have had

experience. (Thomas C. Haliburton, *Nature and Human Nature*, 1855)

4. fly in the face of To defy recklessly or challenge; to act in bold opposition to. A bird or insect that flies in the face of a predator is acting against its instincts and thus courting trouble. The phrase is often used figuratively to describe political or social opposition:

> He had to fly in the face of adverse decisions. (*Nations*, December 1891)

Extensions of the expression include *to fly in the face of danger* and *to fly in the face of providence*, both of which carry a sense of reckless or impetuous disregard for safety.

5. kick against the pricks To protest in vain, to resist ineffectually a superior force or authority, especially to one's own detriment. This expression appears several times in the Bible. In Acts 9:5 Jesus answers Saul's question "Who art thou, Lord?" by answering:

> I am Jesus whom thou persecutest: it is hard for thee to kick against the pricks.

Prick in this case literally refers to a sharp, pointed goad for oxen and figuratively to the voice of authority. To literally kick against the pricks then is a thoroughly futile act.

> For the past ten years he has known what it is to "kick against the pricks" of legitimate Church authority. (Marie Corelli, *God's Good Man*, 1904)

6. kick over the traces To rebel, to resist or rise up against the accepted order, to throw off or defy conventional restraints. A harnessed horse literally kicks over the traces when it gets a leg outside the straps (traces) connecting its harness to a carriage or wagon.

> The effervescence of genius which drives men to kick over the traces of respectability. (Sir Leslie Stephen, *Hours in a Library*, 1876)

7. left-wing Espousing radical or progressive political, social, or economic ideologies; favoring extensive political, social, or economic reform; socialistic; Communistic. This expression arose as the result of the French National Assembly of 1789 in which conservatives were seated in the right side, or wing, of the hall, moderates in the middle, and radical democrats and extremists in the left wing. This seating arrangement persists in several contemporary legislatures including the British Commonwealth Assemblies where politicians with radical or socialistic views usually sit to the left of the presiding officer. After World War II, and especially during the McCarthy era, *left-wing* usually implied that one was a Communist or a Communist sympathizer.

> The left-wing challenge over Europe is expected to unseat at least one member of the Labour Party National Executive Committee. (*Times*, September 5, 1972)

People or groups of people with left-wing philosophies are frequently called *left wing, left-wingers*, or *the Left*. The radical political activists in the United States in the late 1960s and early 1970s were often called *the New Left* in an attempt to dissociate them and their activities from intimations of Communist influence or complicity.

8. sow dragon's teeth See 294. PROVOCATION.

9. take the bit between [one's] teeth To cast off external controls and take charge of one's own life; to rebel against unfair restraints or impositions. The *bit* in this expression refers to the mouthpiece of a bridle, attached to the reins used to control a horse. When a horse takes the bit between his teeth, the pain in his mouth is relieved and he becomes more manageable. This expression, dating from the early 17th century, often implies willful defiance. A variant is *take the bit in one's teeth*.

10. work-to-rule A form of trade union slowdown carried out by applying a strictly literal interpretation of rules and regulations; to observe letter for letter the technicalities laid down by the union rule book in order to force concessions from management. This expression, coined in Great Britain about 1962, is used in reference to a sort of job action involving a deliberate slowing of productivity short of an actual work stoppage, frequently the final procedure taken before a strike. The term is used as a verb phrase or, hyphenated, as a noun.

> Hospital consultants began a work-to-rule on 2 January, in protest against the new contract they had been offered. (H. V. Hodson, "United Kingdom," *The Annual Register of World Events in 1975*, 1976)

11. young Turk An insurgent; one who advocates reform in a staid, conservative organization; a rebel; a political radical or liberal. In 1891, a group of reformists established the Young Turks, a political party dedicated to realigning the priorities of the Turkish Empire and instituting European ideologies and customs in governmental procedures. After inciting a revolt in 1908 in which the Sultan was deposed, the Young Turks remained a viable political force until the end of World War I. By extension, *young Turk* has assumed figurative implications as evidenced in this quote from John Gunther (1901–70), cited in *Webster's Third:*

> The young Turks . . . [are] opposed to the ossified conservatism of the older, so-called statesmen.

Recall . . . See 305. RECOLLECTION

303. RECANTATION
See also 88. DENIAL; 325. REVERSAL; 391. VACILLATION

1. do a 180° turn To do an about-face, to reverse suddenly and completely one's previous position, approach, or point of view. A circle is 360°; to turn 180° is lit-erally to turn halfway around and face the opposite direction. It is easy to see how this literal turnabout gave rise to the figurative sense of the expression as it is popularly used today.

2. draw in [one's] horns See 361. SUBMISSION.

3. draw the nail To release oneself from a promise given; to break a personal contract. This Briticism, seldom heard today, is derived from an old Chelsea practice: when a Chelsea man made a promise, he would drive a nail into the trunk of a tree, affirming that he would always live up to his vow. However, he left himself an escape; if he wished to retract his promise, he simply had to withdraw the nail from the tree, and the vow was no longer considered valid. Some of those who made promises would leave a portion of the nail head protruding from the trunk to make it easier to withdraw.

4. eat [one's] words To retract one's assertions; to be compelled to take back what one has said; to be forced to back down or eat humble pie, to be humiliated and proven wrong. This expression dates from the 16th century, and will probably be popular for as long as putting one's foot in one's mouth is a common practice.

> Unguarded words, which, as soon as you have uttered them, you would die to eat. (James Beresford, *The Miseries of Human Life*, 1806–07)

5. Indian giver One who recalls a gift, either simply from second thoughts or because of subsequent dissatisfaction with a gift received in return. Early American settlers attributed this practice to the natives. The term is now used primarily among children as a name-calling taunt when one decides to renege on a trade or bargain.

6. sing a different tune To do or say something different; to change one's position; to assume a new attitude or express a revised opinion, especially one that is more appropriate and suited to

the circumstances at hand; also *sing another song.* The change in attitude or behavior can be motivated by expediency or, at the other extreme, humbleness. In 1390, John Gower used the phrase in *Confessio Amantis.*

O thou, which has disseized the Court of France by thy wrong, now shalt thou sing an other song.

The phrase is current today, as is the analogous *change one's tune.*

7. turncoat See 33. BETRAYAL.

Recess . . . See 317. RESPITE

304. RECIPROCITY
See also 70. COOPERATION

1. ka me, ka thee Do a good deed for another and the favor will be returned. This expression appeared in print as early as the mid-16th century. The exact origin is unknown and many variants were used interchangeably with *ka,* such as *kaw, kae, k, kay,* and *kob. Scratch my back, I'll scratch yours* is a current analogous expression which like the proverbial *Do unto others as you would have them do unto you* implies reciprocity of service, flattery, or favors.

Ka me, ka thee, one good turn asketh another. (John Heywood, *Works,* 1562)

2. logrolling The trading of votes or favors, especially among legislators, for mutual political gain; the policy of "you scratch my back and I'll scratch yours." In pioneer days a logrolling was a gathering at which neighbors helped each other roll and pile their logs to a particular spot for burning or other means of disposal. It was similar in nature to barn raisings and husking bees. Literal logrolling also played an important part in lumber camps where members of different camps often joined forces in rolling their logs to the water's edge to catch the flood downstream. This U.S. term apparently came from the proverbial expression "you roll my log and I'll roll yours." Political use of the term dates from the early 19th century.

Territorial supreme courts have long since become known as a kind of log-rolling machine, in which the judges enter in the business of "you tickle me and I will tickle you." (*Weekly New Mexican Review,* July 1885)

3. one hand washes the other A proverbial expression originally denoting mutual cooperation in its positive sense only, but now carrying the negative connotations of backscratching, cronyism, and logrolling. It appeared as early as the 1500s in the former sense, but within a few centuries began to take on the latter dubious coloration.

Persons in business . . . who make, as the saying is, "one hand wash the other." (*Diary of Philip Hone,* 1836)

Recklessness . . .
See 187. IMPETUOUSNESS

305. RECOLLECTION

1. hark back See 311. REPETITION.

2. on the tip of [one's] tongue On the verge of being remembered and spoken; known but unable to be retrieved from the recesses of memory. This expression plays on the idea that words awaiting utterance are poised on the tip of one's tongue.

3. penny dropped Used about someone who finally gets the message or belatedly understands a joke; something fell into place. The reference in this expression is to a vending machine, in British English called a slot machine, and the dropping of the coin into place so the vending operation may take place. As the coin is sometimes slow in activating the machine, so are some people sometimes slow in comprehending the significance of a situation or a comment; hence, when the light dawns, one says *the penny dropped.*

4. ring a bell To serve as a reminder, to bring to mind; to have meaning or significance. Although the exact origin of this expression is not known, it may stem from the former practice of ringing church bells to signal the hour or to inform the populace of significant events, such as births, deaths, or weddings.

> The things we talked about meant nothing to them: they rang no bell. (Nicholas Monsarrat, *This Is Schoolroom*, 1939)

5. toys in the attic Unrecognized influences from one's childhood which affect one's adult personality; long forgotten impressions from one's past that emerge unexpectedly. This expression came into popular usage during the 1960s with the success of Lillian Hellman's play *Toys in the Attic*, which won the Drama Critics' Circle award in 1960. Using *toys* as a symbol of the fancies of childhood, the metaphor is made complete by the humorous application of the *attic* as the brain.

> The memoirs contain other hints about characters and situations . . . after all, many of them started out as toys in Hellman's own attic. (Doris V. Falk, *Lillian Hellman*, 1978)

306. RECOVERY

1. Achilles' spear Anything that cures a wound or solves a problem that it created itself. The story is told that Telephus, the son of Hercules, was caused to stumble against the spear of Achilles, thus wounding himself. The oracle informed Telephus that Achilles would be his healer, and when Telephus approached him for assistance, Achilles scraped some rust from his spear and applied it to Telephus's wound; the rust became milfoil, a medicinal plant, which in turn healed Telephus's wound.

> Evolution may be compared to the spear of Achilles; it heals, at any rate, some of the wounds which it causes. (Charles Bigg, *The Church, Past and Present*, 1900)

The expression has been in use in English since at least the late 1300s, when Chaucer employed the term in "The Squire's Tale," one of *The Canterbury Tales*.

2. cheat the worms To recover from a serious illness. The expression *food for worms* is used to describe a dead, decaying body. Thus, when someone recovers from a potentially fatal illness, these worms have been cheated.

3. eat snakes To recover one's youth and vigor, to be rejuvenated. This obsolete expression dates from at least 1603. It is perhaps an allusion to the snake's seasonal shedding of its old skin. The phrase appeared in John Fletcher's *The Elder Brother* (1625):

> That you have eat a snake, and are grown young, gamesome, and rampant.

4. get out from under To recoup one's financial losses, to settle one's debts; to remove oneself from a negative situation; to get back on one's feet. This common expression implies the removal of an oppressive financial or personal burden, allowing one to lead a freer, more comfortable life.

5. Indian summer See 402. WEATHER.

6. out of the woods Having passed through the most difficult or dangerous aspect of any ordeal or endeavor; on the road to recovery; with success assured; safe, secure.

> When a patient reaches this stage [of convalescence], he is out of the woods. (Wister, *The Virginian*, 1902)

This expression, dating from the late 18th century, may be a shortened version of the older proverb *don't shout until you're out of the woods*, although the literal wood or forest has symbolized danger, confusion, and evil for centuries.

7. pick up the pieces To rebuild one's shattered life; to put the past behind one and make a fresh start. Though this

common expression is most often heard in a context of personal, emotional crisis, it is also possible to "pick up the pieces" of any project or undertaking that has been left in shambles and carry it forward to fruition.

8. second wind A renewed source of energy, inspiration, drive, will power, etc.; a second life, a second chance. *Wind* in this phrase means 'breath' both literally (air inhaled and exhaled) and figuratively (the life force or vitality). *Second wind* remains current on both literal and figurative levels: the former refers to an actual physiological phenomenon in which an athlete, after reaching a point of near exhaustion, regains even breathing and has a second burst of energy; the latter denotes renewed "life" where *life* has an unlimited range of possible meanings. The following appeared as an advertisement for the second edition of Thomas Hood's *Epping Hunt* (1830):

> I am much gratified to learn from you, that the *Epping Hunt* has had *such a run*, that it is *quite exhausted*, and that you intend therefore to give the work what may be called "second wind," by a new impression.

9. a shot in the arm A stimulant, incentive, or inducement; anything that causes renewed vitality, confidence, or determination; anything that helps a person toward success; an infusion of money or other form of assistance that gives new life to a foundering project or other matter. This expression alludes to the revitalizing effect of taking a *shot* 'a small amount of liquor' or 'a hypodermic injection of some drug.' In its contemporary usage, however, the expression is usually figurative.

> The United States Olympic Shooting Team received an $80,000 shot in the arm Thursday afternoon. (Tom Yantz in *The Hartford Courant*, March 9, 1979)

10. a whole new ball game A brand new start; a sudden surge that puts everything back even; a chance for victory when a loss seemed imminent; a dramatic recovery from impending doom. This expression was derived from the game of baseball, where the term came into use to designate a situation in which a team, trailing by many runs, say by a score of 18–3, and assuredly losing, suddenly and unexpectedly comes to life, scoring eight runs in one inning and seven in the next to even the score at 18–18; it is as if the game were starting from the beginning, hence *a whole new ball game*. The term became popular about 1940 from its exposure to the general public through the medium of radio sports announcers. Shortly after World War II, the phrase came to be used metaphorically. A shortened version is *new ball game*. A number of related terms exist; among the more common are *a different ball game*, meaning that new rules apply or the rules have been changed; and *the same ball game*, meaning that nothing has changed, the old rules still apply.

> No, I don't believe the European economy must follow the U.S. into a depression. It is no longer, as you say, the same ball game. (*Forbes*, July 1, 1973)

Recuperation . . .
See **306. RECOVERY**

307. REFORMATION

1. clean house To purge an organization of corruption and inefficiency; frequently used of government agencies. This expression and its noun form *housecleaning* have been used figuratively since the early part of this century.

2. cleanse the Augean stables To wipe out a massive accumulation of corruption, to clean house; to perform any seemingly impossible, arduous, and extremely unpleasant task. According to classical mythology, Augeas, king of Elis, kept three thousand oxen in stables

which had not been cleaned for thirty years. As one of the twelve labors for which he was to be granted immortality, Hercules was assigned the task of cleaning them in a single day. This he accomplished by diverting the river Alpheus through the stables. A variant of this expression appeared as early as 1599.

3. clean up [one's] act To make one's actions or outward behavior more presentable or acceptable to others; to shape up. Although the exact origin of this recent American slang expression is unknown, it may derive from the theater; an entertainer is sometimes told to delete offensive or obscene material from his performance. Similar recent American slang expressions are *get one's act together* and the abbreviated *get it together*.

4. have scales fall from [one's] eyes See 102. DISILLUSIONMENT.

5. set [one's] house in order To organize one's affairs for more efficient operation; to eliminate unnecessary confusion and waste; to improve one's moral and spiritual character; to clean up one's act. This metaphorical expression was originally used as a Biblical warning to those who wished to enter heaven.

Set thine house in order: for thou shalt die. (II Kings 38:1)

Today the term is heard most frequently as an admonition to a friend or an underling that he is getting out of line and needs to take a fresh look at himself and make changes for the better.

6. turn over a new leaf To change one's ways for the better, to become a new and better person; to start fresh, to wipe the slate clean and begin anew.

I will turn over a new leaf, and write to you. (Thomas Hughes, *Tom Brown at Oxford*, 1861)

Literally, this phrase means to turn to a clean, fresh page in a book. Since an open book is often figuratively used to represent a person's life, turning to a

blank page in this book of life symbolizes the start of a new and better chapter in one's personal history. Use of this expression dates from the 16th century.

Refuge . . . See 330. SANCTUARY

308. REFUSAL
See also 88. DENIAL; 138. EXPULSION; 310. REJECTION

1. no dice No; no way; nothing doing; absolutely not; a negative response or result. Although many tales surround the derivation of this expression, it is likely that, since *dice* often implies luck, *no dice* simply implies no luck.

I was around at her bank this morning trying to find out what her balance was, but no dice. Fanny won't part. (P. G. Wodehouse, *Barmy in Wonderland*, 1952)

2. no soap No; usually said in refusal or rejection. The origin of this expression is unknown, but it may have been originally used to refuse a bribe, since a slang meaning of *soap* is 'bribe money.'

If you don't know, just say, "No soap." (Marks, *Plastic Age*, 1924)

3. party pooper One who refuses to join in the party mood; a wet blanket; a killjoy. *Pooper* in this phrase is an offshoot of the slang expression *to poop out*, 'to run out of steam.' Of course, one who lacks the vitality to participate in the party atmosphere soon casts a pall over the proceedings, and his presence seems to dampen the joyful mood. The term has been in use since about 1945.

No one can call Mr. Bulganin and Mr. Krushchev party poopers . . . the Russian leaders demonstrated their suavity and cleverness at the party. (Earl Wilson, in syndicated column, July 5, 1956)

The expression is also used to refer to one who leaves a party well before other guests.

4. thumbs down Disapproval, disapprobation, rejection. This expression refers to making a fist and extending the thumb downward, a gesture which, in the days of gladiatorial combats in ancient Rome, indicated that the spectators thought a defeated gladiator had fought poorly and, as a result, should be slain by the victor. The expression is commonly used figuratively as evidenced in a quote from bacteriologist Paul de Kruif (1890–1971), cited in *Webster's Third:*

> The government thumbs-down on penicillin for [treating] endocarditis was published.

See also **thumbs up, 23. APPROVAL**.

5. turn a deaf ear To turn away from; to refuse to listen to another; to reject another's proposition. The reference is to a refusal to listen to another person's plea by turning off one's sense of hearing, whether literally or figuratively, thereby rejecting him. The term has been common since the early 17th century.

> Turn a deaf ear to him, and do not go along with him. (Bishop Simon Patrick, *The Parable of the Pilgrim*, 1663)

6. wash [one's] hands of To renounce responsibility for; to disclaim interest in, or further connection with; to have nothing to do with. The allusion in this expression is to Pontius Pilate's denial of the responsibility of Jesus' crucifixion.

> When Pilate saw that he could prevail nothing, but that rather a tumult was made, he took water, and washed his hands before the multitude, saying, I am innocent of the blood of this just person: see ye to it. (Matthew 27:24)

People, however, did not accept Pilate's casual dismissal of his guilt, and since that time the phrase has had a hint of deviousness about it. Lady Macbeth represents another who tries unsuccessfully to wash her hands of her guilt when she tries to disburden her conscience of the "damned spot."

He had entirely washed his hands of the difficulty, and it had become ours. (Charles Dickens, *Bleak House*, 1853)

7. whistle for it A refusal to do or give something to someone; a rejection; a denial. The reference here is to the old practice of sailors' *whistling for the wind* when their ship was becalmed. A superstition among these seagoing men was that the wind could be influenced to blow if one whistled for it. Somehow the term became corrupted to imply that one would be denied his fancies.

> She rode off, telling him he might whistle for his money. (Lady Bloomfield, *Reminiscences*, 1882)

A variant, *go whistle*, is usually heard as a sarcastic refusal of a request.

309. REGRET

1. bite [one's] tongue off To regret something said, usually immediately after having said it; to feel remorse after hurting another unintentionally through a slip of the tongue or unkind word. This phrase, originally indicating sincere remorse on the part of the speaker, has lost the forcefulness of its original intent through overuse, and is now usually jocular.

Reiteration . . . See **311. REPETITION**

310. REJECTION
See also **1. ABANDONMENT;
88. DENIAL; 138. EXPULSION;
308. REFUSAL**

1. better lost than found Something or someone that one once had but that one is better off without; an expression used to mean 'leave well enough alone.' This expression implies that, when conditions improve after something disappears, one would be foolish to go searching for its return. The phrase dates from the early 16th century.

He is gone to seek my young mistress, and I think she is better lost than found. (Henry Porter, *The Two Angrie Women of Abington*, 1599)

2. blackball To exclude; to cast a negative vote against a candidate or applicant seeking admission to a select group. Such adverse votes were formerly cast by placing a black ball in the ballot box. Thus, the term came to mean to reject or exclude in any sense, though its most frequent application is still in reference to membership rejection by fraternities or other socially prestigious, exclusive organizations. It has been in use since 1770.

3. blacklist To bar or exclude from something as work or a club; also, the list of people so excluded; hence, those under suspicion, censure, or otherwise out of favor with the powers that be. The expression, in use since 1692, is said to date from the reign of Charles II of England, with reference to the list of individuals implicated in the trial and execution of his father, Charles I.

4. cut off with a shilling To disinherit, especially by bequeathing a shilling or other nominal sum to show that the disinheritance was deliberate. This expression is said to have arisen from the erroneous belief that English law was the same as Roman in assuming forgetfulness or unsoundness of mind on the part of the testator who neglected to name close relatives in his will. Out of this grew the practice of giving the scorned heir a shilling or other trifling sum to show that he had not been omitted as an oversight. Although this precise expression dates from 1834, the concept and practice date from much earlier:

My eldest son John . . . I do disinherit and wholly cut off from any part of this my personal estate, by giving him a single cockle shell. (Joseph Addison, *The Tatler*, 1710)

The original sense of this phrase has been distorted in time and it is popularly misconstrued today as *to cut off without a shilling.*

5. Dear John letter A letter from a woman telling her boyfriend, fiancé, or husband that she is jilting him for someone else. Usually a Dear John letter is sent to a man who has been separated from the woman by both time and distance, as a soldier overseas.

"Dear John," the letter began. "I have found someone else whom I think the world of. I think the only way out is for us to get a divorce," it said. They usually began like that, those letters that told of infidelity on the part of the wives of servicemen . . . the men called them "Dear Johns." (*Democrat and Chronicle* [Rochester, N.Y.], August 17, 1945)

6. don't call us, we'll call you Said to one at the close of an interview, almost certainly meaning that one has been rejected. This American expression, associated with the casting of actors for a theatrical production, originally used to intimate at the close of a job interview that one's chances were quite slim, became so trite from overuse that today it is used almost exclusively as a brush-off or expression of certain rejection.

7. Drum's entertainment The ejection of an unwanted guest by beating him and throwing him out; a thrashing.

Tom Drum's entertainment, which is, to bale a man in by the head, and thrust him out by both shoulders. (Raphael Holinshed, *Chronicles of Ireland*, 1577)

Dating from the Middle Ages, this British expression has its origin in the beating a drummer administers to a drum head. Drum's first name seems to be freely interchangeable; besides Holinshed's use of *Tom*, Shakespeare in *All's Well That Ends Well* used *John*, and John Marston entitled a comedy *Jack Drum's Entertainment.*

8. freeze out To exclude; to drive a person from an organization or group by cool treatment. The reference here is to making a structure cold by removing the source of heat, thereby forcing the occupant to depart. Figuratively, the expression suggests that one treat a person so coolly that he finds it impossible to operate within a society or business. The usual stratagem of any group who wishes to *freeze out* an unwanted member is to refuse to speak to him or to treat him as if he weren't there.

> Sherman has no following in Illinois. Several members thought he would lose the state if nominated. One said, "He will freeze us out." (*San Diego Daily Union*, February 11, 1880)

9. get the hook To have one's performance abruptly terminated; to be fired; to receive or be subjected to dismissal. This expression recalls the days of vaudeville when more than a few marginally talented or outrageously untalented performers were forcefully removed from the stage by means of a long stick with a hooked end, somewhat like an elongated cane. In contemporary usage, however, *get the hook* and a variation, *give the hook*, are usually figurative.

10. give a basket To refuse to wed; to discard a fiancé. This expression, derived from the old German custom of placing a basket on the roof of a jilted sweetheart's house, is seldom heard today.

11. give short shrift To pay little attention or give insufficient time or consideration to a person or matter; to treat in a cursory or perfunctory manner. *Shrift* is an archaic word for confession or absolution (from the verb *shrive*). *Short shrift* originally referred to the brief period prior to an execution during which a prisoner could make a confession to a priest.

> Short trial, shorter shrift, had been given to the chief criminals. (William Hepworth Dixon, *Royal Windsor*, 1879)

The phrase eventually came into more general use referring to any brief respite or short period of time. Thus "to give short shrift" means to treat summarily or brusquely, giving little of one's time or energy.

> Every argument . . . tells with still greater force against the present measure, and it is hoped that the House of Commons will give it short shrift tonight. (*The Times*, February 15, 1887)

12. give the air To jilt a lover or sweetheart suddenly; to fire an employee abruptly; also, *give the wind*. Figuratively, this expression might imply either that a person is given nothing, or that he is propelled from another's presence by a blast of air.

> I couldn't change her views . . . nor could she convert me to hers, even when she threatened to give me the air. (R. Graves, *Seven Days in New Crete*, 1949)

13. give the bag To leave a paramour suddenly or unexpectedly; to discharge a person from his job or duties. This phrase carried a nearly reverse meaning, i.e., to 'quit a job without giving the employer proper notice,' before developing its current figurative usage as a reference to the plight of a jilted lover.

> Sent away, with a flea in your ear; some girl has given you the bag. (John Neal, *Brother Jonathan*, 1825)

14. give the cold shoulder To display indifference or disregard toward; to ignore or snub; also *to show the cold shoulder*. Although the exact origin of this expression is unknown, it has been suggested that *cold shoulder* refers to the cold shoulder of meat reputedly once served to unwelcome guests so as to discourage their return. The phrase has been in use since 1816.

15. give the gate To reject or dismiss; to give someone the brush-off; to fire, or let go from employment. This expression, as well as *get the gate* 'to be rejected or jilt-

ed,' is said to be an Americanism dating from the early 1900s. However, *grant the gate* 'to give leave to go' (*OED*) appeared in print as long ago as the middle of the 15th century.

> The King grantit the gait to Schir
> Gawane,
> And prayt to the grete God to grant
> him his grace.
> (*Golagros and Gawane*, 1470)

In the transition from *grant the gate* to *give the gate*, a significant change took place. Today one *gives the gate* in a spirit of disaffection and alienation, whereas, based on the above quotation, good will and magnanimity inspired the king to *grant the gate* to Gawane.

> She billed you for an extra month because Monnie gave her the gate. (E. Fenwick, *Impeccable People*, 1971)

16. give the mitten To jilt a sweetheart; to reject a romantically inclined admirer; to discharge an employee. There are several possible sources of this expression: the medieval French custom of giving a mitten to an unsuccessful suitor; the custom of throwing down a glove to signify defiance or rejection; or a derivation from the Latin *mittere* 'to dismiss.'

> Some said that Susan had given her young man the mitten . . . she had signified that his services as a suitor were dispensed with. (Oliver Wendell Holmes, *The Guardian Angel*, 1867)

17. go begging Available but not taken; offered for sale but not purchased; not claimed by anyone; unwanted. This expression, dating from the 16th century, was originally derived from the idea that if something were available and nobody wanted it, then one must *go begging* to be rid of it or that the object must *go begging* for an owner. However, the expression has come to imply that something is undesirable or unwanted.

> I'll not believe a good horse goes begging in the Coverly country. (Hawley Smart, *Play or Pay*, 1878)

18. gong [someone] To terminate a person's performance before its completion; to fire; to dismiss rudely. This expression stems from the custom in many local and national talent contests of ringing a bell or striking an Oriental-type gong to signify that, in the opinion of the judges, an act is so bad that it does not merit continuation. This concept has been popularized, if not vulgarized, by "The Gong Show," a television series of the late 1970s.

19. step-child One who is left out; one who feels rejected; one who receives less consideration than the others. The *step-child* has proverbially been mistreated or neglected by parents, especially in comparison with their natural children; hence, step-child has the connotation of 'one on the outside.' The term has been in figurative use since at least 1400.

> The navy has been the step-child of both parliaments. (*Quarterly Review*, January 1911)

20. turn up [one's] nose at To regard with disdain, to show contempt for; to reject or refuse scornfully; snub.

> What learning there was in those days . . . turned up its nose at the strains of the native minstrels. (Bayard Taylor, *Studies in German Literature*, 1879)

Dating from the early 19th century, this expression is perhaps an allusion to the way one wrinkles up one's nose at a particularly distasteful odor, or to the way animals, especially dogs and cats, sniff at their food before eating and walk away if the smell fails to suit them. A similar phrase is *to have one's nose in the air* 'to be arrogant or condescending.' The gestural equivalent of the expression consists of putting the forefinger under the tip of the nose and pushing it up slightly.

21. whistle [someone] down the wind To forsake, abandon, or discard. This expression appeared in Shakespeare's *Othello*:

If I do prove her haggard,
Though that her jesses were my dear
 heartstrings,
I'd whistle her off and let her down
 the wind,
To prey at fortune.
(III,iii)

In bygone days, a hawk was released against the wind when pursuing game. If the bird was being set free, however, it was released with the wind. In figurative usage, the expression often implies the jilting of a paramour.

Having accepted my love, you cannot whistle me down the wind as though I were of no account. (Anthony Trollope, *Castle Richmond*, 1860)

Rejoinder . . . See 322. RETORTS

Relaxation . . . See 317. RESPITE

Remedy . . . See 353. SOLUTION

Renewing . . . See 319. RESUMPTION

Renown . . . See 144. FAME

Repercussions . . .
 See 64. CONSEQUENCES

311. REPETITION

1. boil [one's] cabbage twice To repeat one's words or actions; give instructions a second time. This expression, dating from about 1900, is usually heard in the negative.

"I don't boil my cabbage twice," a very common expression in the country towns of Pennsylvania, and signifying that the person uttering it does not intend to repeat an observation. (Sylvia Clapin, *A New Dictionary of Americanisms*, 1902).

The allusion is to cabbage, which loses its flavor and assumes a rubbery texture when boiled a second time, making it highly unpalatable.

2. hark back To revert, to go back, to retrace one's steps, to return to an earlier subject; to recall, to revive. This expression was originally used in hunting in reference to hounds who returned along the trail in order to pick up a lost scent. It has been used in its extended, figurative sense since the early 19th century.

He has to hark back again to find the scent of his argument. (Robert Louis Stevenson, *Familiar Studies of Men and Books*, 1882)

3. harp on To dwell on tediously, to repeat endlessly and monotonously, to belabor, to beat into the ground; also *harp on one* or *on the same string*. Ancient harpists reputedly played on only one string in order to demonstrate more fully their skill on the instrument. The phrase appears in Richard Grafton's *A Chronicle at Large and Mere History of the Affairs of England* (1568), where it is attributed to Sir Thomas More:

The Cardinal made a countenance to the Lord Haward that he should harp no more upon that string.

The expression and its variants date from the 16th century.

4. revolving door A repetitive course of action; a frustratingly constant recurrence. The figurative sense of this term, introduced about 1965, is derived from the action of the mechanical revolving door used at the entrance to many busy buildings.

The revolving door of the court system is expensive and fruitless. Prostitutes plead guilty; the judge slaps down a fine and lets them go. To pay the fine, they have to turn more tricks and soon wind up back in court. (*Time*, October 2, 1978)

5. ride a hobbyhorse See 249. OBSESSION.

6. ring the changes To repeat the same thing in different ways; to vary the manner in which one performs a routine task. Originally, *ring the changes* referred to performing all possible permu-

tations in ringing a set of bells. The expression is commonly applied figuratively to describe changing the order of a series of words, restating a fact or opinion in several different ways, or varying one's technique in accomplishing an otherwise routine task.

> They shall only ring you over a few changes upon three words: crying, Faith, Hope and Charity; Hope, Faith and Charity, and so on. (John Eachard, *The Grounds and Occasions of the Contempt of the Clergy and Religion Enquired Into*, 1670)

7. run that by me again A somewhat rude request to have information repeated, usually (but not necessarily) similar in tone to "Come again." The likelihood is that the expression's origin lies in the electronic reruns and replays made commonplace by tape recordings and videotape.

8. skin the same old coon To do the same thing again and again; to repeat endlessly and monotonously. This Americanism, dating from the 1830s, is a rustic method of expressing disdain about the monotony of repetition. A variant is *hunt the same old coon*.

> In the fifth, sixth and eighth innings, they clung also to that same old coon in the shape of an O. (*Wilkes' Spirit of the Times*, March 11, 1865)

9. squirrel cage A monotonous repetition; the same old thing day after day. The reference here is to an actual squirrel cage, a cylindrical, wire mesh cage on a rotating axis, designed so that when the squirrel tries to climb the mesh the wheel spins and the squirrel remains in the same spot. The parallel to the frustration that can be part of modern work-a-day world is obvious.

Report . . . See **206. INFORMATION**

312. REPRIMAND
See also **78. CRITICISM;**
146. FAULTFINDING

1. bawl out To scold someone in a loud voice; to berate; to reprimand, especially thoroughly and severely; to shout out at the top of one's voice. Although this phrase is generally considered an American slang expression, the word *bawl*, meaning to cry out in a loud or rough voice, has been in use in England since at least the early 15th century.

> "I will fling you out the window . . .," bawled out Mr. Pendennis. (William Makepeace Thackeray, *Pendennis*, 1850)

It is believed that the American phrase, meaning to scold or berate, evolved independently on the ranches of the western United States by cowboys, who applied it to the bawling of angry cattle.

> If you'll go back on your word like this, you'll bawl me out before the priest. (Rex Beach, *The Barrier*, 1908)

2. box [one's] ears To cuff one on the side of the head; to strike sharply about the ears; to reprimand or chastise; to admonish. This expression, dating from about 1600, implies that someone is striking another about the ears and side of the head as one would strike a punching bag or an opponent in boxing. However, the term is most often heard as a figure of speech to warn a youngster that punishment is impending if he doesn't discontinue his present actions. The phrase is also used figuratively to indicate disapprobation or admonishment.

3. cast in [someone's] teeth To upbraid or reproach a person; to throw back at a person something he has said or done. Some say the phrase, popular in Shakespeare's time, is an allusion to knocking someone's teeth out by casting stones. It may be an earlier form of the current expression *throw in [someone's] face*.

> He casteth the Jews in the teeth that their fathers served strange Gods.

(Thomas Timme, tr., *Commentary of John Calvin upon Genesis*, 1578)

4. chew out To reprimand, scold, or give someone a tongue-lashing. This American slang expression dates from the middle of this century.

A verbal admonishing from a superior would be recorded by the victim with "I just got eaten out" or "I just got chewed out." (J. B. Roulier, *New York Folk Quarterly*, IV, 1948)

5. curtain lectures A wife's nighttime naggings; a shrew's bedtime harangues. The *curtains* refers to drapes on old four-posters; the *lectures* to a wife's supposed practice of showering her husband with sermons when he least wants to listen, i.e., when he wants to fall asleep. The expression, in use since the early 17th century, gained popularity when the English humorist Douglas William Jerrold published his fictional "Mrs. Caudle's Curtain-lectures" in *Punch* in 1846.

6. don't hurry, Hopkins Said to one who is late in his payment; a reproof to a person who is working too slowly. The story is told of a Kentuckian named Mr. Hopkins who, when he borrowed money from a friend, wrote upon the note:

The said Hopkins is not to be hurried in paying the above.

This American expression dates from the 1860s, but a similar British expression, *as hasty as Hopkins*, dating from the 17th century, carries an implication that one shouldn't be too hasty. The British expression seemingly derives from the unfortunate experience of a man named Hopkins, legendary since he came to jail one night and was hanged the next morning.

7. dressing down A severe, formal reprimand or reproof; a tongue-lashing; a sharp censure. *Dress* 'to treat someone with deserved severity, to give a thrashing or beating to' (*OED*) dates from the 15th century, and *dressing down* from the 19th century. However, the two theories which have been proffered to explain the origin of *dressing down* do not take this long-obsolete use of *dress* into account. The first theory relates to the preparation of fish.

The order was given [to] . . . fall to splitting and salting [fish]. This operation which is known as "dressing down," is performed on hogshead tubs or boards placed between two barrels. (*Harper's Magazine*, March 1861)

The second theory claims that the phrase derives from the practice of *dressing down* in ore mines which involves breaking up the ore and crushing and powdering it in the stamping mill. It is plausible that either image—of splitting and cutting up fish or breaking up and crushing ore—could have given rise to the figurative *dressing down*.

8. get the stick To be severely rebuked or reprimanded, to be called on the carpet. This expression is British slang and apparently derived from the former practice of birching or caning, i.e., beating misbehaving schoolchildren with sticks. With the demise of corporal punishment in schools, the phrase has become figurative in meaning and now refers only to verbal punishment.

9. give [one] down the banks To reprimand, chastise, or tongue-lash someone; to give someone a dressing down; to haul over the coals. The origin of this expression, which has been attributed to Irish sources, is unclear. It appeared as early as 1884, when Mark Twain utilized the term in *Huckleberry Finn*.

He give me down the banks for not coming and telling him.

10. give [someone] Jesse To punish or scold; to reprimand or castigate. In this expression, *Jesse* may refer to the father of David (Isaiah 11:1,10), a righteous and valiant man. It is more likely, however, that the reference is to the sport of falconry in which a *jess*, or *jesse*, 'a strap used to secure a bird by its leg to a fal-

coner's wrist,' was used as a punishment for poor performance.

> Just as soon as I go home I'll give you jessie. (Alice Cary, *Married*, 1856)

11. give [someone] the length of one's tongue To speak one's mind, especially in verbally abusive terms; to give someone a piece of one's mind. A citation from the *OED* dates the phrase from the turn of the 20th century.

12. haul over the coals To reprimand or scold; to censure, to take to task. Current figurative use of this expression derives from the former actual practice of dragging heretics over the coals of a slow fire. In a 16th-century treatise, St. Augustine was described as knowing best "how to fetch an heretic over the coals." No longer is the phrase used literally as in the above quotation. Today *haul* or *rake* or *drag* or *fetch over the coals* refers at worst to severe criticism or censure.

> If the Tories do not mend their manners, they will shortly be hauled over the coals in such a manner as will make this country too hot to hold them. (James C. Ballagh, ed., *The Letters of Richard Henry Lee*, 1911)

13. have [one's] ears slapped back To be punished either verbally or physically; to suffer defeat; to be put in one's place. This expression, which dates from the late 1800s, probably alludes to actually slapping someone about the ears as a form of punishment. In modern usage, the term is heard only in its figurative sense, 'to suffer a setback of some kind.'

> You're bound to get your ears slapped back. (McKnight Malmar, *Never Say Die*, 1943)

Two common variants of this term are often heard, *pin [someone's] ears back* and *have [one's] ears pinned back*, each connoting the teaching of a lesson.

> Pine was a flip-lipped bastard who should have had his ears pinned back long ago. (John Evans, *Halo in Blood*, 1946)

14. kale through the reek Bitter language; unpleasant treatment; severe punishment. The allusion here is to the unpalatableness of the smoky kale broth which once was a mainstay of meals in Scotland. The kale was cooked over an open fire, and the resulting reek created a most disagreeable atmosphere.

> When my mither and him forgathered they set till the sodgers, and I think they gae them their kale through the reek. (Sir Walter Scott, *Old Mortality*, 1816)

15. a lash of scorpions An extremely severe punishment; an unusually harsh, vituperative, or vitriolic chastisement or criticism. Though now used figuratively, this expression was once literal, the *scorpion* being an ancient instrument of punishment, a whip or lash with four or five "tails," each set with steel spikes and lead weights. The allusion to the arachnoid scorpion with its venomous, stinging tail is obvious. Needless to say, a scourging with a scorpion was a heinous ordeal which inflicted intense pain and, in many cases, permanent injury or even death.

> My father hath chastised you with whips, but I will chastise you with scorpions. (I Kings 12:11)

16. lay out in lavender To chastise harshly and in no uncertain terms; to give someone a dressing down; to knock someone down or unconscious; to kill someone. Although the derivation of *lavender* in this expression is uncertain, *lay someone out* has long meant 'to strike someone so hard as to knock him to the ground.' One source suggests that since both *lavender* and *livid* are derived from the Latin *lividula* 'a purplish-blue plant,' there may be the common theme of intense anger. A more plausible explanation is that branches of the lavender plant were once used to beat freshly washed clothes, and that *lay out in lavender* alludes to this physical act of beating. In contemporary usage, howev-

er, this expression usually refers to a verbal beating rather than a physical one.

> If that woman gets the Republican nomination, . . . I will lay her out in lavender. (Vivian Kellems in a syndicated newspaper column, September 15, 1952)

See also **lay up in lavender**, 285. PRESERVATION.

17. a lick with the rough side of the tongue See **use the rough side of [one's] tongue**, below.

18. on the carpet Summoned before one's superiors for a reprimand; called to account; taken to task; usually in the phrase *call on the carpet*. Although this expression did not appear in this sense until 1900, both the verb *carpet* 'call someone in to be reprimanded, to censure someone' and the phrase *walk the carpet* date from the early 1800s. Both were said of a servant called into the parlor (a carpeted area) before the master or mistress in order to be reprimanded.

19. rap on the knuckles A sharp reprimand or rebuff; an admonishment; a dressing down. The allusion in this phrase is to a type of punishment formerly meted out in the classroom to students who had misbehaved, a *rap on the knuckles* from the teacher's ruler. The practice has been discontinued in most school systems, but the figurative use of the term continues.

> I received a sharp rap on my moral knuckles from my conscience. (Mary Kingsley, *Travels in West Africa*, 1897)

20. read the riot act To reprimand or chastise vehemently and vociferously; to issue an ultimatum, an or-else; to threaten with drastic punishment. The expression derives from Britain's Riot Act of 1715, which provided that a given number of assembled persons perceived to be causing a disturbance were liable to arrest as felons if they refused to disperse on command. Such command or warning was given by formal reading of the Riot Act.

21. skin [someone] alive To reprimand harshly; to abuse verbally or browbeat; to humble or subdue, especially in a venomous, cruel, or merciless manner. The figurative implications of this expression are obvious. Also, *flay alive*.

22. talk to [someone] like a Dutch uncle To rebuke or reprove someone with unsparing severity and bluntness. Although an adequate explanation as to why the uncle in this expression is Dutch as opposed to any other nationality has yet to be found, a possible derivation has been proposed in regard to the term *uncle* itself. Apparently, in Roman times, an uncle was a strict guardian given to administering severe reproofs if his charge stepped out of line. The following passage from Joseph C. Neal's *Charcoal Sketches* (1838) illustrates the use of the phrase:

> If you keep a-cutting didoes, I must talk to you both like a Dutch uncle.

23. tell [someone] where to get off To rebuke, to accuse someone of being presumptuous or stepping on toes; to take down a peg, to tell off. This slang expression of U.S. origin dates from the turn of the century. It may have derived by analogy with the forced ejection of unruly passengers from streetcars or trains. The expression implies that the person who tells another *where to get off* has reached the limits of his endurance and is in effect saying, "You've gone far enough."

> He said he was a gentleman, and that no cheap skate in a plug hat could tell him where to get off. (Ade, *More Fables*, 1900)

24. tongue-lashing A severe scolding or reprimand; a stinging rebuke or censure; a verbal whipping. Current since the 1880s, this phrase is a modernization of *tongue-banging* which was popular throughout the 1800s. An Anglo-Irish variation is *slap of the tongue*.

25. use the rough side of [one's] tongue
To bawl out; to give a severe reprimand;
to spread derisive gossip. Another form
of the expression is *a lick with the rough
side of the tongue.* William Ellis relates,
in *The Housewife's Companion* (1750),
that people, like cows, have a rough side
as well as a smooth side to their tongues,
and the gossiping sort like to use the
rough side. *Rough side* connotes un-
pleasantness, as well, with allusion to
the discomfort a lick from it causes.

> Your average welfare administrator
> would have used the rough side of his
> tongue on him, giving fresh grounds
> for complaint. (Mary McCarthy,
> *House and Garden*, December 1983)

Reproach . . . See 78. CRITICISM

Repugnance . . . See 313. REPULSION

313. REPULSION

1. [one's] gorge rises at it To find re-
pugnant, to hold in revulsion; to feel dis-
gust at; to be sickened or nauseated by;
to turn one's stomach. The gorge is the
craw or stomach, and, by metonymy, its
contents. The phrase is yet another ow-
ing its popularity and quite possibly its
origin to Shakespeare's *Hamlet.* On re-
calling the lively wit that once inhab-
ited the cold, decaying skull of Yorick
then in his hands, Hamlet says:

> . . . how abhorred in my
> imagination it is! My gorge rises at it.
> (V,i)

The expression is still frequently encoun-
tered in literary or formal writing. *Web-
ster's Third* cites a recent usage by Pearl
Buck:

> When he tried to eat the flesh of his ox
> his gorge rose.

2. set [one's] teeth on edge To repel, of-
fend, or disgust; to jar or grate on one's
nerves, to irritate or annoy. This expres-
sion is derived from an ancient proverb,
as evidenced in Jeremiah 31:29–30:

> In those days they shall no longer say:
> "The fathers have eaten sour grapes,
> and the children's teeth are set on
> edge." But every one shall die for his
> own sin; each man who eats sour
> grapes, his teeth shall be set on edge.

The allusion is to the unpleasant, tin-
gling sensation caused by sour or acidic
foods.

> I had rather hear a brazen canstick
> turn'd,
> Or a dry wheel grate on the axle-tree;
> And that would set my teeth nothing
> on edge,
> Nothing so much as mincing poetry.
> (Shakespeare, *I Henry IV*, III,iii)

A variation is *put [one's] teeth on edge.*

3. stick in [one's] craw To be difficult
to accept or reconcile; to rub the wrong
way; to be irritating, offensive, or an-
noying. The concept of swallowing is of-
ten used metaphorically for the accept-
ance or rejection of ideas. In this expres-
sion, which appeared in print by the
18th century, nonacceptance is conveyed
by the image of something being stuck in
one's craw 'crop or gullet.' Variants of
this expression include *stick in the gullet*
or *crop* or *throat.*

> There is one or two things that stick in
> my Crop. (*The Deane Papers*, 1775)

4. turn [one's] stomach To fill with dis-
gust; to sicken; to repel. The allusion in
this phrase is to the nausea one may feel
upon encountering someone abhorrent
or upon discovering a situation which
one finds totally undesirable. The term
has been in use since the Middle Ages.

> Questions that would turn the
> stomach of a school inspector.
> (*Temple Bar Magazine*, September
> 1892)

A related term, *not be able to stomach
someone*, has a similar meaning, al-
though it was coined at a later time.

5. wouldn't touch with a ten-foot pole
This phrase expresses repulsion toward
something or someone. The source of

this common American expression, dating from at least the early 1800s, is uncertain, although its figurative intent is self-evident.

> I wouldn't touch it with a ten-foot pole. (Thorne Smith, *The Passionate Witch*, 1941)

The expression may be a variant of the British terms: *wouldn't touch with a pair of tongs*, and *wouldn't touch with a barge pole*, which predate it by at least 500 years.

> I was so ragged and dirty that you wouldn't have touched me with a pair of tongs. (Charles Dickens, *Hard Times*, 1854)

6. yuk Also *yuck*. An exclamation of disgust or repulsion. This slang expression is derived from an earlier slang word *yecch*, which also indicates revulsion on the part of the speaker.

> Expand your thinking about meats. Too many people say "yuk" to liver because they have never tasted it cooked well. (*New York Post*, January 23, 1979)

The origin of *yecch* is unknown, but it was probably derived in imitation of the sound of vomiting.

> "And lunches. We have terrible lunches. Yecch!" (*Time*, February 14, 1972)

The adjective form *yukky* or *yucky* also describes something that one finds repugnant or distasteful.

> About all Desiree can bring herself to say about her diabetes is that the urine tests are "yukky." (*The New York Times Magazine*, June 12, 1977)

Reputation . . . See 144. FAME

314. RESCUE

1. deus ex machina An eleventh-hour deliverer, a last-minute rescuer; any contrived or unlikely means used to resolve a problem or untangle the intricacies of a plot. Literally 'a god from a machine,' this expression owes its origin to the ancient literary device of relying on divine intervention for the resolution of a plot. The *machine* in the phrase refers to a special piece of stage equipment used in ancient Greek theaters to lower actors playing the roles of gods onto the stage.

2. get [someone] off the hook To rescue a person from a difficult situation, particularly one involving trouble or embarrassment; to exonerate, clear, or vindicate; to absolve of responsibility. This expression refers to the plight of a fish that is hooked by a fisherman. If the fish is able to escape without help, it is by getting off the hook and swimming to freedom. Thus, *to get [someone] off the hook* is to extricate him from a potentially ruinous predicament.

> "It's an idea," said Dr. Craig . . . "It would get Hartley off the hook, sure enough." (J. Potts, *Go, Lovely Rose*, 1954)

3. pull out of a hat See 353. SOLUTION.

4. pull out of the fire To extricate from danger, to save from destruction; to rescue or salvage; to turn threatened defeat into victory. Used in reference to plans, projects, situations, relationships, etc.— virtually anything that can be in jeopardy—the expression's derivation is obvious.

5. saved by the bell Delivered from an undesirable fate by a lucky accident or intervention. The reference is to the bell which signals the end of a round of boxing. At that instant, even if the referee is in the middle of counting out a prostrate fighter, the round is officially over and the count is void, thus giving a losing contestant a reprieve. The expression is used when a doorbell, telephone bell, or other ringing interrupts a potentially unpleasant or embarrassing situation.

315. RESENTMENT

1. dog in the manger A person who out of pure spite prevents others from using or enjoying something that he himself does not need or want. The allusion is to the fable of a dog who situated himself in a manger and selfishly would not allow the ox or horse to feed on the hay it contained. This expression has been in use since at least the late 1500s.

2. gall and wormwood Feelings of intense bitterness and deep resentment; rancor, hostility, or hardness of heart. Both *gall* and *wormwood* refer to bitter substances—the former to bile and the latter to a bitter herb. The earliest use of the phrase *gall and wormwood* appears in Lamentations 3:19.

> Remembering mine affliction and my misery, the wormwood and the gall.

Today the phrase is heard more often in literary contexts than in everyday speech.

3. the green-eyed monster Jealousy. This epithet was coined by Shakespeare; Iago uses it when warning Othello of the destructive nature of jealousy:

> Oh, beware, my lord, of jealousy.
> It is the green-eyed monster which
> doth mock
> The meat it feeds on.
> (*Othello*, III,iii)

Green-eyed 'jealous' and *green with envy* are common variants.

4. put [someone's] nose out of joint See 173. HUMILIATION.

5. sour grapes Disdain or contempt affected as a rationale for that which one does not or cannot have; envy; resentment. This expression is derived from Aesop's fable *The Fox and the Grapes*, in which a hungry fox, unable to reach a cluster of grapes after repeated attempts, finally gives up and leaves, justifying his failure by telling himself that the grapes were undoubtedly sour anyway.

> I have never been able to understand the fascination which makes my brother Philip and others wish to spend their entire lives in this neighbourhood. I once said as much to Hannah, and she replied that it was sour grapes on my part. (C. P. Snow, *Conscience of the Rich*, 1958)

316. RESIGNATION
See also 361. SUBMISSION

1. give her the bells and let her fly To acquiesce to the inevitable, regardless of cost; to acknowledge reality or failure before risking further loss; to make the best of an unalterable situation. This expression originated in the sport of falconry, in which a worthless bird was released without bothering to remove the valuable bells attached to it.

2. like it or lump it To accept and put up with; to resign oneself to the inevitable; to make the best of an undesirable situation. The exact origin of this informal expression is difficult to determine. The most plausible suggestion is that *lump it* originally meant 'gulp it down' and was probably said in reference to distasteful medicine. Figurative use of the expression appeared in print by the early 1800s.

> I'll buy clothes as I see fit, and if anybody don't like it, why they may lump it, that's all. (Harriet Beecher Stowe, *Poganuc People*, 1878)

Sometimes *lump it* means simply 'dislike' as in the following quotation:

> Whether we like him or lump him, he [the Interviewer] is master of the situation. (Grant Allen in *Interviews*, 1893)

Like it or lump it is usually heard in situations where no actual choice exists.

3. take [one's] medicine To submit oneself to punishment; to submit to something disagreeable or unpleasant; to accept the consequences of one's act. The allusion in this phrase is to the unpleasant taste that accompanied most medi-

cines in the past. In fact, certain extremely bitter medicines were administered by parents to their children as punishment for misbehaving.

Princess, inscribe beneath my name:
"He never begged, he never sighed,
He took his medicine as it came."
For this the poets lived—and died.
Sir John C. Squire, *Ballade of the
Poetic Life: Envoi*, 1918)

4. that's the way the ball bounces
That's life; that's the way it goes; there's nothing to be done about it. Just as one cannot determine ahead of time how a ball will bounce, so too no one can predict or prevent the twists and turns of fate. This expression and the analogous *that's the way the cookie crumbles* are usually said in resignation to a fait accompli.

Resigning . . . See 321. RETIREMENT

Resistance . . . See 293. PROTEST;
 302. REBELLIOUSNESS

Resolution . . . See 353. SOLUTION

Resolve . . . See 268. PERSEVERANCE

317. RESPITE

1. busman's holiday A vacation or day off from work spent in an activity of the same nature as one's usual occupation. There are Britishers who say that the regular driver of a London bus actually did spend one of his days off riding as a passenger alongside the driver who was taking his place, but thus far no evidence has been found to substantiate the story. The expression has been in use since 1893.

2. come up for air To take a breather, take five, take time out; to relax, rest, or enjoy a respite. The phrase implies that one has been so inundated with work or immersed in work that he is in danger of drowning, figuratively speaking; like an underwater swimmer or a diver he must pause to refresh himself and recoup his powers for the next lap.

3. hang up [one's] hatchet See 321. RETIREMENT.

4. pit stop A brief stop at a restaurant or rest area to break the monotony of an automobile trip and allow passengers to stretch their legs; a short stay at a place while en route to a distant destination. This expression derives from the auto racing *pit* referring to the area alongside a speedway where cars stop to be serviced or refueled.

5. rest on [one's] oars To relax after strenuous exertion; to suspend one's efforts temporarily; to take it easy for a while. Often this boating phrase is extended to mean ceasing one's labors altogether, relying on the momentum of past performance to carry one along. In this sense it is virtually synonymous with *rest on [one's] laurels*. *Rest on [one's] oars* was used literally in the early 18th century, and figuratively shortly thereafter.

The managers of the usual autumn gathering of paintings . . . will rest on their oars. (*Athenaeum*, April 1887)

318. RESTARTING
See also 319. RESUMPTION

1. change of scene See 270. PERSPECTIVE.

2. different ball game See whole new ball game, 306. RECOVERY.

Restlessness . . . See IMPATIENCE

Result . . . See 64. CONSEQUENCES;
 257. OUTCOME

319. RESUMPTION
See also 318. RESTARTING

1. go on with your birds' egging Continue what you were saying or doing. This 19th-century New England jocular expression is seldom heard today. Its origin is obscure, but apparently lies in the situation of a stranger interrupting a man gathering birds' eggs to ask for di-

rections or some other information. After receiving his information, the stranger urged the man to *go on with your bird's egging*.

> So now go on with your bird's egging, and make your Christmas as fast as you please. (Seba Smith, *Way Down East*, 1854)

A related term, *none of one's bird's egging*, means 'none of one's business.'

2. return to our muttons Return to the business at hand; back to the subject. In Pierre Blanchet's play, *La Farce de Maistre Pierre Patelin*, first staged about 1460, a cloth dealer employs an attorney, M. Patelin, to prosecute a shepherd for stealing the dealer's sheep. While testifying, the cloth dealer suddenly becomes aware that M. Patelin is wearing a suit made of cloth which had been stolen from him. Utterly confused by this turn of events, the dealer constantly digresses from the stolen sheep to the stolen cloth. The judge frequently has to remind the dealer, "*Revenons à ces moutons,* " or 'Let us return to these sheep.' The phrase was much quoted by Rabelais, which may account for its wider currency. Somehow the phrase became corrupted to *revenons à nos moutons*, which British wags translated as 'let us stick to our muttons' or as F. E. Smedley in *Frank Fairlegh* (1850) quips:

> To return to my mutton, as the Mounseers have it.

320. RETALIATION
See also 323. RETRIBUTION

1. an eye for an eye A law which sanctions revenge; to repay in kind. This line from Exodus 21:24 is part of a longer passage in which the Lord sets forth the judgments and laws according to which the people are instructed to live. However, this expression may be even older if, as some speculate, it was part of the Code of Hammurabi (approx. 1800 B.C.). The noted resemblances between Hammurabi's laws and ancient Mosaic laws make this theory plausible.

2. fight fire with fire To argue or fight with an opponent using his tactics or ground rules; to counter an attack with one of equal intensity. This expression refers to the method used to fight a rapidly spreading forest or grass fire. To control such a fire, a firebreak (an area cleared of trees, grass, and other flammable material) is often created some distance in front of the advancing flames. A backfire may then be set to burn the area between the major fire and the firebreak, thereby containing the fire within a limited area where it can be doused with water or dirt. Thus, fire is literally fought with fire in order to defeat it. In its figurative sense, *to fight fire with fire* is to contend with someone on his level, using his tactics to defeat him. The expression usually implies a lowering or abandonment of one's principles.

3. fix [someone's] wagon To get even with, avenge; to prevent, interfere with, or destroy another's success, reputation, or expectations; to injure or kill. This expression may stem from the days of the covered wagons when a person's entire family, possessions, and livelihood could be contained in one of these vehicles. An unscrupulous and vindictive enemy might *fix the wagon* in such a way as to assure that it would break down, causing injury to and possible destruction of both the wagon and its contents. The related expression *fix [someone's] little red wagon* is an updated version, and all the more insidious in its implication of harming a child.

4. give [someone] a dose of [his/her] own medicine To treat someone as he has treated others; to give someone something unpleasant or distasteful; to get revenge upon someone. Since *medicine* carries a connotation of something disagreeable or bad-tasting, the intent of this expression is quite evident. It dates from about 1890. Varients include *treat [someone] with a dose of [his/her] own medicine, give [someone] a taste of [his/*

her] *own medicine*, and *get a dose* (or *taste*) *of* [*one's*] *own medicine*.

> "He snubbed me," . . . explained Miss DeVoe, smiling slightly at the thought of treating Peter with a dose of his own medicine. (Paul Leicester Ford, *The Honorable Peter Stirling*, 1894)

5. guts for quarters Originally this threat was proclaimed seriously, indicating that the speaker meant to unseam his opponent with his sword.

> I'll make quarters of thy guts, thou villain. (Robert Greene, *The Scottish History of James IV*, 1592)

In modern usage the term is employed humorously to indicate that one is in serious trouble.

> If this doesn't work, then I think Parkinson will, as they say, "have my guts for quarters." (Tim Heald, *Deadline*, 1975)

6. heap coals of fire on [someone's] head To repay hostility with kindness; to answer bad treatment with good, supposedly in order to make one's enemy repent. The allusion is Biblical:

> If thine enemy be hungry, give him bread to eat; and if he be thirsty, give him water to drink: For thou shalt heap coals of fire upon his head, and the Lord shall reward thee. (Proverbs 25:21–22)

The usual explanation is that the *coals of fire* supposedly melted a person's "iciness."

7. pay in [one's] own coin To retaliate in like fashion; to give tit for tat. The first written use of this phrase is attributed to Plautus, the Roman playwright. The implication of the expression is negative, indicating that one can expect equivalent treatment for one's dishonesty.

> Glad that he had given her a sop of the same sauce, and paid her his debt in her own coin. (Robert Greene, *Tullies Love*, 1589)

8. pound of flesh Vengeance; requital. This expression derives from Shakespeare's *Merchant of Venice*, in which Shylock agrees to lend money to Antonio only on condition that, if the sum is not repaid on time, he be allowed a pound of Antonio's flesh in forfeit.

> The pound of flesh which I demand of him is dearly bought, 'tis mine, and I will have it. (IV,i)

The expression implies that, while the demanded retribution is justified, the yielding of it would incapacitate or destroy the giver, just as the yielding of a pound of one's own flesh would certainly have deleterious consequences.

> All the other Great Powers want their pound of flesh from Turkey. (*Fortnightly Review*, January 1887)

9. [a] Roland for an Oliver An eye for an eye, a blow for a blow; retaliation in kind. Roland and Oliver, two of Charlemagne's paladins, had adventures which were so extraordinarily similar that it was all but impossible to determine which was the more chivalrous. Eventually, the two men met face to face in combat on an island in the Rhine, where, for five days they fought fiercely, with neither gaining an advantage. The bout climaxed when both men met simultaneous untimely deaths.

> We resolved to give him a Roland for his Oliver, if he attacked us. (*The Life of Neville Frowde*, 1773)

10. serve the same sauce To retaliate in like fashion; to fight fire with fire; to repay in kind.

> They serve them with like sauce, requiring death for death. (Richard Eden, *The Decade of the New World or West India*, 1555)

Variations are *serve a sop* or *taste of the same sauce*.

11. tit for tat Blow for blow, an eye for an eye and a tooth for a tooth, reciprocal retaliation.

Fair Traders, Reciprocity men, or believers in the tit-for-tat plan of dealing with other nations. (*Daily News*, July 1891)

According to the *OED* this expression is probably a variation of the earlier *tip* 'light blow' for *tap* 'light blow.'

> Much greater is the wrong that rewards evil for good, than that which requires tip for tap. (George Gascoigne, *Works*, 1577)

Other conjectures claim that *tit for tat* came from the French *tant pour tant* 'so much for so much' or the Dutch *dit vor dat* 'this for that.' Use of the phrase dates from at least 1556.

321. RETIREMENT

1. apply for Chiltern Hundreds To resign from office; to abandon one's position or responsibility. This British expression alludes to the method used by an M.P. who wishes to resign before his term of office has expired, a forbidden practice. Also forbidden is the holding of paid office under the Crown while a member of Parliament. Consequently, the M.P. who wishes to resign applies for the Stewardship of the Chiltern Hundreds, a no-longer extant Crown appointment. On receiving the appointment, he is forced to relinquish his seat in Parliament. Having done so, he at once resigns his Stewardship as well, thus leaving the fictitious post vacant for the next M.P. in need of the ploy.

2. hang up [one's] hatchet To quit working, to take a rest or break from one's work. The allusion is probably to a wood cutter or other person who uses a hatchet or ax in his trade and literally hangs it up when he stops working. This expression, no longer in use, dates as far back as 1327.

> When thou hast well done hang up thy hatchet. (Richard Hills, *Proverbs from the Common-Place Book*, 1530)

3. put out to pasture Retired, put on the shelf, put away. The expression originally referred to animals, such as workhorses, which, due to old age or poor health, had outlived their usefulness to their owners and were turned out to pasture for the rest of their days. Today the phrase is more commonly applied to older persons who, for the same reasons, have supposedly outlived their usefulness to society and are no longer allowed to play an active role in the affairs of the working world. The implication is that they are not accorded the dignity of human beings but are treated as animals whose only worth is in their work.

4. swallow the anchor To end one's seafaring days by obtaining an onshore job or retiring from a maritime occupation; to be released from service with the Navy. This expression, of obvious nautical derivation, was used by A. E. Marten, as cited in *Webster's Third*:

> [He] swallowed the anchor and stayed ashore.

The expression is occasionally extended to apply to retirement from any occupation.

322. RETORTS
See also 131.
EXCLAMATIONS

1. all round my hat Nonsense; that doesn't make sense. This derisive British retort to another's statement probably derives from an old music hall ballad, *All Round My Hat I Wears a Green Willow*, which first appeared in 1834 according to the *Modern Music Catalogue* in the British Museum Library. The expression is seldom heard today.

> "Well done!" exclaimed Mr. Jorrocks, patting the orator's back
> "All round my hat!" squeaked Benjamin in the crowd. (Robert S. Surtees, *Handley Cross*, 1854)

2. Dick Tracy A mildly sarcastic retort to one who makes an obvious observation as if from penetrating insight. This expression derives from the popular comic strip *Dick Tracy* which features a police detective of that name. *Dick Tracy* is analogous to such rhetorical comments as *Is the Pope Catholic?* and *No kidding!* and *You don't say?*

3. the Dutch have taken Holland An obvious statement, this expression is used sarcastically to put down someone who tells a piece of stale news as though it were new and exciting. "If my aunt had been a man she'd have been my uncle" is a similar British retort to someone who has laboriously explained the obvious.

4. famous last words A phrase expressing the speaker's conviction that the person so addressed is about to engage in an activity that will lead to dire results. The phrase refers to the practice of recording the *famous last words* of distinguished people. It achieved its popularity from its frequent use by U.S. Army Air Corps and RAF personnel during World War II. It was used as a jocular rejoinder to such comments as "This is sure to be a milk run today." Another context might be: "I'm going to tell the boss what I think of her. . . famous last words."

> "If you had any sense, you'd ask me to stick around until you whistled up some reinforcements." "No need for that. Sergeant Goslin will be back soon." "Famous last words," I said. (Hartley Howard, *Million Dollar Snapshot*, 1971)

5. the Greeks had a word for it A comment whose basic sense is that an idea or fact has been known about for a very long time. This expression, frequently used as a denigrating sarcasm, was apparently coined in 1929 by Zoë Akins in her play *The Greeks Had a Word for It*. In a letter to Burton Stevenson, which is included in *The Home Book of Proverbs, Maxims and Familiar Phrases* (1948),

she explains how the phrase grew naturally out of the dialogue.

> In the play there was a conversation which was cut out as the two characters speaking were cut out. One was a photographer who had come to the wedding in the last act, and had had a glass too much, the other his plain little woman assistant. He is speaking rather floridly about the grandeur of Rome and the glory of Greece. He says,
>
> "Girls like the bride—her sort—the Greeks had a word for it."
> "Even the Anglo-Saxons have a word for her sort," the assistant acidly comments.
> "And it's usually spelt with a dash."
> "But the Greeks had a special word for it," he contends. "*Hetaera*, plural *hetaerae*."
> "Meaning tarts," she says.
> "Oh no, meaning free souls—in the days when wives were slaves and slaves were wives."
>
> You will see by this explanation that the phrase is original and grew out of the dialogue.

The phrase caught on shortly after the play opened on Broadway and is occasionally heard today as a sarcastic retort to another's comment.

6. have another think coming A disapproving remark to indicate that one is mistaken and needs to reconsider an opinion or intention. This expression is ordinarily used when one is throwing another's words back in his teeth, frequently out of anger or as an act of provocation, as in: "Well, if you think that, let me tell you, you have another think coming."

7. I can hardly wait This American expression, dating from the late 1920s, is usually heard as an ironic retort to one who has just reminded the speaker of an impending encounter with an undesirable person or with a disagreeable situation, or as a rebuff to another's ego trip.

"And what's so special about you?"
"I might tell you one of these fine
days," I winked at her. "That is, if
you play your cards right."
"I can hardly wait," she parried.
(Frank Norman, *Much Ado about
Nuffink*, 1974)

The British seem to prefer the variant, *I
can't wait*, using it, however, in an iden-
tical fashion to its American counter-
part.

> FRED: She's coming to the station
> tomorrow morning to see us off, you
> don't mind, do you?
> GARRY: I can't wait. (Noel Coward,
> *Present Laughter*, 1943)

8. lareovers to catch meddlers Francis
Grose, in *A Dictionary of the Vulgar
Tongue* (1785), lists this phrase as:

> . .. an answer frequently given to
> children, or young people, as a rebuke
> for their impertinent curiosity, in
> enquiring what is contained in a box,
> bundle, or other closed conveyance.

However, *Halliwell's Dictionary of Ar-
chaic and Provincial Words* (1847) lists
lareovers as whips, or instruments of
chastisement and adds:

> Therefore lareovers for meddlers
> equals a punishment for meddlers;
> hence, something not to be meddled
> with.

In either case, the figurative sense indi-
cates a sharp rebuke to indicate that one
has inquired about something that is
none of his business. Chiefly dialectal to-
day, and used only in the figurative
sense, the phrase has been in use since at
least 1698. Variants of the expression are
layovers to catch meddlers and *larrows
to catch meddlers*.

9. milking ducks as my mother bade me
A facetious answer to a prying question
about one's whereabouts or activities.
This expression apparently was in com-
mon use at the time it appeared in a
15th-century poem.

> My master looketh as he were mad:

"Where hast thou been, my sorry
lad?"
"Milking ducks as my mother bade."

A variation is *milking geese*.

"Well, little corduroys, have they
milked the geese today?"
"Milked the geese! Why they don't
milk the geese, you silly."
"No? Dear heart, how do the goslings
live then?"
(George Eliot, *Scenes of Clerical Life*,
1857)

10. Queen Anne is dead A sarcastic re-
mark made to the bearer of stale news.
A similar, current American phrase is *So
what else is new?* Anne was Queen of
Great Britain and Ireland from 1702–14.
The expression dates from the 18th cen-
tury.

11. touché Literally French for
'touched,' *touché* is a fencing term indi-
cating a hit or score. In verbal fencing or
argumentation the parry *touché* ac-
knowledges accuracy and truth in an op-
ponent's remark or retort frequently
with the implication that the point of
the remark was deserved or well said.

12. zinger A witty retort; a clever
punchline. This term is derived from the
verb *zing*, meaning 'to make a sharp,
shrill sound' as that made by a swiftly
passing object such as a bullet. The defi-
nition carries even further, for a *zinger*
hits with the impact of a bullet, quick
and hard, and usually unexpectedly.

> Cavett's wit is his moat. . . . In
> casual chatter the zingers are just as
> fast and frequent as they are on the
> show. (*Life*, October 30, 1970)

Retraction . . .
See 303. RECANTATION

Retreat . . . See 330. SANCTUARY

323. RETRIBUTION
See also 320. RETALIATION

1. chickens come home to roost An expression indicating that one has received his just deserts or met with a comeuppance. Robert Southey makes reference to this proverbial expression in *The Curse of Kehama* (1810):

> Curses are like young chickens: they always come home to roost.

2. get [one's] comeuppance To receive a deserved reprimand; to get one's just deserts; to be made to see things realistically; to have one's ego deflated. This Americanism, coined sometime during the early part of the 19th century, received a boost in popularity when William Dean Howells made use of it in *The Rise of Silas Lapham* (1885).

> Rogers is a rascal . . . But I guess he'll find he's got his come-uppance.

The term is still in everyday use; however, a variant *come-uppings* has become obsolete.

3. gold of Tolosa Ill-gotten gains; something obtained in an underhanded way that subsequently brings bad luck. This expression is attributed to the actions of one Quintus Servilius Scipio, a Roman consul who removed all the gold and silver from the Cimbrian Temple at Tolosa (Toulouse). As he was departing Tolosa with his booty, Scipio and his forces were set upon and overwhelmed by the Cimbrian army. The calamity, the loss of at least 80,000 men, was ascribed by many to his sacrilegious plundering of the temple.

> More unfortunate to the gentry of England than was the gold of Tolosa to the followers of Scipio. (Thomas Adams, *Sermons*, 1629)

4. have the last laugh See 365. SUCCESS.

5. laugh on the other side of [one's] face or mouth To experience a comedown or to undergo a radical change in mood from happiness to sadness, usually as a result of meeting one's comeuppance; to be sad, disappointed, or depressed; to fail after expecting or experiencing success, with the implication that such failure is deserved. Though the derivation of this expression is uncertain, it may refer to the fact that in a frown the lips are turned down rather than up as in a smile.

> We were made to laugh on the other side of our mouth by an unforeseen occurrence. (Benjamin Malkin, *LeSage's Adventures of Gil Blas of Santillane*, 1809)

A variation is *laugh on the wrong side of [one's] face* or *mouth*.

6. the mills of God grind slowly Retribution may be slow in coming, but justice will eventually triumph; sooner or later everyone will get what he deserves. This expression, a variant of which dates from the early 17th century, applies the metaphor of a mill grinding grain to the meting out of justice by the Almighty. The phrase appeared in the poem *Retribution* by Henry Wadsworth Longfellow:

> Though the mills of God grind slowly, yet they grind exceeding small; Though with patience He stands waiting, with exactness grinds He all.

7. the shoe is on the other foot See 325. REVERSAL.

Revelation . . . See 137. EXPOSURE

324. REVELRY

1. beer and skittles Fun and games, amusement and pleasure. This British expression stems from the days when skittles, a game akin to ninepins, was often played in alleys adjacent to country inns. The phrase usually appears negatively in expressions such as "Life is not all beer and skittles." In *Pickwick Papers*, Dickens used the phrase *porter and skittles*.

2. cakes and ale Pleasure and good times, with connotations of carousing and self-indulgence. In Shakespeare's *Twelfth Night*, the puritanical Malvolio is reproached by the bibulous Sir Toby Belch:

> Dost thou think, because thou art virtuous, there shall be no more cakes and ale? (II,iii)

Somerset Maugham used the phrase as the title of his 1930 satirical novel of the lives of two writers, presumably Thomas Hardy and Hugh Walpole.

3. cock-a-hoop See 115. ELATION.

4. cut a caper To perform a spirited, frolicsome dance step; to behave in a playful, frisky manner. *Caper* is said to derive from the Italian *capra* 'she-goat'; thus, *cut a caper* alludes to the frisky, erratic movements of goats. In Shakespeare's *Twelfth Night* (I,iii), a dialogue between Sir Toby Belch and Sir Andrew Aguecheek lends credence to this explanation. Sir Toby's response to the claim that Sir Andrew can cut a caper plays on the allusion to a goat by reference to a sheep.

> And I can cut the mutton to it.

Today the figurative use is more common, shifting the emphasis from the actual dance step to similarly frolicsome and frisky behavior.

5. dance the antic hay To lead a hectic, pleasure-seeking life; to be a jet-setter, a hedonist. The *hay* was a lively English dance, somewhat like a reel. In an *antic hay*, the dancers wore masks of animal faces and moved with grotesque, uncouth gestures. The emphasis was on lustful and lecherous behavior.

> My men, like satyrs, . . . shall with their goat feet dance the antic hay.
> (Christopher Marlowe, *Edward II* I,i, approx. 1593)

6. good time Charley One whose life style is devoted to social enjoyment; a man whose principal interests in life are carousing and chasing women; a free-spending, hard-drinking hedonist. Although many people equate this 20th-century term with a *Don Juan* or a *gay Lothario*, a *good time Charley* is quite different from these two. He is the hail-fellow-well-met at the corner bar, the free-spending conventioneer; in other words, a *good time Charley* is more of a man's man, one who likes to drink with his buddies and to limit his interest in women to a *love 'em and leave 'em* philosophy.

7. have a lark To go on a spree; to have a carefree adventure; to participate in a spirited escapade. Although the derivation of the meaning of the word *lark* in this expression is uncertain, it is generally believed to come from the Middle English *laik*, 'play,' which in turn comes from the Anglo-Saxon *lac*, 'contest,' thus connoting a sense of playfulness to the phrase. A less plausible explanation ascribes the meaning to the old pastime of netting larks as a form of sport, thus creating the association of *larking* with a merry time, a frolicsome sport. In any event, the expression has been common since the early 1800s.

> Then, Pallas, take away thine Owl,
> And let us have a lark instead.
> (Thomas Hood, *To Minerva*, 1840)

Go on a lark and *skylarking about* are popular variants with the same meaning as *have a lark*.

8. high jinks Unrestrained revelry; unbounded merrymaking; mischievous fun. *High jinks* was originally a 17th-century game in which a person, according to his dice throw, had to gulp down a drink, imitate a famous person, or perform some other prescribed task.

> All sorts of high jinks go on on the grass plot. (Thomas Hughes, *Tom Brown at Oxford*, 1861)

9. kick up [one's] heels To frolic, gambol, or make merry; to enjoy oneself, to have fun. This self-evident expression may be related to either *heelkicking* or *kick-up*, 18th-century terms denoting a

dance. Since dancing is often associated with merriment and high spirits, the activity became synonymous with the mood.

10. kill the fatted calf To rejoice or celebrate; to indulge in jubilant merrymaking; to entertain sumptuously. This expression's Biblical origin lies in the parable of the prodigal son (Luke 15:23):

> And bring hither the fatted calf, and kill it; and let us eat and be merry.

11. knees up A lively social gathering; a party; a wild soiree; fun and games; cakes and ale. This Briticism was extracted from a popular song of 1963, which contained the opening line, "Knees up, Mother Brown!". A dance, which resulted from the song, probably led to the association of the phrase with partying and other forms of revelry.

> The street party . . . wasn't exactly a Cockney "knees-up", but everyone was having a ball. (Carol Kennedy, *Maclean's*, June 27, 1977).

12. Morris dance A ritual dance performed throughout England during May Day ceremonies; grotesque dances performed by people in costume. The term *Morris dances*, a corruption of *Moorish dances*, refers to military dances of the Spanish Moors brought to England from Spain in the mid 14th century during the reign of Edward III. In time the dances became Briticized, with the principal dancers representing characters from the Robin Hood legend, especially Friar Tuck and Maid Marian.

> In the reign of King James I eight old men danced a morris dance . . .
> whose ages put together made 800 years. (John Chamberlayne, *Britannia Notitia*, 1708)

13. a night on the tiles An evening of carousing and merrymaking; a night on the town; a high old time. This British colloquialism comes by analogy from cats' nocturnal reveling and caterwauling on the tile rooftops of city dwellings.

14. on the randan On a spree; on a rampage; having a night on the town; behaving in a riotous or disorderly fashion. This expression, dating from about 1764, is said to derive from a ritual practiced in Cold Aston, Derbyshire. For three consecutive nights a straw image of a man, who was guilty of improper behavior of some sort, was carried about the streets attended by villagers banging on pans and creating a noisy disturbance. After the final parade on the third day, the effigy was burned to the accompaniment of general pandemonium. Any village disturbance might set off a randan, but they were usually the result of marital turmoil. These randans were often accompanied by drinking bouts which lasted late into the evening; hence, to be *on the randan* was to spend a night on the town. A common variant is *on the rantan*.

> They were a' on the randan last night. (Robert Louis Stevenson, *St. Ives*, 1894)

15. paint the town red To carouse, go on a riotous spree; to take part in a reckless and boisterous celebration. This U.S. slang expression appears as early as 1884 in the *Boston Journal*:

> Whenever there was any excitement or anybody got particularly loud, they always said somebody was "painting the town red."

Why *red*?

> A "spectrophotometric study of pigments," by Professor Nicolls, is recommended to young men who intend to "paint the town red." (*Boston Journal*, 1884)

This tongue-in-cheek exhortation plays with the fact that red is the color at the extreme end of the visible spectrum, which perhaps accounts for its association with extremes or immoderation. However, red symbolizes many things, including passion, violence, and promiscuity, to name a few, and there is no evidence to verify that one explanation is more correct than another.

16. play the Greek To be a happy person; to carouse; to indulge oneself. Supposedly, the rule at Greek banquets was *E pithi e apithi* 'drink, or be gone.' A reputation for hedonism has plagued the Greeks throughout history; hence, the allusion in the phrase.

17. pub-crawl To move from one nightspot to another on a drinking bout; to barhop. This expression is commonplace in Great Britain, where *pub* is a shortening of *public house* 'bar, tavern.' The expression implies that the reveler will dawdle at each drinking-hole and that he may be moving on all fours before the evening is over.

18. red-letter day Any day marked by a memorable, happy, or significant event. The Calendar of the Book of Common Prayer, as well as other liturgical calendars, marked festival and holy days in red, a practice retained on many secular calendars which designate Sundays and holidays in similar fashion. Figurative application to any noteworthy day dates from the 18th century.

> I used to dine and pass the evening with Dr. Jeune; and these were my red-letter days. (Thomas A. Trollope, *What I Remember*, 1887)

19. see the elephant To do the town, to visit the "big city"; to see the world, especially its seamy side. This American colloquialism probably stems from an old ballad that tells of a farmer whose horse was knocked over by a circus elephant as the two animals tried to pass each other on a narrow road. Though the horse was injured, and the milk and eggs which were to be sold at the market were ruined, the farmer took solace in the thought that at least he had seen an elephant. In common usage, the expression is usually employed somewhat facetiously.

> He makes his rounds every evening, while you and I see the elephant once a week. (O. Henry, *Four Million*, 1906)

20. sling the monkey A shipboard game played especially aboard sailing vessels; to throw one's body about, particularly into outlandish positions. Originating in the latter half of the 18th century, this game was named for the monkey-rope, the rope attached to a sailor's waist while he was working in a dangerous position. The player, his ankle held in the loop of a rope about six inches above the deck, must support himself on his hands and other foot. While in this awkward situation, he must make a chalk mark as far as possible from his original location.

> Whilst we Middies were playing sling the monkey, the ship's company were diverting themselves in a variety of ways. (Sloane-Stanley, *Remembrances of a Midshipman's Life*, 1893)

21. sow [one's] wild oats See 130. EXCESSIVENESS.

22. tailgating Dining alfresco in a parking area, especially at a football stadium, before a game; driving one's car too close to the rear of another car; playing trombone in a band while riding in a wagon or truck. This slang expression, used metaphorically for a number of situations, is most commonly heard today in reference to a type of picnic eaten prior to a football game. The term, derived from placing the food and drink on the lowered tailgate of a station wagon, originated with Ivy League fans during the 1930s, but didn't become popular until the early 1970s.

> Tailgating started years ago at Ivy League games, where alumni would serve genteel picnics from the backs of their station wagons. (*Time*, October 15, 1973)

Another use of the term, driving one's car too close to the *tail* of the car immediately ahead, has been current since the 1950s. The first known use of the slang term was during the 1890s in the New Orleans area. Dixieland bands played a dirge while leading the funeral procession to the grave, but played hot

jazz while riding back to town in the wagon that had carried the corpse. Because of the slide mechanism, the trombonist had to ride on the lowered tailgate of the wagon to avoid hitting the other band members; thus, the trombone became known as a *tailgate instrument* and playing a slurry, dixieland type of trombone became known as *tailgating*.

23. tear up the pea patch To go on a wild spree, to go on a rampage. According to Wentworth and Flexner *(A Dictionary of American Slang)*, baseball announcer "Red" Barber popularized this expression in his broadcasts of the Brooklyn Dodgers' baseball games (approx. 1945–55). An analogous Americanism is *go on a tear.*

24. trip the light fantastic To dance; to frolic or make merry. This expression is derived from John Milton's *L'Allegro* (1631):

Come, and trip it, as you go,
On the light fantastic toe.

Thus, *trip the light fantastic* combines *trip*, from the Middle English *trippen* 'to step lightly,' with *light fantastic*, converted into a noun phrase by the omission of *toe* but retaining its original reference to movements of dancing.

"You dance very nicely," she murmurs. "Yes, for a man who has not tripped the light fantastic for years." (Archibald C. Gunter, *Miss Dividends*, 1892)

Revenge . . . See 320. RETALIATION

325. REVERSAL
See also 303. RECANTATION

1. back water To retreat from a position; to reverse one's stance on a subject; to withdraw from a situation. This American expression, dating from the early 1800s, has been attributed to the action of paddlewheel steamboats when they were thrown into reverse. However, it seems more likely that the phrase resulted from the action of a man using his canoe paddle or boat oars to avoid a snag or some other damaging obstacle which presented itself in the water; thus withdrawing from a situation or reversing himself.

I don't see why we can't rig it up. How many want to back water? (Louise Rich, *We Took to the Woods*, 1942)

2. bite a file To bite something that bites back; to try something that can only end in misfortune; to suffer an unexpected and serious rebuff. Aesop tells a fable of a viper that found a file and, thinking it edible, bit it. To his surprise he found it not only unpalatable but also injurious, for it wounded his mouth. The file informed the snake that a file's function is to bite, not to be bitten. The expression has been in figurative use in English since the Middle Ages and is occasionally heard as *gnaw a file.*

He bit the file of English obstinacy, and broke his teeth. (William Cory, *Modern English History*, 1880)

3. catch a tartar To experience a reversal of expectations, particularly in dealing with another person; to find intractable one anticipated to be docile; to meet one's match, often specifically to marry a shrew.

What a Tartar have I caught! (John Dryden, *Kind Keeper*, 1678)

By extension the phrase may mean to have a bargain backfire, an advantage prove a liability, a gift becomes a curse, and similar reversals.

4. Frankenstein monster An invention or other creation that eventually works against or kills its creator; something that backfires or boomerangs. The expression comes from Mary Shelley's famous work *Frankenstein* (1818), in which the notorious monster turned against and destroyed its maker, Dr. Frankenstein. The phrase is used figuratively to describe a project or undertaking begun with good intentions, but

which ultimately develops into an uncontrollable agent of destruction or evil.

> Is Great Britain creating for herself something of a Frankenstein monster on the Nile? (*Saturday Review,* April 1907)

5. from Delilah's lap to Abraham's bosom From evil to good; from sin to salvation. This expression, usually heard in the proverb *there is no leaping from Delilah's lap to Abraham's bosom,* connotes that one can't live a life of sin and then expect to go to heaven upon his death. Delilah, of course, is the notorious sinner of Biblical fame, the mistress of Samson, and Abraham was the chosen of the Lord.

6. hoist with [one's] own petard To be defeated by a plan that backfires; to be caught in one's own trap. In this expression, *petard* refers to an ancient, short-fused time bomb or grenade. Obviously, a soldier who placed the charge was endangered not only by enemy fire, but also by the exploding petard if he did not get away soon enough or if the fuse were faulty. So many soldiers were killed by exploding petards that the expression came into widespread literal, and later, figurative, use.

> Let it work;
> For tis sport, to have the engineer
> Hoist with his own petard; and it
> shall go hard
> But I will delve one yard below their
> mines,
> And blow them at the moon . . .
> (Shakespeare, *Hamlet,* III,iv)

7. man bites dog A surprising turn of events; a reversal of the usual order of things. This phrase first appeared in written form in the *New York Sun* about 1880. Charles A. Dana, then editor of the paper, is usually credited with the article that contained the phrase. However, Edward Mitchell, assistant editor to Dana for a good many years, attributes it to John B. Bogart, the City Editor at the time of the phrase's appearance. The connotation of a reversal that causes surprise is self-evident in Bogart's original sentence.

> When a dog bites a man that is not news, but when a man bites a dog that is news.

8. new ball game See whole new ball game, 306. RECOVERY.

9. the shoe is on the other foot The situation is reversed. This expression, with its obvious allusion, is most often used in reference to a certain poetic justice that results from the exchange or reversal of disparate roles: the controller becomes the controlled, the oppressor becomes the oppressed, the critic becomes the criticized, and so on.

> Recently, much to British chagrin, the shoe was on the other foot. (*The Nation,* March 17, 1945)

10. the tables are turned The situation is completely reversed, roles have been switched, positions interchanged; the exact opposite is now the case. The *tables* in this expression refers to the playing boards which, in certain games, are fully turned round, so that the relative positions of the adversaries are reversed. The phrase often implies that one now enjoys (or suffers) the perspective formerly held by an opponent. The following citation shows both figurative application and literal derivation:

> Whosoever thou art that dost another wrong, do but turn the tables: imagine thy neighbour were now playing thy game, and thou his. (Bishop Robert Sanderson, *Sermons,* 1634)

It also illustrates the active use of the phrase, somewhat less common today, *turn tables* or *turn the tables on.*

11. turn the cat in the pan To change sides out of self-interest; to reverse things so cleverly that they appear the opposite of what they really are; to be a traitor. Although the origin of this term is unknown, a number of explanations have been forwarded. Dr. Samuel Johnson in

his *Dictionary* (1755) lists two possibilities:

> the term should be *catipan*, from Catipania, or it is a corruption of *Cate in the pan*.

However, modern philologists have dismissed both of Johnson's suppositions as erroneous. The most plausible explanation ascribes it to the French *tourner côté en peine* 'to turn sides in trouble'. Whatever the case, the expression has continued in use since at least the 14th century. A variant is *cat-in-pan*.

> You are a Villain, have turned Cat-in-pan and are a Tory. (John Crowne, *City Politiques*, 1675)

12. turn the tide To reverse the current trend of events, especially from one extreme to the other; to turn the tables. *Tide* (literally the ebb and flow of the ocean waters) is used here figuratively to represent the course or direction in which any matter or concern is moving.

13. ugly duckling A homely or unpromising child who blossoms into a beautiful or accomplished adult; anything appearing to lack redeeming qualities that subsequently proves worthy of respect and notice. This expression comes from Hans Christian Andersen's *Ugly Duckling*, in which the title character, after struggling through a year of ridicule and hardship, develops into a glorious white swan. While the expression retains its human applications, it is also used for an inanimate object that is initially thought to be worthless but later proves to be a windfall. This figurative use of the phrase was illustrated by W. O. Douglas, as cited in *Webster's Third*:

> From the beginning Alaska was treated pretty much as our ugly duckling.

14. [my] Venus turns out a whelp An expression formerly used on experiencing a reversal of expectations, a failure instead of the anticipated success. The expression comes from dice: the highest roll, three sixes, was called a *Venus*; the lowest, three aces, a *canis* (dog). The aptness was reinforced by the association of *Venus* with beauty and divinity, and of *whelp* with cur and mongrel.

326. REWARD
See also 52. COMMENDA-TION; 265. PAYMENT

1. catch the gold ring To gain a prize or a bonus; to win a premium as the result of a gamble; also *catch the brass ring*. Merry-go-rounds and carousels offer free rides to those who are willing to gamble and try to grab a gold ring, which usually sits in a slot at shoulder height about two feet outside the revolving platform.

> The thing with kids is, if they want to grab for the gold ring, you have to let them do it, and not say anything. If they fall off, they fall off . . . (J. D. Salinger, *The Catcher in the Rye*, 1951)

The origin of the expression dates back to the days of jousting when participants at tournaments would try to pick off a small ring on the points of their lances, thus *winning the ring*. Those who were successful in a *ride at the ring* or a *run at the ring* were allowed to carry off the prize.

> After which they ran at the Ring, and the Marquis de la Chastre got the prize. (*The London Gazette*, 1686)

2. wooden spoon A booby prize; a consolation prize; the lowest on a list. This expression originated with the practice of awarding a *wooden spoon* to the student who finished last on the mathematics tripos test at Cambridge University, the tripos list being a ranking of those who qualified for mathematical honors. Also a *wooden spoon* was originally presented to the person who received the last appointment in the Junior Exhibition at Yale University; more recently it has been presented to the most popular student in the class. Since originally the last person on the list received the *wooden spoon*, the term has assumed a figura-

tive meaning of booby prize in both America and England.

> The international matches . . . have now all been played . . . Ireland, who won the championship last year have only 1 point and take the "wooden spoon." (*Westminster Gazette*, March 19, 1900)

327. RIDICULE
See also 213. INSULT

1. big deal A great fuss; an exclamation used sarcastically to deflate the speaker's ego, or to indicate disbelief; a comment to demonstrate that one is bored or not impressed. Although its origin is uncertain, this American slang term became especially popular during the late 1940s because of the frequent use of the expression on the radio by comedian Arnold Stang. Originally used in a positive sense to specify anything exciting or satisfying, currently, the phrase is most commonly used in a sarcastic manner.

> The game with Saxon Hall was supposed to be a very big deal around Pencey. (J. D. Salinger, *The Catcher in the Rye*, 1951)

2. does your mother know you're out? Said to one who appears exceptionally simple or to a youth who assumes the airs of manhood before his time; an expression of derision. This expression, popular in both the United States and Great Britain, can be traced to the April 28, 1838 issue of *The London Mirror*, which contained the humorous poem that introduced the famous remark.

> And she asked me, "How's your mother? Does she know you're out?" (Thomas Martin, *Does Your Mother Know You're Out?*)

It quickly became a catch-phrase, probably one of the best known of all time. The term is still in common use today.

> Comin' up and tappin' me on the shoulder with her fan, to wake me up like, said she, "Pray my good feller, does your mother know you're out?"

> The whole room burst out a-larfin' at me. (Thomas C. Haliburton, *The Clockmaker*, 1840)

3. dunce block The block upon which dunces sat in school; a dumping ground for employees who have outlived their usefulness but are retained out of necessity or kindness. The literal use of this expression, dating from the 16th century, derives from the schoolroom practice of placing a pupil who doesn't know his lessons on a block of wood, or a stool, in the corner of the classroom with a pointed cap on his head. The word *dunce* is derived from the name of the scholastic theologian, John Duns Scotus (1265–1308), whose followers, the Dunsmen or Dunses, were denounced by the humanists and reformers as "cavilling sophists", as blockheads who were incapable of learning or understanding anything new. Hence the word *dunce* for a dullard or simpleton. The figurative use of the phrase dates from the early 1800s.

> The District of Florida . . . seems to be a sort of dunce block for the government—a place where they send men good for nothing in any other place. (Oliver W. Norton, *Army Letters*, 1864)

4. funny as a crutch Not really funny at all. Usually heard in the statement, *That's about as funny as a crutch*, this American bit of irony is used to ridicule someone who laughs at an inappropriate moment or tells a joke that others present do not find humorous. Of unknown origin, the expression has a variant in an old "sick humor" expression, *funny as a rubber crutch*.

5. give the gleek To poke fun at; to mock or ridicule. In this expression, *gleek* carries its archaic meaning of a joke or jest, thus giving the obsolete phrase its figurative sense of harmless teasing.

> Sir Thomas, seeing the exceeding vanity of the man, thought he needed modesty, and gave him this gentle

gleek. (Christopher Wordsworth, *Ecclesiastical Biography*, 1599)

6. laugh in [one's] sleeve To laugh surreptitiously; to be secretly amused or contemptuous; to ridicule in secret. This expression alludes to the popular 16th-century Englishman's garb which included sleeves large enough to hide a person's face so that he could smile or laugh covertly.

If I coveted now to avenge the injuries that you have done me, I might laugh in my sleeve. (John Daus, *A Famous Chronicle of Our Times Called Sleidane's Commentaries*, 1560)

The French equivalent is *rire sous cape* 'laugh in one's cape,' referring to a French nobleman's cape which could serve the same purpose as an Englishman's sleeve. Another variation which arose in Spain at about the same time is *laugh in one's beard*, implying that a beard could be used to hide the expression on one's face.

7. laugh like a drain See 174. HUMOROUSNESS.

8. nine tailors make a man An expression of contempt and derision, usually used in the context of ridiculing someone's physical stature. Since it was medieval custom to mark the death of a man with nine tolls of the church bell, a woman with six, and a child with three, this obsolete British invective is probably a corruption of *nine tellers mark a man*, *teller* being a variation of *toller* 'a knell.' As the expression became more common, however, the original meaning was lost, being replaced by the stereotypic concept of tailors as being so feeble and physically degenerate that it would take nine of them to equal one man of normal size and strength. The Scottish historian Thomas Carlyle (1795–1881) tells of Queen Elizabeth I (1533–1603) who, upon receiving a delegation of eighteen tailors, greeted them with royal wit: "Good morning, gentlemen both."

9. on a plate This British expression of ridicule had its roots in the practices of the fish and chip shop, where if one chose to eat on the premises, he had to ask for his fish and chips *on a plate* or he would get them handed to him in a newspaper. Most customers looked with disdain upon those who asked the proprietor to put it *on a plate*. Americans express their contempt by commenting: "I suppose you want it served *on a silver platter*."

10. pooh-pooh To express contempt for; to dismiss lightly; to reject; to speak of disdainfully. This term, dating from the early 17th century, is a reduplication of the word *pooh*, the origin of which is uncertain. The term can also be used as an interjection to express impatience with something or someone.

The skeptic will say 'pooh pooh!' (at least on paper—nobody ever says 'pooh pooh!') (Andrew Lang, *Longman's Magazine*, September 1902)

11. put an ape in [one's] hood to make a fool of; to ridicule; to take down a peg. The derivation of this expression is obscure. *Brewer's* attributes it to the one time practice of fools and simpletons carrying apes or monkeys on their shoulders. The term dates back to at least 1100, and can be found in Chaucer's *Canterbury Tales* (1387–1400). In the "Prologue to the Prioress's Tale," the host, Harry Bailey, comments on the preceding tale, "The Shipman's Tale," in which a shipman told of how a monk made a fool of a merchant by seducing the merchant's wife.

Ah ha! comrades! beware of such a jape!
The monk put in the man's hood an ape
And in his wife's also, by Saint Austin.

12. quote-unquote So-called; thus designated. This expression is currently becoming more widely used in American speech, usually in a sarcastic, derogatory, or denigrating reference to a person's

or group's appellation, especially one that is self-assumed. *Quote-unquote* is a verbal representation of quotation marks (" ") which, in writing, are placed around usually complimentary word(s) that are intentionally used cynically or disparagingly. For example, the term might be heard in a context such as "The politician dreaded the thought of again having to meet with the *quote-unquote* pillars of society."

13. roast To mock brutally or ridicule; to criticize severely or put down; to dress down, to take down a peg. This relatively recent American colloquialism is a term which, like *cook, burn,* and *heat,* is heard in expressions that create an image of discomfort or destruction.

> If he were to roast our Skinski it might hurt our business. (Hugh McHugh, *You Can Search Me,* 1905)

14. sardonic smile A bitter, forced, or unnatural smile. This expression, used in the *Odyssey,* is attributed to the consequences of eating an herb, *herba sardonia,* which grows in Sardinia and is so bitter to the taste that it causes an involuntary movement of the facial muscles into the shape of a painful smile; hence, the expression, *sardonic smile* and the variants *sardonic laughter* and *sardonic grin.* In common use today, all three phrases generally reflect a sneering or mocking attitude on the part of the observer.

> 'Tis envy's safest, surest rule
> To hide her rage in ridicule;
> The vulgar eye the best beguiles
> When all her snakes are decked with smiles,
> Sardonic smiles by rancour raised.
> (Jonathan Swift, *The Pheasant and the Lark*)

15. send up To parody; to lampoon; to pull someone's leg; to mock; to tease; to put on. Adopted from the British, this phrase has become a common American synonym for the satirizing of a person or an idea.

> Perhaps the biggest loss in the revival of *The Man Who Came to Dinner* is its satirical thrust. Kaufman and Hart were sending up their Algonquin Round Table friends, all of whom were famous then, but not all of whom are well known now. (Maxwell Nurnberg, *I Always Look Up the Word E-gre-gious,* 1981)

A common variant is to *send [someone] up,* meaning to ridicule or to poke fun at him. The noun derivative *send-up,* 'a satire or parody,' is also frequent.

16. tongue in cheek Sarcastically, insincerely; not seriously, deadpan; mockingly, derisively. The origin of the term is uncertain.

> There was no speaking "with his tongue in the cheek." He spoke straight from the heart. (Sir E. W. Hamilton, *Gladstone,* 1898)

Righteousness . . .
> See 397. VIRTUOUSNESS

Rightness . . . See 73. CORRECTNESS

328. RISK
> See also 81. DANGER;
> 279. PRECARIOUSNESS;
> 281. PREDICAMENT;
> 400. VULNERABILITY

1. African dominoes A game at dice; craps. This expression was born in the New Orleans area sometime in the late 18th or early 19th century. Since dominoes contain the identical number of pips as dice, placed in the same manner upon the surface, and since the game became especially popular among the Blacks of the area, the slang term *African dominoes* was born. The pair of dice used in the game soon became known as *bones,* presumably because of the similarity of color and texture.

> For one, to become proficient in African Dominoes has not been my lot, although the right arm has developed inches from the exercise of

rolling the bones, while the left has increased in the same proportions from reaching for my pocketbook. (*Outing*, December 1922)

A related term, a natural offshoot from the original, was born about the same time, *African golf*.

I got in that African golf tournament because I thought I could grab us enough doubloons to take us in to New York right. (*Collier's*, June 5, 1920)

2. chalk player A bettor who waits for the late odds on a race before placing his bet. Before electronic parimutuel betting systems were installed at race tracks, the bookmakers used chalk and chalkboards to inform bettors of the current odds and to facilitate the rewriting of the odds, which often changed rapidly. Thus, the late odds on a race became known as *chalk*, and a bettor who watched the odds carefully hoping to catch a late advantage in the odds became known as a *chalk player*. Other terms which developed from this association were *chalk horse*, 'the favorite in a race,' and *chalk eater*, 'a bettor who always plays the favorites.'

3. dance on the razor's edge To tempt fate, to invite trouble, to skate on thin ice. The allusion is to the very sharp and very thin edge of a straight razor. This expression is apparently an extension of the earlier phrase *on the razor's edge* 'in a very precarious or dangerous position,' which dates from the early 17th century. George Chapman used the expression in his famous translation of Homer's *Iliad* (1611):

Now on the eager razor's edge, for life or death we stand.

4. do a Brodie To take a chance; to attempt a dangerous stunt. This expression has its roots in a supposed leap from the Brooklyn Bridge by a New York saloonkeeper, Steve Brodie, on the afternoon of July 23, 1886, to win a wager. There are those who believe the jump was never

made, any more than were any of the other jumps Brodie claimed to have made from other bridges at later dates. In each case the same reporter observed the jump and pulled Brodie from the water; there were no other witnesses, and the only evidence of a jump was wet clothing. From the voices of disbelief came a related term, *to pull a Brodie*, meaning to fail in an undertaking (by 'taking a dive') or to commit a fraudulent act. As a result of Brodie's jump, the following delightful conversation supposedly took place between Brodie and the father of James Corbett, the heavyweight boxing champion.

Corbett's father: So you're the fellow who jumped over the Brooklyn Bridge.
Brodie: No, I jumped off it.
Corbett's father: Oh, I thought you jumped over it. Any damn fool could jump off it.

5. fish with a golden hook To take a heavy risk; to be willing to gamble large sums of money to win small amounts. This expression has been attributed to the Roman emperor Augustus by Erasmus in *Adagia*, (1500) where he states that Augustus:

. . . likened those who grasped at slight gains with possible heavy loss to those who fished with a golden hook, the loss of which, if a fish carried it off, could not possibly be made good by the catch.

The situation is often likened to governments who mislead their citizens into believing that they will improve the nation's economy by giving up a bit of their freedom.

To exchange one's freedom for a little gain—I count it fishing with a golden hook. (Richard Flecknoe, *Miscellanies*, 1652)

6. go nap To risk all on some venture; to bet everything one has; to back an enterprise to one's last dollar. This expression arose from a maneuver in the card game *nap*. In the game, originally enti-

tled *napoleon* after Emperor Napoleon I, each player is dealt five cards. Then each player to the left of the dealer bids in turn, and names the number of tricks he believes he can win. The highest bidder must lead a card, and its suit becomes trump. If he succeeds in making his bid, each player must pay him a prearranged amount for each trick; if he fails then he must pay each player. If a player bids five, *goes nap*, then the amount paid for each trick is doubled; hence, the figurative allusion to risk. The expression, in use since about 1880, gave rise to the related *make one's nap*, to succeed in a speculative undertaking.

> The market is going nap on the British Tea Table. (*Westminster Gazette*, February 12, 1898)

7. lay it on the line To risk something valuable such as one's career, reputation, or life; to speak or answer candidly, clearly, and categorically; to say precisely what one means; to give or pay money. In this expression, *line* is a figurative indication of demarcation between two extremes such as success and failure, clarity and obscurity, or debit and credit. Although originally limited to financial matters such as payment of debts, in contemporary usage *lay it on the line* usually refers to speaking frankly or risking something of importance.

> I'll lay it on the line for you, if you like. Are you thinking of asking my girl to marry you? (E. E. Sumner, *Chance Encounter*, 1967)

> It was clear to the President [Nixon] that his credibility was on the line with the leaders of Hanoi. (*Guardian*, May 9, 1970)

Variations include *put it on the line* and *on the line*.

8. leap in the dark See 82. DEATH.

9. play catch up To take risks one would not ordinarily take; to play unconventionally; to change one's normal system of operation. This expression, dating from the late 1960s, was adapted

from the American sports scene. In many sports the coach gives his players a *game plan* that more or less maps out their proposed strategy against an opponent. However, when the team falls behind by a considerable margin, the coach usually has to *play catch up*, i.e., throw out the game plan and improvise. As with so many other sports terms, this phrase has been adopted by the world of business.

> There is yet time to develop the requisite technologies for a number of vulnerable materials before such situations arise, rather than playing catch up as in the case of energy technologies alternative to oil. (Philip Abelson and Allen Hammond, *Science*, February 20, 1976)

10. play with fire To trifle with or become involved in a serious or potentially dangerous matter. This expression uses *fire* figuratively to represent any situation or entity which can be beneficial or useful, but which always holds the potential for harm or disaster.

> I should like to sound a note of warning . . . one who plays with fire . . . can only expect to get burnt. (*Daily Chronicle*, October 9, 1907)

In contemporary usage, *play with fire* is often applied to romantic entanglements or sexual encounters which, by their very nature, carry the risk of moral or emotional distress.

> She led me on, she played with fire, but she wouldn't have me. (L. P. Hartley, *The Hireling*, 1957)

11. put [one's] head in the lion's (wolf's) mouth To court danger; to ask for trouble. In the Aesop fable which gave rise to the phrase, the *mouth* belonged to a wily wolf; a gullible crane inserted its head to extract a bone. At some point in the phrase's development, the *wolf* evolved into a *lion*—perhaps through confusion with *beard the lion in his den*, or perhaps because the size and ferocity of a lion seem more appropriate when

the phrase is applied to human foolhardiness.

12. ride for a fall To invite injury or misfortune by reckless conduct; to court danger, ask for trouble; to behave so imperiously as to be headed for a comeuppance. One source conjectures a derivation from horse racing, saying a jockey *rides for a fall* when he deliberately loses a race, often by riding in such a way as to be thrown. Whether or not its origin is this specific, the literal phrase seems clearly to have its roots in horsemanship. The expression is now used almost exclusively in its figurative sense; conceptually it is akin to the well-known saying from Proverbs:

> Pride goeth before destruction, and an haughty spirit before a fall. (16:18)

13. Russian roulette A risky activity or predicament, especially one which endangers a person's life. In the game of Russian roulette, a revolver is loaded with one bullet, the cartridge cylinder is spun, the gun is pointed at one's own head, and the trigger is pulled. If the revolver can hold six bullets, the odds are one in six that when the trigger is pulled, the person will kill himself. This "game" took its name from roulette, another game of chance in which a small metal ball is spun onto a revolving wheel, coming to rest in one of thirty-seven or thirty-eight numbered compartments. Its *Russian* designation probably derives from its being a popular pastime among the nihilistic intelligentsia of 19th-century Russia. Although both roulette and Russian roulette are forms of gambling, the stakes in the latter are considerably higher. *Russian roulette* is applied figuratively in situations where one takes his life into his own hands; for example, "It's Russian roulette out there on the freeways at rush hour."

14. shoot the moon To go for everything or nothing; to go whole hog; to go for broke; to make an all-out effort; to make a final, no-holds-barred attempt. This frequently used expression implies that one is taking a great risk and suggests, hyperbolically, that he has about as much chance of success as he does of hitting the moon with an arrow or rifle bullet. The term is used in the card game *hearts* where one who *shoots the moon* wins all the hearts and the queen of spades in the course of play, thereby applying a crushing blow to his opponents; however, if he fails, he puts himself in an almost irrecoverable position. See also **shoot the moon**, 89. DEPARTURE.

15. take the bear by the tooth Recklessly to risk danger; to provoke to attack. The phrase's meaning is self-evident, its origin unknown.

Route . . . See 97. DIRECTION

Rowdiness . . .
See 35. BOISTEROUSNESS

329. RUINATION
See also 108. DOWNFALL;
379. THWARTING

1. cut the ground from under To disprove or invalidate someone's argument, case, position, etc., by demonstrating that it has no foundation in fact; to devastate someone by destroying his belief in an idea or his faith in a person. In this expression, *ground* is what supports a person or his perceptions, whatever sustains him or informs his life.

2. flub the dub To ruin one's own chances of success by inept or evasive behavior; to think or act awkwardly, inefficiently, or slowly; to be slothful and indolent; to blunder or bungle. This expression enjoyed limited popularity during World War II, but *flub* has remained in fairly widespread contemporary use. Related expressions are *flubdub* 'pompous bombastic language inappropriate to a situation' and *flubadub* 'awkwardness, ineptitude.' It is interesting to note that Flubadub was the name of the awkward, bumbling, nondescript circus

animal (puppet) in the original *Howdy Doody Show* (1947–60).

> Maybe Mike Todd or [Milton] Berle should take over the management of the conventions. . . . They would remove much of the amateur flubdub. (*Daily Mirror*, July 8, 1952)

3. go to the wall To be overpowered; to get the worst of a struggle; to retreat or give way. Conceived during the Middle Ages, this term, derived from a military situation, indicates that one can retreat no further and must surrender or die; hence, *to go to the wall* in a nonmilitary situation is, by transference, to be in a hopeless position.

> They are both desperately in love with her, and one must go to the wall. (Henry Kingsley, *Geoffrey Hamlyn*, 1859)

The related terms *drive to the wall* and *push to the wall* signify that one is being forced to the extreme, is in a desperate situation.

> That indeed . . . shall drive him to the wall,
> And further than the wall he can not go.
> (John Heywood, *Proverbs*, 1546)

4. gum up the works To botch or mess things up, to screw things up; to spoil or ruin, to interfere with the smooth operation of things; also *gum* or *gum up* and *gum the game*. The allusion is to the clogging effect gum or a gummy substance has on machinery. The figurative use of this American slang expression dates from at least 1901.

> When it comes to you horning into this joint and aiming to gum the works for me . . . well, that's something else again. (P. G. Wodehouse, *Hot Water*, 1932)

5. knock for six To demolish an argument or defeat an opponent utterly and completely; to knock for a loop or into a cocked hat. This primarily British expression derives from cricket; a batsman *knocks for six* when he knocks the ball over the boundary of the field and scores six runs. The feat is analogous to hitting a grand-slam homerun in baseball.

6. knock into a cocked hat To demolish or defeat utterly; to destroy, upset, or ruin. Though it may refer to actual physical combat, the expression is more often used in reference to plans, arguments, theories, etc. Most sources agree it derives from a game similar to ninepins, popular in the United States in the 19th century. When only the three pins forming a triangle were left standing, they were said to have been *knocked into a cocked hat*—by analogy to the shape of the tricornered, brimmed hat worn during the American Revolution.

> A frigate of the modern type would knock a fort armed with obsolete guns into a cocked hat. (*Pall Mall Gazette*, January 1888)

7. make hash of To ruin; to mess up; to make a jumble of; to mismanage. The allusion in this phrase is to the mishmash created when meat and vegetables, often leftovers, are thrown in together, ground up, and cooked. Figuratively, the term, which has been heard since the early 18th century, means to make a muddle of an undertaking and is most commonly heard in that context.

> Lord Grey has made somewhat of a hash of New Zealand and its constitution. (Lord Houghton, *Life*, 1847)

8. make mincemeat of To destroy or annihilate; to beat in a contest. This expression, dating from the 17th century, can be used in referring to actual physical destruction or to the destruction of a person's ideas or theories.

> I'll hew thee into so many Morsels, that . . . Thou shalt be Mince-meat, Worm, within this Hour. (Abraham Cowley, *Cutter of Colman-street*, 1663)

The use referring to beating an opponent in a contest seems to be a later develop-

ment, appearing in print by the mid-19th century.

Maniac made mincemeat of Smoker, who was so stiff that he could scarcely raise a gallop. (*Coursing Calendar*, 1876)

An equivalent slang expression is *make hamburger out of*, an Americanism which applies almost exclusively to severe physical beating or thrashing.

9. make roast meat of [someone] To ruin or overwhelm; to destroy; to murder; to finish off. The derivation of this saying is obvious. Although seldom heard today, the expression and a variant, *make roast meat for worms*, have been in use since the 16th century.

Pandar: . . . The poor Transylvanian is dead, that lay with the little baggage.
Boult: Ay, she quickly pooped him, she made him roast meat for worms. (Shakespeare, *Pericles*, IV, ii)

10. pull the rug out from under To cut the ground from under someone; suddenly and effectively to shatter another's position, argument, or belief by demonstrating its invalidity; to deflate someone by destroying his illusions.

But if . . . Bazargan were to quit, authority in Iran would apparently rest solely with the Komiteh, the mullahs and other fervent Shi'ites whose grab for power has literally pulled the Persian rug out from under Bazargan's regime. (*Time*, March 1979)

11. smash to smithereens To break up into small pieces; to destroy something completely; to demolish. The origin of the word *smithereens* is somewhat obscure. It is generally believed to be of Anglo-Irish derivation, probably a combination of *smithers*, the small fragments found around the forge of a smith, and the Irish diminutive suffix, *–een*; hence, figuratively, anything extremely small. The term has been in use since the early 19th century.

A celestial worthy . . . whose prowess and exploits . . . seem to have beaten St. George and the dragon quite to smithereens. (Clara F. Bromley, *Woman's Wanderings*, 1861)

12. upset the applecart To ruin plans or arrangements, to botch things up, to spoil things, to blight someone's hopes. An *applecart* is a 'pushcart' street vendors use to peddle apples. For a huckster who makes his living selling apples, the overturning of his cart would be disastrous since it would inevitably damage the fruit and thus ruin his business. A variant of the expression dates from at least 1788.

If the Control had done more it might have upset the apple-cart altogether. (*Pall Mall Gazette*, October 1883)

Rule . . . See **107. DOMINATION**

S

Sadness . . . See 87. DEJECTION

Safeguarding . . .
See 292. PROTECTION

Sameness . . . See 120. EQUIVA-
LENCE; 346. SIMILARITY

Sanction . . .
See 29. AUTHORITATIVENESS

330. SANCTUARY

1. **glory hole** A container for the storage of ornaments, personal effects, and other paraphernalia. This term originally referred to a room where the war medals and decorations of a former soldier were stored. The expression is used today to describe any receptacle filled with useless items of sentimental value.

> You can bring out your old ribbon-box . . . It's a charity to clear out your glory-holes once in a while. (Adeline Whitney, *We Girls*, 1871)

2. **ivory tower** A condition of isolation or seclusion from worldly or practical affairs; a sheltered, protected existence removed from the harsh realities of life; an attitude of aloofness or distance from the mainstream of society. The original term appears to have been the French *tour d'ivoire* first used by the French literary critic Sainte-Beuve in reference to the French writer Alfred Victor de Vigny in his book *Pensées d'Août* (1837). The expression appeared in English in Brereton and Rothwell's translation of *Bergson's Laughter* (1911):

> Each member [of society] must be ever attentive to his social surroundings . . . he must avoid shutting himself up in his own

peculiar character as a philosopher in his ivory tower.

The term has spawned the noun *ivory-towerism* and the adjectives *ivory-towerish* and *ivory-towered* 'impractical, theoretical, removed from reality.'

3. **sanctum sanctorum** A hideaway; a room or other place where one can seek refuge from his everyday concerns; a haven or sanctuary. Literally, the *sanctum sanctorum* (Latin, 'sanctuary of sanctuaries') is the Holy of Holies, a room in Biblical tabernacles and Jewish temples which only the high priest is allowed to enter, and then only on Yom Kippur, the Great Day of Atonement. By extension, *sanctum sanctorum* has been applied to any private, peaceful place such as a cabin in the woods or the den in a house which is not to be violated by intruders.

> We went by appointment to the archbishop confessor's and were immediately admitted into his sanctum sanctorum, a snug apartment . . . (Peter Beckford, *Familiar Letters From Italy*, 1834)

Sarcasm . . . See 327. RIDICULE

331. SCHOLARLINESS

1. **bluestocking** A woman of intellectual attainments or pretensions. Most sources agree that the term originated in 18th-century Britain in reference to certain gatherings of both men and women at which literary discussion replaced the former usual cardplaying. However, sources do not agree on whose receptions or whose stockings actually gave rise to the phrase. Regardless of the wearer or wearers, *bluestocking* appears to have reflected the casual dress accepted in

these intellectual circles, the blue worsted being in opposition to the formal conventional black silk. Little used today, the term was derogatory both in its reference to dress and in its subsequent reference to the women who sought intellectual parity with men. In the Colonial United States, however, the term was interchangeable with *blueblood* and simply meant one of aristocratic birth or superior social standing.

2. bookworm One who seems to be nurtured and sustained through constant reading; one whose nose is always buried in a book; a bibliophile. This term derives from different kinds of maggots that live in books and destroy them by eating holes through the pages. However, one source suggests that the term alludes to the Biblical passage in which an angel says to St. John in regard to a scroll:

> Take it, and eat it up; and it shall make thy belly bitter, but it shall be in thy mouth sweet as honey.
> (Revelations 10:9)

The term appeared in print in its figurative sense as early as 1599. It is usually used negatively to connote those qualities characteristic of a pedant.

3. double dome An intellectual or scholar, a highbrow or longhair. This rather derogatory American slang expression is of fairly recent coinage and would appear to be a humorous takeoff on *dome,* slang for head since the late 19th century. *Double dome* not only brings to mind the notion of a double head, and thus twice the average intelligence, but also the image of a particularly high forehead, once believed to be a mark of higher-than-average intelligence.

4. egghead An intellectual or highbrow, an academician or longhair. This disparaging term for an intellectual owes its origin to the visual resemblance between the shape of an egg and the head of a person with a high forehead, the latter feature being considered a mark of

superior intelligence. The term became popular during the 1952 presidential campaign when Adlai Stevenson was the Democratic candidate. His supporters, mostly members of the intelligentsia, were often labeled *eggheads,* perhaps in humorous reference to Stevenson's own unusually high forehead, further accented by his baldness.

5. groves of academe The scholarly life; institutions of higher learning in general. In the 4th century B.C., Plato opened a school for his followers in the grove of Akademe, named for a Greek hero, Akademos. The school came to be known as *Academia,* i.e., *the Academy,* and lasted for centuries, being especially famous because of its first master, Plato, and one of his students, Aristotle. Thus, the term came to symbolize any place of higher learning.

> To seek for truth in the groves of Academe. (Horace, *Epistles* II,2,45)

Today the term is most commonly used to denote the strictly academic side of college life as opposed to the social or athletic sides. Christopher Fry makes a rather different use of the term in *Venus Observed* (1950).

> But how I longed
> As a boy for the groves and grooves of Academe.

6. highbrow An intellectually and culturally superior person; an advocate of the arts and literature. The origin of this expression lies in the belief that people with high foreheads have a greater intellectual capacity. The term is often used disparagingly to describe anyone with intellectual interests. Variations of this expression include *lowbrow,* a person of no breeding and negligible mental capacity; *middlebrow,* a person of mediocre intelligence and bourgeois tastes; and the place name *Highbrowsville,* a rarely used term for Boston, Massachusetts, once considered the hub of American intellectual life.

> The strangely disreputable lady
> "Jazz"—disreputable because she was

not sponsored by the highbrows. (S. R. Nelson, *All About Jazz*, 1934)

Scolding . . . See 312. REPRIMAND

Searching . . . See 216. INVESTIGATION; 299. QUEST

Seclusion . . . See 330. SANCTUARY

332. SECRECY
See also 61. CONCEALMENT; 345. SILENCE

1. behind the scenes In private; not in public; behind what the ordinary spectators see; in a position to see the hidden or secret functioning. The allusion in this phrase is to the business that occurs backstage at a theater, so important in creating many of the illusions of the drama for the audience. The term has been used metaphorically since the mid 17th century.

I . . . have been behind the scenes, both of pleasure and business. (Lord Chesterfield, *Letters*, February 18, 1748)

2. between you and me and the bed-post In secrecy; between ourselves only. This expression, often an indication that a bit of choice gossip is about to be exchanged, has been in use since at least 1832. Common to both the United States and Great Britain, the term is used also when advising a friend of some impending business deal where some fast money can be made.

Between you and me and the bedpost—as the old ladies say—I don't want Jack to have her. (R.D. Blackmore, *Christowell*, 1882)

Many variations exist: *between you and me and the gatepost*, *between you and me and the doorpost*, *between you and me and the lamppost*, and *between you and me and the barn*.

Between you and I and the barn, as we say out west, I am no friend of

such folks as these over here. (Oliver Optic, *In Doors and Out*, 1876)

3. button [one's] lip To keep quiet or silent; to keep a secret; also *button up* and *button up [one's] face* or *lip*. The expression has been in use since 1868.

4. close as a Kentish oyster Close-mouthed; tight-lipped; secretive; difficult to get information from. The reference here is to the superior quality generally attributed to oysters from Kent. Since the best oysters are those that are tightly sealed, one who is *close as a Kentish oyster* is one who can be trusted with any secret.

5. huggermugger Covert or clandestine behavior, secrecy, furtiveness; confusion or disarray. This expression, possibly derived from the Middle English *mokeren* 'to conceal,' appeared in Shakespeare's *Hamlet* regarding the manner of Polonius' burial:

And we have done but greenly
In hugger mugger to inter him. (IV,v)

Although the expression maintains its furtive connotation, *huggermugger* now more frequently carries the meaning of jumbled confusion or disorganization, a meaning it assumed because clandestine activity is often hurried and haphazard.

You find matters . . . so clumsily set out, that you fare in the style called hugger-mugger. (William Jerdan, *Autobiography*, 1853)

6. in petto Undisclosed, kept secret; private, in one's own thoughts or contemplation. This expression is Italian for 'in the breast.' Citations dating from the 17th century indicate that *in petto* is applied almost exclusively to affairs of church or state.

There are seven cardinals still remaining in petto, whose names the Pope keeps secret. (*London Gazette*, 1712)

7. little pitchers have big ears An exhortation or reminder to guard one's tongue because children may overhear

words not intended for their ears. The handle of a pitcher is sometimes called its *ear*. Thus, *pitchers have ears* is a pun on *ears*, and is analogous in meaning to *walls have ears*. This expression appeared in print by the mid 1500s; the later addition of *little* limits the kind of listeners to children.

> Surely Miss Gray, knowing that little pitchers have ears, would have corrected the mistake. (Sarah Tytler, *Buried Diamonds*, 1886)

8. milk in the coconut See 353. SOLUTION.

9. mum's the word Remain silent; do not breathe a word of what was just said. Shakespeare conveyed this meaning in *Henry VI, Part II:*

> Seal up your lips, and give no word but—mum. (I,ii)

This expression may have derived from the *m-* sound, which can be produced only with closed lips. The phrase is particularly commonplace in Great Britain.

> As to Cornwall, . . . between you and me, Mrs. Harper, mum's the word. (Dinah Mulock, *Agatha's Husband*, 1852)

10. on the q.t. Secretly, surreptitiously, covertly, clandestinely, on the sly. *Q.t.* is simply an abbreviation of the word *quiet* in the original expression *on the quiet*.

> It will be possible to have one spree on the strict q.t. (George Moore, *A Mummer's Wife*, 1884)

11. skeleton in the closet A family secret or scandal kept concealed to avoid public shame and disgrace; any confidential matter which, if revealed, could be a source of embarrassment, humiliation, or abasement. Though popularized in the writings of William Thackeray (1811–63), *skeleton in the closet* is reputedly based on an earlier legend that tells of a search for a truly happy person, one free from cares and woes. After such a

person had apparently been found, she opened a closet and exposed a human skeleton. "I try to keep my troubles to myself," she explained, "but every night my husband compels me to kiss that skeleton." The skeleton, it seems, was that of a former paramour whom her husband had killed.

> Some particulars regarding the Newcome family . . . will show us that they have a skeleton or two in their closets. (William Thackeray, *The Newcomes*, 1855)

A British variation is *skeleton in the cupboard.*

12. sub rosa Latin for "under the rose"—in secret, privately, confidentially. Attempts have been made to trace the origin of this phrase to classical times; however, the *OED* states that it has Germanic origins. In Germany, and later in England and Holland, it was a common practice to paint or sculpture roses on the ceilings of banquet halls. The rose was a symbol reminding the revelers to watch their words. The phrase appeared in print by the mid 16th century. The English version *under the rose* is also heard.

> Being all under the Rose they had privilege to speak all things with freedom. (James Howell, *Parables Reflecting Upon the Times*, 1643)

13. under [one's] hat Secret, private, confidential; between you, me, and the lamppost; usually *keep something under [one's] hat.*

> I'd be very grateful . . . if you'd keep the whole affair under your hat. (N. Marsh, *Dead Water*, 1963)

Although the exact origin of this expression is not known, perhaps at one time the space under a person's hat was literally used to conceal things. Use of the phrase dates from the late 19th century.

14. walls have ears An admonition to be discreet in speech, implying that privacy is never certain and that no one is to be trusted. The expression is often

linked with the so-called *auriculaires* of the Louvre Palace, tubes within the walls by means of which Catherine de Médicis reputedly learned of state secrets. There is no evidence, however, that the phrase actually owes its origin to these contrivances. A variant is *even the walls have ears.*

333. SELF-CENTEREDNESS

1. wrapped up in [oneself] Engrossed in oneself; self-centered; concerned only with one's own interests; absorbed in one's own person. This expression signifies one who, like a caterpillar, wraps himself in a symbolic cocoon where he can concentrate on his own interests to the exclusion of other people and their problems.

Self-control . . . See 60. COMPOSURE

Self-deprecation . . . See 334. SELF-DISPARAGEMENT

Self-direction . . .
See 197. INDEPENDENCE

334. SELF-DISPARAGEMENT

1. carry coals To be put upon; to submit to degradation or humiliation; to put up with insults; also *bear coals.* This expression, which dates from 1522, refers to those servants considered the lowest of the low in any household, i.e., the coal and wood carriers, owing to the dirty nature of their work. Shakespeare used the phrase in *Romeo and Juliet:*

Gregory, on my word, we'll not carry coals. (I,i)

2. cry stinking fish To badmouth oneself, to belittle or disparage one's own efforts or character, to put oneself down; to cause others to think ill of oneself. *To cry* means 'to sell by outcry,' 'to offer for sale by auction,' or 'to announce' (*OED*). Obviously one who wishes to sell fish will not say it stinks. *Crying stinking fish* is self-defeating, and—inasmuch as

what one sells is a reflection of oneself—self-deprecating as well. This picturesque expression has been in use since the mid 1600s.

3. dig [one's] own grave To bring about one's own downfall, to be the instrument of one's own destruction.

Of course any *apologia* is necessarily a whine to some extent; a man digs his own grave and should, presumably, lie in it. (F. Scott Fitzgerald, *Letters,* 1934)

4. hide [one's] light under a bushel To conceal or obscure one's talents and abilities, to be excessively modest or unassuming about one's gifts, to be self-effacing. The allusion is Biblical; in his Sermon on the Mount, Jesus urges his followers to let others benefit from their good qualities:

Neither do men light a candle, and put it under a bushel, but on a candlestick; and it giveth light to all that are in the house. Let your light so shine before men, that they may see your good works, and glorify your Father which is in heaven. (Matthew 5:15–16)

Bushel in this expression indicates a vessel or container of this capacity and not the measure itself.

5. make a Judy of [one]self To play the fool; to degrade oneself; to make a fool of oneself. According to the *Dictionary of Catch Phrases* (1977), the full form of this early 19th-century expression is *make a Judy Fitzsimmons of oneself;* however, no one seems to know who Judy Fitzsimmons was. A more likely explanation might be that Judy is a corruption of Judas. John Brougham's *Po-Ca-Hon-Tas* (1855) would seem to substantiate such an interpretation:

Smith: *Judas!* You haven't yet subdued John Smith!
King: Don't make a Judy of yourself.

Another possible origin, or at least corroborating influence, is the character

Judy from the Punch and Judy puppet-show dramas.

6. stand in [one's] own light To injure one's reputation through brazen conduct; to damage one's prospects for success through improper behavior. This self-evident expression is infrequently heard today.

> Take a fool's counsel, and do not stand in your own light. (Ben Johnson, *A Tale of a Tub*, 1633)

7. take eggs for money To allow another to take unfair advantage of oneself; to let oneself be cheated or imposed upon. The expression appears in Shakespeare's *The Winter's Tale:*

> Mine honest friend
> Will you take eggs for money?
> (I,ii)

This expression stems from the fact that eggs were once so plentiful and cheap that they were virtually worthless.

Self-effacement . . . See 334. SELF-
 DISPARAGEMENT

Self-importance . . .
 See 276. POMPOSITY

335. SELF-PITY

1. cry in [one's] beer To overindulge in self-pity; to be inappropriately sentimental or maudlin; to feel sorry for oneself. This expression probably derives from the fact that many people tend to become sentimental, even teary-eyed, after a few drinks. The result of such self-indulgence is often sloppy behavior and a loose tongue.

2. crying towel An imaginary towel offered to the kind of person who chronically complains about ill fortune, minor defeats, or other adversities. The phrase can be used teasingly or judgmentally, implying that one who needs a crying towel is unnecessarily wallowing in self-pity.

3. cry on [someone's] shoulder To reveal one's problems to another person in order to get sympathy; to assail someone's ear with one's woes in an attempt to win pity or to get moral support. Although the image is of a distraught person literally crying in another person's arms, the expression is usually used hyperbolically and sometimes with a sarcastic edge undercutting the seriousness or gravity of the situation.

4. eat [one's] heart To suffer inconsolably; to have sorrow or longing dominate one's thoughts and feelings; to be in a constant state of mental and emotional disquietude. Spenser used this expression in *The Faerie Queene* (1596):

> He could not rest; but did his stout heart eat.

More common today is the expression *eat [one's] heart out*. It is often heard as a playfully sarcastic command, very different in tone from the earlier serious version of the expression.

5. sob story See 341. SENTIMENTALITY.

336. SELF-RELIANCE
 See also 197.
 INDEPENDENCE

1. carry a message to Garcia To accomplish one's assigned task in an independent, resourceful, self-sufficient manner; to do one's job without making a fuss. This Americanism alludes to Elbert Hubbard's article "A Message to Garcia," written during the Spanish-American War. The piece addressed itself to the inability of most people to act without quibbling and procrastinating, citing Major Andrew S. Rowan of the U.S. Army as an exemplary model for his behavior in carrying out the order to find and deliver a message to the Cuban General Garcia. The expression was popular in the early part of this century but is now less frequently heard.

> What you have to do, young man, is to carry a message to Garcia. That's your task. You go back to the

Research Laboratory and do it!
(*American Mercury*, July 1924)

A common variant is *take a message to Garcia.*

2. cottage industry A business which is partly or wholly carried out in the home, often based upon the family unit as a labor force. The connection between *cottage* and home and family is self-evident.

For generations now the sewing of gloves has been conducted largely as a cottage industry. (B. Ellis, *Gloves*, 1921)

3. do off [one's] bat To accomplish by one's own efforts; to make by oneself, independently. This Briticism is another of the many terms adopted from cricket. The allusion is to the score a player makes from his own hits. The expression dates from the 1840s.

You make, I suppose, ten pounds a night off your own bat. (George Bernard Shaw, *Misalliance*, 1910)

Two related terms, derived from Cockney rhyming slang for *on [one's] own*, are: *on [one's] Pat Malone* reduced to *on [one's] pat*; and *on [one's] Tod Sloan*, reduced to *on [one's] tod*, the latter derived from the name of a famous English jockey.

4. every tub must stand on its own bottom Every man for himself, everyone must take care of himself, everyone must paddle his own canoe; sometimes *every tub on its own black bottom*. The *tub* of this expression may mean a vat or cask, or a slow, clumsy ship. *Bottom* may mean either the underside of a barrel or cask or of a ship. Depending on which of these alternative senses one chooses a case can be made for either a nautical or a more general origin for this phrase. Either way the expression is said to have first become popular among southern Blacks before being adopted and reassigned by Black jazzmen to describe complete improvisation. The phrase dates from the early 18th centu-

ry. Another similar expression is *stand on one's own bottom* 'to be independent, to act on one's own or for oneself,' dating from the early 17th century.

5. hoe [one's] own row To make one's own way, to do one's own work, to be independent, to take care of oneself. This self-evident American expression dates from the first half of the 19th century.

Our American pretender must, to adopt an agricultural phrase, "hoe his own row," . . . without the aid of protectors or dependents. (*The Knickerbocker*, 1841)

6. paddle [one's] own canoe To shift for oneself, to be self-reliant, to handle one's own affairs, to manage independently. This expression, which dates from at least 1828, appeared in a bit of doggerel published in *Harper's Magazine* in May 1854. The first stanza is as follows:

Voyager upon life's sea,
To yourself be true,
And, whate'er your lot may be,
Paddle your own canoe.

It is sometimes facetiously rendered as *Pas de lieu Rhône que nous*, in macaronic French.

7. pull oneself up by [one's] own boot straps To better oneself by one's own efforts and resources; to improve one's status without outside help; to start at the bottom and work one's way up. A *bootstrap* is a loop sewn on the side of a boot to help in pulling it on. The expression is a jocular reference to the impossibility of hoisting oneself into the air, even by dint of the mightiest effort.

I had no money, I could have got some by writing to my family, of course, but it had to be the bootstraps or nothing. (Doris Lessing, *In Pursuit of English*, 1960)

Also current are the variants *lift* or *raise oneself up by [one's] own bootstraps.*

A poet who lifted himself by his own boot-straps from an obscure versifier to the ranks of real poetry. . . .

(Kunitz and Haycraft, *British Authors of the 19th Century*, 1922)

8. rowing crosshanded Self-reliant; independent; by oneself; without assistance. This Canadian Maritime expression, which has been adopted in parts of eastern Maine, is traced to a 19th-century practice of rowing crosshanded when one rowed his boat alone. In time *crosshanded* came to signify the ability to accomplish something independently, as *Century Magazine* (September 1882) cites in the case of the self-sufficient wives of Nova Scotia.

> The gaunt women bring their stuff to trade at the village stores, rowing crosshanded.

9. scratch for [one]self To take care of oneself, to be self-reliant; to look out for one's own best interests. This American colloquialism appeared in print by the mid 19th century.

> Shaking off the other child, [she] told him to scratch for hisself a time, while she began to prepare the supper. (Alice Cary, *Married, not Mated,* 1856)

Scratch for [one]self is infrequently heard today.

Self-restraint . . .
 See 60. COMPOSURE

Self-satisfaction . . .
 See 57. COMPLACENCY

Self-sufficiency . . . See 336. SELF-
 RELIANCE

337. SELLING
 See also 74. COST

1. under the hammer Put up for sale at auction. In this expression, dating from the early 1700s, *hammer* refers to the small wooden mallet that an auctioneer raps to indicate an item has been sold.

> He threatened . . . to sell the house under the hammer. (Charles Reade, *It Is Never Too Late to Mend*, 1856)

An earlier form, *under the spear*, arose from the Roman custom of thrusting a spear into the ground to indicate a sale was closed.

> Their houses and fine Gardens are given away,
> And all their goods, under the spear.
> (Ben Jonson, *Catiline*, 1611)

Semblance . . . See 286. PRETENSE

338. SENSATIONALISM

1. ballyhoo Boisterous advertising; sensational publicity; baloney; extravagant praise. The origin of this word is unknown, although some attribute it to Ballyhooly, a village in Ireland located in County Cork, where, it is said, at one time extensive roistering was the order of the evenings. Whatever the case, the term in its modern sense is an American concept, derived from circus and carnival life, where *ballyhoo* was the sample of the sideshow performed on a platform or *bally stand* in front of the tent, accompanied by the spiel of the barker to entice the audience inside.

> It is the practice of almost every statesman to prepare the country for his performance by beating the drum and blatting a few lines of ballyhoo. (*Saturday Evening Post*, November 28, 1908)

2. blood and thunder Melodrama, sensationalism. Of U. S. origin, the expression capsulizes the stock terror-inducing devices and stage effects common to works of the genre.

> Mrs. Bill, left to herself, resumed reading a blood and thunder romance. (*Quinland*, 1857)

3. penny dreadful A cheap, sensational novel of adventure, crime, violence, or sex; a trashy, pornographic, or blood-and-guts magazine or newspaper. This British colloquialism is aptly defined by

James Hotten in *The Dictionary of Modern Slang, Cant, and Vulgar Words* (1873):

> Those penny publications which depend more upon sensationalism than upon merit, artistic or literary, for success.

Although such writings no longer cost a penny, the expression persists. A collection of *penny dreadfuls* is sometimes sold in books nicknamed *shilling shockers*. A more modern American variation is *dime novel*, though even this expression has been dated by inflation.

4. yellow journalism News media coverage that concentrates on the gory and gruesome, blatantly appealing to the public's basest curiosities; flagrant bias and distortion in presenting the news, so as to attract purchasers or otherwise achieve personal gain for the publisher. Many employ the term rather loosely today in disparaging reference to any reporting they consider unfair or "nonobjective." Though the expression gained popularity during the era of muckraking, much of which was attributed to the Hearst syndicate, its origin is rather innocuous, deriving from an early experiment in color printing on newsprint. In 1895 *The New York World* published an edition containing a cartoon of a child in a yellow dress, captioned "The Yellow Kid." Such a novelty was naturally designed to attract buyers, but it was a far cry from tabloids catering to the market for mutilation and perversion—today's *yellow journalism*.

339. SENSIBLENESS

1. rhyme or reason Sense, justification, explanation, cause, motivation; reasonableness, reason. The *rhyme* of the phrase remains as a superfluous alliterative element, providing added emphasis. Apparently it originally referred to amusement or entertainment, since works written in verse were considered aimed toward those ends; the *reason* of the phrase meant instruction or enlight-

enment, the supposed province of prose. Today the words usually appear in negative structures or contexts denoting their absence: *against all rhyme or reason, no rhyme or reason, without rhyme or reason, neither rhyme nor reason, what possible rhyme or reason?* The expression was used in this sense of 'reasonableness' only as early as 1664 by Henry More:

> Against all the laws of prophetic interpretation, nay indeed against all rhyme and reason. (*Mystery of Iniquity*)

An anecdote frequently recounted about Sir Thomas More, however, indicates that the phrase may have been in common parlance by the 15th century. A budding author, on requesting the learned man's opinion of a work, was told to convert it to rhyme. Having done so, he submitted it to Sir Thomas' judgment once again, upon which the scholarly wit devastatingly remarked, "That will do. 'Tis rhyme now, anyway, whereas before 'twas neither rhyme nor reason."

340. SENSITIVITY

1. bowels of compassion This expression is rooted in the ancient belief that the organs of the body and their secretions were the fountainhead of all emotions; since at one time the word *bowels* meant all the major organs of the lower half of the body, they were considered the source of many emotions. The Bible makes several references:

> But whoso hath this world's good, and seeth his brother have need, and shutteth up his bowels of compassion from him, how dwelleth the love of God in him. (I John 3:17)

Also in Colossians, reference is made to the *bowels of mercy, bowels of kindness,* and *bowels of meekness,* all referring to emotional responses involving one's capacity for sympathy and understanding.

2. close to the bone Deep; near to the heart; to the quick; close to home; also *near to the bone*. The deeper a physical wound, the closer it is to the bone. The phrase is usually used figuratively of mental or emotional sensation.

3. have [one's] heart in the right place Compassionate and understanding; kind. This expression has its foundation in a belief of the Middle Ages that the emotions lay in the major organs of the body. Pity and sympathy were emotions of the heart, and, therefore, to say of a man that *his heart was in the right place* was to say that he wanted to be considerate in his relationships with others, that he wished to do the right thing. The expression carries the same connotation today.

> I'll give you my opinion of the human race in a nutshell . . . Their heart's in the right place, but their head is a thoroughly inefficient organ. (W. Somerset Maugham, *The Summing Up*, 1938)

4. rabbit ears One who is excessively sensitive to criticism; one who has his hearing tuned to the crowd. Although this expression, with a more physical metaphor involved, refers to a type of TV antenna, a type of faucet with squeeze handles, or a type of cactus plant, another very frequent application is in the world of sports where it connotes an overly sensitive player, official, or coach who seems to be attuned to the comments emanating from the spectators. More recently it has become a form of verbal abuse hurled at these participants when they react to a spectator's harangue, as "Hey, rabbit ears, forget me and pay attention to the game!"

5. right where [someone] lives In one's deepest, innermost feelings; where one is most sensitive; in one's heart of hearts. The allusion to the heart in this phrase is obvious. Coined in the mid 19th century, the expression has regained current usage.

Fonda's conversation eludes both the esoteric and banal, and has that Will Rogers' sense of immediacy, an ability to capture the moment and zap you right where you live. (*Playgirl*, March 1974)

6. to the quick Where one is most sensitive and vulnerable; to the very heart or core; deeply; often *cut to the quick*. In this phrase *the quick* means 'the tender, sensitive flesh of the body, particularly that under the nails.' The expression dates both in literal and figurative usage from the 1520s, but is commonly used today to denote extreme mental or emotional pain.

7. touch on the raw To touch in a sensitive place, physically or mentally; to recall an old emotional hurt. In this expression an intensely sore or sensitive area of flesh exposed by an abrasion or an injury is compared to a wound of one's emotions. Related terms are *touch a nerve*, *touch a raw nerve*, and *strike a raw nerve*.

341. SENTIMENTALITY

1. bleeding heart A person of excessive and emotive compassion; one of undue sentimentality, whose heartstrings quiver at the slightest provocation. This figurative phrase is of relatively recent origin:

> You want to think straight, Victor. You want to control this bleeding-heart trouble of yours. (J. Bingham, *Murder Plan Six*, 1958)

2. hearts and flowers An expression or display of cloying sentimentality intended to elicit sympathy; sob stuff, excessive sentimentalism or mushiness; maudlinism. This American slang phrase was originally the title of a mawkishly sad, popular song of 1910.

> I believed all the hearts and flowers you gave me about being in love with your husband . . . (J. Evans, *Halo*, 1949)

3. one for the Gipper See 133. EXHORTA-TION.

4. play it again, Sam This phrase is a misquote from the classic motion picture *Casablanca*. In the film the following conversation takes place between Dooley Wilson, who portrays a pianist named Sam, and Ingrid Bergman, who stars as Ilsa.

> Ilsa: Play it once, Sam, for old time's sake.
> Sam: Ah don't know what you mean, Miss Ilsa.
> Ilsa: Play it, Sam. Play "As Time Goes By."

Somehow the lines got twisted, and Humphrey Bogart is credited with the line, *Play it again, Sam*, an expression that was never used in the movie. The term has achieved far-reaching popularity because of Woody Allen's Broadway show and subsequent movie; perhaps Allen created the phrase intentionally, the attribution to Bogart being for artistic effect. Whatever the case, the term has become a catch phrase for nostalgia buffs.

5. sob sister A female journalist who writes human-interest stories, especially those of a sentimental nature. This American slang expression, in common use since about 1910, describes a newspaper woman who writes *sob stuff* or *sob stories*, i. e., stories that appeal to the readers' sympathy.

> Winifred Black, the original sob sister, sets the pattern for countless future sob sister leads. (*Time*, July 26, 1948)

6. sob story A very gloomy story; a sad tale designed to elicit the compassion and sympathy of the listener; a tear-jerker. This common, self-explanatory expression often applies to an alibi or excuse. It also frequently describes the narrative recounting of the trials, frustrations, and disappointments of one's life.

How anyone could heed such a sob story is beyond me. (*Los Angeles Times*, June 1949)

7. tear-jerker A book, play, or motion picture designed to induce gloominess or weeping, a sob story; a speaker or performer who is able to obtain the audience's compassion and sympathy. This common expression describes a work which dwells excessively on inconsolable grief, grave disappointment, tragic frustration, or excessive sentimentality.

> William A. Brady in 1901 decided that New York's sophisticates would like to see the old tear-jerker [the play *Uncle Tom's Cabin*] with an all-star cast. (H. R. Hoyt, *Town Hall Tonight*, 1955)

Serenity . . . See 266. PEACE

Servility . . .
See 248. OBSEQUIOUSNESS

Sexual Desire . . . See 230. LUST

342. SEXUAL PROCLIVITY

1. AC/DC Bisexual; capable of being sexually aroused and satisfied by either sex. This slang term was coined by analogy to an electrical appliance which operates on either alternating current (AC) or direct current (DC). The phrase is often used nonjudgmentally and appears to be losing even its slang stigma. Webster's *6,000 Words* (1976) cites R. H. Kuh:

> . . . help the A.C./D.C. youngster to shape his actions in a heterosexual direction.

2. camp or **campy** See 12. AFFECTATION.

3. kinky Perverse, deviant, or aberrant; sexually eccentric or depraved. This term's sexual sense, derived from *kink* 'flaw, abnormality' enjoys widespread, contemporary use in the United States. Its antonym is *straight*.

In a moment of excessively kinky passion a husband strangles his mistress. (*Daily Telegraph*, July 1971)

4. peeping Tom A voyeur; one who achieves sexual gratification through clandestine observation of sexual activity. This expression is named for the 11th-century peeping Tom of Coventry, a tailor who, when he peeked at Lady Godiva as she rode naked through town in protest of increased taxes, was purportedly struck blind. The evolution of the expression's current voyeuristic application is apparent.

5. switch hitter A bisexual. This recent American slang expression uses baseball terminology for a player who can bat from either side of the plate.

343. SHABBINESS

1. Brumaggem jewelry Inferior, cheap, or counterfeit jewelry; imitation gems; gilt doodads. A local, corrupted form for the city of Birmingham, England, *Brumaggem* has come to be a synonym for anything of inferior quality. Such a connotation apparently arose from the manufacture of counterfeit coins known as *Brumaggem groats* in that city during the 17th century; a groat was a silver coin used in England from 1279 to 1662. Since the city is a center for the manufacture of cheap wares, especially jewelry, the term was soon extended to other merchandise associated with the community, *Brumaggem swords* and *Brumaggem wares*.

> The vulgar dandy, strutting along, with his Brumaggem jewelry. . . . (A. K. H. Boyd, *Recreations of a Country Parson*, 1861)

Eventually it was used to describe persons who performed their duties in a haphazard or fraudulent manner, as *Brumaggem statesmen*. The term remains in everyday use.

2. daggle-tail A slattern whose dress trails in the mire; an untidy woman; a slut. The verb *daggle* 'to trail in the dirt or mud' is a blend of *draggle* and *dabble*, hence, literally, a *daggle-tail* is the tail of a garment that has been dragged in the mire. In use since the 16th century, the term is sometimes heard as *draggle-tail* or *drabble-tail*. In its figurative sense the expression was originally applied only to slovenly women, but came to include prostitutes, for the hems of their dresses were often begrimed from walking the streets.

> To make love to . . . some daggletailed soubrette. (Sir Walter Scott, *St. Ronan's Well*, 1824)

3. dog-eared Folded over or down, as the corner of a page in a book; used, worn, shabby. The term obviously derives from the fact that such a flap resembles a dog's ear. Since a book with many such pages has been read and has acquired a shabby appearance in the process, the word *dog-eared* takes on its secondary 'used, worn' meaning.

4. down-at-the-heel See 277. POVERTY.

5. like a dog's breakfast Sloppy, messy, disheveled, unkempt; showing little taste or style. This British colloquial expression means the opposite of *like a dog's dinner*. Why a canine's breakfast is associated with sloppiness and a canine's dinner with neatness and style is left unexplained.

6. look like something the cat dragged in To look unkempt, disheveled, bedraggled; to appear utterly disreputable or uncouth. This overworked phrase is common to the entire English-speaking world, often as a humorous, self-deprecatory expression. There are many variations of the phrase; in Australia, for example, *on a wet night* is often appended. The term has been in use since about 1920.

> I looked awful, like somethin' the cat dragged in. (Louis Adamic, *Girl on the Road*, 1937)

7. St. Martin's rings Counterfeit jewelry; cheap articles; tawdry ornaments. This expression alludes to the cheap jew-

elry sold on the site where the church of St. Martin's le Grande once stood. When King Henry VIII ordered the dissolution of the monasteries in 1536, St. Martin's le Grande was destroyed, and hucksters adopted the site to sell artificial gems and other cheap articles of jewelry.

> This kindness is but like Alchemy or St. Martin's rings, that are fair to the eye, and have a rich outside, but if a man break them asunder and look into them . . . (Fenner, *Compton's Commonwealth*, 1618)

Related terms are: *St. Martin's beads*, *St. Martin's jewelry*, *St. Martin's lace*, and *St. Martin's wares*, all indicating products of inferior quality. In time St. Martin's name preceding anything came to symbolize cheapness and artificiality.

> I had thought the last mask . . .
> Had . . .
> Taught thee St. Martin's stuffe from
> true gold lace.
> (Edward Guilpin, *Skialetheia*, 1598)

8. ticky-tacky Lacking style; dowdy; tasteless by reason of over-uniformity; inelegant. This expression was coined in 1964 by Malvina Reynolds, an American songwriter, as a descriptive term for the sleazy appearance of the cheap tract houses in the hills south of San Francisco.

> They're all made out of ticky-tacky, and they all look just the same. (Malvina Reynolds, *Little Boxes*, 1964)

The term quickly became a common adjective for any development of cheaply made, uniform houses. It is probably a reduplicative form of *tacky*, an American colloquialism from about 1880 for anything sleazy or shoddy. *Tacky*, used originally to describe an inferior horse, is derived from *tack* 'the saddle, martingale, bridle, and other necessary gear for horseback riding.'

Shock . . . See 368. SURPRISE

Showiness . . .
 See 256. OSTENTATIOUSNESS

Showing off . . . See 276. POMPOSITY

344. SHREWDNESS
 See also 17. ALERTNESS;
 267. PERCEPTIVENESS

1. diamond cut diamond Cunning matching cunning; shrewdness against equal shrewdness; set a thief to catch a thief; an equal match. The allusion in this phrase is to the extreme hardness of diamonds, a hardness that can be matched only by another diamond. The expression has been current since about 1600.

> He felt . . . sure his employer would outwit him if he could, and resolved it should be diamond cut diamond. (Charles Reade, *Hard Cash*, 1863)

2. know what's o'clock To be cognizant of the true state of affairs, to know what's up; to be on the ball.

> Our governor's wide awake . . . He knows what's o'clock. (Dickens, *Sketches by Boz*, 1836)

This expression is rarely heard in the United States, where the analogous negative is a familiar expression of ignorance: "He doesn't even know what time it is."

3. know which way the wind blows To be shrewdly aware of the true state of affairs; to have an intuitive sense of what will probably happen. The origin of this expression may have been nautical. One must know which way the wind blows in order to navigate a vessel. Variants of this expression appeared in print as early as the 15th century. Today it is used figuratively to indicate a commonsensical awareness of outside influences at work.

4. Philadelphia lawyer A shrewd, sharp lawyer well-acquainted with the intricacies and subtleties of the law; a very clever lawyer who uses his knowledge of

legal technicalities and fine points to his advantage; a shyster. The reference is apparently to Alexander Hamilton, a former attorney general in Philadelphia. In a case of criminal libel in 1735, he obtained an acquittal for John Peter Zenger, the publisher of the *New York Weekly Journal,* in the face of what seemed to be irrefutable evidence. The decision established the principle of freedom of the press in America. Use of the term dates from the late 18th century.

> The new violation ticket will be in quadruplicate, and traffic officials say it takes a "Philadelphia lawyer" to fix it. (*The Daily Times* [Chicago], November 1947)

5. sly-boots A cunning, sly, or wily person, especially one who gives the impression of being slow-witted. In this expression, *boots* probably refers to a servant, stereotypically a dullard, who polishes boots and shoes. Thus, a *sly-boots* is one who appears to be a dolt but who is actually shrewd and alert.

> That sly-boots was cursedly cunning to hide 'em. (Oliver Goldsmith, *Retaliation, A Poem,* 1774)

A variation is *sly as old boots.*

6. smart as a whip Extremely bright, alert, witty, or clever; very intelligent; sharp or keen. This commonly used expression may have originated as a humorous twist on *smart* 'sharp pain,' such as that caused by a whip.

> [He] was a prompt and successful business man, "smart as a whip," as the Yankees say. (*Mountaineer* [Salt Lake City, Utah], March 24, 1860)

7. too far north Too clever or shrewd, smart or knowing, extremely canny.

> It shan't avail you, you shall find me too far north for you. (Tobias Smollett, *The Adventures of Roderick Random,* 1748)

This British slang expression is an allusion to the reputed shrewdness of the inhabitants of northern counties such as Yorkshire and Aberdeen.

8. who sups with the devil needs a long spoon A proverbial expression meaning that one needs all his wits about him when dealing with the forces of evil. In "The Squire's Tale" Chaucer made use of this apothegm, which was considered proverbial even then. Shakespeare also used it frequently in various forms.

> COURTESAN: . . . We'll mend our dinner here?
> DROMIO: Master, if you do, expect spoon meat; or bespeak a long spoon.
> ANTIPHOLUS: Why, Dromio?
> DROMIO: Marry, he must have a long spoon that must eat with the devil.
> (*The Comedy of Errors,* IV, iii)

The expression remains in current use.

> . . . and probably she could not do that because she had stayed with father too long, bargaining for freedom. Who sups with the devil must bring a long spoon. (Mary McCarthy, "The Indomitable Miss Brayton," *House and Garden,* December 1983)

Sickness . . . See **181. ILL HEALTH**

Sign . . . See **254. OMEN**

Significance . . . See **234. MEANINGFULNESS**

345.　SILENCE
See also **332. SECRECY**

1. have an ox on the tongue See **38. BRIBERY.**

2. lose [one's] tongue To lose temporarily the power of speech, to be struck dumb. Such speechlessness is usually attributed to emotions such as shyness, fear, or surprise.

3. mumchance A person who is silent and glum; one who has nothing to say; a dummy; one who sits mute. In early 16th-century England the silence which was required in a dicing game called *mumchance* led to the coining of the

proverb *don't sit there like mumchance who was hanged for saying nothing.* By the 1550s the term had been transferred to the stage to refer to one who acts in a dumb show. The term remains current for one who is silent.

> What an unreasonable thing 'tis to make me stand like mumchance at such a time as this. (Author Unknown, *Terence Made English*, 1694)

The origin of *mumchance* can be traced to *mum*, ultimately from Dutch *mommen* 'to act the part of a mummer; to act in pantomime' combined with *chance*, referring to dice as a game of chance. It appears elsewhere in Modern English as *to keep mum* 'to be silent' and *mum's the word* 'silence is the order of the day.'

4. pipe down To become quiet or mute; to cease talking. In this expression, *pipe* may carry any of its numerous sound-related meanings, ranging from a shrill noise to the vocal cords themselves. In contemporary usage, the phrase is most often imperative.

> "Pipe down," replied the husband. "What do you expect for a $10 paint job, grand opera?" (*Kansas City Star*, March 1932)

5. put a sock in it Be quiet; shut up; pipe down; to become quiet; to cease talking. The allusion in this Briticism is to stuffing a sock in one's mouth to act as a gag. It is usually used as an exclamation.

> "Oh, put a sock in it!" she invited him scornfully. (R. C. Ashby, *The Plot Against the Widow*, 1932)

6. see a wolf To lose one's voice temporarily, to become tongue-tied. The phrase expresses the old belief that if a man saw a wolf before the wolf saw him, the man would temporarily lose the power of speech. The expression dates from the late 16th century.

> Our young companion has seen a wolf, . . . and has lost his tongue in

consequence. (Sir Walter Scott, *Quentin Durward*, 1823)

7. you could hear a pin drop Extremely quiet; said of a state of utter silence. This phrase, in use since the early 19th century, is obvious in its allusion. The French equivalent is *on aurait entendu voler une mouche*, 'one could have heard a fly take wing.'

> Sheridan was listened to with such attention that you might have heard a pin drop. (Samuel Rogers, *Table Talk*, 1855)

Silliness . . . See 145. FATUOUSNESS

346. SIMILARITY
See also 120. EQUIVALENCE

1. birds of a feather Persons of like character; those of similar tastes and backgrounds. A truncated version of the old proverb *birds of a feather flock together*, this expression is to be found in almost every language. Its first recorded use was in Ecclesiasticus from the Biblical Apocrypha, dated about 200 years before Christ and hence has become established as an oft-quoted expression.

> We are all in this together;
> We are birdies of a feather.
> (Kaufman and Ryskind, *Of Thee I Sing*, 1931)

2. chip off the old block A son who resembles his father in appearance or behavior. The expression is reputed to have been coined by Edmund Burke (1729–97) addressing the British House of Commons, speaking in reference to Pitt the Younger. However, a citation from the *OED* dates a similar phrase from the early 17th century.

> Am not I a child of the same Adam . . . a chip of the same block, with him? (bp. Robert Sanderson, *Sermons*, 1627)

Chip off the old block is the modern form of the phrase; *chip of the old* or *same block* is the original. The allusion is obvious. A chip has the same charac-

teristics as the block from which it comes. Any connection with "family tree" is amusing but doubtful.

3. copycat An imitator; one who copies another's style or work. The term has been in use since the turn of the century.

> A good architect was not a "copycat;" nor did he kick over the traces. (*Oxford Times*, April 24, 1931)

Copycat is occasionally used as a verb meaning 'to imitate.'

4. dead ringer See **ringer**, 286. PRE-TENSE.

5. follow in the footsteps To emulate; to follow the example or guidance of another; to imitate the performance of a predecessor. The implication here is that in order to be like a respected and admired person, one must follow his example, that is, follow in the figurative footsteps he took along his pathway to success.

> You are obliged to follow the footsteps of your predecessors in virtue. (*Complaint of Scotland*, 1549)

A variation is *walk in the footsteps*. A similar expression dealing figuratively with the feet of a revered person is *big* or *large shoes to fill*, implying that substantial effort will be required to meet the standards established by a predecessor.

6. follow suit To imitate or emulate; to act in the same manner as one's predecessor. This term is rooted in card games such as bridge or setback where rules dictate that, if possible, a participant must follow suit, that is, play a card of the same suit as that which was led.

7. get on the bandwagon To support a particular candidate or cause, usually when success seems assured and no great risk is entailed; often *climb aboard the bandwagon*. In the era of political barnstorming, bandwagons carried the parade musicians. Theory has it that as candidate-carrying wagons moved through a district, local politicos would literally jump aboard those of favorite

candidates, thus publicly endorsing them. The figurative use of *bandwagon* dates from the early 1900s:

> Many of those Democrats . . . who rushed onto the Bryan band-wagon . . . will now be seen crawling over the tailboard. (*New York Evening Post*, September 4, 1906)

Though still most commonly associated with politics, *bandwagon* is used in other contexts as well:

> The next serious outbreak was a three-cornered affair between the gangs of Joe Saltis (who had recently hopped on the Capone band-wagon) and "Dingbat" O'Berta. (Arthur B. Reeve, *The Golden Age of Crime*, 1931)

8. has been in the oven Have the same shortcomings as a relative or friend; guilty of the same sins. This expression alludes to a mother's seeking a child who has hidden to avoid punishment for some act of naughtiness. The implication is that the mother would probably not think to look in the oven unless she had hidden there herself for similar reasons.

> If the mother had not been in the oven, she had never sought her daughter there. (George Herbert, *Jacula Prudentum*, 1640)

Dating from the early 16th century, the term continued in popular use until the end of the 19th century. It is seldom heard today. A related term is *seek another in the oven*.

9. a man of my kidney A person whose character and disposition are similar to one's own. In this expression, *kidney* carries its figurative meaning of nature, temperament, or constitution. The phrase appeared in Shakespeare's *Merry Wives of Windsor*:

> Think of that, a man of my kidney; . . . that is as subject to heat as butter. (III,v)

This figurative use of *kidney* sometimes refers to kind or type of person.

> It was a large and rather miscellaneous party, but all of the

right kidney. (Benjamin Disraeli, *Endymion*, 1880)

10. play the ape To imitate, to copy someone's style, to counterfeit. This expression alludes to the way apes mimic the expressions and gestures of human beings. It appeared in print by the 1500s. Robert Louis Stevenson popularized the expression in his *Memories and Portraits* (1882):

> I have played the sedulous ape to Hazlitt, to Lamb, to Wordsworth, to Sir Thomas Browne. . . . That, like it or not, is the way to learn to write.

11. ringer See 286. PRETENSE.

12. same ball game See **whole new ball game,** 306. RECOVERY.

13. spit and image The exact likeness, image, or counterpart; a duplicate, a double; a chip off the old block. This expression implies that two people are so much alike (usually in appearance) that figuratively, at least, one could conceivably have been spit from the mouth of the other, an interesting concept especially in light of recent breakthroughs in the fields of genetics and cloning. Since an earlier expression was *the very spit, image* serves to emphasize the similarity in appearance.

> She's like the poor lady that's dead and gone, the spit an' image she is. (Egerton Castle, *The Light of Scartney*, 1895)

Variations are *spitting image, spitten image,* and *spit 'n' image.*

14. take a page out of [someone's] book To follow another's example, to copy or imitate someone else; also *take a leaf out of [someone's] book.* The allusion is to literary plagiarism, but the expression is now employed in a positive sense only.

> It is a great pity that some of our instructors in more important matters . . . will not take a leaf out of the same book. (Thomas Hughes, *Tom Brown at Oxford*, 1861)

15. tarred with the same brush All having the same shortcomings; each as guilty as the next. This expression derives from the practice of marking all sheep of the same flock with a common mark made by a brush dipped in tar. Some say the mark was for identification only; others claim it was to protect the sheep against ticks, or to treat sores. A variant of this expression is *painted with the same brush.* These expressions usually imply that what distinguishes a given group of individuals is their shared guilt or their similar negative characteristics.

16. Tweedledum and Tweedledee So similar as to be indistinguishable or undifferentiated. Though the names were popularized by the well-known pair in Lewis Carroll's *Through the Looking-Glass* (1871), the terms were coined in 1725 by John Byrom, who used them in a satirical poem about quarreling musicians. In doing so, he was obviously playing on the meaning of *tweedle* 'to produce shrill musical sounds.'

> Strange all this Difference should be, Twixt Tweedle-dum and Tweedle-dee! *(Handel and Bononcini)*

Even before Carroll's fictional creations were so christened, the terms were used figuratively in contexts concerning insignificant differences, petty squabbles, nitpicking arguments, etc., such as the following later application:

> A . . . war of words over tweedledees of subtle doctrinal differences and tweedledums of Church polity. (*Church Endeavor Times*, August 1911)

17. two peas in a pod Exactly alike; so similar as to be indistinguishable; a duplicate. The allusion in this phrase is to the fact that peas are very similar in appearance. It is often heard as *alike as peas in a pod* or *alike as two peas.* The expression has been in use since at least the late 16th century.

They looked as much alike as peas from the same pod. (Philip Paxton, *A Stray Yankee in Texas*, 1853)

Simplicity . . .
See 114. EFFORTLESSNESS

347. SIMPLIFICATION

1. black and white One extreme or its opposite with no in-between possibilities, such as right or wrong, good or bad, etc.; absolute, inflexible, close-minded. The colors black and white, considered without all the shades of gray in between, represent a simplified and necessarily limited point of view that fails to see things in their full complexity. The phrase is commonly used to describe people's attitudes and opinions.

2. bobtail her and fill her with meat Be terse; say what you have to say and don't waste words. This American expression, seldom heard today, has its roots in the cowboy lingo of the Old West. Since the cowboy was expected to be terse in his speech, he had to compress, *bobtail*, his thoughts and pack them with meaning, *fill them with meat*. The phrase was in common use in the west from the mid 1800s.

3. chew it finer To simplify; to put into simple, clear, unambiguous terms. Apparently the phrase, rarely heard today, was popular among American cowboys. The likelihood is that it stemmed from their practice of tobacco-chewing.

4. copybook Commonplace, conventional, unoriginal, stereotyped; platitudinous. To learn penmanship, students used to imitate specimen entries from copybooks. Today *copybook* is used adjectively to describe complex subjects which are treated superficially and thus take on the triteness characteristic of the maxims used as specimens in old copybooks.

Well provided with stores of copybook morality. (George Lloyd, *Ebb and Flow*, 1883)

As used above, this term dates from the mid 19th century.

5. cracker-barrel Simple, direct, homespun; often in the expression *cracker-barrel philosophy*. This Americanism refers to the practice of local countryfolk gathering around a cracker barrel in country stores to discuss everything from crops and the weather to the political issues of the day.

Politics, rum, riches, and religion—these were the favorite topics of American cracker-barrel debaters. (J. T. Flynn, *God's Gold*, 1933)

6. cut and dried All set, readily solved, having no loose ends or puzzling complexities; perfunctory, lacking spontaneity, boring, run-of-the-mill. This phrase, in use since the early 18th century, originally referred to those herbs sold in herbalists' shops; these were prepared ahead of time and thus lacked the freshness of growing herbs, newly picked.

7. cut the cackle and come to the horses Get down to business; get on with it; stop the silly chatter. This 19th-century expression apparently derives from the story of a horse dealer who had a propensity to talk, especially about his own petty achievements. A farmer, in the market for a team of horses, supposedly admonished the dealer with this phrase. The term is occasionally encountered today.

Cut the cackle and come to the 'osses. (R.A.J. Walling, *The Corpse with the Eerie Eye*, 1942)

348. SINCERITY
See also 43. CANDIDNESS

1. act Charley More To be sincere; to act honestly; to be reasonable; not to take advantage of naive customers. The allusion in this expression is to Charley More, a 19th-century innkeeper on the island of Malta. British sailors returning from Malta spread the word about the man whose tavern sign read, "Charley More—the Fair Thing," and whose ad-

vertisements read "Charley More—the Square Thing"; the phrase became well known because, ostensibly, Charley More practiced what he preached.

2. honest Injun On my word of honor; honestly; truly. This American expression, of uncertain origin, probably owes its popularity to the writings of Mark Twain, who made frequent use of the term, especially in his two most popular books, *The Adventures of Huckleberry Finn* (1884) and *The Adventures of Tom Sawyer* (1876). *Honest Injun* is most commonly heard as a pledge of faith, that is, to affirm that one has held true, or will hold true, to his principles or his word. The equivalent pledge of faith among British schoolboys is *honor bright*.

> Do yer ask honest Injun, no cheatin' nor nuthin'?
> Certainly. Perfectly honest Injun.
> (Blanche Willis Howard, *One Summer*, 1875)

3. in [one's] heart of heart In the deepest, innermost recesses of one's heart; in one's most private and pure thoughts or feelings. The first *heart* in this expression means 'core' and the second *heart* means 'seat of feeling, understanding, and thought.' Although the corrupted *heart of hearts* is frequently heard, the original expression as it appeared in *Hamlet* is *heart of heart*.

> Give me that man
> That is not passion's slave, and I will wear him
> In my heart's core—aye, in my heart of heart,
> As I do thee.
> (III,ii)

Today this expression is used to assure the veracity or sincerity of any statement of belief.

> In his heart of heart Froude would have admitted that. (*Quarterly Review*, October 1895)

4. melt with ruth To be softened by love; to be filled with compassion; to succumb to supplication. Appearing in print as early as 1386 in Chaucer's *Troilus and Criseyde*, this expression refers to the softening of the heart because of *ruth*, i.e., compassion for another's misery. The phrase probably owes its popularity to a well-known passage from John Milton's *Lycidas* (1637):

> Looks toward Namancos and Bayona's hold:
> Look homeward, Angel, now and melt with ruth.

Size . . . See 272. PHYSICAL STATURE

349. SKEPTICISM
See also 369.
SUSPICIOUSNESS

1. doubting Thomas A skeptic, a doubter or disbeliever; one who believes only on the basis of firsthand proof or physical evidence. The original doubting Thomas was the apostle Thomas, who refused to believe that Christ had risen from the dead after His crucifixion until he saw Him for himself.

> But Thomas, one of the twelve, called Didymus, was not with them when Jesus came. The other disciples therefore said unto him, We have seen the Lord. But he said unto them, Except I shall see in his hands the print of the nails, and put my finger into the print of the nails, and put my hand into his side, I will not believe. (John 20:24–25)

2. from Missouri Skeptical, doubting, suspicious; unwilling to accept something as true without proof. Original use of the phrase *I'm from Missouri; you've got to show me* is generally attributed to Congressman Willard D. Vandiver of Missouri in a speech delivered to the Five O'Clock Club of Philadelphia in 1899. However, others have claimed that the expression was commonly known in parts of the country long be-

fore the Congressman popularized it by employing it in this speech.

3. tell it to the marines An expression of disbelief or skepticism, said in response to a tall tale, a fish story, or any far-fetched account. This originally British expression dates from the early 19th century. There are two popular explanations for its origin, one reflecting positively, the other negatively, upon the British Royal Marines. The more involved story is that Charles II said in response to a naval officer's claim that he had seen flying fish, "Go, tell that to the Marines." When accused of insulting the reputation of the Marines, Charles II responded that no slur was intended. To the contrary, he claimed that he would believe the story if the well-traveled and experienced Marines believed it. The second explanation, simple and more plausible, is that the Marines were proverbially gullible and would swallow any yarn. An analogous American slang expression is *tell it to Sweeney.*

4. that cock won't fight No one will believe that; it won't wash; that scheme won't work; tell it to the marines. This expression, which dates from the 1820s, is a product of the cockfighting arenas and indicates that one doubts whether a cock about which another is bragging will fight when placed in the cockpit; hence, 'that's a feeble story.'

> My lawyer argued that . . . no proof had been brought . . . that I had willfully killed anybody. . . . But that cock wouldn't fight. I was found guilty. (Rolf Boldrewood, *Robbery Under Arms*, 1888)

A variant is *that cat won't fight.*

> First I thought I would leave France out and start fresh. But . . . the governor would say, 'Hello here, didn't see anything in France?' That cat wouldn't fight, you know. (Mark Twain, *Innocents Abroad*, 1869)

5. with a grain of salt With skepticism; with reservations. This expression is based on the idea that a pinch of salt

may make palatable something otherwise hard to swallow. Furthermore, Pompey (106–48 B.C.), a member of the first Roman triumvirate, once advocated the use of a grain of salt as an antidote against poison. One source suggests that the minuscule grain of salt may represent the amount of truth in a given statement, assurance, or other matter which has been accepted *with a grain of salt.* The expression occurs in many western European languages, usually in its Latin form *cum grano salis.*

350. SLANDER

1. hatchet man See 76. CRIMINALITY.

2. mudslinging The use of slander, calumny, or malicious gossip to publicly denigrate a person's character or ability. In its most common usage, *mudslinging* (or *mudthrowing*) refers to the vituperative claims, counterclaims, and accusations which may be employed by one or more candidates in a vicious, no-holds-barred political campaign. The rationale for such tactics is well stated in the proverbial statement, "If you throw enough dirt, some is sure to stick."

> This sweeping provision, if constitutional and enforceable, would have the effect of eliminating "mudslinging" in political campaigns, perhaps indeed of revolutionizing campaign methods entirely. (*National Municipal Review*, 1914)

Mudslinging is used in various other contexts, most of which involve slanderous comments made about a person who is in the public eye.

> A woman in my position must expect to have more mud thrown at her than a less important person. (Florence Marryat, *Under the Lilies and Roses*, 1884)

351. SLEEP

1. drive [one's] pigs to market To snore loudly, to log ZZZs. The allusion is probably to the snorting noises of swine

being herded to market. This expression is apparently an elaboration of the phrase *drive pigs* 'snore,' dating from the early 19th century.

2. forty winks A brief nap; a short period of relaxation. This expression, clearly derived from the closed-eye position assumed during sleep, nevertheless implies that the resting person will not fall sound asleep. It is reputed that the first literary use of the phrase appeared in the November 16, 1872, issue of *Punch*, in which the writer surmised that the reading of the Thirty-nine Articles of faith by the communicants of the Anglican Church was indeed a somniferous ordeal:

> If a . . . man, after reading steadily through the Thirty-nine Articles, were to take forty winks. . . .

3. go to Bedlington To go to bed; to hit the sack; to retire for the night. This British expression is a simple cockney slang term playing on the name of a village in Northumberland.

4. go to ruggins to go to bed; to retire for the night; to wander off into dreamland. Apparently this expression had its origins in northern England where to be *at rug* means to be asleep.

> The whole gill is safe at rug, the household are asleep. (Francis Grose, *A Provincial Glossary*, 1787)

There are two probable sources for this term: the Danish *rugge* which translates 'to rock,' as a cradle, and the Norwegian *rugga* 'a coarse coverlet.' Since each can be said to relate to sleep, both provide a plausible explanation of the source of this English expression.

5. hit the deck See 131. EXCLAMATIONS.

6. hit the sack To go to bed; to retire for the night; also, *hit the hay*. During World War II, *sack* was substituted for 'bed' among American soldiers as an allusion to the sleeping bags or blankets they used as beds. J. J. Fahey used the expression in *Pacific War Diary* (1943):

> I hit the sack at 8 p.m. I slept under the stars on a steel ammunition box two feet wide.

Variations of the phrase include *sack time, sack drill,* and *sack duty,* all military slang for time spent asleep; *sack artist,* a soldier who is adept at obtaining extra sleep; and *sack out,* a common term for sleeping until fully refreshed.

7. in the arms of Morpheus In deep sleep; overcome with the desire to sleep. In Greek mythology Morpheus was the god of dreams. The narcotic morphine, which dulls pain and induces sleep, gets its name from the same deity.

8. in the Land of Nod Asleep; in dreamland. After Cain killed Abel, he was banished to wander in the Land of Nod (Genesis 4:16). *Land of Nod* did not mean sleep until Swift made a pun on the Biblical phrase in his *Complete Collection of Genteel and Ingenious Conversation* (1730). Today *Nod* retains the meaning of sleep.

> In the nighttime, when human beings . . . are absent in the Land of Nod. (Chambers, *Journal of Popular Literature*, 1900)

9. pick straws To show signs of weariness or fatigue; to be sleepy. This 18th-century expression alludes to the practice of birds' picking straws to make their nests. A variant is *gather straws*.

> Their eyelids did not once pick straws,
> And wink, and sink away;
> No, no; they were as brisk as bees,
> And loving things did say.
> (Peter Pindar, *Orson and Ellen*, 1783)

10. pound [one's] ear To sleep; to be in deep slumber; to be in the arms of Morpheus. This slang expression has been attributed to the experiences of the railroad man, who, as he sleeps in the caboose, is subjected to the constant pounding of the train as it passes over the rail divisions, and to the hobo, who, as he rides the rods under the freight cars, is subjected to the same constant pounding. With the advent of longer

sections of track and modern rail-welding techniques, this thumping sound has almost disappeared. However, the term, originating in the late 19th century, remains in common use.

11. saw wood To sleep soundly; to snore. This expression came into popular use in the early 20th century primarily as a result of the commonly employed cartoonist's technique of representing sleep with a drawing of a saw cutting through wood, alluding to the sound of snoring.

12. shut-eye Sleep. A 20th-century American colloquialism.

> That shut-eye done me good. (Boyd Cable, *Old Contempt*, 1919)

13. sleep like a top To sleep soundly, like a log; to be dead to the world. The rationale for the seemingly anomalous reference to a *top* is explained by Anne Baker in *Glossary of Northhamptonshire Words and Phrases* (1854):

> A top sleeps when it moves with such velocity, and spins so smoothly, that its motion is imperceptible.

Likewise, when a Yo-Yo spins swiftly at the end of its string, it is said to *sleep*, showing no apparent motion. By extension, then, though a person in a deep, peaceful sleep may seem totally motionless, his internal systems are actually working at a high level of efficiency.

> Juan slept like a top, or like the dead. (George Gordon, Lord Byron, *Don Juan*, 1819)

Slovenliness . . . See 343. SHABBINESS

Smugness . . .
See 57. COMPLACENCY

Snobbishness . . .
See 171. HAUGHTINESS

Sobriety . . . See 373. TEMPERANCE

352. SOLICITATION
See also 265. PAYMENT

1. dun To badger someone to pay a debt; to importune for payment of a bill; to make repeated and insistent demands; to pester or assail relentlessly. Another term of uncertain origin, *dun* dates from the 1600s. Tradition has it that a man named Joe Dun, a London bailiff in the reign of Henry VII, was so successful in collecting bad debts that his name became synonymous with the practice of pursuing someone to deliver payment. *Dun* can be used also in nonfinancial contexts meaning to harass, badger, or plague. Another version offers that the word is cognate with *din* and acquired its metaphoric sense from the raising of a great to-do until the debtor paid up.

> I am so dun'd with the Spleen, I should think on something else all the while I were a playing. (*Shuffling, Cutting, and Dealing*, 1659)

2. fry the fat out of See 140. EXTORTION.

3. mumpers Beggars; spongers; vagabonds; sulkers. This expression derives from *mumping day*, St. Thomas' Day, December 21. On that day the poor would go about the countryside begging for gifts of money with which to buy gifts for Christmas. The term, which dates to the late Middle Ages, probably has its roots in the Dutch *mompen* 'to cheat'; 'to sponge.' It is still in use to designate a vagabond. A variant is *in the mump* 'to go begging.'

> A parcel of wretches hopping about by the assistance of their crutches, like so many Lincoln's Inn Field mumpers, drawing into a body to attack the coach of some charitable lord. (Ned Ward, *The London Spy*, 1700)

4. panhandle To accost strangers on the street and beg money from them. Literally, a panhandle is the handle of a pan. Since the arm and hand project from the body somewhat like a handle from a pan, the act of holding one's hand out to

solicit money came to be known as *panhandling*. Similarly, one who employs such techniques is known as a *panhandler*.

> The prisoners were members of a "panhandling" corporation which operated extensively throughout the district. (*New York Evening Post*, December 9, 1903)

5. pass the hat To solicit money, as for a charity; to take up a collection. It has long been the custom among minstrels and other street performers to collect contributions from the spectators by passing around a hat. In contemporary usage, *hat* has often become figurative, referring to any container into which people in a group or crowd are expected to put money. In fact, *pass the hat* is no longer limited to its original concept, i.e., voluntary payment for entertainment, and usually carries somewhat resentful or contemptuous implications, probably because of the subtle coercion involved.

> It was easy enough to make the hat go round, but the difficulty was to get any one to put anything in it. (Charles J. Matthews, in *Daily News*, September 11, 1878)

6. put the acid on To pressure someone for a loan; to place excessive demands on someone; to coerce someone into granting a favor. This expression alludes to the destructive potential as well as the sharp, bitter taste of an acidic solution. Although the expression's money-borrowing sense originated and is still used in Australia and New Zealand, the phrase is now applied in the United States and Great Britain to any situation in which an inappropriate amount of pressure is being exerted.

> They want to shift the ship at seven. That puts the acid on us. (J. Morrison, in *Coast to Coast*, 1947)

7. put the bite on See 140. EXTORTION.

8. put the sleeve on To stop a friend to ask for a loan of money; to request repayment of a loan; to solicit a contribution. This American slang expression was probably derived from a much older phrase, *hold by the sleeve* or *take by the sleeve*, meaning 'detain for the purpose of conversation'; however, in the case of *put the sleeve on*, the detention is for the purpose of obtaining money, or, occasionally in underworld lingo, 'identify someone to the police.'

9. work the oracle See 232. MANIPULATION.

353. SOLUTION

1. cut the Gordian knot To resolve a situation or solve a problem by force or evasive action; to take action quickly, decisively, and boldly.

> Turn him to any cause of policy,
> The Gordian knot of it he will
> unloose.
> (Shakespeare, *Henry V*, I,i)

According to Greek legend, Phrygia (now part of Turkey) was in need of a leader to end its political and economic woes. The local oracle foretold that a man fit to be king would enter the city in a cart. Shortly thereafter, Gordius, a peasant, rode into town in an ox-cart which was connected to the yoke by an intricate knot made of bark. After being proclaimed king, Gordius dedicated the cart to Zeus, whereupon the oracle predicted that whoever was able to undo the knot would rule over all of Asia. In 333 B.C., Alexander the Great reputedly entered the temple and cut the knot with his sword, thus fulfilling the prophecy. The expression *cut the knot* is a variation.

2. deus ex machina See 314. RESCUE.

3. get the kinks out To rid of difficulties, as in a system or a procedure; to improve one's flexibility after a period of inactivity; to eliminate mental quirks from one's personality; to remove obstructions or hindrances from one's path

to achievement or success. The word *kink* was probably taken directly from the Dutch *kink*, 'twist, twirl,' as in a rope, wire, or lock of hair, especially one that causes an obstruction. Thus the term, which dates from the mid 17th century, fits all modern connotations of the word, whether mental, emotional, or physical:

A little turn . . . to get the kinks out of our muscles. (Frank Norris, *The Octopus*, 1901)

4. a hair of the dog that bit you See 153. FOOD AND DRINK.

5. hammer out To work out laboriously or with much intellectual effort; to figure out, to settle, to resolve. This verb phrase usually appears in a context implying that opposing and conflicting forces have resolved differences or tensions. The term was clearly coined as the figurative extension of the literal pounding and hammering of a blacksmith as he shapes metal objects.

6. just what the doctor ordered Something desirable or restorative. A product of our health- and medicine-conscious culture, this expression is said of anything—a person, a substance, an idea— which has a soothing, palliative, make-it-all-better effect.

The waiter brought her a drink. "Just what the doctor ordered," she said, smiling at him. (Gore Vidal, *City and Pillar*, 1948)

7. milk in the coconut The crucial fact of a matter; the explanation of a puzzle or mystery. This expression had its origin in the 1840s, and by the late 1850s was in quite common use in England. The reference is, of course, to the milk in the heart of the coconut, sealed within the hard shell and layer of meat and difficult to get at.

Here is the milk in the coconut! A frank confession it is. (*Congressional Record*, February 28, 1893)

A catch phrase, *so that explains the milk in the coconut*, is a stock exclamation for

the sudden discovery of the reason behind an action. A variant form is *so that accounts for the milk in the coconut*.

8. open sesame Any agency through which a desired result is realized; the key to a mystery or other perplexing situation; any real or magic act that brings about wanted fame, acceptance, etc. This saying comes from *The Arabian Nights* (1785) where it was used by Ali Baba as the password to open up the door of a robber's hideaway.

Ali Baba . . . perceiving the door, . . . said—"Open, sesame."

Thy name shall be a Sesame, at which the doors of the great shall fly open. (Charles Calverley, *Verses and Translations*, 1862)

9. pull out of a hat To come up unexpectedly with a response or solution, often in the nick of time, when all else has failed. This expression appeared in print during the mid 1900s. It alludes to the magician's trick of pulling a rabbit out of a hat.

I must say you've really pulled one out of the hat this time. (J. McClune, *Steam Pig*, 1971)

10. Rosetta stone The agency through which a puzzle is solved; something that provides the initial step in the understanding of a previously incomprehensible design or situation. The Rosetta stone, discovered in 1799 by the French engineer M. Boussard, is an ancient basalt tablet which bears inscriptions in two languages—Egyptian and Greek— and three alphabets—hieroglyphic, demotic (a cursive type of Egyptian hieroglyphics), and Greek. This archaeological windfall furnished the key to translating the hitherto indecipherable Egyptian hieroglyphics. The expression's current figurative use as a reference to the first clue in unraveling a mystery was illustrated by Ellsworth Ferris, as cited in *Webster's Third*:

This book can be its own Rosetta stone and it is an interesting game to

try to ferret out meanings by comparing passages till the puzzle is solved.

11. tree the coon To solve the problem; to catch an evasive person; to resolve a conflict. This expression refers to the resolution of a coon hunt. Once the animal is treed, then he can be shot easily from the tree. However, until that time the raccoon may escape the dogs and find his way to freedom. The term has been in use since about 1800.

You see, he has the rogue in the city like a coon when he's treed; an old dog's better than a young one in such a fix. (William Carruthers, *The Kentuckian in New York*, 1834)

Speechlessness . . . See **345. SILENCE**

354. SPEEDING
See also **212. INSTANTA-NEOUSNESS; 261. PACE**

1. ball the jack To travel at full speed; to go or act quickly; to stake everything on one attempt. In railroad terminology *ball* is a truncated form of *highball*, a railroad signal for a jack, or locomotive, to accelerate to full speed. The word derives from the signal itself—a raised pole with a metal ball attached to it. *Ball the jack* is a slang phrase now used to apply to swift action of any type. Perhaps the secondary meaning of staking everything on one attempt is related to the opening of the engine's throttle to reach maximum speed. Both are all-out, all-or-nothing, no-holds-barred efforts. Also, in the early 1900s "Ballin' the Jack" was a popular dance and the title of a song by Chris Smith and Jim Burris.

2. burn up the road To drive or move extremely fast; to go at full speed; also *to burn the breeze* (primarily Southwestern use) or *earth* or *wind*. *To burn the earth* or *wind* dates from the late 1800s, while *to burn the road* and *to burn the breeze* did not appear until the 1930s. A similar popular American slang expression is *to burn rubber*, an allusion to the screeching of automobile tires and the streaks of burned rubber left on the road due to rapid acceleration.

3. go two-forty To move at a rapid clip; to run, race, or tear; to bustle, hurry, or rush. In horse racing, the former trotting record for a mile was two minutes and forty seconds. Early use incorporated this time record in phrases such as *at a pace* or *rate of two-forty*, but by the turn of the century *two-forty* had taken on its current adverbial function.

He's going it two-forty a minute. (Mary Waller, *The Wood-Carver of 'Lympus*, 1904)

4. hotfoot To go with great speed, to hurry, to run; also *hotfoot it*. Although the exact origin of this chiefly U.S. expression is unknown, it may refer to the heat generated by running fast. *Hotfoot* is also the name of a practical joke which consists of inserting a match between the sole and the upper of someone's shoe, and then lighting the match. However, this use of the term dates from only the 1930s, while the other was in use as early as 1896.

When O'Dowd did hear . . . he would hot-foot out to Quilty and make the sale. (John O'Hara, *Appointment in Samarra*, 1934)

5. hot rod A rebuilt automobile with its engine modified for speed and acceleration; the owner or operator of such a car. This expression first came into popularity immediately after World War II. In rather limited use at first, two publications brought the term to the attention of the American public, *Hot Rod* magazine, first published in 1948, and Henry Gregor Felsen's best-selling novel, *Hot Rod*, published in 1950. The young people who drove these cars soon became known as *hot rods* or *hot rodders*.

Various cures have been proposed to curb wild and so-called hot rod driving. (Henry Gregor Felsen, *Hot Rod*, 1950)

Guy your age gets a hold of one of these cars and right away he thinks he's a hot rod. (*The New Yorker*, September 8, 1951)

6. let her rip See 388. UNRESTRAINT.

7. lickety-split With great speed; very fast; at a headlong pace.

Whip up and go lickety-split down this hill. (Harriet Beecher Stowe, *Old Town Folks*, 1869)

This American and Australian colloquialism has been in popular use in the United States since the mid 19th century. The term probably derives from the use of *lick* as an indication of speed: "he was moving at quite a lick," and the addition of the subsequent syllables to create a catchy rhythm and sound. Many variations exist, among them *lickety-brindle*, *lickety-Christmas*, *lickety-cut*, and *lickety-tuck*.

8. wings of the wind At full speed; quickly and quietly; almost without notice. This metaphor, in use since the early 16th century, is generally applied to abstract or inanimate things. However, it is also frequently used to describe people who seem to appear and disappear in a mysterious manner, or those who seem to suffer from wanderlust and move freely from place to place.

The foe . . . seems to come and go on the wings of the wind. (Washington Irving, *The Adventures of Captain Bonneville*, 1837)

Spiritedness . . . See 399. VITALITY

Spitefulness . . .
 See 315. RESENTMENT

Spoiling . . . See 329. RUINATION

355. SPONTANEITY

1. off the cuff Extempore, on the spur of the moment, spontaneously, impromptu; offhandedly, informally, unofficially. The allusion is to speakers whose only preparation is notes jotted on their shirt cuffs. Of U.S. origin, this expression dates from at least 1938.

In that scene, shot off the cuff in a shockingly bad light, there leapt out of the screen . . . something of the real human guts and dignity. (*Penguin New Writing*, 1944)

2. off the top of [one's] head Offhandedly, unofficially, informally, without notes or preparation, extemporaneously. In this expression, *the top of the head* represents the superficial nature of the information being given. *Webster's Third* cites Goodman Ace's use of the expression:

Countless conferences at which everyone talked off the top of their heads.

3. on the spur of the moment Impulsively, impetuously; spontaneously, extemporaneously; suddenly, without deliberation. In this expression, *spur* implies speed, alluding to the sharp, U-shaped device strapped to the heel of a boot and used by a rider to prod a horse.

A speaker who gives us a ready reply upon the spur of the moment. (Robert Blakely, *Freewill*, 1831)

4. wing it To undertake anything without adequate preparation, usually with connotations of bluffing one's way through. The term originated in the theater, with reference to actors who would go on stage without knowing their lines, relying on the prompters in the wings to get them through. This literal usage appears as early as 1886 in *Stage Gossip*.

Spurning . . . See 310. REJECTION

Stability . . . See 67. CONSTANCY

356. STAGNATION

1. in a rut Stuck in an established routine; mired in monotony; caught in a stultifying sameness. This figurative use of *rut* 'deep furrow or track' has been common since the mid 19th century.

On his return to civilized life, he will settle at once into the rut. (Sir John Skelton, *Campaigner at Home*, 1865)

Today the expression carries the contradictory connotations of comfort and discontent, with emphasis on the latter, alluding to the fact that movement in a fixed course is smooth and easy but deadening.

2. in the doldrums Inactive, stagnant, nonproductive; depressed, in low spirits, in the dumps, in a blue funk. *Doldrum* derives from *dol*, an obsolete form of *dull*, and is itself an obsolete slang term for a dullard. Thus, *the doldrums* refers to a condition of dullness, low spirits, or depression.

I am now in the doldrums; but when I get better, I will send you. . . .(*Morning Herald*, April 13, 1811)

The doldrums also often refers to the condition of a becalmed ship. By extension, not only ships, but the economy, politics, trade, etc., can be *in the doldrums.*

At the present moment the trade appears to be in the doldrums. (Sir T. Sutherland, *Westminster Gazette*, July 11, 1895)

According to the *OED*, confusion as to whether *the doldrums* referred to a condition or a location gave rise to its use as the name of that specific region of calm near the Equator where neutralizing trade winds often prevent ships from making progress.

Standard . . . See 77. CRITERION

357. STARTING
 See also 31. BEGINNINGS;
 209. INITIATION;
 284. PREPARATION

1. get a move on To get going, to proceed; to move speedily or efficiently. This original U.S. expression dates from the late 1800s.

Come on! Come on! . . . Get a move on! Will you hurry up! (C. E. Mulford, *Bar-20 Days*, 1911)

A more picturesque variant is the American slang *get a wiggle on*, current since the turn of the century. This expression plays on the image of one's posture while running or walking quickly, a more defined image than that conjured up by the word *move* in the former expression.

2. get cracking To get moving, to get started on; to hustle, hurry. Although the origin of this slang expression is unknown, it may be related to a relatively uncommon meaning of *crack* 'to move or travel speedily, to whip along,' which dates from the early 19th century. The phrase *get cracking* itself, however, appears to be of fairly recent origin.

Come on, let's get cracking, we're late now. (S. Gibbons, *Matchmaker*, 1949)

3. get on the stick To get on the ball, to get started or going, to get a move on. Although the meaning of *stick* in the expression is not clear, the phrase nevertheless enjoys widespread popularity. It is often used as an imperative.

4. get the show on the road To get any undertaking under way, but most often to start off on a trip of some kind; to hit the road; usually used in reference to a group of people and their belongings. This expression probably derives from traveling shows, such as theatrical troupes, circuses, etc., which regularly toured the countryside giving performances along the way.

5. let her go, Gallagher! Let's go; let's get started without delay. The *Gallagher* to whom this advice is given may be one or none of the legendary people cited in various folklore explanations. He may have been a cab driver in Australia, a hangman in Galveston (Texas), a warden in St. Louis, the owner of a brokendown nag (horse) in Texas, a streetcar operator in New Orleans, St. Louis, Chicago, Galveston, or Camden, New Jer-

sey; or any of an almost endless list of folk heroes named Gallagher. Most likely, *Gallagher* was chosen because it is close in sound to *let 'er go.* In spite of the amorphous nature of this *Gallagher,* the expression has enjoyed international popularity for more than a hundred years.

6. pull [one's] socks up To get on the stick or on the ball, to get a move on, to shape up, to show more stuff. This British colloquialism apparently had the earlier sense of bracing oneself for an effort, probably in reference to the way runners pull up their socks before starting off on a race. Or the expression may simply refer to making oneself presentable in appearance.

7. put [one's] hand to the plow To undertake a task, to get down to business; to embark on a course of action.

> It was time . . . to set his hand to the plow in good earnest. (George Hickes and Robert Nelson, *Memoirs of the Life of John Kettlewell,* 1718)

The allusion is to Jesus' admonishment of a man who said he would follow Him but only after bidding his family farewell.

> And Jesus said unto him, No man, having put his hand to the plough, and looking back, is fit for the kingdom of God. (Luke 9:62)

8. shake a leg To get a move on, to get going, to hurry up; to dance. This expression meaning to 'dance' dates from the 17th century. Currently, the other meanings are more common.

> . . . if you shake a leg and somebody doesn't get in ahead of you . . . (John Dos Passos, cited in *Webster's Third*)

9. step on the gas To speed up; also, *step on it.* This expression alludes to the speeding up of a car by depressing the accelerator. The phrase enjoys widespread use in the United States and Great Britain.

> Jazz it up. Keep moving. Step on the gas. (Aldous Huxley, *Jesting Pilate,* 1926)

The phrase is often used imperatively, directing a slothful or sluggish performer to increase his pace.

10. stir [one's] stumps To get a move on, to get into action; to shake a leg. In this expression, *stumps* alludes to the legs, or to the wooden prosthetic attachment fastened to a stump or mangled limb. Use of this rather indelicate phrase has declined since the 19th century.

> Come, why don't you stir your stumps? I suppose I must wait on myself. (Baron Edward Lytton, *Ernest Maltravers,* 1837)

Starvation . . . See 175. HUNGER

358. STATUS
See also 269. PERSONAGES; 363. SUBORDINATION

1. above the salt Among the distinguished or honored guests at a dinner; of high rank, important. Formerly a large saltcellar, i.e., a saltshaker or salt mill, was customarily placed in the middle of dining tables. The higher-ranking guests were seated at the upper or master's end of the table, *above the salt,* while those of lesser rank were seated at the lower end of the table, *below the salt.* The phrase has been in use since the late 16th century.

> Though of Tory sentiments, she by no means approved of those feudal times when the chaplain was placed below the salt. (James Payn, *The Luck of the Darrells,* 1885)

2. bacon and rice aristocracy Well-to-do, but boorish landowners; uncouth, prosperous farmers; nouveau riche. This disparaging term from the mid 1800s is seldom heard today. Once popular, especially among the landowners of the South, the term originally signified anyone who had made his money through the production or distribution of the

commodities pork or rice. Shortly after the phrase's inception, it took on a pejorative sense which it has retained, perhaps as the traditionally wealthy looked with disdain upon those with commercially acquired riches.

> Thomas Smith bought his brother's lot, and remained in Charleston, S.C. to build up the 'bacon and rice aristocracy.' (Elizabeth Poyas, *A Peep into the Past*, 1853)

3. blueblood An aristocrat or noble; a thoroughbred. Fair-skinned Spaniards prided themselves on their pure stock, without Moorish or Jewish admixture. Their extremely light complexions revealed a bluish cast to their veins, which they consequently believed carried blue blood, as opposed to the supposed black blood of Moors and Jews.

4. bluestocking See 331. SCHOLARLINESS.

5. born to the purple Of royal or exalted birth. Purple has long been associated with royalty because of its former scarcity and consequent costliness. It was obtainable only by processing huge quantities of a certain mollusk, which was harvested at Tyre, an ancient seaport of Phoenicia, and was called Tyrian purple. *Born in the purple* is a literal translation of *Porphyrogenitus,* a surname of the Byzantine Emperor Constantine VII (905–959) and his successors, most accurately applied only to those born during their father's reign; it was customary for the Empress to undergo childbirth in a room whose walls were lined with purple—possibly porphyry. Today *born to the purple* is more commonly heard.

6. born with a silver spoon in [one's] mouth Born to wealth and high station. It was formerly customary for godparents to give spoons as christening gifts. The child born to wealth could anticipate a silver one from the moment of his birth.

7. born within the sound of Bow bells A British expression denoting a Londoner, especially of the lower classes; a native of the East End district; a Cockney. The church of St. Mary-le-Bow, so called because of the bows or arches that supported its steeple, was known for the peal of its bells, which could be heard throughout the city. The phrase has been used to denote a Cockney since the early 17th century.

8. Brahmin A person from a long-established, highy cultured family, especially one from an old New England family; a member of an aristocratic social class. The allusion in this term is to the priestly, or the highest, caste in Hinduism. Oliver Wendell Holmes is credited with the birth of the expression in his novel *Elsie Venner* (1861):

> That is exactly what the young man is. He comes of the Brahmin caste of New England. This is harmless, inoffensive, untitled aristocracy to which I have referred, and which I am sure you will at once acknowledge.

In modern use, the word is most commonly heard satirically as a synonym for a supercilious intellectual or a snob.

> He took delight, too, in shocking his Brahmin relatives, who belong to one of the oldest and richest families in Massachusetts. (*American Weekly*, November 2, 1947)

9. brown-bagger A person of inferior status or social standing. In the United States, the term derives from the practice of the less affluent, to carry their lunches in brown paper bags. In Britain, a *brown-bagger* is a nonresident student at public school or university; his brown bag is the attaché case in which he carries his books. Such students are usually looked upon with a degree of disdain or condescension by those in residence.

10. bush league Of inferior status; mediocre; second-rate; unprofessional; unsophisticated. This American expression arose about 1900, roughly the time that major league baseball teams began to subsidize the minor leagues. Since most minor league teams were in small cities

and towns, they became associated with the *bush*, i.e., the backwoods and rural areas of America. Hence, these so-called *bush leagues* represented a lower level of baseball than the major leagues. The transition into everyday speech as a synonym for second-rate, or unsophisticated, followed shortly thereafter. The frequently used noun form is *bush leaguer*.

> You may think Sherlock Holmes was pretty good, but he is just a bush leaguer compared to the modern detective. (*Chicago Daily News*, June 27, 1945)

11. chief cook and bottle washer See 269. PERSONAGES.

12. codfish aristocracy A disparaging appellation for the nouveau riche, originally those Massachusetts aristocrats who made their money from the codfishing industry; also *the codfish gentility*. This expression, which dates from 1849, was the title of a poem written in the 1920s by American journalist Wallace Irwin. The first stanza reads as follows:

> Of all the fish that swim or swish
> In ocean's deep autocracy,
> There's none possess such haughtiness
> As the codfish aristocracy.

13. country club set A disparaging term for the fashion-conscious, affluent social group who often consider themselves the elite of a community.

14. the Four Hundred The social elite; the wealthy, refined people generally regarded as "high society." This term dates from 1889 when Ward McAllister, a prominent New York socialite, was given the task of deciding who should be invited to a centenary celebration of the inauguration of George Washington. His list included the names of four hundred people whom he considered to be the true elite, the crème de la crème, as it were. The list received rapid acceptance and the term *the Four Hundred* became an overnight sensation and came to be established in the language.

> To social strivers she is the Queen of the 400. (*Coronet*, August 1948)

In 1904 Mrs. William Astor, grande dame of New York society, increased the number of the class to 800, but *the Eight Hundred* has never gained great currency.

15. gallery gods Those members of a theater audience occupying the highest, and therefore the cheapest, seats; those persons sitting in the balcony or gallery of a theater. The *OED* attributes this expression to the fact that persons occupying gallery seats are on high, as are the gods. However, another source credits the painting on the ceiling over the gallery in London's Drury Lane Theatre as the inspiration for this expression. The ceiling in question is painted to resemble a cloudy blue sky peopled by numerous flying cupids. Thus, it is in reference to the cupids painted on the ceiling above their heads that persons sitting in the gallery first became known as *gods* or *gallery gods*. The term dates from the latter half of the 18th century.

16. gentleman of the four outs A man without manners, wit, money, or credit—the four marks of a true gentleman. This subtle expression used by Englishmen to denote an upstart has been in use at least since the late 18th century. Sometimes the expression varies according to whether the "essentials" are considered more or less than four in number.

> A gentleman of three outs—"out of pocket, out of elbows, and out of credit." (Edward Lytton, *Paul Clifford*, 1830)

17. grass roots The common people, the working class; the rank and file of a political party; the voters. At the beginning of this century the term was used to mean 'source or origin,' the fundamental or basic level of anything. This figurative extension of literal *grass roots* later acquired the political dimension denoting the people of rural or agricultural sections of the country as a factional,

economic, or social group. Finally, *grass roots* was extended to include not just farmers and inhabitants of rural areas but the common people in general, or the rank and file of a political party or social organization.

"No crisis so grave has confronted our people" since the Civil War, Mr. Lowden told the grassroots convention at Springfield. (*Nation*, June 1935)

18. the great unwashed The general public, the masses; hoi polloi. Although its coinage has been attributed to Edmund Burke (1729–97), this phrase has been in print only since the early 19th century.

Gentlemen, there can be but little doubt that your ancestors were the Great Unwashed. (William Makepeace Thackeray, *The History of Pendennis*, 1850)

19. hoi polloi The many; the common people; the masses. This expression, taken directly from the Greek, translates literally as 'the many.' Language purists disdain its use as *the hoi-polloi*, literally 'the the many.' However, such distinguished writers as Lord Byron and John Dryden rendered it that way. Its literal connotation has disappeared almost completely, and, in today's usage, the term conveys condescension on the part of the speaker.

Hoi-polloi trampled, hustled, and crowded him. (O. Henry, *Brickdust Row*, 1907)

20. in the van In the foremost position in an army or fleet; in the lead; in the forefront of a movement. This phrase is derived from an old military term, *vanguard* or *van*, which designates those troops who are in advance of the main body of the army. Both terms are adaptations of the French *avant-garde*, which translates literally 'before the guard'; however, *avant-garde* has been adopted directly into English, and today usually connotes those young artists, painters, writers, composers who lead the way in experimenting in the fine arts. The phrase, *in the van*, in use since the early 17th century, is seldom heard today in its literal sense.

God and Nature together shaped him
 to lead in the van,
In the stress of the wildest weather,
 when the nation needed a man.
(Margaret Sangster, *Abraham Lincoln*)

21. knight bachelor The title of a knight who does not belong to one of the special orders; a knight of the lowest order. The *knight bachelor* is a gentleman who has been awarded a nonhereditary title by the monarch. The honor carries with it a place in the Table of Preference, immediately above County Court Judge and immediately below Knight Commander of the Order of the British Empire, and the honorific *Sir*.

The term has been in use since about 1300.

22. knight banneret A knight created on the battlefield. Originally a *knight banneret* ranked above other knights and enjoyed the privilege of being allowed to bring his company of vassals onto the battlefield under his own banner. He ranked just below a baron. Eventually the term came to designate any knight who had had his knighthood conferred upon the battlefield for deeds of bravery. Apparently the first such conferring of the honor was to Sir John de Copeland, who captured King David Bruce at Neville's Cross in 1346. When the first baronets were established in 1611, the order of *knight banneret* was allowed to lapse into extinction. A variant is *knight of the square flag*.

23. low man on the totem pole The lowest in rank, the least important or experienced person; a neophyte. A *totem pole* is a tree trunk with symbolic carvings or paintings one above the other. North American Indians placed such poles in front of their homes. The apparent hierarchical arrangement of the symbols may have given rise to the current

meaning of *totem pole*, which retains only the idea of 'hierarchy.' Thus, the *low man on the totem pole* refers to one who is at the bottom in the ordering of rank. Its popularity is undoubtedly partly owing to a comic novel, *Low Man on the Totem Pole*, by humorist H. Allen Smith. The following citation from *Webster's Third* shows the corresponding use of a variant phrase for one of superior rank:

> . . . entertain top men on the political totem pole. (Mary Thayer)

24. pecking order Hierarchy; the levels of authority within a group of people or an organization; one's relative degree of predominance, aggressiveness, or power in comparison to others. This expression alludes to dominance hierarchy—a zoological term for the instinctive vertical ranking among birds and social mammals, in which the stronger animals assert their dominance over the smaller, weaker ones. Among domestic fowl, particularly chickens, the hierarchy is virtually uncontested; thus, the bird highest on the barnyard totem pole can peck at the dominated without worry of retaliation. Hence, avian dominance hierarchy came to be known as *pecking order* and, by extension, *pecking order* developed its figurative application to the hierarchy of authority and domination in human affairs.

25. prole A member of the proletariat; one of the poorest class of working people who only serve the state by their labor and by producing children; one who, being without property or capital, relies on his personal labor for a living. This British slang term was coined during the mid 1800s, but did not gain common use until its use, in 1949, in George Orwell's futuristic novel, *1984*, which depicted 85% of the population as consisting of proles.

> American "class" behavior may be even more complicated than Mr. Fussell gives it credit for being, what with low proles sometimes engaging in upper behavior and vice versa all

along the scale. (Christopher Lehmann-Haupt, *The New York Times*, November 18, 1983)

26. ragtag and bobtail The rabble, the riffraff, the masses; also, everyone collectively, the whole lot, every man Jack, every Tom, Dick, and Harry. The term, of British origin, was originally *tag*, then *tag and rag*; later the two words were reversed; still later the addition of *bobtail* (credited by some to Samuel Pepys) completed the term as we know it. Its component words all relate to worthless shreds, tatters, remnants, etc. The expression is sometimes extended to indicate comprehensiveness—every last one—as it was in this passage from T. A. Trollope's *What I Remember* (1887):

> He shall have them all, rag, tag, and bobtail.

27. the rank and file The general membership of an organization, as distinct from its leaders or officers; the lower echelons; the common people in general, hoi polloi. The origin of the term is military, *rank and file* being used to denote common soldiers (privates and corporals as opposed to commissioned officers) since the 18th century; for these were the men commonly required to line up in such formation: *rank* 'a number of soldiers drawn up in line abreast'; *file* 'the number of men constituting the depth from front to rear of a formation in line' (*OED*). By the 19th century the term was popular in government and political circles, as it still is today.

> One of the mere rank and file of the party. (John Stuart Mill, *Considerations on Representative Government*, 1860)

28. run-of-the-mill Average, common, routine; mediocre, ordinary, no great shakes. This commonly used adjective is derived from its application to lots of manufactured goods which have not been inspected and consequently not sorted and graded for quality. By extension the term describes persons lacking

in originality or individuality, those who through blandness blend in with the masses.

29. salt of the earth A person or group of persons epitomizing the best, most noble, and most admirable elements of society; a paragon; the wealthy aristocracy. For centuries, salt has been used in religious ceremonies as a symbol of goodness, purity, and incorruptibility. Thus, it was praise of the highest order when, after preaching the Beatitudes at the Sermon on the Mount, Christ called His disciples the "salt of the earth."

> You are the salt of the earth; but if salt has lost its taste, how shall its saltness be restored? It is no longer good for anything except to be thrown out and trodden underfoot by men. (Matthew 5:13)

30. top billing Stardom; a phrase describing the most prominent or important in a group of persons, events, etc. In theater advertisements and billboards, *billing* is the relative position in which a person or act is listed. *Top billing*, then, is the most prominent position, usually above the name of the play, and is reserved for an actor or actress who has attained stardom, one whose name is readily recognized by the public.

> He made his Broadway debut as Lancelot in Camelot, with billing below the title; now, he is returning to Broadway, with top billing. (*Globe & Mail* [Toronto], January 13, 1968)

Although still most commonly used in reference to the theater, the scope of *top billing* has been expanded to include application in other contexts as well.

31. top-drawer See 129. EXCELLENCE.

32. top-shelf See 129. EXCELLENCE.

33. to the manner born Destined by birth to observe certain patterns of behavior, usually those associated with good breeding and high social status; also, innately or peculiarly suited for a particular position. This latter use is becoming increasingly common. One *to the manner born* is a natural with an instinctive ability in a given area. The former meaning is still the more accurate, however. Shakespeare's Hamlet gave us the expression when he criticized Claudius' and Denmark's drinking customs:

> But to my mind, though I am native here
> And to the manner born, it is a custom
> More honored in the breach than the observance.
> (I,iv)

34. upper crust The highest social stratum; the wealthy; the aristocracy. This expression originated from the former custom of serving the upper crust of a loaf of bread to the most distinguished guests. As used today, the phrase often carries a suggestion of snobbery.

> He took a fashionable house and hobnobbed lavishly with Washington's tight-ringed upper crust. (*Newsweek*, July 1946)

Stinginess . . . See 238. MISERLINESS

Stratagem . . . See 274. PLOY

Strife . . . See 105. DISSENSION

Stubbornness . . .
See 251. OBSTINACY

359. STUPIDITY
See also 145. FATUOUSNESS;
179. IGNORANCE;
246. NONSENSE

1. dim as a Toc H lamp Dim-witted; dense; slow to grasp something. This Briticism refers to the initials of Talbot House—*toc* stands for *T* in military code—a rest center opened for soldiers at Poperinghe, Belgium, on December 15, 1915. The house was named for Gilbert Talbot, a British soldier killed in action earlier that same year. The organization spread throughout the British

Commonwealth as an association of World War I veterans and eventually developed into a Christian social service group.

> The Toc H spirit is one that is wanted very badly in this country today and will be wanted in the future. (*The Times*, December 17, 1923)

Each Toc H house has a dimly lit lamp hanging on a post before it as a mark of identification; hence, the play on *dim*. The expression is seldom heard today.

2. dumb as a beetle Slow-witted; tedious; stupid; dull; rough-hewn. The allusion here is to a type of stupidity or heavy dullness as represented by a *beetle*; a heavy hammering or ramming mallet, usually made of wood, used to drive wedges and pegs or to ram down paving stones.

> That dolt had not a word to say for himself, but was as dumb as a beetle in that matter. (John Knox, *Works*, 1566)

A related term is *dull as a beetle*.

3. flathead A fool; imbecile; simpleton; nitwit. This expression can be traced to the antipathy felt by the early settlers of the western United States toward the Indians. A number of Indian tribes flattened the heads of their infants.

> One infant, evidently malcontent, was being flatheaded. (Theodore Winthrop, *The Canoe and the Saddle*, 1861)

Such flattening of their heads gave the Indians a strange appearance, and in a short time the word *flathead* became an expression of ridicule. This term from the 1800s carries the same connotation today.

> The speaker was a flatheaded idiot . . . (Philip Curtis, *Harpers*, August 1929)

4. the lights are on but nobody's home Said of someone who is in a confused or befuddled state of mind; feeble-minded; daft; inattentive. This phrase, alluding to an empty house with the lights on, is most often used jocularly to indicate to others that the person who is being addressed is not paying attention or is acting in a distant and, hence, seemingly stupid way. However, if accompanied by a tapping of the side of the head, the expression may mean that the person is thought to be mentally retarded or even a bit demented.

5. moonrakers Dolts; simpletons; stupid louts; a nickname for Wiltshire men. One explanation for the source of this word attributes it to some stupid Wiltshire men who mistook the moon's reflection for a piece of cheese and tried to rake it out of a pond. However, the more plausible account, and the one given in Wiltshire, is that the men were trying to rake smuggled kegs of brandy from the pond, and, when accosted by government agents, they faked stupidity and told the agents the story of the cheese, thus outsmarting them.

> I have been immersed . . . in the miserable provincial politics of my brother moon-rakers of this county. (John C. Hobhouse, *Letters*, 1819)

6. palooka An incompetent or bungling athlete, especially a prize fighter; an oaf; a lummox; an enforcer for the mob. Since this term's inception, it has connoted a stumblebum type of boxer, the stereotypical punchdrunk fighter. The origin of the term is unknown, in spite of much conjecture about its derivation. H. L. Mencken in *The American Language, Supplement II* (1948) feels there may be some credence to a suggestion that it derives from the Spanish *peluca*, a term of reproof. *The American Heritage Dictionary* (1969) assigns the coinage of the word to American journalist Jack Conway (1886–1928). Whatever the case, the term is still in common use, especially in boxing circles. Jack Dempsey, the legendary heavyweight champion, was once quoted:

> Anyone who is so inexperienced or so stupid that he can be hit by a swing is

a palooka who can be murdered by straight punches, hooks, or uppercuts.

Although Ham Fisher's popular comic strip *Joe Palooka* has, for many years, depicted the main character, an undefeated heavyweight champion, as a perfect gentleman, the term has retained its derogatory connotation.

7. pumpkin head A stupid person, a dolt, a dunce, a blockhead; one with a big head like a pumpkin; a head with a bowl-like haircut. According to Samuel A. Peters in *A General History of Connecticut* (1781) this term, which was once used to designate all New Englanders, originated in New Haven. Connecticut Blue Laws prescribed that all men have their hair cut round a cap which was fitted over their heads; if a cap was not available, the shell of a pumpkin, cut in half, was substituted. The term developed another, more common connotation, coming to mean simply 'a stupid person, a dolt.'

> Ef we hadn' . . . ben sich punkin-heads, as de sayin' is, we'd a seed de raf. (Mark Twain, *Huckleberry Finn*, 1884)

360. STYLISHNESS
See also 49. CLOTHING

1. à go-go Lively; swinging; fashionable; pseudosophisticated; a term used in reference to night clubs, discotheques, salons, etc. The form of the expression reflects its having been borrowed from the French slang phrase *à gogo* 'galore,' used to characterize the activity of trendy people, especially the jet set. Americans, influenced by the French usage, adapted the term and applied it to certain discotheque dancers, *go-go girls*, chiefly because they never seemed to stop moving. These go-go girls became popular attractions in the 1960s, and the phenomenon led to another term, *go-go boots*, referring to the knee-high, high-heeled, vinyl boots that such dancers

typically wore; these boots were a fashion trend of the 1960s.

2. all the go In vogue; all the rage; fashionably in demand; the latest style. This Briticism is used to indicate that things are moving in the social whirl, and if one wishes to stay in the mainstream of things, he will be *all the go* if he moves with the trends of the times. The expression dates to at least the late 19th century.

> And all day long there's a big crowd
> stops
> To look at the lady who's "all the go."
> (George R. Sims, d. 1922, *Ballads of Babylon*)

3. Beau Brummel An elegant dandy; a fop; the epitome of stylishness and fashion. George Bryan Brummel (1778–1840), better known as Beau, was, in the early 1800s, the acknowledged leader of fashion in London. A close personal friend of the Prince Regent, later King George IV, Brummel is said to have fallen out of favor, when, one day in Bath, he encountered the prince and Lord Westmoreland out for a stroll.

> "Good morning, Westmoreland," said the Beau. "Who's your fat friend?"

The story may be apochryphal, but Beau Brummel is known to have exiled himself to France after his falling out with George, where he died in poverty. His name has become a synonym for one who is overly elegant in his dress and is usually heard in a disdainful context.

4. clotheshorse A person who delights in wearing and showing off fancy clothes; a fashion plate, dandy, or fop; an exhibitionist. A *clotheshorse* is literally a wooden frame on which clothes are hung out to air or dry. The figurative meaning plays on the connections between *horse* 'a frame, with legs, on which something is mounted' and a person. Figurative use dates from the mid-19th century; literal use from the early 19th century.

She ordered her chauffeur to drive her to Fifi's, Shmifi's—a fancy French place for clothes-horses. (J. Ludwig in *Canadian Short Stories*, 1962)

5. daffadowndilly A dandy or fop; one excessively concerned with his appearance; a coxcomb or narcissist. This 19th-century Briticism, also spelled *daffy-downdilly*, originally was a name for the daffodil, a member of the genus of flowers called *Narcissus*. In Greek mythology, Narcissus was a young man overly impressed with his appearance. As punishment, the gods made him fall in love with his own reflection in a pool of water. He stayed by the pool until he died and was then turned into a flower, the narcissus (or daffodil). Thus, the nickname for a daffodil became the nickname for a narcissist.

6. dressed to kill Stunningly or impressively attired; provocatively dressed, specifically in such a way as to completely overwhelm someone of the opposite sex, or, in the words of a similar slang phrase, "to knock 'em dead." Dating from the early 19th century, this expression still enjoys widespread popularity.

7. dressed to the nines Dressed in one's best from head to toe, perfectly attired, dressed in the height of fashion or style; also *dressed up to the nines*. Apparently the original phrase, dating from the late 18th century, was simply *(up) to the nines* meaning 'to perfection, to the utmost degree or extent.' At some point in the evolution of its usage the expression came to apply to a person's dress; it is rarely heard outside of that context today. Although the exact origin of this expression is unknown, several varying theories have been proposed. One suggests that the phrase is actually a corruption of Middle English *to then eyne* 'to the eyes.' Another, less plausible but nonetheless pervasive theory holds that the expression is a reference to the nine Muses and to the magical power formerly attributed to the number *nine*.

8. fashion plate A person who always wears the latest styles, a clotheshorse; a tony dresser; a dandy or coxcomb. Literally, a *fashion plate* is a newspaper or magazine advertisement featuring chic, urbane models nattily attired in the most fashionable clothes. In its figurative sense, a *fashion plate* is anyone who seems to have stepped out of one of these advertisements.

9. Gibson girl The fashionable American girl of the 1890s as portrayed in the sketches of Charles Dana Gibson; the typical mode of dress fashionable in that period. The *Gibson girl* appeared in several series of black-and-white drawings during the 1890s. She was typically dressed in a long, sweeping skirt, a tailored blouse with leg-of-mutton sleeves, and a large hat. She was depicted in a variety of poses. Irene Langhorne, the sister of Lady Nancy Astor, married Gibson on November 7, 1895, and is believed by many to have been the original *Gibson girl*. However, there are those who were close friends of Gibson who report that the *Gibson girl* was a composite of several women. Gibson presented his final series, *The Education of Mr. Pipp*, in 1899 in *Colliers*. A play of the same name appeared shortly thereafter on the New York stage.

> It is a saying among artists that nine out of ten models who come . . . seeking employment say they are the original 'Gibson girl' or the 'Diana of the Garden.' (*Cosmopolitan*, June 1901)

10. the glass of fashion and the mold of form A male fashion plate; a stylesetter; a well-dressed Adonis; a gentleman of excellent physique with exquisite clothes-sense. The expression is a verbatim description of Prince Hamlet by Ophelia (III,i).

11. in full feather Exquisitely dressed, in full regalia, dressed to the nines. The origin of this expression is associated with the molting and subsequent new growth of a bird's plumage.

No words can describe the serene effulgence of the Heartsease appearance when in full feather and high spirits. (J. E. Cooke, *Ellie*, 1855)

12. like a dog's dinner Dolled up, dressed to kill, all decked out; stylish, natty, dapper. This British colloquial expression, the opposite of *like a dog's breakfast*, is of unknown origin.

13. little Lord Fauntleroy See 204. INEXPERIENCE.

14. macaroni A coxcomb or dandy; one with pretensions of sophistication and intellectualism. This British term originally referred to members of the Macaroni Club—an 18th-century group of well-traveled Englishmen who, in affecting Continental mannerisms, became notorious throughout the British Isles for their decadent behavior and pomposity. The phrase is now used to describe conceited, insolent fops.

The weak chin, . . . resolute brow, and good forehead, portray Sheridan to the life, as he appeared, a macaroni and brilliant lounger in Carlton House. (*Athenaeum*, November 1881)

15. spit and polish See 243. NEATNESS.

16. spotted dog under a red wagon Extremely stylish; in the latest fashion. This American expression, dating from the mid 19th century, is of uncertain origin. Apparently the sight of a red wagon with a spotted dog beneath it stimulated someone's poetic muse. Whatever the case, the term is heard occasionally today.

The mother was soft and pretty as a young calf's ear, stylisher'n a spotted dog under a red wagon. (Philip Rollins, *Gone Haywire*, 1939)

361. SUBMISSION

See also 316. RESIGNATION;

362. SUBMISSIVENESS

1. acknowledge the corn To admit or confess to the truth about a matter; to acknowledge losing an argument; to concede one has made a mistake.

The *Evening Mirror* very naively comes out and acknowledges the corn. (*New York Herald*, June 27, 1846)

This expression, of American origin, dates from the early 19th century. Its first recorded use appears in a Congressional exchange between two members on the floor of the House of Representatives in 1828.

2. cry barley To call or cry out for a truce, especially in children's games; to wave the white flag, to surrender. This Scottish and Northern English dialectal expression, which has been in use since the early 19th century, is thought to be a corruption of *parley*.

3. cry uncle To admit defeat, to surrender, to give up; also *say uncle*. Although the precise origin of this expression is unknown, an often repeated story claims that an early Roman, finding himself in trouble, cried out *patrue mi patruissime* 'uncle, my best of uncles.' The phrase first appeared in print early in this century.

4. draw in [one's] horns To retract an opinion or take a less belligerent stand; to restrain oneself, to hold or pull back; to repress one's feelings of pride, righteousness, or pretension. In use since the 14th century, this expression alludes to the snail's habit of pulling in its tentacles when disturbed.

5. go to Canossa See 173. HUMILIATION.

6. knuckle under To submit or yield, to give in, to acknowledge defeat. The origin of this expression has been linked to the obsolete *knuckle* 'knee joint'; hence *knuckle under*, meaning to 'bend the knee before, to bow down to.'

They must all knuckle under to him. (Mary E. Braddon, *Mount Royal*, 1882)

A similar expression with the same meaning is *knock under*, an abbreviated form of the obsolete *knock under board*

or *under the table*. Rapping against the underside of a table with the knuckles was apparently once a sign of submission or defeat as illustrated by the following citation:

> He that flinches his glass, and to drink
> is not able,
> Let him quarrel no more, but knock
> under the table.
> (*Gentleman's Journal*, March 1691)

7. pass under the yoke To make a humiliating submission; to be forced to acknowledge one's defeat humbly. In ancient Rome vanquished enemies were forced to pass under an arch formed by two spears placed upright in the ground, with a third resting on them. This was a symbol of the even older practice of placing a yoke on the neck of a captive. The expression is little heard today, although *yoke* is often used figuratively for 'servitude, restraint, or humiliation.'

> Jugurtha grants the Romans life and liberty but upon condition that they should pass under the yoke. (John Ozell, tr., *Aubert de Vertot's History of the Revolutions*, 1720)

8. raise the white flag To surrender, to indicate one's willingness to make peace; to ask for a truce, to declare an end to hostilities. A white flag, also called the flag of truce, has been the symbol of submission for centuries, perhaps because of its associations with cowardice, or with innocence and goodness.

9. strike [one's] colors To lower one's flag as a sign of submission or as a salute; to surrender. This expression is derived from the nautical use of the verb *strike* 'lower,' as in "a ship strikes sail." A related term is *strike [one's] flag*.

10. strike sail To acknowledge defeat; to surrender; to eat humble pie; to defer or pay respect to. It was long a naval custom for a defeated ship to *strike* 'lower' its sails or flag as a sign of surrender or submission. Also, friendly ships, upon meeting each other at sea, often lowered their topsails to halfmast as a salute and

sign of respect. In the following quotation from Shakespeare's *Henry VI, Part III*, Queen Margaret of England is responding to a request by King Lewis of France that she join him at the royal dinner table.

> No, mighty King of France. Now Margaret
> Must strike her sail and learn a while to serve
> Where kings command.
> (III,iii)

11. throw in [one's] hand To give up, to drop out of the proceedings, to cease work on a project. This expression is derived from card games in which a player who is dealt poor cards or who realizes at some point during the game that winning is impossible has the option of turning in his *hand* 'cards' and dropping out of the game.

12. throw in the sponge To admit defeat, to give up, to surrender, to say uncle. In boxing, a manager has the option of ending a fight if he determines that his contestant has no chance of winning, and is suffering unnecessary physical abuse. The manager signals his desire to stop the bout by throwing his fighter's sponge or towel into the air. This slang Americanism and the variant *throw in the towel* are used figuratively of any surrender or acknowledgment of defeat.

362. SUBMISSIVENESS

See also **85. DEFERENCE**;

248. OBSEQUIOUSNESS;

361. SUBMISSION

1. give [one's] head for the washing To submit to insult or other ill treatment without resistance; to give in tamely or without a fight. This obsolete expression and its variants *give [one's] head for the polling* and *give [one's] beard for the washing* date from the 16th century.

> For my part it shall ne'er be said,
> I for the washing gave my head,
> Nor did I turn my back for fear.
> (Samuel Butler, *Hudibras* I,iii, 1663)

2. kiss the rod To accept punishment submissively, to submit meekly to chastisement. This expression, which dates from at least 1586, is an allusion to the *rod* as an instrument of punishment. Thus, "to kiss the rod," figuratively speaking, is to embrace one's punishment without protest.

> Come, I'll be a good child, and kiss the rod. (James Shirley, *The Witty Fair One*, 1628)

3. like a lamb Meekly, gently, humbly, innocently, harmlessly, naïvely; from *lamb*, referring to a gullible person, one easily deceived or cheated. This expression alludes to the docile, unassuming, placid nature of a young sheep. These characteristics have been associated with the lamb for thousands of years and have been cited in countless works of literature. *Like a lamb* is perhaps best known for its symbolic use in the Bible:

> He is brought as a lamb to the slaughter. (Isaiah 53:7)

> Behold the Lamb of God [Jesus Christ], which taketh away the sin of the world. (John 1:29)

4. live under the cat's foot To be subjected to the whims of another person, especially a woman; to be henpecked. To live under someone's foot is to be dominated and manipulated. In this picturesque expression, the oppressor is the *cat*—a nagging, overbearing woman.

5. milquetoast A timid soul; any person of a meek, retiring nature who allows himself to be pushed around by others. This term is derived from Harold T. Webster's cartoon character, Caspar Milquetoast, who first appeared in the cartoon *The Timid Soul* in *The New York World* in 1924. Named for milk toast, a bland dish of hot buttered toast soaked in warm milk, often fed to sickly people, the cartoon character soon came to represent that type of mushy, timid person who allows the world to walk all over him.

6. patient as Griselda See 264. PATIENCE.

7. pocket an insult To receive an affront without showing resentment; to conceal a rebuff; to accept without protest; to submit to meekly. The allusion in this phrase is to stuffing something in one's pocket where it will be concealed from the general public. The expression dates from the 1500s.

8. pocket [one's] dignity To accept an affront; to overlook a rebuff or insult; to endure a slight; to suppress one's dignity. In print since the early 17th century, this expression, along with the related term *pocket [one's] pride*, refers symbolically to the pocket as a place of concealment or a place to put something aside temporarily. Common variants are *put [one's] dignity in one's pocket* and *put one's pride in [one's] pocket*.

9. take lying down To yield without resisting or fighting back; to give up the fight. A prone position is the most vulnerable and defenseless position one can assume. This expression is used figuratively in referring to a weak or cowardly person who fails to defend himself when subjected to verbal attack.

10. turn the other cheek To refuse to retaliate in kind even when sorely provoked; to answer an affront or attack with meekness and humility.

> The language was certainly provocative, and nothing but the consciousness of a good cause enabled Lord Salisbury to turn the cheek to the smiter. As it was, he made a conciliatory answer. (J. A. Williamson, *A Short History of British Expansion*, 1930)

This expression, of Biblical origin, literally means to allow or even invite another slap in the face. In His Sermon on the Mount, Jesus admonishes the multitudes:

> Ye have heard that it hath been said, An eye for an eye, and a tooth for a tooth: But I say unto you, That ye resist not evil: but whosoever shall

smite thee on thy right cheek, turn to him the other also. (Matthew 5:38–39)

See **an eye for an eye, 320. RETALIATION.**

11. Uncle Tom A black person who assumes a submissive or obsequious attitude toward whites, or one who seeks the favor of whites. This term alludes to Uncle Tom, the black hero of Harriet Beecher Stowe's *Uncle Tom's Cabin* (1851). While the expression is often used disparagingly by blacks for those of their race who deem themselves inferior to whites, *Uncle Tom* may describe also an Afro-American who voluntarily assumes the offensive stereotype.

The South, that languorous land where Uncle Toms groaned Biblically underneath the lash. (Stephen Vincent Benét, *John Brown's Body*, 1927)

363. SUBORDINATION
See also 358. STATUS

1. bench warmer A substitute or replacement; a second- or third-stringer; an idler or observer, as opposed to a participant. The term comes from sports, where it applies to those players not proficient enough to make the first team and who consequently spend most of a game sitting on the bench. The expression has also been used for hobos who while away the time on park benches.

2. on the back burner Not of pressing importance; awaiting further action; secondary. This expression, in popular use since the late 1960s, alludes to the way in which the common kitchen cooking stove is used. Those foods which do not need immediate attention are left to simmer on the back burner, while the cook attends to those on the front burner, which can be watched and attended to more closely.

Integration has become a back-burner issue, by choice or hard political realism. (*Newsweek*, February 19, 1973)

In the U.S. most China analysts interpreted last week's pronunciamento as indicating that detente with Washington was still on Peking's front burner. (*Newsweek*, September 10, 1973)

3. play second fiddle To play a subordinate role, to serve in a secondary capacity; to be of inferior rank or status, to be second-best or second-rate. Violinists, as well as other musicians in orchestras and bands, are generally categorized into classes of first, second, third, and so on. The first class is comprised of the best musicians who play the lead parts; second and third consist of musicians of lesser ability who play subordinate parts. From the musical usage a figurative sense developed, which has been in common use since at least the 19th century.

She had inherited from her mother an extreme objection to playing, in any orchestra whatever, the second fiddle. (James Payn d. 1898, *A Grape from a Thorn*)

4. take a back seat To occupy an inferior or subordinate position; to be put aside in favor of someone or something more important. The expression probably derives from the practice of preferential seating at public functions, where the front seats are always reserved for VIP's and other persons of note, while less socially significant persons have to take the seats to the rear and consequently enjoy a less advantageous view of the proceedings. The phrase appeared in its figurative sense as early as 1859 in *Harper's Magazine.*

Subservience . . .
See **248. OBSEQUIOUSNESS**

364. SUBSISTENCE
See also 149. FINANCE;
277. POVERTY

1. boil the pot To make a bare subsistence living. This self-evident expression

appeared in William Combe's *The Tour of Doctor Syntax in Search of the Picturesque* (1812):

No fav'ring patrons have I got,
But just enough to boil the pot.

See also **potboiler**, 226. LITERATURE.

2. dish up the spurs To drop a broad hint that provisions are running low; to signify approaching starvation. This obsolete term is derived from a practice among Scottish housewives during the period of the border feuds between England and Scotland. To reveal to their husbands that it was time to provide their Scottish tables with more English beef and venison, the wives of the great landowners would dish up a pair of spurs as the final course of the meal.

3. feast or famine One extreme or the other; periods of plenty offset by periods of want. This expression describes the plight of the early independent farmer who might feast one year because his crops were bountiful but starve the next year because of a poor harvest. The term, which first appeared about 1732, became a common figurative expression for any "all or nothing" situation. Burton Stevenson in *The Home Book of Proverbs, Maxims and Familiar Phrases* (1948) has:

In the United States the steel industry has always been defined as "either a feast or a famine" business.

An earlier British equivalent is *feast or fast*.

Dock labour has been graphically described as "either a feast or a fast." (*London Daily Telegraph*, July 26, 1912)

4. keep body and soul together To survive economically; to make enough money to take care of basic needs and thus stay alive, death being viewed as the separation of soul and body. This picturesque expression dates from the mid 18th century.

By never letting him see you swallow half enough to keep body and soul together. (Jane Collier, *The Art of Tormenting*, 1753)

5. keep [one's] head above water Barely to manage to keep out of debt; to remain financially solvent, however slightly. The allusion is to a swimmer too tired to go on who treads water to keep from going under altogether. The expression has been in figurative use since the early 18th century.

Farmer Dobson, were I to marry him, has promised to keep our heads above water. (Alfred, Lord Tennyson, *The Promise of May*, 1882)

6. keep the wolf from the door To ward off starvation; to prevent want and necessity from becoming all-consuming; to struggle to provide the basic necessities. The rapacious wolf has long been a symbol of a devouring force, such as poverty, which deprives an individual of the basic necessities. Recorded use of this expression dates from the middle of the 15th century.

Endowe hym now, with noble
 sapience
By whiche he may the wolf werre
 frome the gate.
(John Hardyng, *Chronicle*, 1457)

7. make both ends meet To live within one's means, to pay one's expenses, to stay in the black financially. A longer version of the phrase is *make the two ends of the year meet*, i.e., live within one's means from January to December. The expressions carry the connotation of struggle and mere subsistence living. The French equivalent expressions are *joindre les deux bouts* and *joindre les deux bouts de l'an*. Use of the phrase dates from the latter half of the 17th century.

Her mother has to contrive to make both ends meet. (*The Graphic*, August 1884)

8. make buckle and tongue meet To make both ends meet; to earn enough money or produce enough food to survive; to get by, to manage. This puzzling

colloquial Americanism was in print by the mid 19th century. The image is confusing. It may derive from either belts or shoes, but neither possibility casts much light on its relevance to financial survival.

> All they cared for was "to make buckle and tongue meet" by raising stock, . . . and a little corn for bread. (*Fisher's River*, 1859)

An even earlier British equivalent is *hold* or *bring buckle and thong together*.

> My benefice doth bring me in no more But what will hold bare buckle and thong together. (*Weakest Goeth to the Wall*, 1600)

9. pie card A union membership card; a meal ticket. A union membership card became known as a *pie card* or a *bean sheet* back in the 1920s when it became common practice for certain restaurateurs and grocery store owners to allow credit to the holder of one of these cards. Additionally, a holder of one of these cards could often borrow money or obtain a night's lodging or a meal by displaying his card to another union member. Union organizers who promised exorbitant and unreal benefits in order to lure additional members into the organization became known as *pie-card artists*.

> Say, Andy, you've just got to jar loose with five bucks, for my pie card is so full of holes it looks like a piece of mosquito bar. (Warren G. Davenport, *Butte and Montana beneath the X-Ray*, 1908)

10. tighten [one's] belt To implement austere measures during a time of financial uncertainty; to endure hunger with fortitude. This expression alludes to the weight loss and subsequent reduction in waist size of an underfed person. The phrase enjoys common use in the United States and Great Britain.

> A travelling troupe who quoted Corneille while tightening their belts. (*Observer*, April 1927)

365. SUCCESS
See also **6. ACCOMPLISH-MENT; 291. PROSPEROUS-NESS; 396. VICTORY**

1. bring down the house To elicit a vigorous and lengthy ovation from an audience; to be a smash or great success; sometimes *bring down the gallery*. The image created by this expression, in which *house* means 'theater' or 'playhouse,' is one of such loud, sustained applause as to bring about the collapse of the building. The phrase was in use as early as 1754.

2. build a better mousetrap This famous expression was first uttered by Ralph Waldo Emerson in April 1871, in Oakland, California. The words never appeared in written form in any of his works, but a Mrs. Sarah S. B. Yule recorded them in a notebook which she was keeping of Emerson's Bay Area addresses. According to Mrs. Yule's transcription, Emerson's exact words were:

> If a man can write a better book, preach a better sermon, or make a better mousetrap than his neighbor, though he builds [*sic*] his home in the woods, the world will make a beaten path to his door.

Not all people see the invention of some improved device as a benefit, however.

> If a man builds a better mousetrap than his neighbor, the world will not only beat a path to his door, it will make newsreels of him and his wife in beach pajamas, it will discuss his diet and his health, it will publish heart-throb stories of his love life. (Newman Levy, "The Right to Be Let Alone", *American Mercury*, June 1935)

3. come down on the right side of the fence To be on the side of the winner; to make a proper moral choice. The fence has long been a symbol of moral, legal, or political division. One may *come down on the right side of the fence*:

They gently decided on the right side of the fence. (*Manchester Guardian*, January 28, 1891)

or *the wrong side of the fence*:

Only be careful, be very careful, lest in the confusion
You should shut yourself on the wrong side of the fence.
(William Dean Howells, *Stops of Various Quills*, 1894)

Someone who *straddles the fence* tries to please those on both sides simultaneously, while someone who *sits on the fence* is guilty of vacillation; he cannot, or will not, choose on which side to come down. Each of these terms is almost always applied in political contexts, and in modern use often jocularly.

A politician is an animal who can sit on a fence and yet keep both ears to the ground. (H.L. Mencken, *A New Dictionary of Quotations*, 1942)

4. have the last laugh To prove ultimately successful after an apparent defeat; to avenge. The idea of having the last laugh is fairly literal, i.e., though others may laugh now, the butt of their humor will laugh later when, in the final analysis, he is victorious. This phrase was popularized in the 1937 song "They All Laughed," by George and Ira Gershwin:

They all laughed at us and how!
But Ho, Ho, Ho!
Who's got the last laugh now?

Related, proverbial expressions are *he who laughs last laughs best*, and *he laughs best that laughs last*. The latter appeared in *The Mistake* (1706) by Sir John Vanbrugh.

5. hit the jackpot See 163. GOOD LUCK.

6. land on [one's] feet To achieve success despite predictable loss; to extricate oneself from a potentially dangerous situation; to escape failure narrowly. This popular expression usually appears in a context implying that the one who *lands on his feet* does so through undeserved luck; he repeatedly gets himself into

scrapes but somehow survives. It is apparently based on the notion that one plummeting downward is unlikely to land safely, let alone feet first.

7. lay them in the aisles To be a smashing success; to elicit a great emotional response from an audience. The image created by this expression is of a theatrical audience so overwhelmed by the brillance of a production, especially a comedy, that they fall from their seats into the aisles in laughter. A common variant is *knock them in the aisles*. The term is now used figuratively of any success with the public.

I was splendid as a public speaker and laid them in the aisles. (Westbrook Pegler, syndicated newspaper column, October 8, 1951)

8. maiden over An extraordinary accomplishment; the surviving of an ordeal. This Briticism signifies a bowler's achievement in cricket. The bowler, the equivalent of a pitcher in American baseball, bowls six balls, which constitute an *over*. If he allows no runs, it is called a *maiden over* (cf. sense of *virgin* in *virgin forest*, etc.).

Half a dozen maiden overs in succession, every ball dead on the middle stump, and yet played steadily back again to the bowler. (*Daily Telegraph*, May 16, 1864)

In a modern connotative sense the term indicates any dramatic achievement or triumph.

9. make [one's] jack To make [one's] fortune; to be fortunate in an undertaking; to succeed in one's endeavors. Although it is almost exclusively American today, the roots of this slang expression probably lie in an old British slang term for a card counter, a small, metal coin-shaped object that resembled a sovereign and was used as a chip. If one accumulated enough of these *jacks*, he could amass quite a large sum of money. Furthermore, if one were underhanded and adroit enough, he could often pass these *jacks* off as sovereigns, thereby increas-

ing his profits a hundredfold. Such a practice was probably responsible for the connotation of dishonesty that seems to accompany *make one's jack* today.

> He made plenty of jack while they were being dull boys. (Stanley Walker, "The Uncanny Knacks of Mr. Doherty," *The New Yorker*, July 12, 1941)

10. make the grade To achieve success; to reach a goal; to accomplish one's desire or ambition; to come up to the proper standard. The source of this expression is uncertain. Some attribute it to a team of horses trying to reach the top of a hill; others to the grading system used in school: A, B, C, etc.; and others to the standard rating that is used in classifying things, as in *Grade A milk*. Whatever the case, the phrase has been employed as a figure of speech since the late 1920s.

> Many thousands of veterans can continue to find new opportunities and make the grade in businesses of their own. (*Great Falls Tribune*, September 27, 1948)

11. pan out To succeed; to yield results, especially favorable ones; to occur. This expression alludes to panning for gold, a method of prospecting in which a shallow pan is used to scoop a small amount of gravel and sand from a stream. Any gold present settles to the bottom of the pan as the gravel and sand are washed away. *Pan out*, then, originally indicated a successful prospecting venture. As the California gold rush that spawned this expression began to subside, *pan out* became more figurative, and has remained in widespread usage since the late 19th century.

> Socialism . . . may pan out as a new kind of religion. (Sinclair Lewis, *Our Mr. Wrenn*, 1914)

12. pay dirt Any desired result or goal, especially one related to wealth or success; a fortunate discovery. Literally, *pay dirt* is a mining term that refers to an area of land that contains enough valuable metals or other resources to merit excavation. After its introduction in the 1870s, *pay dirt* soon became more figurative, commonly being applied to any success, especially in the phrase *hit pay dirt*.

> I didn't hit pay dirt until near the bottom of the second box of discarded telephone directories. (John Evans, *Halo in Blood*, 1946)

In recent years, *pay dirt* has been used frequently to describe the end zone (goal area) of a football field.

13. ring the bell To succeed, to make a hit; to be the best. The *bell* of this expression may be that attached to the strength-testing machine at carnivals which rings when a player is successful. Or it may be the bell in target shooting that rings when the bull's-eye is hit.

14. strike oil To have good luck or success, especially financial; to discover a source of potential personal aggrandizement; to strike it rich; to hit pay dirt. This expression alludes to oil as an entity which inevitably leads to wealth and success, a concept strengthened in recent years by the increasing prominence of Middle East oil barons. Though still used literally to describe the locating of underground oil, *strike oil* is commonly applied figuratively in contexts directly or indirectly related to money or other personal good fortune.

> He has certainly "struck oil" in the Costa Rica and Honduras loans. (*Punch*, March 6, 1875)

15. sweep the board To win everything in a card game; to win all the prizes or awards at a meeting. The denotation of *board* in this expression is a table where games are played; hence, to *sweep the board* is to *clean up* and win everything. The expression has been in use since the 17th century.

> Spadillo first, unconquerable lord!

Led off two captive trumps and swept
the board.
(Alexander Pope, *The Rape of the
Lock*, 1711)

16. turn up trumps To prove successful;
to turn out well despite negative expec-
tations. This expression, dating from at
least the 1850s, refers to the trump suit
in a game of cards and especially to a sit-
uation where the unexpected appear-
ance of a trump card helps save the day.
The term originated in England but soon
found its way to the United States. It is
still in everyday use in both countries.

> Instances . . . of short courtships and
> speedy marriages, which have turned
> up trumps—I beg your pardon—
> which have turned out well, after all.
> (Wilkie Collins, *No Name*, 1862)

A variant phrase is *come up trumps*. The
allusion is to drawing or playing a win-
ning trump card. See **trump card**, 274.
PLOY.

17. with flying colors Victoriously, tri-
umphantly, successfully; handily, easi-
ly; superbly, in extraordinary fashion.
This phrase, usually in expressions such
as *come off with flying colors* and *come
out of it with flying colors*, alludes to a
triumphant fleet of ships sailing into
home port with their colors (i.e., flags)
proudly displayed on the mastheads.
Used figuratively, *with flying colors* of-
ten implies that one has not only sur-
vived a potentially precarious predica-
ment but has been victorious to boot.

Sufferance . . . See 116. ENDURANCE

Suffering . . . See 10. ADVERSITY

Suggestiveness . . .
 See 297. PRURIENCE

Suitability . . .
 See 282. PREFERENCE;
 405. WORTHINESS

366. SUPERFLUOUSNESS
 See also 5. ABUNDANCE;
 130. EXCESSIVENESS

1. third wheel An extra, unnecessary,
or unwanted person, especially one
whose presence serves no useful pur-
pose; a person who interferes with or
prevents the successful completion of a
project, task, or other matter. The con-
cept is undoubtedly similar to the senti-
ments expressed in the familiar adage,
"Two's company, but three's a crowd."
Although the derivation of this expres-
sion is not certain, it probably alludes to
the uselessness of a third wheel on a ve-
hicle which normally has two. Today
one frequently hears the variant *fifth
wheel*, most probably because of the
ubiquity of automobiles, with four
wheels.

Superiority . . .
 See 129. EXCELLENCE

367. SUPERSTITION
 See also 163. GOOD LUCK

1. beware the ides of March A warning
of impending danger, rarely heard to-
day. This expression alludes to the words
of the soothsayer who warned Julius
Caesar to "Beware the ides of March."
Caesar ignored the advice, only to be
killed on that very day, the 15th of
March, in 44 B.C. According to the an-
cient Roman calendar, the ides falls on
the 15th day of March, May, July, and
October, and on the 13th day of the oth-
er months.

2. burning ears If one's ears burn (or
ring), it is commonly believed that some-
one else is talking about him. This an-
cient superstition dates from at least the
1st century. In *Natural History*, Pliny
wrote:

> It is acknowledged that the absent feel
> a presentiment of remarks about
> themselves by the ringing of their
> ears.

This citation suggests the frequent variant *ringing in the ears*. Erasmus, in *Adagia* (1500), explains the burning sensation as stimulating the right ear if the talk is complimentary and the left ear if uncomplimentary. Sir Thomas Browne (d. 1682) agrees with Erasmus but ascribes the action to a guardian angel. Jonathan Swift, in *Polite Conversation* (1738), seems to believe the reverse:

> Lord Sparkish: Miss, did your left ear burn last night?
> Miss Notable: Pray why, my lord?
> Lord Sparkish: Because I was then in some company where you were extolled to the skies, I assure you.

3. cross [one's] fingers To make a mental reservation; to wish for success; to hope for protection from bad luck or from evil. Since the death of Jesus Christ upon the cross, people have made the sign of the cross as an affirmation of faith. Crossing one's fingers is simply a private way of asking for protection through Christ's intervention. There are two popular methods of crossing the fingers: one involves the St. Andrew's Cross, placing the middle finger of the right hand atop the index finger of the same hand; the other involves the Greek Cross, placing the index finger of one hand atop the index finger of the other hand at right angles.

A variant expression *keep [one's] fingers crossed*, which dates from the first half of this century, may be connected with the old superstition that making the sign of the cross kept bad luck away. Today, although the superstition is still practiced by adults, it is most commonly practiced by children, who are led to believe that a lie doesn't count if one's fingers are crossed.

> We'll . . . duck when we hear a mortar, and keep our fingers crossed. (*Penguin New Writing*, 1945)

4. cut [one's] nails on Sunday To assure oneself of bad luck; to invite evil; to tempt the devil; to practice wickedness and depravity. This phrase is predicated upon a superstition dating to at least the Middle Ages. Although originally the day of the week appeared variously as Sunday or Friday, the superstition finally settled upon Sunday for evil and Friday for sorrow. Robert Forby, in *The Vocabulary of East Anglia* (1830), recorded an East Anglian poem designed as a mnemonic device for what befalls one for cutting his nails upon any given day of the week.

> Cut them on Monday, you cut them for health;
> Cut them on Tuesday, you cut them for wealth;
> Cut them on Wednesday, you cut them for news;
> Cut them on Thursday, a new pair of shoes;
> Cut them on Friday, you cut them for sorrow;
> Cut them on Saturday, see your true-love tomorrow;
> Cut them on Sunday, the devil will be with you all week.

5. dead man's hand A pair of aces and a pair of eights in a poker hand; bad luck; misfortune; at a disadvantage when entering a contest. This superstition came into existence shortly after August 2, 1876, the day Jack McCall shot Wild Bill Hickok in the back in Deadwood, South Dakota, while Hickok was holding such a poker hand. Some controversy exists as to whether Hickok held aces and eights:

> Throughout the West the combination of aces and eights is known as the *dead man's hand*. (Ramon Adams, *Western Words*, 1944)

or jacks and eights:

> Dead man's hand, in poker, two pairs, jacks and eights. (*The Century Dictionary, Supplement*, 1909)

Most authorities agree that it was the former.

6. elf locks Tangled hair; hair that is matted and knotted supposedly because of the work of elves. This superstition dates back to at least the time of Shakespeare, who made use of the term, or al-

luded to it, in many of his plays. The creation of these locks was supposedly one of Queen Mab's favorite amusements.

> This is that very Mab
> That plats the manes of horses in the night;
> And bakes the elf-locks in foul sluttish hairs.
> (*Romeo and Juliet*, I, iv)

The expression has remained in use although the superstition has been dead for many years.

> Their hair remains matted and wreathed in elves-locks. (*Gentlemen's Magazine*, 1810)

7. jinx A person or thing supposed to bring bad luck; an unlucky charm or spell; a hex. This word, spelled *jynx* by the British, alludes to the unusual nesting practice of the jinx, or wryneck, (the woodpecker *Jynx torquilla*.) The bird lays its eggs on bare wood without padding its nest. Such an unusual practice led people in the Middle Ages to assign special magical powers to the jinx. As such, its feathers were treasured for the manufacture of potions, talismans, and all types of elixirs, especially by the practitioners of black magic, hence its connotation of bad luck.

> Dave Shean and Peaches Graham . . . have not escaped the jinx that has been following the champions. (*Chicago Daily News*, September 19, 1911)

8. knock on wood A phrase uttered to avoid a reversal of good fortune about which one has just boasted; spoken with the hope of escaping a misfortune which one has thus far averted and to keep away ill fortune or evil spirits. The origin of this phrase lies in superstition, but where the superstition had its roots is anybody's guess. Of the many explanations the knocking on a tree trunk to invoke the spirits who live within seems to be the most popular. Nora Archibald Smith in her poem, "Knocking on Wood" defines the process:

> They'd knock on a tree and would timidly say
> To the Spirit who might be within there that day;
> "Fairy fair, Fairy fair, wish thou me well;
> 'Gainst evil witcheries weave me a spell!" . . .
> An' e'en to this day is the practice made good
> When, to ward off disaster, we knock upon wood.

Other theories refer to the touching of wood to be free from capture, as in the children's game of tag, and the turning of one's thoughts to the wooden cross of Jesus Christ to beseech His assistance. The British equivalent and probably the older phrase is *touch wood*. An old British proverb tells us: "Touch wood; it's sure to come good."

9. old wives' tale A foolish or nonsensical story; a traditional but inaccurate concept or superstition. This expression is derived from the fanciful yarns often related by elderly women.

> These are the sort of old wives' tales which he sings and recites to us. (Benjamin Jowett, *The Dialogues of Plato*, 1875)

Today the expression usually describes a superstitious notion still adhered to by many people even though it has been discredited by modern science.

10. put the whammy on See **379. THWARTING.**

11. right foot foremost See **get off on the right foot, 31. BEGINNINGS.**

12. third time's the charm A desired end will be attained, after previous failures, following a third attempt to achieve it. This expression of superstition goes back to at least the 13th century. Although its exact origin is unknown, most scholars agree that the *charm* refers to a magical effect or spell, and the *third time* alludes to the traditionally mystical associations of the number *three*. An Associated Press release of October 29,

1981, shortly after the Los Angeles Dodgers had defeated the New York Yankees in the 1981 World Series, reveals that the term continues to retain its bewitching connotation:

> "Our feeling after Sunday was there was a certain amount of destiny," Garvey said. "The third time's the charm," a reference to the fact that this was the third World Series for many of the current Dodgers against the Yankees.

13. three on a match Any practice which reputedly brings ill luck, but most often the specific and literal practice of lighting three cigarettes with one match. The superstition supposedly arose among soldiers in wartime who believed that the glow from a match kept alive long enough to light three cigarettes would give the enemy time for careful aim at them as targets, thus quite possibly bringing about their death.

Supremacy . . .
See 107. DOMINATION

Surpassing . . . See 258. OUTDOING

368. SURPRISE

1. blindside To attack the weaker, more assailable side of a person; in football, to hit a player on his unguarded side. In its original literal use, this expression signified the side on which one who is blind in one eye cannot see, but by the early 1600s it had, by extension, come to mean a person's weak side. The term, incorporated into the modern American football vocabulary in the early 1970s, has gained considerable popularity through its widespread use by football announcers on television. In football, *blindsiding*, a dangerous and recently outlawed maneuver which often causes injuries, involves a surprise block of an oncoming opponent who is looking away from the direction of the block to another development of play. The term, like so many sports terms, was quickly picked up by the political and business worlds to indicate any surprise involvement in a situation.

> At one point, Oregon's Tom McCall asked a question most of his colleagues were thinking—whether those Republicans who stand with President Nixon were going to be "blindsided" by any more bombs. (*Newsweek*, December 3, 1973)

2. bolt from the blue A sudden and entirely unexpected or unforeseen occurrence; a complete surprise; also, the adverbial phrases *out of the blue* and *out of a clear blue sky* 'unexpectedly, suddenly; without warning or notice.' The allusion is to suddenness and surprise similar to that which would be experienced if a bolt of lightning were unexpectedly to appear in a cloudless sky. Although *bolt from the blue* was in use as early as 1837, *out of the blue* did not appear until 1919.

3. bowled over Astounded; taken by surprise; knocked down; made to fall. Derived from the game of ninepins, this term refers to the sudden and violent knocking down of the pins by the ball released by the bowler. The phrase took on its figurative implication 'to be knocked down emotionally' during the mid 1800s.

> The news of his son's death quite bowled him over. (Frederick T. Wood, *English Colloquial Idioms*, 1969)

4. bug-eyed Astonished, surprised; aghast with wonder or awe; literally, to have protruding eyes as do certain species of bugs. Though this precise adjective form did not appear until the 1920s, conceptually equivalent expressions date from considerably earlier.

> Wouldn't their eyes bug out, to see 'em handled like that? (Mark Twain, *Life on the Mississippi*, 1883)

5. catch napping as Moss caught his mare To catch someone asleep; to surprise another person. This expression,

which dates from about 1500, achieved extensive popularity during the 16th and 17th centuries. The story is told of a farmer named Moss (in a few accounts Morse) who constantly had trouble catching his mare, especially when he wanted to put her in harness. Some versions recount that he fed her through a hurdle and thus took her napping, i.e., by surprise.

> Fortune feeding them as Moss did his mare, through a hurdle, which made him take her so soon napping.
> (Unknown Author, *Discovery of Knights of Post*, 1597)

Other versions describe his taking her while she actually slept.

> Now Night grows old, yet walks here in his trapping
> Till Day come catch him, as Moss his gray mare napping.
> (*Account of the Christmas Prince*, 1607)

Whatever the case, the phrase is seldom, if ever, heard today.

6. did you ever! Said as an affirmation of complete surprise or astonishment at what someone did. This American exclamation originated in the mid 19th century as an expression of incredulity, probably based on an ellipsis of the idea "did you ever see or hear anything like that?"

> "I could see the train coming along through the woods, and I made a final spurt."
> "Did you ever!" observed Mrs. Milbury, with an upward roll of the eyes. (George Ade, *Doc Horne*, 1899)

7. do tell! An expression of incredulity; said when one hears or sees something exceedingly surprising. This expression, dating from about 1820, is an old New England exclamation, an elliptical form of "do tell me more about it." The term is most frequently heard today as an expression of ironic innocence.

> "It would be runnin' away. We've been runnin' away right along."

> "Do tell," says I, "from what?"
> (Clarence Buddington Kelland, *Cathy Atkins*, 1920)

8. good grief! An expression of surprise or horror. Although the origin of this phrase is unknown, it has become especially popular since the late 1950s from its frequent use by Charlie Brown, one of the characters in Charles M. Schulz's comic strip, *Peanuts*.

> "Gulliver's Travels . . . Part One . . . Chapter One . . . My father had a small estate in Nottighamshire; I was the third of five sons. He sent me to Good grief! This book has two hundred and fifty-four pages. I'll start reading it tomorrow."
> (Charles M. Schulz, *You Need Help, Charlie Brown*, 1964)

9. jump out of [one's] skin To be startled; to be surprised; to feel great delight; to react to fear or shock; also *leap out of [one's] skin*. This figurative expression, in use as early as 1584, suggests the sudden intensity of undergoing an entirely unexpected occurrence, which causes one to start visibly.

> 'Twould make me jump out of my skin for joy. (George Coleman, the Younger, *The Blue Devils*, 1798)

10. knock for a loop See 63. CONFUSION.

11. make [one's] hair curl To cause a reaction of shocked surprise, horror, or disgust; to elicit a feeling of revulsion. The implication inherent in this expression is of suddenness at the presentation of something unexpected and horrifying, from the gruesome to the less heinous, as might be encountered in another's uncivil behavior.

> When he's excited he uses language that would make your hair curl.
> (William S. Gilbert, *Ruddigore*, 1887)

12. make [one] turn in his grave Said hyperbolically of something so alarming that it would even arouse the disapprov-

al of a deceased individual. This expression, which has been in use since the mid 1800s, originated as a jocular phrase to indicate a sharp departure from a tradition established or favored by the (now) dead person who is mentioned. The expression has become so trite that the jocularity has been lost.

> Jefferson might turn in his grave if he knew of such an attempt to introduce European distinctions of rank into his democracy. (James Bryce, *The American Commonwealth*, 1888)

Samuel Goldwyn, however, returned some of the mirth to the expression, if a reputed statement of his is true.

> If Roosevelt were alive, he'd turn in his grave.

13. sandbag To strike unexpectedly; to hit from behind; to check and raise in poker; to take unfair advantage of. One proposed origin for this term attributes it to a term for a long sausage-like bag of sand used by thieves to strike their victims without leaving a mark. However, another credible explanation maintains that the thieves developed their idea of *sandbagging* victims from an old theatrical ploy. Stagehands, who were master manipulators of the sandbags used as counterweights for hung scenery, would *sandbag* cast members who treated them hostilely or haughtily by striking them a glancing blow with these counterweights.

> This district is lying in wait, as it were, from one year's end to the other, awaiting an opportunity to sandbag the public. (*Congressional Record*, January 23, 1901)

Another sense of *sandbag*, coming from the use of sandbags to stem the flood of a rising river by piling sandbags along its banks, appears in poker players' lingo to refer to the ploy of checking (holding back) one's bet the first time around to hire other players into the pot, then raising on the next round. In recent years it had been applied to any situation in which one craftily conceals his capabilities, as in golf, where a player intentionally shoots a high score in order to increase his handicap.

14. Scarborough warning Little or no forewarning, no previous notice; a total shock. This expression may allude to the 1557 siege of Scarborough castle, which took its inhabitants completely off guard. Another possible origin concerns a harsh law enacted in Scarborough which allowed the punishment of robbery suspects prior to a trial. In any event, the expression, used frequently in Great Britain until the mid-1800s, is virtually never heard today.

> The true man for giving Scarborough warning—first knock you down, then bid you stand. (Sir Walter Scott, *Redgauntlet*, 1824)

15. taken aback Surprised or stunned into immobility. This was originally a nautical term describing a square-rigged ship whose sails are blown against the mast, thus preventing further forward movement. An early figurative usage employs the term *all aback*:

> On this subject I am literally as the sailors say all aback. (Edward Winslow, *Winslow Papers*, 1783)

Surrender . . . See 361. SUBMISSION; 362. SUBMISSIVENESS

Survival . . . See 364. SUBSISTENCE

Suspension . . . See 2. ABEYANCE

369. SUSPICIOUSNESS
See also 349. SKEPTICISM

1. bug under the chip Something suspected as an ulterior motive or hidden cause; an undisclosed fact. The allusion here is to the paranoiac bent of some people's minds, people who can be so suspicious as to believe that something is concealed beneath a wood chip. Although the expression has been in use since the 1880s, it is particularly appropriate in today's world of electronic

eavesdropping, for it is possible that there is a *bug* 'miniature microphone' under a chip.

> To those uneasy over the alliance, he gave his word that there are 'no such bugs under the chips.' (*Newsweek*, July 15, 1946)

2. flea in the ear See 223. IRRITATION.

3. nigger in the woodpile Something suspicious, such as an undisclosed fact, hidden element, or ulterior motive. This expression sprang up during the era of slavery in the United States, most specifically in regard to the Underground Railroad, a system whereby abolitionists aided runaway slaves, often concealing them through any expedient—one of which was a woodpile. The phrase first appeared in print in 1852, but the offensiveness of the word *nigger* inhibits the phrase's use in contemporary speech and writing and may well signal its demise.

> Like a great many others ignorant of facts, he finds "a nigger in the wood pile" when there is neither wood pile nor nigger. (*Congressional Record*, February 1897)

4. smell a rat To instinctively sense evil, treachery, or wrongdoing; to be suspicious. A cat has a keen sense of smell which enables it to detect an unseen rat; whether this or another everyday image is at the origin of the expression, the fact is that it has been in use since at leat the 17th century, Samuel Butler employing it in *Hudibras*, part I (1663). The phrase is still quite common in the United States and Great Britain.

> I asked her so many questions, that, though a woman ignorant enough, she began to smell a rat. (William R. Chetwood, *Voyages of W.O.G. Vaughan*, 1736)

5. something rotten in Denmark An expression used to describe a suspected problem which cannot be pinpointed; something of a questionable or suspicious nature; anything that disconcerts and instills anxiety. In Shakespeare's *Hamlet*, Marcellus is uneasy because the ghost of Hamlet's father had appeared to him. He sees this as a portent and conjectures to Horatio:

> Something is rotten in the state of Denmark. (I,iv)

Sustenance . . .
See 153. FOOD AND DRINK

370. SWINDLING
See also 384. TRICKERY

1. Billies and Charlies Counterfeit antiquities; bogus relics. This British term has been in use since 1858 when the British Archaelogical Association exposed the fraudulent activities of William Smith and Charles Eaton. It seems that the two, dubbed "Billy and Charley," had produced thousands of artificially aged metal objects, supposedly of medieval origin, with which they had "seeded" the many archaelogical digs going on about London at that time, 1847 and 1848. Although their impostures were so poorly done that they were evident even to amateur antiquarians, they were able to sell large numbers of their imitations to the general public before the archaeological association uncovered their skullduggery. Popular throughout the latter 1800s and early 1900s, the expression is seldom heard today.

2. bubble scheme A fraud; a swindle; a plan supposedly of great promise that collapses easily. This expresssion came into common use in the early 18th century because of two ephemeral projects, one in England, one in France.

> There have been . . . Mississippi and South Seas Schemes and Bubbles. (Benjamin Franklin, *Writings*, 1767)

The *South Seas Bubble*, the English scheme, was devised in 1711 to eliminate the national debt of England through a trading program with the Spanish in the South Seas. Stock shares in the program inflated to ten times their face value when the "bubble" burst in 1720. The *Mississippi Bubble*, the French scheme,

like the English scheme, was designed in 1717 to eliminate the national debt of France through exclusive trade rights with Louisiana along the banks of the Mississippi river. Shares in France increased to forty times their original value before the bubble burst in 1720, and the country was almost ruined. Both bubbles were based on sound investment policy, but in each case unscrupulous speculators took advantage of the public and shattered the operation.

> A nationally recognized authority on the law brushes the present storm aside by classifying it with the famous Mississippi bubble. (*Chicago Daily News*, January 22, 1947)

3. bucket shop An office operated by fraudulent stockbrokers; a broker's office that swindles its clients. The common practice in *bucket shops* was to charge the client ten percent down and six percent interest on the balance of the cost of the stock. The broker would then delay or neglect to invest the money, gambling that the price would drop, thus allowing him to pocket the money the client thought he had lost. The origin of this expression is clouded in controversy. Perhaps the best explanation attributes the phrase to an old meaning of the verb *bucket*, 'to cheat or swindle.'

> The first indication of incipient scandal came when, at Hearst's instigation, *American* reporter Nat Ferber was assigned by managing editor Victor Watson to find out who was protecting the bucket shops. (Fred Lawrence Giles, *Marion Davies*, 1972)

In current British usage, the phrase refers to an office that sells tickets and tours to travelers at discounted prices.

4. bunco artist A professional swindler or cheat; anyone clever in manipulating things for his own profit. This American expression probably has its roots in the Spanish *banca*, 'a game of chance at cards.' Dating from about 1870, the term is still in common use today and is most frequently heard in the derogatory sense.

> The bunco artists start literally from the skin out, trading on the clothing shortage and the soldiers' natural desire to get into civvies. (*Newsweek*, March 18, 1946)

A variant, *clip artist*, made its appearance in the language about the same time.

> A gentle clip artist, Abadaba robbed bookmakers as well as bettors. (Toney Betts, *Across the Board*, 1956)

Deriving from this is the expression *clip joint*, denoting an establishment where one is likely to be cheated or overcharged.

5. cold deck A stacked or marked deck of playing cards; a "can't-win" situation; to prearrange things in one's favor; to take unfair advantage of; to cheat. This expression, dating from the mid 19th century, had its origin in the world of gambling. In order to cheat his opponents, a player was said to surreptitiously *cold deck* them, i.e., introduce into the game a deck of marked or stacked cards without the other players' knowledge, thus giving himself an unfair advantage.

> I have never gambled from that day to this without a cold deck in my pocket. (Mark Twain, *Sketches*, 1872)

In modern use the term is often applied figuratively to indicate cheating or taking unfair advantage of someone in any field of endeavor.

> The boys in the back room can't deal us a cold deck when the voters bring their own cards to the game. (*Chicago Daily News*, July 17, 1946)

6. con game A swindle or enticement to defraud someone of his money, to deceive someone into thinking he can't lose, to take to the cleaners. An American slang term, *con game* is simply a shortened version of *confidence game*. The game is usually set up by a *confidence man* who gives his assurance to

the victim that he will profit from it. Moved by greed, the victim succumbs to any of a number of tricks, usually involving the switching of purses or envelopes containing money. Ultimately, the con man makes off with the money, leaving the victim penniless. The term was first used about 1880.

> De girl a feller sets his heart upon,
> Jes' keeps him comin' wid a game of con.
> (Coley, *Rubaiyat of the East Side*, 1902)

7. cook the books To falsify; to alter the records; to tamper with for fraudulent purposes; to doctor. This British expression, in use as early as the 18th century, was a forerunner of the Americanism *juggle the books*. Both terms refer to altering records surreptitiously either for personal gain or to cover up some previous discrepancy. The use of the term *cook* as a synonym for *alter* dates back to the 17th century, if not earlier, apparently from the alteration that takes place when one creates or *cooks up* a new dish.

> Some falsified printed accounts artfully cooked up, on purpose to mislead and deceive. (Tobias Smollett, *Peregrine Pickle*, 1751)

8. deacon fruit To pack fruit or garden produce with the finest specimens on top; to display something dishonestly. Dating from the late 18th century, this American term alludes to the hypocritical posing that was practiced by some early New England farmers. Some of these farmers chose to refer to themselves as *deacons* to create an aura of gentility about themselves. However, when they started the practice of camouflaging inferior fruit and vegetables by placing the choice produce on the top of the baskets, their counterfeit title was adopted to describe their counterfeit activities. There are those who allege the practice still thrives today.

> The only change it was known to produce in such farmers' practice was to make them careful afterward to

"deacon" both ends of the barrel. (*Harper's Magazine*, November 1855)

9. fleece To swindle, defraud, or con a person out of a sum of money; to cheat someone, take him for a ride or to the cleaners. This expression stems from *fleece* 'to pluck or shear wool from a sheep.' In its figurative sense, *fleece* implies that a victim, usually a gullible person, is led willingly and unknowingly into giving up some of his possessions.

> To divide what they fleeced from these poor drudges. (Thomas Carlyle, *On Heroes, Hero-Worship, and the Heroic in History*, 1840)

10. fly a kite To raise money through misrepresentation, such as by the sale of bogus bonds, specious stocks, or spurious securities; to write a rubber check, i.e., one for an amount which exceeds available funds. In this expression, *kite*, a Wall Street term for worthless bonds, stocks, or securities, may stem from *kite*, the falcon-like bird with a forked tail (implying dishonesty) and a toothless bill (implying worthlessness). It is more likely, however, that *kite* refers to the paper "toy" that soars in the wind, the implication being that these worthless papers (bonds, etc.) are good only for constructing kites.

11. gazump To cheat or swindle; to defraud. This British term (also written *gezumph* or *gazoomph*) is a descendant of *gazamph*, an obscure word for dishonest auctioneering.

> Grafters speak a language comprised of every possible type of slang . . . These include 'gezumph' which means to cheat or overcharge. (P. Allingham, *Cheapjack*, 1934)

Nowadays, the term usually describes an unethical increase in the price of real estate after the original asking price has been agreed.

12. gyp joint A dishonest business establishment. This American slang expression, in wide use since the 1930s, describes any business that cheats, swin-

dles, or overcharges its customers, or promises more than it can deliver. Although the origin is obscure, the term is obviously an extension of *gyp*, meaning 'to rob, cheat, or steal.' *Gyp* is most likely derived from *gypsy*, a name for a group of people who, apparently because of their nomadic life style, acquired a reputation for being thieves.

> The real gyp joints were the dance schools, the taxi-dance halls, . . . (Stephen Longstreet, *The Real Jazz: Old and New*, 1956)

13. half-sell a duck To cheat the buyer; to pretend to sell; to make a fool of; to make someone believe something false. This expression was borrowed directly from the French sometime during the 16th century. The original French was *vendre un canard à moitié*, which was used figuratively to indicate that one was about to sell something with the intent of cheating the buyer. The comedian, Joe Penner, adopted the idea in the 1930s with his catch phrase, "Wanna buy a duck?"

14. hornswoggle To deceive with larcenous intent; to get the better of; to swindle, cheat, hoodwink. This American slang expression, of unknown origin, is probably of fanciful derivation. H. L. Mencken tells of an Australian lexicographer who observed that *hornswoggle* was the only word of American coinage that left the Australians "breathless with admiration." The word has been in use since the early 19th century.

> If you'll stand by . . . and see your old father hornswoggled out of his eye-teeth you'll never see a cent of my money. (H. Quick, *Yellowstone News*, 1911)

Variants of the term are *honeyfackle* and *honeyfoggle*, neither of which is in regular use today.

15. Jenny Haniver A fraudulent item created by sailors at sea and sold to unsuspecting "landlubbers." Sailors, often with many idle hours on their hands while at sea, started creating *Jenny Hanivers* as early as the 13th century. Carving and shaping the bodies and skeltons of skates, rays, sharks, and other sea creatures, they fashioned weird monsters in human form, dried them out, and brought them back to land where they sold them to gullible merchants and collectors. The origin of the name is unknown. Some of these *Jenny Hanivers* still exist. P. T. Barnum once owned and displayed one, a monkey's body with the head of a fish sewn on.

16. palm off To dispose of fraudulently; to deceive someone into accepting a worthless item, plan, or other matter about which bogus claims have been made. This expression alludes to magicians and other sleight-of-hand artists who are able to trick a viewer into believing that an object concealed in the palm of their hand is actually somewhere else.

> Have you not tried to palm off a yesterday's pun? (Charles Lamb, *Elia*, 1822)

17. Peter Funk A shill; an auctioneer's accomplice. This American expression from the early 19th century designates an accessory who participates at an auction either to push the price higher or to "purchase" items on which the final bid is too low. Such a rigged auction is often termed a *Peter Funk auction*. The origin of the term is unknown, but many believe it can be attributed to a real Peter Funk, who either performed as a shill or conducted these rigged auctions himself.

> A green-looking youth . . . strayed into one of the Peter Funk auctions on Broadway. (*Quincy Whig*, November 4, 1845)

18. pig in a poke A worthless, uncertain, or misrepresented bargain; a risk or chance; some item purchased or accepted on blind, and possibly misplaced, trust. This expression recalls the county fairs which were once common in England and elsewhere. If a customer bought a suckling pig at one of these fairs, he would usually take it home in a

poke 'a small sack'. Since some pigs were sold at bargain prices sight unseen in a sealed bag, an occasional unscrupulous purveyor substituted a cat for the pig, hoping to deceive the buyer of *a pig in a poke*. A cautious customer, however, would open the sack before buying its contents, thus *letting the cat out of the bag*. This expression often appears in the context of *buy a pig in a poke*. The French equivalent, *achêter un chat en poche* 'to buy a cat in a poke,' refers directly to the deceptive practice described above. See also **let the cat out of the bag,** 137. EXPOSURE.

19. scam A swindling scheme; the obtaining of money through fraudulent means; to swindle, rob, or cheat. Although it is alleged to have come from *scamp's game* or to be a variant of *shame*, the origin of this word is in fact uncertain. It is generally felt, however, that its roots may lie in carnival slang, where it denoted the fleecing of small amounts of money from the players in dishonest games of chance.

It was a full scam. My boss was scammin' from the public, and I was scammin' from him. (*Time*, June 28, 1963)

The term has currently come to mean any big-time confidence operation dealing with large amounts of money, fortified in that connotation by the exposure it received in the *Abscam case* in the 1980s. *Abscam*, an F.B.I. code name for "Arab Scam," was an F.B.I. operation in which high government officials were caught accepting large sums of money as bribes.

20. take to the cleaners To defraud someone of all his money; to wipe out; often used passively in the phrase *be taken to the cleaners*. This rather recent American slang expression is thought to be a modernized version of the earlier slang phrase *cleaned out,* still in current use, with a meaning similar to that of *taken to the cleaners*, but lacking the latter's usual connotation of having been duped or swindled.

T

Talent . . . See 3. ABILITY

371. TALKATIVENESS

1. beat [one's] gums To talk excessively but ineffectually; to speak volubly but to no purpose; to ramble on idly. Articulatory power lies in tongue, teeth, and palate. Toothless gums mean feebleness and ineffectiveness. The phrase was particularly popular during World War II.

2. chew the fat To talk or chat; to shoot the breeze; to have a long-winded conversation. This slang expression has been in print since the last quarter of the 19th century. Today it continues to be a popular phrase for indulging in idle chatter. Chewing on fat provides relatively little sustenance for the amount of mastication involved.

3. chew the rag To talk or chat; to discuss a matter, usually in a complaining or argumentative way; to harp on an old grievance. Although *chew the rag* is used interchangeably with *chew the fat*, the former was previously used for complaining or arguing. The insignificance of such conversation is expressed in the following line from *Scribner's Magazine* (1909):

> How better is conversational impotence characterized than by "chewing the rag"?

4. flannelmouth See 150. FLATTERY.

5. flap [one's] chops To drivel inanely, to blather; to talk idly; also *flap [one's] jowls* or *jaw* or *lip*. This phrase is obviously derived from the facial movements of the perpetual chatterbox.

> Well, you weren't just flapping your lip that time. (Peter DeVries, in *The New Yorker*, May 1951)

6. flibbertigibbet A gossip; a mindless and frivolously talkative person; a mischievous and, at times, malicious prattler. This expression, in use since the 16th century, may be either an onomatopoeic representation of meaningless chatter and drivel or a corruption of "flapper of the jibs," where *jib* is slang for 'lip.'

> Good Mrs. Flibber de Jibb, with the French fly-flap of your coxcomb. (Richard Brome, *The Sparagus Garden,* 1635)

People named *Flibbertigibbet* have appeared several times in literature, most notably as a fiend or devil in Shakespeare's *King Lear*, and as a grotesque, ill-mannered, mischievous imp in Sir Walter Scott's *Kenilworth* (1821).

> This is the foul fiend Flibbertigibbet; He begins at curfew, and walks till the first cock. (Shakespeare, *King Lear*, III,iv)

7. gift of gab A fluency or glibness of speech; a volubility or talkativeness, often with connotations of shallowness and lack of substance; also *the gift of the gab*. The original expression was apparently *the gift of the gob*, *gob* being a northern dialectal and slang term for 'mouth,' possibly from the Gaelic and Irish *gob* 'beak, mouth.'

8. jaw-me-dead An extremely loquacious person; one who engages in interminable senseless chatter. *Jaw* in this phrase means 'a long conversation, incessant chatter.' *Jaw-me-dead* is an epithet, hyperbolically describing the effect of one who bends someone's ear.

9. nineteen to the dozen Talkatively; very rapidly; a blue streak. This Briticism refers to the fact that any dozen

containing nineteen is clearly excessive; consequently, anyone talking *nineteen to the dozen* must be speaking at a very rapid rate. A variant is talk *thirteen to the dozen*. The phrase has been in use since about 1850.

> A very cheerful gentleman . . . who was talking away to me, nineteen to the dozen, as they say. (Robert Louis Stevenson, *Longman's Magazine*, 1883)

10. ratchet jaw A windbag; one who talks too much; a chatterbox; a person who is extremely long-winded. This expression, suggesting the jittery movement and constant chatter of a ratchet device, originated in the early 1970s among citizens' band (CB) radio enthusiasts as a slang term for a person who talked too much or too long.

> CBers are supposed to limit calls to five minutes, and those who do not are called "ratchet jaws." (*The 1977 World Book Year Book*)

A related term with the same meaning is *bucket mouth*.

11. shoot the breeze To chat, talk aimlessly, or gab; to gossip; to exaggerate. Since a *breeze* is a mild wind, and *shoot* is to send forth, *shoot the breeze* implies that a person's babbling is of trivial importance, serving only to create a minor current in the air.

> We were sitting outdoors, enjoying ourselves and shooting the breeze. (Billy Rose, in a syndicated newspaper column, 1950)

Two variations are *bat the breeze* and *fan the breeze*.

12. shoot the bull To engage in idle, trivial, or aimless conversation; to gossip; to boast, flatter, or exaggerate; to lie. In this expression, *bull* is most likely a shortened, less offensive version of *bullshit* 'nonsense, lies.' Thus *shoot the bull* implies that though many words are being spoken, nothing of much consequence is being said.

> You could see he really felt pretty lousy about flunking me. So I shot the bull for a while. (J. D. Salinger, *Catcher in the Rye*, 1951)

13. talk a blue streak To speak rapidly, continuously, and at great length; to be voluble or garrulous. Though most commonly used in reference to speech or the flow of words, *blue streak* can also denote rapidity of anything. The term probably stems from the blinding speed and vividness of a lightning flash.

> Interspersing his vehement comments with a "blue streak" of oaths. (*The Knickerbocker*, 1847)

14. verbal diarrhea An excessive talkativeness; logorrhea; the unleashing of a word hoard; an overly pompous or verbose discourse. This obvious analogy has older and more reputable antecedents than might be supposed:

> He . . . was troubled with a diarrhea of words. (Horace Walpole, *Memoirs of George III*, 1797)

372. TARDINESS

1. after meat, mustard Too late; no longer of any use. The original expression was the French *c'est de la moutarde après dîner*, which first appeared in English as 'like mustard after dinner' (John Adams, *Adams-Warren Correspondence*, 1807), before evolving into the more common *after meat, mustard*. This phrase expresses the uselessness of offering something after the need for it has already passed, as does the similar Latin expression *post bellum, auxilium* 'after the war, aid.'

2. [a] day after the fair This British expression, indicating that one is too late, refers to a country fair and the fun one can find there. Fairs have been commonplace in England since the Middle Ages, and this term was probably coined at that time. An entry in John Heywood's *Proverbs* (1546) is the earliest known written example. The phrase is used only metaphorically today, usually

to indicate that one has missed a golden opportunity by failing to act.

> They must make good speed, unless they would be a day too late for the fair. (Mrs. Henry Wood, *Trevlyn Hold*, 1864)

3. kiss the hare's foot To be too late for dinner; to be too late for anything; to be a day after the fair. Some sources explain this expression in the idea of arriving so late that the hare has already passed by and left only its footprint, others to arriving so late that the other guests have eaten all of the beast except its foot. Whatever the case, the expression has been in use since the Middle Ages and, by extension, has come to encompass all cases of tardiness.

> Make haste away, unless we mean to speed.
> With those that kiss the hare's foot.
> (William Browne, *Britannia's Pastorals*, 1616)

A related term, *get the hare's foot to lick* means to get very little or nothing at all.

> Keith got the earldom . . . and the poor clergyman nothing whatever, or, as we say, the hare's foot to lick. (Sir Walter Scott, *Letter to Croker*, February 5, 1818)

4. kiss the post To be shut out because of tardiness or carelessness; to be disappointed; to be left with the keys of the street. This expression, in use since the early 1500s, originally referred to the doorpost of either an inn or a tavern. It was common practice in the past to lock the doors of an inn at a predetermined time each night. Those who attempted to return after hours were forced to spend the night elsewhere, probably on the street. The term has been extended to connote being shut out of any situation.

> Troilus also has lost
> On her much love and cost,
> And now must kiss the post.
> (John Skelton, *Phillip Sparowe*, 1520)

Teamwork . . .
See 70. COOPERATION

373. TEMPERANCE

1. appeal from Philip drunk to Philip sober This expression arose as the result of a tale told by the historian Valerius Maximus about Philip of Macedon. A bit in his cups, Philip, father of Alexander the Great, was sitting in judgment of an old woman one evening after dinner. When he announced his sentence, the old lady immediately appealed. "To whom?" asked Philip. "To Philip when sober," she replied. The next day when he was sober, Philip reversed his decision and allowed her to go free.

> Our appeal is not to men in the flush of excitement, but to them in their hours of solitary sane reflection. It is from "Philip drunk to Philip sober." (Alexander MacLaren, *Exposition: Deuteronomy–I Samuel*, 1906)

2. Band of Hope An organized group of young people in England who pledge themselves to abstinence from intoxicating beverages; teetotalers, with disdainful implication. This expression arises from the name given to a children's temperance association founded in England in 1847. All members were required to take a pledge to abstain from the drinking of alcoholic beverages and to discourage those who drank. As the organization spread throughout the United Kingdom, it incorporated adult subsidiaries.

> Thus we find in every city, town or hamlet, Bands of Hope and Senior Bands of Hope. (*Temperance Record*, January 17, 1878)

The term is seldom heard today except in jocular or scornful use, as when one refuses to stop for a drink: "Did you join the Band of Hope, mate?"

3. bone dry With absolutely no intoxicating ingredients; positively opposed to any alcoholic beverages; a municipality or state where alcoholic beverages are

absolutely prohibited by law. This American colloquialism is an extension of the proverbial comparison *dry as a bone*. *Bone dry* gained popularity as a descriptive phrase shortly after the Civil War when a number of reform movements advocating the prohibition of intoxicating beverages arose. *Dry* soon came to connote that a municipality prohibited the sale of alcoholic drinks, and *bone dry* was expressive of absolute and strictly enforced prohibition.

> Both towns were bone dry. (*Kansas City Times*, April 27, 1932)

With the passing of the 18th (the Prohibition) Amendment to the Constitution, the term became a part of the everyday vocabulary, and even now, long after that amendment's repeal, the term is used of areas where local prohibition laws are still in place. More recently, applied to a dry martini, a cocktail formerly made with equal parts of gin and dry (Italian) vermouth (whence its earlier nickname, "gin and It"), *bone dry* has come to designate a concoction consisting of gin with only a tiny amount of dry vermouth.

4. draw it mild To keep within bounds; to be temperate; to do in moderation; not to exaggerate. The allusion in this phrase is to the drawing of beer. The expression has been in use since the early 1800s, as has its counterpart *draw it strong*.

> Our ladies faithfully promised to "draw it as mild" as possible; but when they made their appearance in most splendid array, I felt rather uncertain as to what the consequences might have been if they had "drawn it strong." (G. A. Sala, *Daily Telegraph*, April 6, 1864)

5. on the wagon Abstaining from alcoholic beverages; said of a teetotaler or nephalist. This expression is a truncated version of the earlier and more explicit *on the water-wagon*.

> But, R-e-m-o-r-s-e!

> The water-wagon is the place for me;
> It is no time for mirth and laughter,
> The cold, gray dawn of the morning after!
> (George Ade, *Remorse*, 1902)

Antithetically, *off the wagon* implies the resumption of alcoholic indulgence after a period of abstinence.

> Like the bartenders, they fell off the wagon. (A. J. Liebling, "Yea, Verily," in *The New Yorker*, September 27, 1952)

6. sober as a judge This expression is usually used to describe a person who is completely free from alcoholic contamination; however, it is used occasionally to indicate a life of moderation or seriousness. Some controversy has arisen over the term's date of origin. Once attributed to Henry Fielding's invention in *Don Quixote in England* (1734), it is now known to have appeared as early as 1694 in *Terence Made English* by an unknown author:

> I thought myself sober as a judge.

7. take the pledge To take a vow to give up intoxicating liquors; to guarantee by a solemn pledge to abstain from alcoholic beverages. This expression was derived from a practice of The Band of Hope, a temperance group founded in England in 1855. Each member signed a solemn pledge resolving total abstinence from alcoholic beverages in any form. A variant is *sign the pledge*.

8. teetotal To abstain totally from alcoholic beverages; as an adjective, advocating total abstinence from intoxicating drink. This word is formed by a reduplication of the initial sound of *total*. It was purportedly coined by Richard Turner (1790–1846) in a speech delivered in England in September 1833, advocating total abstinence from liquor. Accounts differ as to whether *teetotal* was intentional as Turner claimed, or the result of a speech defect which caused Turner to stutter, "N-n-nothing but t-t-t-total abstinence will do." At any rate, John

Livesey, a member of the audience and founder of the Total Abstinence Society, credits the word to Turner in his *Autobiography* (1867), and Turner's gravestone epitaph reads in part: "Richard Turner, author of the word Teetotal as applied to abstinence from all intoxicating liquors." Furthermore, a full-Npage advertisement in the April 1836, issue of *Preston's Temperance Advocate* also credits "Dicky Turner" as the originator of *teetotal*.

> Rev. Joel Jewell, secretary of a temperance society in Lansing, New York, claimed that members of his organization coined the word in 1827 when they handed out pledge cards upon which were printed "O.P." (Old Pledge—partial abstinence) or "T." (Total abstinence), encouraging people to sign the latter by crying out "T—total! T—total!"

Although both England and the United States claim credit for the word, it is possible that *teetotal* developed independently in the two countries. It has since enjoyed extensive and frequent use.

> Much stress has been laid by the teetotal advocates on the paramount influence of parental intemperance on the procreation of a mentally deficient progeny. (Thomas Allbutt, *A System of Medicine*, 1899)

One who abstains from alcoholic consumption is often called a *teetotaler*.

374. TEMPORIZING
See also 2. ABEYANCE

1. Fabian tactics A policy of delay; running away to harass one's enemy; fighting and running away to live and fight another day. This expression is derived from the policy of Quintus Fabius Maximus, the Roman general who defeated Hannibal in the Second Punic War (218–201 B.C.). Recognizing the superior strength of the attacking force, Fabius avoided major pitched battles, engaged the Carthaginians in minor skirmishes, and subverted their supply lines. Eventually his tactics succeeded, and he achieved victory for the Roman Empire and the cognomen Cunctator. The phrase gained great popularity in the late 19th century when William Morris founded a society to bring socialism to Great Britain. Adopting the name, Fabian Society, Morris in 1884 defined the society's policy:

> We must do what we can . . . and like Quintus Fabius, who was never defeated, reform the government, not overthrow it. . . . We must take the present social order and build upon it.

2. filibuster The use of irregular or obstructive tactics, such as long speeches or trivial objections, by a minority legislator to prevent or hinder the passage or consideration of legislation generally favored by the majority; the use of such tactics to force the passage of unpopular legislation; to waste time for the purpose of obstruction. The filibuster, long a staple of U.S. Congressional politics, derives from the French *fribustier* 'pirate' and the British *flibuster* 'rover, traveler.' The French pirates terrorized the Spanish West Indies in the 17th century. The name *filibusters* was later applied to illegal bands of Americans and Texans who, in the 1850s, entered Central America to foment revolution. Soon the term was applied to anyone who took part in illegal or irregular warfare or other obstructionist activity against a government. The transition to its current meaning was then but a short jump.

> A filibuster was indulged in which lasted . . . for nine continuous calendar days. (*Congressional Record*, February 11, 1890)

3. hold at bay To fend off one's literal or figurative assailant by taking the offense, thereby bringing about a standstill as both parties are poised and ready to attack. This expression is said to derive from the modern French *être aux bois* 'to be at close quarters with the barking dogs.' Originally a hunting phrase dating from the 16th century, *hold* or *keep*

at (*a*) *bay* refers to a situation in which a hunted animal, unable to flee further, turns to defend itself at close quarters. Figurative use, also dating from the 1500s, is now heard more frequently than the literal.

> By riding . . . keep death as it were at a bay. (Francis Fuller, *Medicina Gymnastica*, 1711)

4. mark time To await developments; to be active without progressing; to keep time by moving the feet alternately, as in marching, but without advancing; to pause in action temporarily. This expression, its figurative sense adopted from an original, martial application, has been in use since the early 19th century. It is still used in its literal sense by the military, but is always heard as a figurative expression otherwise.

> The agnostic's appeal to us is to halt and mark time. (Frederick W. H. Myers, *Human Personality*, 1903)

5. play for time To employ dilatory tactics to stave off defeat; to postpone making a decision, to drag out negotiations. This expression probably derives from those sports in which one team monopolizes control in the remaining minutes of a game in order to prevent a last-minute turnaround and victory by the opposing team.

6. stonewall To obstruct or block legislation; to delay or impede an activity. This term was applied to the Civil War General Thomas J. Jackson, in honor of his steadfastness at the Battle of Bull Run. The expression is also a cricket term for an exclusively defensive or delaying strategy. Its meaning was subsequently extended to include stubborn blocking and delaying tactics on a government level.

> Obstruction did not merely consist in stonewalling Government business. (*Contemporary Review*, November 1916)

As a result of its use in the Watergate hearings, *stonewall* took on the more specific meaning of the obstruction of or the resistance to government inquiry or investigation, as through vagueness and noncooperation.

Temptation . . .
See 118. ENTICEMENT

Tenacity . . .
See 268. PERSEVERANCE

375. TERMINATION
See also 47. CESSATION;
58. COMPLETION; 79. CULMINA-
TION; 379. THWARTING

1. all over but the shouting This expression conveys the idea that things have become so one-sided that one knows what the outcome will be before the contest has ended. In common use in both Great Britain and the United States, the term first appeared in the mid-19th century. Occasional variations are *all over except the shouting* and, in England, *all over bar the shouting*.

> The Englishman would say the back of a job was broken, or all is over but the shouting. (Kipling, *Man and Beast*, 1891)

2. at close of play At the time of termination; when all is said and done. This Briticism is used to express the end of something or the termination of a cycle. Its root, like that of so many British expressions, lies in the game of cricket, and the term probably had its origin in the late 18th century.

> Let me have the memorandum by close of play on Wednesday. (Norman W. Schur, *English English*, 1980)

A related term *at the end of the day* is roughly the equivalent of the American *when all is said and done*.

> Large housing units may be more efficient, but at the end of the day people want their separate homes. (Norman W. Schur, *English English*, 1980)

3. bitter end A difficult or disagreeable conclusion; the last or ultimate extremity; death; often in the phrase *to the bitter end*. According to Captain John Smith's *A Sea Grammar* (1627):

> A bitter is but the turn of a cable about the bits, and wear it out by little and little. And the bitters end is that part of the cable doth stay within board.

William Henry Smyth in *The Sailor's Word-book* (1867) elaborates further:

> A ship is "brought up to a bitter" when the cable is allowed to run out to that stop. . . . When a chain or rope is paid out to the bitter-end, no more remains to be let go.

A variation of the phrase *bitter end* appears in the Bible (Proverbs 5:4) and some conjecture this usage, rather than the nautical, to be its origin.

> But her end is bitter as wormwood.

The phrase gave rise to the term *bitterender* 'a diehard,' in use since 1850.

4. curtains The end, usually a disastrous or unfortunate one; most often, death itself. This slang term, of obvious theatrical derivation, is often used to indicate the end of some illegitimate enterprise, and as such is similar to expressions such as *the jig is up*.

> It looked like curtains for Ezra then and there. But just that moment he saw a chance of salvation. (Jesse Lilienthal, *Horse Crazy*, 1941)

5. [one's] days are numbered See 181. ILL HEALTH.

6. dead letter The end of the line; an unfortunate conclusion; the termination of usefulness; no longer in force. In postal terminology a *dead letter* is one which cannot be delivered or returned to the sender. Therefore, it sits in the dead letter office for a period of time before it is finally destroyed. In legal terminology a *dead letter* is a law that is no longer acted upon, a statute or ordinance that is

no longer enforced, although not formally repealed. Each of these definitions contributes to the figurative intent of the expression, to come to an ill-fated end.

> Many a treaty of marriage became a dead letter almost as soon as it was signed. (Edward Freeman, *The History of the Norman Conquest*, 1869)

7. draw stumps To leave; to terminate a situation; to clear out. This British expression can be ascribed to the game of cricket; when the game is over, the stumps are pulled from the ground and everybody departs. Since the stumps are an integral part of the equipment, the term has come to signify absolute termination. The phrase has been in use since the early 19th century.

> When the stumps and the match also were drawn, four wickets were down for 96 runs. (*The Field*, July 4, 1868)

A variant is *up stumps*.

8. in the homestretch In the final stages; nearing the completion of a project, ordeal, activity, or other matter; the denouement. In racing terminology, the homestretch is the last leg of a race, i.e., the straight part of a racecourse from the last turn to the finish line. Figurative use of this Americanism was recorded as early as the mid 19th century. It usually suggests some degree of relief because *in the homestretch*, the end is in sight. A variant is *on the homestretch*.

> Already we see the slave states . . . on the homestretch to become free. (*Congressional Globe*, March 12, 1864)

9. the jig is up This is it, it's all over, this is the end of the line; usually used in reference to being caught or discovered in some wrongdoing. This slang or dialectal expression, which dates from the late 1700s, derives from the obsolete 'prank, joke, trick' meaning of *jig*.

10. John Audley it To bring a theatrical performance to a close; to conclude whatever one is doing; to hurry. This expression supposedly arose because of the actions of a travelling theatrical producer named Shuter. He would station an assistant outside the theater, and when enough customers had purchased tickets for the next performance the assistant would enter the rear of the theater and inquire in a loud voice, "Is John Audley here?" Upon this prearranged signal, the production would be concluded as quickly as possible so that the new paying audience might enter. Thus, to *John Audley* anything came to mean to finish up hurriedly. In the United States the phrase has become a circus slang term meaning 'hurry.' A variant is *John Orderly it.*

11. lower the boom See 298. PUNISHMENT.

12. nip in the bud To terminate a project, plan, or other matter in its early stages; to prevent or stop something before it has had a chance to develop. A bud is an undeveloped part of a plant which, if nipped by frost, pests, or a zealous gardener, does not grow to fruition; hence the expression.

> Dost thou approach to censure our delights, and nip them in the bud? (Sir Aston Cokaine, *Masque*, 1639)

13. quit cold turkey See **cold turkey**, 47. CESSATION.

14. ring down the curtain To terminate or bring to an end. In the theater, the person responsible for raising or lowering the stage curtain once received his cue from the stage manager who would ring a bell at the appropriate moment.

> The curtain had to be rung down before the play was ended. (*The Times*, August 31, 1887)

While still used in the theater, *ring down the curtain on* is applied figuratively in other contexts as well. A variation is the shortened *ring down.*

The functionary whose business it is to "ring down" had satisfied himself that nobody wanted any more of it. (*Daily News*, October 2, 1882)

15. stem the tide To stop, terminate, end; to squash, quell, check; to block or stifle; to nip in the bud. The most plausible conjecture is that *stem* in this expression is derived from the Icelandic *stemma* 'to stop the flow of'; attempts to relate it to the stem of an ocean-going vessel defy logic. *Tide* implies a flow of events.

> Aristophanes evidently saw the tide that was strongly in favour of the new candidate for scenic supremacy, and he vainly tried to stem it by the barrier of his ridicule. (Fred Paley, *The Tragedies of Aeschylus*, 1855)

376. TEST
See also 77. CRITERION

1. baptism of fire See 209. INITIATION.

2. dry run A trial; a rehearsal; something done for practice only. The origin of this term is obscure, but it probably came from the military, where *dry run* is frequently used of any simulated situation in which skills are practiced in preparation for use in actual combat. Perhaps the term came from dry-land simulations of troop landings from boats, wherein the soldiers would not get their feet wet as they would in a real landing.

> She had to locate his pulse, get her watch ready, and make a couple of dry runs. (*Saturday Evening Post*, November 27, 1943)

3. go through fire and water See 91. DESIRE.

4. have [one's] work cut out See 96. DIFFICULTY.

5. ordeal by fire A severe test of character; a very distressing situation. In ancient Britain, an ordeal was a type of trial in which divine intervention was considered the only proof of a suspect's in-

nocence. These ordeals took many brutal forms, ranging from having one's arm immersed in boiling water to being bound and tossed into an icy river. In both cases, an unscathed survivor was proclaimed innocent. The harshest ordeals, however, involved fire. The accused was forced either to grasp a red-hot iron in his hand or to walk barefooted through sizzling rocks and embers. Again, a suspect who emerged uninjured was considered guiltless. Although these cruel trials were abolished shortly after the Norman conquest of Britain, the expression has retained its meaning of an exceedingly agonizing experience undergone to test one's worth.

6. put through [one's] facings To require another to exhibit his skill for purposes of scrutiny; to make a person perform to the utmost of his capabilities. Literal *facings* are military maneuvers.

> Grace, not at all unwillingly, was put through her facings. (Anthony Trollope, *The Last Chronicle of Barset*, 1867)

The expression usually carries connotations of being badgered or harassed, as in the following bit of doggerel by F. Egerton.

> We were scarcely wed a week
> When she put me through my facings.
> And walloped me—and worse;
> She said I did not want a wife,
> I ought to have had a nurse.

7. put through [one's] paces To require another to display the full range of his abilities; to test another's resources to the utmost. *Paces* here refers to the training steps or gaits of horses. The equestrian phrase was first extended to persons called upon to perform at their maximum potential, and subsequently to inanimate objects as well.

> The captain affirmed that the ship would show us in time all her paces. (Ralph Waldo Emerson, *English Traits*, 1856)

> The test pilots . . . put the new planes through their paces. (H. H. Arnold and I. C. Eaker, cited in *Webster's Third*)

8. quiz An oral or written examination; an eccentric; a practical joke; to give a test; to kid another person. The origin of this word is questionable; however, it is oftentimes attributed to a Dublin theater manager named Daly, who, it seems, about 1780, wagered with a friend that, within twenty-four hours, he could introduce a meaningless word into the language. The wager was accepted, and that evening Mr. Daly sent his theatrical employees to the streets of Dublin to chalk the letters *Q-U-I-Z* on all available building sides, walls, anyplace where the general populace might see them on the next morning. By the evening of the next day all Dublin was inquiring the meaning of the strange new word. Mr. Daly was said to have won his wager. The word, whatever its origin, acquired a number of meanings and has remained in the language. Today, it is most commonly heard as a noun meaning 'short, quick test,' or as a verb meaning 'question,' or 'give a test.' During the 1930s an American radio show, entitled "Quiz Kids," was introduced and achieved such popularity that the term *quiz kid* is still heard to indicate a precocious youngster. A type of television program that has gained considerable popularity since World War II is the *quiz show* in which contestants win money or prizes for answering pre-determined questions presented by the host. Another related term is *quizzing glass*, meaning 'monocle,' probably from the fact that it can aid one in examining something more closely.

9. take the measure of To judge the character of, to size up, to ascertain the good and bad points. *Measure* in this expression refers literally to the dimensions of a body, information necessary to a tailor who needs exact *measurements* to fit someone for clothes. Figuratively the term refers not to size, but to character.

Our hostess . . . bustled off . . . to take the measure of the newcomer. (Sir A. Conan Doyle, *Micah Clarke*, 1889)

Even further removed from the literal use is the application of this expression to organizations or institutions.

The people have taken the measure of this whole labor movement. (*Nations*, January 5, 1893)

10. test of the boar's head A test with rigid requirements; a test of cuckoldry. The story is told that a boy walked into King Arthur's court and, placing a boar's head upon the famous round table, remarked that no cuckold's knife could cut it. Of all the knights in Arthur's court only Sir Cradock's could sever the flesh. A variant is *test of the brawn's head*.

11. weigh in the balance The allusion in this expression is to the scales upon which Fortune or Justice decides the fates of men; hence, to *weigh in the balance* implies a figurative placing of someone or an idea in one tray of the scales and actions or principles in the other, in order to determine how the two measure up. The term appears in the Bible when Daniel interprets the vision of Belshazzar and informs him:

Thou art weighed in the balances, and art found wanting. (Daniel 5:27)

The phrase has been in use in England since at least the Middle Ages.

Thanklessness . . .
See 208. INGRATITUDE

Thinking . . . See 378. THOUGHT

377. THOROUGHNESS
See also 195. INCLUSIVENESS;
383. TOTALITY

1. bell, book, and candle Thoroughly, completely; formally, with all the trappings. The phrase derives from the Roman Catholic ritual of excommunica-

tion, no longer practised, consisting of: 1) formal declaration of a person as anathema, after which the book containing prescribed readings was closed; 2) extinguishment of a candle, symbolic of the person's expulsion from the community of believers into which he had been received when a candle was lighted at his baptism; and 3) the tolling of a bell, to signalize his spiritual death.

2. go over with a fine-tooth comb To examine thoroughly, to observe every detail or aspect of a thing; to be on the lookout for some problem, defect, or irregularity in order to improve or perfect it. This expression derives from the act of brushing with a comb having narrow, closely set teeth, such as the type used in looking for fleas on a cat or dog. Figurative use of the expression, heard by the late 19th century, remains current.

We've gone through the remains of the helicopter with a fine-tooth comb, but there wasn't much left. (A. Firth, *Tall, Balding, Thirty-Five*, 1966)

3. leave no stone unturned To spare no effort; to exhaust every expedient to accomplish one's aim or goal. This expression was the advice purportedly given by the Oracle of Delphi to Polycrates the Theban when he asked where he could find the treasure believed to have been hidden by Mardonius, a Persian general whom he had defeated at the Battle of Plataea (477 B.C.). Upon following this advice, Polycrates located the treasure beneath the stone floor of Mardonius' tent.

We shall not be negligent; no stone will be left unturned. (Edmund Burke, *Correspondence*, 1791)

4. lock, stock, and barrel Completely, entirely; the whole thing. The allusion is to the three main components of a gun which together comprise essentially the entire weapon. The phrase was used in *Lawrie Todd* by John Galt in 1830.

5. neck and crop Entirely, completely, altogether; bodily. Though there is disagreement as to whether the *crop* of the expression is *crop* 'craw, gullet' or *crop* 'rounded head or top,' it matters little. The concept is clear, no matter the direction in which the neck is extended to indicate entirety. Common in the 19th century, the phrase is less so today.

> Chuck them neck and crop . . .
> down a dark staircase. (Michael Scott, *Tom Cringle's Log*, 1833)

6. root and branch Utterly, completely, without exception or qualification; inside and outside; lock, stock, and barrel. This expression was popularized by the London Petition of 1640 which advocated the abolition of episcopal government.

> That the said government, with all its dependencies, roots, and branches, be abolished. (in John Rushworth's *Historical Collections*, 1659–1701)

When writing this petition, the *root-and-branch men*, advocates of the all-out, total abolition of Episcopacy, probably had in mind the following Biblical quotation from Malachi 4:1:

> And the day that cometh shall burn them up, saith the Lord of hosts, that it shall leave them neither root nor branch.

Root and branch is most commonly heard in the expression *destroy root and branch*.

7. to the hilt Completely, fully, entirely, thoroughly, to the maximum extent or degree; also *up to the hilt*. When a sword or dagger is thrust into an object up to its hilt or handle, the blade is completely covered and can go in no farther. The phrase dates from the late 17th century.

8. to the teeth Entirely, fully, completely; often in the phrase *armed to the teeth*. Conjecture that the phrase dates from the days when pirates roamed the Spanish Main carrying a pistol or sword

in each hand and a knife between their teeth appears dubious because of a 1380 *OED* citation.

9. touch all bases To include either in action or in speech all important facets of a matter; to leave no stone unturned, to be thorough. This American slang expression comes from baseball; in order to score a run, a player is required to touch each base successively.

10. up to the handle Completely, thoroughly; up to the hilt; to the limit; wholeheartedly. This American colloquial expression, an adaptation of the more common *up to the hilt*, has been in use since about 1833. The allusion is to the embedding of the blade of a sword up to the handle.

> If he isn't playin' possum right up to the handle, then he is a fool. (John Habberton, *Jericho Road*, 1876)

378. THOUGHT

1. brain child A creation of one's imagination; an invention, an original idea, or a scheme that is the product of a specific person or a group. This expression personifies the brain as giving birth to ideas as a parent gives birth to children. Shakespeare used the essence of the term in *Romeo and Juliet*.

> True, I talk of dreams
> Which are the children of an idle brain,
> Begot of nothing but vain fantasy.
> (I,ii)

And Jonathan Swift employed a similar application in his satire, *Tale of a Tub* (1704), in which he refers to "Books, the children of the brain." The term itself, however, didn't come into being until the 19th century.

2. brainstorm A sudden and powerful thought; a good idea. The concept of forcefulness contained in the *storm* element seems to be losing ground to that of disorder and chaos, so that *brainstorm* is now most often used ironically to mean

a whimsical or ill-considered notion, a stupid idea.

3. brown study Absorption in thought; a pensive mood; absent-mindedness. This phrase dates from the early 16th century; the *brown* of the expression apparently stemmed from the sense of *brown* 'gloomy.' Citations indicate that the phrase varies in meaning: it may be used for serious thought; for apparent pensiveness masking actual absentmindedness; or for simple idle daydreaming. John Crowe Ransom uses the phrase poignantly in "Bells for John Whiteside's Daughter":

> There was such speed in her little body,
> And such lightness in her footfall,
> It is no wonder that her brown study
> Astonishes us all.

4. consult [one's] pillow To think something over; to sleep on it; to consider a problem for a reasonable amount of time before making a decision. This phrase, along with its common variants, *consult* or *take counsel with [one's] pillow*, has been in use since the 16th century. The expression indicates that one wants time, at least overnight, for serious consideration of a problem at hand.

> Others feared . . . that, if they suffered them to consult with their pillows, their pillows would advise them to make much of their heads. (Thomas Fuller, *The Profane State*, 1642)

5. horseback opinion A guess, an off-hand impression, a hasty opinion or judgment delivered without "stopping to think," as though from horseback. Use of this U.S. colloquialism dates from the late 19th century.

> I am not here as a judicial authority or oracle. I can only give horseback opinion. (*Congressional Record*, April 23, 1879)

6. on the carpet Under consideration or up for discussion. This expression, in use

since 1726, apparently derives from the earlier *on* or *upon the tapis* (circa 1690), a partial translation of the French *sur le tapis* 'on the tablecloth,' referring to a tablecloth covering a council table around which members meet to discuss items of business.

7. put on [one's] thinking cap To think about or consider; to ponder; to reflect or concentrate. Although *thinking caps* have been mentioned in children's literature and various legends for hundreds of years, the most likely allusion is to the official headgear which a British magistrate would wear when considering the disposition of a case and when passing sentence. In its figurative use, *put on one's thinking cap* clearly implies that the matter at hand merits serious thought.

> It is satisfactory to know that the Post Office Department has its thinking cap on. (*Daily Chronicle*, January 1903)

8. rack [one's] brains To strain one's intellect to recall something or to solve a problem; to stretch the mind beyond the normal limit. This expression, dating from the 1500s, is derived from the instrument of torture, the *rack*. As the instrument stretches one's body, so does the straining for recall stretch one's mind.

> Who rack their brains for lucre, not for fame. (Lord Byron, *English Bards and Scotch Reviewers*, 1809)

9. sleep on it To contemplate and reflect upon an important proposal, plan, or other matter without making a hasty decision; to consider something overnight before making up one's mind. This expression, in popular use for centuries, implies that some decisions, particularly portentous ones, merit at least one night of conscious and, while sleeping, subconscious thought.

> His Grace . . . said that he would sleep and dream upon the matter, and

give me an answer [in] the morning. (*State Papers of Henry VIII*, 1519)

Thriftlessness . . .
See 190. IMPROVIDENCE

Thriving . . .
See 291. PROSPEROUSNESS

379. THWARTING
See also 47. CESSATION;
185. IMPEDIMENT; 329. RUINA-
TION; 375. TERMINATION

1. clip [someone's] wings To cripple someone's efforts to reach a goal; to incapacitate; to undermine, directly or indirectly, another's ability to achieve his aspirations. Figurative use of this phrase alludes to the idea that a bird cannot fly with clipped wings. The phrase has been current since its early use in the late 16th century.

Away to prison with him! I'll clip his wings. (Christopher Marlowe, *The Massacre at Paris*, 1590)

2. cook [someone's] goose To destroy someone's chances totally and irrevocably; to do someone in or ruin it for someone; to put the kibosh on someone's hopes or plans. The popular and amusing but implausible story offered as the source of this phrase has to do with King Eric of Sweden and his soldiers, who were not taken seriously when they arrived to capture a town. The townspeople ridiculed the king by hanging out a goose for the soldiers to shoot at. Upon realizing the real threat posed by the king, the people sent someone to negotiate a settlement with him. When asked his intentions, the king replied, "to cook your goose."

The *OED* cites a 19th-century street ballad as the earliest printed use of the phrase:

If they come here we'll cook their
goose
The Pope and Cardinal Wiseman.

This doggerel expressed England's opposition to Pope Pius' attempt to reassert the power of the Catholic Church in England through the appointment of the English cardinal Nicholas Wiseman.

3. lay by the heels To limit or thwart a person's power or influence; to negate the credibility of a once influential person; to imprison or otherwise confine a person. This expression alludes to stocks, the once common instruments of punishment which were made of a framework with holes for securing the ankles (and sometimes the wrists). An offender locked in the stocks was frequently subjected to public derision, abuse, and humiliation as part of the punishment. Thus, to *lay by the heels* is to shackle someone, either literally or figuratively, thereby reducing or eliminating his influence.

4. put a crimp in To thwart or impede; to frustrate; to block. This American slang expression has been in use since the latter part of the 19th century. The usage developed from the literal sense of *crimp* which denotes an obstruction or interruption caused by bending or pinching.

Cigarettes went up to 15 cents a package, which . . . put a crimp in its jubilation. (*Kansas City Times*, July 17, 1931)

5. put a spoke in [someone's] wheel To interfere with, obstruct, or impede the progress of; to frustrate or thwart. This expression, dating from the 16th century, is said to derive from the practice of thrusting a pin or spoke into a hole on a solid wheel to serve as a break and slow down the vehicle. Current confusion over this expression arises because many kinds of wheels are now made with spokes and it is difficult to conceive of a spoke preventing a wheel from turning.

Capitalists . . . were trying to put a spoke in the wheel of Socialism. (*Manchester Examiner*, July 1885)

6. put [someone] off his stroke To interfere with an operation that is progressing smoothly; to spoil somebody's rhythm; to break a person's cadence. The origin of this phrase, which has existed since at least the 1500s, is obscure. One source attributes it to the Roman galleys and the rhythmic beat that was established for the oarsmen; another to rowing and the call of the coxswain; a third to the rhythm of music or poetry. At any event, the expression, and its variant *throw [someone] off his stroke*, is still in common use.

7. put the kibosh on To render ineffective or nonfunctional; to squelch or quash; to put an end to, to dispose of; to put out of countenance. The origin of this expression is obscure. It has been conjectured that *kibosh* comes from the Irish *cie bais* 'cap of death.' The *OED*, however, does not support this hypothesis, but suggests that the phrase has Yiddish or Anglo-Hebraic origins.

> The directive puts the kibosh on one of the few potentially valuable efforts that the United States has been making in the field of psychological warfare. (R. H. Rovere, cited in *Webster's Third*)

Application of this expression is not limited to ideas and activities, but extends to persons as well, as evidenced by the following citation from C. Roberts' *Adrift in America* (1891):

> It was attending one of these affairs which finally put the "kibosh" on me.

8. put the whammy on To jinx or hex; to give the evil eye, to mesmerize; to render speechless, to incapacitate; to overpower, ruin, or destroy. The *whammy* is a gesture or object whose magical properties cast a curse on its victim. As a term it was probably derived onomatopoeically from the sound made by the gesture of *whamming* the fist into the palm. Its popularity stems from the well-known "Li'l Abner" comic strip by Al Capp in which Eagle Eye Feegle's one-eye stare was dubbed *the whammy*. Two eyes made it a *double whammy*.

> So what's put the whammy on the National Science Foundation bill? (H. Alexander, *The Bulletin* [Philadelphia], September 1949)

9. queer [someone's or one's] pitch To spoil one's performance; interfere with another's territory. One explanation of this term attributes it to the game of cricket where the *pitch* is part of the cricket ground. Therefore, to *queer one's pitch* is figuratively to spoil his game. A more plausible explanation lies in the use of *pitch* as the spot where one locates his operation for making book, entertaining, or gaming. If a competitor operates in the same area, he *queers the pitch*. The *OED*'s first listing of the expression seems to agree with the second interpretation.

> The spot they pick for their performance is their 'pitch' and any interruption of their feats, such as an accident or the interference of a policeman, is said to queer the pitch. (Thomas Frost, *Circus Life*, 1875)

10. spike [someone's] gun To thwart someone's possibilities for success; to hamper or prevent someone from reaching a goal. This expression is derived from the practice of driving a spike into the vent of a gun, thus rendering it inoperable. The expression maintains contemporary use.

11. steal [someone's] thunder To reduce or negate the effect of an argument, performance, remark, etc., by anticipating it; to thwart, frustrate, or forestall; to use as one's own the ideas, inventions, or techniques of another. This expression is credited to John Dennis (1657–1734), a playwright who developed a new technique for producing thunder on stage and used it in his ill-fated and short-lived opus, *Appius and Virginia*. Some time later, upon hearing his *thunder* used in a performance of *Macbeth*, Dennis cried out, "Damn them! . . . They

will not let my play run, but they steal my thunder!"

> Harry Truman is no man to let Congress steal his political thunder. (*Time,* May 1950)

12. take into camp To thwart another's power; to defeat; to impede another person's progress. This American colloquialism suggests a soldier who brings a captured enemy back to his base camp as a prisoner of war, thus thwarting his continued participation in the war. The term, dating from the 1860s, has become a part of the common vocabulary as a synonym for a defeat or an impediment, as in this newspaper report on a football game:

> Elkins High School took another contender into camp last Thursday night when Philippi came up here to tackle Frank Wimer's tame tigers. (*Randolph Enterprise* [Elkins, W. Va.], January 16, 1930)

13. take the teeth out of To render harmless or ineffective; to deprive of strength or power. Teeth are basic for nourishment, attack, or defense. Figuratively the word *teeth* refers to any effective means of accomplishment or compulsion, as in the following *Webster's Third* citation:

> . . . reluctant to pass legislation with *teeth* regarding this issue. (T. L. Reller)

An Aesop's fable also cited as a possible source of this expression tells of a lion in love with a maiden who told him to pull his teeth and trim his claws, after which he was easily overpowered. *Take the teeth out of* is currently used almost exclusively of legislation.

14. take the wind out of [someone's] sails To destroy a person's self-confidence by effectively invalidating his argument, stand, or convictions; to frustrate or thwart; to put a pin in someone's balloon. The expression is an expansion of the earlier nautical phrase *to*

take the wind of 'to sail windward of another ship so as to intercept the wind.'

> A young upstart of a rival, Llanelly . . . which has taken a great deal of the wind out of the sails of its older neighbor. (*Harper's Magazine,* February 1883)

15. throw a monkey wrench into the works To interfere with the smooth operation of things, to upset plans or impede their progress; sometimes to sabotage or undermine deliberately; also, especially British, *throw a spanner into the works.* The allusion is probably to the chaotic effect such a literal act of sabotage would have on machinery. The American expression dates from at least 1920.

> It would throw another big monkey wrench into the already wobbly Japanese economy. (*The Christian Science Monitor,* January 1947)

16. throw cold water on To discourage, to have a damping effect upon; to disparage or put down; to put the kibosh on. *Cold* connotes the antithesis of all that is vital, enthusiastic, and passionate. Thus, to *throw cold water on* one's ambitions, ideas, or projects is to have a deadening effect, to be unsupportive in attitude or action.

Tidiness . . . See 243. NEATNESS

Tight-fistedness . . .
See 238. MISERLINESS

380. TIME
See also 110. DURATION;
207. INFREQUENCY; 255. OPPORTUNENESS; 381. TIMELINESS

1. before [one] had nails on [one's] toes Before one was born; long ago, in the distant past. This expression refers to the fact that a baby's toenails develop prenatally. Thus, an event or other matter that occurred before a person's toenails

In its most common usage, the expression cites a younger person's age as the basis for denigrating his status, experience, ideals, or philosophies.

> There's Ulysses and old Nestor, whose
> wit was moldy ere your grandsires
> had nails on their toes. (Shakespeare,
> *Troilus and Cressida*, II,i)

2. between dog and wolf Neither day nor night; dusk. The dog is a domesticated animal and therefore associated with all that is civilized and ordered, such as the day. On the other hand, the wild and mysterious wolf is associated with the night, from the image of a wolf baying at the moon. Although they are of the same family, dogs and wolves are as different as day and night. And *between dog and wolf*, or day and night, is dusk.

3. blind man's holiday Dusk; neither day nor night. This phrase, used as early as 1599, is said to refer to the time just before candles are lighted when it is too dark to work or read—a fitting time to rest, or take a *holiday*. However, this explanation does not account for the use of *blind man* in the phrase. Perhaps dusk is a holiday for a blind man because it offers him a brief respite from his aloneness. He has company because everyone is in the same state of semidarkness until the candles are lit. In fact, being accustomed to the darkness, a blind man can enjoy an advantage. The phrase is rarely heard today.

4. D-day A deadline, the last hour, the moment of truth; a date established for any significant event, originally for a secret military operation. During World War II, the Allied invasion of Normandy was set for June 5, 1944. To avoid referring to the date, for security reasons, the code word *D-day* was adopted. Hostile weather conditions, however, forced the postponement of this famous D-day until the next day. The term is currently used in a similar way, especially in the academic world, where students refer to the due date for the submission of work as *D-day*.

5. gandermonth The month during which a wife is confined after giving birth to a child. This old British term, dating from about 1600, refers to that time after a wife gives birth when her husband supposedly wanders about perhaps even enjoying the company of other women. Such aimless wandering is known as *gandermooning*, and during that period the husband is known as a *gandermooner*. The allusion in all of these terms is apparently to the capricious rambling of the gander while the goose is sitting on the nest.

> I'll keep her at the least this
> gandermonth,
> While my fair wife lies in.
> (Richard Brome, *The English Moor*,
> 1652)

6. graveyard shift A work shift usually from twelve midnight until eight in the morning; any late-night shift; also the *graveyard watch*. Factories running 24 hours a day employ three shifts of workers—day, afternoon or swing, and midnight or graveyard. The expression gained currency during World War II when so many factories were operating around-the-clock. The phrase, American slang and dating from the early part of this century, is an allusion to the late hour of the shift, which works in the dead of night when it is quiet and still as a graveyard.

> A month later he and his fellows went
> on "graveyard" shift. (*The Saturday
> Evening Post*, November 1908)

7. since Hector was a pup A long lapse of time; for ages. This expression, which has been in common use since the Middle Ages, is of uncertain origin. There has been great speculation through the years as to the identity of *Hector*, but a positive identification has never been made. A plausible explanation may be that the phrase refers to the early childhood of the hero of ancient Troy, Hector, and thus implies a very long time ago.

tor, and thus implies a very long time ago.

> He has been here for ages—since Hector was a pup. (Anne Rowe, *The Little Dog Barked*, 1942)

8. St. Tib's Eve Never; when two Sundays meet; the second Tuesday of next week. Since St. Tib never existed, there is, of course, no *St. Tib's Eve*.

> He would return and claim her hand on "Tib's Eve" an Irish festival which is stated to occur "neither before nor after Christmas." (William H. Maxwell, *The Bivouac*, 1837)

A related term, *Greek calends*, also means 'never,' *calends* being a term from the Roman system of marking the days of the month.

> But, quoth Pantagruel, when will you be out of debt? At the next ensuing term of the Greek calends, answered Panurge. (François Rabelais, *Pantagruel*, 1545)

9. zero hour Deadline; an anticipated stressful or critical period of time; the precise time established for the commencement of a military operation. This phrase originated and was widely used during World War I. It was for the most part replaced by the analogous term *H-hour* during World War II. As currently used, the expression often carries an implication of dread.

381. TIMELINESS

See also 255. OPPORTUNENESS
380. TIME

1. at the eleventh hour At the last possible moment; very late. This expression is found in the parable of the vineyard (Matthew 20:1–16), in which the laborers who did not begin work until the eleventh hour of the day received the same wages as those who had worked all day.

> An 11th-hour attempt . . . to block State Bond Commission approval of $2.8 million for the two new buildings

at Western Connecticut State College . . . failed Thursday. (*The Hartford Courant*, March 1979)

2. high time Almost too late; the most fitting time. Since the 13th century, *high* has been used to mean 'well advanced,' or 'fully come' (*OED*). Some speculate that there is a connection between this meaning and the time during the day when the sun is highest in the sky. It is a peak time, like the highest point which is also a turning point on a curve.

> It was . . . high time to make a contrary law. (William Lambarde, *Eirenarcha*, 1581)

This expression is almost always heard as part of an exhortation to act immediately.

3. in the nick of time At the proper or crucial moment; just in time. During the Middle Ages, it was common practice to record payments, debts, etc., by making a *nick* 'a notch or cut' in a stick in order to indicate credits or debits. Since a landowner risked substantial fines or seizure of his property if payments (such as taxes) were not made on time, it was in his best interest to arrive at the appointed place of collection before such penalties would be imposed. But human nature being what it is, a debtor often made payment at the last possible moment, giving rise to the now obsolete *in the nick* 'the precise moment when something requires to be done.' The addition of *of time* is a redundancy that has persisted for centuries.

> If he had not gone at the very nick of time, the ship could not have failed of being very quickly blown up. (Archibald Lovell, *Thevenot's Travels Into the Levant*, 1687)

4. right climate The propitious time; the moment when public opinion is favorable; the crucial moment for accomplishment. The image in this phrase suggests that the social or political opinions of a people, and whether one is operating with or against these prevailing

in that it is changable and must be favorable for one to succeed at many activities. The expression, overused by politicians in the mid 20th century, is considered trite today.

> Last week, in his first meeting with reporters since being made Army Chief of Staff in June, Wickham deemed the climate right for straight talk. (*Time*, August 22, 1983)

5. under the wire Barely meeting time requirements; just at the deadline. The expression comes from horse racing, the *wire* being the tape stretching across the track. The nose of the winning horse strains forward under the wire, breaking it for victory as he crosses the finishing line. The expression's figurative use most often refers to temporal rather than spatial proximity.

Timidity . . . See 75. COWARDICE; 148. FEAR; 362. SUBMISSIVENESS

382. TIPPLING
See also 109. DRUNKENNESS; 153. FOOD AND DRINK

1. back teeth afloat A strong desire to relieve the pressure on one's bladder; an overwhelming urge to urinate. This expression, coined in the late 1800s, originally indicated that one was in his cups, but early in the 20th century came to be used in its present sense, doubtless because of the close relationship between the drinking of beer in quantity and the urge to urinate.

2. belt the grape To imbibe heavily; to get drunk; to get a buzz on. *Belt*, an obsolete slang verb meaning 'swallow,' was popular in the mid-19th century. As part of the U.S. slang phrase *belt the grape*, it again gained currency in the 1930s. *Grape* usually refers to wine but can be used loosely to mean any alcoholic beverage.

> Jack takes to belting the old grape right freely to get his zing back.

(Damon Runyon, *Guys and Dolls*, 1931)

3. bend the elbow To drink liquor excessively and habitually; to tipple, to booze. Variants include *crook* or *tip* or *lift the elbow*, the last apparently the oldest, since it appears in an *OED* citation dated 1823.

4. Brandy Nan A nickname for Queen Anne of England. Queen Anne, who reigned from 1702 to 1714, was called by this nickname because of her fondness for alcoholic beverages, especially brandy. A gin shop once stood on Ludgate Hill across from the statue of Queen Anne in St. Paul's churchyard. Some wit, inspired by the positioning of the two, wrote the following doggerel on the base of her statue:

> Brandy Nan, Brandy Nan, left in the lurch;
> Her face to the gin shop, her back to the church.

5. chug-a-lug To drink an entire glassful of a beverage, usually beer, without pausing for breath. Although this onomatopoetic term, derived from the sound a person makes as he gulps an entire beer, received widespread student use from the late 1930s, the date of its origin is unknown. A *chug-a-lug* game, with an appropriate accompanying *chug-a-lug* song, became popular during the 1940s, and the practice of *chug-a-lugging* or *chugging* is still common on college campuses. The term should not be confused with *chuck-a-luck*, a gambling game played with dice.

> William K. Coors . . . says Coors pays 250 college students throughout the country to promote the beer at campus wet T-shirt contests, and "chug-a-lug" and "get drunk" parties. (*The New Yorker*, January 30, 1984)

6. down the hatch A popular toast, usually said before tossing off a drink in one gulp. *Hatch*, a slang term for 'throat,' is a figurative extension of the

nautical *hatch* 'covered deck opening on a ship.'

7. giggle water Booze; hooch; hard liquor; whiskey. This term is obvious in its meaning, for liquor, if drunk to excess, often gives one a case of the giggles, sometimes to such a degree that the giggles become a *laughing jag*.

> He not only crashed television . . . but has invaded the giggle water places. (*New York Herald Tribune*, December 12, 1951)

There are many variants of the term; among them are: *giggle juice* for champagne, *giggle weed* for marijuana, and *giggle bottle* for a bottle of liquor.

> The St. Louis manager . . . added, "But I never lifted the curfew or brought out a giggle bottle." (AP release, August 27, 1952)

8. have one for the worms To take an alcoholic drink; to have one for the road. The former belief that alcohol kills worms in the stomach furnished yet another convenient excuse for having a drink.

9. here's mud in your eye A jocular toast. This expression probably refers to the sediment which is often found in the bottom of a glass of wine. The *OED* lists 'dregs' as a colloquial meaning of *mud*; the original intent of the toast may have been that if one drains his glass too enthusiastically, he may literally find "mud in his eye."

10. John Barleycorn A personification of beer, whiskey, and other intoxicating drinks made from malted barley. This term, going back to at least 1620, owes its popularity to Robert Burns, who used the expression freely throughout the body of his poetry. In the poem, *John Barleycorn*, Burns uses the processing of the grain to produce whiskey as a symbol of man's life, death, and rebirth. The personified *John Barleycorn* is reaped, ground, roasted, and distilled; his life's blood is drunk by the men of

Scotland bringing them happiness and boldness; finally:

> But the cheerful Spring came kindly on
> And show'rs began to fall;
> John Barleycorn got up again,
> And sore surprised them all.
> (Robert Burns, *John Barleycorn*, 1787)

11. one for the road A final drink to cheer one on his way; one last drink before leaving a bar for home; one last quaff of booze to finish off a night on the town. The genesis of this phrase is uncertain, but it is believed to have originated with traveling salesmen who would order one more drink at a bar to cheer them on their journey to the next city or town. Its present popularity is largely owing to the Harold Arlen—Johnny Mercer hit song *One for My Baby*, which concludes each chorus with the lyrics:

> . . . one for my baby
> And one more for the road.

The expression has become a common catch phrase and is often heard jocularly to indicate that one's departure is imminent.

> As he settled himself in the electric chair, Fairris grinned at Elliot again and said: "Give me one for the road, big boy." (*New York Post*, January 18, 1956)

12. Parson Palmer A jocular name for one who preaches over his liquor, that is, sits and converses while he holds the bottle in his hand, thereby not allowing the dispensation of the liquor. According to Francis Grose in *A Classical Dictionary of the Vulgar Tongue* (1785), the expression derives from one Parson Palmer, who kept his liquor supply in a cellar under his pulpit. Hence, to ask a dinner guest, "Have you heard of Parson Palmer?" was akin to accusing him of detaining the liquor by preaching over it like the good parson. The term has been in use since about 1680.

Did you ever hear of Parson Palmer?
. . . He used to preach over his
liquor. (Jonathan Swift, *Polite
Conversation*, 1738)

13. rush the growler To go with a pail,
a can, or a pitcher to buy a measure of
beer; to drink heavily. In the 1800s it
was a common practice, because of the
lack of home refrigeration, to send some-
one, especially children, to fetch cold
beer in a large container from the local
saloon. The container was known by the
slang term *growler*, and since the chil-
dren were usually told to hurry, they
were said to be *rushing the growler*.
Workmen often made use of the services
of enterprising children who, for a small
fee, would fetch growlers of beer at
lunch time.

The employment by hands . . . of
boys and girls to fetch beer for them,
or in other words to "rush the
growler." (*New York Herald*, July 29,
1888)

A related term *work the growler* means
the same as *rush the growler* in the Unit-
ed States, but in Great Britain it means
to go from pub to pub in a cab, for a
growler in Britain is a four-wheeled car-
riage, so named because of the tendency
of the drivers of these vehicles to com-
plain to their fares. These expressions are
seldom, if ever, used today.

14. smash the teapot To fall off the
wagon, to resume drinking alcoholic
beverages after a period of abstinence.
The teapot of this British expression is no
doubt a punning reference to that of a
teetotaler.

15. splice the main brace To indulge in
alcoholic beverages; to celebrate an oc-
casion with potent whiskey. The *main
brace* of a ship is the rope which controls
the mainsail. In the British navy, the
sailor who performed the difficult task
of splicing the main brace was often
awarded an extra ration of rum; hence
the expression's current figurative use.

I can tell him enough Navy yarns to
fill a book—providing the main brace
is spliced occasionally. (J. H.
Jennings, in *Life*, November 1940)

16. suck the monkey This expression
has its source in the lingo of the seaman.
Sailors named the cask which contained
their liquor *the monkey*; hence, *sucking
the monkey* was to drink clandestinely
from the cask with a straw or tube in-
serted through a small hole. Another
method of *sucking the monkey* was to re-
move the milk from a coconut and fill it
with spirits, thus giving the impression
of drinking coconut milk. In time the
term came to mean drinking from any
container. The expression has been in
use since about 1800.

"Why, he has sucked the monkey so
long and so often," said the
boatswain, "that the best of him is
buffed." (Sir Walter Scott, *The
Pirate*, 1821)

17. tap the admiral To open a cask of
liquor, usually secretly; to open a bottle,
to pop the cork; hence simply to drink,
to hit the bottle, to have a nip—all usu-
ally on the sly. This phrase reputedly de-
rived from an incident in which a group
of sailors surreptitiously broached a keg
of liquor, only to discover that it con-
tained the corpse of an admiral, appar-
ently placed in the brew for purposes of
preservation while being transported
back to England.

18. troll the bowl To pass the drink
around from person to person. This
phrase, dating from the 1500s, derives
from the old practice of one person car-
rying a container of drink, usually alco-
holic, from person to person at a gather-
ing and offering each the opportunity to
partake. In time it came to mean the
simple passing of the bowl from hand to
hand about the table or the room. The
old verb *troll* meant 'ramble' or 'saun-
ter,' and *bowl* became a natural addi-
tion for the sake of euphony. By the ear-
ly 1600s the noun *troll-the-bowl* had

been created to specify one who spent too much time carousing.

19. wear the barley cap To drink too much ale or malt liquor; to get drunk; to be tipsy. This expression, originally from Scotland, alludes to overindulgence in *barley-bree* or *barley-broth,* Scottish names for a malt liquor brewed from barley. The term has been in use since the 17th century.

20. wet [one's] whistle To drink, usually a small quantity of hard liquor; to imbibe a bit, to take a nip. *Whistle* is here used jocularly for the 'mouth' or 'throat,' which must be kept moist in order to speak, sing, or whistle. *Wet whistle* appears with this meaning as early as the 14th century, in Chaucer and in the Towneley mysteries. The expression using *wet* as a verb does not appear until the 1500s.

Lets . . . drink the other cup to wet our whistles, and so sing away all sad thoughts. (Izaak Walton, *The Compleat Angler,* 1653)

Toil . . . See 132. EXERTION

Torment . . . See 170. HARASSMENT

383. TOTALITY
See also 195. INCLUSIVENESS;
377. THOROUGHNESS

1. hook, line, and sinker Entirely, completely; without reservations. The allusion is to a fish so hungry that it swallows not only the bait but the fishhook, the lead weight (sinker), and some of the fishing line as well. The expression appeared as early as 1838 in T. W. Barnes' *Memoir of T. Weed.* It most often describes the naïveté or gullibility of an accepting, unquestioning attitude, and implies that a person can be easily duped.

2. ins and outs All the details of a subject, occurrence, etc.; all there is to know about something, including nuances and subtle particulars. Some say *ins* originally referred to the party in government, and *outs* to the opposition. However, the meaning of *ins and outs* suggests wholeness and entirety because of the conjunction of opposites, regardless of what each opposite signifies. A somewhat literal application of this phrase is in reference to the windings and turnings in a road, and, by extension, to less concrete things, such as a plan or course of action.

3. love me, love my dog A proverbial way of saying "If you love me, you must accept my faults along with my good qualities." *Dog* stands for an unpleasant or undesirable but intrinsic part of a person's character, one that cannot be ignored or avoided. John Heywood used this expression in his *Proverbs* (1546). It is also said to have been a popular 12th-century Latin proverb from the writings of Saint Bernard: *Qui me amat, amet et canem meum.*

4. thread and thrum A whole, a totality; anything taken in its entirety, particularly when such is seen as embracing both positive and negative elements; the good and the bad, the wheat and the chaff, the virtues and the vices. *Thread and thrum* represents the entire length of warp yarn, including the tuft which fastens it to the loom and which remains so attached when the web is cut off. In Shakespeare's *A Midsummer Night's Dream,* Bottom as Pyramus discovers the bloodstained mantle of his beloved Thisbe and presumes her dead, whereupon he asks the Fates to make the destruction complete:

O Fates! come, come,
Cut thread and thrum,
Quail, crush, conclude, and quell!
(V,i)

The above use also plays on the notion that the Fates determine man's life by spinning, measuring, and cutting its thread at whim. See also **threads and thrums, 239. MIXTURE.**

5. whole ball of wax Any entity taken as a totality; any matter or concern together with its ramifications, implications, and consequences; its components, particulars, and details, etc. No satisfactory explanation or origin for this very common expression has yet been found.

6. whole schmear The entire story; anything taken in its totality; the whole ball of wax; all there is to know about something. This American slang expression is simply an adaptation of a Yiddish verb meaning to smear or to spread. Its date of origin as a figurative term is uncertain.

Tommy, I want a complete list of everyone who lives in the place or who works there. . . . Names, ages, business they're in, daily schedules— the whole schmear. (Lawrence Sanders, *The Anderson Tapes*, 1970)

7. whole shebang All one's worldly possessions; everything in its entirety; the whole nine yards; an entire series of actions; a soldier's tent and all his possessions. The origin of this American slang expression is somewhat obscure, but its coinage is generally attributed to Southern farmers sometime prior to the American Civil War. Probably a variation of the Irish word *shebeen*, a low, public house or a temporary habitation where illicit liquor was sold, the expression became popular during the Civil War as a term to denote a Confederate soldier's tent and other personal possessions, all his worldly goods. Union troops, returning from the war, spread the term throughout the North, and it has been common throughout the United States since that time.

Wade and me claims the whole shebang. (*The Daily Ardmoreite*, May 9, 1948)

Traditionalism . . .
See 65. CONSERVATISM

Tranquillity . . . See 266. PEACE

Transportation . . .
See 393. VEHICLES

Treachery . . .
See 33. BETRAYAL

Treason . . . See 33. BETRAYAL

384. TRICKERY
See also 274. PLOY;
370. SWINDLING

1. accidentally on purpose In a sly manner; with the real purpose intentionally obscured; with concealed intent. This American expression, indicating a deliberate action made to appear accidental, has been popular sporadically since the early 1900s.

2. Amyris plays the fool This expression is said of a person who appears to be acting crazily, but who is actually acting wisely. Amyris, an inhabitant of Sybaris, a Greek settlement in southern Italy, was sent to consult the oracle at Delphi, where he learned that his country was doomed to destruction. When he informed his countrymen of the prophecy, they laughed at him and called him a fool. He fled to Peloponnesus and saved his life, for the oracle's prediction proved true.

3. bamboozle To cheat by trickery; to mystify; to perplex; to practice deception. This colloquial expression, of uncertain derivation, has been in use since about 1700. Rejecting the probability of a Gypsy origin, the *OED* conjectures that the word is probably of cant origin.

He has been bamboozled by Miss Pat Ward. (Emanuel Trujillo, *I Love You, I Hate You*, 1955)

4. a dead cat on a line Something suspicious; a deception or bamboozlement; a carrot on a stick; an allurement; an enticement. This American black slang

term is used today to indicate that something is of a suspicious nature, that some unknown trickery is afoot. The term was probably derived from an old practice of dog thieves, or burglars, to lure dogs away from their yards. Mark Twain wrote of the practice, and P. G. Wodehouse in his short story *Ukridge's Dog College* describes the process:

> I borrowed a dead cat and tied a string to it, legged it to Old Nickerson's garden after dark, dug a board out of the back of the shed, and shoved my head down and chirruped. The dogs came trickling out, and I hared off, towing old Colonel Cat on his string. . . . Hounds picked up the scent right away and started off in a bunch at fifty miles an hour.

A less plausible, although highly conceivable, explanation for the connotation of the phrase ascribes it to a voodoo warning: if one awakes in the morning and discovers a dead cat strung up by the neck, one should take it as a signal to pack up and leave.

5. done with mirrors Usually expressing a jocular response to some imaginative or clever happening, this phrase, dating from at least World War I, was probably conceived from a trick used in magic acts on stage. Magicians and escape artists have for years used mirrors to create illusions for the audience.

> No, no, it isn't. Death's very laughable, such a cunning little mystery. All done with mirrors. (Noel Coward, *Private Lives*, 1933)

6. elwetritch hunting The misleading of a person harmlessly as a practical joke; pulling a fast one. This Pennsylvania Dutch expression, dating from the early 1800s, suggests that the victim is naïve and easily misled. The evasive elwetritch, a fictitious bird of Pennsylvania Dutch invention, is known by many other names; *elbedritch* and *elpentrecher* are among them. Reported to be similar to the snipe, the elwetritch is a shy bird; therefore, catching one is a

time-consuming process. The novice hunter is taken out into the deep woods on a cold winter's night, positioned at the intersection of two hunting paths, and left with burlap bag in hand. The "drivers" leave to flush the game toward the waiting hunter, and he waits, and waits, and waits . . .

> Have you ever been taken out to hunt Elwetritches? Have you ever been put out on a cold winter night, in the dark of the moon, to catch this elusive relative of the American snipe? (John Stoudt, *Sunbonnets and Shoofly Pies*, 1973)

7. hocuspocus See 231. MAGIC.

8. Jack Horner One who gains his own ends by trickery; a cunning cheat.

> Little Jack Horner sat in a corner
> Eating his Christmas pie.
> He stuck in his thumb and pulled out a plum
> And said, "What a good boy am I!"

Supposedly the *plum* the real Jack Horner pulled out was the deed to the manor of Mells, which is still owned by his descendants. Horner, who was steward to the Abbot of Glastonbury during the reign of Henry VIII, allegedly delivered the deeds to the king at the dissolution of the monasteries. One version holds that Jack Horner was sent as a courier with the deeds concealed in a pie. He lifted the corner of the crust, and pulled out his *plum*. A more plausible version reports that he secured the deeds by trickery and delivered them to the king, who rewarded him for his fealty.

9. play booty To act as a decoy for confederates in order to victimize another player in a game; to play or act falsely. This expression, dating from the 16th century, refers to the capturing of booty from a victim. Unlike the pirates of old who were outright thieves and plunderers, the person *playing booty* is underhanded and sneaky. The loser is usually unaware that he is a victim, and the

conspirators divide the booty after his departure.

He had scornfully refused a considerable bribe to play booty on such an occasion. (Henry Fielding, *Joseph Andrews*, 1742)

10. pull a fast one To trick by doing or saying something clever and unexpected; to gain the upper hand by a sudden show of skill; to swindle or defraud. Perhaps this originally U.S. slang expression first applied to a deft movement, such as in a game of football or some other sport, which caused control of the ball to change hands.

Brick pulled a fast one in the St. Mary's game. (J. Sayre, *Rackety Rax*, 1932)

However, this expression and the analogous *put one over on* or *put over a fast one* now apply to any remark or action which gives a person unfair advantage.

The thought that a girl capable of thinking up a fast one like that should be madly throwing herself away on Blair Eggleston . . . was infinitely saddening. (P. G. Wodehouse, *Hot Water*, 1932)

11. pull [someone's] leg To mislead a person harmlessly; to bamboozle or trick in a jocular manner; to tease or kid. This expression may have derived from the "trippers-up," a former group of English criminals who tripped and subsequently robbed their victims. The expression's current reference is to a scheme in which the victim is purposely but humorously hoodwinked.

I suspected that he was pulling my leg, but a glance at him convinced me otherwise. (F. Scott Fitzgerald, *The Great Gatsby*, 1925)

12. pull the wool over [someone's] eyes To deceive or delude, to hoodwink or bamboozle.

He said his only purpose was to "cite substantial evidence that will show just who is trying to pull the wool

over the eyes of the American people." (*St. Paul Pioneer Press*, June 1949)

Attempts to account for the use of *wool* in this expression are unconvincing. This popular Americanism dates from the 19th century.

13. Rochester rappings The knocks and rappings heard by spiritualists. This term refers to the supposed rappings heard by two sisters, Margaret and Kate Fox, in their Hydesville, New York, home in 1848. Kate quite accidently discovered that if she snapped her fingers, some ghostly intelligence in the wall would answer with the identical number of raps. A code was worked out whereby the spirit could answer all manner of questions. From this simple beginning the spiritualistic movement was initiated. Nearby Rochester was the scene of the first demonstration of spiritualism in 1849, and by 1855 the movement had spread across the United States and into Europe, where it was received with great enthusiasm, especially in England. Eventually, the sisters admitted faking the noises, but their admission did little to slow the movement.

14. rope in To draw into some scheme or enterprise by deception; to take in, to ensnare or hook. This expression had its origins in the American West when roundups were commonplace and cowboys spent their time roping or lassoing cattle in order to brand them.

He will probably rope the victim into his favorite charity, the Margaret MacMillan Memorial Fund. (*Time*, February 1950)

15. shucking and jiving Tricking another by giving a false impression; putting on the demeanor of a simpleton; deceiving another by passing false information. This American Black English phrase was derived from the two verbs, *shuck* and *jive*, both meaning in Black slang 'to deceive' or 'to hoodwink'. The expression, in use since the 1920s, originally implied

that, on occasion, a black man would assume a shuffling, "yassuh" attitude around whites in order to avoid trouble or to protect himself from a physical or psychological battering. The guise is used also to eavesdrop to gather information or to mislead authorities.

> Harry Belafonte's shucking and jiving preacher in "Buck and the Preacher" was a particularly telling portrayal. (*Newsweek*, October 23, 1972)

16. skulduggery See 76. CRIMINALITY.

17. sting A swindling scheme; a fraudulent claim; a small but successful confidence game; to cheat; to swindle; to steal; to overcharge. In the second edition of his *A Classical Dictionary of the Vulgar Tongue* (1788), Francis Grose defines a *stingbum* as a 'niggard, miser,' and from that term the idea of *stinging* someone, overcharging or soaking him so as to improve one's profits, evolved. By 1812 the verb had come to mean 'cheat' or 'rob,' and by the late 1800s the noun form had come to signify, especially in America, a smalltime confidence game. The term became a part of the common vocabulary with the popularity of the movie *The Sting*, starring Paul Newman and Robert Redford, released in 1973. Since the appearance of the film the word has been used to encompass any fraudulent operation whether carried on by underworld figures or by law enforcement officers.

> The Drug Enforcement Administration has been running an undercover sting operation for several years using advertisements to lure readers who want to manufacture illegal drugs, a magazine editor says. (*Associated Press Release*, August 11, 1983)

A related term, *wire game*, also refers to a big-time confidence game.

18. take for a ride See 82. DEATH.

19. thimblerig To manipulate data cleverly in order to deceive or confuse; to pull a fast one; to cheat or swindle. *Thimblerigging* was a swindling game popular in the 19th century at race courses and fairs. The game involved three thimbles, one of which had a pea hidden under it. The victim of this swindle would bet on which thimble was hiding the pea. Reference to the trick appeared in print by the early 1800s. Soon after, the term was used figuratively for any deceitful or underhanded manipulation.

> Don't let us have any juggling and thimblerigging with virtue and vice. (William Makepeace Thackeray, *Catherine*, 1839)

20. throw dust in [someone's] eyes To mislead or deceive, to dupe; to confuse or bewilder, to prevent someone from seeing the reality of a situation; to throw someone off guard, to render someone temporarily unfit to act. The most popular explanation for this expression is that it derives from the Muhammadan practice of casting dust into the air to confound religious enemies. Apparently Muhammad used this common military expedient on a number of occasions. The following quotation from the Koran alludes to the practice.

> Neither didst thou, O Mahomet, cast dust into their eyes, but it was God who confounded them.

The figurative use of *throw dust in [someone's] eyes* appeared in print as early as the 1600s.

21. two more, and up goes the donkey A statement made to mislead people into paying for something not forthcoming. This British expression, which was in use as early as 1830, derives from an old sham practiced at English country fairs. The showman would promise that as soon as enough pennies had been collected, his donkey would balance itself on top of a ladder. Of course, enough pennies were never collected, and the donkey never balanced itself. The statement is occasionally heard today as a statement of derision, usually thrown at some

1378

entertainer who is performing poorly or who promises something out of the ordinary.

22. whip the devil around the stump To avoid a difficulty by artful excuse or evasion; to achieve illicitly what could be achieved honorably; to dodge a problem successfully but dishonestly. This American expression, dating from the late 18th century, alludes to having such a high degree of guile that one can outmatch the devil himself in a contest of wits. The subject of much conjecture, its derivation remains obscure. It is generally agreed that the phrase was coined in the American South, and it continues to be heard more commonly there than in other parts of the country. Variants are *beat the devil around a bush*, most commonly heard in Great Britain, and *whip the devil round a post*, another American form.

I "whipped the devil round the stump" by hiring a white distiller and calling him "overseer." (J. R. Gilmore [Edmund Kirke], *My Southern Friends*, 1863)

Triumph . . . See 396. VICTORY

Triviality . . .
See 211. INSIGNIFICANCE

Troublesomeness . . .
See 96. DIFFICULTY

Truce . . . See 266. PEACE

Turnaround . . . See 325. REVERSAL

Tyranny . . . See 107. DOMINATION

U

Uncertainty . . .
See 63. CONFUSION;
198. INDETERMINATENESS;
391. VACILLATION

385. UNCONVENTIONALITY
See also 111. ECCENTRICITY;
145. FATUOUSNESS

1. Jesus freak One of a group of zealous and proselytizing converts to the teachings of Jesus Christ. This expression was coined during the 1960s to denote a member of the Jesus Revolution, a religious movement popular with many young people, especially those who were radical or anti-institutional. Their purpose was to re-establish traditional Christian orthodoxy, which according to their beliefs involves accepting a literal interpretation of the New Testament, testifying to the salvation available from belief in Jesus, and carrying the word of Jesus to others.

> In this light the herds of Jesus Freaks, and all the other herds, are as much a product of the New Left action as is anything else we set out deliberately to inspire. (Michael Rossman, *Rolling Stone*, May 9, 1974)

2. lunatic fringe The unconventional minority in a movement; those considered fanatical or foolishly radical on the outer edges of a religious or political group. This American expression can be traced directly to President Theodore Roosevelt, who coined the phrase while speaking about his Progressive Party's movement to unseat President William Howard Taft in 1912. The reference was to those political fanatics who had jumped on the Progressive Party bandwagon and were giving the party a bad name.

> Men . . . form the lunatic fringe in all reform movements. (Theodore Roosevelt, *Autobiography*, 1913)

3. march to the beat of a different drummer See 197. INDEPENDENCE.

4. offbeat Unusual, unconventional, nonconformist, odd, weird. The current meaning of the term is a figurative extension of its use in music to denote the unaccented beat of a measure. In traditional music, the downbeat is accented and the upbeat is unaccented. Black musicians deviated from this norm by playing syncopated music, i.e., music which stressed traditionally unaccented beats. Syncopated or offbeat music was thus considered unusual and unconventional. The term *offbeat* itself eventually acquired these senses, along with their usual extended ones of 'strange, bizarre, weird.'

> The off-beat death . . . in a[n] off-Broadway hotel room. (*The Daily News* [New York], September 1957)

5. off the wall Strange, far-out, way-out, weird; insane, crazy, out of one's mind.

> Deputy Inspector Martin Duffy said Mrs. Morea was "very, very distraught—really incoherent, off the wall." (*The New York Times*, July 1972)

The exact origin of this U.S. slang expression is unknown, but it may be an allusion to the padded walls of mental institutions, designed to protect overly distraught inmates from hurting themselves. Of recent coinage, the phrase enjoys great popularity in the United States; like its synonymous slang terms, *off the wall* describes ideas, schemes, beliefs, etc., as well as persons and their behavior.

Uncovering . . . See 137. EXPOSURE

Unfairness . . . See 210. INJUSTICE;
389. UNSCRUPULOUSNESS

Unimportance . . .
See 211. INSIGNIFICANCE

Unlikeness . . .
See 106. DISSIMILARITY

386. UNNATURALNESS

1. against the grain In opposition to
one's basic temperament, against one's
will. In this expression *grain* refers to the
direction of the fibers in wood. Planing
across the natural direction of the fibers
is difficult. By analogy, the *grain* has
come to mean the human disposition or
will, as exemplified in the following:

. . . and that your minds,
Pre-occupied with what you rather
must do
Than what you should made you
against the grain
To voice him consul.
(Shakespeare, *Coriolanus*, II,iii)

A second explanation is that the phrase
came from the French *contre le gré*
'against the will,' partially translated
into English as *against the gré*, and so
used by Samuel Pepys in his *Diary*.

2. fish out of water A person not in his
regular environment; one working in a
job unrelated to his chosen profession;
someone who is restless, fidgety, or dis-
contented because of his surroundings.
A fish taken out of water begins flopping
about in a desperate attempt to return to
its natural habitat. Eventually, the lack
of its regular environment kills the fish.
Thus, a person who is restless or uncom-
fortable because of strange surroundings
is often likened to a fish out of water.

3. square peg in a round hole A person
whose job is completely unsuited for
him; a person who attempts a project or
undertaking which is incompatible with
his skills and background. This self-ex-

planatory expression is still in frequent
use today.

Was there ever a more glaring case of
square peg in round hole and round
peg in square? (*Westminster Gazette*,
December 1901)

387. UNOBTRUSIVENESS

1. backroom boys The unsung techni-
cians; those who work quietly behind
the scenes; illegal gamblers; political
workers. This expression, which over the
years has acquired several connotative
meanings, was popularized, as a term
for those technologists who never gain
acknowledgement from the public, by
Lord Beaverbrook. In a BBC broadcast
on March 24, 1941, he commented
about Britain's rapid technical advances
in war-making apparatus.

Who is responsible? To whom must
praise be given? I will tell you. It is
the boys in the back rooms. They do
not sit in the limelight, but they are
the men who do the work.

The term was later applied to those po-
litical workers who toil behind the
scenes to assure the election of their par-
ty's favorites. Originally the expression
was applied to those who gambled in the
backrooms of taverns or inns to avoid ex-
posure to lawmen. It is to just such a
group that Marlene Dietrich referred
when she sang Frank Loesser's lyrics in
the film, *Destry Rides Again* (1939):

See what the boys in the backroom
will have,
And tell them I'm having the same.

2. low-key Laid-back, subdued, toned-
down, understated, purposefully low-
profile. Music played in a low key is soft-
er and more muted than that played in a
higher one. Use of the term dates from
the late 19th or early 20th century.

With the UDA building its barricades,
how long can the "low key" phase
last. (*The Guardian*, July 1972)

3. low profile Inconspicuous behavior or policy; an unobtrusive or restrained existence away from the limelight; often in the phrase *keep a low profile* 'stay out of the public eye.' *Profile* in this case symbolizes one's public image, and *low* has the sense of not highly visible, non-protruding—as in low relief.

The Nixon doctrine of "low profile" involvement, in other words a maximum of aid and a minimum of US troops. (*The Guardian*, August 1970)

4. still sow One who looks after his own interests; one who appears reserved but is actually roguish. This expression implies that one is so busy eating that he has no time for conversation. Gleaned from a 13th-century proverb, *the still sow eats the draff*, the term connotes one who serves his own best interest by getting his share while it is available.

You won't bet, Mr. Pelham? close and shy . . . ; well, the silent sow sups up all the broth. (Edward Bulwer-Lytton, *Pelham*, 1828)

5. wallflower A woman who does not join in the festivities at a dance or ball, either by choice or because she does not have a partner; by stereotypic implication, a shy or homely woman. In the world of plants, the wallflower *(Cheiranthus cheiri)* is a yellow or orange flower that grows on old walls and buildings. According to a legend recounted by the English poet Robert Herrick (1591–1674), a woman who had long been kept in captivity tried to reach her lover by climbing down a steep wall, but slipped and died. Herrick continues:

Love, in pity of the deed,
And her loving luckless speed,
Turned her to this plant we call
Now the "flower of the wall."

Thus, a girl or woman who sits along a wall at a dance is sometimes called a *wallflower*, likening her to the blossom of the same name.

[He] dances quadrilles with every wallflower in the room. (*New Monthly Magazine*, 1840)

Unrecoverability . . .
See 221. IRRETRIEVABILITY

Unrest . . . See 103. DISORDER

388. UNRESTRAINT

1. as well be hanged for a sheep as a lamb Once involved in a matter, one might as well commit oneself entirely and go the whole hog.

2. ball the jack See 354. SPEEDING.

3. catch-as-catch-can Anything goes, no holds barred; everything is up for grabs, and any and all means for getting it are permitted; hence also, unplanned, unsystematic, hit-or-miss. The expression derives from a style of wrestling in which no restraints are placed on permissible holds. Antecedents of the phrase appeared in print as early as the 16th century:

Catch that catch may. (John Heywood, *Proverbs*, 1562)

The expression may carry connotations of opportunism and unethical expediency, or simply of haphazardness and disorganization.

4. do it up brown To spare no pains or expense in an endeavor or undertaking; to go all out. According to the *OED*, *to do brown* 'to do thoroughly' may derive from roasting, since meat is brown when thoroughly cooked. Current use of this expression plays on an extended meaning of *thorough*—not just complete but more than complete, or all out, without scrimping or cutting corners.

5. go baldheaded for something To go all out; give one's all; go for something without restraint. This expression is attributed to an incident at the Battle of Warburg in 1760. Lord Cranby, leading the British Life Guards into battle, lost

his hat and wig as he galloped into battle, revealing an utterly bald head.

> It ain't my princerples nor men
> My preudent course is steadied,
> I scent which pays the best, an' then
> Go into it baldheaded.
> (James Russell Lowell, *The Biglow Papers*, 1848)

A related term *go for someone baldheaded* signifies to go whole-heartedly or impetuously, probably from the common action of flinging aside one's headgear as one wades into a struggle.

6. go for broke To go all out, to do or die, to give one's all. This recent U.S. slang expression refers to the gambler's practice of betting all his money on one throw of the dice, thus risking instant impoverishment.

> The enemy is "going all out— . . . he is going for broke." (*The Guardian*, February 1968)

7. go whole hog To engage in an activity completely and unreservedly. The most plausible origin for this expression stems from the British slang term *hog* 'shilling'; thus, to go whole hog was to spend the whole shilling at once. Another explanation relates the phrase to the Muslim injunction against eating one unspecified part of the pig. The term gained popularity in the United States during Andrew Jackson's presidential campaign in 1828 and gave rise to the noun *whole-hogger* 'a diehard political enthusiast.'

8. let 'er rip To allow or cause something such as an engine to go as fast as it can; to move ahead quickly, often violently or recklessly; to open her up. This expression is of uncertain origin, but it is likely that *rip* is adapted from its verbal sense of 'to open up.' One source suggests that the expression should be credited to a steamboat captain who, feeling protected by his newly acquired insurance, may have pushed his vessel's engines to the limit saying, "Let 'er rip (i.e., it doesn't matter if the engines explode), I'm insured!" Although it has further

been suggested that *rip* may have been derived as a bit of cryptic humor from the gravestone epitaph, R.I.P. [rest in peace], this theory, like the other, seems somewhat implausible.

> Why in the name of hell's eternal flints don't the engineer pitch in more pine knots and crack on more steam? Let her rip. (*New Orleans Picayune*, August 1846)

9. let the chips fall where they may Despite consequences, to go at something with reckless abandon; to engage in an activity wholeheartedly; to make an all-out effort; to shoot the works. Often heard in its variant forms, *let the chips fly* or *let the chips fly where they may*, this expression alludes to the activity of chopping wood. It was popularly introduced at a Republican nominating convention on June 5, 1880. Roscoe Conkling, who supported the nomination of ex-President Ulysses S. Grant for a third term despite the fact that Grant had been out of office for four years (1876–1880), used the term in his nominating speech:

> He meant that, popular or unpopular, he would hew to the line of right, let the chips fly where they may.

10. myrmidon of the law A faithful but overbearing civil officer who administers the law without protest or pity; an adherent who executes the commands of his master unthinkingly and without question or conscience. According to Greek legend, when the the natives of the island of Aegina were decimated by a plague, Zeus changed the ants running out of an oak tree into human beings to replace the inhabitants of the island. These people were called *myrmidons*, supposedly after the Greek word *myrmex*, 'ant.' They are best known as the followers of Achilles in the Trojan War, and were notorious for their unquestioning obedience and brutality. Since about 1700, the phrase *myrmidons of the law* has been used to describe policemen and other officers of the law who carry out orders blindly and unscrupulously.

11. no holds barred Without restrictions; anything goes. Although the precise origin of this expression is in doubt, it would seem to come from the wrestling use of *hold* 'grasp or grip.' Consequently, a match in which no holds were barred (disallowed) would permit any and all of the numerous varieties of wrestling locks. The phrase appeared as early as 1952 in the *Economist*.

12. on a binge A high old time; a night on the town; a period of uncontrolled self-indulgence; a spree of any kind. The origin of this expression is uncertain. One source attributes it to an old Oxford University slang word, *bingo*, for 'brandy,' which became *binge*, used in reference to a heavy drinking bout. The *OED*, however, ascribes it to *binge*, an old dialectal word meaning 'to soak a wooden vessel' and records its first use to denote a drinking bout as 1854. In any event, in time the term came to signify any spree, drinking or otherwise.

> Those who haven't traveled for a couple of years are going on a binge and the market is going through the roof. (*Time*, July 25, 1983)

13. over shoes, over boots This phrase expresses reckless abandon in continuing a course of action already entered upon. The *OED* defines *over shoes* literally and figuratively as 'deeply immersed or sunk [in something],' and since boots are usually higher than shoes, *over boots* can only mean even more deeply involved in or committed to a certain course of action.

14. pull out all the stops To use every resource at one's command; to avail oneself of any and all means at one's disposal to achieve a desired end. *Stops* in this expression refers to the stop knobs on an organ console by means of which the player controls the sets of pipes.

15. shoot [one's] bolt To make an all-out effort; to do all that one possibly can; to pull no punches; to shoot the works. This expression is derived from a

13th-century adage later stated by John Heywood in *Proverbs* (1546), and by William Shakespeare in *Henry V* (III,vii): "A fool's bolt is soon shot." A *bolt* is the missile shot from a crossbow, which, once fired, must be cranked up to produce the tension required for the next shot. Since this cranking takes time, the crossbowman was virtually defenseless during the operation. Therefore, a bolt was shot only after careful deliberation and at considerable risk. Although applied in various contexts, the expression is most popular among sports reporters.

> The home players had shot their bolt, and in thirty minutes the Birmingham team added two goals. (*Daily Express*, February 28, 1901)

16. shoot the works To make an intense effort, utilizing all available resources; to go the limit; to gamble or spend all of one's money; to tell all one knows about a given matter. This expression was probably first used by gamblers to describe a person's betting all the money he had on a single throw of the dice. Though now used in many contexts, *shoot the works* still implies an endeavor in which no effort or expense is spared, and one which involves a certain degree of risk.

> It is not my intention to shoot the whole works, but merely to examine a few specimens [of slang] and guess at their meaning. (from *American Speech*, 1941)

17. shoot [one's] wad In gambling, to bet all of one's money on the outcome of a single race, game, throw of the dice, etc.; in any endeavor, to make a final, all-out effort or a last-ditch, no-holds-barred attempt. Since a *wad* is a roll of money or a finite quantity of some valuable resource, to *shoot one's wad* is to expend it all at one time in hopes of success, usually with the implication that a fairly substantial risk of failure or defeat is involved.

18. short fuse A tendency to blow up easily; a quick temper; impatience; lack of tolerance. Usually heard in the phrase *have a short fuse*, the allusion in this American slang term is to the brief interval between the lighting of a short fuse (as compared with a long one) before the detonation of an explosion.

> Ralph, I realize you are psychologically attuned to short-fused people, but these writers are just trying to reduce the general noise level in society. (*Time*, July 25, 1983)

19. the sky's the limit A statement meaning that, in essence, there are no limits, often implying extravagance, lavishness, opulence, etc. This frequently used expression alludes to the concept of *sky* as a limitless, virtually infinite entity, and is derived from an earlier adage, *No limits but the sky*, which appeared in Miguel de Cervantes' *Don Quixote, Part I* (1605). A related variation is the phrase *to the sky* or *skies*.

20. take the gloves off To attack anything or anyone without restraint; to go at it whole hog; to pull out all the stops; to shoot the works. There are two plausible explanations for the origin of this term. One ascribes it to boxing. When boxing gloves were first introduced into the world of professional boxing, many old-timers would become disgusted and *take the gloves off*, so they could get at the business of "real fighting." Although the boxers had to learn to forego this practice, the expression remained in popular use. The second explanation ascribes it to the desirability of the natural feeling one gets when he removes his gloves and works with his bare hands. A related term, is *with the gloves off*.

> It is time, Mr. Mayor, that we took the gloves off and showed the County of London Electric Supply Company that we will fight. (*Daily Express*, March 21, 1928)

21. till all is blue Going all out; doing all one can possibly do; until one is drunk. This expression refers to carrying on until one is *blue in the face*, 'physically or mentally exhausted.'

> The land we till is all our own
> Whate'er the price, we paid it;
> Therefore we'll fight till all is blue,
> Should any dare invade it.
> (*The Balance*, July 22, 1806)

The phrase is used also to indicate that one will continue drinking until intoxicated. Such an idea can be ascribed to an antiquated belief that too much drink had such an effect on one's vision.

> We can drink till all look blue. (John Ford, *The Ladies Trial*, 1638)

389. UNSCRUPULOUSNESS
See also 189. IMPROPRIETY

1. ambulance chaser An overly aggressive lawyer who solicits clients in unethical or at best unprofessional ways. The term derives from those who actually made it a practice to arrive at the scene of a disaster in order to capitalize on its potential for their personal gain.

> In New York City there is a style of lawyers known to the profession as "ambulance chasers," because they are on hand wherever there is a railway wreck, or a street-car collision, or a gasoline explosion with . . . their offers of professional service. (*Congressional Record*, July 24, 1897)

2. blue sky To deal in unsound stocks or bonds; to make a doubtful investment; to deal in worthless or questionable securities. The allusion in this expression is to the *blue sky laws* that were passed in the United States during the early 1900s to protect the public from buying unsound stocks. One Kansas lawmaker allegedly remarked that some business companies would "capitalize the blue skies" if possible, thus giving birth to the phrase.

> "You're operating illegally," he said. "Either you are selling stock in violation of the blue sky law or you are asking charity." (*Reader's Digest*, September 1946)

3. cheap shot A brutal or unsportsman-like tackle or hit in football; taking unfair advantage of someone. The term developed from its use in American football, coming to be used figuratively in reference to a remark or action that is unneccessarily cruel or unfair.

4. crafty as a redhead Unscrupulous; deceitful; cunning; artful. This expression is generally attributed to the guile of Judas Iscariot and his betrayal of Jesus Christ. Since that legendary betrayal, red-haired persons have been unfortunate victims by association with Judas, who is said to have had red hair. The belief was given further impetus during the Middle Ages when the fat of a dead red-haired person was in demand as an ingredient for making poisons. Variants are *cunning as a red-haired person* and *cunning as a redhead.* Shakespeare alludes to the belief in *As You Like It:*

Rosalind: His hair is of the very
 dissembling color.
Celia: Somewhat browner than
 Judas's.
(III, iv)

Related terms which carry the same meaning are *cunning as a fox* and *cunning as a serpent.* Both the fox and the serpent have been associated with craftiness for centuries.

5. crooked as a dog's hind leg Dishonest; unscrupulous; untrustworthy. This American expression, dating from the late 19th century, alludes to someone who is extremely deceitful. The basis of the simile is obvious. Another term, *dogleg,* is used in golf to denote a fairway designed with a sharp angle between tee and green.

6. golden handshake In America this expression refers to a secret understanding between the Department of Defense and a contractor, which is sealed with the so-called *golden handshake.* Such a handshake assures the contractor that, if his costs exceed the specified contract figure, the government will still guarantee him a profit. The phrase has been in use since the early 1950s. See also 240. MONEY.

7. hit below the belt To use unfair means; to go against the rules. The Marquis of Queensberry rules of prize fighting, adopted in 1867, prohibit boxers from hitting their opponents below the waist belt. A derivative, commonly used term is *low blow.*

8. kickback Money returned unethically for a business favor. This expression refers to an underhanded agreement between two parties for the mutual profit of each; for example, returning part of one's salary to the man who is responsible for getting one a job, or *kicking back* part of one's profits for receiving the contract to do a job.

Longshoremen were finding it
tougher than ever to get jobs, even
through kick backs of pay, bottles of
liquor, and cigars. (Felix Riesenberg,
Jr., *Golden Gate,* 1940)

The term has been in use since about 1930, and occasionally is used to imply a simple rebate, or, more ominously, to denote an arrangement whereby a percentage of insurance money will be paid a collaborating thief if he returns stolen goods to the owner after the insurance company has made payment. A related term, *payola,* is used in commercial music circles in reference to a disc jockey who accepts money for playing a particular record frequently to increase its popularity and sales.

9. knave in grain An unprincipled, crafty man; a blackguard; a thorough knave. The allusion in this phrase is to another phrase, *dyed in the grain.* The bodies of kermes and cochineal insects, used to create a bright red dye, look like kernels of grain when dried. Since such dye is of a permanent and deep quality, *dyed in the grain* came to mean 'deep-dyed'; hence, a *knave in grain* is a thoroughgoing rogue.

O maltster! break that cheating peck;
'tis plain

Whene'er you use it, you're a knave in grain.
(Benjamin Franklin, *Poor Richard's Almanack*, 1739)

A common variant is *rogue in grain*.

10. low blow An unfair or unscrupulous attack, a cheap shot. This term probably derives from *hit below the belt*; in prize fighting, a violation of the Marquis of Queensberry rules. The word is almost always used figuratively, meaning to take unfair advantage by striking where one is most vulnerable.

11. phone phreak A cheat who avoids paying for long-distance telephone calls by employing modern technological methods. This expression first appeared in 1972, shortly after the discovery of the original *blue box*. *Newsweek*, in its February 17, 1975 edition, offered a brief, effective description of this illegal device.

> The blue box—which can actually be any color, but was christened after the first one found—beeps electronic imitations of Bell signals so that users can "seize" lines to make free calls all over the world.

Phone phreak, an alternate spelling of *freak* to conform with *phone*, is the name given to anyone who makes use of these illegal devices. A rather loose brotherhood of these *phone phreaks*, who seem to delight in their devious ways, has been put together and is referred to as *phone phreakdom*.

> Placing the signals related to a call on separate circuits . . . will also increase greatly the difficulty that so-called "phone phreaks" have in placing long-distance calls without paying toll charges. (*The New York Times*, January 18, 1976)

12. shyster An unscrupulous person, especially an attorney; a pettifogger. The origin of this American slang term is uncertain. In use since the mid 19th century, the expression has been attributed to a variety of sources: from the German

word *Scheisse* 'excrement'; from a New York attorney named *Scheuster*, who during the 1840s was repeatedly reprimanded in court for pettifoggery; from an extension of *shy* in the sense of 'disreputable'; from a corruption of the word *shicer* a 'worthless individual.' Whatever the case, in today's figurative use the word invariably refers to a person, especially an attorney, who will take advantage of people or a situation to gain his own ends.

> Next we come to his Excellency, the Prime Minister . . . a lawyer of shyster caliber. (Mark Twain, *Roughing It*, 1872)

13. thumb of gold The allusion in this phrase is to the unscrupulous practice of some merchants, especially millers. Since the Middle Ages, millers have been notorious for applying additional weight to the scales by means of the thumb. In the *Prologue* to the *Canterbury Tales*, Chaucer writes of the miller who is making the pilgrimage:

> Wel coude he stelen corn and tollen thries, And yet he hadde a thombe of gold, pardee.

The practice was not resticted to the Middle Ages, for even today many a butcher or greengrocer is accused of having a *thumb of gold*.

14. two-faced Double dealing; false; deceitful; unscrupulous; pretending to be religious when one is actually evil. This expression is derived from the Roman god Janus, who is depicted as having two faces, giving him the power to see backward as well as forward at the same time. Sometime during the 1600s the term came to connote dishonesty or insincerity.

> "I grant you that he's not two-faced," I said. "But what's the use of that when the one face he has got is so peculiarly unpleasant." (C.P. Snow, *The Affair*, 1960)

Variants are *have two faces* and *keep two faces under one head*.

Unsuitability . . .
 See 194. INAPPROPRIATENESS;
 386. UNNATURALNESS

390. URGENCY

1. all hands and the cook A state of emergency which of necessity becomes everyone's top priority. This early American cowboy expression described the precarious state of affairs in which the herds were wild and all available persons were needed to bring the situation under control. Under normal circumstances, cowboys tended herds and cooks fed the cowhands; however, an emergency required that everyone chip in, temporarily ignoring differences of rank or task.

2. at the crunch In a crisis; at the point when the chips are down; at the moment of truth. This 20th-century Briticism, a favorite expression of Winston Churchill's, has since World War II gained wide acceptance in American speech. The operative word here, *crunch*, indicates that moment when something is about to be shattered.

> The first few months of the magazine remain in my mind as a walking nightmare of impossible deadlines. . . . Then came the political conventions that summer, and more crunches. (Clay Felker, *New York*, April 6, 1966)

3. D-day See 380. TIME.

4. moment of truth The critical moment that determines the fate of one's project, or perhaps of one's life; a crucial or urgent situation. This expression, ob-
vious in its implication, was made popular by Ernest Hemingway's frequent use of the term in his early novels. Literally, he employed it in reference to that moment when a bullfighter has to face the bull in order to plunge his sword between the beast's shoulder blades; figuratively, to that moment when a person had to face up to a critical situation in life.

> "We're going through the moment of truth," says Republican Congressman Jack Kemp of New York. "What the Fed does now will determine the fate of the economy for the rest of the year, perhaps longer." (*Time*, July 25, 1983)

5. sands are running out Time is passing; the remaining time is getting short; life is waning. The allusion is to the sands of an hourglass which have long been a symbol of the time allotted for an individual's life.

> I saw, my time, how it did run, as sand out of the glass. (Lord Henry Haward, *Tottel's Miscellany*, 1557)

6. when push comes to shove See 127. EXACERBATION.

7. when the chips are down When the situation is crucial or urgent; when action must be taken; in the clutch. This expression appears to derive from poker; the chips are *down* when they are 'in,' i.e., when everyone has anted up and must play his hand.

8. zero hour See 380. TIME.

Uselessness . . . See 159. FUTILITY;
 203. INEFFECTUALITY;
 366. SUPERFLUOUSNESS

V

391. VACILLATION

See also 303. RECANTATION

1. back and fill To vacillate, tergiversate; to blow hot and cold, to be wishy-washy. *Back and fill* is a nautical phrase describing a method of maneuvering a sailboat in which the sails are trimmed so that the wind strikes them first on the forward and then on the aft side, so as to reduce forward movement. The figurative U.S. informal use of the phrase plays on the idea of the alternating forward and backward motion as opposed to a significant movement in any one direction. It is used to describe any lack of commitment to a particular point of view.

2. blow hot and cold To accept first, then reject; to seesaw, shilly-shally. This phrase stems from Aesop's fable of a traveler who was entertained by a satyr. The traveler blew his fingers to warm them, then, with the same breath, blew his broth to cool it. Apparently the satyr was appalled to meet one who could blow both hot and cold, and said:

> If you have gotten a trick of blowing hot and cold out of the same mouth, I've e'en done with ye. (R. Lestrange, *Fables of Aesop*, 1694)

As commonly used, *blow hot and cold* smacks less of hypocrisy than *back and fill*; it seems more natural and less manipulative.

3. Box and Cox Alternately sharing the same position, serving the same function or occupying the same space. *Box and Cox*, an 1847 farce by J. M. Morton, features two men—John Box and James Cox—who occupied the same apartment without being aware of each other's existence, as one worked the day shift and the other worked at night. The *OED's* earliest citation for the phrase is from 1881.

> Representing mind and body as playing a perpetual game of Box and Cox. (C. E. Raven, *Creator Spirit*, 1927)

> The French Community. . . shares, Box-and-Coxwise, the Luxembourg Palace with the French Senate. (*Spectator*, August 14, 1959)

4. chop and change To vacillate; to change frequently; to vary from moment to moment; to barter; to buy and sell. This alliterative British phrase, which dates back to the 1500s, originally dealt with bargaining. However, the *OED* explains that early in the phrase's history *chop* lost its force in the expression, and the emphasis passed from *barter* to *change*.

> O, who would trust the world . . . That . . . chops and changes every minute. (Francis Quarles, *Emblems*, 1635)

5. Delphic sword A two-edged sword; an argument that works two ways; an ambiguity. In ancient Greece the Oracle at Delphi was notorious for ambiguous prophecies, such as:

> Thou shalt go thou shalt return never in battle shalt thou perish.

Hence, a Delphic sword is double-edged: it slices on either side. Metaphorically, it alludes to the use of argument that forwards positive and negative issues simultaneously.

> "Your Delphic sword," the panther then replied,

"Is double-edged and cuts on either
side."
(John Dryden, *The Hind and the
Panther*, 1687)

6. fall between two stools To be indeci-
sive, to vacillate; to fail because of the
inability to make a choice or decision.
This expression implies that if someone
cannot decide which of two stools to sit
upon, he is likely to fall between them.

The unphilosophical attempt to sit
upon two stools. (Joseph C. Neal,
Charcoal Sketches, 1837)

The French equivalent, *être assis entre
deux chaises*, means literally 'to be seat-
ed between two chairs.'

**7. hold with the hare and run with the
hounds** To straddle the fence; to play
both ends against the middle; to get the
best of both worlds. This hunting phrase
is stronger than *back and fill* or *blow hot
and cold*, implying an inability to com-
mit oneself to one point of view, and an
attempt to cover up by espousing both
sides at once.

8. in dock, out nettle Inconstancy, vac-
illation, changeability, instability. This
obsolete expression was originally part of
a charm repeated while rubbing leaves
of the herb *dock* into nettle stings in or-
der to counteract any ill effects: "Nettle
in, dock out, Dock in, nettle out, Nettle
in, dock out, Dock rub nettle out." An
early figurative use of the expression is
found in Nicholas Udall's *Ralph Roister
Doister* (1553):

I can not skill of such changeable
mettle,
There is nothing with them but in
dock out nettle.

9. Jack of both sides One who tries to
favor both parties simultaneously in an
antagonistic situation; one who tries to
remain neutral; one who sides with first
one party and then the other, usually be-
cause of ulterior motives. This expres-
sion, dating from the mid-1500s, makes
use of the omnipresent English *Jack*, a
term applied to any man in general, to

indicate any person who tries to straddle
the fence. Variations are *Jack-o-both-
sides* and *Jack-a-both-sides*.

How often have those men of honor
. . . play'd Jack a both sides, today
for and tomorrow against. (Daniel
Defoe, *The Complete English
Gentleman*, 1729)

10. Jekyll and Hyde One whose nature
is contradictory—sometimes good and
benevolent, other times evil and malevo-
lent; a split personality; anything char-
acterized by the opposition of antago-
nistic forces. This popular phrase comes
from Robert Louis Stevenson's *The Case
of Dr. Jekyll and Mr. Hyde* (1886). In
this story, Jekyll appears as a kind, re-
spectable character, Hyde as an ugly,
despicable figure; however, both person-
alities belong to one man. The follow-
ing quotation from *The Times Literary
Supplement* (July 2, 1931) shows a cur-
rent use of this phrase.

Turner was a case of Jekyll and Hyde
in real life and oscillated continuously
between the Victorian respectability
of Bloomsbury . . . and the
Rabelaisian society of the London
Docks.

11. mugwump See 197. INDEPENDENCE.

12. on the fence Undecided, especially
in regard to political issues. This expres-
sion alludes to the dilemma of a person
atop a wall who must decide which is
the safer side to descend. In contempo-
rary usage, this American slang phrase
usually describes a politician who waits
to see how an issue fares before commit-
ting his support in either direction.

Now all would-but-dare-not-be-
politicians who insist in sitting on the
fence, will be amerced a penalty for
the same. (*Annals of Cleveland*, 1830)

13. reed shaken by the wind A spine-
less, wishy-washy person whose opinions
shift with the prevailing political or con-
ventional winds; a tergiversator. As
currently used, the image stands on its
own; the phrase bears no relationship to

the New Testament context in which it was spoken by Jesus regarding John the Baptist.

> What went ye out into the wilderness to see? A reed shaken with the wind? (Matthew 11:7)

14. shilly-shally To vacillate between two ways of thinking or acting; to dally with trifles to avoid making a decision. The original phrase was *shall I, shall I,* which was altered to *shill I, shall I.* The present form of *shilly-shally* was used as early as the 1700s. It is an innocuous phrase which, like *blow hot and cold,* suggests no hypocrisy or manipulative behavior.

> To shilly-shally on the matter, to act in one way today and in a different way tomorrow. (F. W. Farrar, *Life and Work of St. Paul,* 1879)

15. weathercock A person of wavering principles; an indecisive person; a trend follower. In the 9th century, a papal decree ordered each church to place the likeness of a cock atop its steeple in allusion to St. Peter's triple denial of Jesus before the cock crowed twice. After a time, these cocks were mounted on pivots so that they pointed to the direction from which the wind was blowing. Thus, *weathercock* acquired the sense of something being directed by the fancy of the prevailing wind. The term, used figuratively since the time of Chaucer, still carries its meaning of one of vacillating principles.

> He was . . . a terrible weathercock in the matter of opinion. (Robert Brough, *Marston Lynch,* 1870)

The expression's figurative meaning has been extended to include a person who quickly adopts the latest styles and fads, suggesting a comparison to the ever-changing directions of the fashion world.

Validation . . .
See 29. AUTHORITATIVENESS

392. VALIDITY
See also
29. AUTHORITATIVENESS

1. hold water To be valid, sound, and defensible; to show no inconsistency or deficiency when put to the test. As early as the beginning of the 17th century, this expression was used figuratively of arguments, statements, etc., although both *hold* and *water* can be taken literally to describe a vessel or other receptacle's soundness in retaining a liquid.

> Let them produce a more rational account of any other opinion, that will hold water . . . better than this mine doth. (John French, *The Yorkshire Spaw,* 1652)

2. hot rod See 354. SPEEDING.

3. leg to stand on Viable proof or justification; something on which to base one's claims or attitudes. A leg provides support and helps to maintain balance. Figuratively this expression is most often heard in the negative *not have a leg to stand on,* referring to one who fails to support his attitudes or behavior. It is frequently used in legal contexts where an inability to provide proof or justification is pronounced. The still current expression dates from the 16th century.

> She hasn't a leg to stand on in the case. He's divorcing her, she's not divorcing him. (M. Spark, *Bachelors,* 1960)

Valor . . . See 37. BRAVERY

Value . . . See 405. WORTHINESS; 406. WORTHLESSNESS

Valuelessness . . .
See 406. WORTHLESSNESS

Vanity . . . See 276. POMPOSITY

393. VEHICLES
See also 228. LOCOMOTION

1. Black Maria A van for conveying prisoners. This U.S. colloquial term reputedly derives from a Black woman named Maria Lee who ran a lodging house for sailors in Boston. Apparently she was a prodigious woman whom the police called on when they needed extra strength to handle rambunctious prisoners. Eventually her name became associated with the van which rounded up prisoners and carried them to jail or court.

> A new Black Maria, . . . a new wagon for the conveyance of prisoners to and from the courts of justice. (*Boston Evening Traveller*, September 25, 1847)

2. bone-shaker A facetious name for early model bicycles; later applied to similarly unsteady automobiles such as the early model Fords. Since the first bicycles lacked rubber tires and other modern cushioning conveniences and few roads were paved, their ride was something less than smooth and comfortable. The term was in use as early as 1874.

3. bucket of bolts An irreverent American slang term for an old rundown car that rattles and shakes noisily when moving, producing a sound similar to the rattling of a bucketful of bolts or screws.

4. flying saucer A mysterious, disk-shaped flying object; an unidentified flying object; a *UFO*. This term was coined in the late 1940s when large numbers of sightings of *flying saucers* were made. When first brought to the public's attention, these bizarre phenomena were the subject of much fanciful speculation as to their origin.

> Theodore Fitch, author of *Our Paradise inside the Earth*, believes that flying saucers originate within the earth and are piloted by small people who have discovered how to

power such vehicles with "free energy." (*The People's Almanac*, 1975)

Originally applied as a general term for all such objects, regardless of shape, in recent years the term has been replaced by *UFO*, for "unidentified flying object," for mysterious aircraft have been sighted not only in the shape of disks but also in the shapes of cigars, cones, and a number of other forms. Shooting across the sky at great speeds, often in formation, they are still reported almost daily by competent observers but remain elusive.

> It was the perfect setting for a UFO landing—a misty, eerie night on a brush-covered hill. (*The People's Almanac*, 1975)

5. meatwagon An ambulance. This slang expression alludes to the damaged human flesh transported to hospitals in these emergency vehicles.

> We'll need a couple of meatwagons. The minister and two other people were killed and . . . there're a lot of injured. (E. McBain, *Hail, Hail, the Gang's All Here*, 1971)

This expression often includes both paddy wagons and hearses.

6. paddy wagon A patrol wagon; an enclosed truck or van used by the police to transport prisoners; a Black Maria. *Paddy*, a corruption of the common Irish name Patrick, was once used as a nickname for anyone of Irish descent. Since many police officers in major American cities at the turn of the century were Irish, through association their patrol wagons came to be known as *paddy wagons*. Although the ethnic implications were gradually lost after the 1920s, the expression has remained in widespread use.

> Police who attempted to enforce city segregation rules met with a torrent of jeers, and several tennis players who sat down on the courts had to be carried to paddy wagons. (*Aurora*

[Illinois] *Beacon News*, November 7, 1948)

7. panda car A police car. This British colloquialism undoubtedly alludes to the appearance of English police cars: white vehicles with a broad horizontal stripe along the middle.

8. prairie schooner A large wagon with a high, canvas-covered frame, used by early American settlers of the West to cross the prairies. This expression is simply a fanciful name invented by the pioneers for the Conestoga wagons with which many moved their entire households westward. These wagons were named for the Conestoga valley in Lancaster County, Pennsylvania where they were first manufactured in the 1700s. Many of the wagons were lengthened or widened before the long trek west, for they not only had to transport the household goods but also to serve as a mobile home for an entire family. The term's first known appearance in print is 1858.

> To send produce to market, the [Pennsylvania] Germans invented the Conestoga wagon . . . the ancestor of the "prairie schooner" which later carried pioneers to California and Oregon. (Henry Bragdon and Samuel McCutcheon, *History of a Free People*, 1969)

The nickname *stogy* for a cigar derives from Conestoga wagon. The drivers of these wagons, before setting out on a long journey, were known to roll a number of crude cigars from tobacco grown near Conestoga. These cigars were quite strong and became known as *Conestogas* which was quickly shortened to *stogas* and then *stogies*. Today a *stogy* refers to any cheap, strong cigar.

9. rattletrap A rickety old car that rattles and clatters and shakes while in motion; a dangerously dilapidated vehicle.

10. Zulu car This American railroad slang term was born in the late 1800s when many foreign immigrants, bearing all their worldly possessions, were making their way westward by means of cheap rail transportation. For some reason not entirely clear the railroad workers nicknamed these immigrants *Zulus*, and the cars in which they rode, often meagerly converted boxcars or cattle cars, became known as *Zulu cars*.

> Zulu cars . . . provided for the transportation of the stock and household effects of the settlers . . . a weird appearance when loaded with all the impedimenta. (Godfrey Irwin, *American Tramp and Underworld Slang*, 1931)

The term is obsolete today.

Vending . . . See 337. SELLING

Vengeance . . .
See 320. RETALIATION

Verifiability . . . See 392. VALIDITY

394. VEXATION
See also 21. ANGER;
158. FURY; 170. HARASSMENT;
223. IRRITATION

1. cross [someone's] bows To annoy, displease, or offend; to overstep one's bounds and behave inappropriately toward another person. This expression has nautical origins. When one ship passes in front of another, crossing her path, the first is said to *cross the bows* of the second. Such a move is considered dangerous and a breach of the nautical rules of the road. Both the nautical and figurative meanings are in use today.

2. darken [one's] door To be an unwelcome visitor; to appear at the door; to enter one's house. This term, employed since the early 1700s, is most frequently applied in a negative sense to indicate that the person doing the darkening is not a welcome caller. The concept behind the phrase is that one's shadow falling upon the door creates a feeling of foreboding or that the blocking of the doorway with one's body causes a degree of uneasiness among those within.

I never darkened his door in my life. (Jonathan Swift, *Polite Conversation*, 1738)

3. daughter of the horseleech Anyone, especially a woman, who is overly demanding, clinging, and critical; an exigent harpy. This expression is based on a Biblical reference:

The horseleach hath two daughters, crying, Give, give. (Proverbs 30:15)

The horseleech is a large, bloodsucking parasite with a forked tongue. It was sometimes used as a medicinal leech in the medieval practice of bloodletting, i.e., removing blood from a diseased person or animal in the belief that this would effect a cure. Because of its size and voracious appetite, the horseleech was thought to be insatiable. Since each fork of its tongue is called a *daughter*, the expression *daughter of the horseleech* is appropriate in describing someone who acts like a leech, sponging off other people. The word *horseleech* was once used to describe a veterinarian.

4. dog [someone's] footsteps To follow another slavishly; to force one's presence upon another; to pester. The allusion here is to a dog following closely at its master's heels, sometimes so persistently that its master tries to rid himself of its constant presence. Metaphorically, the term has come to imply a pertinacious fellow who in trying to collect a debt or to gather information is driving his victim to distraction. The term, dating from about 1500, has acquired a disparaging connotation. Common variants are *dog [someone's] heels* and *hound [someone's] footsteps.*

Spies and informers dogged his footsteps. (William Dixon, *William Penn*, 1851)

5. drive up the wall To plague or badger someone to the breaking point; to drive someone "crazy" by repeated harassment. This slang expression brings to mind the picture of someone literally climbing the wall of an enclosing space to escape the source of annoyance. One so driven is said to *climb the wall.*

6. get [someone's] back up To anger or provoke. The reference is to the way a cat arches its back when angered or threatened. This expression appeared as early as 1728 in *The Provok'd Husband* by Sir John Vanbrugh and Colley Cibber.

7. get [someone's] dander up To arouse someone's anger or temper. There are two theories as to the origin of the phrase. One hypothesis suggests that *dander* derives from *dandruff* 'the scurf of the scalp.' Another theory is based on the meaning of *dander* as ferment used in making molasses in the West Indies. By extension *ferment* means 'agitation or tumult.' Thus, to get someone's dander up is to provoke and agitate him. This expression dates at least from 1831, when it appeared in the *American Comic Annual* by H. J. Finn.

8. get [someone's] Dutch up To arouse someone's ire, to madden; also *get [someone's] Irish* or *Indian up*. Although the exact origins of these expressions are unknown, they would seem to be references to the reputed hotheaded nature of the nationalities in question. Barrere and Leland's *Dictionary of Slang, Jargon and Cant* (1888) offers the following:

Irish, Indian, Dutch (American), all of these words are used to signify anger or arousing temper. But to say that one has his "Indian up," implies a great degree of vindictiveness, while Dutch wrath is stubborn but yielding to reason.

9. get [someone's] goat To annoy or irritate; to antagonize or frustrate a person. The expression is synonymous with the French *prendre la chèvre*, to take the goat.' The phrase, in general use since World War I, implies the prodding of someone to anger or irritability.

"You certainly got my goat" she said in the quaint American fashion, "telling me little No-no was too fat."

(H. L. Wilson, *Ruggles of Red Gap*, 1915)

10. get [someone's] hackles up To irritate or annoy; to anger, often with pugilistic potential. This expression stems from the sport of cockfighting; *hackles* are the long, shiny feathers on the neck of certain birds such as gamecocks. When confronted by its opponent, a gamecock reacts with a show of strength, causing its hackles to become erect. Through the years, this expression and the related *get [someone's] dander up* (where *dander* may be a corruption of *dandruff*, thus implying hair) have been applied to dogs and cats. When these animals are threatened, the hair on their neck involuntarily stands on end. Eventually, the figurative use to describe a person became common.

As my hackles were now fairly up, I crept and ran as well as I could after my wounded game. (Clive Phillipps-Wolley, *Sport in the Crimea and Caucasus*, 1881)

11. get [someone's] monkey up To anger or provoke. The reference is to the irritable and irascible temperament of monkeys. Used as early as 1863 in *Tyneside Songs*, the expression is originally British and has never been common in the United States.

12. make [someone's] nose swell To render someone jealous.

He heard Lord Altham say . . . my wife has got a son, which will make my brother's nose swell. (Thomas B. and Thomas J. Howell, *Cobbett's Complete Collection of State Trials*, 1813)

This expression, dating from the early 1700s, is probably a jocular variation of *put someone's nose out of joint*. At any event, this expression seems to imply that the feeling of jealousy will be manifest in the person experiencing it.

13. pain in the ass An obnoxious person; someone who is disliked; one whose behavior is annoying; a disagreeable ob-

ligation or duty. The origin of this 20th-century slang expression is unknown. The phrase suggests that someone is so annoying that he causes discomfort in a very sensitive part of the anatomy.

Connie is supposed to be attractive, vulnerable, funny, and probably a pain in the ass at times. (Michael Leahy, *TV Guide*, April 9, 1983)

Common variants of the term are *pain in the neck* and the euphemistic *pain in the rump*, both more socially acceptable than the original.

Harcourt without money was just a pain in the neck. (Peter Cheney, *A Trap for Bellamy*, 1941)

14. penny in the slot To bait someone; get someone up on his high horse; to tease subtly. This expression is usually heard when one drops a controversial topic into the midst of a conversation, especially when one knows that an ardent proponent of some cause is present. Any snide remark in opposition to the proponent's beliefs usually evokes a tirade of great proportions. It is at this point that the antagonist turns to a nearby friend and says 'penny in the slot,' an allusion to the activity that follows the insertion of money into a coin-operated machine such as a jukebox.

15. pot-house politician An obnoxious fellow who hangs about taverns expounding on his political views for all who will listen. He is usually of little knowledge or only half-informed about the issues of which he speaks. The term was coined in America in the late 1700s and is occasionally heard today.

He was distracted by petitions of 'numerous and respectable meetings' consisting of some half dozen scurvy pot-house politicians. (Washington Irving, *Knickerbocker's History of New York*, 1809)

A variant is *ale-house politician*.

16. rib [someone] To tease another person; to make fun of someone; to pull someone's leg; to irritate or vex. This expression is derived from the literal act of poking somebody in the ribs with an elbow or a finger, as some jokesters are prone to do. To *rib someone* and *ribbing* assumed their modern connotations of teasing in the early 1900s. Shortly thereafter, the noun *rib* came to connote a joke or a veiled criticism.

Wilt said, "He is a parasite." Maybe this was a rib. (Red Smith, *The New York Herald-Tribune*, January 25, 1952)

17. ruffle feathers To anger, irritate, annoy; to disturb, upset, agitate. When a bird is threatened or challenged, the feathers on its back and neck become ruffled, that is, erect, in a show of strength and apparent anger. This expression is applied figuratively to describe a manifestation of a person's anger.

The dean ruffled his plumage, and said with asperity . . . (Frederic Farrar, *Julian Home*, 1859)

395. VICTIMIZATION
See also 107. DOMINATION;
136. EXPLOITATION; 232.
MANIPULATION

1. April fish The victim of prankish humor; one who is sent on a foolish errand; a dupe; a gullible person. The expression is a borrowing from the French, *un poisson d'avril*, and describes the newly hatched, therefore naive and easily trapped, trout; figuratively, it is used to refer to the type of innocent person who is sent for add-on machines or left-handed monkey wrenches.

2. Aunt Sally A victim or scapegoat; also, an object of derision or abuse. This British colloquial phrase is derived from the carnival game called *Aunt Sally*, in which the figure of a woman's head with a pipe in its mouth is set up, the object being to knock it down by throwing missiles at it. As an object set up to be knocked down, an *Aunt Sally*, is an object for attack. It is a trial balloon on the abstract level when used to refer to a proposition or hypothesis submitted for criticism.

3. babe in the woods See 204. INEXPERIENCE.

4. carry the can To be the fall guy, to get the short end of the stick; often *to carry the can back* 'to do the dirty work.' The *can* of this British slang expression is said to be that containing dynamite used in blasting operations.

5. cat's paw A person tricked into doing another's dirty work; dupe or gull; lackey or flunky; often used in the phrase *be made a cat's paw of*. The term is derived from a fable in which a monkey persuades a cat to use its paw to obtain roasted chestnuts from a fire. The expression, used since the 17th century, appeared in an 1883 issue of *American:*

Making themselves mere catspaws to secure chestnuts for those publishers.

6. do a number on To subject to ridicule; to mock; to deride; to play upon another's neuroses; to hurt another, especially by devious means. This phrase, first appearing in the late 1960s, is seemingly an extension of the theatrical term *do a number*, or *do one's number*, meaning 'to perform before an audience.' Therefore, if someone does a number on somebody, he is obviously using him for the butt of his performance. A related term is *do a job on.*

The wife was shaken. "If I'm doing a number on the kid, I want to know about it," Mrs. Bryan said. (*The New Yorker*, May 15, 1978).

7. fall guy A loser or victim; a scapegoat. The source of this American expression can be found in the early days of professional wrestling near the turn of the century, when contests were often fixed. One participant, the fall guy, would agree to feign defeat, providing

the other wrestler guaranteed him gentle treatment. In modern usage, the term refers to a person who is duped into taking the blame for another's crime or wrongdoing.

8. flesh-peddler A person who procures customers for sexual entertainment; a pimp. The phrase originally referred to the agent of an aspiring actor or actress who *peddled* his client's physical and mental attributes to the show business bigwigs. The term's disparaging slang meaning is usually used in reference to leaders of prostitution rings or other sexually based enterprises.

9. frame-up A scheme in which fabricated evidence causes an innocent person to be accused or convicted of a misdeed; also, *put-up job*. Just as a person must fit wood around a painting or photograph to frame it, evidence must be constructed or *framed* to implicate an innocent person in a crime. The expression remains in common usage.

> He had seen honest men framed, and guilty men let off for political reasons. (Mulford, *Cassidy's Protégé*, 1926)

10. get the short end of the stick To get the worst part of a transaction; to be put at a disadvantage in a bargain or contest; to be taken advantage of and made the fall guy. The precise origin of the phrase has not been found, but it has been conjectured to be vulgar in nature. Another possibility is that the phrase derives from the custom whereby opponents break a stick to determine advantageous starting positions, order, prerogatives, etc., much the way a coin is often tossed today. This concept is preserved in the superstition surrounding the breaking of a wishbone—the person with the longer portion being the one whose wish will be fulfilled. Another possibility is that the expression refers to the practice of drawing straws or sticks to determine which person among several will be given an unsavory task. The one drawing the short straw or stick is the "winner."

11. give [someone] the shaft To victimize, to take unfair advantage of; to deceive, trick, or cheat; to treat in an abusive, harsh manner; to give someone a raw deal. This relatively new American slang expression is used figuratively and is thought to have an obscene, taboo derivation.

12. gold digger A woman who becomes romantically involved with a man, usually rich, middle-aged, and not very attractive, solely for his money and the lavish gifts he bestows on her in return for her sexual favors.

> "Jerry" Lamar is one of a band of pretty little salamanders known to Broadway as "gold diggers," because they "dig" for the gold of their gentlemen friends and spend it being good to their mothers and their pet dogs. (B. Mantle, in *Best Plays of 1919-20*, 1920)

This U.S. slang term dates from the early part of this century.

13. great fleas have lesser fleas Whether important or unimportant, everyone is preyed upon, everyone is a victim of parasitic people. In 1733, Jonathan Swift published a poem that carried the essence of this expression; however, in 1865, Augustus De Morgan put it much more adroitly in his *A Budget of Paradoxes*.

> Great fleas have little fleas upon their backs to bite 'em,
> And little fleas have lesser fleas, and so on ad infinitum.
> And the great fleas themselves, in turn, have greater fleas to go on;
> While these again have greater still, and greater still, and so on.

14. grind the faces of the poor To oppress; to overburden; to persecute; to overtax. This expression first appeared in written English in 1388 in Wyclif's translation of the Old Testament.

> What mean ye that ye beat my people to pieces, and grind the faces of the poor? (Isaiah, 3:15)

Isaiah was referring specifically to the tyranny of the elders and princes of Jerusalem and Judah, but today the term has the more general meaning of any oppression of the poor, most commonly overtaxation.

> Richelieu was grinding the face of the poor by exorbitant taxation. (Isaac Disraeli, *Curiosities of Literature*, 1823)

15. guinea pig One who is manipulated by another; a scapegoat or patsy; a human being or animal used in scientific or medical experimentation. This expression is derived from the popular laboratory rodent of the same name.

> In some of my experiments I used other athletes as guinea pigs. (R. Bannister, *First Four Minutes*, 1955)

In Great Britain *guinea pig* is also used to describe a person in a high business position who exercises little or no authority. It is the practice there for certain distinguished individuals to allow their names to be listed among the directors of a company, thus adding prestige to the firm. The expression may have originated from the token annual fee, a guinea (a pound plus a shilling), paid to such people.

16. Harmonia's necklace A symbol of evil; anything that becomes fatal to the person who owns it. This expression had its inception in an ancient Greek legend. Harmonia, daughter of Ares and Aphrodite, was married to King Cadmus, founder of Thebes. Hephaestus fashioned a necklace which was presented to Harmonia as a wedding gift. This necklace brought nothing but strife and evil to the pair and to their descendants, four daughters and one son who all met with great misfortune. No reason is given for such a disastrous gift except:

> . . . they learned . . . that the wind of the gods' favor never blows steadily for long. (Edith Hamilton, *Mythology*, 1940)

Finally, to alleviate the curse, the necklace was deposited in the temple at Delphi. A related term, *Harmonia's robe*, refers to another wedding gift, a jeweled robe, which also brought wickedness to the married couple and later to their progeny.

17. henpecked To be nagged at constantly or completely dominated by one's wife. Chickens instinctively develop a pecking order—a hierarchy in which the stronger birds assert their authority and dominance over the weaker ones. Once a chicken has established its position at the top of the pecking order, it may peck at the others with no fear of reprisal. Thus, this expression likens the pecking of a dominant hen to the eternal yammering of a harpy.

> An obedient henpecked husband. (Washington Irving, *Sketch Book*, 1820)

18. holding the bag Bearing the sole responsibility or blame; tricked, duped, made the scapegoat or fall guy; often *left holding the bag*. The British equivalent is *holding the baby*. For both versions the idea is that what was to have been shared responsibility ends up as the task of a single person. Frequently the implication is that one has been deserted or double-crossed. One explanation claims the victim is given a bag to hold or watch, thus distracting his attention from the party about to desert. Another theory suggests that the victim has been given a bag of money or goods according to some prearranged scheme, but finds himself flimflammed, with only an empty bag, after his fellows have made off. The former seems more plausible for that meaning related to responsibility; the latter, for that related to trickery.

19. hunt the gowk To go on a fool's errand; to be made an April fool of; to be the victim of a prank. This old Scottish phrase alludes to the stupidity of the *gowk* or cuckoo. Dating from the early 1700s, the expression was originally restricted to those who fell victim to

pranks on April Fool's day, but today has lost its seasonal restriction.

> Has Jove then set me among their folk,
> Cry'd Hermes, here to hunt the gowk.
> (Allan Ramsay, *Mercury in Quest of Peace*, 1728)

20. Jack-o-Lent A target of criticism; a butt; a figure of a man pelted during Lent; an Aunt Sally. The allusion in this expression is to the effigy of Judas Iscariot carried in Lenten processions and pelted by bystanders as it passed; hence, a contemptible person or a subject of criticism. The term has been in use since the Middle Ages.

> See now how wit may be made a Jack-o-Lent, when 'tis upon ill employment. (Shakespeare, *The Merry Wives of Windsor*, V,v)

21. Jack o' the clock One who is easily manipulated by others; one under the influence or control of another person; one who is at another's mercy. The allusion in this expression is to the mechanical figure which, in some old public clocks, comes out and strikes the bell on the outside of the clock. The term, which has been in use since the 16th century, has a number of variants, among which are *Jackaclock* and *Jack o' the clockhouse*. King Richard, in Shakespeare's *Richard II*, contemplating his imprisonment by Bolingbroke and realizing how much he is at his mercy, states:

> I stand fooling here, his Jack o' the clock. (V,v)

22. kangaroo court A mock trial, especially one set up by inmates of a prison; a pseudocourt usually formed by a group of prisoners or campmates for their own administration of justice; extemporaneous courts set up in frontier and backwoods areas of the early American West. Although the source of this expression is unconfirmed, Charles Funk, in *A Hog on Ice*, proposes the theory that the term is American in origin, not Australian as

one might expect. He suggests that since the date of the early usage of the term coincides rather closely with the 1849 Gold Rush, *kangaroo court* may have been coined in jocular allusion to the trials of claim jumpers.

> Harrell . . . blamed outcries heard coming from the jail on a kangaroo court conducted by the prisoners in the jail. (*Democrat*, February 24, 1949)

23. left with the dog to hold Victimized; left holding the bag; gulled; bamboozled. The image suggested by this phrase is that of a victim who has been tricked into doing some unpleasant task. Metaphorically, it suggests a person who has been left holding worthless stock or something of little value. As Roxburghe laments in a late 17th-century ballad:

> This lady of Pleasure she got all my treasure,
> Adzooks! She left me the dog to hold.

Today, the originally British expression *left holding the baby* is far more common on both sides of the Atlantic.

24. looking for a dog to kick Seeking someone to blame, looking for a scapegoat or whipping boy. This expression, apparently first used by American cowboys, is based on the psychological premise that people often tend to vent their frustrations on objects, animals, or persons whose status is inferior to their own.

25. lounge lizard A ladies' man; a man who searches for a wealthy woman to support him; a gigolo; also, *parlor snake*. This expression originated during the 1920s, when certain posh clubs hired handsome young men to dance with and otherwise entertain older women. The term subsequently evolved its connotation of an idle man who seeks a rich patroness in plush hotels, cafes, and other wealthy establishments.

> Formal recognition of those firmly attached appendages of Society, the

lounge-lizards. (*Punch*, November 1926)

The term is sometimes used today to describe a man who, as a fixture of the singles' bars, tries to seduce any woman he meets.

26. man of straw An (often imaginery) person, object, or abstract entity set up for the purpose of being knocked down; a front, a diversionary tactic, a red herring; a nonentity, an ineffectual person, a cipher; also, now rarely, an impoverished person, an indigent. The common denominator of these various meanings of the term is the sense of *straw* as a thing of little worth, substance, or solidity, a sense current in the language since the time of Chaucer. Apparently the original *man of straw* was a man of little substance or means in the monetary sense, i.e., poor. Such were wont to sell their services as witnesses, willing to act as perjurers to obtain money. Supposedly the sign of their availability was a straw in their shoe. Thus, *man of straw* or the equally common *straw man* came to mean one who let himself be used for others' purposes. It is this latter sense which survives today, though the *man of straw* so exploited may be imaginary or fictitious. The phrase first appeared in print in the late 16th century. Thomas DeQuincey used it in its current sense in 1840 (*Works*).

> It is always Socrates and Crito, or Socrates and Phraedrus, . . . in fact, Socrates and some man of straw or good-humoured nine-pin set up to be bowled down as a matter of course.

27. penniless in Mark Lane To have been the victim of a cheat; to have been gulled. This expression from the 16th century is used to refer to someone who has recently been the *mark* 'victim' of some underhanded operation and has lost all his money in the process.

> Bitten of all the bite in his bung and turned to walk penniless in Mark Lane. (Robert Greene, *Works*, 1591)

The use of the word *lane* in phrases connoting a hapless condition is frequent in English; a man who *walked in Hempen Lane* was about to meet the hangman; a man who took a *house in Turn-again Lane* is aptly described by Thomas Fuller in *Worthies of England: London* (1840).

> He must take him a house in Turn-again Lane. This . . . lieth in the parish of St. Sepulchre's, going down to Fleet dike; which men must turn again the same way they came, for there it is stopped. The proverb is applied to those who . . . must seasonably alter their manners.

In this phrase *turn-again* is used in the obsolete sense of going back or returning.

28. pigeon An innocent, naïve, or gullible person; a dupe; the victim of a swindle. The pigeon is a bird easily captured in a snare or trap which would be avoided by most other birds.

> I was instantly looked up to as an impending pigeon . . . and every preparation was made for the plucking. (*The Sporting Magazine*, 1794)

29. scapegoat A victim; a butt or *Aunt Sally*; one who bears the blame for the misdeeds of others. This word is of Biblical origin. On the Day of Atonement two goats were chosen by lot, one to be sent alive into the wilderness carrying the sins of the people upon its back, the other to be offered as a pure sacrifice to the Lord. According to the *OED*, the term was apparently invented by William Tyndale in his 1530 translation of the Bible.

> And Aaron cast lots over the two goats; one lot for the Lord, and another for a scapegoat. (Leviticus 16:8)

The modern scapegoat combines the roles of the two Biblical goats. He is blamed for the wrongdoings or folly of another person or group, and is sacri-

ficed in a figurative sense. The fate of a scapegoat is usually to be treated as an outsider, the object of ridicule or cruel indifference.

30. sponge on To live off another's earnings; to accept hospitality but not return it; to borrow money and not pay it back; to leech or mooch; also, *sponge off of*. This expression alludes to the absorptive properties of sponges. The phrase maintains widespread use today.

It was an easy matter to abandon his own income, as he was able to sponge on that of another person. (Anthony Trollope, *The Warden*, 1855)

A person who leads such a parasitic life is called a *sponge* or a *sponger*.

31. straw dogs Sacrificial tokens; scapegoats. This ancient term was coined in China well before the birth of Christ. During the 6th century B.C., Lao Tse wrote in the *Tao-teh-ching*:

Heaven and earth are without benevolence.
To them all the creatures are but as straw dogs.
The Sage has no benevolence:
To him the hundred families are but as straw dogs.

The *straw dogs* were constructed by the ancient Taoists as tokens for sacrifice. The term underwent a brief revival in the early 1970s when it was used as the title of a Sam Peckinpah film in which human beings became victims of sacrifice.

32. sucker list A list of people who are easily deceived; a list of potential victims in a confidence game; a list of potential donors for a fraudulent scheme. The key word in this expression is the American slang term *sucker*, meaning 'one who is easily duped or gulled.' Confidence men, who are credited with inventing the term, also refer to a *sucker list* as a *list of marks* and insinuate that the original such list was the telephone directory. The term has been in use since the late 1800s.

The Wallace-for-president movement has given communists a new sucker list to work on. (*Daily Ardmoreite* [Ardmore, Oklahoma], April 21, 1948)

33. suck the hind teat To get a raw deal; to get the short end of the stick; to be at a disadvantage. This expression is derived from the supposition that the rearmost nipple of a domestic animal supplies less nourishment to offspring than the other nipples. Thus, the animal that draws from the hind teat will be the weakest of the litter.

34. take in the toils To trap; to ensnare; to force into an enclosure; to outmaneuver. This expression, dating from the late 16th century, suggests that someone has been forced into an indefensible position by another's trickery or wile. *Toils* in this phrase refer to a type of trap, usually nets thrown up around an area inhabited by wild game, or a concealed net thrown up in the bush into which game may be driven.

Jackson has to be moving speedily to escape being taken in the toils of the enclosing enemy forces. (Sir Frederick Maurice, *Forty Days in 1914*, 1925)

35. take the rap See 298. PUNISHMENT.

36. throw to the wolves To sacrifice ruthlessly another person to protect oneself or one's interests; to make someone a scapegoat to divert criticism from oneself. One who is being pursued by a wolf might throw food or other objects to divert the animal's attention, and thereby escape unnoticed. In this expression the *wolf* represents any opposition or threat and the "bait" is a person—friend, colleague, subordinate—who becomes an unwitting victim.

37. wear the cap and bells See 174. HUMOROUSNESS.

38. whipping-boy A scapegoat; one who takes the blame for the wrongdoings of another. The origin of this term is the 17th-century British custom of trans-

ferring the punishment merited by a young prince or royal personage to another youth called a *whipping-boy.* The two boys were playmates and were educated together. William Murray is reputed to have been the first whipping-boy, receiving floggings for the son of King James I. Eventually the custom was abolished, but the term remained in figurative use.

396. VICTORY

See also 365. SUCCESS

1. bear away the bell To be the winner; to carry off the palm; to be preeminent. The old custom of presenting a golden or silver bell to the winner of a race or other contest is the source of *bear away the bell.* It can be used interchangeably with *bear the bell* (See 129. EXCELLENCE) when the emphasis is on the sense of being best, rather than first or victorious. *Lose the bell,* the opposite of *bear away the bell,* means to 'be soundly defeated.'

2. bear the palm To be the best; to win, to come out on top. The allusion is to the practice at the Roman Games of presenting a victorious gladiator or winner of one of the games with a palm branch as a symbol of victory. George Chapman used the phrase in his famous translation of Homer's *Iliad* (1611).

3. bring home the bacon To succeed, to win the prize; to earn the money, to be the breadwinner. Country fairs often had contests in which a greased pig was awarded to whoever could catch it. The phrase probably stems from the custom.

4. carry the day To win out in a struggle or competition, usually one of some duration, such as a political campaign or legislative tug of war. The phrase *carry it* 'to win the battle, bear the palm' appeared earlier than *carry the day,* which too was used first in this more literal fighting sense. The expression implies a series of skirmishes of undecided outcome, a seesawing of ascendancy before a definitive result is ascertained.

5. Garrison finish A spectacular victory against all odds, a finish in any kind of race or contest in which the winner comes from behind at the last possible moment. This expression, in use since 1892, takes its name from Snapper Garrison, a 19th-century American jockey who was known for winning in this manner. Although first applied only to horse racing, the term now denotes an impressive come-from-behind victory in any sport.

6. get the whetstone To be proclaimed the paramount liar; to receive a prize for telling the greatest falsehood. This expression is derived from medieval lying contests in which the greatest liar was awarded a whetstone to hang around his neck. Thomas Lupton discusses the lying sessions in *Too Good to Be True* (1580):

> Lying with us is so loved and allowed,
> that there are many times gamings
> and prizes therefore purposely, to
> encourage one to outlie the other. And
> what shall he gain that gets the
> victory in lying? He shall have a silver
> whetstone for his labour.

Apparently the *whetstone* 'a rock used to sharpen tools' emerged as the prize for this unusual competition because of its figurative association with sharpness.

> By the reading of witty arts (which be
> as the whetstones of wit). (Robert
> Recorde, *The Pathway of Knowledge,*
> 1551)

Although *get the whetstone* is now an obsolete expression, *whetstone* retains its figurative sense despite its infrequent use in literature since the early 1800s.

> Let them read Shakespeare's sonnets,
> taking thence a whetstone for their
> dull intelligence. (Percy Shelley,
> *Epipsychidian,* 1821)

7. hit [someone] for six To knock someone for a loop; to rout decisively in an argument. This Briticism had its genesis in the game of cricket. When someone hits a ball beyond the boundary, a white line marking the outer limits of the play-

ing area, it scores six runs, and a *six* is equivalent to a home run in American baseball.

> When you or Raggles hit a ball hard away for six. (Thomas Hughes, *Tom Brown's School Days*, 1857)

Although the cricket term has been in use since the mid 19th century, its figurative use was not documented until about 1900.

8. take the cake See 258. OUTDOING.

9. whitewash To prevent the opponents from scoring any points. The idea of *no score* in this informal Americanism is conveyed by the image of a *whitewashed* 'clean, having no marks' scoreboard.

> Gene Costello pitched a three-hitter in whitewashing Beaumont with only two men getting as far as third base. (*Daily Ardmoreite*, May 5, 1948)

Vigilance . . . See 17. ALERTNESS

Vigorousness . . .
See 214. INTENSITY; 399. VITALITY

Vindication . . .
See 134. EXONERATION

397. VIRTUOUSNESS
See also 405. WORTHINESS

1. braid St. Catherine's tresses To live a virgin; to declare a life of chastity. This expression is a reference to the virtuous way of life of St. Catherine, a self-proclaimed virgin, who was tortured to death upon a spiked wheel by order of the Emperor Maximus for her public confession of the Christian faith.

> Thou art too fair to be left to braid St. Catherine's tresses. (Henry W. Longfellow, *Evangeline*, 1849)

A related term, *catherine wheel*, refers to the similarity between the wheel upon which St. Catherine was put to death and the firework of that name which is driven by small rocketlike projectiles. Another name for this firework is *pin-*

wheel. The *catherine wheel window* is a wheellike window with radiating divisions, sometimes called a *rose window*.

2. halo effect The allusion here is to a seemingly angelic quality observed in a new acquaintance. The *halo effect* is transference of that quality to all other facets of a person's personality.

> The halo effect of the Senator's advocacy of the consumer caused many to consider him the ideal candidate for the presidency. (J. N. Hook, *The Grand Panjandrum*, 1980)

3. like Caesar's wife Of absolutely impeccable conduct; totally beyond reproach; without even the implication of impropriety. The phrase derives from an episode in the life of Julius Caesar as recounted in Plutarch's *Lives*. The Roman nobleman Publius Clodius was on public trial for having had an affair with Pompeia, wife of Caesar. The latter testified that he knew nothing to substantiate the charges, and Publius Clodius was consequently acquitted. Caesar nevertheless divorced his wife Pompeia as a result of the scandal. When asked why he had done so when he had maintained her innocence, Caesar is reputed to have said, "I thought my wife ought not even to be under suspicion." The more often heard version is the phrase *Caesar's wife must be above suspicion*.

4. lily-white Innocent; guileless; naive; pure; absolutely incorruptible; beyond reproach. The lily has been a symbol of purity since ancient times, and the expression has existed in English since at least the 1300s. It is now almost always heard in the negative, as in: "She's not so lily-white as she lets on to be." See also 300. RACISM.

5. odor of sanctity The appearance of holiness or saintliness; an air of respectability; a virtuous, dignified exterior. This expression grew out of a belief popular in the Middle Ages that the dead bodies of saintly persons exuded a sweet smell. The pleasant odor was interpreted

2nd Edition □ 703

as a sign of the dead person's sanctity or holiness.

> There was also a sensation of aromatic odour, as of a dead body embalmed, for when the celestial angels are present, what is cadaverous then excites a sensation as of what is aromatic. (Cookworthy, tr., *Swedenborg's Heaven and Hell*, 1756)

Today the phrase is usually used ironically to imply a disparity between appearance, such as that of an extravagant funeral, and a contrasting reality, such as the deceased's private life. Here *sanctity* is closer to *sanctimoniousness*.

6. sprout wings See 48. CHARITABLE-NESS.

398. VISAGE

See also 271. PHYSICAL APPEARANCE

1. beetle-browed Having prominent, shaggy eyebrows; scowling, sullen. Although the exact origin of this expression is unknown, it has been suggested that the reference is to the short-tufted antennae, analogous to eyebrows, protruding at right angles from the head of some types of beetles. The phrase appeared in William Langland's *Piers Plowman*.

2. bug-eyed See 368. SURPRISE.

3. fish eye A blank or quizzical gaze; a hostile stare. The vacuity of piscine eyes is clearly the source of this phrase. The following illustration is cited in *Webster's Third*:

> I saw you guys giving me the fish eye . . . so I ran.

4. gag-tooth A projecting tooth; a bucktooth. *Gag-toothed* dates from the 16th century and is rarely heard today. The current word for such a condition is *bucktoothed* or *gat-toothed*.

> If she be gag-toothed tell her some merry jest to make her laugh. (John Lyly, *Euphues, the Anatomy of Wit*, 1579)

5. grin like a Cheshire cat To grin broadly and mysteriously; to be constantly smiling widely for no apparent reason. The phrase usually carries connotations of smugness or vacuousness. The expression, which dates from the late 18th century, gained currency because of the perpetually grinning cat in Lewis Carroll's *Alice's Adventures in Wonderland* (1865). The phrase appeared in response to Alice's question as to why the Duchess' cat grinned so broadly and inscrutably:

> "It's a Cheshire cat," said the Duchess, "and that's why."

6. hangdog look A browbeaten, abject appearance; a guilty or shamefaced demeanor; a sneaky countenance; having a visage befitting a despicable person. The allusion in this expression was originally to a base, despicable person who was mean enough to hang a dog. However, time has tempered that meaning so that today one with a *hangdog look* is generally said to appear defeated, intimidated, or downcast. The expression has been in use since the mid-17th century.

> I can't have the hang-dog look which the unfortunate Theseus has. (Sir Walter Scott, *Journal*, January 7, 1826)

A related term carrying much the same connotation is *hangdog air*.

7. like an owl in an ivy bush With a vacant, dumb look; with an empty stare, such as some people have when drunk. This expression plays on the fact that the ivy bush is the favorite haunt of the owl, known for its wisdom and solemnity; it is also the favorite plant of Bacchus, the god of wine. Rarely heard today, this expression dates from the early 17th century.

> "Pr'y thee, how did the fool look?" "Look! Egad, he look'd for all the world like an owl in an ivy bush." (Jonathan Swift, *Polite Conversation*, 1738)

8. Mona Lisa smile An enigmatic smile; a smile which carries an aura of mystery about it. Known properly as *La Gioconda*, the brilliant portrait of the wife of Francesco del Gioconda known as the *Mona Lisa*, by Leonardo da Vinci (1452–1519), is distinguished by the subject's peculiar smile, a smile whose meaning has been the source of much speculation through the centuries. A common variant is the *Gioconda smile*.

> Here one could be sure that there was some kind of a queer face behind the Gioconda smile and the Roman eyebrows. (Aldous Huxley, *The Gioconda Smile*, 1921)

9. poker face An expressionless face; a visage which does not reveal one's thoughts or emotions; a dead pan. In poker, it is essential that a player not tip his hand by showing emotion in his face, lest the other players bet accordingly and thus limit his winnings or increase his losses. Though still applicable to the card game, *poker face* is also used figuratively in many varied contexts.

> He glanced around the circle and found poker faces, but there was a light in Baldy's eyes that warmed him. (Clarence Mulford, *Rustler's Valley*, 1924)

10. widow's peak A V-shaped hairline in the middle of the forehead. It was once customary for a widow to wear a black hat which had a *peak*, 'a triangular piece of material that extended down on the forehead,' as if pointing at the nose. A similar-looking hairline came to be known as a *widow's peak* by association.

> She had on her forehead what is sometimes denominated a "widow's peak"—that is to say, her hair grew down to a point in the middle. (Henry Wadsworth Longfellow, *Kavanagh, A Tale*, 1849)

A related expression, *widow's lock*, describes a lock or tuft of hair that grows apart from the rest of the hair on the head. The term alludes to an ancient su-

perstitious belief that a woman with such a stray shock of hair would be widowed soon after marriage.

Visibleness . . .

See 252. OBVIOUSNESS

399. VITALITY

1. full of beans Lively, energetic; full of vim, vigor, and vitality. Popular since the mid 1800s, this expression was originally stable slang. It was used in reference to spirited, bean-fed horses.

2. live wire A spry, energetic person. This expression, derived from the jumping and sparking of a fallen power line, enjoys common usage in the United States.

> He was, if anyone was, the live wire of the Senior Common Room. (J. C. Masterman, *To Teach Senators Wisdom*, 1952)

3. rough-and-ready Exhibiting vigor and vitality which, though unrefined and perhaps indelicate, is appropriate for dealing with a given situation; crudely efficient; rough in manner, but prompt and effective in action. Though it has been suggested that this phrase may allude to Colonel Rough, a soldier under the Duke of Wellington at Waterloo, supporting evidence for this allegation is sketchy at best. It is more likely that *rough-and-ready* arose as a description of one's manner or style, its implications being obvious.

> The rough-and-ready style which belongs to a people of sailors, foresters, farmers and mechanics. (Ralph Waldo Emerson, *The Conduct of Life*, 1860)

"Old Rough and Ready" was a nickname given to General Zachary Taylor (1784–1850) for his conduct during the Seminole and the Mexican Wars in the early 1800s. Supporters of Taylor's campaign and presidency (1849–50) were known as the "Rough and Ready Boys."

Vulgarity . . . See 288. PROFANITY

400. VULNERABILITY

See also 81. DANGER; 98. DIS-
ADVANTAGE; 196. INDEBT-
EDNESS; 279. PRECARIOUS-
NESS; 281. PREDICAMENT;
328. RISK

1. Achilles heel Any particularly vul-
nerable area; a weakness; a soft spot.
Legend has it that Thetis, mother of the
Greek hero Achilles immersed him in the
river Styx at birth, in order to make him
invulnerable. In doing so, she held him
by one heel, which was therefore never
touched by the water. Later, as a great
warrior in the Trojan war, Achilles went
unharmed by his enemies until Paris, to
whom Apollo had told the secret of
Achilles' heel, mortally wounded him by
shooting an arrow into his heel. The first
recorded use of the term was in 1810 in
Coleridge's *The Friend:*

Ireland, that vulnerable heel of the
British Achilles!

The sinew connecting the back of the
heel to the calf of the leg is called the
Achilles tendon.

2. between two fires Under attack from
both sides at once; caught in a precari-
ous or dangerous situation with no way
out. A soldier who was exposed to gun-
fire from two or more sides was said to
be *between two fires.* This literal usage
appeared as early as 1885.

He was about to find himself placed
between two fires—viz. the Mahdi
and the reinforced garrison of
Metammeh. (*The Times,* February
20, 1885)

On the figurative level current today,
fire refers to any danger which threatens
from all sides simultaneously.

3. between wind and water In a vul-
nerable, precarious position; exposed or
unprotected, defenseless. Literally, the
phrase refers to that part of the ship's
side which is alternately exposed and
submerged, marking the fluctuation of
the water line. Such an area is particu-
larly vulnerable to attack and corrosion.
Figuratively, the phrase refers to any
vulnerable state or dangerous situation.
The literal use appears as early as 1588,
the figurative as early as 1652.

Now they have crackt me betwixt
wind and water a'most past cure.
Stay, let me feel my self. (Arthur
Wilson, *Inconstant Ladie,* 1652)

Both levels of meaning remain in use to-
day.

4. caught bending Taken by surprise;
at a disadvantage; in a vulnerable posi-
tion. A child bending over is not on his
guard and is particularly well-positioned
for a kicking or spanking. A 1903 song
by George Robey included the line:

My word! I catch you bending!

5. caught flat-footed Caught unpre-
pared, unready, by surprise, not on one's
toes. This phrase probably derives from
baseball or football, and dates from the
early 1920s. It refers to someone's being
caught (thrown out or tackled) while
standing still or flat-footed. A person in
such a position reacts less quickly than
one on his toes.

6. caught with [one's] pants down Tak-
en completely off guard or entirely by
surprise; found in a compromising or
embarrassing position; hence, also un-
questionably guilty; caught in the act,
in flagrante delicto. General acceptance
of this inelegant expression has been at-
tributed to its appearance in a 1946 is-
sue of *The Saturday Evening Post.*

7. chink in [one's] armor A weakness or
vulnerability; an area in which one's de-
fenses are inadequate or ineffective; a
personality flaw. The phrase alludes to
the armor worn by knights. A *chink*
'crack, cleft, or narrow opening' could
cost a knight his life. Figuratively, a
chink in one's armor refers to a personal
rather than physical vulnerability. Some
modern psychologists have adopted the
word *armor* to mean 'character or per-

sonality,' emphasizing those aspects of one's character which are formed in defense and serve self-protective functions.

8. clay pigeon A person or thing in a vulnerable position; an easy mark; one who can be easily taken advantage of; an easy job or task, a cinch. This American slang expression is an extension of the term *clay pigeon* as used in trapshooting, where it represents a disklike object of baked clay thrown into the air as a target. It has been in literal usage since 1888.

9. fair game A legitimate object of attack or ridicule; an easy target of derision. The term originated with wildlife laws limiting the hunting of certain animals to a specific time or season of the year, during which the hunted animals are *fair game*. In its figurative sense, this phrase refers to a person or thing whose manner or appearance makes him a likely victim of mockery.

> In that character it becomes fair game for ridicule. (Jeremy Bentham, *Chrestomathia*, 1816)

10. gone coon One who is in bad straits; a person who is on the brink of disaster, whose goose is cooked; a lost soul, a goner. A *coon* (raccoon) which cannot escape from a hunter is a gone coon. A ludicrous fable probably fabricated to explain this expression tells of a raccoon which, trapped in a tree at gunpoint by Davey Crockett, said to the great marksman, "I know I'm a gone coon." The Democratic party was aware of the fable when they applied the label *coon* to the Whigs during the presidential contest of 1840.

11. gone goose One who is in a highly vulnerable situation; a hopeless case; a lost cause; one in dire straits. This Americanism, dating from about 1830, is probably an alliterative variation of the older term, *gone coon*, which dates from the days of the American Revolution.

> If he hadn't come just as he did, I'd been a gone coon. (Harold Frederic, *The Deserter*, 1898)

A large number of anecdotes exist which tell of treed coons pleading with the hunter not to shoot for they know they are *gone coons*. Apparently the expression was so satisfying that a number of similar terms arose, *gone chick*, *gone beaver*, *gone gander*, and *gone horse*, all conveying the same meaning.

> Two more minutes of her, and I'm a gone goose. (*The Saturday Evening Post*, March 19, 1949)

12. live in a glass house To be in a vulnerable position, to be open to attack; to live a public life, to be in the public eye. The expression plays on two well-known properties of glass—its transparency and its brittleness. The phrase is apparently a truncated version of the old proverb *people who live in glass houses shouldn't throw stones*, dating from the early 17th century.

> In the glass house world of commercial publishing, . . . Peter Mayer is something of a superstar. (*Saturday Review*, February 1979)

13. on the rebound Living through a period of time after an emotional trauma when one is especially vulnerable.

> She caught him on the rebound, i.e., got engaged to him, after he had been refused by someone else. (W. E. Collins, *Contemporary English*, 1927)

The allusion is to grabbing a missed shot in basketball or striking a hockey puck deflected by the goalie and making a goal, implying that the defending team was taken unawares or was in a lax or defenseless attitude. In the game of love, one suffering disappointment from a recently-ended love affair is said to be *on the rebound* and can often be susceptible to another's advances. The term has been in use since the early 20th century.

14. on the ropes On the verge of ruin or collapse; at the mercy of whatever forces threaten to overcome one. The meta-

phor is from the boxing ring. When a prize fighter is on the ropes, he is in a weakened and very vulnerable position. His opponent is in control, and will probably soon be able to finish him off.

15. open season A time when persons or ideas in disfavor are subject to attack from all sides. The expression, of American origin, comes from hunting and refers to those periods during which various types of game are legitimate quarry.

16. out on a limb In a vulnerable, compromising, or risky position; at a disadvantage. This expression refers to the predicament of a person in a tree who, having climbed out onto one of the branches (limbs), faces the prospect of injury if the limb should not be strong enough to support him. The figurative implications are that a person has espoused an unconventional idea or cause which, if it fails, may precipitate his downfall, resulting in a loss of influence, prestige, and credibility.

> No one is willing to go out on any limb. No one is willing to say yes or no to a proposition. He must always go to someone higher. (John Steinbeck, *Russian Journal*, 1948)

17. over a barrel In an embarrassing or uncomfortable position or situation; with one's back against the wall, helpless, in someone else's power. This chiefly U.S. slang expression dates from at least 1939. According to the *OED* the allusion is to the helpless condition of a person who, after having been saved from drowning, is placed over a barrel in order to clear the water out of his lungs.

18. sitting duck An easy mark or target, a ripe victim; a person or thing in an open or vulnerable position. The allusion is to the comparative ease of shooting a duck resting on the water as opposed to one in flight.

19. stick [one's] neck out To expose oneself to danger or criticism; to take a chance, to risk failure; to invite trouble. This early 20th-century American expression plays with the idea that sticking one's neck out is equivalent to asking to have one's head chopped off. Thus vulnerability, usually nonphysical, is also implicit in the figurative uses of this expression.

> We've stuck our necks out—we're looking for trouble, see? (H. Hastings, *Seagulls Over Sorrento*, 1950)

20. turn turtle To be utterly helpless or defenseless. When turned on their backs, turtles are completely powerless and without defense. *Turn turtle* also means 'to overturn, upset, capsize.'

21. up a tree Cornered, trapped, caught; at another's mercy, in another's power. The expression is said to come from coon hunting; once a raccoon is treed by the hounds, he's a gone coon.

> I had her in my power—up a tree, as the Americans say. (William Makepiece Thackeray, *Major Gahagan*, 1839)

22. where the shoe pinches The sore spot or vulnerable area; the true source of trouble or distress. This expression purportedly derived from Plutarch's biography of Paulus Aemilius. Questioned as to why he divorced his fair, faithful, and fertile wife, Aemilius removed his shoe and replied, "Is it not handsome? Is it not new? Yet none knows where it pinches, save he that wears it." This expression, equivalents of which exist in most European languages, appeared in English literature as early as the time of Chaucer.

> Subtle enemies, that know . . .
> where the shoe pincheth us most.
> (Gabriel Harvey, *Letterbook*, 1580)

W

401. WEAKNESS

1. a creaking gate hangs long on the hinges A proverbial expression suggesting that certain people, despite symptoms of frailty or weakness, may well outlive presumably healthier people. Dating from the 1700s and still in occasional use, the term is used in its figurative sense to give a lift to the elderly or infirm. Variant forms include the abbreviated *creaky gates last longest* and, with a different image evoked, *a creaking cart goes long on its wheels*.

> Your mother may live yet a score of years. Creaky gates last longest. (S. Baring Gould, *Mehalah*, 1880)

2. mollycoddle (*n.*) A person of weak character who wishes to be fussed over and pampered; one who is overly concerned about his own health; a namby-pamby; (*v.*) to spoil by pampering and over-indulging; to fuss over; to be overly protective. This term was coined about 1830 by combining the words *molly*, an 'effeminate man' or a 'milksop,' and *coddle*, 'to treat as an invalid.' Theodore Roosevelt, who looked upon those who were physically weak with disdain, was fond of the term and used it frequently in his writing and speech. In his *Autobiography* (1913) he refers to:

> The large mollycoddle vote—the people who are soft physically and morally.

Wealth . . . See 14. AFFLUENCE

402. WEATHER

1. Alvina weeps The wind howls; the wind blows loudly. An ancient Flemish legend tells of Alvina, the daughter of a king, who was cursed by her parents for marrying a man not of their choosing. She supposedly became invisible but roamed about the air, wailing and lamenting her fate. Thus, when the wind howls about the house, one says: "Hark! Alvina weeps!"

2. cold enough to freeze the balls off a brass monkey Exceedingly cold; so cold that it beggars description. In polite company this jocular expression is usually heard as *cold enough to freeze the tail* (or *ears*) *off a brass monkey*. In use since the late 19th century, the phrase is common to all countries where English is the native language. Although the term is sometimes used in its entirety, frequently only a part of it is encountered.

> It was cold enough to freeze a brass monkey. (James Warren, *No Sleep at All*, 1941)

Eric Partridge reports, in *A Dictionary of Catch Phrases* (1977), that the Manchester University *Rag-Bag* once printed:

> The cold in Moscow was so intense that the brass monkeys on top of the Kremlin were heard to utter a high falsetto shriek.

3. **dog days** The most oppressively hot, uncomfortable, and unhealthy time of the year; the height of summer, usually calculated to be from about July 3 to August 11. These are supposedly the days when Sirius, the Dog Star, rises at the same time as the sun. The name *dog days* (Latin *dies caniculares*) derives from the ancient belief that the customary sultriness and unwholesomeness of this season were due to the influence of the Dog Star. The origin of the name has also long been associated with the popular superstition that during this particular time of the year dogs are most apt to go mad. The term has been in use since the early 16th century.

4. **dogwood winter** A few chilly days in late spring; a sudden cooling of a friendly atmosphere. In the lower Appalachian Mountain region and in the adjacent areas along the Atlantic coast, as far north as New Jersey and Pennsylvania, *dogwood winter* is as well established a weather phenomenon as *Indian summer* is throughout the rest of the United States. Any cold spell immediately following the blooming of the dogwood trees, one of the flowering trees to bloom earliest in the northern United States, is referred to as *dogwood winter*.

> "Don't you know what dogwood winter is?" demanded the man from Hickory, N. C. "There is always a spell of it in May, when the dogwood trees is in bloom. For several days there is cold, disagreeable, cloudy weather, and often a touch of frost." (*American Folklore*, 1907)

The term has been in use since the mid 19th century, and occasionally is heard as a figurative expression of coolness and disagreeableness on a person's part.

5. **gully washer** A very heavy rainstorm, a downpour. This American colloquialism, particularly common in the Texas-Oklahoma area, was obviously coined because of the swirling rush of water through gullies during such storms. An especially violent gully washer is sometimes jocularly called a *gully whomper*. The expression has been figuratively extended to include a great onrush or outpouring of anything.

> The drouth of senatorial candidates in Johnston county will be broken with a "gulley washer" here this week. (*The Capital-Democrat* [Tishomingo, Okla.], June 1948)

6. **halcyon days** See 266. PEACE.

7. **Hulda is making her bed** An expression denoting a snowfall. In ancient German mythology Hulda is the goddess of marriage and fertility. Although this expression is of unknown origin, it is reasonable to conjecture that Hulda had a feather bed which she prepared for the delights of newlyweds and from which some plumes periodically escaped to fall to the earth as snow.

8. **Indian summer** A brief respite in the late autumn of North America, characterized by hazy, balmy weather. This expression is thought to have originated in New England, where the Indians took advantage of the unseasonably warm spell to make their final winter preparations. The term is used frequently in the northern United States and Canada, where this short reappearance of summer regularly occurs each fall.

> Meanwhile the Indian summer continued warm and dusty on the trodden earth of the farmyard. (J. Rae, *Custard Boys*, 1960)

Like other terms denoting time of year or day, *Indian summer* is often analogously applied to one's life, indicating a period of renewed vigor or health amidst a stage of general decline.

> The works of his Indian Summer when, in the last five years of his life, inspiration came to him once more. (N. Del Mar, *Richard Strauss*, 1962)

9. **Mother Carey is plucking her chickens** Sailors' slang for falling snow. In this expression, *Mother Carey* is derived from the Latin *mater cara* 'mother dear,' apparently a reference to the Virgin Mary. *Mother Carey's chickens* is a

sailor's appellation for stormy petrels, friendly birds which warn sea voyagers of upcoming inclement weather. Thus, the expression likens fluffy, falling snow to small tufts of white feathers.

10. Queen's weather Ideal weather conditions; magnificent weather occurring on a day set aside for a festival, picnic, or other outdoor activity. This expression originated from the disproportionate number of fine days which coincided with Queen Victoria's public appearances.

> Although the wind is rather high, Queen's weather prevails.
> (*Johannesburg Star*, April 1899)

11. rain cats and dogs To pour, to come down in torrents, to teem. This common but puzzling expression has appeared in the writing of such varied authors as Swift, Shelley, and Thackeray. The most repeated explanation relates it to the storm god Odin, often pictured with cat and dog who according to Norse mythology influenced the weather. More plausible but equally undefinitive is the theory suggesting a derivation from an obsolete French word *catadoupe* 'waterfall,' itself related to an actual waterfall of the Nile in Ethiopia.

12. rain pitchforks To rain hard and piercingly; to rain straight downwards, so that the rainfall appears discernible as separate streaks of water. This primarily U.S. colloquial expression, probably coined by New England farmers, sees infrequent usage today, perhaps because the implement conveying the image is no longer part of most people's immediate experience.

> I'll be even with you, if it rains pitchforks—tines downwards. (David Humphreys, *The Yankey in England*, 1815)

13. socked in Closed in by bad weather, usually said of an airport; fogbound. This expression, usually found in the context of flying, has its roots in the use of a windsock at airports to reveal wind direction. The windsock, a large, open-ended sleeve attached to a post by a pivot, at one time afforded pilots their only indication of wind direction and, roughly, wind velocity. When the weather deteriorated to the point that the sock couldn't be seen or, as in foggy conditions without wind, it just hung down loosely and landings and take-offs were impossible, the field was said to be socked in.

14. three-dog night A bitterly cold night. This expression is derived from the Eskimos, who purportedly gauge the cold by how many sled dogs one must sleep beside to stay warm during the night. Thus, a night which requires the warmth of three dogs is a frigid night indeed. Even though the temperatures in the temperate zone of the United States do not plunge nearly as low as they do in polar regions, the expression has nonetheless become a popular American colloquialism for the coldest winter nights.

15. weather-breeder A day of unseasonably or otherwise exceptionally magnificent weather, formerly thought to be a harbinger of an approaching storm; a daylong respite in a period of inclement weather. This expression originated in England, where the weather is frequently dank and overcast. It can thus be assumed that, since such fine days were almost invariably followed by foul weather, the English saw a weather-breeder as a bad omen.

> Look at a very fair day, as that which may prove a weather-breeder, and usher in a storm. (John Arrowsmith, *A Chain of Principles*, 1659)

Wedlock . . . See 233. MARRIAGE

Weirdness . . .
See 385. UNCONVENTIONALITY

Well-being . . . See 162. GOOD HEALTH

Wholeness . . . See 383. TOTALITY

403. WICKEDNESS

1. show [one's] horns To reveal one's evil intentions; to expose one's malicious, venomous, or insidious nature. This expression alludes to the horns commonly portrayed on the forehead of Satan, an attribute which also gave rise to one of the devil's nicknames, Old Hornie.

2. show the cloven hoof To reveal a treacherous nature or evil intentions. The allusion is to the cloven hoof of Satan, long representative of evil. Although the simple term *hoof* was in use in this figurative sense as early as 1638, the phrase did not appear until much later.

> [It] had caused him to show the cloven hoof too soon. (James Payn, *The Luck of the Darrells*, 1885)

3. son of Belial A thoroughly evil and despicable person; the embodiment of wickedness; the devil. This expression originated in the Old Testament (I Samuel 2:12):

> Now the sons of Eli were sons of Belial; they knew not the Lord.

Belial, apparently derived from the Hebrew *b'li ya'al* 'without use,' became the equivalent of Satan in later Jewish writings. *Belial* was employed also as a name for one of the fallen angels in John Milton's *Paradise Lost* (1667). The expression maintains its theological application for the personification of evil.

> A scoffer, a debauched person, and, in brief, a man of Belial. (Sir Walter Scott, *The Monastery*, 1822)

404. WILDNESS

1. wild and woolly Unpolished, unrefined; crude, untamed, barbarous; rough and in its natural state. This American slang term, coined to describe the characteristics of the country's early western frontier, became extremely popular during the late 19th century. Be-

sides the alliteration, the term probably caught on because of *woolly*, which, in this phrase, means 'rough.'

> How did this relic of the wild and woolly West find its way
> to tradition-steeped New Orleans? (*New Orleans Times-Picayune Magazine*, December 4, 1949)

Winning . . . See 396. VICTORY

Words . . . See 20. ANECDOTE;
 225. LANGUAGE

Work . . . See 132. EXERTION;
 253. OCCUPATIONS

Wornness . . . See 343. SHABBINESS

Worry . . . See 22. ANXIETY

Worsening . . .
 See 127. EXACERBATION

405. WORTHINESS
See also 397. VIRTUOUSNESS

1. fall of a sparrow Small events are significant, especially in the eyes of God; do not underestimate the importance of small things. Although there is an allusion to the fall of a sparrow in the New Testament, Matthew 10:29, the phrase in this exact form derives from Shakespeare's *Hamlet*. Hamlet, who has just accepted a fencing challenge from Laertes, a superior swordsman, explains to Horatio why he is willing to face Laertes.

> Not a whit; we defy augury. There's a special providence in the fall of a sparrow. (V, ii)

2. good wine needs no bush A worthwhile product doesn't need to be advertised; a thing of quality speaks for itself. An ivy bush, the plant sacred to the Greek god Bacchus, was at one time a common symbol hung outside taverns to indicate that wine was dispensed inside.

Although the practice itself has died, one may still see reminders on the sign boards of some taverns and pubs. The implication in this expression is, of course, that if a public-house owner serves good wine, he doesn't need any ivy. The phrase first made its appearance in the 1500s.

Some ale-houses upon the road I saw,
And some with bushes showing they
wine did draw. (*Poor Robin's
Perambulations*, 1678)

3. **nothing to sneeze at** Not a thing to be ignored or rejected as a trifle; not a person to be treated with derision or contempt; worthy of serious consideration; also *not to be sneezed at*. Now used exclusively in the negative, *to sneeze at* 'to regard as of little value' was common in the 1800s, though precisely how *sneezing at* came to be equated with an estimation of worth is not clear. The expression is most often found with reference to sums of money, as illustrated by the following passage from Lockhart's *Memoirs of Sir Walter Scott*:

As I am situated, £300 or £400 is not to be sneezed at.

4. **pay [one's] dues** To prove oneself worthy by fulfilling obligations; to start at the bottom, gain experience, and work one's way up. As early as the 1600s, *dues* referred to a fee for membership in an organization. In the United States, during the 1900s, *dues* gained currency as a figurative slang term for nonfinancial obligations; *pay one's dues* means to earn rights or recognition with hard work and perseverance. The expression is current especially among jazz musicians in referring to the years of anonymity and financial hardship devoted to learning and developing an individual style.

Duke, Thad, Mel and myself, we've paid considerable amounts of dues in trying to get this thing off the ground. (*Down Beat*, April 17, 1969)

5. **worth a Jew's eye** Of great value; extremely precious; worth a fortune. The allusion in this phrase is to the medieval practice of torturing Jews by gouging out an eye to extort money from them or to force payment of the exorbitant taxes which were levied upon them. The expression has been in use since about 1200.

Although the journey . . . would cost
twice the value of a gold seal, yet,
that in the end it might be worth a
Jew's eye. (Frederick Marryat, *Peter
Simple*, 1833)

6. **worth [one's] salt** To be worthy or deserving of one's wages or pay; to be efficient and hard-working; often used negatively in the phrase *not worth one's salt*. The *salt* of this expression is said to have come from the old Roman practice of paying soldiers their wages in salt, then a rare and precious commodity. When money for the purchase of salt was substituted for the salt itself, it was known as *salārium* 'salt money,' the predecessor of the English *salary*, from Latin *sal* 'salt.' *Worth one's salt* has been in common usage since the early 19th century.

7. **worth the whistle** Worthy, deserving; acceptable, commendable; of value and importance. This expression, implying that a person is worth the effort of whistling for him, is derived from a proverb cited by John Heywood in *Dialogue Containing the Number in Effect of All the Proverbs in the English Tongue* (1546):

It is a poor dog that is not worth the whistling.

Shakespeare uses the phrase in *King Lear* when Goneril implies that at one time she was held in high regard by Albany, but that now she is being treated more poorly and with less respect than one would accord a common cur:

I have been worth the whistle. (IV,ii)

The expression is often used in the negative *not worth a whistle*, frequently to

describe a person whose friendship is considered worthless.

406. WORTHLESSNESS
See also 193. INABILITY;
211. INSIGNIFICANCE

1. all leather or prunella Of little importance; worthless; of no account. Prunella, once used primarily for clergymen's gowns, is a worsted material, and probably named for its dark color. The expression was born in 1734 when Alexander Pope wrote in his *Essay on Man:*

Worth makes the man, and want of it
 the fellow;
The rest is all but leather or prunella.

A close reading of the work indicates that Pope's intent was to demonstrate the difference between the functions of a cobbler and a parson. However, later loose usage of the term established a meaning other than that intended by Pope. In his *Epitaph for Joseph Blackett* (1811), Lord Byron used the expression in its modern connotation.

Then who shall say so good a fellow
Was only "leather and prunella"?

2. bishop's cope Something useless to all parties involved in a dispute. The origin of this expression is uncertain, but it is believed to have stemmed from an incident in the town of Bruges, in Belgium. A newly appointed bishop, as he was entering the town, removed his cope and gave it to the people. Eager to own a piece of the cloak, the townspeople ripped it into shreds, thereby assuring each person a small portion of the garment but rendering it useless for any other purpose.

3. bottom of the barrel The dregs; the lowest of the low; the end of the line; financial or moral bankruptcy; often *bottom of the pickle barrel*. Although the exact origin of this expression is unknown, it apparently refers to the barrels formerly used in grocery stores to keep pickles. By the time the last of the pickles were sold, they were often not fit to eat. The phrase is said to have been popularized by baseball announcer Red Barber in his broadcasts of the Brooklyn Dodger games from 1945–55. A variation is *reach the bottom of the barrel. Scrape the bottom of the barrel* means to 'try to find something of use or value after the main resources have been exhausted,' and to 'make do as best one can with what is available.'

4. brass farthing Something worthless or useless; a very little; a wooden nickel. The origin of this expression is usually attributed to an act of King James II. During his reign James reduced the value of the currency by issuing such worthless coins as brass pennies, halfpennies, and farthings; thus, bringing about the expression *not worth a brass farthing.* However, the earliest recorded entry in the *OED* for this expression is:

As bare and beggarly as if he had not
one brass farthing. (Daniel Rogers,
Naaman, the Syrian, 1642)

thus belying the supposed origin. The expression remains in common use.

He did not care a brass farthing.
(George Bernard Shaw, *Fanny's First
Play,* 1911)

5. catchpenny Worthless, cheap, gimmicky, as an article designed to trap the dollars of unwary buyers. Though originally and still often applied to publications, the story that the term originated from a deliberately misleading headline used by the British printer Catnach in 1824 regarding a sensational murder case is belied by Oliver Goldsmith's 1759 reference to:

one of those catchpenny subscription
works.

6. chips and whetstones Worthless objects; trifles; trinkets; gewgaws. During the early pioneer days of America, toys were not readily available for children; hence, it was often necessary to improvise playthings from whatever was available. Since the average rural settler found it necessary to clear his land of

trees and shrubbery, great piles of woodchips accumulated along with many dull, worn-out whetstones. Such items were readily turned into toys by the creative pioneer child.

> When father told children not to exchange money or other belongings for chips and whetstones, he meant not to waste them on worthless trifles. (*American Speech*, December 1952)

7. dicers' oaths Worthless statements; unbelievable promises; falsehoods; hypocritical assertions. *Dicers' oaths* may be applied to all gamblers, not to just to those who play at dice. When caught up in the heat of his passion, a gambler should not be believed. His promises, such as never to gamble again, or to repay borrowed money as soon as he wins, are completely untrustworthy. The expression, dating from the 16th century, is frequently heard as *false as dicers' oaths*.

> Such an act
> That blurs the grace and blush of modesty,
> Calls virtue hypocrite, takes off the rose
> From the fair forehead of an innocent love
> And sets a blister there, makes marriage-vows
> As false as dicers' oaths.
> (*Hamlet*, III,iv)

8. harp shilling See 240. MONEY.

9. kickshaw Trivial; insignificant; worthless; gaudy but useless; garish but without value. This expression, derived from the French *quelque chose* 'something, anything,' originally referred to nonsense or buffoonery. In Shakespeare's *Twelfth Night*, for example, when Sir Andrew Aguecheek states, "I delight in masques and revels sometimes altogether," Sir Toby Belch asks:

> Are thou good at these kickshaws, knight? (I,iii)

The term, occasionally used in reference to small tidbits of food or hors d'oeuvres,

usually describes something of a trivial nature.

> He sang . . . no kickshaw ditties. (Charles Dickens, *The Mystery of Edwin Drood*, 1870)

10. not worth a continental Completely worthless or valueless; good for nothing, useless. A *continental* was a piece of the paper currency issued by the Continental Congress during the American Revolution. Its value depreciated so drastically that it was virtually worthless by the end of the war. Use of this U.S. colloquialism dates from the 19th century.

> The next day he is all played out and not worth a continental. (G. W. Peck, *Sunshine*, 1882)

11. not worth a damn Worth nothing, of no value or use; also *not worth a tinker's damn* and *not worth a twopenny damn*. A *damn* is nothing more than a mild curse word, in common use for centuries.

> A wrong . . . system, not worth a damn. (George Gordon, Lord Byron, *Diary*, 1817)

It is most probable that a *tinker's damn* has nothing to do with the tinker's tool called a *dam* (a piece of dough used to keep solder from spilling over), as has been frequently theorized; but that it rather refers to the reputation of these itinerant jacks-of-all-trades for their propensity toward cursing. The exact origin of *a twopenny damn*, generally attributed to the Duke of Wellington, is not known. It may, however, be connected with *a tinker's damn* since twopence was apparently once the going rate for a tinker's labor.

12. not worth a rap Worthless; valueless; good for nothing. The *rap*, a counterfeit coin worth about a half a farthing, was passed for a halfpenny in Ireland during the 18th century because of the scarcity of authentic small coins. Since the coin was virtually valueless, it came to symbolize anything of little

worth. A related term, *not care a rap*, appeared at the same time.

> For the mare with three legs, boys, I care not a rap. (William H. Ainsworth, *Rookwood*, 1834)

13. not worth a straw Worthless, value-less, insignificant, useless; also *not worth a rush*. Although both expressions date from about the 15th century, *not worth a rush* has been replaced in current us-age by *not worth a straw*, most likely a variant or derivative of the former. The allusion may be to the former practice of strewing rushes, or straws on the floor as a kind of carpeting for visitors. Appar-ently fresh rushes were put down only for the more distinguished guests, while visitors of lower social status used those already trod upon by their superiors or none at all.

> Friends' applauses are not worth a rush. (W. Pope, in *Flatman's Poems*, 1674)

14. not worth powder and shot Not worth the trouble or effort, not worth the necessary cost or energy. The allu-sion is probably to an animal so small that it would provide neither meat nor pelt of sufficient value to compensate for the price of the ammunition necessary to shoot it.

> Meagre mechanics, fellows not worth powder and shot. (Samuel Foote, *The Bankrupt*, 1776)

15. not worth the candle Not worth the trouble, not worth the energy expended, not worth the cost involved; usually *the play* or *game is not worth the candle*. In former times theaters, sports arenas, and other public places were illuminated by the light from candles held by men or boys stationed around the performance area. An extremely poor performance of a play or a game was said to be not worth the candle, i.e., not worth the cost of furnishing the necessary light. The expression, which is a translation of the original French phrase *le jeu ne vaut pas la chandelle*, appeared in a work at-tributed to William Darrell:

> After all, these discoveries are not worth the candle. (*A Gentleman Instructed in the Conduct of a Virtuous and Happy Life*, c. 1700)

Use of the phrase dates from the late 17th century.

16. not worth the paper it's printed on Completely worthless, good-for-nothing, of absolutely no value whatsoever. This recent American slang expression, obvi-ous in its demeaning connotation, is used in reference to inferior writing or non-binding contracts.

17. shreds and patches Of little, or no, significance; unimportant and unim-pressive; inferior; worthless; made up of rags and scraps. This expression, al-though of uncertain origin, is probably attributable to Shakespeare. In *Hamlet* III. iv, Hamlet is trying to convince his mother, Gertrude, that Claudius is un-worthy of her love and of ruling Den-mark and he exclaims that Claudius is:

> A vice of kings!
> A cutpurse of the empire and the rule,
> That from a shelf the precious diadem stole,
> And put it in his pocket! . . .
> A king of shreds and patches!

Although seldom heard today, the term is sometimes used allusively to indicate that something is worthless.

> The theory of the world is a thing of shreds and patches. (Ralph Waldo Emerson, *Representative Men: Plato*, 1850)

It is probably most familiar because of the Gilbert and Sullivan operetta, *Mikado*:

> A wand'ring minstrel, I, of shreds and patches,
> Of ballads, songs, and snatches . . .

18. tumbledown Dick A ne'er-do-well; an inconsequential person; a good-for-nothing. *Tumbledown Dick* is another of the many derogatory British expres-sions derived from the ineffectiveness of Oliver Cromwell's son, Richard. Chosen to assume his father's position as Lord

Protector in 1658, Richard proved to be a weak and vacillating leader and was soon removed from office to make way for the restoration of King Charles II in 1660. Shortly thereafter a host of terms denigrating Richard Cromwell were born. Many are still in use, including this one.

19. yarborough A bridge or whist hand containing no card higher than a nine; something apparently worthless; a bust. Charles Anderson Worsley, Second Earl of Yarborough, was said to have wagered a thousand to one against someone being dealt such a hand. It is not known whether Worsley was aware that the odds of such an occurrence are roughly 1800 to 1. At any rate, since that time such a hand has been known as a *yarborough*.

I have held yarboroughs and been doubled and roughed all evening. (*Blackwood's Magazine*, December 1910)

Wrath . . . See 158. FURY

Writing . . . See 226. LITERATURE

Y

407. YOUTH

See also 15. AGE

1. blue on the plum Freshness; delicate charm; youth. This expression, dating from the late 17th century, alludes to young, newly gathered plums. Figuratively, the term refers to that time in life when one has just achieved the first blush of adulthood. It is often heard negatively to symbolize the loss of youthful beauty and innocence.

> She was handsome in her time . . .
> She has quite lost the blue on the
> plum.
> (Jonathan Swift, *Polite Conversation*, 1738)

A variant of this phrase, *the bloom on the peach*, carries the same connotation.

> The bloom has been off the peach anytime these fifteen years. (Arthur Murphy, *Old Maid*, 1761)

2. hobbledehoy Half man, half boy; a name for a youth in the awkward late teen years when he is neither a man nor a boy. The *OED* defines this term as of uncertain origin, with all instances of the use of *hobble* occurring after 1700, except one dated 1540. Prior to 1700 all other citations have *hobber* or a variant of that spelling.

> The first seven years bring up as a
> child,
> The next to learning, for waxing too
> wild.
> The next keep under *Sir Hobbard de
> Hoy*,
> The next a man no longer a boy.

> (Thomas Tusser, *Five Hundred Points of Good Husbandry*, 1573)

The term, although seldom heard today, is still in use.

> Hobbledehoy, neither man nor
> boy . . .
> There's a god and a devil in
> Hobbledehoy.
> (Witter Bynner, *Hobbledehoy*, 1930)

3. latchkey kids Children who come home from school to an empty house because their parents are still at work. In occasional use since about 1900, this expression came into everyday use during the late 1970s such these children and their plight were brought to the attention of the Amerian public. The term derives from the fact that these children wear house keys on a string around their necks so they may let themselves into their homes when they return from school, there being no one at home since the parent or parents are still working.

> At an inner city school we found about one in three children was a latchkey kid. (Lynette and Thomas Long, *Latchkey Children and Their Parents*, 1983)

4. salad days Youth; the time of juvenile inexperience and naivete; the springtime of one's life. This expression may have derived as an analogy between *green* 'inexperienced, immature' and the predominant color of salad ingredients. This comparison was made in Shakespeare's *Antony and Cleopatra* (I,v):

> My salad days,
> when I was green in judgment.

In addition to the phrase's youthful sense, *salad days* also refers to any period in a person's life or career characterized by callowness and unsophistication.

> In directing "The Pride and the

Passion" Stanley Kramer created a picture as vast, heavily populated, and downright foolish as anything the

Master [C. B. DeMille] confected in his salad days. (*New Yorker*, July 1957)

Z

408. ZEALOUSNESS

1. barnburner A radical, zealot, or extremist; historically, a member of the radical faction of the Democratic party in New York State (1840–50) so eager for political reform that he would through excess of zeal destroy what he wished to preserve. The term, which dates from 1841, comes from the older phrase, *burn a barn to kill the rats,* in use since 1807.

> This school of Democrats was termed Barnburners, in allusion to the story of an old Dutchman, who relieved himself of rats by burning down his barns which they infested,—just like exterminating all banks and corporations, to root out the abuses connected therewith. (*New York Tribune,* 1848)

2. eager beaver A ball of fire, an especially industrious or zealous person; an excessively aggressive or ambitious person, a go-getter. This American expression, dating from the mid 1900s, is a reference to the beaver's reputation for being particularly hardworking and diligent. Earlier similar phrases include *work like a beaver* 'work very hard or industriously,' which dates from the early 18th century; and *industrious* or *busy as a beaver* 'very busy,' in use since the early 19th century.

3. gung ho Wholeheartedly enthusiastic; eager, zealous, patriotic, loyal. *Gung ho* is a corruption of the Chinese *kung ho* 'work together' (*kung* 'work' + *ho* 'together'). The unit of United States Marines that served under General Evans F. Carlson in World War II adopted the expression as its slogan. The phrase appeared in its original form, *kung-hou,* as early as 1942.

> In those days he was very gung ho for National Socialism and the pan-Germanic grandeur it was going to produce. (R. M. Stern, *Kessler Legacy,* 1967)

4. hellbent Recklessly dogged or stubbornly determined; resolute, persistent; going at breakneck speed. The term, of American origin, dates from at least 1835. It has spawned the expanded forms *hellbent for leather, hellbent for election,* and *hellbent for breakfast. Hell* or *hellbent for leather,* thought to be originally British but popular on both sides of the Atlantic, has only the second sense of *hellbent,* i.e., going at tremendous speed. The reference is to riding on horseback, *leather* referring to the leather of the saddle. The expression is found in Rudyard Kipling's *The Story of the Gadsbys,* published in 1888. *Hellbent for election* is said to have originated in the Maine gubernatorial race of 1840. *Hellbent for breakfast,* dating from at least 1931, is used in the second sense only—going at great speed.

5. kamikaze Suicidal; self-destructive; characterized by reckless determination or desperation. Originally a synonym for any suicidal attack, this expression, since its adoption during World War II, has been extended to indicate foolhardiness, as in a *kamikaze taxi driver,* one who bolts headlong through traffic without regard to the dangers of traffic. The Japanese term *kamikaze* means 'divine wind,' believed to have referred to a sudden and devastating typhoon which thwarted a Mongol invasion of Japan many centuries ago. In World War II the term became popular when, as a desperation measure near the end of the war, the Japanese unleashed the *kamikaze pilots,* who attempted to crash their

explosive-laden aircraft into American ships of war.

6. whirling dervish A person who vociferously expounds his opinions and beliefs; a zealot. A dervish is an Islamic priest or monk who, during religious ceremonies and prayers, frequently enters a type of ecstatic rapture marked by wild dancing, violent movements, and loud singing or chanting. Thus, these holy men came to be known as *whirling dervishes* or *howling dervishes*.

> And now, their guttural chorus audible long before they arrived in sight, came the howling dervishes. (Amelia B. Edwards, *A Thousand Miles Up the Nile*, 1877)

This expression is applied in non-Islamic contexts by extension.

INDEX

Index

All references are to category and entry numbers in the text. Items in **bold face type** are headwords, while those in *italic type* are to be found within entries.

Alphabetization in this Index is on the strict letter-by-letter principle; however, initial articles (*a*, *an*, or *the*), the *to* of verbal infinitive forms, and all words within brackets or parentheses have been ignored for the purposes of alphabetization.

A

Aaron's serpent, 69.1.
Abe, 240.1.
Abe's cabe, 240.1.
abiit ad plures, 82.29.
Abingdon law, 298.15.
above-board, 43.1.
above [one's] hook, 193.1.
above the salt, 358.1.
abracadabra, 161.1; 231.1.
Abraham man, 286.1.
Abraham men, 286.1.
Abraham's bosom, 262.1.
Abraham-sham, 286.1.
Abraham ward, 286.1.
Abscam, 370.19.
Academia, 331.5.
the Academy, 331.5.
accidentally on purpose, 384.1.
accord, 16.8.
according to Cocker, 290.1.
according to Cocker, 290.2; 290.3.
according to Gunter, 290.2.
according to Gunter, 290.3.
according to Hoyle, 290.3.

AC/DC, 342.1.
ace in the hole, 9.1.
ace in the hole, 274.1.
ace up [one's] sleeve, 274.1.
acheter un chat en poche, 370.18.
Achilles heel, 400.1.
Achilles' spear, 306.1.
acid, 90.1.
acid head, 90.1.
acid test, 77.1.
acknowledge the corn, 361.1.
across-the-board, 195.1.
act Charley More, 348.1.
act the goat, 237.13.
act the part, 7.1.
Adam's Ale, 153.1.
add fuel to the fire, 127.1.
add fuel to the fire, 28.2.
addicere aliquem canibus, 86.4.
add insult to injury, 127.2.
admirable Crichton, 55.1.
advocatus diaboli, 24.4.
affable as a wet dog, 248.1.
affidavit, 13.7.
afloat at Tyburn, 82.41.
afraid of [one's] own shadow, 148.1.
African dominoes, 328.1.

African golf, 328.1.
after meat, mustard, 372.1.
after [one's] own heart, 282.1.
after you, my dear Alphonse, 85.1.
against all rhyme or reason, 339.1.
against the collar, 132.1.
against the grain, 386.1.
à go-go, 360.1.
agony column, 99.1.
aim to please, 117.1.
air [one's] lungs, 288.1.
airy-fairy, 145.1.
albatross around the neck, 40.1; 185.1.
alea jacta est, 222.4.
ale-house politician, 394.15.
Alexandra limp, 12.2.
Alibi Ike, 119.1; 126.1.
alike as peas in a pod, 346.17.
alike as two peas, 346.17.
all aback, 368.15.
all adrift, 63.3.
all along the line, 195.2.
all around the Wrekin, 195.3.
all balled up, 63.1.
all down the line, 195.2.
alley cat, 289.1.
alley-catting around, 289.1.

beat generation, 302.1.
beat [one's] gums, 371.1.
beat [one's] head against the wall, 159.2.
beating bogey, 77.5.
Beating the Colonel, 77.5.
beat into shape, 168.3.
beat it, 138.2.
beatniks, 302.1.
beat the air, 159.3.
to beat the band, 214.2.
beat the devil around a bush, 384.22.
beat the Dutch, 258.3.
beat the rap, 298.31.
beat the tar out of, 51.9.
beat to the punch, 9.2; 17.2.
Beau Brummel, 360.3.
beautiful downtown Burbank, 211.2.
beauty is only skin deep, 271.4.
bêche-de-mer, 225.13.
Becky Sharp, 119.5.
be cut for the simples, 145.9.
bed of down or *flowers*, 201.1.
bed of nails, 96.1.
bed of roses, 201.1.
be driven round the bend, 111.15.
bedroom community, 227.2.
bedside manner, 60.1.
bedswerver, 205.2.
Beecher's Bible, 244.3.
beech seal, 298.1.
beef up, 28.1.
bee in [one's] bonnet, 249.1.
beer and skittles, 324.1.
beer-belly, 72.3.
bees in the head, 249.1.
bee's knees, 129.8.
beetle, 193.2; 359.2.
beetle-browed, 398.1.
before [one] had nails on [one's] toes, 380.1.
before you can say "Jack Robinson", 212.2.
before you can say "Jack Robinson.", 212.3.
before you can say "knife", 212.3.
beggar on horseback, 14.1.
beggar's bush, 277.2.
beg the question, 24.2.
behind the eightball, 98.1.
behind the power curve, 279.1.

behind the scenes, 332.1.
be in Dulcarnon, 63.19.
be in the same boat, 217.1.
bell, book, and candle, 377.1.
Bellerophontic letter, 81.1.
bell the cat, 62.2.
belly-god, 164.1.
belly-timber, 153.3.
belt the grape, 382.2.
be made a cat's paw of, 395.5.
bench jockey, 170.1.
bench mark, 77.3.
bench warmer, 178.1; 363.1.
bend the elbow, 382.3.
Benedict Arnold, 119.6.
Benjamin's mess, 18.1.
bent, 117.9.
bent out of shape, 21.1.
be on a good wicket, 9.3.
be on a sticky wicket, 96.13.
be out for a duck, 141.10.
be put in the pudding club, 271.18.
beside [oneself], 218.1.
beside the cushion, 219.1.
beside the mark, 219.2.
beside the mark, 219.1.
Bess of Bedlam, 125.7.
best bib and tucker, 49.2.
best side outward, 290.9.
be taken to the cleaners, 370.20.
bet [one's] boots, 46.1.
bet [one's] bottom dollar, 46.1.
bet dollars to doughnuts, 46.3.
to be the guest of the cross-legged knights, 175.3.
bet [one's] life, 46.1.
Betsy, 131.14.
better half, 233.1.
better lost than found, 310.1.
between a rock and a hard place, 281.2.
between dog and wolf, 380.2.
between hawk and buzzard, 198.1; 281.3.
between hay and grass, 198.2.
between Scylla and Charybdis, 281.4.
between the devil and the deep blue sea, 281.5.
between two fires, 400.2.
between wind and water, 400.3.
between you and me and the barn, 332.2.

between you and me and the bed-post, 332.2.
between you and me and the doorpost, 332.2.
between you and me and the gatepost, 332.2.
between you and me and the lamppost, 332.2.
be up tight, 60.5.
beware of Greeks bearing gifts, 286.3.
beware the ides of March, 81.2; 367.1.
beyond the moon, 183.3.
beyond the pale, 189.2.
Bible-banger, 133.1.
Bible Belt, 133.1.
Bible-pounder, 133.1.
Bible-thump, 133.1.
Bible-thumper, 133.1.
bidgin, 225.13.
the Big Apple, 227.3.
big brass, 269.1.
Big Brother, 269.2.
big bug, 269.4.
big cheese, 269.4.
big deal, 131.4; 327.1.
big eyes, 91.2.
big gun, 269.3.
big head, 276.1.
big jump, 82.2.
big shot, 269.3.
big stick, 278.1.
big wheel, 269.4.
big wheel, 269.23.
bigwig, 269.5.
Bilayati, 172.1.
bilberry, 130.15.
Billies and Charlies, 370.1.
billingsgate, 288.2.
Billy Taylor carried off to sea, 33.1.
Bindle, 277.3.
bindle stiff, 277.3.
binge, 388.12.
bingo, 388.12.
the bird, 213.7; 213.17.
bird in [one's] bosom, 67.1.
bird in [one's] breast, 67.1.
bird of [one's] own brain, 67.1.
birds of a feather, 346.1.
biscuit shooter, 253.20.
Bishop, 76.3.
bishop's cope, 406.2.
bite a file, 325.2.

bone-shaker, 393.2.
a bone to pick, 166.2.
boob tube, 244.6.
boodle, 240.4.
book, 23.4; 346.14.
bookworm, 331.2.
boondock, 211.8.
boondockers, 211.8.
boondoggle, 178.2.
Boot Hill, 41.1.
bootlegger, 76.2.
bootlick, 248.4.
boots and saddle, 284.3.
bore four holes in the blue,
 159.5.
born to the purple, 358.5.
born with a caul on [one's]
 head, 163.1.
born with a silver spoon in
 [one's] mouth, 358.6.
born within the sound of Bow
 bells, 358.7.
borrowed plumes, 286.4.
borscht belt, 227.5.
borscht circuit, 227.5.
bosom buddy, 156.1.
bosom chum, 156.1.
bosom friend, 156.1.
bosom-serpent, 33.13.
bottlearse, 271.8.
bottleass, 271.8.
bottleneck, 185.4.
bottom line, 257.1.
bottom of the bag, 274.3.
bottom of the barrel, 406.3.
bottom of the pickle barrel,
 406.3.
bounce off [someone], 53.2.
bouncer, 138.4.
boutes la selle, 284.3.
bowels, 340.1.
bowels of compassion, 340.1.
bowels of kindness, 340.1.
bowels of meekness, 340.1.
bowels of mercy, 340.1.
Bowery boys, 35.1.
The Bowery Boys, 10.8.
bowl, 382.18.
bowled over, 368.3.
bow the knee to Baal, 7.2.
bow the knee to Rimmon,
 176.1.
Box and Cox, 391.3.
box [one's] ears, 312.2.
box [one's] ears, 312.13.
box Harry, 238.2.
boy scout, 26.1.

Boy Scouts, 26.1.
bra burner, 154.1.
brace, 141.10.
Brahmin, 358.8.
braid St. Catherine's tresses,
 397.1.
brain child, 378.1.
brain drain, 1.1.
brain drain, 136.9.
brain gain, 1.1.
brainstorm, 378.2.
brains trust, 11.1.
brain trust, 11.1.
brainwashing, 232.2.
brand-new, 15.2.
Brandy Nan, 244.7; 382.4.
the brass, 269.1.
brass farthing, 406.4.
brass hat, 269.1.
brazen-faced, 192.1.
brazen out, 192.2.
bread and butter, 105.7.
bread and butter letter, 290.4.
bread and butter note, 290.4.
bread and circuses, 83.1.
breadbasket, 244.8.
break a butterfly on a wheel,
 130.5.
break a lance with, 56.2.
break a leg, 163.2.
break his duck, 141.10.
breaking his slump, 141.10.
breaking Priscian's head,
 143.1.
break Priscian's head, 143.1.
the breaks, 163.3.
break the egg in [someone's]
 pocket, 185.5.
break the ice, 209.2.
breed bad blood, 223.1.
brick in [one's] hat, 109.3.
bridewell, 298.2.
bridewell bird, 298.2.
bridle, 171.4.
bridle back, 171.4.
bridle up, 171.4.
brief, 101.7.
bright-eyed and bushy-tailed,
 17.3.
*bring buckle and thong
 together*, 364.8.
bring down the gallery, 365.1.
bring down the house, 365.1.
bring home the bacon, 396.3.
bring to the scratch, 301.5.
Bristol Cities, 125.2.
Bristols, 125.2.

broach [someone's] claret,
 51.2.
broad in the beam, 72.5.
broken reed, 141.3.
Bronx cheer, 213.10.
broomstick, 179.11.
brothel-creepers, 49.3.
Brother Jonathan, 244.9.
broth of a boy, 123.1.
browbeat, 107.1.
brown-bagger, 358.9.
browned off, 223.2.
brownie points, 248.5.
brown-nose, 248.6.
brown nose, 248.5.
brown study, 378.3.
Brumaggem groats, 343.1.
Brumaggem jewelry, 343.1.
Brumaggem statesmen, 343.1.
Brumaggem swords, 343.1.
Brumaggem wares, 343.1.
brush fire, 302.2.
brush-fire war, 302.2.
the brushoff, 213.7.
*brusler la chandelle par les
 deux bouts*, 259.2.
bubble scheme, 370.2.
bucket, 370.3.
bucket mouth, 371.10.
bucket of bolts, 393.3.
bucket shop, 370.3.
Buckinghamshire, 205.5.
buckle down, 132.3.
Buckle down to, 132.3.
buckle [oneself] to, 132.3.
Buckley's chance, 98.2.
Bucks, 205.5.
bucktoothed, 398.4.
buffalo's foot, 179.11.
bug-eyed, 368.4.
bug house, 111.2.
bug under the chip, 369.1.
build a better mousetrap,
 365.2.
build a fire under, 294.1.
built upon sand, 151.2.
bull, 371.12.
bull in a china shop, 30.4.
bullish, 149.1.
bull pen, 244.10.
bulls feather, 205.8.
bull's foot, 179.11.
bullshit, 371.12.
bumf, 225.2.
bum fodder, 225.2.
bump off, 82.5.
bum rap, 298.31.

carry the day, 396.4.
carte blanche, 154.2.
Carthaginian peace, 130.6.
Casanova, 289.6.
case the joint, 216.1.
cash in [one's] chips, 82.9.
cash on the barrelhead, 265.1.
cast a bone between, 105.4.
cast a sheep's eye, 230.1.
cast beyond the moon, 183.3.
cast [one's] bread upon the
 waters, 48.1.
cast [one's] heels in [one's]
 neck, 187.1.
casting couch, 230.2.
cast in [someone's] teeth,
 312.3.
castle of cards, 151.4.
castles in Spain, 183.4.
castles in the air, 183.5.
castles in the sky, 183.5.
cast pearls before swine,
 191.1.
cast stones against the wind,
 159.6.
cat, 124.4; 181.19.
cat among the pigeons, 223.3.
cat and mouse, 170.8.
catcall, 213.4.
catch-22, 281.7.
catch a crab, 30.6.
catch-as-catch-can, 388.3.
catch a tartar, 325.3.
catch a weasel asleep, 9.4.
catch napping, 9.5.
catch [someone] napping, 9.4.
catch napping as Moss caught
 his mare, 368.5.
catchpenny, 406.5.
*catch the bear before you sell
 the skin*, 11.5.
catch the brass ring, 326.1.
catch the gold ring, 326.1.
Caterpillar Club, 77.4.
catherine wheel, 397.1.
catherine wheel window,
 397.1.
cathouse, 124.4.
cathouse, 289.14.
cat ice, 81.3.
cat-in-pan, 325.11.
cat in the mealtub, 61.3.
a cat may look at a king,
 142.1.
catnip fit, 158.8.
cat's cradle, 211.3.
cat's cuff links, 129.8.

cat's eyebrows, 129.8.
cat's galoshes, 129.8.
cat's meow, 129.8.
cat's pajamas, 129.8.
cat's paw, 395.5.
cat's roller skates, 129.8.
cat's tonsils, 129.8.
cat's whiskers, 129.8.
cat wagon, 124.4.
caught bending, 400.4.
caught dead to rights, 46.2.
caught flat-footed, 400.5.
caught with [one's] hand in
 the cookie jar, 169.1.
caught with [one's] pants
 down, 169.2; 400.6.
cauliflower ear, 271.9.
caviar to the general, 194.2.
cess, 10.2.
*c'est de la moutarde apres
 dîner*, 372.1.
c'est la chose, 73.8.
chair days, 15.3.
chalk, 328.2.
chalk eater, 328.2.
chalk horse, 328.2.
chalk it up, 27.1.
chalk player, 328.2.
chalk talk, 53.6.
champ at the bit, 184.1.
chance, 345.3.
change of scene, 270.2.
change [one's] tune, 303.6.
chapbook, 226.1.
chapmen, 226.1.
chapter and verse, 29.2.
charivari, 35.5.
charley horse, 181.1.
Charley Noble, 119.10.
chasing rainbows, 177.7.
Château en Espagne, 183.4.
cheap-Jack, 211.4.
cheap-John, 211.4.
cheap shot, 389.3.
cheat the worms, 306.2.
cheek by cheek, 295.3.
cheek by jowl, 295.3.
cheese and kisses, 233.2.
cheese it, 131.7.
cheeseparing, 238.3.
cheezit, 131.7.
chese, 73.8.
chestnut, 20.1.
cheverel, 7.3.
cheveril conscience, 7.3.
chew it finer, 347.3.
chew out, 312.4.

chew the fat, 371.2.
chew the fat, 371.3.
chew the rag, 371.3.
chhap, 129.13.
chi-chi, 256.9.
chicken feed, 240.5.
chicken guts, 244.58.
chicken in every pot, 291.1.
chickens come home to roost,
 323.1.
Chic Sale, 125.5.
chief cook and bottle washer,
 269.6.
chief itch and rub, 269.7.
chiff chark and bottle washer,
 269.6.
Chinaman's chance, 188.2.
Chinee, 119.11.
Chinese ace, 63.5.
Chinese fire drill, 63.5.
Chinese landing, 63.5.
Chinese national anthem,
 63.5.
Chinese saxophone, 125.6.
Chinese three-point landing,
 63.5.
Chinese tobacco, 125.6.
chink in [one's] armor, 400.7.
chip basket, 239.2.
chip in, 70.1.
chip off Bede's chair, 233.3.
chip off the old block, 346.2.
chip of the old block, 346.2.
chip of the same block, 346.2.
a chip on [one's] shoulder,
 32.3; 166.3.
chips and whetstones, 406.6.
chivaree, 35.5.
chockablock, 295.4.
chock-full, 295.4.
to choke Caligula's horse,
 130.9.
choke-pear, 185.6.
chop and change, 391.4.
chop logic, 245.1.
chord, 16.8.
chose, 73.8.
chowhound, 164.2.
chronicle small beer, 211.5.
chronikers, 153.22.
chuck-a-luck, 382.5.
chug-a-lug, 382.5.
chug-a-lugging, 382.5.
chugging, 382.5.
church key, 68.1.
churchyard cough, 82.10.
cie bais, 379.7.

corn crackers, 244.15.
corner the market, 69.5.
corn in Egypt, 5.3.
corporate gadfly, 223.5.
costermonger, 253.3.
cottage industry, 336.2.
cotton mouth, 96.12.
cotton mouth thirst, 96.12.
cough up, 137.7.
could kick the arse off an emu, 115.2.
could not hit the broad side of a barn, 203.5.
counter, 298.11.
counter-jumper, 253.4.
count noses, 195.8.
country bumpkin, 247.4.
country club set, 358.13.
country mile, 139.6.
count to ten, 60.4.
County Clare payment, 265.2.
courteous as a dog in the kitchen, 85.3.
court holy water, 150.4.
Cousin Betsy, 125.7.
Cousin Betty, 125.7.
Coventry blue, 67.3.
cover all bases, 45.2.
cover [one's] tracks, 45.3; 61.4.
cow college, 124.6.
cowtown, 211.28.
Coxey's Army, 103.6.
crack, 34.2.
crack-brained, 111.4.
crack'd in the ring, 186.1.
cracked up to be, 34.2.
cracker-barrel, 347.5.
cracker-barrel philosophy, 347.5.
cracker jack, 34.2.
crackers, 244.15.
crackpot, 111.4.
crack the whip, 107.3.
cradle to grave, 139.10.
crafty as a redhead, 389.4.
cram, 50.7.
cramp [someone's] style, 185.8.
craps, 119.12.
crash, 189.4.
crash a gate, 189.4.
crash the gate, 189.4.
crash the party, 189.4.
cratch, 211.3.
cratch-cradle, 211.3.
crazy as a bedbug, 218.3.

crazy as a coot, 145.14.
crazy as a loon, 218.4.
crazy bone, 174.4.
a creaking cart goes long on its wheels, 116.2; 401.1.
creaking gate hangs long on its hinges, 116.2.
a creaking gate hangs long on the hinges, 401.1.
creaky gates last longest, 401.1.
cream of the crop, 129.11.
cream-pot love, 176.5.
create bad blood, 223.1.
creep, 148.2.
creeping Jesus, 126.5.
the creeps, 148.2.
crème de la crème, 129.11.
crestfallen, 87.4.
cricket, 290.5.
crimp, 379.4.
crocodile tears, 176.4.
crook, 382.3.
crooked as a dog's hind leg, 389.5.
crook [one's] elbow and never get it straight, 13.3.
crook the elbow, 382.3.
cross as two sticks, 21.2.
cross [someone's] bows, 394.1.
cross [one's] fingers, 367.3.
crosshanded, 336.8.
cross [one's] heart, 13.3.
cross my heart and hope to die, 13.3.
cross over, 82.11.
cross [someone's] palm, 38.3.
cross swords with, 32.5.
cross the Great Divide, 82.11.
cross the Rubicon, 84.3.
cross to bear, 40.3.
crown of thorns, 10.7.
crow over, 34.3.
a crow to pluck, 105.5.
a crow to pull, 105.5.
cry all the way to the bank, 240.6.
cry barley, 361.2.
cry blue murder, 35.6.
cry cupboard, 175.1.
cry [one's] eyes out, 167.2.
cry for the moon, 159.7.
cry in [one's] beer, 335.1.
crying towel, 335.2.
cry on [someone's] shoulder, 335.3.
cry over spilt milk, 222.3.

cry peccavi, 169.3.
cry roast meat, 34.4.
cry stinking fish, 334.2.
cry uncle, 361.3.
cry wolf, 236.3.
cuckold, 205.3.
cuire dans son jus, 64.6.
cum grano salis, 349.5.
cunning as a fox, 389.4.
cunning as a red-haired person, 389.4.
cunning as a redhead, 389.4.
cunning as a serpent, 389.4.
Cupar justice, 298.10.
cupboard love, 176.5.
[one's] cup of tea, 93.2; 282.3.
curate's egg, 19.1.
curry a short horse, 212.4.
to curry Favel, 248.7.
curry favor, 248.7.
Curse of Montezuma, 181.11.
curtain lectures, 312.5.
curtains, 375.4.
Custer's last stand, 108.3.
cut a caper, 324.4.
cut a crab, 30.6.
cut a dido, 237.2.
cut a melon, 18.6.
cut and dried, 347.6.
cut and run, 89.3.
cut a swath, 256.2.
cut blocks with a razor, 190.3.
cut [someone's] comb, 173.1.
cut corners, 135.5.
cut [one's] eyeteeth, 224.4.
to cut ice, 203.6.
cut it close, 279.5.
to cut [one's] lucky, 89.4.
cut monkeyshines, 237.9.
cut [one's] nails on Sunday, 367.4.
cut no ice, 203.6.
cut off [one's] nose to spite [one's] face, 127.4.
cut off with a shilling, 310.4.
to cut off without a shilling, 310.4.
the cut of [one's] jib, 200.2.
cut out of whole cloth, 236.11.
cut out work for, 96.6.
cutpurse, 76.5.
cut shines, 237.9.
cut [one's] stick, 89.4.
cut the cackle and come to the horses, 347.7.
cut the coat according to the cloth, 7.4.

everything that opens and
shuts, 195.11.
every tub must stand on its
own bottom, 336.4.
*every tub on its own black
bottom*, 336.4.
ex cathedra, 29.3.
extracting sunbeams out of cu-
cumbers, 188.4.
an eye for an eye, 320.1.
eye opener, 153.5.

F

Fabian tactics, 374.1.
face made of a fiddle, 162.1.
face the music, 62.4.
fair and square, 142.4.
fair dinkum, 142.5.
faire la figue, 213.8.
fair game, 400.9.
fair-haired boy, 147.4.
fair-haired girl, 147.4.
Fair Maid of Ireland, 183.12.
fair shake, 142.6.
fair-weather friend, 135.6.
fair words butter no cabbage,
203.7.
fair words butter no fish,
203.7.
fair words butter no parsnips,
203.7.
fairy money, 163.6.
fairy rings, 231.2.
fall between two stools, 391.6.
fall by the way, 141.8.
fall by the wayside, 141.8.
fall guy, 395.7.
fall into the hands of, 98.8.
fall of a sparrow, 405.1.
fall off the back of a lorry,
76.7.
fall on [one's] feet, 163.7.
fall on [one's] legs, 163.7.
false as Cressida, 205.4.
false as dicers' oaths, 406.7.
family jewels, 125.10.
famous last words, 322.4.
fancy free, 154.4.
fanfaron, 256.8.
fanfaronade, 256.8.
fanfarrado, 256.8.
Fanny Adams, 4.8.
fan the breeze, 371.11.
fan the fires, 28.2.

far and away, 46.6.
a far cry, 106.4.
a far cry from, 106.4.
fare you well, 129.26.
far from the mark, 121.17.
fart in a colander, 198.3.
fashion plate, 360.8.
fast buck, 240.7.
faster than greased lightning,
261.3.
fast food, 153.6.
fast lane, 261.4.
fast track, 261.4.
fat, 5.4.
Fata Morgana, 118.3; 183.6.
fat cat, 269.8.
fat city, 5.4.
fat farm, 72.7.
father upon, 27.2.
the fat's in the fire, 222.5.
fatten the kitty, 28.3.
fatten the pot, 28.3.
fear no colors, 37.4.
feast or famine, 364.3.
feast or fast, 364.3.
feather in [one's] cap, 6.1.
feather [one's] nest, 136.4.
feed the fishes, 181.5.
feel a draft, 267.1.
feel as if a cat has kittened in
[one's] mouth, 109.8.
feel in [one's] bones, 215.3.
feel [one's] oats, 115.3.
feel the draught, 149.2.
feel the draught, 267.1.
feel the pinch, 149.3.
feel the pulse of, 216.3.
feet of clay, 186.4.
*fetch a flitch of bacon from
Dunmow*, 233.6.
fetch over the coals, 312.12.
fiddlesticks, 246.6.
field day, 255.1.
fifth columnist, 33.2.
fifth wheel, 366.1.
fight fire with fire, 320.2.
Fightin' Blue Hens, 244.5.
fight like Kilkenny cats, 51.5.
the fig of Spain, 213.8.
file 13, 104.2.
filibuster, 374.2.
fill the bill, 55.5.
filthy lucre, 240.8.
fimble-famble, 126.8.
find a giggles' nest, 145.7.
find bones in, 43.9.

find the bean in the cake,
163.8.
fine as a fiddle, 162.1.
fine feathers make fine birds,
256.5.
a fine Italian hand, 200.3.
fine kettle of fish, 103.13.
finger in the pie, 235.3.
finish Aladdin's window,
188.5.
finishing touch, 58.1.
fire, 138.3.
firebrand, 294.4.
fire bug, 244.18.
fire-new, 15.2.
fire [one's] pistol in the air,
126.9.
firewater, 153.7.
first catch your hare, 11.5.
first chop, 129.13.
first-of-May, 204.2.
fish eye, 398.3.
fishing expedition, 216.4.
fish in troubled waters, 136.5.
fish or cut bait, 84.5.
fish out of water, 386.2.
fish story, 128.4.
fish with a golden hook,
328.5.
fishy about the gills, 109.9.
fit as a fiddle, 162.1.
fit as a fiddler, 162.1.
fit like a saddle fits a sow,
194.3.
fit to be tied, 21.3.
*fit your hand exactly in the
place where your marble
lies*, 132.9.
*five eggs a penny and four of
them rotten*, 235.2.
five-finger, 76.8.
five-finger discount, 76.8.
fix [someone's] wagon, 320.3.
flag down, 69.6.
flag station, 69.6.
flag stop, 69.6.
flake, 111.6.
flaky, 111.6.
flannelmouth, 150.5.
flap [one's] chops, 371.5.
flap [one's] jowls, 371.5.
flash in the pan, 110.2.
flat as a pancake, 271.11.
flatfoot, 253.6.
flatfooted, 43.3; 84.6.
flat hat, 256.6.
flat hatter, 256.6.

Index

fustian-a-napes, 237.6.

G

Gabriel rache, 244.25.
Gabriel rachet, 244.25.
Gabriel's hounds, 244.25.
gadfly, 223.5.
gadfly mind, 223.5.
gag-tooth, 398.4.
gall and wormwood, 315.2.
gallery gods, 358.15.
gallery gods, 256.14.
gall of bitterness, 78.3.
game as Ned Kelly, 37.5.
game is not worth the candle, 406.15.
the game is up, 141.9.
game plan, 284.4.
game plan, 328.9.
gandermonth, 380.5.
gandermooner, 380.5.
gandermooning, 380.5.
gandy dancer, 253.9.
gardy loo, 131.9.
gare de l'eau, 131.9.
Garrison finish, 396.5.
the gate, 131.26; 213.7.
gate-crasher, 189.4.
gate-crashing, 189.4.
gatemouth, 235.4.
gather straws, 351.9.
gat-toothed, 398.4.
gay Lothario, 289.6.
gazump, 370.11.
gear up, 28.4.
gear [oneself] up, 284.5.
geezer, 15.4.
generation gap, 53.7.
geneva courage, 34.6; 37.6.
gentleman of the four outs, 358.16.
a gentleman of the road, 244.37.
George-a-Green, 129.16.
German goiter, 72.8.
Geronimo, 131.10.
get a bad break, 163.3.
get a bang out of, 117.2.
get a charge out of, 117.3.
get [one's] act together, 307.3.
get a dose (or taste) of [one's] own medicine, 320.4.
get a duck, 141.10.
get a line on, 206.1.

get a move on, 357.1.
get an even break, 163.3.
get a rise out of, 294.5.
get [one's] ashes hauled, 230.6.
get away with murder, 210.1.
get a wiggle on, 357.1.
get [someone's] back up, 394.6.
get burnt, 224.1.
get cold feet, 75.2.
get [one's] comeuppance, 323.2.
get cracking, 357.2.
get [someone's] dander up, 223.6; 394.7.
get [someone's] dander up, 394.10.
to get down off [one's] high horse, 171.11.
get down to brass tacks, 157.3.
get down to the nitty-gritty, 157.5.
get [someone's] Dutch up, 394.8.
get [one's] feet wet, 209.3.
get [one's] foot in, 31.5.
get [one's] foot in the door, 31.5.
get [someone's] goat, 394.9.
get [someone's] hackles up, 394.10.
get hold of the right end of the stick, 73.1.
get hold of the wrong end of the stick, 143.2.
get hold of the wrong end of the stick, 121.6.
get [someone's] Indian up, 394.8.
get in Dutch, 101.10.
get [oneself] in gear, 284.5.
get in [someone's] hair, 223.7.
get [someone's] Irish, 394.8.
get it in the neck, 298.4.
get it together, 307.3.
get [one's] kicks, 117.4.
get [one's] knickers in a twist, 155.1.
get lost, 138.2.
get [one's] lumps, 10.9; 298.5.
get [someone's] monkey up, 394.11.
get off [someone's] back, 170.5.
get off [someone's] case, 170.5.

get off on the right foot, 31.7.
get off on the right foot, 290.9.
get off scot-free, 134.2.
get [someone] off the hook, 314.2.
get on the bandwagon, 346.7.
get on the stick, 357.3.
get on tick, 265.6.
get out from under, 306.4.
get psyched, 284.10.
get psyched up, 284.7.
get [one's] signals crossed, 53.8.
get something off [one's] chest, 43.4.
get [one's] teeth into, 132.6.
get the ball rolling, 209.4.
get the bounce, 138.4.
get the deadwood on, 69.7.
get the drop on, 9.6.
get the gate, 310.15.
get the goods on, 9.8.
get the hang of, 3.4.
get the hare's foot to lick, 372.3.
get the hook, 310.9.
get the kinks out, 353.3.
get the lead out, 178.5.
get the lead out of [one's] pants, 178.5.
get the nod, 23.3.
get (or give [someone]) the sack, 138.5.
get the short end of the stick, 395.10.
get the short end of the stick, 143.2.
get the show on the road, 357.4.
get the stick, 312.8.
get the weather gage of, 9.7.
get the whetstone, 396.6.
get the whetstone, 236.8.
get the wind up, 22.6.
get the wood on [someone], 9.8.
get the wrong bull by the tail, 121.6.
get the wrong end of the stick, 143.2.
get the wrong pig by the ear, 121.6.
get the wrong sow by the ear, 121.6.
get to first base, 31.8.

go great guns, 291.3.
go haywire, 103.7.
go home by beggar's bush, 277.2.
to go in cahoots, 66.2.
go in one ear and out the other, 203.9.
go in search of the golden fleece, 299.3.
go into the kitchen, 60.11.
go in with good cards, 9.10.
go jump in the lake, 138.8.
goldbrick, 178.4.
gold digger, 395.12.
Golden Gate, 244.26.
golden handshake, 240.9; 389.6.
golden oldie, 129.15.
goldfish in a glass bowl, 252.2.
Gold Gate city, 244.26.
goldilocks, 119.17.
gold of Tolosa, 323.3.
gold record, 129.15.
golf bum, 220.9.
Golfo de las Yeguas, 227.10.
go like hot cakes, 261.13.
go nap, 328.6.
gone beaver, 400.11.
gone chick, 400.11.
gone coon, 400.10.
gone coon, 400.11.
gone coons, 400.11.
gone for a Burton, 125.11.
gone gander, 400.11.
gone goose, 400.11.
gone horse, 400.11.
gone to my uncle's, 196.1.
gone to the bad for the shadow of an ass, 245.5.
gone with the wind, 4.2.
gong [someone], 310.18.
good as George-a-Green, 129.16.
good buddy, 244.27.
good buddy, 156.4.
good grief, 368.8.
good ole boy, 156.4.
good Samaritan, 26.4.
good time Charley, 324.6.
good wine needs no bush, 405.2.
Goody Two Shoes, 119.18; 296.5.
go off at half-cock, 187.5.
go off half-cocked, 187.5.
go off the deep end, 218.9.

go off the deep end, 218.5.
goof off, 220.4.
go on a lark, 324.7.
go on a tear, 324.23.
gooney birds, 244.12.
go on tick, 265.6.
go on with your birds' egging, 319.1.
goose [someone], 237.3.
goose, 125.28; 275.10.
goose among swans, 194.4.
goose bumps, 148.3.
goose egg, 141.12.
goose egg, 141.10; 141.14.
goose flesh, 148.3.
the goose hangs high, 255.2.
the goose honks high, 255.2.
goose pimples, 148.3.
go overboard, 130.11.
to go over like a lead balloon, 141.15.
go over to the majority, 82.29.
go over with a fine-tooth comb, 216.5; 377.2.
go peddle your papers, 138.9.
go play in traffic, 138.8.
[one's] gorge rises at it, 313.1.
go round the bend, 218.10.
go round the bend, 111.15.
gosh, 131.13.
gosh all hemlock, 131.13.
gosh all Potomac, 131.13.
gosh-a-mighty, 131.13.
gosh burned, 131.13.
gospel truth, 29.6.
got drunk, 288.8.
go the way of all flesh, 82.24.
go through fire and water, 91.6.
go through like a dose of salts, 261.6.
go through-stitch, 58.2.
go through the roof, 130.12.
go to bat for, 26.5.
go to Bath, 246.7.
go to Battersea, 145.9.
go to Battersea, to be cut for the simples, 145.9.
go to Bedlington, 351.3.
go to Canossa, 173.6.
go to Goosebridge, 11.6.
go to Halifax, 125.12.
go to heaven in a wheelbarrow, 298.7.
go to heaven in a wheelbarrow, 86.1.
go to hell, 125.12.

go to hell in a handbasket, 86.1.
go to Jericho, 138.10.
go to pot, 86.2.
go to Putney, 213.11.
go to Putney on a pig, 213.11.
to go to rack, 86.3.
go to rack and ruin, 86.3.
go to ruggins, 351.4.
to go to ruin, 86.3.
go to school on, 224.5.
go to the bat, 26.5.
go to the dickens, 288.4.
go to the dogs, 86.4.
go to the pot, 86.2.
go to the wall, 329.3.
go to the well once too often, 108.4.
go to the world, 233.8.
go to town, 291.4.
gotten a good break, 163.3.
go two-forty, 354.3.
go up in smoke, 141.13.
go west, 82.25.
go whistle, 138.11.
go whistle, 308.7.
go whole hog, 388.7.
go with the current, 7.5.
gowk, 395.19.
to go woolgathering, 201.8.
graecari, 115.13.
grand fromage, 269.4.
Grand Guignol, 119.19.
grand slam, 6.2.
grandstand, 256.11.
grandstand finish, 256.11.
grandstand play, 256.11.
grant the gate, 310.15.
grapevine, 53.9.
grapevine telegraph, 53.9.
grasp at straws, 92.5.
grass roots, 358.17.
grass widow, 244.28.
grave robber, 76.24.
graveyard shift, 380.6.
graveyard watch, 380.6.
gravy boat, 14.12.
gravy train, 14.12.
grease [someone's] palm, 38.5.
grease the hand, 38.5.
grease the wheels, 38.6.
great, 52.3.
Great Caesar, 125.13.
Great Caesar's ghost, 125.13.
great cry and little wool, 203.10.

Index

Hookey Walker, 131.18.
hook, line, and sinker, 383.1.
hooligan, 76.14.
hooliganism, 76.14.
hoosegow, 76.4.
Hooverville, 277.11.
hop-o'my-thumb, 272.3.
hopping mad, 21.12.
hop the twig, 89.9.
hornets' nest, 294.14.
horn-mad, 32.9.
hornswoggle, 370.14.
horn-thumb, 76.15.
horny, 230.10.
hors de soi, 218.1.
horse, 82.28; 228.2.
horseback opinion, 378.5.
horse latitudes, 227.10.
horselaugh, 174.6.
a horse of a different color,
 106.5.
a horse of another color,
 106.5.
a horse of the same color,
 106.5.
a horse that was foaled of an
 acorn, 82.28.
hot-box, 281.11.
hot corner, 96.8.
hot-dog, 256.13.
to hot-dog it, 256.13.
hotfoot, 354.4.
hotfoot it, 354.4.
hot potato, 96.9.
hot rod, 354.5; 392.2.
hot rodders, 354.5.
hot rods, 354.5.
hot stuff, 214.11.
hot to trot, 230.11.
hot under the collar, 21.4.
hound [someone's] footsteps,
 394.4.
house cleaning, 307.1.
house in Turn-again Lane,
 395.27.
house of cards, 151.4.
howdunit, 226.7.
huckleberry above [one's]
 persimmon, 54.2.
hue and cry, 293.2.
hu e cri, 293.2.
huggermugger, 103.10; 332.5.
huken, 271.16.
Hulda is making her bed,
 402.7.
human zoo, 244.31.
humbug, 286.7.

humpty-dumpty, 272.4.
*hung higher than Gilderoy's
 kite*, 139.7.
hung in the bellropes, 233.11.
hung on the nail, 196.2.
hungry dogs will eat dirty
 puddings, 175.5.
hunker down, 271.16.
hunky-dory, 129.18.
Hunt's dog, 251.3.
hunt the gowk, 395.19.
hunt the same old coon,
 311.8.
hurdy-gurdies, 118.5.
hurly, 103.11.
hurly-burly, 103.11.
hurrah's nest, 103.12.
hush puppy, 153.10.
hydra-headed, 59.2.
hyped-up, 128.6.

I

I can hardly wait, 322.7.
I can't wait, 322.7.
I could care less, 199.3.
I couldn't care less, 199.3.
idiot box, 244.6.
*I Don't Want to Set the World
 on Fire*, 144.6.
if I had my druthers, 282.4.
if I had my rathers, 282.4.
if I had my ruthers, 282.4.
*If your head is wax, stay away
 from the fire*, 145.11.
ignis fatuus, 183.12; 237.14.
I had rather, 282.4.
I knew him when!, 78.5.
*I knew him when he was only
 a cab driver*, 78.5.
*il faut battre le fer pendant
 qu'il est chaud*, 136.13.
*il faut laver son linge sale en
 famille*, 137.29.
I'll be seeing you, 131.25.
illegitimis non carborundum,
 11.7.
ill repute, 144.1.
ill wind that blows nobody
 good, 93.5.
*ils s'entendent comme larrons
 en foire*, 156.11.
*I'm from Missouri; you've got
 to show me*, 349.2.

*I'm Proud to Be an Okie from
 Muskogee*, 119.34.
in a box, 281.11.
in a coon's age, 110.1.
in a flap, 155.4.
in a holding pattern, 2.3.
in a jam, 281.12.
in a jiffy, 212.5.
in a lather, 155.5.
in a nutshell, 123.2.
in a pick(le), 281.11.
in a (pretty, sad, fine, or
 sweet) pickle, 281.13.
in a pig's eye, 188.6.
in a pig's whisper, 212.6.
in aqua scribere, 203.28.
in a rut, 356.1.
in a scrape, 281.14.
in a snit, 21.5.
in a stew, 22.9.
in a tiff, 21.6.
in a while, crocodile, 131.26.
in a wopse and a wudget,
 281.1.
in [one's] bad books, 101.14.
in bad odor, 101.8.
in bad repute, 144.1.
in bed with [one's] boots on,
 109.16.
in [one's] birthday suit,
 271.17.
in black and white, 29.5.
in [someone's] black books,
 101.9.
in brass, 3.3.
in cahoots, 66.2.
in Carey Street, 277.12.
in chancery, 281.15.
in character, 160.3.
in clover, 163.11.
in clover, 189.10.
in cold blood, 42.4.
in cold storage, 2.4.
in [one's] cups, 109.17.
in deep water, 281.16.
in de pekel zitten, 281.13.
independent as a hog on ice,
 197.2.
independent as a
 woodsawyer's clerk, 197.3.
Indian file, 25.1.
Indian giver, 303.5.
Indian summer, 306.5; 402.8.
Indian summer, 402.4.
in dock, out nettle, 391.8.
in doleful dumps, 87.10.

J

Index

naked truth, 43.10.
namby-pamby, 203.20.
name in lights, 144.3.
[one's] name is mud, 101.13.
name of the game, 123.3.
name to conjure with, a, 269.15.
Nancy boy, 111.11.
nap, 328.6.
napoleon, 328.6.
nappe pliée, 237.1.
narrow at the equator, 175.6.
Narrowdale's noon, 2.6.
the natives are restless, 103.16.
nature abhors a vacuum, 202.1.
nature of the beast, 123.4.
naughty, 237.10.
naughty but nice, 237.10.
the nearer the bone the sweeter the meat, 189.8.
near shave, 279.4.
near the bone, 189.8.
near the knuckle, 189.7.
near to the bone, 340.2.
neat as a bandbox, 243.3.
neat as a pin, 243.4.
neat as ninepence, 243.4.
neat as nine-pins, 243.4.
neck and crop, 377.5.
neck and crop, 108.1.
neck and neck, 120.2.
neck of the woods, 227.11.
necktie frolic, 82.35.
necktie party, 82.35.
necktie sociable, 82.35.
necktie social, 82.35.
Ned Kelly was hanged for less, 37.5.
need, 277.10.
need it yesterday, 184.4.
neither fish nor flesh nor good red herring, 198.7.
neither hide nor hair, 4.4.
neither rhyme nor reason, 339.1.
nerd, 247.6.
nerdy, 247.6.
nert, 247.6.
nest egg, 240.19.
the never-never plan, 265.8.
Never Too Late, 142.1.
new ball game, 306.10.
Newgate frill, 271.20.
Newgate fringe, 271.20.
Newgate knocker, 271.20.

new lease on life, 31.11.
the New Left, 302.7.
a new wrinkle, 8.1; 185.12.
nice going, 52.3.
nice kettle of fish, 103.11.
nice Nelly, 296.8.
Nice Nellyism, 296.8.
nickel and dime to death, 265.9.
nickel nurser, 238.8.
nigger in the woodpile, 369.3.
nightcap, 153.18.
a night on the tiles, 324.13.
nil carborundum, 11.7.
nimble ninepence, 240.20.
a nimble ninepence is better than a slow shilling, 240.19.
niminy-piminy, 12.9.
nine days' wonder, 110.6.
nine tailors make a man, 327.8.
nineteen bites to a bilberry, 130.15.
nineteen bits to a bilberry, 130.15.
nineteenth hole, 153.19.
nineteen to the dozen, 371.9.
nine tellers mark a man, 327.8.
nip and chuck, 120.3.
nip and tack, 120.3.
nip and tuck, 120.3.
nip a nettle, 37.8.
nip in the bud, 375.12.
nit-pick, 245.2.
nitpicker, 245.2.
nitty-gritty, 157.5.
nob, 244.45.
nobby, 244.45.
Nobby Clark, 244.45.
nobby clerks, 244.45.
no bed of roses, 201.1.
Nob Hill, 244.45.
nobs, 244.45.
no butter sticks to [one's] bread, 10.12.
nod, 145.18.
noddies, 145.18.
no dice, 308.1.
a nod is as good as a wink to a blind horse, 159.17.
no eyes, 91.2.
no flies on [someone], 17.10.
no great shakes, 211.17.
no holds barred, 388.11.
no joy in Mudville, 87.13.
no man's land, 103.17.

no money, no mistress, 265.10.
no money, no Swiss, 265.10.
none of [one's] bird's egging, 319.1.
the noose is hanging, 301.7.
no rhyme or reason, 339.1.
Norman blood, 171.10.
nose of wax, 232.5.
nose out of joint, 223.10.
Nosey Parker, 235.8; 244.46.
no skin off [one's] ass, 199.4.
no skin off [one's] back, 199.4.
no skin off [one's] nose, 199.4.
no skin off [one's] teeth, 199.4.
no soap, 308.2.
no strings attached, 154.7.
no sweat, 114.11.
not a ghost of a chance, 188.7.
not a shot in the locker, 240.26.
not bat an eye, 60.13.
not be able to stomach [someone], 313.4.
not by a long chalk, 139.2.
not by a long shot, 139.3.
not care a pin, 199.5.
not care a rap, 406.12.
notch in his tail, 81.5.
notch on [one's] gun, 6.5.
not cricket, 290.5.
not dry behind the ears, 204.10.
not for love or money, 74.4.
not give a continental, 199.6.
not give a continental, 199.9.
not give a continental hoot, 199.9.
not give a damn, 199.7.
not give a fig, 199.8.
not give a hoot, 199.9.
not give a rap, 199.10.
not give a tinker's dam, 199.11.
not have a leg to stand on, 392.3.
not have all [one's] buttons, 145.13.
not have the foggiest (idea), 63.12.
nothing like leather, 283.4.
nothing to sneeze at, 405.3.
no tickee, no shirtee, 265.10.
no tickee, no washee, 265.10.
not just another pretty face, 3.10.

O

Index

part and parcel, 123.5.
Parthian fight, 213.14.
Parthian glance, 213.14.
Parthian shaft, 213.14.
Parthian shot, 213.14.
parting shot, 213.14.
party pooper, 308.3.
Pas de lieu Rhône que nous, 336.6.
passion pit, 244.53.
pass muster, 55.6.
pass over to the majority, 82.29.
pass the bottle of smoke, 286.13.
pass the buck, 220.7.
pass the hat, 352.5.
pass the Rubicon, 84.3.
pass under the yoke, 361.7.
patch the lion's skin with the fox's tail, 274.6.
pâté de foie, 72.11.
patellar reflex, 187.8.
patient as Griselda, 264.1.
patrue mi patruissime, 361.3.
Patty Hodge's chair, 281.25.
Paul Pry, 235.9.
Paul's man, 34.8; 201.6.
Paul's walkers, 201.6.
pave the way, 284.9.
pay as you go, 265.14.
pay [one's] debt to nature, 82.16.
pay dirt, 365.12.
pay [one's] dues, 405.4.
P. A. Y. E., 265.14.
pay in [one's] own coin, 320.7.
pay [someone] in washers, 265.15.
payoff pitch, 79.3.
payola, 389.8.
pay [someone] peanuts, 265.15.
pay [one's] scot, 265.16.
pay scot and lot, 265.16.
pay the fiddler, 64.4.
pay the piper, 64.4.
pay through the nose, 74.7.
pay through the nose, 195.8.
pay too dearly for [one's] whistle, 74.8.
pay with the roll of the drum, 220.8.
p. d. q., 212.11.
peace pipe, 266.10.
The peacock looking at his feet wept, 186.7.

peacock's feet, 186.7.
pea in the shoe, 223.11.
peanut gallery, 211.21.
pebble on the beach, 211.22.
pecking order, 358.24.
Peck's bad boy, 119.35; 237.11.
Pecksniffian, 176.10.
peed off, 223.2.
peeled garlic, 271.21.
peeping Tom, 342.4.
peg out, 82.38.
a peg too low, 87.15.
peg trousers, 256.19.
pelican crossing, 26.9.
pelican crossings, 26.9.
pell-mell, 103.20; 187.10.
peluca, 359.6.
pencil pusher, 253.16.
penniless in Mark Lane, 395.27.
penny-ante, 211.23.
penny dreadful, 338.3.
penny dropped, 305.3.
penny in the slot, 394.14.
penny pincher, 238.9.
penny wise and pound foolish, 190.7.
penny wise and pound foolish, 190.13.
people who live in glass houses shouldn't throw stones, 400.12.
perish forbid, 293.3.
perish the thought, 293.3.
persimmon above [one's] huckleberry, 54.2.
Peter Funk, 370.17.
Peter Funk auction, 370.17.
peter out, 47.7.
Peter principle, 203.23.
Philadelphia lawyer, 344.4.
phone phreak, 389.11.
phone phreakdom, 389.11.
phone phreaks, 389.11.
pick-a-back, 228.1.
to pick a hole in [someone's] coat, 146.6.
pick [someone's] brains, 136.9.
pick holes in, 146.6.
pickle, 298.8.
pick-me-up, 153.5.
pick of the litter, 129.11; 129.14.
pick straws, 351.9.
pick up the pieces, 306.7.
pick up the slack, 70.8.

pick up the threads, 31.12.
pidgin, 225.13.
pidgin English, 225.13.
pidgin English, 228.3.
pie card, 364.9.
pie-card artists, 364.9.
a piece of cake, 114.12.
piece of goods, 244.4.
a piece of the action, 18.4; 217.6.
a piece of the pie, 18.5; 165.3; 217.7.
pie-eyed, 109.26.
pie in the sky, 183.9.
Piers Plowman, 398.1.
pigeon, 395.28.
piggyback, 228.1.
pig in a poke, 370.18.
pigs in clover, 189.9.
pig's wings, 129.8.
piker, 238.10.
pile Pelion upon Ossa, 159.19.
pilgarlic, 271.21.
pillars to the temple, 125.17.
pin, 184.8; 312.13.
pinch-hit, 26.10.
to pinch pennies, 238.9.
pin [someone's] ears back, 312.13.
pink slip, 138.14.
pin money, 240.21.
Pins and needles, 22.14.
pin to [one's] sleeve, 67.9.
pinup, 297.1.
pinwheel, 397.1.
pipe down, 345.4.
pipe dream, 183.10.
pissed off, 223.2.
pissing-while, 110.7.
piss off, 223.2.
piss on a nettle, 37.8.
piss on ice, 14.11.
pitchers have ears, 332.7.
the pits, 87.16.
pit stop, 317.4.
a place for everything, 243.5.
a place for everything and everything in its place, 243.5.
a place in the sun, 142.9; 144.4.
place on the bed of Procrustes, 77.9.
a plague on both your houses, 213.15.
plain as a packstaff, 252.3.
plain as a pikestaff, 252.3.

Pyrrhic victory, 257.4.

Q

quack, 286.16.
quacksalver, 286.16.
quake in one's boots, 148.7.
Quaker bargain, 43.14.
Quaker guns, 286.17.
quantum leap, 8.2.
quarrelsome as Kilkenny cats, 51.5.
quarrel with [one's] bread and butter, 105.7.
queen, 111.11.
Queen Anne is dead, 322.10.
Queen Anne's fan, 213.1.
Queen Dick, 203.25.
Queen of the May, 111.11.
the Queen's English, 94.2.
Queen's weather, 402.10.
queer, 111.11.
queer as a clockwork orange, 232.3.
queer as Dick's hatband, 203.25.
queer in the attic, 111.14.
queer [one's] pitch, 379.9.
queers the pitch, 379.9.
quelque chose, 406.9.
quench [one's] thirst at any dirty puddle, 289.15.
the quick, 99.4; 340.6.
quick as a wink, 261.12.
quick on the draw, 17.14.
quicumque vult, 289.2.
quidnunc, 235.12.
Qu'ils mangent de la brioche, 131.20.
Qui me amat, amet et canem meum, 383.3.
quit cold turkey, 375.13.
quite a dish, 244.4.
quite a number, 244.4.
quite exhausted, 306.8.
"*Qui vive?*", 17.12.
quixotic, 244.38.
quiz, 376.8.
quiz kid, 376.8.
quiz show, 376.8.
quizzing glass, 376.8.
quod in ore mumpsimus, 251.4.
quod in ore sumpsimus, 251.4.

quote-unquote, 327.12.

R

rabbit ears, 340.4.
rack [one's] brains, 378.8.
Rafe, 247.7.
Ragamoffyn, 277.20.
ragamuffin, 277.20.
Ragman Roll, 225.16.
rag on every bush, 289.16.
ragtag and bobtail, 358.26.
railroad, 122.10.
rainbow chaser, 177.7.
rain cats and dogs, 402.11.
rain check, 2.10.
rainmaker, 112.7.
rain pitchforks, 402.12.
raise an eyebrow, 146.9.
raise Cain, 35.4.
raise [one's] screw, 240.23.
raise the ante, 28.8.
raise the devil, 35.4.
raise the dickens, 288.4.
raise the roof, 158.12.
raise the white flag, 361.8.
raise [oneself] up by [one's] own bootstraps, 336.7.
raisin in the sun, 98.10.
rake over the coals, 312.12.
Ralph, 247.7.
Ralph Spooner, 247.7.
ram down [someone's] throat, 50.7.
Rangoon runs, 181.11.
the rank and file, 358.27.
rap, 406.12.
rap on the knuckles, 312.19.
rare as hen's teeth, 207.2.
rare as hen's teeth, 4.6.
rare kettle of fish, 103.13.
raring to go, 301.8.
rat, 33.9.
ratchet jaw, 371.10.
rate of two-forty, 354.3.
rat race, 155.7.
rattle [one's] cage, 63.17.
rattle [someone's] cage, 294.9.
rattle the saber, 32.11.
rattletrap, 393.9.
razz, 213.10.
razzle-dazzle, 63.18.
reach the bottom of the barrel, 406.3.
read between the lines, 267.8.

read [one] like a book, 267.9.
read the riot act, 312.20.
ready rhino, 240.24.
the real McCoy, 160.4.
Received Pronunciation, 94.3.
reckon without [one's] host, 191.5.
reck [one's] own rede, 11.10.
recover the ashes, 56.10.
red-carpet treatment, 147.8.
redder, 235.13.
redding blow, 235.13.
the redding stroke, 235.13.
red-eye, 153.24.
red-flag term, 225.15.
red-handed, 169.5.
red herring, 274.7.
red-letter day, 324.18.
red-light district, 227.15.
redneck, 65.6.
red tape, 59.4.
red up, 284.11.
reed shaken by the wind, 391.13.
regular brick, 67.10.
a regular Trojan, 202.2.
representative for Berkshire, 181.7.
resting on [one's] laurels, 57.3.
rest on [one's] laurels, 45.8.
rest on [one's] oars, 317.5.
resurrection man, 76.24.
retain the ashes, 56.10.
return [one's] breakfast, 181.18.
return to our muttons, 319.2.
Revenons à ces moutons, 319.2.
revenons à nos moutons, 319.2.
revolving door, 311.4.
rhinocerical, 240.23.
rhino fat, 240.23.
rhyme or reason, 339.1.
rib [someone], 394.16.
ribbing, 394.16.
rib someone, 394.16.
riddle and shears, 231.10.
ride a hobbyhorse, 249.3.
ride at the ring, 326.1.
ride backwards up Holborn Hill, 82.41.
ride bodkin, 99.2.
ride for a fall, 328.12.
ride herd on, 107.11.
ride in on [someone's] coattails, 90.7.

S

sail against the wind, 197.9.
sail before the wind, 291.6.
sail close to the wind, 189.12.
sail near to the wind, 189.13.
sail under false colors, 286.19.
Saint Audrey, 256.16.
Saint Audrey's lace, 256.16.
salad days, 204.8; 407.4.
salarium, 67.14.
salt, 244.49.
salt away, 149.10.
salt mines, 260.5.
salt of the earth, 358.29.
salty dog, 244.49.
sam, 156.10.
same ball game, 346.12.
the same ball game, 306.10.
Sam Hill, 125.21.
sanctum sanctorum, 330.3.
sandbag, 368.13.
sandbagging, 368.13.
sand-hiller, 277.4.
sand-lapper, 277.4.
sands are running out, 390.5.
San Quentin Quail, 118.6.
sardine's whiskers, 129.8.
sardonic grin, 327.14.
sardonic laughter, 327.14.
sardonic smile, 327.14.
Saturday night special,
 244.57.
saucered and blowed, 60.11.
sauerkraut, 244.39.
save [one's] bacon, 122.8.
saved by the bell, 314.5.
save face, 101.12.
save the mark, 131.12.
sawbones, 253.18.
saw wood, 351.11.
say an ape's paternoster, 99.3.
say cheese, 11.11.
say uncle, 361.3.
scab, 33.10.
scab, 76.1.
*the scalded dog fears even cold
 water*, 224.2.
scam, 370.19.
scamp's game, 370.19.
scapegoat, 395.29.
Scarborough warning, 368.14.
scarce as hen's teeth, 4.6.
scare, 220.5.
scare the daylights out of
 [someone], 148.6.
scat, 161.5.
scat singing, 161.5.
scattergood, 190.9.

Scavenger's daughter, 50.1.
sceot, 265.16.
schlock, 124.11.
schlock shop, 124.11.
schnüffeln, 55.8.
scofflaw, 76.26.
scot, 265.16.
scot and lot, 134.2; 265.16.
Scotch verdict, 198.8.
scout's honor, 13.6.
scram, 138.2.
scrambled eggs, 244.58.
scrape, 281.14.
*scrape the bottom of the
 barrel*, 406.3.
scratch, 301.5.
scratch for [one]self, 336.9.
scratch line, 301.5.
*scratch my back, I'll scratch
 yours*, 304.1.
scream, cry, 35.6.
the screaming meemies, 22.18;
 36.5.
screw, 240.22.
screwed, 240.22.
screw up [one's] courage,
 37.9.
screw [oneself] up to concert
 pitch, 284.12.
scuttlebutt, 206.4.
Scythian defiance, 75.4.
the seamy side, 86.7.
*se battre contre les moulins à
 vent*, 183.11.
second chop, 129.13.
second wind, 306.8.
*se couper le nez pour faire
 dépit à son visage*, 127.4.
secretary's breakfast, 153.13.
security blanket, 292.5.
see a dog about a man,
 125.22.
see a man about a dog,
 125.22.
see a man about a horse,
 125.22.
see a wolf, 345.6.
see eye to eye, 16.5.
see far in(to) a millstone,
 267.10.
see how the cat jumps, 135.14.
see how the land lies, 216.8.
seek a knot in a bulrush,
 245.3.
seek another in the oven,
 346.8.
see Naples and die, 79.4.

see red, 158.13.
see the elephant, 324.19.
*see the light at the end of the
 tunnel*, 79.2.
see through [someone],
 267.10.
see through a brick wall,
 267.10.
see through a millstone,
 267.10.
see which way the cat jumps,
 135.14.
see-you, 131.25; 147.10.
see you later, alligator,
 131.26.
seize the day, 136.12.
Sejan horse, 10.14.
*to sell a bear: to sell what one
 hath not*, 149.1.
sell down the river, 33.11.
selling card, 118.2.
sell like hot cakes, 261.13.
sell smoke, 286.13.
*to sell the bearskin before one
 has caught the bear*, 149.1.
sell the pass, 33.12.
send a sow to Minerva, 191.7.
send owls to Athens, 194.6.
send packing, 138.6.
send the helve after the
 hatchet, 190.10.
send to Coventry, 298.24.
send to Dulcarnon, 63.19.
send to the showers, 138.16.
send up, 327.15.
send up the river, 298.25.
separate the sheep from the
 goats, 77.12.
serpent in [one's] bosom,
 33.13.
serpent-licked ears, 231.9.
serpent's tongue, 182.5.
serve a sop, 320.11.
serve at Crispin's shrine,
 253.13.
serve the same sauce, 320.10.
serve two masters, 259.5.
set a fire under, 294.1.
set [one's] cap for, 299.5.
set cock a hoop, 115.1.
set [one's] face, 69.17.
set [one's] house in order,
 307.5.
set of drapes, 49.10.
set of threads, 49.10.
set on cinque and sice, 103.2.
set on six and seven, 103.2.

sitting in the catbird seat,
9.14.
sitting pretty, 9.16.
sit upon, 184.5.
sit upon hot cockles, 184.5.
sit up with a sick friend,
274.9.
six, 396.7.
sixty-four-dollar question,
123.6.
*sixty-four-thousand-dollar
question,* 123.6.
skate on thin ice, 279.11.
Skeffinger's daughter, 50.1.
skeleton at the feast, 185.15.
skeleton in the closet, 332.11.
skeleton in the cupboard,
332.11.
ski bum, 220.9.
ski bunny, 220.10.
Skid Road, 227.17.
skid row, 227.17.
Skid Row, 86.6.
the skids, 86.6.
*skim milk masquerading as
cream,* 286.22.
to skin a flint, 238.11.
skin [someone] alive, 312.21.
skin an eel by the tail, 143.4.
skin flick, 297.2.
skinflint, 238.11.
skinning the cat, 135.9.
skinny dip, 125.23.
skin the bear at once, 43.15.
skin the same old coon, 311.8.
skulduggery, 76.27.
skull session, 53.6.
Skylark, 89.1.
skylarking about, 324.7.
the sky's the limit, 388.19.
slapbang, 44.4; 261.14.
slapdash, 44.5.
slaphappy, 145.16.
a slap in the face, 213.16.
slap it on the plastic, 244.54.
slap of the tongue, 312.24.
slapstick, 174.10.
slap-up, 129.25.
sledge-hammer argument,
112.8.
sleep like a top, 351.13.
sleep on a bag of saffron,
115.21.
sleep on it, 378.9.
sleep with one eye open,
286.6.
Sleepy Hollow, 227.18.

sleeveless errand, 159.25.
sleeveless reason, 159.25.
sleeveless words, 159.25.
sling hash, 253.20.
slings and arrows, 78.9.
sling the bat, 225.17.
sling the monkey, 324.20.
slip [someone] a Mickey,
153.14.
slip of the pen, 137.24.
slip of the tongue, 137.24.
slippery as an eel, 126.16.
the slippery slope, 108.7.
slip some skin, 71.5.
slip [one's] trolley, 111.12.
slough of despond, 87.18.
slow as cold molasses, 261.16.
*slow as molasses going uphill
in January,* 261.16.
slow as molasses in January,
261.16.
slow burn, 158.14.
slush, 240.27.
slush fund, 240.28.
sly as old boots, 344.5.
sly-boots, 286.20; 344.5.
small beer, 211.5.
small gun, 291.3.
small potatoes, 211.27.
smart Alec(k), 171.13.
smart alecky, 171.13.
smart as a whip, 344.6.
smarts, 224.11.
smash the teapot, 382.14.
smash to smithereens, 329.11.
smell a rat, 369.4.
to smell of the inkhorn, 225.9.
smell of the lamp, 226.6.
smithereens, 329.11.
smithers, 329.11.
Smithfield, 16.6.
Smithfield bargain, 16.6.
Smithfield match, 16.6.
smoke, 286.13.
smoke the peace pipe, 266.10.
Smokey, 244.60.
Smokey Bear, 244.60.
smooth ruffled feathers,
273.5.
snake eyes, 295.8.
snake in the grass, 81.9.
snap [someone's] nose off,
158.1.
sneaky pete, 153.27.
to sneeze at, 405.3.
a snowball's chance in hell,
188.8.

snow bunny, 220.10.
snowed under, 260.6.
a snowflake's chance in hell,
188.8.
snow job, 236.12.
snuff film, 82.42.
snuff flick, 82.42.
snuff out, snuff, 82.42.
snug as a bug in a rug, 57.4.
soapbox orator, 133.3.
soapy Sam, 133.4.
sober as a judge, 373.6.
sob sister, 341.5.
sob stories, 341.5.
sob story, 341.6.
sob stuff, 341.5.
social butterfly, 145.17.
social ladder, 145.17.
social whirl, 145.17.
sock and buskin, 253.17.
sock away, 149.11.
sockdolager, 84.9.
socked in, 402.13.
soda, 195.16.
sodbuster, 247.10.
Sod's law, 96.11.
soft fire makes sweet malt,
184.6.
soft-soap, 150.7.
soil excavators, 49.8.
something rotten in Denmark,
369.5.
song, 74.3.
song and dance, 128.13.
son of a bitch, 125.24.
son of a gun, 125.24.
son of Belial, 403.3.
son of thunder, 133.5.
Sooner, 184.7.
a sop to Cerberus, 38.9; 273.6.
sorehead, 182.6.
SOS, 153.28.
*so that accounts for the milk
in the coconut,* 353.7.
*so that explains the milk in the
coconut,* 353.7.
sound as a bell, 162.8.
sounding board, 77.13.
sound on the goose, 275.10.
soup-and-fish, 49.11.
soupbone, 244.61.
sour grapes, 315.5.
southpaw, 97.6.
South Seas Bubble, 370.2.
sow dragon's teeth, 294.13.
So what else is new?, 322.10.
sow the wind, 64.5.

straight from the shoulder, 43.17.
strain at a gnat and swallow a camel, 176.11.
to strain at the leash, 184.2.
Strangelove, 32.6.
Strasbourg pie, 72.11.
straw boss, 269.18.
straw dogs, 395.31.
straw man, 395.26.
the straw that broke the camel's back, 79.5.
straw vote, 206.6.
street smarts, 224.11.
stretch [one's] legs according to the coverlet, 7.6.
strike a balance, 120.5.
strike a bargain, 16.7.
strike a raw nerve, 340.7.
strike a sympathetic chord, 16.8.
strike [one's] colors, 361.9.
strike [one's] flag, 361.9.
strike hands, 16.7.
strike oil, 365.14.
strike sail, 361.10.
strike the right chord, 16.8.
strike the right cord, 16.8.
strike the right note, 16.8.
strike while the iron is hot, 136.13.
string [someone] along, 286.21.
string along with, 90.8.
stripped to the buff, 271.17.
stroke the black dog down, 60.12.
struggle and strife, 233.21.
St. Tib's Eve, 380.8.
stubborn as a mule, 294.1.
stuck in the bark, 126.18.
stuff, 131.29.
stuff and nonsense, 131.29.
stuffed like a Strasbourg goose, 72.11.
stuffed shirt, 171.14.
stumble at a straw, 270.7.
stung by a serpent, 125.14.
stupid as a coot, 145.14.
St. Vitus's dance, 155.9.
sub rosa, 332.12.
such a run, 306.8.
sucker, 395.32.
sucker list, 395.32.
suck the hind teat, 395.33.
suck the monkey, 382.16.
sudden death, 212.13.

Suffolk milk, 286.22.
suffragettes, 154.1.
sugar and honey, 240.30.
sugar daddy, 14.13.
Sunday best, 49.12.
Sunday clothes, 49.12.
Sunday Examples, 271.14.
Sunday-go-to-meeting clothes, 49.12.
Sunday-go-to-meetings, 49.12.
sup with Sir Thomas Gresham, 175.7.
sure as eggs is eggs, 46.5.
sure as shooting, 46.14.
sur le tapis, 378.6.
sur l'ongle, 265.12.
sus Minervam, 191.7.
sus Minervam docet, 191.7.
-sville, 5.4.
swallow the anchor, 321.4.
swamp law, 298.16.
swan song, 79.6.
swap horses in midstream, 191.8.
swear like a trooper, 288.8.
sweat a person, 124.13.
sweat blood, 22.22.
sweat shop, 124.13.
sweat shops, 124.13.
sweep the board, 365.15.
sweep under the carpet, 61.8.
sweeten the kitty, 28.3.
sweeten the pot, 28.3.
Sweet F. A., 4.8.
Sweet Fanny Adams, 4.8; 288.9.
swing, 120.6.
swing of the pendulum, 198.9.
swings and roundabouts, 120.6.
switch hitter, 342.5.
sword of Damocles, 81.10.

T

T & A, 125.26.
table, 2.11.
the tables are turned, 325.10.
tabula rasa, 31.4.
tack, 343.8.
tacky, 343.8.
tag and rag, 358.26.
tail, 324.22.
tailgate instrument, 324.22.
tailgating, 324.22.

take a back seat, 363.4.
take a bath, 141.23.
take a deep breath, 116.1.
take a gander, 80.5.
take a gander, 80.3.
take a leaf out of, 346.14.
take a message to Garcia, 336.1.
take a page out of [someone's] book, 346.14.
take a powder, 89.15.
take a ride to Tyburn, 82.39.
take a rise out of, 294.5.
take a run-out powder, 89.15.
take a shine to, 229.8.
to take a sight, 213.5.
take by the sleeve, 352.8.
take [one's] coals in, 125.25.
take counsel with [one's] pillow, 378.4.
take [one's] davy on it, 13.7.
take down a notch, 173.9.
take down a peg, 173.9.
take eggs for money, 334.7.
take for a ride, 82.46.
take for gospel, 29.6.
take [one's] hat off to, 52.5.
take Hector's cloak, 33.17.
take in the toils, 395.34.
take into camp, 379.12.
take in tow, 168.4.
take in water, 121.16.
take in [one's] winter coals, 125.25.
take it in snuff, 21.15.
take it in stride, 114.14.
take it on the chin, 116.6.
take it on the lam, 122.6.
take lying down, 362.9.
take [one's] medicine, 316.3.
taken aback, 368.15.
taken to the cleaners, 370.20.
take soundings, 216.10.
take the ball before the bound, 17.16.
take the bark off, 298.30.
take the bear by the tooth, 328.15.
take the bit between [one's] teeth, 302.9.
take the bit in [one's] teeth, 302.9.
take the bull by the horns, 62.10.
take the cake, 258.10.
take the Fifth, 61.6.

U

upstage, 258.11.
up [one's] street, 282.7.
up stumps, 375.7.
up the ante, 28.8.
up the creek, 281.27.
up the spout, 221.5.
up to scratch, 55.7.
up to scratch, 55.9.
up to snuff, 55.8.
up to the gills, 109.34.
up to the handle, 377.10.
up to the hilt, 377.7; 377.10.
up to the mark, 55.9.
urban cowboy, 256.3.
use the rough side of [one's]
 tongue, 312.25.

V

van, 358.20.
vanguard, 358.20.
Vedi Napoli e poi muori,
 79.4.
vendre un canard à moitié,
 370.13.
venom is in the tail, 96.15.
vent [one's] spleen, 21.17.
[my] Venus turns out a whelp,
 325.14.
verbal diarrhea, 371.14.
verloren hoop, 92.4.
Vermont charity, 238.14.
the very spit, 346.13.
vicious circle, 96.16.
video jockey, 253.5.
vie et bagues sauves, 195.7.
vin de lyon, 109.36.
vin de mouton, 109.36.
vin de pourceau, 109.36.
vin de singe, 109.36.
V.I.P., 269.22.
visiting firemen, 35.8.
"Vive la France", 17.12.
"Vive le roi", 17.12.
*a voice crying in the
 wilderness*, 293.5.
a voice in the wilderness,
 293.5.
*vouloir prendre la lune avec
 les dents*, 159.7.

W

wages of sin, 298.34.
wait for dead men's shoes,
 91.10.
wale, 298.6.
walkabout, 228.3.
walk a tightrope, 45.11.
walked in Hempen Lane,
 395.27.
walking fire, 183.12.
walk in the footsteps, 346.5.
walk on eggs, 45.12.
walk Spanish, 138.19.
walk the carpet, 312.18.
walk the chalk, 55.10.
walk the plank, 138.20.
wallflower, 387.5.
walls have ears, 332.14.
walls have ears, 332.7.
Walter Mitty, 177.8.
to want jam on both sides,
 129.17.
to want jam on it, 129.17.
ward heeler, 248.15.
warm the cockles of the heart,
 117.12.
warts and all, 43.20.
wash a brick, 159.28.
wash [one's] dirty linen in
 public, 137.29.
washed out, 141.24.
wash [one's] hands of, 308.6.
WASP, 244.71.
a watched pot never boils,
 184.9.
watch the birdie, 11.11.
watch the submarine races,
 125.27.
water-cooler talk, 206.4.
watering hole, 124.14.
waterworks, 87.20.
wave the bloody shirt, 294.15.
to wave the red flag, 225.15.
way of the kami, 290.12.
way to go, 52.3.
weak sister, 75.8.
wear different hats, 3.13.
wear [one's] heart on [one's]
 sleeve, 229.10.
wear Hector's cloak, 33.17.
wearing of the green, 242.3.
wearing sackcloth and ashes,
 167.3.
wear the barley cap, 382.19.

wear the bull's feather, 205.8.
wear the cap and bells,
 174.11.
wear the horns, 205.9.
wear the pants, 107.17.
wear the willow, 167.5.
wear two hats, 3.13.
weasel words, 225.18.
weather-breeder, 254.5;
 402.15.
weathercock, 391.15.
weepers, 49.13.
weep millstones, 42.7.
weigh in the balance, 376.11.
well-heeled, 14.14.
wetback, 76.30.
wet behind the ears, 204.10.
wet blanket, 185.18.
wet blanket, 121.1.
wet [one's] whistle, 382.20.
We wuz robbed, 210.3.
wham, bam, thank you,
 ma'am, 230.14.
*what can you have of a cat
 but its skin*, 135.9.
*what has that to do with
 Bacchus?*, 24.5.
*what [one] loses on swings, he
 gains on roundabouts*,
 120.6.
*what possible rhyme or
 reason?*, 339.1.
What's that got to do with the
 price of eggs?, 24.5.
*What's that got to do with
 price of fish?*, 24.5.
what the dickens?, 141.15;
 288.4.
What the Sam Hill?, 125.21.
wheeler-dealer, 269.23.
when all is said and done,
 375.2.
when in Rome . . ., 7.5.
*When in Rome do as the
 Romans do*, 7.5.
when push comes to shove,
 127.10.
when the cat's away the mice
 will play, 237.15.
when the chips are down,
 390.7.
when the dust settles, 63.22.
when two Fridays come
 together, 207.3.

Index

wrangle for an ass's shadow, 245.5.
wrapped up in [oneself], 333.1.
wrinkle, 8.1.
write [someone] down, 78.11.
to write in the dust, on sand or on the wind, 203.28.
write off, 58.4.
write on water, 203.28.
write the book on, 29.7.
the writing on the wall, 254.1.
wrong side of the blanket, 189.14.
wrong side of the fence, 365.3.
wrong side of the tracks, 98.13.

Y

Yankee Doodle, 244.72.
yarborough, 406.19.

yecch, 313.6.
yell blue murder, 35.6.
yellow belly, 75.9.
yellow brick road, 231.3.
yellow dog under the wagon, 121.18.
yellow journalism, 338.4.
yen, 91.11.
yeoman service, 26.11.
you ain't heard [seen] nothin' yet, 131.32.
you can't add apples and oranges, 106.3.
you could hear a pin drop, 345.7.
young Turk, 302.11.
you pays your money and you takes your choice, 282.8.
yuck, 313.6.
yucky, 313.6.
yuk, 313.6.
yukky, 313.6.

Z

Z, 195.12.
zany, 174.12.
zebra crossing, 26.9.
zebra crossings, 26.9.
zed, 195.12.
zee, 195.12.
zero hour, 380.9.
zero in, 152.2.
zero in on, 152.2.
zing, 322.12.
zinger, 322.12.
zoot suit, 256.19.
zoot suiter, 256.19.
Zulu car, 393.10.